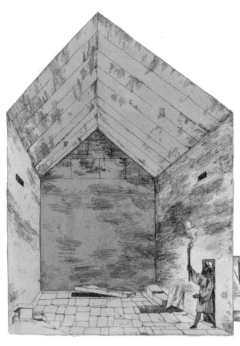

Giza and
the Pyramids

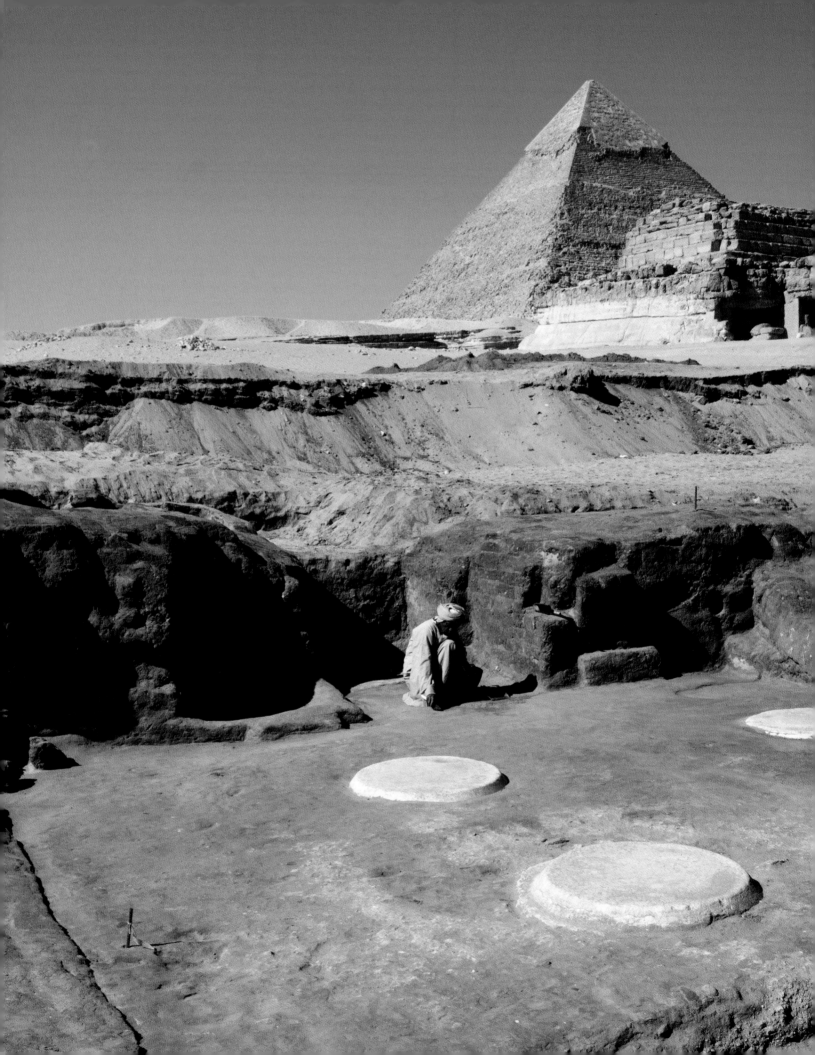

Mark Lehner and Zahi Hawass

Giza and
the Pyramids

The Definitive History

University of Chicago Press

Chicago

To William Kelly Simpson (1928–2017)

Mark Lehner would like to thank David Koch and
Ann Lurie, for making it possible for him to work
on this book over many years

HALF-TITLE Drawing by Giovanni Battista Belzoni
of his expedition entering the burial chamber of
Khafre's pyramid.

TITLE PAGE Excavations by Mark Lehner and AERA
at the Menkaure valley temple.

Mark Lehner is research associate at the Oriental Institute of the
University of Chicago and president of the nonprofit research
organization Ancient Egypt Research Associates. His books include *The
Complete Pyramids: Solving the Ancient Mysteries*. **Zahi Hawass** has
been both Egypt's secretary general of the Supreme Council of
Antiquities and its minister for antiquities. He is the author of many
books, including *The Lost Tombs of Thebes* and *King Tutankhamun*.

The University of Chicago Press, Chicago 60637
© 2017 Thames & Hudson Ltd., London
Published 2017

Printed in China by C & C Offset Printing Co. Ltd.

Published by arrangement with Thames & Hudson Ltd., London

25 24 23 22 21 20 19 18 17 1 2 3 4 5

ISBN-13: 978-0-226-42569-6 (cloth)

Library of Congress Cataloging-in-Publication Data
Names: Lehner, Mark, author. | Hawass, Zahi A., author.
Title: Giza and the pyramids : the definitive history / Mark Lehner and Zahi Hawass.
Description: Chicago : The University of Chicago Press, 2017. | Includes bibliographical
references and index.
Identifiers: LCCN 2016012482 | ISBN 9780226425696 (cloth)
Subjects: LCSH: Pyramids of Giza (Egypt) | Tombs—Egypt—Jīzah. | Egypt—Antiquities.
Classification: LCC DT73.G5 L425 2016 | DDC 932/.2—dc23 LC record available at
http://lccn.loc.gov/2016012482

∞ This paper meets the requirements of ANSI/NISO Z39.48–1992
(Permanence of Paper).

Contents

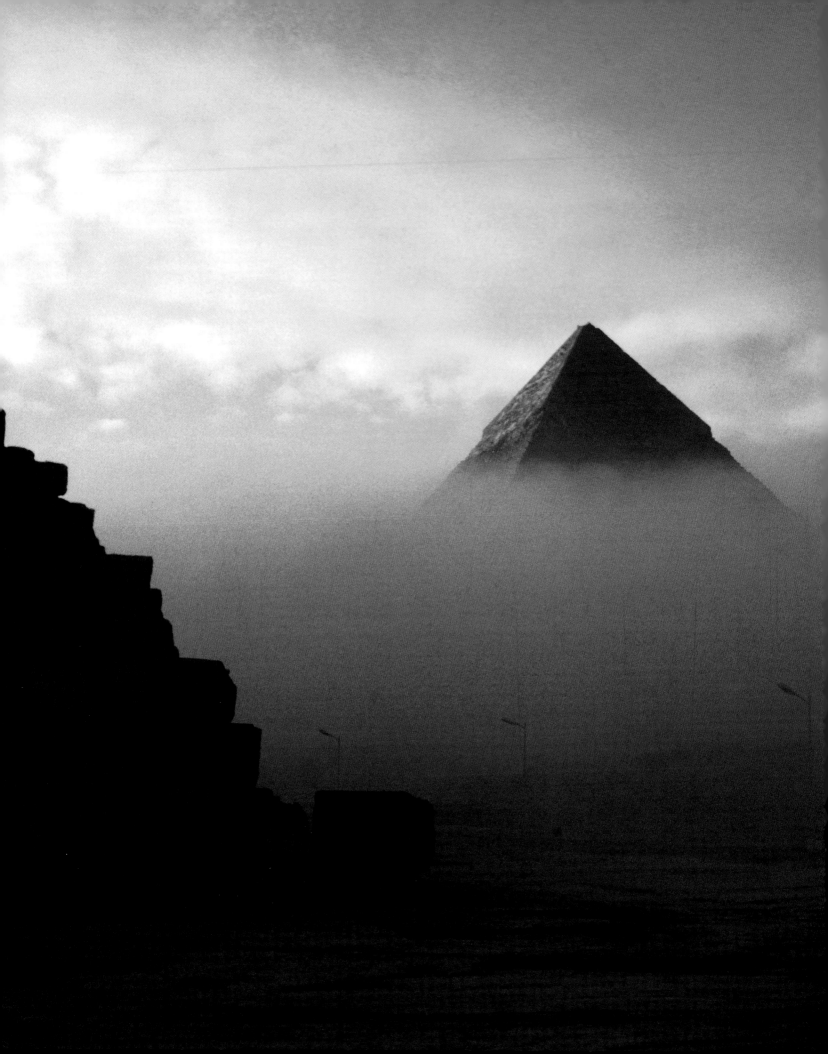

Preface

Our involvement with *Giza and the Pyramids* spans 42 years, longer, probably, than it took to build the Great Pyramid. We have worked on the book by this name for 30 of those years, but it began in 1986 in the hands of our mutual mentor, William Kelly Simpson. He had agreed with Thames & Hudson's indefatigable editor, Colin Ridler, to produce a general book on Giza along the lines of Jean-Philippe Lauer's *Saqqara, the Royal Cemetery of Memphis: Excavations and Discoveries Since 1850* (1976).

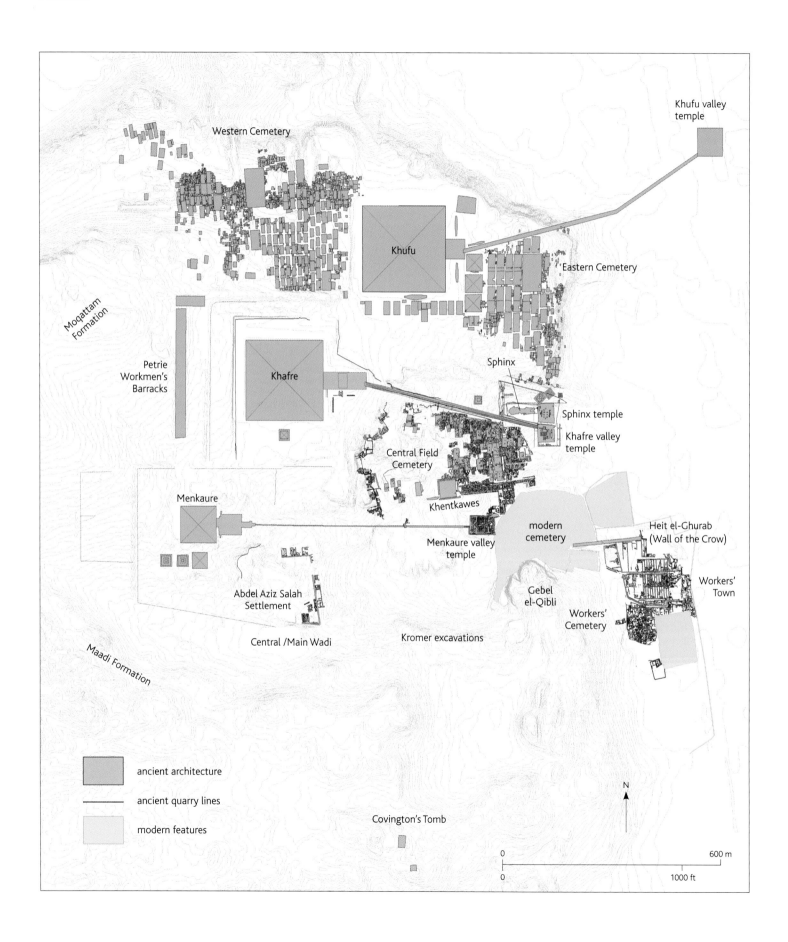

Western Cemetery

Khufu valley temple

Khufu

Eastern Cemetery

Moqattam Formation

Petrie Workmen's Barracks

Khafre

Sphinx

Sphinx temple

Khafre valley temple

Central Field Cemetery

Menkaure

Khentkawes

modern cemetery

Heit el-Ghurab (Wall of the Crow)

Workers' Town

Abdel Aziz Salah Settlement

Menkaure valley temple

Gebel el-Qibli

Workers' Cemetery

Maadi Formation

Central /Main Wadi

Kromer excavations

ancient architecture

ancient quarry lines

modern features

Covington's Tomb

N

0 600 m

0 1000 ft

Zahi Hawass had finished his PhD at the University of Pennsylvania. Mark Lehner was just beginning his PhD at Yale University. Mark remembers walking with Colin across the New Haven commons talking excitedly about all the 'new' material from our work at the Sphinx that we had to add to the history of research at Giza since 1850 – the rich archives and specialist publications of George Reisner at the Boston Museum of Fine Arts, Hermann Junker in Vienna and Selim Hassan in Cairo.

Some years later, in 1988 and 1991, we both were undertaking excavations at Giza beyond the low, southeastern rim of the Giza Plateau, south of the gigantic stone Wall of the Crow, or Heit el-Ghurab: Zahi the 'Workers' Cemetery', and Mark the 'Workers' Town'. Zahi had become Director of the Giza Pyramids and Mark a faculty member of the Oriental Institute at the University of Chicago. Our collaboration on the book *Giza and the Pyramids* became as essential as our collaboration on the Giza Plateau.

And then we became even busier. In Egypt, Zahi was made Chairman of the Supreme Council of Antiquities in 2002 and then Minster of Antiquities until 2012. Mark built up the independent non-profit organization Ancient Egypt Research Associates (AERA), to devote the time needed to salvage the Workers' Town or 'Lost City of the Pyramids', while also remaining a Research Associate at the University of Chicago. Together we developed with the American Research Center in Egypt (ARCE), and funded by USAID, a comprehensive field school programme for young Egyptian archaeologists working for the Ministry of Antiquities, with a dozen field school excavations over ten years at Giza, Luxor and Memphis.

At Giza, Mark and the AERA team, under Executive Director Mohsen Kamel, continued excavations of the Workers' Town over a span of seven football pitches in the Heit el-Ghurab (Wall of the Crow) site below the Gebel el-Qibli. David Koch and Bruce Ludwig were essential in getting Mark and his team started in 1988–89. In 1999 Ann Lurie made it possible for us to launch AERA's major clearing, mapping, survey and salvage of this 'Lost City', with her sustained support and a challenge grant met by the additional major support of David Koch, Peter Norton, Charles Simonyi, Lee and Ramona Bass and many others.

Zahi excavated at sites all over Egypt, from the golden mummies of Bahariya Oasis to the granite obelisk quarries of Aswan and the Valley of the Kings in Luxor, while also producing numerous books, articles and films.

For Thames & Hudson, meanwhile, Colin had Mark write *The Complete Pyramids* (1997), and Zahi, *King Tutankhamun: The Treasures of the Tomb* (2007), *The Lost Tombs of Thebes* (2009) and others. In the midst of our intensified research on the Giza Plateau, we held *Giza and the Pyramids* in abeyance.

At Giza alone, Zahi brought to light, in addition to those of the Workers' Cemetery, many new tombs – not least the tomb of Kay [0.3] and the tomb of the dwarf Perniankhu [0.5] in the Western Cemetery. Zahi also discovered the satellite pyramid

PREVIOUS PAGES
0.1 Fog shrouds the Giza Plateau, with the tip of the pyramid of Khafre emerging into the sunlight.

OPPOSITE
0.2 Plan of the Giza Plateau showing the major features and topography. (Modern contours at 1-m intervals.)

BELOW
0.3 Fine wall paintings in the tomb of Kay (G 1741), discovered in the Western Cemetery. Kay was a priest of Sneferu, Khufu, Khafre and Djedefre.

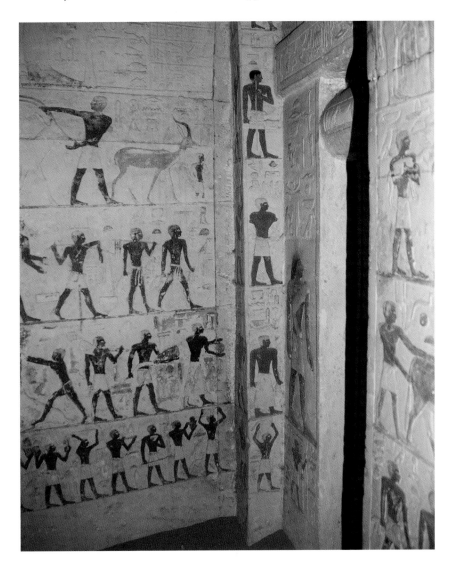

11

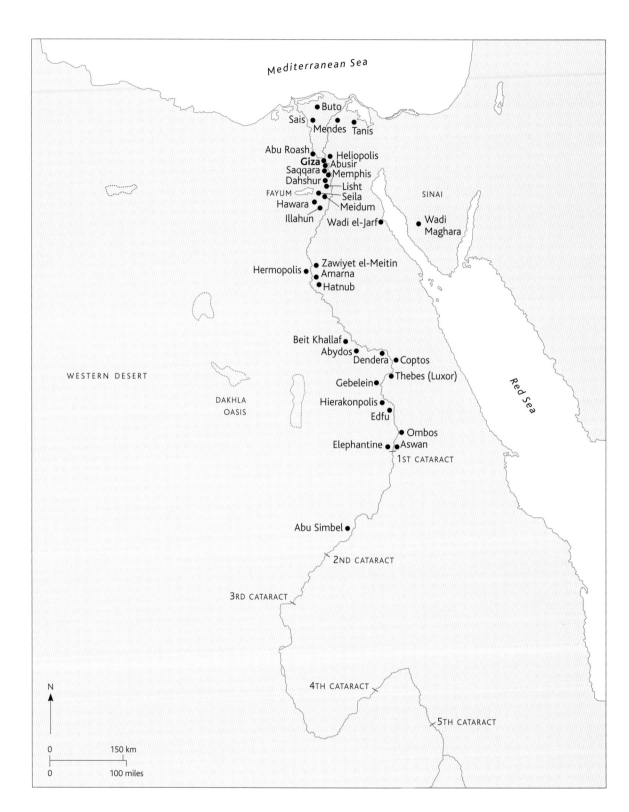

0.4 Map showing the Nile and the major sites mentioned in the text.

of Khufu, and excavated ancient ramps, pyramid builders' marks, and much more. Mark and the AERA team re-examined in detail the Khentkawes Town, excavated in 1932 by Selim Hassan, and the Menkaure valley temple, excavated in 1908–10 by George Reisner. They found a basin, possibly part of Giza's westernmost Nile harbour, and the Silo Building Complex on its eastern bank. Mark reconstructed the 4th dynasty waterways and harbours, based on this and other evidence that had been brought to light over the previous 30 years.

'New' in 1986 had become old hat by 1996, more so by 2006, and a completely changed and vast archive by 2016. The abundance of new tombs and data on the pyramid builders' everyday lives – their clay sealings, plant remains, animal bone, their bakeries, butcheries and workshops – now comprise new archives as rich and robust for further research as those excavated by Hassan, Reisner and Junker in the prior century.

Over the years the book *Giza and the Pyramids* evolved with our research. Chapters had to be added to or rewritten decades apart, and it seemed almost as though we were editing someone else's writing. In fact we were – the writing of our own earlier selves, when we knew much less.

Our paths originally came together when Mark was on a 'New Age' quest and Zahi was beginning as Inspector some ten years before Kelly Simpson handed on the baton of this book. We met in 1974 at the party of a mutual friend. Mark had come in 1973 from North Dakota via Virginia Beach, motivated by Edgar Cayce's 'readings' and the search for the fabled 'Hall of Records', to be a Year Abroad Student at the American University in Cairo. Zahi had begun his archaeological career with excavations at Kom Abu Billo and Merimde in the western Delta.

It was Zahi's research at Giza that became the wellspring of his career. Mark's encounters with bedrock reality and Giza's ground truth transformed him through the cognitive dissonance of a paradigm shift. Together and separately we focused on the Giza Plateau for the next forty years, examining it in depth and in detail. Now we present *Giza and the Pyramids* as our personal overview for all readers.

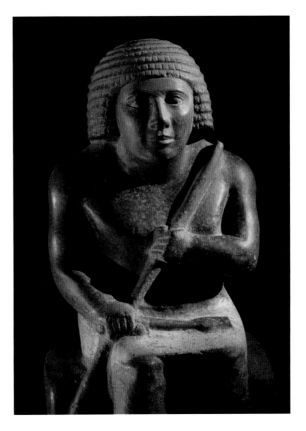

0.5 Seated statue of the dwarf Perniankhu, found inside a serdab in his tomb in the Western Cemetery. A rare example of non-royal statuary carved from basalt, it is a masterpiece of Old Kingdom art. Egyptian Museum, Cairo (JE 98944); 48 cm (19 in.) high.

We have stood on the Giza Plateau in the cold, predawn hour of January days, when a thick blanket of fog completely veils the pyramids. We have watched as the warmth and light of the sun, rising in the east, peels back the veil from the pinnacles of the pyramids, and rolls the fog off their eastern faces, until they stand fully lit in the mist that hangs just above their bedrock platform. Just as the Giza Pyramids then stand brilliant in the sunshine, we hope our work and this reporting of it helps to lift the fog that so often surrounds the pyramids, in both popular and professional thinking, for ourselves, for our own quests for truth, and for the bedrock reality. We offer *Giza and the Pyramids* to shed some more light on the last remaining wonder of the ancient world. Through it all, for your persistence, thank you Colin and all the team at Thames & Hudson, who have worked with us tirelessly for the past decade or more.

Mark Lehner and Zahi Hawass

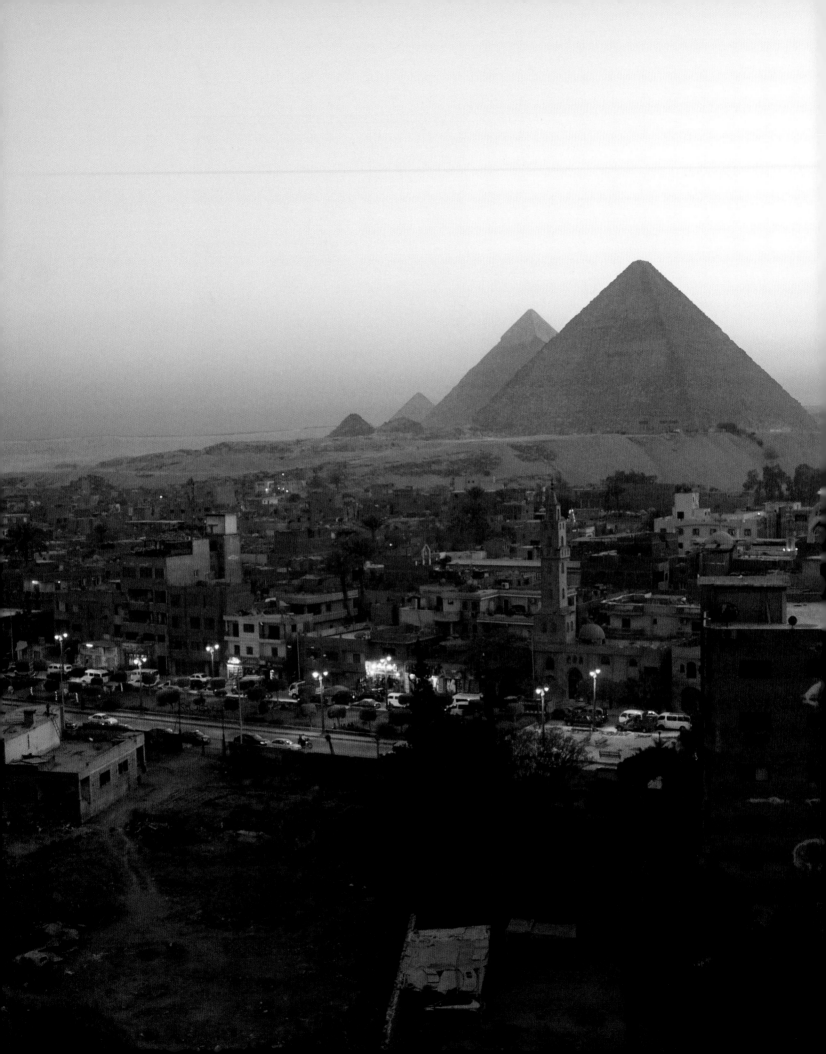

CHAPTER 1
Time's other horizon

We are writing this book about Giza and the pyramids in the early 3rd millennium AD – the beginning of the third thousand-year period after the birth of Christ in the Western count of years. Civilization was born in Egypt at the beginning of the 3rd millennium BC. The pyramids and Sphinx at Giza are towering ancient messages, both to all later Egyptians and to visitors from other countries, that here in the Nile Valley we humans arrived at a dramatic threshold in our career. Here we find the two largest of the over one hundred Egyptian pyramids. They belong to Khufu and Khafre, or Cheops and Chephren as they were known to the Greeks. Smaller and spaced further apart, the third pyramid, belonging to Menkaure, or Mycerinus, the third generation of Giza kings, strikes an informal balance with the larger two on Giza's western horizon. Together they stand like sentinels in a great northeast–southwest diagonal.

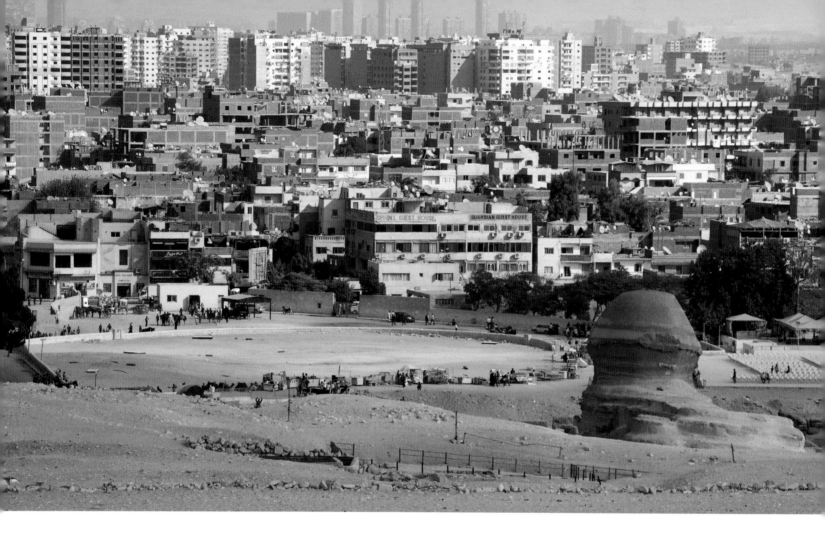

1.1 The pyramids of
Menkaure, Khafre and
Khufu, standing high on
the Giza Plateau, tower
over the modern city
of Cairo.

Each of these pyramids was the tomb of a king,
and stood as the centrepiece of a temple complex
that was standard in the Old Kingdom (c. 2543–
2118 BC). High up in the body of Khufu's pyramid
(GI, in the system used by Egyptologists), also
known as the Great Pyramid, were three chambers,
approached by corridors. The burial suites and
entrance passages in the pyramids of Khafre (GII)
and Menkaure (GIII) were carved into the bedrock
beneath the built stone superstructure.

Surrounding each pyramid a tall enclosure wall
defined a paved courtyard. At the centre of the
eastern base of each, facing the rising sun, was
a large upper temple, often called the mortuary
temple, where the king was worshipped as the
latest, divine incarnation of Horus, falcon god of
kingship. From the doorway of the upper temple
a causeway sloped hundreds of metres down to
the level of the Nile Valley. Walls and a roof of
great limestone slabs lined the Khufu and Khafre
causeways. The broad ceiling beams all but met in
the centre, allowing a narrow band of light to pierce
the long dark corridors. The causeways ended in
lower temples, called valley temples, which served
as monumental entrances to each entire complex.

Smaller pyramids accompanied the three
giant Giza pyramids. Some were for the principal
queens. Egyptologists refer to others as satellite
pyramids, but debate their purpose. Three ruined
queens' pyramids (GI-a, GI-b and GI-c) sit east
of Khufu's pyramid. In 1995 we discovered the
foundation of Khufu's small satellite pyramid (GI-d)
at the southeastern corner of his main pyramid.
No queens' pyramids have been found associated
with Khafre's pyramid, but the ruins of his small
satellite pyramid (GII-a) lie to the south, aligned
on the centre axis of the parent pyramid. At some
time people removed its superstructure so that
only the substructure (passage and chambers
below ground), the outlines in the rock foundation
and a few large stones of the core body remain.
Three smaller subsidiary pyramids stand in a row
south of Menkaure's pyramid. Some Egyptologists
think the king built the first to the north (GIII-a)
as his own satellite pyramid, because its internal
arrangement of T-shaped passage plus burial
chamber is the same as in the satellite pyramids
of Khufu and Khafre (and many later satellite
pyramids). The builders finished GIII-a as a true
pyramid (with sloping sides) while apparently

leaving the other two in steps. All three perhaps eventually housed queens' burials.

Pits containing boats, harbours and special districts in front of the valley temples known as the *ro-she* completed a pyramid complex, with an outer rough fieldstone wall enclosing each further out. Pyramid towns, for workers or for those who maintained the cult at each king's tomb, would also have been part of the living pyramid.

Contrary to many tourists' initial expectations, the Sphinx sits not high in the desert, but down low, near the bottom of the northwest to southeast slope of the Giza Plateau, next to the base of the Khafre causeway [**1.2**]. The ancient builders created the Sphinx by cutting a deep horseshoe-shaped quarry, open to the east, leaving a long stone core from which they sculpted the lion's body and the king's head. So the giant statue lies recumbent in a pit, emerging from the living rock.

Below the mighty outstretched paws, on a terrace 2.5 m (8 ft) lower than its lair, the ruins of a large temple with a central open court extend parallel to and north of the Khafre valley temple. The 4th dynasty builders formed the walls of both temples from huge limestone core blocks probably extracted from the Sphinx quarry. At the northeastern corner of the Sphinx sanctuary

lie the foundations of a smaller temple. This was built of mud bricks by the great-great-grandfather of Tutankhamun, the pharaoh Amenhotep II, in the New Kingdom's 18th dynasty, when the Sphinx was already at least 1,200 years old. Its ruins partly overlay those of the stone Sphinx Temple.

East and west of the Great Pyramid of Khufu stretch cemeteries of large mastaba tombs. 'Mastaba' is the Arabic word for 'bench' and the tombs are so named because their large rectangular structures with slightly sloping sides resemble the benches outside houses in the Egyptian countryside. Before any systematic excavation in modern times, the tops of the great mastabas broke the surface of the sand-sea like the backs of whales moving as a pod. Even before they were excavated, it was clear that these tombs were laid out in orderly streets and avenues, a precocious modernism resembling the gridded high-rise development of the city of Cairo that today presses up against the Giza Plateau on the northwest.

In the Western Cemetery three or four distinct groups of tombs were apparently planned blocks of development [**1.3**]. A smaller group of larger mastabas forms the core of the Eastern Cemetery, some belonging to Khufu's closest relatives, who were also his highest officials. Egyptologists know

OPPOSITE
1.2 The Sphinx crouches in its lair near the bottom of the slope of the Giza Plateau, next to the base of the Khafre causeway, gazing out at Cairo.

BELOW
1.3 The Western Cemetery (or Western Field) stretches away from the Khufu pyramid. Orderly streets of mastaba tombs were planned so that their occupants could benefit from their proximity to the royal tomb.

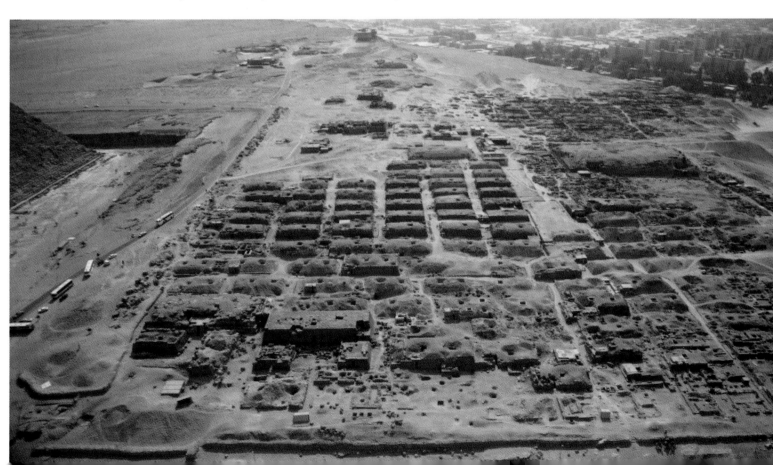

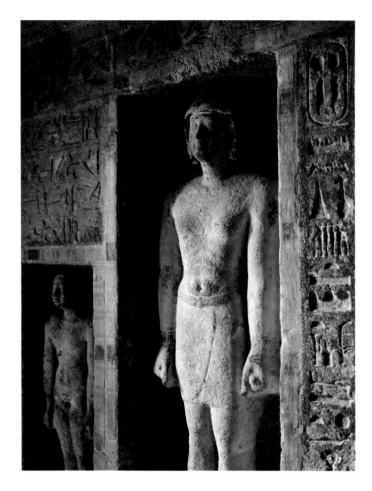

1.4 The tomb of Idu (G 7102) is positioned on the edge of the Eastern Cemetery and dates from the 6th dynasty. In the west wall of the tomb's chapel are six niches (one smaller than the others) containing statues of Idu, or Idu and family members. Carved and painted hieroglyphic inscriptions record his titles.

Overseer of All the King's Works, Greatest of the Ten of Upper Egypt and Master of Secrets [**1.4**].

South of Khafre's causeway lies what Egyptologists call the Central Field. Aligned due south of the Khufu pyramid, the western part of the Central Field is taken up by a great open quarry basin filled with enormous piles of debris. This probably formed the main quarry for the bulk of core stone for Khufu's pyramid, the first built at Giza; the debris must be the remains of the construction ramps and embankments used to construct it, pushed into the quarry when it was finished. The quarrymen cut a series of tombs directly from the bedrock in the western face of the quarry, which is some 30 m (98 ft) high. Three of these belong to children of Khafre who held high-ranking titles. Another series of rock-cut tombs is found in the 10-m (33-ft) high quarried face along the west base of the Khafre pyramid.

More tombs are crowded into the eastern part of the Central Field, behind the Khafre valley temple and southwest of the Sphinx. Older maps show what looks like a series of mastabas, similar to those in the main Western and Eastern cemeteries, but with less orderly spacing. In reality, the mastabas in this part of the Central Field were originally quarry blocks – large rectangular sections of natural limestone first defined by cutting channels as wide as hotel hallways. The ancient quarrymen then made narrower channels through these blocks to define smaller and smaller ones, until they arrived at the size they needed for building. Some of the divided sub-blocks still attached to the parent rock are megaliths and weigh scores if not hundreds of tons – like those used in the walls of the Khafre temples and Sphinx. After megalithic construction at the site ceased, the largest bedrock blocks were used as tombs; like the stone-built mastabas, they can contain shafts, tomb chambers and chapels.

The pyramid plateau proper is part of what geologists call the Moqattam Formation (for more detail on the geological context of the Giza pyramids, see Chapter 3). The plateau slopes gently from a high point west of the Khafre pyramid to the southeast at an angle of about 3 to 6 degrees, dipping into the low desert just south of the Sphinx and Khafre valley temple. The pyramids, causeways, temples and cemeteries were built into this gentle slope [**1.5**]. The Moqattam Formation

these groups by their Giza numbers: the main western groups are cemeteries G 1200, G 2000, G 4000 and G 5000 (the Western Cemetery); the one on the east is cemetery G 7000 (the Eastern Cemetery). A single row of large mastabas flanks the south side of the Great Pyramid (cemetery GI-S). The individual tombs have their own numbers – G 4720, for example.

Builders formed the bodies of the mastabas from debris encased by stone blocks. Shafts descend through them into the burial chambers carved out of the limestone bedrock, which often contain very large stone sarcophagi. Chapels to commemorate those buried below were attached to the exterior east face of the mastaba, the equivalent of the upper temple in the royal pyramid complex. In the mastaba chapels ancient Egyptian artists created small stelae and scenes on the walls, with hieroglyphic inscriptions, beautifully carved in relief and painted. The hieroglyphs include the official titles of the tomb owners – indexes to the social order of the Old Kingdom pyramid builders:

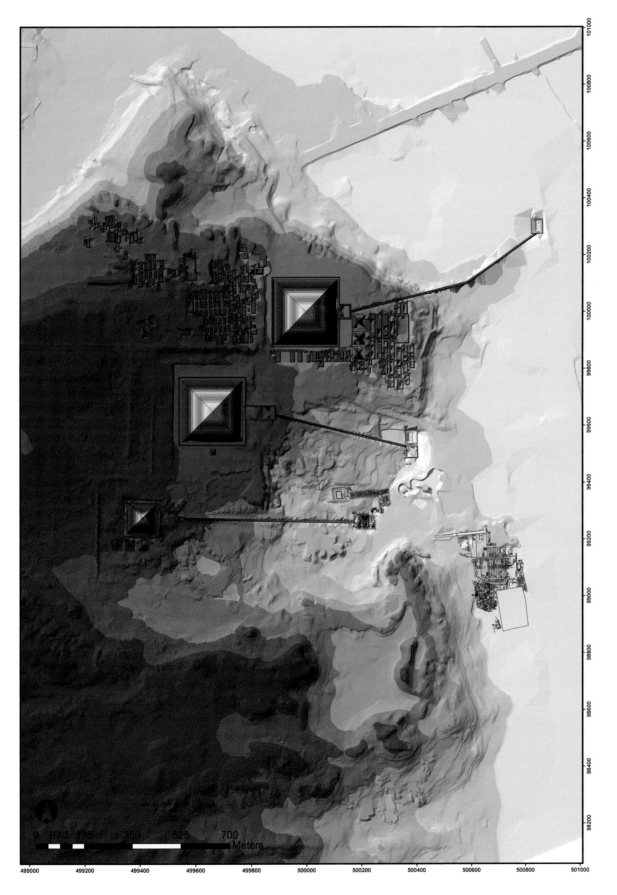

1.5 Rendering of the Giza Plateau to highlight the distinctive topography and how the monuments relate to it. The plateau slopes gently from northwest to southeast, and the three giant pyramids form a diagonal across it. Long causeways reach down to the valley floor, where temples were situated. Also down in the valley is an extensive settlement that we are excavating.

at Giza is bounded along the south by a shallow wadi or valley that we have called the Central Wadi. Along its northern edge, the formation ends abruptly at a cliff, dropping 30–40 m (98–131 ft) just 75–100 m (246–328 ft) north of the base of the Khufu pyramid. The escarpment also falls away immediately north of the north edge of the Western Cemetery.

Another plateau or geological formation, the Maadi Formation, rises along the south of the Central Wadi, about 1 km (⅗ mile) south of the Khufu pyramid. The eastern slope of the Maadi Formation ridge ends at a prominent knoll, the Gebel el-Qibli ('The Southern Mount'), that towers above the opening to the Central Wadi. The face of the knoll has been quarried into a rounded semicircular cliff that drops to the mouth of the wadi. Near its base, a gigantic stone wall with a monumental central gate stretches eastwards nearly 200 m (656 ft). It is called Heit el-Ghurab in Arabic, which means 'Wall of the Crow'.

The most prominent feature of the Maadi Formation at Giza is a large bowl-shaped depression, about 500 m (1,640 ft) across, located just behind the knoll. From the level of the wadi a broad ramp of dumped debris rises from the west – the direction of the Menkaure pyramid – up to the northeastern corner of the bowl. Where this ramp ends, Austrian archaeologist Karl Kromer found masses of stratified settlement debris in the early 1970s, with pottery, fish hooks and seal impressions of Khufu and Khafre (see pp. 56–57). The debris had been carried up the ramp, probably in small one-man baskets, and dumped in the northeastern corner of the bowl.

Across the bowl to the southwest, on the highest part of the Maadi Formation, are the ruins of a huge mud-brick mastaba of the Early Dynastic Period, known as Covington's Tomb, and, nearby, the foundation of another mastaba, also excavated by Kromer. The group lies 1.5 km (1 mile) due south of the Great Pyramid. In the early 19th century, three Early Dynastic mastabas were mentioned as being in Giza's southern zone, one each of the 1st, 2nd and 3rd dynasties. Only the large mastaba is known today (discussed in Chapter 4).

From the knoll that towers above the eastern mouth of the Central Wadi entrance, a ridge runs to the south. Since 1990 we have been excavating along the slope of the ridge and in the tract of low desert at its base. In 1906–07 W. M. F. Petrie had a team excavate a cemetery of rock-cut tombs along the top of the eastern Maadi Formation ridge. The tombs were cursorily mapped and little was known about them from Petrie's brief publication. Then, in 1989, we discovered tombs lower down the slope – simple tombs with chapels made of mud bricks and broken stone. This was the beginning of excavations that continue to this day. Under innocuous-looking drift sand, the eastern slope turned out to be riddled with an extensive cemetery for workers and petty officials, the 'Workers' Cemetery'.

Higher up the slope, the cemetery includes small limestone tombs with beautiful relief carving; three have long causeways formed of clay and stone rubble. There are mud-brick tombs in various shapes – beehive mounds with interior corbelled chambers, shafts and small mastabas the size of a desk top with tiny courtyards – miniature versions of the gigantic stone mastabas in the Eastern and Western cemeteries of the Great Pyramid.

At the base of the slope, we are excavating an extensive settlement of buildings constructed of stone rubble and mud brick that dates to the time of Khafre and Menkaure, the 'Workers' Town'. Four large blocks of parallel galleries, most probably barracks for rotating workers or a paramilitary force, take up the centre of the site. The inhabitants used many of the surrounding structures for storage and production. We find bakeries and facilities for meat- and fish-processing, copper-working and pigment-grinding. We continue to excavate to learn how the pyramid builders arranged storage and production, and what these facilities reveal about the social and economic organization that supported the construction of Egypt's biggest pyramids and the world's largest stone buildings. It is very possible that these facilities belonged to the pyramid towns of the three Giza pyramids. Egyptologists have long known from ancient texts of the existence of towns attached to each pyramid complex. We even know the names of the towns and of their overseers and mayors.

The eastern ridge of the Maadi Formation turns west 800 m (2,625 ft) south of the Wall of the Crow, and opens up into another broad wadi. A cemetery from the Late Period, incompletely excavated and not fully studied or mapped, punctuates

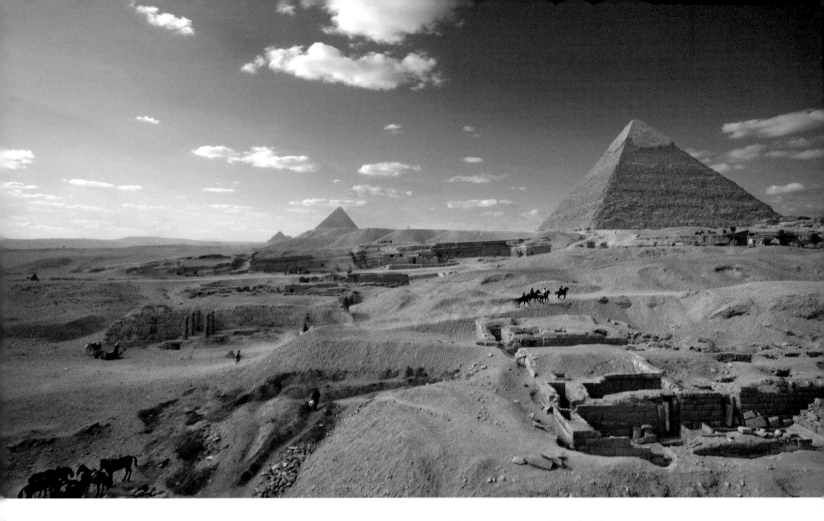

the northern slope of this wadi, facing south. Many tombs probably belong to the 26th dynasty (between 664 and 525 BC), or Saite Period – named after the capital of that time, the ancient site of Sais in the Western Delta. Thus a good 2,000 years after its heyday in the 4th dynasty, yet still 2,500 years before our time, Giza was regarded as sacred, shrouded in the mists of the past [1.6].

Like other Old Kingdom sites, in later times Giza was a choice burial ground for people high and low, so that they could be close to the divine ancestors who had created the massive, otherworldly pyramids. Huge, deep tomb shafts were cut along the path of the Khafre causeway, behind the Sphinx and on top of the ridge of the Workers' Cemetery. In our excavations of the settlement area south of the Wall of the Crow, we have found a field of Late Period graves cut into the thick mud mass of the ruined 4th dynasty buildings.

These are the principal archaeological and monumental features of the Giza Plateau, well known and mostly intensively researched. So why is it that at the beginning of the 3rd millennium AD many people look to Giza for spiritual sustenance? In facing future uncertainty and anxiety, we seem to need to find answers in time's other horizon – the

past. The context of the Giza pyramids and Sphinx – the full archaeological record – is unknown to many of those who turn to Giza as mystical seekers. The pyramids are very big, very old and seemingly permanent in a rapidly changing world. They must, these seekers believe, contain information, records – like the New Agers' legendary Hall of Records – that would help us understand the ever-accelerating human career.

We believe Giza does indeed contain records important for understanding the collective emergence and future of humanity. But these records are not to be found in a single hidden hall or vault where they were deposited by a lost civilization. Every facet and relationship of the material, the archaeological and documentary record – the stones, the hieroglyphs, the landscape and even the layers of dirt – hold stories for us to read. It is a crucial narrative for the common understanding of human history, because it documents a critical threshold, marked by the giant pyramids, of one of the world's oldest, most elegant and longest-lived great civilizations of antiquity. It is those stories that we wish to tell in this book.

1.6 The three pyramids of Khufu, Khafre and Menkaure, with their temples, are the best known of Giza's monuments, but the plateau is also crowded with extensive cemeteries of mastabas and rock-cut tombs, some dating from thousands of years after the pyramids were built.

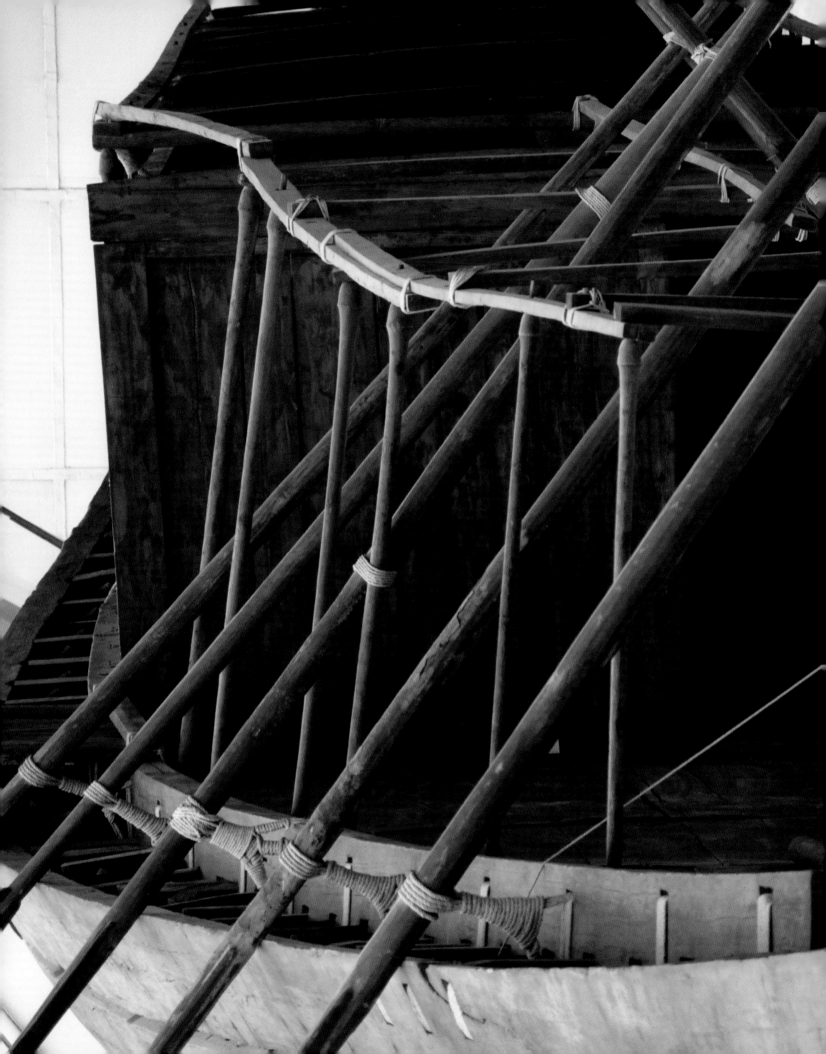

Quests, puzzles and questions

The pyramids stand like giant question marks. Who built these artificial mountains, how – and why? When did their civilization rise and fall? We are still asking these questions and working on the answers. But the pyramids are not a complete mystery. Over two centuries, Egyptologists and archaeologists have learnt much about these structures, their context at Giza and their place in the history of Egyptian civilization.

Even the ancient Egyptians asked one question – what did they hide? Explorations began with direct assaults to find a way inside and to discover their passages and chambers. As early as AD 820, according to Arabic tradition, the Caliph al-Mamun ordered his men to force an entry into the Great Pyramid of Khufu. By 1765, when Nathaniel Davison crawled into the first stress-relieving chamber above the King's Chamber, the pyramid's upper chambers and passages were already known. In 1817 Giovanni Battista Caviglia cleared the Descending Passage and the so-called Well. Two years later Giovanni Battista Belzoni found his way into the burial chamber of Khafre's pyramid – where Arabic script on the wall informed him that quarrymen and dignitaries had preceded him long before [2.2]. In 1837 Colonel Howard Vyse used gunpowder to blast his way into the passages and chambers of the Menkaure pyramid.

Over a century later, exploration of the Khufu pyramid continued. As discussed in detail in Chapter 8, in January 1992 Rudolf Gantenbrink, under the auspices of German archaeologist Rainer Stadelmann, sent a small, wheeled robot, carrying a video camera, to explore the mysterious so-called air shafts of the King's and Queen's Chambers. We already knew that the air shafts of the King's Chamber reach straight through the pyramid to the exterior. But after crawling some distance, Gantenbrink's robot found the southern shaft of the Queen's Chamber blocked by a stone slab with two projecting copper pins. Then in 2002 the Egyptian Supreme Council for Antiquities, in collaboration with National Geographic, sent an even more advanced robot to drill through this plugging block, only to find a continuation of the shaft, followed by another plugging block, this time without copper pins. A day after this event was telecast live to 250 million people around the world, the team members sent the video-bot up the northern Queen's Chamber air shaft, without the live cameras. They were amazed to discover another plug block, with another pair of copper pins. After years of assessment, an English team from the University of Leeds continued the investigations. On the limestone sides of the tiny shaft, the video revealed painted marks, most probably builders' control marks.

Sheer immensity and supremely elegant geometry have long prompted people to ask other questions of the pyramids, especially Khufu's. How big is it; exactly how tall? How many steps? How many stones? People seem perennially fascinated with the precise measurements of the Great Pyramid and what knowledge they might encode about the Earth. As early as 1638, John Greaves, Professor of Astronomy at the University of Oxford, came on a pilgrimage to the pyramid carrying 'a radius of ten Feet most accurately divided into ten thousand parts, besides some other instruments'.[1] Did not its designers use a sacred, 'earth-commensurate' cubit, making it a scale measure of the planet? No less a scholar than Sir William Matthew Flinders Petrie, who went on to become the 'Father of Egyptian Archaeology', came to Egypt for the first time in 1880 in order to

PREVIOUS PAGES
2.1 A close-up of the reassembled boat found dismantled in pieces and sealed in one of the boat pits associated with the Khufu pyramid, currently housed in a museum near where it was found.

RIGHT
2.2 One of the early explorers of the Giza pyramids was Giovanni Battista Belzoni. He located and opened the upper entrance of the Khafre pyramid, and made his way to the king's burial chamber, as illustrated here – but he discovered he was not the first to enter after the king was interred.

survey and measure the Great Pyramid as a believer in the 'pyramid inch'. He had learnt from his mentor, Charles Piazzi Smyth, Astronomer Royal of Scotland, that the inch was the key to the pyramid code [**2.3**]. Petrie's meticulous measurements spelled the demise – for him at least – of pyramid-inch theories (see also pp. 100–01). But interest in the measure of the Great Pyramid, and the potential of its divine dimensions, continues unabated today.

Then there is another question: who built the pyramids? By early Arab times mythical tales named the builder of the Great Pyramid as Surid, an antediluvian king. Another popular Arab legend identified the two largest Giza pyramids as the tombs of Hermes and Agathodaimon. Hermes was the Greek counterpart of the Egyptian Thoth, god of writing and intellect. The third pyramid belonged to Sab, son of Hermes. Like Surid, Hermes built the pyramids and temples to conceal literature and science from the uninitiated, and to preserve this knowledge through the Great Flood. Yemeni Arabs believed the two large Giza pyramids marked the tombs of Shaddad ibn Ad and another of their long-lost kings who defeated the Egyptians.

In fact the names of the Giza pyramid-building kings had never been forgotten, thanks to classical sources such as Herodotus, the Greek 'Father of History', who came to Egypt in the mid-5th century BC when the Egyptians still spoke, wrote and read their original language. Herodotus related many stories about the Giza pyramids (while strangely never mentioning the Sphinx) and about the kings Cheops, Chephren and Mycerinus. In 1638 John Greaves knew from his review of classical sources that the Giza pyramids were built by these three pharaohs as tombs to protect their bodies, in accordance with an ancient Egyptian conviction that this would ensure the endurance of the soul.

Evidence and alternative theories

Over the centuries, scholars and archaeologists have amassed a large body of evidence that testifies to the 4th dynasty (*c.* 2500 BC) pyramid-building kings at Giza, their families, culture and society. But many pyramid aficionados do not want to give up the notion that a lost civilization built the pyramids. Perhaps because they feel lost in our contemporary world, many people adhere to some form of the

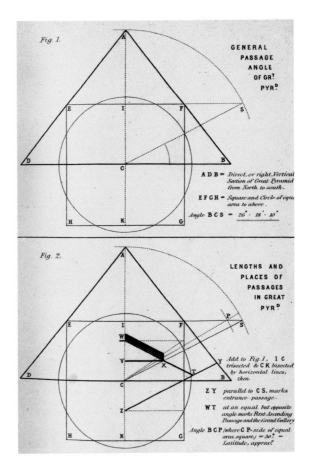

2.3 Two of the diagrams by Charles Piazzi Smyth, one of many theorists who have tried to demonstrate various precise geometrical patterns and meanings in the Great Pyramid.

idea that mysterious beings left us the pyramids and that they contain answers that will assuage our modern anxieties. Drawing on information from 'revealed' sources, including 'psychics' and 'channellers', literature of this genre is more akin to the Coptic and Arab legends mentioned above than real history. New Age theories connect the Giza Sphinx and pyramids to everything from Atlantis and lost tribes, to extraterrestrials and features of the Martian landscape. It is probably true that more people read and believe such alternative ancient histories of Giza than the accounts that archaeologists and Egyptologists write from the evidence. Tours led by guides versed in 'alternative Egyptology' and specializing in New Age ideas have been on offer for many years [**2.4**]. Abundant material evidence of real people and their 4th dynasty society is conveniently ignored.

That evidence ranges from sublime works of art to the simplest objects of everyday life – pottery, bone and stone tools, fish hooks and sewing needles [**2.5**]. Egyptologists have excavated stone statues of Khafre and Menkaure that rank among the finest

RIGHT
2.5 Examples of pottery vessels found at Giza dating to the 4th dynasty – just some of the abundant material evidence of the real ancient Egyptians and their society that built the pyramids.

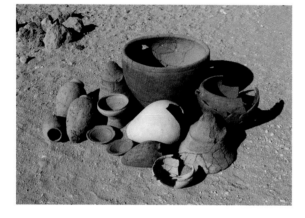

skies. The Egyptian Antiquities Service excavated the eastern boat in 1954, and in 1982 reconstructed it for display in a special museum above its find spot. They left the other *in situ*, viewed only in 1988 by a small camera inserted through a probe hole in one of the slabs that closes the pit, until a Japanese team from Waseda University opened it in 2011 and began to remove the timbers. These impressive ships show at once the combination of practical engineering skill and stylistic refinement of the pyramid builders. An entire world of thinking – radically different from ours – interlaces through the ship's structure, embedded in each and every knot of the massive ropes that bind together the whole. Likewise the boudoir furniture of no less a queen than the mother of Khufu – Hetepheres I – found in a hidden tomb. Her thrones, bed canopy and carrying chair, dressed in hammered gold and offset by dainty inlaid hieroglyphs, manifest imposing power (see Chapter 8). Through such evidence, we know something of these people.

In our popular lectures we show these masterpieces and ask our New Age friends why seek some *other*, lost civilization that built the pyramids? These rank as the most remarkable works of archaic civilizations found anywhere in the world. It doesn't get better than this. As we were excavating at Giza and sharing results immediately with a PBS/NOVA television 'online adventure', one young woman emailed asking, 'Why are you afraid to even consider the idea that the culture [that built the pyramids] was an advanced one and then disintegrated?' We wrote back: 'In fact, right now we *ARE excavating the disintegrated remains of an advanced culture,* the culture of Old Kingdom Egypt, dating around 2500 BC.'

But the alternative ideas do not diminish. Filling numerous boxes among our files, pyramid and Sphinx theories range from the reasonable to the ridiculous. We are awash with analyses of the Great Pyramid and the Giza Necropolis based on mathematical equations, grids of various unit-measures, spirals, angles, triangles, squares and circles. The Great Pyramid serves as a model of planet Earth, the human brain, the hydrogen atom, a volcano. Now dormant, it once served as an energy capacitor, a huge hydraulic pump or an astronomical observatory. The pyramid stands on an upside-down pyramid of pure crystal and equal size (according to

masterpieces in world art history. These, to be sure, are idealized images (the king's body is that of a champion athlete, with perfect abdomen, pectorals and biceps), with but a hint of portraiture in the face. The statues convey iconic divine kingship. Yet their makers etched into the bases the royal names so well known from classical sources, ancient king lists and numerous inscriptions discovered at Giza and elsewhere.

Equipment and furniture found in Giza tombs also offer glimpses of sophisticated elite lives during the time these kings ruled. Khufu's followers dismantled two huge wooden ships and laid the pieces into pits that they cut out of the rock on the south side of his pyramid. Some scholars believe the ships served for hearses, carrying the coffin and burial equipment to the pyramid, while others think that they were 'solar' boats for the deceased king to travel with the sun god through the day and night

a best-selling author of the New Age genre). Dozens of designs locate the legendary Hall of Records (the Lost Civilization's time capsule) in, under or around the Sphinx, or just about any and every place under the Giza Plateau. Maps of Giza's alleged tunnel networks rival the London Underground. Ley lines connect the Sphinx to the pyramids, Bethlehem and sacred sites all over the world.

In recent years John Anthony West, Graham Hancock and Robert Bauval have led the alternative genre relating to ancient Egypt, the Sphinx and the pyramids. We have little doubt that many more people read their books than any of the popular accounts based on the academic Egyptology and archaeology of the pyramids. West is a follower of R. A. Schwaller de Lubicz, who himself was fairly well versed in Egyptian art, language and architecture, but who left orthodoxy in the dust when he imagined that savants of the superior civilization of Atlantis scripted the history of ancient Egypt that would follow. Hancock is an apocalyptic thinker who sees in various monuments around the world hints of an extensive global civilization in times far more remote than any archaic civilizations archaeologists reconstruct from excavated material evidence. All three believe that people created the Sphinx, in some form, thousands of years ago before Egypt's Old Kingdom. They cite as evidence erosional patterns on the Sphinx (see also pp. 58–61), but mostly certain astronomical configurations.

The people of Giza

But these authors offer no explanation of how an Atlantis-dominated world civilization became so dramatically and completely lost – and how the culture of the Old Kingdom, 4th dynasty Egyptians then supplanted this supposed older civilization on the Giza Plateau, leaving instead their own royal statues, boats, tombs, coffins, bodies, texts, massive building dumps and potsherds embedded in every nook and cranny of the pyramids and temples and the bedrock floor around the Sphinx. We have excavated to arm's length natural fissures and cavities in that floor, literally in the shadow of the giant lion body. Up from the clay fill we have pulled Sphinx builders' debris – flint flakes from tool sharpening and small sherds of pottery typical of the Old Kingdom Egyptians. (We have extracted seven tons of similar pottery from our excavations of their cemeteries and settlements.) From as far as we could reach, lying on our sides on the bedrock floor beside the Sphinx, we have retrieved fragments of material characteristic of the Old Kingdom. It is everywhere at Giza, even filling the interstices between stones in the pyramids, where we have seen pottery embedded in the mortar.

One reads almost nothing of this material culture in the alternative literature. Nor will the reader learn anything there of the people who left their images (idealized or not), names and titles at Giza – nothing about Hemiunu, Khamerernebty, Debehen, Meretites, Nesut-nefer, Sheshemnefer – real people who lived real lives over four thousand years ago, lives so abundantly attested at the site of the Giza pyramids and Sphinx. We have so much more knowledge of the people who built the pyramids than is provided by the fabulous statues of their monarchs, their boats and furniture.

Archaeologists have found in the burial chambers of the hundreds of tombs at Giza numerous large sarcophagi, some inscribed with the names of those interred. They have recovered large numbers of human remains, complete skeletons and, sometimes, the deceased's accoutrements. The American archaeologist George Reisner's excavators found one woman's skeleton sprinkled with thousands of faience beads. Thanks to their meticulous records, more than 70 years later an Egyptologist and conservator at the Museum of Fine Arts in Boston reconstructed the beaded dress that covered this woman's body at the time she was buried [**2.6**, **2.7**]. Human remains excavated by Reisner between 1902 and 1932 were coded, catalogued and stored at Giza for many years in a shed west of the Great Pyramid. There one could see the skulls of the grandees of the courts of Khufu, Khafre and Menkaure (and of later reigns) lined up in rows on a wooden table like melons for sale in the market.[2]

Tomb chapels give us names of people and the family relationships of Khufu, Khafre and Menkaure. In the Eastern Cemetery, we can identify the great mastaba of Kawab, eldest son of Khufu, who must have died before he could inherit the throne. Beside it stands the mastaba of Djedefhor, long known for his wisdom texts, read by students

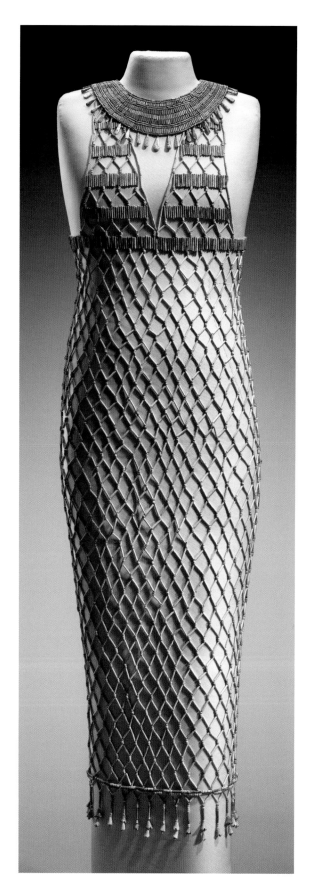

and scribes many centuries later. We can read names and titles: everything from Chief Justice and Vizier, to 'Master of Secrets of the King's Toilet House', as it was translated by early Egyptologists (literally 'House of the Morning'); in effect, if the king is a god, his private ablutions are a secret, but basically the title is that of 'secretary'.

In his rock-cut tomb below the second pyramid, Nikaure, a son of Khafre, inscribed his will: he owned 14 villages or towns, and two estates in the 'Pyramid Town of Khafre', in the proximity of the Giza Plateau. From titles of their overseers, Egyptologists learnt of pyramid towns – settlements dedicated to the perpetuation of each king's memorial. From these and other texts from Giza, Abusir and Saqqara, we glimpse the social history of this remote age. Scholars began to build up a picture of the people who built the pyramids, their families and their familiar concerns, such as property and inheritance.

We also have the likenesses of members of the royal court at Giza in the 4th dynasty, the time when the pyramids were being built. Of course, most statues of officials and nobles are idealized, with the same perfect, adolescent bodies as the

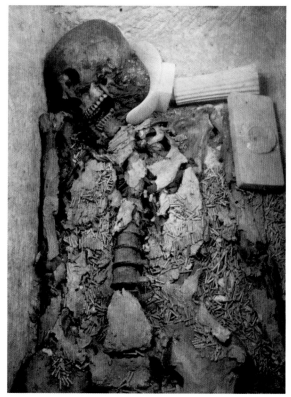

2.6, 2.7 Reconstructed bead net dress, consisting of approximately 7,000 faience beads, and a photograph of the situation in which it was found, in the undisturbed burial (G 7440Z) at Giza, dating from the 4th dynasty. The dress is now in the Museum of Fine Arts, Boston.

royal statues. But we also have the enigmatic 'reserve heads', carved from pure white limestone and found almost exclusively at Giza, usually at the bottom of a tomb shaft [2.8]. Idiosyncratic features suggest personal likenesses, though on the way to idealization. These reserve heads might be sculptors' trial pieces, three-dimensional sketch-drafts in the process of idealizing the life appearance – or perhaps the death-mask – of the subject person. All in a row on display in museums, they seem to gaze at us, pale, ghostly reflections of real personalities in the royal court of the pyramid builders.

Among the likenesses of courtiers who walked the sands of Giza when the pyramids were under construction, perhaps the best example – and among the finest portraiture from the ancient world – is the bust of Vizier Ankh-haf (see 2.10). We now know even more about Ankh-haf and his role in building the Great Pyramid, thanks to the oldest inscribed papyri ever found in Egypt. In 2013 Pierre Tallet and his team from the University of Paris-Sorbonne and the French Institute in Cairo found, amongst other remains, hundreds of papyri fragments at a port complex of Khufu on the Red Sea at the mouth of the Wadi el-Jarf [2.9] (see also pp. 526–27).[3]

Used only in the reign of Khufu, the port features galleries cut into the rocky escarpment and still containing wooden pieces of boats, as well as drystone buildings on the sandy plain. A stone mole curves out into the shallow water; within its elbow, dozens of limestone anchors lay on the sea bottom. Graffiti of gangs and ships' crews and abundant pottery date the site to the reign of Khufu. The port probably served for expeditionary crews crossing to Sinai, where they procured some of the tons of copper needed for tools to dress pyramid stones.

A Memphite man named Merer led one of those crews. Many of the papyri fragments, including one sheet up to 50 cm (20 in.) long, derived from his daily log. Other fragments, including a sheet 80 cm (31 in.) long, belong to accounts of how his men were fed with various foodstuffs, including meat roasts. The French team found the papyri between huge limestone blocks that closed the long galleries, not unlike the portcullises that sealed pyramid passages. Most curiously, nothing in Merer's journal or the account papyri pertain to the port of Wadi

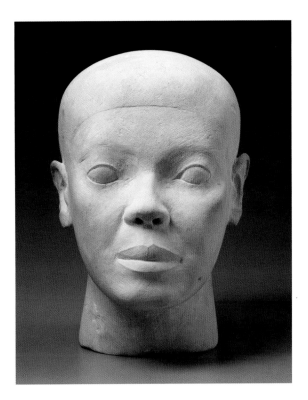

ABOVE
2.8 A fine example of an enigmatic reserve head found at Giza. All the heads have individual characteristics, and while it has been suggested that they are portraits, Egyptologists still debate their function and symbolism. Many of them, though not this one, show intentional damage. Discovered with another in a shaft of a mastaba tomb (G 4440), it is now in the Museum of Fine Arts, Boston (MFA 14.719); 30 cm (11⅞ in.) high.

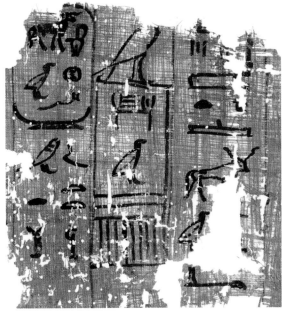

LEFT
2.9 One of the fragments of papyri found at Wadi el-Jarf that form a sort of 'logbook' of a man called Merer, who led one of the crews delivering material for the construction of the Khufu pyramid at Giza. The documents are dated to Khufu's 26th–27th regnal year and include a reference to Ankh-haf as Overseer.

el-Jarf, or to expeditions to Sinai. They are all about building the Great Pyramid at Giza.

Merer and his men must have left these documents during a tour of duty to the Red Sea port and Sinai. The documents date to Khufu's 13th cattle count. If this census for taxation occurred every other year, as Egyptologists believe, we have a textual window on to Khufu's pyramid

2.10 Bust of Ankh-haf, found by George Reisner in the chapel of his mastaba in the Eastern Cemetery at Giza (G 7510). Ankh-haf was a half-brother of Khufu; he has now also been revealed as Overseer of the *Ro-she* of Khufu, and so involved in the construction of the Great Pyramid. This remarkable bust may be a portrait, and shows a mature and powerful man. Museum of Fine Arts Boston (MFA 27.442); 50.48 cm (19⅞ in.) high.

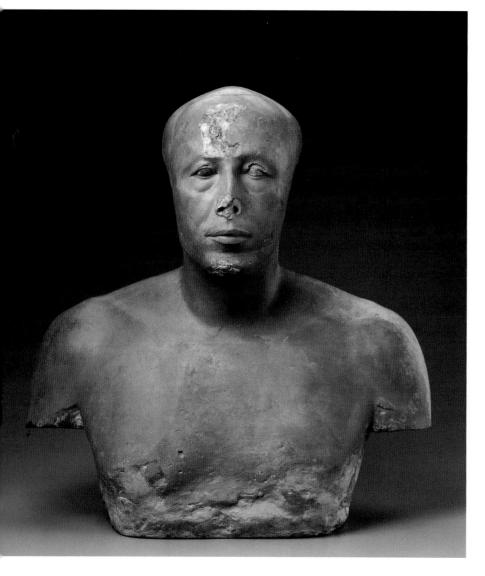

building during his 26th–27th regnal year. As an Inspector (*šḥḏ*), Merer logs his crew's round trips from the eastern quarries at Turah, opposite the Giza Plateau, which provided fine limestone for the pyramid casings, to the construction site, *Akhet Khufu*, the name of the Great Pyramid so well known from titles in tombs at Giza. Fragments of papyri that Tallet and his team pieced together bear accounts of 15 and 16 consecutive days. When complete, Merer's journal might have covered a period of three to six months.

The Wadi el-Jarf account papyri and Merer's journal have ruled rows and columns, not unlike an Excel spreadsheet. Egyptologists already knew of this spreadsheet organization from the Abusir Papyri, the archives of the 5th dynasty pyramid temples of Neferirkare, Khentkawes and Raneferef, and from the Gebelein Papyri, a tally of members of two villages in Upper Egypt dating perhaps to the reign of Menkaure. Merer's journal devoted a vertical column to each day. Two sub-columns allowed entries to record where the team spent the morning, and where they spent the night. Entries note the time of day – morning or afternoon – when the team undertook an operation. The journal specifies when the team is travelling upriver, southwards against the current, or north and downstream. Here is one round trip from the Turah quarries to the Great Pyramid:

[Day 26]: Inspector Merer sailed with his team from Turah-south, loaded with stones, for the Horizon of Khufu (*Akhet Khufu*); spend the night at the Lake of Khufu. Day 27: sail from the Lake of Khufu, navigation towards the Horizon of Khufu, loaded with stones; spend the night in the Horizon of Khufu. Day 28: sail from the Horizon of Khufu in the morning; sailing up the river <to> Turah-south. Day 29: Inspector Merer spends the day with his team to gather stones in Turah-south; spend the night at Turah-south.

When Pierre Tallet showed us a photograph of this papyrus, he commented on the repeated name of the Great Pyramid, Horizon of Khufu, so distinctly sprinkled throughout the text in its oval cartouche, saying: 'This should put the nail in the coffin of the alternative theorists.' We wish we could agree, but no matter what the evidence presented, people will believe what they want.

And who was the Overseer of the *Ro-she* of Khufu mentioned in the papyri? None other than Ankh-haf, the half-brother of Khufu and owner of the gigantic mastaba tomb G 7510 in the Eastern Cemetery of the Great Pyramid, where Reisner found his famous bust and secured it for the Museum of Fine Arts in Boston [**2.10**]. The Wadi el-Jarf papyri offer a precious literary glimpse into the days of Khufu, and to very specific operations relating to building the Great Pyramid. The papyri are the next best thing to our long-held wish for just five, or better still fifteen, minutes in a 4th dynasty day, back in the time and on the Giza Plateau when it bustled with people working on building the pyramids and carving the Sphinx.

Questions still

In spite of all this evidence, huge questions remain. How, indeed, were the pyramids built? All too often people ask this question expecting that one answer will fit all, as though the Egyptians built every pyramid in the same way – a generic pyramid on a neutral surface. In fact, the Egyptians built their earliest giant pyramids as architectural experiments, with remarkable variation in their topography, layout, dimensions and masonry.

Pyramids as large as Khufu's and Khafre's left human disturbances on a geological scale. The landscape tells the story of the builders' organization and activity. We should look for five major features: 1) large quarried areas for core stone; 2) remains of the transport and supply ramp, which must have been huge in its own right; 3) an access route for non-local materials, such as granite from Aswan over 800 km (500 miles) to the south, and fine limestone for the outer casing from east-bank quarries; 4) a harbour at the end of the access road for delivery of these materials, as well as for great quantities of rope, wood for levers, wedges and transport sledges, gypsum for mortar, people for labour, and food supplies to feed the people; 5) settlement to accommodate the workforce. After many decades of research, we can identify these features in the topographical, physical context of the individual Giza pyramids.

There are, of course, certain questions that any pyramid builder had to resolve, regardless of variations in the construction site and style of masonry. How did the ancient surveyors lay out such perfect squares for the pyramid bases, and so accurately orientate them to true north? How did they carry stone blocks and other materials up on to the rising structure, particularly as they neared the top, when the narrowing faces of the pyramid left little room for ramps or for lifting stones by levering? And as the pyramids rose, how did the builders control the straightness and correct orientation of the angles, so that they would meet at the point? There was every possibility that they could be out, and that the builders would need to twist the angles and faces to make them meet. In fact, Petrie detected an ever so slight twist in the top of the Khafre pyramid, where much of the casing is intact, probably caused by an error in the angles. Builders had to keep the pyramid

square and orientated to the cardinal directions at any given level. When the time came to finish the pyramid – probably by shaving off extra stone from the faces of the casing blocks – how did the masons shear smooth a face that literally covered acres, without depressions and bulges?

We examine these puzzles of pyramid building later in this book. In recent years we began to address deeper questions. Egyptologists knew surprisingly little about how the 4th dynasty Egyptians mobilized labour or deployed their social forces on the Giza Plateau to build the pyramids. For that matter, where *were* all the workers who must have been gathered to build the pyramids? We realized that if we could find and excavate the footprint of a workers' settlement, we would discover much about the organization of the labour force. How were the workers fed? They could not be cooking for themselves if they built pyramids all day. With a workforce settled at Giza over the course of three generations of kings, between 70 and 80 years, we knew there must also be a cemetery of minor officials and workers who had died during their time of duty at Giza.

Although we could look into the faces of great men of that time – leaders such as Ankh-haf – we knew little about how they treated or organized the large masses of workers that must have been necessary for building the giant stone pyramids. Builders' graffiti on stone faces never meant to be seen include the names of work gangs, compounded with the name of the king [2.11]. Smaller groups, signified by a word, *zau*, that Egyptologists translate as *phyles*, comprised the gangs. No matter which

2.11 Painted graffiti left by a work gang of Khufu on blocks in one of the relieving chambers above the burial chamber in the Great Pyramid.

gang, the phyles bore one of five specific names (see Chapter 15), but we are uncertain about the nature of phyle membership, because we are not sure how the 4th dynasty royal house organized Egyptian society to accomplish such a colossal task as building Khufu's pyramid. Indeed, the gigantic pyramids, such as those of Khufu and Khafre, challenge any vision of that society – a vision often more implicit than articulated.

Did the royal household coerce people into building pyramids? A persistent popular notion that they used slaves may owe much to Herodotus, who reported that:

> Cheops (to continue the account which the priests gave me) brought the country into all sorts of misery. He closed all the temples, then, not content with excluding his subjects from the practice of their religion, compelled them without exception to labour as slaves for his own advantage.[4]

Near the end of the 1st century AD, Josephus, the Romano-Jewish historian, added pyramid building to the many hardships that the Hebrews endured during their 400 years of labour in Egypt:

> for [the Egyptians] enjoined them to cut a great number of channels for the river, and to build walls for their cities and ramparts, that they might restrain the river, and hinder its waters from stagnating, upon its running over its own banks: they set them also to build pyramids, and by this wore them out.[5]

Egyptian kings built the 4th dynasty pyramids more than a thousand years before the Hebrews appeared on the stage of history. And most Egyptologists would not endorse a view of mass slavery at any time in ancient Egypt. Nonetheless, even Egyptologists' concepts of ancient Egypt are so conditioned by royal symbols and texts that we have trouble interpreting the organization of labour for something on the scale of the pyramids as anything other than some kind of centrally controlled coercion, or militaristic conscription. There are Egyptologists who believe that between the 3rd and 4th dynasties, the time of the rise of the giant pyramids, the pharaohs completely reorganized Egypt, replacing natural villages with planned estates and internal colonization, measuring out administrative districts called nomes along the entire course of the Egyptian Nile Valley, and registering just about everyone in the country in a big book (or papyrus roll), all the while forcing many of them to come to Dahshur and Giza to labour in the creation of these world wonders.

In other pre-modern cultures, large-scale, 'national' projects often involve contributions from natural (as opposed to artificial, forced) social groups – families, households and communities – who labour without the question of free choice ever arising. It is obligatory, yes, but the obligation arises because such labour and participation is the custom and tradition. A simple example in more recent, but pre-modern, American culture would be an Amish barn raising, where the various families help out a household by building a barn, attended by feasting and ceremony, for the greater good. The Great Pyramid is one hell of a barn, and, as we say, it challenges any notion of ancient society. We also have texts from the 4th dynasty and later Old Kingdom, as well as the Middle and New Kingdoms, that are quite explicit that the Egyptians put people they had captured in warfare to work on pyramids and temples. Texts also suggest that they eventually integrated captives into Egyptian society, sometimes by appointing and protecting them as 'household' staff and cultivators in the very temple estate that they had been forced to build.

Whether the accommodations for this workforce were related to, or developed into, the known pyramid towns is a question still debated by Egyptologists. The oldest pyramid town of any size, excluding the small strip of houses along the causeway of Queen Khentkawes' tomb at Giza (see Chapters 12 and 15), is at Kahun (Illahun), attached to the 12th dynasty pyramid of Senwosret II and investigated and mapped by Petrie [2.12]. The town seems to have been organized around 10 great houses, each 40 times larger than the estimated 440 smaller houses that fitted, grid-like, within the town walls (the ground plans of about 220 houses were preserved when Petrie worked there and recorded them, perhaps only half of the original number). Cambridge archaeologist Barry Kemp has estimated that the combined granaries of the big houses could have fed between 5,000 and 9,000

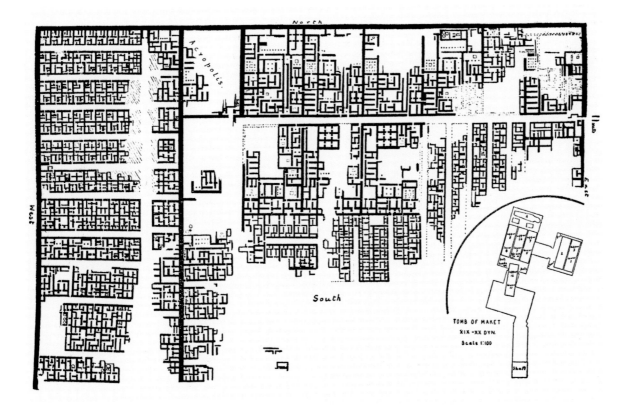

2.12 Petrie's plan of the pyramid town at Kahun (Illahun) belonging to the 12th dynasty pyramid of Senwosret II. The settlement seems to have been organized into a system of 10 great houses and 440 smaller houses.

people. Here the 'state' did not create one central granary, or huge 'public' buildings like mess halls and barracks.[6] Rather, the household was taken as the model and social vehicle in the absence of any other. We have found part of the settlement that housed the estimated thousands of people involved in the construction of the giant Giza pyramids, and it contains both household organizations as well as precociously modern configurations of barracks and bakeries that reflect the economy of scale needed to build something so large as these pyramids.

Finally, there is the question why? Why create gigantic pyramids and temples as tombs for deceased pharaohs? And following on from this, what did the pyramids and the Sphinx mean? We pose this latter question in two senses. First, what did they mean to the Egyptians who built the pyramids – in terms that they might themselves use if we could talk to them in their language, and then translate into ones we would recognize? Secondly, what did the pyramids and the Giza Necropolis mean for the development of Egyptian civilization? How were the pyramids the result of the evolution of Egyptian culture? How did the pyramids affect

that evolution? The Egyptians who built the pyramids could not have fully answered such questions, for which we have both the advantage and disadvantage of hindsight over a very long course of history.

These are the questions that guide our research, literally a search and re-search that has locked our gaze on Giza for more than 40 years. It is a tapestry of understanding that we would now like to convey. We do not agree on all points, but we feel that enough new information has come to light, especially since the 1990s, that it is time to tell the story of the Giza Plateau as we see it – providing incontrovertible evidence that others may then use to argue into the future about the meaning of the Giza pyramids for the human career.

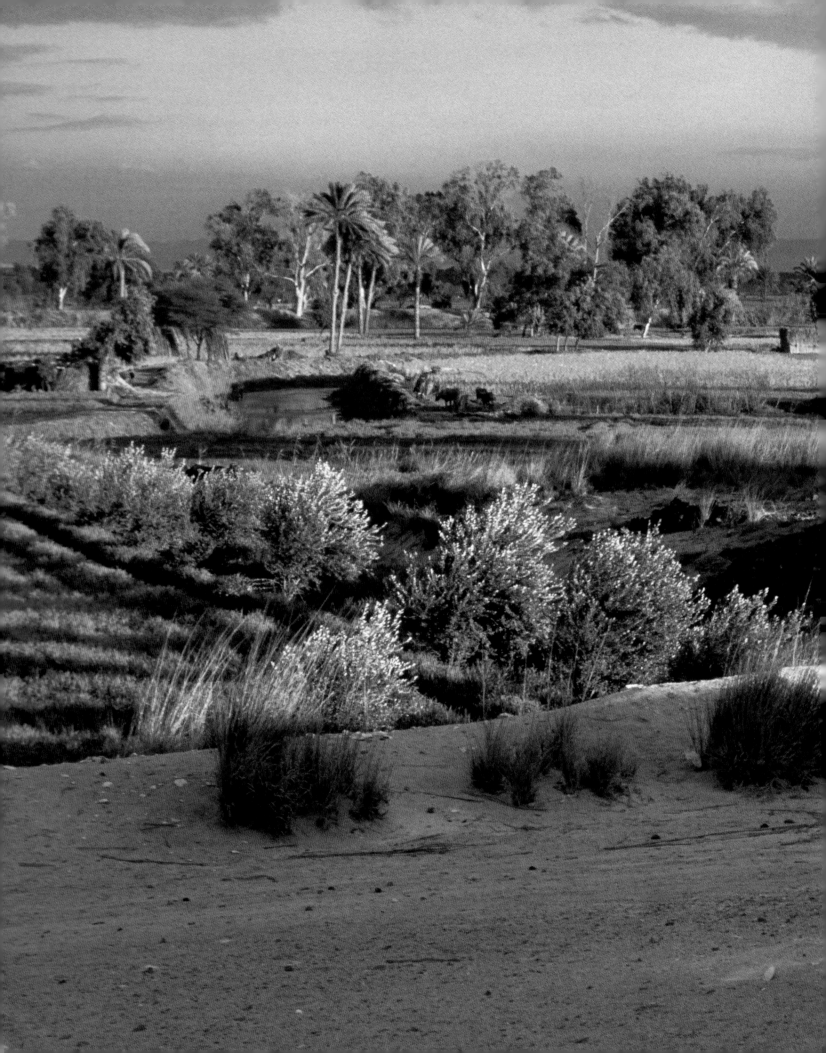

CHAPTER 3
Giza in context

Context is everything in archaeology. Take any sophisticated

human-built structure out of its social context and it will look

mysterious. Suppose, for example, we removed the Empire State

Building from Manhattan and placed it in the middle of the

Mojave Desert – it would seem weird outside the city, the state,

indeed the empire that its very existence implies. So it is for the

Giza pyramids.

3.1 Along the banks of the Nile the line between the desert sands and the cultivation – made possible by the river's life-giving waters – is often stark.

The seed of the civilization that built the Great Pyramid may have come from the Western Desert, west of the Nile. Evidence gathered by archaeologists, prehistorians, geomorphologists and climatologists indicates that around 7,000 years ago the Sahara Desert – now a great arid swathe across North Africa some 800 km (500 miles) wide – was grassland dotted with lakes. The Combined Prehistoric Expedition under Fred Wendorf excavated settlements of simple houses and hearths gathered around the playas (basins) of extinct lakes. Between 7,000 and 6,000 years ago the lakes and grasslands dried up, in the most recent of many large-scale wet and dry cycles over the millennia of human prehistory. People then moved out of the grasslands southwards into what is now sub-Saharan Africa and eastwards into the Nile Valley.

Working independently, some linguists have traced the language families of northeast Africa and the Near East to a locale somewhere west of the Nile Valley.[1] The Nile immigrants brought with them the earliest known domesticated cattle, while sheep, goats, wheat and barley must have been introduced into Egypt from the direction of the northeastern Delta. At about the same time as the drying of the Sahara, the Nile's alluvial carpet that made farming possible began to form. The combination of the two factors resulted in the Nile Valley becoming a refuge and a womb, which nurtured the culture that would evolve into that of the pyramid builders.

Geography of the Egyptian Nile

Egypt was the furthest downstream of several cultures that fed off the life-giving waters of the Nile [**3.2**]. Beginning at the 22nd parallel, 1,138 km (707 miles) of the River Nile run through modern Egypt. The traditional ancient southern boundary of the kingdom was the 1st Cataract, where the granite island of Elephantine and, across the river, the site of Aswan served as the door jambs of Egypt. (By the time it reached here, the Nile had already flowed over the 6th to the 2nd cataracts in Nubia.) At Aswan, the Nile Valley is very narrow, but further north the banks begin to support tracts of cultivation made possible by the annual inundation.

Before it flattens out into the fan-shaped Delta, the Egyptian section of the Nile Valley is 800 km (500 miles) long. Variations in the width of the valley along its length were important in the development and history of ancient Egypt. Just south of the Qena Bend [**3.3**] the floodplain widens, and to its north the valley begins to broaden out, achieving its greatest width through the long stretch of Middle Egypt. Then, north of the entrance to the Fayum basin and just below the apex of the Delta, a thin stretch of valley measures only 6 km (4 miles) wide between the Western and

3.2 Satellite view of the Nile. The strip of green along its banks widens along its course south to north. The Qena Bend and, further north, the Fayum oasis are very clear, as is the great fan shape of the Delta. Near the apex of the Delta the valley constricts and then opens out, just below the Giza Plateau. To either side are vast swathes of desert.

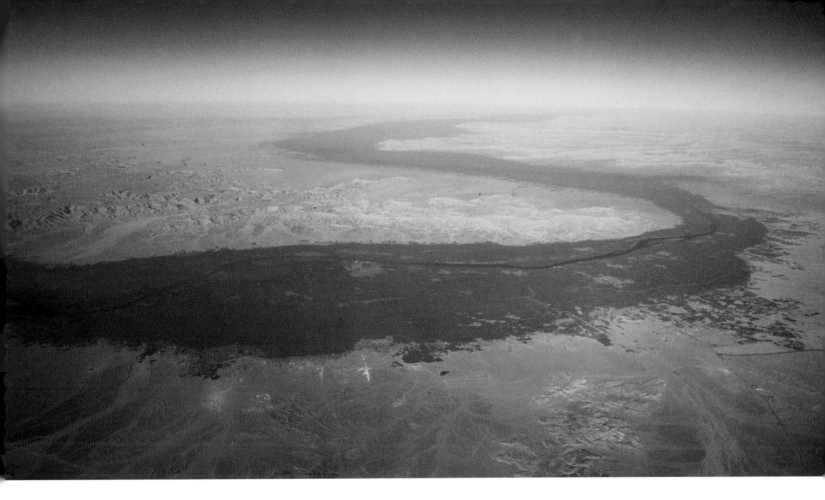

Eastern deserts on either side. As narrow as 3 km (2 miles) in ancient times, this bottleneck suddenly opens out again at the apex of the Delta, just below the Giza Plateau on the west and the quarries of Turah on the east.

An analysis by geographer Karl Butzer of ancient Egyptian site and settlement distributions, based on both archaeological and historical sources, indicates that the highest population densities were in the north, in the stretch of the valley between the Delta apex and the Fayum entrance, and in the south, from the Qena Bend to the 1st Cataract. Both are zones where the valley is constricted. Middle Egypt and the Delta were less densely populated zones of land development and internal colonization well into dynastic times. Population density, it seems, 'was an inverse function of floodplain width'.[2]

The Nile flood regime

Fed by seasonal, southerly rains, the Nile flood laid down fresh silts and sediments every year in late summer and autumn. This annual 'pulse' of the Nile flood made life possible and determined Egypt's natural cycles, including some with consequences for pyramid building. Rain has long been negligible in Upper Egypt – ranging from 0 to 100 mm

(0 to 4 in.) per year over the whole territory – so agriculture has always been dependent exclusively on the Nile. By building up its banks through the sediments it carried, the Nile created a convex floodplain. The highest valley land is therefore near the river, while the lowest is along the contact between the alluvium and the sandy desert – a line so stark it is possible to stand with one foot on either side of it.

At the peak of the inundation, when the water rose 7 m (23 ft) above its pre-flood channel level, the valley would have looked like one vast lake. Villages were islands and movement between them was by boat, or along levees that rose 1–3 m (3–10 ft) above the plain and held the water in a series of great natural basins. These basins were defined by longitudinal dykes running parallel to the river and desert edge, and transverse dykes that ran east to west. In the last century, before the basin system was obliterated by the High Dams at Aswan, the largest basin covered 200 sq. km (over 77 sq. miles), the smallest 2 sq. km (⅘ sq. mile). The floodwaters poured in sequence into the basins in steps or terraces as the valley floor dropped 85 m (280 ft) from Aswan to the Mediterranean. Over the course of 5,000 years, civilization tamed and organized the natural basins and levees, dividing them into

3.3 Aerial view of the Qena Bend. Two significant Predynastic sites, Hierakonpolis and Abydos, bracket the Qena Bend, and research indicates that the stretch of the Nile south from here to the 1st Cataract at Aswan saw one of the highest population densities in ancient Egypt.

3.4 Map of the Nile from Aswan to Cairo, showing the division into nomes and basins in Upper Egypt, the system used to harness and exploit the life-giving waters of the annual Nile flood and the fertile silts left behind.

village territories and sub-basins, each with its own name, with systems for controlling the waters.

The basins are important for understanding pyramids in ancient Egyptian terms because a number of words that the Egyptians used for aspects of the pyramid complex incorporate the term *she*. Written with the rectangular hieroglyph for the sound 'sh', *she* can refer to both a body of water and a tract of land; this fits exactly with the Egyptian irrigation basin, which is a lake during the inundation season and a field during planting and harvest seasons. The *she en per-a'a* was the 'basin of Pharaoh', which Egyptologists have associated with pyramid complexes. Also linked with pyramids in ancient Egyptian texts is the *ro-she*, 'the mouth' or 'entrance of the basin', a place of economic activities, storage and production, while the *khentiu-she* were 'those in front of (or south of) the basin'.

This and other evidence indicates that each pyramid had its own basin stretching some distance east of the valley temple. It would have been a docking place or harbour for the delivery of goods from estates assigned to that pyramid, as well as a location for storage and for facilities for transforming the delivered goods into consumable items, and would have had its own personnel devoted to these activities on behalf of the pyramid, its king and his temples.

The floodwaters would begin to swell in June at Aswan on the 1st Cataract. By mid-August they had risen and threatened to overflow the levees. This was the moment when the gates of the flood basins were opened, one after another in a series connected by a feeder canal. As mapped in the 19th century, one interconnected set of basins just about constituted the area of an ancient nome, an administrative district along the Nile Valley [3.4]. For six to eight weeks the water stood approximately 1.5 m (5 ft) deep, depositing its fresh silt across the basin bottoms [3.5]. In ancient times this was the season *Akhet* ('flood', literally 'to make effective'). By late September the basin 'escapes' were opened, allowing the water to flow back into the Nile channel or into another basin system downstream, to the north. As the water flowed out in gathering streams, the basin bottoms reappeared in October or November (slightly later progressively further north). Parts of the low valley margins could

remain marshy year round. The crops were sown at the beginning of the second season, *Peret* ('coming forth', also the word for 'seed'), which lasted from November to February. The harvest, *Shemu*, came in the third season, from sometime in March into June, when the cycle began again.

Environmental context

In the earliest part of the Dynastic Period, parts of the low desert bordering the cultivation would still have been grassland where animals grazed, with some wood cover, principally acacia. The river banks were forested, and game inhabited the thickets along the Nile Valley: gazelle in the desert and plentiful fowl in the swampy 'papyrus land'. These wetter and grassier conditions in the low desert corresponded to a minor sub-pluvial (rainier) period that was ending just about the time of the Giza pyramids or shortly thereafter, in the middle to late Old Kingdom. Recent studies by Rudolph Kuper and Stefan Kröpelin,[3] based on radiocarbon dating, and an analysis of sediments by Judith

Bunbury[4] support this picture of a transition to increasingly dry conditions at Giza around this period.

The environmental context of the pyramids is significant for an appreciation of aspects of our research. It provided specific opportunities for the early pyramid builders, which in turn may have had an impact on the environment. In our excavations of the production facilities at the southeastern base of the Giza Plateau we are continually amazed at the deep, dense accumulations of ash and charcoal, evidently resulting from burning wood as fuel for cooking, baking and processing copper. Based on this and the findings of our project to radiocarbon-date the pyramids, we suspect that the support activities for building the Giza pyramids may have led the Egyptians to consume large amounts of Nile Valley trees that were perhaps more plentiful then than today. In particular, the ancient Egyptians may have wiped out much of the local acacia that in modern times grows in savannah conditions and would have existed in the low desert during the early pyramid age.

3.5 The dams at Aswan now manage the flow of the Nile, but until relatively recently the waters of the annual flood would have reached to the foot of the Giza Plateau, and the pyramids would have overlooked a lake (as seen in this old photograph of one of the last floods). This event may have facilitated bringing in supplies and materials for the pyramids.

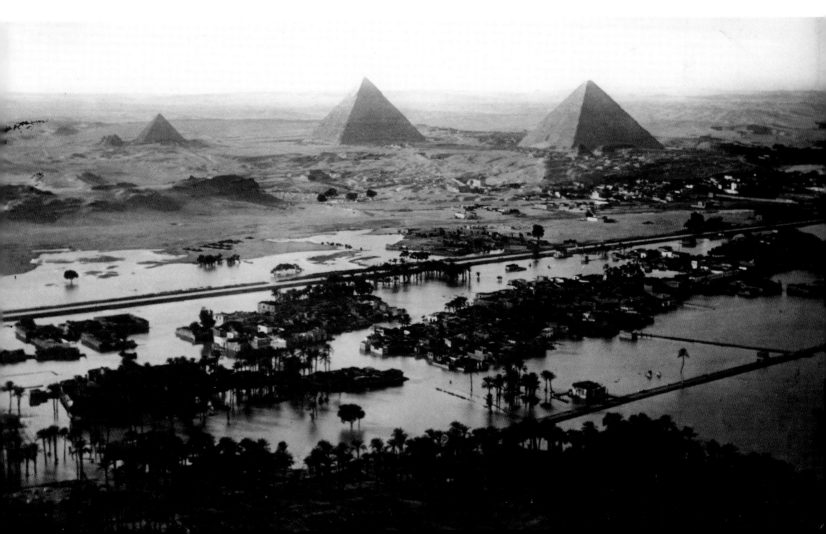

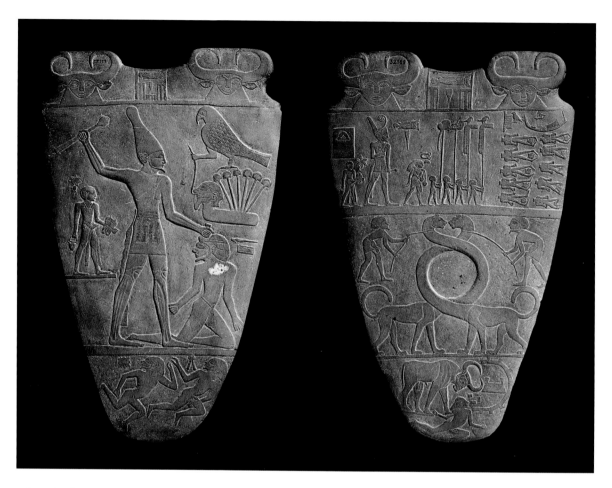

3.6 The two sides of the Narmer palette. The scenes carved on this slate palette relate to conquest and the deeds and authority of Narmer, a ruler of the Late Predynastic Period, *c.* 3000 BC, and perhaps symbolize the unification of Egypt. It was discovered at Hierakonpolis, as part of the Main Deposit, and is now in the Egyptian Museum, Cairo (CG 14716); *c.* 63 cm (25 in.) high.

Historical context

The classic 'pyramid age' of the Old Kingdom saw the first great efflorescence of ancient Egyptian civilization. Some of its earliest stirrings are found at Predynastic sites in the Qena Bend region around 3000 BC, when elements that we normally associate with the term 'civilization' begin to appear.

In the Late Predynastic Period, just prior to the emergence of writing and monumental architecture in mud brick, we find scenes on tomb walls, knife handles and slate palettes that indicate the existence of strong southern rulers and conflict with the north [**3.6**]. At this time, the most important Nile Valley site was Hierakonpolis, just south of the Qena Bend, which has been considered a kind of proto-capital of the south.

According to later tradition, the kings of the 1st dynasty (in the Early Dynastic Period) hailed from the site of This, with its cemetery at Abydos, just north of the Qena Bend. The earliest royal cemetery of these first kings lies in the desert west of Abydos (see Chapter 5), at a site called Umm el-Qaab –

'Mother of Pots' – because of the millions of sherds of pottery vessels left as offerings to the ancestral kings. One of these tombs belongs to a king named Djer, but was believed by later Egyptians to be the tomb of Osiris, the god of the Underworld – the domain of deceased ancestors. Hierakonpolis and Abydos bracket the Qena Bend, and from here the local rulers first expanded their domain over the south and then turned their campaign of conquest north, towards Lower Egypt and the Delta, uniting the country under their rule.

Below the cliffs of North Saqqara (about 20 km/12½ miles south of Giza), the first king of the 1st dynasty, Hor-Aha, the traditional Menes, established the earliest 'capital' of the unified Two Lands (Delta and Valley), as the kingdom would henceforth be called. The modern concept of 'capital' may not be entirely appropriate because this settlement, the origins of the city of Memphis, was probably more like a fortified royal residence. We know it was called 'the White Wall' (*Ineb-hedj*), and David Jeffreys and Ana Tavares have published

evidence that it may have been a double settlement forming a gateway on both sides of the valley, which at that time was as narrow as 3 km (2 miles).[5]

There has traditionally been an assumption in Egyptology that once Egypt was unified, Memphis, the national capital, was founded, and thereafter remained a principal residence of the king. However, evidence that casts doubts on this old assumption has important implications for our research at Giza. It is true that the narrow stretch of valley below the Delta apex was ancient Egypt's capital zone. New capitals were established here each time the Egyptian kingdom expanded or was reasserted, beginning with the White Wall of Hor-Aha/Menes.

When Amenemhet I came north to consolidate the united Middle Kingdom at the beginning of the 12th dynasty following the civil wars of the First Intermediate Period, he founded his capital Itji-tawi, 'Seizing the Two Lands', at a location not firmly identified, but probably at or close to Lisht. And when the kings of the 18th dynasty arose from their stronghold in Thebes to resurrect the kingdom by defeating the Hyksos in the north and the Kerma culture in the south, thus founding the New Kingdom, Egypt's 'golden age', they made Memphis their administrative centre, a knot that tied the 'Two Lands' together.

The arsenal and shipyards called *Peru-Nefer* ('the Good Going Forth'), which allowed the warrior pharaohs to consolidate the kingdom and expand the empire up into Syria and Palestine, may have also been situated here (though the Austrian Egyptologist Manfred Bietak has argued strongly that *Peru-Nefer* was at Tell el-Da'ba in the Nile Delta, a site he has excavated).

The name and location of New Kingdom Memphis proper can be traced back to the 6th dynasty. Men-nefer, from which the name Memphis is thought to derive, was the pyramid town of Pepi I. His pyramid in South Saqqara lies opposite the site of the main ruin field of Memphis in the modern village of Mit Rahina, several kilometres southeast of the Saqqara Plateau, in the middle of the cultivation. The work of the Egypt Exploration Society, under David Jeffreys, suggests that before this time the focus of the settlement that became Memphis moved gradually south and east from its initial location of 'the White Wall' at the foot of the North Saqqara Plateau. This urban migration

followed the course of the Nile, which meandered gradually eastwards in this zone.

There is also evidence of increasingly dry and sandy conditions through the course of the 5th and 6th dynasties. The grasslands and acacia trees that graced the low desert in the Early Dynastic Period and early Old Kingdom may by now have disappeared. At a number of sites – Giza, Abusir and Saqqara – massive sand dunes built up along the edge of the Western Desert, coming in from the north and west. Settlement thus migrated south and east in the plain below the Saqqara Plateau ahead of the dunes and following the river as it moved eastwards across the floodplain. Perhaps shadowing this settlement migration, the late 6th dynasty kings Pepi I, Merenre and Pepi II chose the high desert plateau of South Saqqara as the site for their pyramids.

Egyptologists who have studied texts relating to pyramid towns believe a residence of the reigning king, whose pyramid was under construction on the plateau above, stood as the hub of the town. The king's house, with all its support structures (bakeries, breweries, workshops, storage magazines, scribal offices and archives), must have been accompanied by the houses of courtiers and officials, along with *their* support structures, and the houses of servants. It is for this reason that metropolitan Memphis of later centuries could have developed its name and location from an expansion of one such pyramid town, that of Pepi I.

But if the early pyramid towns moved from the location of one pyramid to another, then the centre of royal interest and administration may also have moved around considerably throughout the Old Kingdom, at least until it became fixed in the late 6th dynasty at the site where the ruins of ancient Memphis stand today. If so, this is relevant to our research at Giza: in the 4th dynasty, for three generations spanning some 80 years, the centre of royal building, and possibly administration, would have been at Giza.

During the Old Kingdom, new towns, estates, farms and ranches were founded throughout Middle Egypt and the Delta to supply produce and cattle to the royal house, to large estates and to the mastaba tomb endowments, as well as to the pyramid temples. The Egyptians intended their tombs and temples to be a kind of petrification:

an etching in stone that ensured their estates (property and people) would last forever (each was called a 'House of Eternity'). At Giza, there had to be facilities to receive, store and process this material, as well as to receive and process the wood, gypsum, Turah limestone, granite, alabaster and copper for the giant pyramid projects, and the people for labour. This required personnel – not just masons and builders, but also brewers, bakers (bread and beer were the main staples), carpenters, potters, metalworkers, sculptors and many others. In effect, for three generations downtown Egypt may have moved to the foot of the Giza Plateau.

Why Giza? After focusing on the Saqqara Plateau during the 1st to 3rd dynasties, and after Sneferu at the beginning of the 4th dynasty had established new royal cemeteries and built pyramids at Meidum and Dahshur (see Chapter 5), why did the royal house decide to move to Giza? The answer lies in the particulars of the topography and geology at Giza, and in what the royal pyramid builders had learnt from Sneferu's experiments with gigantic pyramids, including (perhaps especially) his mistakes. One of Sneferu's younger sons, Khufu, must have been well aware of his father's ambitions and disappointments. Khufu may have come to the throne at a relatively youthful age, full of his own aspirations and encouraged by the successes finally achieved by his father's builders, who by then had gained much practical experience. Khufu was ready to monumentalize his divinity by raising the biggest artificial mountain of all, but to ensure success, the physical constraints and opportunities of the site needed to be just right.

Geological context

When selecting a site for a new pyramid, certain requirements, both physical and symbolic, had to be satisfied. The builders would look at a series of promontories or plateaus rising against the western horizon in the high desert along the capital zone. Geologists call these high places, and the low areas that separate them, synclines and anticlines. A syncline is a trough of layered rock in which the layers, or beds, slope towards each other from either side. An anticline is stratified rock that has been folded into an arch so that the layers slope down in opposite directions from the crest. The

high places where the pyramids were built belong to the Abu Roash complex, a group of geological formations created by forces that folded large rock masses in Cretaceous and Eocene times. The sites of major pyramid complexes correspond to distinct geological formations: the Abu Roash Formation (Djedefre's pyramid); the Moqattam Formation (the Giza pyramids); the Maadi Formation (the Zawiyet el-Aryan pyramid); the Saqqara Formation (the Saqqara and Dahshur pyramids).

At the Giza Plateau, Khufu's planners found a natural plate of limestone that was unencumbered by any monument. It slopes evenly at about 3–6 degrees from the northwest to the southeast, from a high point of 106 m (347 ft) above sea level west of the pyramids, to 23 m (75 ft) above sea level about 200 m (656 ft) south of the Sphinx. Geologists characterize the Giza Plateau as a 'brachy-anticline' – that is short ('brachy-'), because the northwestern side of the fold is considerably shorter than the southeastern side which hosts the three pyramids and makes up the major surface area of the plateau. This limestone bedrock is part of the Moqattam Formation, named after the Moqattam Hills that tower above the eastern boundary of Cairo [**3.7**].

What opportunities did the Giza landscape, with its brachy-anticline of the Moqattam Formation, present to Khufu's builders in their plans to surpass the giant pyramids of the previous generation? To answer this question, it helps to know something about events in the area some 65–38 million years before the pharaohs.

The formation of the Giza Plateau

Tens of millions of years ago, the Tethys Sea, the ancestor of the Mediterranean, repeatedly flooded the area that is now the northeastern corner of the African continent. The floodwaters laid down sediments on top of metamorphic and igneous diorite, granite, gneiss, quartz and schists. These are hard stones that the ancient Egyptians favoured for fine statues and temple elements and they therefore mounted quarry expeditions to the places where these stones were exposed above the covering sedimentary rock: the northern Fayum, the Red Sea mountains, Aswan and the desert quarries southwest of Aswan.

The sedimentary rock began as the deposits on the sea floor. The greatest part of the Egyptian

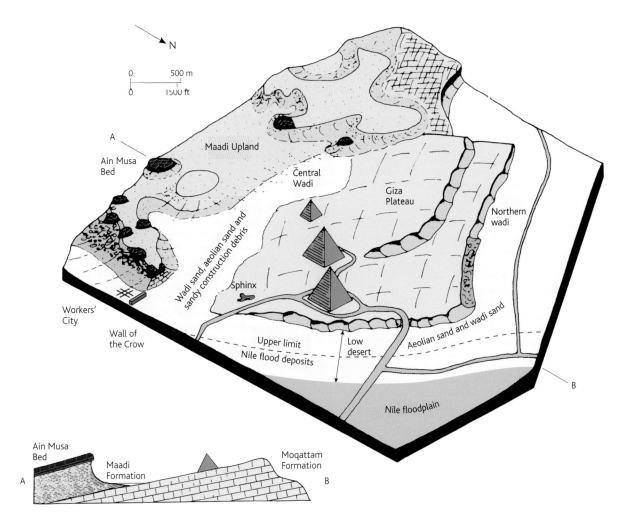

3.7 Simplified model and section of the Giza Plateau showing how the geology, with the different formations and rock types, influenced and facilitated the building of the pyramids and other features.

BELOW
3.8 Fossilized nummulites – extinct plankton-type organisms; they give their name to nummulitic limestone, which makes up the Moqattam Formation, the major type of stone the Egyptian builders used to construct the pyramids and carve the Sphinx.

limestone tableland was created in this way, originating during the Eocene Epoch (55.8–33.9 million years ago). Geological forces began to lift the land and to tilt it from south to north, creating a slope from Aswan to the Delta shoreline. As the tableland rose, the waters of the Eocene bay began to recede, and by the end of the epoch the head of the bay was near the present apex of the Nile Delta. Millions of years later, the ancestral rivers of the Nile cut through the tableland, leaving the cliffs and escarpments of the high desert that now frame the Nile Valley east and west. That is why the limestone formation at Giza, on the west bank, is part of the same layers as are found at Moqattam, on the east.

About 50 million years ago, when the head of the Eocene bay was close to Giza, sediments were deposited that became the layers of the Moqattam Formation from which the Egyptians carved the Sphinx and most of the blocks for the pyramids, tombs and temples at Giza. This limestone is

called nummulitic because of the presence of huge numbers of fossilized *Nummulites gizehensis* – extinct unicellular plankton-like organisms that lived in the warm shallow tropical waters of the Eocene sea [**3.8**]. They take their name from the

Latin word for 'little coin' (*nummulus*), because each organism secreted a calcite shell in a coin-shaped spiral.

Along the northwestern side of the Giza Plateau, a colony of nummulites thrived on a high bank of sea floor in the shallow subtropical water of the retreating sea 50 million years ago.[6] We see the evidence in concentrations of nummulite fossils in the northern and eastern cliffs at Giza, as well as in the surface around the bases of the Khufu and Khafre pyramids. Look closely at the natural limestone floor just east of the Great Pyramid and you will notice it is composed of compacted nummulites where they accumulated as storm waves raged across shallow seawater. The turbulent waters washed away the mud environment of the nummulites and thrust and sorted their shells into a nummulite bank over 30 m (98 ft) high along the north-northwest part of the Giza Plateau. Down the long southeastern slope of the anticline (in the direction of the Sphinx and the Central Field), the waters were deeper. A sandbar developed on the slope of the nummulite embankment. Along the sandbar, in the more protected waters behind the bank, a coral reef grew.

In carving the Sphinx directly from the natural rock, the ancient Egyptian quarrymen cut a cross-section through the principal geological layers of the southeastern slope of the Moqattam Formation. The hard layers of the shoal and reef, for example, make up the lowest layer (Member I) in the Sphinx and its ditch; petrified coral is visible in the cut quarrymen made into the rock to carve out the lower part of the Sphinx's lion body. In addition to coral, shell-encrusted algae, sponges and oysters flourished on the bank.

As the Eocene seawaters retreated further north, the water protected by the sand bank became a muddy lagoon, inhabited by burrowing bivalves and sea urchins. A fairly regular sequence accumulated, which petrified as soft marly layers interspersed with harder beds. These layers make up the body of the Sphinx (Member II). Turbulent waters churned up the mud and silts of the softer layers. Calmer waters laid down more compact sedimentation. The head of the Sphinx is a stone of harder quality (Member III) than the layers of the body, representing, again, calmer waters (as befits the serenity of the Sphinx's gaze).

With the retreat of the Eocene sea, the area temporarily emerged above water. Eventually the seawaters returned and then retreated again in another cycle, leaving the layers of the Maadi Formation that can be seen today in the quarried knoll that rises above the Central Wadi south of the Sphinx. To the west, just south and west of the Menkaure pyramid where the geological surfaces were not quarried away, it is possible to see where the light-grey rock of the Moqattam Formation dips under the more marly, brown and yellow peaks of the Maadi Formation.

Advantages for Khufu

Although Khufu's builders would not have viewed the landscape in our modern geological terms, they nevertheless recognized the opportunities that the formations and different layers at Giza offered for meeting their requirements. The gentle slope of the Moqattam Formation is regular, unbroken by major wadis or gullies. This made it suitable as a location for the largest pyramids ever constructed, while the hard nummulite embankment running northeast–southwest along the northwestern part of the plateau provided a solid foundation.

The series of thick, hard beds alternating with the softer, more marly layers in the southeasterly slope were eminently suitable for quarrying building blocks in the larger sizes that Khufu's architects needed in order to improve on the stability of Sneferu's pyramids. They could cut blocks from the bedrock along the thinner, softer, marly beds, and then remove blocks from the harder layers. These exploitable layers ran northeast to southwest, parallel to the nummulite embankment. The quarries were therefore located at the lower end of a gentle slope up to the pyramid platform, which facilitated hauling the blocks up transport roads and ramps.

Further south, the builders could exploit the thinly bedded, soft and crumbly rock layers of the younger Maadi Formation. These layers are filled with loose conglomerates, making them unsuitable for quarrying large blocks or for founding large monuments, but a good source of tafla – calcareous desert clay – and loose material for secondary buildings such as fieldstone walls, construction ramps and embankments, some of which still exist at Giza. And the broad and low wadi where

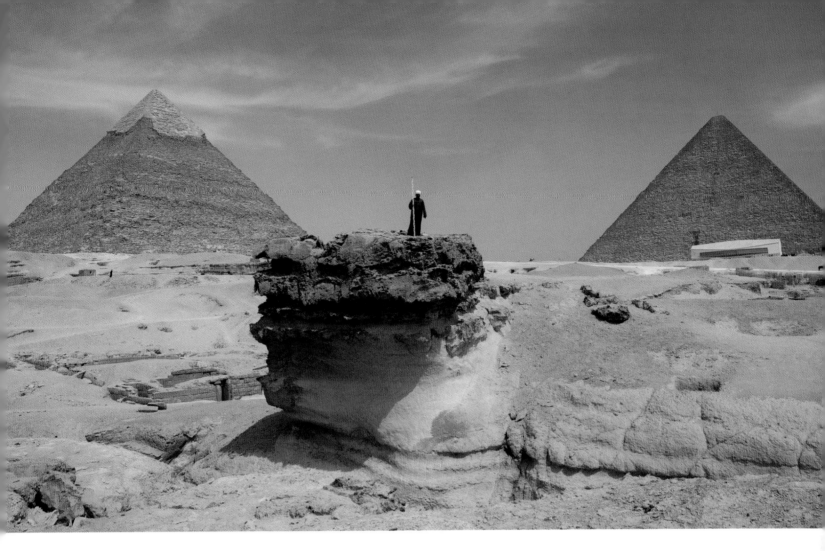

the Moqattam Formation slopes under the Maadi Formation was the perfect conduit for bringing in materials from outside Giza. Finally, the flood basin in the valley floor at the mouth of the wadi would become a harbour for the boats and ships needed to deliver these materials.

On the Giza Plateau, across an area of 1.69 sq. km (⁷⁄₁₀ sq. mile), the 4th dynasty Egyptians created the most carefully designed cluster of royal pyramids. Over the course of three generations they quarried 7 million cu. m (247 million cu. ft) of the local limestone to raise the superstructures of the Giza giants [3.9]. Probably handing down skills from one generation to the next, the builders aligned the southeastern corners of the three kings' pyramids on what could be called the great Giza diagonal. It runs about 43 degrees east of true north, almost perpendicular to the dip of the plateau. In doing so, the builders followed what geologists call the *strike* of the Moqattam Formation, that is, a line perpendicular to the direction of slope (when you walk along the side of a hill without going up or down, you are following its strike). By aligning them to the strike of the plateau, the builders ensured

that the bases of the three main pyramids would be approximately at the same level (the base of Khafre's pyramid is 10 m (33 ft) higher than that of Khufu).

At the base of the slope, the quarries run roughly parallel to this diagonal, from the area of the Sphinx on the northeast to the area below the Menkaure pyramid to the southwest. The long southeasterly slope of the Giza anticline allowed the causeways of Khafre and Menkaure to descend gradually to the level of the floodplain.

The skilful use of the Giza landscape by the ancient builders, who were good and instinctive geologists in their own right and in their own terms, resulted in the spatial and geometric harmony of the three Giza pyramids and Sphinx. For many reasons, these 4th dynasty compositions in stone rank as one of the greatest wonders of the ancient world.

3.9 A small massif of stone in the Central Field area at Giza preserves the original surface level of the plateau – all around it the rock was quarried and removed for building the pyramids and temples and creating tombs.

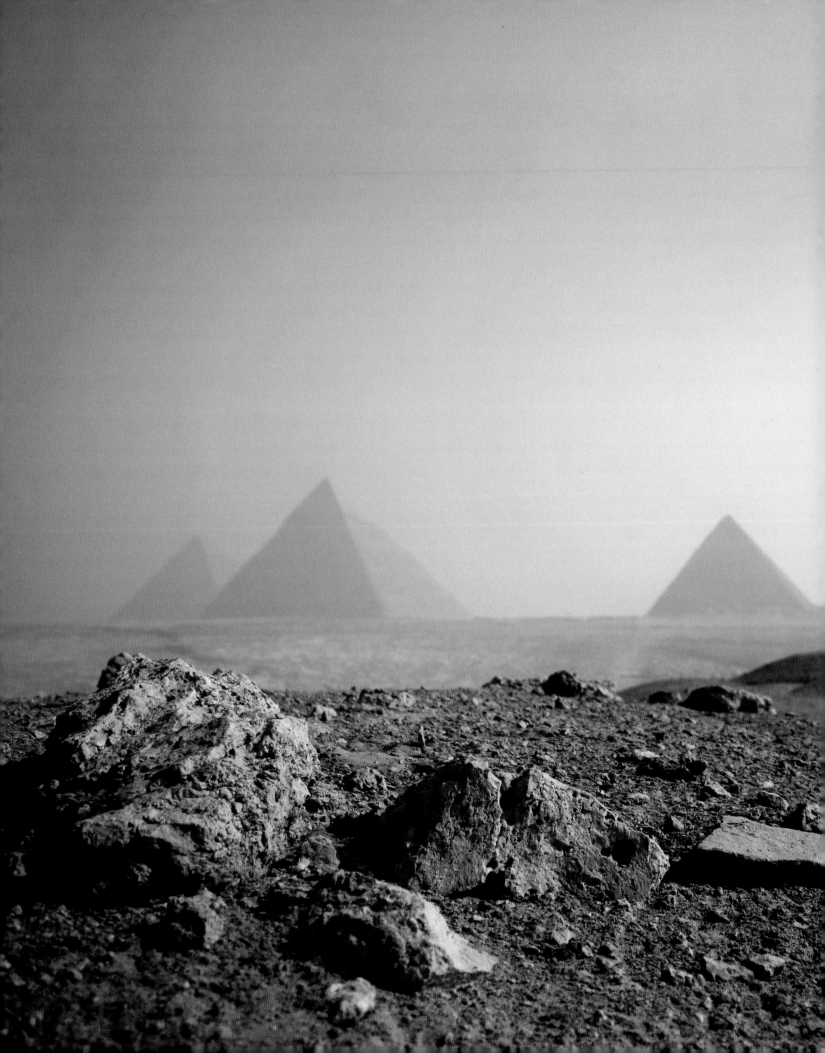

CHAPTER 4
Giza before Khufu: beginnings as a burial ground

The Giza Plateau rises at the apex of the Nile Delta, midway between two very old sacred centres, Memphis to the south and Heliopolis to the northeast. Long before Khufu's builders recognized the advantages of the plateau for constructing his pyramid, people must have settled near the base of the plateau. And surely they would have built tombs for their community leaders, surrounded by subsidiary burials, on the low desert, up into the ravines and possibly on the high plateau itself.

In the Late Predynastic and Early Dynastic periods, people living in the region of Giza belonged to a network of settlements on both sides of the Nile. We have almost no physical remains of the settlements themselves. Tombs and cemeteries are evidence of their former presence, stretching on the west bank from Abu Roash to Dahshur, and from Heliopolis to Helwan on the east. The largest tombs cluster between Abusir and Dahshur, Helwan and Maasara. These settlements coalesced into Egypt's traditional capital, later known as Memphis.

Pottery vessels typical of the northern Predynastic Maadi culture have turned up on the low desert close to the northern plateau edge. Maadi vessels are also said to have been found near the base of the Great Pyramid, though we do not know exactly where. And we have found fragments of Predynastic Maadi pottery in our excavations of the 4th dynasty Workers' Town, south of the Wall of the Crow, providing evidence of much older activity.

It is reasonable to suppose that Early Dynastic tombs would once have occupied the Moqattam Formation at Giza, but the fact that the 4th dynasty pyramid builders quarried and built on such a massive scale there probably accounts for the fact that we now find large Early Dynastic tombs only at the southern rim of the Maadi Formation – one each for the 1st, 2nd and 3rd dynasties. Furthermore, drawn to the great stone mastaba fields and pyramids on the north, archaeologists have paid only scant, intermittent attention to the southerly zone. Closer investigation might fill in the picture of the plateau's beginnings as a burial ground, one that the 4th dynasty pyramid builders erased on the north.

A 1st dynasty mastaba

The oldest known mastaba at Giza dates to the 1st dynasty. A single clay sealing places it in the reign of Djet, more than 400 years before Khufu. Alexandre Barsanti and Georges Daressy excavated the tomb, which was called Mastaba V, in 1904, on the low desert plain at the southeastern corner of the Maadi Formation escarpment.[1] Two years later Petrie and his team re-examined it and documented it [**4.2, 4.3**]. Built of mud brick, it was originally sheathed in niched projections and deep bays characteristic of the Early Dynastic Period.

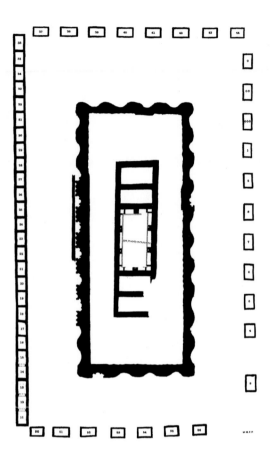

At least 52 subsidiary graves, lined with mud brick and each with their own little ribbed and vaulted superstructures, surrounded the mastaba. With these subsidiary graves, the complex stretched 55 m (180 ft) north–south and 33 m (108 ft) east–west. At 36 m (118 ft) long and 16 m (52 ft 6 in.) wide, the mastaba must have memorialized a very prominent person and her or his household estate. Toby Wilkinson proposed it was for the wife or mother of King Djet himself. If so, this would mark Giza as a site for the royal dead already in the 1st dynasty.[2] Most of the subsidiary graves had been plundered, but from contents that survived Petrie saw hints of specialized retainers. Two slate palettes with round paint receptacles suggest the burial of a scribe or artist. Rows of numbers – one of the scribe's spreadsheets – remained on a flint ostracon that lay near his hands. In another grave, copper chisels and an adze signal a carpenter. In yet another, Petrie found ivory wands topped with carved gazelle heads. Seeing these as clappers, Petrie suggested the deceased had been a dancer.

Archaeologists have found such smaller, subsidiary tombs, albeit more numerous, around the large burial pits and niched enclosures of 1st dynasty kings at Abydos, as well as two of the large 1st dynasty mastabas at North Saqqara. We can see these as antecedents of the Old Kingdom mastabas and rock-cut tombs for scribes, officials and other courtiers flanking the Giza pyramids.

Petrie's measurements of Mastaba V's central burial chamber as more than 10.82 m (35 ft) long and 5.59 m (18 ft) wide make it very close in breadth and width to the King's Chamber in the Great Pyramid. Brick piers projected from the sides to stabilize a wooden frame or shell, of which Petrie documented traces of the bottom beam and upright posts, which reduced the chamber internally to 9.04 m (29 ft) by 4.16 m (13 ft 8 in.). Here again we find a precedent for Khufu, as dark stains on the stone ceiling beams of the granite box of the King's Chamber may indicate wooden uprights for such a wooden framework shrine (see Chapter 8). At each end of the mastaba's burial chamber, two shallower chambers served as magazines for burial goods.

We no longer know the exact location of this 1st dynasty tomb, though it was possibly located in 2010, when contractors constructing a building for the police's Giza camel corps cut through a patch of mud brick and pottery on the northern side of the southern wadi, a couple of hundred metres from the south end of the Maadi Formation escarpment.

A 2nd dynasty tomb

We know even less about the 2nd dynasty tomb at Giza, the location of which is also now lost. Petrie reported he found the tomb 'on top of the ridge facing the cultivation, looking down on the site of the tomb of the 1st dynasty'.[3] He reports a sloping passage with two stone portcullises leading to a burial chamber. His plan shows no continuation after the second portcullis, as though builders left the tomb unfinished [4.4]. But Petrie found numerous alabaster and limestone fragments of dishes, bowls and cylindrical vessels, as well as a pottery jar, and he stated that a tomb shaft of the 26th dynasty cut the chamber to pieces, which must be why his plan does not show it. Five clay jar sealings of King Ninetjer 'thrown into a small well' date the tomb to the reign of this 2nd dynasty king.

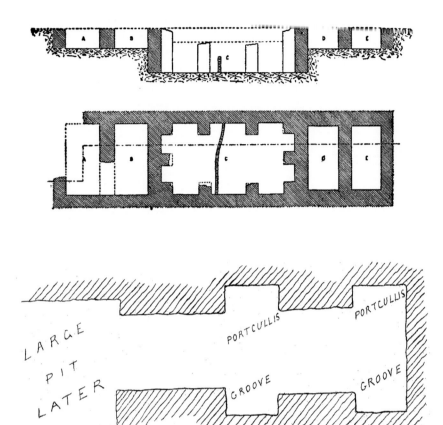

A 3rd dynasty mastaba: Covington's Tomb

A 3rd dynasty mastaba, called Tomb 1 or Mastaba T (by Petrie), measuring nearly 62 × 35 m (202 × 113 ft), occupies a promontory 20 m (66 ft) higher than the base of the Khufu pyramid, nearly on line with its centre axis and about 1,600 m (5,250 ft) to the south. In June 1902 and January 1903, with J. E. Quibell, the American Dow Covington excavated 'Mastaba Mount', and the tomb often bears his name – Covington's Tomb [4.5]. Petrie re-examined it four years later; his plan and report lack much of the information in Covington's publication, while adding a few details.

Unlike other Early Dynastic monuments (and most of the vernacular architecture we have cleared in the nearby settlements), which are orientated slightly west of north, this mastaba is shifted east of north by 9 degrees.

The dimensions given include an 'enclosure wall', 3. 05 m (10 ft) wide at the base, which locks so tightly against the main mastaba as to be part of its structure. Abutments that project from the

TOP
4.3 Daressy's profile and plan of Mastaba V.

ABOVE
4.4 Petrie's plan of the 2nd dynasty tomb on the southern end of the Maadi Formation ridge. It shows the position of the two portcullises and the shaft of a later tomb that cut through the earlier one. The location of this tomb is now also lost.

RIGHT AND BELOW
4.5, 4.6 Covington's plan of Mastaba T, and his schematic drawing of a recessed bay with niches, panels and wooden lintel. The tomb is often known as Covington's Tomb.

inner face of the wall, 14 on the long sides and 7 on the ends, fit into rectilinear bays, 1.75 m (5 ft 9 in.) wide, in the sides of the mastaba, leaving a space of just 25 cm (10 in.) – too narrow for a person to pass. The excavators found the space filled with clean sand, no doubt left there by the builders to protect the elaborate niches and panels on the outer mastaba faces, so characteristic of Early

Dynasty funerary architecture and later 'false doors'. The design is fractal, in that the faces of the projections featured miniature bays and niches, smaller versions of the main ones [**4.6**].

Each bay served as an abbreviated 'false door', with the rear centre featuring a narrow niche that receded 1.27 m (4 ft 2 in.) from the enclosure wall. Evidence from other niched and panelled Early Dynastic tombs shows that the niches served as places for the living to leave offerings and to communicate with the dead. The interlocking enclosure wall and sand fill rendered this function symbolic here. Near the tops of the niches on the east and west sides of the mastaba, Covington found either sockets for round wooden rods that served as symbolic lintels or the crumbling remains of the actual rods. A lack of evidence for wood lintels in the niches of the north and south sides suggests the builders emphasized the west to east orientation that is so clear in later mastaba offering chapels.

A 3rd dynasty pyramid precedent?

The 3rd dynasty builders created Mastaba Mount with a distinctly pyramidal shape. The superstructure might itself have taken the form of a stepped pyramid, similar to the stepped tumulus of 1st dynasty tomb 3038 at North Saqqara, once ascribed to the pharaoh Adjib (and discussed in the following chapter).

Covington thought that he had found the enclosure wall still standing to its original height, 2.7 m (8ft 10 in.), in several places, while the abutments on its inner face stood 2.45 m (8 ft) high. The outer face, plastered white, sloped up from the base at 75 degrees, except on the southern side, where it rose vertically.[4] The niched and panelled vertical faces of the mastaba itself rose 25 cm (10 in.) higher than the enclosure wall, allowing the wooden lintels to barely show above.

But just how did the mastaba rise above this level? Covington was perplexed. Near the centre of the tomb he found intact brickwork almost 7 m (23 ft) above the base, 4 m (13 ft) higher than the top of the enclosure wall. His concern was that if the faces of the mastaba proper rose vertically to this height, they would not have been stable. But this is not necessarily the case. The mastaba was a mass of brickwork fill, not an enclosure formed of free-standing walls. The massive walls of Khasekhemwy's 2nd dynasty enclosure at Abydos, the Shunet el-Zebib, still stand 10–11 m (33–36 ft) tall (see 5.8). But Covington doubted that the delicate niches and panels of the outer faces could be sustained to a height of 7 m (23 ft), so he suggested the builders might have fashioned the upper superstructure in steps, with each face sloped at 75 degrees like the enclosure walls – and also like the accretions and steps of 3rd dynasty step pyramids. The result would have been an oblong, stepped mastaba, comparable to the superstructure of a large 3rd dynasty mastaba, K2, that John Garstang excavated at Beit Khallaf, north of Abydos, which he assigned to King Sa-nakht. Even if the upper faces of Covington's Tomb did rise vertically, the batter of the enclosure wall, together with the steep promontory on which it stood, would have rendered the mastaba pyramidal.

Bipartite substructure

In the interior of the tomb Covington excavated four steps leading from the east down to the top of a stairway passage with battered sides, narrowing to 1.58 m (5 ft 2 in.) at the bottom, the width of the steps. The passage runs for 17 m (almost 56 ft) south, closer to an alignment with true north than the superstructure, to a depth of 8 m (26 ft 3 in.). The stairway was so packed with cemented desert sand that Covington excavated his own passage

4.7 Covington's detailed plan of the substructure of Mastaba T, from the publication of his excavations.

from the eastern flank of the mastaba, through the brick masonry and bedrock. He struck a second, 'stone stairway', which builders might have used before building the mastaba on top.

This stone stairway led Covington directly to the top of the central shaft. At the bottom of the main stairway, an oval-shaped limestone portcullis, 4.5 m (14 ft 9 in.) high, nearly 2 m (6 ft 6 in.) wide and 0.67 m (26 in.) thick, blocked access to the almost square vertical shaft, 2.4 m (7 ft 10 in.) wide. The stairway enters the central shaft about 7 m (23 ft) above its base, which finds a parallel in the northern stairway that opens high in the central shaft of the Djoser Step Pyramid.

The mastaba's central chamber opened east and west of the shaft for a total length of 11.9 m (39 ft), with a width of 2.06 m (6 ft 9 in. or 4 cubits) and a height of 2.62 m (8 ft 7 in./5 cubits) [4.7]. The debris filling two-thirds of the chamber contained much pottery of the 'early Ancient empire'. Four smaller chambers opened off the northern and eastern sides of the central one; two (D and E) feature broad niches. Except for D, these rooms open around 1.8 m (almost 6 ft) above the floor level of the main chamber. Covington called the side chambers 'tombs', which would imply multiple burials. The auxiliary chambers of a comparable mastaba, K1, at Beit Khallaf, also excavated by Garstang, were strewn with alabaster vessels and stone bowls, as well as large wine jars and other pottery, so the auxiliary chambers in Covington's Tomb may have served as magazines for a single burial.

Chamber L, which opens due south of the central shaft, might represent the audience hall of the proprietor's house. At the south end of L,

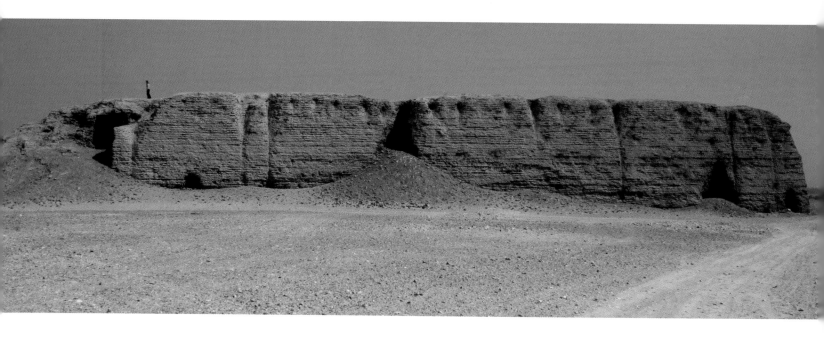

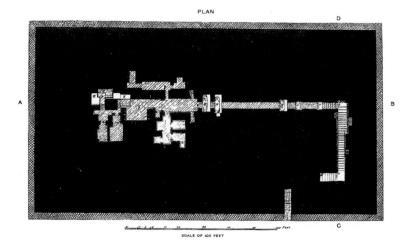

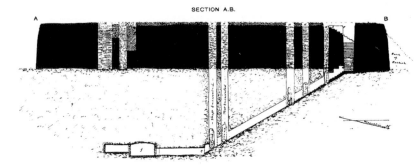

4.8, 4.9 Remains of the huge, rectangular mud-brick 3rd-dynasty Mastaba K1 at Beit Khallaf, north of Abydos, excavated by John Garstang, with his published plan and profile (left).

Two panelled false doors that flank the entrance to chamber L reinforce our interpretation of this as a representation of the master's audience hall.

Rooms H and F (with a closet-sized side room) form a circuit from the rear end of this hall and back to the main chamber. These chambers could be the equivalent of a side gallery (the horizontal chamber at the top of the plan in 4.9) in the Beit Khallaf K1 mastaba [**4.8, 4.9**]. Garstang reported that this gallery 'proved to have been stored with grain in sacks'. The side galleries in Covington's Tomb and K1 are probably the equivalent of the long gallery 4 under the Djoser Step Pyramid, and of Magazine L under the Djoser south tomb. Both were for storing symbolic or actual foodstuffs. The loop formed by these chambers with the central long chamber, which probably represents an open court, make the substructure a simulacrum of the houses of the living. Djoser's builders made this explicit in the substructure of his Step Pyramid by rendering the walls in fine limestone and faience tiles to represent reed mats and wooden frames.

In Covington's Tomb a gallery, A, circumvents the west chamber, 4.8 × 1.8 m (15 ft 9 in. × 5 ft 11 in.) and 2.5 m (8 ft 2 in.) high, which represents

pilasters connected at the top by a drum-roll lintel set off a niche or rear chamber (I). We think that similar north–south rooms with southern niches in houses of the Khentkawes Town served for the master of the house to receive visitors or staff.

the private room of the house. As in houses of the
Khentkawes Town (pp. 394–95), a passage allows
the master direct access from his audience hall. A
small square chamber (K) opens on the southern
end of the west wall. If this was for a canopic chest,
it would be a very early example; debris contained
numerous fragments of stone disks. A broad alcove
topped by a round lintel opens off the western side
of the main chamber, representing the bed niche in
the house of life. This equation of bed and burial
was not unique for ancient Egypt. However, here
the tomb builders created a second shaft that drops
from the floor immediately before the alcove to the
tomb's lower level [**4.10**].

The second shaft, which Covington found
filled with cemented clay, cut through the clayey
limestone of the Maadi Formation down to a bed
of harder rock. At the bottom, an evenly chiselled
limestone portcullis slab, 1.46 m (4 ft 9 in.) wide
and 2.65 m (8 ft 8 in.) high, blocked access to the
lower chamber. To get round it, robbers had cut
a very small hole – too small to remove a large
coffin or mummy. The chamber, 5 m (16 ft) long and
2 m (6 ft 6 in.) wide and high, featured an alcove
opening west, mirroring the upper chamber and its
alcove, but shifted south. Covington found no trace
of a sarcophagus, only some human bones on the
floor of the alcove and in the chamber immediately
in front. Robbers must have removed the rest of the
body, 'doubtless a most important burial'.[5]

A local Giza ruler

Who was this 'most important' person buried high
up on the southern mount nearly a century before
Khufu implanted his pyramid to the north?

Perhaps, as with the 1st and 2nd dynasty tombs
at Giza south, Covington's Tomb belonged to
a powerful local ruler. Its closest architectural

relatives are those large 3rd dynasty mastabas
excavated at Beit Khallaf by John Garstang.
Garstang, who was excavating there in 1900–01,
the year before Covington started at Giza, and
before Firth, Quibell and Lauer excavated and
published the Saqqara Step Pyramid, believed that
Netjerkhet (Djoser) was buried in K1 because of its
size, wealth in stone vessels and numerous clay jar
sealings bearing that king's name. Egyptologists
now believe the five big Beit Khallaf tombs must
have belonged to local rulers. Like Covington's
Tomb, K1 rising above its base on a desert
promontory is visible from afar, making for a
'ponderous effect'.[6] At 85 × 45 m (280 × 148 ft),
K1 was much larger than Covington's Tomb,
but rose to nearly the same height, 8 m (26 ft).

However, none of the Beit Khallaf mastabas
have the elaborate 'palace façade' niching and
panelling seen at Covington's Tomb. Nor do they
feature the Giza tomb's peculiar enclosure wall with
projections that gear into the niched bays. With
its long entrance stairway closed by a portcullis,
the substructure of Covington's Tomb fits into the
3rd dynasty class of 'stairway tombs', examples
of which were found at Beit Khallaf. And yet it
differs in featuring two levels, whereas the large
Beit Khallaf mastabas have only one. The elaborate
niching and panelling on all four sides may suggest
that Covington's Tomb is transitional from 1st and
2nd dynasty forms to the later, 3rd dynasty type, as
George Reisner thought.

Khufu's alignment

The early date, prominence and pyramidal form
of Covington's Tomb, high on Mastaba Mount,
draw our attention back to the alignment with the
centre axis of the Great Pyramid far to the north.
Did Khufu wish to align himself with the memorial
of an early ruler?

Covington documented this alignment on a
map that he did not include in his publication.
More than 90 years later, Geoffrey Martin published
it, prepared by G. Curtis in 1905.[7] Curtis drew a
dashed line from the north–south centre axis of the
Great Pyramid direct to the centre of Covington's
Tomb. We have measured this alignment several
times, and find that Covington's Tomb lies 1,600 m
(5,250 ft) south of the Khufu pyramid and in fact
about 50 m (165 ft) west of the line.

4.10 Profile drawing of
Covington's Tomb, from
his publication, showing
the two-level substructure
which is cut from the
rock below the mud-brick
mastaba.

The centre axis of the Great Pyramid projected south actually intersects a platform, measuring 28 × 12 m (92 × 39 ft), of bluish-grey, oyster-filled limestone, 11 m (36 ft) east of Covington's Tomb [**4.11**]. Covington briefly mentions Mariette excavating it as a mastaba, but we have no further reference. The platform originally featured at least four courses of roughly hewn stones. On the west side, between it and the mastaba, Petrie found more than a dozen stone vessels. He suggested the platform could have been base for the memorial temple for 'the king buried in the mastaba' (or possibly queen).[8] In the middle of the platform he excavated a pit that led to nothing. Could this have been the socket of a tall pole for Khufu's builders to sight an axis line?

While prominent on its rocky mount, we know that Covington's Tomb was not the only Early Dynastic monument in the southern cemetery. It is clear from Covington's map, published by Geoffrey Martin, that his concession included the entire ridge around the bowl-shaped depression of the Maadi Formation outcrop. He found and numbered tombs along the whole of the southern and eastern ridges. Those along the east are in fact the upper part of the so-called Workers' Cemetery (see Chapter 14).

Continuity and the 'Workers' Cemetery'
The 1st, 2nd and 3rd dynasty tombs described above thus probably did not stand alone. They could have been part of a larger cemetery of contemporary tombs that were destroyed or are yet to be found. Karl Kromer excavated a mastaba a short distance east of the stone platform that Covington numbered 3.[9] Through the 4th and 5th dynasties builders enlarged a small, core mastaba, doubling its area, and added offering niches, chambers and burial shafts. Kromer believed that the original, small mastaba (11.6 × 5.7 m/38 ft × 18 ft 8 in.), with a deep central shaft, dated to the late 3rd dynasty. But since he could not reach the burial chamber, we cannot be certain it is not Old Kingdom. If it does belong to the 3rd dynasty, we see here, within a single tomb, continuity and rebuilding over several generations, stretching from the Early Dynastic through the heyday of 4th dynasty pyramid building at Giza and into the 5th dynasty.

A limestone lintel from one of the eastern additional burials was inscribed with the offering formula and list for an 'Overseer of the Gang(s) of Craftsmen, Hemu'. This group burial around the older core mastaba belongs to the continuation around the southern ridge of the so-called Workers' Cemetery on the eastern ridge. Other Old Kingdom tombs have been excavated in recent years on the southern ridge, which are not yet published.

A few years after Covington, Petrie reworked the very same excavation zone, the southern and eastern Maadi Formation ridges. Along the eastern ridge, Petrie excavated the upper tombs of the Workers Cemetery. Unfortunately, he published the tombs in very cursory fashion. (It is possible that Covington's unpublished papers contain more information.)

Along the top of this eastern ridge Petrie noted 'many small brick mastabas' – so characteristic of the lower tombs excavated in the 1990s – as well as rock-cut tombs fronted by mud-brick walls defining small courtyards, just as the Giza Inspectorate excavators also found in the 1990s. From inscriptions on lintels over the tombs, which he discovered largely plundered, Petrie published rough translations of titles, such as royal sealer of the granary, a maker of date wine, an overseer of the commissariat (*Per Shena*), a ship's captain and other titles comparable with those from the Workers' Cemetery. On the basis of names compounded with the god Ptah, such as Nefer-ptah-her-nefer, and other evidence, Petrie dated the tombs to the 5th and 6th dynasties.

Petrie came close excavating the entire escarpment, but thought it would not be worth his expense in workers.

I should have wished to plan and explore this hill more completely; but the inexorable necessity of finding work on a very limited ground for a hundred workers brought from a distance, who could not be temporarily dismissed; and the loss of their wages on unprofitable work, compelled me to start digging at Rifeh sooner than I had wished.[10]

So it would be left to young Egyptian archaeologists, working for one of the authors (Hawass) through the 1990s, to complete the excavations down the escarpment, and present them to the world as the tombs of the pyramid

OPPOSITE
4.11 The central axis of the Great Pyramid projected south intersects a stone platform just to the east of Covington's Tomb.

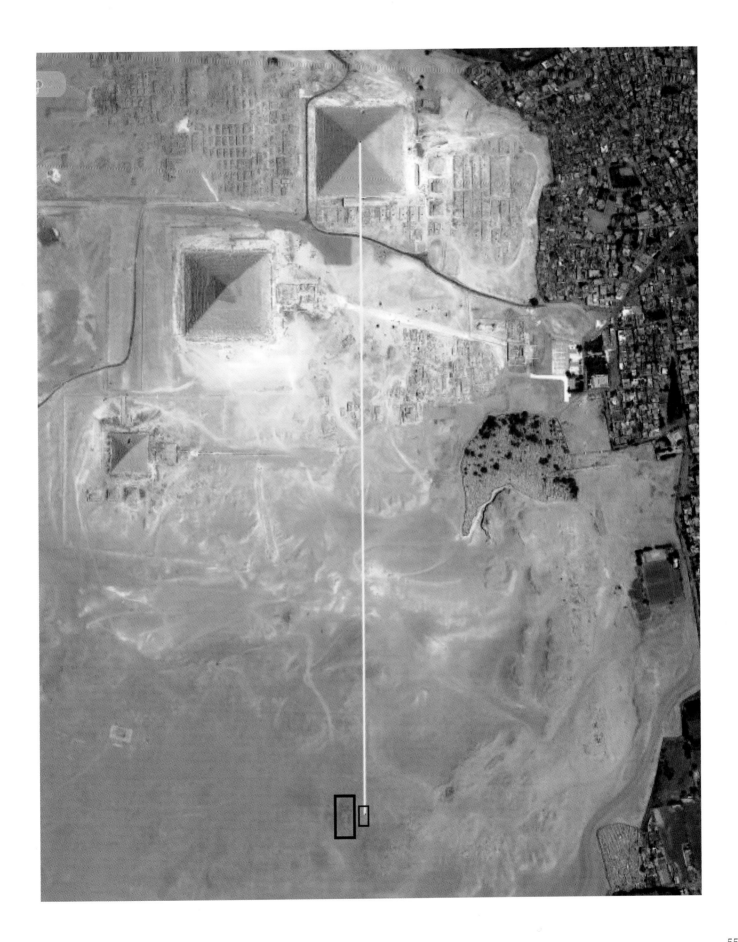

builders. It is now hard to believe that the entire cemetery, on a hillside directly above the so-called Workers' Town or 'Lost City' – the Heit el-Ghurab (HeG) settlement site discussed in Chapter 15 – did not begin in the 4th dynasty, when the town teemed with people. Continuities back into the Early Dynastic in the cemeteries of the upper, southern ridge strengthen this suspicion.

Other Early Dynastic features at Giza?

This seems an appropriate place to address other archaeological features that researchers have claimed are Early Dynastic at Giza, not least the Great Sphinx itself. We, however, believe that builders and quarrymen created all these features in the 4th dynasty or later.

Settlement debris excavated by Kromer

As noted, the extensive 4th dynasty quarrying and building operations could have removed any older tombs and structures from the northern Moqattam Formation outcrop – the pyramid plateau proper. Quarrying for the calcareous, marl desert clay (tafla) on the top of the southern Maadi Formation could also have removed earlier tombs there. The pyramid builders used tafla extensively in their ramps and embankments, and as mortar and plaster in the walls of the settlements. It is our impression that they dramatically deepened by quarrying the distinct, bowl-shaped depression on the Maadi Formation outcrop, for when we walk at its base we can expose marl rock by simply sweeping the sand from the surface.

At the northeastern edge of this bowl, just behind the Gebel el-Qibli knoll, in the early 1970s Karl Kromer excavated a tremendous dump of settlement debris that included much pottery, flint, animal bone and everyday items such as copper needles and fish hooks. He saw in this material, especially in certain seal impressions, evidence that people settled at the Giza Plateau as early as the 1st dynasty.[11] In fact this was already indicated by the Early Dynastic tombs described above – but not, as it turns out, by the seal impressions that Kromer found.

Kromer believed that Menkaure's builders had razed a long-lived settlement in the area where they began his valley temple. But we have considered instead the idea that 4th dynasty quarrymen demolished and removed an older settlement on the Maadi Formation bowl and dumped it to the northeast, where Kromer excavated it. It is true that the high desert is not where we would expect to find a settlement, unless for workers of the first massive construction projects of Khufu and Khafre, the only royal names on the sealings that Kromer found. Yet Kromer believed this debris contained significant Early Dynastic material.

In particular, on half a wooden cylinder seal and on clay sealing fragments, Kromer noted sketchy images of paired *tête-bêche* (head to tail) animals, horned gazelles, figures of people and other crude incised signs. Kromer was not alone in regarding such seals and sealings as signatures of the Early Dynastic, as early as the beginning of the 1st dynasty.

In fact, from our 26 years of excavations at the Heit el-Ghurab site, the so-called Workers' Town, we have a large corpus of just such sealings. The sealings team of John Nolan and Ali Witsell call them 'informals'. They relate to a quasi-literate, non-textual marking system, quite probably for those in positions of administrative responsibility who could not read or write. This system co-existed with, and was dependent on, the literate scribal administration represented by the 'formal' seals and sealings – those which included titles and names of kings and gods. Formal and informal motifs can appear on the same seal or sealing, with gazelle, hare, ape or monkey in registers beside hieroglyphs for such titles as 'sealer of the storeroom'. The AERA team has found many informal sealings at the Heit el-Ghurab site, including some of the same informal motifs that Kromer and others took as being Early Dynastic. The conclusion is that people used these motifs from the Early Dynastic well into the Old Kingdom.

Also, Kromer found no formal sealings with kings' names other than Khufu (5 sealings) and Khafre (38 sealings); he found no names of Early Dynastic kings. In the Heit el-Ghurab sealings corpus we have at least one official title on a Khafre sealing that matches a sealing from Kromer's material. So the informal motifs occur in the same context as formal sealings, with 4th dynasty royal names, in both Kromer's dump and the Heit el-Ghurab site.

Kromer did discover Early Dynastic stone vessels, but archaeologists have similarly found older stone vessels in pyramids and temples from Djoser to Menkaure – they were probably handed down as heirlooms. Other material that Kromer interpreted as Early Dynastic, such as fragments of painted pottery, we have also found in the Heit el-Ghurab settlement.

The dump also included small faience tiles, and Kromer thought that in its Early Dynastic phase the settlement at Giza must have been producing these for the 3rd dynasty palace and even for the Step Pyramid's subterranean apartments. He was correct that a nearby settlement was producing faience tiles – we have found a facility for manufacturing them at the Heit el-Ghurab site, but dating to the 4th dynasty. We can match nearly all the material from Kromer's deposit with the same or similar material from our 4th dynasty Workers' Town, which raises the possibility that 4th dynasty builders demolished an earlier 4th dynasty phase of the site, carted it up behind the Gebel el-Qibli, and tipped it where Kromer later excavated it.

The Wadi Cemetery

In late 1903, in his earliest work at Giza, George Reisner was looking for a place free of ancient remains where he could dispose of the debris he planned to remove from the great stone mastaba field west of the Khufu pyramid. He first excavated below the Western Cemetery, on the northern slope of the northern wadi, about 125 m (410 ft) north of the giant stone mastaba G 2000. Here he found small fieldstone and mud-brick mastabas. His assistant, Arthur Cruttenden Mace, had already excavated west of the main mastaba field and come across 5th and 6th dynasty mastabas, establishing that the mission could not dump spoil in that direction.

The tombs that Reisner found in the Wadi Cemetery are like many of those in the so-called Workers' Cemetery on the eastern slope of the Maadi Formation: small mud-brick superstructures with narrow offering niches, in a few cases featuring small rectangular limestone offering basins at the base of the false doors, and sometimes fronted by a low line of mud brick defining a symbolic courtyard.

Reisner had yet to develop his excavation and recording protocols at Giza, or his ideas about

the development of the core cemeteries. As far as we know, he did not document the pottery and correlate it with the various tombs, which he assigned a running sequence of GW ('Giza Wadi') numbers. Photographs of his excavations show pottery fragments piled on the tombs, and from these it appears to be Old Kingdom [4.12]. In 2009 Peter Der Manuelian studied and presented the information on the Wadi Cemetery excavations, pointing out that 'Reisner was primarily interested in a quick interpretation of the Wadi Cemetery so that he could begin clearing the Western Cemetery proper, up on the plateau, and use this northern area for dumping his excavation debris.'[12] Reisner did throw spoil into the wadi, but ran his main dump lines just west and east of the Wadi Cemetery.

Reisner, and later Manuelian working from the 1903 photographs and reprising Reisner's thinking, see at least two phases to the Wadi Cemetery. They base this inference on photographs showing later tombs built over earlier ones, a situation we have seen in the very similar Workers' Cemetery. But they considered the possibility that the whole cemetery pre-dates Khufu. This interpretation hangs on one of Reisner's earliest observations of stratification. He discerned three layers that

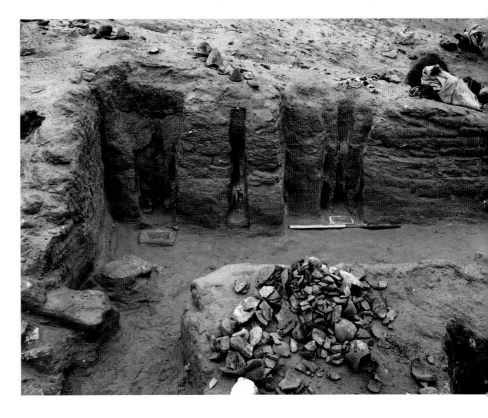

4.12 Photograph of Reisner's excavations in the Wadi Cemetery, 1904, with fragments of pottery piled on top of the remains of tombs. Two offering basins are visible at the base of niches in the mud-brick structures in the centre. View looking west.

engulfed and covered the cemetery, which were, from the top down: (1) 'Clean disturbed sand above'; (2) 'Decayed mud brick or plaster and limestone chips'; (3) sandy dirt.

Reisner interpreted these three layers as material that Khufu's builders had removed from the high plateau directly above in order to build the giant mastaba G 2000 (the largest mastaba in Egypt). He thought that the builders thus tipped the material, in inverse order, over the Wadi Cemetery below and 125 m (410 ft) to the south. In their original sequence, the layers would have derived from: 'the sandy dirt overburden' (3) – originally the highest layer on the upper plateau; 'the remains of mud-brick structures formerly occupying the plateau' (2); 'and finally the clean geological stratum from just above the plateau's bedrock' (1).[13]

This, then, is Reisner's reasoning: if the layers that covered the tombs of the Wadi Cemetery derive from clearing the high plateau for the earliest of Khufu's constructions (G 2000), the wadi tombs must be older. Manuelian notes that Reisner's conclusion would add the Wadi Cemetery and possibly portions of the Western Cemetery 'to the list of other known structures predating Khufu'.[14]

With great respect, we believe that Reisner's interpretation is 180 degrees wrong. Yet on this now hang certain other arguments for pre-Khufu, and even Early Dynastic, structures on the high plateau, which is why we must examine this line of evidence in detail here.

Certainly, part of the stratified sequence covered the wadi tombs. But because Reisner neither excavated nor drew stratigraphic sections of the tombs, we cannot be certain which layer ran under, up to or over the tombs. Observing and recording these elementary relationships would have made all the chronological difference to the very significant claim that here we have pre-Khufu burials. It seems to us probable, looking at the one image of the stratification we have so far seen,[15] that the tombs (with the two phases one directly upon the other) did not lie 'beneath' these three layers. We would suggest instead, from the bottom to the top:

Layer 3 The lower layer of sandy dirt is surface sand that accumulated in the cemetery soon after the tombs were built and during the life of the cemetery.

Layer 2 The 'remains of mud-brick structures' derive from the decay of the cemetery itself. This layer is, in fact, 'the hard packed mud between the walls', which Reisner began clearing.[16] We always find the remains of mud-brick structures embedded in the material of their own decay. As Manuelian noted: 'The upper portions of the tombs had largely disintegrated due to exposure.' In the photograph of the section it appears the dark layer of disintegrated mud brick extends from the tombs, not from over them.

Layer 1 The 'clean disturbed sand' accumulated over the cemetery, as we have also found covering the Workers' Cemetery.

Manuelian points to strong similarities between the Wadi Cemetery and the southern Workers' Cemetery, as well as other 'lower class' burials at Saqqara and Dahshur. He rightly points out that the Heit el-Ghurab (Lost City) settlement ruins extend up the slope *under* the lowest of the Workers' Cemetery. People had abandoned the 4th dynasty settlement – it lay in ruins and forces of erosion had scoured the ruins down to waist or ankle level *before* the lowest tombs of the Workers' Cemetery were built directly upon those ruins.

Like the southern Workers' Cemetery, the Wadi Cemetery saw a long life, well into the end of the Old Kingdom (as the names Teti and Pepi on two inscribed lintels from the Wadi Cemetery would suggest). The various configurations of these small tombs, with their miniature courtyards, mastabas, false doors, basins and sometimes small conical or pyramidal superstructures, are the long enduring forms of common folk, made up of the same elements as 'elite' stone tombs on the high plateau, but on a scale and using material those of lower rank could afford (see p. 78). The folk cemeteries at Giza, on the low desert close to the settlements, up the lower draws and peripheral escarpment, may well have begun in the very early 4th dynasty, and possibly even earlier. Most of the tombs we see in these cemeteries most probably date later, to the 4th dynasty and to the later Old Kingdom.

The Sphinx
Colin Reader has suggested that people venerated the Sphinx as an eastward-facing rock outcrop of

some form as early as the Predynastic Period, and he believes the Egyptians quarried the huge lion body from the bedrock in the Early Dynastic. Only later, presumably in the 4th dynasty, did craftsmen then carve the Sphinx head as we know it, wearing the *nemes* headdress.

The people who created the Sphinx carved the lion body from a block more than 70 m (230 ft) long, which they isolated by quarrying more than 12 m (40 ft) deep into the northwest to southeast dip of the Moqattam Formation. This Sphinx quarry is typical of the deep and extensive 4th dynasty quarrying at Giza. To isolate the base of the Khafre pyramid and the pedestal of the Khentkawes monument, quarrymen cut 10 m (33 ft) deep into the bedrock; in the Central Field, to furnish stone for the pyramids, they cut down 30 m (98 ft) over a extent of more than 230 m (755 ft). Unless we accept without question the Sphinx as Early Dynastic, nowhere else at Giza – or anywhere in Egypt – do we see this scale of stonework in the Early Dynastic, before the 3rd dynasty step pyramids. That the Sphinx is a creation of the Early Dynastic Period is an extraordinary claim. So it would require extraordinary evidence.

Reader's main argument is as follows. The rear, western, end of the Sphinx ditch is more eroded than the front, eastern end of the south side, or the Sphinx body; rainwater running over the sides of the ditch caused the enhanced erosion. But the quarry west of the Sphinx would prevent rainwater running over the sides sufficient to produce this erosion; it was Khufu's workers who quarried the bedrock west of the Sphinx. Therefore the Sphinx ditch and body must predate Khufu.

As Reader himself states, erosion by runoff by itself tells us nothing about the age of a monument. He cites evidence of desert flash flooding at Giza and in the Valley of the Kings from the Old to the New Kingdom. His argument runs aground in the quarry west of (behind) the Sphinx and north of the Khafre causeway (we call this area the Central Field North, CFN). We now see good reason to believe Khafre's workers made this quarry. Khufu's main quarry extends south of the (later) Khafre causeway (which, for convenience, Reader would also move into the Early Dynastic period).

Over the last decade, a team from the Giza Inspectorate has excavated down to bedrock in this quarry west of the Sphinx, clearing a series of Late Period tomb shafts west of Campbell's Tomb. For a run of around 150 m (490 ft) the quarry is only 2.5 to 3 m deep (*c.* 8–10 ft), with the bedrock base of the Khafre causeway forming its southern edge. Quarrymen, probably in Khafre's reign, worked the quarry floor even and smooth, following the natural southeasterly dip of the limestone strata. The floor of the shallow quarry and the Khafre causeway thus appear to have been a unified shaping of the bedrock. To the west, below and north of the causeway and Khafre's upper temple, quarrymen worked much deeper. To the east, immediately behind the Sphinx, they left a kind of north–south bridge in the bedrock, 25 m (over 80 ft) wide, perhaps for construction purposes in order to move stone and materials from the Central Field East quarries to the Eastern Field, east of the Khufu pyramid.

We might think that this bedrock bridge behind the Sphinx and the quarry to the west, even as shallow as 3 m (10 ft), would prevent water spilling over into the western ditch. But this is too simplistic. Over our 40 years at Giza, we have seen a number of sudden, heavy downpours. If the rain lasts long enough, the Sphinx first sheds a tear – a dark wet stain appears down the cheek from its right eye. A sustained, hard rain will cause little torrents of water to run from any and all sized catchments and down any channel and crevice. During long downpours, we have witnessed a sudden stream running along the channel in the southern Sphinx floor, where the lowest, most clay-like, soft bedrock stratum of Member II dips into the floor. Repeated rains eroded this layer into a channel along the Sphinx. (Reader ignores the fact that the southeasterly sloping lower beds of Member II, which show the greatest erosion, are not exposed at the eastern end of the ditch.)

During these heavy rains and flash floods, the water washes over western side of the Sphinx ditch – and more so in particular areas. (Reader also ignores the fact that the bedrock slopes south, away from the Sphinx ditch, as well as east, towards it.) The quarry to the west does not prevent this flow and the consequent erosion.

In a recent publication, Reader cites a letter that Richard Lepsius wrote about a sudden storm on 2 January 1843 that brought down his tents

behind the Sphinx. A downpour and flash flood washed through his camp, carrying equipment, books and drawings 'into a deep hollow behind the Sphinx', forming a 'muddy, foam-covered, slimy lake'.[17] This hollow would be the quarry west of the Sphinx. In 1843 sand filled the quarry and the entire Sphinx ditch. Running water could not erode the western Sphinx ditch if sand filled it, but nonetheless, Reader cites the Lepsius account as evidence that after the quarry existed such floods could not wash over the western side and into the Sphinx ditch.

On the night of 25 February 2010 we witnessed one of the longest and heaviest rainfalls at Giza of our careers. Like Lepsius's storm, the initial onslaught brought hail. Unlike in Lepsius's day, massive excavations had emptied the Sphinx ditch. Sand still filled much of the bedrock bottom of the quarry to the west, but excavations of the prior few years had exposed a large area of the bedrock floor. In every sustained rain, water flows not only as one or two convergent streams from west to east, it runs over any and all surfaces. And rainwater does run over that east-facing western edge.

The next morning we saw that streams of rain had cut rivulets and runnels into the sand banked against the bottom of the quarry face [4.13]. These little channels show that the rainwater flowed down the joints or fissures in the Member II beds. These joints, however, are not primarily features of surface erosion: other forces, perhaps tectonic, created them in geological ages past and they appear in some parts of the Giza Plateau more commonly than in others. They happen to be more numerous in the bedrock of the western Sphinx ditch. Once quarrymen opened the ditch, any rainwater would then have worked to enlarge each crevice.

In 2010 a 'muddy, foam-covered, slimy lake' had formed, just as Lepsius witnessed in the sand-filled quarry. But this time the lake was in the Sphinx ditch [4.14, 4.15]. The Sphinx looked like a marine creature, emerging from and entirely surrounded by water that remained more than a foot deep, well into the next day, when Giza Inspectors began to pump it out. This Sphinx flood was post-Khufu. The quarry to the west, a good part of it excavated down to bedrock, did not prevent water flowing over the western Sphinx ditch.

More erosion might be visible at the western end of the Sphinx ditch than the eastern, and it is possible running rainwater contributed. But the Member II bedrock at that end, which geologically has more joints than to the east, is always eroding through other processes. The bedrock surface of the harder beds continuously spalls, pushing off flakes up to 2 cm (1 in.) thick and 30 cm (1 ft) wide. This mechanical erosion does not require rainwater – efflorescing salts are the culprits. The more clayey layers have eroded back further into great recesses ('sub-horizontal' erosion). You can crumble these surfaces with your bare fingertips. Over our 40 years at Giza we have seen the loss of the Sphinx ditch surfaces.

Other aspects of the dating of the Sphinx are addressed in Chapter 10. For now, in summary, two main points:

1 Whether through mechanical processes or the effects of rainwater, the more eroded western end of the Sphinx ditch (and the erosion of the Sphinx under the earliest casing) does not require centuries or millennia to have taken place. Given the processes and changes we have witnessed over 40 years, it could have happened over the few generations following Khafre. We believe it was the same forces over the same period that cut the ruins of the Heit el-Ghurab (HeG) site down to waist or ankle level – before the end of the Old Kingdom.

4.13 Member II layers showing many joints in the western side of the Sphinx ditch. A sustained, hard rain in February 2010 sent water running down the joints, as evidenced by the channels cut in the sand banked at the base.

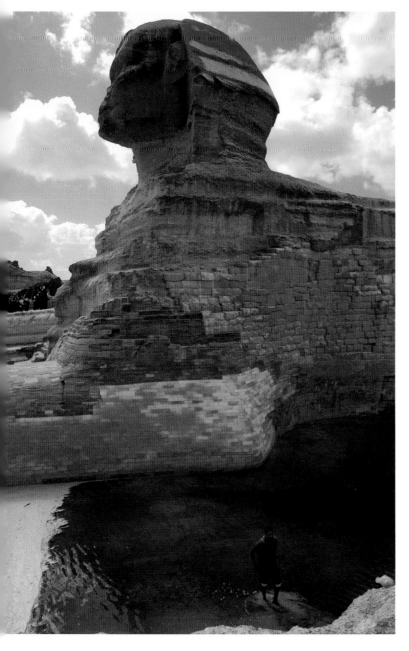
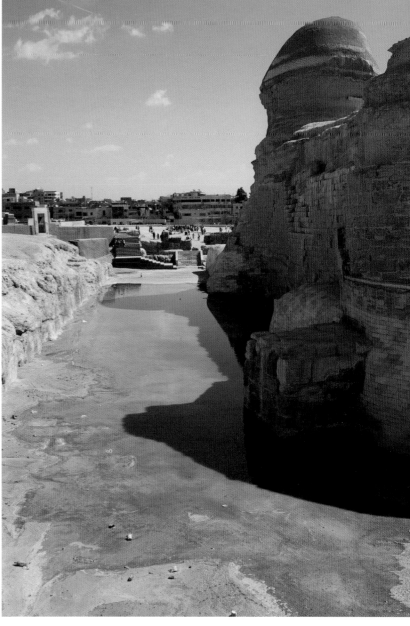

2 An argument for the age of the Sphinx based on erosion must take second place to the broad archaeological and cultural context. As we noted (Chapter 2), we have excavated artificial holes and natural fissures in the bedrock floor of the Sphinx and Sphinx Temple sometimes down to arm's reach. We find in every nook and cranny 4th dynasty pottery; we do not find any traces or residues of the Early Dynastic Period.

During Predynastic and Early Dynastic times, people must have settled on the Giza plain. Local rulers and their dependents built tombs in the low desert and up into the ravines flanking the plateau. In at least one case, Mastaba V, a royal family member created a large tomb at Giza. By the 2nd and 3rd dynasties, local residents and rulers may have built tombs at Giza partially of stone or cut into the bedrock. It is even possible that the Sphinx began life as a venerated natural outcrop. But the evidence shows it was 4th dynasty quarrymen who created the Sphinx, its ditch and the Sphinx Temple in a generation prone to gigantism on the Giza Plateau.

4.14, 4.15 An unexpected view of the Sphinx surrounded by a lake of water after sustained, hard rain on the night of 25 February 2010.

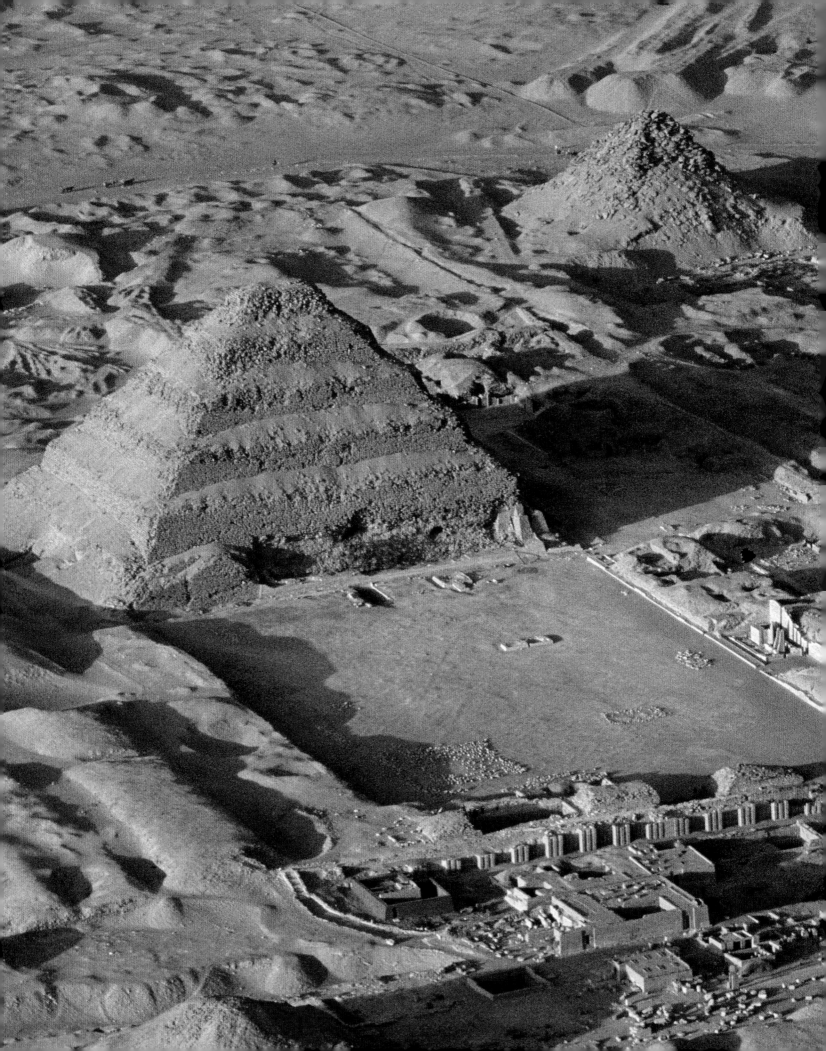

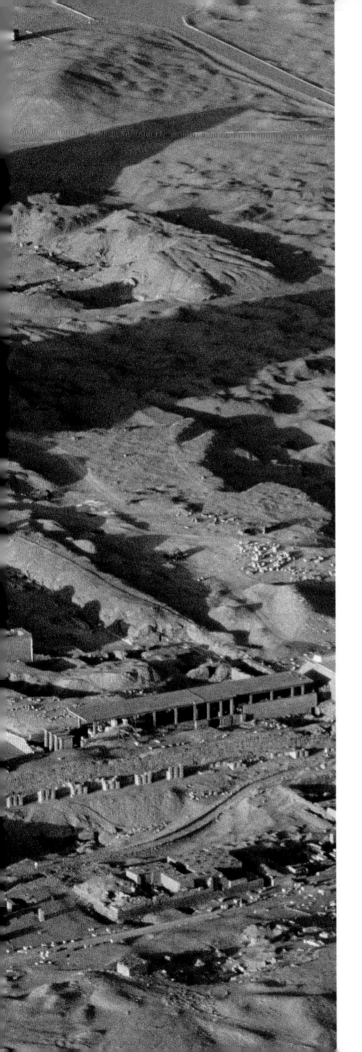

CHAPTER 5
Origins of the pyramid

The 3rd dynasty Step Pyramid of Djoser at Saqqara heralded

the classic pyramid age, taking the form of a royal grave mound

on a scale and level of sophistication previously unknown.

But Egyptologists trace the origins of even the giant pyramids

back to the low mounds of sand and gravel that covered simple

Predynastic pit graves.

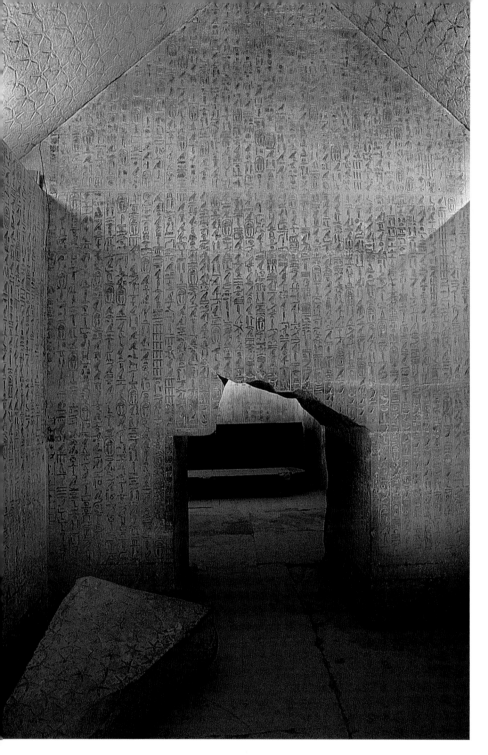

5.2 A wall in the antechamber to the burial chamber of the 5th dynasty pyramid of Unas at Saqqara, covered in Pyramid Texts – spells and recitations for the deceased king's success in the Afterlife. This is the first time that the Pyramid Texts appear inside a pyramid.

king's body in the primeval mound allowed his life force (*ka*) and renown (*ba*) to be resurrected as an *akh*, an effective being that could intervene from 'That City' of the Afterlife on behalf of the living (see Chapter 7).

Egyptian literature about the Afterlife contains abundant references to divine mounds. The Pyramid Texts, the oldest literature of all (first inscribed in the interior chambers of pyramids in the late 5th dynasty) [**5.2**], describe the Creator, Atum, rising as a mound in the enclosure at the sacred site of Heliopolis. They also refer several times to the 'Mounds of Horus', as well as to the mounds of Horus' arch-rival, Seth. The dead king's soul is told to come to these mounds, to occupy them, to circle around them and to govern them. 'Raise yourself, O King', the Pyramid Texts exhort, 'that you may see the mounds of Horus and their tombs, the mounds of Seth and their tombs.' In the texts the primeval mounds are identified with the royal cities and cemeteries, so we might imagine that the Egyptians saw the pyramid also as a magical mound, rising above the necropolis below – the physical counterpart to 'That City' of the Afterlife.

Hierakonpolis: the mound of Horus

The earliest association of king, mound and Horus, the god of kingship, comes from the site the Greeks called Hierakonpolis – Nekhen in ancient Egyptian and known as Kom el-Ahmar today. Hierakonpolis became an important centre in the Early Predynastic Period (*c.* 4000–3200 BC) and emerged as a 'capital' of southern Egypt. Here, in the middle of the local temple precinct, Egyptians of the Early Dynastic Period, perhaps as early as the beginning of the 1st dynasty, raised a circular mound, nearly 50 m (164 ft) across, revetted with stone.

Later Egyptians of the fully mature pharaonic state regarded this mound, which from their perspective belonged to their own remote antiquity, as extremely special to the cult of Horus. They

Mythic mounds: pyramid as mound

For three millennia the Egyptians believed that placing the bodies of their dead under a burial mound gave the departed the seed of renewed life. Just as the first mounds of earth to emerge from the annual Nile flood sprouted new plants, in Egyptian belief the primeval mound represented the fertility from which all creation grew. Planted in the earthen mound of his grave, the king's mummy, like new seedlings after the withdrawal of the flood, would live again. To put it in terms drawn from later pharaonic times, planting the wrapped relic of the

PREVIOUS PAGES
5.1 The Step Pyramid of the 3rd dynasty King Djoser at Saqqara was the first of the classic pyramid age, but the origins of the mound within an enclosure can be traced to Predynastic times.

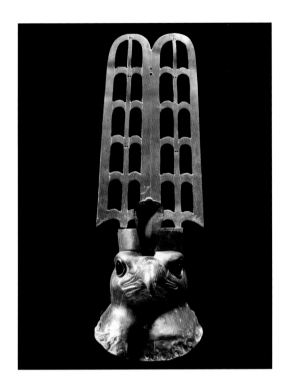

built a sanctuary of five chambers on top of the mound, recalling the five niches that became standard in the sanctuaries of the upper temples of pyramids following the reign of Khafre. Under the central chamber they carefully buried an icon to embody both the essence of the cult of Horus of Nekhen and the emergence of the deity from the underlying Early Dynastic mound that, for these later Egyptians, must have seemed to reach back to the beginning of time.

In the centre of the chamber they constructed a brick-lined crypt, covering it with a basalt slab. Beneath this cover, in the moist earth, they embedded a beautiful hawk fashioned of copperplate, with head and plumes of gold sheeting [5.3]. The craftsmen made the body of the hawk as a mummiform or nested bird – an image of fecundity. They intended this Horus falcon of Nekhen as the totem image to be carried on a standard in sacred processions. For its burial, in place of the wooden pole of the standard, they set the base of the falcon on a metal rod pushed vertically down into the pit and anchored in a ceramic jar. The rod and jar, in turn, were set within a cylindrical ceramic offering stand.

With this buried composition, the ancient mound became a virtual tomb of the sacred cult falcon of Nekhen. Whether it was done in the

Middle Kingdom or the New Kingdom, for those who installed this divine implantation this ritual burial of Horus reactivated the archaic mound – it was a replanting of the sacred seed. The Old Kingdom Egyptians expressed this same basic concept in the grandest sacred mounds they ever constructed – the pyramids.

Abydos: tombs of the first pharaohs

The ancient Egyptians thought that their first pharaohs hailed from This, capital of Nome 8, of which Abydos was the necropolis and religious centre. It is at Abydos, set far out in the desert near the high cliffs, that we find the communal cemetery of Egypt's earliest kings [5.4].

Just before the beginning of the 1st dynasty (c. 2920 BC), the graves of local rulers and the elite consisted of neat mud-brick boxes sunk in the desert and divided, like a house, into several chambers. The 1st dynasty rulers of a united Egypt built tombs in the same style, but on a much larger scale and with greater complexity. The subterranean mud-brick boxes now formed a shell for an internal construction – shrine or chamber – made of wood; the stone chambers of the pyramids may likewise have housed inner chambers of wood.

Then beside each grave, the Early Dynastic Egyptians set up pairs of large stelae bearing the name of the buried ruler, of which several examples survive. And we think a mound must have covered these subterranean royal tombs, because it is hard for us to conceive of a king's grave modestly hidden away beneath the flat desert surface marked by nothing except the inscribed stones (though perhaps the later towering pyramids influence our vision). We do know that in at least one case the Egyptians built a concealed tumulus above the subterranean burial chamber but buried below the desert surface by a little under 1 m (3 ft).

Günter Dreyer, who re-excavated the royal Early Dynastic cemetery at Abydos, believes that for the ancient Egyptians the tumuli over the kings' graves resonated as an image of the generative primeval mound that ensures resurrection.[1] Beneath the ground, the magical mound would be safeguarded against erosion. Dreyer reconstructs another mound, rising above the desert surface, composed of sand with a mud-brick casing. Although he

5.3 The falcon head of Horus of Nekhen, with its tall plumes made from beaten gold, was discovered by J. E. Quibell buried beneath a chamber at Hierakonpolis in 1897. The body of the hawk was made from copperplate. It is now in the Cairo Museum (JE 32158); 37.5 cm (15 in.) high.

5.4 Plan of the royal cemetery of Umm el-Qa'ab at Abydos, ranging from the smaller Predynastic graves to the 1st dynasty tombs and the large, complex royal tomb of Khasekhemwy of the 2nd dynasty.

BELOW
5.5 The tomb of Den at Abydos with its numerous subsidiary burials, after its re-excavation by Günter Dreyer for the German Archaeological Institute. View to the southwest.

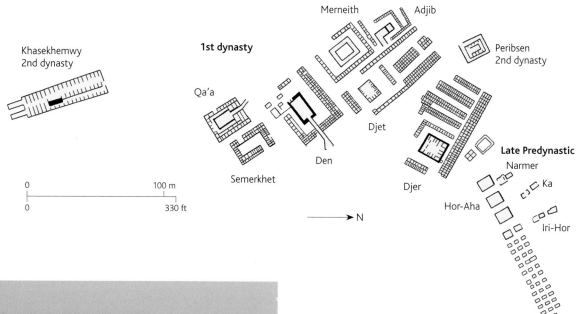

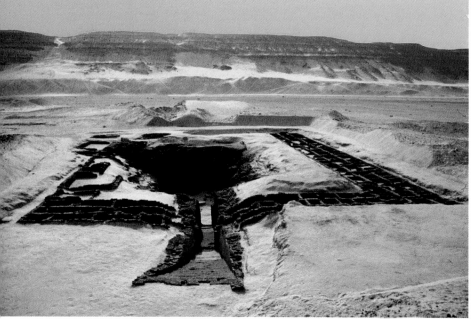

has found no evidence of the mud brick of this second tumulus, Dreyer is not only influenced by the idea that the Egyptians must have marked a royal tomb with something more than just a pair of tombstones, but also points to the vast quantity of excess loose material on the restricted surface area of the royal cemetery as the residue of the missing mounds. It would have been impossible to replace all the sand excavated for the great tomb pits once they had been fitted with mud-brick and wooden chambers, and the surplus material must therefore have been piled above the grave. This second tumulus would have risen no more than 1.5 m (5 ft)

high in the case of the tombs of two of these early kings, Djer and Djet, and only 20–40 cm (8–16 in.) for another, Den [**5.5**]. We see the double mound construction again in private tombs of the pyramid age, and in the pyramids themselves.

Retainers' graves
Trailing behind the three large chambers of the tomb of the first king at Abydos – Hor-Aha – around 35 smaller, mud-encased, square pits line up in rows like a royal entourage in procession behind the king. And it is exactly for an entourage that these pits were intended – attendants of the king who were possibly sacrificed to follow him into the Afterlife. This interpretation gains support from Dreyer's analysis of the human bones that earlier excavators carelessly plucked from these pits and scattered nearby: they almost all belonged to young males, no older than 20 or 25 years of age. Curiously, the bones associated with the rectangular chamber bringing up the rear were from young lions. While this deathly train of retainers' graves may be the antecedent of the organized cemeteries that accompany the 4th dynasty pyramids, ritual sacrifice had already ceased by the end of the 1st dynasty.

Over 300 subsidiary burials surround King Djer's tomb, considerably more than those of Hor-Aha, his immediate predecessor. Some were

found empty, but there was evidence that in others the body had been wrapped in cloth soaked in natron, the naturally occurring salt later used in mummification, and then placed in a wooden coffin. Small stone stelae, inscribed with the name and crude visage of the owner, stood by many of these tombs. These reveal that the majority belonged to women, a smaller proportion to males and two to dwarfs, giving the appearance of the members of a court, with harem and attendants.

Sacred enclosures

A long wadi stretches down from these earliest royal burials at Abydos to the edge of the cultivation, about 1.5 km (just under 1 mile) away, where the 1st and 2nd dynasty kings constructed a second element of their tombs – large rectangular mud-brick enclosures [5.8]. Elaborate bastions, niches and panels decorated the outer faces of the walls of these massive structures, with each bastion and recess likewise niched in a kind of fractal repetition. Whatever the origins of this complex, niched architecture – some scholars see it as one of several traits that the Egyptians seem to have borrowed

from the Mesopotamian lands of Sumer and Elam, while others believe that it was an invention of the Late Predynastic Delta culture taken over by the conquerors from the south after unification of the 'Two Lands' – it became an important and distinctive symbol of the palace, as represented in the *serekh*. The *serekh* is the rectangular frame that contains the name of each king as an incarnation of the god Horus. In the lower part is a representation of the niched palace-façade, and on top perches the falcon of Horus [5.6].

In 1991 and 2000 a team from the University of Pennsylvania under David O'Connor and Matthew Adams made a spectacular and unique discovery associated with the Abydos enclosures. Between the largest enclosure, the Shunet el-Zebib, assigned to the 2nd dynasty ruler Khasekhemwy, and the enclosure named 'the Western Mastaba', they excavated a 'fleet' of 14 boat burials arrayed in a southeast–northwest row [5.7].[2] The hulls, averaging 18 or 19 m (59 to 62 ft) long, constructed of wood planks lashed together, had been lowered into shallow trenches. Each trench was filled with mud brick and the entire grave was covered by a low

ABOVE
5.6 *Serekh* of the 1st dynasty King Djet. Hieroglyphs of the king's name appear in a space above a niche-and-panel façade with narrow doorways, representing the royal residence.

LEFT
5.7 Some of the row of boat burials excavated by David O'Connor and Matthew Adams at Abydos. In the background is the Shunet el-Zebib.

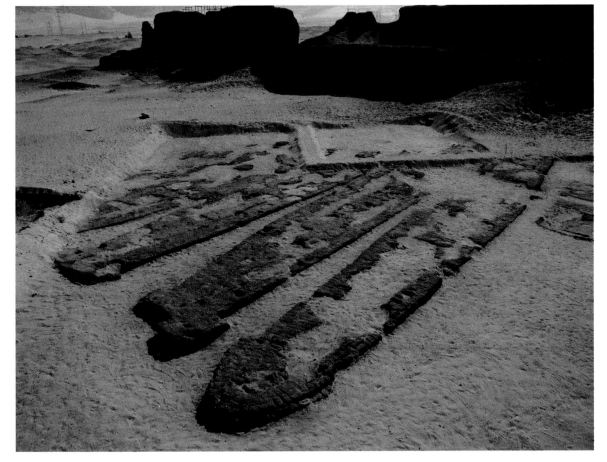

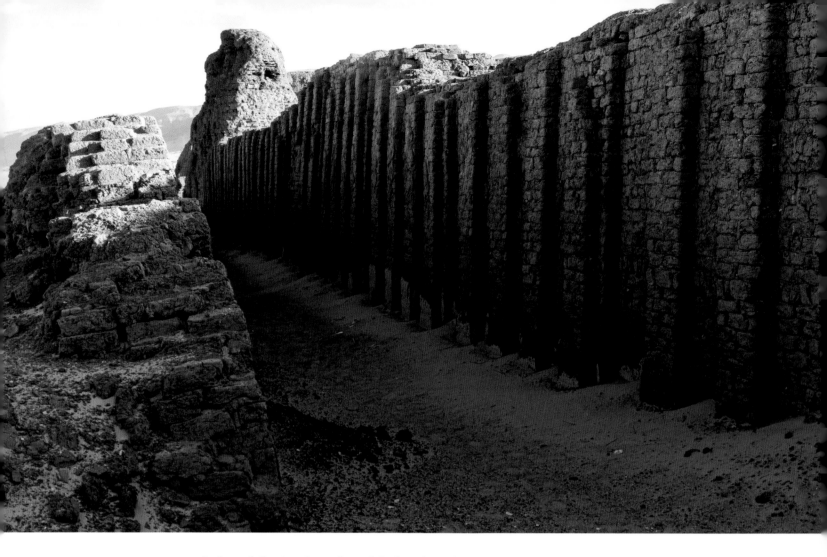

5.8 The niched and panelled façade of the inner wall of the Shunet el-Zebib, the largest of the royal 'valley enclosures' at Abydos, assigned to Khasekhemwy. View to the south down the corridor formed by an outer enclosure wall.

platform, following the outline of the boat buried below, and then plastered and whitewashed. The line of graves gives the appearance of boats docking at the 'port' of the large enclosures.

Pyramid precedents

Over the course of the 1st dynasty the structures of the tombs built by rulers at Abydos evolved. Petrie summarized succinctly the principal changes in the royal tomb and the features that were later incorporated into the pyramids:

> By Merneit[h] these [offering] chambers were built separately around [the burial chamber]. By Den an entrance passage was added, and by Qa the entrance was turned to the north. At this stage we are within reach of the early passage-mastabas and pyramids. Substituting a stone lining and roof for bricks and wood, and placing the small tombs of domestics further away, we reach the type of mastaba-pyramid of Seneferu, and so lead on to the pyramid series of the Old Kingdom.[3]

Egyptologists also find incipient forms of some principal elements of later pyramid complexes in a series of large mud-brick mastabas lining the escarpment at North Saqqara. These mastabas, which are contemporary with the 1st dynasty royal tombs at Abydos, would have dominated the Early Dynastic settlement, called the 'White Wall', occupying the western bank of a Nile channel below them. This and another extensive settlement due east on the other side of the Nile Valley formed the first 'Gate of the Delta', precursor to the national capital of Memphis. Egyptologists have disagreed whether the Saqqara mastabas are the actual tombs of the 1st dynasty kings, or whether they are secondary tombs that the kings built to represent their presence in the northern part of the recently united kingdom. Most, however, now favour a third possibility – that they belong to the kings' highest officials who administered in the north.

At Saqqara the two separate elements found at Abydos – grave mound in the desert and model funerary palace near the valley – were combined. The elaborate niche-and-panel motif seen on the Abydos enclosures decorated the exterior walls of

the 1st dynasty mastabas at Saqqara, a series of tent-like enclosures, 'petrified' – not yet in stone but rendered in solid mud brick and colourfully painted plaster – to last the ages above the northern capital. And within the mastaba, the tomb builders enclosed mounds or, in at least one case, a low stepped pyramid of mud brick over the grave pit. Here the symbolic mound is set directly within the model funerary palace.

North of mastaba 3357, the earliest of the series, which the excavator Walter Emery ascribed to the first king of the 1st dynasty, Hor-Aha, on the basis of sealings with his name, the builders created a set of model buildings, possibly granaries, with two large terraces enclosed by thin, low walls.[4] The terraces extend northwards to walls bordering a boat pit, giving the appearance of a simulated quay or dock for off-loading commodities to be stored in the model buildings. When Emery excavated these remains in 1937 he was initially not certain that they related to mastaba 3357, but later reached this conclusion. If correct, the whole arrangement – tomb and simulacral buildings – could be seen as the precursor to the offering chapels of later tombs and the upper pyramid temples, such as that on the north side of the Djoser Step Pyramid. Emery also found boat pits north of mastabas 3503 and 3506, the forerunners of the boat pits at the pyramids.

Mastaba 3505, dating to the very end of the 1st dynasty, features a much more developed north chapel that is an even closer parallel to the temple at the northern base of the Step Pyramid, although it also fits within the development of officials' tombs and chapels, as Barry Kemp has shown.[5] The fact that it is a parallel for both a royal temple and the chapels of high officials is one of many indications that the gulf between the king and his administrators, who were probably close family members, was not as great in certain respects as has long been assumed.

Subsidiary burials appear around the North Saqqara mastabas from the reign of Djer, though fewer in number than at Abydos. Mastaba 3504 [5.9] from the reign of Djet has around 62, but they gradually seem to have gone out of fashion. Mastaba 3506, from Den's reign, has only 10,

while 3035 of the same reign has none; mastaba 3500, dated to the reign of Qa'a, the last king of the 1st dynasty, has just four, as far as we know.

In the core of these early mastabas at North Saqqara we see striking features that provide convincing precedents for the later pyramids. The substructure of the earliest mastaba, 3357, consisted of simple rectangular pit, 1.35 m (4 ft 5 in.) deep, divided into five rooms by cross walls. The builders stuck reed mats on the walls, representing a lightweight reed enclosure, perhaps to create an interior counterpart to the painted niches and panels on the exterior. Two rooms, probably magazines for offerings, flanked the burial chamber, the central and largest room. Round wooden beams roofed all five rooms of the substructure, and over them the builders laid a continuous layer of wooden planks. This they then covered with reed mats, and topped the whole sequence with mud brick. Within the mastaba, above the lower rooms, they divided the interior into 27 smaller magazines with a chequerboard pattern of unbonded walls. They filled each small magazine with sand to a depth of 1 m (3 ft) to create a false floor, upon which those who prepared the royal funeral placed additional burial goods.

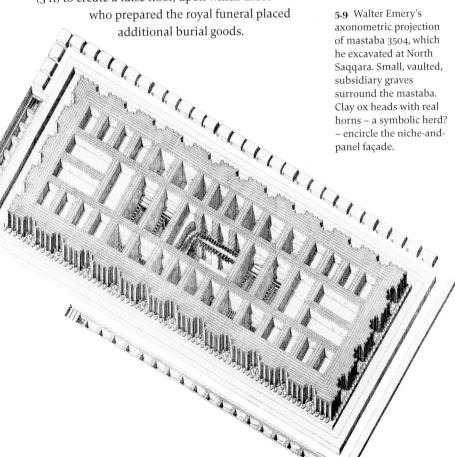

5.9 Walter Emery's axonometric projection of mastaba 3504, which he excavated at North Saqqara. Small, vaulted, subsidiary graves surround the mastaba. Clay ox heads with real horns – a symbolic herd? – encircle the niche-and-panel façade.

Mastabas that followed 3357 at North Saqqara correspond more or less to this model of sunken burial chamber and chequerboard upper magazines. But in mastaba 2185, for the first time, we find great stone beams over the burial chamber. Major innovations appear in the reign of Den. Mastabas 3036 and 3035, which contained sealings of the officials Hemaka and Ankhka, are the first to feature a stepped entrance corridor built into a sloping trench that approaches the burial chamber from the east. These corridors include the first known grooves and slabs of a portcullis – the sliding stone door that would be used in pyramid passages through the entire Old Kingdom. In mastaba 3500 two portcullis slabs still stood in position [5.10].

The approach corridor and portcullis meant that people could now enter the burial chamber and magazines after the builders had covered these interior spaces with the mastaba superstructure.

Before, the builders had to wait until the body had been interred before constructing the mastaba, and once the burial was in place and the mastaba was built over it, no one could re-enter the substructure.

The mound within the mastaba

By covering the burial chamber and lower magazines with a mound of sand encased with mud brick, the builders were able to enclose those elements after the funerary party had interred the deceased but before they constructed the niched mastaba over the whole tomb. Emery found a striking example of just such a central tumulus in mastaba 3507, directly over the burial chamber. The builders subsequently constructed a grid of small magazines over the mound. While it had a practical, structural function for the builders, this mound within the mastaba must also have carried the same magical significance as the sunken mound of Djet's Abydos tomb. And in this arrangement of mound overbuilt by magazines, the tomb resembles the Hierakonpolis temple mound beneath the square mud-brick chambers that were constructed later. Emery conjectured that mastabas 3506 and 3471, and perhaps others, might also have had low central mounds within the mastaba that he had either missed or that were only faintly indicated in the ruined state in which he found them.

In the configuration of mastaba 3507's mound within a niched surrounding wall we can also see a certain similarity with the basic pattern of the Djoser Step Pyramid set within its enclosure of a niche-and-panel wall. But the Saqqara tomb that shows the closest parallels to the Step Pyramid is mastaba 3038, dating from the reign of Adjib [5.11].

Its substructure consisted of a 4-m (13-ft) deep rectangular pit flanked on the north and south sides by smaller rooms on a higher level. One on the north contained nine round granaries set within a bench built around three sides of the room; the tops of the granaries were covered with ceramic lids. Wooden beams and planks formed the ceilings of the two levels inside. The builders enclosed the entire substructure with mud-brick walls rising from the edge of the pit to a height of 6.1 m (20 ft), and then covered the top of this rectangular structure with brickwork.

On the north, south and west sides they then built eight shallow steps, rising at an angle of

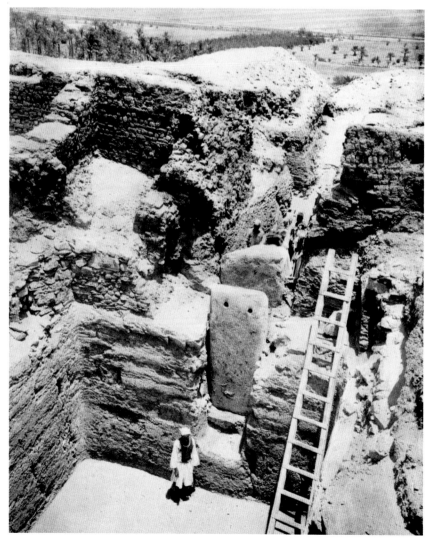

5.10 View into the interior of mastaba 3500 at Saqqara from the reign of Qa'a, showing the great stone portcullis slabs still blocking the entrance passage.

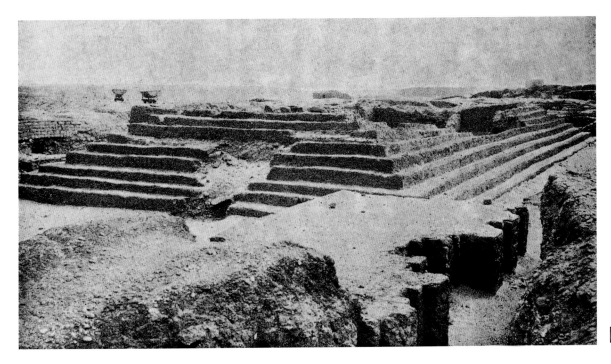

5.11, 5.12 The stepped tumulus inside the niched and panelled outer façade (lower right) of mastaba 3038 at Saqqara, associated with sealings of the king Adjib, which include a representation of a stepped mound.

49 degrees, using sand and rubble encased in mud brick. In so doing they created an oblong step pyramid – except that on the east side, where two small stairways entered the two levels of the substructure, the vertical face of the core building remained. In the next phase of construction, broad mud terraces, 1 m (3 ft) high, were extended from the northern and southern sides, covering the mound up to its fourth step. In the final phase, the builders surrounded the terraces with a typical niched enclosure wall, with three broad recesses on the short sides and nine recesses on the long sides. They then filled the area within with sand to the top of the niched walls, completely burying the stepped mound within. Two stairways led up from the central broad niches on the north and south sides to upper magazines built within the mastaba.

While these different building phases are distinct, they may not represent changes in plan. Rather, those who directed the builders may have envisioned the mound within the mastaba as having the same magical purpose as in other tombs as well as the buried mound in Djet's Abydos tomb, that is, to represent the primeval mound. In mastaba 3038, the buried mound – almost a step pyramid – within the niched mastaba wall is remarkably similar to the basic pattern of the Djoser complex.

When Emery stripped away the niched mastaba and revealed the stepped mound within this tomb,

Egyptologists were struck by its resemblance to the motif of a stepped mound linked with the name of Adjib found etched on pottery, stone vases and ivory tablets from both Saqqara and Abydos. In these representations, on top of the stepped mound is a stela with hieroglyphs that read 'protection around Horus' (i.e. the king) [**5.12**]. Could this innovative stepped mound, buried inside mastaba 3038, have been held in such renown by the literati of the 1st dynasty court that they associated it with King Adjib's name?

As noted above, in mastaba 3505 a well-developed association between tomb and a chapel or temple on the northern side was already apparent at the end of the 1st dynasty. The burial chamber of 3505 is orientated east–west, while the entrance corridor to the substructure approaches from the north for the first time, before turning west towards the chamber. From this point until the end of the Old Kingdom, entrance passages in royal tombs would point north.

A gap in the record for the 2nd dynasty was formerly an obstacle to tracing royal tomb development from the 1st dynasty through to the pyramid age, but then Günter Dreyer established that Khasekhemwy, at the end of the 2nd dynasty, directly preceded Djoser, at the beginning of the 3rd.[6] At Abydos, Khasekhemwy built for himself a large, linear, subterranean tomb with numerous

magazines [**5.13**], together with the largest and best-preserved of the enclosures down near the valley, the Shunet el-Zebib (see 5.8). A predecessor of Khasekhemwy in the 2nd dynasty, Peribsen, also had a tomb and an enclosure at Abydos.

However, earlier 2nd dynasty rulers were buried in a location south of the Djoser pyramid at Saqqara, in two, possibly three, large substructures in the form of vast complexes of magazines connected by long corridors. Inscriptions on objects found within these substructures identify the tomb owners as Hetepsekhemwy, Raneb and Ninetjer, the first three kings of the 2nd dynasty, for whom tombs are lacking at Abydos. Since 2003 the German Archaeological Institute has been excavating the labyrinthine substructure of Ninetjer, which sprawls over an area 50 × 77 m (164 × 253 ft) and includes 191 rooms.

What kind of superstructure stood above these Saqqara tombs is uncertain. Rainer Stadelmann suggested elongated mastabas, like the extraordinarily long tumulus above a vast network of underground chambers on the western side of the Djoser complex; in fact, he sees this substructure as an unidentified royal tomb of the 2nd dynasty.[7] It is possible that in addition to their tombs on the high Saqqara plateau, the 2nd

dynasty kings also built separate large rectangular enclosures in the desert to the west, at the high, southern end of the broad Abusir wadi. Among these we might count the huge Gisr el-Mudir, defined by a thick, low, limestone wall, and another unexcavated enclosure that lies between it and the Djoser Step Pyramid complex.

The superstructures of the subterranean 2nd dynasty royal tombs at Saqqara remain problematic, and so far we have no good evidence that any of the kings of this dynasty repeated the symbol of the primeval mound. Nonetheless, it is tempting to see the magical mound that rises in the Early Dynastic Hierakonpolis temple, and in the Early Dynastic tombs of Abydos and Saqqara, as the seed from which the pyramids would develop.

Djoser: the first pyramid complex

With Djoser's pyramid at Saqqara the archetypal mound and panelled enclosure come together again, as in the Early Dynastic mastabas just to its north. In size, shape and structural techniques, however, the Step Pyramid is a dramatic leap forward [**5.14**]. This first Egyptian pyramid is a stepped mound of stone around 60 m (197 ft) high set in the middle of a large rectangular enclosure,

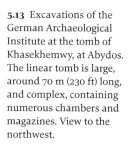

5.13 Excavations of the German Archaeological Institute at the tomb of Khasekhemwy, at Abydos. The linear tomb is large, around 70 m (230 ft) long, and complex, containing numerous chambers and magazines. View to the northwest.

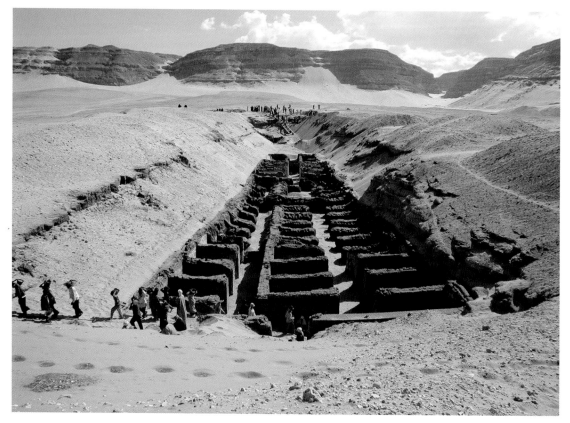

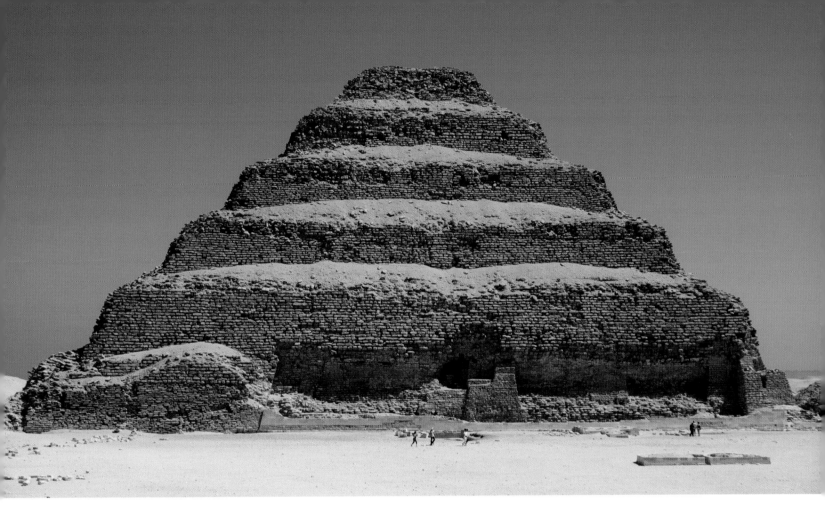

now defined by a wall more than 1,600 m (5,249 ft) long and enclosing an area of 16 ha (40 acres).

Djoser's Step Pyramid began as a mastaba, built with small, grey, 'one-man' (i.e. of a size that one man could carry) limestone blocks set in roughly horizontal courses in gravel and tafla (the natural desert clay), and encased in fine white limestone. The builders twice expanded the mastaba before they conceived the idea of a pyramid of six steps built from larger, roughly shaped core stones laid directly over the fine Turah limestone casing of the earlier mastaba. They constructed the core as a series of accretions that lean inwards at an angle of about 74 degrees, achieved by tilting each course towards the centre of the pyramid. This kind of core masonry is found in all later step pyramids: Sekhemkhet's at Saqqara; the Zawiyet el-Aryan Layer Pyramid; seven small 'provincial pyramids' located at or near Elephantine, Edfu, Hierakonpolis, Ombos, Abydos, Zawiyet el-Meitin and Seila; and the two step pyramid stages (E1 and E2) inside the Meidum pyramid (see below).

In the same way that they created the Step Pyramid in stages, progressing from the initial square mastaba to the final six-step pyramid, the builders also added the surrounding structures and enclosure wall in stages. The German Egyptologist Werner Kaiser pointed out that the first, smaller stage of the enclosure is similar in certain ways to Khasekhemwy's Abydos funerary enclosure.[8]

Part of Djoser's first enclosure wall is still preserved a short distance north of the structure called 'House of the North' and the pyramid temple, and retains evidence of an entrance at its far eastern end. The existence of a northeastern entrance, plus a second at the southeastern corner, parallels the locations of entrances in the Early Dynastic enclosures.

The 'Building Askew', standing just inside the southeastern entrance, if indeed it was a separate building in the first stage, compares to the 'token palaces' just inside the southeastern entrances of the Peribsen and Khasekhemwy enclosures at Abydos. And the position of the original Djoser mastaba – off-centre to the northwest in the original enclosure – can be compared to that of the mound within the temple enclosure at Hierakonpolis.

Following Djoser, no king was able to complete a pyramid for the remainder of the 3rd dynasty, which was a period of only 30 to 40 years by the reckoning of some Egyptologists, or as much as 150 by that of others.

5.14 The southern side of Djoser's Step Pyramid at Saqqara. For many years the recess in the bottom tier revealed the stages by which builders had begun with a mastaba, which they extended twice to the east and then covered with the six-tier pyramid.

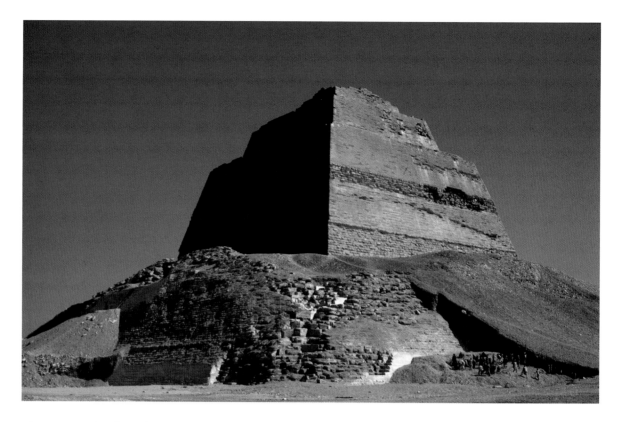

RIGHT
5.15 The pyramid of Sneferu at Meidum began as a seven-stepped pyramid and was then enlarged to one of eight steps. Towards the end of his reign, Sneferu set his builders to work on transforming it into a true pyramid. Today, the stepped tower rises from a mound of debris.

OPPOSITE ABOVE
5.16 Around the 15th year of his reign, Sneferu moved his necropolis to Dahshur, and his builders began work on what was intended to be a true pyramid. They encountered problems, however, as the structure rose and had to reduce the angle of slope, resulting in the Bent Pyramid.

The pyramids of Sneferu
The stepped pyramid of Meidum

At the beginning of the 4th dynasty the builders of King Sneferu began a seven-step pyramid at Meidum, near the Fayum, which Egyptologists now call E1. At some point they began to cloak the seven steps and raise the structure's height to create an eight-step pyramid (E2). Following the style adopted for the cores of all known step pyramids, they built accretions leaning against one another at the steep slope of around 74 degrees, with the stones set at an inward tilt. If completed, E2 would have stood about 85 m (279 ft) high with a base length of 120.75 m (396 ft or 230 cubits) [**5.15**].

The builders filled the core of each accretion with pieces of local limestone of irregular shape and size set rather loosely in a tafla mortar. For the outer faces of the individual accretion layers they used better-quality stone laid in more regular courses, and fine white Turah-quality limestone for the exterior surfaces of the steps. The limestone that capped each step bound together two accretions.

The move to Dahshur

Then, around the 15th year of his rule, for reasons unknown, Sneferu stopped the work at Meidum

and founded a new pyramid necropolis at Dahshur, about 40 km (25 miles) south of Giza. At South Dahshur Sneferu's builders attempted the first true pyramid, with sloping sides instead of steps. Initially the sides had a slope of 60 degrees, and the builders still set core blocks in the old step-pyramid style – tilted towards the centre of the pyramid rather than in horizontal beds. As at Meidum, they built on the desert gravel and clay, but here at Dahshur the surface was softer and this soon threatened the steep pyramid with settling and collapse. To counter this, the slope was reduced to around 54 degrees and the base widened by adding a kind of girdle. Serious structural difficulties still afflicted the pyramid, however, culminating in Sneferu's regnal year 26–27 (or 'counting year' 14, the biennial year of assessing livestock for purposes of taxation, a system of reckoning time in the Old Kingdom). The builders now reduced the slope of the upper part to 43 degrees – hence the bend in the Bent Pyramid profile [**5.16**].

As they capped this experimental bent pyramid, the king launched his work crews on yet another pyramid – workers' graffiti on stones found there refer to counting years beginning 15, Sneferu's regnal year 28–29, with a highest counting year

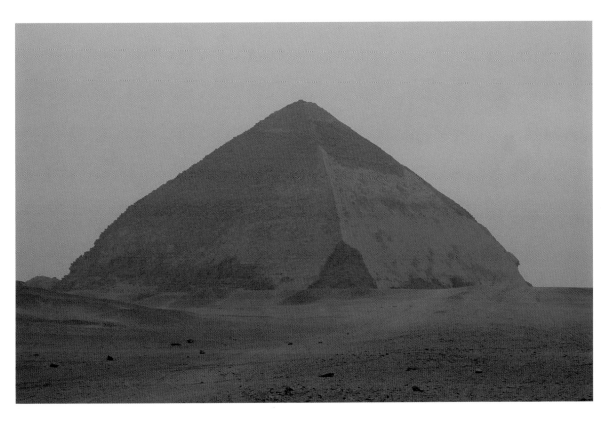

BELOW
5.17 After the Bent Pyramid, Sneferu began work on a third pyramid, also at Dahshur, the North Pyramid. This has a lower angle of slope and is the first true pyramid.

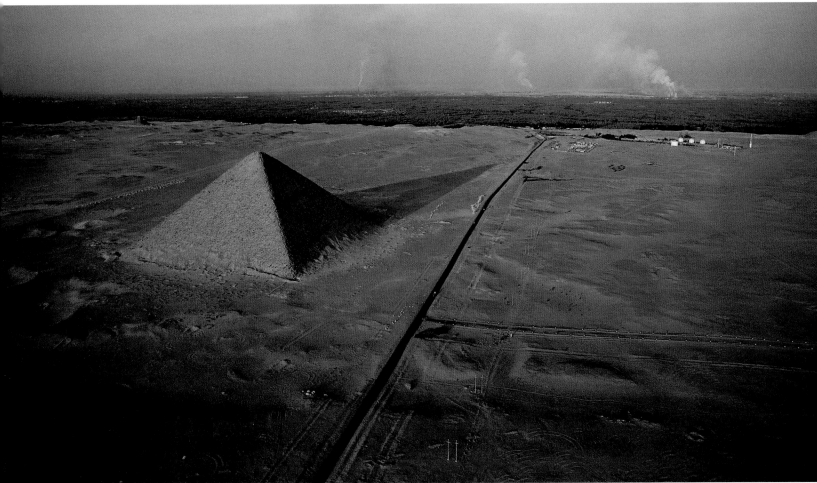

of 24. Rainer Stadelmann suggests that this could mean Sneferu reigned double the 24 years ascribed to him by the chroniclers of the New Kingdom Turin Royal Canon, who must have mistaken the biennial cattle count for consecutive years.[9] Sneferu's builders adopted the low facial angle of about 43 degrees for the North Pyramid, and, crucially, laid the stone courses horizontally. This elegant, true pyramid reached a height of 105 m (345 ft), with a base length of 220 m (722 ft) [5.17].

Return to Meidum: transition to Giza

As he was finishing the North Pyramid and the top of the Bent Pyramid at Dahshur (according to Rainer Stadelmann's chronology, regnal year 28 or 29), Sneferu sent his forces back to Meidum to transform the old unfinished step pyramid into a true pyramid, which would be the closest transitional form to Khufu's at Giza. Counting years 15, 16 and 17 have been found on casing blocks of the Meidum pyramid, which according to Stadelmann would correspond to Sneferu's regnal years 28 to 33.

Another strong signal that E3 was completed towards the end of Sneferu's reign is the fact that the casing stones of fine Turah-quality limestone, and the packing stone of cruder grey, or, near the bottom, yellowish marly limestone, are now laid in horizontal courses, without the inward tilt of the old step-pyramid accretion layers. The builders changed to this masonry style when they began the upper part of the Bent Pyramid and then used it for the North Pyramid at Dahshur.

In transforming the Meidum edifice to a true pyramid with an angle of 51 deg. 51 min., the builders added 11.79 m (*c.* 39 ft) to the sides to give a new base length of 144.32 m (*c.* 473 ft) and an intended height of around 92 m (302 ft). The slope of the Meidum pyramid is practically the same as that of Khufu's pyramid and within the 52–53 degree range of the classic Old Kingdom pyramid. Today Meidum consists of a three-stepped tower rising out of a mound of debris, the remains of the packing and outer casing the builders had added to create a true pyramid.

In terms of the internal chambers of Egyptian pyramids, Sneferu at Dahshur and Khufu at Giza are the exceptions. Their designers were daring innovators who placed some of the chambers high up in the body of the pyramid. For the most part, Old Kingdom rulers had their burial chambers built in or carved out of bedrock below the base of the pyramid at the end of a sloping corridor that generally pointed towards the northern circumpolar stars. This was true at Meidum, where Sneferu's workers built the bottom of the descending passage and a vertical shaft in an open trench. The burial chamber was positioned at the top of the shaft, near ground level, and sealed by the immensity of the pyramid above. As they completed the pyramid, the builders extended the interior passage up through the masonry at an angle of 30 deg. 23 min. to its opening in the northern face, about 19 m (62 ft) above the pyramid base.

Development of the standard pyramid complex

The pyramid – the superstructure of the royal tomb – was the central element in what Egyptologists call the 'pyramid complex', a standard east–west axial layout consisting of an upper temple or chapel at the eastern base of the pyramid and a causeway leading to an entrance or valley temple. The first such layout appeared in simple form at Sneferu's Meidum pyramid, although it also seems to have been intended, but was never fully accomplished, at his Dahshur North Pyramid.

With the completion of Meidum E3 as a true pyramid, the builders added both a small stone temple or chapel directly against the centre of the pyramid's eastern base, and a long causeway reaching from the pyramid enclosure down to the level of the valley floor [5.18]. At the lower end of the causeway where we might expect to find a valley temple the excavators discovered only mud-brick walls leading off to the north and south for many metres, belonging perhaps to a pyramid town or possibly a quay. Valley temples were at all times glorified docking places, either actual, for real boats, or symbolic, serving as portals to the pyramid. Given the basic forms of the other elements of the pyramid complex at Meidum, the causeway may have led to a simple enclosure and landing platform.

The chapel of the Meidum pyramid is amazingly diminutive in comparison to the enormous size of the pyramid [5.19]. Rainer Stadelmann suggests

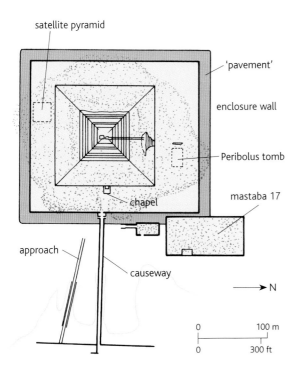

that this is an indication that it was a mere cult chapel to commemorate the king and not a true funerary temple, because Sneferu finished E3 more as a cenotaph than a tomb.[10] The chapel entrance is at the southern end of its façade; a right turn leads through a small chamber to a doorway diagonally opposite into a second rectangular chamber. A third doorway in the centre of the western wall of this room opens into a small, unroofed court at the foot of the pyramid. The side walls of the chapel continued back to the sloping face of the pyramid to enclose the narrow court, wherein stand two stately round-topped limestone stelae. At 4.2 m (14 ft) tall, the stelae reach well above the top of the chapel. Had the stelae been inscribed with the *serekh* of Sneferu like the similar stelae found at Dahshur, people approaching from the causeway would have seen the large Horus falcons as though they were perched on the roof of the chapel. But the stelae were never inscribed – they were left completely blank.

Origins of a western cemetery

At Meidum, as well as introducing basic features that became elements of the standard pyramid complex, Sneferu's builders also set the pattern for the organized cemetery of officials and family members. They first planned 10 or 12 large mastabas in a series along the northern escarpment. All that exists of five of these (numbers 1–3, 14–15) is an outline in mud brick of a superstructure. Petrie thought that the missing mastabas had been systematically removed, but it is more likely that they were never built as the king decided to move to Dahshur to begin another new royal necropolis and his closest relatives and high officials abandoned the cemetery.

Shortly after work had begun on the mastabas on the north escarpment, those responsible for the royal necropolis conceived the idea of a cemetery for privileged persons that was more organized spatially and set apart some distance to the west of the pyramid. This was the seed of the concept that would find its fullest expression in the great Western Cemetery of Khufu at Giza. Of these 15 early western tombs built in two clusters we know that nine are of a sloping-passage type; the rest are unpublished.

Most of these tombs remained unused until some were usurped much later, in the 22nd dynasty. No mastabas were built above them. As with the unfinished tombs on the northern escarpment they were perhaps abandoned with the move to Dahshur around Year 15 of Sneferu's reign. This date is suggested by the vertical shaft that the

ABOVE LEFT
5.18 Plan of Sneferu's Meidum pyramid complex. The band around the pyramid is Petrie's 'chip and stone dust bed pavement', the bedding for an enclosure wall or its remains after robbing. A female skeleton was found in the Peribolus Tomb. Sneferu's builders filled mastaba 17 with chips – waste from work on the pyramid.

ABOVE
5.19 The small, unfinished chapel at the centre east base of the Meidum pyramid. It is now embedded in limestone debris, either from pyramid building or later robbing, which has slumped back on to the chapel since the last excavations. Sneferu's workers never finished dressing the outer walls, and left the two tall stelae uninscribed.

The *baladi* embedded mound

The configuration of tomb mound in a rectangular precinct was not the exclusive prerogative of the ruler, even at the height of the Old Kingdom. The pattern occurs commonly in small mud-brick tombs of so-called 'private' people, both at provincial sites, such as Nag ed-Der, and at 'downtown Egypt' – the Giza Plateau – in the Workers' Cemetery (see Chapter 14). We could call these tombs *baladi*, the modern Egyptian word for 'provincial', 'country-like', 'folkish'.

Baladi tombs in the Workers' Cemetery at Giza cluster together in a zone far removed from the great stone pyramids and mastabas of the elite. Some of these *baladi* tombs are miniature copies, smaller than a desk top, of the large stone mastabas, with tiny false doors in the eastern façades fronted by miniature courts with small limestone offering basins. Tomb superstructures are barrel-vaulted, beehive-shaped or stepped and conical, above a simple shaft grave. Some of these mounds are tightly fitted within a rectangular enclosure or mastaba, similar to the Early Dynastic mastabas at North Saqqara. Others sit in the middle of a square courtyard surrounded by an enclosure wall, a miniature version of the configuration of the Djoser Step Pyramid.

These are the people's version of the primeval mound within a sacred enclosure. One tomb contains a mound within a mound, not unlike the mounds of bedrock or mastabas internal to certain pyramids. And another small dome or mound has a tiny ramp ascending one side and spiralling up and round – a model of the construction ramp for the larger pyramids?

The finds at Giza make us wonder if the stone pyramids and mastabas were a completely new idea of the royal designers – the commonly held assumption of Egyptologists – or simply the grandest expression of the long-term, widespread *baladi* tradition at that time.

5.20 An example of a dome tomb in the so-called Workers' Cemetery at Giza. A small mud-brick tumulus covers a simple oblong burial shaft in the centre of an enclosure, a folk version of the royal pyramids.

builders devised for two of the sloping-passage tombs, designated A and 202. In both cases the builders situated the shaft, which they lined with mud bricks, about halfway between the burial chamber and the north end of the tomb pit. The shaft dropped straight down to the lower end of the sloping passage. This introduction of a vertical shaft is a link to a very similar, though more developed, type of tomb in the field of 26 mastabas that Sneferu's builders started northeast of the Bent Pyramid at Dahshur around Year 15. The German Institute excavations have shown that the Dahshur mastaba field was certainly used. These large mastabas were built and decorated with relief-carved offering chapels for the elite of Sneferu's court.

With the return to Meidum to transform the old step pyramid (E1 and E2) into a true pyramid (E3), work seems to have begun again on some of the large mastabas along the northern escarpment. Sneferu's overseers also renewed the concept of the planned western cemetery. However, they moved away from the location of the earlier clusters of unfinished tombs to a new one about a quarter of a mile west of the pyramid. Here Petrie's team cleared 35 substructures of fully developed shaft tombs in the Far Western Cemetery, laid out in neat rows like the streets and avenues of mastabas at Giza.[11]

The substructures of these tombs are so similar to those of the earliest mastabas in the great Western Cemetery at Giza that Reisner thought some of them might have been made in the reigns of Khufu and Khafre. Once again, the tombs of the western cemetery at Meidum were never used, and no superstructures were built, though mastabas must have been intended. As with the stelae of the pyramid chapel that were left blank, all work suddenly stopped. Why? Perhaps because an ambitious young son took the throne of Horus, and immediately launched into work on the biggest mound ever – the Great Pyramid at Giza.

A burst of pyramid building

The 4th dynasty Giza pyramids, although radically altered from the oblong layout of the enclosures of 3rd dynasty step pyramids, are still essentially mounds within rectangular enclosures. The fine limestone precinct walls running close around the bases of these large pyramids may be vestiges of the great Djoser enclosure, while cruder fieldstone walls describe much broader rectangular enclosures further out around the pyramids. The areas the latter define are comparable in scale to the great Djoser complex.

We are thus able to trace something of an evolution from simple primeval grave mound through mastaba and step pyramid to the true pyramid. It is the case nonetheless that the first true pyramid, and the gigantic pyramids – the classic pyramids of popular imagination – were built in just three generations. All other kings' pyramids combined, including those of the Middle Kingdom (but excluding queens' and other satellite pyramids) contain only 54 per cent of the total mass of the pyramids of Sneferu, of his son, Khufu, and of his grandson, Khafre. The size of stone blocks and the quantity of gypsum mortar, as opposed to tafla, increased from the Dahshur to the Giza pyramids. Khufu's was the largest and most accurately built and aligned of all Egyptian pyramids. Menkaure, Khufu's grandson, still used multi-ton stone blocks for the third pyramid of Giza, but the total mass was less than that of Djoser's Step Pyramid.

In this period of great experimentation, it was builders under Sneferu who achieved the first true pyramid. It may seem surprising that the true, as opposed to the stepped, pyramid was invented just one generation before the biggest and best-built pyramid ever. But within what must have been the very long reign of Sneferu, evidence suggests that the inventing took some time and struggle. The sudden explosion of pyramid building might be compared to the space rocket programme of the 1960s and 1970s – a critical threshold of a civilization in sudden acceleration.

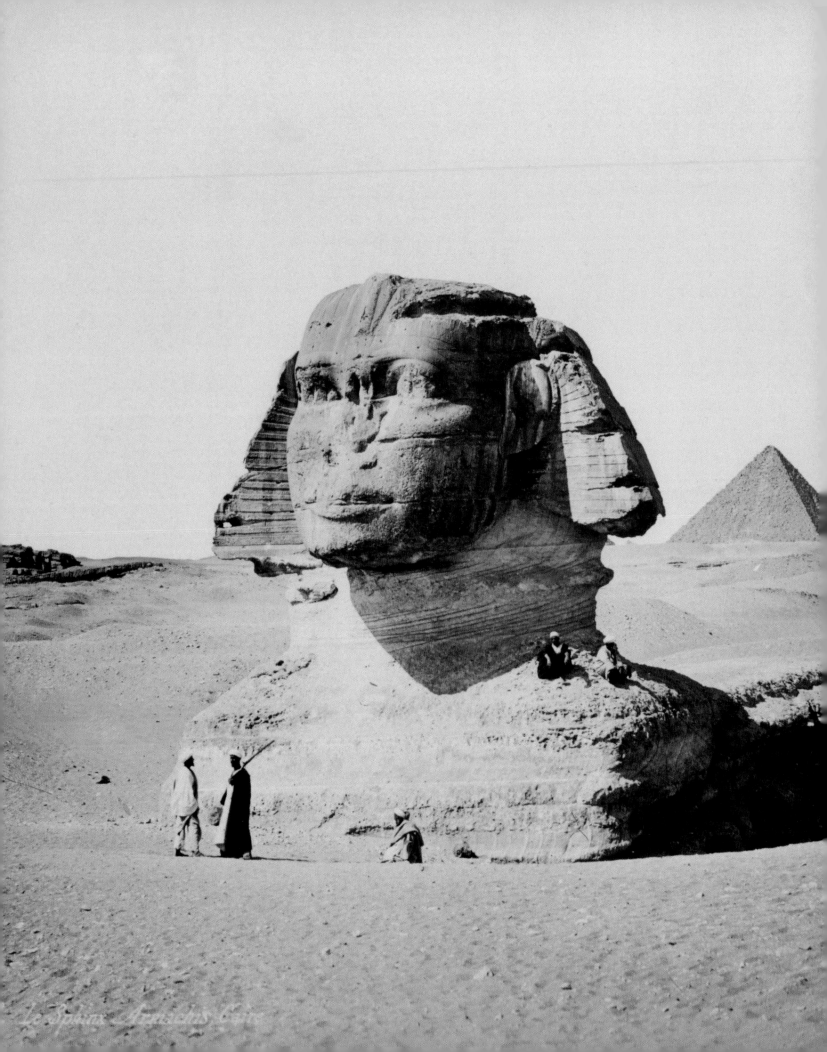

Le Sphinx Armachis Caire

CHAPTER 6
Explorers, scholars and expeditions

Even before the collapse of the Old Kingdom, towards the end
of the 3rd millennium BC, drifting sands began to engulf the
great Giza Necropolis. Through the entire Middle Kingdom,
Egyptians paid little attention to the site, except to quarry pieces
of worked stone from its mighty monuments to incorporate
into other royal pyramid complexes. For celebrated rulers such
as Hatshepsut, Thutmose III, Akhenaten, Tutankhamun and
Ramesses II who reigned over Egypt's New Kingdom empire,
the Giza pyramids and giant mastabas would have emerged from
the encumbering desert, hinting at a former period of greatness.
Though New Kingdom pharaohs knew the names of Giza kings
of old, the pyramid temples lay in ruins and the lion body of the
Great Sphinx was swallowed up by sand, until some of them
excavated it. The powerful pharaohs who fought to rebuild the
kingdom and expand an empire then repaid the gods for their
successes by building new temples and renewing many old ones
throughout Egypt (see Chapter 19). So the earliest explorers and
excavators at Giza were the ancient Egyptians themselves.

PREVIOUS PAGES
6.1 The Sphinx almost engulfed by sand, prior to Émile Baraize's massive excavation, which began in 1926. View to the southwest.

Anyone approaching Giza from the southeast, the direction of the capital, Memphis, would have seen the Sphinx's head emerging from the sand, framed by the towering pyramids of Khufu and Khafre. It resembled the sun disk between two mountains in the hieroglyph for 'horizon' – the place where the sun rises and sets, the place of death and rebirth.

The New Kingdom Egyptians deified the Sphinx with the name Horemakhet, 'Horus [god of kingship] in the Horizon'. Almost from the beginning of the 18th dynasty, in the reign of Amenhotep I,[1] New Kingdom pharaohs, officials and commoners came to make offerings and dedicate stelae to the Sphinx in the name of Horemakhet. Amenhotep II, son of the warrior pharaoh Thutmose III, built a mud-brick temple in the northeastern corner of the Sphinx sanctuary and erected a large stela with a hieroglyphic text. In it Amenhotep refers to the Sphinx as the abode of Khnum-Khuf (Khufu) and Khafre, and says he wishes to 'make their names live'.

It must have been during his reign that his own son and successor, Thutmose IV, began to clear the sand and restore the Sphinx. The earliest excavation and conservation report on the Sphinx is that carved on the famous granite Dream Stela that Thutmose IV erected between the Sphinx's forepaws in 1400 BC, the year he took the throne. Tutankhamun built a royal rest house to the south of the Khafre valley temple; Ramesses II added to this and other structures nearby; and other rulers such as Ay, Horemheb, Seti I and Merenptah left stelae or inscribed architectural elements at the site.

Greeks and Romans at Giza

By the time the Greeks and Romans visited Giza, fact had become inexorably mixed with folk tale in stories about the pyramids. Around the mid-5th century BC Herodotus received a decidedly negative report of Khufu, whom he called Cheops. And it was Herodotus, as we saw in Chapter 2, who was responsible for the enduring tradition that slaves were forced to build the Great Pyramid. There is no doubt that Khufu would have had to command a huge amount of resources and hard labour to build his pyramid, but the credibility of Herodotus' account is strained when he goes on to report that:

No crime was too great for Cheops: when he was short of money, he sent his daughter to a bawdy-house with instructions to charge a certain sum – they did not tell me how much. This she actually did, adding to it a further transaction of her own; for with the intention of leaving something to be remembered after her death, she asked each of her customers to give her a block of stone, and of these stones (the story goes) was built the middle pyramid of the three which stand in front of the Great Pyramid.[2]

Herodotus was fortunate to see the Khufu causeway intact with 'polished stone blocks decorated with carvings of animals...a work of hardly less magnitude than the pyramid itself'. This causeway, he was told, took ten years of 'oppressive slave labour' to build; the pyramid took twenty, 'including the underground sepulchral chambers on the hill where the pyramids stand; a cut was made from the Nile, so that the water turned the site of these into an island'.[3]

Strabo, the Greek geographer and historian who sailed up the Nile in around 24 BC, reported a movable stone that allowed access to the Descending Passage of the Great Pyramid – could this have been a provision for tourists to enter and descend to the 'vault' (Subterranean Chamber) below? He does not mention the upper chambers or passages in the Great Pyramid, perhaps because no one at that time had found the way into them.

In the 1st century AD the Roman author Pliny the Elder mentioned the village called Busiris at the foot of the pyramid plateau, whose inhabitants would climb the pyramids, probably for tourists, just as the dragomans from the village of Nazlet es-Samman at the base of the plateau used to do in the 19th and 20th centuries. If the pyramid casings were still largely intact, the Busirites must have had a trickier climb than their modern counterparts. Pliny also reported a local tradition that the Sphinx hid the body of a king, Harmaïs, and that it was built using elements of his tomb.

The delight of early visitors, whose aim seems to have been more pleasure than scientific observation, is reflected in a poem inscribed in Greek on a broken tablet found near the Sphinx:

Our ornaments are the festive clothes, not the
arms of war,
 And our hands hold not the scimitar,
 But the fraternal cup of the banquet;
 And all night long, while the sacrifices are
burning;
 We sing hymns to Harmakhis [Horemakhet –
the Sphinx],
 And our heads are decorated with garlands.[4]

Mythic history of the Copts and Arabs

In the emerging Judaeo-Christian tradition, people
imagined that the Giza pyramids were built long
before the Great Flood of the Old Testament, and
then functioned as a kind of Noah's Ark. Already by
the 4th century AD, the Roman historian Ammianus
Marcellinus recounted that the subterranean
passages were 'dug by those acquainted with the
ancient rites, since they had a foreknowledge that
a deluge was coming, and feared that the memory
of the ceremonies might be destroyed'.[5]

The native Egyptian legend of Surid and the
pyramids, recorded by two Arab authors, was said
to have been copied in the reign of the 3rd-/4th-
century AD Roman emperor Diocletian from a
manuscript of the time of a King Philippos, who
in turn had it copied from a golden sheet. And it so
happened that the two brothers who translated the
legend for Philippos were descended from the one
and only Egyptian who escaped the Great Flood
on Noah's Ark.

King Surid dreamt of great cosmic calamities
and gathered the high priests from all the provinces
of Egypt, who also had forebodings of disaster.
They scanned the stars for prophetic hints of a
catastrophic flood and fire, the eventual drying
up of the Nile and the complete desertion of Egypt.
Surid then ordered the pyramids to be built, and
in them he recorded the sciences and also piled up
treasures and sculptures. Finally, he set an idol to
guard each of the three pyramids, who would kill
anyone approaching. After his death, Surid was
buried in the 'Eastern' (Khufu) pyramid, his brother
Hujib in the Western (Khafre) and Hujib's son,
Karuras, in the 'pied' (Menkaure) pyramid.[6]

Such was an Egyptian history of the pyramids
some time after the 3rd or 4th centuries AD. The tale
is a blend of the Judaeo-Christian flood legend

and very old Egyptian themes. Surid may be a
corruption of Suphis, itself a late form of Khufu;
Hujib may relate to the Horus name of Khafre,
User-ib; and Karuras may stem from Menkaure
(Greek Mycerinus).

A more popular Arab legend of the pyramids
is credited to the pagan Sabaeans, star and planet
worshippers from either the Arabian Peninsula
or the Syrian city of Harran. According to this
version, it was Hermes, the Greek equivalent of
the Egyptian god Thoth, who built the pyramids,
also for the purpose of concealing knowledge
from the uninitiated and saving it from the flood.
Hermes was buried in one of the two large pyramids
and Agathodaimon in the other, while the third was
the tomb of Hermes' son Sab. A Yemeni tradition,
recorded by the Arab author al-Masudi, claimed
that the two large Giza pyramids were the tombs
of their kings Shaddad ibn Ad and another who
defeated the Egyptians. This is perhaps a distant
memory of the Hyksos invasion of Egypt in the
2nd millennium BC.

The 15th-century historian al-Maqrizi reported
several renditions of the Coptic Surid story.
King Surid decorated the walls and ceilings of his
pyramid chambers with representations of the
stars and planets and all the sciences. The rooms
contained treasures of every kind: precious gems,
iron weapons that would not rust and mysterious
glass that could be bent without breaking. And if
Surid is indeed a corruption of the name Khufu,
the Coptic tradition recorded by al-Maqrizi that
King Surid was entombed in the pyramid with all
his possessions and treasures might be a true echo
of the original burial.

The Copts also believed, according to al-Maqrizi,
that each pyramid is possessed by its own ghost.
The ghost of the 'northern' (Khufu) pyramid is an
entirely naked youth with a yellow complexion
and great canine teeth. The ghost of the
'southern' pyramid is a beautiful woman, likewise
shamelessly nude, whose smile so bewitches a man
that he is robbed of his senses. The ghost of the
'coloured' pyramid (Menkaure) is an old man with
an incense burner.

The breach of al-Mamun

6.2 Painting by the English Victorian orientalist Edward Lane of the breach at the opening into the Descending Passage in the northern face of the Khufu pyramid. The modern tourist entrance, a tunnel through the masonry said to have been ordered by the Caliph al-Mamun, is below and to the right of this view.

A tale of pyramid treasures made its way into *The Thousand and One Nights*, along with a story told, retold and embellished by many Arab writers, that the son of the Abbasid Caliph Haroun al-Rashid, the Caliph al-Mamun, was the first to break into Khufu's pyramid around AD 820. Al-Mamun had wanted to demolish a pyramid to ascertain what it contained, but had to settle instead for making an opening in the Great Pyramid. His men forced the passage with iron picks and crowbars after cracking the stone by heating it, then pouring on cold vinegar. So far this seems reasonable enough, but the story

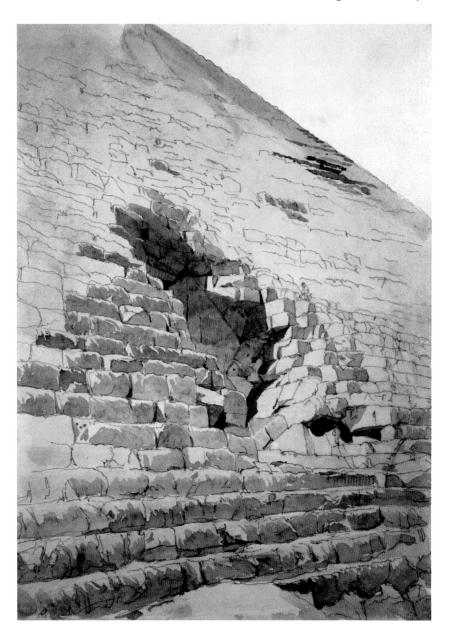

continues. The outer wall of the pyramid proved to be 20 cubits thick. Breaking through, the men found a green vase containing exactly the amount of golden money that al-Mamun had expended on the operation. Mamun and his court were stupefied that the ancients could have foreseen their intrusion into the pyramid so accurately, down to the details of how much it would cost.

There is in fact a yawning breach through the solid masonry in the north side of the Khufu pyramid that is used today as the tourist entrance. It is roughly on the pyramid's centre axis and some 7 m (23 ft) above the base. A larger breach opens on to the original entrance to the pyramid, topped by gigantic gabled blocks, above the Descending Passage about 17 m (56 ft) up from the pyramid base and over 7 m (24 ft) east of the pyramid's centre axis [6.2]. Al-Mamun's tunnel, forced through the pyramid, continues horizontally for about 35 m (115 ft) until it turns to meet the juncture of the Ascending and Descending Passages, just beyond the three granite plug blocks that sealed the lower end of the Ascending Passage.

According to one tradition, al-Mamun's men were about to give up when they heard the slab that concealed the end of the first granite plug block fall from the Ascending into the Descending Passage, whereupon they turned their tunnelling in the direction of the crash to discover the passages. There are problems with the Mamun account. The lowest granite plug remains intact at the end of the Descending Passage, and exactly when the pyramid was first breached is something of a puzzle. When the Greek author Diodorus Siculus sojourned in Egypt between 60 and 57 BC, the Great Pyramid casing seems to have been intact:

> The entire construction is of hard stone, which is difficult to work but lasts forever; for no fewer than a thousand years have elapsed, or, as some writers have it, more than three thousand four hundred, the stones remain to this day still preserving their original position and the entire structure undecayed.[7]

The pyramid must have been missing its capstone, however, since Diodorus says the length of the sides at the top is 6 cubits (*c.* 3 m or 10 ft), implying a truncated pyramid. Then there is

Strabo's reference, mentioned above, to some kind of swinging door slab: 'high up, approximately midway between the sides, it has a movable stone, when this is raised up, there is a sloping passage to the vault'.[8] Flinders Petrie decided that the movable stone must have been a trapdoor, because he found traces of pivot holes at one of the entrances to the Bent Pyramid of Dahshur, but this seems unlikely. And as we have seen, Pliny the Elder mentioned that the local villagers would climb the pyramids. How did they manage to ascend 17 m (56 ft) to the entrance to the Descending Passage? If there had been footholds up the steep, smooth and slippery faces would these not have signalled the original entrance? In any case, repeated openings and closings would surely have left traces, and if so, why did these not reveal the original entrance to the Arabs in AD 820?

It is possible that Egyptians forced the passage in ancient times. In fact, it seems that whoever carried out the operation made straight for the critical point just where they could break through to the Ascending Passage while avoiding the hard granite plugs that blocked its junction with the Descending Passage. If the passage was forced in pharaonic times, it must have been gaping open in AD 820 – unless the opening was re-covered by ancient repairs or sand and debris piled up against the face.

Priests served the memory of the Giza kings in the Saite Period (26th dynasty), two thousand years after the 4th dynasty. Perhaps they made repairs, since during this time there were some attempts to copy and renovate Old Kingdom monuments. Or perhaps Prince Khaemwase, son of Ramesses II in the 19th dynasty, some 700 years earlier than the Saites, repaired the pyramid. He is known to have restored Old Kingdom pyramids in Saqqara and Abusir, where he recorded his work with his name in hieroglyphic. Mamun's men may thus have enlarged a passage made by ancient Egyptian robbers, but the matter is by no means clear.

Quarrying the pyramids and hacking the Sphinx

Abd al-Latif from Baghdad, philosopher, doctor, geographer and historian, left us an account of how workers quarried the pyramids for stone in the time of the great Saladin (AD 1138–1193):

Formerly there were a great number of pyramids, small indeed, at Giza, but these were destroyed in the time of Salah-eddin Yusuf ibn Ayoub Saladin. Their ruin was effected by Karakoush, a Greek eunuch, one of the Amirs, and a man of genius.[9]

It must have been Karakoush, then, who removed the satellite pyramid south of the Khafre pyramid, and who began to dismantle the subsidiary pyramids of Khufu, including Khufu's own diminutive satellite pyramid, only discovered in the late 20th century. Karakoush used the stones to build a series of arches that formed part of a causeway from Giza out over the floodplain to the Nile. He transported additional stone across the causeway, probably from the two large Giza pyramids, to build the wall around the old city of Cairo and the citadel on the Moqattam Hills. The arches were still in place when Frederik Norden crossed the plain of Giza in 1737 (see below).[10]

Abd al-Latif repeated the story of al-Mamun opening the pyramid and said that people now entered by means of the breach. He himself went in part way but, 'owing to the terror I experienced in the ascent, I returned, half dead!' He also wrote that the pyramids were covered with indecipherable writing. 'So numerous are the inscriptions that were only those to be copied that are found on the surface of the two pyramids, this would fill about ten thousand pages.' This must have been the graffiti of visitors going back to pharaonic times. No writing exists on the intact casing at the top of the Khafre pyramid, so it is unlikely that the entire pyramid surfaces were inscribed. Abd al-Latif's passage implies that much of the casing was still intact when he visited in 1197.

In November 1196 the son of Saladin, Malik Abd al-Aziz Othman ben Yusuf, launched a concerted effort to dismantle the third pyramid at Giza:

Hither the sultan dispatched drillers, stonecutters, and ropers under the conduct of some of the principal officers and Amirs of his court.[11]

A camp with a vast number of workmen was pitched near the pyramid. For eight months the labourers suffered

oppressive labour and utter exhaustion...
[removing] at most but one or two stones.
Some were appointed with wedges and levers to
move the stones forward, while others with cords
and cables pulled from the bottom. When at
length one of the stones fell, it occasioned a
tremendous noise, which resounded at a vast
distance, shook the very earth, and made the
mountains tremble. In its fall it buried itself
in the sand, and it required extraordinary
efforts to disengage it, after which notches were
wrought for receiving wedges. By means of these
the stones were split into several pieces, each
of which employed a wagon for its transport to
the foot of the mountain a short distance away
where it was left.[12]

Many of the granite casing blocks of the
Menkaure pyramid lie tumbled around the base
and some still show wedge slots. In the end, the
strength and resolution of the king's men gave out.
As Abd al-Latif reports, 'so far from obtaining their
promised success and accomplishing their design,
all they did was to spoil the pyramid and exhibit
manifest proof of their inability and failure'. But
other pyramid-stone plunderers followed, until the
outer mantles of the Giza pyramids were largely
stripped away.

Abd al-Latif was obviously captivated by the face
of the Sphinx, already known by its modern Arabic
name, Abu Hol, 'Father of Terror':

On the face are a reddish tint, and a red varnish
as bright as if freshly painted on. The face is
remarkably handsome, and the mouth expresses
much grace and beauty: one might fancy it
smiling gracefully. A sensible man inquiring
of me as to what, of all I had seen in Egypt,
had most excited my admiration, I answered:
'The nicety of proportions of the head of the
Sphinx.' In fact, between the different parts of
the head, the nose, for example, the eyes, and
the ears, the same proportion is remarked as is
observed by nature in her works.... Hence the
wonder that in a face of such colossal size, the
sculptors should have been able to preserve
the exact proportion of every part, seeing that
nature presented him with no model of a similar
colossus or any at all comparable.[13]

Abd al-Latif's remarks lead us to think that the
Sphinx's nose was still intact, although there are
indications that it was cut off as early as the 10th
century. The nose was long gone, at any rate, when
Napoleon visited the Sphinx in 1798, although he is
often blamed for its removal. Already in the early
15th century al-Maqrizi wrote that a Sufi named
Sa'im El-Dahr, outraged that the local peasants
still made offerings to the Sphinx, destroyed the
nose in 1378.[14]

Europeans arrive at Giza

The earliest European representations of the
pyramids were woodcuts, paintings and a mosaic
in the dome of St Mark's basilica in Venice, which
portrays the pyramids as Joseph's granaries, an
idea suggested by the 4th- and 5th-century Latin
writers Rufinus and Julius Honorius [6.3]. For those
at home in Europe who could not make the journey
to Egypt themselves, imagination was their only
recourse to picture the Sphinx and the pyramids.

Athanasius Kircher (1601–1680), considered 'the
Father of Egyptology' because of his publication of
the first Coptic grammar and vocabulary, drew the
pyramids with huge double mausoleum entrances
the size of garage doors in his *Turris Babel, sive
Archontologia*, published in 1679 [6.4]. Kircher had
read that the Sphinx was a colossal bust protruding
from the sand nearby, and since his knowledge of
ancient busts consisted of those of classical form,

6.3 Mosaic in St Mark's basilica, Venice, Italy, showing the pyramids as Joseph's granaries. Created in the AD 1220s, it is perhaps based on an illustration in the Cotton Genesis dated to the 4th–5th century AD.

he pictured the Sphinx with the rounded breasts of the female sphinx in the Greek legend of Oedipus.

Many of the illustrations by those 15th- and 16th-century Europeans who did travel to Egypt are scarcely better facsimiles than Kircher's. For example, the pyramids they drew had impossibly steep angles. These versions must been drawn from memory when the voyagers wrote up their travels on their return home – and their memories of monuments they had seen were conditioned as much by what was familiar as by the pharaonic structures the travellers had actually beheld for a brief moment.

The Sphinx in particular was slow to come into European focus. André Thevet, who visited Giza in 1549, related in his *Cosmographie de Levant* (1554) that the Sphinx was 'the head of a colossus, caused to be made by Isis, daughter of Inachus, then so beloved of Jupiter'. He depicts the Sphinx as a very European curly-headed monster with grass sprouting from a collar around its neck. Johannes Helferich, a much-quoted visitor to the Sphinx and pyramids, told in his German travelogue of 1579 of a secret passage by which the ancient priests would get inside the giant head and pretend to be the voice of the Sphinx making pronouncements to the people. (In fact, in the top of the Sphinx's head there is a hole big enough for a person to crouch in, possibly for the attachment of a crown.) Helferich's Sphinx, illustrated in a woodcut, is a pinched-faced, round-breasted woman with straight parted hair.

Helferich's rendering began to suggest that the Sphinx represented a harlot. Indeed, George Sandys stated flatly after his travels in 1610 that the Sphinx represented exactly that. Balthazar de Monconys' 1647 Sphinx interprets the headdress as a kind of hairnet, while Boullaye-le-Gouz's 1650 Sphinx is once again a European face with rounded hairdo and bulky collar (the collar must be how the travellers remembered the protruding and weathered limestone layers of the neck). All these authors show the Sphinx with its nose complete, even though, as we have seen, it may have been cut off as early as the 10th century. And as already noted, it is certain that someone had purposefully removed the colossal nose before the early 15th century when al-Maqrizi was writing.[15]

Many of these early visitors accepted the idea that the pyramids were the tombs of kings or that

they contained the burial of the pharaoh of the Exodus, but other opinions were also current, such as the above-mentioned notion that they were Joseph's granaries. The German knight Martin Baumgarten retold a tale by Diodorus that building the pyramids had so infuriated the Egyptian people that the pharaohs had to be buried elsewhere, in secret tombs, to prevent the populace from tearing their mummies apart in revenge. Kircher promoted the idea, still very much alive today, that the pyramids contain some secret, mystic significance.

6.4 Athanasius Kircher, a renowned Jesuit scholar, published this illustration of a pyramid with huge double doors, and the Sphinx in the form of a classical bust.

The travelogues of early visitors to Egypt have been published as a series, *Voyageurs occidentaux en Égypte,* beginning in 1970, by the Institut Français d'Archéologie Orientale in Cairo. Some contain ambiguous clues to the obscure history of when the pyramids were stripped of their outer casing. In 1546, Pierre Belon observed that the third Giza pyramid was in perfect condition, as if it had just been built. But what about the attack of Malik Abd al-Aziz in 1196 as reported by Abd al-Latif? Jean Chesneau, who visited Egypt in 1549, mentioned that the 'other two' pyramids at Giza (besides that of Khufu) were not 'made in degrees'.[16] Were their surfaces still covered with the smooth outer casing?

Prosper Alpinus, one of the first Europeans to attempt an accurate measurement of the pyramids, wrote in 1584 that the viceroy of Egypt, Ibrahim Pasha, enlarged the entrance to the Great Pyramid 'so that a man could stand upright in it'.[17] This could indicate a widening either of the forced passage ascribed to al-Mamun, or the original entrance, if sand and debris had filled the breach.

The beginning of scientific description

In the midst of the quirky 17th-century illustrations of the Sphinx and odd ideas about pyramids came the first scientific reports on the Great Pyramid of Giza. John Greaves (1602–1652), Professor of Astronomy at the University of Oxford, reviewed practically all the existing literature relating to the pyramid, and then went to Egypt in order to study it for himself, with the purpose of

> shewing in what manner, upon Examination, I found the Pyramids in the yeares one thousand six hundred thirty eight, and one thousand six hundred thirty nine…. For I twice went to Grand Cairo from Alexandria, and from thence into the deserts, for the greater certainty, to view them.[18]

Greaves brushed aside all mythical accounts of the Giza pyramids. From his reading of classical authors he concluded that Cheops, Chephren and Mycerinus built the pyramids as their tombs. Greaves calculated the perpendicular height (499 ft or 152 m), slope height (693 ft or 211 m), base area (480,249 sq. ft or 44,617 sq. m) and summit area

(a square of about 13 ft or 4 m) of the Khufu pyramid. By his count he climbed 207 or 208 steps to the top of the pyramid, and he described scaling a mound of rubbish to the original entrance in the 16th course of masonry – since the pyramid had been stripped bare of its outer casing, the entrance stood open for all to see. He followed the Descending Passage downwards at a slope that he calculated as 26 degrees. He gave the lengths and cross-section dimensions of the passages and chambers, described the details of the Grand Gallery, the well shaft and the 'Queen's Chamber' (rank-smelling and rubbish-filled) with its gabled roof and niche in the eastern wall. He marvelled at the Antechamber with its portcullis slab, and the smooth granite walls of the King's Chamber. He measured the sarcophagus and its exact position in the chamber. Remarkably for his time, Greaves even noted the basalt pavement east of the pyramid that hinted at the existence of the pyramid temple.

Greaves's 1646 publication of his research, *Pyramidographia*, included the first measured cross section of the pyramid and its internal passages. The Ascending Passage is out of proportion and the Descending Passage ends abruptly at the level of the pyramid base, for it had yet to be cleared down to the Subterranean Chamber. He also adds yet another note in the murky history of pyramid destruction when he writes that while the stones of the second pyramid were not as large or regularly laid as those of the Great Pyramid, the surface was smooth and even and free of inequalities or breaches, except on the south. Today, the casing remains only on the upper third of the second pyramid.

Benoît de Maillet (1656–1738) was the French Consul General to Egypt from 1692 until 1708, and he visited the Khufu pyramid more than forty times. De Maillet vividly described the conditions inside:

> Visitors are half dead when they reach the gallery dragging their faces over the sand at the entrance. The Arabs pull them up so forcefully, and they are so frightened they think they are going to be stifled. The forty feet they must next pass lying on their bellies completes their exhaustion. These hardships, combined with the dread of the return, leave them in no mood to undertake the necessary examination of the interior.[19]

De Maillet's drawing of the passages and chambers is more accurate than that of Greaves. The lengths and proportions of the Ascending Passage and Grand Gallery are nearly correct, as are his measurements of the different parts of the well shaft; the Descending Passage was still unknown deeper than the level of the pyramid base [6.5]. Between 1638, when Greaves was at Giza, and 1692, when de Maillet began to visit, the second pyramid seems to have been stripped to its present condition, since de Maillet mentions that the casing stones remained only at the top.

The Englishman Richard Pococke (1704–1765) came to Egypt in 1737. His illustration of the Sphinx in his 1743 account of his travels [6.6] is far closer to its actual appearance than anything published in the previous century, with the exception of the 1698 illustration 'Bau der Pyramide' by Cornelis de Bruyn. Indeed, it looks as if Pococke extracted the Sphinx bust from de Bruyn's drawing, down to the gentleman gesturing with his left arm under the left lappet of the Sphinx's headdress. Both drawings render the nose, if in somewhat flattened form, even though it had long been missing. Pococke's map of Giza is extremely schematic and his profile of the Great Pyramid is borrowed from de Maillet.

Pococke's report included a curious description of the Khufu causeway. He said it was 20 ft (6 m) wide, 1,000 yds (914 m) long, built of hewn stone and reinforced by 61 circular buttresses, 14 ft (4 m) in diameter and spaced 30 ft (9 m) apart. He wrote that the causeway turned westwards, passed two bridges, each of 12 arches, and was built on 10-ft (3-m) wide piers, after which it continued 100 yds (90 m) further south. This in no way fits the solid causeway foundation that runs to the east from the Khufu pyramid. But the mystery clears when we realize that Pococke was describing the arches in the floodplain north of the Khufu pyramid, built under Saladin by Karakoush, as Abd al-Latif reported, from Giza pyramid blocks.

Pococke's mistake in thinking that the pyramids were made by encasing natural mounds of rock calls to mind the assertion of another famous 18th-century traveller, James Bruce (1730–1794): 'anyone who will take the pains to remove the sand on the south side will find the solid rock there hewn into steps'.[20] Bruce must have noticed that at the northeastern corner of Khufu's pyramid, and

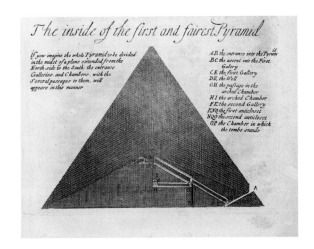

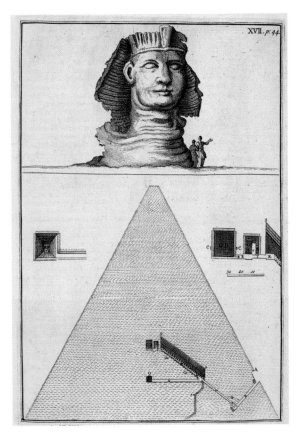

the northwestern corner of Khafre's, the bedrock is clearly visible in the cores of each pyramid, fashioned into steps.

Frederik Norden (1708–1742), a Dane, journeyed through Egypt in 1737. His *Travels*, published in 1755, included the first good map of the Giza pyramids, showing the ruins of the upper temples of Khafre and Menkaure, as well as Khufu's and Menkaure's causeways [6.7]. In his plan of the Giza pyramids across the floodplain to the north of the Khufu

89

pyramid he shows the arches that Pococke mistook for Khufu's causeway. Norden's profile and full-face drawings of the Sphinx show the break of the nose and weathered outlines essentially correctly.

The Englishman Nathaniel Davison (1737–1809) is generally credited with being the first to enter the lowest of the five stress-relieving chambers directly above the King's Chamber in the Khufu pyramid in 1765. However, in 1761, the German Orientalist Carsten Niebuhr (1733–1815) had searched for this chamber, after apparently having learnt of it from a French merchant named Maynard, though his search was in vain. Niebuhr did correctly describe the chamber as being directly above the King's Chamber, although lower in height, so it seems he must have heard about it from someone who had entered before Davison. Davison must have noticed, possibly after one of his informants had pointed it out, the dark opening in the upper south corner of the east side of the Grand Gallery. On 8 July 1765, he somehow climbed up to the breach, entered, then crawled through quantities of dirt and bat dung filling a tunnel just 75 cm (30 in.) high and 67 cm (26 in.) wide to the chamber that would henceforth carry his name.

On the day that Davison entered the pyramid, recent rains had washed away some of the sand and debris choking the Descending Passage. He perceived that the passage sloped down into the bowels of the bedrock beneath the pyramid and followed it into the darkness for 40 m (131 ft), where he encountered more debris that blocked it. Davison also investigated the well shaft. Lowering a light as he went, he descended from the bottom of the Grand Gallery down beyond the grotto to a depth of 47 m (154 ft), where the well, too, was closed off with rubble. It would remain for Caviglia, more than 50 years later, to discover that the two choked passages communicated (see below).

Napoleon at Giza

The expedition to Egypt led by Napoleon Bonaparte in 1798 marks a major threshold in the study of ancient Egypt. In addition to his political and military objectives, Napoleon had a vision for Egypt similar to those of Julius Caesar and Alexander the Great. He too wanted to revive an ancient seat of knowledge, now with the aid of French enlightenment. Napoleon ordered the leading French scholars to assemble a team of savants and surveyors for the survey of all Egypt. Eventually, the huge quantity of material collected on the geography, people, flora, fauna and antiquities of Egypt was published in a series called *Description de l'Égypte*. The volumes on antiquities appeared between 1809 and 1818.

During the time the French were in Egypt, Colonel Coutelle (an engineer) and J.-M. Le Père, with a guard of 100 soldiers, hired 150 workers to clear the chambers and Descending Passage of the Great Pyramid. Military duties called the mission away from Giza, however, before they had completed the work either in the interior of the Great Pyramid or at the Sphinx, where they had begun to clear the sand. The end of the Descending Passage in the Khufu pyramid still remained unknown, but the French scientists did take accurate measurements of the outside of the pyramid, including the height of each individual course of stones, and the architect F.-C. Cécile measured and drew the Grand Gallery.

Napoleon himself visited the Giza pyramids during the French expedition. His savants

6.7 Frederik Norden's map of the Giza pyramids shows the floodplain to the east, with the arches built under Saladin by Karakoush from Giza pyramid blocks.

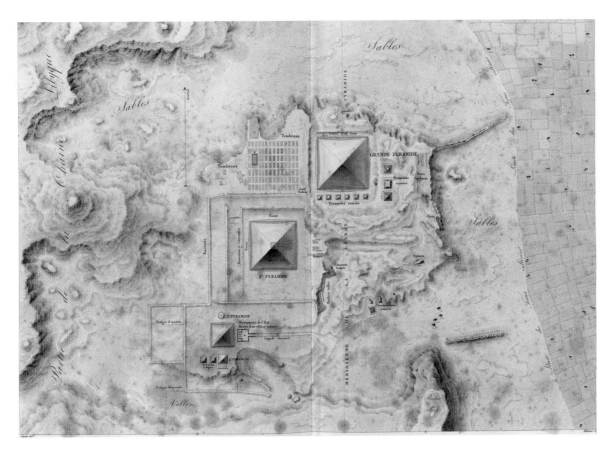

6.8 In his large-scale map, Pierre Jacotin accurately rendered the contours and relief of the Giza Plateau. The map shows the site as it was before two centuries of excavation and modern building, and so is still of value today.

calculated for him that the mass of stone of the three main pyramids would be enough to build a wall half a metre (*c.* 1 ft 8 in.) thick and 3 m (10 ft) high around France; and that if the stones of the pyramids were laid end to end, they would cover two-thirds of the circumference of the Earth. While they probably based their calculations on the assumption that the pyramids were built entirely of regular-cut blocks rather than the irregular stones and debris that actually comprise the core, the volumes they calculated may nevertheless be roughly correct to scale. After making his way up into the King's Chamber, Napoleon asked to be left alone for a while. He is reputed to have been unwilling or unable ever to answer those who asked him what he had experienced.

Pierre Jacotin (1765–1827) of the French Mission produced a larger-scale map of Giza that is still useful today, particularly because it shows the condition of the site before two centuries of excavation and modern building [**6.8**]. The views of the Sphinx and the pyramids are the most accurate, though impressionistic, drawings ever done. (The mission's maps of Giza were equalled or perhaps

even surpassed by those of John Shae Perring and Carl Richard Lepsius, see below.) It is ironic that with this massive French effort at accurate documentation also began the era of plunder and destructive, unsystematic excavation that was a hallmark of Egyptian archaeology and pyramid exploration in the 19th century. In 1801, Coutelle and Le Père began to dismantle pyramid GIII-c, the westernmost queen's pyramid of Menkaure, in the hopes of finding an undisturbed burial or the secrets of how the pyramids were built. They succeeded in removing the upper north quarter of the pyramid before abandoning their plan.

Hieroglyphs had not yet been deciphered, and the history and cultural context of the pyramids remained largely unknown apart from information from classical Greek and Roman sources. Edmé François Jomard (1777–1862), who prepared the chapter on pyramids in the *Description de l'Égypte*, was drawn to the conclusion that the pyramids, particularly the Great Pyramid, were not just the tombs of kings, but were also built to conceal and incorporate the knowledge of a civilization lost and buried in time. As Rainer Stadelmann points out, at

the same time as he published exact observations, renderings and measurements of the Giza Sphinx and pyramids, Jomard also fostered the tradition of pyramid mysticism, and believed that further precise research would reveal the secrets of Giza.[21]

Caviglia at the Great Pyramid and Sphinx

A ship's captain from Genoa, Giovanni Battista Caviglia (1770–1845) explored the Great Pyramid and Sphinx in 1816. His *firamun* (permission or concession) allowed him to probe the ancient monuments at will. In January 1817, he decided to see exactly where the so-called well shaft led. Starting from the opening in the bench against the lower north end of the west wall of the Grand Gallery, just beside the juncture of the Ascending Passage, Grand Gallery and Horizontal Passage, Caviglia and a small team of local workers plunged into the debris, fine dust, bat dung and bats that choked the narrow shaft. Even today, in chambers and shafts at Giza that have not been visited for a long time, the fine dust hangs suspended in the air, invading the lungs with each breath. To clear the air Caviglia burnt sulphur, but the workers refused to go on. So Caviglia turned instead to the less difficult (but by no means pleasant) task of excavating the Descending Passage.

After 65 m (213 ft) Caviglia came upon a yawning hole in the right (west) wall of the Descending Passage. The smell of sulphur emanated from the gap – Caviglia had found the bottom of the well shaft. On clearing the remaining rubble, a stream of fresh air suddenly flowed through the tube-like passages, making it easier to push forwards into the Subterranean Chamber, hewn entirely out of limestone bedrock some 30 m (98 ft) below the base of the pyramid. On the ceiling of the chamber Caviglia saw Greek and Latin letters, written in torch-black. The British Consul General, Henry Salt (1780–1827), who now joined the Genovese captain, noted this inscription. They concluded that the Descending Passage and Subterranean Chamber must have been open to Greek and Roman tourists. Caviglia also had his men remove the debris, about a metre (3 ft) deep, from the so-called Queen's Chamber, in the hopes of discovering a sarcophagus. Finding nothing, he next turned his attention to excavating at the Sphinx.

Until the 19th century, investigations of the Giza Plateau had consisted of pyramid probes and measuring, surveying and mapping, with only limited excavation. Now, excavators began to roll back the sand and debris that blanketed the great necropolis.

After his disappointment in clearing the Queen's Chamber in the Great Pyramid, in 1817 Caviglia excavated a great trench eastwards from the Sphinx's chest. Henry Salt recorded the results of the excavation in notes and sketches that Richard Howard Vyse published 25 years later [**6.9**]. Directly east of the Sphinx, at a distance of 32 m (105 ft), Caviglia found a flight of 11 steps that descended to a limestone platform roughly 10.5 m (34 ft) wide, with low side walls. About 19 m (62 ft) east of the Sphinx's forepaws the excavation then revealed a podium approached by a small set of four steps on its east side. Another stairway descended in 30 steps, broadening to more than 12 m (39 ft) wide, to a Roman Period pavement extending from the Sphinx's forepaws; a second podium stood halfway down. This was a ceremonial approach to the Sphinx in the Greco-Roman Period. Coming from the east, the visitor looked down from the podiums into the Sphinx sanctuary and to an altar between the gigantic outstretched front paws. Salt observed that:

> the spectator advanced on a level with the breast [of the Sphinx] and thereby witnessed the full effect of the admirable expression of countenance, which characterizes the features, whilst, as he descended the successive flights of stairs, the stupendous image rose before him... for the contemplation of which, even when he had reached the bottom of the steps, a sufficient space was allowed for him to comprehend the whole at a single glance.[22]

Caviglia found inscriptions in Greek on small stelae that had been set into the side walls of the approach and also carved on the front of the Sphinx's paws. These, including the poem about a night of merriment spent at the Sphinx quoted above, invoked the statue as the god Harmachis.

Walls of limestone slabs projected from the front of the back toes to close off the space between the giant stone forepaws. According to Salt, an opening was left between the two walls, with its threshold

raised some 0.6 m (2 ft) above the pavement.
In front of this window or doorway, Caviglia found
a granite altar with a limestone top that still showed
the traces of the last burnt offering made to the
Sphinx in antiquity, probably in Roman times.

Caviglia excavated the area between the
Sphinx's forepaws, which he found paved entirely
with limestone slabs. He then laid bare a small
open-air chapel tucked into the tight space at the
base of the Sphinx's chest. A pair of short walls
that jutted out from the inner sides of the forepaws
defined the chapel. In the entrance between these
walls sat a small stone lion, with its face towards
the Sphinx.

The western wall of the chapel was entirely
taken up by a tall red granite stela inscribed with
horizontal bands of hieroglyphs topped by a mirror
image of a scene of a king offering to the Sphinx
couchant upon a high pedestal (see Chapter 19).
Limestone masonry built against the inner sides of
the forepaws formed the north and south walls of
the chapel. Stelae, painted red apparently to match
the granite stela forming the west wall and showing
another pharaoh worshipping the Sphinx, had been
set into the upper face of both walls. Salt mentions
that not only the stelae but also the pavement, walls
and even 'other lions, rudely carved, and the head
and shoulders of a sphinx' that were found in the
chapel were all painted red. The stela on the south
remained in place, while the other one had fallen
into the inner chapel when the upper half of the
northern wall had toppled. The southern wall was
capped by a decorative series of rounded crenels
that make it certain that this was a hypaethral
(roofless, open-air) chapel.

Following Champollion's later decipherment,
the vertical band of hieroglyphs on each side of the
southern stela could be read as beginning with the
words 'the Horus, Strong Bull, Beloved of Maat...
Two Mistresses, Protector of Egypt and Subduer
of Foreign Land(s), Horus...'. Who was this king?
At the tops of both stelae were hieroglyphs that
gave the king's name and title – it was none other
than the great Ramesses II of the 19th dynasty. The
Sphinx is addressed as Horemakhet, 'Horus in the
Horizon' – the origin of the Greek Harmachis. So
scholars had an ancient Egyptian name attached to
the great statue and also knew that the Sphinx had
to be at least as old as Ramesses the Great.

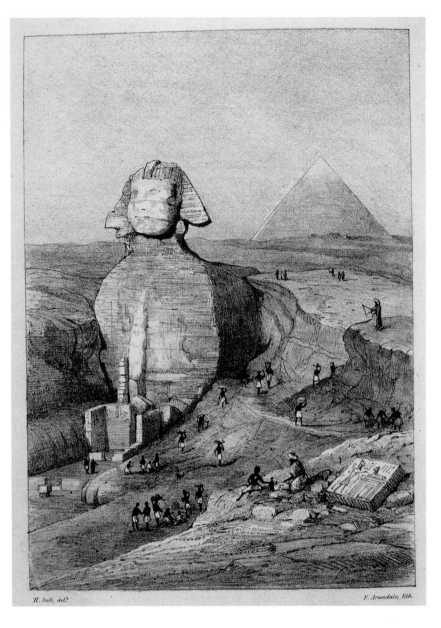

H. Salt, del.ᵗ F. Arundale, lith.

The centrepiece of the chapel, the 3.6-m (11-ft) tall
granite stela (the so-called 'Dream Stela'), had an
inscription that could be dated by hieroglyphs to
Year 1, Month 3 of Inundation, Day 19 of a pharaoh
that we know was Thutmose IV of the 18th dynasty.
He preceded Ramesses by over a hundred years.
In fact, Thutmose IV dated the 'Dream Stela' to his
first year on the throne, to which we can assign a
date very close to the year 1400 BC.

Behind the Dream Stela, Caviglia found a
rectangular structure of large limestone blocks,
and then a pair of thinner, rectangular columns
of masonry built against the Sphinx's chest.
Pieces of a gigantic beard lay nearby. In his report,

6.9 Henry Salt's drawing
of Caviglia's excavation
at the front of the
Great Sphinx shows
the hypaethral chapel
between the forepaws
and a stela of Ramesses
II, displaced to the lower
right, which once formed
the top of the southern
chapel wall.

Salt illustrated four large pieces of this beard that bear the typical braided pattern of divine beards. These pieces clearly belonged to a long, curled divine beard such as the Sphinx wears on the chapel stelae. Salt suggested that the masonry columns against the Sphinx chest must have been the support for the divine beard. The flat surfaces of the plates that connected the beard to the chest of the Sphinx were carved in relief with a kneeling pharaoh wearing the royal scarf (*nemes*) and a *uraeus* on his brow. When the beard and these connecting plates were in place, the king, carved in relief, would have been positioned just below either side of the Sphinx's chin (see 19.8). He holds the hieroglyph of a golden broad collar up towards the Sphinx. Hieroglyphs behind the pharaoh read: 'life and protection around and behind him' (for further discussion of the beard and details of recent work, see Chapters 10 and 19).

Belzoni and the second pyramid

Giovanni Battista Belzoni (1778–1823) was a hydraulic engineer and an imposing figure, 2 m (6 ft 7 in.) tall. He came to Egypt in 1815 to sell a water-lifting contraption to the ruler, Muhammad Ali, who was keen to improve the country's irrigation system. Belzoni failed as a

6.10 Belzoni's breach into the upper passage of the Khafre pyramid in 1818. He had worked out where the entrance to the pyramid should be sited by comparing evidence on the north side of the Great Pyramid and its entrance.

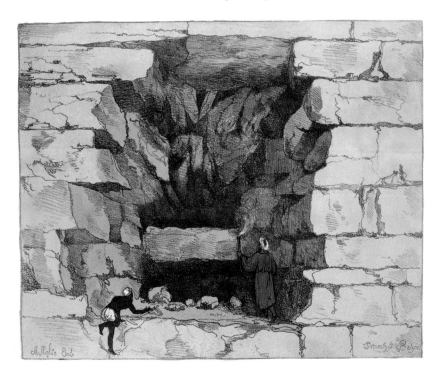

salesman but he stayed to become one of the earliest archaeologists of ancient Egypt. He worked in the service of the British Consul General Henry Salt, who was locked in a fierce rivalry to acquire antiquities with the French Consul General, Bernardino Drovetti (1776–1852), formerly a colonel in Napoleon's expeditionary force.

Belzoni made several significant discoveries in Egypt, but his sole contribution to the exploration of Giza was his opening of the then unknown upper entrance of the Khafre pyramid in 1818 [**6.10**]. He succeeded just as there was talk of a possible French attack on the pyramid, under Drovetti, using gunpowder. Belzoni had studied the condition of the debris and the position of the entrance on the north side of the Great Pyramid. He then compared this to the debris on the north side of the second pyramid, noticing a slight depression near the centre of the pyramid. After obtaining an excavation permit, he pitched his tent in secret at the foot of the pyramid and hired a small crew of local villagers. After they had cleared the debris on the north side and revealed the square opening of the upper passage, Belzoni was able to make his way down the granite-lined sloping passage and along the horizontal passage that runs to the burial chamber (see 2.2):

> I reached the door at the centre of a large chamber. I walked slowly two or three paces, and then stood still to contemplate the place where I was. Whatever it might be, I certainly considered myself in the centre of that pyramid, which from time immemorial had been the subject of obscure conjectures of many hundred travellers, both ancient and modern.[23]

The rectangular chamber was carved from the limestone bedrock, while its gabled ceiling was formed of huge limestone beams, laid in two rows with the upper ends resting against each other in order to relieve the weight of the pyramid pressing down on the chamber. Thick granite slabs paved the western part of the chamber, and a large, dark granite sarcophagus was set into this floor. But the sarcophagus had been opened, no doubt in remote antiquity, its lid pushed off and broken in the process. Long before Belzoni, visitors had entered and left a record of their presence in Arabic

script on the walls of the chamber: 'The master Mohammed Ahmed, quarryman, has opened them, and the Master Othman attended this opening, and the King Alij Mohammed.'

News of the pyramid breach spread to Cairo. Almost immediately, a stream of visitors began to arrive. A day after Belzoni's entry, one of the curious, rummaging in 'the rubbish inside of the sarcophagus', found bones that were identified as those of a bull. Just what this 'rubbish' was, Belzoni does not otherwise say, but if the chamber had been entered in a more modern, scientific spirit, with the skills of contemporary archaeology, we might have had valuable clues. Maybe the cattle bones belonged to an original food offering.

Further back along the horizontal passage, near its north end, Belzoni discovered a shaft that dropped to another passage; this sloped down to a lower horizontal corridor, much shorter than the one above. From the middle of the lower horizontal passage, a short passage sloped down on the west to another room with a gabled ceiling. Lower and longer than the burial chamber, this had been hewn entirely out of bedrock. At the north end of the lower horizontal passage, Belzoni found a portcullis arrangement of slots and sliding stones for blocking this corridor. From here, the passage slopes up to emerge outside and in front of the north baseline of the pyramid, but because it was filled with debris, Belzoni only suspected its existence as he peered up into the clogged passage from the interior depths.

Richard William Howard Vyse and John Shae Perring

Richard William Howard Vyse (1784–1853), a genteel Englishman and army officer, came to the pyramids in 1835. Initially he collaborated with Caviglia, but it was not long before they differed over means and ends, and parted ways. Howard Vyse found Caviglia unstable and uncooperative, and he was upset that Caviglia spent time and money hunting mummies, a valuable commodity used in medicine since before the time of Abd al-Latif, 600 years earlier.

Howard Vyse was more interested in surveying and exploring the pyramids, and pitched camp among the rock-hewn tombs of the Eastern Cliff at Giza. John Shae Perring (1813–1869), an engineer who assisted him, measured the Giza pyramids

using the most modern means available at the time. He drew maps, plans and profiles of many of the pyramids from Abu Roash to Giza, Abusir, Saqqara and Dahshur, which he published in 1839 in three huge tomes entitled *The Pyramids of Gizeh*. Howard Vyse's own publication, *Operations Carried on at the Pyramids of Gizeh in 1837* (with *Appendix*), published in 1840 and 1842, was basically a daily journal.

In the course of his investigations of the pyramids, Howard Vyse had no qualms about dismantling parts of pyramids or blasting his way through with explosives. He notes that his assistant Daoud was very good with gunpowder, but that he smoked too much hashish. When he wrote in a typical day's journal entry that 'the excavations' continued, what he meant was that he was boring, blasting or tunnelling his way right through the solid masonry of the pyramids. In one example, he wrote of the middle queen's pyramid of Menkaure (GIII-b) that it 'was prepared for boring by removing the stones from the top of it, as I expected to find the sepulchral chamber by penetrating through it'. But having ploughed straight through the superstructure of this queen's pyramid, he in fact discovered no other passage than the one that led to the subterranean burial chamber.

Howard Vyse also tunnelled straight into the core of the Menkaure pyramid, starting from the chasm that Saladin's son had made in AD 1196. Burrowing first horizontally, he then turned his tunnel downwards just short of the pyramid's centre axis and forced it to the base of the pyramid without finding any passages or chambers [6.11]. Only later did his crew discover and open the original entrance on the north side of the pyramid, 4 m (13 ft) above its base. When Howard Vyse reached the burial chamber, Arabic graffiti proved that, as with Belzoni in the Khafre pyramid, explorers had been there earlier in Islamic times, well before him.

But Howard Vyse did find what is presumably Menkaure's original dark-stone sarcophagus, beautifully decorated with false door niches, the so-called 'palace façade' design – the elaborate panelling on representations of building façades thought to be the royal residence. The lid was already missing and the sarcophagus was empty. Howard Vyse discovered pieces of the lid in the bedrock-hewn 'large apartment' above the burial

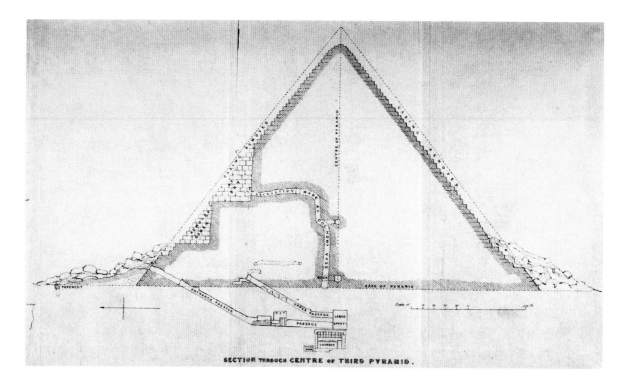

SECTION THROUGH CENTRE OF THIRD PYRAMID.

6.11 Howard Vyse and Perring's section drawing of the Menkaure pyramid, showing the tunnel that Howard Vyse blasted from the chasm that Saladin's son had made in 1196 to near the pyramid's centre axis and down to the level of the base.

chamber; these allowed him and Perring to reconstruct graphically its cornice form, completing the 'divine booth' or temple outline of the sarcophagus. With great difficulty, his men removed the sarcophagus from the pyramid, in the process damaging the false door decoration of the chamber at the bottom of the sloping entrance passage. It was then loaded on the ship *Beatrice* for transport to England, but on the way a storm sent both ship and sarcophagus to the bed of the Mediterranean Sea off the Spanish coast; underwater searches have so far failed to find it.

Along with the fragments of the stone sarcophagus lid in the 'large apartment', the excavators also found some human bones, linen wrappings and parts of a wooden inner coffin (see p. 250 and p. 506). An inscription on the front of the coffin identifies its occupant as the deceased ('Osiris') Menkaure, 'given life forever, born of the sky, the sky goddess Nut above you...'. Curiously, the style of the wood coffin suggests that it dates to Ramesside or Saite times, while radiocarbon dates on the human bone suggest that they are from late antiquity or even Christian times (see also Chapters 11 and 20).

This apparent burial of Menkaure some 1,200 to 2,500 years after he lived and died might relate to the inscription on the granite casing just below the

entrance to the pyramid that was only discovered in 1968 when the debris was cleared from the base (see p. 507). It gives the year (unfortunately damaged), month and day that Menkaure was buried in the pyramid. Yet the inscription is also thought to date much later (see p. 251). This seemingly 'fake' burial, with the much later body and the Ramesside or Saite coffin, is certainly confusing. Who might have done this and why? Remains of a Late Period mummy were also found in the burial vault of the 3rd dynasty Djoser Step Pyramid; we wonder whether the history of pyramid burials was more complex than one tomb for one king at one time.

Howard Vyse also cleared the lower entrance of the Khafre pyramid. In looking for possible additional rooms and passages, he and his team damaged the pavement of the burial chamber. As well as explosives, Howard Vyse employed boring rods in his search for hidden chambers. Wondering if a chamber existed in the body of the Sphinx, he ordered his men to drill straight down through from the top of its back, just behind the head. When the rods became stuck, Howard Vyse ordered that gunpowder be used to free them. 'Being unwilling to disfigure this venerable monument,' he wrote, 'the excavation was given up, and several feet of boring rods were left in it.' This was rather disingenuous, because when in

1978 we cleared out the cavity created by his blasting, we found not only his drill hole but also a large chunk of the Sphinx's headdress with its relief-carved pleating.

Howard Vyse's investigations of the pyramids were taking place a mere 15 years after Jean-François Champollion had deciphered Egyptian hieroglyphs. Samuel Birch, an Egyptologist at the British Museum, was able to provide Howard Vyse with a rough translation of the texts that his team was beginning to find in and on the mastaba tombs around the Giza pyramids. Copies of the inscriptions were sent to Birch, and his crude transcriptions of the glyphs include their Coptic equivalents. Written largely with the Greek alphabet, Coptic had been readable for a long time prior to the decipherment of hieroglyphs, for which it provided a key. It was at this very early stage in the understanding of ancient Egyptian scripts that Howard Vyse found the first and, until recently, only hieroglyphs inside the Great Pyramid – a discovery that arouses controversy to this day.

After Davison had entered the first relieving chamber in the Great Pyramid in 1765, Caviglia had begun to blast his way along its southern side in the hope of finding a communication with the so-called 'air shaft' running upwards from the south wall of the King's Chamber. This, he thought, would lead him to a secret room. Howard Vyse, now having fallen out with Caviglia, suspected the existence of another chamber directly above Davison's, since he could thrust a reed up a crevice and into a cavity at its northeastern corner. He therefore directed the blasting straight upwards at the east end of Davison's Chamber, and found, in succession, four additional low chambers, roofed, floored and walled with granite, except for the topmost, which was roofed with limestone. Howard Vyse named the four chambers from the bottom up after important British figures and colleagues: so in addition to Davison, there were Wellington, Nelson, Arbuthnot and Campbell.

It was in the course of this work that Howard Vyse discovered numerous red-painted graffiti that the builders left at the time they constructed the pyramid (see 2.11). Here were levelling lines, marks defining the axis of the chambers, directional notations and cubit measures. The graffiti include names of the work gangs compounded with one form of Khufu's name, 'Khnum-Khuf' ('the creator god Khnum protects him'). One of the gangs was named something like 'how powerful is the great White Crown of Khnum-Khuf!' On the south ceiling towards the west end of the topmost chamber (Campbell's Chamber), Howard Vyse found a single instance of the king's name as simply 'Khufu', again as part of a work gang name. Today, the black carbon graffiti of very recent visitors is close by. Since nobody had entered this chamber from the time Khufu's workmen sealed it until Howard Vyse blasted his way in, the gang names clinch the attribution of this pyramid to the 4th dynasty pharaoh Khufu.

This is awkward for alternative theorists, who wish to hold out against what was, even by Howard Vyse's time, a coherent picture of the pyramids as the gigantic tombs of powerful kings who ruled during Egypt's 4th dynasty. First transmitted by classical authors, this view was recognized by Greaves and had now been confirmed by archaeology and the hieroglyphic texts. According to 'New Age' folklore, however, Howard Vyse took red paint up into the relieving chambers and forged the builders' graffiti. Our own experience and the facts convince us that this is highly improbable.

We have been in the relieving chambers many times with powerful lamps (such as 'sun guns' for filming) and in recent years one of us (Hawass) installed lighting and carried out an intensive study of these marks, clearing the stone rubble and sand from the five chambers and recording all ancient and modern graffiti. Shining these lights down certain spaces between large wall blocks that are sandwiched between 25- to 40-ton granite beams, we can see marks far from arm's reach in spaces too tight for a hand and paint brush. Some of the marks clearly must have been put on the great blocks before they were set in place. Furthermore, it is not true that the appearance of these hieroglyphs reflects the primitive understanding of ancient Egyptian at the time of Howard Vyse and Birch. Rather, we now know they belong to a type of graffiti that has been found on other Old Kingdom monuments. For example, George Reisner found the graffiti of a work gang, 'Friends of Menkaure', similar to the 'Friends of Khufu', on the unfinished walls of the third pyramid upper temple in 1904, 67 years after Howard Vyse and Perring documented the marks in the stress-relieving chambers.

Carl Richard Lepsius

Carl Richard Lepsius (1810–1884) came to Egypt in 1842 at the head of a Prussian expedition commissioned by King Friedrich Wilhelm IV. Lepsius's team worked at Giza from 10 November 1842 to 10 February 1843. His architect Georg Erbkam and the painter brothers Max and Ernst Weidenbach produced both impressionistic views and the most accurate map of the Giza Plateau since the French Napoleonic Expedition of 1798–1803 [6.12]. Following Perring's and Erbkam's, the next large, true-to-scale contoured maps of the Giza Plateau were produced in the late 1970s. The Lepsius expedition also cleared and drew a plan and sections of the chapel between the Sphinx's forepaws, which had once more filled with sand after Caviglia's work.

By now, the understanding of the ancient Egyptian language was increasing, and Lepsius felt fluent enough to leave his own hieroglyphic inscription on one of the great gabled beams on the west side of the original ancient entrance to the Great Pyramid. Like an expeditionary leader of ancient times, his hieroglyphic text honoured his patron and sovereign, Friedrich Wilhelm IV, on his birthday:

Thus speak the servants of the King, whose name is the Sun and Rock of Prussia, Lepsius the scribe, Erbkam the architect, the brothers Weidenbach the painters, Frey the painter, Franke the former, Bonomi the sculptor, Wild the architect: Hail to the Eagle, Shelterer of the Cross, the King, the Sun and Rock of Prussia, the son of the Sun, freer of the land, Frederick William the Fourth, the Philopator, his country's father, the gracious, the favourite of wisdom and history, the guardian of the Rhine stream, chosen by Germany, the giver of life. May the highest God grant the King and his wife, the Queen Elisabeth, the life-rich one, the Philometor, her country's mother, the gracious, a fresh-springing life

6.12 Lepsius and his team worked at Giza in 1842–43; the map of the plateau and its monuments they produced was the most accurate since the Napoleonic Expedition.

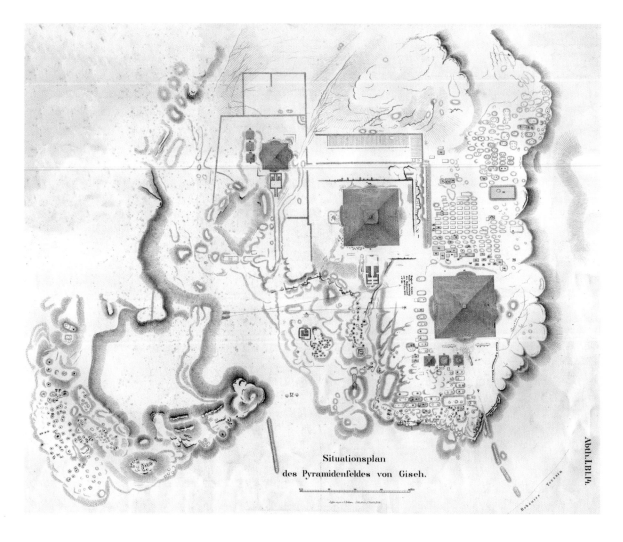

Situationsplan
des Pyramidenfeldes von Gisch.

on earth for long, and a blessed habitation in Heaven for ever. In the year of our Saviour, 1842, in the tenth month, and the fifteenth day, on the seventh and fortieth birthday of His Majesty, on the pyramid of King Cheops; in the third year, the fifth month, the ninth day of the Government of His Majesty; in the year 3164 from the commencement of the Sothis period under King Menephthes.[24]

Lepsius's party also lit bonfires from the tops of the Giza pyramids on New Year's Eve, 1842.

One of Lepsius's most significant contributions was his work clearing, studying and architecturally documenting the tombs around the pyramids – his records are still the most valuable documents for some of them. He could read the inscriptions and so identify the names of the owners of 45 tombs, and he registered another 37. His expedition also copied the scenes and inscriptions in the tombs – the people's own portrayal of themselves, their names, family relationships, titles and the elementary structures of everyday life. Slowly, the story of the society and the real people of the pyramids began to emerge through archaeology at Giza.

Auguste Mariette

In 1850 the Louvre's Department of Egyptian Antiquities sent Auguste Mariette (1821–1881) to Egypt with 6,000 francs to buy manuscripts from Coptic monasteries. Having been less than successful in this mission, Mariette was nevertheless consumed by a lust and fascination for pharaonic antiquity. His first great discovery was an avenue lined with sphinxes that led to the Serapeum at Saqqara, a great subterranean mausoleum where generations of ancient Egyptians had buried their sacred Apis bulls. This launched Mariette into a career not only as the most prodigious excavator ever of ancient Egyptian monuments, but also as the virtual tsar of Egyptian archaeology when he became the first head of the Egyptian Antiquities Service, as it was then called.

On 15 September 1853, Mariette began his excavations at Giza on the Sphinx. He was supported financially by the Duc du Luynes, who wanted Mariette to investigate Pliny's statement that the Sphinx was built from pieces of the tomb of

a King Harmaïs or Armais. By this time, knowledge of the Greek stelae and graffiti that Caviglia had found invoking the Sphinx as Harmachis should have suggested the source of this idea. Mariette plunged into the sea of sand that had once again filled Caviglia's trench of 30 years earlier. The more he dug, the more sand would pour down into his trench, and there was no immediate flow of discoveries as in his excavation at the Serapeum. He soon lost patience.

So he shifted the work a short distance to the southeast, where he discovered the Khafre valley temple. This temple stands more than 12 m (39 ft) tall, but so great was the accumulation of ages that it was unknown before Mariette began work there. An early map drawn before Mariette's excavation by John Gardner Wilkinson (1797–1875), one of Britain's earliest Egyptologists, labels the mound covering the site of the valley temple as 'pits, probably unopened'.

Mariette suspended his work at Giza while he visited Egyptian collections in Berlin and Turin. He returned to the Sphinx in 1858 and eventually cleared the sand down to the natural rock floor, uncovering several sections of large mud-brick walls around the site that appeared to have been built to protect the Sphinx from the encroaching desert. He also found the strange masonry boxes built on to the body of the Sphinx (see Chapter 10).

Clearing out an irregular shaft in the top of the Sphinx's back, Mariette realized that this was the widening of a natural fissure that cuts across and down through the entire height of the Sphinx's body at the waist. He came to the conclusion that the Egyptians created the Sphinx body by shaping a natural rock formation that already resembled the leonine body, finishing the head from the natural rock and completing the body with added masonry. Mariette worked again at the Sphinx in 1880; he also completely cleared the interior of the valley temple of Khafre but left the exterior walls hidden in the unexcavated debris.

The most beautiful and sensational of Mariette's discoveries at the valley temple – some might say anywhere – is the diorite (anorthosite gneiss) statue of Khafre, 1.68 m (5 ft 5 in.) high with the Horus falcon [**6.13**]. He found it, with three others more damaged, in a crude pit hacked into the alabaster floor of the vestibule of the temple; they had

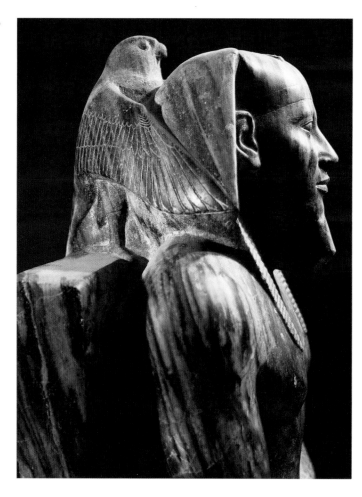

6.13 One of the masterpieces of ancient art, the seated statue of Khafre with the Horus falcon enfolding the king's head in its wings. It was found by Mariette in his excavations of the valley temple of Khafre, where it had been thrown into a pit, along with others, by robbers in antiquity. It is now in the Egyptian Museum, Cairo (see 9.25 for the whole statue).

been thrown into it antiquity. Mariette's discovery coupled a surprisingly sophisticated image of a king with the name of Khafre, the Chephren of the Greeks, long known from classical sources and Lepsius's documentation of tombs at Giza.

East of the Great Pyramid, Mariette discovered a piece of information about Khufu and his lineage. A limestone false door stela from a queen's tomb carried the text:

> King's Wife, his beloved, Meritites beloved of the favourite [the king] of the two goddesses [of the north and south crowns], she who says anything whatsoever and it is done for her. Great in the favour of Sneferu, great in the favour of Khufu, devoted to Horus, honoured under Khafre, Meritites.

Here was a royal woman whose life spanned the time from the reign of Sneferu to Khafre – yet another firm link between the 4th dynasty and the Giza pyramids.

A text found by Mariette in the Eastern Field, however, at first sight might seem to weaken that link. Digging into the ruins of a small temple at

the eastern base of the southernmost queen's pyramid (GI-c) of the pyramid of Khufu, he found a rectangular stone block with a sunken face lightly etched with crude hieroglyphs and relief scenes of statues of deities. It is called the Inventory Stela because of the list of the statues that are shown; another name for it is the Stela of Cheops' Daughter (see 20.16). We now know that later Egyptians dedicated this 4th dynasty queen's temple to the goddess Isis, 'Mistress of the Pyramids'. The text hails Khufu, under his Horus name, Medjedu, and states that Khufu found the Temple of Isis in ruins and gives its location in reference to the 'House of the Sphinx of Horemakhet'.

The text also mentions Khufu repairing the Sphinx's *nemes* headdress and therefore fuels the arguments of the alternative theorists who believe in an earlier civilization at Giza, since it would suggest that the Temple of Isis and the Sphinx existed prior to Khufu. But the Isis Temple was in fact a 21st and 26th dynasty adaptation and expansion of the small 4th dynasty chapel attached to the queen's pyramid. The texts and statues carved on the Inventory Stela were standard in those much later periods. So the stela must be an example of a fictional 'authenticating apparatus', common to ancient Near Eastern cultures, where a text or temple is cast as much older than its actual date in order to increase its authenticity and authority.

Petrie at Giza

William Matthew Flinders Petrie (1853–1942) came to Egypt in 1880 with the specific aim of measuring the Great Pyramid. He was inspired by the ideas of Charles Piazzi Smyth (1819–1900), Astronomer Royal of Scotland, as set out in his book *Our Inheritance in the Great Pyramid* (1864). According to Smyth, the British inch was derived from an ancient 'pyramid inch'. He believed that the Great Pyramid was laid out with the precise number of 'pyramid inches' required to make it a scale model of the circumference of the Earth, and also that its perimeter measurement corresponded exactly to the number of days in the solar year. Smyth further theorized that the British were descended from the lost tribes of Israel, and that the chambers and passages of the pyramid functioned as a divinely inspired record and prophecy in stone of

the great events in world history, a gigantic text made by scientifically advanced ancestors of the British. Petrie rejected the latter notions but fully adhered to the idea of the pyramid as a gigantic, earth-commensurate measuring rod. However, his meticulous survey of the pyramid was the death knell for the pyramid inch and demolished Smyth's theory.

Petrie worked at Giza during two winters in 1880–82. By this time, the tourist industry was in full swing. At night, Petrie worked in the pyramid comfortably naked in the heat stored during the day. Outside, he worked in vest and underpants. 'If pink,' he wrote, 'they kept the tourist at bay, as the creature seemed to him too queer for inspection.'

As the great mounds of debris still obscured the sides of the Great Pyramid, Petrie measured its exterior through an elaborate set of triangulations that encompassed all three Giza pyramids, resolving the positions of the corners and the lengths of the sides trigonometrically [**6.14**]. Petrie's triangulated map was never published at a large scale, but the measurements he provided remain a valuable reference to this day. In addition to the whole of the Great Pyramid, he measured the exterior and the chambers of the Khafre and Menkaure pyramids, and the chambers of the 'Granite Temple' – Khafre's valley temple. Only the interior was then known, as the exterior was still buried in debris. He took 500 photographs, mostly of architectural details, in the days when photography was much more laborious than today.

Petrie's keen eye could discern the people behind the pyramids – not just the 'elite', but also the common workers. He recognized remains of their material culture and the infrastructure for building the gigantic pyramids: secondary enclosure walls, embankments, pottery and evidence of masonry tools and techniques. He investigated the set of galleries west of the Khafre pyramid, and concluded they were the 'Workmen's Barracks' – a label that stuck until our recent work (see Chapter 15). He looked into great dumps of construction waste, north and south of the Great Pyramid, and estimated that they equalled more than half the mass of the pyramid. The layers told him what materials the workers were using on given days. He could see fragments of their water jars and food vessels, charcoal from their cooking fires,

chips of wood, pieces of baskets and even string. Petrie would go on to train his eye for the signs of everyday material culture on numerous other sites of various ancient periods. We have many occasions to use Petrie's work in the following chapters.

As for the 'pyramid inch' that brought him to Giza in the first place, Petrie's summing up, reached more than a century ago, can still be applied to the many current alternative theories when compared with the real evidence of an actual ancient people:

As to the results of the whole investigation, perhaps many theorists will agree with an American, who was a warm believer in Pyramid theories when he came to Gizeh. I had the pleasure of his company there for a couple of days, and at our last meal together he said to me in a saddened tone, – 'Well, sir! I feel as if I had been to a funeral.' By all means let the old theories have a decent burial; though we should take care that in our haste none of the wounded ones are buried alive.[25]

The era of large-scale expeditions

Soon after Petrie pointed out the wealth of information that all ancient material culture – not just impressive architecture and art objects – could provide about ancient Egyptian civilization, there followed a period of great expeditions that focused mainly on monumental tombs, temples

6.14 Petrie's map of the three Giza Pyramids showing the angles measured between his survey points. The intersections of angles between various fixed points and the feature to be mapped (for example, a point on the pyramid baseline) determine the location of that feature.

and pyramids. These projects used large bands of diggers and basket carriers, as well as iron railcars, to remove the enormous accumulations of sand and debris from the pyramid complexes and their cemeteries [**6.15**]. Expeditions of this kind at Giza were part of a larger trend found throughout Egypt and Nubia.

Division of the Giza Necropolis

In 1901–02 Gaston Maspero (1846–1916), the head of the Antiquities Service after Mariette, asked the missions of Italy (under Ernesto Schiaparelli for the Turin Museum), Germany (under George Steindorff of Leipzig University) and America (under George Reisner) to divide up the Giza Necropolis for excavation. At the time Reisner was working in Upper Egypt, funded by a vein of gold in the South Dakota mine of Phoebe Hearst, and so sent his assistant Arthur Mace north to reconnoitre Giza. Mace reported that the third pyramid of Menkaure appeared to be the most untouched of the three pyramid complexes, and therefore the most promising for finds.

So it was that later, Reisner for the Americans, Ludwig Borchardt for the Germans, and a representative of the Italian Turin Museum met on the veranda of the Mena House Hotel, looking out on the Great Pyramid. Mrs Reisner drew lots from a hat to divide up the coveted Western Field Cemetery, where the tops of giant mastaba tombs could be seen rising above the sand. The dividing line between the northern and middle strip was aligned on the north side of the Khufu pyramid, and the division between the middle and southern strip was aligned to its east–west centre axis. Reisner drew the lot for the northern of the three strips, the Germans took the middle and the Italians the southern one.

The Italians later gave up their concession and so George Reisner (1867–1942) excavated the southern strip as well as the Eastern Cemetery of mastaba tombs in front of the pyramid. George Steindorff (1861–1951) led excavations in the German concession in the Western Field from 1903 until the 1906–07 season. Uvo Hölscher (1878–1963), meanwhile, took on the German excavations of the Khafre upper temple and valley temple in 1909. In 1912, Steindorff, in exchange for part of the Austrian excavation concession in Aniba in Nubia, offered the German Giza concession to the Vienna

Academy (Akademie der Wissenschaften). Seeing an opportunity to build up the meagre collection of Old Kingdom art in Vienna through what was at that time a customary division of objects between the Egyptian Antiquities Service and the institutions that fielded excavations, the Academy accepted the offer.

Hermann Junker (1877–1962) became the director of these Austrian excavations in the middle strip of the Western Field, and eventually of the row of mastabas south of the Khufu pyramid, cemetery GI-S. Major financial support for the German mission at Giza was provided by the philanthropist Wilhelm Pelizaeus, and so much of the art and artifacts from the division of finds with the Egyptian Antiquities Service went to the Pelizaeus Museum in Hildesheim.

George Reisner at Giza

Reisner later related how, when the time came to choose the pyramid complexes for excavation, he held his tongue. The Antiquities Service took on the Khufu pyramid and the Sphinx, and the Germans were allocated Khafre's pyramid, while Reisner was left with the smaller and seemingly much less promising Menkaure pyramid. But in the ruins of its temples, finished in simple plastered mud brick instead of fine granite and alabaster, he found some of the most exquisite pieces of sculpture from any period or culture worldwide. The masterpieces included the famous triads of the king, Hathor and nome deities, and the dyad of Menkaure and his queen [**6.16**]. And that was not all. Menkaure's complex yielded a more complete profile of a pyramid, its builders and society than any other pyramid complex, though the picture was not a simple one to work out.

In the pyramid's upper temple, left unfinished apparently when Menkaure died, Reisner found the tools, ramps and embankments of the 4th dynasty builders still in place. Stripping away some of the mud-brick casing, he revealed the graffiti of the builders, along with their cubit notations and levelling-in lines, in bright red paint. In the valley temple he was able to identify the various phases of rebuilding during the generations after Menkaure. Representatives of higher-status shareholders in the temple offerings stayed in small apartments in the central court of the valley temple serving

LEFT
6.15 One of the tremendous mounds of debris tipped at the end of a long Decauville rail and wagon track and tip line from Reisner's and Junker's massive excavations of the mastaba cemeteries next to the Khufu pyramid.

BELOW
6.16 Reisner's photograph of the greywacke dyad of Menkaure and a queen, possibly the queen mother, as he first saw it at the bottom of a deep pit that robbers had dug through the walls in the southwest corner of the Menkaure valley temple (see 11.37).

the memory of the king, and Reisner even found fragments of the royal decrees of Shepseskaf and later pharaohs that exempted these people from taxation. As the numbers of inhabitants grew, and as they wished to cling tightly to the temple that spared them from being taxed, the small apartments and granaries crowded up and over the exterior walls – a progression that Reisner traced. Thus, Reisner's reticence served him well when the smallest of the three Giza pyramids fell to him – it was a very rich concession indeed, more rewarding even than Mace's reconnaissance could have predicted.

When Phoebe Hearst's gold mine was exhausted, her support of Reisner ended. The Boston Museum of Fine Arts and Harvard University stepped in to sponsor the mission. Reisner remained its leader from 1902 until 1942, during which time he brought to light a major portion of the Giza Necropolis. His excavation of 'Queens' Street', east of the Great Pyramid, led his crew to the unmarked tomb of Hetepheres, the mother of Khufu (see Chapter 8). Reisner carried on despite near total blindness in the early 1940s until his death in 1942; he is buried in Egypt. The headquarters of Reisner's great expedition was Harvard Camp, a rambling series of low-slung stone and cement buildings on the highest part of the Giza Plateau, overlooking the pyramids to the west, which was until recently still used by the Egyptian Antiquities Service.

Like Petrie before him, Reisner made important advances in Egyptian archaeological methods. Stratigraphy and site formation interested him. He was also responsible for improvements in photography and for comprehensive systems of site and artifact documentation and the use of typologies. It was Reisner who devised the numbering system for pyramids and tombs that we still use at Giza (GI, GII, GIII, G 2100 etc.). However, he did not come close to publishing all the mastaba tombs he excavated, and was unable to bring his typologies together into one systematic chronology of tomb building at Giza. The Egyptian Department of the Museum of Fine Arts in Boston, under the leadership of William Kelly Simpson, carried on the publication of the individual mastabas of Reisner's concession. Recently, Peter Der Manuelian has completed the digital formatting of the entire Reisner record for Giza and made the published and unpublished notes, photographs, maps and plans available on the internet.[26]

Work by the Germans at Giza

At the Khafre pyramid complex, the Germans excavated the upper temple and valley temple under Uvo Hölscher in 1909–10. This work helped establish that the valley temple is in fact a free-standing structure, but connected by a causeway to the upper temple and pyramid court. By the terms of the Giza partitioning under Maspero, the Sphinx was first in the German concession and later transferred to the Austrians, but the Egyptian Antiquities Service usurped the Sphinx excavations during the First World War. Émile Baraize (1874–1952) excavated the Sphinx and the area in front from 1925 to 1936. Selim Hassan (1886–1961) carried on large-scale excavations north and east of the Sphinx in 1936–38.

Baraize worked under the authority of Pierre Lacau (1873–1963), then Director General of the Antiquities Service. It was only between 1925 and 1928 that large teams of workers finally cleared the Sphinx itself completely of the sand and debris of the millennia. The Baraize crew then turned their attention to the 12-m (39-ft) high cultural deposits in front of the Sphinx, where they uncovered a series of viewing platforms, terraces, royal rest houses and, finally, the Old Kingdom Sphinx Temple. They excavated for a total of 11 years, yet published not a single excavation report. As Baraize cleared the statue, he immediately began restoration, replacing ancient repair masonry with modern cement, and shoring up the head with cement and limestone blocks.

From 1912 to 1914, and 1925 to 1929, with a hiatus caused by the First World War, Hermann Junker cleared the great mastaba fields on the west and south of the Khufu pyramid [6.17]. His Western Cemetery concession was sandwiched between Reisner's and that of the Italians (and also later Reisner). When he began, in order to dump the immense quantities of sand and debris cleared from the streets and avenues between the mastabas, Junker had to negotiate an easement with Reisner for a raised embankment to run the rail lines for the iron Decauville tip-wagons to shoot the spoil out over the north edge of the plateau. Junker's Decauville track stretched nearly 200 m (656 ft) across a part of the American concession (west of

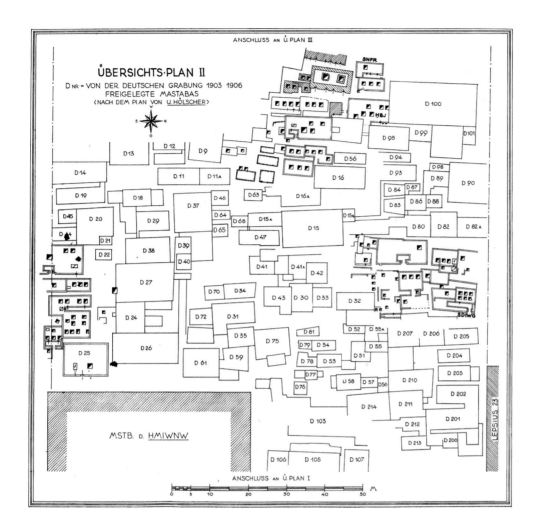

6.17 One of Junker's published maps of the Western Cemetery, the cemetery of courtiers' mastaba tombs west of the Khufu pyramid. When the Giza Necropolis was divided up for excavation between the Italian, German and American missions, the Germans received the middle strip of the Western Cemetery.

cemetery G 2100) that Reisner had investigated in 1905–06. As Junker's excavations progressed, he needed a second track, some 80 m (260 ft) further east. Junker excavated with teams of 200–300 men, with one overseer (a *reis*), divided, like ancient Egyptian building crews, into sub-teams, each with its own sub-*reis*.

Steindorff had built a German dig house on barren flat ground southwest of the Khafre pyramid. In 1925 Junker built a new, more convenient field headquarters in the Western Field, directly north of the great Hemiunu mastaba (G 4000). Junker's house and storage areas expanded into a complex that Ahmed Fakhry later occupied. We have used the rooms and magazines of this complex for the storage and study of materials from our own excavations. While most of the complex has now been removed, the Giza Plateau Mapping Project storeroom and field laboratory occupies some of the rooms that expanded from the Austrian house, still directly north of Hemiunu.

This is a fitting location because Hemiunu, the Overseer of All the King's Works under Khufu, may well have been the architect of the Great Pyramid. His life-sized statue is possibly Junker's most spectacular find. As with Reisner, who came upon the famous Menkaure dyad statues within days of opening his excavation of the valley temple of the third pyramid, Junker found the Hemiunu statue within the first week after he took over excavations in the Western Field. On 19 March 1912, his workers opened a robber's hole in the *serdab* (statue chamber) behind the northern false door of mastaba G 4000 and saw Hemiunu, frozen in white Turah limestone, staring back at them [**6.18**]. The master builder is shown with the pendant breasts and pot belly of respectable old age. He had a massive build and facial bone structure, with a determined jaw – just what we would expect from this Overseer, who was a close relative of Khufu himself. Hemiunu's statue, one of the great masterpieces of Old Kingdom art, now resides in

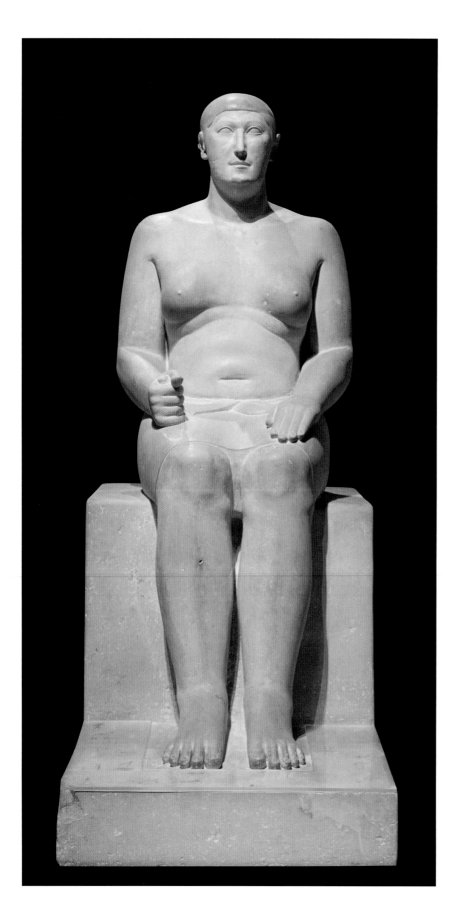

the Pelizaeus Museum in Hildesheim (see Chapter 13 for more details of the tomb of Hemiunu).

With the gap in work at Giza during the Second World War, Junker was able to publish 12 great volumes on his Giza excavations – a more organized and timely presentation of his discoveries than Reisner was able to accomplish in his lifetime. With his many discussions of hieroglyphic titles and texts, such as the offering ritual, pictorial scenes and other attributes of the tombs, Junker's work is a virtual culture history of the Old Kingdom.

Egyptian-led missions

Junker's publications were not his only legacy. In 1929 he took over the directorship of the German Archaeological Institute in Cairo and in 1934 he became a professor of Egyptology at Fouad I University (later Cairo University), where he tutored Egyptian Egyptologists who would go on to excavate major cemeteries at Giza. Abd el-Moneim Abu Bakr (1907–1976) excavated from 1949 to 1953 in a number of parts of the Giza Necropolis, including a field of small tombs arrayed west of the giant mastaba G 2000 in the Western Cemetery. Curiously, in spite of the diminutive size and inferior construction of many of these tombs when compared to the major stone mastabas of the Eastern and Western Cemeteries, several of the people buried here held titles connected with Khufu and his cult.

After working with Junker, in 1928 Selim Hassan mounted an Egyptian expedition on behalf of Cairo University on a scale equal to those of his foreign colleagues, which cleared the mastabas and rock-cut tombs of the Central Field, south of the Khafre causeway. He also discovered and excavated the tomb of Queen Khentkawes and her mortuary town, and the royal boat pits flanking Khafre's pyramid temple. At the Great Sphinx,

6.18 Limestone statue of Hemiunu, Overseer of All the King's Works under Khufu, which Junker found in the *serdab* behind the northern false door of mastaba G 4000. Hemiunu may well have been the architect of the Great Pyramid. Pelizaeus Museum, Hildesheim (Inv. Nr. 1962); 1.55 m (5 ft) high.

Hassan discovered the temple of the 18th dynasty pharaoh, Amenhotep II, dedicated to the Sphinx as Horemakhet. Like Junker, Hassan published his work at Giza, producing a series of 10 great volumes on the tombs, the Amenhotep II temple, the Sphinx, Khafre pyramid boat pits and Khufu upper temple.

Various missions of the Egyptian Antiquities Service cleared the base of the Great Pyramid of the piles of debris that resulted from the stripping of its fine white casing in the Middle Ages. This task was not completed until the early 1950s, when the debris on the south side was cleared by Kamal el-Mallakh (1918–1987), who found there the boat pits of Khufu.

With the completion of Junker's excavation of the southern row of mastabas (cemetery GI-S) and his and Reisner's excavations of the Eastern and Western Cemeteries, the overall plan of the royal and official tombs was largely complete. More was now known about the idealized state in death of the cemeteries' occupants – a 'community of *kas*' as Reisner put it – than about their lives and those of the people of lesser status.

In the late 1930s the great expeditions began to decline. This was not entirely due to the old age of the expedition leaders – tensions over the discovery of Tutankhamun's tomb in 1922 contributed to a growing nationalism concerning Egypt's ancient cultural heritage. Political turmoil in Europe and the Second World War effectively ended this era of Egyptian exploration. The demise of the large-scale foreign expeditions was also not unrelated to the rise of Egyptian-led missions during and after the Second World War, and following the Egyptian Revolution of 1952. Gamal Moukhtar appointed Ahmed Fakhry (1905–1973) as Director of the Pyramid Studies Project, with its headquarters at Giza.

As mentioned, in 1954 Kamal el-Mallakh discovered the two boat pits on the southern side of the pyramid of Khufu. In the eastern pit he found and extracted the elements of the great barque that the ancient Egyptians had dismantled and interred within. Master craftsman Hag Ahmed Youssef, who first trained under Reisner, reassembled and restored the ship.

Abdel Aziz Saleh (b. 1921) excavated at Giza on behalf of Cairo University. In the early 1970s he investigated the walls, houses and workshops of an industrial settlement southeast of the Menkaure pyramid, including 12 horseshoe-shaped hearths, perhaps for working copper. The structures were arrayed around an open area where the excavation found many large pieces of alabaster. It is possible that in the time of Khafre, the community here cut alabaster for the pavements of his pyramid temples, and continued to work alabaster to create statues of Menkaure, such as the colossus that Reisner found in the third pyramid's upper temple (see p. 255).

From pyramid probes to people

The long series of explorations of Giza brought the pyramids out of the fog of myth and legend that surrounded their origin and purpose. The earliest explorers had struggled to find their way into the pyramids and to discover all their passages and chambers. In a way, this exploration continues to this day – no longer with gunpowder, wedges and crowbars, but with geophysical methods, 'remote sensing', lasers and pyramid probes such as the robot camera that we sent up the air shafts from the 'Queen's Chamber' in the Great Pyramid. Early investigators laboured to obtain accurate measurements of the pyramids, not simply to come to terms with their immense size, but also out of intense curiosity about the attainments in surveying and science of the people who built these biggest of all monuments.

Eventually, Giza researchers realized that they could learn as much or more about the pyramid age by turning their backs on the pyramids themselves, and excavating the city of tombs that surrounded the pyramids. With the decipherment of the hieroglyphic script, the names and titles, and therefore the family relationships and governmental organization of these people came back into the light. This phase of Giza explorations is still ongoing. We are now scientifically excavating the tombs of the workers and lower-status members of this society, and the city where troops of these workers and their administrators lived. Analysis of their skeletal remains, and the traces of their daily lives – pottery, animal bones and food, the structures of their everyday routines and their tools of chipped stone – now reveal the people of the pyramids down to the scale of their diet and health, and the changing environment in which they lived.

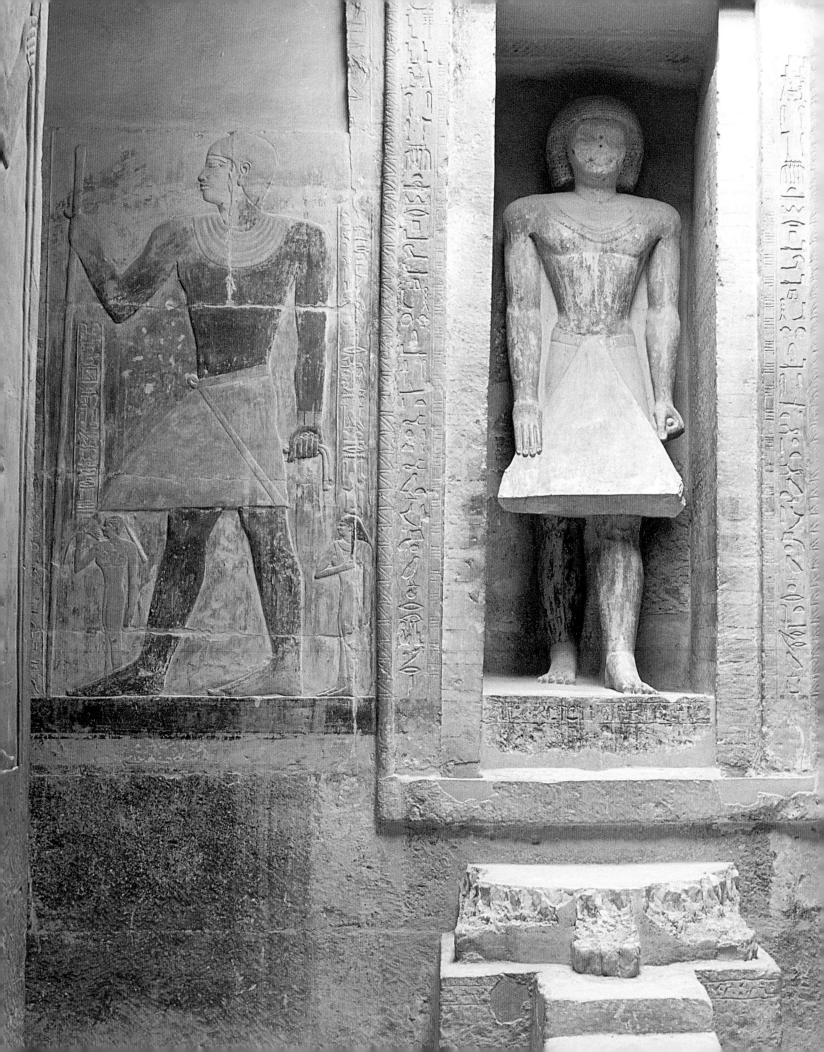

Pyramids: funeral, palace and ritual process

The giant pyramids are the most obvious and ostentatious

elements at Giza. But for the ancient Egyptians, the pyramids

stood on the high plateau at the end of a rite of passage

embodied by valley temples, causeways and upper temples.

To paraphrase Barry Kemp, we tend to think of the pyramids as

tombs with temples incidentally attached, but for the ancient

Egyptians, these were temple complexes with tombs attached.[1]

What purpose did these temples serve and how did they function? We can draw on later, 5th and 6th dynasty pyramid temples, with their rich repertoire of carved relief and painted scenes, to guess at the meaning and symbolism of the more massive, yet plainer, 4th dynasty pyramid complexes. Egyptologists know that major changes took place in the administration of temple personnel in the later Old Kingdom. Hieroglyphic texts of temples and priestly titles suggest a simpler organization in the 4th dynasty.

Given the sudden appearance of the giant pyramids with Djoser's Step Pyramid at Saqqara, followed by the rapid development of the standard elements of a pyramid complex in the 4th dynasty, we have to wonder to what extent those architectural forms sprang from ideas and traditions already embedded in the culture of the Egyptian Nile Valley, or how much the spectacular architectural achievements moulded and transformed those traditions. With these considerations in mind, we can discern two aspects to the meaning of the pyramid complex – one as a stage, or a simulacrum of a stage, for the royal funeral, and the other as a simulacrum of the royal residence, with its associated daily rituals.

The pyramid complex and the royal funeral

As a gigantic mound built over a chamber containing a sarcophagus enclosing the body of the dead king, the pyramid has the obvious appearance of a tomb. So it is understandable that Egyptologists have viewed the temples and causeway of the standard pyramid complex as a monumental platform for the royal funeral ceremonies. We would further expect this ensemble to reflect the Egyptians' beliefs about the transformation from death to renewed life in the Netherworld beyond. And we suspect that the pyramid complexes encapsulate a ritual process that the Egyptians believed would effect that transition.

The funeral of the king is never shown in any of the pictorial fragments we have from the walls of pyramid temples. So we must take our clues from the scenes and texts that appear in the tombs of high officials and nobles from the later Old Kingdom onwards, from Giza and elsewhere. Pieced together, over the entire course of ancient Egyptian history, such funeral scenes and texts are sufficiently detailed for Egyptologists to be able to divide the complete funeral ceremony into four or five, or as many as 16 episodes. In typical Egyptian fashion, the funeral ceremony consisted of rituals embedded within rituals: an embalming ritual, purification ritual, burial ritual and an offering ritual.

Though not all agree (and we are among that number: see below), many Egyptologists have interpreted the components of the pyramid complex as the physical stages for these various rites. It is certainly possible to identify correspondences between the ancient Egyptian funeral and the original form and layout of the Giza pyramid complexes.

Dramatis personae

We first witness the opening scenes of the funeral pageant in relief decoration of elite 6th dynasty tombs. Women shriek and wail, men and women fall to the ground, rend their clothing and throw dirt on their heads as the coffin is carried on a long-poled bier. Already we see a cast of characters who will remain the principals throughout the funeral [7.3].

The Old Kingdom procession includes a woman labelled 'the Kite', either a professional mourner or the wife of the deceased. Later there are two Kites, identified with the divine sisters Isis and Nephthys,

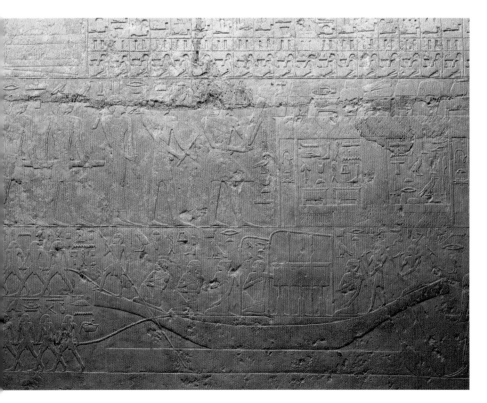

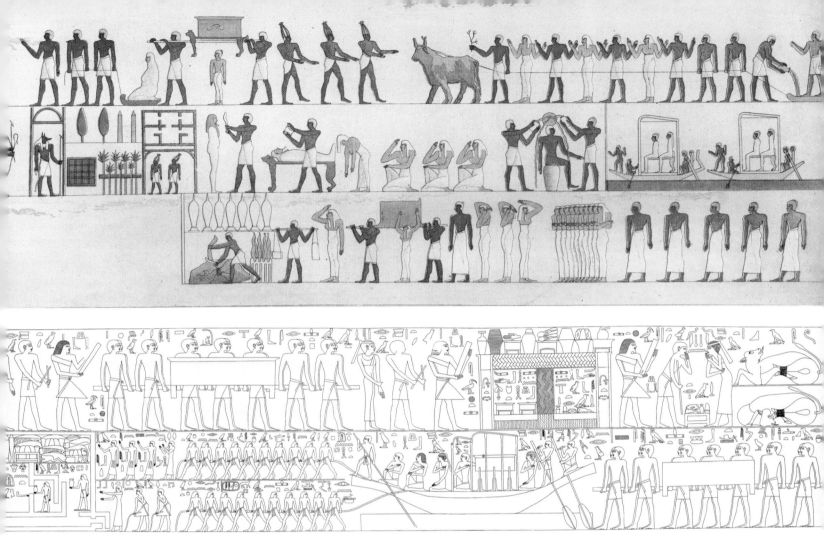

who mourned Osiris after his murder by his brother Seth. The two Kites are mentioned in the Pyramid Texts, which also identify the dead king with Osiris.

In the procession we find the 'Embalmer', whose name, *Wet*, means literally 'the Wrapper', because he was in charge of mummification. The 'Lector Priest', 'one who carries the ritual', was a 'professional initiate into these mysteries' whose knowledge and performance were key to the deceased being transformed into an *akh* (see box overleaf). The 'Seal Bearer of the God', that is of the king, accompanies the funeral because the process of embalming and burial of a prominent householder was, in part, dependent upon the king's largesse for the best oils and resins imported from distant foreign lands, and for the right to moor at and be buried in the royal necropolis.

The voyage to the pyramid necropolis

The dead must make a crossing of the Nile Valley, from the world of the living on one bank to the necropolis and the world of the dead on the other. People took the body in its coffin and loaded it on a boat, flanked by the two Kites and covered by a canopy [**7.2**]. At Giza, the funeral would reach the pyramid necropolis by old residual river channels or flood basin feeder canals running roughly parallel to the Nile, and possibly by a desert-edge irrigation basin that had been modified as a harbour for the pyramid complex and surrounding cemeteries. The fact that many of these scenes show rows of men on the banks towing the coffin boat indicates that part of the journey was a token, ritualized towing along a canal.

Such harbours and waterways have been hinted at by probes and salvage archaeology, 500 m (1,640 ft) east of the Khufu valley temple, in front of the Sphinx and Khafre valley temple, and north of the Wall of the Crow. The boat transport of the dead corresponds to texts referring to the 'traversing of the lake [or basin]', or 'crossing the firmament' while 'there is performed for him a glorification [*sakhu*, i.e. 'making into an *akh*'] by the Lector Priest'. Docking at the pyramid harbour, the deceased was unloaded before the 'Doors of Heaven', the counterpart to the celestial doorway in the Pyramid Texts. In tomb scenes, the doors were associated with the *Ibu*, the 'Purification Tent' [**7.4**].

TOP

7.3 Drawing of the relief depicting the funeral procession of Renni, from his tomb at el-Kab, dating from the reign of Amenhotep I, early New Kingdom. It includes scenes of embalming and the journey by boat. At top left the *tekenu* is drawn along on a sledge.

ABOVE

7.4 Funeral pageant from the 6th dynasty tomb of Qar at Giza. Top register, left to right: led by the Lector Priest, men carry the coffin on poles to the *Ibu*, 'Purification Tent'; this is followed by a ritual meat offering and meal of communion (top right). Lower register, from right to left: men carry the coffin to the *Sabet* boat, then tow it to the *Wabet* (far left), the 'Pure Place' of embalming.

The parts of a person: the *ka*, the *ba* and the *akh*

As in all cultures, the Egyptians' image of death reflected their concept of the nature of life. In ancient Egypt, growing up was called *iret kheperu*, 'making transformations'. Death was the second to last of a person's transformations; the final change in status depended upon the first chore in the housekeeping of death – the treatment of the corpse.

The body

Discoveries at Hierakonpolis and elsewhere in Upper Egypt bring us back to the idea of the intentional dismemberment of at least certain of the dead by the Predynastic Egyptians, something Petrie and his colleagues surmised from their excavations in the last century. Study of the earliest mummies, or parts of mummies, makes it quite clear that the Egyptians prepared the dead bodies of particular members of their society by purposely allowing them to decompose almost completely (excarnation), in order to be rid of all soft tissue that would putrefy. They then reassembled the skeletal parts in a linen-wrapped effigy, a stylized simulacrum of the deceased. Mummification was not intended to preserve the earthly body as it had been during life, but to transfigure the corpse into a new body 'filled with magic'.

The mummified bodies of the highest nobles of the land from tombs at Meidum, dating to the early pyramid age, show that even in this period mummification began with intentional dismemberment and recomposition. These are the bodies of royalty belonging to the generation just before Khufu – his aunts and uncles and the grandparents of the courtiers of Khafre.

The practice of removing internal organs, a stage in mummification for the next two and a half millennia, itself constitutes partial dismemberment of the body in order to recreate an incorruptible body from whatever relics remained – one that would not mould and decay within the successive layers of resin-soaked linen, coffin, sarcophagus, stone burial chamber and tomb superstructure. For each noble person the undertakers reassembled a new, perfected body: the mummy, *sah* (the same word as for 'noble'), a linen effigy around the skeletal core laid out in full-length, extended position. Dismemberment or excarnation of the corpse in the preparation of the mummy was thus the practical, if perhaps not the intentional, result of undertakers' work far into the later Old Kingdom. Well into the Middle Kingdom, the human remains inside mummies are often little more than skeletons.

Dismemberment and decay were among the primary fears of the Egyptians relating to death. This anxiety, and hopes for restored wholeness, relate to Egypt's central myth about the god Osiris, who was killed and dismembered by his brother, Seth, god of turmoil and confusion, then reconstituted by his wife Isis as the archetypal mummiform god, and finally avenged by his son, Horus, who was the god incarnate in every reigning king. Despite, or perhaps because of, this fear the Egyptians seem to have been fascinated by the idea that life forms could be dismembered and then reassembled to live again. In the 'Tale of King Khufu and the Magicians', a magician named Djedi establishes his credentials by reattaching the severed heads of

birds and an ox and making them live again. Khufu requested that the demonstration be made on a human prisoner, but was told by Djedi that it was not permissible.

Recomposition and rebirth

The goal of mummification was to reassemble the body so that the deceased could live again in another plane of existence. Mummification was in this way the transfiguration of the corpse into a new body, a *sah* body of nobility 'filled with magic'. The mummy was not the preservation of the earthly body as such, but a simulacrum of it; not a portrait but a statue idealized in wrappings and resin, with carefully moulded facial features, eyeballs and genitals. In the later Old Kingdom, undertakers coated the head in plaster and sometimes the entire top of the wrapped body, which was moulded not into life-like verisimilitude, but instead was the completion of a stylized form. In fact all these mummies, like the vast majority of ancient Egyptian human statues, have the bodies of adolescents – flat abdomen, perfect pectorals. This is why the mummy hieroglyph, the idea-sign of *sah*, is also used for the words 'statue', 'image', 'form' and 'shape'.

The mummy as simulacrum is an example of the Egyptian 'false door principle'. In each tomb the entrance to the Netherworld consisted of a blind 'dummy' door carved from solid rock. The false door was more efficacious in the Afterlife precisely because, as a dysfunctional simulacrum, it could not be profaned by actual use in this life. Neither could the mummy. The bound mummy within its sarcophagus and tomb made possible continued life – not so that the dead could haunt this world of the living, but so they could be reborn in the Netherworld of gods (*netjeru*) and spirits (*akhu*), two realms separated by death but mutually dependent.

Death is a ritual process for the living. The Egyptian rite of the passage through death to a higher status, as in many societies around the world and throughout time, involved a stage during which the distinguishing structures of earthly life were stripped away and dissolved. As a collection of excarnated bones and desiccated flesh and hair, the naked body of king or courtier looked like that of anyone else. Once past this stage of commonality, a renewed 'noble' status was bestowed by the reassembly and wrapping of the body as the mummy, as well as by its accoutrements and its stone tomb.

This reassembly, wrapping and elaborate physical containment was necessary for spiritual release. The physically reassembled, perfected mummy-body served as an anchor, a lodestone for a spiritual reassembly on the other side of that false door – a mysterious alchemy of a person's separate parts, the *ka* and the *ba*.

The *ka*

One of the most important dimensions of the human being in Egyptian thought, the *ka* has no easy translation into modern European languages. It is written with the symbol of arms upraised, bent perpendicular at the elbows. Egyptologists' most succinct

7.5 False door from the 5th dynasty tomb of Ty at Saqqara, bearing the deceased's name and titles. This dummy door served as the connector from this world to the Netherworld. Servants and relatives could leave token offerings on the top of the block at the base of the door, carved in the form of the offering hieroglyph (*hetep*), a stylized loaf of bread on a reed mat.

translation is 'life force'. The *ka* is associated with 'food sustenance', *kau*, necessary for life, and therefore with the food offerings in the tomb chapel. 'For your *ka*' was an Egyptian toast with food and drink offerings similar to our salute, 'to your health'.

The *ka* life force, while residing discretely in each and every person, was characterized by its transferability and commonality. The upraised arms of the *ka* hieroglyph actually represent an embrace, which the Egyptians believed transferred vital force between two people, or between gods and king. *Ka* was transferred through family, clan and lineage. *Ka* was generic and, in our terms, genetic. A father could say of the birth of his child, 'my *ka* repeats itself'. Conversely, an Egyptian could say, 'my *ka* is my father'. The *ka*s of common people were their ancestors. This life force extended back through innumerable generations to the Creator god who first transferred his *ka* to the gods, who in turn transferred their *ka*s to the king.

The king is the life force, the *ka*, of his officials and people – the living *ka*s. He gives them nourishment. When we understand that human *ka*s are collective and that the king is their source, the

enormous pyramids towering above the smaller tombs of noblemen and officials make sense in Egyptian terms.

Because the *ka* is so tied to continuity in a kinship and social sense, at death the state of the *ka* becomes critical. At death one's *ka* went to rest, as though subsumed back into the generic fold. This return to commonality took place while the body was prepared and transformed into the mummy. The ritual of burial reawakened the *ka*. This was particularly important for the *ka* of the king in the early pyramid age. The Pyramid Texts speak of arms around the pyramid, hinting at its function as an 'Estate of the *Ka*'. The concept of the *ka* as clan is probably reflected in the clustering together of royal tombs and pyramids. In the Old Kingdom, queens' pyramids flanked that of the king, for queens transferred the royal *ka* from one living king to the next.

After death, the *ka* had to be reactivated so that the spiritual transformation of rebirth could take place and so that the link to the land of the living – through the tomb – could be established and maintained. For this to happen the deceased had to travel to rejoin his or her *ka*, but not as the mummified body, transformed and bound up in its wrappings deep in the burial chamber. It was the *ba* that made the journey.

The *ba*

If the *ka* is generic life force, the *ba* is a person's individual renown or distinctive manifestation, the impression made on others. Perhaps the most succinct definition of the *ba* is 'manifestation of power or distinction'. The Egyptians considered the *ba* a part of the total human being along with the *ka* and the *akh* (discussed below). They conceived of the *ba* not as a spirit in contrast to the physical, but as a fully corporeal mode of existence, which included the ability to eat, drink, travel and copulate. During life people manifest themselves primarily through their bodies. With death the body becomes inanimate and passive. So the *ba* could travel to the realm of the Afterlife and return to the tomb. The hieroglyph for *ba* is the ibis. Beginning in the 18th dynasty, the *ba* was pictured as a bird with the head of the deceased.

The *ba*s of gods manifested in natural forces – stars, inanimate objects, even other gods. Likewise the *ba*s of the king are the manifestations of his power – an armed expedition that he might send to defeat his enemies, for example. Cities such as Buto, Hierakonpolis and Heliopolis had *ba*s, which probably belonged to their deceased rulers and large householders. Even inanimate objects such as temple pylons, threshing floors, doors and sacred books had *ba*s – their power, manifestations and the impressions they made on the Egyptians.

The *ba* was anchored to the corpse in a relationship of mutual interdependence in the Afterlife. One of the Middle Kingdom Coffin Texts, an expansion of the older Pyramid Texts, states 'the heart of thy *ba* remembers thy corpse and makes happy the egg which created thee'. The egg is the mummy encasing the bodily relics, one of many Egyptian references to tomb as womb for rebirth. The *ba* could not function in the Afterlife if the corpse were decaying and putrefying – it was for this reason that all potential for decay had to be stripped from the body. The Coffin Texts tell the deceased 'thy *ba* awakest upon

thy corpse', but for this to happen the corpse had to be made 'firm', 'established', 'stable', 'enduring', 'whole', 'sound'.

The burial ritual re-established physical structure, social status and personality, now realized as the *ba*, and this was especially true for the king. The Pyramid Texts speak of the royal insignia, the *uraeus* and the Eye of Horus, being given to the king. And in order to pass through the doors of heaven, the mythical doors identified with the pyramid valley temple, the king puts on a *ba*-garment, the leopard pelt of princely and priestly power.

The reactivation of status and personality brings – with its hypostasis as a distinct entity – the ability to change forms, to manifest in any number of shapes, and the ability to travel. These marvellous powers were signified by the human-headed *ba*-bird, and possibly in the Khafre pyramid complex by the Great Sphinx.

As miraculous as this new mode of existence may have been, it was only part of the final transformation. There followed a journey to the sky, to sunlight, to the stars. The king's destination was the Imperishable Stars that circle the celestial north pole. In the celestial realms, the deceased Egyptian hoped to attain the highest status of all – resurrection as an *akh*.

The *akh*

The Pyramid Texts (245, 250–51) speak of the king ascending to Nut, the sky goddess, leaving 'a Horus' (that is, a new living king) behind him: 'His two wings have grown as those of a hawk, [his] two feathers are those of a holy hawk. His *ba* has brought him. His magical power has adorned him. Mayest thou [Nut] open thy place in heaven among the stars.' Joining the stars, the king has become an *akh*: 'This powerful one has become an *akh* because of his *ba*' (Pyramid Text 789).

Akh is often translated as 'spirit' or 'spirit state'. It derives from the term for 'radiant light', written with the crested ibis, as though the ordinary ibis bird of the *ba* has been elevated by the plume on its head. The *akh* is the fully resurrected, glorified form of the deceased in the Afterlife. *Akh* is also a word for 'effective', 'profitable', 'useful'. *Akhu* means 'power' or 'mastery', for example of a god.

It is the reunion of the *ba* with the *ka* through the burial ritual that creates the final transformation of the deceased as an *akh*, glorified and in full control of all faculties in the Afterlife sphere of spirits and gods. As a member of the starry sky, called *akh-akh* in the Pyramid Texts and Book of the Dead, the king is free to move on and over the earth. The Egyptians conceived of the *akh* as a complete entity, coexisting with the *ka* and the *ba*.

The idea that the dead can be transformed into an *akh* is very ancient. In the Early Dynastic cemeteries a common title is '*Akh* seeker'. Old Kingdom tomb scenes show a series of ritual body movements labelled *sakhu* that helped the dead make the transformation to an effective glorified state of being. The spoken words of the ritual are also called *sakhu*, 'that which makes an *akh*'. An 'effective, equipped *akh*', a term found in the tomb inscriptions, comes close to our concept of a ghost, for the effective *akh* could reach across the liminal zone of the tomb to have positive or negative effects on the realm of earthly life.

The tomb as the place of transformation

The success of an ancient Egyptian in the Afterlife depended first on the proper conduct of the burial rites and thereafter on the continued offering ritual in the tomb. The focus for this ritual was the false door, with a stone slab at its base for ritual libations and food offerings, and above it a stela showing the deceased at a table piled high with such offerings. The false door was the symbolic portal to and from the Netherworld.

In the 5th and 6th dynasty pyramid temples, huge false doors stood at the back of the offering chapels, built right into the flank of the pyramid. The upper temples of the Giza pyramids probably had similar false doors at the back, but where they would once have stood, there are now only gaps in the masonry of the temple.

The pyramid tomb was the place of ascension and transformation of a god-king whose independent modes of being – particularly his *ka* – stood at the head of all his living and dead subjects. This was especially true in the Old Kingdom, when the king's pyramid tomb towered physically above all others. As early as the 2nd dynasty, we find the pyramidal mound as the symbol of resurrection, etched on the shoulder of a statue of Hetepdief, a Memphite mortuary priest of kings. Here the mound, or *benben* (see p. 136), is surmounted by the solar disk on which perches the heron or falcon, serving as the soul-bird. The names of pyramids tell us that they were conceived as places of ascension and transformation. The Great Pyramid of Khufu was named Akhet, 'the Horizon', of Khufu. Built on the root word *akh*, the name signified not just the horizon but also the 'radiant place' of glorification. A series of 5th dynasty pyramid names contain a reference to the *ba*, that part of the king that flew to join the *akh*; for instance, the (unfinished) pyramid of Raneferef was 'The Pyramid which is Divine of the *Ba* Spirits'. As the kings ascended and re-established their courts and households in the Afterlife, generations of Egyptians moved as cohorts in the ritual passage across death's threshold to live again as a 'community of *kas*', focused on the pyramid and its surrounding necropolis.

7.6 The hieroglyphic name of the Great Pyramid, Akhet (the crested ibis and horizontal sign) Khufu (written in the oval cartouche), 'the Horizon', or the 'Place of Glorification' of Khufu, from the tomb of Senenuka (whose name is written at far left, including the upraised arms sign for *ka*) at Giza (G 2041).

Ibu: *purification tent*

Before being allowed to enter the sacred necropolis, the corpse, which up to this point had probably not undergone any elaborate treatment, had to be purified. Based on the examples of Old Kingdom mummies that have been investigated beneath their wrappings, the 'cleansing' must have involved the removal of most of their soft tissue, or all body matter whose putrefaction could not be prevented, and the desiccation of whatever remained (see box).

The cleansing released the *ka*, as indicated by Pyramid Text 268, Paragraph 372, where it is the son, Horus, the living king, who administers to the dead king Unas:

> Horus takes him to his fingers, that he may cleanse this Unas in the Jackal [Anubis] Basin [or lake];
> He will release the *ka* of this Unas in the Morning Basin [or lake];
> He will wipe off the flesh of the *ka* of his body;
> He conducts the *ka* of this Unas and of his body to the Great House.

The ritual lustration or cleansing was identified with the revitalizing solar bath, that is, the rebirth of the sun from the primeval waters. The lustrations were also seen as the first step in recomposing the body in the form of the mummy. In the Middle Kingdom tomb of Djehuty-hotep at el-Bersheh, Middle Egypt, during the lustration (with what Egyptologist A. M. Blackman took as natron water[2]) the Lector Priest reads: 'Unite for thee thy bones, what belongs to thee is complete.'

This most traumatic part of the transformation was shielded from all but the morticians in a shelter called the *Ibu*. The name *Ibu* probably derives from the word for 'refuge' or 'shelter', like those used by fishermen along the Nile banks where they splayed and gutted fish [7.7]. Perhaps the *Ibu* is also suggested as the place of desiccation by the similarity of its name to the Egyptian word, *ibi*, 'thirsty'.

The tomb scenes give the impression that almost immediately upon mooring at the shore of the necropolis, the body was taken to the *Ibu*, or the *Ibu en Waab*, the 'Shelter of Purification' [7.8]. In the 6th dynasty tomb of Mereruka at Saqqara, for instance, the funeral fleet docks directly before the

LEFT
7.7 Relief from the tomb of Niankhkhnum and Khnumhotep at Saqqara depicting a fisherman in a booth or shelter, perhaps similar to the sort of structure used in the mummification process known as the *Ibu*.

BELOW
7.8 Frieze from the 6th dynasty tomb of Idu at Giza (G 7102), showing a shrine under a canopy (containing the body?) on a papyrus skiff coming to the 'head' of the *Ibu* (Purification Tent). A Kite woman and the embalmer ('Wrapper') stand to the left, the other Kite and the boatman are to the right.

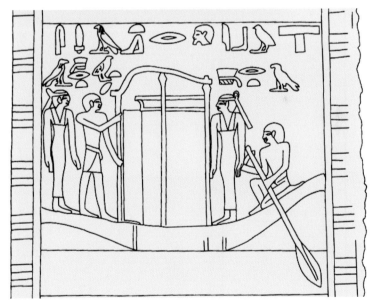

Ibu, while in the tomb of Pepi-ankh at Meir and Qar at Giza (see 7.4 and Chapter 13) the coffin is carried to the *Ibu* on a long-poled bier accompanied by the two Kite women, the Embalmer, the Overseer of Embalmers and the Lector Priest. Qar's embalmers keep time with percussion sticks while the Lector Priest chants the ritual. In New Kingdom scenes of the burial ritual the equivalent structure is called

the *Sah Netjer*, 'Divine Booth' of Anubis. Texts speak of the deceased arriving at the 'tent district'.

The *Ibu* is shown as a pavilion on a quay or wharf, defined by a low terrace with a T-shaped basin in front. In the tomb of Mereruka, two swinging leaf doors stand at either end of the terrace. With the hieroglyph for 'sky' above them, the whole scene renders the text 'Doors of Heaven' on a colossal scale.[3] In the tomb of Qar, the ends of the *Ibu* are framed by two gate-like structures with paths labelled 'road' or 'way'. A band of reed mat stretches across from one gate to the other, and a woven reed screen in the centre separates the space between the gates and paths into two broad rectangles, which represent the interior of the *Ibu*. In the tomb of Pepi-ankh, the *Ibu* is a long pavilion of poles and cross pieces from which reed mats, not shown, were meant to hang. Gates flank the two ends of the pavilion and a simple ground plan of the *Ibu*, inserted into the long front view of the pole frame, shows it consisted of two empty rectangular spaces. These images present the *Ibu* as a light reed-mat construction shielding a rectangular space, on or near the edge of a watercourse, with pathways and doors at either end.

The arrangement of two pathways, terrace, quay and rectangular spaces can be compared to what we know of the plans of pyramid valley temples, particularly those of Khafre at Giza and Pepi II at South Saqqara. At Pepi II's valley temple, ramps ascend from the level of the harbour and floodplain to either end of a terrace. Doorways opened through small kiosks built on to the north and south ends of the thick wall that enclosed the terrace on three sides – the other side, on the east, was open to the harbour. Khafre's valley temple is also approached by two long stone ramps that lead up to a low terrace along the front of the temple. The ramps retain traces of double swinging doorways built into gatehouses over a token canal that filled with water during the Nile inundation.

These similarities between pyramid valley temples and the depictions of the *Ibu* would seem to offer strong support for the suggestion that the structures in front of the valley temples represented the *Ibu* cast in stone, and were possibly the stage for actual reed-mat shelters for the treatment of bodies of the members of the royal household as they began their rite of passage into the necropolis.

Wabet: *the pure place of wrapping*

From the *Ibu* the funeral party took the treated corpse into the *Wabet*, a name built on the root word meaning 'pure'. The tomb of Pepi-ankh calls this the 'Pure Place of Wrapping'. Egyptologists usually translate *Wabet* as 'mortuary workshop' and believe it is where the embalmers wrapped the mummy. In the New Kingdom, this institution was called the 'Hall of Uniting'.

Each tomb complex in the Old Kingdom might have had its own *Wabet* located in the desert next to the tomb. Some Egyptologists suggest that the upper pyramid temples could have served as the king's *Wabet*. However, if the embalming operation began with the desiccation of the body in the *Ibu*, it would have been transported to the *Wabet* in a vastly reduced – probably fragile – state. Texts and pictorial representations suggest that the *Wabet* was in the valley area of the necropolis and close to the *Ibu*. The location of the *Wabet* in the valley is also suggested by the part played by sacred geography in the elite funeral.

In tomb scenes of noble funerals, Egypt's geography plays a symbolic and ritual role. The complete ceremony featured a voyage to Abydos, the centre of Osiris worship and the necropolis of Egypt's earliest kings. The Delta cities of Sais and Buto play an equal or even more significant role. Sais was the home of the goddess Neith. Greater Buto, comprising the twin towns Pe and Dep, was the legendary Predynastic capital of the north and home of the crown cobra goddess, Wadjit. Sais and Buto are prominent in Egypt's earliest hieroglyphic texts and scenes dating to shortly after the first union of Upper and Lower Egypt. The Egyptians considered that the resurrection of any important nobleman or householder, in wholeness of body and soul, was coextensive with the national wholeness of Egypt itself. It is possible that after the unification of the kingdom, northern customs were integrated with those of the south to form the complete funeral repertoire.

By comparing pyramid age funeral scenes with textually more explicit examples from the New Kingdom, Hartwig Altenmüller notes that in the older scenes the transfer of the body from the *Ibu* to the *Wabet* was allegorically connected to the 'Voyage to Sais'.[4] This rite was particularly associated with sacrificial slaughter of cattle

for the burial ceremonies. The Delta, where Sais was a cult centre, was an area of cattle herding. The requirement for carnal offerings probably relates to the excarnation of the body in the *Ibu* and its recomposition in the *Wabet*. Altenmüller cites evidence that the symbolic 'Sais' of the funeral rite was generally an area in the valley around the valley temples of the pyramids.

Old Kingdom tombs show the body journeying to Sais by barque on the *Weret* Canal, a wavy or winding waterway that was perhaps symbolic of both the feeder canal that led to the necropolis and the western Nile branch that led to the actual towns of Sais and Buto. The barque arrives at an area of multiple booths topped with a frieze of tall pointed elements that the ancient Egyptians called *kheker*, 'ornament'. A Lector Priest stands in a gateway or booth flanked by a pair of opposite-facing *netjer* ('divine') signs. From an open scroll he reads a ritual of glorification. One tomb labels the scene 'Conducting the Water Festival by the Lector Priest' and 'the drowned have arrived!' This watery ritual may relate to the purifications of the body. Another water reference comes with the reception of the entourage by high-stepping *Muu* dancers, whose name may mean 'those of the water'. The *Muu* figure even more prominently in the arrival at the tomb at a later stage of the funeral (see below).

A 'place of uniting', accomplished by wrapping the remains into a linen effigy, would be needed if the desiccation and partial dismemberment of the body had occurred in the *Ibu*. The whole process lasted the better part of 70 days, while texts in the tomb of Queen Meresankh III in the mastaba cemetery east of the Khufu pyramid mention the passing of 272 days between her death and burial. The *Ibu* may not have been secure enough for such a long period. It is possible that the undertakers performed a ritual lustration, followed by the removal of the viscera and brain, in the *Ibu*, while the longer period of desiccation took place in the *Wabet*.

Tomb scenes show men carrying the coffin from *Ibu* to *Wabet* on the long-poled bier. In the Giza tomb of Qar we see, just after the *Ibu*, an Embalmer and a Kite woman chanting words over the same collection of items that in one of the *Ibu* compartments were labelled 'Requirements of the *Ibu*: A Meal'. Here these items are labelled simply

'a meal'. Two calves are tied up preparatory to being sacrificed. Next, the coffin is taken to a papyrus boat called *Shabet* and towed by lines of men towards the *Wabet*. Women and 'friends' from an institution called 'the Acacia House' dance in front of the *Wabet*, which is here clearly labelled and rendered in a ground plan.

The ground plan of Qar's *Wabet* shows some similarities to the internal plan of the valley temple of Pepi II. Although Qar's *Wabet* has a porch or projecting entrance room while Pepi II's valley temple is accessed by a recessed pillared portico, both have three main central rooms, a long and narrow blind corridor, and one complete side taken over by magazines, rendered in Qar's *Wabet* as a chamber crammed with offerings. We find a very similar ground plan in the last 'house' to the west in the pyramid town of Queen Khentkawes at Giza (see Chapter 12), with a rock-cut basin with steps leading down into it immediately to the northwest (at the northeastern corner of the queen's mastaba). If the building and basin do represent Khentkawes' *Ibu* and *Wabet*, they are situated in proximity to her tomb because it is located near the harbour area of the valley, and not up on the desert plateau.

In other tombs we find images of the exterior form of the *Wabet*. The Giza tomb of Idu (also discussed in Chapter 13) depicts a building with a crude *kheker* frieze, a portico with a papyrus column (no doubt one of a pair) and a recessed doorway. The *Wabet* is shown, along with the *Ibu*, in two similar scenes in the tomb of Pepi-ankh. Here it is a rather plain rectangular building entered through a portico with two slender columns with lotus capitals. Inside the portico a double recessed doorway opens to a tall narrow shrine topped by the cavetto cornice with torus moulding typical of Egyptian shrines and temples ('cavetto' is a concave moulding with a curve that roughly approximates a quarter of a circle). Set into the lower left corner of this elevation view is an abbreviated ground plan of a zigzag, off-axis entrance similar to the one that leads to the inner room of Qar's *Wabet*.

To the left of Pepi-ankh's *Wabet* façade are great piles of offerings in the centre of what we understand to be the interior of the *Wabet*. The offerings also fill two long upper registers. There seems to be a preponderance of cut meat, fowl and (desiccated?) fish offerings. Oblations are

made; ritual is read. A Lector Priest summons the deceased to this carnal meal in the 'Hall of Uniting'. Here, where the undertakers recomposed the bones and whatever else was left of the corpse and made them whole again as the mummy, the deceased is called upon to partake of sustenance in the form of dismembered flesh and bones of food animals. Meat is essential to this corporeal recomposition. The Kite women and the Master Embalmer stand by. To the far left of the scene is what appears to be a back door through which the coffin is again carried on a litter in one of the two similar scenes in Pepi-ankh's tomb. The label 'Conducting to the *Ibu*' has led some to suggest there was a return to the Purification Tent before the procession to the tomb.

Journey to the desert: the causeway and the liminal zone

Tomb scenes dating to a period later than the Giza pyramids show the coffin, now containing the wrapped mummy, on a sledge pulled by oxen in a procession to the tomb accompanied by the funeral entourage. Just as the landing place at the edge of the valley is 'Sais', the necropolis represents 'Buto', the legendary Predynastic Delta capital. The Egyptians pictured the Buto cemetery as a row of tombs interspersed with palm trees. The tombs have a round top between two vertical poles – the form of the *Per Nu*, the 'House of Nu', the emblematic shrine of Lower Egypt.

The coffin procession still includes the two Kite women and priests, one of whom now dons the black jackal mask of Anubis in New Kingdom illustrations. Lamenting men and women are said to be residents of Buto and Sais and other northern towns. The Delta and its people also play a prominent role in two of the most mysterious and enigmatic elements of the journey to the tomb, those involving the *Tekenu* and the *Muu* dancers.

The enigma of the *Tekenu* Two major objects besides the coffin and statues of the deceased that were dragged up to the tomb on their own sledges, primarily in New Kingdom funeral scenes, were the *Tekenu* and the canopic chest. The canopic chest contained the viscera, which the undertakers had removed prior to desiccating and mummifying the body and embalmed separately. Closely associated with the canopic chest, and sometimes pulled along just behind it, the *Tekenu* takes a number of forms: a shrouded figure with only the face showing; a cloaked kneeling figure with the head free; an egg-shaped object wrapped in a spotted animal skin; or a black, pear-shaped object. In the 18th dynasty tomb of Montuhirkhepeshef at Thebes (Luxor) the *Tekenu* is a man lying in a contracted foetal position [7.9].

It is worth exploring this strange Egyptian tradition in order to understand the transitional zone between the valley temple and the upper pyramid temple, represented by the causeway. The name *Tekenu* probably derives from the word *teken*, 'be near', 'approach', 'border'. There is a word, *tekenu*, for 'neighbours'. But *teken* can also mean 'attack', and *tekekw*, 'attackers', is determined by the hieroglyph of a prisoner with his hands bound behind his back. Hartwig Altenmüller noted that the dragging of the *Tekenu* is associated with the

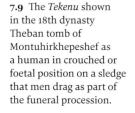

7.9 The *Tekenu* shown in the 18th dynasty Theban tomb of Montuhirkhepeshef as a human in crouched or foetal position on a sledge that men drag as part of the funeral procession.

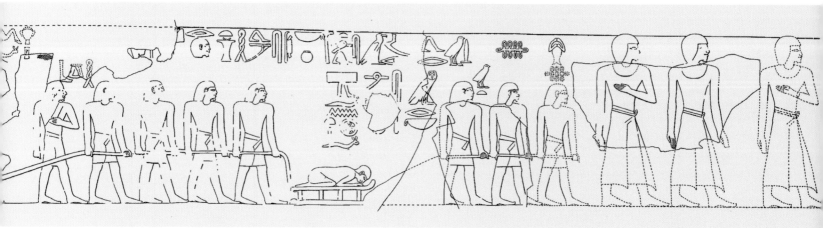

'coming out of the townspeople', specifically of the ritually significant towns in the Delta.[5]

The reason that the *Tekenu* is visible as a full human figure in the tomb of Montuhirkhepeshef is that he is free of his animal-skin shroud, called *mes-ka*. Carried by a man at the head of the procession, the wrap is also labelled 'City of the Skin'. In the next register down we see cattle being slaughtered, and one more register below this shows the scene of two bound 'tribesmen', the *Iuntiu*, another word written with the determinative of a prisoner with his hands tied behind his back.

The scenes associated with the *Tekenu* convey not only the sense of 'community' (of northerners), but also an element of apotropaism – warding off chaos, which throughout ancient Egyptian history is symbolized as the tribesmen along Egypt's borders. The bound tribesmen, and the *Tekenu*, imply an ambivalence between community and enemy tribe as both protection and threat, here in the state of greatest vulnerability during the critical passage from a person's former status in the land of the living to the tomb and resurrection in the land of the dead.[6]

Death is rebirth, as conveyed viscerally (literally, by its association with the viscera) by the *mes-ka*, as seen in the famous Theban tomb of Thutmose III's vizier, Rekhmire. The *mes-ka* is equated with the 'Pool of Kheperi'. *Kheper* is 'to become', 'to transform', 'to evolve'. *Kheperi* is deified rebirth, and god of the rising sun. Hence some Egyptologists see the *Tekenu* as the bull form of the sun god, possibly played by a priest who, for the occasion, crawled into a bull's skin.

The *Tekenu* is the ritual focus of the vulnerable passage through the liminal space between embalming hall and tomb, between death and rebirth. The contracted foetal position the *Tekenu* sometimes takes is similar to that of burials of ordinary people ranging from the earliest Predynastic periods of Egyptian culture well into the Old Kingdom – a death posture that was very possibly always meant to effect rebirth. This is not inconsistent with one suggestion that the *Tekenu* was the wrapped and shrouded corporeal remnants of embalming that were not placed in the coffin or canopic chest. Such 'efflux' of Osiris was fecund fluid, the fertilizing and reviving essence of the Nile flood. If the *Tekenu* was the remnant from the

purifying wash following the desiccation of the body by natron, that wash was itself associated with the solar bath, hence the 'Pool of Kheperi', the rising sun. Figuratively, there was much riding in the *Tekenu* bag with the body to the tomb.

As the anthropologist Victor Turner points out in his book *The Ritual Process*, all ritual moves the subject from one position of structure and status to another. The liminal zone between the two states is a time of great vulnerability, dissolution into commonality, when community can both protect and attack. The causeway, with its massive stone walls and roof, protected the ritual passage through the liminal zone of the pyramid complex.

The mysterious *Muu* When the funeral procession arrives at the cemetery, the Lector Priest calls out, 'Let the *Muu* come forth!' And come forth they do, stepping high or dancing in unison [**7.10**]. Some scenes show the *Muu* already stepping forth at the ritual landing in 'Sais', but they seem to be most prominent here, on arrival at 'Buto', where they greet the canopic chest and *Tekenu* in particular. On their heads the *Muu* wear tall, conical, wickerwork crowns, apparently of papyrus, or, in late Old Kingdom examples, the three-stalk papyrus symbol of Lower Egypt. They also wear a short, wrap-around kilt called *shendyt* in ancient

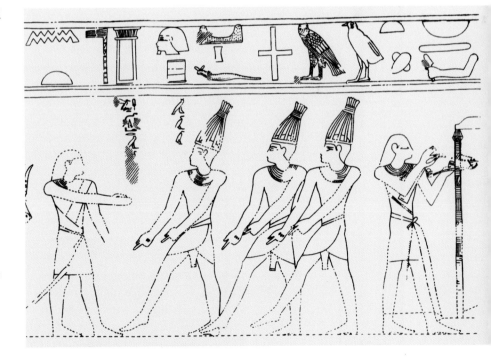

7.10 The mysterious *Muu* dancers wearing kilts and tall, conical, wickerwork hats, stepping forth and making strange gestures with their hands, from the New Kingdom tomb of Tetiky at Thebes. On the left, a priest extends his arm towards them.

Egyptian, a garment that was otherwise worn by the king. Sometimes they are simply a pair of dancers facing each other. In the New Kingdom the *Muu* are shown in the Hall of the *Muu*, a shrine with a rectilinear ground plan of several chambers projected above it. As they step forth in unison, they extend their hands and fingers in peculiar gestures resembling modern gang signals.

Egyptologists have tried to explain the *Muu* as buffoons or jesters, demigods or ancestral 'Souls of Buto'. Altenmüller connects the *Muu* with certain Pyramid Texts that, while not mentioning the *Muu* directly, speak of the ferryman whose name, His-face-in-front-His-face-in-back, is a reference to the act of crossing a canal or river and looking in both directions, like the *Muu* who face each other or look both ways. In the Pyramid Texts, the ferry crossing is equated with the king's journey through the sky on reed floats. The name, *Muu*, is itself a reference to 'those of the water'. Like boatmen in northern Egypt in recent times, the ancient Delta ferrymen must have had their own special dances and headgear, as hinted in Pyramid Text 1, 223, Utterance 520:

> If you delay to ferry me over in this ferry boat,
> I will tell your names to men whom I know, to everyone, and I will pluck out those dancing tresses which are on top of your heads like lotus buds in the swamp gardens.

Why do the *Muu* participate in the funeral? As mentioned above, the dead must make a crossing of the Nile Valley, so the *Muu* as boatmen are a fitting image, sitting as they do in daily life on the threshold of the river bank in their huts ('the Hall of the *Muu*'), waiting to ferry the traveller. The *Muu*'s gestures are very similar to those found in Old Kingdom tomb scenes showing ordinary boatmen in simple papyrus skiffs, who make special finger gestures and point out over the heads of cattle during a water crossing to ward off potential danger, such as crocodiles lurking nearby. So the *Muu*'s gestures are yet another apotropaic insurance against any harm during the vulnerable passage that in reality must have been left in the hands of boatmen from Egypt's most common class.

We do not know how much these traditions of *Muu* and *Tekenu*, so strange to us, played out

in the king's funeral during the early pyramid age. The liminal passage up to the high necropolis was protected by the thick causeway walls and ceiling, with only a narrow slit admitting a shaft of light. We do know that in place of apotropaic *Muu* and boatmen gestures, the relief-carved scenes that graced the walls of the lower parts of 5th dynasty pyramid causeways included sphinxes and griffins, one paw outstretched to ward off attackers, another trampling tribal enemies underfoot. Alternatively, the traditional tribal enemies of Egypt's border areas are tied as prisoners, restrained by the gods. The function of these depictions may be the same as in the noble person's funeral – to ward off evil during the vulnerable transition to the security of the tomb – but for the god-king it is the gods themselves and mythical beasts who ward off evil, rather than common folk and simple boatmen.

At the tomb

Following the progression of tomb scenes showing the noble funeral, we now see the mummy, sarcophagus, canopic chest and *Tekenu* gathered at the offering place in front of the false door – the magical entrance to and exit from the Netherworld. In the tomb of Debehen at Giza (LG 90; see also Chapter 13), probably contemporary with the construction of the Menkaure pyramid, the dancing women of the 'Acacia House' appear again when the funeral arrives at the tomb. The women dance to a song of lament that begins, appropriately for greeting the mummy, 'His flesh is complete'.

The significance of the Acacia House is uncertain (perhaps a reference to the wood of the coffin?). In the New Kingdom there are a few vague references to a relationship between the Acacia House and a 'Women's Tent', and between the Women's Tent and the *Per Wer* ('Great House'), the name of the national shrine at Hierakonpolis. The rare New Kingdom depictions of the Women's Tent show a pole-frame reed-mat structure. Just such a booth is being assembled, in the shape of the *Per Wer*, in the funeral scenes of the Old Kingdom tomb of the Vizier Ptahhotep at Saqqara.

In the procession to the tomb, bearers carry all the furnishings needed for setting up house in the Afterlife: chests of linen, tools, weapons, pottery and metal vessels, ointments, oils and symbols of social status. Offerings of food and drink were also

brought up from the valley. In the Old Kingdom the offering ritual involved 'Taking a stand on the roof' of the tomb. This was not possible on a pyramid of course. Yet those burying the king must have performed a similar rite on the roof of the upper temple, or in front of the entrance to the pyramid itself, which, in the 4th dynasty, they would have had to reach by a temporary ramp because it opened so far up the pyramid slope. The Debehen scene shows a ramp sloping up to a shrine with a statue of Debehen, which forms the focus of all the proceedings (see 13.16). In Old Kingdom mastabas, where the burial chamber was entered by means of a vertical shaft through the superstructure, a ramp up to the roof would have been required to install the body and coffin. Such ramps have been found still attached to mastabas at Meidum, Dahshur and Giza, left over, perhaps, from their ritual use in the final phase of the funeral.

The Invocation Offering, called 'Coming forth at the voice', was the central performance of the tomb ceremonies. This was the first summons to the deceased to come and partake of the offerings, a summons that was to be performed 'forever' and for 'every feast and every day'. On festival days in particular, a crowded necropolis must have resounded as a Muslim city does at the call to prayer. The Invocation Offering was performed in a 'booth' or 'hall'.

In the 4th dynasty, the Embalmer conducted the Offering Ceremony. In the tomb of Debehen, the Embalmer is shown left of the uppermost register, holding the papyrus with the ritual text in one hand and gesturing to the deceased with the other. Kneeling people present offerings. The scene is labelled 'Offering things, feeding the spirit and making glorifications [sakhu] by the Embalmer.' Behind the Embalmer, the gridded offering table provides a graphic representation of the offerings being recited.

As time went on, the offerings became lengthier and more complex. From his examination of Old Kingdom tombs, Hermann Junker counted 17 different ritual presentations that he could relate to those for the king found in the Pyramid Texts, including censings, libations and gifts of strips of cloth, cattle and fowl. Such correspondences between royal and so-called 'private' rites suggest that we may be justified in using the noble person's

funeral as some kind of guide to the royal funeral at the pyramid complex. The gifts are equated with the 'Eye of Horus'. The New Kingdom Book of the Dead states: 'Take thou the Eye of Horus, which thou hast requested, the requirements of the Offering Table.'

With the addition of a second set of utterances and rites for glorifying the dead, or making them effective (akh), the ritual was so complex that a ritual specialist was required, and this was the Lector Priest, who accompanied the body during the entire funeral. In some tombs the offering ritual involved an official called the Master of Reversions, who was in charge of the flow of goods from the temples to the tombs for the occasion of a noble burial by the grace of the king. However, over the long term the offerings were sustained by the landholdings of the deceased's fields, estates and, for the larger households, whole villages. Maintenance of the household was the core social and economic role of the burial ritual, and the one who conducted it for the now-deceased head of the house stood to inherit his position. In the case of the king and his pyramid, the son inherited the 'Great House' – the meaning of the word 'pharaoh' – inclusive of all others, that is the land of Egypt.

Another key ritual, the Opening of the Mouth, made it possible for the deceased to breathe, eat and speak in the Afterlife. In the early periods this rite was performed on a statue, like that of Debehen in the shrine on the 'roof' of the tomb. The tomb statue(s) also partook ritually in the 'Journey to Abydos', which, as we have seen, was the cult centre of Osiris and Egypt's oldest royal burial ground.

Priests clapping sticks in rhythm, similar to drum rolls, accompanied the interment. John A. Wilson cites 6th dynasty texts that speak of 80 men, in the charge of the Embalmer, Head Mason and the Lector Priest, who helped set the heavy lid of the stone sarcophagus upon 'its mother'.[7] Eighty may have been the full complement of workers who lowered the coffin and accomplished its closure, but it is doubtful that so many would have fitted into the burial chamber. The final rite was 'Bringing the Foot', that is, erasing the footprints of the officiants by dragging a brush across them, accompanied by more censing, libations and glorifications.

Funerary simulacra?

Such plausible comparisons between the Pyramid Texts and depictions of the noble person's funeral led some Egyptologists to see the elements of the pyramid complex as the platform for the performance of the funeral for the king. But did the dead king's funeral procession actually move through the pyramid complex? What we have outlined so far assumes that it did, based on correspondences between pyramid and tomb, and between components of the funeral and the valley temple, causeway and upper temple.

Or did the architecture of the pyramid complex merely commemorate, in huge stone simulacra, the ephemeral structures, perhaps of wood and reed mat, erected for the actual funeral? Is this commemoration of the royal funeral the principal meaning and message of elements of the pyramid complex [7.11]?

Hans Bonnet[8] and Dieter Arnold[9] have brought into serious doubt the possibility that the pyramid temples and causeway were actually used for the royal funeral ceremony. Not a single relief fragment from a pyramid temple relates directly to the funeral, although admittedly only a small fraction of the scenes that once existed have been

recovered. Perhaps we should in any case not expect to find representations of the funeral on the walls of the pyramid temples since it was a one-off, unrepeatable act. The king would certainly not wish for a continuing funeral, implying the feared 'second death' in the Afterlife. However, if this is true, why was the funeral sequence depicted in noblemen's tombs of the late Old Kingdom? Would these nobles not have harboured the same fears?

More serious is the practical, architectural argument: the various rooms, passages and doorways seem physically too small for the passage of the royal funeral cortège from the valley temple – whether or not that was the actual or ritual *Wabet* and *Ibu* – up through the causeway and to the upper temple, where the priests would have conducted the Opening of the Mouth and offering ceremonies. If the Egyptians did conduct the funeral through the pyramid complex, they would have had to carry the body and all the grave goods from the upper temple into the pyramid court, defined by the enclosure wall surrounding the pyramid, and then around to the pyramid's north side in order to gain access to the entrance, internal passages and the burial chamber.

7.11 Diagram of a generalized pyramid and upper temple of the 5th– 6th dynasties, showing the major elements. Whether or not the royal funeral actually took place within its chambers and passages, this was the tomb of the king.

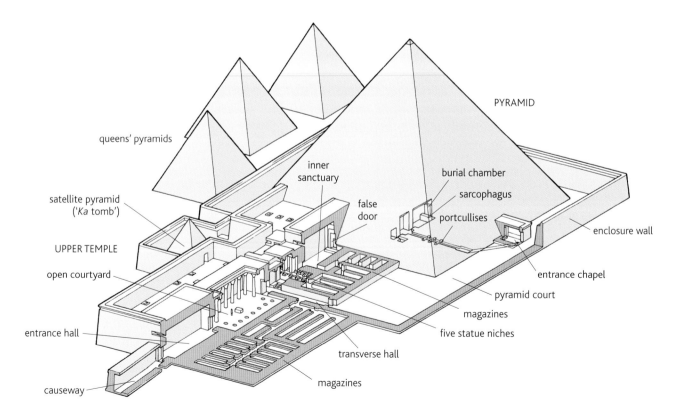

In the 5th and 6th dynasties the exit from the upper temple to the pyramid court was at the ends of the transverse hall. This prominent corridor-like chamber, perpendicular to the temple axis, made a pronounced separation between the front temple and the inner temple. The inner temple's façade is formed by the east wall of this corridor, giving it the status of a separate temple. Arnold draws attention to the fact that the doorways at the northern ends of the transverse hall are only 70 to 90 cm (28 to 35 in.) wide – surely too narrow for the passage of a grand funeral procession. Also, the swinging wooden door opened into the transverse hall, not out of it, indicating that it was meant to be an *entrance* from pyramid court *into* the temple – perhaps for the king's soul or for priests when they circumambulated the pyramid – rather than an *exit* for the funeral procession.

The 4th dynasty Giza pyramid temples were built before the development of the transverse hall, though someone later created one in the Menkaure upper temple by building a mud-brick wall at the west side of the court. But the doorways of these temples also seem extremely narrow for the passage of a major procession of people bearing the royal body in a coffin, the canopic chest, possibly a *Tekenu,* furniture for the tomb chamber and grave goods. The doorway to the Khafre upper temple is only 1.05 m (2 cubits, or 3 ft) wide.[10]

In the funeral processions depicted in tombs of the 6th dynasty, men carry the coffin at each end by means of a bier with long extending poles, but others also support the coffin from the sides. If we grant 1 m (3 ft) for the width of the coffin alone, plus 50 cm (20 in.) for men on either side and leave 25 cm (10 in.) clearance, we arrive at a width of 2.5 m (8 ft) for a dignified procession.

Once inside the pyramid passages, the coffin was no doubt slid or dragged towards the burial chamber – the Ascending and Descending Passages in the Khufu pyramid are as narrow as 1.05 m (3 ft). In the Djoser Step Pyramid complex, the doorways and openings along the route from the entrance hall through the upper temple and down into the burial vault are about a metre (3 ft) or less.

Arnold suggests that the ancient Egyptians would have conducted the royal funeral rituals in light structures, composed of wooden frames and reed mats, outside the rooms and corridors of the pyramid complex. He points to the fact that the ancient Egyptians purposely placed *outside* the walls of the pyramid complex items that probably served the funeral procession: the wooden boats of Khufu, the boats and sledges of Senwosret III, the statue-carrying shrine of Khafre buried separately outside his satellite pyramid, caches of funeral materials and mud-brick constructions near but outside the enclosure of the pyramid and its temple. The royal body, according to Arnold, would have been brought into the pyramid court by means of a side entrance. The winding route through the narrow doorways and passages from valley temple to the pyramid interior was far more suited to the magical movement of a royal *ka* than a real procession of people and grave goods.

As for the valley temples of later pyramids being representations in stone of the *Ibu* and the *Wabet*, the match between the depictions in 6th dynasty tombs and the pyramid valley temples is best with those of Khafre and Pepi II. The eight valley temples that have been excavated, of 28 that probably once existed, differ significantly from each other in their ground plans. Egyptologists cannot agree on a place in these ground plans for the processes of mummification.

Whatever the practical difficulties in conducting a king's burial procession through the narrow doorways of the valley and upper temples and the pyramid's internal passages, it would be a mistake to reject any meaningful association between the pyramid complex and the royal funeral since the pyramid was the tomb of the king. Hundreds of mastaba and rock-cut tombs surround the Giza pyramids, which thus form the centrepieces of a vast necropolis.

The pyramids and their temples share features, albeit on a higher order of magnitude, with the surrounding tombs and their chapels, such as offering places, statues and chambers containing sarcophagi. It seems, however, that we must consider the possibility that the funerary components of the pyramid complex were largely symbolic – simulacra of the structures in which the Egyptians carried out the practical housekeeping of death and the treatment of the body of the king.

Eternal residence: pyramid as palace

If the pyramid valley temple, causeway and upper temple were a simulacrum of the stage for the royal funeral, and if the actual funerary rituals were conducted in temporary structures outside, though still associated with, the pyramid complex, did the temples also represent something else? Many features of the pyramid complexes suggest that, again like the so-called 'private tombs', each was a 'house of eternity' (*per djet*), bearing similarities to houses of the living [**7.12**]. Most Egyptologists agree that the pyramid temple served, in at least one of its aspects, as an eternal residence for the dead king.

The Giza pyramid temples, both the valley and upper, stand at the beginning of a long development that continued through the later Old Kingdom and the Middle Kingdom.[11] As the temples became more elaborate, the relief-carved scenes increased. Egyptologists interpret the remnants of these scenes and hieroglyphic texts as evidence for identifying the functions of the various rooms, building up a compelling case for the temples as eternal residences. The more massive, and simpler, 4th dynasty pyramid temples already included some of the same basic elements that made up large houses known from Egypt's archaeological record: an enclosure wall; vestibule; a central meeting and working place in the light of a pillared hall or open court; a platform or station for the head of the house to receive visitors formally; private rooms in the rear; storage magazines. The pyramid

temple was a simulacrum of the living house and household to the same extent that the mummy was a simulacrum of the living body.

Valley temple: gatehouse and entrance corridor

Unfortunately we have no true palace of the Old Kingdom to which we can compare the pyramid complex. Large houses from the Middle Kingdom pyramid town of Senwosret II at Kahun (Illahun), dating to around 500 years after the 4th dynasty, have an off-axis entryway followed by a long corridor extending the length of the central part of the house to a court and portico, which are turned away from the entrance for greater privacy. New Kingdom palaces were approached by long royal roads (at Amarna), and entered by causeway-like corridors, ramps and bridges (at Malkata and Amarna). House-like structures were attached to the front end of long entrance ramps or corridors, such as that leading to the northern palace of Akhenaten at Amarna, and to a palace of his father, Amenhotep III, at Malkata. Larger than a nobleman's house but smaller by far than the actual palace, these buildings served as gatehouses, probably to control access to the residence. The palace of the 19th dynasty pharaoh Merenptah at Memphis had a long entrance corridor, like those in 12th dynasty Kahun houses, running the length of the building to the rear, which was turned to face in the opposite direction from the entrance.

The valley temples and long causeways of the pyramids might have been similar in concept,

7.12 Diagram of a generalized pyramid and upper temple of the 5th–6th dynasties, equating elements with features of a royal residence. We have to consider with caution the latter form and function when looking back to the earlier 4th dynasty pyramids and their temples.

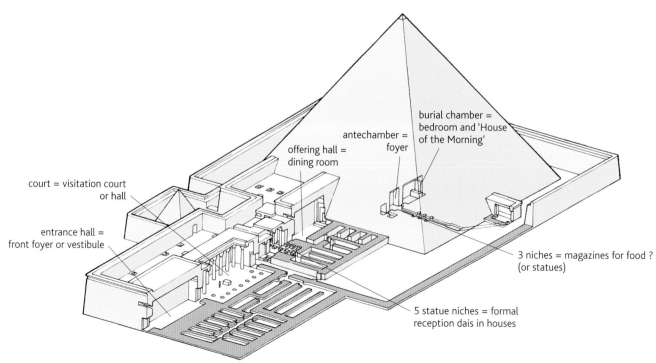

court = visitation court or hall

entrance hall = front foyer or vestibule

offering hall = dining room

antechamber = foyer

burial chamber = bedroom and 'House of the Morning'

3 niches = magazines for food ? (or statues)

5 statue niches = formal reception dais in houses

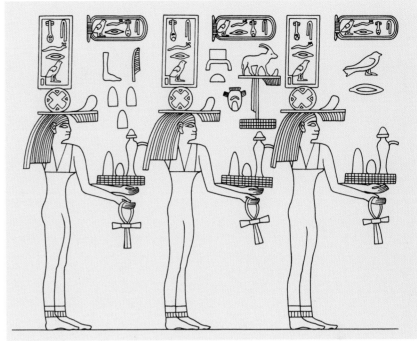

albeit turned and straightened for a great east–west axial alignment. The valley temples were indeed gateways to the pyramid complex, as the German word for these buildings, *Torbau*, denotes. The lengthening of the access corridor into a causeway, and the separation of the entrance vestibule or gatehouse in the form of the valley temple from the house proper in the form of the upper temple, is what gives the pyramid complex its special character, in addition, of course, to the towering, triangular pyramid itself.

The pictorial programme on the walls of the 5th and 6th dynasty valley temples gives us hints of the ancient Egyptians' beliefs concerning these portals to the pyramid complex. On the walls of the portico, the goddess Sekhmet, matron of Memphis, receives and suckles the king [7.13]. Entering the valley temple, the king crossed the threshold of rebirth, emphasized further by the association of the goddess Hathor with these temples, as is clear from hieroglyphic texts. From the valley temple and into the causeway the wall decoration played out the theme that runs through 3,000 years of pharaonic iconography: the triumph of order over chaos, represented in scenes of hunting, fowling and netting fish, and the defeat of tribal enemies. Here the tribesmen are taken as bound prisoners or trampled by the king in the form of a giant sphinx.

In the Khafre valley temple, 23 statues perhaps represented the king ruling over all the hours of the day and night (24 may have been the intended number), or possibly the meaning lay in the king's central statue ruling all 22 nomes of Upper Egypt. In the Menkaure valley temple the various triads depicting Menkaure, Hathor and one of the nome deities might have conveyed something similar if the set was originally larger than the half dozen examples found by Reisner. The older valley temple of the Dahshur Bent Pyramid of Sneferu, Khufu's father, contained six statues of the king. The walls were carved with offering bearers who personify estates, towns and nomes – order imposed on the natural, wild floodplain [7.14].

The upper temple: entrance hall and vestibule

The upper temples of Khafre and Menkaure both featured prominent entrance halls. Egyptologists identify the entrance halls of later pyramid temples with the term *Per Weru*, literally 'House of the Great Ones'. The Abusir Papyri, the archives of the 5th dynasty pyramid temple of Neferirkare, mention this term, as do texts and scenes in both the Pepi II pyramid temple at Saqqara and the Niuserre sun temple at Abusir. In the last instance *Weru* is written inside an abbreviated ground plan of a vestibule or hall, which follows the word

ABOVE LEFT
7.13 Relief scene from the valley temple of the 5th dynasty pyramid complex of Niuserre at Abusir, showing the goddess Sekhmet suckling the king, indicating rebirth, youth and nurturing.

ABOVE RIGHT
7.14 Relief from the valley temple of Sneferu's Bent Pyramid at Dahshur showing estates, personified as female offering bearers, bringing goods to the pyramid. Sneferu's name appears in the rectangular sign for 'estate' above the crossed circle for 'town' or 'village' on the head of each figure.

Weskhet, 'broad court', itself written inside an abbreviated plan of a square court. Egyptologists infer that the 'great ones' are the followers of the king who assembled in the vestibule and court of the real palace during the king's lifetime, as he moved through it to take the throne during royal ceremonies such as those of the Sed Festival.

Warding off evil The vestibules of later pyramid temples had vaulted ceilings, and remains of the decoration of the tympanum show the king enthroned in the company of the national deities, Nekhbet, Wadjit, Horus and Seth, as well as Hathor, the divine mother. The pictorial programme of the vestibules and courts, reconstructed mostly from the temples of Sahure and Pepi II, included the royal hunt, fowling in marshes, spearing fish, the conquest and slaughter of enemies, and the delivery of tribute. We also find such themes in the decoration of New Kingdom palaces, where, for example, the traditional tribal enemies of pharaoh, the 'Nine Bows', were painted on the floor so that the king routinely trod them underfoot.

In the later Old Kingdom, rows of prisoner statues lined the walls of the pyramid causeway, vestibule, court and perhaps the transverse hall of the upper temple, as evidenced by many broken examples, although none has been found in position. The Nine Bows were also inscribed beneath the king's feet on the statues of him set up before the pillars in the courts of some of the later pyramid temples. The whole composition represented the stylized and ritualized ecology and anthropology of the Nile Valley, with natural and human forces brought under control by the power of the divine king and through his mediation with the gods. This fulfilled an apotropaic function: chaos was controlled in advance of entry to the inner sanctum.

We know little about the relief scenes that once graced the limestone parts of the walls of the Khufu and Khafre causeways and temples (Menkaure's builders did not complete his temples, so his craftsmen probably never reached the stage of the relief-carved decoration). While the fragments hint at the existence of elaborate decoration, they are not sufficient to be certain that the scenes were apotropaic. In place of relief-carved sphinxes and griffins trampling enemies, the Great Sphinx sits at the base of Khafre's causeway, stately and recumbent, but possibly also serving to ward off evil.

Public and private: front and inner temple In Khufu's upper temple the prominent transverse corridor between the front and inner temple found in standard pyramid temples of the middle to late Old Kingdom is represented only by the recessed western bay, stepped back from the court and its colonnade, and by the inner sanctuary and magazines. In Khafre's upper temple the separation between front and inner parts is stark. The open court separates the front temple, consisting mainly of a vestibule and entrance hall embedded within massive core-block masonry, from the inner temple, which includes a set of five statue niches, inner magazines and an offering niche, probably for a false door. A mud-brick wall that was built as part of the modifications of the Menkaure upper temple in the later Old Kingdom formalized the separation between the front entrance hall and court and the inner statue hall, magazines and offering platform at the foot of the pyramid.

Audience: proprietor of house and temple As far as we know, Khafre's upper temple is the first to contain five niches in the inner temple. In place of these niches, Menkaure has a single large hall, perhaps originally graced by his alabaster colossus now in the Boston Museum of Fine Arts (see p. 255). The five niches were picked up again in the Userkaf pyramid temple at Abusir, and became standard in the pyramid temples of the 5th and 6th dynasties. Egyptologists believe that a statue stood in each of the niches.

In the 5th and 6th dynasty temples, the floor of the statue niches rises about a metre (3 ft) above the level of the front temple and transverse corridor, with alabaster steps leading up, an arrangement we can compare with the throne dais of later palaces. In fact, not only palaces, but also larger houses of noblemen had limestone platforms at the back of the open courts or halls. The platforms, sometimes approached by steps, were apparently where the head of the house would be seated, slightly raised, in order to greet visitors formally.

In the statue chambers of the later pyramid temples, this seat of the householder is combined

with symbols of womb and tomb. Scenes from the walls at the sides of the steps leading up to the statues showed the goddesses Nekhbet, Wadjit, Sekhmet or Hathor suckling the king. These are the patron goddesses of Upper Egypt (Nekhbet of el-Kab), Lower Egypt (Wadjit of Buto) and of a centralized, unified Egypt (Sekhmet of Memphis); Hathor is the divine mother and female counterpart to Horus. The goddesses nurture the king as they would suckle an infant; here, at the rear of his funerary chapel, the idea of death and rebirth combine.

Only the base of a single statue has been found in place in a set of the five niches – in the pyramid temple of Pepi II – so we cannot be certain what the statues depicted. One suggestion is that they represented the five names of pharaoh. It may be significant that the niches first appear in Khafre's upper temple, just after the earliest known use of a Son of Re name, making a total of five names for each pharaoh: Horus; He of the Two Ladies; Horus of Gold; He of the Sedge and Bee; Son of Re. It has also been suggested that the statues might have been associated with the five phyles into which the priests who served in the pyramid temples were organized. Another possibility is one niche for the sun god, Re, one for Hathor and three for the names of the king as Horus.

The Abusir Papyri indicate that the central statue in the temple of the pharaoh Neferirkare there depicted the king as Osiris. Paule Posener-Kriéger, who edited and analysed these documents,[12] suggests that the statues at each end might have depicted the king wearing the crowns of Upper and Lower Egypt, leaving the precise meaning of the two intermediate statues uncertain. From the Abusir Papyri we also learn that these five niches were called *Tjephet*, 'cavern', pointing to the chthonic aspect of this temple-residence as the transition between life and Afterlife. Priests ritually clothed the statues, performed the Opening of the Mouth ceremony in connection with the lunar months and offered them ritual meals. The statues in the five niches, or Menkaure's colossus at the back of the western hall in his temple, probably represented the king emerging from the underworld of the pyramid to look out across the court and entrance hall and down the causeway to extend his beneficence to the world of the living.

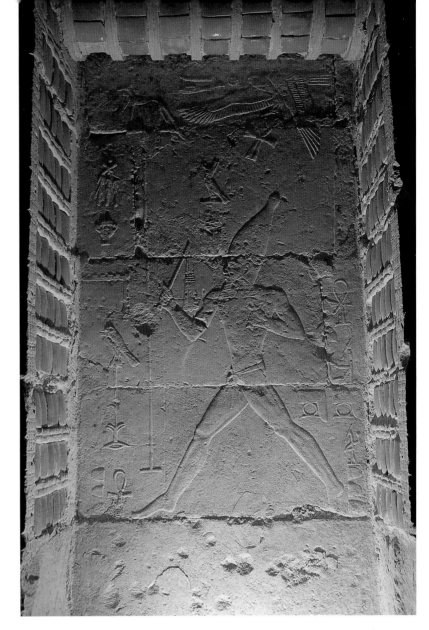

In the Khafre temple the route back to the innermost chambers, indirect and off-axis, leads from the southwestern corner of the court, while in the Menkaure temple it leads from the northwestern corner of the inner temple. In 5th and 6th dynasty pyramid temples the route to the offering chapel from the statue sanctuary passed through a small, square antechamber to the left (south) of the statues. Wall fragments from this antechamber in the temples of Pepi II and Senwosret I carried scenes of the Heb Sed, the king's celebration of renewed life and power over his household and its members, which encompasses all Egypt. In the Sed Festival the king symbolically runs the entire Egyptian territory, carrying the *imyt per*, the title to his estate (literally, 'that which is in the house') [7.15]. In the later temples the square antechamber was preceded by a small vestibule, the walls of which were decorated with scenes of

7.15 King Djoser performing the ceremonial Heb Sed run on one of the false door stelae in his South Tomb at Saqqara. In his hand he carries the title to his estate – Egypt.

enemies being defeated and the hunting of wild birds and animals – a last apotropaic purging before entering the most intimate part of the temple.

In Egyptian houses, indirect and off-axis paths led back to the innermost, private chambers. Small square antechambers with single columns are found in large 12th dynasty houses at Kahun and in 18th dynasty houses at Amarna, either as an element of the off-axis entryway to the house, or, more commonly, forming part of the route from the public 'throne' or receiving room back into the more private chambers.

Royal commissary: magazines Ancient Egyptian houses, from the smallest to the largest – including the palace – typically contained storage facilities towards the rear, either flanking the core house or behind the intimate living quarters. In the Khafre and Menkaure temples, magazines were situated towards the western end. In later pyramid temples, magazines proliferated in the temple proper. They stored both real offerings and simulacra, that is, 'dummy' offerings, such as staves, weapons and furniture replicated in wood, stone, metal and clay. In turn, the magazines themselves were simulacra of the actual food stores, arsenals and linen closets that complemented the real palaces of the living pharaohs. In this sense, the magazines underscore the role of the pyramid temple as a replica palace, effective in the Afterlife to the extent that it is but a simulacrum, dysfunctional in this plane.

Royal repast for eternity: the offering chamber Just behind the statue sanctuary and close to the magazines lay the focus of the entire pyramid complex. In later pyramid temples, as in other tombs, this was the offering chapel with a false door through which the deceased, in this case the king, could commune with those attending to him and his cult. In 5th and 6th dynasty temples the false door generally stood at the back, western end of the offering chambers, up against the pyramid itself. Red granite framed the doors on the northeast and southeast sides of the offering hall. Decoration on the walls represented a 'booth' of reed mat and wooden frame, here rendered in stone. In fact the Abusir Papyri call this room *sah*, the word for 'booth'. The vaulted ceiling, studded with stars, indicates the prototype booth was open to the sky.

The offering chapel or hall corresponds to an inner dining room of an Egyptian residence. The 5th and 6th dynasty relief-carved scenes in the offering hall show the king seated before a table piled high with good things and under a list of the offerings that he would receive forever. It is altogether fitting that the royal householder should be seated and fed here, behind the scenes of power and domination on the walls of the temple entrance hall and court. The householder, in this case the king, can now sit and take his meal in peace, sheltered from the threatening forces of chaos kept under control by the magic of the apotropaic scenes around him.

We gain a better understanding of the pyramid temple in ancient Egyptian terms when we consider the evidence, in the form of titles on clay sealings and in texts in the Abusir Papyri, that men who held the title Coiffeur had special access to the innermost part of the upper temple in the 5th and 6th dynasties. For us, Coiffeur may seem a lowly title, but for the Egyptians these people actually touched the divine body of the god-king in life. Egyptologists Paule Posener-Kriéger and Wolfgang Helck emphasize the special importance of royal coiffeurs in the innermost part of the temple and the offering hall, because of their continued intimacy with the royal body in death, now mummified and interred 'behind' the false door, beneath the pyramid.[13] Some of the largest and finest mastaba tombs of the Old Kingdom – those of Ptahshepses at Abusir and of Ty and of the 'Two Brothers', Khnumhotep and Niankhkhnum, at Saqqara – belonged to royal coiffeurs.

The fact that those who touched the king's person and prepared his meals in life continued to play important roles in the innermost part of the pyramid temple after his death fits exactly with our understanding of the pyramid chambers as the eternal equivalent of the private rooms of the palace, the *Per Duat*. When the king emerges from death each morning, his personal attendants still service him before he strides forth (in the form of the statues) in the outer parts of the temple.

Eternal rest: the pyramid

In the history of the royal tomb complex it is possible to trace the gradual transfer of elements of an eternal residence from below to above ground. In the 2nd dynasty the royal tombs took

7.16 Walls of the underground apartments of King Djoser's Step Pyramid at Saqqara are rendered with faience tiles inlaid on a carved limestone tableau as a simulacrum of a reed mat structure.

the form of long subterranean corridors leading to comb-like galleries that were probably storage magazines similar to those in the standard Old Kingdom pyramid temples, albeit carved from solid rock. When we compare them with non-royal 2nd dynasty tombs, we can see that chambers at the end of these subterranean complexes represented water closets and latrines – this would make the burial chamber the eternal bedroom. Egyptologists have viewed the 3rd dynasty Djoser Step Pyramid complex as one vast simulacrum of the royal residence. Djoser's subterranean, blue-tiled chambers, which connect to the burial vaults under both his Step Pyramid and South Tomb, are simulacra of the king's private 'apartment' [**7.16**]. The king's tomb is the royal house, here as the prototypical reed-mat and wood-frame palace.

We suspect that this idea carried over into the later Old Kingdom pyramids and that the burial chamber represented the bedroom found in the house in life. The Pyramid Texts that cover the walls of the burial chambers, beginning with the 5th dynasty pyramid of Unas, reinforce the idea that the pyramid chambers were the eternal counterpart of the most intimate rooms of the king's earthly palace, his bedroom, wardrobe and 'House of the Morning'.

Summary: pyramid and palace

The pyramid complex extended over a great east–west axis. Palaces, at least those we know from the New Kingdom, are orientated north–south. At Thebes, for example, palaces lay perpendicular to the main temples, which were orientated east–west. The principal parts of New Kingdom temples were also arranged along a more direct axial alignment than palaces. On the occasions of major festivals, king and god would emerge from palace and temple respectively along the two major cardinal lines that formed the east–west and north–south axes of the world.

While the pyramid complex might be seen as an eternal residence, and its individual components

matched to those of large houses and palaces known from later periods, the arrangement has been straightened and orientated east–west. Palace and temple were here united for the king who, in the Old Kingdom, reigned as god both during life and after death.

Rituals and the meaning of the pyramid

In searching for the meaning of the pyramid for the ancient Egyptians, we could do no better than to look at the rituals they conducted in the pyramid complex every day, long after the royal funeral had taken place. The Abusir Papyri are a textual window on to these daily services, as well as the administration of the pyramid temples of the 5th dynasty pharaohs Neferirkare and Raneferef. The Papyri, and the administration they document, cover the period from the 5th dynasty reign of Djedkare Isesi to that of Pepi II in the 6th dynasty.

We should note that evidence shows there were significant changes in the administration of pyramid temples at just about the time these documents were written, but they do still provide important clues about the meaning of pyramids and their temples in earlier times. The details in the Abusir Papyri suggest that the daily ritual reflected both the funerary aspect of the pyramid temple and its function as a residence for the deified king.

Communicative life force: reversion of offerings

Even in the earliest period, the continuing, long-term ritual in the king's tomb centred on the presentation of offerings before the royal statues or at the base of the false door. In a sense, the entire temple can be seen as an elaboration of the place in the simplest tombs where food offerings, *kau*, could be presented to the *ka*, 'vital force', of the deceased (see box p. 112). However, because the king was the '*ka* of the living', a cult service to him was a cult service for everyone. The entire Egyptian community shared a communicative life force passed from creator god to king, from parent to child.

This basic ancient Egyptian belief was reflected in society by a hierarchy of embedded households. The household estates of wealthy noblemen contained smaller households, even whole villages, in ties of patronage and dependence. In theory, the noble households were part of the domain of *Per-aa*, the 'greatest house' or, as we say, 'Pharaoh'. The funerary reflection of communicative life force and embedded households was the concept *imakhu*, sometimes translated as 'honoured'. Jaromir Malek has shown that it could mean 'being provided for'[14] and it signified receipt of a share of the offerings from a tomb of a higher-status household by means of a *wedjeb*, a redistribution of the offered provisions. For example, a man named Netjerpunisut recorded in his Giza tomb that he was 'possessor of provisioning' from kings Djedefre,

Khafre, Menkaure, Shepseskaf, Userkaf and Sahure (see also Chapter 13).[15] So in a very real sense, offering to pharaoh in his temples was offering to the wider community.

The evolving temple administration

Hieroglyphic tomb texts indicate that temple organization in the early pyramid age was fairly simple. An *imy-ra*, 'overseer' (literally 'one who is in the mouth'), administered the pyramid. Then there were *wabu*, purification priests, and a *kheri-heb*, a lector priest who read the ritual, one of the members of the funeral ceremony described above. There were also *hemu-netjer*, literally 'servants of the god', a title that is listed on the decorated tombs of highly placed Egyptians, but which could also be held by simpler folk such as craftsmen and farmers in the nearby pyramid town.

In the late 5th and 6th dynasties a more complex social and religious organization emerged, contemporaneous with the dramatic reduction in pyramid size, the expansion of the upper temple and the development of the standard temple components. The Tables of Service in the Abusir Papyri divide the temple personnel into two broad groups, the *hemu-netjer*, the older title, and the *khentiu-she* [7.17]. The literal meaning of the latter term is straightforward: 'those in front of the *she*'. But the term *she* and the character of these people have been problematic for Egyptologists.

In the New Kingdom, *khentiu-she* seems to have meant 'gardeners'. Translations of its Old Kingdom meaning range from 'settler' to 'tenant farmer' and 'palace attendant'. The problem lies in the word *she*, which the ancient Egyptians seem to have used for ideas as diverse as 'cultivated land', 'lake', 'quarry', 'workshop'. A solution can be found in the translation 'basin', and the awareness that, as we saw in Chapter 3, the entire Egyptian Nile Valley was organized into great basins that were annually flooded to become virtual lakes, with trees and gardens on the banks. Open-air quarries likewise took the form of basins. From the ancient texts we know of institutions such as the *ro-she* ('mouth of the basin') of a pyramid, and the '*she* of pharaoh', which has been thought to denote the royal funerary precinct. However, if we consider that each pyramid complex was fronted by a large, annually inundated basin, which was

7.17 Organization of service in Neferirkare's temple, both rotating and permanent, as revealed in papyri found in his pyramid temple.

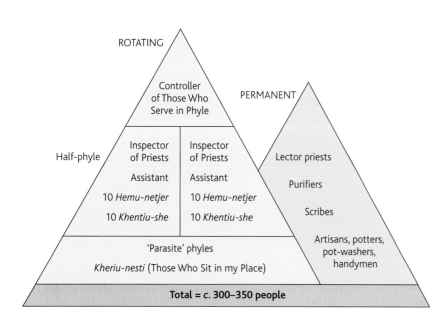

ROTATING

Controller of Those Who Serve in Phyle

PERMANENT

Half-phyle

Inspector of Priests	Inspector of Priests	Lector priests
Assistant	Assistant	Purifiers
10 *Hemu-netjer*	10 *Hemu-netjer*	Scribes
10 *Khentiu-she*	10 *Khentiu-she*	Artisans, potters, pot-washers, handymen

'Parasite' phyles

Kheriu-nesti (Those Who Sit in my Place)

Total = *c*. 300–350 people

part of a total ensemble of pyramid town, palace, harbour and canal entrance (*ro*) to the basin (*she*), the attachment of the *khentiu-she* to both the palace of the living king and the temple of the deified king makes sense.

The *khentiu-she* were residents of the pyramid town to which some of them may have been tied from birth, evidenced by many holders of this title who compound their name with that of the king in whose temple they served. Some may have been named after the royal estate where they were born. They were, in effect, members of the king's extended household, which included all classes: farmers, gardeners and even high officials. In the Abusir Papyri the younger *khentiu-she* were especially occupied with the transport of meat and other provisions into the temple, while elderly members did guard duty. Together they formed a human filter for the transformation of all raw materials into sustenance for the pyramid and its clientele.

While the title *khentiu-she* first becomes prominent in the scenes of Sahure's pyramid temple, Paule Posener-Kriéger and Rainer Stadelmann believe that the institution goes back to the time of Sneferu, when the standard layout of the pyramid complex came into being.[16] The decree of Pepi I protecting the *khentiu-she* of Sneferu's double pyramid town is well known to Egyptologists. The town and its inhabitants must date back to the time when Sneferu's pyramids were built. If so, there were *khentiu-she* at Giza and we have to consider whether the term derives from the expansive settlement we are now excavating south of the Wall of the Crow, south of the central Giza basin (*she*), and in the valley temple towns of Khentkawes and Menkaure (see Chapter 15).

The *hemu-netjer* do not seem to have been so tied to a specific pyramid, since they could hold this title in more than one pyramid temple. Those mentioned in the Abusir Papyri appear to be of a higher status than the *khentiu-she*: they do not transport meats and provisions; they are listed first; they receive their allocation of the offerings in the inner sanctum of the offering hall; other titles they hold that are sometimes given indicate middle to high rank. Although ranked higher than the *khentiu-she*, the *hemu-netjer* still seem to have performed fairly menial tasks alongside personnel of lower status. Several examples can be found in the Tables

of Service. One person who was simultaneously Judge and Scribe is recorded as doing guard duty over temple pottery alongside a Dancer and a Coiffeur of the Palace; a Superintendent of the King's Meal, and a Chanter and a Judge all act as night guards at the temple doorways. While counterintuitive to us, obligatory labour appears to have been common, with those of varying rank performing similar duties in the ritual processes of the temple. On the other hand, the Raneferef Papyri indicate that servant-substitutes performed menial duties for their high-ranking patrons.

The *khentiu-she* and the *hemu-netjer* served together in a social unit called *za* (plural *zau*), written with the hieroglyph of looped rope forming a cattle hobble (see pp. 357–58) – all those thus tied must walk together. In the Greco-Roman Period certain bilingual texts translate the Egyptian word *za* with the Greek word *phyle*, 'tribe'. The *za* is the same organizational unit that we find in building crews, and the temple phyles in fact have the same names as those crews, which bear some correspondence to the parts of a ship (as also discussed in Chapter 15). Four of the names, 'Last', 'Little Ones' (or stern), 'Green' or 'Fresh' (or prow), and 'Great' or 'Old' (or starboard), also connote a vague sense of juniority/seniority. The fifth name (second after 'Great' in the canonical sequence) meant something like 'Asiatic' (port, larboard). Each phyle was divided into two sections, with a half-phyle serving one month in ten. The divisions were named with single hieroglyphs, denoting ideas such as 'strength', 'life', 'dominion'. This rotating involvement in the temple cult gave people other than the permanent staff the chance to experience the propagandistic effects of the elaborate symbolic programme of the temples and statuary, and the numinous effects of sudden transitions from mysterious semi-darkness to blazing light.

Others who served in the temple do not appear to have been part of the rotation, including the *wabu* purification priests. The *kheriu-heb*, lector priests or liturgists, whom we saw in the funeral rituals, are in daily service in the pyramid temple; three served at the same time. A group called *kheriu-nesti*, literally 'those who sit in my place', seem to have been younger heirs in training of the *hemu-netjer* and *khentiu-she*. We also find indications that the regular rotating personnel

were supplemented by phyles attached to the proprietors of the great mastaba tombs in the necropolis. Posener-Kriéger called these 'parasite phyles' because their rotations in the temple service probably gained them a share of its revenue [7.17].[17]

An inspector of priests (*sehedj hemu-netjer*) supervised the phyles, with an assistant for priests. Any given shift would comprise about 20 *khentiu-she* and *hemu-netjer*, an inspector and his assistant, giving a total of about 220 men for the regular rotations of Neferirkare's temple. When the lector priests, the non-rotating personnel, scribes, artisans and 'parasite phyles' are added, the figure climbs to about 300–350 people serving Neferirkare's temple.

Daily service

What happened during an average day in the life of a pyramid temple? The Abusir Papyri do not provide a complete picture, but we are given revealing glimpses. We do not see any obvious assimilation of the burial rites, nor their perpetuation, in the temple service, just as there is no depiction of those rites in the decorative schemes. There was a good deal of 'watching' and 'guarding', particularly during the days of redistributions of provisions. Members of those phyles in service did guard duty at all the main temple doorways.

Each day saw morning and evening rites, apparently identical, centred on a ritual meal. The Pyramid Texts provide the theological background, telling us that the king had a right to five meals a day, three in the sky and two on earth. The earthly meals were the responsibility of those who served in the temple and required the Opening of the Mouth ceremony to be performed on the royal statues in the five niches or shrines at the interface between the front and inner temples. The officiants first opened each shrine in turn to present cloth and unction of sacred oil and to recite sacred formulae appropriate to each statue. It was the *khentiu-she* who unveiled, cleaned, dressed and adorned the statues, while the *hemu-netjer* fumigated with incense. Next came the offering ceremony, that is the ritual meal. It is not clear if this presentation was made before the statues in the court of the front temple or in the offering hall, or both. If the distribution of offerings to the *hemu-netjer* took place in the offering hall,

it is possible the meal was also consumed there, below the painted relief scenes of the king's repast. The attendants performed more libations and then ritually wiped the offering table.

We should note that purifications, censings, ritual meals and libations also made up the burial ritual, another confluence of the housekeeping of death and of eternal life. And in this connection it is interesting that a special feast took place each lunar month, focused on the statue of the king as Osiris. The holiday lasted from the day of the moon's invisibility to the appearance of the first quarter, and on this occasion the statue ceremony was more extensive, undertaken by a special 'unveiler', 'purifier', 'dresser' and 'censor', as five men stood guard in the transverse corridor.

Other elaborations on the ritual sequence were also enacted for the feast days of deities such as Sokar and Hathor. In Neferirkare's temple there was also a cult of the Queen Mother, Khentkawes, possibly focused on a larger niche immediately north of the set of five statues, and all these actions would have been repeated for her. We wonder if this was peculiar to Neferirkare's temple, or whether other kings' temples integrated a cult of the royal mother, with its implications for the theme of tomb and womb.

When the ceremony was completed, one of the *khentiu-she* and one of the *hemu-netjer* took the basin that served to catch the libation water and emptied it into an outlet under the east wall of the offering hall. This points to the significance of the drainage systems such as those found in the 5th and 6th dynasty pyramid temples, for instance that of Sahure, and the elaborate drains lined in limestone and granite leading out of the upper temples of Khufu and Khafre. The Raneferef Papyri inform us that each phyle had its own set of sacerdotal equipment, and basin, ewer, papyrus roll with the text of the ritual and other equipment were all then carefully accounted for and put back in chests.

One of the most intriguing aspects of the daily ritual followed. Officiates half-emptied a jar of natron water in quadruple salutations to the king. A *khentiu-she* then carried it away and handed it to another man in service. Each evening and morning one of the *hemu-netjer* and one of the *khentiu-she* took the jar and circumambulated the pyramid, sprinkling it with the sacred natron

water. The journey was called: 'the way of the *hem-netjer* when he goes around the pyramid'. Starting from the south door of the inner temple, the pair returned through the north door, making a clockwise tour that symbolized the circuit of the sun. We suspect that this circumambulation of the pyramids goes back to the early Old Kingdom, and was the function of the broad court defined by tall enclosure walls that surrounds the pyramids of Khufu and Khafre. Prominent drains leading off the four corners of these courts collected the water – and released the excess – that the pyramid priests might have used in the daily ritual.

In death, pharaoh's palace moved from the valley floor, where it had been in life, up to the foot of the pyramid, the primeval mound at the centre of the sun's rotation, ensuring the deceased king would awake each day, be coiffured, dressed and prepared to meet (or become) the Lord of Heaven – as long as the daily ritual was conducted by those who serve.

King's culture and common culture

We have been following ideas that associate individual features of the pyramid complex with the ancient Egyptian funeral, and with the ancient Egyptian house and household. The two themes – pyramid as stage for the funerary rituals and simulacrum household of eternity – mix, but do not always match. For example, we have suggested that the colossus of Menkaure facing out from the rear western hall of his upper temple, and the five statues at the back of Khafre's upper temple (and in 5th and 6th dynasty pyramid temples) in one respect may have signified the king as mature house proprietor – his household being all Egypt. Yet, if we take our clues from the relief scenes on the side walls of the five statue shrines in 5th and 6th dynasty temples, where the king is being suckled like a baby by goddesses, ideas of Lord of the House and rebirth were here in counterpoint.

In the 5th and 6th dynasty pyramid complexes, a certain cycle of themes begins in the valley temple, extends up the causeway and into the front part of the upper temple, and is then repeated in the inner temple. In the first sequence goddesses suckle the king (valley temple); griffins and sphinxes annihilate his enemies (causeway); the great ones of the court receive

him (upper vestibule); and representatives of the land make offerings to him (court). Then, in the inner temple, the goddesses suckle the king again (five-statue chamber); his enemies are annihilated (small vestibule); both gods and people receive him (square antechamber); and, after he has established title to his household (Sed Festival), he is installed forever to receive offerings (the offering hall).

Egyptologists often place great weight on the distance between the ancient Egyptian king and everyone else in Egyptian society, as though Egypt had a king's culture and a separate, more unknowable, common culture (and religion). As part of this, they often emphasize the extreme disparity between the pyramid complex and the tombs of large householders (usually designated by the term 'private' people, which is meaningless – the king was hardly 'public'; such a dichotomy did not exist). However, we might understand more about the place of pyramids within Egyptian society if we consider the correspondences between the pyramid complexes and so-called private tombs, before emphasizing the differences.

Just as the pyramid temple represented an eternal residence for the king, each tomb of consequence was considered an eternal residence for the head of the household that saw to its building and maintenance. The central focus of each and every tomb chapel, like the pyramid temple, was the offering place and the false door, the entrance to the Netherworld. In both pyramid complexes and large tombs the pictorial programmes included scenes of hunting (by pharaoh or patrician), fowling, spearing fish and the supply of food and delivery of offerings from the tomb owner's towns and estates [**7.18**]. Both displayed offering lists and showed the proprietor seated at tables of offerings. Funeral ceremonies of both pharaoh and noble included symbols of southern and northern Egypt – the deities of crown and capital for the king, and the ritual visit to 'Sais' and 'Buto' for the noble. The tombs of both contained statues representing the continued existence of the head of the household. In nobles' tombs the arrival at the tomb is labelled 'landing at the *Tjephet* ['Cavern'] of the Great Palace'. This name, *Tjephet*, was also given to the five statue niches and signifies the inner offering temple as the portico of the earthly Afterlife abode, the burial chamber of the pyramid.

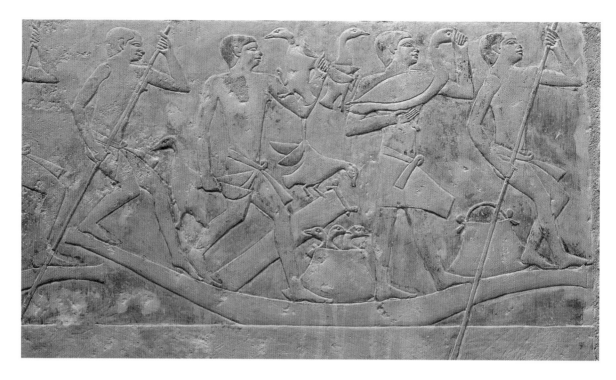

7.18 Men on a papyrus skiff transport geese and ducks, in a detail of a wall relief from the tomb of Idut at Saqqara, 6th dynasty. Some of the reliefs in this princess's tomb are well preserved, and also include scenes of agriculture, fishing, hunting, offering bearers and the funeral.

The main difference in the wall decoration between pyramid temple and 'private' tomb chapel was that the king's temple depicted gods, and, at this period, the noble person's chapel did not. Wall reliefs in elite tombs included, from the 6th dynasty, the funeral rituals, while the king's did not. Basic themes of ritual transformation were expressed in different ways for the god-king and for lesser, but prominent, householders.

Professional, albeit common, boatmen – the prancing *Muu* dancers – greet the deceased noble person on arrival at the valley entrance to the necropolis ('Sais'). In the scenes of arrival in Sahure's valley temple, troops and boat crews ('gangs of young followers') step forth in unison to greet the pharaoh. The *Muu* boatmen greet the noble person again on arrival at the tomb precinct ('Buto'); in the transverse corridor of Sahure's upper pyramid temple, the crews of seagoing ships greet the king once more.

Along his causeway, apotropaic scenes protect the pharaoh, warding off ill will and disorder. In the pyramid complex the defeat of chaos and evil is signified by the defeat of traditional tribal enemies and by the many prisoner statues that would have been ranged along the causeway and in the upper temple vestibule and court. In the noble person's funeral the *Muu* boatmen make apotropaic gestures against any evil that might thwart a successful 'crossing'. The *Tekenu* is associated, at least in the New Kingdom tomb of Montuhirkhepeshef, with bound 'tribesmen'. The idea of binding and warding off danger is embedded in the very name, *Tekenu*, which, as we have seen, conveys ideas of 'to approach', 'to be near', and also 'to attack'. The pharaoh's causeway, bridging the valley world of the living and the desert realm of the dead, forms a passage of rebirth. The rebirth of the noble person, during the passage from the *Ibu* and *Wabet* in the 'Sais' of the valley to the 'Buto' of the necropolis, is signified by the *mes-ka*, the animal-skin wrap of the *Tekenu*.

In life and in death the pharaoh, as expressed throughout Egyptian royal iconography, was considered coextensive with the body politic of the country and its Two Lands – Nile Valley and Delta. In the pictorial programme of the pyramid complex this theme is expressed, among other ways, in the suckling of the king by the crown goddesses of north and south (Wadjit and Nekhbet) and of the central 'capital' Memphis (Sekhmet). But a noble person was also considered in some sense coextensive with the body politic. The burial rituals were construed as 'virtual' visits to Abydos in the south, and Sais and Buto in the north. This identification with Egypt north and south may have had a practical aspect. Much evidence suggests that the large households in early Egypt controlled a portfolio of landholdings that could have a wide distribution. Many of these holdings were new towns and estates in the Delta, granted to prominent people by the king. In his funerary journey to the north, the noble person was ferried by the *Muu* boatmen and greeted by the *niutiu*,

the 'citizens', of Delta towns. In his funerary journey, the king, on the other hand, was greeted by the *netjeru*, the 'gods' of all the nomes and towns.

Do these multiple correspondences re-establish the probability that the royal funeral did move through the temples and causeway on its way to instalment in the eternal household of the pyramid? The most detailed scenes of the *Tekenu*, *mes-ka* and *Muu* derive from New Kingdom tombs, a millennium later than the pyramids. By this time the transformation and rebirth of pharaoh is expressed in whole new compositions (Book of What Is in the Underworld, Book of Gates, Book of Caverns, etc.) carved and painted on the walls of the royal tombs in the Valley of the Kings. However, it seems evident that the pyramid complex *signified* – at a higher order of magnitude and elaboration – a rite of passage along the lines of that depicted in the funeral scenes of late Old Kingdom nobility, though accompanied by *netjeru* (gods) rather than *niutiu* (people).

The correspondences between *Ibu*, *Wabet* and some of the valley temples are compelling. These are liminal structures where both physical and spiritual transformation takes place – vestibules and entryways to eternity. At the same time, it cannot be denied that the physical restrictions posed by doorways and passages make it difficult to imagine the actual funeral cortège, with tomb equipment of any size, moving through the pyramid complex along the route from valley temple to burial chamber. The valley temple may correspond to the *Ibu* and *Wabet* at least as a stone simulacrum of the 'first threshold' to the Netherworld, just as the pyramid temple is a stone simulacrum of a royal residence, with simulated magazines holding simulated tools, weapons and offerings. The first pyramid of Djoser is surrounded by simulacra of temporary wood-frame and reed-mat structures associated with the rituals of the Sed Festival, if not those of the funeral.

The king moved 'virtually' through the simulacra of the pyramid complex in the cycle of rebirth and transformation that the funeral ritual effected and signified, even if the housekeeping of death and burial required real but temporary wood-frame and reed-mat structures and alternate side routes or temporary ramps and embankments over the enclosure walls. Pharaoh then virtually

lived on in the company of the *netjeru*, just as the leaders of every large household lived on, in the company of their families and the *niutiu*, the 'citizens' of 'That City' of the Netherworld. The whole pyramid necropolis simulated a 'community of *ka*s', subsumed under the pharaoh, who in life encompassed all households and *ka*s of the living, and who in death led his household in 'That City' of eternity, dominated by the pyramid.

Pyramid and ritual process

Of course, the all-too obvious difference between the tombs of noble people and that of pharaoh, in addition to sheer size and long axial layout, was the towering pyramid. The complete pyramid, especially each of the earliest giant pyramids, was above all else an icon, an immense symbol, unique for its size and geometric purity in all the land.

The pyramid's capstone – the pyramidion – is in miniature the essence of the complete pyramid, bringing the pyramid to a point with the same angle of slope and the same proportions between height and base length.[18] The most complete royal capstone is the pyramidion of Amenemhet III from his Dahshur pyramid [7.19].[19] Made from hard black stone, all four faces bear an inscription and one is carved with an incised composition. Below a winged sun disk are two *wedjat* – sacred

7.19 The pyramidion of Amenemhet III's pyramid at Dahshur. The eyes are the pharaoh's, gazing up from within his pyramid to the beauty of the sun.

eyes – below which are three (i.e. plural) *nefer* ('beauty' or 'perfection') signs; below these again is the hieroglyph for the sun disc, flanked by the name and titles of Amenemhet III. The whole composition reads: 'Amenemhet beholds the perfection of Re.' The sacred eyes are those of the king himself.

As with the names of the pyramids – 'Sneferu gleams', 'Great is Khafre' – the eyes tell us that the pyramids were personified as the dead kings buried and revivified within them. The eyes *are* the dead Amenemhet watching the sun god sail the sky, so the texts on the east side of the pyramidion say: 'The sight of the King of Upper and Lower Egypt, Lord of the Two Lands, "Nemaatre", is opened, that he may see the Lord of the Horizon (when) he crosses the sky; may he cause that the Son of Re, "Amenemhet", appears as a god, Lord of Eternity, who perished not.'

Pyramid and benben

The phrase 'beholds the perfection of Re' is one of many clear indications that while the true pyramids personified the deceased king, they were also symbols of the sun. The identification of the pyramid with the sacred *Benben* stone of Heliopolis, centre of the sun cult, emphasized the fact that the pyramids were sun symbols, but our attempts to interpret the *benben* also demonstrate that there is no simple and exclusive meaning to anything in Egyptian religion. The Egyptians endowed each symbol and icon with multiple related meanings through centuries of embellishments on certain themes in a kind of 'language-game'[20] where the script itself consisted of divine images (hieroglyphs).

In order to understand the *benben* we must first look at Atum, probably the oldest god worshiped at Heliopolis. He forms one aspect of the sun god – the 'old' sun of the evening as opposed to Re at noon, and Khepri, the scarab beetle, as the morning sun. Atum was also the earliest creator god at Heliopolis; in his most primeval form, he was the singularity within the primeval waters of the Abyss. The root verb *tm* in Atum's name means 'complete', 'finish'. In later funerary texts Atum is called 'Lord of Totality' and 'the Completed One', and in the Pyramid Texts Atum is 'self-developing' or 'self-evolving'.[21] He is a chthonic god, that is, virtually everything that exists is part of Atum's 'flesh', having evolved as his 'Millions of *kas*' (vital forces). How did this evolution begin?

According to Pyramid Text 527,

Atum is the one who developed, getting an erection in Heliopolis.
 He put his penis in his grasp that he might make orgasm with it,
 and the two siblings were born, Shu and Tefnut.[22]

Shu was the god of air and atmosphere, and he and his sister Tefnut form the second generation of primeval gods. Next in the genealogy come Geb (earth) and Nut (sky), who beget Osiris, his sister and wife, Isis, his brother and adversary Seth, and Seth's counterpart, Nephthys. Osiris and Isis then beget Horus, the god of kingship. Kingship can thus be traced back to the Creator himself. In other texts, Atum's erection and ejaculation are connected to the *benben* pyramidion through a serious cosmic pun on the root, *bn*, which is associated with procreation, and could mean 'become erect', or 'ejaculate'.[23]

Bn could also connote the idea of swelling in general. An image as old as Atum's masturbation was that the god expanded as a mound (*bnnt*) in the abysmal waters of Nun. To the Egyptians this must have symbolized the Nile Valley high land emerging from the receding waters of the annual inundation. Within a few lines of Pyramid Text 600 that speak of Atum's primeval mound, the ancient theologians are already mixing metaphors with impunity, associating Creation with the image of the scarab beetle that gave birth to its offspring from a ball of dung. Through this connection with the primeval mound, the pyramid is, therefore, a place of creation and rebirth in the Abyss. The verb *weben* is often used for the sun, as in 'to rise and shine', thereby providing a linkage between the rising of the primeval mound and the solar disc.[24]

Pyramid and sun

In the swelling of creation, the sun plays the role of a seed or nucleus. The birth of the god Shu creates an air bubble within the primordial waters of the Abyss, and 'like the air inside a balloon, the void and its light fill the entirety of the world'.[25]

Both *benben* and pyramid may have symbolized the sun's rays, particularly as they appear shining

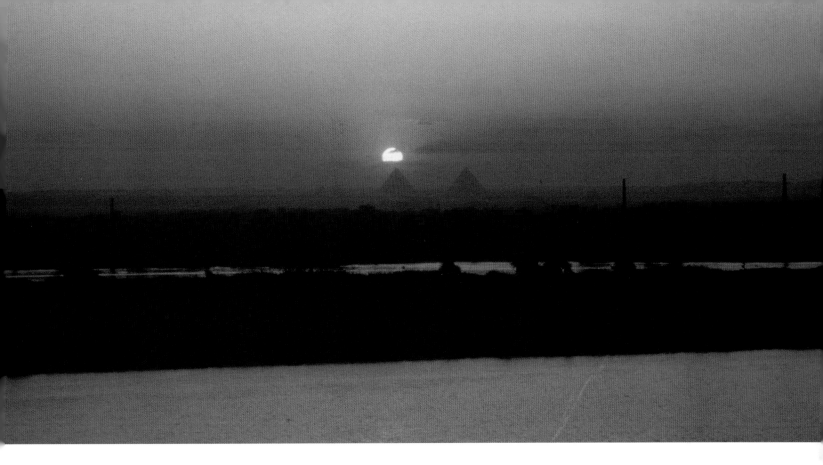

through a break in a cloudy sky. When this
happens in the sky behind the Giza pyramids, 'the
impression...is that the immaterial prototype and
the material replica are here ranged side by side'.[26]
In the Pyramid Texts the sun's rays are said to be
a ramp by which the king mounts up to the sun.
But the pyramid was much more than simply a
magical device for the king to reach heaven. It was
a place of physical and spiritual transformation that
linked the king's ascent to the creation of the world
and to the daily rebirth of the sun [**7.20**].

The *Benben* stone at Heliopolis may have been
cone-shaped; the pyramid is the easiest way to
mimic this form in monumental architecture.[27]
And when most of the surface of the pyramid
was newly covered with smoothed white limestone
as intended, the reflected light must have been so
brilliant as to be almost blinding. The peak must
have caught the first light in early dawn, and shone
powerfully with the mass of the pyramid during
the day. Did the Egyptians see in this the brilliant
bubble of Shu expanding against the blue waters[28]
of the sky, with the pyramidion gleaming like the
seed of the sun in the primeval waters of the Abyss?

A kind of 'picture-window' principle in Egyptian
art and architecture could apply to the pyramid as a
stone model of immaterial sunlight. The Egyptians
often built heavy architecture as a permanent and
perfective window that opened on to imperfective

events and environments – that is events that
repeated themselves continuously. So, for example,
the walls of tomb courtyards carry relief scenes of
sacrificing cattle and the presentation of funerary
offerings, activities that actually took place in the
courtyard, as though the viewer is on the outside of
the stone walls looking through them like a picture
window. The pyramid may have been a gigantic
reflector,[29] a stone model of sunlight and a window
to the sky, as though we were inside the mass of
stone looking out at the actual sunlight. In fact, this
is exactly what the eyes of King Amenemhet are
doing on his black stone pyramidion.

Immediately we can see that the pyramid
presents a paradox. On the one hand, it is the
primeval mound, an image that conveys the
entire mass of material creation; on the other, it
is immaterial light. This counterpoint runs even
deeper as we consider the pyramid as a gigantic
capsule of the Duat, the dark Egyptian Netherworld.

The pyramid of the Netherworld

The interiors of the pyramids, consisting of long,
echoing, tube-like passages and cave-like chambers
in profound darkness under millions of tons of
stone, are entirely suitable as tombs. But for the
king, the tomb was not the end of life – it was the
point of rebirth. A word for sarcophagus, *neb ankh*,

7.20 The sun appearing
through breaks in clouds
over the Giza pyramids.
The pyramid may
have been thought to
symbolize the sun's rays.

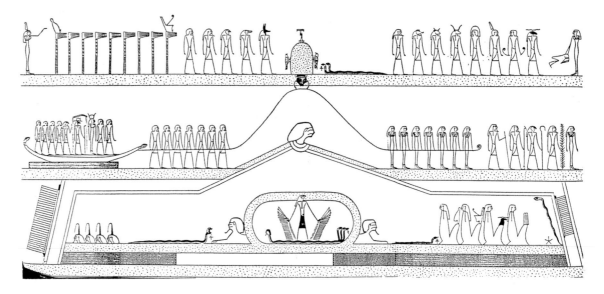

7.21, 7.22 Scenes from the *Am Duat*, the Book of What Is in the Underworld, from the tomb of Thutmose III in the Valley of the Kings, concerning the journey of the sun god through the Underworld, riding in his barque. In the middle register in the drawing below, the sun god's barque is blocked by a pyramidal mound with a head at its apex.

means 'Lord-' or 'Possessor-of-Life'. Planted in the darkness of the earth, the body was like a seed that would allow the king to be reborn as an *akh*, a glorified spirit of light. Thus, in another paradox, or what we might call the inversion principle, the tomb was also a womb, the womb of the sky goddess Nut. The Pyramid Texts speak of the sky, Nut, conceiving and giving birth to the king as she does the sun and the stars.[30]

The Egyptians of the New Kingdom created elaborate pictures of the interplay of light and darkness, of daylight and Duat, during the rebirth of the sun, with whom the deceased king was identified. They composed these illustrations in new 'books' that they painted on the walls of the royal tombs in the Valley of the Kings: the Book of Caverns, Book of Gates, Book of Aker (the lion earth god). Like the Pyramid Texts of a thousand years earlier, they are variations on the creation theme, but now the theme is played out as a journey, and the illustrations and text are guidebooks through the Netherworld.

The oldest of these guides is the *Am Duat*, the Book of What Is in the Underworld, which appears from the reign of Thutmose I on [7.21, 7.22]. Guided by an entourage, the sun god rides the barque of the night, a journey divided into 12 Hours. In the 5th Hour of *Am Duat* a pyramid-like mound rises up to interrupt the orderly division of the composition into three registers. It is worth examining this

strange setting to increase our understanding of the role of the pyramid in the Egyptian concept of life and death.

This pyramid rises up in the deepest, darkest pit of the Underworld, the Cavern of the Abyss, the nadir of the Duat. To arrive at this point the entourage of the sun god descends through a sloping passage in the previous, 4th, Hour. Looking very much like those found in the pyramids, the passageway in the 4th Hour is called 'the Secret Way of Rosetau' (see Chapter 19 for more on Rosetau). In the 5th Hour the sun god, labelled 'flesh of Re' as he approaches in his boat, has to be towed past the pyramid since it interrupts the Nile of the night. In the register above the solar barque are nine flags – the hieroglyph for *netjer*, 'god'. The texts identify these nine gods as Khepri (the sun god in the aspect of morning and rebirth, evolution), and the gods of the primeval generations (with Horus replacing Seth): Shu, Tefnut, Geb, Nut, Osiris, Isis, Nephthys and Horus of the Netherworld.

The sun god asks the nine gods to stand guard. In front of them are five more guardian deities, led by Anubis, the jackal-headed god of embalming and burial, who face a small mound of sand with the hieroglyph for 'night' or 'darkness' at the top. The small sand mound of 'night' – a stylized grave – is directly above the pyramid rising up from the registers below. The scarab Khepri, symbol of rebirth, emerges from the bottom of the mound to help the sun god on his journey by grabbing the tow-rope of his barque. The pyramidal mound is itself covered by a band of sand to indicate that it is subterranean. A head protruding from the pyramid's apex is in some versions identified as 'the flesh of Isis, who is over the Land of Sokar'.[31]

Sokar, the most mysterious form of the god Osiris, Lord of the Netherworld, is the core of the whole scene, awakening inside his ellipse or oval within the pyramidal mound. The oval, labelled 'flesh of Sokar', 'Land of Sokar' and 'Sokar guarding the mysterious Flesh', is stippled to indicate that it too, like the pyramidal mound, is sealed under the sand. Sokar's chamber is within the body of a double sphinx who is called Aker, the god of the gateways of the earth. Aker is labelled 'Flesh', and 'what he does is to guard his [Sokar's] image'.

Sokar's chamber is thrice-sealed; the texts state that not even the sun god can penetrate. The gods,

however, ask that the sun god speak to Osiris in his form of Sokar. The very passage of the sun god in his barque, 'the Power of Life', and his words to Sokar in Sokar's dark, sealed chamber set off a reaction within the 'egg'. The hieroglyphs say that a 'noise is heard in the egg, after the Great God has passed by it, like the sound of roaring in the sky after a storm'.[32]

This exchange between light, the sun god in the 'Power of Life' boat, and darkness, the cavern of Sokar, enables the resurrection to take place at the end of the night journey in the 12th Hour of *Am Duat*, when the scarab Khepri pushes the ball of the sun through the gates of the horizon, as the mummiform Osiris slips back into the Duat. The renewal of creation in the depths of the earth allows the king's soul to ascend from the tomb and the sun to rise again. Once activated, the seed of Sokar sprouts as the soul of the king. This is why the scene places such emphasis on 'flesh'. The introduction to the 5th Hour speaks of 'the Land of Sokar which carries the divine flesh', and 'the Flesh, the body, in its first manifestation', an allusion to the royal tomb and its mortal remains. The downward-sloping passage in the 4th Hour *is* the tomb corridor. Sokar's egg *is* the sarcophagus and tomb chamber. In the deepest and darkest region of the Netherworld, when the Flesh is protected against decay, the mummy becomes a foetus, a seed activated by the passage of light and life. It happens within the pyramidal mound 'where the Nether and Upper worlds communicated'.[33]

The 5th Hour of *Am Duat,* with its scene of the opened pyramid mound, was composed more than one thousand years after the Pyramid Texts were compiled and after the giant 4th dynasty pyramids were built. But the same theme of renewal, creation and rebirth in the Netherworld is found in the Pyramid Texts, albeit in more pristine and fragmented form. At the tomb's centre, the king's now imperishable body lies awaiting rebirth in the amniotic sac that is 'Nut in her identity of the coffin' (Pyramid Text 616d–e). This, in turn, lies within the innermost chamber of the pyramid (beneath the earth), like the body of Osiris within the Duat.

The paradox of transition from darkness to light and death to life was expressed in stone – as it was pictorially in the New Kingdom – in the massive pyramids of the Old Kingdom.

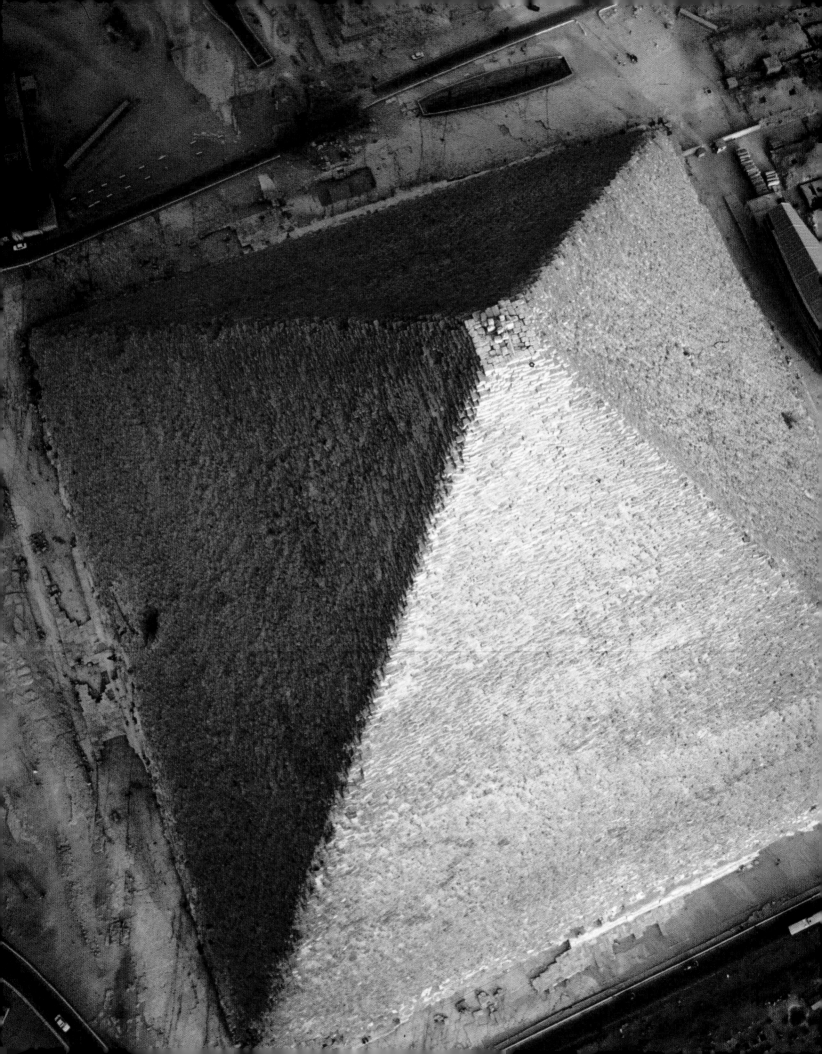

CHAPTER 8
The Great Pyramid of Khufu

Because the Giza pyramids are so well known we might assume that scholars are well informed about the lives and reigns of the three kings who built them – Khufu, Khafre and Menkaure. In fact, in some respects, we know little. This is not to say that we lack evidence either of the existence of 4th dynasty society or that its people built the pyramids. The material evidence that they did so is overwhelming, and hieroglyphic texts in tomb chapels provide details about royal family relationships and courtly titles. Egyptologists believe that Khufu, builder of the Great Pyramid, was the son of Sneferu, the founder of the 4th dynasty: Khufu's name is found after Sneferu's in the ancient king lists. Khufu's mother is thought to have been Hetepheres I, on the basis of evidence from her secret tomb at Giza, and he married at least three queens, one of whom was named Meretites. She may have been buried in one of the queens' pyramids associated with the Great Pyramid. Khufu was also known as Khnum-Khuf ('the god Khnum is his Protection'), the version of his name etched into the diorite quarry northeast of Abu Simbel, about 1,200 km (750 miles) south of Cairo. Ancient builders also left this name in the stress-relieving chambers above the King's Chamber in the heart of the Great Pyramid itself.

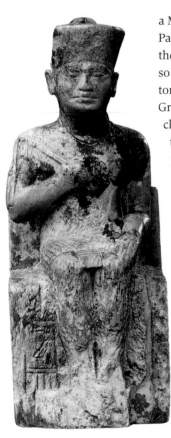

In the mining area of Wadi Maghara in Sinai, not far
from an inscription of Sneferu, a text was pecked
into a rock face: 'Khnum-Khuf, Great God, Smiter
of the Troglodytes. All protection and life are with
him.' R. Kuper and F. Förster of Cologne University
have also found an inscription that mentions
Khufu, etched into the rock face of a natural stone
mound in the Western Desert southwest of Dakhla
Oasis. According to the text, Khufu ordered two
men named Imery and Beby to lead an expedition
of 400 men to collect *mefat,* probably a mineral
used to make paint.[1] Another text may give the
name of this rest stop for expeditions. It translates
something like 'Djedefre's Water Mountain' –
Djedefre was Khufu's son and successor. And now
of course we have the graffiti and papyri from Wadi
el-Jarf, which include the name of Khufu and his
pyramid: *Akhet Khufu*, 'the horizon of Khufu'.[2]

Yet only one certain complete representation of
Khufu has ever been found. A tiny ivory figurine
from Abydos (some 7.6 cm or around 3 in. tall)
shows the king wearing the Lower Egyptian crown
and seated on a throne inscribed with his Horus
name, 'the Horus Medjedu' [**8.2**].

After the Old Kingdom, Khufu appears in
a Middle Kingdom legend recorded on the
Papyrus Westcar, seeking from a magician
the secret plans of the god of wisdom, Thoth,
so that he can incorporate them into his own
tomb. Later, Herodotus, calling him Cheops, the
Greek version of his name, reported that Khufu
closed the temples and prevented offerings to
the gods, as well as forcing slaves to build his
pyramid. Manetho, the Egyptian chronicler who
lived during the Ptolemaic Period (and who
devised the system of dynasties we still use),
mentioned that Suphis, as Khufu was known
in Manetho's day, built the Great Pyramid
and also composed a sacred book that he
bequeathed to later Egyptians.

But from these sources we can write
nothing approaching a narrative history.
Part of the reason is that the 4th dynasty
pyramid builders themselves wrote scarcely
any narrative history on the stone walls of
their tomb chapels. In the absence of such
written history, scholars raise reasonable
hypotheses based on the very real evidence
of archaeology and architecture.

The pyramid

In his single pyramid, GI (in Reisner's system of
labelling the Giza monuments), Khufu may not
have equalled the total mass of his father's three
pyramids (3,682,500 cu. m; over 130 million cu. ft),
but he came close, and he far surpassed them in
size and accuracy. We know from tomb inscriptions
at Meidum and Dahshur that Khufu had three older
brothers, and we must assume that they were in
line for the throne ahead of Khufu. We must further
assume that they died before their father. Khufu
may therefore have been a young man when he
ascended the throne of Egypt.

Perhaps this gave him the confidence necessary
to lay out a square of 5.3 hectares (13.1 acres) on
virgin bedrock at Giza, 40 km (25 miles) north of
Dahshur, and raise a true pyramid at the same
slope as his father's at Meidum (almost 52 degrees).
In doing so he created the largest standing pyramid
ever built. If he had not been a young man, how
could Khufu have started out in the belief that his
workforce would finish the enormous task within
his lifetime? Based on the king list in the papyrus
known as the Turin Royal Canon dating from the
New Kingdom, it was long thought that Khufu ruled
for 23 years, but the inscription found at 'Djedefre's
Water Mountain' in the Western Desert dates to
Khufu's '13th Year of Counting', that is the count of
livestock for taxation thought to take place every
two years, which would then indicate his 27th year
on the throne. Egyptologists now calculate that he
ruled between 30 and 32 years, allowing him more
time to build his gigantic tomb [**8.3, 8.4**].

The fabric of the pyramid body

While the size of the Great Pyramid is astounding,
it is still a very human monument, though the
numbers and figures often obscure this fact.
For example, the pyramid contains an estimated
2.3 million blocks of stone often said to weigh on
average about 2.5 tons each. However, this does not
mean that all, or even most, of the stones weigh
2.5 tons. The word 'average' encourages a mental
image of the Great Pyramid as being uniformly
composed of squared, well-fitted blocks – but
anyone who looks closely at the pyramid can see
that this is far from the case.

Khufu's builders raised his pyramid on a
platform of carefully levelled limestone bedrock,

Great Pyramid statistics

Area	5.3 hectares (13.1 acres)
Length of sides	230.33 m (756 ft)
Original height	146.59 m (481 ft)
Current height	(*without outer casing*) 137 m (449.5 ft)
Original baseline	921.44 m (3,023.09 ft)
Slope	51 deg. 50 min. 40 sec.
Number of blocks	*c.* 2.3 million

accommodating the natural slope of the Giza Plateau. They left a massif of natural rock in the pyramid body – clearly visible today in the core of the northeast corner, where it rises 4 m (13 ft) above the base [**8.3**]. Like other pyramids, Khufu's consisted of core blocks and a fine outer casing, with packing blocks in between. The outer casing had been stripped off by the Middle Ages, so what we see today are the outermost core or backing stones. These become progressively smaller towards the top, and in places where enough stone has been removed we can see that the core comprises masses of stones of irregular size and shape. To use an American auto-mechanic's expression, we might say the core masonry has a considerable 'slop factor'.

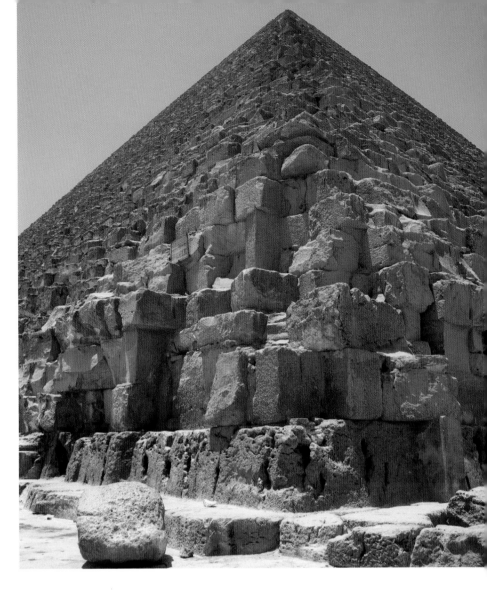

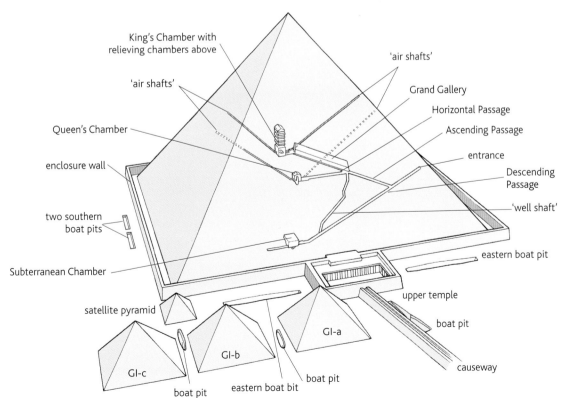

ABOVE
8.3 The northeast corner of the Khufu Pyramid, where the builders left bedrock protruding more than 4 m (13 ft) high in the pyramid core as they worked the bedrock down in a surrounding street-sized strip for the foundation of the pyramid court and platform for the pyramid casing.

LEFT
8.4 The Great Pyramid, built by Khufu was called *Akhet Khufu*, 'The Horizon of Khufu'. In addition to this astonishing achievement, Khufu also built three queens' pyramids, boat pits and a satellite pyramid, as well as a causeway, temples and tombs.

King's Chamber with relieving chambers above

'air shafts'

'air shafts'

Grand Gallery

Horizontal Passage

Queen's Chamber

Ascending Passage

enclosure wall

entrance

Descending Passage

'well shaft'

two southern boat pits

Subterranean Chamber

eastern boat pit

upper temple

satellite pyramid

boat pit

GI-a

GI-b

GI-c

causeway

boat pit

eastern boat bit

boat pit

As the pyramid rose, the builders constructed the passages and chambers of fine stone blocks as separate structures and then filled around them with the looser masonry of the pyramid body. While the pyramid passages and chambers were under construction they would have been open to the sky at the given course of masonry that the workers were adding to the then truncated pyramid.

Howard Vyse (see p. 95), searching for an entrance into Khufu's pyramid, made a hole in the centre of the south side, 18 courses above the base, and here we can see how the builders dumped large quantities of mortar and stone rubble in wide spaces between core stones. Some blocks are over a metre (3 ft) long; other chunks are smaller and wedge-shaped, oval and trapezoidal. Fragments of variable shapes and sizes are jammed into spaces as wide as 22 cm (9 in.) between larger blocks. Hardly any theorist – amateur, alternative or academic – keeps this irregularity, this 'slop factor', in mind when puzzling about how the pyramids were built [**8.5**]. Instead, most start from the assumption that the pyramid is composed of generic blocks; and they then set about theorizing how the builders moved them, lifted them and set them in place.

In setting the core stones, Khufu's builders used great quantities of gypsum mortar. Their predecessors constructing the pyramids of

Khufu pyramid: major explorations

Years	Monument	Explorer or excavator
1638; 1639	pyramid	J. Greaves
1761	pyramid	N. Davison
1798	pyramids	Napoleon's Expedition
1817	pyramid	G. B. Caviglia
1837	pyramid	R. W. Howard Vyse & J. S. Perring
1872	'air shafts'	W. Dixon
1880-82	pyramid	W. M. F. Petrie
1909	pyramid	J. Edgar and M. Edgar
1920/2–38	pyramid	various SAE and Selim Hassan (SAE – Services des Antiquités de l'Égypte)
1954	boat pit (east)	K. el-Mallakh (Egyptian Antiquities Organization)
1961–69	valley temple	H. Messiha
1968	causeway	G. Goyon
1974–78	Giza pyramids	SRI International, remote sensing
1986	pyramid	A. Qadry, microgravimetric survey
1986	pyramid	G. Dormion and J. P. Godion
1987	pyramid	S. Yoshimura (Waseda University, Tokyo)
1987	boat pit (west)	Farouk el-Baz and National Geographic
1990	valley temple	Z. Hawass (Supreme Council of Antiquities)
1990	causeway	Z. Hawass (SCA)
1990	pyramid	J. Kerisel, J.-B. Kerisel and Alain Guillon
1992	queens' pyramids	Z. Hawass (EAO)
1992–95	pyramid	J. Kerisel
1992	queens' pyramids	Z. Hawass
1993	satellite pyramid	Z. Hawass
1993	pyramid	R. Stadelmann and R. Gantenbrink (DAI) and Waseda University
1995	satellite pyramid	Z. Hawass
2002	'air shafts'	Z. Hawass and National Geographic
2011	'air shafts'	Leeds University team
2011–	west boat pit	SCA and Waseda University

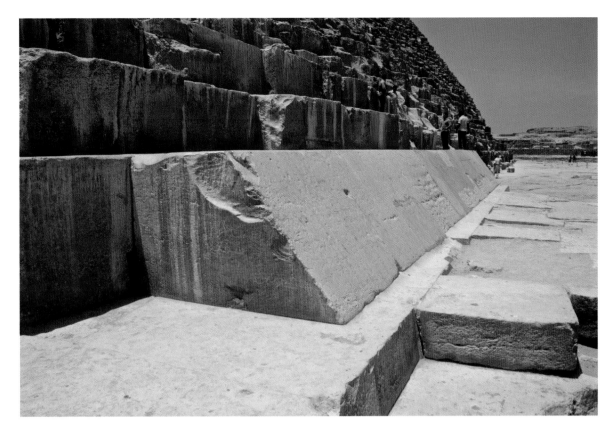

OPPOSITE
8.5 Irregularity of the pyramid core, as seen exposed at the far western end of the northern side. The builders used no modular blocks of standard size to make the core; rather, each stone is unique in size and shape – a fact that is underappreciated.

LEFT
8.6 At the centre of the north side of the Khufu pyramid we can see the best-preserved assemblage of casing, foundation platform and court pavement.

Djoser and Sneferu had predominantly used tafla, natural desert clay. Unlike tafla, gypsum mortar has to be heated as part of its preparation, and an enormous amount of wood fuel must have been burnt for the mortar used in the Giza pyramids. Indeed, flecks of charcoal from this fuel can be seen in the mortar. The Giza pyramids were thermodynamically expensive and building them would have impacted on the economy and ecology of the time. Most likely, as in the bakeries we excavated south of the pyramids (see Chapter 15), the builders used Nile acacia and other local woods as fuel. They must have stripped the surrounding countryside of much of its vegetation to power the construction dynamo at Giza.

The core stone was so irregular because it was really only packing around the internal chambers and passages, and fill for the gleaming exterior shell. It was in this outer casing that the pyramid builders achieved the precision that has inspired so much modern speculation. Some of the surviving casing stones at the base may weigh as much as 15 tons, and from the very few that remain we can see the skill and care the builders used in placing them to form the foot of the pyramid [**8.6**]. Joins between large casing blocks are often so fine that it is not possible to insert a razor blade, and these fine seams sometimes run back from the outer face for more than a metre.

Theorists often point to the extraordinary exactitude of the pyramid's outer dimensions. The maximum difference in the level of the base is said to be 2.1 cm (0.83 in.); the average deviation of the sides from the cardinal directions is 3 min. 6 sec.; the greatest difference in the length of the sides, each measuring a little over 230 m (755 ft), is said to be just 4.4 cm (1¾ in.). But pyramid theorists overlook the fact that most of the finished outer lines of the pyramid have disappeared, and these figures are largely the result of our own reconstruction. The corner angles and apothems (the lines from the apex to the midpoint of the sides) are missing. Surveyors such as Petrie and J. H. Cole (a surveyor with the Egyptian Ministry of Finance) reconstructed the corner positions by extrapolating from small sections of baseline indicated by the few surviving casing blocks near the centre of each side, or impressions left in the bedrock by the setting line of the foundation platform. They used these reconstructed corners to calculate the original lengths of the sides. A recent survey by Glen Dash has produced estimates with a certain degree of probability to show the possible differences in the lengths (see pp. 531–32).[3] As for the baseline, our survey in 1984 noted that only ¹⁄₁₇ of the original base remains, and much is badly worn. When we read of the cosmic significance that some authors deduce from the exactitude of the pyramid dimensions, we should bear this in mind.

The fact remains, however, that the evidence indicates that Khufu's surveyors and builders did an extraordinary job. The base of the Khufu pyramid is a nearly perfect square, accurately oriented to true north. Why were they so careful? Perhaps the exactitude itself had a cosmic significance in the beliefs of the royal court. They may also have been responding to the near disaster that occurred in their lifetime – or in that of their immediate predecessors – with the architectural failures in the Bent Pyramid at Dahshur.

Inside Khufu's pyramid

Pyramid builders in the 4th dynasty seem to have been experimenting with the architectural expression of religious ideas, producing some extreme variations. However, three chambers appears to have been the rule for Old Kingdom pyramids, and in this respect at least Khufu follows the pattern. His pyramid contains what we now call the Subterranean Chamber, the Queen's Chamber and the King's Chamber, accessed by a system of interlinking passages (see 8.18). But, more than any other pharaoh preceding or following him, Khufu attempted to use the engineering capabilities of his time to create chambers as high into, and as far under, the pyramid as possible.

For a long time, many Egyptologists have accepted Ludwig Borchardt's suggestion that the three chambers in Khufu's pyramid represent two changes in plan. First, work ceased on the Subterranean Chamber – perhaps the original intended burial chamber – before it was only half cut from the natural rock, followed by the abandonment of the middle, so-called Queen's Chamber, in favour of the granite-lined King's Chamber built high up in the body of the pyramid as construction proceeded.

Rainer Stadelmann, however, documented a long tradition, found before and after Khufu, of a standard model of three chambers in Old Kingdom pyramids,[4] and so other Egyptologists see the whole inner arrangement as a unified design, planned from the outset, and we agree. In fact, some evidence suggests that the Subterranean Chamber, which Khufu's workers left unfinished, was the last of the three to be created. The so-called 'Trial Passages' (see below and Chapter 17), which appear to be a sort of practice model of the principal parts and passages inside the Khufu pyramid, can be taken as support. Stadelmann suggested that, in one sense, we might look at the Khufu pyramid as a daring, almost delusionary scheme for passages and chambers, without a complete, pre-designed plan as to how to wrap the pyramid around them.

The entrance and Descending Passage

Tourists today enter through a tunnel in the northern side of the pyramid known as Mamun's Entrance (or Mamun's Hole) because, as noted in Chapter 6, tradition says it was cut by this Caliph's soldiers around AD 820. The original entrance to the Great Pyramid is above and slightly east, built into the 19th course of stones, about 17 m (56 ft) above the base and 7 m (23 ft) east of the centre axis. It is topped internally by massive gabled blocks, now visible after the outer casing has been removed [8.7]. However, when the workmen sealed the pyramid after the king's burial, they presumably would have closed off the Descending Passage with a limestone block that made the entrance indistinguishable from the pyramid casing.

From the original entrance, the Descending Passage slopes straight down to the Subterranean Chamber at an angle of 26 degrees, first for almost 35 m (115 ft) through the pyramid masonry and then for around another 71 m (233 ft) through the natural rock, without deviating more than a centimetre in angle or orientation, giving a total length of 105.36 m (345 ft 8 in.). In fact, rather than following it downwards we should view it the other way round: looking upwards from the bottom. This long stone tube, only 1.05 m (3 ft) wide and 1.2 m (4 ft) high, points to the circumpolar stars, 'the Imperishable Ones' that neither rise nor set, an image of eternity and a destination for the king in the Afterlife. The human suffering required to create the Subterranean Chamber in the bowels of the bedrock was inconsequential compared with the need to aim the king's ascension to the imperishable stars.

The Subterranean Chamber

Khufu's workers quarried the Subterranean Chamber out of natural rock 30 m (98 ft) below the pyramid base – the first pyramid chamber carved entirely out of bedrock [8.8]. Did they carve the

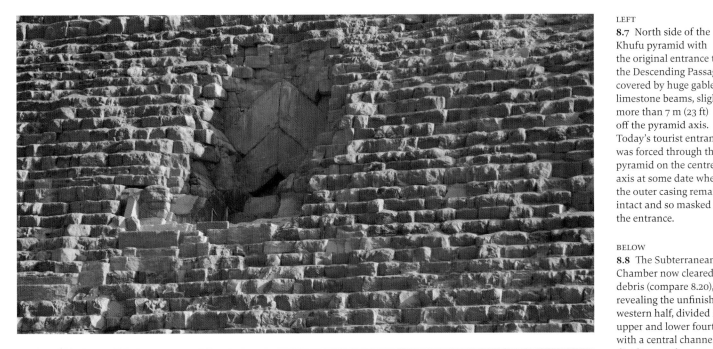

LEFT
8.7 North side of the Khufu pyramid with the original entrance to the Descending Passage covered by huge gabled limestone beams, slightly more than 7 m (23 ft) off the pyramid axis. Today's tourist entrance was forced through the pyramid on the centre axis at some date when the outer casing remained intact and so masked the entrance.

BELOW
8.8 The Subterranean Chamber now cleared of debris (compare 8.20), revealing the unfinished western half, divided into upper and lower fourths, with a central channel dividing northern and southern eighths.

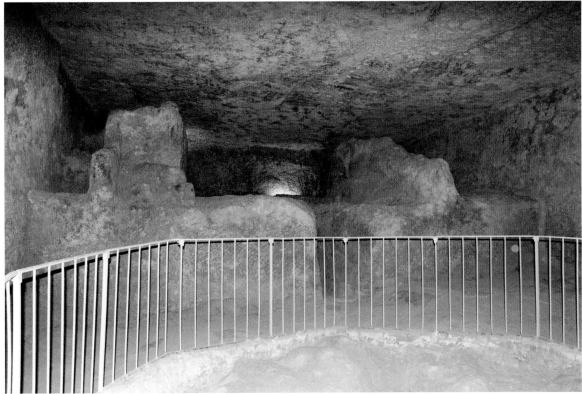

bedrock section of the Descending Passage and begin work on the Subterranean Chamber at the same time that other workers levelled the pyramid perimeter, but before the body of the pyramid started to rise? Or did the quarrymen labour deep underground even as the rising structure of the pyramid lengthened the Descending Passage upwards, making it so much further to carry the chips and dust out? Perhaps the act of lengthening the route up and out slowed the quarrymen below, to the point where they could not finish before work on Khufu's pyramid ceased.

At the bottom of the Descending Passage a short horizontal stretch, less than 85 cm (34 in.) wide and 95 cm (37 in.) high, leads to the chamber. A little more than half complete, this space presents an excellent picture of how the workmen organized their task. The quarrymen intended to cut a room 8.28 m (27 ft) wide by 14 m (46 ft) long and 5.3 m (17 ft 5 in.) high, which would have made it the largest in the pyramid. Having freed the entire eastern half of the space from the bedrock, they initially left the western part as a bank of solid rock, but had begun to open the upper part of this solid bank, dividing it into upper and lower sections. They sank a channel that divided the lower quarter into northern and southern eighths as they worked on carving out the upper quarter, which they also divided into two eighths of the intended chamber volume. Banks of unquarried bedrock further divide each of the upper eighth portions into two sixteenths of the total chamber. Either side of these partitions are square blocks or compartments, evidence of the different stages of the removal of stone: each hump or compartment is the work allotment for a single quarryman, who used pick and point to chip away the 'removal channel' around the edge of his allotment, after which he could hammer away the isolated hump.

The most difficult job of all was cutting 'lead' channels that moved the work further into the solid rock. One man lay on his belly and swung the long-handled pick ahead of him to make a lead channel that can still be seen in the chamber's upper southwest corner. The work would have been cramped and far from pleasant, with chips flying from the stonework and the air filled with both dust from hauling the waste up and out of the passage and the smoke from oil lamps or slow-burning torches, which provided the only light.

One of the real puzzles about the Subterranean Chamber is the rough passage that leads south from its lower southeast corner. It extends for around 16 m (52 ft) with a height of just 80 cm (32 in.) and a width of 68 to 97 cm (27 to 38 in.). Only one man could have fitted at the end of the passage, pushing it forwards into the blind rock with hammer and chisel. Where was it going? To another chamber? If so, the Subterranean Chamber could not have been meant for the king's burial, as this was always the last chamber in a series.

What, then, was the purpose of the Subterranean Chamber? Rainer Stadelmann suggests that its very rough and unfinished state may indicate that it was associated with the chthonic aspect of the Afterlife, an earthly, symbolic representation of the Underworld cavern.[5] Those Egyptologists who believe in two changes of plan think that Khufu's architect initially intended the Subterranean Chamber to be the king's burial chamber, which would correspond to later Old Kingdom pyramids in which the burial chamber is just below surface.

Whether the upper chambers represent a change in plan, or whether they were intended from the beginning, we can only speculate on the cosmic, religious reasons for interring the king so high. One such speculation is that during his life Khufu saw himself as an incarnation of the sun god, or at least as merged with the sun after death, resurrected, like the sun, from this 'Horizon of Khufu'.

Queen's Chamber

At a distance of 28 m (92 ft) from the entrance, within the body of the pyramid masonry, the Ascending Passage leads off the Descending Passage and runs up into the pyramid at a slope of 26 deg. 2 min. 30 sec. After a crawl, hunched over, through nearly 38 m (125 ft) of passage, just 1.2 m (4 ft) high and 1.05 m (3 ft) wide, the visitor can stand upright again and take in the soaring space of the impressive Grand Gallery. At this junction the Horizontal Passage leads off straight and level to the next of the pyramid's three chambers to be built in the construction sequence [8.9].

The low Horizontal Passage leads 38.7 m (127 ft) from the bottom end of the Grand Gallery direct to the northeast corner of the pyramid's middle chamber, which lies exactly on the east–west centre axis of the pyramid. Early Arab explorers called it the 'Queen's Chamber', but it was certainly not intended for the burial of a queen.

Khufu's builders roofed the space with huge limestone beams to form a gable in an upside-down letter 'V', so that the weight of the pyramid pushes down on the lower end of the beams rather than on

the centre of the ceiling [**8.10**]. Generations of later pyramid builders would use this technique, first devised by Khufu's architects.

The walls of the chamber were also faced with fine limestone. In the eastern wall, slightly south of centre, is a niche with corbelled sides resembling the cross section of the Grand Gallery. At the base of the niche, an existing square pit in the floor had been deepened by early explorers. The niche probably once held a larger-than-lifesize statue of Khufu, about 4 m (13 ft) tall, its base secured in the pit. It is likely therefore that the 'Queen's Chamber' was a *serdab*. In ancient Egyptian tombs, a *serdab* was an entirely sealed chamber that contained a statue of the deceased especially associated with the *ka* or life force (see box, p. 112). Many nobles' tombs had a roughly finished blind chamber, housing a statue of the deceased. And like *serdab*s in other tombs, the floor and walls of this version

LEFT
8.10 The Queen's Chamber ceiling, comprised of massive gabled limestone beams assembled in an upside-down V shape, spreading the weight of the pyramid to the side walls.

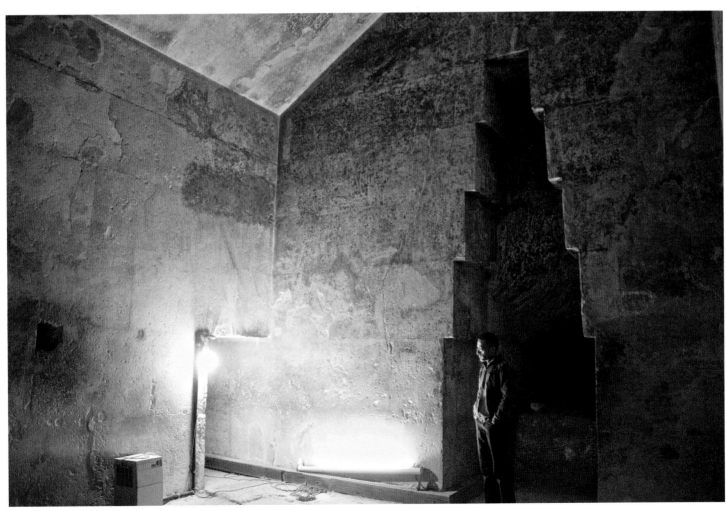

Queen's Chamber dimensions

Width	5.25 m (17 ft 2 in.) (average)
Length	5.75 m (18 ft 10 in.)
Height	
north and south walls	4.69 m (15 ft 4 in.)
east and west walls	6.23 m (20 ft 5 in.)

8.11 Sockets in the side walls of the juncture between the lower end of the Grand Gallery and the Horizontal Passage to the Queen's Chamber would have held massive wooden beams that carried a false floor between the floor of the Gallery and that of the Ascending Passage, possibly for sliding down plugging blocks.

in Khufu's pyramid were left slightly rough and unfinished. The chamber was also originally (though not now) completely sealed off by the floor slabs of the ascending Grand Gallery, which would have covered the opening of the Horizontal Passage leading to the chamber [**8.11**].

In 1986, a French team of Gilles Dormion and Jean-Yves Verd'hurt conducted an investigation inside the Great Pyramid using microgravimetric techniques to 'see' through the walls. They claimed that they detected 'cavities' behind the limestone blocks comprising the western side of the passage leading to the Queen's Chamber. Permission was given to drill into the blocks, and the drill penetrated through solid masonry before hitting a pocket of sand.[6] A team from Waseda University later employed non-destructive electromagnetic waves to examine the pyramid. At the level of the corridor to the Queen's Chamber the Japanese also found anomalies that they believe indicate unidentified cavities. However, the Great Pyramid is full of cavities. In this case the geophysical surveys probably detected empty spaces and sand fill between the fine, Turah-quality limestone casing of the Horizontal Passage and the rough masonry filling the pyramid core.

The French team then approached the Supreme Council of Antiquities (SCA) with a new proposal to drill in the middle of the Queen's Chamber, where they thought lay a hidden chamber, but one of us (Hawass), together with Rainer Stadelmann, recommended that the pyramid should not be drilled simply to test theories.

Grand Gallery

The cramped Ascending Passage suddenly opens out at its top into the Grand Gallery, one of the glories of the Great Pyramid. This magnificent gallery slopes upwards at the same angle as the preceding passage for over 46 m (150 ft) to the Great Step, the Antechamber and the King's Chamber. The walls of the gallery are corbelled – each of seven courses of limestone blocks juts inwards slightly. The final gap left at the top – which is the same width, 2 cubits, as the passage that runs between two side benches or ramps for the length of the gallery below – is spanned by slabs [**8.12**].

A series of notches or slots punctuates the tops of the benches at regular intervals, each aligned with a rectangular niche in the wall, with a total of 25 niches in each wall. After using them for some purpose, masons later closed the niches with tightly fitted stone slabs, and later still chiselled a rough, trapezoidal cut across the face of each of the patched niches and the adjacent wall, roughly parallel to the slope of the tops of the benches.

Why is the Grand Gallery such a vast space compared with other passages in the pyramid, and what was the function of these mysterious elements? Most researchers have concluded that the niches served a purpose that was either abandoned or had been completed, after which they were filled and the cuttings made subsequently for a similar or different purpose. We have no completely satisfactory answer to the question of the original function of the niches. Several theorists believe the notches served as sockets for the ends of beams forming a wooden framework that held back the granite plugging blocks to seal the pyramid. After the king's funeral, the granite plugs would have been released to slide down the centre passage

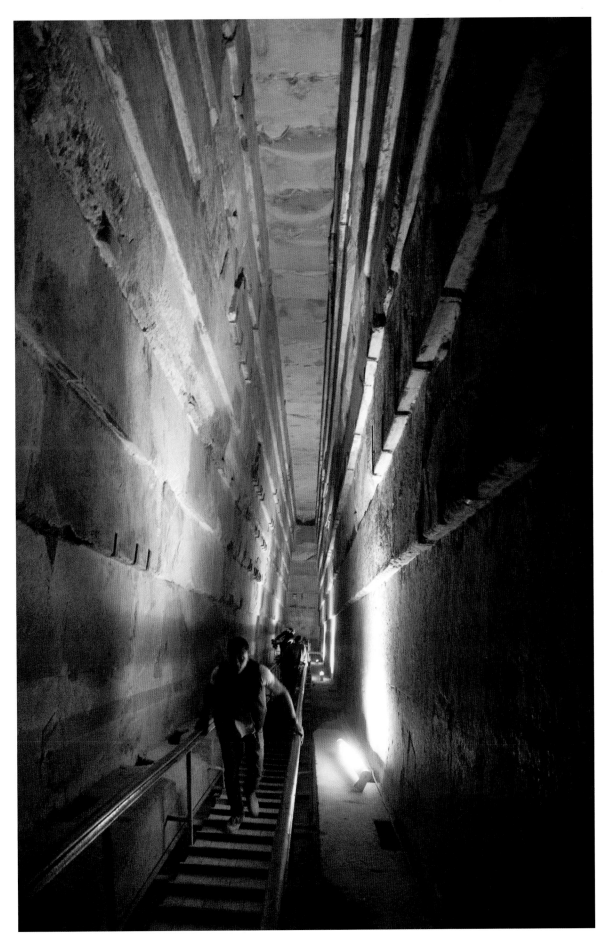

8.12 The Grand Gallery within the Khufu Pyramid: the walls, 8.7 m (28 ft 6 in.) high, are corbelled or stepped in, to bring the ceiling to the same width – 2 cubits – as the floor passage between the side benches or ramps. View looking down the 26-degree slope to the north.

Grand Gallery dimensions

Width (at widest point)	2.09 m (7 ft)
Height	8.7 m (28 ft 6 in.)
Width (ceiling)	1.05 m (3 ft)
Length	46.71 m (153 ft)

and straight into the Ascending Passage below, a closure that was intended as the second line of defence against robbers (see below for a discussion of the various defence mechanisms). A problem with this idea is that the granite plugs that remain at the bottom of the Ascending Passage are longer than the spaces between the notches.

One of us (Lehner) has suggested that such a timber framework might also have been a safeguard against structural failure in the Grand Gallery, based on evidence in the King's Chamber.[7] Could Khufu's builders have thought that a wooden frame was essential to ensure the stability of the Grand Gallery as they were constructing it? An internal supporting frame might have been necessary if the gallery was built somewhat in advance of the pyramid core masonry that was later packed around it. However, certain details, such as the crude chiselling of the grooves in the already dressed side walls and the cuttings across the patched niches, indicate that such a wooden frame was an afterthought, and so we should consider it in connection with other traces of structural difficulties that afflicted the builders *after* they had completed the King's Chamber and the Grand Gallery.

In the face of ominous settling and cracking, the builders may have felt that they needed an internal wooden frame. With wooden planking embedded in the grooves and supported by bound uprights planted in the notches, the framework may have been built to prevent the long, corbelled side walls collapsing inwards. These frames would then fall into a class of wood shoring and support systems known from other monuments such as Sneferu's Bent Pyramid, an earlier interior corbelled structure, where a wooden frame was found *in situ* in the upper western chamber, though no such remains are recorded for the Grand Gallery.

At the bottom of the Grand Gallery where the floor opens into the Horizontal Passage, pairs of very large rectangular holes at the sides must have

served as sockets for the ends of thick wooden beams that carried a 'false floor' to bridge and mask the entrance to the passage (see 8.11). The paving would thus have made the narrow passage at the bottom of the Grand Gallery continuous with the Ascending Passage. This is another feature that has prompted many investigators to believe that the floor of the Grand Gallery must have contained the granite plugging blocks before they were slid down to close the Ascending Passage – for this mechanism to have worked, the Horizontal Passage leading to the Queen's Chamber would need to have been previously sealed. If this, or something similar, was indeed the purpose of the Grand Gallery, this magnificent structure would have been in effect a parking place.

King's Chamber and Antechamber
The Grand Gallery climbs steeply upwards until a large limestone block known as the Great Step stops dead the channel in the floor. Beyond this, a low, short passage leads to the small Antechamber. Three sunken panels on either side received portcullis slabs that could be lowered, forming the first mechanism in securing the pyramid after the king's burial [8.13].

After crouching again for another few steps, the visitor can stand in the King's Chamber, this time appropriately named, for here priests laid Khufu to rest in the red granite sarcophagus, still in place. At first glance the King's Chamber is a deceptively simple, austere room – a rectangular box, itself rather like a sarcophagus, lined with beautifully fitted red granite blocks and resonating with each murmur and footstep [8.14]. The chamber turns at a right angle to the west off the axis of the passage system, which is itself 7.2 m (23 ft 6 in.) east of

King's Chamber dimensions

Length	10.49 m (34 ft)
Width	5.24 m (17 ft)
Height	5.84 m (19 ft)

Antechamber dimensions

Length	2.9 m (9 ft 6 in. – 9 ft 9 in.)
Width	1.65 m (5 ft 5 in.)
Height	3.78 m (12 ft 5 in.)

OPPOSITE ABOVE
8.13 Arrangements for lowering portcullis slabs in the Antechamber, consisting of semi-round grooves for ropes and semicircular cuttings for large round wooden beams; raised bars (now damaged) defined sunken panels that served as slide ways for the slabs that would have closed off the King's Chamber.

OPPOSITE BELOW
8.14 A film crew sets up behind the sarcophagus in the King's Chamber; both sarcophagus and the chamber walls are made of red granite. View to the west.

the pyramid's centre axis; the sarcophagus in the western end of the chamber therefore sits exactly on the north–south central line of the pyramid.

Petrie meticulously measured the sarcophagus, 2.28 m (7 ft 6 in.) long (exterior), 98 cm (38½ in.) wide and 1.05 m (3 ft 5 in.) high, hewn from a single piece of stone. But his careful examination left Petrie unimpressed with the workmanship. He found the northern and southern planes out of square with the east and west, and he noted that Khufu's workers had left behind the marks of their saw, probably a toothless copper blade that guided an abrasive powder (see Chapter 16). Too large to have been carried through the entrance to the King's Chamber, Khufu's builders must have put the sarcophagus in place before they added the beams of the ceiling of the chamber and raised the pyramid up around it.

The nine massive roof beams of red granite are each estimated to weigh from 40 to 60 tons. The ceilings of both the King's and the Queen's chambers presented the Egyptians with an unprecedented challenge: this was the first time they had attempted to close off such wide spaces in stone. In order to safeguard the king's burial from possible structural failure, Khufu's engineers devised one of the most astounding features of any pyramid. Directly above the burial chamber they added four more granite ceilings, each with the same floor area as the chamber below and spaced at about a metre (3 ft) apart, separated by one course of stones, to form four stress-relieving chambers. Above these again they built a fifth relieving chamber, this one 2 m (6 ft 7 in.) in height and crowned with huge gabled limestone slabs, as in the Queen's Chamber [**8.15**], which distribute the crushing weight of the pyramid to either side of the burial chamber. The entire system was independent of the chamber's end walls. It was on blocks in these relieving chambers that workmen painted grafitti that included the name of Khufu (see 2.11).

There has been an obvious settling of this stacked system, noted by Petrie and further studied by Jean Kerisel,[8] some of which must have occurred during construction. The southern end of some of the granite beams roofing the King's Chamber cracked. In ancient times someone tried to fill the cracks and the seams between the beams with plaster, perhaps creating for this purpose the crawl passage from the

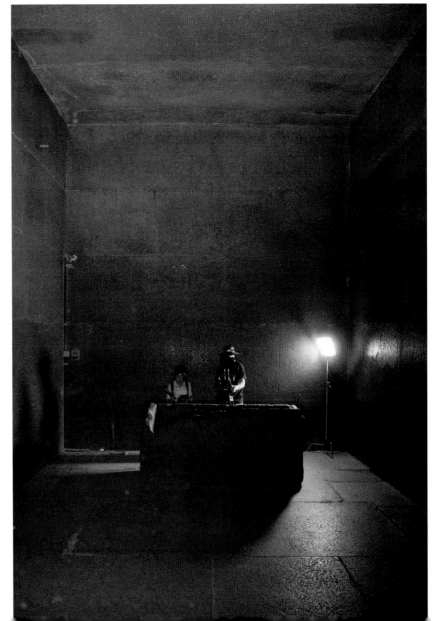

top of the eastern side of the Grand Gallery to the first of the five stress-relieving chambers.

Dark rectangular patches on the underside of the granite ceiling beams may also relate to these structural difficulties [8.16]. The patches, about 30 cm (12 in.) wide and extending about a metre (3 ft) from the join of the ceiling beams with the long sides of the chamber, appear to be stains produced by some structural element. One interpretation is that they were left by the resinous tops of wooden upright posts or struts set up to ensure that the massive granite beams did not collapse, perhaps after the cracks appeared and about the same time as the attempts at repair in plaster noted by Petrie. However, it would have been difficult if not impossible to introduce wooden posts this long through the Antechamber, so if the patches do indicate wooden supports, they would

8.16 Ceiling slabs in the King's Chamber showing dark, rectangular patches at either end of each slab. View to the west.

probably have been introduced as the granite beams were laid in place and before the chamber was completely roofed. If this hypothesis holds, people must have completely removed the wooden uprights in antiquity – not one of the accounts of exploration mentions finding pieces of wood in the King's Chamber.

Even if they did serve the practical purpose of helping to support the ceiling, wooden posts may also have had a religious and magical role. There was a tradition, beginning in the 1st dynasty royal tombs at Abydos and already ancient by the 4th dynasty, of real or simulated wooden frameworks and reed shrines placed within the burial chambers of large tombs.

The Italian scholars Vito Maragioglio and Celeste Rinaldi, who made a meticulous study of Old Kingdom pyramids, compared the conjectured Grand Gallery frame to the wood panelling that once lined the slightly vaulted subterranean galleries under the eastern side of Djoser's Step Pyramid.[9] Jean-Philippe Lauer further suggested that the builders might have purposely hung this wooden framework with reed matting to transform a utilitarian scaffold into a ritual passageway up to Djoser's burial chamber. He recalled both the reed-mat and wooden-post enclosures inside the great 1st dynasty mastabas at North Saqqara and Djoser's royal apartments under his Step Pyramid, where reed is rendered in blue faience (see 7.16).[10]

It is a great irony that Khufu's builders struggled to engineer systems for chambers and passages

8.15 John Shae Perring's published cross-section drawing of the King's Chamber, topped by the five relieving chambers. The Antechamber, with the arrangements for portcullis slabs, and the upper, southern end of the Grand Gallery are also shown.

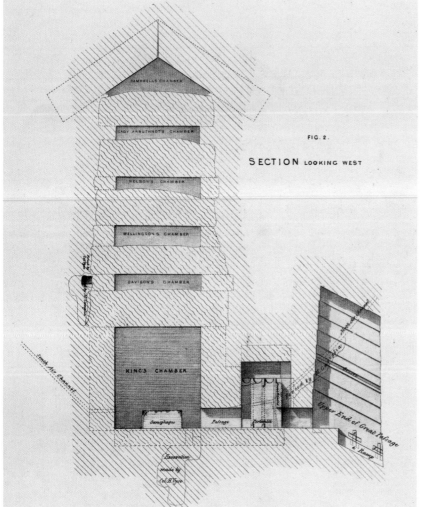

that would withstand the crushing pressure of the pyramid. Built to protect pharaoh and ensure his resurrection, the giant and conspicuous pyramid itself was one of the greatest threats to the royal body that it was meant to preserve.

Other features of the pyramid
Closing the pyramid

When the king's burial rites were complete, the workmen put into operation the first line of defence against potential robbers. They slid heavy granite portcullis slabs down the three sunken panels in the side walls of the small Antechamber with the aid of thick ropes that were wound around cedar logs set in the semicircular sockets at the top of the panels. They may then have removed restraints on granite blocks in the Grand Gallery, allowing the plugs to slide down into the Ascending Passage, the second closing mechanism. Three great granite plugging blocks are still in place, jammed into the passage [**8.17**]. These must have been stored in the Grand Gallery until the time came for them to be slid down to block the passage. But how were they stored?

The tight turns and narrow entrance passages that often form the route to the burial chamber in many pyramids would surely have compromised the ceremonial decorum of the funeral procession carrying the royal body. And might it not have been considered unacceptable, indeed comical, for the royal burial detail with the king's coffin to have to clamber over the granite plugs had they been stored between the benches in the floor channel of the Grand Gallery?

Ludwig Borchardt was the first to suggest that the niches and notches described above indicated a massive system of scaffolding.[11] He imagined an elaborate wooden framework supporting a platform of wooden planks whose ends fitted into the grooves that run along the level of the third corbel. According to Borchardt, the granite plugs were stored on this platform, allowing the burial procession to pass decorously below. Following the king's burial, the plugs were let down into the channel and slid down into the Ascending Passage to plug it. This hardly seems feasible, however, and Borchardt never explained how the multi-ton granite blocks would have been lowered down, so few others have accepted this notion.

Jean-Philippe Lauer believed that the niches were intended to hold brake logs for the plug blocks, but were never used.[12] His hypothesis depends on the theory that the plan for the royal burial chamber was changed. When it was decided to make the King's Chamber the burial chamber instead of the so-called Queen's Chamber, the builders could seal the new burial place with the portcullis slabs lowered vertically in the Antechamber. According to Lauer, with this additional device, only about three plugs would be needed at the bottom of the Ascending Passage. The floor channel of the Grand Gallery could then be cleared of the many more plugs that had previously been put there, so that the burial party could pass through. The niches in the wall of the Grand Gallery were therefore closed with patches, and the slots in the top of the benches were created to receive the uprights of a wooden frame very similar to the one Borchardt envisioned.

Like Borchardt, Lauer saw the trapezoidal cuttings across the patched niches as a way to create a space between the wall and the posts

8.17 The juncture between the Descending Passage (below) and the Ascending Passage (above) closed by a granite plugging block that remains suspended thanks to a slight narrowing of the passage. View to the south.

to thread rope bindings around the foot of each upright. Since the foot bindings were tied from one post to another, the rope would have followed the slope of the gallery – as do the cuttings. Also as in Borchardt's explanation, longer slots were for uprights of three beams tied together. Lauer argued that these needed to be stronger because they were fashioned with sockets for round logs that served as fixed pulleys for hoisting the plugs up and out of the top, southern end of the Grand Gallery. The blocks were then re-employed for making the Antechamber and parts of the King's Chamber. To test Lauer's idea we could determine how many of the granite blocks in the Antechamber and King's Chamber correspond to the width of the channel in the Grand Gallery floor, although of course Lauer's hypothesis is nullified if the designers did indeed plan all three chambers together as a unified arrangement.

Whatever the system and methods used, once the three plugging blocks obstructed the lower end of the Ascending Passage, the last workmen presumably made their escape by slipping down the so-called 'well shaft' or 'Service Shaft' cut into the west wall at the bottom of the Grand Gallery and descending through pyramid masonry and bedrock. This was no robber's tunnel, as some have believed. The workmen probably first cut this shaft to conduct air to the bottom of the Descending Passage so that they could continue hewing the Subterranean Chamber. But work on the chamber might have been abandoned when the Grand Gallery and King's Chamber were sealed when the construction of these two interior spaces was completed, thus cutting off the flow of air.

Once they had reached the Descending Passage via the Service Shaft, the pyramid sealers could climb up past the now plugged mouth of the Ascending Passage, and out through the pyramid entrance. They probably also plugged the Descending Passage from its mouth to the juncture with the Ascending Passage – the third line of defence for the king's burial. They then sealed the opening of the Descending Passage in the face of the pyramid with a limestone block that blended perfectly with the rest of the casing.

Ultimately, none of the defence mechanisms worked. Today thousands of tourists swarm into the pyramid through the tunnel that violators

hacked along the pyramid's centre axis. The tunnel turns to the east to connect with the Ascending Passage precisely at the point above its juncture with the Descending Passage just beyond the plugging blocks. As we have seen, legend has it that this tunnel is the work of Caliph al-Mamun in AD 820. But the violators appear to have known exactly how far and where to tunnel to gain access to the Ascending Passage. They might have lived within a generation or two of Khufu himself, holding a memory of the defence system handed down from the very workmen who were the last to leave the mysterious interior. In fact, it is likely that the first violation of the Great Pyramid happened not too long after it was built, just after the end of the Old Kingdom at the latest.

The 'air shafts'

Perhaps the most enigmatic features of the Khufu pyramid are the so-called 'air shafts', long narrow passages that lead from the north and south sides of both the King's and the Queen's chambers upwards at an angle through the masonry of the pyramid.[13] Those from the King's Chamber extend to the pyramid's exterior, where we can locate their openings. Even so, they probably had nothing to do with conducting air. In fact, smooth white casing stones may have obstructed the openings on the pyramid face, if not covered them completely, as with the entrance to the Descending Passage. Egyptologists interpret them instead as soul passages: because the final resting place of Khufu's mummy in the King's Chamber was so high in the pyramid, and reached only by corridors leading up to it from below, his spirit needed the small model passages to ascend from the chamber upwards to the sky and to stellar images of eternal life [**8.18**].

The shaft leading from the north wall of the King's Chamber measures 21 cm (8 in.) wide and 14 cm (5½ in.) high, and is positioned 2.49 m (8 ft 2 in.) from the chamber's eastern wall. Sloping up through the pyramid body at an angle of about 31 degrees it emerges between the 100th and 101st course. This shaft may have directed the royal soul to the circumpolar stars, the 'Imperishable Ones', just as the Descending Passage did in relation to the Subterranean Chamber. I. E. S. Edwards believed that the shaft aimed more specifically at Alpha Draconis, the pole star in the time of Khufu.[14]

In fact it does not run in a completely straight line, as described by John and Morton Edgar, who made a thorough examination of the pyramid in 1909: 'after running horizontally northward for a short length, it takes a number of short sharp bends, each succeeding bend tending upward and toward the north-west, before it finally bends northward to proceed directly to the outside of the Pyramid at a steep angle.'[15]

The southern shaft of the King's Chamber is 18 cm (7 in.) wide and 14 cm (5½ in.) high. It opens in the south wall, 2.48 m (8 ft 2 in.) from the chamber's eastern wall, sloping upwards at about 45 degrees. This could have been a conduit for the King's spirit to ascend to Orion, the southern constellation associated with Osiris, god of the Netherworld, and to Sirius, 'the companion of Orion'. Miroslav Verner suggested that the southern shaft directed the royal spirit specifically to Zeta Orionis.[16]

Hawass believes that the southern shaft was instead for the soul of the king as Re to travel from his tomb to the solar boats of the day and the night to journey east and west. On the south side of the pyramid are two of Khufu's boat pits, which still contained disassembled boats. The northern shaft could have been for the king as Horus to travel by boat to control the north and south of Egypt.

One of several curious aspects of these air shafts in Khufu's pyramid was discovered near the opening at the pyramid face of the southern shaft from the King's Chamber: allegedly one of the oldest known pieces of non-meteoritic iron, discovered in 1837, as recorded by Howard Vyse. According to the adamant sworn testimonials from various people involved, including the famous engineer of the pyramid, Perring, the piece of iron came to light under two 'tiers' of stones.[17] It then found its way to the attention of Alfred Lucas, the chemist and author of the authoritative *Ancient Egyptian Materials and Industries* (1926), who wrote that it 'is not a tool, and does not appear to be part of a tool of any sort, and it is significant that the earliest iron objects are chiefly weapons and amulets and not tools'. Lucas went on to say that since the iron was not meteoritic, he believed that it had been dropped down a crack by stone robbers in more recent times.[18]

While we tend to agree with Lucas's conclusion, it is noteworthy that the next oldest known iron

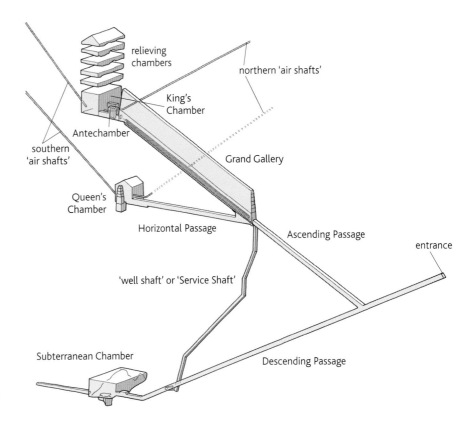

relieving chambers

northern 'air shafts'

King's Chamber

Antechamber

southern 'air shafts'

Grand Gallery

Queen's Chamber

Horizontal Passage

Ascending Passage

entrance

'well shaft' or 'Service Shaft'

Subterranean Chamber

Descending Passage

in Egypt is also non-meteoritic and is associated with another of the Giza pyramids. George Reisner discovered a *peseshkef* (from *peshes*, 'to divide'), the wand used in the Opening of the Mouth ceremony, as part of a magical funerary set in the valley temple of Menkaure. A 'swallow tail' piece of copper that Waynman Dixon found in the southern Queen's Chamber shaft has also been identified as a *peseshkef* (see below).

Shafts similar to those in the King's Chamber, though smaller, 21 cm (3¼ in.) square, extend from the north and south walls of the Queen's Chamber – 2.9 m (9 ft 6 in.) and 2.88 m (9 ft 5 in.) from the east wall respectively. These shafts may have been for Khufu's *ka*-spirit to ascend from a statue set in the niche in that wall. Miroslav Verner believes that the northern Queen's Chamber shaft is aimed at the star Beta Ursae Minoris, and the southern at Alpha Canis Majoris – Sirius, the Dog Star. Some of the most recent work in the Great Pyramid has been carried out on these shafts and the results have aroused a great deal of interest and speculation, so it is worth examining them here in some detail.

No one would have known that the shafts in the Queen's Chamber existed at all if Waynman Dixon,

8.18 Isometric model of the passage and chamber system in the Khufu Pyramid, indicating the so-called air shafts.

an engineer who worked with Charles Piazzi Smyth, had not been suspicious of a crack in the chamber's southern wall. In his book, *Our Inheritance in the Great Pyramid,* Smyth tells how in 1872 Dixon took time off from building a bridge over the Nile to investigate the pyramids in the company of a Dr Grant, and was rewarded with the discovery of the Queen's Chamber 'air shafts'. The details of the discovery highlight one curious difference between these shafts and those in the King's Chamber: the builders purposely left the ends of the shafts in the Queen's Chamber hidden. According to Smyth, after Grant had noticed a crack in the south wall, Dixon, pushed in a wire to a great depth and then set one of his workmen, Bill Grundy, to break through the wall with hammer and chisel.

In this way they discovered the first air shaft and could follow it to a depth of 2 m (6 ft 7 in.) before it rose at an angle to an unknown distance. Predicting the existence of a shaft in the opposite wall, Dixon measured a similar distance along it and set the 'invaluable Bill Grundy to work there again with his hammer and steel chisel', with a similar result.[19] Smyth then relates how Dixon's party found objects within the shafts that must have lain there since Khufu's day: 'a little bronze grapnel hook; a portion of cedar-like wood, which might have been its handle; and a grey granite, or green-stone ball'.[20] Dixon's great-granddaughter, Mrs Beth Porteus, donated these objects to the British Museum in 1972, and they were featured in the exhibition *Egyptian Art in the Age of the Pyramids* at the Louvre in Paris and the Metropolitan Museum of Art, New York, in 1999 [**8.19**].

We now recognize the stone ball as one of the dolerite pounding stones so ubiquitous around Giza and in ancient Egyptian quarries. As the ancient workmen repeatedly turned these

8.19 Copper double grapnel hook and dolerite pounder that Waynman Dixon's party found in the so-called air shafts of the Queen's Chamber. Both were donated to the British Museum in London (EA 67819 and EA 67818); 4.5 cm (1¾ in.) high and 6.9 cm (2¾ in.) diameter.

pounding stones to get a good striking edge when shaping hard stone, they became rounded into balls. Dolerite balls have also been found beneath heavy sarcophagi in tomb chambers at Giza, where workers used them as ball bearings for manoeuvring the heavy coffers in the tight confines of underground rooms. As for the copper 'grapnel hook', Stadelmann called it a dove's tail, used to handle ropes and resembling similar instruments from later times.[21] Others call it a swallow's tail. The piece has also been compared to the ancient Egyptian *peseshkef*, used in the funerary ritual.

As Smyth's description of Dixon and Grant's observations makes clear, Khufu's workers designed and built the Queen's Chamber channels as dead ends – they had neatly carved the end of each shaft into the interior side of the final block, leaving just a thin 'plate' so that the block fitted flush in the chamber's wall.[22] More than 4,300 years were to elapse before Waynman Dixon's handyman, Bill Grundy, unsealed them. Why were they created like this? The Edgar brothers, John and Morton, framed the question that has remained open, like the shafts, ever since: 'What purpose could the ancient architect have had in view to induce him to expend so much time and trouble in constructing two long air-channels, in such a way that they would be useless as conductors of air until someone would seek, find, and remove the barrier?'[23]

It was the Edgar brothers who pointed out that the Queen's Chamber shafts 'are situated in the same vertical plane' as those of the King's Chamber.[24] In 1928 Morton Edgar [**8.20**] obtained permission to clean out the 'air-channels' in the King's Chamber using boring rods. When he turned his attention to the Queen's Chamber shafts, Edgar noted that, unlike those from the King's Chamber, no opening on the outside of the pyramid had yet been found. George Reisner and other Egyptologists thought that the Queen's Chamber shafts were dummies.

Morton Edgar used jointed rods in his attempt to probe the shafts. The rods needed to be flexible because, as Edgar soon discovered, the shaft on the north side of the Queen's Chamber does not run directly upwards in a straight line but has to make a bend towards the west to avoid the Grand Gallery. He succeeded in pushing his probe for a distance of 53.34 m (175 ft) in the northern air shaft until, under the strain, his rods broke; the same thing happened

8.20 Morton Edgar is shown seated in the foreground in the Subterranean Chamber, before the limestone debris left over from the ancient work of hewing the chamber from bedrock was cleared. He investigated the Queen's Chamber air shafts using jointed rods.

at exactly the same distance when he tried again about a week later. Leaving the two sets of rods inside the northern shaft, Morton Edgar then made an attempt on the southern one. Here, he was slightly more successful, finding that beyond the first bend the shaft is straight. After two attempts he was able to push his rods about 63.4 m (208 ft) up the shaft, before he was stopped by an unknown obstruction. He estimated that just over 6 m (20 ft) stretched between this obstacle and the exterior of the pyramid, and spent several days on the outside searching the pyramid's steep southern slope, but failed to find an opening.

Modern probes and surveys Decades later Rainer Stadelmann of the German Archaeological Institute (DAI) in Cairo agreed to conduct a joint investigation of the air shafts with the engineer, Rudolf Gantenbrink, who had devised a small, remote-controlled machine. Assisted by Ulrich Kapp of the DAI, Gantenbrink attempted to send his first robot up the air shafts in the Queen's Chamber in March 1992, but it became stuck. Gantenbrink then mounted his second robot, called

Upuaut-1 (after the ancient Egyptian god whose name means 'Opener of Ways'), with a video camera and a laser rod with which he could measure the height and width of the shafts. During his second campaign in May 1992 to explore the King's Chamber shafts, he first cleared debris clogging the northern shaft at the exterior face of the pyramid. Upuaut-1 crawled the entire length of the northern and southern shafts, measuring the block joints and establishing that both King's Chamber shafts bend in their north–south axis.

According to Gantenbrink's diagram, the southern King's Chamber shaft first ran horizontally for around 1.7 m (5 ft 7 in.), then sloped upwards for a total length of 53.6 m (175 ft 10 in., close to 100 Egyptian cubits) to the projected outside of the pyramid casing when it was intact. Initially the shaft slopes upwards at 39.2 degrees, before increasing to 50.54 degrees and then sloping at 45 degrees for the remainder. Gantenbrink saw two slots or niches in the sides of the shaft, one at around 45 m (148 ft), the second at around 45 m (149 ft). These could have been for a small portcullis, possibly like the small blocking slabs discovered in

the Queen's Chamber shafts (see below), although, based on his observations, Gantenbrink rejects that possibility.

The northern shaft runs horizontally for a little more than 2.6 m (8 ft 8 in./5 cubits), then slopes upward at 32.6 degrees for a total distance of 71.5 m (234 ft 7 in.) to the projected exterior of the pyramid casing (68.56 m or 224 ft 11 in. to the exterior of the core masonry).

In March 1993 Gantenbrink returned to the Queen's Chamber with his third, improved, robot, Upuaut-2. This crawled 19 m (62 ft) up the northern Queen's Chamber shaft, past one of Edgar's long metal rods, before reaching a sharp bend, which Gantenbrink measured at 45 degrees on the horizontal, and could go no further. In the southern Queen's Chamber shaft numerous obstacles made for rough going, but eventually the little machine penetrated 53 m (174 ft) up the slope. A step in the floor, 6 cm (less than 2½ in.) high, initially impeded progress, but Upuaut-2 then managed to climb over and continued for another 6 m (19 ft 8 in.) in the shaft, which from this point is constructed of better quality masonry. As a result, Gantenbrink was able to track the course of the southern shaft as horizontal for 2.65 m (8 ft 8 in./5 cubits) and then sloping at 39.6 degrees for a distance of 59.5 m (195 ft) from the south wall of the Queen's Chamber. He and Kapp determined that if projected to the outside of the pyramid, the southern Queen's Chamber shaft should emerge at the 90th course of blocks, but surveys of the exterior of the pyramid could not find an opening.

Gantenbrink's survey provided valuable information about how Khufu's builders created the shafts. They meticulously custom-cut small limestone blocks carved with a gutter-like channel, 25 or 26 of which remain in the southern shaft of the King's Chamber and 31 in the northern. Like the other passages and chambers in the pyramid, the builders carefully made the shafts as separate structures, embedding the blocks within the rising pyramid core at a dramatically different angle from the general horizontal courses, and filling around them with the looser masonry of the pyramid body.

In a configuration Gantenbrink called Type A, these blocks were turned over to form the sides and ceiling of each shaft, laid on to a normal block whose upper surface became the floor. That is

why the video showed no seam or separation in the upper corners and a gap along the bottoms of the walls for most of the length of the shafts. Gantenbrink also saw places where the builders did just the opposite: they left the cut of the channel as the floor and sides, and covered it with a normal block for the ceiling, leaving a seam along the top, which he designated Type B. The first two blocks in the Queen's Chamber's southern shaft are laid in Type B configurations. His Type C configuration is similar to Type A, except the builders also carved a shallow part of the shaft into the floor block. The third block in the Queen's Chamber northern shaft is laid in a Type C configuration. Type D is more complex: an L-shaped block forms one side and the floor, while an upside-down L-shaped block forms the other side and the ceiling. The builders only used Type E for the outlet of the higher shafts into the King's Chamber. Here they cut out the facing upper corners of two granite blocks, and when they brought these blocks together, the missing corners formed the channel, which they roofed with the underside of a granite block of the course immediately above.

At the furthest point in its journey up the southern shaft of the Queen's Chamber, the eye of the robot stared at a fine limestone slab that sealed off the passage. Two corroded copper pins projected from the slab's smooth face – the only other metal yet found in the pyramid apart from the objects mentioned above, and the first that is part of the structure. The world's media hailed the discovery as a blocked 'door' before the Egyptian antiquities officials even had time to make an assessment and issue an official press release.

A team from the company iRobot of Boston, USA, then developed a combination of robotics, camera and lighting technology specifically for the continued exploration of the Queen's Chamber air shafts, sponsored by National Geographic and the Supreme Council of Antiquities. The American team named their small robot the Pyramid Rover [8.21]. Similar to Gantenbrink's, it moved tank-like on two sets of treads.

By August 2002 the Pyramid Rover had made a video of its journey through the narrow, southern Queen's Chamber shaft. This confirmed the earlier observation that Khufu's builders had used the finer, more homogeneous Turah-quality limestone

for the blocking slab with the copper pins and for the side walls for a short distance in front of this so-called 'door', rather than the limestone quarried locally from the bedrock at Giza which they used in the pyramid core. They used the same finer stone for the outer casing of the pyramid and for the Queen's Chamber.

Nine years after Gantenbrink, the new team stared once again at the stone slab and the mysterious copper pins. The copper pin on the right was bent or drooped – the end may have come into contact with the limestone, the natural salts of which perhaps caused corrosion. The shaft of the pin on the left may be in better condition because it is lifted slightly away from contact with the limestone. A device attached to the robot ascertained that the lower, horizontal part of the southern shaft is 'bang-on level'. However, after the small 'step', there is a marked shift, 'with the whole shaft (apparently) twisted a small amount counter clockwise'. The step had been created when the builders failed to place two of the floor blocks flush.

At 4.30 in the morning of 13 September 2002, the robot drilled a small hole through the blocking stone; the drill encountered no resistance and found no debris beyond the stone, suggesting there was empty space. But what exactly lay behind? A tiny video camera was inserted, beaming the images live for a televised audience worldwide, so that they could see everything exactly as it happened. On 17 September a billion viewers in 141 countries watched

while the team directing the Pyramid Rover inserted the pencil-thin camera probe through the small round hole. The remote control eye revealed the continuation of the shaft, followed by the blank face of another blocking stone, with visible tool marks. The thickness of the limestone slab, measuring 20 × 20 cm (almost 8 in. square), was estimated as possibly only 5.08 cm (2 in.).

In fact the most intriguing results came the day *after* the broadcast, when the team used the Pyramid Rover robot to explore the northern Queen's Chamber shaft, this time without the live broadcast. The north shaft was an even greater engineering feat than the southern one, as it had to change direction sharply four times to skirt around the upper end of the Grand Gallery. The robot also had to navigate around Morton Edgar's metal rods. When it finally reached the end of the shaft, the team was astounded to find themselves staring at another blocking slab, exactly the same as that in the southern shaft, and again with two mysterious copper pins or 'handles' protruding from it.

The investigation ascertained that the two blocking slabs with copper pins seem to be about the same distance from the Queen's Chamber (65 m/213 ft) in both northern and southern shafts, although Gantenbrink measured the distance of the southern one as 59.5 m (about 195 ft). This was the first time that the entire northern shaft had been explored, since the bends and sharp corners had frustrated earlier efforts. So it came as a surprise that it extended up towards the north as far as the southern one slopes in the opposite direction, in an amazing piece of symmetry.

The Pyramid Rover recorded some more artifacts in the northern shaft, albeit dating from the 20th century AD. Two pieces of paper were found around the first corner. One was blank, possibly rubbish; the second seems to be a ticket for admission to the pyramids. Unless it dates to the 1950s, the ticket might have arrived during Morton Edgar's probing in 1928, perhaps attached to one of his metal rods. There was another intriguing object: a flattened cylindrical disk, probably metal, with a hole in the middle, discovered at 20.3 m (66 ft 6 in.), after the first 45 degree turn. Gantenbrink's machine never reached this far, though it seems Morton Edgar's flexible metal rods did: the object is probably part of his equipment.

8.21 The Pyramid Rover, used in 2002 to ascend the so-called air shafts or channels running from the Queen's Chamber. In the southern shaft it videotaped and drilled the plugging block with copper pins.

ABOVE
8.22 The Djedi robot, used to examine the Queen's Chamber southern shaft.

RIGHT
8.23 Red paint markings, probably masons' marks or builders' graffiti, on the rear side of the so-called air channel blocking slab, captured by the camera on the Djedi robot.

Planning began almost immediately for a further mission to investigate the blocking slabs in the southern shaft, and if possible to examine the rear side of the first slab while minimizing the impact on, and any further damage to, the fabric of the pyramid. After various trials and assessments, a team from Leeds University, with members from different institutions and companies, led by Robert Richardson, was selected for the work and examined the southern shaft in the Queen's Chamber in early 2011.[25] The project was named Djedi, after the magician Khufu was said to have consulted for the design of his tomb.

The robot used was a completely different design from previous ones: rather than the tracked, 'tank-like' mechanisms, Djedi had wheels and was also propelled in a different way [**8.22**]. Other innovations specially designed for this

new exploration included a much smaller sonic surveyor for echo-sounding and, perhaps most important, a 'snake' camera that could be turned to any angle – even backwards.

The equipment on the Djedi robot confirmed measurements obtained by the earlier projects, and was also able to ascertain the distance between the two blocking slabs as around 19 cm (7½ in.). By examining photos from the camera, the team also determined that the same U-shaped block that formed the walls and ceiling of the shaft in front of the first blocking slab continued beyond it. A tiny chip in one corner revealed a small lip carved into one side wall against which the slab rested. It is probable that a corresponding channel exists on the other side, though none was identified.

The rear face of the first blocking slab was now seen for the first time, thanks to the snake camera. Like the front face, the rear is polished smooth, and the copper pins also project from this side, one forming a small, very neat loop. In contrast, the surface of the second blocking slab has not been smoothed, but was left rough and unfinished.

Perhaps the most remarkable discovery made by Djedi was the existence of markings in red and black paint that include lines and what appear to be masons' marks, possibly numerical notations in hieratic script [**8.23**].

The meaning of the mystery There are still many unanswered questions about these mysterious shafts from the Queen's Chamber. What, if anything, might lie behind the second blocking stone in the southern shaft? And did the copper pins have a practical function, or were they talismans? A 4th dynasty wooden shrine found under the satellite pyramid south of the Khafre pyramid features U-shaped copper nails in the top, and similar nails of copper or bronze stud the upper edges of Tutankhamun's gilded shrines and are set into the sides of his alabaster canopic chest near the upper rim. The nails pierce the alabaster walls of the chest, which are a couple of inches thick, and are then bent over to form a loop. Ropes would have been threaded through to tie the chest and shrines to a wooden sledge, or, in the case of the larger gilded shrines, to secure the doors. The sockets where the pins are set into the alabaster chest are similar to the joins of the copper

pins in the blocking slab of the southern Queen's Chamber shaft.

The symmetry of the two blocking slabs in the northern and southern Queen's Chamber shafts, both carefully crafted into the very core of the pyramid and with identical copper pins, certainly reflects intention and forethought. It is possible that within the masonry between the ends of the shaft and the original outer face of the pyramid the ancient builders secreted a small niche – a *serdab* – which might hold a small statue of the king, pointed up to the sky, a miniature version of the life-sized Djoser statue in his stone box tilted up at 13 degrees on the north side of his Step Pyramid at Saqqara.

In 2000 the French explorers Gilles Dormion and Jean-Yves Verd'hurt (the same team that drilled inside the Queen's Chamber) found previously unknown small compartments and chambers in the giant Meidum pyramid built by Khufu's father, Sneferu (see Chapter 5). These consist of corbelled stress-relieving chambers above both the lower part of the pyramid's descending passage and the two niches or antechambers preceding the vertical shaft leading up to the burial chamber. One of the chambers is large enough for one or two people to crouch inside. This discovery underscores the possibility that such small chambers or niches could yet be discovered in the Great Pyramid.

For the moment, the precise meaning of these features still eludes us. It seems almost unavoidable that the blocking slabs and copper pins carried a ritual function, possibly related to the bolts of the sky, spoken of in the later Pyramid Texts. We can only think that Khufu's builders blocked the shafts – both where they might have emerged on the exterior of the pyramid, and at their beginning in Queen's Chamber itself – in keeping with the function of this chamber as a *serdab*. Some *serdabs* have small, slanted open windows, presumably for the *ka* to emerge and return. As with any *serdab* or false door in a tomb, the blocking would not prevent the king's spirit from coming and going.

Hawass believes that there are chambers still hidden inside the pyramid, and that these doors may be the keys that will open these secret rooms. Both of us have been inside the Great Pyramid many times. But it is when we are alone that the silence captures our hearts. Each chamber holds its own secrets, and each time you enter, you feel that you are part of an adventure in history. When the robot went inside the tunnels in the Queen's Chamber, revealing how the stones of the interior are interlocked, it reminded us of what the Arabs said about the pyramids: 'Man fears time, but time fears the pyramids.'

While the pyramid itself is the most obvious, it is certainly not the only, element of a standard pyramid complex, all parts of which had an important role to play in the death, burial and memorial service of the god-king. We now emerge from the dark interior to examine these other features.

Upper temple

Little survives of the upper (mortuary) temple because it served as a quarry for building stone perhaps as early as the Middle Kingdom. Later, either in the Saite (26th dynasty) or Roman Period, someone dug a huge, deep shaft, either a well or an unfinished tomb, into the centre of the western part, completely destroying the layout of that area. However, Egyptologists have been able to recover the original plan of most of the temple from the bedrock cuttings that served as foundations for walls and pillar sockets. The temple extended a little more than 43 m (140 ft) from the inner face of the enclosure wall and slightly more than 52 m (170 ft/100 cubits) wide north to south [**8.24**, **8.25**].

Today, the temple's remains include a large patch of black basalt pavement, belonging to the inner, open court situated on the east–west axis of the pyramid. The pivot sockets for the swinging wooden entrance door from the causeway can still be seen in the thick basalt threshold. A colonnade of square, monolithic, red granite pillars surrounded the court. Based on surviving fragments, we think that Khufu's artisans probably decorated the temple's limestone walls with delicate low relief carvings depicting, among other things, offering bearers bringing in the produce from the new towns and estates dedicated to Khufu's pyramid. These reliefs, when they still retained their bright colours, must have made a striking contrast to the sombre black pavement, the polished red granite pillars and the gleaming white casing stones of the pyramid towering above the open court.

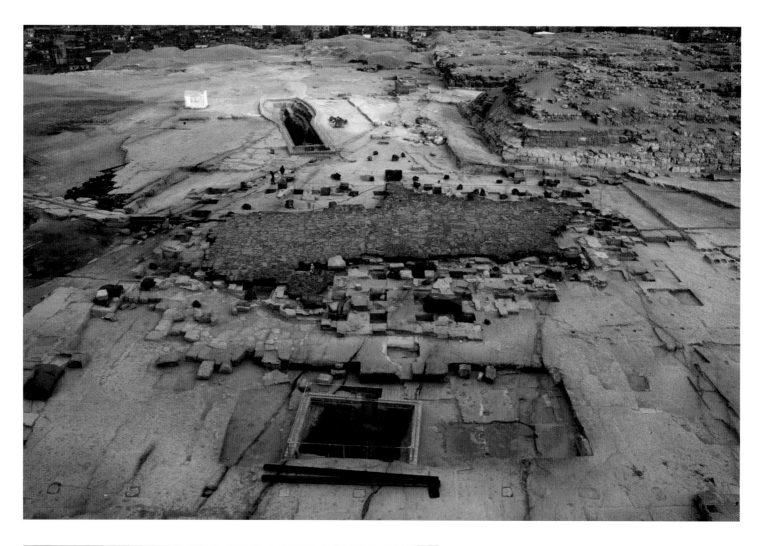

The remains of the black basalt pavement in the court of the Khufu pyramid upper temple, surrounded by bedrock cuttings for pillar sockets and the outer walls. A wide cutting in the foreground served as the foundation for an inner sanctuary of unknown form. In later times (Saite or Roman Period) someone sank a deep shaft into this feature near the centre axis of the temple.

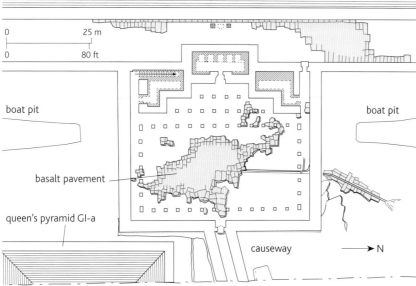

8.25 Plan of the upper (or mortuary) temple at the centre of the eastern side of the Khufu pyramid, based on Jean-Phillipe Lauer's schematic plan published in 1947.

Rows of additional granite pillars lined a bay that stepped back towards an inner sanctuary close to the pyramid's eastern base. A door at the centre of the bay gave access to the back inner room, which would have been the most sacred area of the temple. Unfortunately, this innermost sanctuary is impossible to reconstruct – it is just here that someone quarried out the deep shaft in Saite or Roman times. Most Egyptologists agree that it would have been an oblong hall, but differ as to its contents. One possibility is a single or two false doors in solid stone, symbolic of the king's exit from and entry to the Netherworld of the pyramid. Or there might have been five niches for statues (possibly, as Hawass believes, one each for the names of Khufu, with one perhaps dedicated to Re), a feature that would become standard in later pyramid temples; or stelae inscribed with the king's names, as at Sneferu's Bent Pyramid; or an offering room with an altar. Others imagine the altar and stelae between the back wall of the temple and the base of the pyramid, though no obvious traces of stelae survive. The offering chamber and false door were standard in later pyramid temples, where they

were set behind the five statue niches. The area where the sanctuary stood is now only a patch of bedrock worked flat by the masons, leaving the question unresolved.

The pyramid court and enclosure wall

A narrow court enclosed by a tall limestone wall ran round all four sides of the pyramid. The valley temple, far down on the valley floor below the plateau, may have provided the ultimate access to this court. Visitors ascended up the dark causeway corridor (p. 185), passed through the doors of the upper temple, crossed the black basalt-paved courtyard, and moved between the square red granite pillars of the colonnade on the north side of the temple to a narrow roofed corridor leading to the court, paved with thick limestone slabs flush with the pyramid platform. Patches of this pavement remain on the north and west sides of the pyramid. After the long journey in gloom, the visitor stepped from the corridor into brilliant sunlight reflecting dazzlingly off the white limestone of the pyramid sweeping upwards into the sky.

Built with the same fine white limestone from the eastern quarries across the Nile Valley as the pyramid casing, the wall of the enclosure was originally approximately 3 m (10 ft) wide at the base and rose more than 8 m (26 ft) high to a rounded top. The wall has entirely disappeared, except for two fragments of the rounded shoulder: one lies off the northwest corner of the pyramid, the other in the area of the upper temple. The second piece formed part of the corner where the wall attached to the back of the temple [8.26].

Before setting the court's pavement slabs, the builders carefully formed a dip, or impluvium, into the bedrock floor. Today the keen observer can see the surface dipping away from the line of

the pyramid's foundation platform – it sinks about 40 cm (16 in.) then rises to the bed of the enclosure wall. The dip becomes shallower towards the centre of the court along the length of the pyramid and practically disappears. It is probable that the pavement, which is now mostly missing, followed the dip towards the corners. This subtle feature may well have been intended to drain rainwater that washed off the face of the pyramid towards the corners, where it was discharged beyond the court. Such facilities might hint that the climate was wetter in the 4th dynasty than today in this area of Egypt.

Long channels lead away from the court at its northwest and southwest corners, both of which we cleared as part of the work of the Giza Inspectorate [8.27]. That at the southwest corner exits the court at a sharp angle to the southeast. Measuring 70 cm (27½ in.) wide, it still retains a lining and cover of limestone slabs as it makes a turn to run south for 30 m (98 ft) along tall blocks of limestone bedrock left by Khufu's quarrymen when they dressed the surface down for levelling the pyramid court. The total length of this channel is 41 m (135 ft). A modern asphalt road covers the exit of the northwest corner, but on the other side

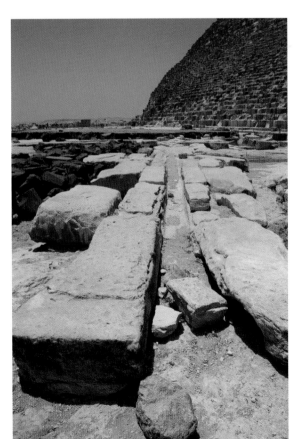

FAR LEFT
8.26 One of the two fragments of the rounded top of the enclosure wall that once ran round the pyramid to define the perimeter court.

LEFT
8.27 A channel forming a drain leading away from the Khufu upper temple.

of the road we cleared the channel as it runs to the north at a gradual downwards slope for more than 75 m (246 ft). Around 1 m (3 ft) wide, it still retains a lining of limestone slabs for about 5 m (16 ft) at the southern end near the modern road.

Boat pits

Khufu flanked two sides of his pyramid with five boat pits of such monumental size that there can be no doubt he intended the pyramid to be, among other things, a gigantic port for embarkation for his voyage to the world beyond this life (two smaller ones were also associated with the queens' pyramids – discussed below).

On the eastern side of the pyramid are two giant boat-shaped pits, oriented north–south and parallel to the pyramid's base, one on each side of the upper temple. Now open, for many years the northern pit was buried under the same modern asphalt road that passed directly over the basalt pavement of the temple. Between 1992 and 1995 we removed the

8.28 View to the west down the length of the eastern boat pit on the southern side of the Great Pyramid, with some of the huge limestone roofing slabs still in place.

Boat pit dimensions

Pit	Length	Width
East side:		
Northern	53 m (174 ft)	7.5 m (25 ft) (widest)
Southern	56.7 m (186 ft)	11.5 m (38 ft) (widest)
Upper Causeway	45.5 m (149 ft)	7 m (23 ft) (top), 2.5 m (8 ft) (bottom)
South side:		
Eastern	40 m (131 ft)	5 m (6 ft 5 in.) (top)
Western	?40 m (131 ft)	?

road, re-excavated this boat pit and cleaned out the other; they were mapped by David Goodman in 1995. Khufu's planners may have intended the pits to contain boats around 100 cubits in length (52.5 m, 172 ft) – they could easily have held Khufu's barque in its fully assembled state.

A third boat pit on this side of the pyramid lies alongside and parallel to the upper end of the causeway, and is thus nearly perpendicular to the other two. At its eastern end the pit takes the form of a rectangular trench, 21 m (69 ft) long. Its floor slopes from the level of the causeway foundation down to a deeper, boat-shaped section, 8 m (26 ft) lower than the surface along the causeway. The pit's location just outside and to the north of the door of the upper pyramid temple gives the appearance of a boat docked here for the king to travel to and from his tomb and temple.

In 1954, on the southern side of the pyramid, Kamal el-Mallakh discovered two boat pits parallel to the pyramid's base, oriented east–west. One difference between these and those on the eastern side is that they are rectangular, rather than boat shaped; another, crucial, difference is that they still contained actual boats. Both pits were roofed with great limestone slabs [8.28], and when el-Mallakh removed those covering the eastern pit he found the dismantled elements of a full-sized wooden ship.[26] The ancient Egyptians who buried the great barque had first deconstructed it, cutting all the stitching rope and separating the 1,224 pieces that make up 664 major parts. They then laid the pieces in their correct relative position, but

crammed into a rock-cut trench only 40 m (131 ft) long – the fully assembled boat was 43.3 m (142 ft) long. Mallakh extracted the pieces of cedarwood, reed matting and rope [**8.29**]. A number of mason's marks and inscriptions including notations, measurements and the names of crews, which incorporate the name of Djedefre, were found on blocks forming the boat pit [**8.30**].[27]

Hag Ahmed Youssef Moustafa, the master restorer who worked with George Reisner on the conservation of the objects from the tomb of Hetepheres I (p. 175), was the first person since ancient times to assemble this pharaoh's ship. It was a giant simulacrum in wood of a papyrus boat, with the prow and stern curving upwards like the bound ends of the reed original, and the stern bending sharply back over on itself. The wooden barque's construction reflects its evolution from the original reed prototype. Reed boats had no internal frame, and the hull of Khufu's ship was constructed 'skin-first', with the timber pieces stitched together with rope, albeit with the addition of mortise and tenon joints binding together the planks of the hull. Reed luting (sealing) was probably used between the hull planks in place of caulking. Long narrow slats covered the reed-stuffed joints and were held in place by cross braces that formed a kind of *de facto* frame. In the middle of the boat a cabin, or shrine, is enclosed within a reed-mat structure. Ten oars were provided for propulsion (there is no sign of a mast for a sail), and the ship could be steered by the two large rudder oars at the stern (though one imagines steering would not be required if the boat were only towed).[28]

We can only stand in amazement at the skill of the ancient boat builders who put together all the separate pieces to form the whole, since the larger individual cedar planks of the 'skin' may weigh as much as 2.5 tons – the average weight of the blocks in the Khufu pyramid – and their ends locked together in jigsaw patterns. When Hag Ahmed restored the barque he used two chain lifts, block and tackle, each with a 5-ton capacity, to lift and join the planks. Relying only on rope, the ancients somehow fitted together the pieces of this giant puzzle to exactly the right shape.

How they arrived at that shape may reveal something about the difference between construction concepts in Khufu's time and those

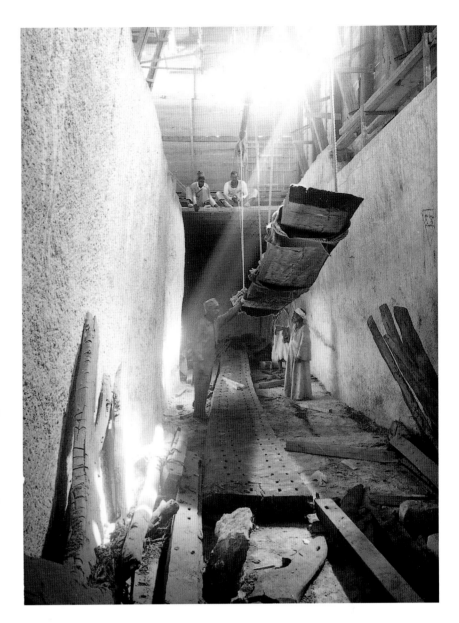

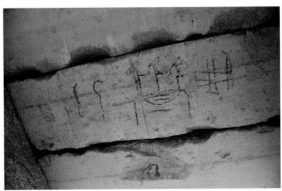

of contemporary nautical engineering, or modern engineering in general. Modern boat builders establish the shape of the vessel – its sheer – in blueprint drawings that give precise measurements from a reference line. Traditional boat builders, such as those who still work today in the Egyptian countryside, will create the shape of a boat in more

ABOVE
8.29 Workers carefully removing heavy hull planks of the Khufu boat using modern lifting equipment. All the individual elements were then reassembled.

LEFT
8.30 Graffiti written by the ancient builders on the underside of roofing slabs left in place over the boat pit include the name of a work gang.

Why did they bury boats?

Some scholars believe that the two dismantled boats in the pits on the south side of the Khufu pyramid were actually used in the king's funeral ceremony. The gangplank on the reconstructed barque appears worn from use, and rope has left impressions in some of the other pieces of wood, perhaps softened when the boat was in the water. On the other hand, sails would have been required for southward voyages against the northward Nile currents, yet there is no evidence for a mast to carry such sails. The reassembled boat has five oars on each side; photographs of the second boat reveal that it too had oars. There are three main schools of thought concerning the function of the boats once contained in all five of Khufu's large pits:

• **Cardinal direction carriers** Jaroslav Černý, citing Pyramid Texts, thought that the boats symbolically carried the king to the four cardinal points: those on the south of the pyramid provided transport east and west, while the two flanking the upper temple carried pharaoh north and south. In this interpretation, the pit alongside the causeway was for the funerary barge that carried the dead king to the pyramid.

• **Solar boats** Several Egyptologists (Walter Emery, Selim Hassan, Kamal el-Mallakh, Abd el-Moneim Abu Bakr, Elizabeth Thomas) believe the boats carried the king as the sun god Re through the heavens. Again, Pyramid Texts are cited, such as: 'the king comes to Re ... he ascends with Atum, rises and sets with Re and the solar barges.' The celestial daytime sky boat was called Mandjet, while that for the night was called Meskhetet.

• **Ritual boats and floating hearses** Abu Bakr initially thought that the southern boats might have been symbolically solar, but that the three on the east were used during the king's lifetime and during his funeral for ritual visits to the important cult centres of Buto, Sais and Heliopolis – all of which figure prominently in the coronation ritual and in the most elaborate representations of elite funerals. Later, he and Ahmed Youssef Moustafa argued that all five boats served the ritual voyages, one each for pilgrimage to Heliopolis, Sais and Buto, one for coronation rites and one for the sons of Horus who attended coronations.[29]

Hawass's theory

Hawass believes that the marks seen on the reassembled boat may have come from humidity, not water, and that the boats are solar boats for Khufu to sail magically as the sun god Re on his daily trips across the sky. There is also evidence that both boats in the southern pits were constructed and dismantled nearby. The two pits that flank the upper temple to the east of the pyramid housed boats that were probably intended for Khufu as Horus, the sky god. These pits run

north–south because Horus had power that extended north and south in the land of Egypt. Their location near the upper temple suggests that these boats were also connected with the living king because the upper temple may have corresponded in some degree to the palace of the living king as Horus (see Chapter 7). The third boat pit on this side (by the causeway) may have been connected with the cult of Hathor, who was one of the triad of deities worshipped at Giza, as understood from the Abusir Papyri.

Evidence for this hypothesis can be found in the layout of the two southern pits. A wall of living rock aligned on the north–south axis of the pyramid separates them. The southern of the so-called air shafts ascending from the King's Chamber emerges close to the centre of the southern face of the pyramid directly above the separation between the two pits. Perhaps the king's soul was thought able to emerge and magically reassemble the boats for celestial journeys east and west.

Lehner's theory

Lehner sees significance in the fact that the two pits on the south are narrow rectangular trenches, while all three pits on the east of the pyramid are boat-shaped. It is also worth pointing out that all the pits lay outside the main enclosure wall of the pyramid, while a secondary, stone-rubble 'peribolus' wall ran across the blocks that concealed the southern pits. The southern boats may have been dismantled because they had indeed been used in the funeral and they would thus fall into a class of items found at other pyramid sites – such as the wooden frame found under Khafre's satellite pyramid (see Chapter 9). Because they used these items for the funeral, the Egyptians dismantled and buried them separately, close to but outside the royal funerary enclosure. Why would the Egyptians have dismantled the boats if they were to be used by the king in the Afterlife? Dismantling or dismembering something rendered it non-functional in the Afterlife.

Fully assembled, the boats are a few metres longer than the southern pits, but the Great Pyramid builders could easily have made the pits large enough, and of the right shape, for fully assembled barques. The eastern boat pits could have held fully assembled barques that were buried for the king's chthonic and celestial Afterlife.

Furthermore, the cabin of the reassembled southern boat has no ventilation, whereas travelling boats for the living would have had canopied, but open, seating areas. The reed-mat-covered wooden frame that shielded the cabin could have served to keep the royal body cool, by pouring water over the mats. The reed shrine is similar to that simulated by elaborate niching and painting on Early Dynastic mastabas and funerary enclosures. A specialized function for the southern boats as funerary transport fits the evidence that the reassembled boat had been used, albeit not very often.

intuitive ways, but they too still rely on a skeletal frame. Without a prior internal frame, it is possible that the flare and sheer of the Khufu boat could have been different each time it was assembled, for its methods of construction were such that it could be deconstructed and put back together.

This contrast in thinking and doing is not limited to Khufu's boat. The same is true also of the pyramid. If modern engineers built Khufu's pyramid, they would probably use modular, standard block sizes, set to a predetermined, exact plan. But as we have seen, the core blocks show immense variability of shape, size and fit. The pyramids in general reflect an ad hoc 'design-as-they-built' approach.

In the 1960s a glass museum was constructed directly over the pit in which el-Mallakh found the boat. Its designers originally wanted the pyramid to be visible from the interior in relation to the boat, while the boat could be seen from the outside in relation to the pyramid. But the glass panels created a greenhouse effect and 200 electric fans were needed to cool the great ship, which was raised up on stilts along its axis. In the early 1980s the Egyptian Antiquities Organization took over the project from the original Italian firm and replaced the glass with buff panels, installed air conditioning and climate control, then opened the museum to the public in 1982 [8.31]. At the time of writing it is planned to move the boat to the Grand Egyptian Museum, and to demolish the old museum, long a modern eyesore in the ancient landscape.

In September 1987 a geophysical survey by Waseda University of Japan confirmed the existence of the second rectangular pit to the west, still under the row of huge cover blocks. In October of that year, Farouk el-Baz and a team of National Geographic scientists re-examined it. By drilling a small hole and inserting a tiny camera, they were able to videotape the interior. Inside lay the pieces of yet another great barque, similar to the one from the eastern pit, also dismantled [8.32]. The team hypothesized that if the pit was hermetically sealed, they might be able to radiocarbon-date the air inside. However, the video camera immediately made it clear that the pit was not airtight: one of the first images was of a common black desert beetle crawling along one wall. The team also saw streaks running down the side of the pit. Analysis of the

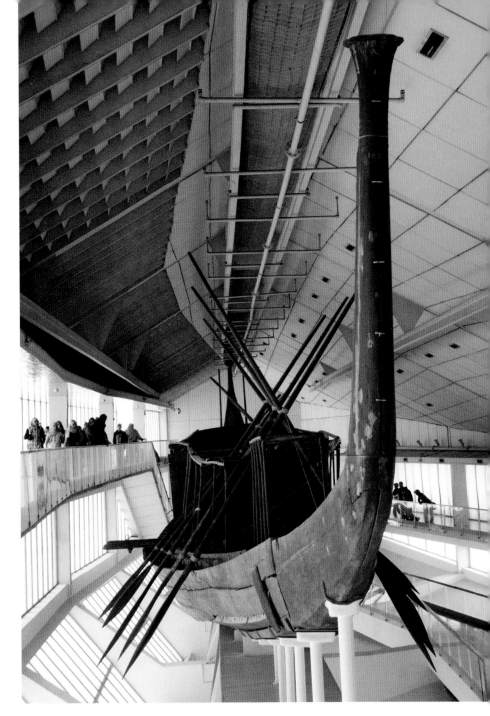

air inside indicated that this boat was deteriorating in the darkness, a process probably accelerated by water spilt by a cement mixer that worked over the spot during the construction of the boat museum.

A subsequent study by Waseda University in 1993 concluded that 'the air outside is mixing with that in the pit' and that 'these facts mean that the second boat is unfortunately kept in an unfavourable environment for preservation'.[30]

The team from Waseda University, led by Sakuji Yoshimura, returned in 2008 and inserted a tiny camera to assess both the condition of the boat and whether it would be possible to excavate, conserve and reassemble it. The next phase began

8.31 Khufu's boat on display in the purpose-built museum opened to the public in 1982. The boat was reconstructed by Hag Ahmed Youssef Moustafa from over 1,000 individual pieces found in the eastern pit on the south side of the Great Pyramid.

8.32 The deconstructed boat of Khufu in the western pit on the southern side of the Great Pyramid, before the team from Waseda University removed the cover slabs and began in 2011 to remove and conserve the pieces.

in June 2011, when under a covering of a large hangar the team lifted the 41 limestone cover blocks with winches. They began carefully to extract the boat's wooden beams piece by piece; these will now undergo restoration and reassembly. Work continues under the field direction of Professor Hiromasa Kurokochi and the Institute of the Solar Boat.[31]

Satellite pyramid: GI-d

The Step Pyramid complex of Djoser at Saqqara contains a second royal tomb, the South Tomb, in addition to the main burial vault under the pyramid itself. Djoser's builders tunnelled deep into the bedrock to the south of his pyramid and then capped the tomb with an elongated mastaba built into the Step Pyramid enclosure wall. Egyptologists are not sure of the purpose of this second tomb. Was it the burial place for a statue that represented the king's *ka*, his vital force? Were the crowns of Upper and Lower Egypt buried here? Could it have contained the canopic chest that held the internal organs removed from the king's mummy? Or was it a special tomb for the royal placenta, preserved since birth and buried after death as a kind of focus for the king's *ka*? All the above alternative explanations have been proposed. Egyptologists do

agree that the satellite pyramids, of which the first known is found at the Bent Pyramid at Meidum, performed the same function as Djoser's South Tomb, whatever it may have been. And as with Djoser's second tomb, these little pyramids were generally located south of their parent pyramid.

Until our excavations in 1995, no satellite pyramid had been located for Khufu. However, there were theories about where he might possibly have begun but failed to finish one. Hermann Junker found a sloping passage cut into the bedrock floor at the eastern end of the south side of the Great Pyramid.[32] Calling it the *Nebenpyramide* ('Side Pyramid'; see also below), Junker thought that Khufu's builders had planned to construct a queen's pyramid here, before they abandoned it, possibly for topographical reasons, and then built it further to the east of the main pyramid.

One of us (Lehner) had suggested that there might have been a kind of satellite pyramid north of Khufu's causeway and approximately on line with the queens' pyramids.[33] Here, not far north of the tomb of Hetepheres, three openings in the bedrock mark the so-called Trial Passages, underground corridors that model parts of the passages inside the Great Pyramid (see below, and, for a detailed discussion, Chapter 17). Petrie thought that Khufu's workers executed these as a kind of practice run for constructing the passage system within the pyramid. It is also possible that the 'Trial Passages' were created as the substructure for a small pyramid that was never built due to changes in the plans of the upper temple and causeway. But one problem with the idea that this feature could have been the equivalent of a satellite pyramid is its position on the north side of the main pyramid. All other known satellite pyramids sit on the south side of the main pyramid, or on its eastern side, south of the upper temple – which is exactly where one of us (Hawass) found the ruins of Khufu's true satellite pyramid, GI-d, in the process of clearing the entire area east of the Great Pyramid.[34]

Very little remains of the satellite pyramid's superstructure, but enough survives to ascertain that it once had a base length of 21.75 m (*c.* 71 ft) and was orientated to the cardinal directions. No one suspected that such a tiny pyramid of Khufu stood here. The large, rough blocks from its inner core lay exposed for a long time, just above the surface,

in a pile of debris, after the great expeditions had finished at Giza. Reisner, Junker and Hassan all stopped their excavations at this spot because it was on the border of their assigned areas.

Although the masonry of the pyramid itself is now destroyed, the subterranean elements survive [**8.33**]. The builders cut a sloping passage and chamber as open trenches in the bedrock in a T-shape that would be standard for satellite pyramids through the rest of the Old Kingdom. The passage, 1.05 m (3 ft 5 in.) wide, is aligned north–south and slopes down at an angle of between 25 and 28 degrees for 5.25 m (17 ft 2 in.). The floor of the chamber is lower than the bottom of the horizontal passage, so a small ramp was left in the rock. The north and south walls of the chamber curve inwards, giving the impression of a subterranean tent or vault. The underground galleries under the eastern side of the Djoser pyramid are similarly shaped.

On the south side of the pyramid we found a large piece of an individual block of fine Turah-quality limestone carved with three exterior sloping faces of the pyramid. Measuring 2.7 m (9 ft) long and 56 cm (22 in.) thick, and with a mean slope of the preserved faces of 52 deg. 40 min., this is one of the rare surviving elements from near a pyramid pinnacle [**8.34**]. It would have made up a little

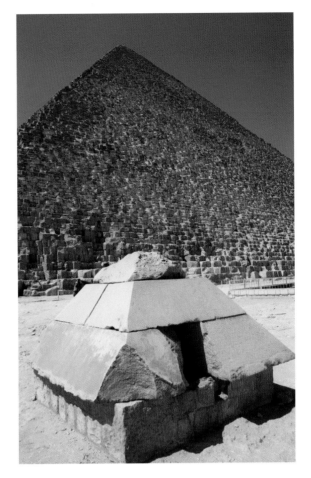

more than half of the south side of the third course below the apex. The block's underside is flat, while the top surface was shaped as a concavity. Four triangular planes slope into the centre, forming the lines of the pyramid diagonals, which must have helped the builders square the top of the pyramid so that the sides met at a point. The concavity was also intended to receive the corresponding convex underside of the block(s) forming the second course from the top. At this point, as the pyramid is narrowing to its apex, the superstructure consists entirely of casing, with no fill or core material.

The block or blocks of the second course from the top are missing, but we later located the actual pyramidion – the capstone that topped the pyramid.[35] It is the second oldest pyramidion ever found; the earliest, belonging to the North Pyramid of Sneferu at Dahshur, was discovered by Rainer Stadelmann. With the placing of the pyramidions, the Egyptians completed the construction of each entire pyramid. The underside of the Khufu pyramidion, a single piece of fine Turah-quality limestone, was convex, with four triangular faces sloping slightly to the centre point of the base. This convex, protruding base was intended to fit into the concavity of the second course from the

LEFT
8.33 The substructure of Khufu's satellite pyramid, GI-d, consisted of a slightly vaulted chamber approached by a passage (on the left), forming a T-shape, cut from the bedrock. View to the east.

ABOVE
8.34 The apex of Khufu's satellite pyramid, reconstructed from parts of the original capstone, or pyramidion, and the third course down. Modern pieces replace the second course down, which was missing. The ancient parts were found when excavations uncovered the satellite pyramid in 1993.

top, just as the blocks of the second course had evidently fitted into the convex top of the third course down.

The edge along the base of the pyramidion was broken away, as was its top, but Joseph Dorner established the mean slope of the faces as 51 deg. 45 min., about one degree less than the slope of the third course down: the sides of the satellite pyramid towards its top bend slightly inward.[36] Below this bend, the slope is nearly the same as that of Khufu's main pyramid. This translates to a ratio of rise to run (increase in height to the setback to create the slope) of 28:22, meaning the builders of the pyramid could have measured up by 28 units and in by 22. The ancient Egyptians measured slopes as a *seked*, the amount set back from a vertical. Khufu's *seked* was a setback of 5 palms, 2 fingers. Based on these proportions we can calculate the original height of the satellite pyramid as 13.8 m (45 ft 4 in.).[37]

The pyramids of Khufu's queens: GI-a, GI-b, GI-c

Khufu's three queens' pyramids, GI-a, GI-b and GI-c, stand in a roughly north–south line 56.2 m (18 ft 5 in./107 cubits) east of the king's pyramid [8.35]. The northern face of the first, GI-a, close to the upper temple, aligns with the northern boundary of the Eastern Cemetery.[38] While it may be coincidence, this northern boundary is also on the axis of the King's Chamber in the Great Pyramid if projected down on to the plateau. In the 4th dynasty development of the Eastern Cemetery, no pyramid or mastaba tomb was allowed beyond the line forming the north limit of the cemetery, except the possible small pyramid that Khufu's builders may have begun, then abandoned, over the so-called Trial Passages (see box and p. 428). Khufu's builders also placed the tomb of Queen Hetepheres, evidently the queen mother, on this same line. This alignment may hint that Khufu's builders laid out the Eastern Cemetery at around the stage of construction of the main pyramid when they had reached the level of the King's Chamber, but had not yet completed the chamber's roof and surrounding masonry, so it was still open to the sky.

Building sequence

Khufu's planners may originally have intended to array his three queens' pyramids along the southern side of the main pyramid, rather than its eastern side. As already noted, Junker identified a so-called *Nebenpyramide* 21.5 m (70.5 ft) from the southern baseline and 42 m (138 ft) from the southeast corner of the main pyramid. The *Nebenpyramide* consists of a very short sloping passage, 4.3 m (14 ft) long,

The Trial Passages: Khufu's secret chambers

The Westcar Papyrus contains a story of how the magician Djedi was brought before Khufu because he 'knew the number of the secret chambers of the sanctuary of Thoth'. The story relates that the king 'had spent much time in searching for the secret chambers of the sanctuary of Thoth in order to make the like thereof for his horizon, that is to say his pyramid, named the "Horizon of Khufu"'.[39]

Maragioglio and Rinaldi cite this legend as one of many indications they marshall to refute the idea, first developed by Borchardt, that the three principal chambers in the pyramid correspond to two changes in plan for the location of the burial chamber. The legend implies a preconceived plan, and so do the so-called Trial Passages, since, if they are a test run, they model parts of passages – and the critical juncture between them – that in the actual pyramid lead to all three chambers.

Following a suggestion by Perring and Vyse, in 1985 Lehner examined the hypothesis that Khufu's workers started the Trial Passages as the substructure for a pyramid that was intended as a satellite pyramid but was never built. Although this now seems less likely, especially after Hawass subsequently located the actual satellite pyramid at the southern end of the eastern side of the main pyramid, it remains true that, according to the best surveys so far, this model of passages and their meeting point aligns closely with the corresponding elements in the Great Pyramid.

To the west of the Trial Passages the workers cut a long, shallow trench, which is almost the same distance from the Trial Passages as the north–south centre axis of the Great Pyramid is from its passages. If we slip the plan of the pyramid due east so that its centre axis lies over the trench, the real passages and the replica passages align. John Romer is probably correct that the Trial Passages, the trench and series of holes that may mark points for sighting rods represent an architectural diagram, the ancient equivalent of a 'blueprint', which, like the Greeks much later, the 4th dynasty builders executed on the spot: design and build were concurrent.[40] We should also see the Trial Passages in a class with three-dimensional working models, along the lines of the one for the passages in the 12th dynasty pyramid of Amenemhet III at Hawara.

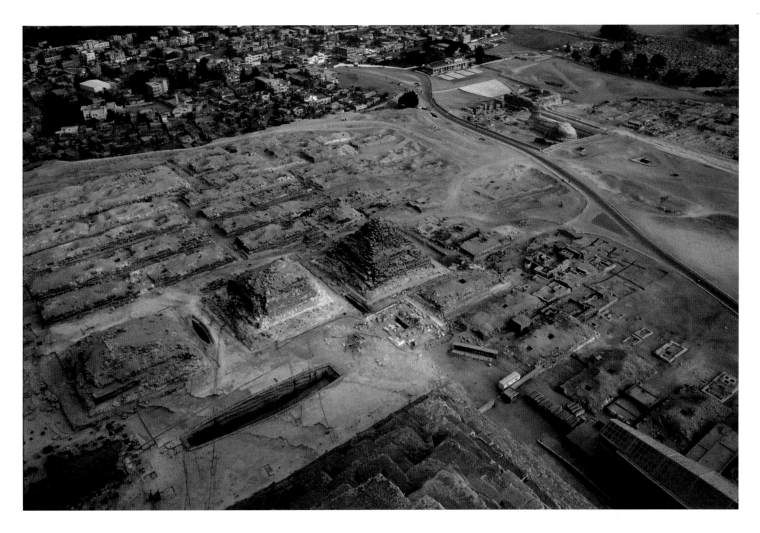

which opens into a small rectangular chamber, 1.5 × 1.2 × 0.8 m (4 ft 11 in. × 3 ft 11 in. × 2 ft 7 in.). The top of the chamber is only 1.3 m (4 ft 3 in.) below the bedrock surface. Junker believed that this passage was the beginning of a queen's pyramid which the builders abandoned. Reisner suggested that 'on this side the terrain was judged unsuitable because the revetted space is too small for such a pyramid.'[41] Reisner also thought that after abandoning the small pyramid the builders began work on GI-a, followed soon after by GI-b and GI-c.[42] Logistically it would have been eminently practical to build all three queens' pyramids simultaneously.

There is further evidence that Khufu's builders began pyramid GI-a as the first in the series, and probably as the tomb that established the northern boundary of the Eastern Cemetery, early in the construction of the king's mortuary complex. GI-a's northern side and northwest corner rest on a ridge of limestone bedrock that rises 1.6 m (5 ft 3 in.)

above the levelled foundation of the main pyramid causeway, which passes to the north. While the builders cut only 30 cm (12 in.) deep into this ridge for the foundation of the northern casing of GI-a, they quarried to a depth of 1.6 m (5 ft 3 in.) for the foundation of the southeast corner of Khufu's upper temple and causeway, leaving a ridge of rough, unworked bedrock between them and GI-a less than a metre (3 ft) wide. This configuration suggests that the workers laid out the base and began to construct the first queen's pyramid, and therefore the Eastern Cemetery, before they had dressed the rock down to the level required for the temple and causeway, so possibly also before they had done the ground survey and measurements for them.

However, Peter Jánosi, who carried out a masterful study of all queens' pyramids of the Old and Middle Kingdoms, doubts that pyramid GI-a preceded Khufu's upper temple and causeway,[43] believing instead that the small pyramids were

8.35 The three queens' pyramids of Khufu, GI-a, b and c (left to right in the photograph) form a row along the eastern base of his pyramid. One of the Khufu boat pits lies between them, and Khufu's satellite pyramid (GI-d, centre) and cemetery GI-S (right) as well as the Eastern Cemetery (background) are also visible. View looking down the southeast corner of Khufu's pyramid from the top.

173

built after the temple and in harmony with it. But this does not explain why, if they had so carefully levelled the bedrock for the east side of the main pyramid and the temple and causeway, they would then have founded the first queen's pyramid, GI-a, so much higher up, on a rougher, much less carefully dressed bedrock surface. In our opinion, the differently worked bedrock surfaces are evidence that the builders came up with the temple and causeway plans *after* they had begun the queen's pyramid, with the design evolving during the course of construction.

Reisner also assumed the builders began the queens' pyramids after the temple. He cited a graffito, which his assistant Alan Rowe read as Year 13 (of Khufu's reign), near the entrance to Khufu's upper temple as a possible start date for the building of GI-a, followed by GI-b, which he thought could have been completed in one or two years. William Stevenson Smith had his doubts about the graffito, which Rowe had read off a very faint photograph, but Reisner and Smith generally saw Khufu's builders finishing the upper temple and pyramids GI-a and GI-b, along with the original 12 great mastaba cores of the Eastern Cemetery, by Khufu's Year 15.

GI-c may have been something of a laggard. The builders positioned it closer to GI-b than GI-b is to GI-a (4–6 m/13–20 ft and 10–12 m/33–39 ft respectively); in addition GI-c is set back from the

eastern baseline of the other two pyramids by 3.65 m (12 ft), giving it a smaller base. All of which could be taken as evidence it was added later. To our eyes, the builders used the same quality of soft, yellow backing stone, and darker stone for the inner structure, for GI-c as they had for GI-b, and possibly GI-a as well. This suggests that the builders had reserved supplies of the different qualities of stone for the various elements, thus adding to the impression that the three were created as a set piece.

Ownership

George Reisner and William Stevenson Smith assigned GI-a to a woman named Meretites. On the basis of a (now lost) stela dedicated to her that Mariette found in the Eastern Cemetery, she is thought to have been the daughter of Sneferu and Hetepheres I, and the chief queen of Khufu. The stela gives her name and her titles as queen to both Khufu and his father, Sneferu, implying that a wife of Sneferu passed into the harem of Khufu. The same female name appears in the texts of three small relief fragments found in the chapel of a mastaba belonging to Kawab, an 'eldest son' of Khufu (G 7110-7120), immediately to the east of pyramid GI-a, suggesting Meretites was his mother.

Reisner and Smith believed that the loose principle of familial proximity – that tombs of immediate family members are situated close to one another – strengthens Meretites' claim to the first queen's pyramid. Smith was confident that 'the position of Kawab's tomb makes it certain that he was the son of Cheops's chief queen buried in the Pyramid GI-a. The above evidence strongly suggests that this chief queen was [Meretites].'[44]

By similar reasoning, Reisner and Smith assigned the southernmost queen's pyramid, GI-c, to the mother of a prince called Khufukhaf, whose giant mastaba is the one immediately to the east (G 7130-7140). In the relief-carved scenes of his chapel, Khufukhaf depicts himself with his mother, who is labelled as a queen though not named [8.36]. The name of a Queen Henutsen is associated with GI-c only on the basis of the Inventory Stela, a 26th dynasty text found in the Isis Temple east of this pyramid. Although Henutsen was a common name in the Old Kingdom, so far we have no contemporary texts of a wife or daughter of Khufu bearing this name.

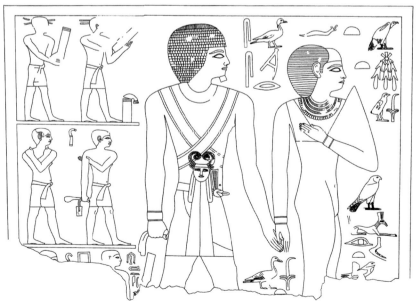

8.36 Royal son Khufukhaf and his mother, from Khufukhaf's chapel on the east side of his large mastaba tomb (G 7130-7140) east of queen's pyramid GI-c. Hieroglyphs read 'his mother who bore him, she who sees Horus and Seth', an epithet of a queen, and 'her son, her beloved, the king's son'. The queen's name is missing, but it has been suggested that it was Henutsen, the queen's name associated with GI-c in the Late Period, though this is only hypothetical.

A glance at the map shows that if we accept the principle of familial proximity, the middle queen's pyramid becomes problematic. To which adjacent mastaba might it correspond? Smith suggested this pyramid belonged to the mother of Djedefre, who became king (presumably after Kawab predeceased him) and moved to Abu Roash to build his own pyramid tomb. But this occurred well after the initial layout and early construction of the Eastern Cemetery, when Khufu's builders began 12 mastaba cores in four rows (east–west) of three mastabas (north–south), which would have positioned three large mastabas opposite the three queens' pyramids. Reisner stated: 'These twelve original cores, as far as can be seen, were never assigned but were probably intended for the same persons who were afterwards buried in the twin mastabas constructed later.'[45] By 'twin mastabas', Reisner alluded to the joining together of the two northern mastabas in each row, and the lengthening of the southern mastabas by adding a block of masonry to each. The result was eight mastabas in four rows, leaving, on the west, the three queens' pyramids opposite two, not three, large mastabas.

The name of the owner of the middle queen's pyramid is unknown. Clearly the evidence is sparse enough to admit different possibilities, and it should be noted that we do not know for certain the identity of any of the owners of these three queens' pyramids.

The tomb of Hetepheres I

One of us (Lehner) advanced the possibility that the first queen's pyramid was actually begun for the queen mother, Hetepheres I, whose burial assemblage, though not her mummy, Reisner's team found in 1925 at the bottom of a shaft, 27.42 m (90 ft) deep, just 28 m (92 ft) to the east of GI-a, nearly on line with its northern base (G 7000X) [**8.37**].[46]

Some time after the tomb builders cut the mouth of Hetepheres' deep burial shaft, they dressed the surface immediately to the south and began the unmistakeable T-shaped cutting of a descending passage and its support masonry – a passage like those in queens' pyramids GI-a–c. Reisner called this cutting GI-x. Jánosi doubts it is the beginning of a pyramid passage, but we agree with Reisner's interpretation, on the basis of similar cuttings for the descending passage of Khafre's satellite

pyramid, now exposed because the pyramid itself has been almost entirely removed down to bedrock.

Originally the builders had perhaps intended the first queen's pyramid to be above this cutting, on line with Hetepheres' tomb shaft. But then they shifted its position, constructing GI-a 28 m (92 ft) to the west. Reisner believed they did this to avoid Hetepheres' shaft, which he thought they sunk *after* they had begun the descending passage for GI-x. But why would they inconvenience themselves by placing this deep tomb directly in front of and on axis with the planned pyramid? An alternative view is that they began GI-x *for* Hetepheres – in other words, that the first queen's pyramid on the north was to have been for the queen mother. For whatever reason, and there are several possibilities to consider, they then moved this first queen's pyramid, which established the Eastern Cemetery, to the west. Lehner suggested the move could explain why Hetepheres' mummy was not found in her empty alabaster coffin in the tomb (even though her canopic chest and other equipment, albeit much of it in disintegrated condition, were there for Reisner to retrieve). Did Khufu's mortuary workers remove Hetepheres I from her coffin in this first tomb, and place her in the burial chamber of GI-a, possibly with an identical set of equipment?

We may never know whether or why Hetepheres' mummy was moved, but the enquiry reveals something about a queen's boudoir and burial goods of this time – and, perhaps, something about the queens' pyramids. Hetepheres I's equipment included furniture such as a bed canopy, bed and carrying chairs. Khufu's workers could install the larger pieces of furniture in the tomb only in a dismantled (but apparently not broken) condition, because the chamber at the bottom of the vertical shaft – 5.22 m (17 ft 1 in./10 cubits) long, 2.67 to 2.77 m (8 ft 8 in. to 9 ft/5 cubits) wide, and only 1.95 m (6 ft 5 in.) high – was too small [**8.38b**]. On the other hand, the burial chamber of GI-a appears to have been designed to be able take the queen's furniture in fully assembled condition. The floor space of this chamber, within the masonry casing, is 3.55 × 2.97 m (11 ft 7 in. × 9 ft 8 in.) according to Reisner, or 3.57 m (E–W) × 2.72 m (N–S) (11 ft 8 in. × 8 ft 11 in.) according to Maragioglio and Rinaldi. When assembled, Hetepheres' bed canopy

measures 3.2 × 2.5 m (10 ft 6 in. × 8 ft 2 in.), with a height of 2.2 m (7 ft 2 in.). This would leave about 18.5 cm (just over 7 in.) clear between the assembled canopy and the east and west walls of the chamber, and around 11 cm (a little over 4 in.) clearance to the north and south walls, according to Maragioglio and Rinaldi's dimensions for the chamber. The clearance to the ceiling would be 15 cm (6 in.).

In this scenario, because her bed canopy would take up nearly all the space in the burial chamber, not unlike the shrines of Tutankhamun, the workers would have had to place all the burial goods inside the canopy. As shown by the reconstructed graphic plan of the furniture and equipment within the confines of the GI-a burial chamber, the entire assemblage makes a near perfect fit [8.38a].

The equipment could not have been introduced if the canopy had been set up first, since it opens on one of its long sides, which would face the north or south wall of the burial chamber, whereas its entrance is on the east. Just as with Tutankhamun's shrines, it would have been necessary to assemble the canopy within the chamber.

Khufu's workers could have made the whole assemblage fit by positioning the heavy alabaster

coffin first, with enough space between it and the chamber walls for the canopy. They then could have assembled the canopy except for the poles and roof beam of the side facing the entrance to the chamber. Next they would have neatly stacked the rest of the equipment inside the erected canopy (having first placed the royal body within the

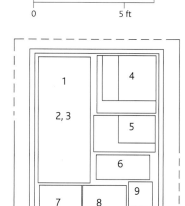

8.37 Noel F. Wheeler excavates the disintegrated and fragile contents of the tomb of Hetepheres I on 22 July 1926, in a photograph by Mustapha Abu el-Hamed.

coffin). The final items introduced would be the curtain box and the pottery. The curtains hung from hooks on the inside of the canopy and so the workers would have fixed them on the three sides as they erected them. They then set the three 'tent' poles of the last side facing the entrance into their sockets in the floor beam and joined the roof beam to the tops of these poles and to the perpendicular roof beams of the long sides of the canopy. Finally, they would have hung the curtain over this side, leaving the queen to sleep forever in her royal boudoir [8.39]. Hawass agrees with Lehner's theory, although he believes that the equipment was moved during the First Intermediate Period.

The chambers of the other two queens' pyramids, GI-b and GI-c, vary only slightly in their dimensions from GI-a, which suggests that they were designed to house an assemblage comparable to that of Hetepheres I. This implies, further, that her assembly was something of a standard for queens of this time. This idea is reinforced by the relief-carved depiction of a queen's burial assembly in the chapel of Queen Meresankh III under her mastaba in the Eastern Cemetery (G 7530-7540), which matches that of Hetepheres I. We see a bed canopy, bed, carrying chair, throne-like chair and

curtain box, all similar to the pieces that Reisner's team so carefully reconstructed from the remains in Hetepheres' tomb.

Does the fit between Hetepheres I's equipment and the chamber of GI-a suggest that it was in fact first installed in GI-a, and later dismantled and transferred to the chamber at the bottom of the deep shaft, rather than the other way round, as Lehner believes? Or were the chambers of Khufu's queens' pyramids designed to accommodate a standard set of queenly equipment? These are only hypotheses, and others might be equally plausible. No earlier, comparable queens' pyramids are known, but we could check the fit of such a set in the chambers of the mastabas near Sneferu's pyramids at Meidum and Dahshur.

The quarrymen never completed the chamber at the bottom of the deep shaft of G 7000X; they may have opened the annex cut high into the western wall, where Reisner found the canopic chest, as a widening of the chamber. The cuttings in the bedrock certainly suggest that Khufu's workforce began GI-a after GI-x and G 7000X, but just when they installed Hetepheres' burial equipment in its final resting place, and what happened to her body, are more open questions.

OPPOSITE RIGHT
8.38a, b Drawing of Hetepheres' funerary equipment as found in her tomb (below), and a diagram to show how it could have fitted into the burial chamber of GI-a (above). In the latter, the alabaster coffin (1) has been placed in the southwest corner of the canopy (13), with the bed (2) and carrying chair (3) on top of it. Eight boxes, of the same height but otherwise of varying dimensions, could have been stacked in the northwest corner, the first stack of five boxes (4) leaving a 20-cm (8-in.) clearance to the top of the canopy. The second stack (5) immediately east of the first would comprise three boxes, leaving a 1-m (3-ft) clearance to the top of the canopy. Beside this stack of boxes is the inlaid box (6). The two armchairs (7, 8) fit into the northern end of the canopy enclosure, along with the canopic chest (9), the curtain box (10) and on it the case with walking sticks (11). A small space is left for the pottery (12), which could also have been placed on the second stack of boxes, or, if necessary, on the other objects.

ABOVE
8.39 Hetepheres I's bed, chair, curtain box and canopy as reconstructed in the Museum of Fine Arts, Boston. Hieroglyphs on gold sheets that had once covered the furniture spelled the name Hetepheres, with the title 'Mother of the King of Upper and Lower Egypt' and the name of Khufu's father, Sneferu.

Superstructure of the queens' pyramids

Khufu's builders founded the queens' pyramids on a surface that slopes from northwest to southeast, as does the overall Moqattam Formation at Giza. Because they decided to accommodate the bases of all three pyramids to this slope, rather than levelling the surface first, the bases are not true squares but trapezoids. Further, the bases appear to be slightly twisted with regard to the cardinal directions and do not have exact corners.

Different researchers have come up with different measurements for the bases. In general terms, the first two queens' pyramids are around 46.5 m (152 ft 6 in./88–89 cubits) to a side.[47] Pyramid GI-c is roughly 3.65 m (12 ft) shorter, as the builders set back its east face by this amount in relation to the others. Its base is therefore smaller: 85 × 85 cubits (44.63 m/146 ft 5 in.). So the average length of a side is 87.5 cubits (46 m/151 ft). Maragioglio and Rinaldi took a fictive plane through the highest corner (always northwest for all Giza pyramids) as a base reference and came up with a side length of 90 cubits for GI-a and GI-b, and 85 cubits for GI-c.

When compared to the accuracy of the king's pyramid, where the variation can be measured in centimetres, there is certainly a huge difference in the lengths of the sides. The builders may have had in mind an ideal base length of 88 cubits (46 m/151 ft), which is one-fifth of the area of the Khufu pyramid.

Slope and height Again, the fact that the three pyramids accommodate the slope of the ground to the south and east means that their actual height from ground level varies according to the side of the pyramid. The builders may have planned for the apexes to be at about the same height visually, and this is perhaps in part why they enlarged the lower side of GI-b. On the other hand, they made the base of GI-c smaller, though it occupies yet lower ground, so they may have made the slope steeper to compensate. All three pyramids were robbed of most of their outer casings in antiquity, but parts remain at the base [**8.40**].

GI-a and GI-b had the same slope as the Khufu pyramid: 51 deg. 51 min. They rose to one-fifth of the height of the king's pyramid, giving a rise to run of 14:11. Petrie ascertained a slope of 52 deg. 11 min. (+/–8 minutes) for GI-c, a rise to run of 9:7.

Cores No one has been able to determine, either from the outside or from tracking the bedrock inside the descending passages, whether the builders left a bedrock massif in the centre of the core, as they did for the pyramids of Khufu and Khafre, though it is doubtful.

In addition to the casings, robbers also removed much of the core stone, especially from GI-a, of which only the lower half remains, leaving the core of GI-c the most complete. The inner cores of all three pyramids show crude steps, not like the regular steps of the older step pyramids, but rather tiers or stages of building, with distinctive masonry in each stage.

In both GI-a and GI-b relatively well-squared blocks composed an outer shell for each 'step', with stretchers and headers at the corners to provide greater stability. The builders set each course of the faces of the inner steps back from the one below to achieve a batter or slope, which Jánosi states is about 75 degrees – similar to the cores of the large mastabas at Giza. It is not entirely clear whether the builders made the steps as a series of accretions – 'skins', or internal casings – or whether the steps are simply massive mastaba-like chunks formed of looser fill inside the outer shell. Maragioglio and Rinaldi, as well as Jánosi, see it as probable that GI-a is formed of accretions; if so, GI-b probably follows suit.

One intriguing piece of evidence of the builders at work survives at the northwest corner of the first step of GI-a. There, a kind of masons' control wall, comprising smaller blocks than those of the first step, is stepped back 3.15 m (10 ft 4 in./6 cubits) from the north and west sides of the step, running for about 4.5 m (14 ft 9 in.) to the south. Three red-painted horizontal levelling marks are visible on the face of the little wall. The notations '7 cubits' and '8 cubits' accompany the highest lines. A painted triangle hangs down from the higher, 8-cubit line; a sloping line that corresponds with the slope of the face of the inner steps intersects with the lower 7-cubit line.

Maragioglio and Rinaldi interpreted this wall as a guide for the builders when creating the top of the first step and for the orientation and slope of the second step of the core pyramid, set back 6 cubits from the first. The sloping line indicated the alignment and the batter of the next step up.

8.40 A corner of Turah limestone casing blocks of queen's pyramid GI-b, set on a foundation platform.

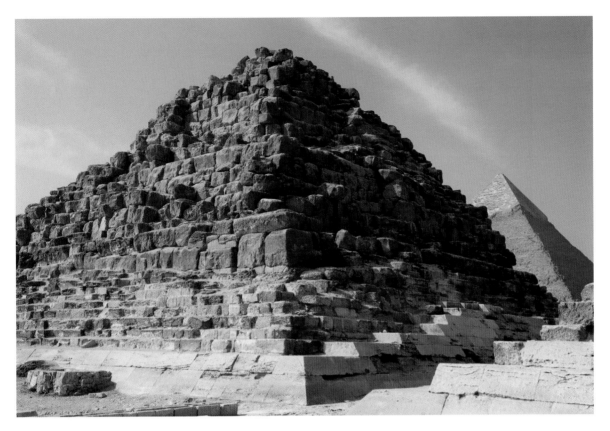

8.41 The northeast corner of queen's pyramid GI-c, revealing casing at the bottom dressed down to the bedrock floor, then soft yellow backing stones, two steps or tiers to the core, with packing stones, and the upper pile of boulders. View to the southwest, with the Khafre pyramid in the background.

They saw each queen's pyramid as composed of three steps. But Jánosi pointed out that if each of the three steps averaged 8 cubits (4.2 m/13 ft) high, as the control wall seems to indicate for the height of the first step in GI-a, the core body of each pyramid would be only 12–13 m (39–43 ft) tall, something more than a third of the final height of the pyramids, and too small for a core construction. In fact, Jánosi measured the height of the upper steps in GI-b and GI-c as 6.5 m (21 ft 4 in./12 cubits), and the lowest step in the same pyramids as 11.5 m (37 ft 8 in./22 cubits) – that is, almost double the height of the upper ones. The first step at the northwest corner of GI-a is 4.2 m (13 ft 10 in.) or 8 cubits, as the small control wall indicates. From this, Jánosi concluded that the three queens' pyramids must have had four steps, like the pyramids of Menkaure's queens GIII-b and GIII-c.

The first steps of pyramids GI-b and GI-c are thicker than that of GI-a because they accommodate a greater southeasterly slope of the ground and so extend further down than GI-a. In this way the builders could make a platform at roughly the same level as the top of the first step of GI-a. The builders continued to compensate for the downward slope

of the ground in the second step of GI-b, which is 6.5 m (21 ft 4 in./12 cubits) thick, compared to 5 m (16 ft 5 in.) for the equivalent in GI-a. However, it is not entirely clear what different observers take as the steps in the core, and these questions require fresh survey and measurement.

GI-c Queen's pyramid GI-c is the most complete and so reveals most about the methods of construction used for these small pyramids, which in turn may also tell us something about those used for the giant pyramids. We base the following interpretations on our own observations of this pyramid, rather than published descriptions and measurements by others.

The structure of the core of GI-c can be viewed most clearly by looking up at it from some distance from the northeast corner [**8.41**]. From here, we discern three tiers or steps, composed of very large limestone blocks with a dark patina, in courses that vary in height between 90 cm (3 ft) and 1.5 m (5 ft). Packing stones filling in the steps obscure the pattern. They are about the same size and quality, and with the same dark patina, as the stones forming the three tiers of the inner step pyramid.

179

The builders made no pretence to accuracy as they built the inner steps of crude masonry. Because of the irregularity of the stones, the width of the top of the first step varies between 3.7 and 3.8 m (12 ft to 12 ft 6 in., or 7 cubits). Sand and debris now covers the top of the second step; we measured on the slope that it extends out about 5.7–5.8 m (18 ft 8 in.–19 ft) and suspect a true horizontal measure would be 5.2–5.3 m (17–17 ft 5 in.) – exactly 10 cubits, a royal cubit being 0.525 m in the Old Kingdom. We lack a good measurement for the width of the projecting top of the third tier.

The top of the pyramid core is now simply a pile of unsquared stones, practically boulders, where the builders abandoned even the approximate regularity of the lower tiers. If we accept that there are four steps in the pyramid core, then this general jumble of stones is the fourth. But the builders did not create this pile of unshaped stones and then case it – rather, it is the remains of the fill that they put between the four faces of the casing as they brought them to the point at the top of the pyramid.

In summary, it appears to us that Khufu's builders formed the pyramid's core in three tiers or steps, filling in the steps with packing stones. Then, beginning at the bottom, they encased the whole with fine Turah limestone. On top of the third tier, they filled the space between the four faces of the outer casing with packing stones that are little more than unshaped boulders.

At certain places in the core masonry we can see roughly vertical discontinuities or seams running through the irregularity of the stones. The seams suggest the builders formed each tier of the inner step pyramid of GI-c in two mastaba-like chunks, leaving this rough join between the two sides. The pattern is not entirely clear, and the seams are more visible on the south and west sides.

An accretion layer of small, soft, yellowish limestone blocks remains near the base. We call these 'backing stones' because the builders inserted

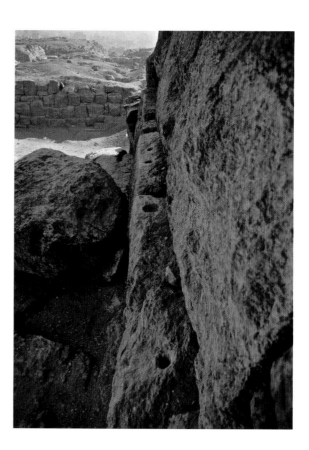

8.42 Small holes in the top of the projecting lower course of the second tier or step of the core of queen's pyramid GI-c, possibly used to help maintain the straight lines of the casing. View to the east.

them immediately behind the outer casing to fill the space, about 3.5 m (11 ft 6 in.) wide, between the pyramid core and the casing. The backing stones are lighter in colour, irregular in shape and weather differently from the core and packing stones. The builders used this stone because it was easier to shape to fit between the already laid core masonry and the outer casing. There is no standardization in these stones – they are a little over 40 cm (16 in.) high and thick, and range from 54 cm to 1.2 m (21 in. to 3 ft 11 in.) in length.

Small holes, 5–6 cm (around 2 in.) in diameter and up to 7 cm (almost 3 in.) deep, at the corners of the core steps or tiers might indicate how the builders maintained the straight lines and the square of the fine, outer casing as they raised the crude inner core [8.42]. One possibility is that wooden pegs inserted in the holes carried cord that could be used for levelling or as a reference from which the masons measured out to establish the lines of the pyramid face on the undressed casing blocks (though some of the holes seem too shallow to secure pegs). The masons cut away the outer edges of the tiers into rebates or little steps, which we also see in the core masonry of other pyramids

Reconstructed lengths of the sides of Khufu's queens' pyramids' bases[48]

	GI-a	GI-b	GI-c
N	46.8 m (153 ft 6 in.)	47.8 m (156 ft 10 in.)	45.5 m (149 ft 3 in.)
E	49 m (160 ft 9 in.)	48.9 m (160 ft 5 in.)	46.7 m (153 ft 2 in.)
S	48 m (157 ft 6 in.)	48.2 m (158 ft 2 in.)	46.8 m (153 ft 6 in.)
W	46 m (150 ft 11 in.)	47.1 m (154 ft 6 in.)	45.2 m (148 ft 4 in.)

and mastabas at Giza. These rebates may mark the line where they stretched the cord between the pegs at the corners, though the rebates do not always extend all the way along a course from one corner to another. Here and there on pyramid GI-c, there are also short rows of holes near the corners of the tiers. One suggestion is that they were used as backsights: the masons put a pole in the hole and sighted to it from down on the ground for aligning the inner step pyramid, in which case the holes simply functioned as a position point.

Casing At the very bottom of pyramid GI-c the original casing is preserved, with blocks ranging in thickness from 1.38 to 1.44 m (4 ft 6 in. to 4 ft 9 in.) as they project more or less deeply into the soft backing stones. As you look along the line of the northern base of the pyramid towards the west, it is apparent that the builders dressed the casing down to the bedrock, accommodating its slope up to the west. Then, from a point just east of the pyramid entrance, they set the casing blocks into a slight depression cut into the bedrock. From here, below their intended ground level, they left these blocks undressed and rough, with an increasing amount of extra stock of stone protruding (up to 84 cm/33 in. at the foot). It is clear that the builders custom cut the casing to fit the slope – in other words, they fitted the base of the pyramid to the slope of the plateau, rather than the reverse, and did not level the bedrock [**8.43**].

On the top of the casing block that forms the northwest corner of GI-c, which sits directly on the bedrock, we noted two fine, incised lines made by the masons to mark the intersection of the western and northern faces of this course of casing – thus defining the corner. The stone outside the line on each side was left as extra stock, and would have been removed in the final dressing. At the point where the corner of the finished pyramid would be, the ancient masons took a chisel and bevelled a line as a kind of preparation for cutting away the extra stone to free the pyramid faces. Looking down the western side of the pyramid to the south, the bevelling along the outside of that line becomes progressively wider and deeper, forming a virtual channel. The upper, inner side of the channel is the crude pyramid slope, still lacking its final smoothing. From the fourth or fifth casing block

from the northwest corner, the channel becomes the smoothed, angled face of the pyramid, with some chisel marks visible where the masons had not yet finished the final dressing. The channel represents the point the workers had reached in dressing the face of the pyramid from the top down when they stopped.

In general, it seems the masons dressed pyramid casing from the top down – but perhaps not from the very top of the pyramid. There is some evidence from Khafre's pyramid that the builders pre-cut the uppermost casing courses to their desired finished shape and size, and did not leave any extra stock of stone to be dressed later. The casing courses that remain intact near the top of Khafre's pyramid are smaller than the casing stones at its bottom, or at the bottom of GI-c. They are also not flush – they protrude or recede by millimetres. This could be a result of the settling of the pyramid, but perhaps space was so tight at the top of the pyramid that it would have been difficult for the masons to custom cut one block to another, as they did with such care at the base, as seen at GI-c.

The substructure of the queens' pyramids

The chief characteristic of all queens' pyramids at Giza is a bent passage system that offsets

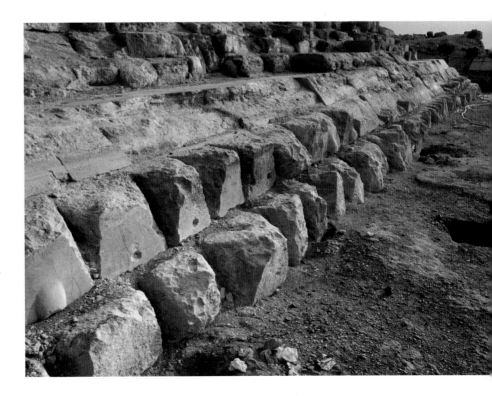

8.43 The southern base of queen's pyramid GI-c, showing the extra stock of stone on the faces of the undressed casing blocks that were meant to be below the intended floor level, made up by stoneworking debris that we excavated away in 1992–93. View to the east.

Entrance corridor

	Length	Height*	Width	Slope
GI-a	16.8 m (55 ft)	1.21 m (4 ft)	1.03–1.05 m (3 ft 4 in.– 3 ft 5 in.)	33 deg. 35 min.
GI-b	11.38 m (37 ft 4 in.)	1.24 m (4 ft 1 in.)	1.1 m (3 ft 7 in.) (mouth)	33 deg. 10 min.
GI-c	16.98 m (55 ft 8 in.)	1.21 m (4 ft)	0.97 m (3 ft 2 in.) (lower end)	27 deg. 30 min.

*Perpendicular to slope

Horizontal corridor

	L (N–S)	H	W (E–W)
GI-a	3.2 m (10 ft 6 in.)	1.2 m (3 ft 11 in.)	1.03 m (3 ft 4 in.)
GI-b	3.45 m (11 ft 4 in.)	1.25 m (4 ft 1 in.)	0.98–1 m (3 ft 2 in.–3 ft 3 in.)
GI-c	0.22 m (9 in.)	1.34 m (4 ft 4 in.)	0.97 m (3 ft 2 in.)

Antechamber

	L (N–S)	H	W (E–W)	Ramp slope
GI-a	4.25 m (14 ft)	2.94 m (9 ft 8 in.)	1.78 m (5 ft 10 in.)	29 deg. 30 min.
GI-b	1.83–2.78 m (6–9 ft)	2.4 m (7 ft 10 in.)	3.01 m (9 ft 10 in.)	24 deg.
GI-c	3.34 m (11 ft)	2 m (6 ft 6 in.)	2.64 m (8 ft 8 in.)	level

the subterranean burial chamber to the west. The chamber of GI-a lay almost exactly under the apex of the pyramid, being just west of centre, while the burial chambers of GI-b and GI-c were under the northwest quadrant of the pyramid base. In all three queens' pyramids the entrance corridor opens in the north face and slopes to a short horizontal passage leading to an antechamber, from which another short, steep corridor leads west to the sarcophagus chamber [**8.44**].

The entrance passage in GI-a slopes for around 4.73 to 5 m (15 ft 6 in. to 16 ft) through the pyramid's masonry, with the rest cut through bedrock. For reasons unknown, the passage of GI-b is significantly shorter than those of the other two.

8.44 Profiles of the three Khufu queens' pyramids by John Shae Perring, showing the cross-section of the substructures carved from the bedrock.

The antechambers were in effect just enlargements of the entrance corridors, probably to create space to bring in the Turah-quality limestone casing blocks for the interior of the burial chambers, and to introduce the sarcophagus. The east walls of the antechambers in GI-a and GI-b are further widened for this purpose: the former looks like an afterthought, while that in GI-b was planned, probably due to prior experience in GI-a. The blocks of Turah limestone the builders brought in to encase the burial chamber of GI-a measured around 2.9 × 0.8 × 0.55 m (9 ft 6 in. × 2 ft 7 in. × 1 ft 10 in.), which would have just cleared the widened space in the antechamber when making the turn. A putlog hole in the east wall of GI-a, and a similar one in GI-b, probably held a wooden post for ropes to help manoeuvre the big blocks around the bend.

The floors of the antechambers of both these pyramids slope in the form of a ramp from the end of the horizontal passage to the entrance into the burial chamber. In spite of the planning and provisions evident in GI-b's antechamber, no trace of ceiling blocks has been found, so we cannot be certain that the builders installed the ceiling in this burial chamber. GI-c has a simpler antechamber, lacking the steep ramp and the widening of the eastern wall, but the builders made the space larger than the preceding entrance passage by creating a rectangular chamber.

The sloping connecting corridors make a right-angle turn, placing the burial chamber squarely to the west. In GI-a the builders narrowed the original width of the passage by adding limestone casing blocks to its north side; neither GI-b nor GI-c have such casing in their connecting corridor.

The builders encased the walls of all three burial chambers in limestone blocks. In addition to the

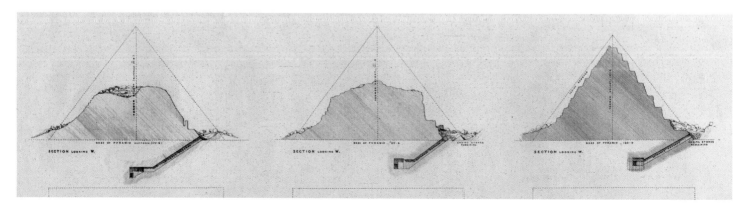

walls, the builders encased the ceiling of GI-a's burial chamber. In GI-b and GI-c the casing is badly damaged, and it is not certain if it covered the ceiling, though Maragioglio and Rinaldi thought it probably did. In their architectural drawings, they reconstruct a ceiling casing 55 cm (22 in.) thick for GI-b, leaving a height of 3.53 m (11 ft 7 in.) between floor pavement and ceiling. They suggest a ceiling casing 62 cm (24 in.) thick in GI-c. However, the length of the slabs required to span the roof of GI-b (3.15 m/10 ft 4 in./6 cubits) seems too long for them to have been manoeuvred round the turn through the antechamber, and as Maragioglio and Rinaldi stated that none of the pieces of blocks that remained in the burial chambers during their 1960s survey could have belonged to ceiling slabs, it seems unlikely that the builders encased the ceilings of GI-b and GI-c.

Peter Jánosi further points out that no ceiling existed in the oldest completed limestone-encased burial chambers of mastaba tombs.[49] As with the queens' burial chambers, slabs long enough to bridge the gap between wall casings were just too difficult to bring into the subterranean chamber. (That the task was not beyond ancient Egypt's builders is shown by the ceiling slabs in the burial chamber of Menkaure's queen's pyramid GIII-b, but here the antechamber and burial chamber were built into a single space hewn from bedrock.)

As can be seen from the table, there is a marked difference in size between the spaces that Khufu's builders hewed from bedrock to form the burial chambers of his queens and the final dimensions of those chambers after they encased them in Turah limestone. (Reisner also took measurements of these chambers, which vary from those of Maragioglio and Rinaldi.[50])

The burial chamber of GI-a, both as cut from the bedrock and when encased, is orientated east–west. The bedrock chamber of GI-b is almost square, 10 × 10 cubits (5.35 m/17 ft 7 in. north–south), but when the builders cased the chamber, the blocks of masonry on the north side occupied an extra 1.7 m (5 ft 7 in.) as opposed to about half a metre (1 ft 8 in.) on the south, shifting the encased chamber to the south, though it is also orientated east–west. In GI-c the builders similarly cut a relatively square chamber from bedrock, 5.15 m (16 ft 10 in.) north–south, and encased the burial chamber towards the south of this space, again orientated east–west.

Connecting corridor

	L (E–W)	H*	W (N–S)	Slope
GI-a	4.15 m (13 ft 7 in.)	1.04 m (3 ft 5 in.)	0.94–0.98 m (37–39 in.)	34 deg. 15 min.
GI-b	3.35 m (11 ft 1 in.)	1.15 m (3 ft 9 in.)	0.97–0.98 m (38–39 in.)	29 deg.
GI-c	2.85 m (9 ft 4 in.)	1.05 m (3 ft 5 in.)	0.98–1.05 m (39–41 in.)	25 deg.

*Perpendicular to slope

Burial chamber

Bedrock hewn:

	L (E–W)	H	W (N–S)
GI-a	5.15 m (16 ft 10 in.)	3.45 m (11 ft 4 in.)	4.34 m (14 ft 3 in.)
GI-b	5.5 m (18 ft)	3.75 m (12 ft 4 in.)	5.35 m (17 ft 7 in.)
GI-c	5 m (16 ft 5 in.)	3.85 m (12 ft 8 in.)	5.15 m (16ft 10 in.)

Encased:

	L (E–W)	W (N–S)
GI-a	3.57 m (11 ft 8 in.)	2.72–2.86 m (8 ft 11 in–9ft 5 in.)
GI-b	3.95 m (13 ft)	3.15–3.16 m (10 ft 4 in.–10ft 5 in.)
GI-c	3.7–3.72 m (12 ft 2 in.–12 ft 3 in.)	2.95 m (9 ft 10 in.)

Queens' pyramid chapels

After the pyramids were completed and the royal women had been interred, the chapel on the eastern side of each pyramid became the cult focus, where family and descendants brought offerings and possibly petitioned these influential persons in 'that city' of the Afterlife. Unlike all three of the kings' upper pyramid temples, where a space was left between the back of the temple and the pyramid, the chapels of Khufu's queens' pyramids were built directly against the bases of the pyramids, with limestone walls enclosing a long north–south room.

The chapel of GI-a was removed down to bedrock before modern times, but it is clear from the foundations where the builders dressed the bedrock that it was about the same size as the chapel of GI-b.

GI-b chapel dimensions

Ground plan:

14.75 × 6.2 m (48 ft 4 in. × 20 ft 4 in.); 28 × 12 cubits; 7:3

Cult room:

10.5 × 2.1 m (34 ft 5 in. × 6 ft 10 in.); 20 × 4 cubits; 5:1

GI-c chapel dimensions

Ground plan:

11 × 4.2 m (36 ft × 13 ft 11 in.); 21 × 8 cubits

Cult room:

7.9 × 2.1 m (26 ft × 6 ft 10 in.); 15 × 4 cubits

Given the indications that these two pyramids were built at about the same time, it is likely they had similar chapels. The remains of GI-b's chapel rest on a foundation of levelled bedrock. Like the chapel of GI-c, it is positioned slightly off the centre axis of the pyramid (even given the fact that the lengths of the sides of the pyramid differ), by about 90 cm (3 ft) to the north. A section of the western wall still stands against the base of the pyramid. A double-recessed niche – a stylized false door – survives in the northern part of this wall. Reisner thought an identical niche once stood in the southern part of the same wall. He also interpreted four limestone slabs in front of the entrance of the chapel as the remains of an entrance hall or vestibule orientated east–west, though this is not certain.

The builders placed the chapel of GI-c on foundation blocks, rather than on levelled bedrock, because the surface here slopes away too much to position the chapel at the right height in relation to what they took as the baseline of the pyramid. Even with the lack of a true square to the pyramid base, this chapel is about half a metre north of the ideal east–west central axis of the pyramid. The chapel's ground plan is well preserved, in part because by the Late Period people had incorporated it into an expanded Temple of Isis, Mistress of the Pyramids (discussed in Chapter 20).

The original GI-c chapel is smaller than that of GI-b. The entrance is also offset north of the chapel's centre axis by 1.05 m (3 ft 5 in./2 cubits). In the south end of the western wall one side of a false-door niche is preserved. The chapel had probably suffered much damage prior to the 18th dynasty, when there is evidence it was already the focus of a cult of Isis. People in both the 21st dynasty and in the 26th altered the chapel and expanded its ancillary structures to the east across the street, and up and over the ruins of mastaba G 7140. Remains of the eastern wall show it was built of large upright slabs with limestone debris fill, though this could have been a rebuilding of the later periods. Part of a recessed panelled 'palace-façade' decoration survives, carved in relief on the outer face of the eastern wall. Someone also rebuilt the southern wall of the chapel with limestone blocks set irregularly.

Given that GI-b has a niche preserved in the northern end of its inner western wall, and that

GI-c has one preserved in the southern end of the equivalent wall, it is probable that both chapels had a symmetrical pair of these abbreviated 'false doors', like the double false-door niches on the eastern façades of certain early large mastaba tombs. The false-door niches were the focus of offerings and communion with the dead. William Stevenson Smith and Rainer Stadelmann both suggest that one of the false doors in each chapel was for the king. Jánosi points out that two niches are found only on the façades of mastaba chapels, never in the interior.

The L-shaped chapels attached to some early Giza mastabas, including the 12 immediately east of Khufu's queens' pyramids, have a single niche in the back wall. The chapels of some of the largest and oldest 4th dynasty mastabas, G 4000 (Hemiunu) and G 7510 (Ankh-haf), have two niches (see Chapter 13). Jánosi also notes that the unfinished, and uninscribed, limestone chapel attached to the southern end of the eastern face of mastaba 17 is nearly the same size and configuration as the chapel of pyramid GI-b, but has only one niche in the southern end of the west wall.

8.45 The boat pit cut into bedrock between queens' pyramids GI-b and GI-c. View to the west. The hole just visible at the far end may represent a ring for attaching mooring ropes, while walls of small stones perhaps represent cross bracing and a groove or trench along the bottom a keel.

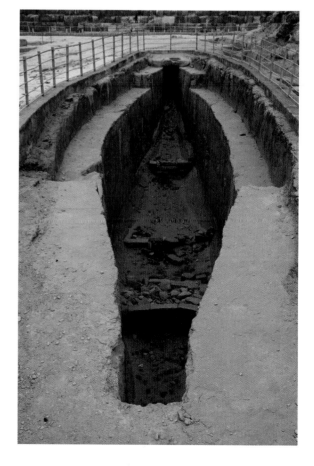

Boat pits

In addition to the five giant boat pits belonging to Khufu's Great Pyramid, two smaller boat-shaped pits lie between the queens' pyramids. One end (the prow?) is fitted with a limestone block with a round hole – a kind of mooring ring. The ends of the pit between GI-b and GI-c are narrow and boat-like. Running along the bottom of this pit is a groove, 40 cm (16 in.) wide, which may simulate a keel. Five lines of stones that cross the widest part look like the cross bracing between hull planks in the reassembled ship of Khufu. The ancient quarrymen may have fashioned this pit out of bedrock to imitate the form of a real wooden boat [**8.45**].

The western end of this pit is in fact close to Khufu's satellite pyramid and it is therefore possible that it represents a 'docking' there – in the same way that the boat pit alongside the causeway 'docks' at the entrance to the mortuary temple – rather than being associated with the queens' pyramids. Hawass excavated the south side of GI-c and found evidence of levelling, presumably for a boat pit, but this was never cut because the pyramid was left unfinished.

The causeway

Although the northernmost queen's pyramid, GI-a, stood less than a metre from Khufu's upper temple, there was no access from the queens' pyramids into the temple. It is entirely possible that the only way to gain entrance to the upper temple and pyramid court began hundreds of metres to the east, in the valley temple. From there, a causeway ran for approximately 825 m (2,707 ft) to the upper temple. If Khufu's causeway followed the pattern of Khafre's, it would have been roofed with great limestone slabs that left a narrow space down the centre. This slit allowed a continuous shaft of light to pierce the dim corridor.

Based on the testimony of Herodotus and a few carved pieces found near the upper temple, the causeway walls must have been covered with fine relief carving. Herodotus says the causeway took ten years to build, and this seems no exaggeration when we consider that its foundations rose to a height of 45 m (148 ft) to bridge the eastern escarpment and accommodate the difference in height between the floor levels of the upper and lower temples.

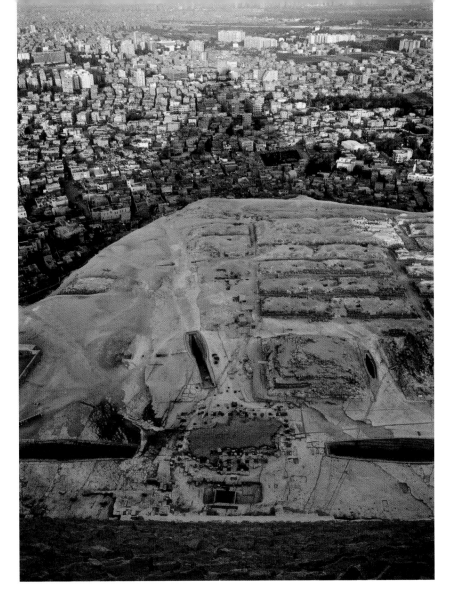

The valley temple also lies 280 m (918 ft) north of the east–west axis of the Khufu pyramid, so the causeway had to bend, increasing its overall length.[51]

From the upper temple, the causeway heads off in a straight line at an angle 14 degrees north of due east. It first descends the gradual slope of the plateau until it reaches the steep edge of the escarpment, called Senn el-Agouz ('the Old Tooth'), overlooking the Nile Valley. All that remains is the cutting in the bedrock for the causeway's foundation [**8.46**]. A century ago, the causeway foundation east of the escarpment was still visible, and it appears on the earliest maps of Giza. But this mighty work has since been largely dismantled for building stone as the settlement of Nazlet es-Samman expanded from what was originally a village to become a sprawling suburb of 300,000 people along the base of the pyramid plateau.

At a point 135 m (443 ft) from the upper temple, a tunnel 1.57 m (3 cubits/5 ft 2 in.) wide passes beneath the causeway. Including the open trenches

8.46 View from the top of the Khufu pyramid, with the eastern base just visible, as well as the temple remains and the line of the causeway's foundation cut into bedrock to the edge of the escarpment. The pyramid's shadow points due east, out over Cairo.

8.47 Remains of the masonry ramp at the edge of the escarpment that would have supported the causeway.

that slope down into the tunnel at either end, the entire passage extends for 33.85 m (111 ft). One of two pairs of holes in the walls of the southern trench have cuttings to allow wooden beams to be slid into the sockets. After the walls of the causeway made it impossible to haul material across its route, stones may have been dragged beneath it.

At the escarpment edge, remains of the huge masonry ramp that carried the causeway out over the low desert are visible as isolated groups of blocks [**8.47**]. From here the ramp disappears under the modern conurbation. In 1989, a project began to improve sewage disposal for this urban area as part of the Greater Cairo Wastewater Project, and, at the request of the Supreme Council of Antiquities, to lower the groundwater in the vicinity of the Giza pyramids and especially the Sphinx. A British–American consortium, AMBRIC, carried out the work. Archaeologists from the Giza Pyramid Inspectorate monitored the archaeology, in co-operation with Michael Jones. The work was extremely difficult because of the narrow streets and alleyways between the houses of the crowded village, but the trenches opened for the drainage project provided an unprecedented opportunity to examine the remains of monuments belonging to the lower level of Khufu's pyramid complex.

At six points excavations revealed a monumental limestone construction on axis with the projected direction of the causeway of Khufu's pyramid (see p. 389). In Khaled Ibn el-Walid Street one trench hit a

fragment of the south wall of the massive limestone revetment constructed to support the causeway, the first time that a clear view of the south side of the embankment had been drawn and photographed, although a large part of the north side remains exposed at Senn el-Agouz. In 1968, excavations by G. Goyon in Abdel-Hamid el-Wastani Street successfully exposed another part of the causeway in the same direct line. Goyon believed he had found the end of the causeway and the location of the valley temple. But then in 1990, Michael Jones ascertained that at that point of the excavation, the causeway in fact turns 32 degrees to the north of its original direction and continues from there an additional 125 m (410 ft) to the actual valley temple.

Valley temple and harbour

The location of the valley temple of the Great Pyramid of Khufu had been a matter of speculation and conjecture ever since it was recognized that the standard pyramid complex included an upper and a lower temple, connected by a causeway. In March 1990, a pavement of black-green basalt blocks was discovered during the AMBRIC sewage system construction mentioned above. It is a match to the basalt pavement in the upper temple and must mark the location of Khufu's lower, valley temple.

The blocks lay around 14–14.5 m (46–48 ft) above sea level, and 4.5 m (15 ft) below the present ground level in the area. Overlying strata of pure

Nile alluvial silt had sealed them in their current condition. The basalt pavement was neither continuous nor complete – blocks had been removed in antiquity, reducing the original area, although some of the apparent gaps may represent the positions of dividing walls of mud brick or stone that were either destroyed or have disintegrated.

At the southern edge of the area of basalt blocks, excavation revealed part of a mud-brick wall, possibly as much as 8 m (26 ft) wide, although its south side was not definitely determined. North of this wall, the basalt blocks extend for 56 m (184 ft) in the trench. Five test trenches dug west of the original one yielded valuable details about the configuration of the basalt blocks. The fact that no remains of later periods were found in the overlying material, and that there was no indication that pits or trenches had been cut through the silt to extract blocks, makes it seem safe to assume that the temples were destroyed in antiquity. Further evidence to support this conclusion comes in the form of one typically Roman amphora sherd found among a group of basalt flakes.

The contours of the modern valley show a subtle depression, 325 m (1,066 ft) east–west and 550 m (1,804 ft) north–south, which extends 500 m (1,640 ft) east of the valley temple location. This broad depression may be the buried ancient harbour that Egyptologists believe was situated in front of pyramid valley temples. In 1993, construction workers digging for the foundations of apartment complexes 500 m (1,640 ft) east of the Khufu valley temple location hit a colossal stone wall made of basalt and limestone and running north–south along the eastern limit of the depression. We call it the Zaghloul Street Wall after the nearby thoroughfare. It was about 2.5 m (8 ft 2 in.) below the surface, and thus slightly higher than the level of the basalt blocks that probably mark the location of Khufu's valley temple. We measured the wall as 4 m (13 ft) wide across its limestone foundation, narrowing to about 3.5 m (11 ft 6 in.) wide across the basalt slabs that cap the top. These remains appear to be the undressed foundation for finished faces that sloped up to a rounded shoulder, just like the pyramid enclosure wall [8.48].

In AMBRIC sewage trenches, Michael Jones documented other fragments of similar walls, running east–west, one to the north and the other on the south of the subtle depression in the valley floor. A rectangle drawn joining the wall fragments on its northern and southern perimeter, the Zaghloul Street wall on its east and the Khufu valley temple location on the west, measures 400 m (1,312 ft) north–south by 450 m (1,476 ft) east–west. Could this outline a huge, artificially dredged harbour for Khufu's pyramid complex? Another possibility is that the walls were parts of a city wall, defining the settlement associated with the Khufu pyramid.[52] Having thus tentatively located the valley elements of Khufu's complex, we can calculate that from the western side of the pyramid to the Zaghloul Street wall, the whole stretched more than 1.5 km (almost 1 mile) from west to east.

After Khufu's death and burial, his pyramid, temples, causeway, harbour and cemeteries stood in splendid isolation on the Giza Plateau; the familiar alignments between the pyramids, and the concern for an overall unity of design, were yet to appear. Khufu's son and successor, Djedefre, moved his pyramid to Abu Roash, 8 km (5 miles) to the north. It was with Djedefre's successor, another son of Khufu, that a second pyramid was to rise on the Giza Plateau, to vie with, and to complement, the Great Pyramid, and it is to this we now turn.

8.48 The Zaghloul Street wall of limestone and black-green basalt, 500 m (1,640 ft) east of the Khufu valley temple. View to the south.

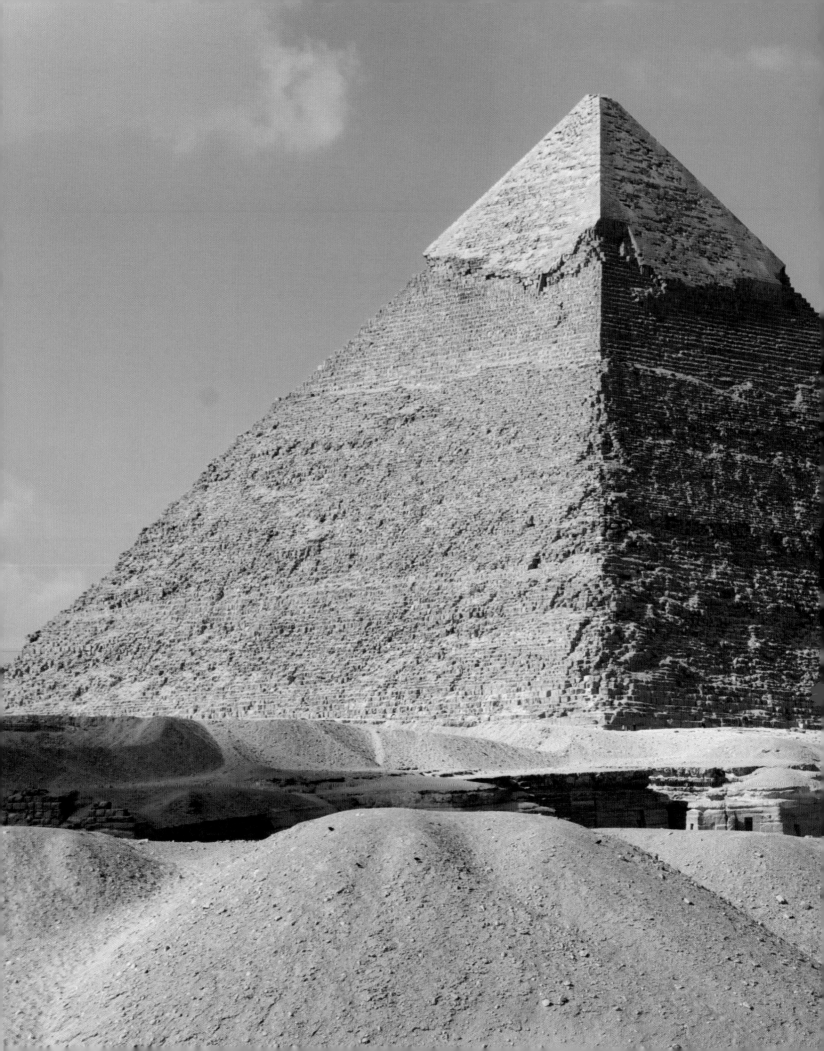

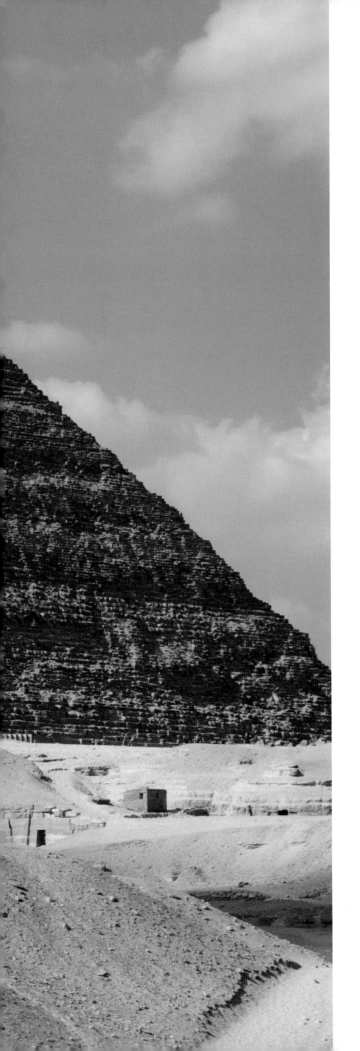

The second pyramid: Khafre

After the completion of the Great Pyramid there was a gap in pyramid building at Giza as the royal construction crews shifted several miles north to build the pyramid of Khufu's son and immediate successor, Djedefre, on a high ridge at Abu Roash. The length of Djedefre's reign is uncertain, though evidence has now been found to suggest it was as long as 23 years,[1] after which construction returned to Giza. Builders now raised the pyramid of Khafre, Khufu's second son, directly southwest of his father's. It was once generally thought that some kind of family rift was behind the interruption of the Giza sequence, but the true cause remains a matter of speculation.

PREVIOUS PAGES
9.1 The Khafre pyramid looking over the Central Field West quarry that furnished most of the stone for Khufu's pyramid. Khafre's children, princes and queens carved their tombs from bedrock in the vertical quarry cut or cliff, the upper ridge of which is visible just above the spoil heaps that Selim Hassan left when he excavated the quarry cemetery in the 1930s. View to the northwest.

Traces of all the major components of Khafre's pyramid complex survive, so it is still possible for visitors to experience them today. They can progress from the valley temple to the upper temple, walk round the pyramid itself and penetrate to the heart of the complex – the burial chamber, here carved into the bedrock rather than built high up in the pyramid. In ancient times – at least at flood season – visitors probably arrived from the east by way of a harbour. As well as this harbour, Khafre's valley complex also included the valley temple and a landing stage, and, in our view, the Sphinx and Sphinx Temple; these last two form major monuments in themselves and are the subject of the next chapter.

Khafre pyramid: major explorations

Years	Monument	Excavator or surveyor
1798	Sphinx measured	M. Colonel Jacotin and E. Jomard
1817	Sphinx east excavation	G. B. Caviglia
1818	pyramid entered	G. Belzoni
1837	pyramid and Sphinx explored	R. Howard Vyse, J. S. Perring
1853, 1858	valley temple interior cleared	A. Mariette
1880–82	valley temple interior mapped	W. M. F. Petrie
1885	Sphinx sanctuary cleared	G. Maspero
1909–10	upper temple, valley temple, satellite pyramid excavated	U. Hölscher
1925–35	Sphinx, Sphinx Temple, valley temple east excavated	E. Baraize
1936–38	Sphinx north, Sphinx Temple east, valley temple east excavated	S. Hassan
1960	satellite pyramid cleared	A. Hafez Abd el-'Al
1965–67	Sphinx Temple surveyed	H. Ricke, G. Haeny
1966	whole complex surveyed	V. Maragioglio and C. Rinaldi
1967	Khafre's pyramid geophysical survey	L. Alvarez
1974–78	Sphinx, pyramid geophysical survey	SRI International, remote sensing
1979–83	Sphinx, Sphinx Temple, valley temple survey	M. Lehner and James Allen
1980	Sphinx Temple east test trenches	Z. Hawass
1995–96	valley temple east cleared	Z. Hawass
2008–09	drilling around the Sphinx	Z. Hawass and M. Lehner

The pyramid

Everyone today knows Khufu's pyramid as the Great Pyramid; however, in ancient Egyptian hieroglyphs it was Khafre's pyramid that was called *Khafre Wer*, 'Great is Khafre'. But then Khafre shows hints of pyramid envy. Though Khufu's pyramid is slightly taller, the builders founded the second Giza pyramid on ground 10 m (33 ft) higher than the base of Khufu's and they chose a steeper angle of slope. So the finished height, on the higher base, actually brought Khafre's apex 7 m (23 ft) higher than Khufu's, at 213.5 m (700 ft) above sea level.

The existence of two entrance passages could suggest that Khafre might initially even have hoped for a pyramid much larger than Khufu's. One passage begins in the body of the pyramid, about 11.54 m (38 ft) above the level of the base; the other opens at ground level in front of the north baseline [**9.3**]. If the pyramid had been larger by 30 m (98 ft) on each side (or centred 30 m further north), this second passage would have continued and risen within the body of the masonry to open at the same height as the upper entrance. With a total length of 470 cubits (246.75 m/809 ft 6 in.), Khafre's pyramid would then have surpassed Khufu's base by 30 cubits (15.75 m/51 ft 8 in.) to a side.

The fabric of the pyramid body

After the three immense pyramids of Sneferu at Dahshur and Meidum, and Khufu's pyramid at Giza, it might be assumed that the 4th dynasty builders would by now have arrived at standard methods for the next giant pyramid. But Khafre's builders continued to design and build ad hoc in many ways. They employed the basic masonry techniques that Khufu's builders had used, but we see many differences between the two projects. No 'manual of pyramid building' existed yet – standardization was still several generations away.

Because the limestone formation of the Giza Plateau slopes from northwest to southeast, Khafre's builders had to cut the bedrock down by 10.5 m (just over 34 ft) on the northwest and build up the southeast with laid in blocks in order to level the broad terrace of the pyramid and its court. In the core of the pyramid they reserved a massif of bedrock, cutting it into steps to accommodate the lowest four courses of masonry. The natural rock core massif can now be seen along the entire

western side of the pyramid, rising to a height of around 5 m (16 ft).

The coursing of the core masonry at the base of the pyramid was not always horizontal; blocks were sometimes tailored to fit the sloping bedrock left protruding in the core. In the northeastern and southeastern corners, where the slope of the natural plateau surface meant that the bedrock dipped below the desired level, the builders used enormous limestone blocks, two courses thick, to build up the ground surface [**9.2**].

Most of the exposed surface of the lower two-thirds of the pyramid consists of very rough and irregular stones. This lower band of loose material might be taken for packing material between core and casing, still attached after the casing was ripped away. Indeed, in certain lights the rubble appears to form irregular bands, thinly veiling the more regular stepped courses underneath. However, when we climb the corners of the pyramid we can see that the irregular masonry appears to continue for some depth into the pyramid.

The core structure of the upper third of the pyramid, from the level just below the intact original outer casing, appears to differ from the lower two-thirds. Here, just beneath the casing, a band of regular stepped core masonry is visible. Where is the rubble that adheres to the lower two-thirds of pyramid? Perhaps at this point the builders began to lay more regular masonry as they sought to achieve a more precise fit between core and casing. This would give them better control as the sides narrowed towards the top. At the top of the northeastern corner and just below the point where the surviving casing overhangs the core masonry by 1 m (3 ft), we can see small limestone

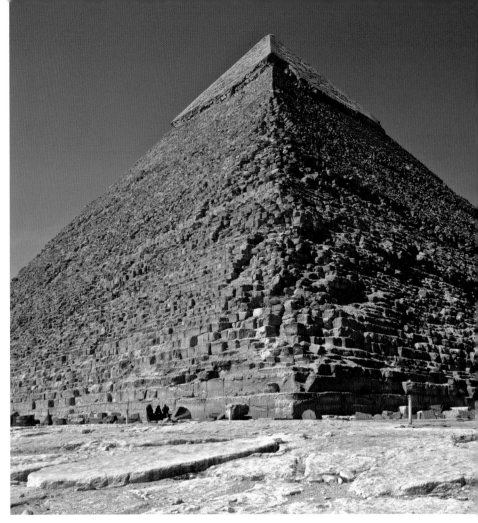

ABOVE RIGHT
9.2 The southeast corner of the Khafre pyramid reveals the fabric: two thick lower courses of cut blocks; irregular masonry for most of the lower part of the pyramid; more regular masonry on the upper third; and the projecting casing at the top after backing stones have been pulled away. Note the slight difference in the diagonals of the upper core and casing.

BELOW RIGHT
9.3 The Khafre pyramid components: pyramid, substructure (passages and chambers), with two entrance passages, enclosure wall, satellite pyramid, upper temple and the beginning of the causeway.

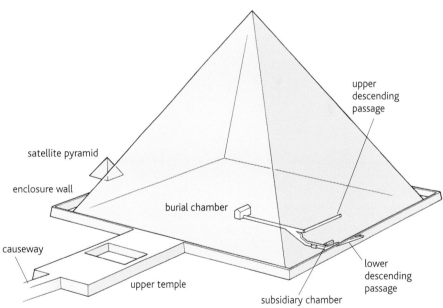

packing slabs exposed in the fill between the stepped core and casing. These slabs range from 38 to 67 cm (15–26 in.) thick, probably a match to the thickness of the missing casing at this level, though higher up on this same corner we measured the thickness of the intact casing as ranging from 44 to 82 cm (17–32 in.).

Khafre pyramid statistics

Area	4.6 ha (11.4 acres)
Height	143.5 m (470 ft)
Total mass	2,211,096 cu. m (78,084,000 cu. ft)
Original baseline	215 m (705 ft)
Slope	53 deg. 10 min.

9.4 The two original entrances of the Khafre pyramid, about 12 m (39 ft) east of the pyramid centre, are marked by a granite lintel (upper), and by the modern hood where people now enter (below). Two forced holes mark the approximate pyramid centre. At the base, a large patch of the original limestone paving of the court remains, as well as two blocks of the lowest granite casing course (other pieces have been replaced). A roughly pyramidal section of well-cut and well-laid masonry rises to the upper entrance. Above it, small loosely laid stones predominate, visible after the casing was removed.

At the same northeastern corner, from the casing down to the rubble zone, we also measured the widths and heights of each course of the interior core masonry, exposed when people removed the casing and packing masonry that once covered them. Even this stepped, seemingly more regular core of the upper pyramid body shows considerable variation, with steps ranging between 83 cm (33 in.) and 1.2 m (4 ft) in height, and from 23 cm (9 in.) to 1 m (3 ft) in width. In seams and gaps we can glimpse the interior fill of limestone chips and rubble, so it seems likely that the steps are an outer skin or accretion beneath the casing and packing material and enclosing much looser material. Our impression of the Khufu pyramid is that its entire core fabric consisted of loosely laid masonry with

a lot of rubble and mortar dumped into gaps in between – that is, a mix, rather than a separate layer of masonry forming a skin covering a rubble fill as with Khafre's. The loose internal composition of the Khafre pyramid is evident in the robbers' tunnel forced through the centre of the pyramid's north side, about 8.5 m (28 ft) above the base [**9.4**]. When Belzoni cleared this, the fabric of the pyramid kept collapsing. As Maragioglio and Rinaldi observe:

This was due without doubt to the incompactness of the internal masonry and the lack of mortar, so that the blocks are not always in contact at the sides, and cannot mutually support each other.... This observation can easily be extended to the entire nucleus of the pyramid and seems to prove that, while the outer part of every course of the nucleus is regular and formed of square blocks, the inner part consists of a filling made of very roughly shaped blocks with large joints devoid of mortar.[2]

The core masonry of the Khafre pyramid is not entirely devoid of mortar. Nevertheless, one of

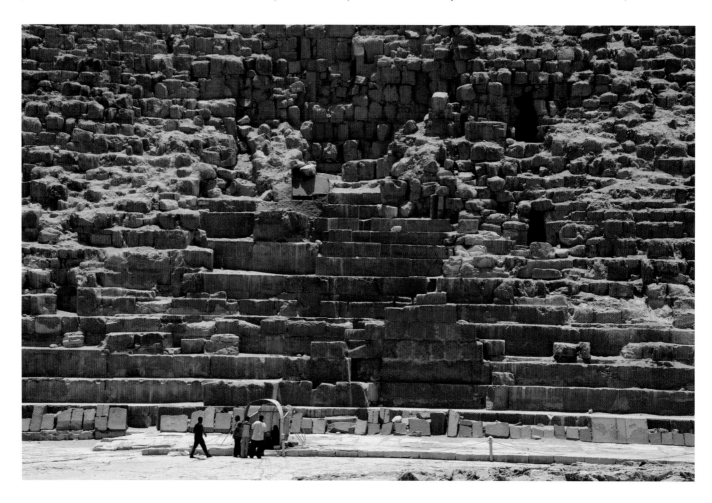

the big differences between Khafre's pyramid and Khufu's is the evidence of internal skins, and within those skins even looser and more irregular fill.

Baseline

Maragioglio and Rinaldi also noted that the top of the first course of masonry, which corresponds to the top of the course of granite casing and first step in the bedrock core massif, is remarkably level. This and the bed for the pyramid enclosure wall are the most level surfaces around the base of the Khafre pyramid. Contrary to the impression given in many theories of pyramid building, the builders did not level the base of the pyramid itself and then begin to raise the pyramid on that.

Khafre's masons set red granite blocks forming the lowest course of casing into sockets cut in the limestone bedrock to depths that vary by more than 35 cm (14 in.) in order to make it easier to bring the tops of the blocks flush. Using a surveyor's level, we took spot heights on the top of the first step of the core massif where it backed the casing at the southwestern and northwestern corners. The level differs by an average of only 3 cm (a little more than 1 in.) over a length of 215 m (705 ft). The top of the first course may thus have been the builders' true reference level for measuring the rise and run of the pyramid slope.

The builders created the *visual* baseline of the pyramid only when they laid the pavement of the pyramid court, using thick limestone slabs so they would not crack [**9.6**]. They cut the bedrock sockets for the pavement deeper than those for the granite casing so that when they laid the paving it would be flush with the line that formed the bottom of the slope of the casing blocks. This left a raised edge in the bedrock, which tells us where the outer line of the casing once ran, even when both casing and pavement slabs have been removed.

Casing

We agree with Petrie that Khafre's builders used granite blocks only for the lowest course of the casing. Today, just five of the granite casing blocks remain in place around the entire base of the pyramid. The sockets or emplacements cut into the bedrock for the northwestern and southwestern corner blocks indicate that both were huge – 2.2 × 4.5 m (7 × 15 ft).

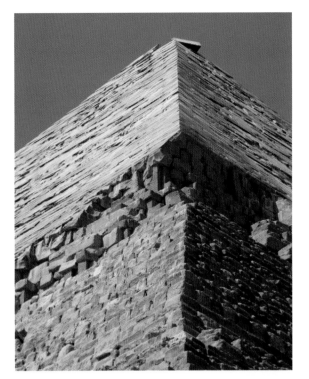

9.5 The southeast corner of the Khafre pyramid, near the truncated top. Removal of the casing and backing stones has exposed the more regular stepped courses of the core. Well-squared 'backing stones' make the join between core and casing. Note the difference between the corner line of core and casing, and the changes to the angle line of both. Builders twisted the casing angle towards the top to bring the corners to a point at the apex. A displaced casing slab projects over the top of the eastern side.

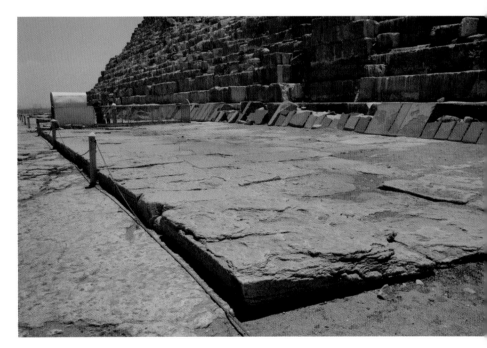

At the top of the pyramid, the limestone casing remains intact for a height of about 45 m (148 ft) from the irregular horizontal limit where those who exploited the pyramid as a quarry stopped stripping the fine limestone [**9.5**]. The truncated apex, which consists entirely of fine casing stone, reveals the socle or anchoring of the last blocks, which would have received the pyramidion or capstone, perhaps carved from granite to match the base.

At the highest point we could reach to measure at the northeastern corner, the thickness of the

9.6 The original limestone pavement of the Khafre pyramid court: the pavement completed the baseline of the pyramid at the point it met the bottom of the slope of the lowest course of casing, here of granite. The long edge of the pavement, lower left, marks the line of the court's enclosure wall, entirely missing today.

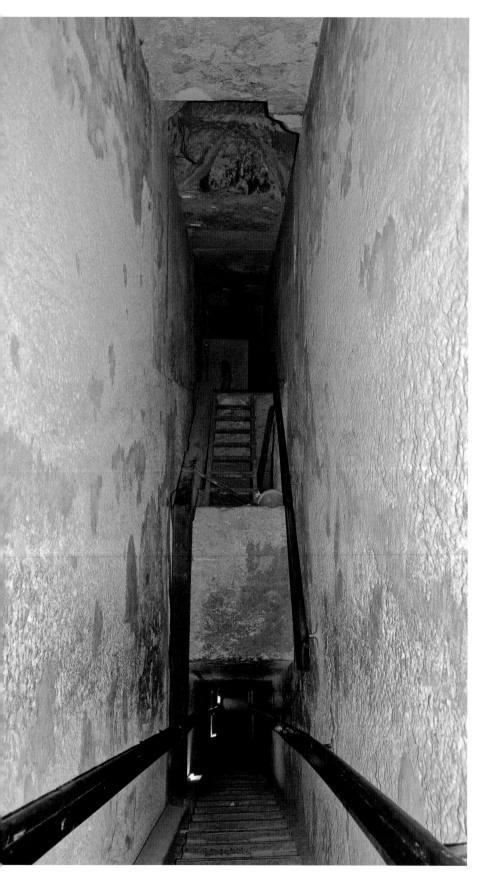

casing courses ranges from 82 cm (32 in.) to 35 cm (13 in.). Where the joining sides and the underneath of individual casing blocks are exposed, we can still see the marks left by chisels. The casing stones of the north face do not appear to be as well dressed as those of the east face, and while this could be the result of weathering, the different texture seems to arise from the actual tooling. The north face casing is whiter and more pounded in appearance, with slight, rounded undulations. The east face casing is thinly crusted, granular, with a brown patina.

Looking out across the whole expanse of casing, it is noticeable that the slabs are not in fact flush, but jut in and out by a few millimetres. One explanation might be that at this level the masons cut the slope into the blocks before they laid them in place and so the fit is not exact; alternatively, the slabs might have shifted when people removed the casing further down (see also pp. 452–54).

Petrie established the square of the pyramid base by extrapolating the corners from the casing socle. He checked the rise of the pyramid from this square, and so the accuracy of the pyramid, by locating precisely the base corner points and the corners of the overhanging casing by triangulation with his theodolite. His measurements indicated a slight twist in the structure of 3 min. 50 sec. – the builders may have had to bend the corner angles slightly to make them meet at the apex.

Inside Khafre's pyramid
Upper descending passage

The fact that the system of corridors and chambers is both so much simpler and lower down in Khafre's pyramid than in Khufu's has led people to speculate whether there are more, hidden passages and rooms. Today the upper passage opens 11.48 m (37 ft 8 in.) above the base and 12.45 m (40 ft 10 in.) east of the north–south centre axis of the pyramid. Originally the entrance would have been slightly higher up on the pyramid face, at about 12 m (39 ft), because the passage continued at an angle up

9.7 View north into the juncture of the upper and lower passages (see 9.9). The robbers' tunnel breaks through the ceiling of the upper passage.

Upper descending passage statistics

Cross-section	1.19 m (3 ft 11 in.) height
	× 1–1.05 m (3 ft 3 in.– 3 ft 5 in.) width
Present length	31.7 m (104 ft)
Slope	26 deg. 30 min.

through the masonry of the packing and casing that was later removed. Those who ripped the casing off the pyramid destroyed the original entrance.

As it slopes down through the pyramid body at an angle of 26 deg. 30 min. (approximately 1:2), the upper passage is made from blocks of red granite, dressed but not polished. The masons filled any flaws with plaster, which they painted red to match the stone. At the point the passage enters the bedrock it levels to become horizontal, and here a drum roll, or torus, such as is found at the top of false doors in tombs, is carved in the roof. A portcullis lies just beyond.

When Belzoni entered the pyramid in 1818, he found the blocking slab lowered to within 20 cm (8 in.) of the floor, but he lifted it sufficiently to slide his mighty frame underneath. Howard Vyse later severely damaged the portcullis when looking for an additional passage. Some 7 m (23 ft) along the horizontal passage, Belzoni then came upon an immense trench or opening cut into the natural rock occupying the width of the corridor. This is where the lower system rises up to connect with the upper [**9.7**, **9.9**].

Lower descending passage and chamber

When Khafre's complex was completed, the pavement of the pyramid court would have covered the opening of the lower entrance passage, which aligns exactly with the upper one. Perring seems to have found pavement slabs still concealing the mouth. This lower passage is hewn through the bedrock at a slope of 21 deg. 40 min. 40 sec. Perring also discovered limestone blocks that must be the original plugs still in place and mortared together – one was 3.5 m (11 ft) long. The blocking probably continued as far as the granite portcullis at the bottom of the sloping section [**9.8**]. After the portcullis the passage runs horizontally for a short length, with a height of 1.83 m (6 ft).

Near the middle of this horizontal stretch a passage of comparatively crude workmanship

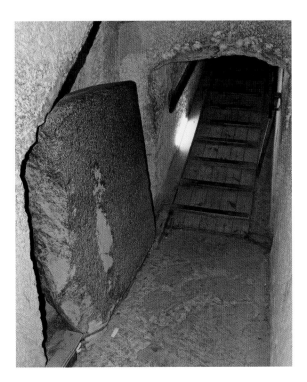

LEFT
9.8 The portcullis granite slab displaced at the bottom of the slope of the lower passage. Workers originally set the slab above the passage in slots formed into the sides so they could slide it down to close the passage.

BELOW
9.9 Diagram of the Khafre pyramid substructure, with the upper and lower entrances and passages, the lower subsidiary chamber, the niche, the juncture where the passages meet and the horizontal passage to the burial chamber.

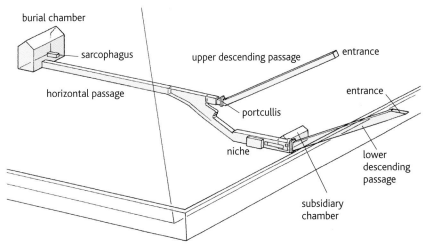

opens and slopes down at a right angle to the west to a chamber with a gabled ceiling, like the Queen's Chamber in the Khufu pyramid, albeit in this case quarried from bedrock. In the east wall of the horizontal corridor opposite this short passage is a niche, similar to the recesses found in the passages of Khufu's queens' pyramids to allow a sarcophagus to be turned round the corner into the burial chamber [**9.10**]. Maragioglio and Rinaldi reported two small holes at the lower corners of the entrance to the passage that leads down to the lower chamber, which may therefore have been closed by a double-leaf wooden door. The passage

walls are much more coarsely finished than those of the main passages, but were plastered with gypsum. Inside the chamber, Perring found numerous small, squared limestone blocks. Abandoned chambers in the Bent Pyramid were filled with small limestone blocks, so if those in the Khafre chamber were put there as fill by the 4th dynasty builders, they would indicate a similar abandonment.

The lower chamber and passage system have been taken as evidence for a change in plan for the size or position of the Khafre pyramid, as mentioned above. If the pyramid superstructure had been positioned slightly more than 30 m (98 ft) further north, the lower chamber would have been close to the centre of the pyramid and the lower passage would have emerged in its north face. This would have matched part of the pattern of Khufu and Menkaure. One possibility is that, having cut the substructure from the bedrock, and after beginning construction further north, the builders shifted the pyramid to its present position to take advantage of a ridge of natural rock for constructing the causeway.

A position 30 m (98 ft) to the north would also have brought the north baseline of the pyramid to about 30 m from the northern vertical ledge formed when the broader pyramid terrace was quarried down. The west side of the finished pyramid is

Lower descending passage and chamber statistics

Lower descending passage

Cross section	1.05 m (3 ft 5 in.) height × 1.19 m (3ft 11 in.) width
Length	34.15 m (112 ft) (mouth to portcullis)
Slope	21 deg. 40 min. 40 sec.

Lower chamber

East–west	10.45 m (34 ft 3 in.)
North–south	3.15 m (10 ft 4 in.)
Height	3.13 m (10 ft 3 in.)

Ascending passage (to join with horizontal passage)

Cross section	1.20 m (3 ft 11 in.) height × 1.05 m (3 ft 5 in.) width
Length	24.4 m (80 ft)
Slope	21 deg. 30 min.

exactly this distance from the equivalent western vertical ledge. If the causeway in this hypothetical earlier plan ran straight, and 30 m further north, its lower end would correspond to the modern road – possibly built on an ancient ramp or embankment – that descends along the north side of the Sphinx quarry.

Abandoned bedrock cuttings for a substructure of a northernmost pyramid of Khufu's queens (GI-x) and unfinished pyramids such as that at Zawiyet el-Aryan, consisting for the most part of an enormous passage and pit, indicate that pyramid builders located and began the substructures well in advance of the superstructures. We might then consider the possibility that the lower chamber in Khafre's pyramid was the original intended burial chamber in an earlier scheme, except for the fact that Petrie showed that the king's sarcophagus is too large to have been brought through the passages to this chamber. The same is true of the actual burial chamber, but this was open to the sky until the builders roofed it with gigantic gabled limestone beams, so they could have lowered the mighty coffer in before the chamber was completed. The question then arises, if the lower chamber, hewn entirely from bedrock, was the original burial chamber, how would Khafre's builders have proposed to bring in his sarcophagus? Remember the niche – this might have been created for turning a sarcophagus. It is also possible that the sarcophagus now in the actual

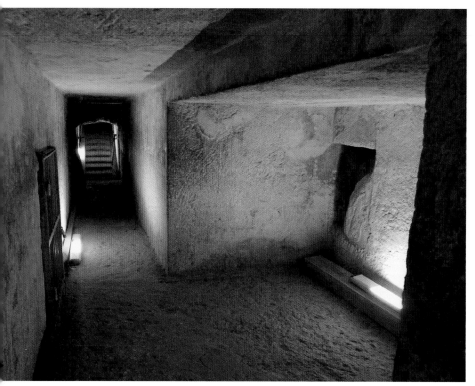

9.10 View to the north of the lower end of the lower passage and the niche in the east wall. On the left edge of the view, a metal grating covers the entrance to the passage down to the lower chamber.

burial chamber was itself a change in plan, and that the builders had originally made arrangements for a smaller one.

At its southern end, the lower passage slopes up at about 21 deg. 40 min. to meet the opening that Belzoni encountered in the floor of the main horizontal passage to the burial chamber.

The burial chamber

Close to the point where the upper and lower passages join, the robbers' tunnel breaks through, having burrowed around the granite blocks lining the corridor and the portcullis of the upper passage. As in the Khufu pyramid, the violators succeeded in hitting a point close to a juncture of two passage systems, suggesting they knew something about their arrangement, which would in turn indicate that the violation took place not long after the pyramid had been sealed.

From the intersection of the upper and lower systems, the single main horizontal passage leads straight to the burial chamber. Cut through bedrock, the passage rises to a height of 1.8 m (6 ft) and runs for a length of 56 m (184 ft, a little more than 100 cubits) with a width of 1.05 m (3 ft 5 in.). At 1 m (3 ft) beyond the upper portcullis the passage ceases to be clad in granite. Here and there the walls are plastered with gypsum, and near the middle a stretch is lined with masonry that fills and covers a patch of poor-quality rock and natural fissures.

The passage opens into the north side of the burial chamber, about 3 m (10 ft or 5 cubits) from its eastern wall. The chamber is situated just shy of being directly under the centre of the pyramid: its interior western face is 1.19 m (3 ft 11 in.) from the north–south pyramid axis. The intention may have been to position the sarcophagus, at the west end of the chamber, on the centre axis [**9.11**].

Burial chamber statistics[3]

Width (average north–south)	4.97 m (16 ft 4 in.)
Length (average east–west)	4.16 m (13 ft 8 in.)
Height	6.84 m (22 ft 5 in.)
Sarcophagus	
Height	0.97 m (3 ft 2 in.)
Length	2.63 m (8 ft 8 in.)
Width	1.07 m (3 ft 6 in.)

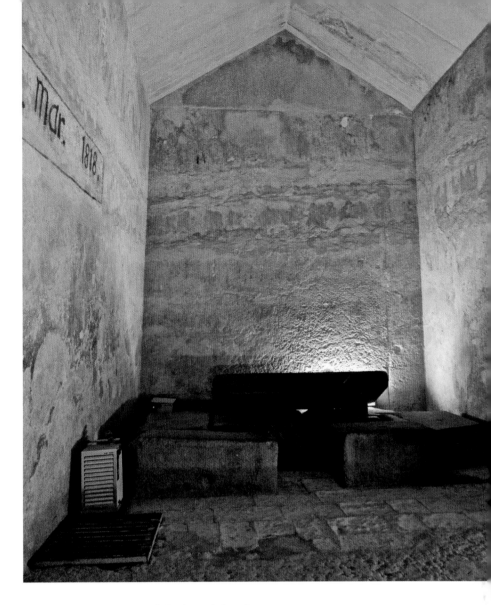

The quarrymen carved the burial chamber as an open pit in the bedrock core that they then incorporated into the body of the pyramid. The level of bedrock visible in the chamber indicates that the core massif at this point would have been 3 m (10 ft) higher than the pyramid baseline. As mentioned above, on the western side of the pyramid the bedrock rises up to 5 m (16 ft), so the massif in the core must slope or step down eastwards and towards the centre of the pyramid. The masons had to build up the lower, eastern side of the pyramid core masonry.

To roof the burial chamber, Khafre's builders used pairs of enormous limestone beams laid at an angle of 34 deg. 10 min. to form a gable resting on the upper edges of the bedrock pit. They then covered this with the masonry fill of the core. Perring made a hole in one wall and discovered that the ends of the beams at that point extend 2.67 m (10 ft or a little more than 5 cubits) beyond the sides of the bedrock pit.

9.11 The builders cut Khafre's burial chamber as an open pit in the bedrock and then roofed it over with pairs of enormous limestone beams. The king's dark granite sarcophagus still stands at the western end, embedded among granite pavement blocks.

Except for the long side walls, which are 10 cubits high, the burial chamber's measurements are not round cubits, which may suggest that it was once clad internally with stone, reducing its volume and rounding the cubit numbers. Stadelmann suggests that a difference in the level of the floor may indicate that the chamber was originally partitioned into two, with a wooden wall separating an antechamber.[4] In the western part of the chamber the builders laid a pavement of fine limestone and granite. Belzoni saw the pavement relatively intact. Perring and Howard Vyse ripped it up in 1837–38.

The dark granite sarcophagus, measuring 0.97 m (3 ft 2 in.) high, 2.63 m (8 ft 7 in.) long and 1.07 m (3 ft 6 in.) wide, still stands near the west wall. Though it would not have been visible when embedded in the original pavement, the whole of the dark box, except its base, was polished. Petrie noted saw marks on the bottom. As outlined above, the sarcophagus must have been lowered in from above before the chamber was roofed because it is too wide to have been brought in through either pyramid entrance passage.

The builders set the coffer on a large block of granite, itself mortared into a socket cut in the chamber's bedrock floor, and then laid granite pavement blocks around it up to the level of its rim. The sarcophagus was closed by sliding a lid along a mortise groove in the top of the interior of the box. Holes in the underside of the lid probably held copper pins that dropped into corresponding holes in the coffer when the lid was in place. The masons no

doubt hoped that these features would prevent the sarcophagus ever being opened again once the king's body was sealed inside. But someone managed it, breaking the lid into two pieces, as Belzoni found it. About a day after Belzoni penetrated the chamber, a visitor noticed cattle bones inside the coffer; could they have been from an offering?

A square pit in the southwestern corner, perhaps once covered by the pavement, must have been for the canopic chest that held the royal viscera. Square cuttings high in the chamber's north and south walls probably mark the intended exit of 'air shafts' that were not completed. Painted red lines drop from these cuttings to squares also marked in red, which are either an earlier or later plan for similar channels that were never begun. Stadelmann suggests that the builders decided that these symbolic upward channels were not necessary because the second, upper corridor system was a suitable conduit to allow the king's spirit to leave the burial chamber and ascend to the sky.

Upper temple

Khafre's upper temple stands on a spur of raised bedrock that fades into the sloping rocky ridge of the causeway foundation [**9.12**].[5] The eastern, front part of the temple is composed of cyclopean 'core blocks' that were quarried locally and weigh up to 200 tons. Such megalithic core work is unique to the Giza temples of Khafre and his successor, Menkaure. In Stadelmann's view, the explanation

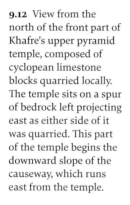

9.12 View from the north of the front part of Khafre's upper pyramid temple, composed of cyclopean limestone blocks quarried locally. The temple sits on a spur of bedrock left projecting east as either side of it was quarried. This part of the temple begins the downward slope of the causeway, which runs east from the temple.

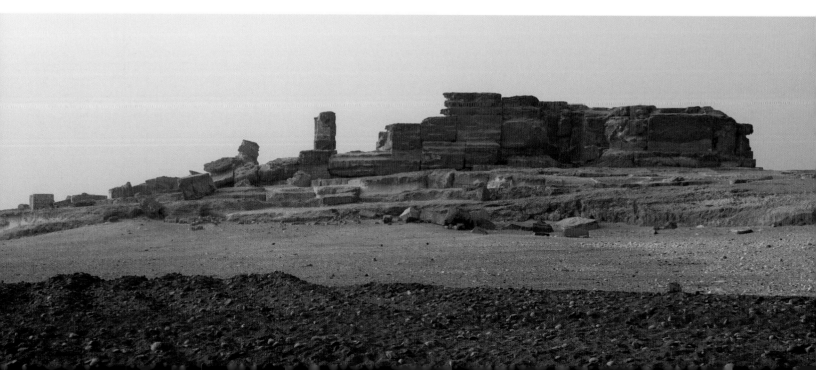

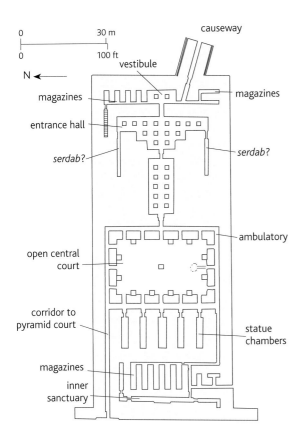

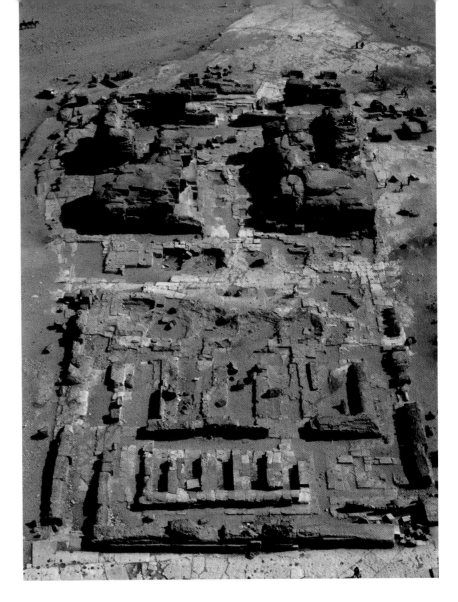

for this method of using huge core blocks cannot lie in economy of labour or material, nor in architectural stability, but in a concept of the upper temple that is different from Khufu's and Sneferu's. Those earlier temples are essentially open courts surrounded by covered magazines and colonnades. Stadelmann thinks that the massive quality of Khafre's temple is a deliberate attempt to convey the chthonic – to create a series of chambers, corridors and magazines embedded in earth or bedrock, or a kind of artificial mound.[6] Indeed, moving through the complex must have been a gloomy and subterranean experience, as in the narrow dark passages of a giant mastaba.

The builders clad the exterior of the temple with Turah-quality limestone, except for the lowest course, which was red granite. Much of the interior was also sheathed in granite.

One might imagine that after progressing a quarter of a mile up the long causeway from the valley temple to the monumental upper temple, visitors would enter a grand hall, but instead, after passing through a double-leaf door just 1.05 m (3 ft or 2 cubits) wide, they were faced by a blank wall. The causeway projected about 3 m (10 ft) into the temple interior towards this wall. To the left, a tight squeeze through a 75-cm (30-in.) wide doorway led only to two magazines, while a doorway on the

right led to a vestibule measuring about 5 × 10 m (16 × 33 ft), its roof supported by two pillars. A narrow corridor led off north, parallel with the front of the temple, passing four magazines on the left and ending at a stairway on the right that ascended to the temple roof. In the centre of the western wall of the vestibule, on the east–west axis of both temple and pyramid, another doorway gave access to the temple's interior by way of an entrance hall in two sections [**9.13, 9.14**].

The transverse section of the entrance hall narrowed in stages towards the pyramid, with 14 monolithic granite pillars arranged in three rows of eight, four and two supporting the roof. Off either end of the first bay of the hall, long tube-like corridors, only 1.5 m (5 ft) wide, stretched 15 m (49 ft) into the core masonry, like the upturned arms of a *ka* hieroglyph. We believe, as did Uvo Hölscher, that these long dark corridors were *serdabs*, or statue chambers.[7] Herbert Ricke, on the other hand, thought that they housed the day and night

9.13, 9.14 The Khafre pyramid upper temple, thumbnail plan and view from the pyramid looking down to the east.

barques of the sun god.[8] In favour of Hölscher's idea is the fact that someone in later times took the trouble to hack passages over 4 m (13 ft) wide through more than 6 m (20 ft) of limestone core wall to reach the ends of both corridors. It seems likely that the aim was to remove Khafre's statues, just as people systematically removed his colossal statues from both the temple court and from the court of the Sphinx Temple. This act could only have been by royal command: a subsequent king usurping Khafre's images (see also Chapter 18).

Stadelmann, in accepting Ricke's interpretation of the long narrow corridors over that of Hölscher, suggests that the breaches were secondary entrances used during the life of the temple to reach the barque shrines. But there is no evidence of doors or any indication that the cuts are other than later intrusions. In commenting on the tube-like chambers, Stadelmann saw no precedent for statue cults in the forward part of an upper temple. Later, however, he discovered a pair of statue shrines encased by thick masonry at the front of the Dahshur North Pyramid upper temple, which might be seen as being a precedent for Hölscher's theory.

From the centre of the western, inner bay of the recessed entrance hall a narrow doorway, 2 cubits (1.05 m/3 ft) wide, opened to a chamber that formed a deep extension, reaching 18 m (59 ft) further west, with a span of 8.7 m (29 ft). It is worth noting that nothing much wider than a metre could have passed from the causeway and through the temple to reach this point. Two rows of five columns ran along the length of this deep hall to support the roof.

The entrance hall, comprising both the recessed section and deep extension, was a basic element of later upper temples. The ancient Egyptians called such entrance halls in later temples *Per Weru*, 'House of the Great Ones'. They were associated with the royal retinue and were the equivalent of the reception hall in the king's earthly palace (see Chapter 7).

So far, darkness would have prevailed in the temple, broken only by the glow of lamps or torches, or pierced by light streaming through slits at the tops of the walls and reflected off the polished red granite. A thick wooden door must have hung at the western exit of the deep hall. When the mighty door swung open, light reflecting from the white alabaster paving of the open central court and the acres of white limestone casing on the pyramid soaring upwards beyond must have dazzled the eyes, which had grown accustomed to the gloom during the long passage through the valley temple, causeway and front part of the upper temple. This was the principal special effect built into the Khafre complex.

The temple court is essentially a rectilinear hole cut through the roof of this long dark house. It occupies almost the width of the temple and is broader than deep. Twelve colossal granite statues of the king, at least 4 m (13 ft) high, surrounded the pool of brilliant white created by the polished Egyptian alabaster floor. All that remains now are the sockets for the bases, cut into the limestone bedrock foundation. But when the temple was complete, the giant images of the king, aglow with the light bouncing off the floor, must have seemed ethereal.

The statues were set into recesses in granite piers that formed an ambulatory or cloister, 1.5 m (5 ft) wide, around all sides of the court. Spaces between the piers, also 1.5 m wide, allowed passage from the ambulatory to the court. Ricke thought that a band of carved hieroglyphs giving the king's names and titles surrounded each opening. He also envisioned vultures, representing Nekhbet, the goddess of the southern crown, carved in relief above each statue, wings spread in protection.[9] Peter Jánosi's analysis, however, casts doubt on Ricke's reconstruction. Jánosi suggests Khafre's craftsmen left the interior granite blank, as in the valley temple.[10] Above a granite dado, the cloister walls were built of

9.15 Part of a scene in extremely delicate relief depicting prisoners tied by a rope, found east of the Khafre valley temple, so possibly from the lower end of the Khafre or Khufu causeway. More complete scenes of the presentation of prisoners are known from causeways of Sahure and Niuserre at Abusir and of Pepi II at Saqqara, and other fragments are known from Giza that may have belonged to the Khufu or Khafre pyramid complexes. Reliefs in the temples may also have represented the king's dominance over the forces of chaos represented by enemies.

limestone and were decorated with relief scenes. Hölscher found a fragment of a scene of a bound Asiatic captive.[11] Already here in Khafre's temple, the court must have represented the king's clearing of the land of the forces of chaos represented by wildlife and human enemies [**9.15**] (see Chapter 7 for an investigation of these). On the south centre axis of the court a granite-lined drain conducted rain and libation water to the outside of the temple.[12] It has been suggested that the drain was to take away fluids from the sacrifice of animals,[13] but it is hard to imagine beasts being brought through the narrow doorways, little more than a metre wide, that led from the causeway to the court.

On the west, inner side of the court, behind the ambulatory and deeper into the temple, lay five long chambers that probably housed statues, either of the king in his various aspects or of deities. Hawass believes that three of the five statues were intended for the names of the king; another was for his father as Re, while the fifth one was for Hathor.[14] Stadelmann, as well as Ricke, suggests instead that each was a barque shrine, not unlike those in New Kingdom mortuary temples in which divine statues rested in their boats.[15] Each chamber was 10.5 m (34 ft) long and entered by a doorway about 1.27 m (4 ft) wide that aligned with the openings of the ambulatory into the court. At 3 m (10 ft), the central chamber was 45 cm (18 in.) wider than the others. The Abusir Papyri hint that the centre statue in later pyramid temples represented Osiris, Lord of the Dead, or the king as Osiris.

On the south side of the temple court a long corridor led from the ambulatory to two narrow chambers embedded in the southwestern corner of the temple. Here, a short connecting corridor gave access in one direction to the outside of the temple on the south, and in the other to the temple sanctuary to the north. This inner sanctuary consisted in fact of nothing more than another corridor, stretching 19 m (62 ft) north–south and 1.8 m (6 ft) wide. In the west wall of the sanctuary, towards the pyramid and on the centre axis of both pyramid and temple, a recess may have held a false door – the symbolic exit and entrance between the temple and the underworld of the pyramid substructure.[16]

Between the sanctuary and the five statue chambers, five smaller magazines probably held offerings and ritual equipment relating to the five statues. The sanctuary corridor ended on the north in a blind chamber that could be taken as a sixth magazine. All these chambers at the very back of the temple would have remained in darkness, or at best very dim light, as long as the temple was roofed.

The pyramid court and enclosure wall

On the north side of the temple court another corridor, 1.5 m (5 ft) wide, equivalent to that on the south, led from the ambulatory and stretched more than 33 m (108 ft) to the narrow enclosed court that ran round all four sides of the pyramid. Based on Hölscher's map, the pyramid court on the east side, between the temple and the pyramid, was 10.05 m (33 ft) wide. The back wall of the temple merged with the pyramid enclosure wall. Between temple and pyramid, on line with the central axis, an irregular break in the foundation might be an indication of a socket for the structures of an offering place, either a pair of stelae or perhaps a false door, which would have formed a symbolic entry from temple to pyramid if there was not one in the rear wall of the temple's inner sanctuary.

Today no part of the enclosure wall still stands, but it once rose at a taper from a base about 3 m (10 ft) wide to a rounded shoulder at a height of approximately 8 m (26 ft). Based on our own measurements at the southwestern corner, the paved court was probably close to 10 m (33 ft) wide, or just under 20 cubits. The foundations for the enclosure wall, pyramid court and pyramid base were fashioned carefully in the bedrock as a set piece [**9.16**]. As we mentioned above, the builders created the baseline of the pyramid only when they laid the thick limestone paving slabs of the court, between the enclosure wall and the vertical foot in the bottom of the lowest course of pyramid casing – the seam between pavement and granite casing formed the baseline.

As with Khufu's pyramid enclosure court, the floor around the base of the Khafre pyramid shows a gentle but clearly discernible trough fashioned in the bedrock. Following Maragioglio and Rinaldi's description of it, we call this feature an 'impluvium', the Latin term for the sunk part of the floor in the atrium of a Greek or Roman house which received

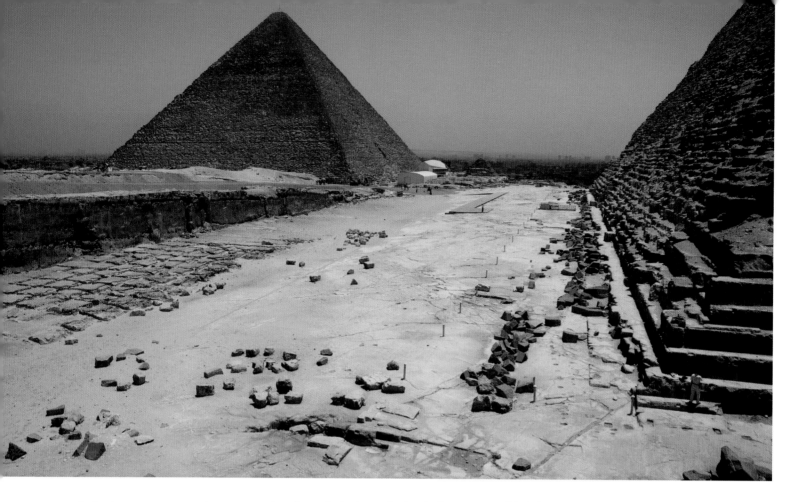

9.16 Bedrock foundations of the northern side and northwest corner of the Khafre pyramid terrace, looking east. To the left can be seen the ledge left when Khafre's quarrymen worked the bedrock down 10 m (33 ft) for levelling. The gridwork of channels at base of the ledge remains from their final working of the surface into a slope away from the pyramid court. On the far right, the backing of the top of the first course of granite casing – now missing – is levelled for the length of the northern side of the pyramid. Below this step, the socle and lever sockets can be seen. Khufu's pyramid rises in the background from a base 10 m (33 ft) lower than Khafre's.

rainwater passing through the 'compluvium' of the roof. In the centre of the court, between one pyramid corner and the other, it is barely visible, but gradually becomes more pronounced as one walks towards either corner, to its deepest point in the floor opposite the pyramid diagonals. At both the Khufu and Khafre pyramids, the trough or impluvium is somewhat obscured by the patterns of the emplacements for the individual, thick slabs of limestone that paved the court. Where the pavement exists, we can discern the impluvium in its surface, albeit less pronounced.

At the four corners of the pyramid court, the builders cut trenches or channels into the bedrock, 6 m (20 ft) long and 90 cm (35 in.) deep, which ran under and beyond the enclosure wall. Orientated north–south, these channels are 7 m (23 ft) from the corners of the pyramid court as defined by the outer line of the enclosure wall. Within the court the ends of the channels lie at the bottom of the trough described above.

We studied the details of the trenches at the northwestern and southwestern corners and found that the ends are vertical, rather than sloping to facilitate drainage. This means that the rain that ran off the pyramid faces and towards the corners would have been retained in the channels before

it filled them high enough (to within 21 cm/8 in. below the base of the enclosure wall) to drain away from the court. The intention seems to have been to hold the water (to a depth of 65 cm/26 in.) for a time, turning the trenches into reservoirs. When we cleared and mapped the channel in the southwestern corner we found many fragments of alabaster, which may derive either from a special lining of the channel or from a receptacle for water. Maragioglio and Rinaldi suggested that the trenches collected rainwater from the pyramid.[17] Perhaps the Egyptians regarded the water as sacred after it had flowed down the faces of the pyramid, personified as the king himself.

Boat pits: Netherworld harbour and landing stage

The broad terrace in front of Khafre's pyramid, to the east, is made up of massive limestone blocks that weigh hundreds of tons. On both sides of the temple, workmen had to build up the level of the ground to compensate for the natural slope. At the northeastern and southeastern corners of the terrace two huge piers project forwards about 30 m (98 ft). Between them, symmetrical broad channels on either side of the spur of bedrock on which

the upper temple is founded look like slipways. This aspect of giant docks is strengthened by the fact that Khafre's quarrymen cut five narrow boat pits into the natural rock channels between the piers and the upper temple.[18]

Three of the boat pits are on the south side of the temple. The southernmost is orientated north–south, parallel to the pyramid base and 31 m (102 ft) from it. It appears that the quarrymen took advantage of a natural fissure here to create this pit, which is about 26 m (85 ft) long but only about 90 cm (35 in.) wide at the top. Its north end is badly damaged and it has long been filled with debris, but if it is like the others, it broadens below the surface to receive or imitate a boat.

The two other southern pits are orientated east–west, parallel to the temple and about 15 m (49 ft) from its core wall [9.17]. The widening of the lower part of the western of these pits and the ribbing modelled on the bottom suggest that it was fashioned as a symbolic boat, 'inside out'. Holes and notches in the rough sides of the trench allowed workers to climb in and out. A covering of two layers of large limestone slabs remains intact.

The two pits on the north side of the temple are also parallel with it. The one nearest the pyramid retains its cover of two courses of blocks; the eastern pit is badly damaged. Where a sixth boat pit has been conjectured, corresponding to the one orientated north–south to the south of the temple, Maragioglio and Rinaldi could discern nothing more than a natural fissure in line with the gap between the two northern pits.[19]

The shape of the pits – wider at the bottom and very narrow at the top – indicates that if actual boats were interred, they must have introduced in pieces and assembled in the pits. As with Khufu's boat pits, these earth-embedded boats, docked in the recesses between the temple and the piers of the pyramid terrace, convey the concept of the pyramid complex as a port for the voyage to the Netherworld.

Satellite pyramid: GII-a

Perring, Howard Vyse and Petrie all suspected that the large ruined structure south of Khafre's pyramid might be his satellite pyramid, but it was left to Hölscher to confirm this in 1909.[20]

This diminutive pyramid is located 25 m (82 ft) south of the main pyramid, and on its north–south axis. All that remains of the superstructure are a few large, irregular limestone blocks of the nucleus, though its outline is discernible on the foundation platform, which, as with that of the Khufu satellite pyramid, projected beyond the baseline.

Hölscher found three pieces of casing carved with an angle of 53 to 54 degrees; it is probable that the slope was the same as the main pyramid. He also calculated that the entrance passage on the north–south axis originally began 1.7 m (5 ft 6 in) above the base and sloped into the bedrock at an angle of 30 degrees; it measured 1.05 m (3ft 5 in./2 cubits) in cross section. The pyramid's substructure is preserved in the bedrock: after a short horizontal stretch, a passage leads to the centre of one side of the single chamber – the T-shaped configuration of passage and chamber characteristic of satellite pyramids. The floor of the chamber is lower than the

9.17 The eastern boat pit south of the Khafre upper temple; five known boat pits flank this temple on the north and south. View to the east.

Satellite pyramid statistics

Length of side	21.1 m (69 ft 2 in.) square
Estimate slope	53–54 deg.
Passage length	11.5 m (37 ft 9 in.)
Passage cross section	1.05 m (3 ft 5 in.)
Passage slope	30 deg.

burial chamber

Length	7.86 m (25 ft 9 in.)	15 cubits
Width	2.63 m (8 ft 8 in.)	5 cubits
Height	2.1 m (6 ft 11 in.)	4 cubits

9.18, 9.19 On the right is a reconstruction drawing of a wooden frame in the form of the 'divine booth'. The frame was found in pieces in a wooden box placed in a niche under Khafre's satellite pyramid. The drawing shows the shrine tied by rope to a wooden sledge for transporting a statue that might have been placed in the satellite pyramid burial chamber. Below is a drawing of a scene of a shrine of similar shape mounted on a sledge for transport, as depicted in the tomb of Queen Meresankh III at Giza.

bottom of the horizontal passage, so a small ramp was left in the rock, similar to the one we found in the satellite pyramid of Khufu. The bedrock walls are plastered in many places.

While he saw no trace of a sarcophagus, Hölscher did find items that made him think the little pyramid was for a queen's burial: traces of wood from some unidentifiable structure, cattle bone, carnelian beads and fragments of mud jar sealings, one inscribed with Khafre's Horus name and the title 'King's Son'.[21] An enclosure wall of rough stone and mud mortar surrounded the satellite pyramid. Hölscher found no cult structure on the east where we would normally expect an offering chapel.

We do not know why Khafre's complex lacks the queens' pyramids that were built alongside the pyramids of both Khufu and Menkaure. But the lack of an offering chapel, the T-shaped passage and burial chamber, the alignment on the centre axis of

the Khafre's main pyramid, all point to this being his satellite pyramid, possibly for the burial of a statue.

This interpretation received support during clearing work south of the Khafre pyramid in 1960, when Abdel Hafez Abd el-'Al discovered a sealed passage 4 m (13 ft) west of the satellite pyramid and aligned to its east–west centre axis. After clearing the sandy debris that filled the entrance, Abd el-'Al removed three limestone plugging blocks. The passage he revealed has a square cross section of 80 cm (31 in.) and slopes at around 35 degrees for a length of 7.15 m (23 ft) to reach beneath the satellite pyramid. At the end, a small niche that the masons seem to have finished cutting in a hurry opens off the southern side. The niche contained a wooden box sealed with string. Inside, Abd el-'Al found pieces of wood in three layers.[22] Hag Ahmed Youssef (who reassembled the barque found in one of Khufu's boat pits) was able to reconstruct a frame of four rods supporting a cavetto cornice. The assembled object, now in the Cairo Museum, stands 186 cm (73 in.) high. The frame had been systematically dismantled and several of the pieces had been deliberately broken by being first planed with an axe or chisel, broken at that point and then sawn.

The cavetto cornice gives the wooden frame the general form of the 'divine booth', *sah netjer*. Old Kingdom tomb scenes show funerary statues being drawn on sledges encased in these tall rectangular shrines [**9.18, 9.19**]. U-shaped nails in the top of the frame could have held the rope that secured the statue in its frame to a sledge; the cross pieces would have helped to stabilize the statue and strengthen the frame as it was dragged.

Given the proximity of the passage to the satellite pyramid, its location on the centre axis and the fact that it slopes down beneath the satellite pyramid, it must have been an annex to the satellite pyramid substructure, even though the passage opens outside the pyramid court proper. The fact that the deconstructed frame was buried in a passage created specifically for this purpose suggests that it belongs to a class of objects associated with funeral ceremonies rather than part of the burial assemblage. Transport items in particular, such as sledges and boats (the southern Khufu boats being the most famous example), were often buried outside the tomb itself but close

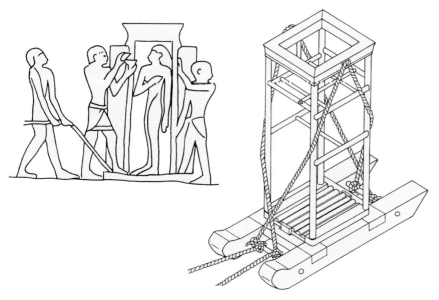

by. This proximity and special burial suggest that the statue carried on the frame was interred in the burial chamber of the satellite pyramid.

The causeway

Khafre's causeway ran for 494.6 m (1,627 ft) in an unbroken connection between the front (east) entrance of the upper temple and the rear (west) exit of the valley temple [**9.20**]. The causeway follows the slope of the plateau, at an angle of about 14.5 degrees south of due east according to our estimates, and drops nearly 50 m (164 ft) in elevation. Its foundation, 20 m (66 ft) wide, is composed partly of bedrock and partly of large, locally quarried blocks and was built on a sloping ridge that the quarrymen must have reserved for this purpose between quarries to the north and south. The walls, vertical inside and slightly sloped on the exterior, were encased with Turah-quality limestone. There is no surviving material evidence of painted relief decoration, though if Khufu's causeway had been decorated as Herodotus described, we might surmise that Khafre's was also.

Today the base of the walls remain for a stretch of only 30 m (98 ft) near the valley temple exit. They enclose a corridor 1.8 m (6 ft) wide that must have run the entire length of the causeway – just wide enough to allow the passage of two people carrying a litter or bier between them. A large fallen slab found by Hölscher must have come from the roof laid on top of the walls. Slits in the roofing slabs allowed some light, as well as rain, to enter what was otherwise a long, dim tunnel. The water flowed out of a drain at the lower south side of the causeway walls, 7 m (23 ft) from the valley temple.

The causeway locked directly into the rear of the valley temple and the front of the upper temple, a little like an airport tunnel connecting the doors of a plane to the terminal building. As we saw, there was no grand entrance to the upper temple – the door to the entire complex was the valley temple.

Valley temple and harbour

Khafre's is the oldest true valley temple belonging to a pyramid that has been excavated. While Sneferu's Bent Pyramid at Dahshur has a temple at the eastern end of a causeway leading from the

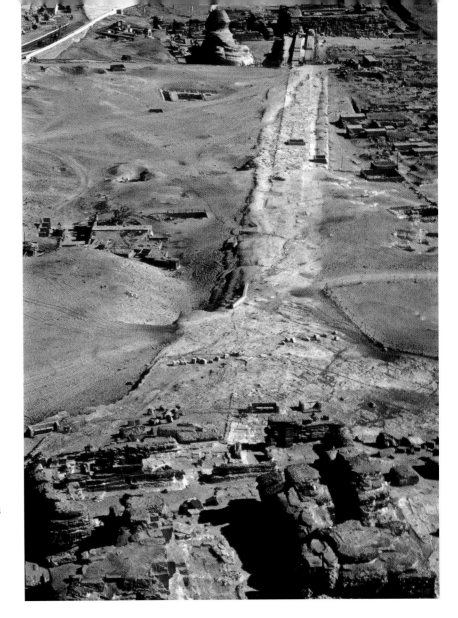

pyramid court, it is located some distance from the valley floor, albeit in a wadi that continues down to the valley. A team from the German Institute in Cairo discovered a mud-brick causeway with a vaulted roof further east from this temple sloping down the wadi to a basin, perhaps a harbour, cut into the bedrock at the level of the Old Kingdom floodplain, which possibly flooded during high Nile inundations.[23] Of 16 Old Kingdom and 10 Middle Kingdom valley temples, only 7 have been systematically excavated. Writing nearly a half century ago, Herbert Ricke decried the fact that the older valley temples of Khufu, Djedefre and Sneferu had not yet been excavated – they still have not.

During his 1965–67 survey of the Sphinx Temple, Ricke[24] established that a red granite cavetto cornice crowned the Khafre valley temple, which once rose more than 12 m (39 ft) high. Baraize had found pieces of this cornice in 1928 in the sandy debris filling the southwestern corner of the

9.20 The foundation of the Khafre pyramid causeway was fashioned in the bedrock except for an irregular patch of blocks that filled a gap near the middle, perhaps a pre-causeway conduit between quarries north and south. The causeway walls and roof of fine Turah limestone are now missing, but would have formed a tube that connected the upper temple (left foreground) and valley temple (right, top of view). The Sphinx sits within its ditch (a deeper quarry) at the left eastern end of the causeway.

Digging the valley temple and the Grateful Dead

Until its excavation by Auguste Mariette in 1853, the Khafre valley temple was unknown.[25] John Gardner Wilkinson's map, drawn before Mariette's excavations, labels the mound covering the site of the valley temple 'pits, probably unopened'. Mariette excavated intermittently in 1853 and 1858, and in 1869 he cleared the valley temple sufficiently for visits by dignitaries attending the opening of the Suez Canal. By 1880 he had completely freed the interior, while leaving the exterior walls piled up with unexcavated debris. Many postcards and stereo views from around the turn of the century show the site at this stage of excavation. When Petrie took his careful measurements of the interior of the valley temple in 1880–82, no one knew for certain whether it was a free-standing structure or whether it was built into a large pit.[26] And because the valley temple and Sphinx were the only monuments visible here for several years, the valley temple was called the Temple of the Sphinx; the true Sphinx Temple remained buried and unknown until it was discovered by Émile Baraize when working on the Sphinx between 1925 and 1935.

Before Baraize, in the popular tourist view from the southeast, the doorway in the north wall of the valley temple, which gave access to the roof, resembled a tunnel descending under the half-excavated Sphinx in the immediate background, while the Great Pyramid towered behind, up on the plateau. How influential was this viewpoint in encouraging the many speculations about a hidden passage under the Sphinx, and to the Great Pyramid beyond?

Hölscher established that the valley temple was a free-standing building in 1909, when he cleared the front of the temple.[27] In doing so, he had to excavate through an accumulation of stratified sand, cultural debris and mud-brick architecture deposited over two and a half

millennia to a height of 15 m (49 ft). In a trench barely 10 m (33 ft) wide, Hölscher cut through Greco-Roman buildings attached to the front of the temple and below these, from a thousand years earlier, an 18th dynasty villa in the Amarna style that served as a royal rest house when the temple was already 1,400 years old. Hölscher exposed about 1 m (3 ft) of the valley temple's two entrance ramps.

As part of his excavations of the Sphinx area, Baraize freed the northern, western and southern sides of the valley temple for the Antiquities Service. Selim Hassan expanded the clearing east of the Sphinx and valley temple from 1936 to 1938, but the area east of the temple was not adequately mapped at this time.[28] Sand quickly reburied the area. By 1966, when Maragioglio and Rinaldi visited the Sphinx and Khafre valley temple as part of their overall survey of pyramid complexes, arrangements made for tourists already obscured the Old Kingdom structures east of the temple. Then, in 1969, a modern cement and stone stage, built for a performance of *Swan Lake* as part of a celebration of the Cairo Millennium, covered the site. This was the first of many performances on the stage cemented to the front of the 4,600-year-old valley temple. From here Frank Sinatra crooned Cairo; and in 1978, under a full moon (and an eclipse), we met Jerry Garcia sitting on the granite casing blocks of the temple façade when he came with the Grateful Dead to perform at the Sphinx. A more appropriately named group could not have appeared in front of this temple, for evidence hints that its original purpose was to host the grateful Egyptian dead of the pyramid age.

It was not until 1996 that we removed the stage and cleared the area east of the Sphinx Temple and valley temple for the first time.

9.21 This Keystone View Company Stereoview uses a photograph taken from a popular viewpoint after Mariette's excavation of the interior of the Khafre valley temple. Although it was already known that this temple was a gateway to a causeway up to the second pyramid, a dark doorway that may have accessed the temple roof looked like an opening to a passage under the Sphinx. Did this inspire the notion that a subterranean passage led to the Great Pyramid?

Sphinx Temple, which are now lined up between the two temples, and he uncovered more pieces at the southeastern corner of the valley temple. The cornice [**9.23**] crowned walls clad in blocks of red granite from Aswan, which ranged in thickness from 40 cm (16 in.) to more than a metre (3 ft). Megalithic limestone blocks, some weighing more than 100 tons, formed the massive core of the walls. With these blocks, the builders formed a thick trapezoidal mass in which the rooms occupy less space than the walls.

Ricke was the first to recognize that the ground plan of the valley temple is not square – the north wall is pushed outwards at its northwestern corner [**9.22**]. It is just here, inside this corner, that a corridor rises in a 1:11 slope to meet the causeway. What Ricke did *not* see is that Khafre's builders created the massif of the valley temple in two phases, and altered the enclosure around it in yet a third phase. Striking evidence of the first two phases is a vertical seam that runs through the core work on both the north and south walls about 20 m (66 ft) east of the back wall. The seam has the same slight batter or lean towards the east as the finished outer faces of the temple. A granite casing block embedded at the bottom of the seam in the northern wall must remain from an earlier cladding of the back of the temple. The builders expanded the temple to the west after they had already begun to add casing.

In the first stage, the causeway may have run further east to attach to the northern end of the transverse 'bar' of what became the valley temple's T-shaped hall. In the second stage the builders extended the temple backwards to the west, adding the 'leg' of the T-shaped hall. At this point, they incorporated the causeway into the interior of the temple as the rising corridor mentioned above. By enveloping the causeway corridor within the temple's core masonry, they created the pronounced angle of the northern side of the temple, turning its baseline into a trapezoid. The expansion of the temple westwards thus explains both the deviation of the northern wall and the fact that bedrock is left protruding to such a height in this wall. The builders left a bedrock slope through the core of the temple to provide a continuous foundation for the causeway and the internal corridor.

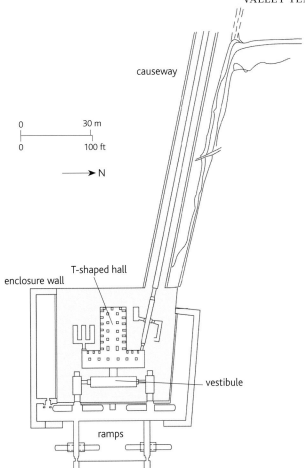

Ricke noted that the valley temple was once flanked on the north and south sides by enclosure walls of enormous limestone blocks that ran exactly 8.5 m (28 ft) from the temple walls. The southern wall still exists, composed of a single course of locally quarried monolithic limestone blocks. At its western end, two blocks make a corner and attach to the valley temple wall, slightly east of its back corner. The end block is fitted over a small granite block that remains *in situ* from a low bench, 75 cm (30 in.) wide, that ran along the base of the

ABOVE
9.22 Schematic plan of the Khafre valley temple at the lower end of the causeway by Herbert Ricke, showing the enclosure walls that extend from the back corners of the temple to the front, leaving an opening for the entrance ramps. Builders took down the northern enclosure wall when they built the Sphinx Temple as the last part of Khafre's valley complex.

LEFT
9.23 Cornice blocks of red granite that once crowned the Khafre valley temple, re-exposed by excavations in 2010 at the lower end of the southern entrance ramp. This is the oldest cornice known, except for a shrine in the Djoser pyramid complex.

south, east and north sides of the valley temple. Ricke recognized that the 'bench' and probably the entire granite casing of the valley temple were completed before the enclosure wall of large limestone blocks was built.

In our excavations we discovered that at the edge of the bedrock terrace in front of the valley temple, the wall turns 90 degrees. A single large block remains of the wall that ran parallel to the front of the valley temple after this turn; in line with it, the rock floor is cut as an emplacement bed for an additional long block that must have been removed. This missing piece would have brought the wall just shy of 5 m (16 ft) of the southern stone entrance ramp.

In front of the opposite corner of the valley temple we mapped the foundation bed of a similar wall, sunk into the bedrock. This ran parallel to the northern side of the temple and, as on the south, 8.5 m (28 ft) from it; also exactly like the southern wall, the bed on the north is just under 2.6 m (5 cubits or 8½ ft) wide. Again mirroring its counterpart, the foundation cutting of the north wall shows that it turned a corner to run along the edge of the terrace in front of the valley temple, similarly stopping just shy of 5 m (16 ft) from the northern stone entrance ramp. The northern wall attached

to the back end of the temple, 6 m (20 ft) east of the rear corner; as on the south, this connection is marked by a single surviving granite block of the bench along the base of the temple. The walls once formed an enclosure, like two arms attached to the back corners of the valley temple and reaching out to enclose the front corners, leaving a wide space for the approach ramps and front terrace.

In yet another stage of construction of Khafre's temples, when the king's builders were set to work on the Sphinx Temple, they removed most of the northern enclosure wall, but left in place some blocks, which they incorporated into the southern wall of the Sphinx Temple. The foundation trench cut into bedrock remained as a record of where the northern wall had once stood.

The builders were well advanced on the core walls of the valley temple, or had even finished them, before they started to add the granite casing. And they had set all or much of the casing before they dressed its outer face. This is why we see throughout the temple a few inches of the massive granite blocks turning the corner of a doorway or chamber. The masons did not pre-cut the blocks to their final precise shape, they literally sculpted the doorways and rooms from the roughly faced granite after they had set it in place.

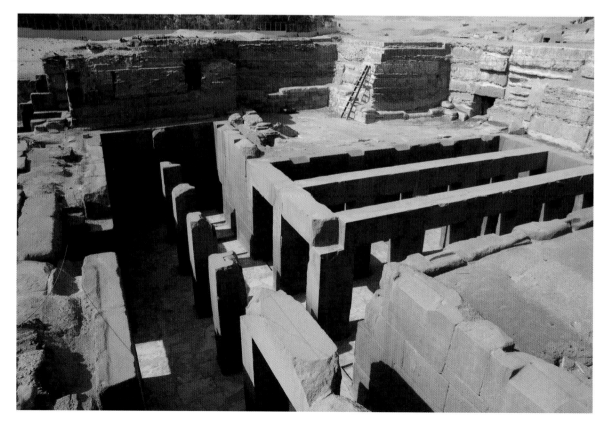

9.24 View of the rear interior of the Khafre valley temple, showing the T-shaped hall with granite pillars, architraves and cladding on the walls. A raised floor covered the hall, with steps down to an open-air court on the south (where the ladder is). Fine limestone cladding covered the locally quarried large core blocks that shielded the court from the outside.

Inside the valley temple

At the front of the valley temple two massive doorways, one north and one south, rose to a height of more than 5 m (16 ft). A band of hieroglyphs framed each door, giving the name and titles of the king, beloved of two goddesses – Hathor on the south and Bastet on the north. Huge, single-leaf doors (as indicated by single pivot sockets), probably of cedar wood and creaking on great copper hinges, swung open to give access to the dark interior of the antechambers, which were a staggering 9.4 m (31 ft) high. The rooms of the temple decrease in height from front to back, as was the case in the upper temple (and in many temples of later periods). High up in the back walls of these antechambers, oversized baboons carved from dark granite (but perhaps originally painted) stood in niches to greet the rising sun.

Short corridors led off the antechambers at right angles and sloped up to the floor level of the vestibule, a rectangular hall that stretched 18.5 m (61 ft) north–south between the two antechambers. Its roofing beams must have spanned nearly 5 m (16 ft). Like the rest of the temple interior, the floor was paved with white alabaster slabs joined together in a complex jigsaw pattern, the result of each slab having been custom cut to fit its neighbour. Red granite covered the walls of this plain, rectilinear space, devoid of statues, hieroglyphs or images of any kind.

At the northern end of the vestibule an irregular pit opens through the pavement and bedrock; tourists today unaccountably drop paper money and coins into it. It was in this pit that Mariette discovered several statues of Khafre, where they had apparently been thrown in antiquity.[29] The most complete is one of the most famous pieces in the history of art worldwide – carved from streaked dark stone, it depicts Khafre seated on his throne with the Horus falcon perched on the back, enfolding its divine wings around the king's head [**9.25** and see also 6.13].

In its first stage, the Khafre valley temple consisted of the two antechambers, the vestibule and the cross room of what would become the T-shaped pillared hall [**9.24**]. Perhaps this was nothing more than a monumentalized entryway, a door building, with entrances on both left and right – north and south.

From the centre of the west wall of the vestibule a doorway led to the transverse pillared hall. At 6.8 m (22 ft 4 in.) across, the 'bar' of the T-shaped hall is too wide to have been roofed by stone slabs supported only by the side walls – the width of the King's Chamber in Khufu's pyramid, at 5.24 m (17 ft), was the greatest span the Egyptians had yet attempted in stone. Khafre's builders erected six monolithic shafts of red granite, 2 cubits (1.05 m/3 ft 5 in.) thick, to support the roof. These they attached to the architraves by mortise and tenon joints – the mortises can still be seen at the tops of the pillars. The builders later spanned an even greater width in the leg of the T-shaped hall, which is 10 m (33 ft) wide, supporting the roof with two rows of four monolithic granite pillars, again 2 cubits thick.

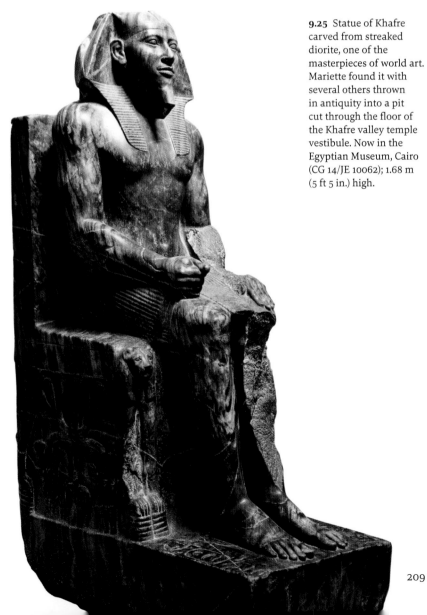

9.25 Statue of Khafre carved from streaked diorite, one of the masterpieces of world art. Mariette found it with several others thrown in antiquity into a pit cut through the floor of the Khafre valley temple vestibule. Now in the Egyptian Museum, Cairo (CG 14/JE 10062); 1.68 m (5 ft 5 in.) high.

Chthonic and celestial: the internal circuit

The leg of the pillared hall, built in the second stage, was an expansion of the original vision for the temple, and its significance must derive from the nearly two dozen statues of the king that once lined the walls of the completed T-shaped hall. Their existence is revealed by the surviving pits in which they once stood. The builders also added courts and terraces on the temple's roof (see below), and these elements became part of a circuit through the temple, between the dimly lit or dark lower rooms and what must have been an upper ritual platform, open to the sky, brilliantly lit.

Some of the statues were carved from dark hard stone, as shown by the seven that were recovered from the vestibule pit. But based on the numerous fragments he found, Hölscher thought that most of the statues were carved from alabaster. The statue sequence began at the southern end of the western wall of the crossbar of the T-shaped hall, at the doorway into a magazine formed of three chambers, each with two storeys. It continued down the southern wall of the leg of the T-shaped hall to its western rear wall, and then back along the north wall and into the cross room again, ending at the door of the causeway corridor. It has been remarked that the hall exhibits neither goal nor focus, but when we mapped it we noted that the central statue pit in the rear wall was wider, at about 1 m (3 ft), than the others (those flanking it are at most 60 cm/24 in. wide). This central statue may thus have been larger, and if we count it as two, or imagine it received double the rituals that were performed before the other statues, the total number would be 24. By such machinations we could further speculate that the 24 iterations were rituals performed for the 24 hours of the day and night.

Using similar number manipulation and guesswork, Ricke and his companion interpreter of ancient Egyptian ideology, Siegfried Schott, believed the statues represented the deified 26 members of the king's body, with two of the statues representing three members – hence a total of 23 statues.[30] Whatever their meaning, all these statues were probably originally painted in bright colours. But more than simply art objects to be admired, the statues were intended to have spiritual efficacy.

With the complete circuit down to the central statue in the leg of the T-shaped hall and back, the statue series made a connection between the doorway to the magazines on the south and that of the causeway corridor on the north, forming the lower part of a closed loop within the temple. The upper half of the loop continued halfway up the causeway corridor. A right turn through a doorway led to a dark chamber dubbed a 'Porter's Room', while a left turn led to a stairway ramp ascending to the upper level of the temple.

In the temple's interior, light entered only through narrow shafts between the tops of the walls and the undersides of the ceiling slabs. The royal statues sat in eerie, perpetual twilight, faces intermittently aglow with the light of a passing priest's lamp. Now, suddenly, from the dim underworld, one emerged via the stairway ramp into the open brilliant sunlight reflecting off the limestone masonry of the roof terraces. Here was another special effect of chiaroscuro designed into Khafre's pyramid complex, seen also in the upper temple.

Five terraces, bathed in sunlight, were stepped across the roof according to the heights of the rooms below. The highest terraces were over the antechambers, the vestibule and the T-shaped hall. The lowest were above the roofs of the Porter's Room on the north and the set of magazines on the south. Rain that collected on the lowest terraces flowed out through massive granite drains built into openings in the west wall of the temple. The surrounding high outer walls, their interior faces encased in Turah-quality limestone slabs, obscured the roof terraces from the view of anyone outside the temple. The cornice around the upper rim rendered the archetypal form of the 'divine booth'. On the south side, a small court was specially framed, exactly above the dark magazines embedded in the core masonry of the temple below.

Ricke and Schott, looking for correspondences between mute architecture and later religious texts, suggest that these magazines in the temple interior were temporary receptacles for the king's coffin, his viscera and two crowns of Sais, the ancient Delta capital. Here, according to this theory, they lodged while the rites of purification, the 'Opening of the Mouth' and deifying the king's bodily parts were carried out in the temple.[31]

Whatever the actual functions of the three magazines, each double-decker set of two was fitted with a shaft connecting to the court above. These

shafts are similar to the light shafts along the upper edges of the pillared hall except that they had two bends, giving them a rectilinear C-shape, with one end opening in the upper sunlit court and the other in the lower dark magazines. Even with their white alabaster lining, Hölscher doubted that these shafts could conduct light into the magazines, so he concluded that they must have vented lamp smoke or odours. We might ask: odours produced by what? (A similar 'vent' was installed in the so-called Porter's Room.)

The connection between above and below, and the care taken to line these 'vents' with alabaster, suggests a conscious design of a circuit within the temple – from the dark lower magazines, round the statue series in the T-shaped hall and the corridors up to the sunlit roof. We can only speculate that the designers intended a circuit between celestial sunlight above and earthly darkness below, a solar–chthonic connection that we see in royal tomb paintings and mythological papyri from thousands of years later.

Priests' houses and workshops

Like a mummy, the soft tissue of the valley temple has almost completely disappeared, desiccated by time to leave the stone ruins we see today. Missing are the mud brick and plaster, reed and clay roofing, wooden doorways and windows that made up the structures of everyday life around the temple core. Only a hint of the priests' houses and workshops remains on the south, where a series of melted mud-brick walls project from the remains of the enclosure wall of massive limestone blocks to form comb-like magazines. A larger structure built of mud brick stood to the south of the wall, where the surface dips below a thick sandy overburden.

When he cleared the Sphinx area between 1925 and 1935, Baraize left a standing section, about 4 m (13 ft) high, on the west, behind the valley temple. The remains of an 18th dynasty mud-brick building, 'Tutankhamun's Rest House', stood at the top of this section, which consists mostly of drift sand. The contemporary photographs show another dark mud or mud-brick layer on the bedrock surface on top of the ledge marking the limit of Terrace 1 (see Chapter 10 for a discussion of these terraces). This layer probably marks the remains of Old Kingdom mud-brick structures, like those along the south side of the valley temple. Unfortunately, here on the west side there is no indication of their form.

Harbour and landing stage

Fine silt deposited over the centuries during the annual inundation has raised the Nile floodplain more than 4 m (10 ft) since the Old Kingdom period. But the deepest and largest floodplain features from the time of the pyramids may still be discernible along the base of the Giza Plateau. Until recent decades, the contours revealed a pronounced rectangular depression, 200 m (656 ft) west-southwest, between modern Amirah Fadya Street and the old canal, Collecteur el-Sissi. The line of the old canal and the rectangular depression both head straight towards the Khafre valley temple and Sphinx Temple. Could these features be the vestiges of a channel and flood basin that fed the harbours of Khafre and Menkaure? This low southeastern corner of the Giza Plateau would already have been a general delivery area from the time when the Khufu pyramid was under construction.

We have discovered other evidence for a harbour in front of the Khafre valley temple and Sphinx Temple.[32] Both sit on a broad terrace cut into the limestone, around 17 m (56 ft) above sea level. In June 1980 we excavated trenches to the east, that is in front of the Sphinx Temple, through less than 2 m (7 ft) of sand to hit that rock terrace as it slopes gradually to the east about 1 m (3 ft) lower than in front of the Sphinx. Later that year the Institute of Underground Water of the Ministry of Irrigation drilled 22 m (72 ft) further east through 16 m (52 ft) of sand and debris soaked in groundwater, before hitting a hard surface at around 4 m (13 ft) above sea level. Between our trench and the drill hole, the bedrock surface drops a steep 12 m (40 ft), forming a buried cliff. From the bottom, the core drill pulled up fragments of red granite that can only have been imported from Aswan. Did a block of granite, like those that clad the Sphinx Temple and valley temple, fall from a transport barge to the bottom of a deep harbour? We suspect so, and that the buried cliff is the ancient quay for docking boats at the front of Khafre's valley complex.

Just south of where the cores were drilled is an area in front of the Khafre valley temple where two stone ramps, over 24 m (79 ft) long and 1.2–1.5 m (4 to 5 ft) wide, extend out from the temple

eastwards more than 26 m (85 ft), before diving under the sand. In spring 2010 we excavated the southern ramp to its eastern end, marked by a pavement slab set into a cutting in the bedrock surface (at 12.9 m/42 ft above sea level), which slopes yet deeper and farther east [**9.26**]. These arms of the valley temple must be reaching for the harbour, perhaps along the line of the buried cliff.

Patterns of cup-shaped depressions mark the sloping eastern ends of the ramps. This pocked surface stops where the ramps level out at the threshold of doorways indicated by pivot sockets and swing marks on the limestone surface. We first conjectured that the lapping waters of many years of high Nile floods had eroded the lower slopes of the ramps to produce the depressions. However, the threshold where the marks end is 16.9 m (55 ft) above sea level, and we have reason to believe that the Old Kingdom floodplain lay at an elevation around 12.5 to 13 m (42–43 ft) above sea level. It would take a Nile flood of more than 4 m (13 ft) deep to reach the thresholds on the ramps; this would be catastrophic, and nearly impossible, given that an average flood depth at the valley margins was 1.5 m (5 ft). Another suggestion is that the surfaces of the ramps were deliberately roughened to provide traction on what might have been a slippery slope up from the wet, muddy harbour edge.

The pivot sockets and swing marks remain from double doorways of entrance kiosks or gatehouses where the ramps level off, about 12 to 16 m (39–52 ft) in front of the temple terrace. Moulding on the ramps indicates the positions of the jambs of the gates. They were built partly on a pavement, now missing, which extended out over thick mud-brick walls attached at right angles to the ramps at this point. Beneath the ramps and kiosks the builders cut trenches or tunnels into the bedrock, which slope up at either end where they emerge from under the ramps. Parallel mud-brick walls framed the tunnels within a corridor 4 m (13 ft) wide running between the ramps and extending north and south of them.

The ramps led up to the terrace running along the front of the valley temple. The pavement that once covered it is now missing, but marks in the limestone bedrock indicate a small square structure that could have been the socket for a purification booth that stood at the centre of the terrace against the low granite curb that ran along the base of the temple. The emplacement for this missing structure is 2.5 m (8 ft 2 in.) north–south and 2 m (6 ft 7 in.) east–west. If this was too small to accommodate a 'purification booth', the structure might have been a shrine housing a statue of the king. At the corners, small sockets held corner posts of wood or stone, and at the front Hölscher identified a threshold and pivot socket for a small swinging door.[33] Rectangular depressions along the four sides of the shrine anchored thick pavement slabs that framed its foundation. Off the northeast side of the valley temple, a mud-brick platform was also found, from which Hawass believes the queen and the royal children could have observed the king's purification.

Reservoirs or sacred boats?

Selim Hassan interpreted the tunnels under the ramps and the walls that frame them in front of the valley temple as a 'watercourse' connected to the *Ibu* or 'washing tent' where the Egyptians took corpses to be 'cleansed' during the mummification process (see Chapter 7). A large round limestone basin that Uvo Hölscher found at the southern end of the low terrace fronting the valley temple may have been used in these rites. Herbert Ricke also saw the ramps, tunnels and corridor connecting them as being related to water and funerary purification, noting that boats could not have navigated the token or symbolic canal formed by the flooded corridor.

We differ about the purpose of the mysterious tunnels under the ramps. Hawass believes they are pits for the ritual burial of sacred barques of Horus, an abbreviated version of the larger boat pits at the base of the pyramid. Lehner sees them as reservoirs that collected the water that would have filled the corridor at peak inundation and retained it when the floods receded. The floors of the corridor and the tunnels might be deep enough (around 14.5 m or 48 ft above sea level) for higher floods to have reached them through a southern conduit as yet still unexcavated. A square hole at the deepest point of the tunnel under the southern ramp was fitted with a limestone cover pierced with holes through which ropes could be slipped to raise and lower it. The highest inundations, added to perhaps by workers with water jars, might have filled the corridor with water to form a narrow canal; when the flood receded the water was held in the tunnels or reservoirs. Those approaching the valley temple thus crossed a token body of water or canal as they passed through the kiosks on the ramps.

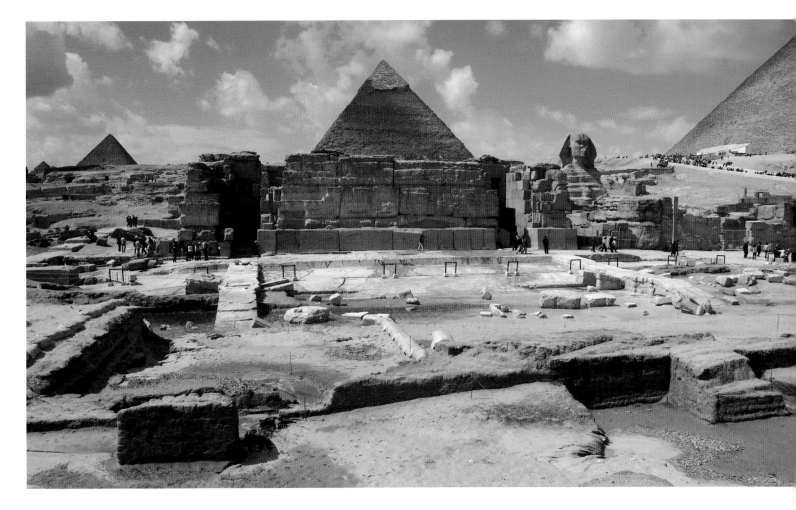

Two long elliptical emplacements flanked both entrance doors of the valley temple. These would have held mighty statues, perhaps of lions but more probably of sphinxes, as indicated by their curved backs, typical of sphinx bases. At 2 m (6 ft 7 in.) wide and 8 m (26 ft) long, they would be the largest sphinxes known from ancient Egypt, apart from the Great Sphinx and the 18th dynasty alabaster sphinx of Amenhotep II at Mit Rahina, also 8 m long. Each emplacement is surrounded by sockets for the ends of wooden levers for setting the statues into place. The terrace slopes markedly at its southern end. Here Hölscher found a large round basin (see box), partially carved into the terrace and partially built of limestone.

Khafre's complex is the last major fanfare of the exuberant gigantism that characterizes the experimental age in pyramid building. He may have originally planned a pyramid even bigger than that of his father, Khufu. While he failed in that ambition, and simplified the pyramid's internal passages and chambers, he did advance temple layout and set off an explosion of statue making. We estimate that there were hundreds of statues at life-size and smaller, in limestone, alabaster and hard igneous rock, depicting Khafre – images of his divine kingship. And in addition, from foundation cuttings, it seems that Khafre installed more than 50 colossal or larger than life-sized statues in his complex, not the least of which is the Great Sphinx, discussed in the next chapter.

Whether the extreme monumentality of three generations of pyramid builders (Sneferu, Khufu and Khafre) had exhausted both the royal house and Egypt, or attention turned to other priorities, we do not know. But the evidence is clear that Menkaure scaled down the design and construction of the third pyramid at Giza. Even then, his builders could not finish the job, leaving us candid 'frozen moments' in the pyramid-building processes, as we shall see in Chapter 11.

9.26 The area east of the Khafre valley temple, looking towards it, with the entrance ramps descending into water (on the left) – groundwater that rose in 2010. In the foreground is a bastioned mud-brick wall, built in the 18th dynasty, and re-excavated in 2010 after it was first exposed in 1936, which remains from a New Kingdom complex all around the Sphinx, Sphinx Temple and Khafre valley temple. The pyramids of Khufu (right), Khafre (centre) and Menkaure (left) rise in the distance.

213

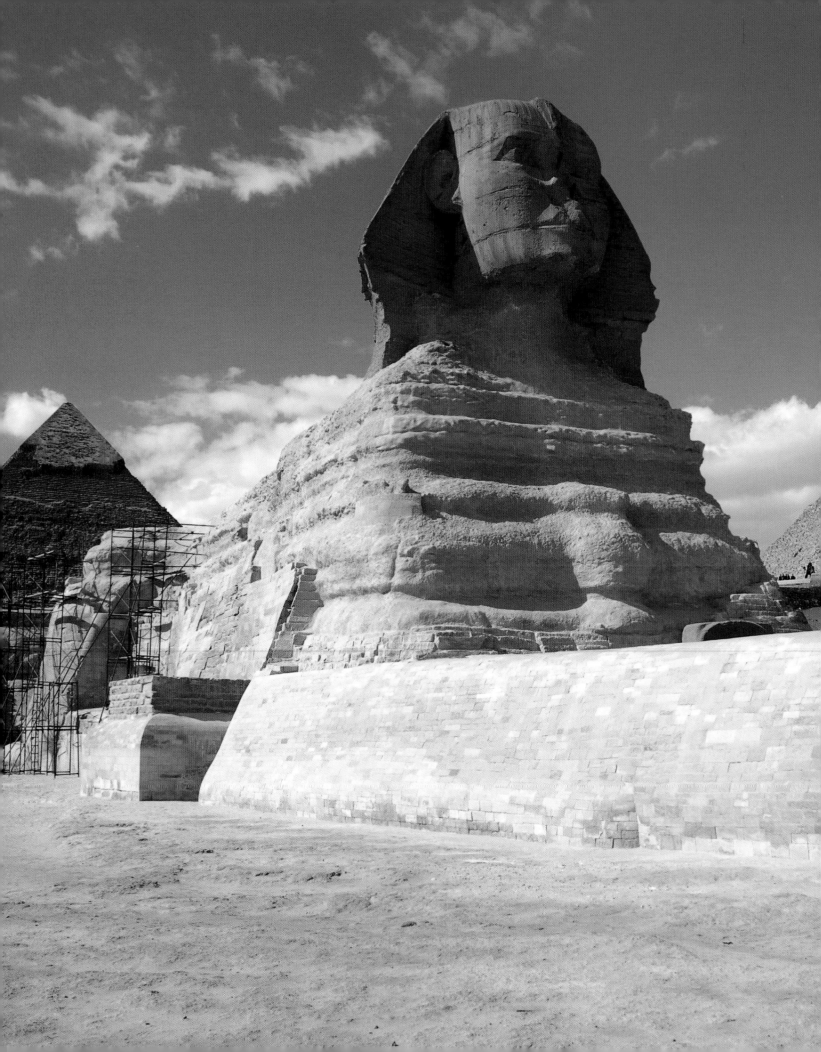

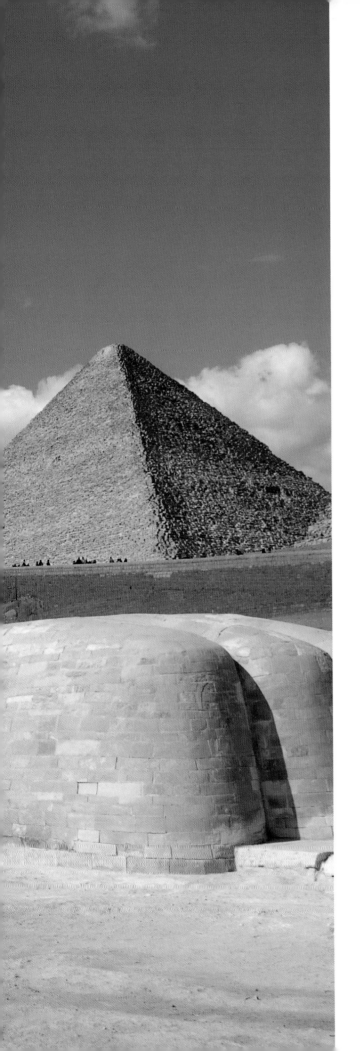

CHAPTER 10
The Great Sphinx

How strange the Great Sphinx of Giza was for its time! We fail

to see this now because for us the Sphinx typifies ancient Egypt.

The Sphinx is a national symbol of Egypt, ancient and modern;

it is an archetype of antiquity whose image has stirred the

imaginations of poets, scholars, adventurers and tourists for

centuries. But when it was carved in the 4th dynasty, the Sphinx

was probably the first statue ever created at this colossal order

of magnitude, sculpted directly from the living rock, looming out

of the earth itself, a hybrid with the body of a lion and a human

head, suggesting the magical shape-shifting power of the ruler –

man-god and king of beasts. The Great Sphinx would also be the

oldest sphinx known, and therefore a prototype for what became

a classic Egyptian form, were it not for the possibility that a life-

sized stone head of Khafre's predecessor, Djedefre, wearing the

nemes scarf, was broken off a sphinx.

The Giza Sphinx is intimately connected to the base of the Khafre causeway and his valley temple [**10.2**]. It also fits within the great rectangle formed by the secondary fieldstone walls that described precincts around each of the pyramid complexes, if that of Khafre is extrapolated east down the slope of the plateau. This situation, plus the architectural relationships discussed at the end of this chapter, suggest that it was Khafre who built the Great Sphinx as part of his pyramid complex. He was, after all, perhaps the greatest statue maker of the pyramid age. As noted at the end of the previous chapter, in addition to hundreds of smaller statues, in his valley and upper temples there are emplacements for more than 50 statues on a scale ranging from life-size to colossal. Ten more huge statues stood around the court of the Sphinx Temple. The floor plans of no other pyramid

temples of the Old Kingdom indicate so many statues on such a large scale.

And the Sphinx was the largest of all. As far as we know, the next royal sculpture created at this order of magnitude dates to the New Kingdom, more than 1,000 years later.

The natural rock statue

The Sphinx is carved directly from the layers of natural limestone of the Moqattam Formation, known as Members I to III (see Chapter 3 for a description of the geology of Giza).[1] The builders first quarried out a horseshoe-shaped ditch down into Member I to isolate a huge rectangular block of natural limestone, orientated east–west, for creating the Sphinx. The ditch opened to the east, where the workmen had already cut out a lower broad terrace (Terrace I) from the hard and brittle reef limestone. On the south end of Terrace I they erected the Khafre valley temple. The Sphinx, on Terrace II, forms a standing section of the deeper limestone layers of the Giza Plateau, although much of the bedrock body is now masked by ancient and modern restoration.

The 4th dynasty quarrymen must have sculpted the Sphinx's head from a block of limestone reserved from Member III measuring exactly 20 × 20 royal cubits wide and long (10.5 m/34 ft 5 in. square). We can see this by overlaying a grid of squares of 1 royal cubit (0.525 m/21 in.) on an overhead view. The great head is symmetrical to a fair degree of accuracy. But the reserved block was not a cube, because the height of the head is a little less than 12 cubits (6.3 m/20 ft 8 in.).

The Sphinx's body, carved mostly from the lower and softer Member II, but at its lowest part from Member I, is also quite symmetrical. In total it measures 72.55 m/238 ft long from the tip of the masonry-covered south forepaw, which extends a little further east than the north forepaw, to the masonry-covered tail at the rump. Without the length of the forepaws, 17.4 m (57 ft) (north) and 17.05 m (56 ft) (south), it is probable that the designers intended the body to be a round 100 cubits (52.5 m/172 ft) long. In sum, the head and body of the Sphinx are individually symmetrical. Commenting on the generic sphinx form, the art historian Edna Russman points out that:

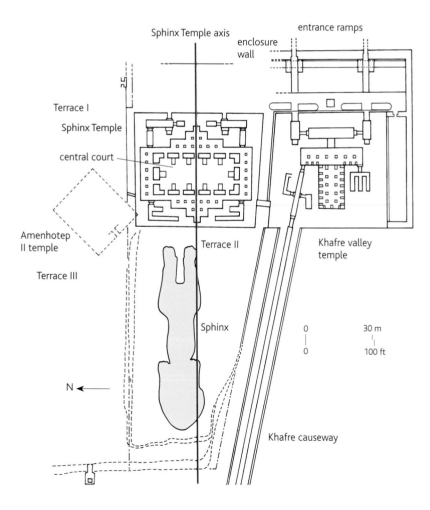

Usually a sphinx lies peacefully recumbent, but its body is massive, with muscular shoulders, a rib cage like a barrel, and hindquarters ready to spring. A human head on this body, if it is not to look ridiculous, must be disproportionately large. The Egyptians perceived this, and they also realized that the royal pleated head cloth, the *nemes*, gave needed width to the head, framing it in a setting not unlike a mane.[2]

Viewed from the side, the Great Sphinx at Giza does not conform to this proportionate relationship, even though the human head is on a scale of about 30:1 and the lion body is on the smaller scale of 22:1. This is primarily because of the length of its body. Classic, later Egyptian sphinxes, like those of the 18th dynasty pharaohs Hatshepsut and Thutmose III, are four heads in length, measured from the base of the chest to the end of the rump where the tail begins. The forepaws are a little more than one head in length from the base of the chest

to the tip of the paws. The body of the Giza Sphinx is five heads long and the forepaws are a little under two heads long (allowing for the missing nose and back of the *nemes*). In other words, the body and forepaws of the Giza Sphinx are both about one head-length too long, making the head itself proportionately too small. Also, the Sphinx's back is almost level for most of its length, whereas the 'classic' sphinx/lion body slopes from high front shoulders to a much lower level between the rear haunches [**10.3**].

The Sphinx head is thus drastically smaller in proportion to the *length* than to the frontal *height* of the body. Why did the builders make the body too long? The question of whether or not they finished the Sphinx body in the natural limestone is discussed below, but the fact that the 4th dynasty workmen did complete the general shape, including the rear haunches, rear paws and tail, suggests they never intended to make it shorter. Nor can this disparity between body and head have been

10.3 The Great Sphinx, seen from the north. To the front left (east) are the 18th dynasty temple of Amenhotep II near the modern road, the Sphinx Temple and the Khafre valley temple. In the background the Gebel el-Qibli (Southern Mount) rises above the temples. The Central Field East cemetery lies south of the Sphinx. The Khentkawes I mastaba can be seen to the southwest, above the rear of the Sphinx.

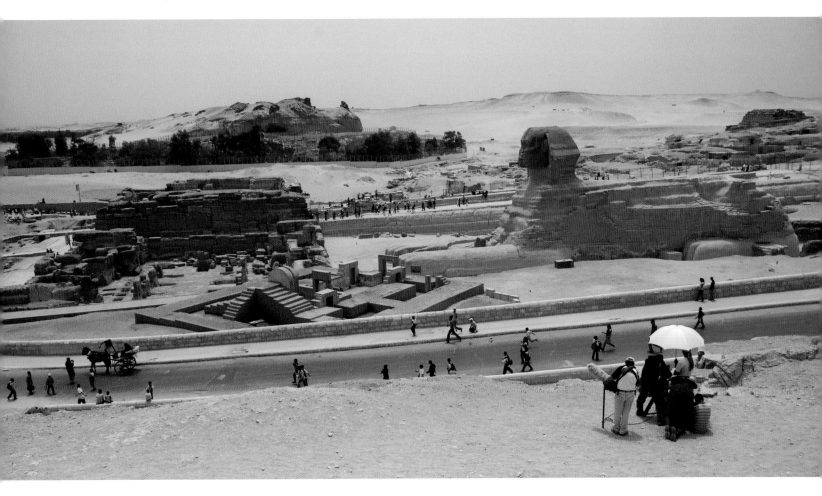

because the Sphinx designers lacked a canon of proportion, even if the Sphinx is a prototype – the Egyptians had been carving lions on a smaller scale in the round since the 1st dynasty and in relief even earlier, since the Predynastic, and some of these are reasonably correct in their proportions.

Geological constraints may account for the elongated Sphinx body. At four heads in length the rump would have ended about where the Sphinx's waist is situated. It is just here that a major fissure, the most serious flaw in the bedrock, cuts through all the rock layers, opening to more than 2 m (6 ft 6 in.) wide at the top of the statue's back. The Egyptians may have extended the body by one head-length in order to bypass this flaw, which would otherwise have disturbed the outer contours of the sculpture.

Viewed from the front, however, the head and body of the Great Sphinx are more in proportion

The Great Sphinx: major explorations

Years	Excavator
1816–19	G. B. Caviglia
1837	R. Howard Vyse and J. S. Perring
1842–43	C. R. Lepsius
1853, 1858	A. Mariette
1925–36	É. Baraize
1936–39	S. Hassan (SAE)
1965–70	(Temple) H. Ricke and G. Haeny Swiss Archaeological Institute
1977–78	M. Lehner and Z. Hawass (EAO)
1977, 1978	SRI International/EAO
1979–83	J. Allen and M. Lehner (ARCE – American Research Center in Egypt)
1987	S. Yoshimura (Waseda University, Tokyo)
1988–2012	Z. Hawass (SCA – Supreme Council of Antiquities)
1990	UNESCO
1991	R. Schoch, T. Dobecki and J. A. West
1992	I. Marzouk and A. Gharib
2010	Z. Hawass, M. Lehner, G. Dash (geophysical survey of the northwest box)
2012–present	Ministry of Antiquities

The Great Sphinx dimensions

Total length	72.55 m (238 ft)
Length of bedrock body	71.9 m (236 ft)
Width across haunches	19.1 m (62 ft 8 in.)
Width across waist (at base)	10 m (32 ft 10 in.)
Width across waist (top)	3.6 m (11 ft 10 in.)
Width (elbow to elbow)	18.5 m (60 ft 8 in.)
Width across chest	12.7 m (41 ft 8 in.)
Height (to tip of cobra on forehead)	20.22 m (66 ft 4 in.)

[**10.4**]. A cubit grid laid over the front elevation suggests general harmony. It was just this front view that was most important for the cult the Egyptians intended in the temple they built on the terrace below the statue. In the 4th dynasty, the walls of the Khafre causeway would have rendered the familiar tourist view of today – from the south-southeast – impossible. And the Sphinx's body would have been partially obscured from the west and north because of the way it lies down inside its rock-cut sanctuary.

The sculptors may have slightly reduced the thickness of the head in order to keep it within the upper layers of Member III. These beds of harder rock allowed them to carve the fine details in the only part of the statue where this was necessary, the head and face. The lion body was more massive and lacked such fine detail, except that we know from exposures through the masonry cover that the fronts of the toes were fashioned with claws.

Because the head was carved from the harder Member III it is better preserved than the body and still retains some of its original features, such as the mouth, the eyes and eyebrows, hinting at its pristine appearance. At the centre of the Sphinx's forehead are the remains of the divine cobra, or *uraeus*, worn by ancient Egyptian gods and kings. The head of the serpent is broken off at a point about 1.5 m (almost 5 ft) above the head band of the *nemes*; chisel marks are still visible at the break [**10.6**].

In 1916, Caviglia found a large serpent head, thought to be original to the Sphinx, at the base of its chest [**10.5**]. It was taken to the British Museum and a plaster cast is in the Cairo Museum.[3] The piece measures 61.7 cm (24.3 in.) in length

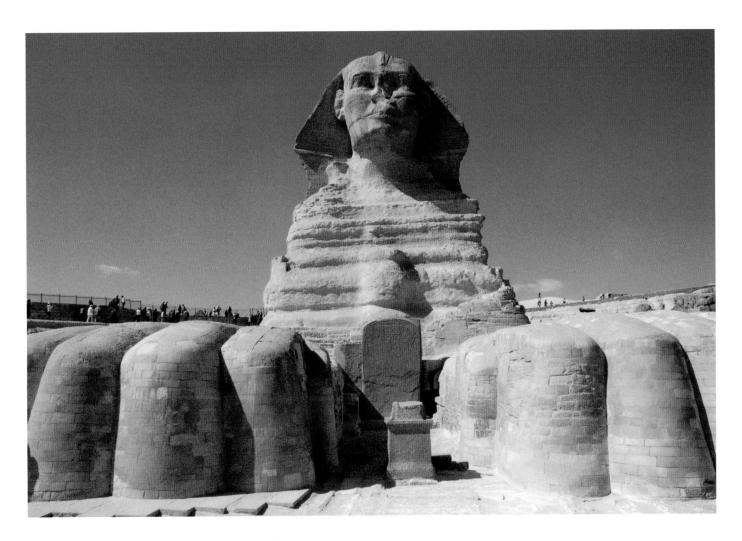

and 45.7 cm (18.7 in.) in width, dimensions which approximately match the break at the top of the Sphinx's head. However, the unfinished parts of the *uraeus* head do not match neatly the rough break at the top of the forehead. The back of the *uraeus* head is a sheer cut, almost square with the axis of the body. Towards the back of the underside of the head there are chisel marks similar to those at the top of the *uraeus* and the entire underside is rough

LEFT
10.5 Remains of the *uraeus*, carved in relief, on the Sphinx brow. We can discern chisel marks at the point where someone broke off the projecting serpent head.

FAR LEFT
10.6 Serpent head of limestone found by Caviglia at the base of the Sphinx's chest. The back is a sheer cut that does not match the break on the Sphinx forehead. Now in the British Museum, London (EA1204); 61.7 cm (24.3 in.) long.

and pocked and does not look like a break from the natural rock. Rather it is similar to pocking on surfaces that were meant take mortar to hold a piece in place. In sum, while the *uraeus* body, relief-carved on the forehead, must have certainly ended in a cobra head, it is unclear whether the detached piece Caviglia found was original, detached and reattached later, or whether this is a piece that was carved separately and added. A closer geological inspection of the piece could resolve this issue.

Other elements are also now missing or damaged – the nose, the beard and the headdress, including its knotted back. The lappets of the headdress might once have covered the front of the statue's shoulders. Caviglia also discovered fragments of the divine beard in the 19th century, which we discuss below.

As for the style of the head and face, a comparison between the famous Khafre statue (see 9.25) and the Sphinx shows that the eyes, nose, mouth, chin and headband of the two statues are fairly well matched, but only if the Khafre statue is tilted off its vertical axis. This is because the Sphinx's left eye (N) is higher than the right (S), and the mouth is slightly off centre in the frame of the face (see box, p. 238). The axes of the Sphinx's facial features and that of its head (ear to ear) do not quite match, perhaps due to the monumental scale involved, unless we choose to believe that the Sphinx face was never meant to depict Khafre (but rather Khufu, as Stadelmann would argue, in part on the form and proportions of the head and face[4]). In fact the eyes, eyebrows, headband and mouth of an alabaster face in the Museum of Fine Arts,[5] thought to depict Khafre, provide a good match with features on the Sphinx – better than the famous Khafre statue. And the flat-topped Sphinx head has, perhaps, its best parallel in the small 4th dynasty seated royal statues from Mit Rahina in the Egyptian Museum, Cairo (CG 38 and 39), attributed to Menkaure, but especially one (CG 41) attributed to Khafre.[6]

But because of the degree of stylization required in sculpture of this magnitude, and the lack of other comparable statues on such a colossal scale from this era, we doubt we can ascribe securely the face of the Sphinx to any individual king. In any case, Egyptologists would no longer dispute that the style dates the Sphinx to the 4th dynasty, even if they might disagree as to which king.

The Sphinx Temple

Given that it was unprecedented in scale, and almost so in iconography, what meaning did the 4th dynasty Egyptians attempt to convey in the Great Sphinx? Around 8 m (26 ft) directly in front of the Sphinx's paws is a temple which might offer some clues. Like the Khafre valley temple adjacent to its south, this temple is constructed from monolithic locally quarried limestone core blocks that were intended to be clad in red granite. It was built mostly on Terrace I, 2.5 m (8 ft) lower than the level of the Sphinx on Terrace II.

Egyptologists have expressed doubts as to whether the temple in front of the Sphinx served a cult of the giant statue. There is no direct access from inside the temple on Terrace I up to the Sphinx ditch on Terrace II – no ramp or obvious sign of a stairway. Yet it seems perverse to us to think that this large building, directly in front of the colossal image and below its outstretched paws, is not the cult emplacement such as the ancient Egyptians attached to any divine image. So we are happy to call it the Sphinx Temple.

East–west (front to back), the Sphinx Temple measures 45 m (148 ft), but on the north–south axis it is 51.5 m (169 ft) wide at the front and 49 m (161 ft) at the back. The difference in width is because the south wall runs parallel to the north wall of the valley temple, which is angled, as described in the previous chapter. The fact that the Sphinx Temple south wall follows the angle of the valley temple north wall is one of many indications that the Sphinx Temple was the later of the two temples. A corridor 6.5 m (21 ft) wide separates the two, the front and back walls of which are almost on line.

In fact, the Khafre valley temple and the Sphinx and its temple were all created as part of the same quarrying and construction process. Herbert Ricke, who carried out a detailed study of the Sphinx Temple from 1965 to 1970,[7] noted the improbability that the Sphinx Temple and Khafre valley temple would have been built at the foot of a towering rock outcrop that only later became the Sphinx. He suggested that blocks removed from the Sphinx quarry were used in the core construction of the temples. Even in 1910, when the Sphinx Temple was hidden under accumulations 15 m (49 ft) high, Uvo Hölscher perceived that the

Sphinx and the Khafre valley temple were built concurrently.[8]

Close study in 1980 with geologist Thomas Aigner of the geological layers in the Sphinx and each of the 173 core blocks in the Sphinx Temple and valley temple has enabled us to unravel the sequence of quarrying and building that created this complex.

For the valley temple the builders probably took huge blocks from the same layers that run through the upper part of the Sphinx body and head. Some may also have come from quarries southeast of the Sphinx, from bedrock layers higher in the geological sequence than those at the Sphinx.

Most of the Sphinx Temple core blocks were taken from layers that are seen in the Sphinx body, which the quarrymen removed when they excavated the ditch around the Sphinx. The most common block type, with a soft yellow band between two harder bands, came from layers corresponding to those just below chest height in the Sphinx body (see 10.10). These limestone core blocks can weigh up to as much as 100 tons.

What kind of temple were they building? A large proportion of the Sphinx Temple was taken up by an open central court, in which 10 colossal statues of Khafre stood in front of pillars made of massive core blocks that would have been encased in red granite [**10.7**]. A covered colonnade surrounded the court, its roof supported by 24 square granite pillars. Two recessed sanctuaries, one on the east and another on the west, aligned on the centre axis of the temple. The temple also contained northern and southern entrance chambers and a pair of magazines at the back corners. Granite casing on the temple's inner walls would have created and defined sacred spaces about the size of small closets. Directly in front of each of the two sanctuaries stood two pillars, in addition to and set back from the 24 of the colonnade.

Ricke pointed out that the temple's central court copied that in Khafre's upper temple, except the latter contained 12 colossal statues rather than 10. This forms another link between the Sphinx and Khafre's pyramid complex. Also like the upper temple court, the builders intended to pave that in the Sphinx Temple with white alabaster, so that the reflected light would have been brilliant, if not blinding.

10.7 Court of the Sphinx Temple, on Terrace I, 2.5 m (8 ft) lower than the floor of the Sphinx sanctuary (Terrace II, marked by the Sphinx's paws on the left). Granite sheathed the limestone core walls and standing monolithic pillars, each fronted by a socket for a colossal statue of the king, while 24 additional pillars of single granite blocks in square sockets formed a colonnade around the court. The remains of the 18th dynasty Amenhotep II temple rest on Terrace III, in the centre top. The top of the north ledge can be seen running under the overlapping corner of this temple. The ledge was well cut and dressed to the east (right), and left unfinished to the west (left).

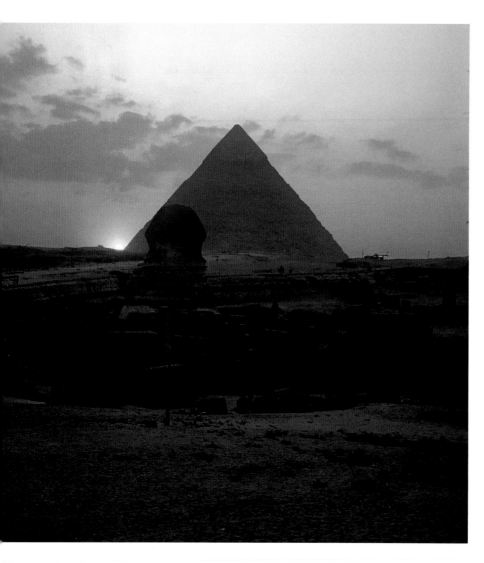

equivalent of the arms and legs of the goddess Nut, who is depicted on the ceilings of New Kingdom royal tombs arching over and giving birth to the sun in the morning and swallowing it in the evening. If Ricke's interpretation is correct, the Sphinx Temple embodied the divisions of time.[9]

Working at the Sphinx between 1977 and 1983, we noticed that the east–west axis of the temple aligns over the Sphinx's shoulder with the point at which the sun sets at the south foot of the Khafre pyramid at the equinoxes (21–22 March and 21–22 September). Light from the setting sun would have travelled over the western colonnade, across the court and into the eastern sanctuary, possibly illuminating a cult object within. At the very same moment, the Sphinx and the second Giza pyramid – both symbols of the king as Horus – merge as one silhouette [10.8]. This alignment is yet another element tying the Sphinx to the Khafre pyramid complex, and one of several indications that the Sphinx was not an ad hoc creation from a block of unused stone in a quarry of Khufu, as some Egyptologists have suggested – rather, its position was carefully selected with regard to other features of Khafre's complex.

Since the Sphinx Temple is built on a terrace lower than that on which the Sphinx sits, the great statue looked down over the roofed western colonnade and into the open court. We concur with Egyptologists who see the Sphinx as representing the king – Khafre – as the incarnation of the god Horus, possibly combined with the sun god Re, in a posture of receiving or giving offerings presented on an altar in the open court. The association of the Sphinx with the sun god might relate to a general Egyptian term for 'sphinx', *seshep ankh Atum*, 'Living image of Atum', known from later texts. Atum is the creator of the world in the Pyramid Texts – all matter evolved from his being, and so did kingship, which he passed down through Shu (atmosphere), Geb (earth) and Osiris, to Horus and to each living king (see p. 136).

The question of whether the generic Egyptian sphinx represents the king as a powerful lion, a god as a powerful lion, a king in the leonine form of a god, or a powerful god revealed in the person of the king, is one to which the Egyptians themselves might have answered 'all of the above'. In Egyptian thought, as further noted by Alan Gardiner, the

10.8 At the equinoxes (21–22 March and 21–22 September), the sun sets at the southern base of the Khafre pyramid, over the right shoulder of the Sphinx and along the axis of the Sphinx Temple. Sphinx and pyramid, symbols of the king as Horus, merge as one silhouette, and Re, the sun god, sinks into the western horizon.

The sun and royal ideology

The open court and the two sanctuaries at the back of recessed bays on the east and west make it highly probable that the designers intended the Sphinx Temple for sun worship. Ricke believed that its designers originally envisaged the Sphinx as an image of the god Horemakhet, a combination of Horus and the sun god. However, this name only occurs in hieroglyphic texts on artifacts dating from the New Kingdom, more than 1,000 years later. Ricke also interpreted the temple's internal arrangement as symbolic of the sun's circuit: the eastern sanctuary for the rising sun (Khepri), the western for the setting sun (Atum), with each colonnade pillar representing one of the 24 hours of the day and night, similar to iconography seen in New Kingdom temples. As for the pairs of pillars before each sanctuary, Ricke saw them as the

great English Egyptologist, there would be no contradiction between the Sphinx being both the king as Horus, presenting offerings to the sun god, and at the same time identified with the sun god.[10] The creation of the Sphinx must have been related to an increased emphasis on the sun in royal ideology in the 4th dynasty. After all, it was in the reign of Djedefre, who ruled for a short time between Khufu and Khafre, that kings adopted the title 'Son of Re'.

We are left to such speculations because there are no known Old Kingdom hieroglyphic texts that refer either to the Sphinx itself or to the temple. It is possible that inscribed blocks from the Sphinx Temple remain to be discovered, reused in later monuments – granite blocks from Khafre's other temples and pyramid have been found, for example, in the 12th dynasty Amenemhet I pyramid at Lisht and the New Kingdom Ptah Temple at Memphis.

Ricke suggested that the 4th dynasty Egyptians might have begun a religious service in the small chapels that stood opposite the entrance doors of the Sphinx Temple. Closed with double-leaf doors (as shown by pivot sockets), these chapels must have contained some kind of cult image. He also pointed to evidence from the false doors, probably of the late 4th dynasty, from the tomb of Djedi, an official of Khafre's pyramid, and his wife, Dbeyet, a Priestess of Hathor, Mistress of the Sycamore, in the House of Khafre and Priestess of Neith in the House of Khafre (now in the British Museum). Another false door, that of Weneset from Giza, also 4th dynasty, relates that the owner was Priestess of Hathor, Mistress of the Sycamore and Neith, North of the Wall. According to Ricke, since there are no chapels of these two goddesses known at Giza, 'House of Khafre' may refer to the Sphinx Temple, where the goddesses were worshipped in the two chapels near the entrances. The temple as a whole may have carried the general designation 'House of Khafre', according to Ricke, because the main cult had yet to be organized.[11]

An unfinished royal project

Aside from the possibility of cults of Hathor and Neith in the entrance chapels, the Sphinx Temple was probably never activated – 'turned on' – because the builders did not finish it. From the hundreds of Old Kingdom tombs at Giza,

we find no titles of priests and priestesses that we can recognize clearly as belonging to the Sphinx Temple.

The temple was stripped of its statues, granite casing and alabaster paving in antiquity. However, anyone who visits today can still see the seats or emplacements the builders cut into the floor at the base of the walls where they were setting the granite blocks to encase the limestone core blocks. In adjusting each casing block, the builders found it easier to trim away the softer limestone rather than the hard granite. The 10 colossal statues that graced the central court fitted into deep sockets cut into the floor in front of each pillar – the bases of the statues would originally have been flush with the alabaster paving. The builders also cut deep square sockets for each pillar of the colonnade. Since they only made such sockets and cuttings at the time they brought in the granite pillars or casing, these features are a record of the stage they had reached.

From his meticulous study, Ricke believed that the workmen had completed the interior of the temple and were just about to begin on the exterior when they stopped. The cuttings for the casing blocks cease just outside the entrance doorways.[12] The masons left extra stock of stone protruding from the huge core blocks forming the front corner hubs of the temple; at the base of the northeastern corner, removal channels in the bedrock show exactly where a team came to a halt levelling the floor in advance of the casing crew working just behind them.

We found evidence that Khafre's builders had also not quite finished carving out the Sphinx ditch. By cutting the temple terrace lower than the Sphinx floor, the builders left a tall, vertical bedrock ledge that forms one side of a corridor with the north wall of the Sphinx Temple and extends eastwards to run under the modern road descending from the Great Pyramid [10.9]. To the west, the ledge forms the north side of the Sphinx ditch, cut into Member I, but here the quarrymen did not finish cutting the line. The point at which they stopped is just opposite the Sphinx's left forepaw and below the 18th dynasty mud-brick temple of Amenhotep II built on Terrace III; from here to the back of the Sphinx ditch the unfinished ledge takes the form of a rock shelf of decreasing width. Behind the Sphinx,

the workmen were nowhere near finishing the outline of the ditch. When they stopped work they left a huge massif of hard Member I rock jutting out to within a few metres of the rear of the Sphinx.

In 1978 we cleared the top of the unfinished north ledge and uncovered rectangular humps, depressions and channels. A similar pattern is found in many places at Giza where work was left unfinished, forming a record of how the ancient masons worked a stone surface from the top down: first they cut a channel to isolate humps that they would then knock away with heavy hammer stones. In the channels and depressions on the north ledge of the Sphinx ditch we found very compact sand and gypsum which we had to remove with small

pick hammers. Embedded in the fill we found fragments of pottery, including half a typical 4th dynasty jar used for beer or water, and hammer stones, one of which still had copper flecks on the percussion end where it had been used to strike a chisel. These must be the bits and pieces of tools used by the Sphinx builders, simply dropped when they stopped work.

We discovered more evidence of the Sphinx builders later in 1978 in a small mound of debris in the northeastern corner of the Sphinx ditch. Left by previous excavators, this mound supports the southwest corner of the 18th dynasty mud-brick temple of Amenhotep II, built 1,200 years after Khafre, when the Sphinx Temple was already buried. At the base of the mound we uncovered three of the massive limestone core blocks left where the ancient builders had abandoned them as they were dragging them to complete the core work on the corner of the Sphinx Temple. One block rested on debris containing numerous pieces of 4th dynasty pottery; the other two rested on a layer of desert clay, tafla, that the builders used as lubrication for dragging the blocks. Just below the clay layer we found cuttings in the rock floor that were used as lever sockets for manoeuvring the ends of the blocks. This little archaeological tableau, conserved under the 18th dynasty temple, is the end trail of the quarry and construction process that created the Sphinx and the 4th dynasty stone temples immediately to the east.

These preserved 'frozen moments' in the construction process lead us to wonder whether in fact the builders walked off the job without clearing the interior of the temple from the debris and embankments they had built in order to work on the upper parts of the walls. In the Menkaure upper temple, Reisner found an unfinished room still filled with debris on which the builders had raised the upper courses of core blocks.

When work stopped on the Sphinx Temple, the builders had already lowered the immense court statues and the colonnade pillars into their sockets. They had raised three courses of core blocks at three of the temple's corners [**10.10**] – but not at the northwestern one, where we found the blocks that they left en route to the third course.[13] The builders had also encased at least the lower part of the interior walls with granite. In 1979

10.9 The north ledge: the quarry cut down into Member I, running north of the Sphinx Temple and parallel to it. At this point the quarrymen finished the ledge by cutting it straight and dressing its face. To the west (bottom) it runs under the southwest corner of the 18th dynasty Amenhotep II temple.

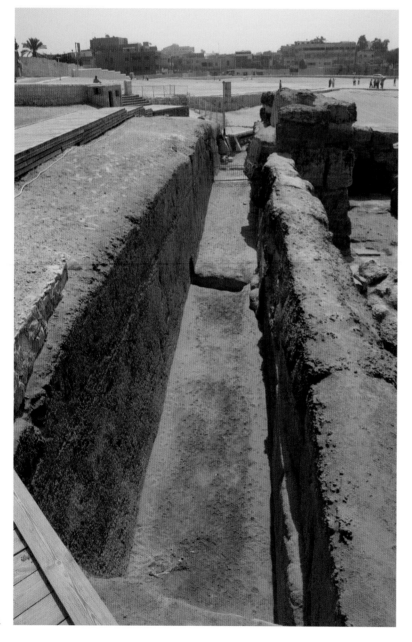

we excavated a trench, designated R16, through a pile of ancient debris inside the north end of the temple. Previous modern excavators had left this pile undisturbed because it supports a toppled core block of colossal size. The bulk of the material we excavated looked like construction debris. Underneath the debris, we found a layer of sky-blue granite dust on the floor. Granite dust, a blend of the red feldspar, black hornblende, mica and quartz that constitutes granite, is produced from sanding and polishing the stone. This granite dust stopped at the edge of the socle cut for the granite casing of the wall, a small fact that confirmed for us that just before the builders stopped, they had been smoothing the interior granite sheathing. As they sanded it with quartzite abraders, the dust collected at the foot of the wall. Much later, when despoilers pulled the granite casing out of its socket, the debris spilt in and over the granite dust.

We see little evidence that the alabaster pavement had been finished. Ricke discusses a series of small conical protrusions of bedrock found here and there in the temple floor. He suggests they were used in levelling the floor, and that the alabaster pavement, 50–60 cm (20–24 in.) thick, would have covered them. We believe these odd protrusions would have been eradicated had the pavement been completed across the temple floor. Furthermore, we do not find cuttings for fitting individual slabs, such as exist in the pyramid courts of Khufu and Khafre.

If the original builders did leave the Sphinx Temple unfinished, the immediate area in front of it to the east must have been a rather untidy construction yard, littered with masonry waste, ramp material and temporary facilities for the ongoing delivery of granite and alabaster. Indeed, as our clearing in front of the Khafre valley temple moved north to the front of the Sphinx Temple, we encountered just such debris. In their work, Émile Baraize and Selim Hassan did not remove the lowest archaeological layers directly on the bedrock surface of Terrace I. Walls frame a corridor, or canal, that runs north and south from tunnels under the ramps in front of the valley temple (see p. 212). From being well built in mud brick, the western wall changes to a stone-rubble wall that retains construction debris just where it passes in front of the Sphinx Temple.

In 1983 workers from the Supreme Council of Antiquities cut a north–south trench through this debris, 12 m (39 ft) in front of the northeastern corner of the Sphinx Temple, in order to install an iron fence. The deposit here consisted of concentrated granite dust, 38 cm (15 in.) thick, just like that we encountered inside the Sphinx Temple. Fragments of bread moulds and the bases of crude red-ware jars date the deposit to the Old Kingdom. The granite dust must be waste dumped here from work on the granite sheathing inside and near the north doorway of the temple, 4,500 years ago. Underneath, down to the bedrock, was a compact layer, 32 cm (12½ in.) thick, of yellowish-brown or tan debris, also comparable to deposits in R16, and in our 1978 trenches outside the northwestern corner of the Sphinx Temple.

If the Sphinx Temple and the Khafre valley temple had been excavated according to modern archaeological standards we would know far more about the state in which the builders left the site. Unfortunately, the large-scale clearing and poor recording of earlier work have left us scant stratigraphic clues about the temple's history. We are convinced that the complete archaeological picture would have shown that the Sphinx Temple was the last major item left unfinished when Khafre died. As mentioned above, it is even possible that the 4th dynasty builders left the whole interior of the temple filled with the kind of construction debris that the earlier large-scale excavations left behind here and there. Centuries after the Sphinx

10.10 Limestone core blocks of a magazine in the southwest corner of the Sphinx Temple showing a recessed yellow clayey stratum running continuously from one block to another. (A vertical seam shows faintly between two blocks in the centre left. Another, wider seam shows in the lower left corner.) The continuity of the geological strata indicates the blocks were moved in sequence from the quarry (of the Sphinx ditch) directly east to the temple.

Temple was abandoned, those who systematically stripped it of its granite casing and colossal statues must have turned over the construction embankments and debris abandoned by the original builders.

Ricke thought there had been two periods of stone robbing in the Khafre valley complex, the first in the 12th dynasty reign of Amenemhet I, when the Sphinx Temple interior was stripped, and the second when the granite was removed from the valley temple exterior. We see evidence that this second removal took place in the New Kingdom, specifically in the 18th dynasty (Chapters 18 and 19).

If the builders left the temple not only unfinished on the exterior, but also buried in debris on the interior, the special effect of solar lighting on the equinoxes may never have been activated before the temple was stripped.

Bare, naked Sphinx

The question then is, in what condition did the 4th dynasty builders leave the Sphinx itself? It is our conviction that the head has never been recarved and that the features we see today are those left in the natural rock of Member III by the original Sphinx builders. Member II, the bulk of the body, does not offer much help on this question since so much of the original surface has eroded away – but if all the eroded recesses were filled in we do have the contours of a complete lion body. Several places in the lower part of the Sphinx body, carved out of Member I, which weathers relatively little, suggest that the original sculptors created the intended surface in bedrock.

When he cleared the Sphinx in 1925–26, Baraize found the front of the north (left) hindpaw free of its ancient restoration veneer masonry, which had fallen off. Although the surface of the bedrock is rough and gnarled, the toes retained their relief-carved claws. This detail suggests that, like the head, the sculptors finished this hindpaw in the natural rock, without a coating of masonry. During the removal of veneer masonry on both front paws in the 1980s, we discovered that these toes also had claws carved in the Member I rock [**10.11**].

On the other hand, when Baraize, and again recently the Egyptian Antiquities restoration team, worked on the south (right) hindpaw, they found

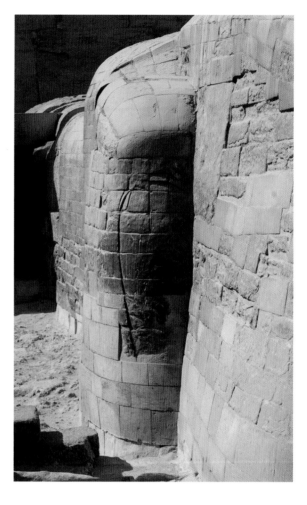

10.11 A claw carved in masonry casing the rear right toe of the Sphinx's right paw. This masonry and carving probably date to the Late Period and Greco-Roman Period.

an enormous gap in the natural rock, part of the major fissure that cuts through the entire Sphinx. The gap here is so large and the bedrock so rough and irregular that the greater part of this paw was built of large masonry blocks. However, the bottom of the toes are finished, each with a claw, in the sound rock of Member I, which here rises only a couple of feet above the Sphinx terrace floor.

Would the Sphinx builders have left serious gaps in the right (south) hindpaw, and the fissure cutting through the body, and not filled or covered the flaws with masonry? Could some of the larger blocks encasing the lower parts of the Sphinx represent the beginning of a 4th dynasty casing that masked these flaws? Given the evidence that the builders stopped work before completing the sides of the ditch and the temple, however, they may equally have left these flaws. Also, as noted above, one should remember that its ancient designers intended the Sphinx to be viewed from the front, not from the side – commoners glimpsed it from

outside the Sphinx Temple and priests saw it from the temple's court (if the court was ever functional). The modern tourists' view from the shoulder of the Khafre causeway would not have been possible, since the causeway was then walled and roofed.

It seems certain that where the bedrock was sufficiently sound – the head, the north hindpaw and the bottoms of the other paws, for example (all Member III or Member I bedrock) – the Sphinx builders did indeed carve the finished surface of the sculpture in the natural rock. They probably also would have filled in major flaws, like the fissure. They may have intended, and even begun, to cover the weaker rock, primarily Member II of the Sphinx body, with a casing in which they would have modelled the lion body. During the SCA's restoration from 1980 to 1987 and our restoration work from 1988 to 1989 we have found very large blocks of fine limestone casing at the northwestern rear haunch. Our investigation of the passage that we reopened in 1980 in the Sphinx rump (see below and box p. 232 ff.) also allowed us to obtain a close look at the bedrock surface of the lower Sphinx body, but unless we get larger exposures there is just not enough evidence to answer conclusively whether the 4th dynasty builders had begun, and if so how far they had progressed, filling in and building up with masonry the weak spots in their massive sculpture.

What is clear is that, as with so many other royal monuments, the builders simply stopped work shortly after the king's death to turn their attention to the monuments planned for his successor.

The Sphinx beard

The Sphinx's beard is also relevant to the question of the degree to which the 4th dynasty Egyptians finished the Sphinx from the natural bedrock. In 1817, Caviglia found several fragments of the beard at the base of the chest in the earliest recorded modern excavation of the Sphinx (see pp. 92–94). Baraize retrieved the pieces more than a century later. Altogether six fragments are known [**10.12**]. Howard Vyse illustrated four and labelled them A, B, C and D.[14] A and B formed the left side of the plate connecting the beard to the chest, and C formed part of the right connecting plate – both of which show a kneeling king carved in relief (see

19.8). The top plate fragment A and fragment C are missing, while D is in the British Museum [**10.13**] and a cast is in Cairo. They formed part of a long braided 'divine beard', curled at the end, such as gods and deified kings wore, as opposed to the short square beard sported by statues of living kings.

Egyptologists have questioned whether the beard was original to the Sphinx or was a later addition. As noted, Caviglia's pieces included two from the flat limestone plates that connected the outward-thrusting beard to the Sphinx chest. Fragment A–B preserves part of the side of the beard with its braiding, as well as part of the plate. The top of these two pieces, A, is now lost, but an examination of the other in the Cairo Museum shows that it was only about 30 cm (12 in.) thick, with the back roughened to assist bonding it with gypsum mortar to another surface. This would suggest that someone added the beard after the original carving.

On the other hand, the surviving beard fragments seem to be carved from the same stone as the corresponding limestone layers found in the Sphinx chest and neck where the beard would have attached. This match suggests that the beard was carved from the natural rock, like the rest of the statue. It is certainly possible that the beard was

10.12, 10.13 Diagram of the Sphinx beard showing where five of the known pieces would have fitted in a long divine beard curled at the end and with relief-carved braiding. Top: Piece D (broken in two) is now in the British Museum (EA58); 78.7 cm (31 in.) long.

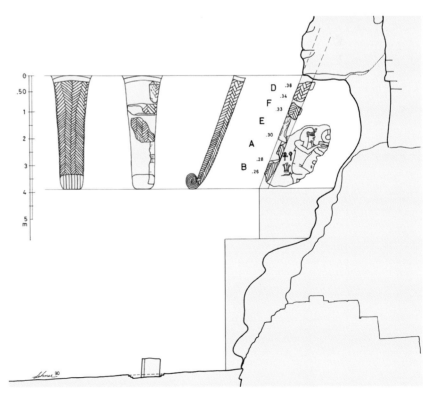

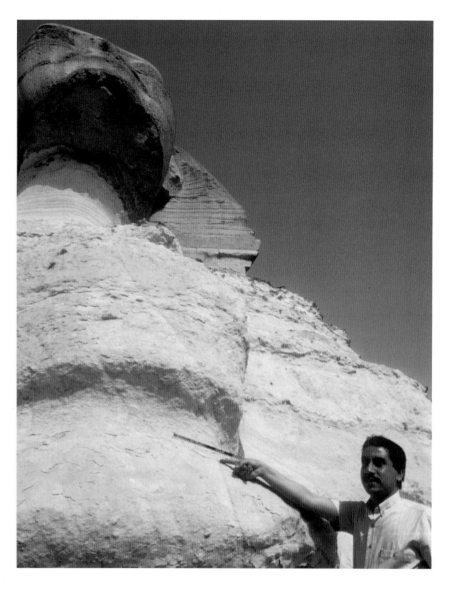

10.14 Ministry of Antiquities Inspector Emad Fahmy points to flakes detaching from the bottom of a prominent boss on the bedrock core body of the Sphinx chest that probably once supported the long beard.

originally carved from the bedrock but had later become detached, fallen and broken into pieces. During a later restoration, the pieces that connected the beard to the chest were then recut as thin slabs and reattached.

If the long divine beard is indeed original to the Sphinx and carved from the natural rock, it is perhaps odd that there is little trace of its attachment to the chest. The contours of the chest are fairly flat from the neck to about halfway down the chest; in fact, the upper chest is almost concave between subtle protrusions on either side that could be vestiges of the breast lappets hanging from the *nemes* headdress. However, because the beard bridge-plate was so thin, any traces of it on the chest may have weathered away.

At the bottom of the chest, a very prominent boss lies exactly on line with, and projects slightly forwards from, the chin of the Sphinx [**10.14**]. This boss only makes sense as the base of a support

for a long divine beard. The sculptors could not extend the beard's thin supporting plate below the curl all the way to the ground level between the paws, nor could they simply leave the beard and its plate suspended – both options would have made the beard even more fragile – so they left a thicker column of rock at the base of the chest as a support.

We visualize the end of the beard positioned directly above the top of this boss. Ricke came up with a similar, albeit more sketchy, reconstruction. Like us, he believed the beard was original to the Sphinx, was then broken into pieces and was restored by ancient Egyptians centuries later.[15] For our reconstruction (see box, p. 238), we made scale drawings of the surviving fragments and then fitted them into our scale profile of the Sphinx. The resulting reconstruction took into account the thickness of the side of the beard (minus the bridging plate), the angle of slope and the most likely proportions of the beard length to those of the face. We also noted the correspondences of the rock of the various fragments and their position in the beard to the natural limestone layers at the respective heights of the Sphinx's chest and neck. By extrapolating the slope of the face from the cheekbone to the chin we established the angle of the beard. We also used the ratio of beard length to head height on the 18th dynasty alabaster Sphinx from Mit Rahina, the only good example of another sphinx with a divine beard.[16]

As reconstructed, the bottom of the beard would have been about 2.5 m (8 ft) directly above the top of the boss at the base of the chest and about 2.5 m (8 ft) forward from the surface of the upper chest and neck. It is unlikely that the beard itself extended down to rest on the top of the boss because, for one thing, this would have made the beard almost vertical. Instead, there must have been a masonry support built around and on top of the boss. This again raises the possibility that the Sphinx builders planned to encase the lion body with limestone blocks, since the beard support would then have been part of the casing masonry. Though if the beard fragments are from the same rock layers of the Sphinx, it is also possible that the original sculptors attempted to finish their work in the natural stone. As with the rest of the Sphinx, the evidence remains conflicting.

Ancient restoration of the Sphinx

Over the course of its long history, numerous attempts have been made to repair, restore and patch up the Sphinx. Today, a veneer of restoration masonry of different periods covers its paws and lower leonine body, sometimes in flush patchwork and sometimes in overlapping layers [**10.15**]. The layering of this masonry veneer, and the way it adheres to the bedrock core body, offer insights into the history of the Sphinx. Restorations fall into two broad categories, ancient and modern, which are easily distinguishable.

The modern veneer covers or replaces much of the ancient work. Baraize's restorations in the 1920s are the most extensive, although additional work has been done up to the present day. During Baraize's excavations, workers picked up many of the blocks found on the ground and mortared them back into place – in most cases these can be identified by the cement mortar used.

There are three ancient phases, differing in stone quality, block size, surface tooling, structural configuration and the appearance of the mortar used for bonding blocks to the bedrock. We have categorized the ancient masonry as Phase I, Phase II and Phase III in order of age.

Working backwards in time, Phase III, of Greco-Roman date (332 BC–AD 395), patched and replaced parts of the Phase I and II veneer using small blocks of white, relatively soft and friable limestone. Unlike Phases I and II, Phase III stones flake and powder and only develop a protective patina or

crust close to the floor. Phase II probably dates to the 26th dynasty (*c.* 664–525 BC); it is essentially a patching of the Phase I exterior. Over large areas, the face of the Phase I casing was cut back 15–25 cm (6–10 in.) to insert the new, smaller slabs. Elsewhere, the Phase II masons laid new casing directly over the original surface of the Phase I restoration. The limestone used in Phase II is the same fine-grained, homogeneous limestone as employed in the first restoration.

We believe it was the New Kingdom 18th dynasty pharaoh Thutmose IV who began the Phase I restoration of the Sphinx, about eleven hundred years after Khafre. (In Chapter 19 we discuss the clues that point to him as the Phase I restorer.) Today, Phase I blocks cover the lower third to two-thirds of the Sphinx body, reaching a height of 8.65 m (28 ft 4 in.) above floor level on the rear south haunch. The indications are that when complete, Phase I masonry probably encased the body up to and over the back, finishing off the lion body of the Sphinx. Phase I covered the Sphinx body at a time when the surface formed from Member II bedrock had already eroded drastically into deep recesses and rounded protrusions, indicated by the fact that Phase I fills in the recesses. This casing masonry is therefore of considerable interest in the controversy about the age of the Sphinx.

Evidence suggests that at the time of the Phase I restoration, large chunks of natural rock were about to fall off the Sphinx, just as in recent years.

10.15 Diagram to show the patchwork of repair on the south elevation of the Sphinx throughout the ages up to 1979, as recorded with photogrammetry, with the colours coding the different periods of masonry remaining. Much of the modern repair was changed and more masonry added in the 1980s to 1990s. Elevation by Ulrich Kapp.

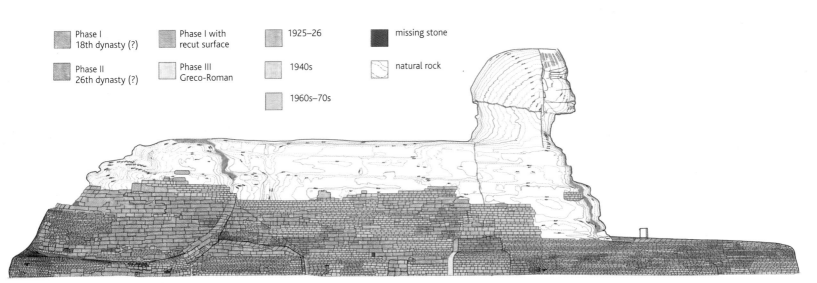

Phase I
18th dynasty (?)

Phase II
26th dynasty (?)

Phase I with
recut surface

Phase III
Greco-Roman

1925–26

1940s

1960s–70s

missing stone

natural rock

At the upper part of the rump near the centre we found a wide ledge formed by the curve of Phase I slabs around the end of the Sphinx [10.16]. In 1926 Baraize filled the space between these slabs and the bedrock body with cement and packing. But as the photographs of his work show, a huge boulder of bedrock had already detached from the Sphinx body in ancient times, tipped over and was held in position by the Phase I restoration slabs. Another large boulder is shored up by Phase I masonry at the Sphinx's rear left haunch. Restoration work in the 1980s concealed most of these features.

As the Phase I blocks fit the contours of the body, they vary in length, from 50 cm (20 in.) to 2 m (7 ft),

and height, from 27 to 77 cm (11 to 30 in.). Where they are exposed at the top of the rump the widths are visible, ranging from 98 cm (39 in.) to as much as 1.55 m (5 ft). The fine-grained and homogeneous Phase I stone is characteristic of Turah or Turah-quality limestone and developed a brown patina that has protected it against weathering.

Phase I masonry includes some mortises for dovetail cramps between adjacent blocks. In most cases, the mortises are cut a few centimetres into the bedding surface of the blocks and contain a residue of mortar. Dovetail mortises and cramps appear in Egyptian masonry from the Old Kingdom to late antiquity, but are more common during the Middle Kingdom and later. The Egyptian masons used them for particularly unusual or delicate masonry, or when they perceived special stresses were present. In the Khafre valley temple they are found in joints between the granite pillars and architraves. Made of wood, lead, copper or stone, the dovetail cramps stabilized the blocks after they had been laid and before the mortar set. Once the mortar bonding the blocks dried, the actual dovetail peg might be removed, leaving a mortar residue in the recess.

Here we might consider again the possibility that the lower casing blocks are part of an earlier, 4th dynasty casing that finished off the lion body of the Sphinx. We obtained a different view of both the natural rock surface of the lower Sphinx body as the builders must have left it, and the underneath of the Phase I casing, in the passage in the Sphinx rump found by Baraize in 1926 and reopened by us in 1980 (see box overleaf). The three courses of Phase I casing next to the bottom course are thicker than the blocks immediately above them. When our restoration team removed the outer, thinner veneer in the 1980s, consisting of Phase III slabs that Baraize had replaced with grey cement, we observed that the thick blocks continue around the curve of the rump to the north large masonry box attached to the haunch (see below).

In profile, the lower veneer of large blocks resembles the masonry casing on some Old Kingdom mastaba tombs at Giza. The blocks above them are thinner, but also look like Old Kingdom casing, and their range in thickness is comparable to slabs forming the walls of the Khafre causeway near the point where it meets the valley temple (36–38 cm/14–15 in. is common). The surface of the core

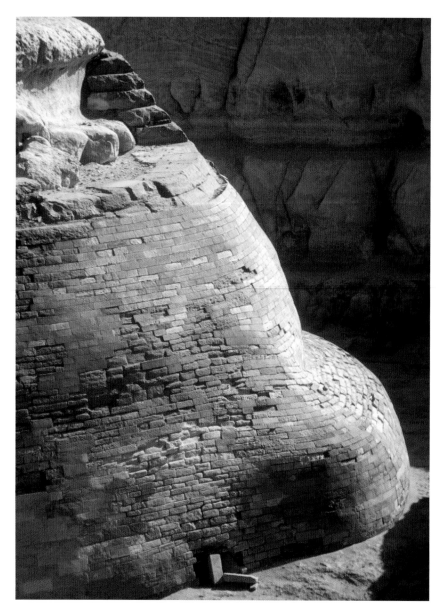

10.16 Large slabs of Phase I casing fit the eroded contours of Member II bedrock at the south upper curve of the Sphinx rump, revealing boulder-size pieces of bedrock. Lower, Phase III small slabs cover Phase I casing. The opening at floor level marks the position of the passage leading down below and up through the rump (see box p. 232).

body carved in Member I preserved by the earliest casing at the rump passage (as at other points on the statue) suggests that the lion body was here shaped only roughly from the bedrock, and a casing of fine Turah-quality limestone blocks completed it. The question is, was this casing already begun in the 4th dynasty, or was it entirely a reconstruction of a later period?

Nothing in the profiles exposed in the passage suggests a structural break between the thick lower courses and those above. The Phase I casing, seen from within the passage, is continuous with that exposed on the upper part of the north rear haunch and the masonry ledge at the upper rear of the Sphinx. And the same casing forms the back upper curve of the rump where it is exposed in section abutting the already weathered part of the core body carved from Member II.

We have to conclude that the Phase I casing restored a Sphinx body when the section of the body carved from Member II had severely eroded. It is very possible that the surface of the bedrock rump is rough because the rear was the last part of the Sphinx being worked when activity stopped. The workers had only separated the rump and tail from the massif of bedrock behind the Sphinx by a little more than a metre when they evidently put down their tools before squaring off and finishing the northern end and back of the Sphinx ditch.

Modern restoration of the Sphinx

Any conservation campaign undertaken on the Sphinx must heed the lessons of the past. Only with a clear understanding of what has been done from the time of the earliest restorations in the New Kingdom through the interventions of the early and later 20th century and right up to the present day can we approach any conservation work on the Sphinx. Many of the conservation campaigns in the recent past were conceived as stop-gap solutions, with no long-term strategy in mind; some of these temporary measures may even have damaged the Sphinx more than benefited it.

Sporadic restoration work was carried out by the Egyptian Antiquities Organization's restoration department in 1955, 1977, 1979 and in the 1980s. There was no over-arching plan of work, nor was the conservation work completely recorded or

photographed. Unfortunately, the workmen cut into the original modelling of the claws of one of the paws and some of the work used mortar which consisted of cement and gypsum, well-known even at the time to be harmful to the monuments. Also stones from ancient restorations were removed without recording or preserving them. When this was discovered, work was suspended.

Then in February 1988 a stone from a previous restoration fell from the Sphinx's right shoulder. A new, long-term programme of restoration consisting of several phases began in 1989 under the guidance of a Sphinx committee. This work used the elevations and plans produced in 1979 by the American Research Center in Egypt and that of the German Archaeological Institute as guides to begin restoring the contours of the Sphinx as they existed prior to 1982–87 interventions. Older restorations using large blocks that had changed the proportions of the Sphinx were removed, as was the damaging cement. A team of sculptors was brought in to replace blocks more accurately and sensitively. Following on from this programme, new masonry was added to cover the entire bedrock exposed on the north side of the Sphinx body and the upper rump, covering the ledge and exposures as Baraize left them. A consolidant paste was smeared over this new masonry and much of the exposed bedrock of the sides and chest of the Sphinx.

The mysterious masonry boxes

Considering all the rumours and speculation that swirl around the Sphinx, we have always found it strange that for 150 years after Mariette found them, visitors, art historians and Egyptologists have not questioned why large masonry boxes are attached to the Great Sphinx.

Four stone boxes protrude from the veneer-covered flanks of the Sphinx at floor level, two – one large, one small – on each side. Mariette, who was the first to clear the Sphinx along both its flanks, mentioned three boxes on the north side. In 1882 he suggested that the boxes on the north were buttresses for the casing of the Sphinx body.[17] This seems unlikely, however. A buttress need not take the form of a box extending so far from that which it braces; columnar masonry supports would be sufficient.

Passages in the Sphinx

Many age-old legends claim that the Sphinx hides some kind of secret passage, tunnel, chamber, tomb or temple. In 1980, to our surprise, our investigations proved one of these to be true. We were told of a hidden passage by Mohammed Abd al-Mawgud Fayed, who had worked with the official antiquities service for 40 years and assisted us in many ways in our early days at Giza; he died in the summer of 2000. Mohammed began his career as a basket boy, carrying sand away from the Great Sphinx during Émile Baraize's excavations in 1926. He remembered that Baraize had found a passage under the Sphinx at the northwestern curve of the rump, where the covering masonry had fallen away, and he recalled that the passage went down to the water table.

In 1980, because of growing concern about the role of the water table in the deterioration of the Sphinx, we decided to remove one of the thousands of brick-sized Phase III stones that Baraize had cemented back in place on the massive rear of the Sphinx to see if we could find the passage. Fifty-four years after he had witnessed the event, we brought Mohammed to the spot and asked which single stone we should move. Mohammed paced back and forth deliberating for a few moments, then said, 'this one'. We removed the stone and forced a small hole through the cement packing. Dumbfounded, we peered into a deep, dark void where the bedrock floor dropped away.

We removed several other brick-sized slabs and exposed a round opening that led to an artificial shaft dropping below ground level and under the body of the Sphinx. Shining our torches upwards, we could see that the passage also continued up into the curve of the rump, at roughly 90 degrees from the direction of the lower section, its roof formed by the stepped Phase I masonry. The sides of the passage provided a clear profile of the relationship between the Phase I blocks and the geological layers of the Sphinx core body, Members I and II. Like so much of Baraize's work, the passage went entirely undocumented and, since it was covered with masonry, it was almost forgotten. We spent several weeks mapping the passage and studying its details.[18]

The passage opens at the base of the north side of the Sphinx, near the start of the tail. The lower part descends from a circular hole in the floor and slopes downwards at a steep angle for 4 m (13 ft) to a depth of 5 m (16 ft), terminating in a cul-de-sac in the natural rock. From the entrance, 1.3 m (4 ft 3 in.) wide, the passage narrows to 1.07 m (3 ft 6 in.) near the bottom. On the sides of the shaft long, stroke-like tool marks made with a pointed chisel are visible, and small, half-cup-shaped footholds.

The upper section of the passage rises to a height of 4 m (13 ft) above the Sphinx floor and ends in a niche about 1 m (3 ft) wide and 1.8 m (6 ft) high. Without its cover of large Phase I blocks and an overlying thin layer of Phase III masonry and modern cement, the upper passage would be an open trench in the curve of the Sphinx's bedrock rump. The large slabs of Phase I project progressively inwards in increments to meet the curve of the rump. The foothold cuttings continue in the upper passage and appear on all three sides of the niche, two on each side, to within 1 m (3 ft) of the top. A large blob

10.17 Mark Lehner enters the Sphinx Rump Passage in 1980, soon after opening it. Large Phase I blocks, reset in modern cement by Baraize's workers in 1926, bridge the entrance. Smaller Phase III slabs, also reset, covered the Phase I masonry and veiled the entrance.

of modern grey cement seals the top of the upper passage. It seems to adhere to the underside of the adjacent Phase I blocks and probably oozed down into the passage when Baraize filled the gap between the Phase I slabs and the bedrock core on the ledge of masonry at the upper part of the rump, about 3 m (10 ft) above the top of the passage.

The bedrock profile visible on the sides of the passage shows that the curve of the rump was generally shaped from the Member I layer, but not dressed smooth or finely finished. At the top end of the niche (southeastern side) is a layer of very soft, clay-like bedrock, about 26 cm (10 in.) thick: this is the first layer of Member II and marks the division between it and Member I. We compared the profile of Sphinx bedrock core and casing inside the passage with that of the rump above and outside it. From this it appears that, while the harder Member I rock preserves its original surface, up to 1.5 m (5 ft) was weathered away from the profile in the Member II rock. By the time of the Phase I restorations, the lower Member I rock would have jutted out in a shelf from the heavily weathered back profile of Member II. The top of the passage, partially sealed by Phase I slabs, corresponds with the top of this Member I shelf.

The Sphinx core body must have stood exposed to the elements for a long time before the Phase I casing was built against it in order for such drastic scouring back of the Member II layers. The same forces of erosion must have reduced the workers' settlement south of the Wall of the Crow down to waist or ankle height during the same post-4th dynasty period.

When we opened the passage, very damp debris clogged the bottom of the lower section. Mohammed remembered that Baraize stopped clearing the lower passage because of the rising water table. We wondered if we were seeing ancient fill, where Baraize had stopped. If so, the contents might reveal the purpose of the Sphinx passage. Could it be an ancient tomb, as legend would have it? We took great pains to map every detail of this deposit – no easy task at the bottom of the narrow shaft, in dank darkness, with the loud buzzing of large green flies that, amazingly, found their way into this underworld. To our disappointment, our first finds were the base of a modern ceramic water jar and a small piece of tin foil. Next we came upon modern cement and two old leather shoes. Baraize's workmen must have left these artifacts before they sealed the passage. More disturbing were fragments of human bone, including a femur. After we removed all the debris, groundwater filled the bottom 39 cm (15 in.) of the shaft.

Date and significance of the passage

We need to consider several facts in determining the date and significance of the passage:

1 The footholds look like those found in the sides of ancient tomb shafts.
2 The top of the passage corresponds to the boundary between the hard Member I and the weathered Member II bedrock layers in the Sphinx core body.
3 On the ledge formed by the Phase I slabs, 3 m (10 ft) almost directly above the top of the passage, a boulder has separated from the bedrock core and lies wedged against the back of the Phase I blocks.
4 Above this a shallow channel runs from the top of the haunch down over the weathered core body roughly in the direction of the core boulder on the masonry ledge. During a hard rain, water would flow down this channel and on to the ledge.
5 The backs and underside of the Phase I blocks revealed in the passage are not damaged, but have an occasional residue of mortar, limestone chip, sand and clay packing.
6 Limestone pieces on the threshold of the niche at the top of the passage are solidly in position and may be mortared to the passage.

One possibility is that the shaft was cut from the top down, beginning at the ledge after it had been created on the rump by the removal of masonry veneer. Perhaps the large core boulder had separated and attracted attention, arousing the suspicion that it concealed an opening. Subsequently, a later explorer could have channelled down through the bedrock following the curve of the rump rather than stripping off the large blocks of the Phase I casing. If the lower part of the Sphinx was encumbered with debris it may simply have been easier to cut down behind the casing than to mount a large excavation and strip the veneer. With this in mind, we might consider whether Howard Vyse made the passage. As we saw in Chapter 6, during his aggressive explorations at Giza in 1837, Howard Vyse drilled and tunnelled through the pyramids, using explosives where he deemed it necessary. On 27 and 28 February he reported in his

diary: 'Sphinx. Boring near the shoulder, and near the tail.' He did not discuss the operation near the tail, the location of which has not been identified – could it be the rump passage?

Whoever created the passage, it is remarkable that the tunnelling did not damage the backs and undersides of the Phase I blocks. The mortar and packing residue on these surfaces suggest the blocks were originally bonded to either the natural rock core or a packing and fill in the passage.

If explorers did channel down behind the Phase I casing, perhaps having found nothing from the ledge down to the Sphinx ditch floor level, they broke through the lowest course of veneer stone to the outside. They may have then turned their probe to the northeast to tunnel under the base of the statue. A less likely alternative is that the passage was forced after the 18th dynasty from floor level in both directions: upwards and downwards. In this case someone cut the passage when the floor was cleared of sand, but after the 18th dynasty Phase I casing had been added to the Sphinx. This could have been during the 26th dynasty Phase II repairs. However, cutting the upper passage from the bottom would have been difficult and impractical. Furthermore, the tool marks on the sides of the passage suggest that the excavation work proceeded from the top down.

Yet another possibility is that the passage could even be earlier than the Sphinx, remaining from an exploratory hole to test or 'prove' the quality of the bedrock before the Sphinx builders isolated the massive bedrock core from which they sculpted the lion body. If so, the workers may have cut the passage too deep. Centuries later, the passage had to be filled in when Phase I casing restored the shape of the Sphinx body. It is possible that the blocks mortared on to the threshold of the upper niche are all that remain of the masonry that filled the passage. The case for such an early date for the passage would be stronger if we could look past Baraize's patch of cement at the top of the passage to see if it continued. In fact, this patch of cement may itself be the clue that the passage is earlier than the Phase I masonry. Baraize's workmen must have poured the cement from above when they filled gap between the Phase I masonry and the bedrock core on the rump ledge, and it is hard to see how this thick patch of cement could have been held in place at the top of the passage unless the passage was filled to the very top of the niche when the cement was poured.

Baraize undertook some of his repairs on the Sphinx before he had cleared the base of the statue – he began work on the head, for example, as soon as he started his excavation in the area of the forepaws. The most likely explanation is that Baraize plugged the rump ledge with cement before he had discovered the passage. At that time the upper part of the passage was filled with ancient masonry and packing. Later, probably when he cleared the base of the rump, Baraize discovered the opening at floor level and proceeded to clear out the passage, removing the ancient packing from the upper part. This left the patch of his cement hanging at the top of the passage. Such a sequence would explain why there is a residue of sand, pieces of ceramic and charcoal, and limestone fragments adhering to the underside of the cement patch, and why there are traces of mortar on

the underside of the Phase I slabs that bridge the passage. If the blocks mortared into place at the threshold of the upper part are remnants of the Phase I packing of the passage, the passage pre-dates the Phase I masonry on the rump.

More hidden passages?

Old photographs of Baraize's work show another spot on the Sphinx where it appears that there might be a passage in and under the statue. When Baraize cleared the north flank down to floor level in 1925, his workers found a large number of toppled blocks of Phase I size among the debris. One photograph shows a close-up view of a large gap in the Phase I casing at the base of the north belly. A man is standing below floor level in what may be a niche cut into the bedrock core body; another man stands on a small mound of sand and toppled blocks just outside. We located this exact spot on the basis of fissures in the core body above the casing. Baraize sealed the breach through the casing with grey cement and large stones, some of which are replaced Phase I slabs. The photographs suggest that there is at least this one additional niche, grotto or passage cut into the bedrock of the Sphinx body, hidden behind the veneer of ancient repair masonry.

It is plausible that 19th-century explorers, including Howard Vyse or Mariette, who cleared the north flank in 1853, created gaps in the body, but it also possible that this gap in the north flank is ancient, as we believe the passage in the rump is also, though exactly who made them – and why – are questions that remain unanswered.

In more recent times many people have made requests to the Egyptian authorities to drill under the Sphinx because they believe they will find evidence of lost civilizations. Drilling by SRI International on the south side of the Sphinx found nothing but natural fissures in the rock. The Center of Archaeology Engineering at Cairo University then undertook drilling around the Sphinx to determine the level of the water table, which is known to be rising. Drillings were undertaken at various positions around the Sphinx, including one in front of the Dream Stela, some reaching 10 m (33 ft) deep. These ascertained that the water table was around 4.3 m (13 ft 9 in.) below ground level, but nothing else was found.

10.18 In this 1926 photograph at the base of the north flank of the Sphinx, just after Baraize's clearing, one man stands on sand and toppled blocks from the ancient masonry casing, while another stands in a kind of grotto in the exposed bedrock, below floor level, perhaps on the fill of a passage.

A sealed cube: the north large box

Until our radar investigations in April 2010, (below) no one had investigated the interior of the box attached to the north rear haunch. A closed masonry construction jutting out from the side of the haunch, it consists of six courses of some of the largest blocks attached to the Sphinx. Thinner slabs closing off the top have irregular, non-parallel joins, not unlike Old Kingdom paving in the pyramid temples. On its west side, the stones of the box form the corner between it and the Phase I masonry of

the Sphinx. the box must belong to the same period as the Phase I casing.

During our restoration work, a team removed a veneer of smaller blocks on the west side of the box, but instead of exposing the bedrock of the Sphinx body, they found large square blocks that exceed the average size of Phase I. At over 72 cm (28 in.) in height they match the large blocks located immediately behind the Thutmose IV stela at the base of the Sphinx's chest, which we think formed the base of a statue (see Chapter 19).

The box, therefore, abuts not to the bedrock core body of the Sphinx, but to added large blocks set into what must be some sort of gap in the bedrock statue. This differs from the situation in the rump passage, a short distance away, where the bedrock line of the Sphinx core body is close behind the masonry cladding. It differs also from the east side of the box, where the Phase I casing is only 45 cm (18 in.) thick over the bedrock. We suspect the large blocks fill a recess in the bedrock core of the Sphinx behind the box. This only deepened the mystery of this sealed cube, locked into the Sphinx haunch.

In 2010 we returned to the question. The Glen Dash Foundation for Archaeological Research probed the box with a ground penetrating radar (GPR) under our supervision [**10.19**]. The team surveyed the box, the floor of the Sphinx ditch around it, and a portion of the rump towards the tail, passing over the enigmatic 'rump passage'. Glen Dash reported the box appears to be built throughout of regular tiers of rectangular, well-fitted blocks: 'In effect, it looks on the inside much as it looks from the outside.' The radar image mapped the rump passage clearly and also showed another anomaly adjacent to the box on the west about 3 m (10 ft) within the Sphinx. The anomaly could be a gap between the casing and the core, which the masons failed to fill with mortar and stone, or a large fissure, filled with the large blocks we observed when we stripped and replaced the outer veneer of small slabs. But we cannot close the case of the mysterious, seemingly solid, northwestern box.[19]

The north small box

The north small box is attached to the Sphinx 1 m (3 ft) in front of the hind paw. As with the other north box, the blocks that remained *in situ* from ancient times correspond in size to those of the Phase I additions to the Sphinx. The box was almost entirely dismantled and rebuilt during the Sphinx restoration work of 1982 to 1988; here we describe its condition during our investigation in 1979–80.

When Baraize cleared this part of the Sphinx on 3 December 1925, he discovered that much of the box had already been dismantled. The excavation photographs indicate that the entire east side of the box, except for a single block, was missing. It is unclear whether this had occurred in ancient times

or when Mariette excavated in 1853. Baraize then reconstructed the east and west sides.

In 1979 when we cleared the box, the two lower courses, some blocks of the upper three courses of the north wall, and part of the masonry filling of the interior remained of the original. Inside, we found several irregular limestone boulders as well as shaped blocks and granite fragments. A large piece of local Moqattam Formation limestone was propped against the interior north wall – had this detached from the Sphinx core body before being built into the fill of the box? Some of the pieces were mortared together and appeared to have remained *in situ* since ancient times. Two flat slabs of limestone form an even surface level with a step cut into the large boulder against the north wall of the box. The slabs were mortared to the masonry casing of the Sphinx body. Seven courses of Phase I casing remain on the Sphinx body where the box attaches to it; the second and third courses extend inside the box, level with the top of the flat slabs.

The slabs appear to be the remains of a platform; the boulders, smaller limestone pieces, granite fragments and sand were used to build up the floor level to support it on the interior of the box. The crude step cut into the side of the boulder

10.19 Glen and Joan Dash use radar to probe the north rear box attached to the Sphinx's right haunch in April 2010.

against the inner side of the north wall was intended to receive the regular slabs forming the surface of the platform. These details all point to the conclusion that this (and the two southern boxes) served as bases or plinths for statues or shrines (*naoi*). The thickness (85 cm/33 in.) of the north wall of the box and the outward curve of the casing on the flank of the Sphinx would allow for a platform 1.25 m (4 ft) in length (north–south) and about 1.5 m (5 ft) in width (east–west).

The missing north box

As noted, Mariette claimed that he found three stonework boxes attached to the north side of the Sphinx. The third, missing box might have been located 9.3 m (30 ft 6 in.) to the east of the north small box, where in 1979 two Phase I blocks protruded from Baraize's modern veneer patching. Photographs of Baraize's excavation show large numbers of Phase I slabs along the base of the north flank of the Sphinx, which Mariette may have left when he dismantled the box. The missing box was located very close to where photographs show a recess in the bedrock core body, a grotto or perhaps another passage in and under the Sphinx (see p. 234).

The south small box

Armed with our hypothesis that the curious boxes might have been plinths for statues or shrines, we turned to the south small box at the base of the Sphinx's belly. This consists of four courses of blocks, about 36 cm (14 in.) thick, that abut Phase I blocks; it probably also dates to the time of the Phase I casing.

The upper courses on the east and west sides of the box line an interior platform. The mortar on the platform between the walls is flattened, indicating that something has been removed from the space. This could have been another block, though if our hypothesis is true that the boxes are plinths or bases, the level centre may be the impression of the bottom of the socle for a statue or shrine. We then carried our hypothesis on to our investigation of the largest of the Sphinx boxes.

The south large box

The south large box attaches to the Sphinx body just behind the elbow of the south forepaw [**10.20**]. The walls, 1.7–1.9 m (5 ft 7 in. to 6 ft 3 in.) thick, rise

Sphinx masonry boxes dimensions

North large box	
Width	4 m (13 ft)
Height	2.7 m (9 ft)
Depth	2.9 m (10 ft) bottom–3.4 m (11 ft) top

North small box	
Width	2.45 m (8 ft)
Height	1.75 m (5 ft 8 in.)
Depth	2.3 m (7 ft 6 in.)

South small box	
Width	1.9 m (6 ft)
Height	?
Depth	2.4 m (8 ft)

South large box	
Width	5.26 m (17 ft), close to 10 royal cubits
Height	3.29 m (11 ft)
Depth	4 m (13 ft)

to a rounded shoulder that curves into a narrower, square top, roughly level with the top of the adjacent forepaw. Against the Sphinx body, the box is open and empty; a patch of bedrock floor, 1.85 m × 2.6 m (6 ft × 8 ft 6 in.), is exposed at the bottom.

In 1853 Mariette was the first in modern times to excavate this structure. He noted that it rose to the same height as the paw, and at first thought that, like the boxes on the north side of the Sphinx, it was a buttress to support the slope of the masonry on the Sphinx's body. However, based on pieces of the statue that he found on the spot, he concluded that it was in fact the plinth for a colossal statue of the god Osiris. Here, he reasoned, was the explanation for a Greek inscription that Caviglia had found etched on the giant forepaw calling the Sphinx the guardian of Osiris.

Mariette's brief comments are practically all that exists in the literature. There is no published archaeological record of the Osiris statue. But a certain R. P. Laorty-Hadji happened to visit the Sphinx during Mariette's excavation, and he reported in his published travelogue that the young Mariette found a colossal Osiris statue, formed of 28 pieces, that had once stood against the Sphinx's right shoulder.[20]

When Baraize cleared the south large box in 1925 it was mostly intact, although a large hole had been forced through the Phase I masonry covering the part of the Sphinx body enclosed by the box. It is possible that Mariette himself created this gap in the masonry. Inside the hole, the Baraize photographs show two large pieces of shaped limestone that could plausibly be pieces of an Osiris statue, including one with a rounded side that might be part of a torso. The photographs also show what appears to be the natural rock of the core body behind. Baraize ripped away the east and west walls of the box where they joined the body of the Sphinx in order to patch the hole in the body masonry and he then rebuilt the walls.

In 1978 we cleared the box of rubbish and sand. Inside we found small limestone pieces against the south wall, probably the remains of masonry that once filled the box. At the bottom, we came upon five blocks laid in two courses; their thickness, 37 and 36 cm (14½ and 14 in.), corresponds to that of the two lowest courses of Phase I blocks on the Sphinx body inside the box. Baraize's patchwork plugging the gap in the Sphinx casing begins on top of these two courses of Phase I slabs.

From this we conclude that the south large box was built with the typically large blocks during the Phase I restoration of the Sphinx, probably in the 18th dynasty, and filled with smaller, more irregular limestone slabs and mortar. The walls were extensively patched during Phase II, when the box's rounded shoulder and squared upper part were added in smaller blocks.

We also found subtle traces inside the box of a sunken platform: the fourth course down from the top of the south wall juts out 4 or 5 cm (1½ or 2 in.), possibly the remains of a level surface that extended across the interior. This could be the bottom of a socle for Mariette's Osiris statue.

In 1977, a team from the SRI International Radio Physics Laboratory carried out a remote-sensing survey of the Sphinx floor. Using electrical resistivity, the SRI team detected an anomaly 'typical of the behaviour expected from a vertical shaft' immediately beside the south large box.[21] The team returned the following year for a more thorough resistivity survey of the entire Sphinx ditch floor. They checked 'anomalies', which could indicate voids, with an acoustical sounder, similar to sonar. They could not confirm the indications of a shaft beside the box, but an advanced acoustical probe indicated the existence of a significant blind spot beneath the south large box.[22] On 9 May 1978, we lifted the large blocks of the lower course, revealing only the bedrock floor underneath.

10.20 A view looking down from the back of the Sphinx into the top of the south large box. Small limestone slabs that adhere to the southern interior wall remain from a packing that once filled the box and supported the floor of a plinth, possibly for a colossal statue. Large Phase I slabs from the original core box remain on the bedrock floor.

The face of the Sphinx

In the early 1990s Mark Lehner's computer reconstruction of the Sphinx face became caught up in the debate about the monument's age, thanks to newspaper stories that hailed it as evidence that it portrayed Khafre. 'Needing a face to use as a model, Mr Lehner chose Pharaoh Khafre, the Sphinx's master planner. Khafre's visage, taken from an existing statue, was digitized and merged onto the model.' And 'One of the most significant results of Lehner's findings was to confirm what Egyptologists had long suspected – the face on the Sphinx was that of the Pharaoh Khafre…'[23] If the Khafre–Sphinx face match were our test for who built the Sphinx, it would be, as critics have said, a tautology.

In fact the Sphinx face and our computer reconstructions are the very last things we would use to date the Sphinx. Like almost all archaeological, indeed almost all scientific, issues, the question of the original ownership of the Sphinx and whose portrait it is can only be demonstrated with varying degrees of probability. We do not believe that the ideas put forward by the proponents of the genre of alternative Egyptology are completely impossible. But we do believe that they hold an extraordinarily low degree of probability.

To reconstruct the original appearance of the Sphinx, I (Lehner) first spent five years (1979–83) mapping the statue, assisted by Ulrich Kapp of the German Archaeological Institute, who produced front and side view drawings with photogrammetry (a technique of stereoscopic photography from which scale drawings can be plotted – this was the technique that existed at the time; today we could use laser scanning, or more commonly 3-D modelling from a series of normal photographs). The photogrammetric survey enabled us to produce not only elevations to scale, but also contoured elevations of the front and sides, capturing the Sphinx's image graphically in precise line drawings for the first time. This in turn allowed us to generate any profile we chose, in which every stone is drawn to scale. I mapped the overhead view of the head by triangulation with a theodolite, and had the drawings digitized to create a 3-D wireframe model. Some 2.5 million surface points were plotted to put 'skin' on the skeletal view. Eventually we arrived at a reconstructed side and front view of the Sphinx with the 4th dynasty head and face, and with the New Kingdom additions to the body discussed in detail in Chapter 19.

Various known fragmentary elements, such as the pieces of the beard and the *uraeus*, were drawn to scale and then matched to the finished surfaces in the scale drawings. I repositioned these parts, and other elements that are missing entirely, such as the breast lappets, by projecting slide images of several other sphinxes and royal statues on to the side and front elevations of the Sphinx. The proportions between the beard and the face were partly derived from comparisons with numerous other sphinxes, and with royal heads such as the gold mask of Tutankhamun. There are of course pitfalls and shortcomings to this technique, not the least of which is the lack of a true eye-level or straight-on photograph of the sculpture.

There was no need to add a face to our reconstruction of the Sphinx since it already has one. Most of the surface of the face is intact, though pocked by erosion, and of course the nose is missing, and part of the upper lip and right eye are damaged. The finished surfaces preserved on the head are original 4th dynasty sculpture; they are not a New Kingdom recarving.

I had to consider the pleated *nemes* headdress together with the face because the proportions of this hood affect the face that it frames. Perhaps not surprisingly, attempting to reconstruct the original form of the Sphinx *nemes* by projecting on to it front views of New Kingdom sphinxes, such as those of Thutmose III, Hatshepsut or the alabaster sphinx at Mit Rahina, proved frustrating. A better match was achieved by projecting a nearly straight-on view of the life-size head of the Khafre diorite statue. While it was immediately clear that the two statues have different proportions between the headdresses and faces, the outline of the flaring side folds of the two statues matched well.

The comparison of Khafre and the Sphinx highlighted other features of the Sphinx. As noted (p. 220), the eyes, position of the nose, mouth, chin and headband of the two statues correspond fairly well, but only by turning the Khafre statue off its vertical axis to compensate for the fact that the Sphinx's left (north) eye is higher than the right (south), and the mouth is slightly off centre within the face. The axes of the Sphinx's facial features and that of its head (ear to ear) do not quite match. The sculptors may be excused for this, given the enormity of the task and that this may have been the first time that they had attempted such a colossal sculpture.

For those elements missing from the face, I turned to Khafre's statues. The nose was added by overlaying an alabaster face of Khafre in the Boston Museum of Fine Arts, which provides an overall better match with the traces of particular features on the Sphinx – eyes, eyebrows, headband and mouth – when the widths and heights of the two faces were equal, than the face of the famous diorite statue of Khafre. I also added the cosmetic lines around the eyes to my Sphinx reconstruction from the alabaster face. These are mostly missing on the Sphinx's eyes, yet a scant trace of the lower rim on the right (south) eye indicates that they were once modelled in this way.

For the profile view of the nose – the sole, critical missing element of the face – I used an eye-level side view of the Khafre diorite statue. When I superimposed the two there was a good match of the facial features; after I aligned the mouths the other elements of the face, the eyes, eyebrows, nose position, frame of the face, also aligned. This match is not one of portraiture but the relative formal spacing of stylized facial components. This is critical for the debate about the Sphinx face. It is significant that the match of facial elements was only achieved when I tilted the superimposed image of the Khafre diorite face back about 3.5 degrees from its vertical axis. This may indicate that the head of the Giza Sphinx, like the heads of certain New Kingdom sphinxes, is tilted slightly upwards. It did, however, mean that the Khafre ear fell behind and below the ear of the Sphinx.

In any discussion of the Sphinx–Khafre match, the obvious fact to be remembered is that most ancient Egyptian sculptures and relief

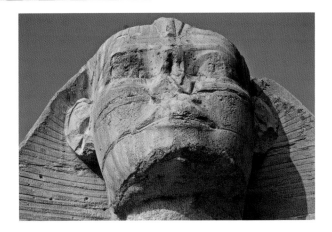

10.21, **10.22** Left: Ulrich Kapp plotted the front view of the Sphinx in 1979 using photogrammetry, contouring the core body in 25-cm intervals. We then digitized the drawing and used computers to produce a three-dimensional image. Above: The face of the Great Sphinx, looking up from between the paws. Along with the beard, the lower part of the chin is missing, particularly on the Sphinx's left (north or right) side.

carvings are idealized, not realistic, images. If a portrait is 'a work that reveals the inner and outer qualities of a person who cannot be mistaken for anyone else', it is a serious question in Egyptian art history whether 'portraiture in our sense of the word, ancient or modern, Western or otherwise, existed only intermittently, if at all, in ancient Egypt'.[24] In place of realism, we find in Egyptian art a highly developed canon of spacing and proportion, especially in royal representations, corresponding to the king's embodiment of *maat* – cosmic and social order. The royal image may be fixed according to such rules, while in all probability having little or nothing to do with the real appearance of the king. Think of the sublime statues of Ramesses II – he reigned for 67 years, and as his mummy shows, by the time he died he was bent over and suffering from bad teeth. Sometimes the royal face varies on different statues of the same king, for instance Senwosret III and Amenemhet III of the Middle Kingdom, and the same ruler could have both idealizing statues as well as more natural ones. And while a royal sculpture may or may not have had a facial resemblance to the king, it is an adolescent king that is represented; the bodies in most Egyptian statues are those of youthful champion athletes. Statues of the 4th dynasty in particular represent the kings as adolescents.

It is beyond doubt that the Sphinx face, at a scale of around 30:1, is highly idealized. One sign of this is the rendering in relief of the eyebrows, which look like the pasted on eyebrows of Old Kingdom mummies. The scant trace of cosmetic lines around the rims, and the telltale continuation of the cosmetic line back from the outer corners of the eyes, show the Sphinx face, like so many sculpted, idealized ancient faces, is 'made up', just as mummies and statues are made up for entering the great and elite court of the Afterlife. The Khafre diorite statue does not have the eyebrows and cosmetic lines around the eyes sculpted in relief, perhaps because these were added when, as is likely, the whole statue was painted.

There is some evidence that Egyptian sculptors may have intentionally moved in stages away from the reality of portraiture towards more idealized, generic images as they worked in successive drafts. Evidence comes from the 18th dynasty gypsum plaster heads or faces, royal and non-royal, found in a cache with other sculptures in the house of the sculptor Thutmose at Amarna. The German art historian Günther Roeder showed that the heads and faces are casts of clay models, which represent the different drafts for final stone carvings.[25]

Given the Egyptians' penchant for idealized, adolescent bodies, and youthful, wrinkle-free faces, with sculptors rendering an ideal that they purposely abstracted from earthly verisimilitude, can we expect to date the Sphinx on the basis of an analysis of its colossal face at a scale of 30:1 and a comparison with any life-size or smaller statue? We cannot do so with any high degree of probability. The true-to-scale contoured drawings of the Sphinx make it possible to attempt a reconstruction of its ancient appearance, but we do not use the Sphinx face and our computer reconstruction to date the Sphinx. It is possible, but we think not probable, that the face and head of the Sphinx were carved for one pharaoh while the lion body in its quarry lair was finished for another. We return to ground truth and rely on archaeological and architectural stratigraphy – recording what came before what – for the evidence that makes it most probable that the Sphinx was the last major element of Khafre's pyramid complex.

If Mariette was correct in claiming that the
south large box was once the base of a colossal
statue of Osiris, we might expect to find other
architectural evidence of the cult connected
with this image – perhaps that of Osiris, Lord of
Rosetau. However, there are reasons for thinking
that Osiris of Rosetau had his own separate temple
(see Chapter 19). It is worth noting that the south
large box is directly on line with the Sphinx Temple
axis. Had the Sphinx Temple been functioning
when a colossal statue of Osiris stood on the box,
the equinoctial sun would have set behind the
image of the Lord of the Underworld at the same
time as it lit the image of Re, Lord of the Heavens,
in the eastern sanctuary of the Sphinx niche. It is
true that fragments of the statue recovered by
Baraize beside the box more likely derive from
an Osiride statue – that is, the mummiform king
– rather than a statue of Osiris. In either case, as
dramatic and appropriate as the configuration
seems, it is almost certain that the Sphinx Temple
lay buried when the south large box and Osiris
statue were added to the Sphinx's right flank.

What were the boxes?

The boxes attached to the Sphinx statue are
odd structures that defy immediate and easy
explanation. The north large box remains a mystery.
It does not seem either constructed or properly
located as a pedestal for a statue. However, the
south large box and the small boxes on both sides
show evidence of use as plinths or bases – flat
socles built on a fill of limestone and mortar.
Mariette's suggestion that the south large box was
a base for an Osiris statue must be taken seriously,
since Baraize found pieces of a statue, possibly a
statue of a king in Osiride form, near the spot more
than 70 years later.

The evidence indicates that the masonry boxes,
including at least the core of the south large box,
are contemporary with Phase I, which likely dates
to the 18th dynasty reconstruction of the Sphinx.
This image of the Sphinx – which we think of as an
austere, isolated and enigmatic presence – flanked
by smaller statues within shrines on pedestals
here and there against its leonine body may seem
bizarre, but in the New Kingdom the giant statue
took on a very different aspect (see pp. 481–84).

Dating the Sphinx

As mentioned in Chapter 4, the date of the Sphinx
has been the subject of much discussion in recent
years. Writer John West and geologist Robert
Schoch have claimed that the shape and amount
of erosion of the Sphinx surface proves that the
statue is much, much older than Egyptologists
think, originating not around 2500 BC but more like
7000 to 10,000 BC.[26] Graham Hancock and Robert
Bauval have used Schoch and West's ideas to
advance the belief that the Sphinx is the remnant
of an advanced civilization now mostly lost to
archaeology.

From within the ranks of orthodox Egyptology,
Rainer Stadelmann believes the Sphinx was
created for, and represents, Khufu.[27] Vassil Dobrev
of the French Archaeological Institute in Cairo
concluded that the Sphinx was the work of
Djedefre, Khafre's half-brother and another son
of Khufu.[28] Leaving aside art historical questions
of whose face is represented on the Sphinx, and
whether it is possible to date the monument in this
way, far more compelling arguments tie the Sphinx
and its temple to the Khafre pyramid complex.
Concrete architectural and structural relationships
also suggest that these elements were constructed
late in the building sequence during the reign of
Khafre:

1 Khafre's valley temple sits on the same levelled
terrace as the Sphinx Temple. The fronts and
backs of the temples are nearly aligned.
2 The walls of both the Sphinx Temple and the
Khafre valley temple are built using the same
style of large limestone core blocks, with harder
red granite casing blocks added as a finish.
The surviving traces of Khufu's upper temple
indicate it was not built with monolithic core
blocks.
3 The court of the Sphinx Temple is similar in
design and dimensions to the court in Khafre's
upper temple, except that the upper temple
contained 12 instead of 10 colossal statues.
There is no evidence of colossal statues in the
Khufu upper temple.
4 The Sphinx and Sphinx Temple were part of
the same quarry and construction sequence.
Blocks for Khafre's valley temple probably derive
from higher layers in the geological sequence of

the Sphinx area. Sphinx Temple blocks derive from the lower bedrock layers in the Sphinx ditch.

5 The Sphinx Temple was clearly left unfinished, indicating that it was the last project under construction in the area of the Sphinx and the Khafre valley temple, which was finely finished inside and out.

6 The Sphinx Temple south wall is parallel to the valley temple north wall, showing the same deviation north of due east. The Sphinx Temple builders must have adjusted it to the already existing Khafre valley temple.

7 A drainage channel runs along the north side of the end of the causeway and opens into the upper southwestern corner of the Sphinx ditch. The builders would not have cut a channel that drained water into the Sphinx ditch, suggesting that the ancient quarrymen formed the Sphinx ditch *after* the Khafre causeway had been built.

8 The south side of the Sphinx ditch forms the north side of the foundation of the Khafre causeway just where it enters the Khafre valley temple. Again, the Sphinx ditch was sunk along the side of the causeway that already existed.

Like Herbert Ricke, we see additional incontrovertible evidence that the Sphinx Temple, and therefore the Sphinx, were built in Khafre's reign, and after the valley temple, with its early enclosure wall described in Chapter 9. As described there, the wall on the temple's south side, running parallel to and 8.5 m (28 ft) from it, still survives, composed of locally quarried monolithic limestone blocks. On the north side of the temple we mapped the foundation bed of a similar wall, sunk into the bedrock. Like the south wall, this ran parallel to the valley temple and the same distance from it. Also exactly like the wall on the south, the bed on the north is close to 2.6 m (5 cubits or 8½ ft) wide. The walls once formed an enclosure attached to the back western corners of the valley temple and reaching round the front corners, leaving a space in front of the temple.

However, the wall on the north was almost completely removed, leaving only its track in the bedrock. The reason for this was the construction of the Sphinx Temple, the south wall of which was placed directly over it. Ricke points to one

block of the northern wall still in its track because the builders had incorporated it into the core of the southeastern corner of the Sphinx Temple. We ascertained that there are several others to the west. These blocks are very close in size and shape to the blocks of the valley temple southern enclosure wall.

On top of all the other relationships that tie the Sphinx and Sphinx Temple to the final phases of building Khafre's valley complex, the path of the missing northern enclosure wall makes it as certain as we can be that Khafre's builders had completed Khafre's valley temple with its granite casing and had built the northern and southern enclosure walls, but then removed the northern wall in order to build the Sphinx Temple. Thus regardless of any arguments based on who the Sphinx represents, or any ideas about 4th dynasty religion or politics, the bedrock facts of the quarry-construction history point to Khafre as the builder of the Sphinx.

Archaeological evidence indicates that Khafre's builders left the Sphinx and its temple as an idea never fully actualized. As we read the evidence, the Sphinx was much more a functioning monument in the New Kingdom, when its cult was first truly activated, 1,200 years after Khafre. It then became a far more colourful and complex image than the desert-buffeted ruin so familiar to us, as will be described in the New Kingdom chapter.

CHAPTER 11
The third pyramid: Menkaure

Menkaure, presumably the son of Khafre and grandson of Khufu, was the builder of the third Giza pyramid, called 'Menkaure is Divine' (*Menkaure Netjeri*). Perhaps because it is the smallest of the three at Giza, this pyramid complex has remained the least disturbed since the Old Kingdom. At his death, Menkaure's builders left the pyramid complex unfinished in stone, but in the temples that they completed in mud brick for the dead king and his queens, people continued services for around 300 years. Excavation of the third Giza pyramid has thus yielded more information about what people actually did in the pyramid temples than the two other, larger pyramid complexes. In his excavation of the Menkaure pyramid from 1906 to 1910, George Reisner found evidence for the total profile and life history of a pyramid complex – an archaeological reality far richer and more complex than just its architectural layout. However, this archaeological window on to the life-cycle of a pyramid has left us with as many questions, puzzles and mysteries as the two grander Giza pyramids, and perhaps even more.

The pyramid

Two of the first questions to ask about the Menkaure pyramid are: why was it so much smaller than his predecessors', and why did his builders use so much hard and difficult granite instead of Turah limestone for casing the lower part? The pyramid's base area is less than a quarter of the size of those of the preceding two, and the building mass equals about one-tenth that of Khufu's pyramid [**11.2**]. It is as though the amount of granite cladding was intended to make up for the diminution in size.

Menkaure's builders chose as the site for his pyramid and upper temple a ridge of limestone at the far southwestern corner of the Moqattam Formation. A sharp drop to a drainage channel bounded the ridge on the north; on the south the plateau sloped to the east and into the Main Wadi.

Menkaure pyramid statistics

Estimated average length of base sides	105.5 m (201 cubits/346 ft)
Estimated height (Petrie)	65.12 or 65.55 m (213 ft 7 in. or 215 ft)
Measured height (Vyse & Perring)	61.87 m (203 ft)
Approximate slope	51 deg. 10'30"
Deviation of mean orientation from cardinal directions	14'03"
Base area	11,025 sq. m (118,675 sq. ft) estimated

The dimensions of the ridge must have constrained the size of the pyramid. The builders extended and evened out this natural shelf, just as their predecessors had done for Khafre, by constructing on the low east-southeast slope a foundation platform of enormous limestone blocks weighing from 5 to 20 tons. Because of the slope, the platform is three courses deep on the southeast and only one on the northeast.

As Maragioglio and Rinaldi pointed out, Menkaure's builders also left bedrock protruding into the pyramid core, as they had done in the Khufu and Khafre pyramids.[1] Based on observations in the tunnel blasted through the pyramid by Howard Vyse in 1837, and in the descending corridor, the builders left a rise of about a metre as they levelled the outside terrace by cutting away bedrock in one direction and building up the foundation in the other.

The fabric of the pyramid body

The gaping wound made in 1196 in the north side of the pyramid by Saladin's son, Malik Abd al-Aziz Othman ben Yusuf, and Howard Vyse's tunnel from within this breach, give a good section view of the core structure [**11.3**]. This reveals that the builders raised the nucleus in steps. Each major step consists of seven to eight courses of relatively good stone, including long blocks as an outer shell. Maragioglio and Rinaldi stated that the second to the fourth steps are about 9 to 10 cubits (5.25 m/17 ft 3 in.)

PREVIOUS PAGES
11.1 The pyramid of Menkaure under a full moon, with the three subsidiary pyramids (left to right), GIII-a, b, c. View to the southeast.

BELOW
11.2 Reconstructed model of the Menkaure pyramid, its upper temple, enclosure wall and three subsidiary pyramids on the south, one a true pyramid, the other two left as step pyramids. The enclosure wall and temple were completed in mud brick rather than stone. Granite casing on the lower part of the pyramid was in fact never smoothed.

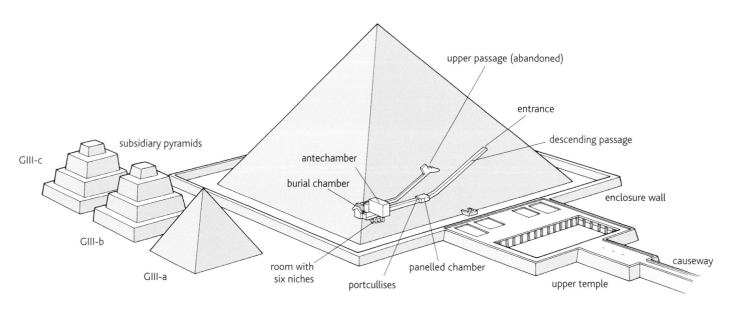

Casing and baseline

Although Menkaure reigned, according to the Turin Royal Canon, for only five years fewer than Khafre and eight fewer than Khufu, his workmen did not complete dressing the casing of his much smaller pyramid. Given that one quarter of the original height, certainly more than 16 courses, was composed of hard granite, this was a much more difficult operation than finishing the limestone used to case the other two pyramids. It seems, however, that the masons did at least take care to dress square patches around the entrance and behind the platform in the inner offering chapel of the temple. They also managed to complete the upper casing which was of limestone, as shown by fragments with worked faces found in the debris around the base, though none of this casing now remains in place.

Petrie noted the foot of the granite casing at some points around the pyramid, but there was no clean baseline. The pyramid base was left undressed. The bottoms of the lowest casing stones follow the undulating bedrock or rest on the rough limestone foundation blocks. As the builders laid the individual granite blocks next to one another, they smoothed the sides to join them together. And as they set each block, they bevelled the rough extra stock of stone on the outer face away from the smooth sides along the joins to its neighbouring blocks [11.4]. This bevelling, or chamfering, followed the intended slope of the pyramid face right down to the bedrock, as we saw in a 2012 trench at the western end of the northern side.

Perhaps Menkaure's builders had intended to dress the bottom of the lowest casing course into

11.3 The breach made in 1196 by Malik Abd el-Aziz Othman ben Yusuf in the centre north side of the Menkaure pyramid reveals alternating well-laid and looser masonry in tiers or steps, with a packing of looser blocks over the steps. The dark hole is the beginning of Howard Vyse's tunnel.

high. The builders filled in each step with smaller blocks, not well squared – the same method they used to build mastaba tombs nearby. No inner accretion layers like those in the old-fashioned step pyramids are visible in Howard Vyse's long tunnel.

To complete it as a true pyramid the ancient masons then filled the outside of the steps with 'packing stone' and with masonry very similar to that composing the steps. This is comparable to Khufu's queen's pyramid GI-c (pp. 179–81), where it is difficult to see the steps, though once recognized it is clear that each step was composed in mastaba-like chunks.

Menkaure's workers must have built his pyramid in a similar fashion. As they filled the steps of the inner step pyramid, they used smaller blocks as fill or 'backing stone' between the core masonry and the granite casing. The stepped limestone courses we see today where the casing has been ripped away are the outer shell of the packing of the steps and some of the backing blocks. According to Petrie's measurements, the height of the limestone courses varies from 53 cm (21 in.) to 1.12 m (3 ft 8 in.).[2]

Menkaure pyramid: major explorations

Years	Monument	Excavation
1638	upper temple	J. Greaves
1837	pyramid	R. Howard Vyse and J. S. Perring
1906–10	pyramid	G. A. Reisner (HMFA – Harvard Museum of Fine Arts)
1974–78	Giza pyramids	SRI International, remote sensing
1996	pyramid	Z. Hawass (SCA)
2004	causeway	Z. Hawass and the Giza Inspectorate
2009	northern base	Z. Hawass and the Giza Inspectorate

a vertical foot. The slabs of the pavement of the court – had it ever been finished – would then have been laid to join the bottom of the slope of the casing to form the true baseline of the pyramid. As we saw in Chapter 9, this is the same configuration as found at the Khafre pyramid.

11.4 Undressed granite casing stones, with extra stone still protruding, on the north side of the Menkaure pyramid, next to the dressed area of casing (foreground) around the pyramid entrance. Masons had bevelled or chamfered each individual casing stone back to the intended plane of the pyramid face around the edges.

BELOW
11.5 Excavation through a thick layer of debris reached down to the bottom of the lowest casing blocks at the base of the Menkaure pyramid.

At the same time as building up the slope with blocks to create the foundation platform, the builders also began work on cutting down the higher northwestern bedrock, starting with a crude grid of channels. And as at the corresponding corner of the Khafre pyramid, they left behind some of this grid for us to find. When in 2009 the Giza Inspectorate excavated here, they found that the ancient workers had barely begun to work down the original plateau surface. Despite this, the builders began laying the granite casing stones of the pyramid. Oddly (compared to other pyramids), because they were so behind in levelling, they did this by cutting a deep trench (1.7 m/5 ft 7 in. deep) into the bedrock along the intended line of the northern base, not far from the grid, and laid the first course of casing blocks into it. The result is a shoulder of bedrock that thrusts up nearly 2 m (6 ft) high at the western end of the northern court. The builders then accommodated the bottom course of casing to the sloping irregularity of the bedrock and masonry foundation [**11.5**].

As the pyramid was unfinished at Menkaure's death, later workmen, probably under Shepseskaf, filled in the trench with sand, mud brick and limestone debris to create a level floor on which they could construct a mud-brick enclosure wall to define the pyramid court. Giza Inspectorate archaeologists found traces of this wall built on debris at a much higher level than the bottom of the casing. In our 2009 trenches we excavated through this thick layer of debris to the bottom of the casing.

Where, then, should we locate the true baseline of the pyramid? At the point where the bottoms of the lowest casing blocks follow the rise and fall of the bedrock left by the quarrymen as they rather hastily cut it down? Or where the limestone debris meets the higher casing courses (left undressed)? Today, debris from later times still covers most of the pyramid base. But even if we excavated it entirely and could map where the lowest casing touches the bedrock, that baseline would no doubt prove a trapezoid, which those who finished Menkaure's pyramid never intended to be seen. So the answer to our question about the baseline, as Petrie recognized from his own trenches, is that there isn't one. The builders left the pyramid no true, level baseline, and the base lengths of the pyramid's sides must differ. It may seem odd, and

contrary to everything written about pyramid building to date, to conclude that the builders created a level base and baseline as the last, rather than the first, tasks of constructing the pyramid, but such was their procedure.

But if there is no true baseline, how did the ancient builders control the pyramid's square? Petrie took the average height of the granite casing courses, which are all nearly the same – 'a rather short two cubits each'[3] – except for the bottom course, which is 10–20 cm (4–8 in.) thicker. He then reckoned the baseline as being the height of one course measured down from the top of the first course.

The builders presumably used the top of the first course as a level reference, as they had for Khafre's pyramid. They could certainly not have used the bottom of the lowest course as their reference because while they shaved the tops of the blocks even and flush, they left the bases at different levels on the rough foundation, so that the blocks vary in thickness from 1.11 to 1.4 m (3 ft 8 in. to 4 ft 7 in.). For laying in the bottom course they must have used a temporary external reference line, which may or may not have left traces like the lines of postholes found around the bases of the Khufu and Khafre pyramids (see Chapter 15).

If a baseline for Menkaure's pyramid remains somewhat of an abstraction, we can still satisfy our penchant for absolute pyramid dimensions. From Petrie's measurements he calculated the base on three sides as averaging 105.5 m (346 ft), or 201 cubits; it is probable that Menkaure's builders intended a round 200-cubit length. Petrie was unable to find the north end of the western side; nor could he find a clear answer to the angle of the pyramid, but since the base of the pyramid has still not been fully excavated, his survey remains the best we have. Petrie's measurements and calculations show again how our clean mental templates of pyramids are generalizations laid over a much messier and more complex physical reality.

Inside Menkaure's pyramid

Certain features inside the pyramid have led some scholars to believe that Menkaure altered his original plan. Two sloping corridors descend from the bedrock surface to a system of chambers. The upper passage, created first, was later covered and

blocked by the core masonry of the pyramid when it was built on top, which suggests to some that the pyramid was planned to be either much smaller or situated further south, and was subsequently expanded or moved northwards, closing off the top of the corridor. According to this view, the first entrance and passage were abandoned for a more impressive descending corridor lined with granite. Much of the substructure of the pyramid would have been built before the superstructure, so that both descending passages would have remained open as work proceeded underground [11.6].

The true entrance passage now opens in the thickness of the fifth granite course, 4.2 m (13 ft 9 in.) above the base of the pyramid, in the middle of the north side. Unlike the entrance passages of Khufu and Khafre, it is not offset to the east. With Menkaure we see the beginning of a trend for pyramid planners to lower the entrance. Instead of openings high in the faces of pyramids, like those of Sneferu and Khufu, the entrances now move towards the ground-level entrances we see in the 5th dynasty pyramids. Stadelmann pointed out that a lower passage made it easier to insert plugging blocks to seal the passage, and, eventually, to build small chapels with false doors directly above the entrances.

Maragioglio and Rinaldi noted that the top and side edges of the entrance are cut back 8–20 cm (3–8 in.), as if someone was making a rebate to fit

11.6 Model of the substructure of the Menkaure pyramid, view to the south-southwest. The entrance passage comes in from the north.

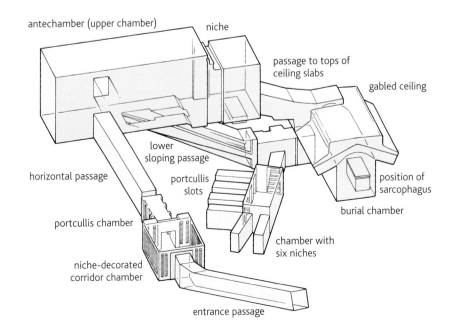

11.7 Antechamber or upper chamber in the Menkaure pyramid with pilasters and a 'back' niche, like 'pilaster and niche' audience halls found in elite Giza houses (albeit here oriented east–west instead of north–south). A drum roll spans the underside of the carved architrave.

a cover slab, though one of granite would have been too breakable. However, the rebate might have been carved much later and could be associated with the 'symbolic' burial of Menkaure in the New Kingdom or Late Period, evidenced by the wooden coffin found in the burial chamber and the text inscribed below the entrance to the pyramid (see below and p. 506 for details of this burial).

Entrance passage and niche-decorated chamber

As it passes through the pyramid masonry the descending passage is lined with granite, but beyond the point where it enters the bedrock it ceases to be sheathed. Maragioglio and Rinaldi suggested that after the king's burial his workers plugged the lined upper part of the passage with granite blocks. The final granite plug would then simply have blended with the granite casing

on the exterior. The solidity of the casing and plugging combined might have discouraged would-be robbers, even if they knew the location of the entrance.

At the lower end of the passage a short horizontal stretch with a higher ceiling leads to a chamber that is in effect a widening of the corridor, with a doorway at each end. All four bedrock walls are carved in relief with a series of tall and narrow false-door motifs, the first time relief decoration is found in the chambers of a pyramid [**11.8**]. This 'corridor chamber' anticipates a similar feature in 5th dynasty pyramids, and the widening of the way must have helped the workers manoeuvre the sarcophagus between the steep angle of the descent and the horizontal section of the passage.

The doorway to the continuation of the passage was once framed in masonry, with granite jambs and a granite lintel carved as a drum roll, in imitation of a rolled up reed-mat curtain. Howard Vyse found the lintel lying on the floor of the chamber, along with two granite blocks that probably once plugged the descending passage.

Portcullis chamber

Just beyond the niche-decorated chamber, another chamber, also in effect the continuation of the passage and somewhat irregularly hollowed out of the rock, is fitted with slides for three portcullis blocks. The blocks are missing, but they were probably made of granite like the portcullises of Khafre and Khufu. The introduction of the vertical sliding portcullis blocks into their upper, waiting position was one of the most difficult operations in preparing a pyramid for a king's burial. The fact that practically no remains of the closure blocks were found may indicate that the builders never introduced them. Given the evidence that Menkaure died with his pyramid unfinished, those now working under the orders of the new king perhaps closed the passage with simpler, but less effective, limestone masonry. However, above the sliding slots are the holes ready to receive the cross logs for ropes to lower the blocks into place.

The doorway leading on from the portcullis chamber is again adorned with a drum roll lintel. After this point the corridor continues at a slight grade (4 deg.) upwards, with a height of about 1.77 m (6 ft). A remarkable thing about this corridor is that

Upper passage and chamber statistics

Cross section	1.2 m (3 ft 11 in.) height
	× 1.05 m (3 ft 5 in.) width
Length	31.7 m (104 ft)
Slope	26 deg.

Antechamber statistics

Length	14.2 m (46 ft 7 in.)
Width	3.84 m (12 ft 7 in.)
Height	4.87 m (16 ft)

it was hollowed out of the bedrock from the south to the north – that is *towards* the portcullis chamber. Both Howard Vyse and Petrie noted the evidence in the masons' tool marks where they cut too deep from south to north and pulled back to the intended plane of the sides of the passage. They must have made the upper passage first (see below) and begun hollowing out the rectangular antechamber before proceeding northwards to join the lower horizontal corridor leading to the lower descending passage.

The antechamber

The passage leads into a large rectangular chamber hewn from bedrock [11.7]. Directly above the point where this corridor enters the chamber, 2.99 m (9 ft 9 in.) higher up, is the opening of the upper descending passage. From here, this upper passage, over 1 m (3 ft 3 in.) wide, runs for a length of 24.5 m (80 ft 5 in.) up to the bedrock surface, where its

opening is covered over and blocked by the core masonry of the pyramid. Above its mouth, the builders placed a huge lintel block weighing up to 50 tons, similar to those over the entrances of queens' pyramids. It certainly looks as if the builders intended this to be the main pyramid passage in an earlier plan and then abandoned it. If so, as noted above, the builders either designed the pyramid to have been much smaller or to have been positioned further south. A third possibility, however, is that they planned to continue the upward slope of the passage through the masonry some 15 m (49 ft) further north, so that it would have emerged much higher in the pyramid's north face, and what we witness here is the decision to abandon an entrance high in the pyramid.

The large, rectangular antechamber is orientated east–west, and has a flat ceiling. The entrance corridor opens 2.63 m (5 cubits/8 ft 8 in.) west of the east wall. At the chamber's western end, jambs and a lintel carved from bedrock create a division in the length of the room, defining a niche. A carved drum roll lintel adds to the formality with which the niche is set off from the rest of the chamber. It is possible that in an earlier plan for the substructure which included the upper descending passage, this chamber was the burial chamber; in this case the niche could have been the setting for the king's stone sarcophagus. It was in this chamber that Howard Vyse found parts of a wooden coffin and other remains, discussed below.

11.8 Southern doorway of the niche-decorated passage chamber, framed in red granite with a drum roll lintel.

Burial chamber

A trench cut roughly in the centre of the floor of the antechamber opens into a granite-encased sloping passage that descends 10 m (33 ft) deeper into the bedrock towards the west, to a short horizontal stretch with another set of portcullis slots. Beyond lies the burial chamber, beautifully lined with granite and with a barrel-vaulted ceiling [11.9]. The curved ceiling was hammered out of the underside of great granite beams set saddle-like above the wall casing.

This difficult work – not just shaping the granite, but also bringing in the beams to begin with – took place some 15.5 m (51 ft) below ground in the

11.9 Menkaure's burial chamber, hewn from bedrock and lined with granite. The barrel-vaulted ceiling was carved from great granite beams. View to the north.

Burial chamber statistics

Width	2.65 m (8 ft 8 in.)
Length	6.6 m (21 ft 8 in.)
Height	(max.) 3.43 m (11 ft 3 in.)

bedrock cavern hewn out for creating the king's final resting place. It was Stadelmann's insight that this must have presented the same problems with airflow that Khufu's quarrymen had experienced while carving out his subterranean chamber far below ground at the end of the Descending Passage. And therein may lie the solution to the puzzle of the 'abandoned' entrance passage. Perhaps the builders made the passage to provide a supply of air to breathe while they created the rest of the apartments deep underground.

When Howard Vyse entered the burial chamber in 1837 he found an empty basalt sarcophagus standing against the western wall. Its exterior was decorated with relief-carved recess panelling ('palace façade'). The lid lay broken into pieces in the 'large apartment' (the antechamber) above the burial chamber. With great difficulty, and causing much damage to the first corridor chamber, Howard Vyse's men removed the sarcophagus for transport to England. Unfortunately, the sarcophagus sank to the bottom of the Mediterranean Sea along with the ship carrying it from Alexandria to London. We know the approximate location the vessel sank in the western Mediterranean, somewhere between Malta and Cartagena in Spain.

Together with the fragments of the stone sarcophagus lid in the antechamber, Howard Vyse's men also found some human bones, linen wrappings and parts of a wooden inner coffin (now in the British Museum) [11.10].[4] As noted in Chapter 6 (p. 96), an inscription on the front of the coffin states that its occupant is the deceased ('Osiris') Menkaure, 'given life forever, born of the sky, the sky goddess Nut above you...'. However, the style of the wooden coffin suggests that it is later in date – Stadelmann thought it dated from Ramesside or Saite times, though Zivie-Coche says its style and inscription mean it can date no earlier than Saite times (26th dynasty; c. 664–525 BC).[5] The mystery deepens as radiocarbon dates on the human bone suggest that the person died in late antiquity or even early Christian times.

We might suspect that this apparent burial of Menkaure some one or two millennia after his death relates to the inscription found on the granite casing just below the entrance to the pyramid (see p. 507). Ali Hassan discovered this inscription as late as 1968 when he had the debris cleared from the base of the pyramid for the Antiquities Service. The text states the year (unfortunately damaged), month and day that 'the king was buried' in the pyramid. It is certainly a restored text. After a close examination, Roman Gundacker concludes the 26th dynasty king Apries recorded here that he restored Menkaure's burial. Gundacker detects places for cartouches that show Menkaure as the tomb owner, Shepseskaf as the host of the original burial (perhaps with a date) and Apries as the restorer. This would explain the Saite-style wooden sarcophagus found in the antechamber.[6]

Cellar with niches

From the short horizontal stretch of passage that opens into the burial chamber, a crude set of steps leads northwards to a room measuring about 5 cubits (2.62 m/8 ft 7 in.) long and 1.5 cubits (0.79 m/2 ft 7 in.) wide, with six niches roughly carved in bedrock [11.11]. Stadelmann sees this niche cellar as the descendant of Khufu's subterranean chamber, and the forerunner of niche cellars under the tombs of Khentkawes at Giza (see Chapter 12) and Shepseskaf at South Saqqara, as well as the niche chambers east of the antechamber in the pyramids of the 5th and 6th dynasties.

Egyptologists offer several suggestions for the purpose of the niches, for instance that they are for the interment of the canopic jars or the king's crowns, or of equipment used in the burial ritual. An even more speculative idea is that by not building their burial chambers high up in the pyramid superstructure, Khentkawes and Shepseskaf departed from the solar cult and emphasized underworld, chthonic features, symbolized by the underground niches.

In the later Old Kingdom, the niches inside the pyramid are directly in line with the inner offering hall of the pyramid temple and its false door against the outside base of the pyramid, where food was ritually placed before the dead king. It probably makes most sense to see these niche cellars as the equivalent of underground storage cellars such as might have existed in the houses of the living, and that they were stocked with food and drink offerings for the Afterlife.

The upper temple

The upper temple of Menkaure stands before the centre of the eastern face of his pyramid. Rectangular in plan, it covers about 54 sq. m (581 sq. ft), without the entrance hall. The core walls are still fairly well preserved. John Greaves, who visited the temple area in 1638, was the first to describe its ruins. Lepsius published a plan of it, but Howard Vyse was the first to excavate in the temple and in the area between it and the pyramid, in 1837. Reisner began his systematic excavations of the whole pyramid complex in 1906.[7]

The central part of the upper temple rests directly on the bedrock ridge that Menkaure's builders chose for the site of his pyramid.

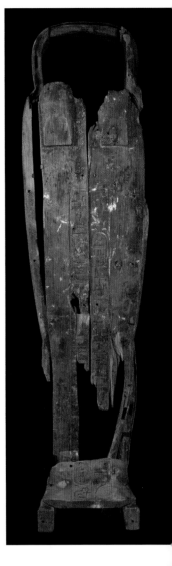

ABOVE RIGHT
11.10 Wooden anthropoid coffin of 26th dynasty style found by Howard Vyse in the Menkaure pyramid antechamber (upper chamber), now in the British Museum (EA 6647); 166 cm (65 in.) high. The coffin was made from pieces of different kinds of wood for a restoration of Menkaure's burial.

RIGHT
11.11 Six niches in the substructure of the Menkaure pyramid, located off the passage into the burial chamber, possibly for storing foodstuffs and other offerings for the Afterlife.

During the king's reign, his workers laid out the structure's principal walls in gigantic core blocks of locally quarried limestone – the largest weighs over 200 tons. They began to encase some of the interior walls with granite. It was presumably during the reign of Menkaure's son Shepseskaf, who ascended the throne after his father died, that the workers finished off the temple in plastered and whitewashed mud brick. Additional rooms and walls were made at the back of the temple, between it and the pyramid, at some time between the 5th and 6th dynasties [**11.12**, **11.13**].

Menkaure's temple is divided into two parts: the 'public' or front part, with the entrance hall and open court; and the 'private' or inner temple. The initial plan, completed in mud brick, confined the private part to a chapel between the back, western wall and the eastern face of the pyramid. Later, in either the 5th or 6th dynasty, builders added a mud-brick screen wall across the western side of the court. This incorporated more of the temple into the private area, and achieved a stricter separation of the inner from the outer temple.

The original separation was the precursor to the outer and inner temples divided by a transverse corridor that would be found in 5th and 6th dynasty pyramid temples. The later screen wall achieved something of this effect, and was one of several modifications to make Menkaure's upper temple correspond more closely to later royal thinking about what a king's memorial temple should include (see below).

Outside the entrance to the temple Reisner found a heap of rubbish consisting of Old Kingdom potsherds and miniature votive offering vessels that

ABOVE
11.12 George Reisner's detailed plan of the Menkaure upper temple as excavated.

RIGHT
11.13 View of the upper temple of the Menkaure pyramid, from the granite-paved inner temple sanctuary in the foreground (below) to the beginning of the causeway (above). View to the east from on the pyramid.

seem to have been discarded by officiating personnel after they had used them in temple services.

A long entrance hall, framed in large core blocks as a massive, direct extension of the causeway, led into the temple in the centre of its eastern face. The doorway was formed in the interior casing of mud brick. At less than 1 m (3 ft) wide, the threshold – with pivot sockets indicating the existence of a wooden door – is one of many examples of pyramid-temple interiors entered through the narrowest of doorways, in spite of the colossal monumentality of the exterior architecture.

In the debris of the northwest corner of the entrance hall Reisner uncovered the bottom of a limestone stela that he believed may either have been built into a jamb of the doorway or perhaps stood just outside it. The few remaining lines of hieroglyphic text suggest that it matched other stela fragments inscribed with the name of Menkaure's son Shepseskaf, some of which were found in the upper temple portico (below). The text dates the royal statement to the year after the first counting (inventory for taxation), so early in Shepseskaf's reign. Reisner reconstructed the text as: 'He made it as a monument for his father, King of Upper and Lower Egypt, Menkaure',[8] with the rest relating to the endowment of Menkaure's cult – clear evidence, it would seem, that Shepseskaf finished the temple. A block of stone cut with a niche rested against the mud-brick casing in the northwestern corner of the entrance hall; a similar niche may have once existed against the opposite wall. The function of the niche or niches is not known, but they may have contained a pair of Shepseskaf's stelae, showing through the mud-brick casing, dedicating his father's temple just before the open court.

A narrow corridor through the mud-brick casing then led into the large open court that stretched 44.6 m (146 ft 4 in.) north–south. Menkaure's builders had begun sheathing the interior walls in black granite, but after his death they simply cased over whatever granite they had already set with plastered mud brick. They then decorated the new mud-brick casing with a repeated series of niches to represent a false door. The use of this motif in the courts of Menkaure's upper and valley temples echoes its appearance in the granite casing of the corridor chamber inside his pyramid.

Masons, probably again under Shepseskaf, levelled the court with mud and debris and paved it with limestone slabs laid, as usual for the Old Kingdom, in an irregular jigsaw pattern. As the pavement does not continue under the mud-brick casing of the walls, it must be contemporary with or later than the casing. They also laid a path of regular yellow limestone slabs across the courtyard on its east–west axis. A slight slope from all sides towards the centre meant that rain falling into the unroofed court would drain into a trough protected by low curbs on each side. The masons raised the limestone path slightly above the trough so that when the court filled with water people could cross it without getting their feet wet. A small channel cut through the pathway directed the rainwater to a sunken area north of the centre of the court, which once probably held a stone basin similar to that seen in the valley temple, and in the courtyard of the temple of the queen's pyramid GIII-a.

Ricke believed the original design of the court called for pillars around its interior, 12 each on the east and west sides, and 7 on the north and south.[9] However, since there is no evidence – for instance in the form of sockets – that any pillars were ever set up, we can only guess what Menkaure's architect had in mind. Perhaps the false-door motifs in the plastered mud walls somehow fulfilled a symbolic function similar to a colonnade. As Stadelmann

11.14 Corridor 13 in the northwestern corner of the Menkaure upper temple leading from the court to the inner temple. Eroded mud brick survives from the final casing (once white-washed) that covered the unfinished black granite casing blocks set by Menkaure's workers.

noted, numerous fragments of statues of Menkaure were found, and some of the originals may have stood around the open court, although the niches are too small to have contained them.

On the western side of the court is a recessed bay or portico, separated off by the plastered mud-brick screen wall. It was entered by a central doorway closed by a wooden door. The south end of the screen wall attached to the mud-brick casing of the temple, evidence that it was added sometime after the initial completion. As noted above, the clear separation between the front temple and the inner part where priests presented offerings is also seen in pyramid temples of the 5th and 6th dynasties, and Menkaure's screen wall was probably added during this period.

The portico is in the form of a three-stepped recess, similar to the arrangement in the courtyard of both the upper temple of Khufu and the antechamber of the upper temple of Khafre. During Menkaure's reign, his builders had finished sheathing the portico walls with red granite casing. Sockets in the floor reveal that six pillars in two rows – four to the east and two to the west, no doubt also of red granite – supported the portico roof. Reisner believed the pillars rose to a height of 7 cubits (3.66 m/12 ft) above floor level, set into sockets about 2 cubits deep. The granite shafts would thus have been about 5 m (16 ft) long. Plunderers had removed them, probably during the New Kingdom.

Based on the ground plan of Khufu's temple, Ricke proposed that a third row of pillars crossed the front of the portico, where the screen wall now stands. He called this area the 'Gate of Nut' and suggested that statues of various gods were set up along its walls.[10] However, there is no archaeological evidence for this reconstruction. Reisner thought that the portico floor, like the walls, was finished with granite. In the debris filling the portico, his team found fragments of two limestone stelae dated to the reign of Shepseskaf, and fragments of two decrees in limestone, one possibly bearing the Horus name of Merenre, a king of the 6th dynasty.

In the centre of the rear wall of the portico, granite jambs and a lintel once framed a doorway, probably closed with a double-leaved door, which opened into a long narrow hall. On line with the east–west central axis of pyramid, temple and causeway, this inner hall is the focus of the whole temple. Its walls were finished with red granite casing and its ceiling was built of granite beams. The floor might have been paved with alabaster, as in other Old Kingdom temples, but most likely the pavement was never laid; Reisner found only packed dirt.

In the portico behind the court, a passage from the first recess leads to a large unfinished area that presents a 'frozen moment' in the construction of the large core-block walls. Whoever completed the rest of the temple in mud brick did not touch this southwestern part of the temple, so it remains in the state it was left at Menkaure's death. Menkaure's builders had filled most of the room with a construction plane of limestone rubble used to raise the gigantic core blocks of the walls. Flush with the tops of the first and second courses of core blocks were two layers of debris. The debris was held back on the southeast corner by a stone-rubble retaining wall. In the southeastern corner, an L-shaped rubble wall formed a hut, perhaps a shelter for a workman acting as guard.

A long corridor leads from the north end of the western side of the portico straight back and sloping up into the northwest corner of the temple [**11.14**]. Here Menkaure's builders had begun to sheathe the walls of the corridor in black granite, starting in the centre of the walls. But again they never finished, leaving another 'frozen moment' in the construction process. Reisner discovered these granite blocks when he cut away the later mud-brick casing. Builders' marks in red pigment covered the granite casing and core blocks. It was on blocks of the southern side of this corridor, and elsewhere in the northwestern corner, that Reisner found graffiti of the gang name translated as 'Drunkards of Menkaure', which seems to have formed a pair with another gang, 'Friends of Menkaure', whose graffiti Reisner found in the southwestern part of the temple. The gang names, often followed by names of phyles and divisions, were painted on to the sides of the blocks before they were set in place.

Masons drew their levelling lines over the names; one graffito was sideways because the block had been turned when set in place. Although these marks have now faded, it is still possible to see how the masons cut deep into the faces of the huge limestone core blocks in order to make the fronts of

The Menkaure alabaster colossus

Scholars have long speculated about the object that would have graced the long inner hall of Menkaure's upper temple. George Reisner believed that placement marks of missing granite casing on the wall at its western end indicated a niche, perhaps for a false door. However, Maragioglio and Rinaldi interpret these as traces of granite ceiling beams. Leslie Grinsell believed the room might have contained a statue of the king. Ahmed Fakhry compared the long hall with the sanctuaries in the upper temples of the 5th and 6th dynasties. According to Herbert Ricke, it was a shrine that replaced the five statue niches of the upper temple of Khafre and held a statue of the god Osiris.[11] Zahi Hawass believes the hall contained a statue of the god Re, in honour of the sun god and of Menkaure's grandfather, Khufu, who was considered an incarnation of Re. Mark Lehner follows William Stevenson Smith, who believed that the alabaster colossus of Menkaure once stood at the back of the hall.[12] Reisner's team found pieces of the colossal statue widely dispersed. The head and shoulder lay outside the northwest corner of the temple, where a drain exits from a magazine. The largest part, including the knees, lay in the corridor in front of the nearby magazines.

Originally almost 2.35 m (8 ft) high, the statue shows the king wearing the royal headdress of pleated linen and the false beard, a symbol of royalty; he holds a folded cloth in his right hand. The face featured a painted chinstrap (for the false beard) and a thin painted moustache. It is noticeable that the head is small in proportion to the body. Peter Lacovara and Nicholas Reeves suggest that the royal sculptors recarved the head, either to change the original design of the headdress or because of a flaw in the stone.[13]

If this statue did stand at the back of the inner hall, Menkaure would have gazed out down the axis of his temple and causeway. Behind, the inner offering chapel probably contained an emplacement for a 'false door', symbolic of the king's exit from and entrance to the Netherworld of the pyramid. The colossus would thus have represented the king risen from the Netherworld, looking down the causeway towards his pyramid town and the continuing pageant of life in the Nile Valley. In this respect, Menkaure's upper temple and colossal statue are a simpler version of later upper temples that have five statues of the king in front of an offering hall, with a false door behind, separated by a thick wall.

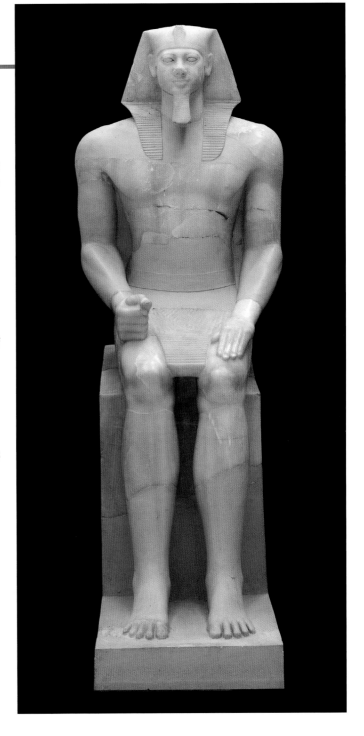

11.15 Colossal statue of Menkaure in travertine (alabaster), reconstructed from many fragments, now in the Museum of Fine Arts, Boston (09.204); 2.35 m (7 ft 8½ in.) high. The statue may have once stood at the back of the long inner hall on the centre axis of Menkaure's temple, representing the king emergent from the pyramid.

the granite casing flush. Further down the corridor, another team was roughing out the southeast corner from the excess stock of stone on the mighty core blocks.

Three doorways opened off the western end of the corridor. Straight ahead, one led to the innermost temple. A second on the left opened to a large magazine and a narrow stairway to the temple roof, where priests and guards probably observed the sun, moon and stars in order to fix the time for various festivals and cult activities, and could also monitor the activities in the complex. On the right, the third doorway led to five magazines entered by means of a shared corridor.

In the magazines Reisner found several layers of deposit, consisting, in sequence, of sand and limestone chips, then mud decayed from the walls, sealing deposits of ash, charcoal, mud and finally

organic material on the floors. This lowest layer contained material from the decay and collapse of wooden lofts and roofs, along with some of the original objects that had been stored in the magazines. Flint implements and pottery were most numerous. The pottery included a cache of small model vessels – 'votives' for symbolic offerings in temples and tomb chapels, of the same kind that Reisner found discarded in the heap outside the entrance to the temple. Among the many flint flakes, knives and scrapers was a flint wand inscribed 'Mother of the King, Kha-merer-nebty'. Other objects included a hammer stone, some copper ore, 15 halves of bivalve shells, blue pigment, faience beads and remains of copper chisels and drills, which appear to be tools and raw materials for craft activity. Did craftsmen work inside the temple? Reisner also found fragments of statues in or near the magazines.

The magazines might also once have contained cult equipment for the 'Opening of the Mouth' ritual performed on Menkaure's statues, or papyrus rolls that recorded the daily activity of the temple. The Abusir Papyri – records of the administration of the pyramid temples of the 5th dynasty kings Neferirkare and Raneferef – were found in magazines in the northwest corner of their respective temples, as well as in other parts of the Raneferef temple. Egyptologists suggest temple personnel would normally have stashed the papyrus archives in boxes in the valley temples, where we would not expect them to have survived because of the damp, but since neither of these kings completed their valley temples, the temple staff kept the papyri in the magazines of the upper temple. We see a good possibility this is where some archives might have been kept – high, dry and away from pyramid town residents and visitors.

The westernmost magazine was longer than the other four and probably lacked a loft or second storey. In the back wall a kind of shelf was cut into the limestone core block, which supported an altar built of limestone slabs. Behind and below, at floor level, a small tunnel was cut back through the core wall leading to a covered drainage channel in the foundation outside the temple walls. This arrangement was similar to one Reisner found in the chapel or temple of queen's pyramid GIII-a (see below). In the debris near the exterior

channel Reisner discovered parts of two alabaster statues of the seated king, including the head and shoulder of the colossus (see box, p. 255) that might have graced the back of the offering hall behind the portico. Reisner believed that the statues had been located in the large magazine and that robbers had broken them up and pushed them out through the drainage channel.

If a single statue originally stood in the western magazine, with a drain for libations, this chamber could have been a *serdab* or shrine. On the other hand, more than one statue stored here would suggest that, like the triads and dyad in the valley temple below, at some point in the temple service the attendants stored the statues in the back magazines for safe keeping. If they had been carved – or, as ancient Egyptians said of statues, 'given birth' – in the temple precinct in the first place, these images of the divine king were born, lived (or performed) and died in their eternal house.

The inner temple

At the end of the long corridor leading back from the recessed portico, in the antechamber of the turn that led to a magazine and the stairway to the roof, Reisner excavated eight mud-seal impressions with the Horus names Menkaure, Niuserre, Djedkare Isesi, Teti and Pepi I. If we combine the royal names on these sealing fragments with those of Merenre and Pepi II found on stelae fragments in the upper and valley temples respectively, the list includes every Old Kingdom ruler from Niuserre on, with the exceptions of Menkauhor and Unas. The gap in this series as we have it is widest in the early 5th dynasty (Userkaf, Sahure, Neferirkare, Raneferef, Shepseskare). The list suggests that service in Menkaure's temples continued over a span of 220 to 320 years.

The Egyptians used pellets of fine clay to seal pots, boxes, bags and door locks; before the clay dried, they impressed it with a stamp or cylinder incised with hieroglyphs giving the names of officials, institutions and kings. Most of the sealings Reisner found were probably from the string lock of a door. He believed this was the door into the stairway and magazine, which perhaps contained special equipment for services in the inner temple. Maragioglio and Rinaldi noted a limestone pivot socket at the base, indicating a wooden door once

OPPOSITE ABOVE
11.16 Doorway from the end of Corridor 13 from the outer court to a square antechamber with a single pillar, on the route to the inner temple. View to the northwest.

OPPOSITE BELOW
11.17 The foundation and floor of the Menkaure inner temple offering chapel, at the centre east base of the pyramid. A stela or false door might once have stood where there is now a break in the floor. A patch of the granite pyramid casing has been dressed behind.

closed this access. But the sealing fragments could also have been discarded here after the king's officials unlocked the doorway on the west, at the end of the corridor, which led to the inner temple. Just here we can still see a small hole through the corner of the southern jamb that might have taken the string for the lock and seal between ritual services. At some stage, temple personnel closed off the doorways to the inner magazines with mud-brick walls, but left open the one to the inner temple [**11.16**].

We know little about the original plan of the innermost temple. It is certain that between the temple and the pyramid, immediately behind the long central hall, Menkaure's builders created a granite offering platform approximately on the east–west axis of both pyramid and temple. A sunken groove against the base of the pyramid probably held a stela, or possibly a false door, although in the latter case we might expect to find signs of it being been bonded to the slope of the pyramid with masonry. The masons, who left most of the granite casing on the pyramid undressed, thought it important to smooth a square patch at the point the platform joined it [**11.17**].

Over this platform, masons then built an L-shaped room of Turah limestone. Reisner believed that it was Shepseskaf who ordered this inner stone offering chapel to be built, while he had the rest of the temple finished in mud brick. Those who later robbed the fine-quality limestone destroyed most of the plan of this chapel, leaving only its outlines. Based on the few clues and parallels to the chapels of the nearby queens' pyramids, Reisner believed that the chapel was entered through a long corridor with decorative niches in its west wall. An inner offering room enclosed the stela or false door set into the west wall, flanked by an auxiliary chamber and antechamber.[14]

Maragioglio and Rinaldi, however, believe that the Turah limestone chapel was built later than Shepseskaf. They thought that the whole arrangement of the 'private' temple, at the very base of the pyramid, was rebuilt several times in different periods.[15] What is certain is that the offering platform of granite was built first, followed by the chapel.

Later builders roughly composed an arrangement of corridors and magazines from

locally quarried nummulitic limestone on the north. After the modifications, the doorway, *c.* 66 cm (26 in.) wide, at the western end of the northern corridor, opened to a small square antechamber with a single pillar, a feature of pyramid temples that we otherwise find in the route to the offering hall for the first time in Niuserre's pyramid temple at Abusir.

A doorway in the south wall of the single-pillar anteroom opened to a long north–south room with a row of six square limestone pillars along its central axis. This 'hall of pillars', as Reisner called it, was left unfinished. A doorway in the west wall of the anteroom led either via a sharp left turn to a north–south corridor that sloped up to join the entrance of the Turah limestone offering hall, or straight on to another north–south corridor, which gave access to four magazines built against the sloping granite casing of the pyramid.

The builders never finished dressing the limestone walls of these magazines – in places the walls had yet to be sculpted smooth from the rough-faced rock. The two southern magazines were, however, fitted with stone shelves. A fifth magazine was formed into a kind of ledge along the pyramid face, with a higher floor level than the other four. These five magazines might have fulfilled the same function as the five magazines that match the central five statue niches in the upper temple of Khafre and in later mortuary temples.

The pyramid court and enclosure wall

Shepseskaf's work in completing the pyramid complex must have included an enclosure wall of mud brick around the pyramid, about 10 m (33 ft) from its base, forming a court. Reisner discovered part of it, about 2.62 m (8ft 7 in./5 cubits) thick, on the east. Ali Hassan in the 1960s and our own recent work along the pyramid's northern side found the lowest of the wall's mud bricks, though we saw no trace of it when we cleared the foundation at the eastern end of the southern side of the pyramid. The original plan no doubt called for the court to be paved with stone, but this was never begun.

We presume that when the enclosure wall stood complete, the only access into the pyramid court was through the upper temple. The intended entrance would have been through the western end of the long corridor on the north side of the temple from the recessed portico, as in the upper temples of Khufu and Khafre. In the 5th or 6th dynasty, however, this entrance was replaced by the square anteroom with a single pillar, through an opening on the north, where people later added a small, L-shaped exterior vestibule, its walls composed of limestone rubble, probably construction debris.

The doorway into the court was fitted with a limestone threshold and a socket for the turning peg of a single-leaf door. On top of sand that had drifted into the vestibule someone built a stairway, Reisner thought in the Roman Period. This might have served to bring in bodies for burial in the six-pillared hall, where Reisner excavated 87 human skeletons.

Inside the pyramid court, Reisner found a construction ramp of worn limestone fragments leaning against the south wall of the inner temple and leading up to the roof level of the six-pillared hall. Another 'frozen moment' in the history of the complex, this embankment belonged to the period long after Menkaure, but seems to have offered no opening into the temple.

It is interesting to speculate whether the priests of this time practised the daily rite of circumambulating the pyramid and sprinkling it with sacred natron water. As described in Chapter 7 (p. 132), a pair of officiants departed from the south door of the inner temple and returned through the north door, making a clockwise tour that symbolized the circuit of the sun. Here, at the Menkaure pyramid, if they departed from the south they would have had to go to the temple roof, reached by the stairway, and then down the construction ramp. They then could have gone round the pyramid and returned through the exterior vestibule on the north of the inner temple.

No archaeologists in modern times had attempted to clear the rest of the pyramid court until our excavations in 1996 along the southern base.[16] The south and west sides of the pyramid base remained covered by debris, including any toppled granite casing blocks. When we began to excavate the south side we soon revealed the foundations consisting of a row of large laid-in limestone beams with bedrock underneath. Like Howard Vyse and Perring two centuries before us, we found no pavement, only the rough tops of the megalithic blocks. If completed, the court would have been paved with limestone slabs, but the paving was never even begun before work in stone abruptly ceased with the death of Menkaure. Here we found no trace of the mud-brick enclosure wall.

Boat pits

No boat pits have been found associated with the pyramid of Menkaure. In view of the many parallels between his complex and those of the following 5th and 6th dynasties, it is possible that there were one or two boat pits, as have been found at the Unas complex in Saqqara. However, even though a large amount of the area around the base remains unexcavated and covered with debris, evidence is scarce that boat pits exist around Menkaure's pyramid.

In the 1970s Abdel-Aziz Saleh cleared an area immediately north of the western end of the upper temple north wall, where he thought boat pits might exist.[17] He discovered that the mud-brick pavement here overlies a bed of gravel, which in turn lies above a layer of megalithic limestone blocks joined with mortar. Among the quarry marks on these blocks were four elaborate drawings of boats. Although partial removal of the blocks revealed nothing, Saleh believed that Menkaure's boats may lie below this pavement, although the blocks do not resemble the long slabs of fine limestone that cover Khufu's southern boat pits. The boats drawn by the quarrymen may depict those they used when transporting the pyramid stones.

In contrast to the missing boat pits, there is a very present large mastaba-like structure ignored by most pyramid surveys, 20 m (65 ft) north of the pyramid and on its centre axis [**11.18**]. It is equal in scale, about 25 m (82 ft) long north–south by 15 m (49 ft) wide, to some of the larger mastaba tombs, and like many of those it is composed of walls of limestone slabs retaining a fill of debris. Eleven not very regular courses remain upon a foundation of larger stones. Howard Vyse removed some of these stones, which continue to the east beyond the mastaba as part of the foundation of the pyramid itself where the irregular bedrock slopes away. Both Howard Vyse, and Maragioglio and Rinaldi 130 years later, interpreted the mastaba as a great stone-lined pit, so high was the debris banked up against its outer faces. Unlike other mastaba tombs, however, this one reveals no substructure, even though modern excavations subsequent to Howard Vyse trenched and removed most of the fairly fine quarry debris fill, exposing rough bedrock. We suggest that the mastaba might remain from operations and rituals attendant on the burial of

Menkaure (or his symbolic later re-interment) and was similar in purpose to a structure Ahmed Fakhry excavated north of the Bent Pyramid at Dahshur.

The subsidiary pyramids

Three subsidiary pyramids stand to the south of the pyramid of Menkaure, like sentinels guarding his southern flank (unlike Khufu's, which are on the east side of his pyramid) [**11.19**].[18] The three smaller pyramids are lined up just outside where the inner enclosure wall would have run, and within the outer fieldstone enclosure wall of Menkaure's complex. The furthest west, GIII-c, lies 13.6 m (45 ft) west of GIII-b, which is 10.15 m (33 ft) west of GIII-a. On the eastern side of each is a small mud-brick temple or chapel. Reisner stated that a rubble wall enclosed all three small pyramids, running a few metres outside the pyramid bases, with an opening

11.18 Mastaba north of the Menkaure pyramid and aligned to its centre axis, composed of limestone debris and retaining walls. The structure may have played a role in Menkaure's original burial ceremony.

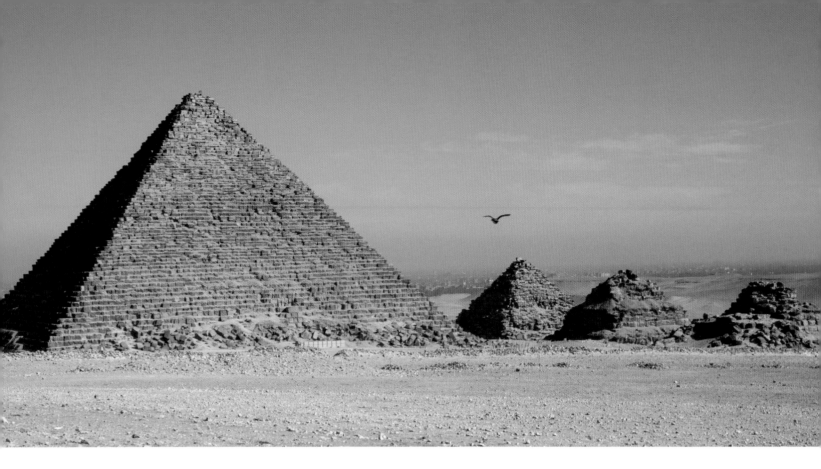

11.19 The Menkaure pyramid with the three subsidiary pyramids on the south, one a true pyramid, the other two left as step pyramids. View to the southeast.

and pathway on the northeast that led towards Menkaure's upper temple. We have not been able to verify this enclosure wall; nor did Maragioglio and Rinaldi in the 1960s. They doubted that the wall Reisner mentioned ran as far south as to enclose pyramid GIII-c.

We assume that principal queens of Menkaure were eventually buried in all three subsidiary pyramids, though this has to remain merely an assumption since we have no evidence to identify their owners.

GIII-a

Pyramid GIII-a was finished as a true pyramid to such an extent, and was provided with a temple with a sufficiently complex room structure, that it constitutes a pyramid complex in its own right. The much larger size of both pyramid and temple distinguish GIII-a from its two companions to the west. Indeed it has sometimes been called the fourth pyramid of Giza.

For a number of reasons, Egyptologists believe Menkaure in fact probably intended GIII-a as his own satellite pyramid. First, it is located south of the main pyramid and close to an alignment with its central north–south axis. Also, in contrast to the typical plan of queens' pyramid substructures of the 4th dynasty, which feature a turn from the entrance passage to the burial chamber, the passage

and chamber of GIII-a form a T-shape, like the substructures of the satellite pyramids of Khufu and Khafre, and those of the later Old Kingdom.

But a number of other aspects also make it probable that at some point the royal house decided to bury one of its members, probably a principal queen, in GIII-a. A granite sarcophagus was placed in the burial chamber and the builders created a portcullis closure in the connecting corridor between it and the descending passage. An elaborate memorial temple was also constructed against the eastern face. Some major questions about GIII-a remain unanswered, however. When and why was the satellite pyramid transformed for a burial? And who was buried here?

We tend to presume it was a queen because such subsidiary pyramids were traditionally for royal women. Reisner, who did not accept the evidence that this pyramid fits in a class with other kings' satellite pyramids, assigned it to the burial of a queen Khamerernebty II, who, he assumed, was the most important woman in the house of Menkaure.[19] On the other hand, Peter Jánosi points out that there is little evidence that Khamerernebty II was in fact Menkaure's principal queen. He cites the conclusion of another Egyptologist, Elmar Edel, on the basis of inscriptions, that a large rock-cut tomb behind the Khafre valley temple (the Galarza Tomb) belonged to this queen (see p. 328 ff.).[20]

In the offering hall of the temple attached to GIII-a, Reisner found fragments of a beautiful alabaster statue of a queen, but no name was inscribed. Exactly who this queen was remains a mystery.

Fabric of the core Reisner observed that GIII-a was built of small local limestone blocks laid in shallow courses, while the stepped faces of the other two pyramids were composed of large blocks. It is likely that the innermost core of GIII-a is also built of large blocks in step form and that the smaller masonry we see today is the blocks the builders used as fill between the packing that covered the steps to create the slope of a true pyramid and the casing, now removed [11.20].

This general description of the core construction was confirmed when the Giza Pyramids Inspectorate began to re-excavate the area around the northeast corner of GIII-a in 1996. As with the eastern side of the pyramid of Menkaure, the builders prepared a foundation of large, locally quarried limestone blocks for GIII-a. On the south side, where the surface slopes away, this foundation extends about 7 m (23 ft) south of the base of the pyramid.

As they did not have to incorporate a reserved massif of bedrock into the pyramid core, the builders used large, well-positioned core blocks. One of these lies exposed on the northeast corner where the pyramid body has been ripped away. Weighing many tons, the block is about 5 m (16 ft) long and more than 1.5 m (5 ft) wide. Up against and on top of this core work of large blocks, amounting to about 1.3 m (4 ft) high, is a vastly sloppier, loose fill of odd-sized and -shaped stones (they hardly merit the name blocks), set with large amounts of limestone chip infilling.

A platform of Turah-quality limestone surrounds the base of the core work, extending out about 5 m (16 ft) on the east, and at least 4 m (13 ft) to the north. In our clearing of the pyramid we traced this platform for about 10 m (33 ft) westwards.

GIII-a statistics

Length of sides	44 m (144 ft 4 in.)
Angle	52 deg. 15 min.
Original height	28.4 m (93 ft 2 in.)
Current height	25.4 m (83 ft 4 in.)

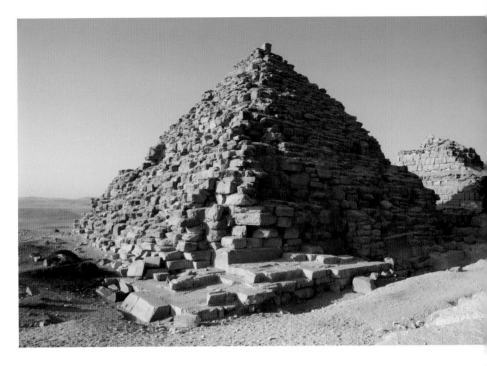

After a gap for the entrance passage to the pyramid, it continues for a stretch further west. The use of Turah-quality fine limestone for the platform indicates the masons' need for control in creating the square of the pyramid base.

During our clearance work around the northeastern foundation of GIII-a, we were surprised to find an unfinished statue pair that sculptors, probably in the New Kingdom Ramesside Period, were fashioning from a reused 3.5-ton granite slab from the GIII-a pyramid, more than 3 m (10 ft) long (see box, p. 490).[21]

The casing The lowest casing course, 96 cm (38 in.) high, consists of granite blocks, nine of which remain in place on the south. Like the granite casing of the main pyramid, the faces of the blocks were not trimmed. The exposed sides reveal the line of the intended slope of the pyramid face (52 degrees), and the upper surface bears the line of the course of casing above, which is missing. Reisner thought the intention was to case the entire pyramid with granite (though he was unsure how much had been completed), but in fact we see evidence that the builders were adding a casing of fine limestone on the upper part of the pyramid. The fact that the casing was at least begun in granite may suggest that this pyramid was being built at the same time as Menkaure's own.

11.20 Subsidiary pyramid GIII-a south of the Menkaure pyramid; view to the southwest. Masonry removed from the northeast corner exposed the internal structure of the pyramid core and foundation, including a broad platform of finer, Turah-quality limestone.

11.21 The massive limestone lintel over the entrance passage of the Menkaure subsidiary pyramid GIII-a.

Excavations in recent years have turned up numerous fragments of Turah-quality limestone casing stones around GIII-a. Slabs from the northeastern corner reveal how the masons gave this area special treatment to ensure closer joints. The underside of one large corner slab is rebated, or recessed, to fit a raised edge carved on the casing course below.[22] Another large piece on the south side of GIII-a has two angled faces – this slab once joined to others to form one of the final upper courses where the pyramid, too narrow for any loose and irregular core construction, was entirely composed of fine casing stone. The underside of this piece is also rebated, but in what must have been the centre of this course, rather than along the edges.[23] The raised edge panels fitted, Lego-like, into the recessed panels of the course below.

The rear sides of this slab are vertical, where they would be fitted to others to complete an upper casing course. One of these vertical join faces has a protrusion out beyond the plane of the join, as though the masons did not finish it. This could imply that it never left the ground, where masons were cutting it to make the precise fit needed up on the pyramid.

On the other hand, Jánosi described the remains of what he called a pyramidion, or capstone, that he saw on the same spot as this large casing slab and took as the crowning stone of GIII-a. If correct, this capstone would imply that the masons had finished setting and dressing the entire limestone casing of GIII-a.

GIII-a substructure The entrance to GIII-a, capped by a massive lintel, opens slightly above ground level in the pyramid's north face [**11.21**]. From there, a descending passage, 1.05 m (3 ft 5 in.) wide and 1.21 m (4 ft) high, slopes at 27 deg. 12 min. (Howard Vyse's measurements) for 17.3 m (56 ft 9 in.). The builders created the upper section in masonry while they cut the lower part through the bedrock. The corridor was once sealed with blocks and mortar, but robbers had dug a way around the west side of the blocking; Howard Vyse found their tunnel filled with sand and rubble.

At the bottom of the descending section the passage widens, and at the point where the floor becomes horizontal the ceiling slopes up to a height of 3.15 m (10 ft 4 in.). The builders created this space for a portcullis with closing slab. Masonry would have been required to hold the slab in place, but this was missing when Howard Vyse entered the pyramid. The size of the granite slab indicates the builders must have slid it down the entrance passage at an angle. The plunderers bypassed the portcullis by making a hole in the bedrock above it.

After the portcullis, a short corridor, 1.24 m (4 ft) high, leads into the burial chamber, which is 3.17 m (10 ft 5 in.) wide, 7.72 m (25 ft 4 in.) long and 2.61 m (8 ft 7 in.) high, positioned almost at the centre of the pyramid. As already noted, the passage and chamber form a T-shape in plan, but the passage does not enter the chamber in the middle of the north wall. Instead, the axis of the chamber is just over 75 cm (30 in.) west of the axis of the passage, which lies close to the north–south axis of the pyramid. The name of Menkaure is written in red ochre on the ceiling.

The walls of the burial chamber were left in the natural rock. In a socket in the floor in the western side, the builders embedded a granite sarcophagus measuring about 2.45 × 0.99 m (8 × 3 ft 3 in.) externally; the lid lay apart from it. Inside, Howard Vyse found fragments of green-glazed and red pottery and remains of burnt wood and reeds. Stadelmann doubts whether, even with the sarcophagus and these remains, the chamber ever received a body.

GIII-a temple The temple at the eastern base of pyramid GIII-a [**11.22**] presents a problem for the idea that the pyramid was initially built as a king's satellite pyramid, because no other satellite pyramids – such as those of Sneferu at Dahshur, and of Khufu and Khafre at Giza – show evidence of having extensive cult places. The eastern base of pyramid GIII-a and its temple rest on a foundation platform of large blocks from the local quarries at Giza. Reisner reasoned that the builders would only have prepared such a foundation platform if they had intended from the beginning to build a substantial stone temple.[24]

Whatever the original intention, the ancient masons created the GIII-a temple entirely of mud brick. Reisner believed it was built in two stages, possibly within weeks of one another. The bricks of the western, inner part appear to be the large, dark bricks such as we see in Shepseskaf's finishing work in all parts of Menkaure's complex (and in the Khentkawes Town). Lighter bricks comprise the eastern part. Where the walls of the eastern part were attached, the masons had left projections in the existing brickwork, as though anticipating building the extensions of the walls. They even included the western jambs of the internal

doorways, while the eastern jambs were completed by the later brickwork. And yet the builders plastered and whitewashed the eastern front of the first part before making the addition. These details and the timing of the stages are important, given the evidence Reisner found of changes to the main temple generations after Menkaure, and the significant additions we find in Menkaure's valley temple, dating, again, much later than Shepseskaf's original finish work.

Whatever the precise timing of the two parts, the earlier western part was where those in service provided offerings; the later eastern, or forepart, consists of the courtyard flanked on the north by an entrance corridor and on the south by a magazine. Reisner reconstructed the history of the temple as follows:

all three temples [of the subsidiary pyramids] were planned in stone and finished in crude brick; and the very plastering on the walls is the same. There can be no doubt that the massive stone constructions were interrupted in all three cases by the death of Mycerinus [Menkaure] and that the crude-brick structures were executed on the orders of Shepseskaf.[25]

11.22 Photograph from the Reisner archives of the temple east of subsidiary pyramid GIII-a, looking down to the east from the pyramid itself.

We might ask why, if Menkaure alone had died, all the queens' temples had to be finished so quickly, or did the king and his principal wives perish together? And was it on the death of the ruler and possibly his consorts that the royal house turned the king's satellite pyramid over to a queen's burial?

The mud-brick walls of the temple were truly massive for such a little building. The front wall of the earlier, inner temple was 2.15 m (7 ft) thick, like all the exterior walls. The interior dividing walls ranged from 1.35 to 1.65 m (4 ft 5 in. to 5 ft 5 in.) thick, evidently to support the weight of people walking on the roof, perhaps to take observations for ritual purposes.

The temple of GIII-a was surrounded on the south, east and north sides by a narrow guard wall, running 32 cm (13 in.) from the main wall of the temple, forming what appears to have been a gutter for collecting rain that ran off the temple. A double-leaf door once closed the entrance at the temple's northeast corner, opposite the beginning of a fieldstone-lined path running towards Menkaure's main pyramid temple. The door opened inwards into a long, east–west entrance corridor whose walls were plastered white. A doorway at the other end of the corridor gave access to a portico of four columns along the west side of an open courtyard. Reisner believed that the portico was once roofed with wooden planks supported by columns, of which the limestone bases survive. Marks on the bases show that the columns were replaced at some time with thinner ones. Along the eastern sides of the columns a screen wall with a door in its centre was built later, in the 5th or 6th dynasties and probably at the same time as the screen walls across the courts in Menkaure's upper and valley temples, to divide the courtyard from the portico. Thus we see, on a smaller scale, the same transformation as in Menkaure's main temple, from a late 4th to a 5th or 6th dynasty form that includes a transverse corridor – here the walled portico – separating the more open front, 'public' temple from the more restricted, 'private' interior.

In the court a pavement of yellow limestone slabs sloped towards a sunken stone basin at the centre. Reisner found the north wall of the courtyard decorated with niches similar to those found in the court of Menkaure's upper temple –

forming a series consisting of three simple niches and one complex. He was certain that the east and south walls were once similarly decorated, though his plan shows the eastern wall as plain and flat.

At the south end of the portico a narrow doorway, only 65 cm (26 in.) wide and originally closed with a single-leaf door, opened into a magazine orientated east–west, parallel to the entrance corridor and similar in size and shape. At some point, perhaps in the later Old Kingdom, someone added a stone wall to divide the magazine into two rooms. Reisner called these rooms 'the kitchens' because each contained a hearth.[26] That in the corner of one room was formed of two upright slabs of stone set into the pavement, reddened and blackened by fire; the floor was strewn with coals and ashes. A rectangular hearth in a corner of the other room was built of bricks and stones set on edge. It appears that someone lived in the temple, perhaps a caretaker who cooked his share of the offerings that had been presented in ritual to the dead queen.

A doorway pierced through the eastern wall led into the inner temple. Pivot sockets on each side indicate that a double-leaf wooden door once opened into an anteroom. From here another doorway on the south led to a chamber that served as a landing for the L-shaped stairway to the roof. Reisner found the stairs had been rebuilt: the original stairs turned north, while the later ones, built over the top of the original, ascended due west. He also discovered a passage exiting the temple from the stairway room through the southern wall of the temple. But since what he took as the original plaster covered the blocking of this access, he thought it was a service access used only during construction. This is another of the many details we would like to check further, because an access here would allow the southern exit for the daily rite of circumambulating the pyramid, with a return through the northern door.

A doorway in the centre of a broad shallow niche in the centre of the west wall of the anteroom opened to what Reisner called the 'hall of niches'.[27] Its western wall was decorated with of a pair of matched arrangements, one on either side of a central opening, each comprising one deep, double compound niche flanked on both sides by three small compound niches, making 12 in all. In the

northwest corner, Reisner's team found a small box-like table composed of seven limestone slabs, with a rectangular limestone basin set into the floor beneath, perhaps used in purification rituals. In the debris under and in front of the table the excavators found 50 or 60 small model jars and saucers – miniature vessels serving as token offerings. Reisner saw evidence of offering tables similar to that in the northwest corner in front of each of the large compound niches. Here, like the communion set of a modern church pastor, we see the furniture and utensils of cult service.

One other clue to bygone services was a small pot sunk upright in the floor nearby. It contained five model alabaster vases inscribed 'King's Son, Kai'. Was Kai a son of Menkaure making offerings to his deceased mother?

A small inner chamber that opened to the west from the hall of niches was in effect an expansion of a third, wide, central niche. No door closed the entrance. The inner room had its own niche, possibly for a false door, almost against the casing of the pyramid, but it was too badly damaged for Reisner to ascertain its exact plan or dimensions.

An opening with a double door led off the northern end of the hall of niches to an L-shaped chamber in the northwestern corner of the temple, matching the L-shaped stairway on the south side of the temple. Reisner recorded more limestone slabs and emplacements for three offering places in the southern, innermost end of this room. A turn in the opposite direction through the doorway from the hall of niches led to a magazine, probably a store for precious objects used in the daily funerary rituals of the temple. Reisner observed that the plastering of the interior walls of the temple had been renewed repeatedly, indicating a fairly long period of service. He found no evidence of painted decoration except a black band that ran around the walls of the anteroom and the room to its south.

GIII-b and GIII-c

We have no better idea of the identity of the queens buried under the small step pyramids GIII-b and GIII-c than for whom GIII-a was transformed from a king's satellite to a queen's burial pyramid. We are confident, however, that these two pyramids were designed for queens' burials because the substructures have the right-angled turn from

passage to chamber characteristic of other known queens' pyramids. In the initial plan, when GIII-a was intended as a satellite pyramid, GIII-b must have been for the leading lady of the royal house.

The large block masonry of GIII-b [11.23] and GIII-c is of good quality and may suggest that they were finished as step pyramids (for more on that question, see below). Both consisted of four steps. The number of courses and dimensions are so similar as to make them almost duplicates (see table below).

As the measurements indicate, the stepped faces produced a slight batter, like the mastaba tombs.

GIII-b and GIII-c statistics

	GIII-b	GIII-c
Step I (lowest)		
Base length	31.24 m (102 ft 6 in.)	31.55 m (103 ft 6 in.)
Top length	29.14 m (95 ft 7 in.)	29.17 m (95 ft 8 in.)
Width	2.91 m (9 ft 7 in.)	2.54 m (8 ft 4 in.)
Courses	3	3
Height	5.26 m	5.94 m (19 ft 6 in.) (10 cubits/17 ft 3 in.)
Step II		
Base length	23.31 m (76 ft 6 in.)	24.08 m (79 ft)
Top length	20.55 m (67 ft 5 in.)	21.57 m (70 ft 9 in.)
Width	3.52 m (11 ft 7 in.)	3.92 m (12 ft 10 in.)
Courses	5	5
Height	5.94 m (19 ft 6 in.)	5.94 m (19 ft 6 in.)
Step III		
Base length	13.5 m (44 ft 3 in.)	13.72 m (45 ft)
Top length	10.97 m (36 ft)	10.97 m (36 ft)
Width	1.98 m (6 ft 6 in.)	1.79 m (5 ft 10 in.)
Courses	5	5
Height	5.94 m (19 ft 6 in.)	5.94 m (19 ft 6 in.)
Step IV (top)		
Base length	7.01 m (23 ft)	7.38 m (24 ft 2 in.)
Top length	5.98 m (19 ft 7 in.) (damaged)	? destroyed
Width	?	?
Courses	4 (+ 1?)	5? (damaged)
Height	?	?

11.23 Queen's pyramid GIII-b was constructed with four steps of blocks of good quality masonry. It is debated whether this and GIII-c, also of four steps, were intended to remain as step pyramids when complete.

The masons dressed the stepped faces after setting the courses, which means the steps and the beds between courses do not always coincide. At the corners of the lowest step (I) the builders placed extra thick blocks, or a combination of blocks, which did not match the rest of the courses. Reisner was of the opinion that 'the carelessness with which the courses were laid seems to indicate that the structure, like the cores of the Chephren [Khafre] mastabas, was intended to be cased with some better stone'.[28] But Maragioglio and Rinaldi, as well as Jánosi, point out that the masons took care to square the blocks, set them with tight joints, dressed the faces well and then chiselled clean the corners to produce the thinner steps, 20 to 25 cm (8 to 10 in.) wide, of each course.[29] This is all in marked contrast to the sloppy inner step pyramids, or tiers of the inner cores, of Khufu's queens' pyramids.

The relatively good masonry of large blocks forms a kind of casing or retaining work, although the limestone is local and not the Turah-quality stone that the pyramid builders commonly used for casing. The builders filled each major step with smaller, roughly squared blocks with wide joints and limestone chips. Although they built GIII-b and GIII-c in steps, they did not raise these pyramids with accretion layers in the fashion of the step pyramids of the 3rd dynasty. And as Jánosi pointed out, there is no indication of the backing

stones that would have filled the space between any true casing and the packing to fill out the steps. Even if the pyramids had been stripped of their casing in antiquity, would not such material be evident, as it is on the Khufu and Khafre pyramids?

One possibility is that the builders left them incomplete, like so many of the other stone elements of Menkaure's complex. In that case, what we see may be only the inner step pyramid core, which the pyramid builders raised first, ahead of the packing, backing blocks and casing that then would have filled out a true pyramid.

Certain facts, however, suggest that the builders planned them to be step pyramids in their finished state. Maragioglio and Rinaldi pointed out that if GIII-b and GIII-c had been completed as true pyramids, with something like the same dimensions as GIII-a, then the space between GIII-a and GIII-b would have been only 4 m (around 8 cubits/13 ft), and between GIII-b and GIII-c only about 1 m (2 cubits/3 ft), leaving little room for chapels for the queens buried within. As it is, the chapels on their eastern sides had to be squeezed into very tight spaces. They further considered the possibility that the temple east of GIII-a, comparatively large for any queen's pyramid, served for the offering and memorial of all three queens who were ultimately buried in the three pyramids, which would have made it the equivalent of the chapel in a family mastaba, where false doors and offering slabs are sometimes set for different members. However, this hypothesis has not found favour with Egyptologists.

Another curious fact about GIII-b and GIII-c is that both pyramids are not properly positioned over their substructures – they are too far south and east, so that the substructures lie under their northwest quadrants. Had the pyramids been properly placed with respect to the substructures, which were most probably quarried out first, there would have been more room for the chapels. Indeed, beneath the mud-brick chapel of GIII-b Reisner discovered another foundation platform of large limestone blocks, as though a more substantial stone chapel had been planned here. But the positions in which the two pyramids were actually built brings them more into alignment with the centre east–west axis of GIII-a, and this may have become an overriding consideration. We find

it difficult to believe that the master mason of Giza might have made a mistake in locating either the pyramids, or, initially, their substructures.

It appears that the workers had just begun the substructure of GIII-c when the decision was taken to shift the position of the pyramids, because its entrance corridor is 5.64 m (18 ft 6 in.) longer than that of GIII-b, positioning its underground chambers closer to the pyramid centre than those under GIII-b.

Jánosi thinks that with the change in position, the builders decided to increase the size of the pyramids, so that GIII-b would lie above more of its substructure. They then began to build the larger stepped cores of GIII-b and GIII-c. Jánosi's reconstruction of the sequence would have the builders making entire stepped pyramid cores, before beginning again at the bottom adding packing and then casing, instead of raising them together in one process. At one stage in this scenario, GIII-a stood complete as a true (satellite) pyramid, the stepped cores of GIII-b and GIII-c were complete and the substructure of GIII-b was finished, while the passage and chambers of GIII-c were works in progress.

According to Jánosi, the relatively good masonry of the step pyramids is not necessarily an indication that the builders intended this to be the finished product. It resembles the masonry of the cores of the Khentkawes monument at Giza, and the great mastaba of Shepseskaf at South Saqqara. Furthermore, certain cuttings in the masonry courses are similar to features on both the Khentkawes core and on the cores of mastabas at Giza that had casings. The casing on all these other monuments completed faces at a much steeper slope – 60 to 75 degrees – than on contemporary pyramids, which were 52 degrees. If the builders encased the lowest step of GIII-b and GIII-c with such a steeper slope, Jánosi calculated there would have been 7.35 m (14 cubits/24 ft) in the spaces between GIII-a and GIII-b, and between GIII-b and GIII-c – enough to build small chapels.

Jánosi offers three possibilities for the intended final form of GIII-b and GIII-c after the builders had completed them with casing: pyramids of four steps, like the older step pyramids of the 3rd dynasty (though note that the core steps of GIII-b and GIII-c are of different widths, unlike

3rd dynasty step pyramids); pyramids of two steps; bent pyramids.

Whatever their final form, the theory that these two pyramids were once cased is eminently testable. A thorough excavation and cleaning of the bases of GIII-b and GIII-c would reveal the socle or bedding that surely must exist for the casing if the workers finished these pyramids before all work in masonry ceased and they turned to the use of mud brick.

GIII-b and GIII-c substructures The entrances to the underground chambers of both GIII-b and GIII-c are located on their north side (between them and the Menkaure pyramid), outside the base perimeter. For **GIII-b** the builders cut the short descending passage entirely from bedrock, for a length of 9.9 m (32 ft) at a slope of about 27 degrees [**11.24**]. At the bottom is a rectangular antechamber. Howard Vyse found a block with the hieroglyphs 'giving life'.[30]

The antechamber and the burial chamber initially formed one rectangular L-shaped chamber hollowed from bedrock. The builders then lined the burial chamber in white limestone, as in the chambers of Khufu's queens' pyramids, and made

11.24 John Shae Perring's detailed profile and plan of GIII-b, the middle subsidiary pyramid south of Menkaure's pyramid, showing the shaft and tunnel that Howard Vyse blasted down through the centre and along the north–south axis of the pyramid in search of the inner chambers. These were later found via the entrance passage located beyond the north base and 1.83 m (6 ft) west of pyramid centre, the reason they were missed in the initial tunnelling.

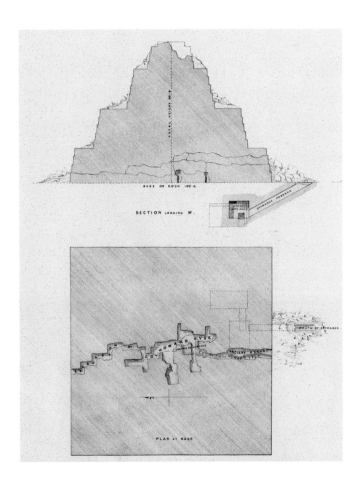

the separation between the antechamber and burial chamber with an extension of the limestone masonry. A short inclined passage through this was fitted with a portcullis slot. Howard Vyse found and removed the remains of the granite closure slab. Beyond the portcullis the ceiling of the passage had a torus moulding, after which it continued horizontally to the burial chamber.

The limestone cladding reduces the internal dimensions of the burial chamber to 5.84 × 2.67 m (a little more than 10 × 5 cubits/19 × 9 ft) and about 3.15 m (10 ft) high. The quarrymen cut the room slightly higher on the north near the entrance so that the masons could introduce the ceiling slabs. Howard Vyse found Menkaure's cartouche on one of the slabs, probably part of the name of one of the two work gangs, 'Friends of Menkaure' or 'Drunkards of Menkaure', also found on the core blocks of Menkaure's upper temple.[31] Reisner thought it was the latter. This is the only burial chamber of the three subsidiary pyramids of Menkaure to have been cased.

Against the west wall of the burial chamber Howard Vyse found an undecorated red granite sarcophagus, 2.03 × 0.79 × 0.79 m (6 ft 8 in. × 2 ft 7 in. × 2 ft 7 in.), slightly smaller than the one he discovered in GIII-a. Inside were some bones belonging to a young woman, including the jawbone and teeth, as well as rotted wood and fragments of bandages. The lid lay to the south, along with more remains of wood.

The entrance to **GIII-c** opened beyond the north base of the pyramid, 1.83 m (6 ft) west of centre. The builders cut the sloping descending passage in bedrock for a distance measured on the horizontal of 15.64 m (51 ft 3 in.), and a slope length of 18.4 m (60 ft 4 in.), the first 14.15 m (46 ft 5 in.) at an angle of about 30 degrees. Although no trace of blocking was found, the 4th dynasty Egyptians must have buried a royal person in GIII-c, given the temple attached to the pyramid and the fact that this was plastered repeatedly, showing that a cult was maintained here. The passage ended in an antechamber hewn from bedrock but not finished.

A short passage led from the antechamber to the burial chamber, also hewn from bedrock, 3.45 m (11 ft 3 in.) wide, 7.93 m (26 ft) long, and intended as 2.9 m (9 ft 6 in.) high. But the masons did not complete this either, leaving their chisel marks on the surfaces and reference lines in various places. The chisel marks show that the masons hollowed out the burial chamber from top down and south to north (compare the Subterranean Chamber in the Khufu pyramid, where work proceeded top down and east to west). When work was halted, a large amount of rock was yet to be cut away in the northern part. Howard Vyse discovered numerous stone chips, along with hard hammer stones that the masons must have left when stoneworking stopped. No sarcophagus was found.

The temples of GIII-b and GIII-c Because of the narrow spaces between the pyramids, the temples on the east sides of both GIII-b and GIII-c were much longer (north–south), than they were wide or deep (east–west). Reisner found the little temple east of GIII-b filled with debris of decayed mud brick mixed with sand, with 'a layer of ashes, coals, and dust' on the floor.[32]

When building the temple of **GIII-b**, the workers had prepared a foundation of massive stones. The platform, as noted above, probably indicates their original intention to build the temple in stone. However, masons completed this temple, like other elements of Menkaure's complex, in mud brick. Reisner noted that 'work on all four of these temples was proceeding simultaneously at the death of the king'.[33]

The temple of GIII-b was about the same size as (roughly 9 × 25 m / 29 ft 6 in. × 82 ft), and similar in design to, some of the chapels belonging to mastabas at Giza that had to be built in the narrow streets between the planned rows of tombs. The entrance was in a broad shallow recess in the approximate centre of the north wall. A single-leaf door opened into a small anteroom. From here, another doorway opened west to a small room that might have accommodated a watchman, while a doorway in the south wall of the anteroom led to the court, open to the sky, with a mud-plastered floor. At the eastern end of the south wall of the court a doorway opened to a long corridor room, which Reisner called the 'wide outer offering room' and which he compared to the hall of niches in the GIII-a temple. Jánosi stated that the room in GIII-b would have been a place for purification rites, using water in the limestone basin set into a

bin in the northeast corner, just inside the entrance from the court. Purified, the cult attendant could then enter the main offering room, parallel to the outer offering hall and aligned to the east–west axis of the pyramid. At the southern end of the west wall, against the pyramid base, was a simple niche. A second niche is a possibility, either for offerings or, if deeper, to house a statue of the deceased queen. A second door in the outer offering room opened to a magazine or possibly a second offering room, in the southwestern corner of the temple.

The builders squeezed **GIII-c**'s temple into the small space between it and GIII-b; it stretches 36 m (118 ft) north–south and just 13 m (42 ft 8 in.) east–west [**11.25**]. It took Reisner considerably more time and manpower to excavate this queen's temple than those of the others because the site was covered by numerous heavy stones from the nearly complete deconstruction of the upper two tiers of the pyramid itself, which took place mostly during the years of the Napoleonic Expedition (1798–1803). After that, someone had dug a trench through the temple, cutting through the inner offering room against the side of the pyramid and ploughing eastwards through two other rooms.

The fill of the rooms consisted of decayed mud-brick tumble; Reisner stated that 'No evidence of a burning of the roof was found',[34] implying that the ash and charcoal he had found spread across the floor of the GIII-b temple were there the remains of the collapse of a burnt wood and reed roof. Reisner reported that the builders founded pyramid GIII-c and its temple directly on the bedrock slope, with a drop in the floor level of 60–65 cm (24–26 in.) north to south.

A double-leaf door in the temple's north wall swung inwards to a small anteroom. To the west was a small magazine or guard's room in which Reisner found pottery, including offering jars, trays and votive miniatures, all on hand for the ritual offerings to the dead queen. A doorway at the southeastern corner of the anteroom led to an open court. This was more elaborate than the one in the GIII-b temple, having niches in three of the surrounding walls.

A portico graced the western, inner side – Reisner found the limestone bases of three wooden columns in a line between pilasters projecting from the side walls. Within the portico a large circular

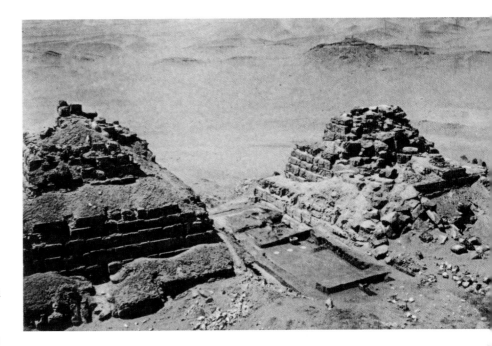

limestone basin sat against the southern wall. Reisner made a remarkable discovery here – 278 small model offering jars and 620 small model offering bowls of the type well known from Old Kingdom tombs and temples.

The anteroom and court would normally have been at the eastern front of the inner offering temple. Here and in temple GIII-b these more public elements are swung to the north because of the narrow space available for each temple.

A doorway in the southeastern corner of the court and portico led to the inner offering temple, by way of an anteroom. Reisner thought that a doorway from the west wall of this room led into the central hall of niches, but the earlier trench destroyed the wall here so it is not certain. Like the hall of niches in the temple of GIII-a, the western wall of this room in GIII-c was decorated with a symmetrical arrangement consisting of one large and six small compound niches on either side of a doorway that represented a third large, central niche. The niched halls in the two pyramids are of a similar size.

The doorway in the centre of the niched western wall led to what Reisner described as the main offering hall. Unfortunately, this part of the temple had been badly ruined by excavation prior to Reisner's. Jánosi believes this chamber would have housed a statue of the queen who was buried in the pyramid.

11.25 Photograph from Reisner's excavations of the temple of GIII-c squeezed in between it and GIII-b.

The walls of the temple had been repeatedly plastered with 'a yellow mud' that must be marl or tafla.[35] Over this was a thin layer of fine white plaster. On the floors the builders had first laid a layer of clean debris plastered with mud. Then after the mud had worn down, someone renewed the floor with another layer of clean masons' debris and fresh mud plaster. This second floor was only slightly worn before the temple was abandoned.

The care shown for the little temple, the hundreds of votive vessels that Reisner found inside, and indeed the existence of the temple itself, certainly indicate that, in spite of the unfinished burial chamber and lack of a sarcophagus, a queen must have been buried within pyramid GIII-c. In fact, the temple of GIII-c, with its niche-decorated court, portico and hall of niches, is more elaborate than that of GIII-b, where there is evidence for a burial.

The outer enclosure

As with the pyramids of Khufu and Khafre, an outer enclosure wall made of tafla and stone rubble surrounds the entire pyramid complex on the north, west and south, measuring about 350–400 m (1,148–1,312 ft) north–south by 400–500 m (1,312–1,640 ft) east–west. Attached to its western side is another large rectangular area whose function is not known. Its position in relation to Menkaure's complex is comparable to the galleries west of the Khafre pyramid – Petrie's 'Workmen's Barracks' (see Chapter 15).

On the north, the wall separates Menkaure's complex from that of Khafre, while on the south it runs at a pronounced angle south of due east, then turns north making a sharp elbow. The deviation at the southeast corner of the outer enclosure seems to have been made in order to take in an industrial complex excavated in 1972–74 by Abd el-Aziz Saleh (see Chapters 15 and 17). He discovered houses, ovens, courtyards and evidence for copper smelting, alabaster working and other industry situated just at the shallow mouth of a horseshoe-shaped quarry that Reisner believed furnished most of the stone for the pyramids of Menkaure and his queens. The outer enclosure takes in the pyramid, upper temple, queens' pyramids, industrial settlement and quarry.

The causeway

Maragioglio and Rinaldi suggested that the entrance hall of the upper temple forms the start of the causeway begun by Menkaure.[36] Internally this hall measures 3.3 m (10 ft 10 in.) wide; if the walls of large limestone core blocks are included, the total width is more than 13 m (43 ft). We doubt that Menkaure's builders intended to carry the walls of the entrance hall as such further east. In fact, it is possible Menkaure's builders never linked up the sections of the causeway that stretched towards each other between the upper and valley temples, a distance of about 608 m (1,994 ft).

At the upper end, the causeway's foundation is an extension of the foundation platform of the temple, built with large local limestone blocks. Reisner traced the foundation for 250 m (820 ft) from the temple down the slope to the 'edge of a low rock cliff', at which point he thought the water channel of desert flooding had washed away all traces of the causeway.[37] This low rock cliff is actually the western edge of the large Central Field quarry. In between the upper temple and quarry edge, traces of the causeway are not entirely clear. From the entrance hall to about 60 m (196 ft) east we see a band of crushed limestone – the bedding? – framed by dark bands, which must be traces of the causeway's mud-brick walls [11.26]. Further east we see exposed under a light sand cover a dark silty patch, 1.6 m (5 ft 3 in.) wide, which appears to be the causeway corridor framed by deflated fieldstone walls. Where the edges are clear enough to measure, the walls are about 2.5–2.6 m (8 ft 2 in. to 8 ft 6 in. or 5 cubits) thick. It is possible they are a later rebuild of walls that Shepseskaf made in mud brick. In 2004 Mansour Boraik cleared patches of causeway walls composed of large, dark, silty bricks the same size as those used in Shepseskaf's work elsewhere in Menkaure's complex. Only the lowest levels of the bricks remains. All traces of the causeway disappear east of the quarry edge.

But just at this point, in 1980, a Cairo University team excavated a trench through several metres of quarry debris to a level much lower than the causeway, and immediately south of it, on a line with the western side of the quarry. The trench left a section through a huge dump of limestone chips several metres high, which covered the stepped faces of the quarry. Red painted lines indicated where

angle to the quarry edge. From our measurements we calculated a slope of around 6.5 degrees.

At first we thought that this colossal stepped ramp formed a foundation for the Menkaure causeway to cross the deep western face of the older Khufu quarry. But on surveying the ramp, and taking into account the traces of the causeway higher on the slope to the west, and the doorway of the upper temple entrance hall, we found the ramp lies 10 to 12 m (33–39 ft) north of an alignment with the causeway. The ramp must have been used for construction during the reign of Menkaure, given the evidence of the quarry graffito with his name. If the causeway once crossed the ledge, it would have done so on more quarry debris that partially buried the ramp and extended the bridge to the south. Embedded in the debris, we found remains of three mud-brick pillars, which appear to have been raised incrementally as more debris was dumped, and which show a close alignment with the north side of the causeway. Did Shepseskaf's builders use these pillars to mark and raise the intended causeway line as they extended the bridge to the south when completing the causeway in mud brick?

However, we found no trace of the causeway east of this quarry ledge. In 1908 Reisner laid out four trenches on the axis of the causeway and starting about 100 m (328 ft) further east. In the first two he found compacted limestone debris but no causeway walls. About 60 m (197 ft) further east, towards the valley temple, his trench C hit massive limestone blocks of the causeway's foundation, and trench D uncovered the mud-brick walls of its corridor. Menkaure's builders must have begun his causeway in the large stone blocks at either end, but it is not clear whether Shepseskaf finished its entire length in mud brick. Reisner stated that the mud-brick corridor built during Shepseskaf's reign was roofed by wooden logs covered by reed mats and bricks, but it is possible it was left open to the sky. No evidence has been found that the causeway was decorated.

The valley temple

The valley temple of Menkaure lies in the lowest part of the Giza Plateau, at the far southeastern base of the slope of the pyramid plateau. It occupies the northern shoulder of the mouth of the Main Wadi, which separates the Moqattam and Maadi

11.26 Traces of the causeway corridor immediately east of the entrance hall to the upper temple. Here (centre), two dark bands, which must remain from the corridor walls, frame a band of crushed limestone – the bedding for the central corridor? Further east, a central dark band, 1.6 m (5 ft 3 in.) wide, the same width as the causeway near the valley temple, runs between two thick, deflated fieldstone walls. Further survey is needed to map the corridor between the upper temple and the quarry edge where all traces disappear.

blocks were to be cut along softer yellowish bands of bedrock, and a cubit notation gave the depth of the bed from which blocks were to be taken. At the bottom, two large blocks had been extracted but not moved out of place. Behind them on the quarry face was a badly faded graffito of the name of a work gang compounded with the cartouche of Menkaure. No evidence for the massive foundation of Menkaure's causeway was uncovered – his builders probably never laid the large blocks here.

In 2004 we returned with Giza Inspectorate archaeologists to excavate at the top of the quarry debris about 12 m (40 ft) north of, and above, the Cairo University excavations. Here we had long observed a small segment of a fieldstone wall with a sloping northern face plastered in marl desert clay, attached perpendicularly to the quarry edge. The wall turned out to be the face of an upper tier of an immense ramp formed of quarry debris and plastered fieldstone retaining walls, spreading out to either side in at least three major steps, each about 2 m (over 6 ft) wide with sloped faces rising from east to west. Previous excavations must have removed the lower, southern side of the ramp, but the total width was once more than 25 m (82 ft). We did not reach the bottom in the debris filling the quarry. What we exposed of the ramp rises more than 5.74 m (18 ft 10 in.) and extends 20 m (66 ft) east, at a right

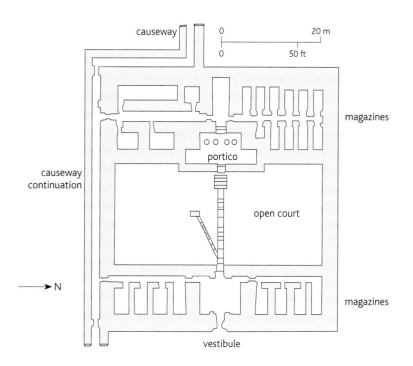

causeway

0 20 m

0 50 ft

magazines

causeway continuation

portico

→ N

open court

magazines

vestibule

11.27 Thumbnail plan of the 'first' Menkaure valley temple, as completed by his successor Shepseskaf in mud brick, based on Reisner's reconstruction. The 'second temple' of the 6th dynasty altered substantially this original, functioning layout.

limestone formations. Already in Reisner's time, the modern cemetery of the village of Nazlet es-Semman was inexorably encroaching on the site from the east. A tall cement and steel mesh security wall, built in 2004, halted the cemetery's expansion. A sandy bank along the wall serves as the conduit to the open desert for horse and camel riders.

When Reisner came to dig here in early summer 1908, not a trace of the temple was to be seen under the broad clean sheet of sand filling the wadi. He came upon the ruins as he traced the eastern end of the causeway. Surprised that the causeway did not end at a doorway into the temple but turned to the south, Reisner assigned his team to excavate the temple itself. What they plunged into was an extremely complex archaeological situation. For Reisner, this made for a very different set of ruins from the Khafre valley temple that Hölscher was excavating at much the same, and it might be useful to give an overall summary of the life of the temple, before going into greater detail.

Although Menkaure's pyramid was considerably smaller than his predecessors', his builders began with the same confidence as they did for Khafre. They were already well advanced with building the upper temple and upper and lower ends of the causeway in colossal limestone core blocks quarried nearby. In the valley temple they used the giant blocks to lay in a massive foundation platform

and two to three courses of parts of the northern and western walls. As Reisner said, it was 'planned as a stone temple of grandiose proportions'.[38] Then came an abrupt halt, presumably because Menkaure died. His successor, Shepseskaf, abandoned the giant core-block construction and had the temple finished in plastered mud brick as part of the same extensive mud-brick works that completed the upper causeway, upper temple and the temples of the three queens' pyramids. This stage of the life of the temple constituted what Reisner saw as the first valley temple [**11.27**].

At some point, possibly near the end of the 5th dynasty or in the early 6th dynasty, torrents of water washed down the desert, along the northern side of the causeway, cutting through the sanctuary and offering room of the valley temple. People then abandoned the temple until later in the Old Kingdom – most probably in the reigns of Merenre and Pepi II, based on the evidence of limestone decrees Reisner found in the upper temple and vestibule of the valley temple. The vestibule, sanctuary and western, southern and northern walls were rebuilt above the ruins of the old, creating in effect the second valley temple. So Reisner recognized three major building phases: Menkaure's massive stone foundation; Shepseskaf's completion in mud brick; and the late 6th dynasty renewal. Our work of the last few years reveals evidence of another phase of building activity: an extension with stone additions in the middle of the 5th dynasty, possibly in the reign of Niuserre.

This work also reopens the question of whether Menkaure's builders positioned his valley temple as a landing place for a harbour. After the turn to the south along the rear of the temple, the causeway turned again to run east and straight along the temple's side (south) wall. The causeway corridor then continued further east; neither Reisner nor Selim Hassan found its end. A seam or joint running through both walls of the causeway in a line with the front vestibule of the valley temple indicates that the eastwards extension was a later addition. A doorway 4.2 m (13 ft 9 in.) east of the temple opened from the causeway on to a terrace – what we have now identified as the Annex (see below) – in front of the temple, its southern end crowded with granaries and other small domestic structures. The thick eastern wall of the Annex

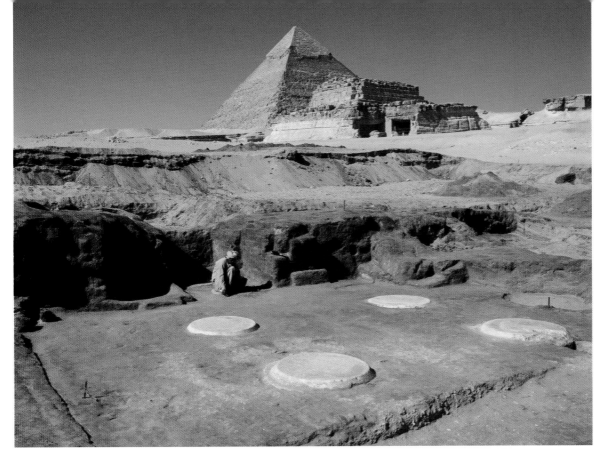

11.28 The vestibule of the Menkaure valley temple, with four circular column bases fashioned in Egyptian alabaster (travertine) just inside the main temple entrance. Wooden pillars would once have stood on the bases. To the northwest, the Khentkawes I monument overlaps Khafre's pyramid from this angle. View to the northwest.

drops 2 m (over 6 ft) from the valley temple and Annex floor level, possibly into a basin. Today, the causeway corridor runs under the dense modern Muslim cemetery. About 50 m (165 ft) due north and slightly further east, we have discovered the northern side of a deep basin east of the Khentkawes Town; its southern extent also runs under the cemetery. It appears very possible that both the Khentkawes Town and the Menkaure valley temple fronted on to a common deep basin, perhaps flooded, at least seasonally, as a harbour, functional or symbolic.

Anyone moving up through the causeway from the east passed through an exterior corridor, just 1.6 m (5 ft 3 in.) wide, outside and south of the temple. A doorway offered the option of entering the Annex. Further west, two doorways opened into corridors running north into the temple proper. Proceeding along the causeway to the temple's southwest corner, one turned north, moving through the corridor along the rear of the temple to its central east–west axis where a right-angle turn offered a straight route to the upper temple (though perhaps not complete all the way). It was thus possible to ascend to the pyramid and enter the upper temple without passing through the valley temple – a very different situation from the Khafre complex where the only way to the upper temple and pyramid enclosure was through the valley temple interior, thus making it a true gatehouse.

In the period of the second valley temple (6th dynasty), the corridor was blocked off and built over; Reisner could find no formal architectural passage from the valley temple up towards the pyramid. In both phases, the valley temple thus stood somewhat detached, an entity in its own right.

The first valley temple

The first temple, completed in mud brick, is very similar in its essentials to the front part of the Menkaure upper temple. To finish the foundation platform, Shepseskaf's workers compacted limestone debris over the foundation blocks set in Menkaure's time. Initially, the temple was to have been on two levels: the large foundation blocks created a higher terrace to the west on which stood the sanctuary, with a lower terrace to the east for the court. As completed in mud brick, the floor level simply rose towards the interior, as is common in Egyptian temples of all periods, as well as palaces and large houses.

A double-leafed door closed the entrance to the temple in the centre of its east wall. The door opened into a small square vestibule, whose walls were plastered and whitewashed [**11.28**]. Reisner found four alabaster bases, each 1 m (3 ft 3 in.) in diameter, for the wooden pillars that would have supported the roof. At the rear of the vestibule, a doorway on each side led to a north–south

corridor with a row of four magazines. At the end of the northern corridor a staircase led to the temple roof. The southern corridor ended at a doorway opening into the causeway corridor. Reisner found remains of logs on top of the walls of the northern magazines, evidence that they were all roofed with wood.

In the centre of the rear (west) wall of the vestibule a doorway opened to a large open court, similar to the one in the upper temple except that it was not paved with stone. It measured 19.4 m (63 ft 8 in.) east–west and 41 m (134 ft 6 in.) wide north–south. All four walls of the court were decorated with a pattern of niches and recessed panelling rendered in plastered mud brick comprising three simple niches and one compound niche in alternation (five compound on the north and south sides; ten compound on the east; and six compound on the west side). A limestone paved pathway ran in a straight line across the court from the doorway of the vestibule to a stone ramp leading up to the sanctuary at the rear. South of the path, a basin carved from a single limestone block was embedded in the rock floor of the court; a channel made of limestone blocks ran at an angle between this basin and the paved walkway.

The stone ramp rose from the court to a portico formed by a recessed bay originally open to the court except for a low parapet wall. Reisner discovered the limestone bases of six columns that supported the portico's roof. The floor was compact gravel and mud plaster – a far cry from the expensive basalt or alabaster floors of the Khufu and Khafre temples. A screen wall built, Reisner guessed, in the early 5th dynasty, later closed the portico on the east, just as in Menkaure's upper temple and in the temple of GIII-a. Reisner found four alabaster statues of Menkaure seated upon a throne against the west wall of the portico.

From the inner side of the portico a doorway led to a long, narrow offering room or sanctuary, 8.5 × 3 m (27 ft 11 in. × 9 ft 10 in.), on the central axis of the temple. Mouldings on the limestone threshold marked the lines of the mud-brick jambs and pivot sockets of a double-leaf door; a hole received the vertical peg to lock it. On the floor of the first-phase offering room, Reisner discovered coarse red offering pots, pieces of statues and stone vessels, flint flakes and fragments of faience vessels.

The offering room of the temple's second building phase corresponds closely in size and shape to the first. In it Reisner found a bench, similar to the one made of limestone in the temple of GIII-c, but here topped by a water-worn alabaster slab, and four small unfinished statues (see also p. 280) [**11.29**].

Doorways in the side walls of the offering room led to complexes of corridors and rooms in each direction. The northern doorway opened to a corridor with 11 magazines opening off it, five on the east and six on the west, which was the rear wall of the temple. The magazines were once fitted with wooden lofts, making them two-storeyed; both the corridor and all the magazines were roofed with wood. Inside the magazines Reisner's team excavated flint implements, ritual wands and model vessels of copper and stone.

The other doorway from the offering room led to a corridor that ran straight to the south wall of the temple, where another doorway opened into the causeway corridor. Reisner found traces of the wooden beams that roofed this area. Small chambers stood on either side of the corridor, in one of which Reisner noted three rectangular depressions in the floor, which he thought were sockets for statues, though four unfinished statuettes uncovered here did not fit them.

Three royal statues and one private statue were discovered in the corridor, as well as the four famous triads representing the king with Hathor and various nome goddesses. The celebrated dyad of Menkaure and a queen, now in the Boston Museum of Fine Arts, was pulled from a robber's hole below the floor of the corridor (see 6.16). It was Reisner's impression that the set of magazines to the north was for cult utensils, and those to the south for storing statuary. It has been suggested that the triads were originally in a long room to the west of the corridor and that Menkaure intended to have statues to represent every nome of Upper and Lower Egypt (see box, p. 282).

The Annex

In 1910 Reisner cleared just the southwest corner of the terrace in front of the valley temple, where the extension of the causeway corridor runs on east beyond it. Later, in 1932–33, Selim Hassan's excavation team advanced from clearing the southern foot of the Khentkawes Town to the front

11.29 One of the unfinished granite statues of the king found on the higher 'second temple' (6th dynasty) floor of the valley temple sanctuary and in the southeastern magazines; this one (Reisner's no. 26), in diorite, was at the second stage of sculpture, as shown by lines in red paint; 35.2 cm (13⅞ in.) high.

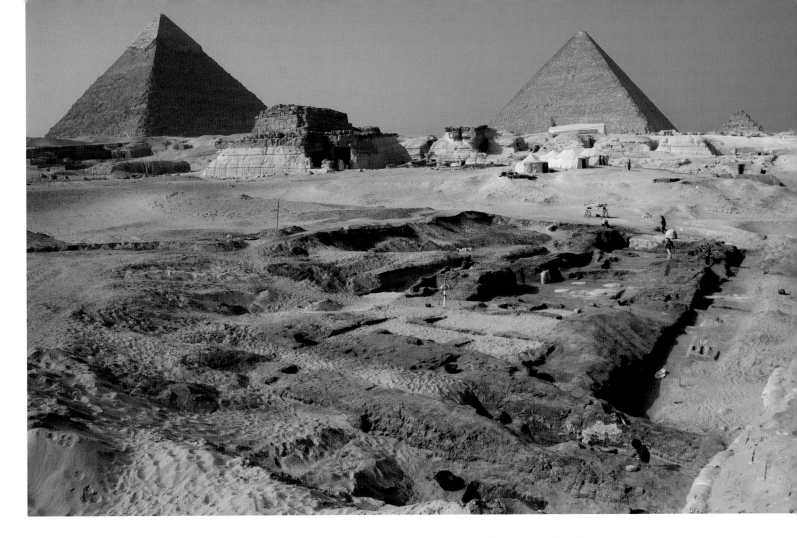

of the valley temple. In the process, they discovered several features, including a vestibule of four alabaster column bases, which Hassan interpreted as the valley temple of Khentkawes.[39] Our work since 2005 has ascertained that the features on the terrace represent instead an expansion of the Menkaure valley temple, as Maragioglio and Rinaldi recognized.[40] They coined the term ante-temple; we call the extension the Annex [11.30].

The Annex is not square with the valley temple – its thick walls, which made the town within practically fortified, bounded a trapezoidal enclosure that extended no more than 15 m (49 ft) east from the front of the first temple. The thick eastern enclosure wall drops, with a glacis-like slope, 2 m (over 6 ft) below the floor level of the temple and Annex before we lose it under the embankment of the modern road and cemetery.

A broad ramp with low shoulder walls ascends from the east up to the terrace. Over the 21 m (69 ft) of the ramp we have cleared, it fans out from a width of 7 m to 12 m (23–39 ft) (see 11.35). This, right from the beginning, must have offered the main access up to the valley temple via its front terrace. So, like other valley temples (those of Khafre and Pepi II,

for example), two ways offered an approach to the Menkaure valley temple – here the broad ramp and the causeway corridor. The massive outer walls of the Annex were reinforced with accretions at least once. Exactly when people did this and added the features on the terrace is more open to question.

Hassan's excavations revealed that an entrance opened from the Annex on to the top of the broad ramp. Two thin wooden columns set on round limestone bases graced the corners of a recess through the northern Annex wall, forming a portico, 3.85 m (12 ft 8 in.) wide. A limestone threshold, mostly still in place, incorporated the curious and telling feature of a pivot socket for a swinging wooden door that had been bored into a foot fragment of a diorite statue of Khafre – the king's cartouche and Horus names are visible beside the royal foot [11.31]. We have ample evidence from the valley temple that the town's inhabitants were breaking up Menkaure's statues as early as the 5th dynasty, and this utilitarian use of Khafre's royal foot certainly reflects ambivalence, if not some cynicism, towards the deceased god-king.

Beyond this doorway was a square vestibule with four alabaster column bases, 1 m (3 ft 3 in.)

11.30 AERA's 2012 re-clearing of the eastern front of the Menkaure valley temple, revealing (centre right) Vestibule 1 with four-column bases, the southern causeway corridor (foreground), and the floor of the Annex or eastern extension (right). The Khentkawes I monument and the pyramids of Khufu and Khafre rise in the background. View to the northwest.

in diameter, identical to the arrangement of the first vestibule Reisner uncovered inside the central entrance of the valley temple [**11.32**]. Perhaps because of concerns about security at the new temple entrance, or in order to narrow the interior space that roof beams would have to span after the columns had been removed, the builders successively added accretions to the interior walls, making a girdle around the vestibule to a total thickness of nearly 5 m (16 ft). More than once people plastered the walls in yellow marl, sometimes with a whitewash.

A doorway in the south wall of this northern vestibule, which we call Vestibule 2 to distinguish it from its twin, Vestibule 1 in the main temple, opened to a court of about 10 sq. m (108 sq. ft). A path of limestone slabs led diagonally across the court from the vestibule to the entrance doorway in the centre of the eastern wall of the valley temple, which had been blocked at some point late in the life of the temple. The fact that the limestone path leads directly to this door indicates that the temple extension was built before the blocking was added, and before the first temple was abandoned.

As for the remainder of the Annex, a room between Vestibule 2 and the temple divided into three parts might have served as a magazine or porter's lodging. To the southeast of the court, a long corridor runs inside the thick eastern wall of the Annex. Traces of

BELOW
11.31 Foot, with cartouche and *serekh* (Horus name), in the base of a diorite statue of Khafre that was later used as a pivot socket for the northern wooden door that opened into the Menkaure valley temple's eastern Annex from the broad northern ramp. A round hole was carved to receive the peg on which the door swung open and shut.

burning on the walls from hearths indicate this corridor may have been incorporated into the domestic structures, round grain silos, bins and huts that filled the southern end of the extension. A thin wall separated the court from what Hassan called 'a maze of later walls forming a conglomeration of mean hovels'.[41] Both Reisner, who had excavated a small part of this area, and Hassan recognized two periods of domestic structures here. Two doorways in the southern wall of the Annex gave access to the causeway corridor, showing that at least during the first-phase life of these structures, the causeway must still have been passable.

Town and temple

Town and valley temple evolved together almost from the very beginning, when the royal house moved from Giza to South Saqqara and Abusir for building memorial complexes for the king at the end of the 4th dynasty. Already during the use of the first temple, following Menkaure's death and Shepseskaf's completion of the structure in mud brick, people built houses, bins and grain silos on the floor of both the temple court and the Annex. As noted above, at some time after Shepseskaf completed the temple, builders added a thick mud-brick screen wall across the open portico on the western side of the temple's court to prevent the settlement from expanding into the offering hall and sanctuary. Reisner believed that this wall was added in the 5th dynasty, possibly as part of the project that also included the limestone threshold of the doorway through the wall and the limestone ramp flanked by low parapets leading up to it. He noted that the yellow limestone of the ramp was different from the white limestone of the pathway leading to it. The door opened to the inner sanctuary where Menkaure's four alabaster statues flanked the door to the offering hall – the *raison d'être* of the town.

We now wonder if it was likewise in this significant middle phase, the 5th dynasty, that builders, probably under royal order, added the second vestibule in the Annex, the limestone pathway across the Annex court to the original eastern entrance to the temple, the limestone thresholds of both vestibules and possibly also the alabaster column bases in both. We have clear stratigraphic evidence that both the limestone thresholds and the pathway through the Annex

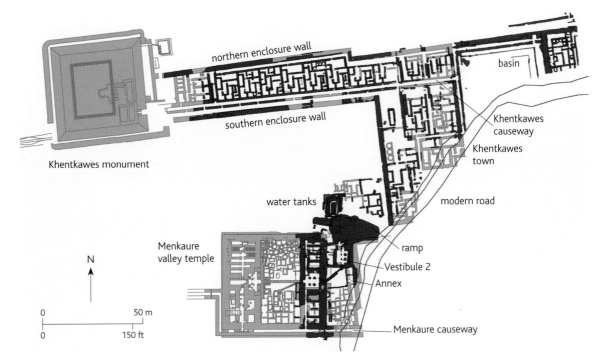

northern enclosure wall

basin

Khentkawes causeway

Khentkawes town

Khentkawes monument

southern enclosure wall

water tanks

modern road

Menkaure valley temple

N

ramp

Vestibule 2

Annex

0 50 m

0 150 ft

Menkaure causeway

court were added later than the eastern wall of the main temple that Shepseskaf built.

Shortly thereafter people rebuilt houses in the southern part of the main court on top of 20–70 cm (8–28 in.) of accumulated debris. The court occupation now comprised five fairly orderly apartments, together with more bins and small silos in the northern side of the court (see 11.37). We know now that temple personnel undertook this rebuilding before a flash flood damaged the temple and these symbiotic structures.

Around the time of the middle occupation in the court, builders renewed the focus of the cult, perhaps during the reign of King Niuserre, following a time of relative neglect after Shepseskaf had moved to South Saqqara to build his huge mastaba tomb. At first this was just a hunch, based on the fact that following a gap after Shepseskaf at the end of the 4th dynasty in which the names of the early 5th dynasty kings are missing, the royal names found on stelae and sealings in the Menkaure complex begin again with Niuserre (see p. 256). We have now found a silo storage building complex on the lower terrace in front of the basin east of the Khentkawes Town with more sealings bearing Niuserre's name (see p. 308). Through privilege, certain people under Niuserre rebuilt, reorganized and settled in the valley temple as part of a renewal of Menkaure's pious foundation. The inhabitants probably enjoyed exemption from taxes as long as they served the cult in the temple in memory of the dead king.

Place of the 'purification tent'?
The podium, the basin and the well

With our recognition that the Annex was an extension of Menkaure's valley temple and not the valley temple of Khentkawes, as Hassan believed, we must now consider that the podium and monumental basin to the north also belong to Menkaure's pyramid complex [**11.33**]. These had been excavated and described by Hassan, but our new excavations have revealed them in more detail.

At the top of the broad ramp [**11.34**], at the point where the visitor would turn left to enter Vestibule 2 of the Annex, is a low brick bench, platform or podium (also called a mastaba), almost square at 1.7 by 1.9 m (5 ft 7 in. by 6 ft 3 in.). Today it has a low convexity about 30 cm (about 1 ft) above the surface, with a projection to the east resembling a miniature ramp, but when Selim Hassan uncovered it, its faces were flat and stood several centimetres higher. It has no doubt been worn away by erosion. Thin, low walls, which Hassan also found higher than we see now, form an enclosure around the podium on three sides, but do not all date from the same period. The debris within the enclosure contained numerous fragments of pottery and stone vessels, and flint implements. Hassan proposed that this arrangement was the 'washing tent' or purification tent used to prepare Queen Khentkawes' body for burial, based on his belief that the Annex, including the second vestibule of the Menkaure valley temple, was the queen's valley temple.[42]

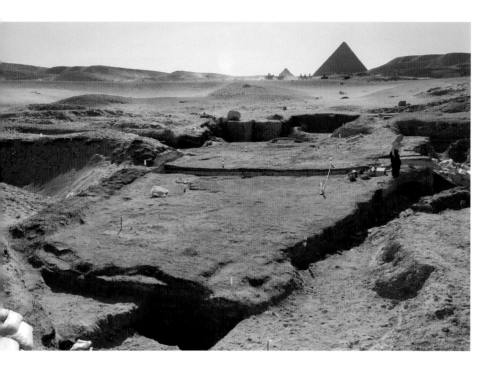

11.34 The broad ramp ascending from east to west, and expanding from 7 to 12 m (23 to 39 ft) wide, between the Khentkawes Town and the Menkaure valley temple Annex. Running water, probably ancient flash floods, made an irregular canyon-like cut (right and left foreground) through the ramp, showing its was paved several times with compact clay over limestone quarry debris. View to the west-southwest.

The podium and its enclosure must have been related to a drain that led north to a masonry-lined basin we call Water Tank 2 (Water Tank 1 is an arrangement within the southern foot of the Khentkawes Town). Builders terraced the basin, 1.03 m (3 ft 5 in.) wide and 3.91 m (12 ft 10 in.) long, into four steps of decreasing size, with a total depth from the upper level of 3.8 m (12 ft 6 in.).

It is certainly possible that the podium, with Water Tank 2, served the cult and funeral of Menkaure, though we find it hardly suitable for washing, or purifying, the prone corpse of the king. As with the socket at the front of the Khafre valley temple, which is also referred to as the 'purification booth', these telephone-booth-sized emplacements appear more appropriate for purifications performed on an upright statue, or finished mummy (Old Kingdom mummies were essentially linen statues moulded around the re-assembled skeleton of the deceased and whatever soft tissue remained). The drain begins at the northwest corner of the podium enclosure, then runs as a slightly rounded pipe, just 9 cm (3½ in.) wide, for 6.7 m (22 ft) under a thick embankment forming the southern side of Water Tank 2, to emerge above the south edge of the tank.

What is remarkable, and rather enigmatic, is the small volume of water or other fluid that this little channel could have conducted, compared to the immense capacity of Water Tank 2 – 132,100 litres

(over 29,000 gallons). We think the tank must have been designed with functional as well as ritual purposes in mind. The total capacity would hold enough water for 400 people if each consumed 2 litres (around 4 pints) a day. At the top of the southern embankment covering the drain we recorded remains of a small mud-brick structure, possibly a guard hut for controlling access for anyone ascending to the rim of the tank. We also found remains of an enclosure wall on three sides of the tank, a terrace on the west and the remains of mud-brick and fieldstone houses between the tank and the southern, foot-end of the Khentkawes Town. It seems unlikely that people would want to drink water from this tank if it had flowed over a corpse, even a royal one, but they might be eager to drink or wash with water that carried the blessing (*baraka* in Arabic) that had poured over a hardstone statue of their god-king and patron.

Hassan also described a well:

> Behind the brick cell [podium] and west of the valley temple lies a well, the sides of which are of rubble on the north and east, and of enormous blocks of limestone on the south and west. According to Dr Reisner these blocks of limestone mark the northwestern end of the platform of the Valley Temple of King [Menkaure]. This well was probably also constructed by him, and afterwards utilized by Khent-kawes.[43]

Hassan's 'well' [**11.35**] is actually a rounded hole or pit, 5.8 m (19 ft) wide and nearly 3 m (10 ft) deep at the northeast (not the northwest) corner of the valley temple, and was without doubt created long after the time of Menkaure or Shepseskaf. The pit cut into the mud-brick casing of the east and north valley temple walls, so that they hang slightly out at the edge of the hole, which also exposed three (not two) courses of huge limestone blocks from the initial construction under Menkaure. It also cut through the upper end of the broad ramp, allowing us to see that it is built up on enormous deposits of quarry debris. Remains of accretions of large irregular limestone pieces to retain the sides on the north and east of the pit show that it was used for some definite purpose. In 2008 we cleared the sand that had built up after Hassan's work to the water table, which that year was around 2.5 m (8 ft 2 in.)

below the top. A telling feature is a mini-glacis, a kind of skirt with a sloped face composed of limestone pieces, compact sand and silt, against the north face of the Annex wall and abutting the east side of the hole. We think this could be a segment of what Reisner termed the 'water wall', built along the base of the west and north walls of the valley temple to protect against the flash flooding such as cut through the temple sometime in the late 5th or early 6th dynasty.

Why would residents in the late period of occupation of the valley temple need this well when they had the large Water Tank 2 just on the other side of an embankment? We see evidence that sand had filled the tank, and Reisner said that by the time of what he termed the second temple, sand and debris had engulfed the west and north sides of the temple. A gully formed by desert flooding after rains cuts right across the southeast corner of the tank. So this yawning, deep hole might have served as a new catchment to store water from episodic flooding, and, as with other aspects of the temple and its town, the residents had by now stopped caring about its appearance. This brings us to Reisner's second valley temple, its final phase.

The reconstructed or second valley temple

Reisner called the valley temple during the last period of its use and occupation 'the second temple'. As we now see it, the valley temple went through three major stages of life, corresponding to the 4th, 5th and 6th dynasties. At some point during the late 5th or first part of the 6th dynasty, probably before the reign of Pepi II, the temple was badly damaged by torrents of water running down off the desert plateau after downpours of rain. Such flash flooding also cut a mini-canyon through the broad ramp ascending to the northern entrance of the valley temple Annex (see 11.35). Reisner believed that a kind of trough in the Moqattam Formation, beginning west of the Khafre pyramid, carried flash floods down the north side of the Main Wadi and along the north side of the causeway to its corner and the back of Menkaure's valley temple. (In our excavations south of the Wall of the Crow we have found evidence of extremely powerful flash floods that also washed through the Main Wadi south of the Menkaure complex.) A gap left at this point by Menkaure's builders in the coursing

of large limestone core blocks of the back wall created a weak spot. The desert run-off cut through the western mud-brick wall of the valley temple, washing away the western end of the offering room and portico. Reisner wrote that the flood pooled in the court, destroying structures there, but spared the middle period houses, bins and silos at the north and south ends. He thought that the water might have drained away into the gravels and limestone block foundation, but he also suggests that it could have streamed on, cutting through the southern side of the east part of the temple. In his unpublished version of Reisner's multi-phase map of the temple, Clarence Fisher shows the contours of the gully sweeping over the southern walls of the vestibule. The southern wall of the temple's vestibule (Vestibule 1) was cut down at its lowest to 30 cm (12 in.), as were the original walls of the southern magazines in the east side of the temple.

Layers of sand over the mud-brick decay of the first temple indicated that it had been severely neglected, if not completely abandoned, before the rebuilding. As the temple was abandoned, the corridors and magazines filled with sand; roofs collapsed on to this, forming a surface of decay.

Sometime around the middle to last third of the long reign of Pepi II (c. 2246–2152 BC), this 6th dynasty ruler seems to have renewed Menkaure's cult and rebuilt his valley temple. A decree of Pepi II

11.35 Hassan's well is actually a deep hole that cut through Shepseskaf's mud-brick casing at the northeast corner of the Menkaure valley temple, exposing four courses of monolithic limestone core blocks set by Menkaure's builders. In 2008 AERA excavated sand filling the hole, leaving a section shored up by sand bags. This hole cut through the western end of the broad ramp. Late in the life of the temple, people built a glacis-like 'water wall' against the northern wall of the Annex (far left). View to the southwest.

awarding privileges to the priests of the pyramid city was discovered in the vestibule. It reads in part 'A royal decree to [the overseer] of the pyramid town of Menkaure… My Majesty [Pepi II] ordered the exemption and protection of this pyramid town.'

On its west, north and south sides, this reconstructed, second, temple was enclosed by less substantial walls than the first [11.36]. As we saw above, the causeway corridor on the south was blocked, covered and rendered non-functional. Reisner found no eastern wall of the second temple; he reasoned instead that the northern and southern walls once continued further to the east, enclosing Menkaure's pyramid city in its latter days. Though he found a few domestic structures in its southwest corner, he was unaware of the extent of the Annex on the east terrace, and the steep drop into some kind of basin only 15 m (around 50 ft) east of the temple. However, before he had to stop

11.36 Reisner's multi-phase plan of the Menkaure valley temple, with walls built in mud brick under Shepseskaf in green, 'second temple' walls in orange, and walls of apartments, bins and silos in black and grey (north is to the right). In his original unpublished and uncoloured version, Clarence Fisher shows the contours of the cut created by flash flooding extending over the eastern walls of the temple.

his exploration at the modern cemetery, he did find an extension of the southern wall 70 m (230 ft) east of the temple, which could delimit the basin, or a lower level of settlement.

Rooms were built over the ruins of magazines and in the open court. In the western sanctuary the builders made a rectangular anteroom with thick walls, oriented north–south, right up against the screen wall and over the old recessed portico in front of the sanctuary. Four pillars on limestone bases in a north–south row supported the roof. The stone ramp up to the sanctuary was now buried by the accumulation of debris in the court; two limestone bases on the fill above the ramp indicated that a porch had replaced it. In fact the floor of the court now sloped *down* to the sanctuary rather than up to it.

The walls of this second north–south offering hall and of the deep sanctuary perpendicular to it were founded over the walls of the first temple, preserved here to a height of only 20 to 30 cm (8–12 in.). On the trodden dirt floor of the offering room Reisner found a simple bench made of water-worn alabaster slabs where the townsfolk must have left the deceased king his token sustenance. A limestone libation basin and, curiously, four small, unfinished statues of Menkaure lay beside it.

On the southern side of the entrance vestibule the second temple builders raised a massive mud-brick wall, 1.91 m (6 ft 3 in.) thick, with straight, square ends at each doorway – one from the Annex and one opposite it into the court. On the court side the builders founded the wall on debris 24 cm (9½ in.) thick, and up against the niches decorating the older wall. They laid the higher courses over the ruins of the original court wall and over the eastern wall of the valley temple, which by now had been reduced to less than 1 m (3 ft) in height. The thick wall crossed and completely blocked the corridor to the magazines south of Vestibule 1 and turned to frame the original eastern entrance. This wall was built on or close to the floor level of the Annex. Unfortunately, from what Selim Hassan published and left on site we are unable to ascertain if, or how, people used the Annex during the life of the second temple; it is likely they still used the broad ramp, northern entrance and Vestibule 2.

At some later point, which Reisner believed was also within the 6th dynasty, people reinforced

the inner face of the southern wall of Vestibule 1 with a thinner wall. Since the original southern wall had been reduced to less than 30 cm (1 ft) in height, it might have formed the floor of some kind of magazine, dead space or, more likely, a compartment filled with debris to make an even thicker barrier on the south of Vestibule 1, perhaps as extra protection against flooding.

Reisner mentions possible traces of 'second temple' walls on the original north wall of Vestibule 1 (or anteroom as he calls it), but he is less certain, and his map of this latest building phase shows only a thin accretion wall here. The second temple builders appear to have focused their concern on the south wall. If the corridor giving access to the northern magazines from Vestibule 1 remained open through most of the life of the second temple, the small stairs constructed in this corridor might have been the way up into the court and its settlement, now elevated on the accumulated debris of centuries. We have some evidence from our re-excavation of this space that the corridor did indeed remain in use through the late phase of the temple.

In the inner part of the temple the northern magazines were left as before. In the southern magazines, the long room at the rear of the temple was divided into three shorter chambers. We cannot now be certain that all these changes took place in the latest phase, Reisner's 'second temple', and it is possible that many took place during the 5th dynasty. The 6th dynasty builders provided doorways from the second temple offering hall to the inner magazines on the north, and to at least one magazine on the south, but Reisner noted that people had blocked them before they had seen much use. The doorway at the end of the southern corridor was closed off, denying all direct access from the temple to the causeway, which was anyway rendered dysfunctional by the superposition of the second temple southern wall.

During the period of the second temple the small mud huts, storage bins and grain silos of a renewed pyramid town again filled the open court of the valley temple. Reisner acknowledged the complication of the sequence, making it impossible to discern distinct pancake layers through a settlement modified continuously by its inhabitants. But he saw three principal phases that probably correspond, with some time-lag and hiatus, to the three major building phases of the temple we now recognize: (1) settlement structures built on the original floor; (2) settlement structures (probably 5th dynasty) built on 20 to 70 cm (8–28 in.) of debris; (3) settlement structures built over the ruins of the original outer walls, magazines and earlier domestic structures in the open court.

Overall, the 'second temple' amounted to a thick outer enclosure wall on the south, west and north, a thick reinforcement framing the southern side of Vestibule 1, and another massive frame around the sanctuary and offering hall, forming a T-shape. Though Reisner could not extract the entire plan of the structures of settlement of this phase, they probably filled the space in between, so that the whole was a fortified village pressed up against the sacral spaces that were its purpose. The inhabitants maintained the cult of the king in the dark, closet-sized sanctuary at the rear of the valley temple and in the upper temple. They must have exited the valley temple from its eastern side, and trekked across the sand to reach the upper temple, for Reisner found no exit through the late phase enclosure wall (for more on the town see Chapter 15).

Shepseskaf revisited

Many questions remain unanswered about the Menkaure pyramid complex. Egyptologists have differed about the length of Menkaure's reign, but it might have been as much as 18 years. If so, the question is why the stone masonry work was taking so long, considering the scale accomplished by Khufu and Khafre in reigns perhaps only five to eight years longer? Granted, pyramid and temple building is hard work, especially when platforms and core walls are formed of limestone blocks weighing many, even hundreds of tons, and when casing and finishing work is in such a hard stone as granite. But we sense that some of the force and power behind this massive scale of building at Giza was beginning to wane in the reign of Menkaure. This impression comes not only from the fact that his pyramid is so much smaller than those of Khufu and Khafre, but also because work was not very far advanced on his pyramid temples, and his causeway was incomplete. Work had hardly even begun in stone on the temples of his queens' pyramids.

Royal statues

Several masterpieces of ancient Egyptian art were found by Reisner in the corridor leading south from the offering room at the back of the Menkaure valley temple. Four complete triads (plus one broken one) and a dyad feature the king with female figures. All were carved from a beautiful dark greyish-green stone, greywacke, a crystalline sedimentary rock with very fine grain that allowed the sculptor great control in modelling detail.

The dyad emerged from the dirt at the very beginning of Reisner's excavation (see 6.16).[44] Treasure seekers, digging long after pharaonic times, abandoned the dyad at the bottom of one of their exploratory pits. Menkaure's sculptors had not quite finished the piece. They still had to polish the lower parts of the queen's legs and the base, where they would have incised the royal hieroglyphic names and titles. It was long thought that the woman is a queen named Khamerernebty (II), a royal wife. However, art historians Dorothea Arnold and Florence Friedman point to aspects – the embrace and equal height of the queen – which suggest that here stands the royal mother, in the guise of Hathor.[45] Lehner proposes, based in part on the dyadic relationship of the Khentkawes Town and Menkaure valley temple, that the royal mother here depicted is Khentkawes I.

The triads (three figures) represent the mother goddess, or royal mother as the goddess, Hathor, with Menkaure and one of the goddesses of certain nomes. To their makers, the triads conveyed ideas of fecundity, rebirth and sustenance for the king in the Afterlife. The representations of the various nomes symbolized the provinces that provided food for the king, just like the scenes frequently found in royal temples and tombs of nobles showing men or women, each a personification of a province, town, estate or village, bringing offerings.

Some Egyptologists thought that there might have been as many as 40 triads in the valley temple, one for each of the nomes of Egypt; another opinion is that there may have been only eight, one for each of the provinces where Hathor was especially worshipped. The eight

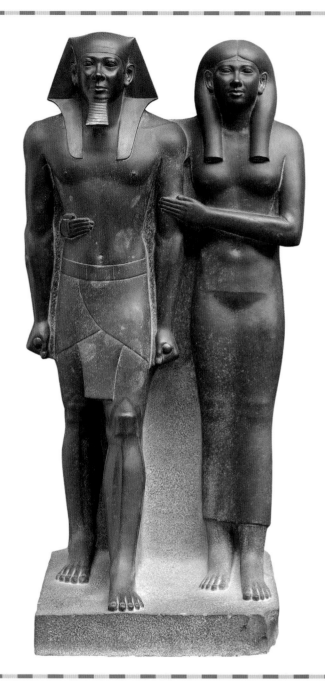

11.37 The dyad of Menkaure and a queen, or the queen mother. As it was unfinished, with no inscription on the base, the identity of the queen remains unknown, but was long thought to be Khamerernebty II, a royal wife. The embrace, the equality in height and other aspects have led more recently to the suggestion that it is the royal mother who stands with King Menkaure. Now in the Museum of Fine Arts, Boston (11.1738), 139 cm (54¾ in.) high.

When were the subsidiary pyramids, GIII-b and GIII-c, begun? Did the builders leave them as step pyramids, and if so why? If GIII-a was designed to be the king's satellite pyramid, why did the builders prepare a foundation platform of huge limestone blocks as though they intended a stone temple, such as would be required for a queen's pyramid, from the beginning? And when were all the queens' temples finished in mud brick? They seem to have

been built at the same time, yet it would be hard to believe that all three queens died and went to their graves at the same time as Menkaure.

The common assumption has long been that after Menkaure died, builders under Shepseskaf completed the mud-brick finish work on Menkaure's upper and valley temples, his causeway, enclosure wall and the queens' pyramid temples. Under current chronologies, all this work, plus

chapels right and left of the temple entrance would have been their original locations.

In one triad, now in Boston Museum of Fine Arts, Hathor, rather than the king, is the central, seated, figure. Menkaure wears a kilt and the crown of Upper (southern) Egypt, and holds a ceremonial mace in his right hand and a small enigmatic object (his personal seal?) in his left. Hathor's hand, delicately carved in relief wrapped round the king's abdomen, conveys her embrace of the king. The goddess on Hathor's right in this triad personifies the Hare nome, the 15th province of Upper Egypt. Hathor is both a celestial and an earthly divinity; her emblem is the sun between cow's horns. She is the divine mother goddess. Her name is written with the falcon of Horus, god of kingship, within a rectangle, which is the hieroglyph for 'mansion' or 'estate'. She is literally 'the estate of Horus', no doubt a reference to the kingship passing through the female line of the royal family. On this unique triad her hieroglyphic name is carved in the base in front of the kings right foot. Friedman sees the queen mother in the dyad as the earthly manifestation of Hathor. Here, in her celestial aspect, Hathor dominates as the central figure, and like the queen in the dyad, embraces the king, a gesture of legitimation.

As with the dyad, the ancient Egyptian artists painted the triad in bright colours. When the excavators brought it out of the ground, it retained traces of red on the king's face, yellow on the women's faces, black on their tripartite wigs, black and green on the king's belt, and green and yellow necklaces. The Egyptians believed that painting the statues brought them to life, literally, as figures who could perform favours (such as bringing in offerings and sustenance in the Afterlife).

In spite of giving the king and the deities perfect bodies, the artists sculpted faces that were probably unique in certain elements to the king and queen. The king's fleshy round nose, full cheeks, prominent eyeballs and faint smile are all typical of Menkaure's other statues. His real face probably resembled this face, as the facial features of the goddesses probably resembled those of the queen, perhaps Khamerernebty II, a queen named in tomb inscriptions. Hathor is the queen and the goddesses at the same time, just as the king is both Menkaure and Horus.

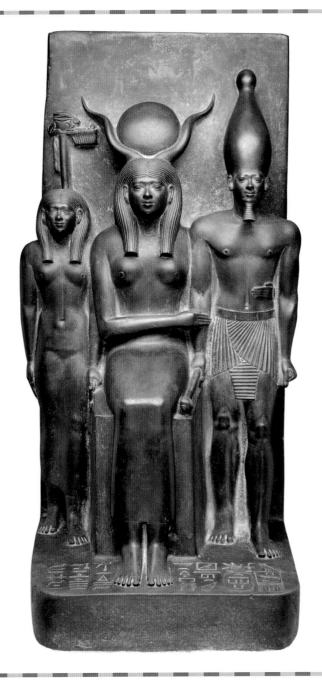

11.38 Triad of Menkaure in the Museum of Fine Arts, Boston (09.200); 84.5 cm (33¼ in.) high. Here it is the goddess Hathor who is the central and largest figure, rather than the king.

Shepseskaf's building of his own memorial complex at South Saqqara, would have been finished within the five to seven years between the end of Menkaure's reign and the end of Shepseskaf's, to say nothing, so far, of the stonework and extensive mud-brick town of Khentkawes. Was some of the brickwork done under Khentkawes, this mysterious female monarch who declared upon her own colossal monument at Giza that she was 'Mother of the Two Kings of Upper and Lower Egypt', or 'King' herself of Upper and Lower Egypt? Her titles imply that she ruled in her own right at the end of the Giza dynasty. Further clues are to be sought in an examination of her monument, with its own pyramid town, in the following chapter.

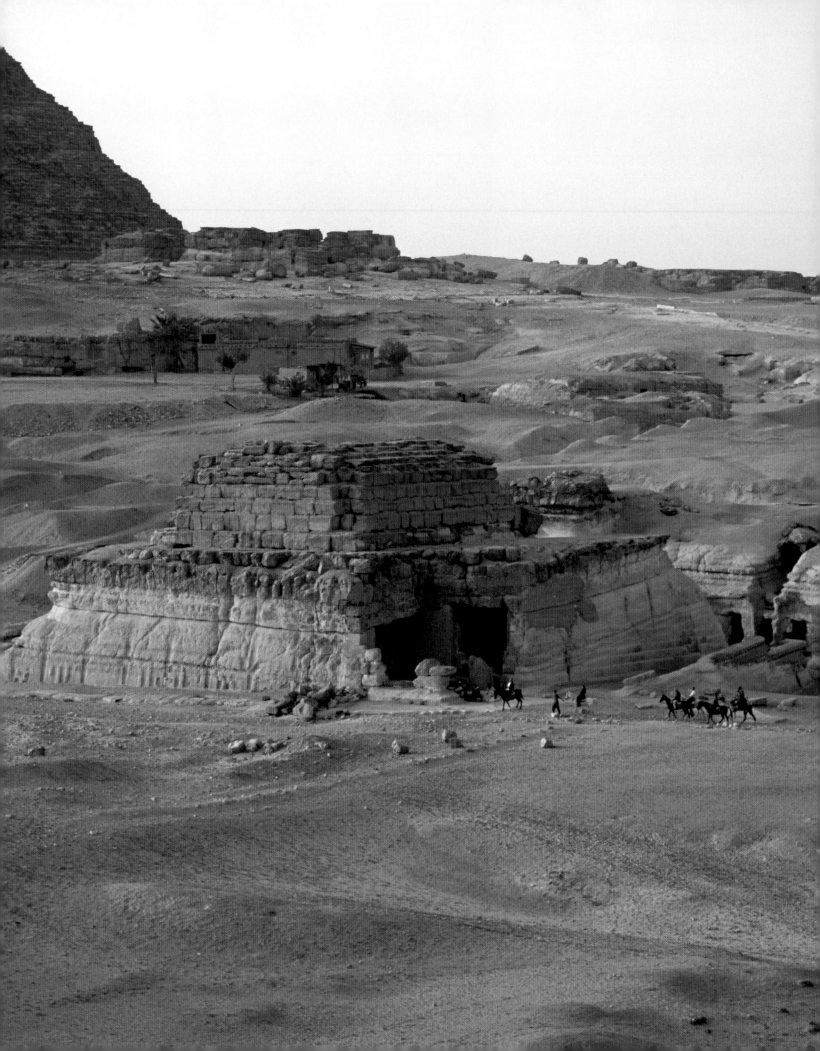

CHAPTER 12
The Khentkawes monument: Giza's punctuation point

Any survey of Giza and the pyramids must include the funerary monument of the enigmatic queen named Khentkawes. Although dwarfed by the pyramids of the kings who preceded her, Khentkawes' tomb (LG 100) surpasses those belonging to all other nobility. Standing at the mouth of the Main Wadi, which had served as the supply conduit for three generations of pyramid builders, her monument occupies the centre of a gigantic circular quarry that furnished much of the limestone for the pyramids of Khufu and Khafre. As they removed the stone, quarrymen reserved a roughly square block of limestone bedrock, about 10 m (33 ft) high, which then became the pedestal for Khentkawes' tomb. Khentkawes' builders hollowed out the inner chambers and substructure of the tomb from this bedrock pedestal and erected on top a stepped, vaulted mastaba superstructure that rose around another 8 m (26 ft). Whether or not the 4th dynasty builders had intended this reserved limestone block for the tomb of a queen mother, the Khentkawes monument serves as a gigantic punctuation point – the full stop at the end of the dynastic sentence inscribed by her predecessors across the Giza horizon.

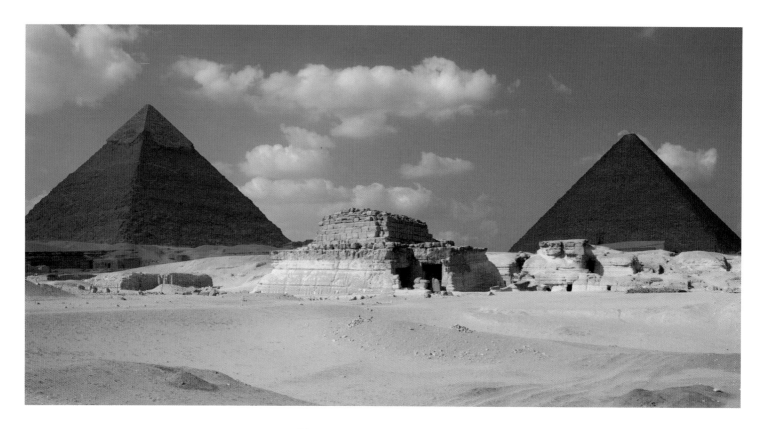

PREVIOUS PAGES
12.1 The monument of Queen Khentkawes I, viewed to the northwest from the Gebel el-Qibli (Southern Mount). To the right, dark tomb doorways punctuate bedrock blocks left over from massive 4th dynasty quarrying. The western Central Field quarry lies between the monument and the Khafre pyramid temple (upper left).

ABOVE
12.2 Viewed from the southeast, Khentkawes' monument centres between the pyramids of Khufu (right) and Khafre (left), suggesting a planned spatial and visual connection with these early 4th dynasty progenitors.

RIGHT
12.3 Thumbnail plan of the Khentkawes I monument and town.

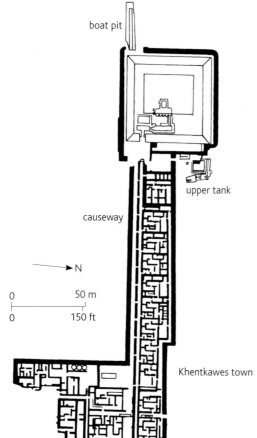

boat pit

upper tank

causeway

→N

0 50 m
0 150 ft

Khentkawes town

Khentkawes' tomb is a highly unusual monument that is difficult to classify and has long puzzled scholars. Lepsius mapped it and gave it the number LG 100. Perring described it as a pyramidal building. Hölscher and Reisner saw it as an unfinished pyramid for the pharaoh Shepseskaf, who succeeded Menkaure and built a much more gigantic mastaba as the superstructure for his tomb at South Saqqara.[1] Selim Hassan, who excavated the tomb and its associated town in 1932–33, called it the fourth Giza pyramid.[2]

Neither pyramid nor mastaba, the Khentkawes monument occupies a special place and its own typology in the catalogue of funerary monuments of the Old Kingdom [12.2]. Egyptologists had long believed that the natural bedrock pedestal and the upper mastaba superstructure represented two different phases of building. Our survey of the entire monument, which began in 2005 and still continues, suggests otherwise – that the builders completed the pedestal and mastaba together as the queen mother's tomb.

The approximate centre of Khentkawes' monument aligns with the eastern side of the Great Pyramid of Khufu and nearly to the northern side of Menkaure's pyramid. From the area of the

Menkaure valley temple, the queen's gigantic tomb overlaps visually the much bigger pyramid of Khafre. The town attached to the monument runs east along her causeway and then turns 90 degrees south to within 30 m (98 ft) of the Menkaure valley temple [12.3]. These alignments give emphasis to the name of the woman buried here, *Khentkawes*, '[The male one] whose *kas* are foremost.' *Ka* is the communal, generic life force transmitted through ancestors. Khentkawes' eternal abode stands literally as the vanguard of those of Khufu, Khafre and Menkaure, leaving us to wonder at the family connections.

A queen who would be king?

Who was Khentkawes? The queen had her titles etched into the granite door jambs at the entrance to her chapel and on monolithic granite false doors inside as 'Mother', and then, twice, 'King of Upper and Lower Egypt' (*mwt njswt bjtj njswt bjitj*) [12.4]. Egyptologists interpret this either as 'Mother of the Two Kings of Upper and Lower Egypt', or 'Mother of the King of Upper and Lower Egypt and King of Upper and Lower Egypt'.

The latter reading implies that we should count Khentkawes among the few Egyptian queens who ruled as king in their own right. The question is further complicated by the fact that at Abusir, where four kings of the 5th dynasty built their pyramids, Czech archaeologists found the name of another Queen Khentkawes, with the same ambiguous title. They excavated a small pyramid complex for the Abusir Khentkawes to the south of the pyramid of Neferirkare. This queen, Khentkawes II, who we know was the wife of Neferirkare and the mother of Niuserre and Raneferef, lived two or three generations later

than the Giza Khentkawes. And the tomb of a third Khentkawes, possibly the wife of Raneferef, was discovered at Abusir in 2015.

Khentkawes I would have lived and ruled at the end of the line of great 4th dynasty pyramid-building kings at Giza – Khufu, Khafre and Menkaure. But we do not know exactly how she was connected with the 4th dynasty family, or with the kings of the 5th dynasty. She could have taken the title of 'Mother of Two Kings' only if two of her sons had already assumed the throne. We have no evidence of her father or husband, nor the king or kings to whom she gave birth. Egyptologists have reasonably suggested she may have been the daughter or wife of Menkaure and mother of Shepseskaf, the last king of the 4th dynasty; or she may have been the wife of Shepseskaf and the mother of Userkaf and Neferirkare, the first and third kings of the 5th dynasty. But the quarry history and alignments between her unique monument and the pyramids of Giza must signify some connection back into the 4th dynasty.

Khentkawes I and the great circle of quarrying

If we take a wider bird's eye view of this area of the Giza Plateau and draw a circle with the Khentkawes monument as its central point and the distance from it to the Khafre causeway – 200 m (656 ft) – as its radius, so roughly 400 m (1,312 ft) in diameter, the monument can be seen as occupying the centre of the gigantic circular quarry that the pyramid builders gouged out as they extracted the vast quantities of stone needed for pyramids, mostly those of Khufu and Khafre [12.5].

On the north, the circle touches the Khafre causeway, on the west it reaches the face of the Central Field quarry that furnished much of the stone for the Khufu pyramid, and on the east it hits the limit of the bedrock exposure just southwest of the Khafre valley temple. If we then quarter the circle by extending the centre axes of the queen's monument, we see that the less-worked sector of the vast quarry fits within the northeastern quarter, and this quarter, between Khentkawes and the Sphinx, still shows the deep channelling that reserved a series of bedrock blocks, each the size of a modern house, a frozen moment of the initial subdivision of the bedrock to isolate and remove blocks.

12.4 Granite piece of one of the jambs of the doorway giving access to the chapel of the Khentkawes I monument, inscribed with the title *mwt njswt bjtj njswt bjitj*, either 'Mother of Two Kings of Upper and Lower Egypt', or 'Mother of the King of Upper and Lower Egypt and King of Upper and Lower Egypt'.

Khentkawes monument: major explorations

Years		Excavator/explorer
1842–43	monument	C. R. Lepsius
1932–33	tomb and town	S. Hassan
1967	tomb and town	V. Maragioglio and C. Rinaldi
2005–	tomb, town and valley complex	AERA

Within this greater quarry, the Khentkawes monument stands as a massive corner post of a horseshoe-shaped quarry, the western half of the circle, which furnished most of the stone for Khufu. The eastern (Khentkawes) and western sides of the horseshoe quarry align rather neatly with the corresponding sides of the Great Pyramid, located 300–600 m (985–1,970 ft) to the north. The volume of missing stone here is close to that of the bulk of the pyramid.

The 4th dynasty Egyptians exploited the great circle of quarrying anticlockwise. Khufu's forces began in the northwestern quarter, the closest to his pyramid. As they quarried deeper, they extended southwards, into the southwestern quarter, forming the southern end of the horseshoe shape. Next they exploited bedrock further south yet, and east into the southeastern quarter. The Menkaure valley temple and Khentkawes Town (KKT) fit into this southeastern quarter (see plan, p. 277). By the end of their major quarrying works, the builders had isolated great rectangular blocks of bedrock in the northeastern quarter where they had not yet worked the bedrock down anywhere near as deeply as in the other three quadrants of the quarry circle. Standing tall along the northern side of the KKT, these bedrock blocks were used for rock-cut tombs, mostly by high-ranking 5th dynasty officials, many of whom lived and died during the time of the 5th dynasty Abusir kings and the reign of the second Khentkawes (II), making us once again curious about family connections, although we can only speculate until further evidence comes to light.

We would certainly not be correct if we suggested that the 4th dynasty surveyors and quarrymen intended to create such a neat and perfect circle, but it seems they did approximate a centre to their greater quarry area and reserved much of the original height of the plateau immediately around this point. The top of the Khentkawes block, and the bedrock immediately to the north from which it was separated, serve as a reference to the original Giza Plateau surface. Why did they reserve the original plateau surface here? It was perhaps simply a result

12.5 Quickbird satellite view of the Central Field at Giza, showing the circle of 4th dynasty quarrying (north at the top). The Khentkawes I monument is at the centre of the circle, projecting south from the northeastern quarter. While never intended to be accurate, the radius of quarrying extends 200 m (656 ft) to the west, north and east of the Khentkawes I monument. The quarry workers did not exploit the northeastern quadrant, between the Khentkawes monument and the Sphinx, so deeply. From the late 4th dynasty and particularly in the 5th dynasty, people used the quarry blocks of this quadrant for mastabas and rock-cut tombs.

of quarrying by quarters – since they never reached the stage of working the northeastern quarter deeply, they left its corner standing tall. But the fact that the bedrock pedestal later used for the tomb juts forwards from the corner, and also occupies the centre of the greater quarry circle, does suggest that they reserved this patch of bedrock as some kind of benchmark [**12.6**]. We might guess the purpose was to calculate volume of stone or to monitor work.

How appropriate, then, that at the end of the 4th dynasty of pyramid-building kings, the benchmark at the centre of the great quarry circle became the monumental tomb of the queen mother who was Khentkawes, and thus 'in front of her *ka*s' in a spatial sense. Khentkawes' builders separated off the square bedrock pedestal for her tomb by cutting a deep corridor, 6 m (20 ft) wide, on the north side, and levelled the top of the pedestal in order to build the stepped and vaulted mastaba on top, directly over the burial niche in the substructure.

Together, the Menkaure valley temple with the Khentkawes monument and town closed off the passage up to the Giza Plateau, and gated the quarries that had served to build the pyramids. Khentkawes' tomb stands like a sentinel on the southeastern entrance to the pyramid necropolis of her ancestors.

The bedrock pedestal

Before her builders transformed this huge reserved bedrock block into the pedestal for Khentkawes' tomb, it stood only a few metres from southern and western ledges that dropped many metres deeper, with the sides of the pedestal stepped back from a much deeper quarry cut. A roughly level terrace was created all around by filling in the deeper quarry on these sides with limestone quarry debris. At the southwest corner the masons built up the foundation for the pavement with three courses of limestone headers butted up against a vertical face that drops at least 1.8 m (almost 6 ft), and laid three trapezoidal or triangular slabs to extend the floor. On the south side, a series of limestone beams resting on the previous quarry ledge were used to build up the terrace.

At the southeastern corner of the pedestal itself, the builders cut out the bedrock to form the southern, outer room of the chapel. At this corner,

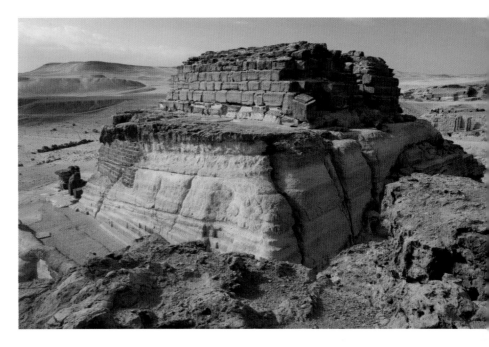

The bedrock pedestal dimensions

Height

NW corner	9.8 m (32 ft 2 in.)
NE corner	9.9 m (32 ft 6 in.)
SW corner	9.7 m (31 ft 10 in.)
SE corner	8.83 m (29 ft) at NE corner of chapel cutout
	8.55 m (28 ft) at NW corner of chapel cutout
	7.88 m (25 ft 10 in.) at SW corner of chapel cutout

Base length (from on site measurement)

N side	42.3 m (138 ft 9 in.)
S side	41.85 m (137 ft 4 in.)
E side	43.5 m (142 ft 9 in.)
W side	43.35 m (142 ft 3 in.)

Estimated base length with casing

N–S	45.85–46 m (150 ft 5 in. to 150 ft 11 in.)
E–W	44.3 m (145 ft 4 in.)

Top length (from laser scan orthophotography)

N side	35.34 m (115 ft 11 in.)
S side	37.3 m (122 ft 4 in.); estimate before SE corner removed for chapel
E side	37.2 m (122 ft); estimate before SE corner removed for chapel
W side	35.34 m (115 ft 11 in.)

12.6 Khentkawes I's monument consists of a natural bedrock pedestal with a mastaba built on top. The queen's builders isolated the pedestal from adjoining bedrock by cutting a 6-m (20-ft) wide corridor (right). A substructure carved from bedrock below contained the burial chamber and other rooms. View to the southwest.

masons built up the top of the pedestal with masonry, which varies in thickness from 1.1 m to 1.48 m (3 ft 7 in. to 4 ft 10 in.), a procedure they also used at the southeastern corners of the bases of the Khafre and Menkaure pyramids to compensate for the natural dip of the limestone bedrock strata of the plateau.

At the base, after they had completed all stonework, masons raised a thick mud-brick enclosure wall with rounded corners that circumscribed the monument [**12.7**]. From our work in 2012, we know that east of the chapel entrance, beyond a flat apron of bedrock that began the gradual downward slope of the causeway, prior quarrying had dropped the bedrock around 2 m (over 6 ft) lower. At the same time as they made the enclosure wall, workers founded the western part of the Khentkawes Town over debris they used to fill the quarry and on the gently sloping bedrock surface.

If we take into consideration the fact that the pedestal's exposed bedrock top has eroded somewhat on the north and west, together with the clear evidence that the masons once paved it, it is likely the original intended height was 10.5 m (34 ft 5 in.) – 20 royal cubits. To accommodate the upward slope of the natural strata at the top of the pedestal, the masons reduced the thickness of the masonry laid on top halfway along its eastern side. Along the southern side, the blocks of the lowest course of the mastaba are set on this masonry; the masons must therefore have levelled the top of the pedestal before building the mastaba.

Khentkawes' builders finished off the top of the pedestal with a pavement of fine Turah-quality limestone slabs, not unlike the pavements of the pyramid courts. In our work on the monument we recorded the remains of this pavement. They then encased the mastaba itself with fine limestone blocks. Though these are now missing, we can still see the cuttings in the mastaba core masonry where the builders trimmed it back to fit the casing blocks, leaving the linear tracks of their successive courses. The sequence of rough masonry for levelling the pedestal, then building the mastaba core, to the finer paving, and finally the traces of the mastaba casing, which once sat on the fine pavement – all tie the pedestal and mastaba together into one building project.

At its base, the bedrock pedestal is slightly longer east–west than north–south, but it is still closer to square than at the top. Our measurements at the top of the pedestal are approximate because the corners curve, probably from the original quarrying, with erosion rounding them more. However, it is certain that the top edges ran 5 to 8 m (16 ft 5 in. to 26 ft 3 in.) shorter than the sides at the base. In fact, the bedrock pedestal is trapezoidal, as revealed in the plan view obtained by laser scanning (see box overleaf).

The northwest corner of the pedestal is rather obtuse – particularly so at the top. It seems that before Khentkawes' builders finally separated the massive bedrock block by cutting the corridor on the north, quarrymen had already cut into the bedrock at this corner too far east, leaving insufficient rock higher up to form a good 90 degree corner. Although the masons then tried to square the upper northwest corner by adding a thick packing of crude, locally quarried blocks between the bedrock and the casing, it still remained slightly obtuse. This attempt at squaring up the northwest corner is further evidence that casing and bedrock core were part of a single building

12.7 The fine Turah limestone casing, now heavily eroded, on the western side, northern end, of the bedrock pedestal of the Khentkawes monument. The casing sits on a limestone platform that extends slightly out from the base. The low remains of the mud-brick enclosure wall are visible curving around the corner.

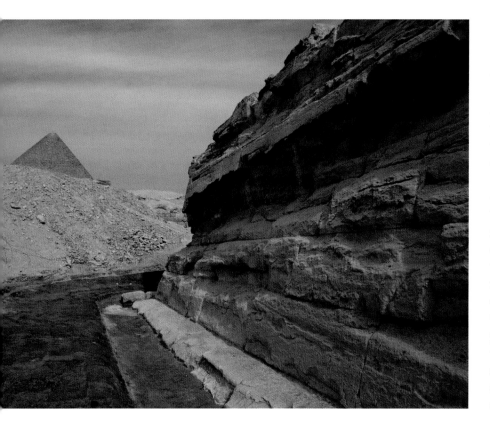

phase, rather than, as Egyptologists have long accepted, the casing being a later addition.

False door panelling

One reason for the interpretation that the casing was a later addition takes the form of traces of a series of false door panels carved in the southern face of the bedrock pedestal, giving the distinct impression that there were two stages in the building of the Khentkawes monument. Having carefully carved this false door motif, the builders then covered it with the casing, which is now entirely missing from the southern side [**12.8**, **12.9**].

In their survey 40 years before ours, Maragioglio and Rinaldi noted that at least two of the niches next to the southeast corner had been completed.[3] They must have eroded considerably since that time. Remarkably, however, where the natural limestone beds that run through the upper part of the pedestal are harder and more resistant to erosion, the original surface of two of the false doors, one broader and shorter and the other taller and narrower, still exist at the top of the far eastern end of the southern face.

The shorter, broader false door, 90 cm (35 in.) wide, is the easternmost. Consisting of three planes, it is deeper and more complex than the taller one next to it. Two outer panels, one on each side, define a narrow, inner, deep niche, 38 cm (15 in.) wide, topped by a relief-carved drum roll, 1.44 m (57 in.) wide, which is in turn topped by two 'lintels' or cross bars framing a recessed panel. The taller, shallow false door to the west has only two planes of relief: an outer surface flanking either side of a niche, 38 cm (15 in.) wide and carved about 7 cm (2¾ in.) deep. It, too, is topped by a drum roll, above which is a sunken, narrow horizontal panel. The top of the drum roll is about a cubit (52 cm/20 in.) below the top of the bedrock pedestal.

Nowhere else on the southern face is the false door motif so well preserved. However, it is evident that the series once continued across this side. Worn, vertical niches visible on the rest of the southern face belonged to the innermost niche of the broader, deeper, shorter false doors. These faint traces survive precisely because the sculptors cut them deeper. They occur at intervals of between 3.44 m and 3.5 m (11 ft 3 in. and 11 ft 6 in.), from which we calculate that eight of the broader false

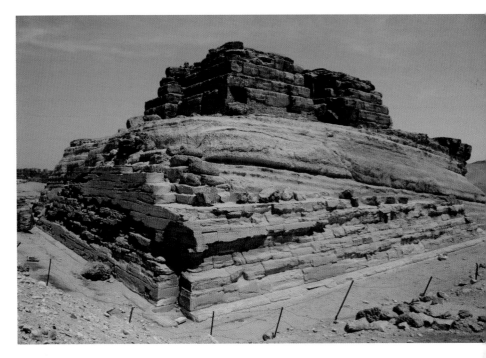

ABOVE
12.8 The northwest corner of the Khentkawes monument with intact casing over the bedrock pedestal and the upper mastaba. The casing sits on a platform of fine white limestone. Differentially weathered geological beds in the pedestal reveal the 6-degree dip to the south. View to the southeast.

LEFT
12.9 Worn vertical niches mark the positions of deep, complex false doors that once decorated the southern bedrock face of the pedestal.

doors alternated with seven of the taller, thinner, simpler ones to decorate the southern bedrock face. As noted above, the builders then cased the bedrock pedestal, covering up this false door pattern that the craftsmen had carved so painstakingly on such a monumental scale.

Casing

Much of the casing survives on the northern and western faces of the monument – 12 courses on the north and seven on the west – and evidence for it is found on the eastern face. Except for a broad false door rendered in the casing at the northern end of the eastern side [**12.13**], no trace of the repeating false doors is found on the eastern, northern and western faces, and we think it very possible that

Mapping Khentkawes

In 2006 AERA team member Yukinori Kawae put a powerful technology -- 3-D laser scanning – to work on the task of mapping the Giza Plateau and its monuments, setting up the Giza Laser Scanning Survey (GLSS), with a consortium of Japanese universities and scientific institutes. The aim is to produce detailed 3-D models of the monuments, recording their current state, including restorations, and thus establishing a basis for long-term monitoring. Unlike conventional mapping and line drawings, laser scanning involves minimal interpretation, capturing the whole site as it actually is, including manmade structures and their natural context, in three dimensions.

Laser scanning equipment uses microwave or infrared signals to gather the coordinates and elevation of a point on a monument, amassing data at incredibly fast rates, such as 10,000 points per second. The product is a raw data 'point cloud' of the subject. We can then produce extremely detailed 3-D representations and orthophotographs (photos without distortion) of plans and sections.

Two steps produce 3-D models from laser scanning: modelling and rendering. Modelling converts the subject into numerical data; rendering then uses that data to produce a digital image. In recording the Khentkawes monument the team used a long-range and a middle-range laser scanner (Riegl LMS-Z420i and Riegl LPM-25-HA) and a laser range finder (Konica Minolta Vivid 910), according to the accuracy required and the range of the measurements. For instance, team members used the long-range scanner for scanning the exterior of the monument from 55 positions; they used the middle-range scanner to measure inside the tomb, its individual features and the masonry superstructure; and they used the laser range finder for scanning in detail the inscriptions with Khentkawes' titles and her image.

0 30 cm

0 1 ft

12.10, **12.11**, **12.12** Laser scanning images of the Khentkawes monument. Above: Khentkawes' titles; below: profile and east elevation of whole monument, with the southeast corner cut out to form the outer room of the chapel; opposite: aerial view. In the aerial view the trenches cut into the mastaba by people searching, unsuccessfully, for chambers are clearly visible.

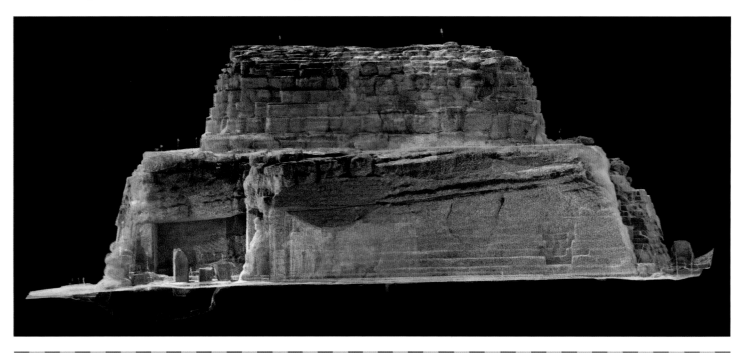

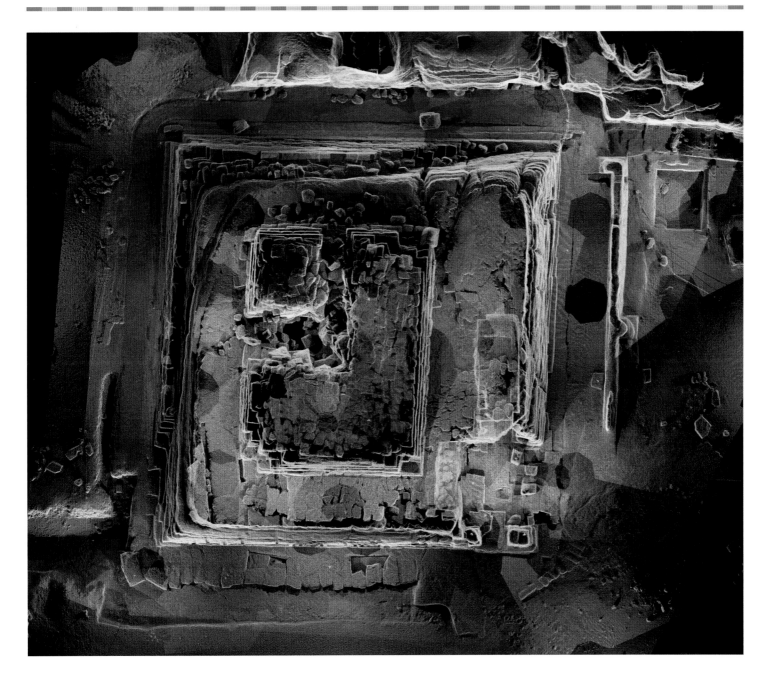

After scanning section by section, the team integrated the data into a single model, aligning the positions of all the scanned point clouds precisely with laser markers distributed on the monument and fine tuning their alignment using an algorithm. Then they merged all the scanned data into a single point-cloud model. Finally, colour information from a digital camera was added to improve visualization.

Not only do the results include the information we need to record and interpret the site, but we could also export the data to other systems, such as GIS (Geographical Information Systems) to understand the spatial configuration of the Giza Plateau, or to AutoCAD to calculate the volume of the masonry structure. Using a laser scanner to record may also be effective when investigating a large structure in a limited amount of time. Looking beyond, laser scanning can play a role in long-term monitoring of monuments and capture details of inscriptions and reliefs that are often deteriorating beyond rescue, even facilitating the production of 3-D replicas.

12.13 View of the northeast corner of the Khentkawes I monument where the face of the bedrock pedestal shows the steps masons cut to receive casing blocks, which are now missing. The stepped patch at the far southern end (left) is modern repair. The deeper recess near the northern end (right) is where the casing was formed into a broad false door. Casing and packing are revealed in profile against the north side of the pedestal (right). The segment of the enclosure wall cut in bedrock is visible in the lower left. View to the southwest.

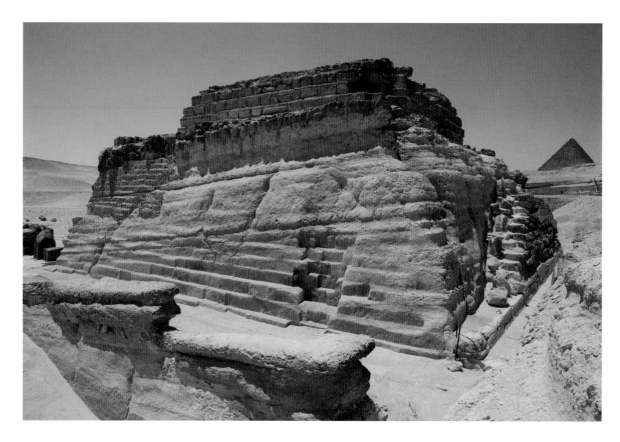

Khentkawes' builders only decorated the southern side. It may be that they originally intended to continue the decoration on the other sides, but abandoned this plan when they realized that in order to square the pedestal they had to finish it with packing and casing.

The queen's builders set the casing on a platform of fine white limestone, as with the casing of the Khufu pyramid. Where both casing and platform remain on the northern side, the platform extends 74 to 84 cm (29–33 in.) beyond the foot of the casing. The variation results from the fact that the masons never completed dressing back the extra stock of stone to create a straight, even, upper edge and angled slope for the front face of the platform. Where it is dressed, the platform's upper edge extends 48 to 52 cm (19–20½ in., or around 1 cubit) from the bottom of the slope of the casing. The masons did not even begin dressing the foundation platform along the western side.

The casing itself consists of fine Turah-quality limestone, the individual courses ranging in height from 43 to 78 cm (17 to 31 in.). The width of the individual slabs varies greatly (65 to 180 cm/25 ½ in. to almost 6 ft) because in places the masons filled the space between the undressed rear face of the casing blocks and the bedrock face with packing. This packing, which is visible where courses above have been removed, consists of very irregular fragments of locally quarried limestone. Not surprisingly, the packing is especially thick

(up to 2.2 m/7 ft 3 in.) where the builders had to fill out the upper part of the northern face to bring the northwest corner as close as possible to a true square, as noted above. The filling to create a good 90 degree corner here is one of the compelling reasons we think that the casing was neither an afterthought nor a second phase of building.

In a gap at the northwest corner we can see the lowest five courses of casing in section on both the northern and western sides [**12.14**]. From our measurements of the thickness of the casing here – 1.25 m (4 ft 1 in.) on the north side and 1 m (3 ft 3 in.) on the west – and assuming it was the same thickness respectively on the corresponding southern and eastern faces, we calculate that when the casing was added the pedestal was slightly longer north–south than east–west.

Maragioglio and Rinaldi averaged numerous measurements of the intact casing to calculate a slope for the pedestal of 74 deg. 2 min., which they cite as two palms setback to a rise of one cubit.[4] We measured the slope or batter of the casing on the northern and western sides, and of all four sides of the core bedrock pedestal, graphically, using the elevation plots of the laser scanning. From this, we obtained an average slope of the bedrock pedestal of 74.5 deg., and 72.75 deg. as the average slope of the casing; this gives 73.33 deg. as an average slope of all the bedrock and casing faces.

At the southern end of the western bedrock face we can see the steps the masons cut to fit the casing slabs. A vertical section where the slabs are exposed reveals the tight fit between the two at this point, with little or no packing material. As noted, at the northwest corner we can see the lowest five courses of casing in section, and here the masons cut the bedrock face into steps 15 to 24 cm (6–9½ in.) wide to receive casing slabs tight against it. At the base of the north end of the eastern side, harder beds, buried by debris until Selim Hassan's excavation, show the steps where the masons cut back the bedrock face to receive casing ranging in height from 54 to 60 cm (21¼ –24 in.). Although we see none of the stepped cut-backs for casing on the southern face, the fact that the deeper niches of the false door motif retain a fill of small stones and mortar make it likely that the builders also completed this side with casing, as on the other three sides, covering the false door decoration.

The exposed areas of the northern, eastern and western faces of the bedrock pedestal reveal no trace of the false door decorative motif of niches and panels found on the southern face. The northern face is worn and cleaned white by continuous weathering. The original surface, just behind and above where the packing material presses against it, has a dark, crusted, patina and shows marks left by dressing with a pointed chisel and the undulations where the masons worked the bedrock back.

A huge fissure, 0.50 to 1.3 m (20–51 in.) wide, runs down through the bedrock pedestal 11 m (36 ft) west of its upper northeast corner. Together with the deficiency of the northwest corner, this and other fissures make it hard to believe that the builders ever intended this face to be dressed smooth and carved with elaborate relief decoration. Where the original bedrock face is preserved on the eastern side, sweeping linear tool marks still show through the brown patina, left when the masons dressed it using pointed chisels.

False door niche

On the eastern side of the pedestal, the masons cut a broad niche or recess 5.4 m (17 ft 9 in.), but perhaps an intended 10 cubits (5.25 m/17 ft 4 in.), south of the northeast corner. Within this recess they carved the steps or setbacks for the casing 12 to 80 cm (4¾ to 31½ in.) deeper into the bedrock face (see 12.13). A step for the foundation platform of the casing at the base of the niche is missing. The niche, which shows up prominently in the laser scanned profile view (see 12.11), varies in width from 1.06 m at the bottom to 2.94 m at the top (3 ft 6 in.–9 ft 6 in.).

Maragioglio and Rinaldi are surely correct in seeing this as the vestiges of a false door that the builders framed into casing set deeper into the bedrock face.[5] They pointed out that the distance of the recess from the northeast corner is about the same as the distance of the setback for the entrance to the chapel from the southeast corner. The arrangement of the pair of features – a false door to the north and the actual door to the chapel to the south – finds a counterpart in other large mastaba tombs, where a large niche or chapel entrance occupies the southern end of the eastern face, complemented by a smaller niche to the north.

OPPOSITE BELOW
12.14 At the bottom of the northwest corner of the pedestal, the removal of blocks provides a section through the casing, which sits on a platform of fine limestone. The base of the mud-brick enclosure wall, exposed in 2006, wraps tight against the monument. Masons built this wall at the same time as the Khentkawes Town, after work in stone stopped and the queen's monument stood completed.

The chapel

Among several elements that mark out Khentkawes I's tomb complex as unique is her chapel. This consists of a southern, outer room and a broad niche, which occupy the corner the builders cut away from the bedrock pedestal, together with a northern, inner room, which was entirely hewn inside the pedestal. The entrance to the chapel stood at the end of a long and narrow causeway leading up from a valley complex that we discovered in 2007–11 (see below, p. 305).

When the quarrymen hollowed out the chambers and substructure of Khentkawes' monument, they made their job that much easier by following major fissures and joins for the vertical faces and chambers, and softer, marly (more clayey) beds for surfaces, floors and ceilings. In creating the large recess in the southeastern corner of the pedestal they removed the bedrock from between upper and lower clay-like marl beds up to a major north–south fissure that corresponds to the front of the broad niche in the southern chapel room, and to an east–west fissure that corresponds with

the northern wall of the same room. We can still see this fissure running through the upper beds above the level of the ceiling of the broad niche.

In doing so, the masons completely cut away the bedrock from the southeast corner of the pedestal, except for a low shoulder that formed the foundation of the southern wall of the outer room and an overhang of bedrock that formed the ceiling of the broad niche. They then finished the outer chapel room with masonry walls.

Entrance bay

The entrance to the chapel is set within a small recess or bay, 8.7 m (28 ft 7 in.) wide. Casing (1 m/ 3 ft 3 in. thick) on each side reduced the width but increased the depth of the entrance to a total of 3.12 m (10 ft 3 in.). The builders paved the floor area of this entrance bay with limestone, as shown by pavement slabs that survive intact or emplacements for others cut into the bedrock floor.

Within the entrance bay, two red granite jambs flanked the doorway to the passage into the chapel [12.15]. On the front faces of the jambs sculptors

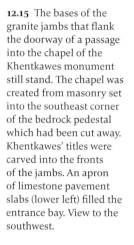

12.15 The bases of the granite jambs that flank the doorway of a passage into the chapel of the Khentkawes monument still stand. The chapel was created from masonry set into the southeast corner of the bedrock pedestal which had been cut away. Khentkawes' titles were carved into the fronts of the jambs. An apron of limestone pavement slabs (lower left) filled the entrance bay. View to the southwest.

carved the false door motif topped by a drum roll. It was on these jambs that identical vertical inscriptions gave the names and titles of the queen and ended with her seated figure [**12.16**]. One surviving figure is 19 cm (7½ in.) wide and 29 cm (11 in.) high; the queen's tiny head might feature a *uraeus* on the forehead and a short square beard, although it more likely she wears the vulture headress of queens, so that the projection is the head of the vulture, not the *uraeus*.

These details are historically crucial because they are icons of either kingship or queenship, and some Egyptologists have taken the minuscule tick on the forehead of the little figure as evidence that Khentkawes declared herself king, along the lines of the famous Hatshepsut, a millennium later. We have looked at the diminutive figure many times, in various lights, and cannot discount the possibility that the 'tick' is in fact just a small mark in the texture of the granite.

The doorway framed by these jambs opens to the entrance passage leading back into the southern, outer room of the chapel.

The southern chapel room

Today, almost all the masonry of the walls of the southern room of Khentkawes' chapel has disappeared, leaving the cutout in the bedrock opening like a yawning garage door. The chamber measured 2.62 m (8 ft 7 in.) by 7.35 m (24 ft). Builders founded the thick southern wall of large, locally quarried core blocks on the low, broad shoulder of raised bedrock that they reserved when then cut and levelled the exterior terrace. Stacked core blocks remaining at the eastern and western ends were once sandwiched between the fine limestone casings. Both the room and the bedrock foundations of its eastern wall are now open to the sky, but originally it must have been roofed with large stone beams that spanned the space, resting on the casing of the walls. The pavement, consisting of two rows of large slabs laid north–south, remains intact, lying flush with the thick, raised bedrock foundation of the eastern wall.

Khentkawes' builders appear to have installed some kind of statue shrine in this room. Evidence for this takes the form of an emplacement, previously unnoted, near the southern end of the eastern wall, behind one of the granite jambs of the entrance corridor. A rectangular hole or shaft opens through the pavement and penetrates the underlying bedrock for 1 m (3 ft 3 in.). The shaft may have received the bottom of another granite upright that continued the entrance passage to the west (although no corresponding shaft or socle exists for a counterpart upright on the north of this passage). At the western edge of this shaft, two long cuttings through the pavement and into the bedrock appear to have been sockets for jambs of a narrow doorway, about 90 cm (35½ in.) wide. The cuttings flank the corners of an emplacement in the pavement, which seems to be framed by the adjacent pavement slabs as opposed to having been cut through them when they were already in place. Within the emplacement is a square cutting into the bedrock, 80 cm (31½ in.) north–south and 1.04 m (41 in.) east–west. The arrangement of the emplacement and the sockets for small door jambs suggest that Khentkawes' builders framed a niche that contained a *naos* or shrine, about 61 cm (24 in.) deep, with double doors, possibly for a statue of the sovereign.

The broad niche

A broad niche or small chamber, about 7.6 m (25 ft) wide and 5.2 m (17 ft or 10 cubits) deep, carved into the bedrock, opens off the western side of the chapel room. The quarrymen left a bedrock ceiling that overhangs the rear by 2.5 m (8 ft 2 in.), giving this niche a cave-like character. It is not clear whether the niche remained open along its entire length on to the southern room, albeit at a higher floor level (72 cm/28 in. above the chapel). We are likely missing an access – perhaps a short corridor between the southern room and the niche, or an incline up to the higher floor level such as we see in the five-statue niches in pyramid temples.

Indeed, the builders probably framed statue shrines, or chambers, within this niche: Selim Hassan and Maragioglio and Rinaldi tentatively reconstruct three chambers with dashed lines. If, however, the niche contained five statue chambers, it would form a further correspondence between the funerary monument of Khentkawes and those of kings. Beginning with Khafre, skipped by Menkaure, but continuing in the 5th and 6th dynasties, upper pyramid temples contained five statue niches facing eastwards in the direction of the open court and causeway axis. These niches,

12.16 On the southern granite jamb of the entrance to her chapel, Khentkawes I is shown in relief, possibly as a statue, seated on a block throne, the determinative of her name and titles. The small image is probably intended to show the queen wearing the vulture headdress of queen mothers. A tick at her forehead conveyed the projecting vulture head rather than a *uraeus* – if it is not simply a natural fleck in the granite surface.

referred to as 'caverns' in the Abusir Papyri, were set at a higher floor level and had a lower ceiling. The feature in Khentkawes' tomb has sufficient space to contain five statue niches each a little more than a metre wide, with four dividing walls about half a metre wide.

In the area of the chapel and in the ruins of the town to the east, Selim Hassan's workers found numerous fragments of relief scenes of offering bearers, scribes and the signs for towns and estates carved into fine limestone, which he thought derived from the queen's chapel.[6] Maragioglio and Rinaldi suggest that the walls of the southern chapel room and broad niche were decorated with scenes and inscriptions in painted low relief.[7]

The northern chapel room

The long, inner, northern chamber of Khentkawes' chapel was hewn entirely within the giant bedrock pedestal. Again the builders may have exploited the natural geology of the site to facilitate their work, probably hollowing out the space by cutting east and west of a major vertical fissure that we can see running north–south down the approximate centre of the northern wall. They left a screen of bedrock between the southern and northern rooms forming a wall with an entrance. Today, much of this bedrock partition has fallen

away and in modern times workers restored the wall and erected an iron fence and gate [**12.17**].

Two blocks laid end to end slope up slightly through a passage from the southern chamber. From the threshold of the northern block of the entrance passage to the bedrock face of the opposite wall, the northern room extends 11.05 m (21 cubits). The overall length of the western side is 11.82 m (38 ft 9 in.), though this would have been reduced to 10.02 m (32 ft 10 in.) when the room was cased, based on the width of the socle of bedrock left when the masons cut down into the floor as they trimmed the face of the casing.[8] East–west, the chamber is only 4.26 m (14 ft) wide (measured between the base of the walls at the southern end), though if we include the missing casing it would have been 2.62 m (8 ft 7 in./5 cubits) wide; it is 5.53 m (18 ft 2 in.) high (measured in the southwest corner).

The builders laid out the northern and southern rooms to the same finished width (5 cubits) and on the same north–south axis, though there is a slight bend at their juncture, so that the northern, interior room is about 3 degrees west of the alignment of the southern room.

Several limestone casing blocks remain at the southern end corner of the chamber, against both the eastern and western walls. The upper part of the eastern wall has been much restored in modern times using small blocks and mortar. However, where the original bedrock face is exposed, we can see it is cut in stepped panels, showing where the masons trimmed this face when they set in the courses of casing blocks. The heights of the panels and cutbacks indicate the thickness of the missing courses, ranging from 42 to 68 cm (16½ to 26¾ in.), commensurate with the thickness of casing courses that remain on the exterior northern and western sides of the pedestal.

The false doors

A large granite slab (2.05 m/6 ft 8 in. wide and 3.72 m/12 ft 2 in. tall) stands against the southern end of the western wall, where modern workers re-erected it. Only the lower part of the outer face retains its relief carving. Simple false door motifs flank a deep central niche; to either side, a third, higher plane features more complex false door patterns with two-step compound niches [**12.18**]. The granite slab has a convex, humped back, and

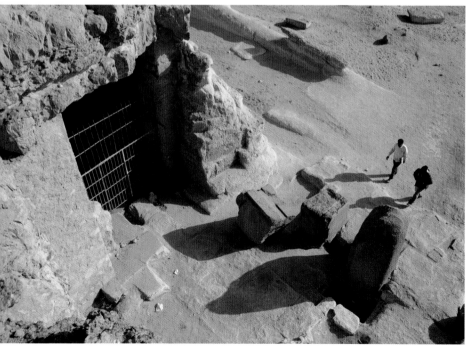

12.17 The opening to the inner (northern) room of Khentkawes' chapel, cut into the bedrock. The outer, southern, room of the chapel, now open to the sky, was originally fitted into the cut away southeastern corner of the pedestal. A finer, narrower passage, framed in masonry, connected the two chapel rooms. Modern reconstructed jambs and an iron fence and gate now close access between the two rooms. View to the northeast.

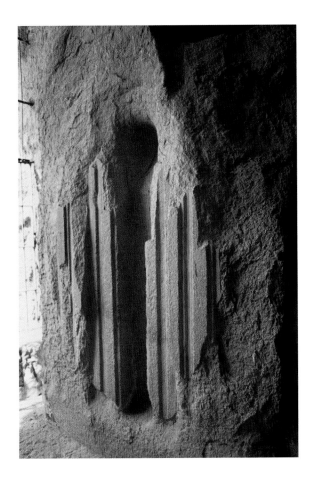

the masons cut the face of the bedrock wall behind to accommodate it.[9] As elsewhere at Giza, when it came to laying granite blocks over limestone, the builders found it easier to cut the softer limestone than the harder granite to achieve the fit.

A second large granite false door slab may have stood in another recess (2.9 m/9 ft 6 in. wide and 4.13 m/13 ft 6 in. high) carved in the western bedrock wall. Here the masons cut the rock back 20 to 40 cm (8–15¾ in.) deeper than the general plane of the wall. The cutting rises to about the same height as that for the granite false door slab restored in place to the south, but its lower southern corner is 90 cm (35 in.) above the bedrock floor and just above the southern side of the sloping passage that opens in the floor of this chamber and leads down into the tomb's substructure. Did it rest on a support that bridged that passage?

A major fissure runs down through the cutback, directly above the sloping passage (the quarrymen probably opened the passage by expanding from it); beyond the fissure, the cutback is flush with the wall all the way to the northwest corner of the room. A large square hole near the top of the panel, possibly to receive a beam to assist bringing in the granite slabs, could define the northern side of this emplacement for a second false door.

Against the eastern wall of the northern chapel room another piece of granite lies on its side. On one face it is carved in relief with part of the title of Khentkawes as [*mwt*] *njswt bjtj njswt bjitj* – '[Mother of] the King of Upper and Lower Egypt' ('Mother of' is missing), together with part of an offering table scene. Maragioglio and Rinaldi thought that this might be the remains of the false door that once stood above the sloping passage. If so, the queen would receive sustenance at her dining table at the exit from her eternal abode below.

In a bar of bedrock that masons left along the top of the western wall when they carved it in preparation for the casing and false door slabs, we see a series of seven holes, each about 18 cm (7 in.) square and 12 cm (4¾ in.) deep and irregularly spaced. A larger square hole below the lower south corner of the recess for the second false door may have been for a wooden beam to help manoeuvre the granite slabs that lined the sloping passage.

The builders carved another large rectangular recess in the northern bedrock wall of the chamber. Up to 72 cm (2 ft 4 in.) deep, it rises to within 60 cm (23½ in.) of the ceiling, narrowing slightly towards the top from a width of about 3 m (9 ft 10 in.) at the base. No real edge exists to the recess on the east, possibly because it was from this side that the builders inserted a third, missing granite false door slab. Approximately in the centre of this third recess is a large, almost vertical fissure, which opens into a kind of grotto. The grotto appears to be an artificial widening of the fissure and penetrates 3.24 m (10 ft 8 in.) into the bedrock, narrowing and diminishing in height. Did the workers enlarge the grotto as a 'proofing hole' to test the fissure before erecting the granite slab of the false door?

In front of the northern wall, between it and the trench of the sloping passage, a linear bar of bedrock, 2.18 m (7 ft 2 in.) long, rises 25 cm (10 in.) high off the floor. This feature may have been connected with the introduction and placement of the third, northern large granite false door. Mortar residues on the northern wall west of the recess may remain from limestone casing that framed the granite false door slab.

Altogether, then, it seems that three large granite false doors, two on the west, and one on the north, dramatically framed by a casing of fine white limestone, dominated the northern room.

12.18 Remains of a false door motif in the tomb of Khentkawes.

The substructure

The substructure of Khentkawes' tomb adds to the royal aspect of her funerary complex. Its sloping entrance passage, subterranean false doors and six grottos, all hewn from the bedrock, are unlike the substructures of other queens' tombs [12.19]. However, the arrangement bears strong similarities to the substructure of the Menkaure pyramid and that of the gigantic mastaba of Shepseskaf; indeed, it appears transitional between the two.

The sloping passage

The granite-lined sloping passage leading to the tomb's substructure opens in the trench sunk into the bedrock floor towards the northern end of the inner chapel room, passing under its western wall. From the eastern end of the trench to the eastern face of the subterranean vestibule, the passage slopes for a length of about 9.39 m (30 ft 9 in.) at its base, with a width of 2.3 m (7 ft 6 in.) and a height of 1.7 m (5 ft 7 in.). The bedrock floor and the granite beams that line the sides slope at an angle of 26 deg. 5 min. The workers damaged the southern edge of the trench when they used large wooden levers to lower the granite slabs in from this side.

Our laser scanning and 'point cloud' mapping reveal that the southern side of the passage lines up exactly with the northern wall of the burial niche, and this line is close to perpendicular with the major lines of the northern chapel room and the vestibule. On the northern side of the passage trench the builders cut back the bedrock face to create a sloping ledge that supports the huge granite beams lining the passage.

For the last metre of the passage the ceiling levels out, creating a kind of antechamber or vestibule. The top of the bedrock passage meets the northern end of the subterranean vestibule 1.85 m (6 ft) above the floor level of the vestibule. At its base, however, the sloping bedrock trench drops to a square pit, about 2 m (6 ft 7 in.) wide east–west by 1.5 m (4 ft 11 in.) north–south, and 45 cm (18 in.) deeper than the general floor level of the vestibule. Inset into the floor at the bottom of the passage a stone block remains in place, probably intended to level the floor for the final granite paving of the passage. The builders first cut the floor deeper in order to manoeuvre something large down into the lower chambers – most likely the sarcophagus.

The granite slabs paving the bedrock floor of the sloping passage were laid into a deeper central channel so that they came up flush to the bottoms of the large granite beams at either side of the passage. Four pavement slabs survive, about 48 cm (19 in.) thick. Three large granite beams remain in place on the northern side of the passage and two on the southern [12.20].[10]

It is interesting that a series of six small, rectangular cuttings in the northern side of the bedrock passage, probably for wooden levers used to manoeuvre the granite beams into place, have some resemblance to the niches and notches above the ledges in the Grand Gallery of the Khufu pyramid (p. 150). Similar lever sockets in the southern bedrock face of the passage are less distinct.

Measured between the granite beams, the sloping passage is 88 to 90 cm (around 35 in.) wide. There is thus a progressive narrowing of access into and through the chapel rooms and down into the burial chamber, from 96 cm (38 in.) at the entrance into the southern chapel room, to 93 cm (37 in.) at the passage into the northern room.

The subterranean vestibule

The vestibule opens out to the burial niche, or chamber, with a set of six grottos (Selim Hassan called them magazines). Two square cuttings at ceiling level may have been to receive the ends of a wooden beam or log that was used in the operation to manoeuvre the sarcophagus into the burial niche.[11] The width of the vestibule – 5 cubits – is the same as the southern and northern chapel rooms.

12.19 Point cloud profile of the subterranean chamber in the Khentkawes monument, from east (left) to west (right), view looking south. The profile cuts through the more rectangular subterranean vestibule on the left and, on the right, the burial niche with the depression and remains of the socket that received a sarcophagus, now missing.

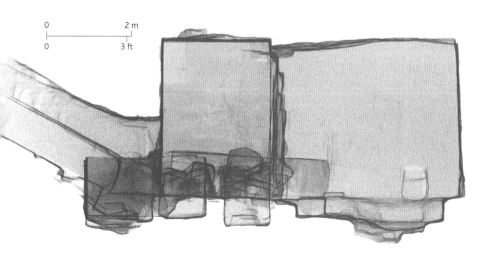

| 0 | 2 m |
| 0 | 3 ft |

Subterranean vestibule dimensions

Length (N–S)	7.85 m (25 ft 9 in.) 15 cubits
Width (E–W)	at floor level
	2.62 m (8 ft 7 in.) 5 cubits
Height	
North end	c. 3.69 m (12 ft 1 in.)
Centre	c. 3.65 m (12 ft) 7 cubits
South end	3.81 m (12 ft 6 in.)

Khentkawes' masons began to carve two crude false doors into the bedrock faces of the western wall, one immediately on each side of the opening into the burial niche, but never completed them. The southern false door (about 1.52 m/5 ft wide), has a series of vertical panels of rather irregular width stepped back and flanking a deep, central niche; that to the north (1.48 m/4 ft 10 in. wide and 23 cm/9 in. deep) also has narrow panels flanking a deeper central niche. Both doors lack a drum roll above, but are topped by a roughly square panel of bedrock surface, which must have been intended for a standard carved scene showing the deceased sitting before an offering table, though this was never executed. Selim Hassan thought that, rather than being unfinished, both roughed out false doors would have been completed in a finer stone casing.[12]

The burial niche
Directly between the two false doors lay a deep niche or chamber, 4.2 m (13 ft 9 in./8 cubits) wide and with a depth of 4.5 m (14 ft 9 in.); its eastern side was completely open to the vestibule. Here once rested the queen's sarcophagus, which is now missing.

In this niche the quarrymen cut the floor down to an uneven depth in a roughly rectangular patch that probably formed a socle for the sarcophagus; if so, they would have needed to level the bottom with stone debris to create an even base. As they cut down, the quarrymen left ledges along the eastern, northern and western sides of the burial chamber. A rectilinear cutback into the northern ledge might mark the exact fit of the sarcophagus. The quarrymen then cut a lower, less regular lower ledge. The deeper area within this lower ledge measures 2.38 m (7 ft 10 in.) wide (east–west) and 2.68 to 2.8 m (8 ft 10 in. to 9 ft 2 in.) long north–south, approximately 5 cubits.

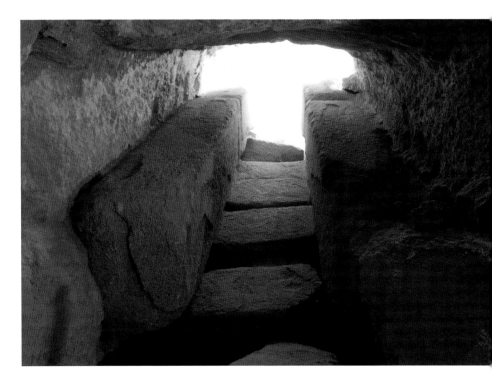

Within the deeper level, the workers cut down yet another area, roughly square and half a metre (20 in.) lower, probably to take the ends of wooden levers that they inserted under the sides of the sarcophagus as they manoeuvred and lowered it into position. On the south, the higher bedrock floor forms more of a slope and the ledges are less defined, which may indicate that workers introduced the sarcophagus from this side, easing it down the sloping floor and pushing it up against the more defined upper ledge on the north. When he cleared the chamber, Selim Hassan saw in the stone debris indications that the sarcophagus might have been of polished alabaster, set within a granite casing of the burial chamber in the form of a vaulted chamber. He reported:

> [The niche] is now filled with huge blocks of red granite, some of which are intact, and measure 1.78 × 0.70 × 0.71 m., and also many large fragments of white Turah limestone. From the size and shape of these granite blocks it would appear as though they had once formed a chamber in the shape of a sarcophagus, and having a vaulted top similar to the superstructure of the pyramid. A similar arrangement occurred in the Step Pyramid at Sakkara, and here the stones

12.20 View back up the descending passage that leads to the Khentkawes substructure. Some of the granite blocks remain that once encased the passage cut through bedrock. View to the east.

had been carefully marked to facilitate their assemblage. This chamber seems to have housed a sarcophagus of polished alabaster, many fragments of which we recovered from the debris and sand with which this chamber was filled.[13]

If he had recorded these pieces and attempted to reconstruct the granite vault and alabaster sarcophagus, we might know whether the latter fitted into the bedrock emplacement. From the various dimensions of the burial niche and indications in the form of rebates and holes, we can calculate the size of the sarcophagus as roughly 1.04 m (3 ft 5 in./2 cubits) wide and about 2.1 m (just under 7 ft/4 cubits) long, and possibly 1.22 m (4 ft) high (the distance from the bedrock floor at the base of the lower ledge along the northern and western walls to the bottom of the cutting in the southern wall). Holes in the northern and southern walls of the burial niche may have been cut to assist in the operation of placing the sarcophagus, or its lid, in its final resting place, or for placing the granite blocks of the vaulted chamber.[14]

The grottos

The six grottos or niches with well-finished walls, four opening off the eastern wall and two off the southern, are comparable with those in the substructure of the Menkaure pyramid (see p. 251), though smaller. Each has a short, narrow entrance, from 24 to 30 cm (9½ to 12 in.) long, a little more than 60 cm (just under 2 ft) wide and 90 to 97 cm (3 ft to 3 ft 2 in.) high. The tops of the entrances are carved into a rebate representing a lintel. The ceilings drop 17 to 25 cm (7–10 in.) below the tops of the entrances, while the floors widen, ranging from 98 cm to 1.22 m (3 ft 2½ in. to 4 ft) wide, and drop to a level 50 to 60 cm (20–24 in.) deeper than the floor of the vestibule. They range in length from 1.46 to 1.71 m (4 ft 9 in. to 5 ft 7 in.) and in height from 1.35 to 1.6 m (4 ft 5 in. to 5 ft 3 in.).

Top of the pedestal

The terrace

Moving from the substructure to the superstructure, as already noted, the masons first levelled the top of the pedestal with masonry to compensate for the natural dip of the rock strata, and then built the mastaba on top of this. On three sides they set the mastaba back about 10 cubits from the upper pedestal edge, while on the east it was set back further, by 10.5 m (34 ft 5 in.), exactly 20 cubits. Along the northern and western sides the terrace is now 4.8 m (15 ft 9 in.) wide; where the upper edge of the bedrock pedestal is better preserved on the southern side, the width is 5.5 m (18 ft).

The mastaba casing would originally have taken up some of this width, while the casing of the pedestal would have added to it. We do not know if the builders left a sharp or rounded edge to the top of the pedestal, but given that they paved the terrace they might have constructed a low wall or parapet around the edge. We see no sign of ramps or stairways to reach the top from ground level.

The terrace was paved with slabs of Turah-quality limestone joined in the jigsaw patterns so characteristic of Old Kingdom pavements around the pyramids and in the temples of Giza and elsewhere. We can still see the emplacement cuttings for individual pavement slabs. Patches of pavement, 28 to 31 cm (11–12 in.) thick, remain at the northern ends of the western and eastern sides. Three or four slabs of an irregular patch of pavement on the east press up against the face of the lowest course of mastaba core masonry, revealing that the builders first raised the mastaba core then laid the paving of the terrace up against it. The casing slabs of the mastaba must subsequently have rested upon the pavement.

By shifting the position of the mastaba to the west on top of the pedestal, the eastern side lies directly above the subterranean burial chamber. Our laser scanning shows the east–west centre axis of the mastaba is about 3.72 m (12 ft 2 in.) north of the east–west centre axis of the burial chamber. The intention was to have the burial chamber directly under the mastaba, which took the form of a gigantic sarcophagus.

Once again, given that the builders founded the mastaba on top of the levelling masonry and then paved around it, it seems certain that they created the bedrock pedestal, the levelling masonry, the mastaba, the paving of the terrace and the casing of the mastaba as one, unified project, rather than the pedestal and mastaba representing two chronologically different building phases, as has been accepted by Egyptologists until now.

The mastaba

Like the pedestal, the mastaba on top of it was once encased with fine, white Turah-quality limestone. Without its casing, we measured the length of the core mastaba as 26.85 m (88 ft) north to south along its eastern side, and its width as 20.44 m (67 ft) along the southern side.

The mastaba is a solid structure of masonry consisting of ten courses of stone [12.21]. Of these, the first five courses of thick blocks make up most of the total height, which at its best preserved is 8.31 m (27 ft 3 in.). The height of the blocks in each of these courses varies, and the tops are very irregular.[15] The side joins between adjacent blocks are not perpendicular to the horizontal beds or to the joins between courses, but often angle or lean, the result of the masons custom-cutting the ends of one block to fit the end of the block previously laid down in any given course.

More regular is a flat, relatively level ledge or rebate (up to 17 to 33 cm/c. 7–13 in. wide and 10 to 12 cm/4–4¾ in. deep), cut into the upper edges of the outer faces of the blocks and running for the most of the length of each of these lower five courses. The courses are successively stepped back flush with the rear, vertical side of the ledge in the course below,

thereby creating the slope or batter in the faces of the mastaba. Sometimes the builders used blocks of extra thickness to make up a given course and even part of the height of the course above, whereas the ledge or rebate remains very level. The 'height' of a course might therefore be measured as the distance from top of the ledge of one course to the top of the ledge of the course above.[16]

Such ledges are commonly found on the upper edges of masonry courses of the three pyramids of Menkaure's queens (GIII-a–c) and other mastabas at Giza. In the Khentkawes mastaba this horizontal line seems to mark the true coursing of the masonry, rather than the joins between the stones, and may have served as some kind of control for height or level during building.

The stones of the five upper courses (6–10) are thinner and far more irregular than the lower five,[17] and are set back a metre or more from one another to create the round, vaulted top of the mastaba. Our laser scanning survey indicates that overall the top of the mastaba is close to level, with a very slight slope down to the south.[18]

At some point people dug into the mastaba from two directions, removing blocks from the core to create one channel from the middle of the north

12.21 The Khentkawes mastaba, north side, perched on the bedrock pedestal. Blocks are missing and one is tipped from the northeast corner (left). In the past someone trenched through the core masonry looking for a chamber. View to the south.

side and another from almost the middle of the western side. These trenches met in the centre of the mastaba, isolating its northwest corner as a block. The objective was no doubt to discover whether the mastaba contained a chamber, which it apparently does not. The queen's burial chamber lies instead carved from the bedrock below the mastaba and pedestal, as described above.

The breaches do, however, provide useful cross sections of the mastaba core. Large limestone 'blocks', barely squared and measuring up to 2 m (6 ft 7 in.) high and wide, comprise its centre. The builders simply piled up these irregular pieces with very few continuous, horizontal courses, the fill being held in place by the outer courses, which in effect formed a crude inner casing.

The mastaba casing

The exterior of the mastaba was once covered in casing, probably of fine white Turah-quality limestone. Shallow horizontal rectangular panels are visible on the lower courses where the masons cut back the core blocks to receive casing slabs around 36 cm (14 in.) thick. With this outer casing, the mastaba must have measured 28.85 m (94 ft 8 in./55 cubits) long, 22.44 m (73 ft 7 in./43 cubits wide) and about 9.5 to 10 m (31 ft 2 in. to 32 ft 10 in./18 to 19 cubits) high.

It is reasonable to assume that the inward lean of the sides of the cased mastaba would correspond roughly to our measurements for the sides of the core masonry obtained from our laser scans – 73 degrees for the southern face, better preserved than the north, and 76.5 degrees and 73.5 degrees for the eastern face, since the irregularity in the core masonry is greater on the long east and west sides than on the shorter ends. The average, 74.3 degrees is close to the 74.02 degrees Maragioglio and Rinaldi obtained for the slope of the casing.

Maragioglio and Rinaldi refer to Selim Hassan finding a terminal casing block that indicates the top edge of the cased mastaba was slightly curved. We do not know whether the short ends of the mastaba projected above the vault of the top, as is the case on many sarcophagi of the time, as well as the gigantic mastaba superstructure of Shepseskaf, but if such projections did exist, the builders must have fashioned them in the casing, because no traces of end projections survive in the core masonry.

External elements of the tomb

As with the substructure, the external layout of Khentkawes' funerary monument includes features, such as a long causeway to a valley entrance, that are normally reserved for the tombs of kings. But it is only in the last few years that we have found the true valley complex of Khentkawes at the end of her causeway.

The boat pit

At the southwestern corner of her tomb, Khentkawes' builders created a boat pit oriented east to west, lining up with the southern side of the tomb superstructure. Boat pits flanked the pyramids or temples of both Khufu and Khafre, though none have been found associated with Menkaure's pyramid. However, Khentkawes' boat pit cannot be included in the list of the exclusively kingly elements of her complex because boat pits accompany two of the pyramids of Khufu's queens.

The boat pit of Khentkawes is built partly in the limestone fill banked up against the deeper quarry face on which the pedestal stood; limestone retaining walls coated in mud plaster hold back the rubble. Today, the lower part of the pit, where it is cut into the limestone bedrock, is buried in sand that has drifted in since Selim Hassan's excavations, but he established that it descends 4.25 m (almost 14 ft) into the rock and is 30.25 m (99 ft 3 in.) long.[19] The western end of the pit is pointed, possibly symbolizing the queen's journey to the direction of the setting sun, the Land of the Dead; the eastern end abuts the deeper bedrock face.

Hassan's profile shows the pit as a narrow trench that widens and deepens in the middle to mimic the hull of a boat. Vertical ends may represent the upraised prow and stern that we see in Khufu's reconstructed cedar barque. Large limestone slabs and a dark granite block that Hassan mentions as lying nearby might have formed part of the roofing of the pit. He also suggested that another pit might lie below unexcavated debris to the north, the two boats signifying the day and night barques of the sun.

The enclosure wall

A mud-brick enclosure wall once ran round the Khentkawes superstructure. Hassan's map shows a gap at the south end of the west stretch of the wall, where the 'stern' of the boat pit interrupts it.[20]

He suggested the builders left the gap deliberately, in which case they might have intended to symbolize the queen's exit from her funerary enclosure as she sailed forth from her subterranean abode. Hassan calculated the average width of the wall as 2.75 m (9 ft); we measured its width along the northern side as 2.05 m (6 ft 9 in./4 cubits), where it runs 1.6 m (5 ft 3 in.) from the foot of the casing.

On the southern side of the pedestal, the wall is now completely eroded away, but Hassan measured its length as 61 m (200 ft); at the southeastern corner it turned at a right angle, whereas the other corners were rounded, ending in a gap between it and the southern enclosure wall of the Khentkawes town. This gap allowed access to the open area in front of the queen's chapel entrance. From here it would have been possible to progress east, either along the queen's causeway or the road that ran parallel with it on its south (see p. 277, 11.33).

The wall has completely disappeared at the northeast corner since Hassan's excavations in 1932, but according to his plan at this point it wrapped tight against the eastern side of the pedestal before attaching to the end of a bedrock wall the quarrymen had reserved running parallel to the eastern side of the pedestal. Between the bedrock wall and the pedestal a long court, just under 5.5 m (18 ft) wide, extended for 30 m (98 ft), where a thin mud-brick wall, now missing, closed it off from the open area in front of the entrance to the queen's chapel. Hassan believed that in this court the morticians embalmed the queen's body.[21]

The Upper Tank

From the northeast corner of the court, a channel slopes down under the bedrock wall. At some point someone mortared a block of red granite into the opening beneath the wall, but before this, water or other fluid would flow from the court along a curving narrow channel across the bedrock floor and into a rectangular rock-cut basin or tank. Hassan found low walls composed of limestone fragments surrounding the top of the basin, which measures 5.4 m (17 ft 9 in.) east–west by 6.25 m (20 ft 6 in.) north–south, and drops to a depth of 3 m (9 ft 10 in.). An inward curve of the northern wall suggested to him that a vaulted roof once covered it.

At the southwest corner, a bedrock ramp sloped down into the tank; Hassan mapped and photographed a stairway of 11 rock-cut steps descending from the ramp into the tank.[22] We wonder if most of the stairway was built of mortared fieldstone, since it has largely disappeared in the 75 years since Hassan excavated, except for the stubs of two larger steps at the top.

Hassan believed that the long court, drain and tank played a role in the ritual embalming of Khentkawes' body – in fact that they formed her personal *Wabet,* literally, the 'Purification Place', which functioned with the *Ibu* (the 'Purification Tent') in the ritual embalming process. As discussed in Chapter 7, some Egyptologists place the royal *Ibu* and *Wabet* in the valley, near the valley temples, if not actually in them; others, including Hassan, see the *Ibu* as situated near the valley temple, and the *Wabet* in the higher desert, near the tomb.

The valley complex of Khentkawes I

From the late 4th dynasty and through the 5th and 6th dynasties, the queen's memory must have been preserved and perpetuated by the people who lived in a series of houses in one of the oldest examples of a planned and carefully laid out urban structure in ancient Egypt, discussed in more detail in Chapter 15. The houses of the Khentkawes town (KKT) formed a linear settlement that extends along the causeway from the queen's tomb, and then suddenly turns at 90 degrees to form an L-shape, stretching south towards the Menkaure valley temple. Selim Hassan, who excavated the settlement, believed that the eastern Annex (see p. 272) of the valley temple of Menkaure served as the valley temple of Khentkawes I. In his view, Khentkawes built this vestibule right up against the façade of Menkaure's valley temple to reflect her intimate association with the king who was either her father, husband or possibly her son. No formal roadway connects Khentkawes' tomb to the Menkaure valley temple Annex, as discussed in the previous chapter. The south turn of the Khentkawes' town might suggest an intimate connection between Khentkawes I and Menkaure, even though the broad ramp separates their layouts.

The Khentkawes causeway, 1.6 m (5 ft 3 in.) wide, runs from the court in front of her tomb chapel

entrance for 150 m (492 ft) due east, ending at an opening in the thick, eastern enclosure wall of her town. Between 2007 and 2009 we discovered the reason both why the town turns at a right angle at this point and why the causeway stops here when we excavated the final element of the Khentkawes funerary monument – her actual valley complex, associated with a truly large basin, possibly a harbour.

Rediscovering Khentkawes' valley complex

In 2007, when we cleared the surface sand immediately east of the KKT at the point where it turns at a right-angle, we discovered that the thick enclosure wall runs flush along the upper edge of a vertical drop or ledge formed when quarrymen removed the limestone to the east. Sloping against the vertical face of the drop we found a bank of toppled mud brick that must derive in large part from the collapse of the KKT eastern enclosure wall. Within the ruined mass of mud brick we could discern walls – the town continued further east, but at a lower level. We also ascertained that the northern enclosure wall of the KKT, in addition to turning south, also continued straight eastward. Beyond the turn, we could see the outlines of a doorway through this wall from the north.

We found probe pits and trenches that Selim Hassan's workers must have made in 1932, and they also must therefore have seen this continuation of the Khentkawes complex. But being absorbed in excavating the extensive town to the west and south, they overlooked the lower-lying ruins to the east. Soon after they stopped, sand drifted back over this part of the complex. By the time Selim Hassan's cartographer mapped the town several years after the excavation, the eastern extension was reburied, and went unrecorded. After having worked intensively on the ruins east of the KKT, we have now ascertained the broad features of the true Khentkawes valley complex (see 11.32).[23]

In 2008 we discerned in the ruins a ramp rising against the face of the bedrock drop up to the threshold at the eastern end of the Khentkawes causeway. We called it the southern lateral ramp (SLR) following the discovery of evidence during our next season that there had once been a matching northern lateral ramp (NLR) sloping up to the causeway threshold from the north.

The builders created the SLR ramp in a corridor, about 1.25 m (4 ft 1 in.) wide, formed between the bedrock ledge on one side and a mud-brick wall running parallel to it. They filled the corridor with crushed limestone to make a floor surface ascending to the causeway. At the top of the ramp, just before the causeway threshold, a jamb projected from the mud-brick wall of the corridor to create a doorway, 1.05 m (3 ft 5 in./2 cubits) wide.

In its first phase the SLR sloped up at an angle of 14 degrees over a horizontal distance of about 6.3 m (20 ft 8 in.); later, the queen's builders lengthened the ramp and raised it to a slope of around 11 degrees to level off at a platform of compact silt just below the bedrock threshold of the causeway. Finally they lengthened and raised the ramp a third time, finishing it with a plaster surface on a thin layer of crushed limestone that sloped 8 to 10 degrees to arrive at the same level as the causeway threshold.

At first, the SLR was the only way to ascend to the causeway, but then the builders added the second ramp (NLR) sloping up to the causeway entrance from the opposite side. The tops of the two ramps met at the causeway threshold. While the NLR is badly ruined and dug away, we can distinguish the line of its original gentle slope up to the causeway threshold as a sub-ledge, created when the builders cut back the face of the bedrock along the slope of the ramp.

Like its counterpart on the south, the NLR rose within a corridor, 1.42 m (4 ft 8 in.) wide, formed between the marl plastered face of the bedrock ledge and a parallel mud-brick wall, whose marl plaster lines we had discerned in the mass of ruined mud bricks in 2007. Builders prepared the surface of the ramp with a bedding of crushed limestone topped by a thick layer of alluvial silt and a paving of desert marl clay. In ancient times, people had dug into the corridor to make burial pits, removing the slope of the northern ramp. Although its roadbed has mostly disappeared, the sub-ledge in the bedrock face marks the 4 degree slope of the NLR from the north upwards over a length of 8.41 m (27 ft 7 in.).

Descending from the causeway threshold, the NLR slopes down to a corner where the bedrock ledge makes a turn eastward, forming a foundation for the continuation of the northern enclosure

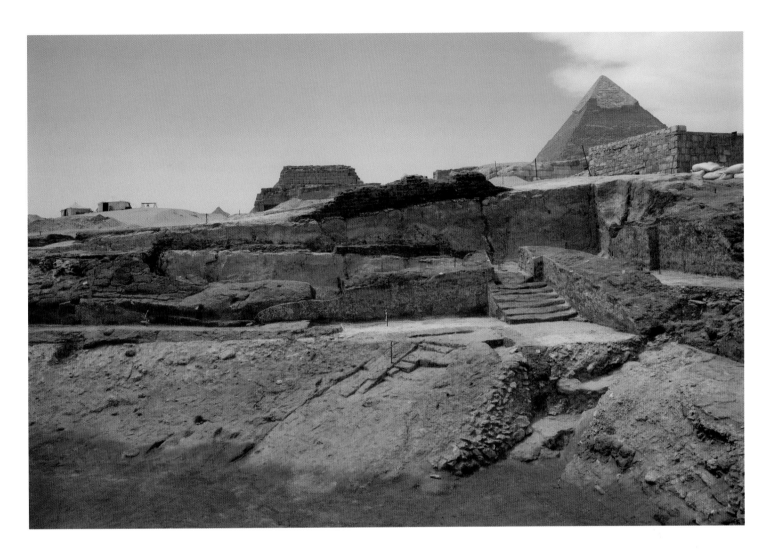

wall of the Khentkawes town. Starting in this corner in 2009, our archaeologists and workmen used shovels and pickaxes to remove the toppled mass of mud and mud brick that filled and buried a corridor running east, between the northern enclosure wall and a parallel wall, 1.1 m (3 ft 7 in.) thick. The corridor is the same width as the Khentkawes causeway, and it seems that the builders intended the NLR and its right-angled turn to the east into this northern corridor as a continuation of the causeway passage. The Menkaure causeway corridor follows a similar arrangement, turning to the south and then east to run around the southern side of the Menkaure valley temple before continuing to the east. The end of that causeway corridor has not yet been located. Both corridors are 1.5 m (4 ft 11 in.) wide.

At the bottom of the NLR, a doorway opens to a stairway, 1.45 m (5ft 9 in.) wide, built against the

northern corridor wall and descending in six steps to the corner of a lower shelf or terrace [12.22]. In one direction the terrace runs north–south along the base of the ramps and in the other along the base of the northern corridor wall. A mud-brick wall retained limestone debris that the builders dumped to make up the foundation of this terrace. The terrace extended about 1.8 m (almost 6 ft) from the base of the wall below the ramps. Forces of erosion over time have removed the retaining wall on the north and scoured the crushed limestone foundation into a glacis-like 30 degree slope. Our 2011 excavations ascertained that the glacis was intentional along the western side, sloping down into the deep basin (see below).

At the northwest corner, near the bottom of the stairway, a second stairway ramp, 3.9 m (12 ft 10 in.) long and 2.1 m (6 ft 11 in.) wide, slopes down into a deep and wide basin. In 2009 we

12.22 The northwest corner of the Khentkawes valley complex. A lower stairway ramp, badly eroded, ascends a corner of the basin to a terrace that ran along two sides of the basin. A second, higher, stairway ascends to a doorway that opens to an upper level at the bottom of the northern lateral ramp (NLR) and the beginning of a corridor running east from it. The original slope line of the NLR, mostly dug away, can be seen on the bedrock face, sloping up to meet the southern lateral ramp (SLR) (out of view to the left) at the threshold of the Khentkawes causeway.

discovered two yellow marl lines, the traces of the plaster of a banister on the south side of the ramp. After excavating the lower ramp down for a depth of 55 cm (22 in.) we discovered the bottom, which slides into the clean sand, wet with ground water, filling the deep basin.

In 2011 and 2012 we found the northeastern corner of the basin, including the mud-brick retaining wall that bounded the basin and terrace here. We measured the distance between the western to the eastern terrace as 37.2 m (122 ft/71 cubits), and have, so far, found no opening or outlet for a canal that might have come in from the east. The feeder canal perhaps lies further south, buried under a modern cemetery.

We also found the eastern end of the northern corridor in 2011, running from the bottom of the NLR. The corridor ended at a small niche, possibly a guard post, built into the enclosure wall at the corner where it turned to run along the east side of the basin. Perpendicular to the niche, a broad limestone threshold spanned the traces of a doorway opening through the northern enclosure wall, which thickened here to more than 3 m (10 ft). It is possible this access continued down into the basin via a doorway in the southern wall of the corridor, but gullies caused by running water have erased any traces.

Not the least surprising discovery was finding that the settlement continued east of the basin on a terrace of limestone debris [12.24]. Our excavations in early 2012 revealed the Silo Building Complex (SBC), a discrete unit consisting of a core residence surrounded by facilities for bread baking, and possibly brewing, and five round silos, probably granaries [12.23]. Initially we assumed these belonged to the Khentkawes complex, but excavation revealed the SBC was set into the northwest corner of another enclosure, formed of walls 2.62 m (8 ft 7 in. or 5 cubits) thick. The western wall of the SBC enclosure ran exactly against the eastern wall of the basin enclosure, of which only traces remained. This bank ran up against the western SBC wall, proving the SBC wall was older than the basin, counter to pre-excavation intuition.[24]

If the basin enclosure belonged to Khentkawes, then for whom (and for what purpose) was the older enclosure built? The puzzle was compounded

by our discovery that the pottery and walls of the residence, bakeries and storage unit were younger than Khentkawes, dating in fact to the 5th dynasty. The SBC, later than Khentkawes, had been built within the older enclosure. A likely answer to our riddle came from our limited excavations of only two of the SBC silos. Many clay sealings bore the Horus-name (serekh) of the 5th dynasty pharaoh Niuserre, and one of these featured, between two of Niuserre's serekhs, the title 'Overseer of the Pyramid, Great is Khafre' [12.25]. We may have stumbled into the enclosure associated with the pyramid town of Khafre – his valley temple lies just 70 m (230 ft) to the northeast (albeit the newly discovered corner of the older enclosure opens to the southeast). More answers must lie further to the east, beneath 8 m (over 26 ft) of sand.

Temple harbour? The lower basin

As we excavated the sand in 2009 we followed the eroded slope of the crushed limestone foundation of the lower terrace deeper and deeper into a very large depression. We hit the water table at an elevation of 14.75 m (48 ft 4 in.) above sea level (asl). From this level, we sank a probe at the base of the 'glacis' in the northwest corner down to a depth of 14.6 m (47 ft 11 in.) – all clean, wet, sand with no bottom in sight.

It is hard to convey the immensity of the sand deposit, and the great depth we had to excavate through it to discover the queen's valley complex east of the KKT. At the beginning of our season in 2009, the sand rose to around 24 m (over 78 ft) asl. Our deepest probe through the sand filling the deep basin reached 14.6 m (47 ft 11 in.) asl – a drop of 9.4 m (30 ft 10 in.). The surface falls 5.4 m (17 ft 9 in.) from the level of the bedrock floor at the northeast corner of the KKT to the lowest point we could excavate in the basin.

This deep drop east of Khentkawes reinforces the picture gained from many probes and excavations east of the Giza Plateau over the course of over three decades. How much more exalted would the buildings of the necropolis have appeared in their prime, 4,500 years ago, when the valley floor was at least 4 m (just over 13 ft) deeper than in recent years. Visitors would then have ascended to the sacred space, up and up, on ramps, stairways and causeways.

OPPOSITE ABOVE

12.23 The Silo Building Complex, a 5th dynasty house, office, storage facility and bakery tucked into the northwest corner of an older, 4th dynasty enclosure that backs on to the Khentkawes basin, here filled with ground water. In the background, right to left, are the Khafre pyramid, the Khentkawes I monument and the Menkaure pyramid. Protective, clean sand covers the Khentkawes town and causeway. View to the northwest.

OPPOSITE BELOW

12.24 The northern 'leg' of the Khentkawes town as cleared by AERA in 2012. The western end of the town has eroded down to bedrock or crushed limestone foundation. Mud-brick foundations of the middle houses remain, as well the extruded walls of a house AERA restored. The Silo Building Complex was exposed in the clearing through deep sand in the background. View to the east.

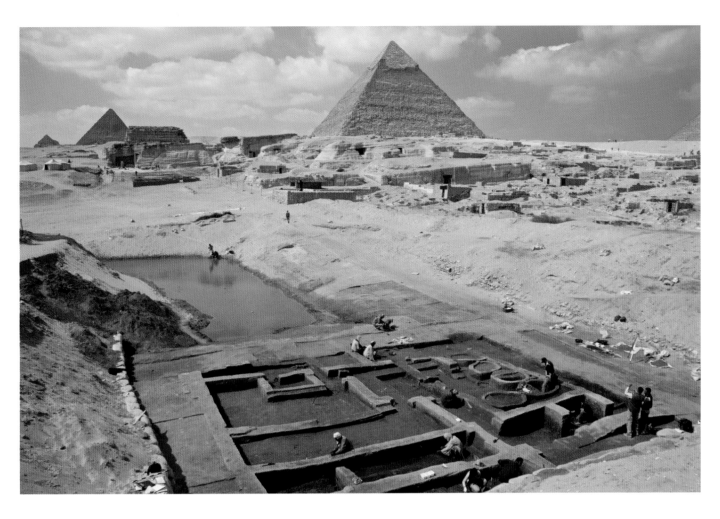

12.25 Clay sealing found in one of the silos of the Silo Building Complex, impressed with the title 'Overseer of the Pyramid, Great is Khafre' between the repeated Horus-name (*serekh*) of the mid-5th dynasty King Niuserre.

We have not yet reached the bottom of the yawning depression east of the KKT. Between 2009 and 2014 we carried out drill cores across the northern end of the basin, hitting the deepest hard surface furthest to the centre and south at 11.97 m (39 ft 3 in.) asl, deeper than our best estimate of the Nile Valley floor in the 4th dynasty (*c.* 2500 BC). We also know from the many core drillings and trenches undertaken for the AMBRIC sewage project of the late 1980s (see pp. 388 and 392) that buried Old Kingdom settlements east of the Giza Plateau were based around elevation 14.74 m (48 ft 4 in.), and would have stood on islands and levees rising just above the inundation water during peak flood season (August–September).

In 2014 we found on the east and west sides of the basin remains of a second terrace, around 1.13 m (3 ft 8 in.) lower than the upper one. The average elevation of the lower terrace of the Khentkawes valley complex is 14.62 m (48 ft) – almost the same as the base of Old Kingdom settlements. The lowest point we have hit by augur on the bottom of the basin is nearly 3 m (around 9 ft) lower. We estimate that if Nile floodwater reached here, it would have filled this basin for a depth of more than 3 m (around 9 ft).

We also have to integrate these results east of the Khentkawes town with other evidence of the relationship between the Giza monuments of the high desert, the settlements on the low desert

(including the Workers' Town, the Heit el-Ghurab site, south of the Wall of the Crow that we have been excavating, see Chapter 15) and the Nile and its floodplain 4,500 years ago.

In 2004 to 2006 we dug trenches 20 to 30 m (65–98 ft) north of the Wall of the Crow and about 300 m (985 ft) east-southeast of the Menkaure valley temple, which revealed desert and wadi-derived sediments, but no Nile alluvium, down to 14.56 m (47 ft 9 in.) asl. We concluded from this that the Menkaure valley temple could never have fronted directly on to Nile water. The 4th dynasty builders capped these natural desert sediments with dumped limestone debris to create a terrace at 16.3 m (53 ft 6 in.) asl – close to the elevation and foundation of the upper terrace of the Khentkawes basin. Access to the Nile lay 700–800 m (2,300–2,600 ft) east. The terrace running along the northern side of the Wall of the Crow slopes down in this direction, perhaps to the ancient west bank of the Nile itself or to a tributary channel.

In 2011 Ashraf Abd el-Aziz logged the deposits in four drill cores sunk 20 m (66 ft) deep by the Tarek Waly Center at the southeastern corner of a bus parking lot as reconnaissance for a site management programme. The southernmost drill hole is located about 44 m (144 ft) north of the Wall of the Crow and only 30 m (98 ft) north of our northernmost clearing of the terrace. These probes encountered dark, dense, concentrated silt or clay 11 to 13 m (36–42 ft 6 in.) below the surface, or 7.57 m (24 ft 10 in.) to 9.57 m (31 ft. 5 in.) asl – Nile sediments at the bottom of a very deep basin or waterway that we missed in our trenches.

But Nile water could not come straight from the east. Nor could Nile water come from the south-southeast, blocked off by the Wall of the Crow, its northern terrace and the Heit el-Ghurab site. A waterway that fed the Khentkawes basin would have had to come in from the north and then turn west. We have put all the evidence into a reconstruction of water transport infrastructure east of the Giza pyramids, which includes a deep basin canal that thrusts forwards to the Sphinx and Khafre valley complex, turns south towards the Wall of the Crow, and then west (see p. 393, 15.42).

As the ancient engineers tried to reach west with their waterways, they were forced to step up from 4 m (13 ft 1 in.) to 7 m (22 ft 12 in.) to 11 m (36 ft) asl at

a double, forked basin that served the Khentkawes complex on its north end, and the Menkaure valley temple on its west end.[25]

Approaching Khentkawes

We now have a much fuller picture of the entire Khentkawes complex, from our laser scanning of her highly unusual tomb to our discovery of her valley complex and the waterways that fed into it. As we have so far revealed it, the valley complex consisted of two ramps, one from the south and one from the north, sloping gently up across the face of a bedrock cliff to the causeway of the Khentkawes monument at a threshold within a corridor. At the bottom of the southern ramp a corridor leading west into the southern 'foot' of the town led to a higher terrace where the inhabitants accessed granaries and storage magazines. At the bottom of the northern ramp the continuation of the causeway corridor turned and headed east. Just before this turn, a stairway descended to a landing in the northwest corner of a terrace running along the base of the corridor walls. From this landing another stairway ramp descended into a deep basin.

We believe the basin may have been a functioning harbour. The bottom is lower than our best estimate of the level of the Old Kingdom floodplain. If connected to the floodplain, water from the Nile could have filled the basin, but probably only seasonally, during the inundation. So people may have arrived via water to access the sloping ramps leading up to the causeway and from there walked the 150 m (492 ft) to the chapel at the tomb of Khentkawes and passing the houses of the town along the way.

Before our discoveries, Egyptologists regarded the Khentkawes complex as an unusual, and unusually large, stone tomb and town of priests' houses flanking a long causeway. Altogether this complex spanned 210 m (about 690 ft) east–west – a complex far greater than that of any other queen of this period. Our excavations revealed the complex was even grander, extending another 70 m (230 ft), with a harbour basin and lower settlement.

And what of Khentkawes herself? Despite our vastly improved knowledge of her monument, she remains something of an enigma. But the gigantic size and unusual form of her tomb, her long causeway, her dedicated pyramid town and now her own valley complex only reinforce the impression that Khentkawes I reigned in her own right as a supreme sovereign.

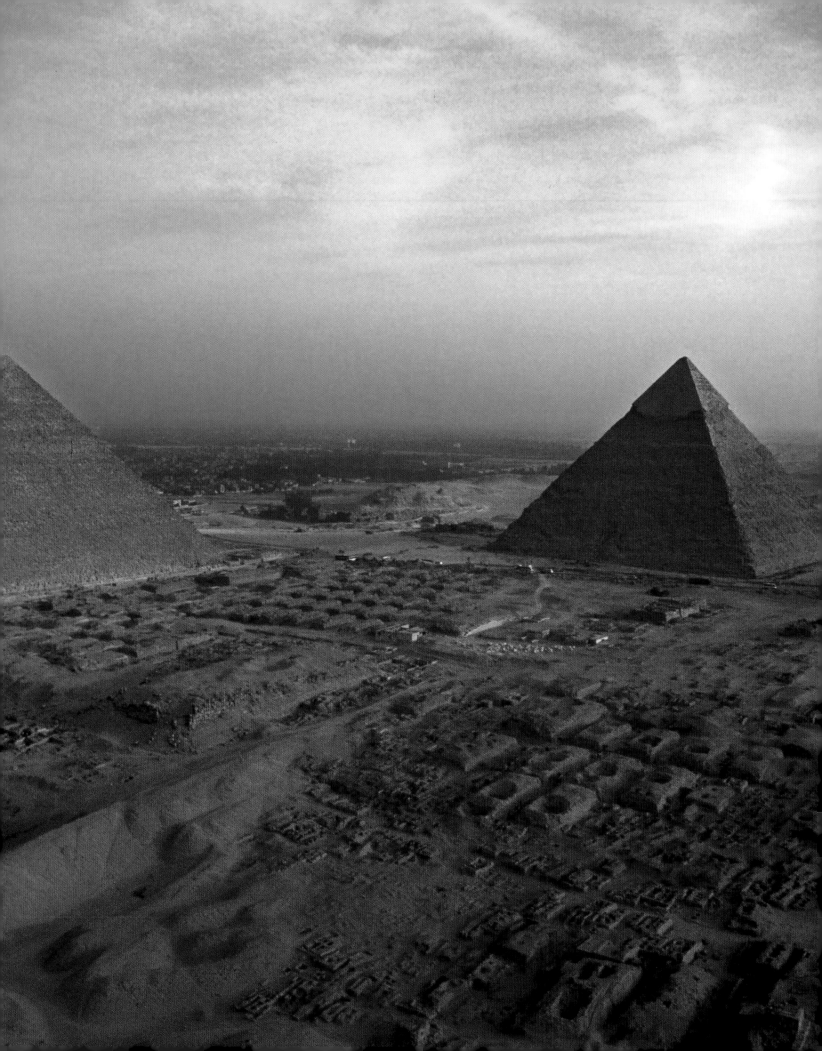

CHAPTER 13
The development of the Giza cemeteries

Erasing almost anything that had already been built on

the northern Giza Plateau, Khufu established four nucleus

cemeteries of massive mastaba tombs, east and west of his

pyramid. Laid out in streets and avenues they look, in hindsight,

precociously modern, like urban housing projects. Each member

of his family and court might receive a mastaba, to which they

could attach chapels in mud brick, occasionally embellished with

fine limestone, so that their descendants could leave offerings

that would empower them in the Afterlife. Thus empowered, they

could act magically, as spiritual intermediaries in the affairs of

their households in this life. Such at least was their hope.

Khufu took the idea of planned urban communities
for the Afterlife from his father, Sneferu, who had
built mastaba cemeteries east-southeast of his
North Pyramid at Dahshur, and north and west of
his pyramid at Meidum.

The Eastern Cemetery

On the east, Khufu's workers began by cutting
a shaft (G 7000X) into the original, rough bedrock
surface, more than 80 m (262 ft) east of Khufu's
pyramid and aligned close to its eastern axis –
a line that would become the northern limit of
the Eastern Cemetery [**13.2**]. At the bottom of the
shaft, nearly 30 m (98 ft) deep, they hollowed out a
chamber that would receive the burial equipment
of Hetepheres I, the queen mother (though Reisner
found the sarcophagus empty – see Chapter 8).

With the positioning of this burial, Khufu
signalled his intention to give the Eastern Cemetery
to his queens, sons and daughters, but 'designing
as they built', his architects had yet to survey a
plan on the ground. Several metres south of the
Hetepheres I shaft, the builders began to cut a

sloping, descending passage (GI-x) for a queen's
pyramid. But work did not proceed far before they
moved 28 m (92 ft) west to build pyramid GI-a on
bedrock not yet levelled.

As they raised queen's pyramid GI-a, they also
built a gigantic mastaba, G 7510, 117 m (384 ft) yet
further east. They aligned the ends of this great
mastaba with the southern side and centre axis
respectively of Khufu's pyramid. One of the two
largest mastabas at Giza, this became the tomb
Ankh-haf, a half-brother of Khufu (see 2.10), whose
name we now read in the Wadi el-Jarf Papyri
as 'Overseer of Khufu's Port Authority' (*Ro-she*),
a position he held at the end of Khufu's reign
(see Chapter 2, p. 30). From texts in his tomb,
we know he also served as 'Overseer of All the
King's Works' and 'Vizier'.

Khufu's crews next built queen's pyramid
GI-b, and the 'cores' of 12 more mastabas, each a
rectangle of stone retaining walls filled with debris
and each measuring 15–17.25 m (49–57 ft) wide and
35–36 m (115–118 ft) long, in four neat rows, slotted
in between queens' pyramids GI-a and GI-b on
one side (west) and Ankh-haf's giant mastaba on

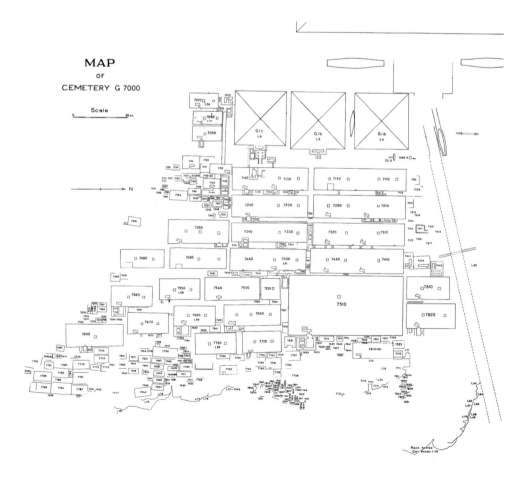

the other (east). But before anyone was buried underneath, in chambers cut from bedrock at the bottom of deep shafts, the builders converted these 12 mastaba cores into eight by joining the two northernmost cores in each of the four rows to create twin mastabas (83.55 × 19.93 m/274 × 65 ft 5 in.), and elongating the four southern ones into two-shaft mastabas (68.47 × 18.9 m/264 ft 8 in. × 62 ft). About this same time, they also built queen's pyramid GI-c, on line with the southern ends of the elongated mastabas.

From the half dozen names with titles that accompany the group of eight, it is evident that king and court assigned these Eastern Cemetery tombs to royal siblings, children, nephews, cousins and/or queens. But for only two of the twin-shaft mastabas do we have good evidence that they were prepared for married couples: G 7110-7120 for Kawab and Hetepheres II and G 7130-7140 for Khufukhaf (Khaf-khufu) and Neferetkau. Khaf-khufu was a Vizier and the son of a queen, probably of Khufu, though her name is missing [**13.3**].

Kawab was also a son of Khufu; his mother may have been a queen Meritites named on a relief fragment from his mastaba. For many years Egyptologists thought Kawab was a crown prince who died before Khufu. Kawab's wife, Hetepheres II, later married a king, possibly Djedefre. This may explain why Hetepheres II was not buried in the twin mastaba with Kawab – its second shaft and burial chamber remained unfinished and unused. We have no good evidence for her final burial place, though Peter Jánosi has suggested that it was in queen's pyramid GI-c. We do know that Kawab and Hetepheres II were the parents of Meresankh III, a queen of Khafre. In her own tomb Meresankh III does not does mention Kawab's parents, whereas she does specify that her mother, Hetepheres II, was a daughter of Khufu. Like other 'King's Sons' of this time, Kawab's titles may have been honorific, not literal. From the excavated and published tombs at Giza, we know of 42 'royal sons', alleged princes of the 4th dynasty.[1]

We cannot be certain that two of the other twin mastabas, G 7230-7240 and G 7330-7340, were ever occupied; the latter was never finished. And for four of the twin mastabas, evidence indicates a single burial of an individual whose identity remains unknown.

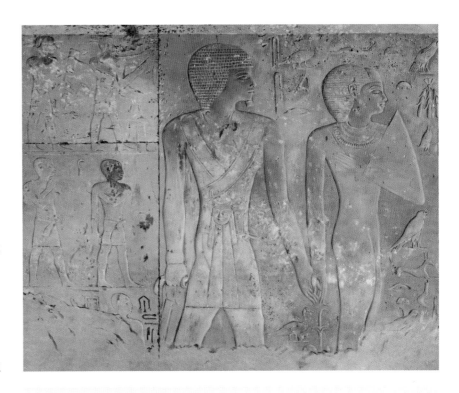

Giza cemeteries: major explorations

Years	Monument	Excavator
1842–45	Giza cemeteries	C. R. Lepsius
1902–32	Western Cemetery	G. A. Reisner (Phoebe Hearst Expedition / Harvard University-BMFA)
1902–05	Western Cemetery	E. Schiaparelli (Turin Museum)
1903–07	Western Cemetery	G. Steindorff (Leipzig University)
1912–14	Western Cemetery	H. Junker (Deutsches Archäologisches Instituts, Abteilung Kairo)
1924–32	Eastern Cemetery	G. A. Reisner (Harvard University-BMFA)
1925–29	Western Cemetery	H. Junker (Vienna Academy)
1928–35	Central Field	S. Hassan (Cairo University)
1949–53	Western Cemetery	Abd el-Moneim Abu Bakr
1987	Western Cemetery	Z. Hawass (EAO)
1989–90	Western Cemetery	Z. Hawass (SCA & Giza Inspectorate)
1992–2000	Western Cemetery	Z. Hawass (SCA)

In twin mastaba G 7410-7420, tight against the western side of Ankh-haf's giant mastaba, a royal daughter, Meresankh II, and possibly a prince named Horbaef were laid to rest. In her burial chamber, Reisner recovered Meresankh II's granite sarcophagus. Into its long sides, craftsmen had cut hieroglyphs that give her name and the title 'royal

wife' (*hemet nesut*), indicating that at some point she, like Hetepheres II, must have married a king (Khafre? Djedefre?). As a queen, she would have been buried in this mastaba alone.[2]

The northern mastaba (G 7210-7220) of the second row from the west was designated to Djedefhor, who was deemed a Vizier by later sources, a prince by the Westcar Papyrus, and a sage and author by later ancient Egyptian literature. George Reisner thought he was another son of Queen Meritites, to whom he assigned pyramid GI-a. Someone had erased some of the relief-carved texts and images in Djedefhor's chapel, and Reisner worked this fact into his narrative of a royal family feud that prompted Djedefre to flee to Abu Roash to build his pyramid. But Jánosi points out that these are precision erasures, which removed the king's name in the funeral prayer. That, and the evidence that the reliefs were never finished, must signify something other than feuding.

In the burial chamber of this mastaba Reisner found a large unfinished granite sarcophagus (see Chapter 17, p. 428), remarkable for the way masons had fashioned the vaulted lid on the bottom and were in the process of sawing it off when it broke and they abandoned the work with half the lid still attached.[3] Putting together the abandoned coffer with the unfinished and erased chapel reliefs, Jánosi suggests that someone other than Djedefhor, and of a later generation, used the incomplete mastaba, a common pattern at Giza, as we shall see.

A man named Minkhaf was buried in G 7430-7440, the southeastern corner mastaba of the group of eight. Like Kawab, Minkhaf was an 'Eldest King's Son', 'Vizier' and another 'Overseer of All the King's Works'. As Minkhaf was proprietor of one of the group of eight mastabas, it is possible his father was Khufu, but we lack other evidence for this. He appears to have finished his mastaba tomb with limestone casing – Reisner thought during Khafre's reign. Unusually, Minkhaf was buried, in his elaborately inscribed granite sarcophagus,[4] in a chamber at the bottom of the northern of the two shafts, while the southern shaft remained unfinished, whereas it was usually the southern shaft that was reserved for the principal burial.

Although lacking any textual or archaeological evidence, Reisner suggested the third twin mastaba

from the west (G 7310-7320) belonged to Baufre, a brother of Djedefhor mentioned in the Westcar Papyrus, and whose name is listed last with Khufu, Djedefre, Khafre and Djedefhor in a Middle Kingdom inscription from the Wadi Hammamat.[5]

The Western Cemetery

For those high officials who were not so intimately connected with the royal house, Khufu's forces began work on the Western Cemetery, on the other side of the Khufu pyramid, in three separate clusters [**13.4**]. Each cluster had one extra large mastaba for the head – as Reisner and Junker thought – of a family of builders.

Cemetery G 1200, possibly the oldest of the three clusters, was begun more than 400 m (1,300 ft) west of the Great Pyramid, with ten mastabas. Its southern boundary aligns with the north side of the pyramid. The largest of the mastabas, G 1201, which sticks out from the southeast corner of the group, belonged to Wepemnefret, a master of scribes of architectural projects, as we know from one of his titles on his beautifully carved and painted stela walled into the eastern face of his mastaba [**13.5**].

Why build this cluster, G 1200, so far west of the pyramid? Perhaps it was to leave room for the truly huge mastaba, G 2000, which, at 105 × 53.2 m (344 × 174 ft 6 in./ 200 × 100 cubits), is as large as Ankh-haf's in the Eastern Cemetery. Also like Ankh-haf's tomb, G 2000 initially stood alone, far apart from other mastabas. And it, too, was oriented to the Great Pyramid – its southern end comes close to aligning with the pyramid's north side. Unlike Ankh-haf's tomb, however, other large mastabas did not initially crowd up against G 2000. Instead, the builders left a respectful 50–75 m (165–245 ft) between it and the three nucleus cemeteries. Only in later generations did people create graves that surrounded and pressed up against it. Reisner believed it was built after the three western clusters, but the evidence is inconclusive. From its size, we imagine G 2000 must have been for an official equal in rank to Ankh-haf, but we lack texts. In the chamber at the bottom of the one original shaft, Reisner found remains of a simple wooden coffin, an offering of jars and ox bones, and a male skeleton. He cited the opinion of Douglas Derry,

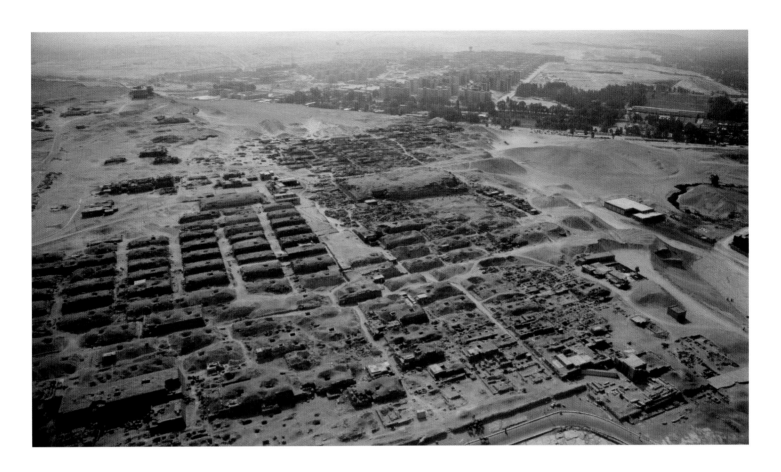

13.4 View to the west-northwest of the organized rows of mastaba tombs in the Western Cemetery, looking from the top of the Khufu pyramid.

LEFT
13.5 Painted relief-carved limestone slab of Wepemnefret found in 1905 by George Reisner in G 1201, the largest mastaba in the 1200 cluster. Wepemnefret's titles include 'Commander of the King's Scribes', 'Foremost of the Archives of the Keeper of the King's Property' and 'King's Son'. Now in the Phoebe A. Hearst Museum of Anthropology, University of California, Berkeley (6-19825); 45.7 cm (18 in.) high.

BELOW
13.6 Remains of the southern part of the chapel of Hemiunu, 'Overseer of All the King's Works', lined with fine Turah limestone. In the dark chamber, Junker found the statue of Hemiunu now in Pelizaeus Museum in Hildesheim (see 6.18).

anatomist, that 'the skull is of a very old man and its dimensions indicate a person of unusual mental capacity'.[6]

To the east, Cemetery G 2100 is a cluster of 11 tombs, of which the largest, G 2210, also remains anonymous. Khufu's builders created the five western, older mastabas of this cluster 'en échelon', that is, staggered in position from north to south. Like Cemetery G 4000 (see below), the builders proceeded from west to east, perhaps as they

cleared the ground of embankments, materials and roadways used in building Khufu's pyramid.

Immediately southwest of Cemetery G 2100, Khufu's builders created the largest of the three tomb clusters of the Western Cemetery, G 4000, again proceeding from west to east. They began with the giant mastaba of Hemiunu (G 4000: 47 × 21.45 m/154 × 70 ft) [**13.6**], aligning its southern side with the east–west axis of Khufu's pyramid. As 'Overseer of All the King's Works', Hemiunu is thought to have been in charge of building the Great Pyramid and is well known from his statue (see 6.18), which Junker found seated in the northern *serdab* of his tomb. To the east of Hemiunu's mastaba, the other 41 smaller mastabas of this nucleus cemetery line up like soldiers in six regular rows. But at the end of Khufu's reign, most of these tombs were left unfinished and unoccupied.

Cemetery en Échelon

Expanding the Western Cemetery eastwards, towards the Great Pyramid, Khufu's forces next developed the Cemetery en Échelon, so called because 25 mastabas, in three north–south lines, are 'stepped' diagonally when compared to the orderly rows of cemeteries G 4000 and G 2100 and

RIGHT
13.7 Plan of the western part of the Western Cemetery, west of the Great Pyramid of Khufu (labelled 'Cheops' Pyramid'). The 'Cemetery en Échelon' is outlined in red and highlighted blue. Six names are known from the 25 mastabas of the Cemetery en Échelon, from left to right: Tjeti (G 4910); Seshemnefer I (G 4940); Hetepsheshat (G 5150); Nesut-nefer (G 4970); Seshemnefer II (G 5080); and Seshemnefer III (G 5170). (Adapted from MFA EG002029 and Reisner, 1942, Map 2.)

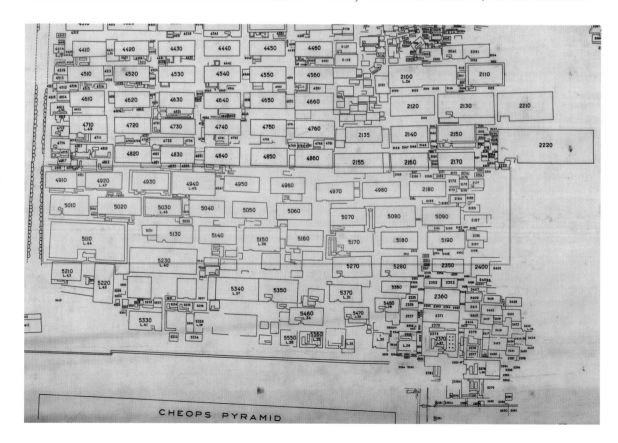

with respect to each other [**13.7**]. As with half the mastaba cores in G 4000, the tombs in the Cemetery en Échelon stood unoccupied for at least 75 years, and perhaps for more than a century (see below).

Also like the other nucleus cemeteries, once again we find one much larger mastaba (G 5110), here added on the southeast. It belonged to Duaenre, 'King's Son of His Body', who became Vizier, probably under Menkaure. But we are not certain when G 5010 was built or its relationship to the other 25 mastabas of this cemetery.

Empty houses for the dead

With Khufu's death, his urban development for the dead came to a halt. Jánosi points out in his masterful study, *Giza in der 4. Dynastie*,[7] that of 64 mastabas in the Western Cemetery, just 19 were completed with a fine limestone casing. If the Eastern Cemetery and the Cemetery en Échelon are included, of a total 102 mastaba tombs built under Khufu, 39 were assigned, almost a third stood empty, and nearly all were incomplete.

Khufu's successor Djedefre moved 8 km (5 miles) northwest of Giza to the higher Abu Roash plateau for his pyramid. Theories of a family feud – with Djedefre later damned and his memorials destroyed as Khafre returned to Giza – suffer from a lack of any real evidence. We also now know from the work of the Swiss–French team led by Michel Valloggia at Djedefre's Abu Roash pyramid that instead of a reign of only around eight years, as was once thought, this king ruled for 23 years.[8] At Abu Roash, he began a new mastaba cemetery for his courtiers on a promontory to the northeast and below the high pyramid plateau and south of his causeway. Some of the mastabas are equal in area to the largest at Giza (excluding G 7510 and G 2000), and include burials of 'Royal Sons', and a princess.[9]

What happened at Giza during this time? Building apparently stopped in the nucleus cemeteries west and east of Khufu's pyramid, and 'scarcely resumed in the latter part of the Fourth Dynasty'.[10] Some individuals who had served in Khufu's courts might have continued in Djedefre's administration and built their tombs at Abu Roash. Others must have completed and even extended their assigned tombs at Giza, adding chapels with decoration. Certainly, during the quarter of a century under Djedefre, tomb builders must have

finished mastabas erected under Khufu, and this work continued under Khafre. Older courtiers must have died and been laid to rest at Giza. (So, for example, Hetepheres II, mother of Meresankh, after her second marriage, possibly to Djedefre, was probably buried at Giza,[11] or Ankh-haf, who probably finished the chapel of his large tomb and installed his remarkable bust under Khafre.)

Return to Giza: Khafre and Menkaure

With Khafre's return to Giza, in spite of the many empty and unfinished mastabas left over from Khufu's reign, builders added new ones to the existing nucleus cemeteries and also built a whole new series.

In the Eastern Cemetery workers built 11 more mastabas south and two more north of Ankh-haf's giant mastaba, as well as three south of queen's pyramid GI-c. Mastaba G 7530-7540, one of the first additions, became the superstructure over the tomb of Meresankh III, a wife of Khafre (see below). Reliefs and texts in her chapel cut from the rock below the mastaba depict and name her mother, Hetepheres II, and her father, Kawab, who was buried in G 7120. Unusual are the ten female figures carved from the rock in a long row [**13.8**].

13.8 The pillared north wall of the rock-cut chapel under mastaba G 7530-7540, belonging to Queen Meresankh III, whose titles included 'King's Bodily Daughter' and 'Royal Wife'. In a room behind the pillars, ten statues of women carved from bedrock are topped by an architrave that identifies Meresankh III and her mother: '[King's wife Hetep]heres. Her daughter, beholder of Horus and Seth, great favourite, companion of Horus, consort of him who is beloved of the Two Ladies, follower of Horus, King's daughter of his body, belov[ed] companion of Horus, [King's wife Mer]esankh.'

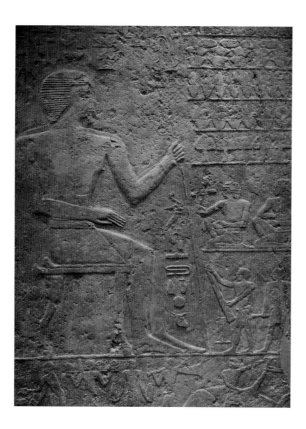

13.9 Image of Merib (also known as Kapunesut) on the north wall of the chapel attached to mastaba G 2220-I-annex, removed to the Neues Museum, Ägyptisches Museum und Papyrussammlung, Berlin (ÄM 1107). Merib is presented with sealed goods, while a scribe unrolls the list of offerings, and servants bring oil and linen.

Small figures depicted standing at the queen's feet in separate painted relief images represent her sons Nebemakhet, Khenterka, Duaenre and Niuserre.

In the Western Cemetery, Khafre's builders added to Cemetery G 1200, including mastaba G 1221, belonging to a man named Shad, and in Cemetery G 2100 they added G 2220, 'the largest private tomb at Giza after the anonymous mastaba G 2000 and the tombs of Ankh-haf (G 7510) and Hemiunu (G 4000)'.[12] The owner of G 2220 also remains anonymous, never having completed his chapel decoration. G 2100-I-annex was expanded for a man named Merib, another 'Overseer of All the King's Works', 'High Priest of Heliopolis' and 'Priest of Khufu' [13.9]. In Cemetery G 4000, little or nothing new was built at this time.

Cemetery GI-S

As though mastaba building was a compulsive royal ritual, builders under Khafre and Menkaure created yet another new series of tombs – Cemetery GI-S. Tight against the south side of Khufu's pyramid, outside the enclosure wall and passing very near the two southern boat pits, royal builders reserved spaces for ten mastabas of similar size, which Junker, the excavator, numbered from west to east.

In these spaces, builders began mastaba cores, stretching eastwards from M.I (Mastaba I) to the southern side of Khufu's small satellite pyramid. Six contained two shafts, the others a single shaft.[13] Junker discovered builders' graffiti with the Horus name of Menkaure on fallen casing from M.VII. Two of the graffiti give tax-counting years 2 and 11 of an unnamed king. Assuming a regular biennial tax, the so-called 'cattle count', the numbers suggest the blocks were quarried in Menkaure's regnal years 3–4 and 21–22. Such an extended span does not inspire confidence in relying on builders' graffiti for exact dating. The casing could perhaps have come from a royal stockpile of fine limestone brought over from the eastern quarries at Turah over a long period of time.

Construction work had barely begun on a mastaba in the second space from the west (Junker's M.II), and in the empty space intended for M.V the builders only cut the shaft for a future mastaba. In the 6th dynasty a man named Iimeri II used this shaft for his burial, after a Niankhre in the 5th dynasty had already built his smaller mastaba in the southeast corner of the lot.[14] That these spaces were left unbuilt makes us wonder whether GI-S was in fact a unified building project, or whether the royal house assigned plots to proprietors, leaving them to construct their own mastabas.

But as with the Cemetery en Échelon, after taking the care to begin them, the courtiers of Khafre's and Menkaure's generations left the mastabas of GI-S unfinished. With Menkaure's death, work stopped as the royal house of Shepseskaf and then rulers of the 5th dynasty moved their building crews (and courts?) to Saqqara (Userkaf) and Abusir.

With cemetery GI-S, 74 mastaba tombs now stood empty and incomplete at the end of the 4th dynasty. Compounding the puzzle of why Khafre and Menkaure built this regular series of mastabas flanking Khufu's pyramid is the fact that at this time tomb builders began making a very different kind of burial place for the highest-ranking royal family members.

Rise of the rock-cut tomb

Curiously, Khafre built no subsidiary pyramids for his queens. And although the many older mastabas were available, most of Khafre's queens, sons and a daughter opted not for mastaba tombs at all, but for

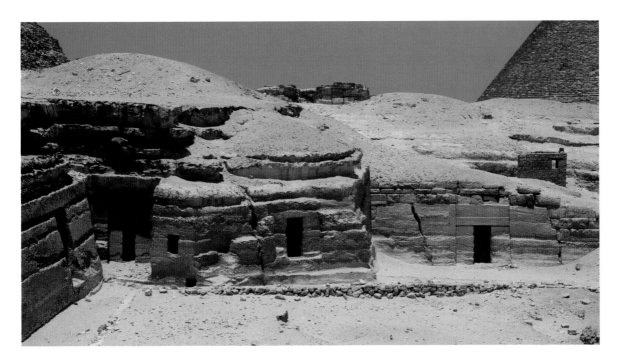

BELOW
13.11 Idu seated at a table of offerings (with stylized half-loaves of bread), with his wife kneeling below the chair; relief from the west wall of his rock-cut tomb in the Eastern Cemetery, south of the Khufu causeway (G 7102). Idu was 'Overseer of the Pyramid City "The Horizon of Khufu"', 'Inspector of the Purification Priests of the Pyramid "Great is Khafre"' and 'Overseer of the Pyramid City "Menkaure is Divine"', in the 6th dynasty.

tombs cut entirely from the living rock. These new rock-cut tombs were made possible by the previous large-scale quarrying of stone for Khufu's pyramid, which left extensive, vertical bedrock walls into which quarry workers could hollow out passages and chambers.

Khafre's queens and children began a trend that continued at Giza for the next 300 years, to the end of the Old Kingdom. Rock-cut cemeteries are found in the western artificial cliff created by the Khufu quarry in the Central Field West [**13.10**]; the western bedrock face of Khafre's western pyramid terrace; in the quarry blocks and channels of the Central Field East, between the Khentkawes monument and the Sphinx; the escarpment east of the Eastern Cemetery, which wraps around to the north of the Sphinx; the northern edge of the quarry southeast of the Menkaure pyramid; and in the natural cliff to the far northeast of the Western Cemetery.

Tomb development at Giza
Expansion of the chapel

In the earliest assigned and occupied mastabas at Giza a modest slab stela showed the deceased at a table of offerings, as also seen in reliefs in later tombs [**13.11**]. These beautifully carved and painted slabs were walled up in the eastern face of the mastaba. While unseen, they were magically

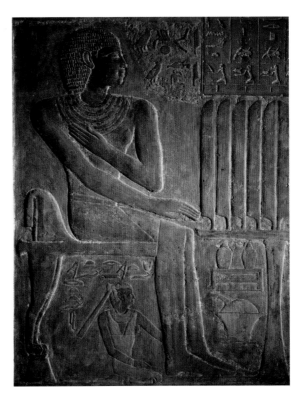

effective as relatives came to give offerings in an adjacent, simple mud-brick chapel, sometimes embellished with limestone cladding, attached to the outside. This cult focus – where the living interacted with, and gave offerings to, the dead – took place before a simple dummy door, the 'false door'.

The magical false doors ranged from a simple recess to an elaborate framed panel sunk in stone, with inner frames stepping inward and back to a narrow slot topped by a drum roll [**13.12**]. At Giza, the earliest tomb builders placed this instrument of communication between the realms of living and dead as far from the entrance as possible, resulting in an L-form chapel. A turn from an entrance corridor to the left (south), generally, though not always, led to a single false door recess at the far end of a deeper rectangular chamber. Later, with a symmetrical pair of false doors, the minor, secondary one was placed opposite the entrance.

For rock-cut tombs, designers had to rethink this cultic layout because of the physical exigencies of cutting it from bedrock. They adapted their ideas accordingly, setting off an independent development that had a profound influence on

13.12 An elaboration of the false door, with the statue representing 'coming forth of the deceased', in this case Neferbauptah, in his tomb (G 6010) in the Western Cemetery, west of the Khufu pyramid.

Egyptian funerary architecture. The quarry face now substituted for the mastaba superstructure. Masons sometimes cut it to correspond to the slope of the mastaba façades, and in certain cases they built a solid, 'blind' mastaba above the rock-cut tomb.

In mastabas, the shaft that led down to the burial chamber penetrated through the mastaba from the top, down into the bedrock. The mastaba itself made the connection between burial chamber and chapel. In rock-cut tombs, the shaft had to descend from one of the interior rooms to connect chapel and burial chamber. So tomb builders now often added a third room where they sank the shaft into the floor. As a rule, this shaft room lay west of the entrance chamber, sometimes completely separate from it, or sometimes just an expansion of it but divided by two or three pillars or a wall of masonry or bedrock. Artists did not decorate the walls of the shaft room as they did the other rooms. Sometimes yet another room was created, in which a statue of the deceased was placed, making it a *serdab*. In later tombs the shaft room moves west, deeper into bedrock; and in some the original shaft room becomes the statue chamber after burial (the deceased could then rise straight up from the burial chamber through the shaft to incarnate the statue).

Rock-cut tombs also greatly increased the amount of surface available for display compared with the earlier masonry chapels. In place of simple slab stelae showing the deceased at an offering table, the expanded wall surfaces of rock-cut tombs allowed for more extensive and elaborate scenes.

In general, as a genre, rock-cut tombs evolved over time from simple to more complex. Almost all individual tombs also show successive building stages, expanding or being modified from an initial design, with tomb makers adding rooms and dividing walls. Tombs were always more works in progress than one-time construction events.

Khafre pyramid terrace west

Khafre's senior courtiers wanted to be as close as possible to their sovereign in death and the Afterlife. To this end, quarrymen began cutting a series of tombs into the artificial cliff, 10 m (33 ft) high, just 28 m (92 ft) west of the Khafre pyramid. This linear series, flanking the pyramid, would have served as a rock-cut version of Cemetery

GI-S tight against the southern side of the Khufu pyramid. But here again, these tombs for the elite were apparently left unfinished, perhaps because of the poor quality of the bedrock. We cannot be certain because no one has properly mapped and published these tombs, although the Napoleonic Expedition, Lepsius and Mariette all noted them. We do know that, as it dips far to the south of the Khafre pyramid, the cliff hides many more tombs than have been reported. Most appear to date to the later 5th and the 6th dynasties.

The oldest tomb in the cliff west of the Khafre pyramid, LG 12, was begun for a key person of the 4th dynasty – Nebemakhet, a 'King's Son of His Body'. The cliff entrance, once closed with a wooden door, opens into the centre east wall of a rectangular chamber divided by a difference in the height of the ceiling into two parts: an entrance room, 3 × 7.65 m (almost 10 ft × 25 ft), and a second, inner room, 2.3 × 3.15 m (7 ft 6 in. × 10 ft 4 in.). The ceiling of the entrance room is reportedly carved to imitate the underside of wooden logs and the west wall shows remains of a palace façade decoration.[15] False doors grace the western wall at the northern end of the entrance room and southern end of the second room, the latter probably the primary offering place. At the southern end of the west wall of the first room, a doorway with a raised threshold and topped by a drum roll opens to a smaller rectangular chamber in which it may have been intended to set up a statue of Nebemakhet. Two shafts penetrate the floor of the entrance room, one perhaps a later addition.

West cliff cluster: Central Field West tombs

Nebemakhet must have rejected this simple tomb in the western shadow of Khafre's pyramid for a more elaborate one, Tomb LG 86, cut from bedrock in the far northwest corner of the old Khufu quarry – the Central Field West, if the Nebemakhet named there is the same person. Nebemakhet was a Vizier and true son of Khafre and Queen Meresankh III. Thus we can trace Nebemakhet's family line from the Eastern Cemetery, where his mother Meresankh III in her rock-cut chapel beneath her mastaba depicts the prince as a child, in addition to her own mother, Hetepeheres II, and father, Kawab – Nebemakhet's grandparents – as well as two brothers and a sister, probably younger siblings.

Nebemakhet's tomb is also a good example of how the tombs of the wealthy continued to be modified. Tomb makers first cut an entrance in the east-facing Khufu quarry wall and then a rectangular room, 9.55 × 3.36 × 3.5 m (31 ft 4 in. × 11 ft × 11 ft 6 in.) In the centre of the western wall they carved in relief a palace façade, and at the far northern end of the wall they cut a niche with a pair of false doors and two round basins sunk into the floor. Against the base of the north side of the palace façade they cut a shaft 2.85 m (9 ft 4 in.) deep to a slightly sloping passage leading west into a rectangular burial chamber. This was Nebemakhet's original, single substructure.

In a second stage, the masons blocked the eastern entrance and made a new entrance corridor and chamber to the northeast. In the older chamber the tomb makers cut a second deep niche in the western wall, with two more false doors. A second shaft was sunk to complement, symmetrically, the earlier shaft to the north. The smaller southern shaft and chamber may have received the burial of Nebemakhet's wife, Nubhotep. Workers appear to have begun to case the northern wall of this room with fine limestone, remains of which Selim Hassan found.[16]

Artists decorated all the walls of the newer, northern room and the east wall of the southern, earlier room, as well as the passage between them. On the western wall of the northern room offering bearers bring produce from estates named after Khafre. One of the more important and unusual scenes graced the eastern wall of the second room. Here, Nebemakhet's artists depicted him and his sister, Shepsetkau, in front of Meresankh III, his mother, who stands before a canopy with Hathor-headed columns sheltering a bed with a headrest that Lepsius took as a bull's head [**13.13**].[17]

Nebemakhet must have abandoned his first tomb and started his second near the end of Khafre's reign. Work on the expansion and modifications of the tomb might have continued through to the end of the 4th dynasty, while the painted decoration of the walls dates to the early 5th dynasty.

From Nebemakhet's tomb south, quarrymen cut 10 to 11 tombs in tight proximity in the northeast and southeast faces of a bedrock massif that Khufu's quarrymen left when they removed stone

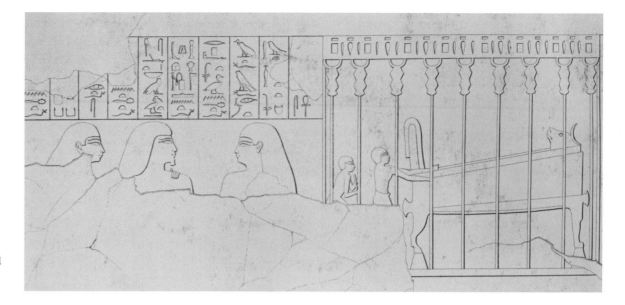

13.13 Lepsius' drawing of a scene showing Nebemakhet, with his sister Shepsetkau, facing his mother, Meresankh III, who stands before a canopy with Hathor-head columns sheltering a bed with a headrest.

for his pyramid. To hollow out the tombs, they took advantage of the natural joints and fissures that trend northwest to southeast over this part of the Giza Plateau,[18] the direction of the natural, geological dip of the Moqattam Formation.

As quarry face and geology now governed tomb orientation, those who planned the necropolis were forced to abandon the broad orthogonal layouts of the mastaba cemeteries. However, we still see in this cluster a degree of separation between princes and 'private' people. Two principles that governed the Eastern Cemetery of Khufu's nearest family members are still evident: (1) no tombs should be built north of the king's causeway; (2) royal family tombs should lie to the right (east) front of the pyramid and its upper temple.

In this same corner as Nebemakhet's tomb, four smaller tombs (LG 85z, LG 86x, y and z) remain anonymous. At the southeast corner of the projecting massif, Lepsius found the tomb of Nikaure, LG 87. Nikaure was another son of Khafre (we don't know the name of his mother; his wife was Nikanebtiu) and a Vizier, presumably in the reign of Menkaure. On one wall of his chapel craftsmen inscribed his will, which he set down 'while alive on his feet and not ill'[19] in the 12th cattle count of a king who is not named. Nikaure etched in stone that he gave his son, daughters and his wife 14 of his estates, named after Khafre, in provincial nomes, and his estate, or house, or tomb (*pr*) 'in the Pyramid of Khafre', perhaps 'the necropolis of' or 'the pyramid town of Khafre'.

Several metres southwest of Nikaure's tomb, another doorway in the cliff face opens into the tomb of Persenet, LG 88, a king's daughter, presumably of Khafre and a royal wife. This we know from texts on the east side of the southern of two pillars that stood before her burial shaft, the only documented texts in her unfinished tomb. Because Persenet's tomb lies so close alongside Nikaure's, some have suggested she was his mother.

The next doorway on the quarry cliff opens into the tomb of Sekhemkare, LG 89, who gives his title as 'Eldest King's Son', almost certainly of Khafre, and Vizier, perhaps as late as the early 5th dynasty since texts on the north wall state that he was '*imakhu* [provisioned by, honoured] in the sight of the Great God, and in the sight of the king of Upper and Lower Egypt Khafre'[20] and four succeeding kings, Menkaure, Shepseskaf, Userkaf and Sahure. This text shows that from beginning of construction to burial, we must measure these tombs against the lifetimes of their occupants.

We have to set the evidence that Sekhemkare lived until the reign of Sahure, and possibly beyond, against the observation that his tomb is one of the simplest[21] – a basic, corridor-like, rectangular hollow, like the beginnings of other tombs in the princely cluster (although his tomb does show expansion).[22] While we do not know exactly when he began his tomb, Sekhemkare was born under Khafre and died under Sahure, or even the next king, Nefeirkare, when artisans applied the text and decoration to this wall. If he were aged

ten at the end of Khafre's reign he would have been around 50 at the beginning of Sahure's. As a young man he must have walked the Heit el-Ghurab site we are excavating (Chapter 15), among others of the generation of Menkaure.

Doorways open to three more anonymous tombs (LG 89x, y, z) in the southeast-facing quarry cliff as it swings west into a great rectangular bay that Khufu's quarrymen cut from bedrock. Then, at the end of this quarry bay, we find the tomb of Niuserre (G 8140), a younger brother of Nebemakhet. Niuserre's mother, Meresankh III, shows him in her tomb as a youth. The last of the older princely cluster on the north, Niuserre's tomb, with its main pillared hall, begins a transition to a younger group that continues south in this line. In the corner of a bedrock block that juts out into the bay, Niankhre cut his tomb (G 8130) into bedrock and topped it with limestone masonry (see 13.10). He held the title 'King's Son', probably as an honour, not as a 'son of the royal body'. Like so many large tomb owners, either mastaba or rock-cut, Niankhre's titles relate to construction management, for he was 'Overseer of All the King's Works', probably towards the middle of the 5th dynasty.

Debehen's tall tomb tale

At the southern end of the bay of the old Khufu quarry we find a false door carved in relief, and then the real entrance into the tomb of Debehen, LG 90 [**13.14**]. The false door and actual door form a set, the southern one being the main entrance, as in other tombs of the period (for example, the Khentkawes monument). Together the two doors fix the length of the tomb's façade, which quarrymen sloped back slightly like the face of a mastaba, as 37.5 m (123 ft). The length and blankness of the bedrock façade here accentuate just how tightly the tombs of the royal children cluster to the north. A remarkable feature of Debehen's tomb is a narrative of the granting of his tomb location by none other than King Menkaure himself while he was on his way to the plateau to inspect work on his pyramid:

> With regard to this tomb of mine, it was the King of Upper and Lower Egypt Menkaure [may he live forever] who gave me its place,[23] while he happened to be on his way to the pyramid plateau to inspect the work being done on the pyramid of Menkaure...

13.14 Entrance to the tomb of Debehen, cut into the sloped western face of the Central Field West quarry. The tomb façade also featured a false door. View to the southwest.

The royal master builder, the king's seal bearers (who accompany expeditions), fifty craftsmen and their 'controllers' (High Priests of Ptah) came, so Debehen says, to inspect the place, to clear the building site and then to work on his tomb. 'His majesty decided to pay a visit to the work that had been assigned.... Stone was brought from Turah as well as a double false door.' Debehen adds the dimensions of this tomb: 100 cubits long (52.5 m/ 172 ft 3 in.) and 50 cubits wide. The length exceeds that of the actual façade, but he might have claimed 100 cubits if an anonymous set of three statues carved into the cliff face further north were his.

The craftsmen placed this remarkable text in a niche containing 13 little rock-cut statuettes of a striding man, probably Debehen, cut into the eastern wall of the first room of the tomb, which measures 7.8 × 3.9 m (25 ft 7 in. × 12 ft 10 in.), and 3.9 m high. A torus moulding topped by a cavetto cornice frames the niche, rendering it a kind of shrine. On the southern side of a wing wall that divided the tomb into main chambers north and south, artists created a scene of Debehen seated on a stool, a pet monkey beneath, facing his titles in hieroglyphic columns, with horizontal registers of offerings, musicians and dancers [13.15].[24] On another wall artists depicted the last part of Debehen's funeral [13.16] (also discussed in Chapter 7).

Jánosi points out that Debehen's tomb is not only one of the most peculiar in this part of the necropolis, but is also one of the largest, exceeding the tombs of Khafre's royal sons. Yet from his titles, which are only those of a middle-ranking palace bureaucrat, Debehen was not a member of the royal family. Therefore, the extent of quarry rock wall he was allocated for his tomb, and its size and complexity, are astounding. What so distinguished Debehen that Menkaure granted him permission to cut his tomb in the company of Khafre's family members, and helped him equip and decorate it?

In fact, scholars suspect that Debehen's text is a tall tale, fabricated much later. Jánosi and others read the crucial opening line instead as: 'As for this tomb of mine, it was the King of Upper and Lower Egypt, who gave it to my father...', which would suggest a descendant had the text composed and inscribed after Debehen's time. Some who have looked closely at the text, including Nicole Kloth, who carried out a study of biographical texts of the Old Kingdom,[25] see Debehen's story as a type of biography characteristic of the later 5th dynasty.[26] Further, they interpret the fact that Debehen's tomb includes a scene of his own funeral, as well as some features of that scene, as another indication of a date in the middle of the 5th dynasty or later. If Debehen's text and tomb do date to the reign of Menkaure, then certain details, such as ones in the offering list, so characteristic of later tombs, would make their first appearance here. One title, 'Administrator of the Vineyard "Horus, Foremost of the Sky"', occurs in combination with Debehen's other titles only in the 5th dynasty.

According to Jánosi, Debehen lived and died around the middle of the 5th dynasty, some 70 years after Menkaure, and came to Giza and took over one of the empty, unused tombs in the quarry cliff, long after this section was reserved for royal household members. So other tombs in this stretch would also date to the middle of the 5th dynasty. Debehen enhanced and decorated the rock tomb, but did not finish the work (entirely usual for any period). After his death, but before the mid-5th dynasty, a descendant then had the text inscribed as an 'authenticating apparatus', linking Debehen's tomb and his right to be in this part of the Giza Necropolis back to a decision of Menkaure.

13.15 A drawing by Lepsius of the scene on the south face of the wall dividing the two main rooms of Debehen's tomb. Debehen sits on a stool with his pet monkey beneath. He holds a fly whisk and faces registers filled with offerings, dancers and musicians. Hieroglyphs in front give his titles: 'The Confidant, Director of the Palace, Master of the Distribution in the House of Life, Doing what His Lord Likes, Debehen.'

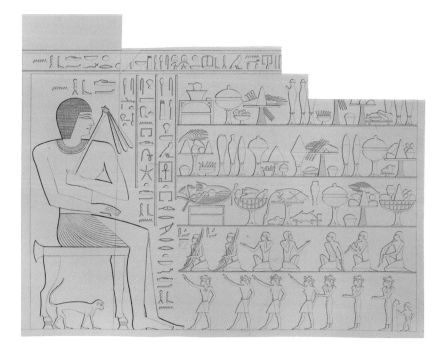

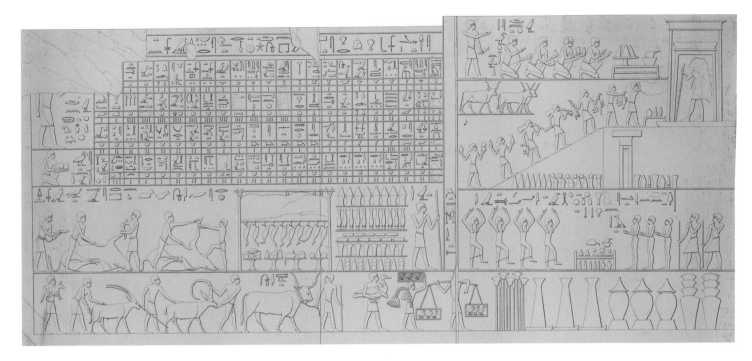

While this is a compelling hypothesis, we should consider possible alternative explanations. Could not Debehen have been among those early non-royal family members who took on more of an expanding bureaucracy, a trend we know was underway in Menkaure's reign, just as the king's pyramid shrank in size from the gigantism of the early 4th dynasty, when the king and his real sons and siblings were, in effect, the state? Among the reasons for his suspicions, Jánosi points to the fact that Debehen cites explicitly Menkaure's personal name, which is not characteristic of the 4th dynasty. However, Sekhemkare in his tomb cites Khafre's name, albeit in a list with other kings,[27] and Meresankh in hers names her mother as the 'daughter of the King of Upper and Lower Egypt, Khufu',[28] though not in a narrative text.

But if Debehen's descendants did concoct the story, it is as interesting as if it were true. It would add to our picture of mid-5th dynasty people coming to Giza nearly a century after the 4th dynasty heyday of tomb building to claim a piece of the necropolis real estate, and assert pride of ancestry with the Giza pyramid-building kings and their families (see below).

From Debehen's tomb, the western edge of the Central Field West quarry thrusts east again, forming the southern side of the bay, and then turns to run south. At this corner we find the tomb of Prince Iunmin, the most southerly of the tombs of Khafre's true family members (LG 92). From texts on the lintel and drum roll of the doorway into the rock-cut interior of his tomb, we know that Iunmin bore the titles 'Eldest King's Son', probably of Khafre, and Vizier. The lintel also shows Iunmin with his wife, named Khamerernebty.

Iunmin's impressive tomb complex saw several building phases and long use, with six burial chambers and seven shafts. Masons probably built the exterior chapel sometime around the middle of the 5th dynasty. Yet the imposing overall design stands in contrast to its unfinished decoration. Iunmin's artists seem barely to have begun work during the first phase of the tomb. Pointing to the great difference between Iunmin's tomb layout and those in the northern cluster, Jánosi suggests this is the youngest of the 4th dynasty princely tombs in the Central Field West quarry face. Iunmin may have been a son of Menkaure.

Rock-cut tombs for queens: Central Field East

In the great circle of quarrying for building the pyramids at Giza, the quadrant of the Central Field East was never exploited as deeply as the Central Field West. Quarrymen here left huge bedrock blocks the size of large mastabas defined by broad channels. Tomb makers took advantage of these blocks, combining features of mastaba and rock-cut tombs with chapels, burial shafts and chambers in the many bedrock exposures.

13.16 Funeral scene from the tomb of Debehen, as recorded by Lepsius. At the top, a ramp slopes up to a building with a side door, with a statue of the deceased standing in a double shrine atop the building. People ascend or kneel to present offerings, while to the left offerings are listed in standard tabular form, and below people prepare offerings and women dance.

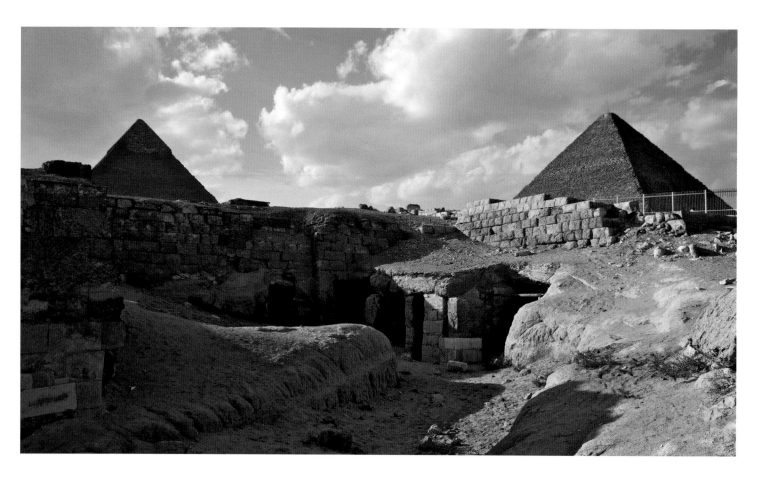

13.17 The so-called Galarza Tomb of Khamerernebty II, showing the approach channel, the northern pillars of space C, and the entrance to chamber H. The tomb has suffered much loss since it was excavated in the early 20th century. View to the northwest.

In addition to the gigantic tomb of Khentkawes I (Chapter 12), three of the six or seven tombs that Jánosi interprets as the oldest in this quarry cemetery[29] belonged to queens: Khamerernebty I and/or Khamerernebty II (G 8978) at the eastern point [**13.17**],[30] Rekhitre (G 8530) near the northwest extremity[31] and Bunefer (G 8408) at the southwest corner of the cemetery. [32] The tomb of Hemetre (G 8464), an 'Eldest Daughter' of a king who has been assumed to be Khafre (but see below), and the tomb of Iuenre, 'Eldest Son of His Body of Khafre' (G 8466), are located in the far northwest part of the Central Field East quarry, close to the Khafre causeway.[33]

Jánosi highlights this dispersal across the Giza cemeteries of tombs of royal family members in the reign of Khafre in contrast to the dedicated zones of regular mastabas for royal family members planned and begun during Khufu's reign, as well as the fact that Khafre provided no pyramids for queens in his funerary complex.[34]

The Galarza Tomb and the two Khamerernebtys
Two of the royal women of Khafre's generation located their rock-cut tomb, G 8978, close behind Khafre's valley temple and immediately south of his causeway, at the far eastern point of the triangular section of quarry. It is one of the most important tombs of the Giza necropolis, and, unfortunately, one of the most poorly excavated and recorded. It is known as the Tomb of Chephren's Mother, or the Galarza Tomb, after a Count de Galarza who excavated it in 1907–08 under the supervision of Ahmed Bey Kamal. Kamal published a short report on the work, as did Georges Daressy.[35]

An inscription on a lintel over the innermost, largest and oldest rock-cut chapel, room H, is the critical document both for this tomb and for royal family history at Giza. This text makes explicit that Khamerernebty II was the daughter of Khamerernebty I. Two registers of hieroglyphs span the lintel. The top register begins:

> Mother of the King of Upper and Lower Egypt, Daughter of [the King of Upper and Lower Egypt and Daughter of] the God, She who sees Horus and Seth, Great One of the *hetes* Sceptre, One Great of Praise, Priestess of Djehuty, Priestess of Tjaspef, the Greatly Loved Wife of the King, King's Daughter of His Body, Revered Mistress, Honoured by the Great God, Khamerernebty.[36]

The register ends with a figure of the queen wearing the vulture headdress – which distinguishes a queen mother from a queen consort – seated and holding a papyrus (*wadj*) sceptre. The lower horizontal register repeats several of the titles, but begins with 'her eldest daughter', apparently referring to the Khamerernebty of the upper register, and adds different titles.

The final determinative (the idea hieroglyph) is missing at the left of Khamerernebty II's name in the lower register, so we do not know if she was shown with the iconography of a queen mother. Her titles tell us she was the daughter of Khamerernebty I of the text above, the daughter of a king and the wife of a king. The lintel provides an explicit link between the two Khamerernebtys, and establishes that the elder woman was the mother of a king.

On the interior face of the northern jamb of the doorway into the chapel (H), Daressy found the remains of a scene showing a queen holding a papyrus wand. Traces survived of the head and shoulders of a daughter and four servants. Above these figures Daressy could see fragments of the titles of one of the queens, possibly the elder,[37] based on the papyrus sceptre, and the titles 'King's Wife' and 'Eldest beloved Son of the King' (possibly Khuenre – see below).

At the top of the northern exterior face of the doorway, Daressy reported the remains of a text that reads: 'Royal Wife and Royal Daughter, [Khamerer]nebty'. Lower down, he made a rather poor copy of two patches of another inscription. By comparing these to other texts, Elmer Edel reconstructed the original to include a reference to Khamerernebty II paying the craftsmen who prepared her tomb.[38] Such texts detailing payment for tombs are otherwise known only from the first half of the 5th dynasty, so this would be the oldest.[39]

We know from other Old Kingdom texts that proprietors paid craftsmen in advance for work on their tombs. Payment took the form of cloth and other goods, such as copper, oil and grain, and bread, even, in one case, a bed; beer was also provided during the work. Carried by porters in a sled-like carrying chair, the owner would visit the tomb as the work progressed to oversee the labour and make payment.[40] Edel deduced that Khamerernebty II was the sole proprietor and

occupant of the Galarza tomb, and it was she who paid the craftsmen. This is rather astonishing. The queen, in addition to not being granted her own pyramid built by 'the state', had to pay for her own tomb, which was left unfinished.

Callender and Jánosi, however, conjecture that the tomb was originally made for Khamerernebty I, indicated by the primacy of her titles on the lintels, but that Khamerernebty II took over and expanded it as hers.[41] The inscribed lintel spanned the entrance into the chapel (H), a large oblong room, 3.17 × 11 m (10 ft 5 in. × 36 ft) cut within a bedrock block. In spite of the importance of the two queens, as expressed on the entrance lintel, the walls of this room were never decorated with scenes and texts. The original tomb consisted of this room and a passage running from southeast to northwest, also cut into bedrock [**13.18**]. On site, we observed that this passage was longer than anyone has so far mapped, beginning further to the southwest, lined by masonry.

Opposite the entrance into room H, quarrymen cut a niche in the western wall, probably for the placement of small statues. In front of the niche, a passage opens in the floor and slopes down to a lower chamber (J), divided into two spaces by a narrowing in width from 3.32 m (10 ft 10 in.) on the east, to 3.1 m (10 ft 2 in.) on the west, and a rise in

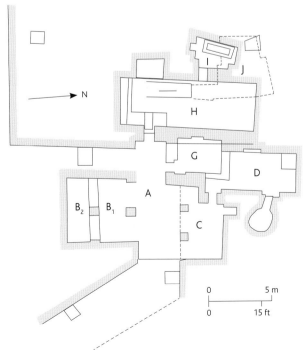

13.18 Plan of the Galarza Tomb of Khamerernebty II (after V. Callender and P. Jánosi, (1997) fig. 3).

floor level of the western part where Daressy found the poorly preserved and incomplete remains of two human skeletons.

Tomb builders later cut a short passage in the northern end of the western wall of H to a small chamber (I), 3.2 × 2.15 m (10 ft 6 in. × 7 ft), above and slightly south of room J. The passage may have been cut through a niche, perhaps for a false door, which had been part of the original design.[42] Against the western wall, Daressy found an undecorated white limestone sarcophagus; a niche in the middle of the southern wall could have received a canopic chest. In the debris Daressy found several bones of a mummified human body. Callender and Jánosi, who have reassessed the tomb, point out that the canopic niche and sarcophagus cannot have been part of the original plan, since in none of the rock-cut tombs at Giza is the burial place at the same floor level as the chapel, and it would seem unlikely the concept was acceptable for Khamerernebty's tomb.[43] After the burial, the passage into this room was blocked.

Then at some point, masons built a wall across the southern end of room H, probably as a *serdab*. At this end of the room, Daressy found fragments of limestone servant statues, substituting for the relief scenes lacking on the unfinished walls of the chapel.

The presence of two burial chambers, an upper and lower, along with the information on the lintel, does support the idea of mother and daughter being interred in the same tomb, and it certainly points to the fact that a double burial was considered. The remains of two skeletons in one of the chambers is also interesting, but from Daressy's report it is not possible to know whether these, or the mummy in room I, were original or intrusive.

Callender and Jánosi suggested that it might have been after Khamerernebty II took over the tomb that builders made chapels on the east, and built a masonry superstructure – in effect, raising a mastaba over the bedrock quarry block. If so, this may be the oldest combined rock-cut and mastaba tomb, perhaps even the prototype.[44]

Possibly at the same time that masons built the mastaba, quarrymen extended the tomb by cutting pillared porticoes out of the bedrock on either side of the central passage to chapel H, though not symmetrically, leaving two bedrock pillars in each. A sculptor began carving a statue of a woman in

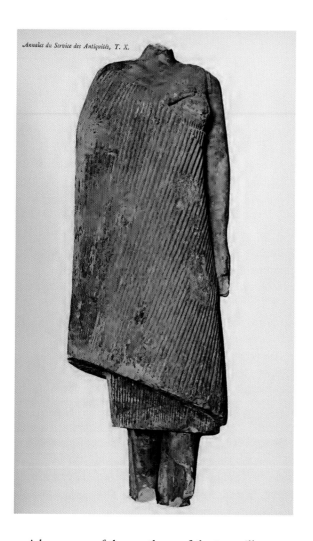

13.19 Life-sized statue of a queen wearing a pleated tunic, found in the southern portico (room B2) of the Galarza Tomb. Egyptian Museum, Cairo (48828); 1.34 m (4 ft 5 in.) tall.

a niche on one of the southern of the two pillars in the southern portico, and Daressy found six near complete statues, including two of the most unusual statues of women from the Old Kingdom, as well as alabaster and diorite fragments of other statues.

Four statues are more or less complete. One (Egyptian Museum no. 48828), found lying on its side, with head and feet missing, is the life-sized figure, 1.34 m (4 ft 5 in.) tall, of a woman against a narrow plinth, her left leg positioned forward [**13.19**]. She is wearing a pleated tunic, wrapped twice around her body; her left arm hangs bare against her body, while her right arm is shown bent under the tunic, with her hand emerging at her left breast. It presumably represents Khamerernebty I or II. Daressy also found two seated statues of a woman alone, and one pair statue of a woman with a man, whose name ends *n-re*, possibly, Khuenre, a son of Khamerernebty II.

Two statues were also discovered at the back of a northern portico, including an unfinished colossal seated statue of one of the two queens named Khamerernebty. At 2.28 m (7ft 6 in.) tall, at least twice life-sized, it is the only monumental statue of a queen from the Old Kingdom, 'the largest rendition of a woman extant from the Old Kingdom and quite possibly the first large statue of a woman in history'.[45] The front of the seat on either side of the queen's legs is inscribed. What remains includes part of her name, Khamerernebty, and the titles 'King's Daughter of His Body' and 'King's Wife', as well as queenly titles 'She Who Sees Horus and Set', and 'Great One of the *hetes* Sceptre'.[46] The statue, now in the Cairo Museum (no. 48856), is presumed to be Khamerernebty II because the inscriptions do not use the title 'King's Mother'.

The other statue from the northern portico sat in a small niche and depicts a seated Prince Sekhemkare. Just beyond this niche, a narrow access opens to a room (D) with a false door carved into its western wall. A shaft descends from the floor in the northwest corner to a burial chamber (E). The room contained the bones of at least two people and some alabaster cups, though no sarcophagus was found. A square cutting in the eastern wall of the upper room opens to a rounded dead end, perhaps work on a new chamber left abandoned. A second false door, without inscription, was built in limestone into the west wall of a room (G) immediately to the right of the entrance into the western room (H). In this complex tomb Daressy also found a shaft apparently dating to the New Kingdom.

In the whole complex two rooms contained the only false doors, 'one of the most essential features of a private tomb'.[47] Were these for the two queens? Both Khamerernebty I and II were wives of kings, but in both cases the king is unknown. This mother–daughter pair is one of the rare, secure, royal family links (like those of Meresankh III) from the ancient sources that survive in the Giza Necropolis. Egyptologists have concluded that the older queen was married to Khafre, and the younger to Menkaure, but this is nothing more than inference. We do know that Khamerernebty II was the mother of a prince Khuenre, whose rock-cut tomb Reisner found in the quarry cemetery southeast of the pyramid of Menkaure (see below), supposedly Khuenre's father.

Other queens' tombs

The Galarza Tomb stands at the eastern point and vanguard of the Central Field East, behind Khafre's valley temple. Another queen, Rekhitre, made a tomb 155 m (508 ft) further west (G 8530) and also alongside the Khafre causeway. Rekhitre displays the titles of a queen, including 'King's Daughter', and 'King's Wife'. In the nearby tomb of one of her funerary priests, Kaemnefret, she is called 'Horus Wesir-ib' [Khafre's Horus name], His Daughter', though this text could date as late as the 6th dynasty. She has been assumed to be a daughter of Khafre; her husband could have been a little-known successor of Khafre (Bicheris), Menkaure or Shepseskaf.

Rekhitre's tomb, with a superstructure of locally quarried limestone, is a combination of rock-cut and mastaba. As with the Galarza Tomb, a long corridor, cut into bedrock, formed the approach, running 53.6 m (176 ft) parallel with and 8 m (26 ft 3 in.) to the south of the Khafre causeway. The corridor ends in a rock-cut courtyard, from where a turn to the south (left) led through two antechambers with floors cut into the rock and upper parts (now mostly missing) built of masonry. Quarrymen cut the entrance to the rock-cut chapel in bedrock and masons cased it with fine limestone. Here artists carved the queen's name and titles in raised relief. Based on the form and location of the tomb, so close alongside Khafre's causeway, Jánosi accepts that tomb builders made Rekhitre's tomb near the end of the 4th dynasty.

Another queen, named Bunefer, was given a rock-cut tomb (G 8408) in the eastern end of the northern side of the wide corridor that quarrymen cut to separate the giant block of bedrock that served as the pedestal of the monument of Khentkawes I. Bunefer herself was a 'King's Daughter of His Body' and 'King's Wife', but not a royal mother. Her husband was possibly Menkaure, Shepseskaf or the supposed short-reigned King Thampthis (unattested by contemporary sources).

In her tomb Hassan found a limestone slab with an inscription, only partially preserved, with the vulture and cobra each on the basket hieroglyph, *nb*, for 'lord' or 'mistress.' These 'Two Ladies' icons of Upper and Lower Egypt are followed in the text by the mummy on a chair, *shepses*, the first part of the name of Shepseskaf. This must be

the 'Two Ladies' name of Shepseskaf, Shepses-Nebty. Bunefer's titles include 'Beloved Priestess of Shepses-Nebty'. Bunefer also inscribed the title, 'Priestess of Horus...' where a break probably had Shepses-a'a, the Horus name of Shepseskaf.

Priestess of a king is an uncommon title to be held by a queen. From her title Priestess of Shepseskaf, scholars suggested Bunefer was a daughter or wife of Shepseskaf. Hassan reasoned that because Bunefer's son had the modest titles of 'Judge' and 'Inspector of Scribes' and is not designated as a king's son, Bunefer must have married again and bore this son after Shepseskaf died, though Jánosi points out that the text was probably added later, possibly by a more distant relative who wanted to perpetuate his name.

Last of the 4th dynasty: Khuenre

Perhaps the last of the 4th dynasty family tombs to be built was Khuenre's, far from the princely cluster in the Central Field West quarry face. A son of Menkaure, or so Egyptologists generally surmise, he followed the practice of sons of Khafre in cutting the substructure of his tomb in a bedrock quarry face below and about 100 m (328 ft) to the southeast of his father's pyramid. Labelled MQ1 (Menkaure Quarry 1), Khuenre's tomb lies in the deep northwest end of the quarry that supplied the stone for Menkaure's pyramid, and is the largest and most important tomb in this rock-cut cemetery.

Although Reisner excavated the tomb in 1913, this and others in the cemetery are unpublished. Khuenre's texts name him as a 'King's Eldest Son of His Body', and it is presumed Menkaure is his father in large part because of the location of the tomb. Reisner inferred that Khuenre had been crown prince and died before his father. As certain as we can be in such matters, Khamerernebty II was his mother, for she is shown in his tomb, seated on a throne, with Khuenre standing before her. The queen holds a lotus flower and grasps with her other hand the arm of the prince, who is represented as a small boy

13.20 Prince Khuenre shown as a seated scribe. Reisner found the statue in the offering chamber of the prince's tomb in the quarry for the Menkaure pyramid. Yellow limestone. Museum of Fine Arts, Boston (13.3140); 30.5 cm (12 in.) high.

wearing the side lock of youth. His right hand rests on her knee; in his other hand he grasps a hoopoe. The queen's name and titles, inscribed above her head, designate her as 'King's Eldest Daughter'.

Quarrymen dressed the rock face of Khuenre's tomb to a flat sloping surface and masons crowned it with a low sloping mastaba of stone blocks. As usual, workers left the rock-cut part unfinished. The entrance in the middle of the east (northeast) side opened into a rectangular entrance room. Artists decorated only the south half of the east wall, on which they carved scenes of boat-building and statue-making, and the south wall. A tomb shaft was sunk in the southeast corner of this room. Workers cut a smaller room to the north, intended as an offering room, but then closed it by building a massive stone wall. A shaft in the floor leads to a corridor that slopes down to the burial chamber, which contained a granite sarcophagus. Craftsmen left two false doors blank, with neither text nor image, as they did so often in the rock-cut tombs at Giza. In the offering chamber Reisner found a fine statue of Khuenre as a seated scribe [**13.20**].

Although the builders never completed Menkaure's pyramid, it was nearly finished when they stopped. So Khuenre must have made his tomb during the last phase of the 4th dynasty activity at Giza in the quarry created for building the pyramid. We do not know if tombs of other members of the Menkaure's house exist in this quarry as it remains incompletely excavated. The other tombs visible belong to later generations.

Fictive family claims to the Giza kings?

Another cluster of tombs is located at the far northern point of Central Field East quarry patch, close to the Khafre causeway. Their location might make us think that the people buried in these tombs lived in the 4th dynasty. But tell-tale features suggest otherwise.

A narrow corridor, 18.1 m (59 ft) long – a kind of causeway – led to the entrance of the largest tomb (G 8464) of this cluster, indeed one of the largest in this part of the necropolis, at 73.74 sq. m (794 sq. ft), exceeding in size of all those rock-cut tombs attributed to Khafre's sons. Perhaps this is fitting. After all, the drum roll above the entrance bears in carved relief the queen's name and titles, Hemetre, 'Priestess of Hathor' and 'King's Eldest

Daughter of his Body' [**13.21**]. In an upper register on the lintel over the entrance, artists carved an offering formula, which includes the phrase 'a boon which Osiris gives, a burial in the Necropolis of the western desert'. The lower register on the lintel lists the feasts when the offerings should be brought to the tomb.

One word in the upper register – the mention of Osiris, god of the Underworld – hints that this text was added much later than the 4th dynasty. Quarrymen may have prepared the tomb for someone in the late 4th dynasty, perhaps even for a princess, but Hemetre usurped the tomb some 60 to 80 years later, in or after the reign of Niuserre in the 5th dynasty.

Artists decorated either side of the entrance with scenes of offering bearers and personifications of villages, farms and ranches (estates) named after Khafre, with the royal name in cartouches. Because of her titles, the location of her tomb next to Khafre's causeway, and these estates, scholars took Hemetre as a daughter of Khafre. But Andrey Bolshakov argued compellingly, based on the structure of the offering formula, the placement of the offering scenes and a scene of dragging a statue, that artists must have decorated Hemetre's tomb as late as the reign of Niuserre or later.[48]

Just southeast of Hemetre's is the tomb of Ankhmare (G 8460), another 'Eldest King's Son of His Body' and, like other king's 'eldest sons', also a 'Chief Justice and Vizier'. Again we might assume, from the location in this part of the cemetery, and the proximity of his tomb to the Khafre causeway, that his parents were Khafre and an unknown queen. A fragment of fine limestone casing from the inner room of Nebemkahet's tomb (LG 86) bears part of the name Ankhmare, and the title 'King's Son of His Body', so Ankhmare might be Nebemakhet's brother. However, Ankhmare is not shown as a sibling in Meresankh III's tomb.

If Ankhmare was a son of Khafre, he must have begun his tomb in that reign or later. Why was he not buried in a rock-cut tomb in the Central Field West quarry face, like Khafre's other sons? Plenty of space was available there. Jánosi suggests that the position of Ankhmare's tomb in the Central Field East, as well as its more developed layout, indicate that he prepared his tomb later than those sons of Khafre. From that, Jánosi suspects that Ankhmare

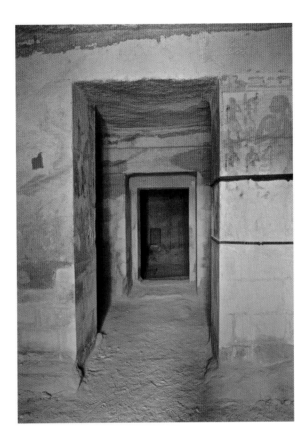

13.21 Doorway to the inner, western room in the tomb of Hemetre. View to the west.

was not a true son of Khafre, but a more distant descendant, who, like Hemetre, chose to return to the ancestral cemetery at Giza.

Another of these later returnees who claimed 4th dynasty family ties was Iuenre, who occupied a tomb (G 8466) to the northeast of Hemetre's. Major features of Iuenre's unfinished tomb suggest it was made in the late 4th dynasty. From a niche cut out of bedrock in an open court, a life-sized statue, 1.55 m (5 ft) tall, striding forth, left leg forward, greeted visitors. The west end of the back wall featured another statue of a man, 1.45 m (4 ft 9 in.) high, in a pleated kilt, also striding forward from within a niche.

The tomb entrance opens in the centre of the west wall of the court. The drum roll above it was covered by an upper horizontal register and nine vertical rows of dense text, and began 'The King of Upper and Lower Egypt, Khafre: His Eldest Son of His Body'. Hassan excavated the tomb in 1934–35 and concluded from the unfinished condition of the walls that Iuenre died before the completion of his tomb. Although they did not finish the chamber, sculptors carved two false doors in the western wall. As so often in the rock tombs, however, they left

the false doors blank, without inscribing the name, titles and image of the proprietor.

Egyptologists have taken Iuenre as a son of Khafre because the drum inscription explicitly says so. But Jánosi doubts whether Iuenre, as with Ankhmare and Hemetre, even belonged to the generation of Khafre's children, and argues that instead he lived and died some 70–80 years later, in the mid-5th dynasty, or later, and took over an older tomb that necropolis workers had left unfinished in the transitional period between the end of the 4th dynasty and the beginning of the 5th.

It seems strange, Jánosi observes, that a royal son who died early did not receive from his father, the king, the most important location and architectural requirements of a princely funerary cult, such as inscribed false doors. The very specificity of Iuenre's princely title also raises suspicions. After the name and title of his alleged father, Iuenre adds his filiation 'His Eldest Son of His Body'. We know at least six 'Eldest King's Sons', presumed actual sons of Khafre.[49] It was common for princes of the 4th dynasty to give their title simply as 'Eldest King's Son' or 'Eldest Bodily Son of the King' and not to mention the name of the king in their tomb. If Iuenre was a son of Khafre, why did he emphasize it?

The idea that prominent people of a later time came to Giza, reused older, unfinished tombs and in their décor adopted fictive relations with the 4th dynasty kings raises a number of questions. If Ankhmare and Iuenre were princes of their time, why, in the inscription they hoped would last eternally, would they fake affiliation with the 4th dynasty royals at the expense of any mention of their own royal family? If Debehen and Iuenre needed a 4th dynasty affiliation to legitimize their claim to a tomb in the Central Field East, why did the dozens of 5th dynasty proprietors whose tombs honeycomb this old quarry not need a similar legitimizing connection to the Giza pyramid kings?

The final word has probably not been said on the dates of Debehen, Hemetre, Ankhmare and Iuenre. In judging a narrative like Debehen's as fiction, and projecting it generations later than the narrative itself alleges, and in seeing Iuenre's explicit statement as being Khafre's son as invented, it would be a shame if we were rejecting important pieces of the 4th dynasty royal family puzzle.

Necropolis expansions and densities

We do know that by the middle to late 5th dynasty, many other tombs had begun to fill in and expand the old nucleus mastaba cemeteries and clusters of rock-cut tombs. Tombs crowded together and cemeteries expanded through ties of family and dependency, and through a use of old, unfinished tombs. Streets filled in, sons joined their tombs to those of their fathers. Where space allowed, family tomb clusters developed.

A man named Senenuka (nicknamed Keki) inscribed his titles on his tomb (G 2041): 'Overseer of the Pyramid Town, "Horizon of Khufu"' and 'Administrator of a Settlement' (gerget). A gerget, from the verb 'to settle' or 'found', was literally a 'settlement' or 'foundation'. In Senenuka's title, the word was probably short for 'The Northern Settlement [of Khufu]', which would indicate two terms for Khufu's pyramid town, or two settlements associated with his pyramid. Estimates of when Senenuka made his chapel range from the 4th dynasty to the end of the 5th (Unas), a span of some 150 years or more, but most range between the mid- to late 4th dynasty (Khafre to Menkaure) to the early 5th dynasty. However, certain evidence makes Egyptologists' push the date back into the 4th dynasty.

Reisner thought Senenuka Keki was the same person as a man named Senenuka shown attending to Nefer in the relief carved in the latter's chapel [13.22], attached to his much larger mastaba (G 2110) directly east and north of Senenuka's. The mastaba of Senenuka was built against the southern side of a mastaba (G 2051) belonging to a man named Tjenti, who held office as 'Overseer of the Scribes of the Pyramid, "Horizon of Khufu"'. So Senenuka's mastaba (G 2041) must have been built after Tjenti's.

Peter Der Manuelian suggested Tjenti and Senenuka were contemporaries of Nefer,[50] and may have been dependents of his household. Reisner dated Nefer's chapel 'to the last years of Khufu or the middle of Khafre's reign'.[51] Manuelian dated Nefer's chapel decoration to the reign of Djedefre or to the reign of Khafre, saying that the evidence for its final occupation best fitted the latter.[52]

If the Senenuka of tomb G 2041 and the scribe Senenuka shown in Nefer's chapel are the same person, Senenuka Keki was probably a young man during the reign of Khafre. Suppose Senenuka

was 15 years old midway through Khafre's reign and lived another 35 years, when craftsmen began (but did not finish) decorating his chapel. By Egyptologists' chronologies, this would be at the end of Menkaure's reign. Were he 18 at the end of Khafre's reign and lived another 30 years, when craftsmen decorated his chapel, they would have done so in the reign of Userkaf, the first king of the 5th dynasty.[53] Senenuka would have been 48 years old; he would need to have lived to the age of 61 to see Niuserre ascend the throne, not impossible, even in an age of life expectancy less than that of today.

To understand the Giza Necropolis, it is thus essential to see tombs in term of lifetimes. Only then can we use the tombs, their texts and titles, to construe political and social developments during the Old Kingdom. We can take, as another example, the curious case of Nesut-nefer.

Nesut-nefer built his chapel into a corner of one of the stone mastabas (G 4970) that Khufu's teams had erected in the western line of the Cemetery en Échelon (see 13.7). For Nesut-nefer, builders added a new façade and outer casing over the eastern and southern sides of the older stepped mastaba core. They left this work unfinished, but dressed the casing stones smooth round the entrance to his chapel. On the northern wall of his chapel, Nesut-nefer's craftsmen carved a remarkable arrangement of titles in six vertical columns above the heads of figures of himself and his wife [**13.23**].[54] The titles refer to offices he held in the pyramid 'Great is Khafre'.

Like Senenuka, among his titles Nesut-nefer also held the abbreviated title *Adj-mer Gerget*, 'Administrator of a Settlement',[55] which he inscribed on the drum roll above the entrance into his chapel.[56] Was this an abbreviation of the Northern *Gerget* of Khufu? This title follows that of 'Overseer of the Houses of the Royal Children'. If Nesut-nefer held these titles in the reign of Khafre, that might place him as one of the occupants of our Heit el-Ghurab site, described in Chapter 15, which was in its heyday in the reigns of Khafre and Menkaure. On the other hand, Junker thought that when Nesut-nefer held his titles relating to the Khafre pyramid complex and the royal house, Khafre was long dead, and that the titles related to the mortuary service for the dead king. The crux of the

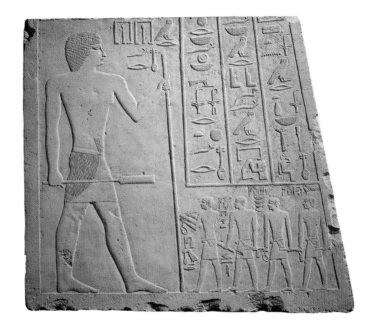

issue is the date of Nesut-nefer's tomb. Junker dated it to the 5th dynasty, by which time people had abandoned the Heit el-Ghurab.

Career ties and retirement return: stepping stones across a dynastic threshold

Nesut-nefer may be one of several officials whose tomb chapels probably date to the 5th dynasty, but whose titles, relief-carved scenes and statues look back a generation or more into the 4th dynasty. In fact, any of these men could have administrated aspects of the Heit el-Ghurab site. Their careers overlap the reigns of successive kings spanning the end of the one dynasty and the beginning of the next. This generation or two saw the transition from pyramid building at Giza on gigantic scales to the smaller 5th dynasty pyramids elsewhere, with more elaborately decorated temples, as well as increased organization of the countryside, and a bureaucracy more detached from the immediate royal family. As James Henry Breasted noted: 'the period from the last years of Menkaure to the first of Niuserre was not longer than a man's lifetime'.[57]

We have seen how Sekhemkare, an 'Eldest King's Son', inscribed in his tomb (LG 89) that he was *imakhu* (provisioned by, honoured) in the sight of five kings: his father, who was almost certainly Khafre, and four succeeding kings, Menkaure, Shepseskaf, Userkaf and Sahure. A man named Netjerpunisut recorded in his tomb northeast of the Khentkawes I monument that he was honoured

13.22 Relief from the tomb of Nefer (G 2110) showing the standing figure of Nefer, attended by four scribes identified as Nefru, Weni, Khentikauf and Senenuka.

by kings Djedefre, Khafre, Menkaure, Shepseskaf, Userkaf and Sahure (see also p. 130). Sekhemkare's career must have spanned 43 years minimum and 80 maximum, while, based on the lengths of the reigns in question, Netjerpunisut must have lived to an age of at least 69 years and possibly as much as 89. We should view the tombs of the Giza Necropolis as testimonies in stone of careers that spanned reigns and dynasties.

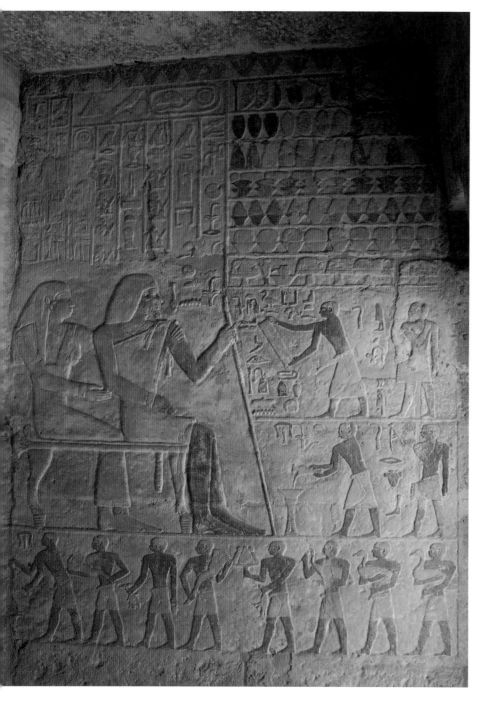

Three generations of scribes named Seshemnefer, all buried in tombs in the Western Cemetery, form another line whose titles appear to have crossed the transition from the 4th to the 5th dynasties (see 13.7). John Nolan suggested that Seshemnefer II may have owned one of five seals that left impressions on sealings found in the Pottery Mound at the Heit el-Ghurab site (see p. 383).[58] This sealing bears the title 'Scribe of Royal Documents for Royal Instruction', which is unique except for the fact that Seshemnefer II inscribed the same title in his tomb (G 5080).

Seshemnefer II's probable father, Seshemnefer I, held titles relating to provisions, construction and labour, and also 'Overseer of the King's Writing Case', perhaps taking this office from Nefer (G 2110) in the late 4th dynasty.[59] Seshemnefer III (G 5170) held the title 'Overseer of Scribes of the Royal Documents', which is common in the Pottery Mound sealings, and became Vizier. It is certain that five seals that Nolan reconstructed from clay sealing fragments found in the Pottery Mound bearing the title 'Scribe of Royal Documents for Royal Instruction' date to the reign of Menkaure. Yet most scholars date Seshemnefer II's tomb to the reign of Niuserre, while Michel Baud dates it earlier in the 5th dynasty or to the end of the 4th dynasty.[60]

Seshemnefer II's tomb is one of 25 in the Cemetery en Échelon [13.24]. Khufu's forces created this series after they had built the other nucleus cemeteries. Of 25 mastabas in the three main rows in the cemetery, we know of only six names from the remains of decorated chapels, one of whom is Nesut-nefer. Most Egyptologists date the chapels of these six men to the 5th dynasty, from 63 to 82 years after Khufu, or to the reigns of Neferirkare and Niuserre, some 82 to 192 years after Khufu. Nine mastabas appear to have never received offering places or chapels. Apparently they were never used.[61] Where people did use the other unnamed mastabas, their shafts and substructures are much less substantial.

Jánosi speculates persons buried in the lesser substructures, probably in the late 5th dynasty, may have been of a class of people who were poor compared to the courtiers of Khufu for whom the tombs were intended, and compared to the six officials whose names we know.[62] Perhaps certain officials returned to the royal cemetery at Giza

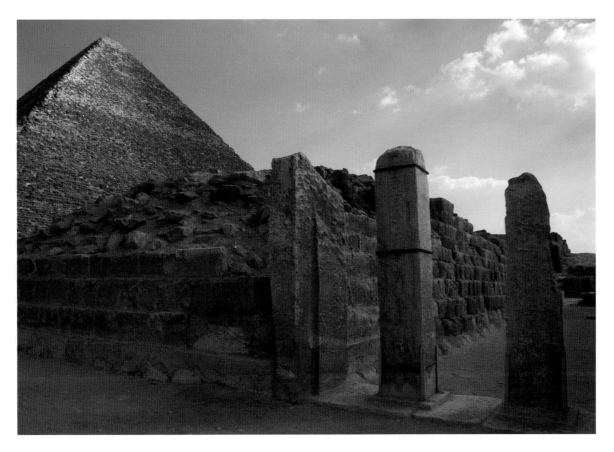

where they had served as overseers of provisions, of builders, of troops and as supply-expedition leaders early in their careers.

Colonizing a 4th dynasty necropolis

It is clear that people inserted their chapels in some of the old mastaba cores at a much later time. The conspicuous temporal discrepancy between the creation of mastabas in modular series at an early period, and their completion with chapels, and occupation and use much later, characterizes the early history of the use of the Giza Necropolis.

It is as though the 4th dynasty Giza kings intended to create tomb-housing projects that would take the mortal remains and relics not only of immediate family members and courtiers, but also those of their descendants, their descendants' descendants, their *ka*-priests and their descendants. These kings were planning for future generations to cross over, through those false doors, to the Afterlife, to join the 'community of *ka*s (spirits)', as Reisner called the Giza Necropolis.

Many of the colonizers were old people who had served in the massive 4th dynasty pyramid projects in their youths. They returned to Giza in the 5th dynasty for their eternal rest. Many could not finish their tombs; their craftsmen left their false doors blank. But they chose to return there in old age, with limited time for tomb building, because Giza had been the place of the most dramatic work and experiences of their lives. The expansion and infilling of the great Giza Necropolis by succeeding generations has left us the thick, dense galaxies of tombs around the old nucleus cemeteries flanking the pyramids and Sphinx.

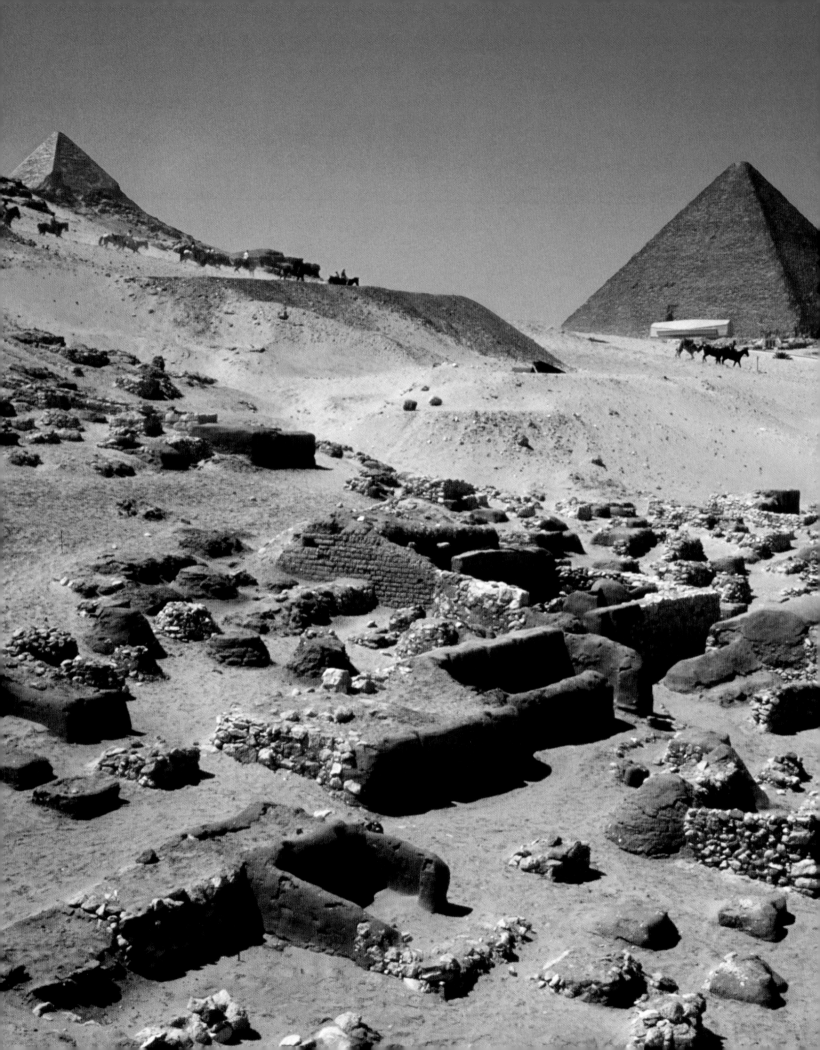

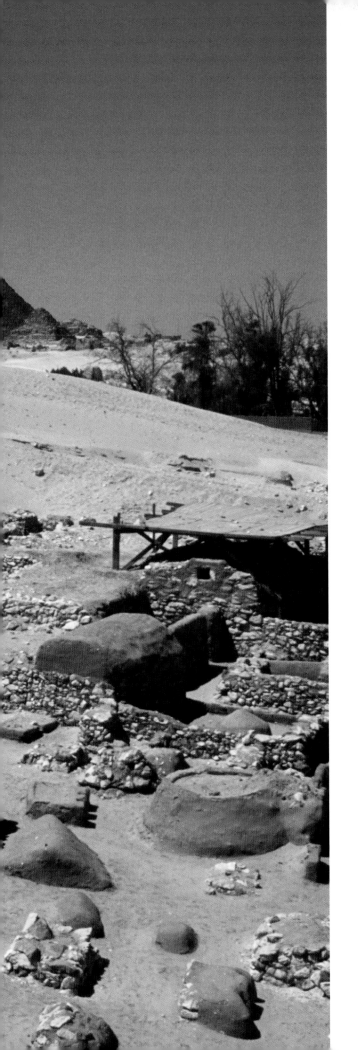

The Workers' Cemetery

For nearly 400 years, in the second half of the 3rd millennium BC, workers and their overseers toiled to build the Giza Necropolis. They laboured on the three giant pyramids over the course of at least 67 years, the combined minimum lengths of the reigns of Khufu, Khafre and Menkaure. During this time other workers prepared the great mastabas and rock-cut tombs described in Chapter 13. And tomb builders remained employed at Giza for officials and noblemen long after pyramid builders had moved away to Saqqara and Abusir in the 5th dynasty.

The massive labour force required to build a pyramid probably came under the direction of one man who held the title 'Overseer of All the King's Works'. Men who held this title were each buried in one of the giant mastabas up on the main plateau in the elite pyramid cemeteries. Hemiunu held the title under Khufu, and his mastaba (G 4000) in the Western Cemetery (see p. 106 and Chapter 13) is one of the largest at Giza, where Junker found his impressive statue (see 6.18).

But could we expect lesser officials and common labourers to have been buried in the royal necropolis? At least five to ten generations of tomb builders must have come and gone. What became of those who died while at Giza? Were they buried anywhere near the grand tombs they constructed? Were lesser officials and common labourers treated differently?

In 1988–89, during the first season of our excavations in the area of Giza south of what is known as the Wall of the Crow, we came across a hint of a tomb builders' cemetery in a tract of low desert about 400 m (1,312 ft) south of the Sphinx. On the low, sandy eastern slope of the escarpment we uncovered a building with pedestals that served as the foundations, we believe, of storage compartments. Slightly higher up the slope we

exposed a structure that we thought might also be for storage, possibly a granary. Oriented north–south, it had stone-rubble retaining walls on the long sides cased with mud brick. When we uncovered a human skeleton in each of its two vaulted mud-brick chambers we reasoned that they had been 'repurposed' as tombs for the poor. In fact the structure had been built as a tomb. The bodies lay in a contracted position, head to the north and facing east, utterly devoid of accompanying grave goods or pottery. In the centre of the east wall of each chamber, a small gabled opening was blocked by the stone-rubble retaining walls.

Since there were no other features to be seen on the innocuous sandy slope rising behind us, it was reasonable to assume that this was no more than an opportunistic burial. That would all change the following year.

The discovery

On 14 April 1990, the chief of the guards of the Giza pyramids, Mohammed Abdel Razek, reported that an American tourist riding across the plateau had been thrown – but fortunately was unscathed – when her horse struck something hard. It was a small section of previously unknown mud-brick wall located about 10 m (33 ft) from the 1988–89 excavations. On 4 May 1990 the Egyptian team from the Giza Inspectorate began excavations on what we would come to call the Workers' Cemetery. For several years following the discovery, we (Hawass) spent nine months there, with a full complement of archaeologists and specialists as well as 70 workmen.

After over a decade of investigation we revealed a unique hillside necropolis with two major components [14.2]. On the lower slope lie the mud-brick and fieldstone tombs of more prominent people, possibly overseers, surrounded by the smaller tombs that must belong to workers and kin under their supervision. On the high escarpment stand the larger, stone-built tombs of the skilled craftsmen and administrators, in a series running

PREVIOUS PAGES
14.1 The Workers' Cemetery as excavated in 1991, in a view to the northwest across the Maadi Formation escarpment to the pyramids of Khufu and Khafre in the background.

BELOW
14.2 Point cloud of the Workers' Cemetery 'captured' in 2006 by the Giza Laser Scanning Survey, directed by Yukinori Kawae.

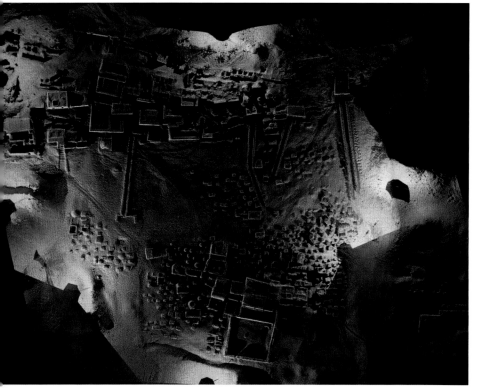

Workers' Cemetery explorations

Years	Excavator
1906	W. M. F. Petrie (upper tombs)
1990–2009	Z. Hawass (SCA)

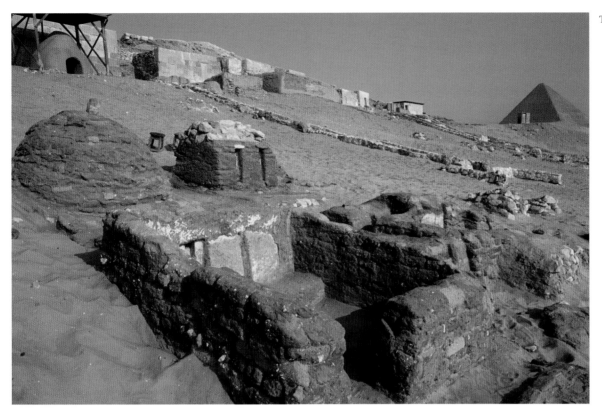

14.3 Within sight of the giant pyramids a multitude of small tombs in different forms cover the slope: some have domes, others have miniature courtyards with diminutive false doors. Causeways lead up the slope to other tombs.

north–south. This upper cemetery also follows a system of small tombs for workmen and larger tombs for overseers. We also found children's burials between the graves.

The organization of the cemetery on various levels and the distribution of smaller tombs around larger ones probably reflect social stratification and grouping during life: possibly larger householders and lesser family members, or phyles and work gangs. Or, if labour was organized along family lines, the cemetery organization might reflect both.

The lower cemetery

We began to excavate in 1990 in the lower cemetery. The wall that the horse exposed turned out to belong to a tomb chapel constructed of mud brick and stone rubble with a long, vaulted chamber and two false doors, GSE 1901. The vaulted ceiling of the chapel is fashioned into rolls, plastered and painted red to imitate palm logs. Unfortunately, the plaster peeled quickly and was very difficult to conserve. On one of the false doors we found crude hieroglyphs, almost a scrawl, written with an unskilled hand, but legible enough to identify the tomb owner as a man named Ptah-shepsesu. Behind and west of the chapel, three shafts each contained a skeleton, probably the mortal remains of Ptah-shepsesu, his wife and his son. To the front

of the chapel, stretching eastwards, we discovered a courtyard. Ptah-shepsesu's tomb was large compared to those that we would find around it, yet it was constructed in cheap materials.

Arrayed all around Ptah-shepsesu's tomb and courtyard was a series of smaller tombs of mud brick and broken stone, with superstructures in the form of miniature mastabas and small domes. Niches in the west face of the little mastabas served as false doors. In some cases, tiny courtyards fronted the tombs, much-reduced versions of Ptah-shepsesu's layout. These mastabas cover single shafts, probably for people who worked under Ptah-shepsesu's supervision, and perhaps also members of his extended family.

The entire lower cemetery follows this pattern – clusters of larger tombs surrounded by smaller ones. We excavated more than 60 larger tombs and 600 smaller tombs in the necropolis that sprawls across the lower slope of the Maadi Formation, including many remarkable and unique tombs. The small tombs come in an amazing variety of forms: diminutive domes, tombs with gabled roofs, and miniature mastabas with little courtyards and tiny, inset stone false doors [**14.3**]. The domes cover simple rectangular grave pits, sometimes located in the centre of a surrounding courtyard. In extremely basic form, this follows the configuration of the pyramids, which are positioned in the centre

of a square or rectangular enclosure. One small domed tomb inside a square courtyard even had a miniature ramp leading up to and around it: could the builder have intended to commemorate the construction ramp on a royal pyramid [14.4]? The miniature mastabas are not much larger than a child's classroom desktop, and their tiny false doors are sometimes carved with crude inscriptions mentioning the names and titles of the deceased [14.5]. These tombs are scaled-down versions of the great stone mastabas belonging to the most important members of Old Kingdom society that flank the Khufu pyramid on the east and west, discussed in the previous chapter.

At least one of the tombs in the lower cemetery had a gabled or pented mud-brick roof, reminiscent of the great pented roofs formed of enormous limestone beams first built in the pyramid of Khufu, and frequently found in the pyramid burial chambers of the 5th and 6th dynasties.

We took to calling one tomb the 'Egg-dome tomb': an outer dome, about 2 m (7 ft) in diameter and still preserved to a height of about 1.5 m (5 ft), was formed of mud brick that had been plastered smooth with light-tan tafla (clay) [14.6]. Many of the domed tombs had been similarly

finished, although the plaster had worn off, and they would have resembled the domed tombs of more recent Islamic cemeteries in rural Egypt. A narrow rectangular courtyard enclosed by a fieldstone wall was attached to the east side of the dome. Nearby, we found typical Old Kingdom jars, perhaps left as offerings. Inside the outer domed shell an additional miniature egg-shaped vault covered a rectangular burial pit. When we excavated the tomb, the space between the two vaults was filled with sand, but since the outer shell was broken, the space might have originally been left empty. The builders created the inner 'egg' dome by corbelling – that is, setting each layer of brick so that it overhangs the one below by a small amount until the bricks nearly meet at the top of the dome. The builders of Khufu's pyramid used stone corbelling to form the Grand Gallery leading up to the royal burial chamber; they in turn followed the technique of their fathers, who had built an impressive series of corbelled galleries in the pyramids of Khufu's father, Sneferu. In the 'Egg-dome tomb', the corbelling continued down the sides of the rectangular burial pit. At the bottom lay the skeleton of the tomb owner in the contracted, 'foetal position', possibly the posture of rebirth.

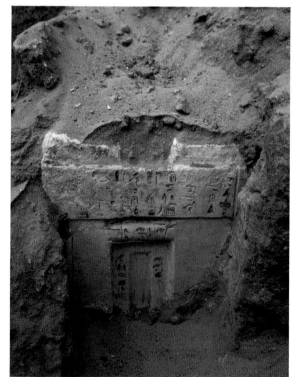

BELOW LEFT
14.4 A small dome over a burial compartment within a courtyard defined by a crude mud-brick and fieldstone wall. Does the miniature ramp imitate a construction ramp up on to one of the large royal pyramids?

BELOW RIGHT
14.5 A tiny false door set into the façade of a diminutive mud-brick tomb in the Workers' Cemetery. Simple hieroglyphs, crudely incised and filled with black pigment, give the name and titles of the deceased.

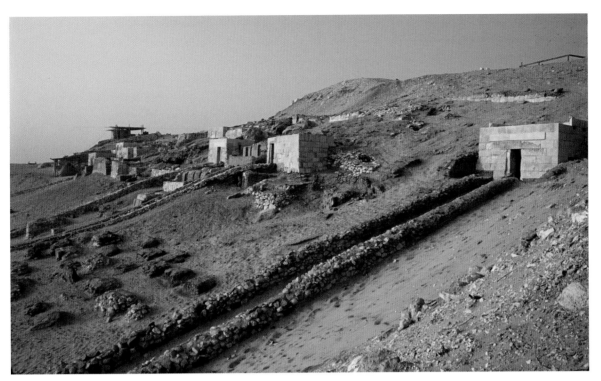

This tomb echoes the symbolism of the pyramids themselves, whose inner mounds may have represented the primeval mound of regeneration (see Chapter 4 for the origins of the pyramids).[1]

The tombs of the lower cemetery are similar to others found in the provinces of Middle and Upper Egypt at such sites as Nag ed-Der and Dendera. They reflect folk-burial customs at a time when the elite burial customs – large tombs with particular patterns of decoration and containing mummified bodies in the extended position – were just beginning to spread from the core of the Egyptian kingdom to the provinces. This lower cemetery at Giza prompts us to look again at provincial ones, and to consider more about how the tombs compare to the giant stone tombs and pyramids. It is a firmly entrenched idea in Egyptology that for

the highly ritualized passage of death and burial the royal house created and defined architectural forms (and literary compositions) that then later spread to subordinate classes. However, do we misread the picture? Did the royal house elaborate by several orders of magnitude, and set for eternity, in mud brick and later stone, architectural forms that derived from a long-held and widespread popular culture in the Nile Valley? Were the builders of these diminutive mud-brick tombs at Giza copying innovations of the royal house – what archaeologists call 'elite emulation' – or were they simply building their own tombs according to their inherited custom, while constructing similar forms in stone on a substantially grander scale for the members of the greatest households of the land?

The upper cemetery

We uncovered the lower cemetery by removing a blanket of clean, wind-blown sand. As we cleared towards the west and up the slope, we moved deeper and deeper into the sandy overburden that increased to several metres thick. It was evident that the sand had accumulated fairly quickly by archaeological timescales, for the small mud-brick tombs had suffered less erosion from the time they were built until the time we uncovered them than they did over the course of the several seasons of our excavation. It was the task of our restorers to arrest this deterioration.

BELOW
14.6 The 'Egg-dome tomb', so-called because a corbelled, vaulted 'egg' shell of mud brick covers the burial, and a second, larger, dome then covers the egg.

ABOVE
14.7 Stone-clad tombs of craftsmen along the upper ridge are connected by long causeways of fieldstone walls to the bottom of the slope, where clusters of smaller tombs surround the causeway entrances. View to the south-southwest.

Eventually we came upon the bottom of a ramp that led up the slope through the thick layer of sand to a second cemetery at a higher level, closer to the top of the ridge of the Maadi Formation [14.7]. In 1906, a team nominally under Petrie's supervision excavated a series of Old Kingdom tombs along the top of the ridge, but they did not map and study these high-lying tombs very thoroughly. We had now uncovered the extension of that cemetery, down and across the east face of the slope.

The tomb of Inti-shedu

Following the ramp upwards for more than 23 m (76 ft), near the top we first came upon two children's graves with no offerings. Then the covering of sand fell away from the façade of a limestone masonry mastaba. Attached to its north side was a cave-like room hollowed out of the bedrock. Inside we found an intact Old Kingdom burial. Peering through the darkness, we could make out a niche in the west wall of this chamber sealed with limestone blocks, mud bricks and mortar. One small hole was left uncovered. We suspected that a *serdab* lay behind the niche, with an opening for the soul to gaze out and emerge from the tomb statue. In spite of this conjecture, I (Hawass) was not prepared for the sight that greeted me when I shone my torch light inside the hole: the eyes of a beautiful limestone face stared back at me.

I began carefully to remove the mud-brick wall until I could see the head of the statue clearly. But when I completed the removal of the limestone blocks, I found not one but four exquisite statues: a large seated figure in the centre, flanked by two smaller figures (one seated and one standing) to the right and another seated figure to the left [14.9]. This immediately struck me as very unusual: the

Statues of everyday life

We have found a number of small but nevertheless remarkable statuettes in the lower cemetery. One of the most interesting is an unfinished 'reserve head' of limestone, which we found discarded between the tombs and not associated with any of them in particular. One of 37 reserve heads that have been found to date (see Chapter 2 for more about these mysterious heads), this example does not seem to have been used and was perhaps discarded because of mistakes the artist made and could not correct. It shows a man with close-cropped hair, the hairline marked by a straight line across the forehead. He has high cheekbones and a straight nose, and he wears a faint smile.[2]

In a small limestone box formed of three upright stone slabs placed against the west face of a small mud-brick mastaba (Tomb 7) we discovered three limestone statuettes, the tallest 38 cm (15 in.) high, and a limestone vessel. One of the sculptures is of a man named Kaihep, standing and striding forwards; another shows a woman, Hep-ny-kawes, seated on a backless chair. The third depicts an unidentified woman kneeling to grind grain, successfully conveying the sense of someone hard at work, with strong shoulders and long, muscular arms. Her clothing consists only of a short kilt, since the work she was doing would have been hot and strenuous.

It is thought that the purpose of such figures was to provide the deceased with food in the Afterlife and to assist with any work that might be required. Since this statuette is as well carved and painted as the other two and has indications of a wig and a bead collar, it must represent the lady of the house, Hep-ny-kawes herself. As the wife of a workman, it is unlikely that Hep-ny-kawes could afford to hire someone else to do such labour for her.[3]

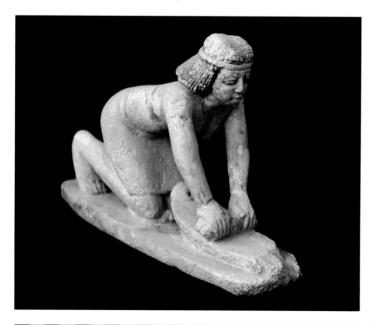

14.8 A painted limestone statue of a woman grinding grain using a hard hand stone on a saddle quern (both would have been granite or quartzite). Such 'servant statues' sometimes depict the householder or tomb owner; this one may belong to the lady Hep-ny-kawes, in whose tomb it was found; 20.5 cm (8 in.) high.

ancient Egyptians would normally have created a symmetrical arrangement, with two statues on each side; when I looked more closely, I noticed the disintegrated remains of a wooden statue that had stood on the left.

Inscriptions on the statues identify the owner as Inti-shedu, an 'Overseer of the Boat of Neith'. The largest figure, about 76 cm (30 in.) tall, also bears the title 'King's Acquaintance'. All four statues were beautifully carved of limestone and then painted, and perhaps represent Inti-shedu at different stages of his life.[4] The skin of the three seated statues was painted a dark reddish-brown, and in these images Inti-shedu wears a short, flaring black wig. The standing statue has much lighter skin and wears a short, curled wig. They all wear knee-length kilts and broad beaded collars, which may have had religious significance.[5]

We have no parallels for Inti-shedu's primary title, Overseer of the Boat of Neith. Neith was an important goddess, a daughter of the sun god Re, who seems to have had a minor cult at Giza. We have evidence for priestesses of Neith and for many more people bearing titles associated with her sister Hathor. Inti-shedu's title, however, is unique, and might suggest that there was a shrine or temple of Neith that contained her barque at Giza. Behind Inti-shedu's tomb we found six burial shafts. Two false doors graced the chapel.

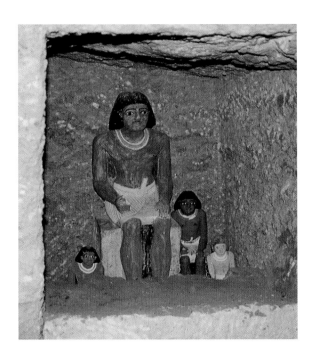

Near the front of Inti-shedu's tomb one of the mud-brick mound tombs is built in the shape of a large beehive. It was constructed in three stages. In the first stage the burial chamber was cut into the rock, with steps leading down to an entrance on the east side. This chamber was later covered with a limestone ceiling, and the 4-m (12-ft) high domed pyramid was then built above. We have covered this unique tomb with a roof to protect it from the elements [**14.10**].

The stone and causeway tomb series

The tomb of Inti-shedu (GSE 1915) was one of a series of fine white limestone mastaba tombs that stand out in the upper cemetery. Four of these tombs feature a long causeway flanked by low walls of fieldstone and clay leading down to the lower cemetery. Inti-shedu's is the first causeway tomb on the south. Smaller mud-brick and fieldstone tombs flank the tombs in this series and lie alongside the causeways [**14.11**].[6]

In general, the tombs of the upper cemetery are different in style and building material from those in the lower cemetery – some are partially rock-cut and others are built of limestone blocks or mud brick – and the artifacts, statuary and inscriptions associated with them are of better quality.

BELOW LEFT
14.9 Four painted limestone statues of Inti-shedu, in their original place in the *serdab* of his tomb. A fifth statue, of wood, which stood on the left of the group, had disintegrated. All are now in the Egyptian Museum, Cairo; the largest (JE 98945) is 76 cm (30 in.) tall.

ABOVE
14.10 The largest domed or pyramidal tomb in the Workers' Cemetery, covered with a protective canopy in 1991. View to the southwest.

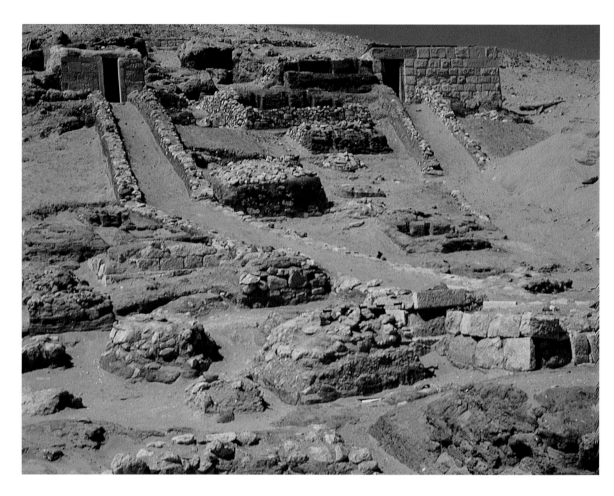

14.11 Low walls of fieldstone and clay form causeways leading down from stone tombs on the upper ridge to the lower cemetery, where clusters of small mastaba, courtyard and domed tombs cluster round the causeway entrances.

Titles such as Director of the Draftsmen, Inspector of the Craftsmen, Inspector of the Sculptors, Chief of the Estate, Overseer of the Linen, Overseer of the Tomb Makers and Overseer of the Harbour indicate a higher status than the few titles found in the lower cemetery, and confirm that those buried in the upper stone tombs were artisans. In addition, we found an inscription in GSE 1925 which included the titles Overseer of the Side of the Pyramid, Inspector of Dragging Stones and Director of the King's Work. Were the workers buried in this cemetery involved in building the Giza pyramids? We need to analyse further the names of the owners, the pottery and the styles of decoration associated with the tombs to date them more precisely within the Old Kingdom before we can answer this question (for more on this, see below).

The tomb of Ni-ankh-Ptah

The next causeway tomb to the north of Inti-shedu's belonged to a man named Ni-ankh-Ptah, who was an Overseer of Craftsmen and an Overseer of Confectioners (*bnr*), that is, he supervised the making of sweets.

His tomb provides an insight into the tomb chapels as functioning places of worship. Built of limestone, the tomb consists of a narrow antechamber and a small square inner chamber. From the end of the causeway, several stairs lead down to the antechamber, which has small windows high up in the north wall and another on the south wall. These features are designed for the comfort of the living rather than the dead, since the family of Ni-ankh-Ptah would have come here at festival time to make offerings and celebrate his cult. From the south wall of the antechamber, stairs lead to the roof where the family may have cooked their feast before coming inside to eat it.

The inner offering chapel is roughly carved from the living rock [**14.12**]. The only inscribed artifacts it contained were a very small false door, propped in a corner, and an offering table, crudely incised with the name of Ni-ankh-Ptah and another of his

titles, Overseer of the Bakers. One item in the tomb was a large bread loaf. In the tomb's burial shafts we discovered five skeletons. Near its causeway we found an unfinished statue pair of a standing man and woman. The woman's figure was finished, but the man, whose right foot is extended in a striding pose, was left incomplete. Perhaps the sculptor abandoned the work when a mistake was discovered – the man is striding with the wrong leg, since in Egyptian conventions his left leg should be in front.

At the level of the lower cemetery Ni-ankh-Ptah's causeway makes a decided bend and is flanked by very small tombs, possibly belonging to retainers of Ni-ankh-Ptah's household. Small limestone offering basins lay at the end of the causeway walls; their function may have been equivalent to that of the valley temples located at the ends of the royal pyramid causeways.

The tomb of Weser-Ptah

To the north of Ni-ankh-Ptah's tomb the next causeway tomb belonged to a man named Weser-Ptah. The very steep causeway leading up to it is built over some older mastabas of mud brick. A stela to the north of the entrance shows the tomb owner wearing a kilt and holding a sceptre and staff, with an inscription that reads: 'The Inspector of the Officials, who is Behind the Officials, Weser-Ptah'. The tomb's builders set two false doors into the walls of his chapel, which was crudely hewn from the bedrock. One of the false doors, for Weser-Ptah himself, is inscribed with offering formulae and a long list of feasts. To the south is a small false door inscribed for his son, Iy-meru, who was an Inspector of the Doorkeepers of the Palace; mysteriously, someone has deliberately covered the son's name with mud.

One interesting feature of this tomb is that the ceiling is very low, perhaps because the rock was not of the best quality and was difficult to carve successfully. However, just in front of Weser-Ptah's false door, a dome was roughly hewn into the ceiling, making it possible to stand upright at this spot. This provides a wonderful glimpse into the use of the chapel: the dome was cut to ensure that there was a place where family members could stand in order to make offerings to the deceased. Underneath the chapel the builders cut three burial shafts into the rock.

14.12 The rock-cut chapel of the tomb of Ni-ankh-Ptah, with a small offering basin positioned in the floor in front of a false door, which is set into masonry blocking filling a fault. A simple offering of beer jars is placed on the floor of the tomb. View to the west.

The tomb of Ny-su-wesert

We found the last of the causeway tombs to the north in 2002. Low causeway walls of fieldstone set in mud led straight up the slope to a squat mastaba of good quality limestone. Fine hieroglyphs in horizontal registers graced the lintel of the entrance to the mastaba. They include the name Ny-su-wesert ('He belongs to the Powerful') and speak of his 'having attained great old age under the Great God (the king)'. His titles were Custodian of the King's Property and Steward of the Great Estate. This man must have been the manager of a farm, estate or some other property. The 'Great Estate' is interpreted as land belonging to the king, rather than to a temple or high official. Ny-su-wesert was responsible for an area of land that would have been settled with people, and which may have had villages on it as well as workshops or other establishments.

With a causeway and a well-built stone tomb, we expected Ny-su-wesert to be among the very elite of the Workers' Cemetery. And in a crudely hewn, cave-like chamber at the rear southwest corner of his chapel, we found the only stone sarcophagus in all the tombs we have excavated

on this slope, though it was rather roughly hammered out of unpolished limestone and not finely carved. I (Hawass) lifted the lid for the public on a live National Geographic television broadcast on 17 September 2002 [**14.13**]. In spite of all the indications of relatively high status, the sarcophagus contained a simple skeleton of a body that had not been mummified, presumably that of Ny-su-wesert himself or one of his family.

The tomb of Nefer-theith

In addition to those distinguished by causeways, there are other notable and interesting tombs in the Workers' Cemetery. One of these is the mastaba tomb to the north of Inti-shedu's, belonging to Nefer-theith and his two wives, Nefer-hetepes and Ni-ankh-Hathor (GSE 1919). Nefer-theith was Overseer of the House, Overseer of Linen, Overseer of the Royal House of Purification. Though simple in plan, the tomb is inscribed with beautiful hieroglyphic writing and contains three elaborately inscribed limestone false doors and stelae with the name of the deceased, his two wives and his 18 children, making it a family tomb of some 21 people [**14.14**]. West of this white stone mastaba are eight and possibly nine shafts, and with another nine shafts to the east and three to the north, a total of 21 shafts matches the number of named family members.

The three false doors stand along the west wall of a long chamber. The northernmost one is for Nefer-theith himself; some unique scenes at the bottom show people grinding grain and baking bread. Between this false door and the central one, craftsmen carved an elegant 'menu' listing the various breads, beers, clothing, oils and other items needed for the funerary cult. The false door in the middle is dedicated to Nefer-theith and his first wife, Ni-ankh-Hathor. An inscription on the door tells us that he made the false door for his beloved first wife, who had died and gone to the necropolis. A list records offerings of natron, sacred water, oil, incense, kohl, 14 types of bread, cakes, onions, beef, grain, figs and other fruits, beer and wine. The third false door is for Nefer-theith and his second wife, Nefer-hetepes, who bore the unique title *inꜥt*, which Henry Fischer, one of the greatest interpreters of ancient Egyptian titles, first translated as 'weaver' but later suggested meant 'midwife'.[7] She would

14.13 Zahi Hawass lifts the lid of the coffin of Ny-su-wesert in his tomb in the Workers' Cemetery, revealing the skeleton of the deceased, who had not been mummified.

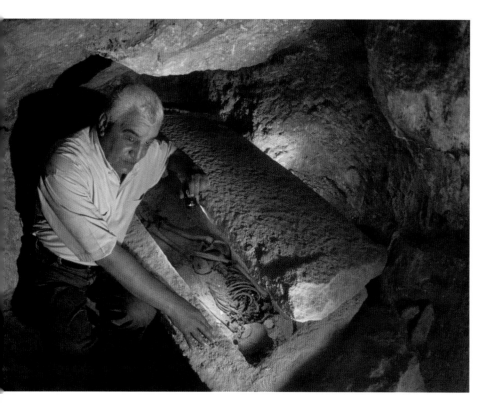

certainly have had lots of experience at home with the 18 children represented in the tomb. Below a standing figure of Nefer-theith carved on this door a man makes beer while another pours it into four storage jars [**14.15**].

The curse of Petety

Another interesting artisan's tomb belongs to Petety (GSE 1923), a Royal Acquaintance, whose titles also included the Eldest Inspector of the Small Ones, of Good Reputation. Builders created his tomb in three phases and it has a rather complex plan, with many courtyards, several interior chambers and nine associated burial shafts. While the main burial chamber is rock-cut, the rest is mostly built of mud brick, with some walls of limestone plastered with mud. Door sockets in front of several doors suggest that some of the entrances into the tomb were closed with wooden doors.

Five inscribed stelae belong to the first phase of the tomb's construction, and emplacements suggest that there were originally others, which were removed in antiquity. In one of the courtyards a limestone block covered with white plaster and surrounded by a large quantity of charcoal may have been used to burn incense. To the west of this is an unusual structure built of mud brick and

covered with mud plaster. Inside a niche on top was the upper part of a strange, anthropoid statuette of unbaked clay with the head of a monkey. Perhaps this served a protective function, to ward off unwanted spirits or visitors.

Two stelae face each other on the jambs of the doorway leading to the innermost court of the tomb. The southern stela was dedicated to Petety, and the northern one was for his wife, Nesy-Sokar, 'beloved of Neith, Priestess of Hathor, Mistress of the Sycamore'. These are unusual as they both bear 'curse' inscriptions warning against desecration of the tomb.[8] Petety's states:

Listen all of you!
 The priest of Hathor will beat twice any one of you who enters this tomb or does harm to it.
 The gods will confront him because I am honoured by his Lord.
 The gods will not allow anything to happen to me.
 Anyone who does anything bad to my tomb, then the crocodile, the hippopotamus and the lion will eat him.

Nesy-Sokar's curse is similar, but she threatens the evil-doer with a crocodile, snake, hippo and

LEFT ABOVE
14.14 False doors and offering list in the tomb of Nefer-theith. In the foreground is the figure of Nefer-theith himself and one of his titles, 'Overseer of the Royal House of Purification'.

ABOVE
14.15 A scene showing stages in brewing beer, carved in relief at the bottom of one of the false doors in the tomb of Nefer-theith.

scorpion. Clearly, Petety and his wife were concerned that their tombs remain undamaged. Nesy-Sokar is shown standing by herself on the door jamb of one of the chapels in the traditional pose with one arm raised on her breast and the other behind her back. She wears a tight dress that leaves a breast bare, a collar and a broad beaded necklace. Her hair is divided in front and behind her shoulders.

The tomb's builders added an open courtyard at a later stage to its eastern side, where nine shafts were dug, each covered with a rectangular superstructure. Four skeletons were found in these shafts: one male, aged 25 to 30 years; one female, aged 40 to 45; and two children under the age of one year. The female, in a wooden coffin, was positioned with her head facing west rather than east, as is usual in this cemetery. This skeleton is odd in other ways too: the head is large, with a full set of teeth, but the body is comparatively small. The woman may have been a dwarf or alternatively she could have had some disability; an unusual patch in her skull may also point to some pathology. Pottery in the shafts dated to the 4th dynasty; other finds included charcoal and one cylindrical faience bead.

This is one of the finest and most elaborate tombs in the upper cemetery, but I (Hawass) am

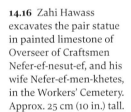

14.16 Zahi Hawass excavates the pair statue in painted limestone of Overseer of Craftsmen Nefer-ef-nesut-ef, and his wife Nefer-ef-men-khetes, in the Workers' Cemetery. Approx. 25 cm (10 in.) tall.

not convinced that Petety himself was buried here, at least in one of the nine shafts in the added courtyard. The tomb, and its enigmatic owner, will benefit from further study.

Other tombs

Near the tomb of Ni-ankh-Ptah is that of Wenen-em-niwt, 'The One Who Will Exist in the City'. The reference is to 'that city' of the Afterlife where the necropolis community lives on. A small mud-brick bench fronts the stone superstructure, which features a small window to the chapel.

Wenen-em-niwt, who held the simple title 'tenant farmer', has left us one of the masterpieces of this upper cemetery: a small limestone statue of himself.[9] We discovered this beautiful statue in a *serdab*, a blind chamber, high in the east wall of his small limestone mastaba. Wenen-em-niwt is shown standing, striding forwards, wearing a short kilt and a shoulder-length wig.

In another, very small and simple tomb (GSE 1948) a *serdab* at the south end of the eastern face of the chapel contained a beautiful double statue of painted Turah limestone. The statue, which is only about 25 cm (10 in.) tall, shows a man named Nefer-ef-nesut-ef, who was an Overseer of Craftsmen, seated next to his wife, Nefer-ef-men-khetes [**14.16**]. The faces of this couple are very distinctive and different from the royal and noble portraits of the Old Kingdom, but still clearly in the style of the period.

Three burial shafts were associated with the tomb, each containing a skeleton. One shaft held the body of a woman buried in a wooden coffin and dressed in robes that suggest she held some important position, or was the wife of the man buried nearby.[10]

Early in 2010 a new group of tombs was found near the far northern edge of the Workers' Cemetery, on the edge of the plateau [**14.17, 14.18**]. Three large tombs belonged to overseers, including a man named Idu, as we know from an inscription on a stela. The overseers' tombs are surrounded by shafts that contain the skeletons of the workmen who laboured under them. Inside the shafts, we found pottery dated to the 4th dynasty. Based on the style of the shafts, which is similar to ones excavated in the cemetery at Dahshur, and the location of the tombs close to the pyramid, these

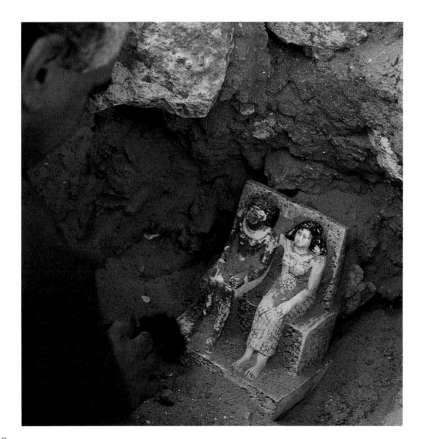

could be the earliest tombs built in this cemetery, and may date to the reign of Khufu.

Women in the Workers' Cemetery

Many women were buried in the Workers' Cemetery, either with or next to their husbands. However, two tombs found so far belonged to single women, who may have been working at Giza alone, without husband or children. One, Repyt-Hathor, was buried in a simple shaft surmounted by a small mastaba. An offering basin inscribed with her name and her title, Priestess of Hathor, stood in front of her false door.

The second woman was a Priestess of Neith, the only woman so far found in this cemetery with this title. Her very simple tomb is built of stone rubble with an entrance to the east. Inside the single burial shaft an offering table bears the tomb owner's name and titles: 'The King's Acquaintance, the Honoured One, the Priestess of Neith, Ninubi'. This offering table acted as a substitute for a false door and as a place for the deceased to receive offerings. It is

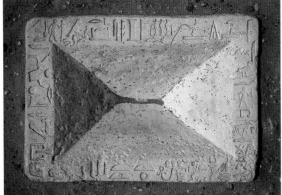

one of the most beautiful artifacts to have been discovered in the cemetery.

In a shaft to the west of the main shaft in GSE 1914, a tomb on the northwest side of the site and not connected with any other tombs, we excavated the skeleton of a young woman about 15 years old. In her right hand she held an oyster shell filled with kohl, a material used to line the eyes which was associated with ritual purity. Around her neck was an elegant necklace of semi-precious

ABOVE AND LEFT
14.17, 14.18 The small tomb in the northern part of the Workers' Cemetery belonging to Keki, an Overseer of the House (Steward). The limestone offering basin set into the ground names him as the tomb's proprietor. Hieroglyphs around the rim give the standard offering formula. Keki's name is crowded into the lower right corner.

stones. The tomb contains two main burial shafts, with an entrance on the north side opening into a short passage leading to an open court. In the southernmost of three false-door niches on the western side of the court was a wonderful statuette of limestone, painted mostly black but with traces of red and yellow. It shows a moustached man in a short flaring wig and a kilt striding forwards energetically, either the father or husband of the young woman.[11]

Two of the female burials are those of dwarf women, little more than a metre (3 ft) tall. One of them had apparently died in childbirth – we found the skeleton of an infant with her remains.

The bodies

The human remains in these cemeteries show no evidence of having been mummified. In this period mummification was still the prerogative of the elite members of the ruling households of kings and nobles. As we saw above, not even the body inside the stone sarcophagus in Ny-su-wesert's tomb was mummified.

Many of the burial shafts in the upper and lower cemeteries contained skeletons curled in the foetal position, usually lying with their heads to the north and their faces to the east. Occasionally (more often in the upper cemetery), the dead were buried in a coffin of sycamore wood, associated with Hathor as 'Lady of the Sycamore'.

We are fortunate to have an excellent laboratory at Giza, including X-ray equipment with which to study the skeletons. Our principal forensic anthropologist, Dr Azza Sarry el-Din, and the team from the National Research Centre, are skilled scientists who have helped us shed light on the lives and deaths of these men and women. The bones of the majority of the skeletons, especially their spines, showed the effects of stress, probably resulting from hard physical labour.[12] Simple and multiple limb fractures are also found in skeletons from tombs in both the upper and lower cemeteries. Most frequent were fractures of the bones of the upper arm, and of the more delicate of the lower leg bones. Most had healed completely and had clearly been set. Depressed fractures of the frontal or parietal skull bones were found in both male and female skulls, mostly on the left side, which may indicate that

these injuries were the result of face-to-face assault by right-handed attackers.

Evidence shows that very good medical care was available for the people buried in the tombs. Most broken bones had been properly set, and the leg of one worker had been amputated successfully (the person lived for approximately 14 years after the operation), indicating that they had received emergency medical care on site. One skull showed signs of brain surgery.

Average height was between 1.5 and 2 m (5 and 6 ft), and the typical lifespan was 35 to 40 years (as opposed to 50 to 60 years for nobles at this time). Women under 30 had a higher mortality rate, probably as a result of the dangers of childbirth.

The date of the cemetery

Unfortunately the name of the king is not given in the fine limestone inscription above the door to Ny-su-wesert's tomb, so we cannot be certain which king was the 'Great God' he served and in whose reign he therefore lived. Several other people buried at Giza also held the title Overseer or Steward of the Great Estate; the majority are thought to date from the mid-5th dynasty, or possibly a little later.

Most of the pottery found in association with the tombs was deposited outside them. Our studies and analysis so far reveal that the types – including beer jars, various kinds of baking moulds, bowls with recurved rims and plates – appear to represent a good corpus of the middle Old Kingdom, from the reign of Khufu in the 4th dynasty to the end of the 5th dynasty.[13]

Many of the tomb and cemetery walls of broken stone include fragments of imported hard stone such as granite, diorite and basalt, stones used in the pyramid temples. This fine stone could have been left over from work on royal buildings, but it is also possible that the tomb builders of the Workers' Cemetery could have reused some of this material, as well as the mud brick for their tombs, from the 4th dynasty settlement we are excavating in the plain below the escarpment.

Since the early 1980s we had observed a mud-brick wall in the area below the Workers' Cemetery, a feature that first suggested to us that settlement remains of the pyramid age might lie below this tract of low desert. The sand diggers from the

nearby riding stables probably exposed this wall, which measures about 2.8 m (9 ft) east–west and 4.7 m (15 ft) north–south. In 2004 we began to clear the ancient surface around the wall and it emerged that it was the core of a tomb, an extreme eastern outlier of those mud-brick and fieldstone tombs of the lower cemetery. The tomb rests directly upon the ruins of the already razed workers' settlement, with marl-lined walls running under the tomb.

We are able to find and map the remains of so much of this ancient town described in the following chapter because forces of erosion had cut the ruins at between waist and ankle height and then blew the material away, thus creating a low-level horizontal section through the ancient city. The remains of the settlement were already reduced to the height at which we find them today before someone built this little tomb. We have also found clear evidence, particularly in the southwestern part of the Workers' Town, that people extensively robbed the walls of bricks and fieldstone. In some cases the robbers took out the bricks so neatly that they left the marl plaster intact along the sides of the trench. This robbing happened before the sandy overburden covered the ruins of the town and cemetery.

As mentioned above, the little outlier mastaba was built on top of the settlement remains after they had been reduced. We presume this tomb dates from the middle to the late Old Kingdom, and so these facts make a strong case that the brick and fieldstone robbers were the tomb builders of the later Old Kingdom, and that many of the bricks in the cemetery up the slope, as well as some of the broken stone, derive from the walls of the town that lay below.

At the same time, however, it seems perverse to think that this crowded cemetery of poorer people and minor officials bears no relationship to the Workers' Town nearby. A most compelling hypothesis is that here we have the Old Kingdom version of the New Kingdom site of Deir el-Medineh on the west bank at Luxor. The village there, which housed the builders of the royal tombs in the Valley of the Kings, expanded over time in the natural gully between desert outcrops, while a crowded cemetery grew on the western hillside.

The tomb chambers at Deir el-Medineh contain some of the finest funerary painting of the New Kingdom, created by the very artists who were decorating the royal tombs. And here, on the western slope above what is more and more convincingly a workers' settlement at Giza, we have a cemetery of a poorer class of labourers, as well as minor officials and some craftsmen. Inscribed texts we have found scrawled on some of the false doors and stelae and carved into several offering basins tell us that the people of the cemetery bore titles such as 'Overseer of the Side of the Pyramid', 'Inspector of Dragging Stones' and 'Director of the King's Work', 'Inspector of Building Tombs' and 'Director of Building Tombs': titles that certainly suggest that those buried here were involved in constructing tombs, pyramids and their temples.

The cemetery had its own complex development. The causeway of the tomb of Weser-Ptah runs over earlier small mastabas, and other tombs are partially built over previous ones. We have also excavated several deep sections, going down below the level of the tombs, and it is clear that there is some sort of building activity here too, perhaps remains of older burials or settlement. The Workers' Cemetery must have begun when the settlement in the plain below was in its heyday, and continued to spread and grow in density as some of the households of tomb builders stayed on, or returned, in the later Old Kingdom, even as the royal house moved on to build pyramids at Saqqara and Abusir. Based on the pottery, names and titles found in this cemetery, our conclusion is that it was begun as early as the reign of Khufu and continued in use to the end of the 5th dynasty.

It will be the work of many years to excavate this cemetery fully and then interpret our results, but as the work continues, we are building a fascinating picture of the lives and families of the people who built the pyramids. In the previous two chapters we have looked at the community of the dead, where the pyramid workers were laid to rest, but what about their lives while they were labouring at Giza? How were they organized, accommodated and fed? What do we know of the community of the living?

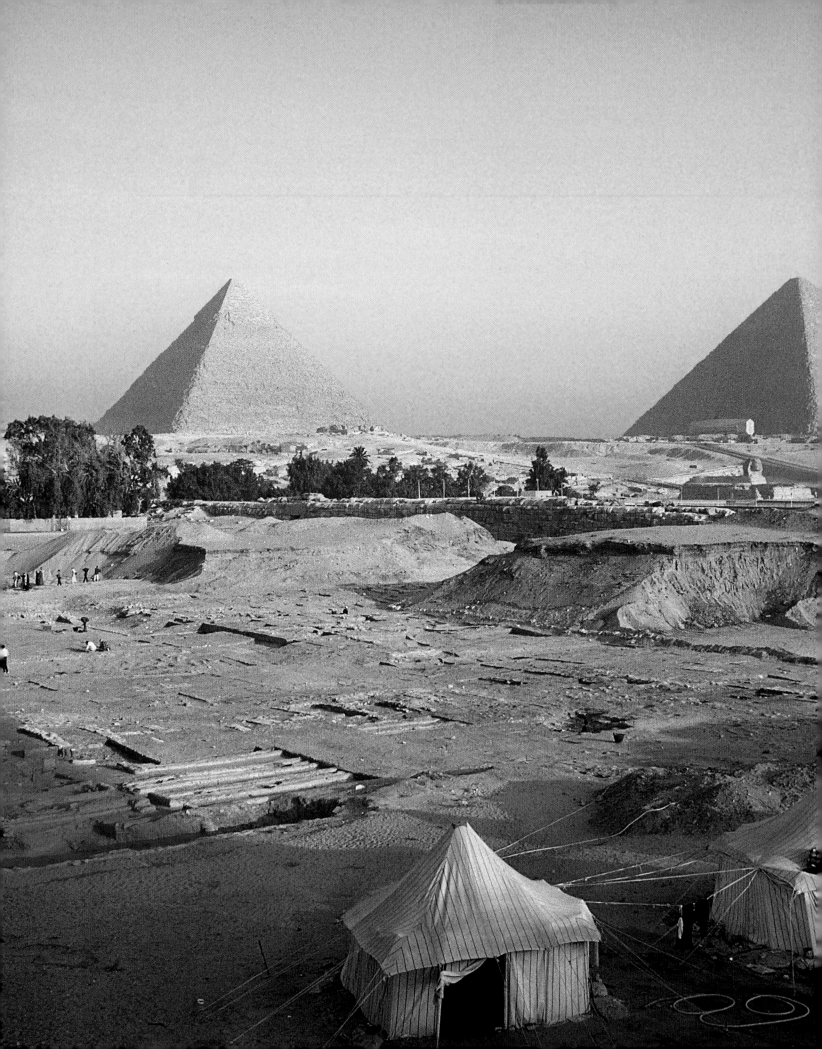

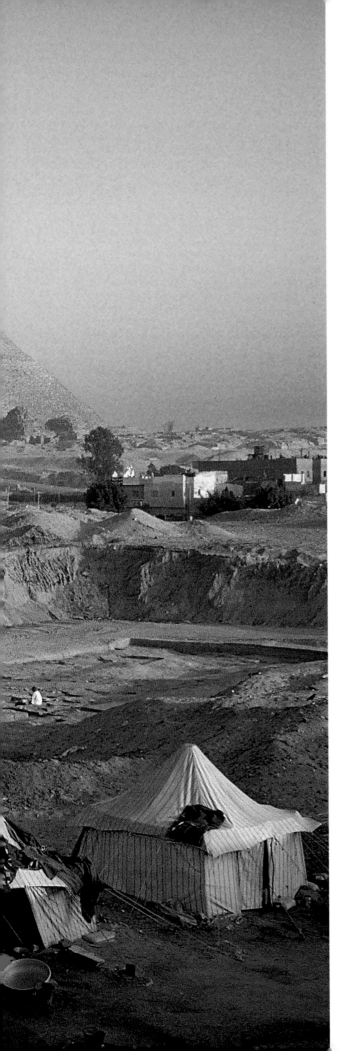

CHAPTER 15
Living at Giza: worker settlements and pyramid towns

The pyramids at Giza are often viewed in the popular imagination in stately isolation, and thus out of context. The tombs of the elite clustering round the pyramids, and now those of the Workers' Cemetery, with their titles, statues and scenes of daily life, are part of the human dimension of the pyramids. So too are the traces left by ancient tools, techniques and operations in the course of construction work. People comprising a workforce must have lived within walking distance of each pyramid as it rose over the course of years and decades. Altogether, Giza must have seen vibrant communities for a span of nearly 75 years. In addition, Egyptologists have long known from texts that some people stayed on in towns attached to the pyramids after the workforce had dispersed: a community of souls (*ka*s) that existed to create and service the cult of the pharaoh and others, what George Reisner called the community of *ka*s of the ancestral dead. These pyramid towns bore the name of the pyramid and king, living or deceased, to which they were assigned.

For the early giant pyramids, a massive inflow of materials – wood, gypsum, copper, fine limestone, granite, basalt, rope – would have begun with the start of building operations. Somewhere, somehow, it all had to be stored, processed and redistributed. The earliest settlements at Giza must have housed the workforce and infrastructure that facilitated pyramid building: accommodation for the labourers and their families; production facilities for meals, pottery, metal tools; enormous storage capacity for food, fuel and other supplies. The colossal pyramids imply an equally extensive support apparatus. A workforce of even 10,000 for pyramids like those of Khufu or Khafre suggests a sizeable, if temporary, settlement for the 3rd millennium BC. Where might this have been?

Rainer Stadelmann suggested that, at least during the lifetime of the king whose pyramid was then being built, the valley temple and harbour would have been the focus of the pyramid town.[1] Nearby, he believes, lay a royal residence, no doubt with its own facilities for storage of offerings. With the palace would have come everything needed for governing the country, as well as structures and industries to provide for the royal household. While the remains of very few residential palaces have been excavated in Egypt,

there is a line of evidence that the palace, like any large household, included granaries, bakeries, breweries, butcheries and workshops for carpentry, pottery, weaving and other industries attached to the core house in modular fashion.

Such modular organization of large households is widely evidenced. The 5th dynasty nobleman Nikanesut indicated in his Giza tomb that his household included two overseers of the property in charge of his estates, eleven scribes, a director of the workforce in charge of fields and peasants, two directors of the dining hall, two overseers of linen, a seal bearer, three butchers, two bakers, one cook and five butlers. If the royal house maintained a residence at Giza for three generations, then buildings for the butchers, the bakers, the sandal makers and all the rest of the dependent workforce and its activities – to say nothing of those for court officials, with their own households and whatever they needed to fulfil their functions – must have filled the low desert along the length of the plateau and extended far out into the floodplain.

Indeed, a letter inscribed by the 5th dynasty official Senedjemib mentions that, in addition to planning and constructing a pyramid for Djedkare Isesi, he built for the king's jubilee a new enclosure called 'Lotus Blossom of Isesi', presumably close by this king's pyramid at South Saqqara. The numbers are a bit obscured, but the dimensions seem to have been '1,000 cubits and a width of 440 cubits'. These cubit dimensions equal 521 × 231 m (1,709 × 758 ft). Even if this signified the outer enclosure, this was larger than the base of the Khufu pyramid and comparable to the Djoser Step Pyramid enclosure (545 × 278 m/ 1,788 × 912 ft) – not an inconsequential structure. And we should suspect the existence also of other residences belonging to courtiers and retainers.

The movement of the royal house to Giza for three generations could have contributed to an agglomeration of people and industry that amounted to a kind of proto-town. Such a pyramid town might have lived on for several generations after the king had died and been interred in his pyramid. We should then expect there was a settlement at Giza – the longer-term pyramid town – occupied by priests who maintained the funerary cults of the three kings, Khufu, Khafre and Menkaure. With time the town perhaps became

Settlement archaeology at Giza: major explorations

Years	Monument	Excavator
1880–82	Workmen's Barracks west of the Khafre pyramid	W. M. F. Petrie
1908	Menkaure valley temple settlement	G. Reisner
1932–33	Khentkawes Town, eastern end of Menkaure	S. Hassan
1971–75	settlement dump	K. Kromer (Austrian Institute)
1972–74	settlement SE of Menkaure pyramid	Abd al-Aziz Saleh (Cairo University)
1988–89	Workmen's Barracks west of the Khafre pyramid	Z. Hawass and M. Lehner (Yale University)
1988–present	settlement remains south of the Wall of the Crow	M. Lehner (Oriental Institute/Ancient Egypt Research Associates (AERA))
1989	settlement remains in Nazlet es-Samman	Z. Hawass and M. Jones (AMBRIC/SCA)

less organized and more crowded, as descendants of the original inhabitants multiplied and held a position for the tax exemption and grain allocations that pyramid and royal mortuary service brought. Archaeological evidence suggests that these long-lived towns eventually became small settlements, housing perhaps a few to several hundred people. Barry Kemp referred to this process as the 'villagization of a monument'.[2]

Was the pyramid town the remnant of the accommodation for the thousands, if not the tens of thousands, of people required for building the mammoth pyramids at Giza? Did it then devolve over generations into a village of hangers-on? Would it be possible to locate the workforce on the archaeological landscape of the Giza Plateau? Previously, Egyptologists could not fully answer such questions because only one Old Kingdom pyramid town, that of Queen Khentkawes, had ever been excavated at Giza, as well as the settlement associated with the Menkaure valley temple. This was the case until excavations, beginning in 1988 [15.2].

The evidence of the texts

Given the paucity of Old Kingdom, pyramid age, settlement excavated systematically by archaeologists, Egyptologists turn for information about the accommodations for a pyramid workforce and pyramid towns to the texts.

The za: organization of labour

From hieroglyphic inscriptions and graffiti we infer that skilled builders and craftsmen on the pyramids probably worked year-round at the construction site. Young men from surrounding villages and provinces rotated in and out of competing gangs with names compounded with that of the reigning king. In the uppermost relieving chamber above the King's Chamber in the Great Pyramid, a bright red graffito records the 'Friends of Khufu' (see 2.11), and Reisner found graffiti of a gang called 'Friends of Menkaure' on massive core blocks on one side of the upper temple of Menkaure and 'Drunkards of Menkaure' on the other.

Each gang was further divided into groups called *zau* (sing. *za*), written with the hieroglyph of a cattle hobble – a rope tied into a series of loops to bind

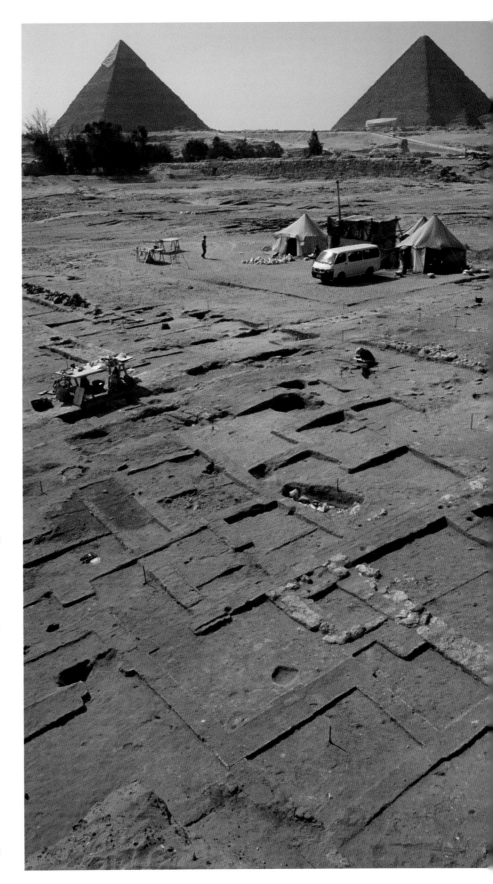

ABOVE
15.3 The cattle-hobble hieroglyph for *za*, 'phyle', a rope tied in (often ten) loops. In actual hobbles, each loop went round one leg of a young animal, so that the whole group would move together. The same word was used for 'protection'.

BELOW
15.4 A scene of young conscripts from the valley temple of Sahure at Abusir. Hieroglyphs above label the troop: 'The Gang, Sahure is Noble'. Others below stated 'Escort of a Following of Young Recruits'. In the full original relief, these troops run below a depiction of the (king's) ship of state. Such troops formed gangs that moved large blocks overland and delivered stone on boats for building pyramids.

the legs [15.3]. In the bilingual Decree of Canopus of Ptolemy III Euergetes in 237 BC the Greek word *phyle* was used to translate *za*, and Egyptologists have followed suit. Phyle means 'tribe' in Greek, and although that meaning does not exactly fit the groupings involved in pyramid building, the phyles could have originated in some natural social grouping of more ancient times. By the pyramid age there were five phyles in a gang, whose names – always the same in each gang – bear some resemblance to ancient Egyptian nautical terms: the 'Great' or 'Old' (or starboard), the 'Asiatic' (or port or larboard), the 'Green' or 'Fresh' (or prow), the 'Last' and 'Little Ones' (or stern) Phyle (see also p. 131). One idea is that the phyle was the broader grouping, with affiliations like the modern fraternities, named with Greek letters, in different universities, and that the gangs were composed from the natural, national phyle order for royal projects as needed. The smallest labour units, the divisions of a phyle, consisted of 10 to 20 men and were named with single hieroglyphs for ideas like 'life', 'endurance' and 'perfection' (see 15.14).

We do not know how far and wide throughout the land the king's household reached for its unskilled labour, but 'Phyles of Upper Egypt' are known from hieroglyphic titles. Because the phyle system was also used for rotating temple service in the later Old Kingdom, Egyptologists surmise that unskilled workers likewise rotated in and out of the immense pyramid projects. In the 4th dynasty, crews, gangs and divisions were used to organize workers spatially, but phyles may have had 'some sort of overlapping rotation'.[3] We have no good evidence for the length of time men might have served in the work gangs.

Service in the royal project must have exerted a tremendous social influence on the early Egyptian kingdom. Young men were registered in their hamlets and villages before being hauled off to a scene resembling the most dramatic cinematic spectacles of Cecil B. DeMille. Here they entered their respective crew, gang, phyle and division [15.4]. What kind of archaeological footprint should we expect for the structures that housed such a large force of rotating workers?

The Gerget *of Khufu and the* Tjeniu *of Khafre*

Egyptologists know of pyramid towns from ancient Egyptian written sources, primarily from the titles of people who held important positions in the Giza towns and who had their titles inscribed on their tombs (see Chapter 13 for numerous examples of such inscriptions).

Eight individuals held titles connected with the funerary establishment of Khufu and the *gerget* of this king; a *gerget* was literally a 'settlement' or 'foundation', from the verb '*gereg*', which means 'found' or 'settle'. Of these individuals, one is dated to the 4th dynasty, one to the 5th dynasty, two to both the 5th and 6th dynasties, two to the 6th dynasty and two remain undated.

A man who died around the end of the 5th dynasty named Senenu, son of Ikhetneb, held titles that included *Adj-mer* of the *gerget* and priest of Khufu. *Adj-mer* literally means 'canal cutter', but the title indicated the position of headman, somewhat like a mayor, probably because the heads of traditional villages in the Egyptian countryside were responsible for cutting the levees to let the water into the canals that flooded the agricultural basins late in each summer (see Chapter 3).

Senenu then transferred this office to his son, Akhethotep, who was also Inspector of the Purification Priests, Director of Gangs of Young Recruits and Director of Those in the Phyles. Reisner dated the tomb belonging to Ikhetneb (G 1206) to the middle of the 5th dynasty or later; his son and grandson could have lived at the end of the 5th dynasty and the beginning of the 6th dynasty. A man named Kaitep, whose tomb may date to the 4th dynasty, was a priest of Khufu and *Adj-mer* of the Northern *Gerget*.

Another title we encounter is *Adj-mer Tjeniu*. The word *Tjeniu*, written with the bottom half of

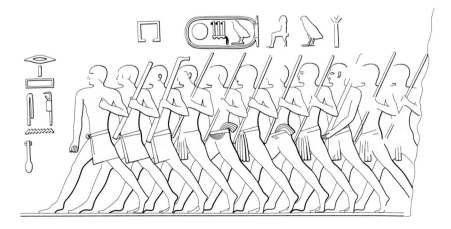

the rectangular hieroglyph for 'estate' topped by a snake, seems to mean 'cultivation edge', or the bank of the floodplain, where we might expect to find settlements. *Tjeniu* can also mean 'frontier district' or 'border'. We know of four individuals who held this title. In his tomb at Giza (G 4970) a man named Nesut-nefer specifies that he was *Adj-mer* of the Southern (*resi*) *Tjeniu* of the pyramid, 'Great is Khafre' [15.5]. Nesut-nefer also listed a title *Adj-mer Gerget*, without specifying northern or southern (see also p. 335).[4]

Just where were the settlements referred to in these titles? Hermann Junker hypothesized that *Tjeniu* was the border area south of the Wall of the Crow. For Elmer Edel, the Southern *Tjeniu* of Khafre[5] meant the settled desert edge of the pyramid of Khafre. The Northern *Gerget* of Khufu was at the edge of the desert in front of his pyramid, possibly flanking his valley temple. Rainer Stadelmann saw two separate towns belonging to the pyramids of Khufu and Khafre. These two settlements would have thus formed the northern and southern boundaries of the access up into the high desert of the Giza Necropolis. Would it be possible to find these towns, or any archaeological evidence of their existence? And what might the remains tell us about everyday life when the inhabitants were building the great Giza pyramids?

Formal pyramid towns

The Northern Settlement of Khufu and the Southern Boundary of Khafre might have been precursors, or parts, of the pyramid towns proper. By the 5th dynasty we find texts in which the names of towns are written with the hieroglyph for town. These towns are governed by people bearing the title of 'Overseer', who were probably in charge of both the town and the pyramid complex. The Overseer (*imy-ra*) of a pyramid was sometimes a high-ranking position, occupied by a Vizier, and at other times a middle- or low-ranking position, depending on the period. Nevertheless, 'Overseer' seems to have been a rank above *Adj-mer*. The pyramid towns at Giza had the same names as the pyramids: *Akhet Khufu*, Horizon of Khufu [15.6]; *Khafre Wer*, Great is Khafre; and *Menkaure Netjeri*, Menkaure is Divine.

Senenu-Ka mentions in his tomb at Giza (G 2041), dating from the early to mid-5th dynasty, that he

was 'Overseer of the Town, Horizon of Khufu'. The town of Khufu's pyramid was thus designated with the town determinative as early as the beginning of the 5th dynasty.

We know of nine Overseers of Khafre's pyramid town during the 5th to the 8th dynasty, though the names and dates of two of these individuals are missing. A stela found close to the south side of the Khafre valley temple reads, 'a gift the king gives and Anubis, who is upon this mountain to the chief of the pyramid [town?], "Khafre is Great"'. So in the 5th dynasty, the name of Khafre's town, Khafre is Great, was also written with the town determinative hieroglyph.

Four tombs include the title 'Overseer of Menkaure's Pyramid Town, Menkaure is Divine'. Three of them date to the 6th dynasty; the name and date of the owner of the fourth tomb are missing. Unless this tomb dates to the 5th dynasty we are not aware of any official in charge of the pyramid town of Menkaure at that time.

The pyramid towns appear to have been populated by craftsmen, farmers, butchers, physicians and necropolis guards, yet they were administered – up to the 5th dynasty – by the second generation of princes, leaving them and their progeny in charge of the king's priesthood even after the royal court had moved on to another site. Later, middle- and lower-level officials governed the towns, although the Vizier and

15.5 Detail of the inscription in a relief carved and painted scene from the northern wall of the tomb chapel of Nesut-nefer (G 4970) (for context, see 13.23). The titles in the vertical columns above the head of Nesut-nefer refer to his offices in the complex of the pyramid, 'Great is Khafre', written above in larger hieroglyphs in the horizontal register. From left to right:
1. Administrator of the Southern *Tjeniu*;
2. Overseer of the Ah Palace (Shrine); 3. Director of Members of a Phyle;
4. Judge, Master of Secrets; 5. Overseer of Purification Priests;
6. Priest of Khafre; Priest of the Royal Statue. One Known of the King, Nesut-nefer.
His wife Khentet-ka's titles, above her, read:
7. Priestess of Hathor; Priestess of Neith;
8. One Known of the King, Khentet-ka.

various nomarchs could designate themselves as residents of a pyramid town. Some of these claims were fictive, allowing these high officials to enjoy the income and tax-exemption that went with residence and service in a pyramid town.

Ro-she *of Khufu*

Another topographic term from the ancient hieroglyphic sources that we must take into account in our search for the pyramid towns is 'Ro-she of Khufu'. It appears in the early 5th dynasty tomb of a man named Meri-ib at Giza as one of 16 estates. The term is also mentioned in the 5th dynasty Abusir Papyri, along with the 'Ro-she of Kakai' (King Neferirkare). The Papyri mention the delivery of goods from the Ro-she of Khufu. The Palermo Stone mentions a Ro-she of another 5th dynasty king, Sahure. The 6th dynasty decree of Pepi I, which exempted the residents of the double pyramid town of Sneferu at Dahshur from labour, mentions the personnel of the 'Ro-Shes [plural] of Ikauhor's pyramid'. And now the Wadi el-Jarf Papyri prove that the Ro-She of Khufu was, at least seasonally, a waterway, a kind of port authority, under no less a person than Ankh-haf, who is mentioned as the Overseer of the Ro-she of Khufu (see pp. 29–30).

The literal meaning of this ambiguous term is 'mouth (entrance) of the basin'. The Abusir Papyri reveal it was a place of deliveries, storage and production. One entry, for example, reads: 'brought from the ro-she of King Kakai [Neferirkare]: three *des* jars, one loaf of *pesen* bread, one loaf of another variety of bread'.[6]

Why would such a place be called ro-she, 'entrance to the basin'? And where was it?

The hieroglyph for the word *she* (basin or pool) is a rectangular enclosure. It occurs in terms like *khentiu-she* and *she en per a'aa* (the *she* of the pharaoh). The Palermo Stone and Early Dynastic inscriptions mention the planning, measuring and opening of *shes* with names like 'Thrones of the Gods', 'Libation of the Gods' and 'Nurse of the Gods'. *She* sometimes signifies a body of water, at other times a tract of cultivated land, and in another context a stone construction yard. These terms reflect the basin organization of the Nile floodplain

15.6 Fragment of relief carving, probably from the walls of the Khufu causeway or pyramid temple, depicting a personified estate of Khufu. Metropolitan Museum of Art, New York (22.1.7); 30 cm/12 in. high.

that we described in Chapter 3 (see 3.4). There is evidence that the inauguration of a pyramid precinct was accompanied by staking a new claim to a flood basin. Up to the 19th century, each large basin had a name (then in Arabic); the same was probably true in ancient times, and *these* may be the names in the Early Dynastic inscriptions.

As the entrance to the large pyramid basin excavated into the floodplain, the ro-she was the interface between the temporal world of the living and the eternal world of the dead. It was the site for the delivery initially of products for pyramid building, and later for offerings and the pyramid temple economy. At Giza, that would position it on the stretch of low desert between the Nile Valley floor and the high pyramid plateau. This of course recalls one of the ancient settlement names at Giza mentioned above, Southern *Tjeniu* of Khafre.

Stadelmann believes that ro-she should refer to the area of the pyramid complex located before the harbour and canal where there was a town for the class of people who served in the pyramid temples, the *khentiu-she*, a term that could be translated as 'those at the head of the basin' (see Chapter 7 for a discussion of this term and possible meanings).[7]

The ancient texts suggest that the pyramid towns were the homes of these special people. So we should expect harbours, perhaps dredged from an adjacent agricultural basin, for the exchange and delivery of goods. We might envisage that this arrangement operated for generations after the lifetime of the king for whom the pyramid was built. However, the texts do not say whether these installations devolved from the settlement for the workers who built the pyramids and the harbours that received huge stone blocks and other materials.

The evidence of archaeology

More than a century ago, Flinders Petrie believed that he had identified the accommodation for the pyramid workers at Giza in a rectangle of comb-like galleries west of the Khafre pyramid.[8] He called them 'Workmen's Barracks' and the label has long been a feature of published maps of the Giza pyramids. As part of our search for the workers' town we dug within Petrie's Workmen's Barracks to test his conclusion.[9]

Royal workshops: the so-called Workmen's Barracks

The Workmen's Barracks form an enclosure built of walls of irregular limestone pieces set in clay, nearly 450 m (1,476 ft) long (north–south) and 80 m (262 ft) wide (east–west). This enclosure belongs to a pattern of fieldstone walls that divide the Giza Plateau into great rectangular zones, oriented east–west, around each of the three principal pyramids. In our investigation we called this enclosure Area C.

A series of galleries arranged like the teeth of a comb, each about 3 m (10 ft) wide and some 30 m (98 ft) long, attach to the west wall of the enclosure. A smaller number of galleries built on to the north end of the enclosure are orientated north–south [15.7]. The space in front of the galleries, 50 m (164 ft) wide, was left open, and today the modern asphalt road winds southwesterly through it towards Sahara City. On either side of the road the natural rock surface of the plateau is exposed under a light sand cover.

When Petrie dug in the area of the galleries he found fragments of royal statuary. In spite of this, he concluded that the galleries had served as lodging for about 4,000 men, presumably the permanent pyramid workforce. But as we walked the site, we got the impression that the galleries could not be the ruins of a workers' dormitory. While the galleries themselves are filled with sand, the open area in front of them and the stony surface behind the enclosure are unencumbered with the kind of waste one would expect if people had been settled here over a long period. We saw no obvious heaps or scatters of sherds, ash and bone, and no indications of cooking fires. The overall footprint is very similar to that of storage magazines attached to New Kingdom royal residences and temples like those at el-Amarna and Thebes. So our initial hypothesis was that Area C was for storage, perhaps of raw materials and food – the reserve that fuelled pyramid building, separated, for security, far up on the plateau.

In 1988–89 we identified and mapped 78 galleries attached to the west wall of the enclosure and about 15 galleries at the north end. Petrie had said that there were a total of 91 galleries, with 17 attached to the north wall of the enclosure. Our Chief Surveyor, David Goodman, staked three north–south lines over the galleries, dividing them into 10-m (33-ft) segments. We then selected a random series of 13

excavation squares that sampled the entrances, centres and rear parts of the galleries.

In the majority of the squares clean drift sand filled the galleries from floor level to the top of the eroded walls. The sand contained stones that had tumbled from the walls and numerous shells of land snails. It appeared that, for the most part at least, the galleries had either never been used or had been deliberately emptied in ancient times – perhaps when pyramid building moved on to Saqqara and Abusir at the end of the 4th dynasty.

Although their overall emptiness was disappointing, we did get a good look at the architecture. We found the eastern ends of the galleries near the entrances were more severely denuded than the rear, but the threshold and jambs of well-laid limestone slabs still remained [15.8]. The gallery walls are composed of unshaped limestone pieces set into or pointed with alluvial mud. Like the floors, the walls were plastered with desert clay (tafla). At the rear of the galleries, the shared north–south wall, a massive, solid construction, is preserved to a height of between 3 and 3.6 m (9 ft 10 in. and 11 ft 10 in.). The interior dimensions of the galleries are fairly consistent, with widths ranging from 2.5 to 3 m (8 ft 2 in. to 9 ft 10 in.) at floor level. Pieces of mud and hard gypsum with impressions of sticks, reed and rope indicate that at least some of the galleries were roofed, although none of the fragments revealed the spring of a vaulted or arched ceiling, like those

15.7 Plan of the so-called Workmen's Barracks west of the Khafre pyramid. Our excavations in 1988–99 found the galleries mostly empty and filled with clean sand. Where people occupied the fronts, they used the galleries for craft work on royal statues.

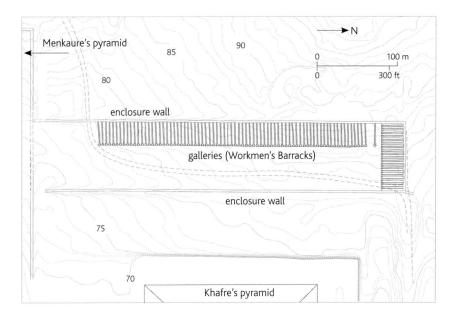

over New Kingdom storage galleries, or the vaults we hypothesize might have covered the galleries in the Heit el-Ghurab (Wall of the Crow) site (see below). It is possible that all these galleries were roofed over, leaving the area in front as a kind of open court.

We did discover a few bits and pieces left behind by people when they occupied the galleries. From the middle and rear parts of the galleries came tiny bits of copper, unworked feldspar, malachite ore, diorite pounders and several small flints, including flakes that had been struck from a core lying nearby. Excavation near the entrances to the galleries yielded more cultural material, and in support of Petrie's hypothesis these ancient deposits do have a settlement quality to them. In addition to roofing fragments, the grey ashy soil contained Old Kingdom pottery sherds, cattle and

pig bone, evidence of barley, emmer wheat and lentils, and bits of wood charcoal – the kind of mix that we might expect from some kind of habitation. We found charcoal of tamarisk and some acacia – tamarisk wood, probably a cheaper fuel than acacia, is commonly found on village sites. It appears that someone was burning small pieces of gathered wood as fuel for fires to cook and provide heat, and the ashy component suggests nearby hearths. We could interpret three sickle blades that we recovered among the flint artifacts as having been left by people engaged in farming. In the floral samples, the high proportion of chaff might have suggested a village if we had analysed the material without being aware of the clearly planned and state-organized character of the Area C galleries. Chaff might be expected in a grain storage facility (and here the galleries of New Kingdom temple storage facilities might again be noted), although where burnt storage facilities have been found at Abydos, there is almost no chaff at all. As for the pottery, the high number of bread moulds and trays also leads to the impression of food production or consumption – again giving the deposits near the gallery entrances a domestic cast.

On the other hand, the overall pattern of the galleries is about as different from a village as one might imagine. In our excavation units we found no obvious hearths, internal walls or other installations (ovens, pot stands, etc.) that we would expect from living areas, even the austere temporary domicile of a barracks.

A second kind of material suggests that these galleries were specialized craft workshops. Mixed in the same deposits as the apparently domestic refuse were bits and pieces of small royal statues and beautifully carved limestone human and lion figurines. The larger statues, originally about knee-high, depicted a king, though only the torso, *shendyt* kilt and upper legs are preserved. Two of the smaller figurines are particularly noteworthy. One, about the size of an index finger, shows the king wearing the tall conical south crown and *shendyt* kilt; the eyes and beard are painted black [**15.9**]. One arm is missing at the shoulder, but the cut is flat and smooth. Small sculptures known from other contexts that have such carefully truncated limbs are usually identified as sculptor's models or trial pieces.

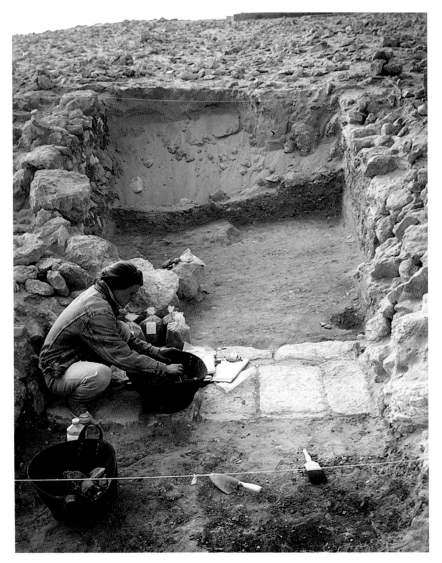

15.8 Archaeologist Diane Kerns sorts pottery from her excavation at the front entrance of one of the galleries west of the Khafre pyramid in 1988–89. A threshold of limestone slabs spans the entrance. View to the west.

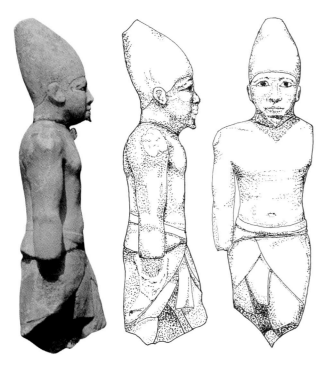

ABOVE LEFT

15.9 Painted limestone figurine of the striding king wearing the *shendyt* kilt and crown of the south, from the so-called Workmen's Barracks west of the Khafre pyramid.

ABOVE

15.10 Painted limestone conceptual model for an architectural statue of the king wearing the south crown and seated or standing against a back pillar with the projecting roof of a colonnade, also from the so-called Workmen's Barracks. Emplacements for such statues are found in Khafre's Sphinx Temple and upper pyramid temple.

Another set of fragments of an unfinished figurine also hints at a sculptor's working environment. Only the head is preserved, showing the king again wearing the south crown but here set against a back pillar and a projection that must represent the roof of a colonnade [**15.10**]. The whole was painted red and stippled black to imitate granite. The sculptor had begun to recarve the face and one side of the crown when the little royal head broke off the back pillar and the piece was discarded. It must represent the working out of an idea for an architectural granite statue set in front of one of a line of pillars around an open court surrounded by a covered colonnade, the ceiling of which projects out over the pillars and statues. There are in fact two temples at Giza (and only two) that have exactly these features – Khafre's upper temple against the eastern base of his pyramid, and the Sphinx Temple directly below the paws of the Great Sphinx.

Petrie also mentioned pieces of royal statuary from his excavations of the 'barracks'. And, as he noted a century before us, numerous pieces of granite, dolerite, quartzite and basalt – the hard stones that had to be imported to the site for architectural elements and statuary – litter the surface. All this, and the fragments of copper, worked feldspar, malachite ore and a few flint-tool fragments from the emptied galleries, suggest that the enclosure of Area C was for the storing and working of materials for the royal craft workshop.

The configuration of an open front court (the 50-m/164-ft space in front of the galleries) and covered magazines in the rear reflects the simple layout of ancient Egyptian workshops depicted in wooden models and tomb scenes of periods later than the 4th dynasty – but expanded here by several orders of magnitude. The galleries were probably planned initially as storage facilities for high-volume materials. In practice, this could have included foodstuffs, raw craft material and manufactured objects including copper, statues as well as other goods related to the royal cult of the dead. The evidence indicates that the galleries, and the areas in front of them, were also used for a variety of crafts, particularly sculpting and stoneworking. Perhaps the location of this immense range of galleries near the highest part of the Giza Plateau, west of the pyramids and far from the presumed main settlement near the floodplain, was a form of security and control for stores of food and precious materials and the finer craft industries.

An industrial settlement southeast of Menkaure

A Cairo University team under Abd el-Aziz Saleh found more evidence of industrial activity when they excavated the remains of a workyard with stone-rubble houses in the desert southeast of the Menkaure pyramid.[10] The settlement occupied the sharp southeastern corner of the secondary, outer enclosure around the Menkaure pyramid, at the southeastern rim of the main quarry used for that pyramid's core stone. A large open area was strewn with pieces of alabaster, perhaps left over from the Khafre temple pavements and the Menkaure statues. One area contained a row of horseshoe-shaped hearths, perhaps for copper working. The open courts provided spacious and well-lit working areas, while materials and supplies could be stored in buildings along the walls. The craftsmen who worked here probably retired each evening to a series of houses with ovens that stood in the court and up against the enclosure walls. Three sets of double, gallery-like enclosures, about 25 m (82 ft) long, were built in a comb-like pattern against the northern enclosure wall. Their internal arrangements are different from those in the galleries we have now excavated south

of the Wall of the Crow (see below), though one similarity is that rooms and chambers occupy the rear ends.

We suspected that these ruins of workers' housing and other infrastructure must be just the tip of the iceberg, if the analogy is not too inapt for the desert around the pyramids. Much more surely existed at Giza for building the gigantic 4th dynasty pyramids over three generations – but where might such structures be?

The Workers' Town found?

Our study of the Giza monuments in relation to the local landscape features pointed to the east-southeast part of the Giza Plateau, along the foot of the Maadi Formation, as a likely spot for settlement and the infrastructure that supported pyramid building. And it is in this area, 400 m (1,312 ft) south-southeast of the Sphinx, that we have been excavating since 1988 a major urban layout of the 3rd millennium BC stretching along the base of the escarpment known locally as Gebel el-Qibli (Southern Mount). We designate the site after the Arabic name, Heit el-Ghurab (HeG), 'Wall of the

Crow', because the 200-m (656-ft) long stone wall, rising 7 m (23 ft) above the surface, is the site's most outstanding feature and forms its northwestern boundary [15.11]. To the south the site lies between the bottom of the slope where we excavated the Workers' Cemetery in recent years (Chapter 13) and the modern paved road and houses of Nazlet es-Semman and Kafr el-Gebel.

The Heit el-Ghurab site lies beyond the major quarries for pyramid core stone in the southeastern slope of the Moqattam Formation. The Main Wadi, between the Moqattam and Maadi formations, offered access for imported non-local materials from the low valley floor, via a harbour, to the higher quarries and construction yards. At the southern side of the wadi, the massive stone Wall of the Crow, partially buried, projects further eastwards from the escarpment of Giza than any other structure apart from the causeway of Khufu to the north, with its roughly parallel orientation (for more on the Wall, see below, p. 385). The 4th dynasty settlement ruins extend 400 m (over 1,312 ft) southeast of the wall [15.12].

We first excavated at HeG in 1988–89, in the part we designate Area AA. Here we found a substantial

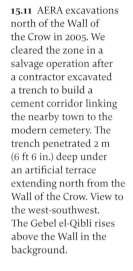

15.11 AERA excavations north of the Wall of the Crow in 2005. We cleared the zone in a salvage operation after a contractor excavated a trench to build a cement corridor linking the nearby town to the modern cemetery. The trench penetrated 2 m (6 ft 6 in.) deep under an artificial terrace extending north from the Wall of the Crow. View to the west-southwest. The Gebel el-Qibli rises above the Wall in the background.

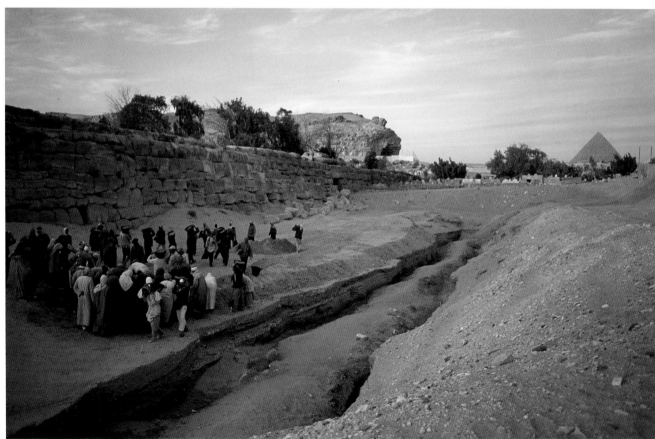

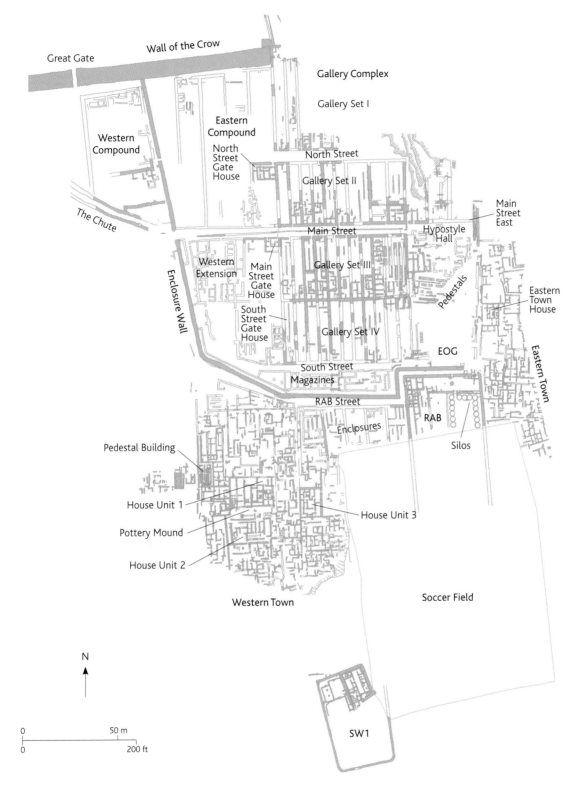

Great Gate

Wall of the Crow

Gallery Complex

Gallery Set I

Western
Compound

Eastern
Compound

North
Street
Gate
House

North Street

Gallery Set II

Main
Street
East

The Chute

Hypostyle
Hall

Main Street

Western
Extension

Main
Street
Gate
House

Gallery Set III

Enclosure Wall

Pedestals

Eastern
Town
House

South
Street
Gate
House

Gallery Set IV

Eastern Town

EOG

South Street
Magazines

RAB Street

RAB

Enclosures

Pedestal Building

Silos

House Unit 1

House Unit 3

Pottery Mound

House Unit 2

Western Town

Soccer Field

N

0 50 m

0 200 ft

SW 1

15.12 Map of the Heit el-Ghurab (HeG) site, dating mostly to the reigns of Khafre and Menkaure. Excavations have revealed an underlying, older phase, perhaps of Khufu's time, with a somewhat different organization.

building, probably for storage, with what looked like part of a large house on the east. Between this area and the modern soccer field, almost in the path leading from the modern road up to the Workers' Cemetery, an ancient mud-brick wall protruded from the ruins underlying the thick blanket that the sand diggers of the riding stables removed over recent decades. As mentioned in the previous chapter, when we cleared the area of this 'wall' in 2004, it turned out to be an outlying tomb. Before this, pottery scatters in the area were among the first clues that the overburden hid substantial settlement remains from the pyramid age. At the time of writing we have cleared 8.75 ha (over 21 acres) of sandy overburden,

exposing the surface of Old Kingdom settlement remains over an area 250 m (820 ft) east–west and 400 m (1,312 ft) north–south.

When the 4th dynasty settlers founded their settlement, the site was already low desert. Not long after they abandoned it, wind deposited a thick blanket of sand over the compact ruins of the mudbrick and fieldstone walls. Over recent decades, as horse- and camel-riding stables proliferated in the nearby communities, boys with pack donkeys took the sand to the stables, where they use it to clean the floors, afterwards returning it (until recently) to the site with its new inclusions. Their incremental daily sand digging and dumping has turned over most of the original sandy overburden that covered the ancient settlement remains. It is this sand – as well as some of Selim Hassan's dumps from his 1930s excavation in the Sphinx area and more recent rubbish deposits – that we cleared in our excavation squares to reach the 3rd-millennium BC deposits. Before we began a marathon of intensive salvage archaeology in 1999, the eastern part of the site was being lost to excavations by heavy machinery such as backhoes.

Underneath the sandy overburden we come to the 'mud mass', a compact surface of grey soil that resulted from the rapid, possibly deliberate, deconstruction of mud-brick walls. When the inhabitants abandoned the site, people removed almost everything of value, including wooden columns and mud bricks from the massive walls. All the evidence – pottery, seal impressions and stratigraphy – suggests this abandonment took place at the end of the 4th dynasty. Forces of erosion subsequently reduced the tumbled ruins down to waist or ankle level. As noted in the previous chapter, thanks to these processes we can discern the outlines of major walls with only shallow excavation through the mud mass – sometimes by just scraping lightly or even brushing its surface. Very often the walls reveal themselves by lines of marl – the plastering of desert clay on the faces.

The Old Kingdom 'mud mass' is a hard, compact (sometimes almost cement-like) seal over the fragile layers and living floors resulting from the use of the architecture. As we became increasingly familiar with the conditions of the site, it became clear to us, and to our colleagues in the Giza Inspectorate,

that it was safe to use a front loader to remove the enormous and ever-increasing overburden. In October 1999, thanks to extraordinary grants from the Ann and Robert H. Lurie Foundation, David Koch, Peter Norton, Charles Simonyi and Ted Waitt, and our other benefactors, we were able to clear and reveal the footprint of the ancient complex in a marathon 21 months of fieldwork, to June 2002. Our main goal was to capture the overall architectural plan in a broad horizontal exposure by mapping walls, but we also intensively excavated certain areas to investigate particular aspects of the architectural arrangement.[11]

General layout and date

The Wall of the Crow bounds the site on the northwest; the remains of a large enclosure, the Royal Administrative Building (RAB), lie at the far southeast. An Enclosure Wall, composed of broken stone, attaches at an angle to the south face of the Wall of the Crow and runs southeast, then thickens and curves round to run first more sharply southeast and then due east to the Royal Administrative Building. The Wall of the Crow, the Enclosure Wall and the Royal Administrative Building thus frame our site on the northwest, west, south and southeast. Within this enclosure lie the mud-brick ruins of four huge rectangular sets of galleries; on the west are the fieldstone ruins of small rooms and open courtyards that we call the 'Western Extension'. Three broad streets cut west to east through both the Western Extension and the Gallery Complex – North Street, Main Street and South Street – dividing an area about 185 m (607 ft) north–south [15.13]. We do not know the full extent of these thoroughfares, each about 10 cubits (5.25 m/17 ft) wide, but have traced Main Street, which is the only one with an opening through the Enclosure Wall, for a length of 160 m (525 ft) east–west.

While these streets allowed direct crossings of the blocks east to west, it appears so far that there was only one major way through the site from north to south – or more precisely from northwest to southeast. A way led south through the gateway in the Wall of the Crow and then merges with a corridor, 'The Chute', that turns to the east and stops outside the Enclosure Wall, about 15 m (49 ft) before the opening of Main Street that we call

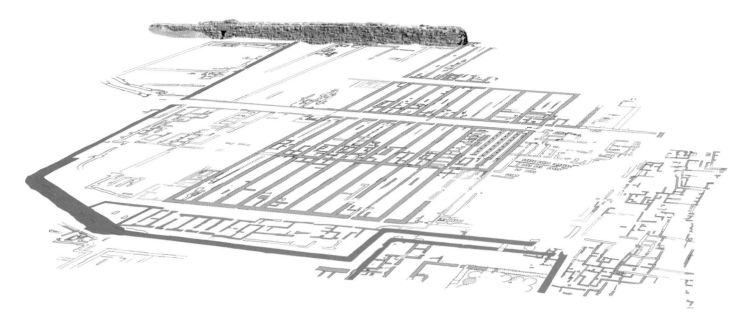

West Gate. From a turn right (south) inside West Gate, a route that we dubbed 'Wall Street' runs south along the inside of the Enclosure Wall. At the southwestern curve of the Enclosure Wall, South Street turns due east to the northwest corner of the large royal building.

Our work in 2002 added to the map a settlement of small chambers and courtyards along the eastern part of the site, the Eastern Town. This neighbourhood is crowded up against the Royal Administrative Building and extends further east than our excavation concession, underneath the modern towns of Nazlet es-Semman and Kafr el-Gebel. In 2004 we exposed and mapped the Western Town, a dense cluster of walls forming what appear to be several large house compounds, with smaller structures in between, extending 100 m (328 ft) south of the southern part of the Enclosure Wall. The Western Town ends on the south at a waterlogged, sand-filled depression (Lagoon 1), south of which the site reappears in the

form of two large enclosures opening into another sand-filled depression, Lagoon 2. We discovered in 2011 that this southernmost depression is surrounded by a thick fieldstone wall with rounded corners, enclosing what was probably a corral. Then in 2015 we found the eastern enclosure occupied by a large house, probably of an administrator. The western enclosure might yet prove to have been an abattoir where inhabitants butchered the many animals consumed in the HeG settlement.

It is reasonable to ask if this extensive and substantial settlement had a long life, and whether its production facilities furnished offerings for cult practices that took place in the Giza pyramid temples well after the 4th dynasty. George Reisner found evidence of priests serving in the Menkaure pyramid temples from the late 5th dynasty until the collapse of the Old Kingdom, and Uvo Hölscher cited evidence that the Khafre temples also functioned into the late Old Kingdom. However, in spite of a substantial depth of deposit, and fairly

ABOVE
15.13 Perspective view of the Gallery Complex of the Heit el-Ghurab (HeG) site, attached to the Wall of the Crow (background). View to the northwest; graphic by Wilma Wetterstrom.

BELOW
15.14 Simplified diagram to show the division of the workforce into crews, gangs and *zau*.

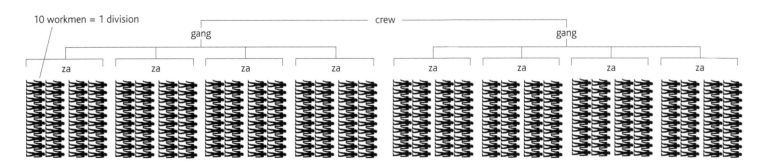

10 workmen = 1 division
crew
gang
gang
za za za za za za za za

complex phases of use and rebuilding, most of the material we have excavated points to occupation during the middle to late 4th dynasty. We have analysed more than a million pottery fragments, of which hundreds are 'diagnostic' (fragments of rims, carinations or bases that allow us to determine what kind or type of vessel they derive from) – any pottery later than the 4th dynasty would have been quite apparent. In addition, we also have 4,826 fragments of clay sealings, 3,079 of which are incised or inscribed. Of the legible royal names, many are clearly Khafre and most belong to Menkaure. No other names of kings have been recognized, except for a few fragments of the 5th dynasty pharaoh Userkaf, possibly left when the site was being deconstructed. We have no mention of pharaohs dating from later than the 4th dynasty, and also none from Khufu, although we know that a whole earlier horizon of settlement, with

a different layout, exists below much of the settlement as we have mapped it. The earlier phase could date to Khufu, although excavation down into certain parts of it have so far not yielded sealings with his name.

Although it is probable that the worship of the 4th dynasty Giza kings continued for a long time in their pyramid temples, the evidence is that our site went out of use soon after the reign of Menkaure. Archaeological and historical sources indicate that the royal funerary complex, and so perhaps also the royal house, moved from Giza to Saqqara under King Shepseskaf at the end of the 4th dynasty.

The Gallery Complex

Between 1999 and 2001 we discovered in the mud mass the general outlines of the Gallery Complex, consisting of four great sets or blocks (I–IV) made

RIGHT
15.15 The Gallery Complex, with enlarged detail of Galleries III.3 and 4, which we excavated in 2002 and 2012 respectively. While differing in layout, the galleries feature in common a long, extended front, once with slender columns, and a rear living area, with chambers in the back for cooking, roasting and baking.

OPPOSITE ABOVE
15.16 Galleries III.3–4 after excavations in 2002 (III.4) and 2012 (III.3). View to the south.

OPPOSITE BELOW
15.17 Reconstruction of the gallery fronts with the vaults filled in to form a broad, flat roof terrace, and an interior loft supported by slender wooden columns in the front colonnades. Graphic by Wilma Wetterstrom based on a study by Günter Heindl.

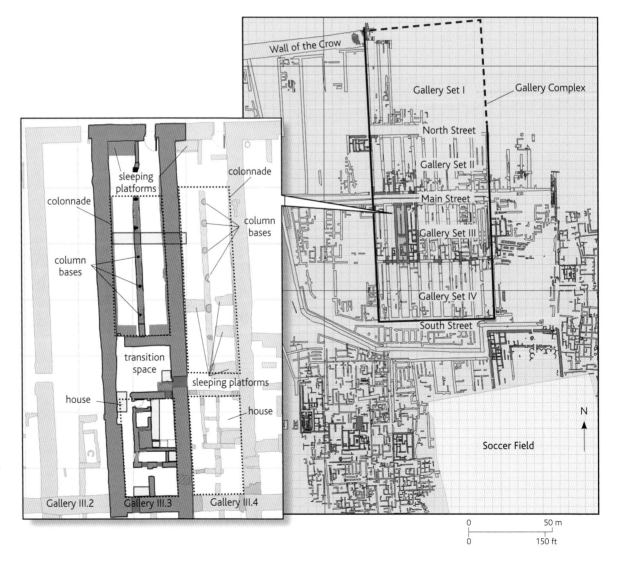

colonnade

sleeping platforms

colonnade

column bases

column bases

transition space

sleeping platforms

house

house

Gallery III.2 Gallery III.3 Gallery III.4

Wall of the Crow

Gallery Set I

Gallery Complex

North Street

Gallery Set II

Main Street

Gallery Set III

Gallery Set IV

South Street

Soccer Field

N

0 50 m
0 150 ft

up of individual galleries. Unfortunately, erosion in antiquity badly damaged and probably removed much of the Gallery I set, which extended 55 m (180 ft) south from its connection at its northwestern corner with the eastern end of the Wall of the Crow. The southernmost set, IV, is attached directly to Gallery III [15.15]; sets II and III are separated by Main Street. Each set of galleries, except I, is 34.5 m (113 ft) long, north–south and about 52 m (100 royal cubits/171 ft) wide, east–west (excluding the areas on the east ends that we designated the Hypostyle Hall and the Manor enclosure; see below). Each set consists of eight long, narrow galleries ranging in width from 4.5 to 4.8 m (14 ft 9 in. to 15 ft 9 in.). By selectively excavating 5 × 5 m (16 ft 5 in.) squares dotted across the complex we gained an idea of the internal details [15.16].

In each gallery more complex room structures occupied the southern end, while the central and northern sections, about three-quarters of the gallery's length, remained open and clear. In Sets II and III a low wall or narrow bench parallel with the side walls divided these outer parts of the galleries into two nearly equal strips lengthwise. In at least eight or nine (and probably most) galleries the builders set wooden columns, about 23 cm (9 in.) in diameter, on stone bases embedded within and below these low walls as a kind of extended porch or colonnade. These colonnades may have had light roofs, possibly of movable mats. On the other hand, the side walls of the galleries are unusually thick, up to 1.57 m (5 ft 2 in.) or 3 cubits wide, sufficient to have supported two storeys. We have considered the possibility that the thickness was to support the springing of vaulted roofs in two directions from each side wall. Architect Günter Heindl, who has specialized for many years in building and restoring mud-brick structures, developed this hypothesis into a reconstruction that sees double-decker galleries, each with a vaulted roof, while the slender columns supported a light, loft-like second floor [15.17].

The rear, southern ends of the galleries in Sets II and III contain a complex of rooms resembling houses in other ancient Egyptian settlements. Like the northern colonnaded ends of the galleries, the southern ends are often partitioned into two nearly equal halves. A pattern repeated in eight of the galleries comprises a small vestibule, main room and small niche or inner (sleeping?) room. A short

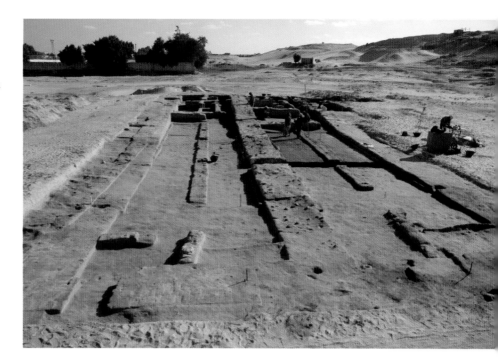

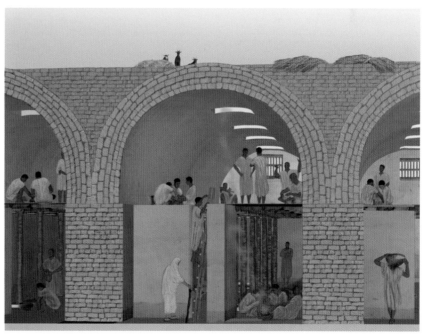

wall at right angles to the east side of the gallery forms an additional room or corridor on the north.

Thick deposits of concentrated ash in the back chambers of the galleries in Sets II and III suggest cooking, baking or roasting. Several of the layers in these back chambers included large numbers of bread-mould sherds, and the floor levels in some galleries were pitted with trenches and sockets that the occupants used as baking pits.

In one chamber in Gallery III.8 we found clear evidence of copper working using bread moulds as crucibles or small furnaces. It seems that in these rear spaces inhabitants produced small household items, since, along with abundant slag, charcoal and ash, we discovered a copper fish hook and needle [15.18]. Cooking installations were located in the back chambers of another gallery, and in yet another we found evidence of pigment grinding in the form of red and yellow ochre and a cache of dolerite hammer stones on or near the floor.

Gallery III.4 Although we knew the general outlines and some details of the great sets of galleries, by 2002 we were still in the dark as to their function. True, the galleries included some of the principal elements of ancient Egyptian houses: an open, 'public' area with columns, and separate, more private, domestic rooms with cooking, roasting or baking areas at the rear, forming a kind of 'kitchen'. But why did the 4th dynasty planners elongate these elements of a typical house into a

corridor shape, with a 1:7 ratio of width to length, and repeat the pattern in a huge series? To help answer this question, Ashraf Abd el-Aziz took up the challenge of excavating an entire gallery, III.4, during our 2002 season.

From Main Street a wooden door once swung on a limestone pivot socket to give access to a small, roughly square foyer or vestibule demarcated by thin partition walls of mud and stone. Beyond the foyer, in the colonnade, we found an important clue to the meaning and function of the gallery: a number of low platforms formed of mud, about 1 m (3 ft) wide and just long enough for a person to stretch out on. The platforms rise only a few centimetres off the ground at their lower end, and slope up against the gallery's thick side walls. This gallery contains several of the curious platforms: one tucked in beside the foyer, four at various points along the length of the central colonnade and one in the back house, which here had nine rooms.

We think these platforms are most probably beds – it is hard to imagine another function. In houses at other ancient Egyptian settlements, a raised dais fitted in an alcove or between two walls is identified as a sleeping platform. The slight slope offered a higher head end. The platform within the house at the rear of the gallery is larger than the others, and slopes down from west to east. At its low foot end a mud-daub stairway leads up to a higher level, with the back 'cooking' chambers. The walls are reddened by fire, especially apparent on the southern walls and in the southeastern corners. Three small rooms in the centre of the house, entered from the west of the bed platform chamber, also show much evidence for cooking, roasting or baking.

What were the galleries for? During our excavations we picked out every scrap of animal bone: we first sieved the dirt to find small bone fragments and then washed the sieved soil in our storeroom, where a team picked out the tiniest bones of birds and fish. Our faunal specialist Richard Redding identified the bone against a reference collection – pig, sheep, goat, cattle, bird and catfish. By 2002 he had examined 2,928 bags of bone containing 151,083 bone fragments, including 10,610 fragments of fish, 7 of reptile, 503 of bird and

15.18 In the partitioned back chamber of Gallery III.8 the occupants worked copper, producing small implements such as fish hooks and needles. They used thick-walled bread moulds as crucibles – one can be seen fixed in place at the centre of the south wall, another in the northeastern corner – and then cooled and annealed implements in water held in jars sunk into the ash. View to the south.

139,963 of mammal – 2,356 cattle, 6,897 sheep and goat, and 386 pig. A significant number of the cattle consumed on our site were male, under two years old. Redding believes authorities culled royal herds to provision the site.

The faunal evidence perplexed us when set against the architecture. Why in the Gallery Complex, covering an area of nearly 2 ha (5 acres), is there so much empty space, primarily made up of the long front ends of all the galleries? And why, in such a large complex, are only three dozen formal housing units clearly recognizable? Yet why is there such an abundance of material culture, especially pottery, ash and animal bone? Who and where were all the consumers?

The idea that people slept on the low platforms in the colonnade of Gallery III.4 suggested the hypothesis that the galleries could have functioned as barracks. It is true that we found only seven of the low, sloping platforms in Gallery III.4, but people could also have slept next to each other down the length of both sides of the front section of each gallery. As noted above, for more than 100 years Egyptologists accepted, following Petrie, that the narrower galleries (3 m/10 ft wide) in the enclosure west of the Khafre pyramid were 'Workmen's Barracks', where as many as 4,000 to 5,000 people could have slept.

As an experiment, our team members volunteered to lie next to each other along either side of the colonnade in Gallery III.4 to see just how many people could have slept here at one time [15.19]. Each side, between the outer wall and the low wall with embedded column bases, was wide enough for a person to stretch out. The two sides could accommodate 40 to 50 people with room to spare. The entire Gallery Complex could have sheltered as many as 2,000 workers.

The galleries might reflect the 'team- or gang-organization of dependent population...common in ancient Egypt',[12] and more precisely, as seen in the textual evidence outlined above, possibly the gangs and phyles who left their graffiti on the blocks of the Khufu and Menkaure pyramids. However organized, we might expect the galleries to have sheltered the labourers who rotated in and out of the pyramid-building project. Evidence from ancient Egyptian texts suggests that groups of common unskilled workers were temporary,

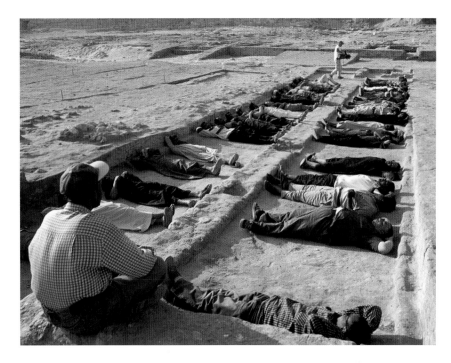

serving overlapping rotations on the royal project. Barracks and dormitories have throughout time accommodated conscripts away from home, either for labour or war, mostly the young under the direction of the old. The house in the rear of each gallery might have been for the overseer of the team who slept in the front part [15.20]. Another hypothesis is that the galleries as barracks may have housed a royal guard force that maintained order and provided protection for the pyramid project.

ABOVE
15.19 AERA workers and team members test reclining in the front colonnade of Gallery III.4 in 2002. Ashraf Abd el-Aziz, who excavated the gallery, sits on the front wall of the rear overseer's house.

RIGHT
15.20 Reconstruction by Wilma Wetterstrom of Gallery III.3, with a sleeping niche and hearth for guards near the front (north) entrance, a long columned colonnade with sleeping mats and platforms, a back domicile and rear chambers.

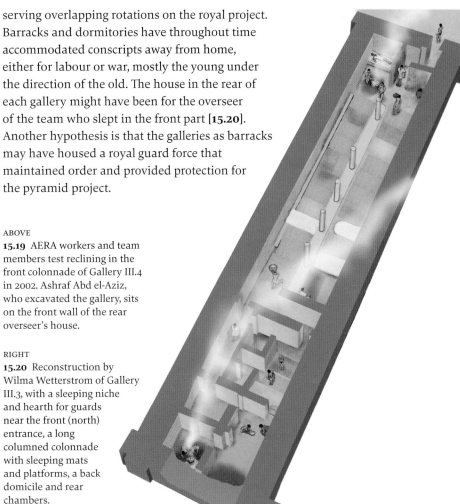

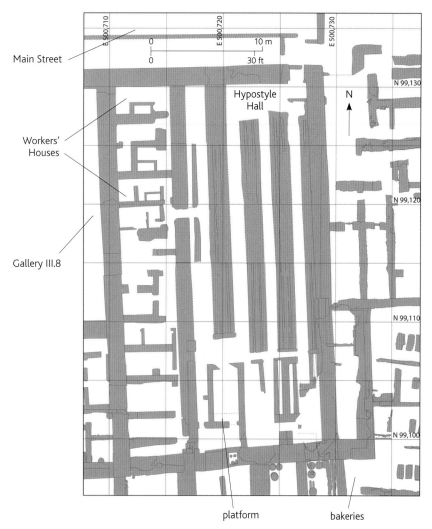

Main Street

Workers' Houses

Gallery III.8

Hypostyle Hall

N

platform

bakeries

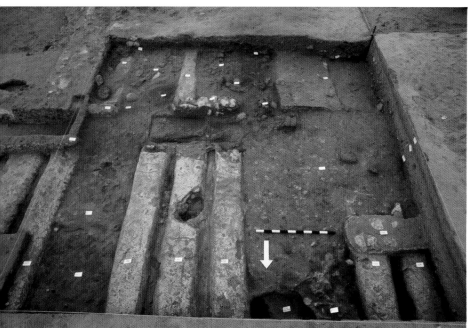

If the galleries were a single storey, the long colonnades might have been half-covered, or selectively covered, with a light roof to provide shade and allow some light in, while smoke from ovens or hearths (evidenced in other galleries) could escape. If the galleries rose as high as 7 m (23 ft) with vaulted roofs, and the thin columns of the colonnade supported a loft, the galleries could have accommodated many more men. And if the builders filled in between the spring of the vaults to either side of the thick walls that partition the galleries one from another, they would have created raised open terraces over the span of the entire gallery set, and yet more could have slept on the roof, which also probably afforded space for storing wood and reed fuel, even goats and poultry.

The Hypostyle Hall: a common dining area? On the eastern side of Gallery Set III, the Hypostyle Hall (a large space with a roof supported by columns) and small units ('Workers' Houses') of fieldstone walls occupy the width of three normal galleries [15.21]. The hall measures 15 × 25 m (49 × 82 ft) and is orientated north–south. A series of low troughs and benches, 30–40 cm (12–16 in.) wide and about ankle height, run lengthwise across the hall [15.22]. Three sets of three benches run through the centre, each set separated from the adjacent one by about a metre of open floor. Along the base of the east and west walls run sets of two benches separated by a single trough.

Under the middle bench in each group of three in the centre is a series of fine limestone column bases, set at intervals of 2.62 m (5 cubits/8 ft 7 in). The east and west rows of column bases run about 2.62 m (8 ft 7 in.) from the respective side walls of the hall. This appears to have been a standard spacing for supports of light roofs. The columns were probably wooden, each about 23 cm (9 in.) in diameter, like those in the gallery colonnades.

With the exception of a token hypostyle structure in stone at the western end of the entrance hall in the Djoser Step Pyramid complex, where the columns did not stand free, this small hypostyle was the oldest known in Egypt until the archaeologists at Hierakonpolis found evidence of hypostyle funerary structures of the late Predynastic, evidenced by holes for large (probably wooden) posts. Our hypostyle appears,

however, to have served some practical rather than ceremonial function. In the excavations here, fish bone seemed to be more abundant than in most other floor deposits. Much of it was of tilapia and schal (a type of catfish, *Synodontis schall*), generally around 5 cm (2 in.) long. Nowadays in Upper Egypt and the Delta, just such small fish are soaked in saltwater then dried for long-term storage and later consumption. We hypothesized that the curious troughs and benches were used for cleaning, salting and drying fish.

Archaeologists have found 'parallel wall structures' (PWS) comparable to the low benches and troughs at a variety of sites throughout the ancient Near East, ranging in date from the 7th to the 3rd millennium BC. At Tell Karrana, a site of the late 4th to the early 3rd millennium BC on the left bank of the Tigris, Carlo Zaccagnini excavated similar PWS, consisting of thin, low parallel walls with 'spaces between the walls resembling elongated narrow canals about 15 centimeters wide...'. The tops of the low walls sometimes show the imprint of reed matting. In his report, Zaccagnini concluded from a survey of examples of PWS at other sites that 'the same principle lies at the basis of these structures... namely, to build super elevated platforms isolated from the ground level and provided with under floor ventilation...the prevailing opinion is that these structures served as grain-drying platforms'. The excavators found abundant cereal seed on top of, and between, the Tell Karrana PWS. 'At the same time, the retrieval of numerous bones belonging to domesticated and wild animals hint at the possibility that these platforms also served as open air support for salting/drying/smoking(?) pieces of chopped meat of freshly slaughtered animals.'[13]

Why process fish or other foodstuffs under a roof supported by columns? Modern facilities for drying grapes and plums for raisin and prune production involve expansive canopies to filter sunlight so the fruit is not too rapidly desiccated, and the same might be true for meat and fish. In the Middle Kingdom tomb of Antefoker (TT 60) on the west bank of the Nile at Luxor, meat, and possibly a fish, is shown hanging from lines strung between columns on bases. We might imagine a similar function for the slender columns of our Hypostyle Hall.

Or could the evidence point to fish *consumption?* It is possible that the Hypostyle Hall was a communal dining hall for those who bivouacked in the galleries. The fish bone that we found alongside the low troughs and benches running the length of the floor included fragments of gills, fins and cranial parts that may not have been removed before consumption. Old Kingdom tomb scenes show fishermen gutting and splaying fish near the riverbank or on boats (the guts could be thrown back in the water), but not cutting off the heads, fins and gills. Thus the fish remains, and the other small animal bones that we found, could be debris from meals.

In the southeast corner of the Hypostyle Hall on the troughs and benches along the main wall we found a cache of complete cylindrical jar stands together with small shallow bowls with an internal flange that might have served as lids. Examples of these types appeared in excavations across the length of troughs and benches.

In our total pottery assemblage, the third most common form is a distinctive carinated bowl (CD7) [15.23]. Although similar in form to a classic type known as Meidum ware bowls (CD6), ours are thicker and coarser. We found several such bowls embedded in the floor and troughs here and there in the Hypostyle Hall. Old Kingdom tomb scenes and archaeological finds suggest that Meidum bowls were mainly used for presenting prepared food and as drinking bowls. Tomb scenes show such bowls on stands, covered with lids, like the ones we found, which were held in place with basketry, cloth and ribbon or cordage. Given the open 'public' nature of the Hypostyle Hall, the ceramics left behind might hint that it was a communal dining facility.

'Workers' Houses' Gallery III.9 runs along the western side of the Hypostyle Hall and differs from other galleries in that it is filled with a row of oblong chambers, about 2 m (6 ft 6 in.) wide and 4 m (13 ft) long. Each is divided into two chambers by a partition wall, with evidence of cooking in the rear (west) chambers. The units resemble simplified versions of workers' houses known from other sites and periods. A sloping floor or

OPPOSITE ABOVE
15.21 Plan of the Hypostyle Hall and 'Workers' Houses' filling Gallery III.9.

OPPOSITE BELOW
15.22 Sets of low benches at the southern end of the Hypostyle Hall, exposed in a 1999 excavation square, before the AERA team had cleared and mapped the entire hall. View to the north.

BELOW
15.23 A carinated bowl (CD7) of marl ware sitting on a cylindrical jar stand. AERA team members found several examples of both pottery types embedded within the low troughs and benches of the Hypostyle Hall.

simple stairway gave access down to the floor of the Hypostyle Hall. Those who prepared and served food in the Hypostyle Hall may have stayed in these small apartments.

The Manor: overseer's residence? Directly across Main Street from the Hypostyle Hall lies a large house within a compound that, like the Hypostyle Hall with the Workers' Houses, occupies the width of three galleries, though not for their entire length. The 'Manor' [15.24] measures 10.8 m (35 ft 5 in., close to 20 cubits) east–west by at least 15 m (49 ft) north–south; its outer walls are about 1.5 m (5 ft) thick, like the gallery walls. Although separated by the street, the Manor and the Hypostyle Hall appear to have been part of the same plan and functioned together. We cannot help but wonder if the Manor accommodated the overseer of the

Gallery Complex and the administrator of the Hypostyle Hall. The walls of the Manor are so thick (1.57 m/5 ft 2 in., 3 cubits) for such a confined interior space (7.6 × 9 m/25 × 30 ft) that perhaps the structure rose as a kind of tower house, with a roof from which someone could overlook much of the Gallery Complex, at least the extensive combined roofs of the galleries, the walls of which, of the same thickness, might have supported an upper storey and substantial activity on the roof.

Two bakeries attach to the eastern side of the Manor, with their own entrances through the North Street wall. They are similar in size and orientation (north–south) to bakeries we excavated in 1991 (see below). Within the compound of the Manor on the west, at least one, possibly two, additional bakeries are orientated east–west. To the north of the Manor, two low, long, thin benches run north–south within an enclosure of the same width. Here is a larger version of the colonnades in the galleries, where some 60 to 75 people could have slept.

The gatehouses On the western side of the Gallery Complex, at the entrances of the three streets that run through them, we excavated three house-like structures built on fieldstone foundation walls. These functioned as guard posts for overseers or gatekeepers to control and monitor the movement of material and people through the streets into and out of the gallery system.

North Street Gatehouse, about 10 m (33 ft) north–south by 12 m (39 ft) east–west, features long corridor-like rooms along the west, as narrow as 80 cm (31 in.) for a length of 6.2 m (20 ft 4 in.). These appear to be for storage – we found various types of nearly complete pottery vessels stacked against the walls, including bread moulds, beer or storage jars and carinated bowls. Main Street Gatehouse occupies the better part of 100 sq. m (1,076 sq. ft). This building of fieldstone walls has a well-paved floor and a pillar made of stone and clay. The small chambers of South Street Gatehouse, 9 × 10 m (29 ft 6 in. × 32 ft 10 in.), were filled with ashy soil containing large quantities of pottery sherds of many different types. On the floor of one chamber were several dolerite hammer stones.

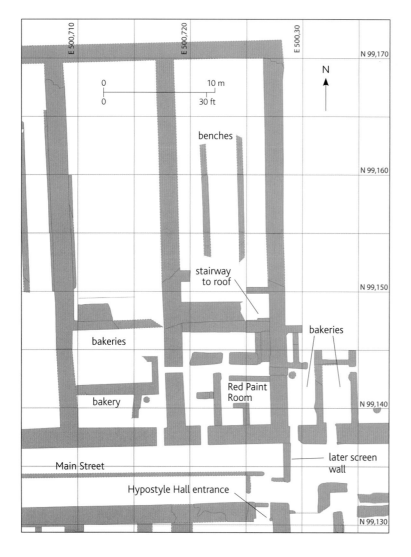

15.24 Plan of the Manor, possibly a tower house for monitoring and administering the Hypostyle Hall and the Gallery Complex.

The bakeries: loaves and fishes revisited

In our second excavation season, before we had realized the full extent of the site we were investigating, we came upon two bakeries from the pyramid age. The first intact Old Kingdom bakeries of this kind discovered in Egypt, these are the kind of elementary structures on which even the most magnificent pyramids and complex civilizations are founded.

We already knew that in the pyramid age Egyptians made bread in large bell-shaped pots that they called *bedja* [15.25]. Old Kingdom tomb reliefs and figurines show the empty pots first being stacked and heated over an open fire. Workers then placed the pots in baking pits in the ground, filled them with dough from nearby vats and covered each one with another pot upside down. Then they surrounded the pots with hot embers and ash to complete the baking.

The ancient Egyptians began to use bread moulds of this type just about the time that the pharaonic state emerged around 2900 BC and continued to use them until near the end of the Old Kingdom, *c.* 2200 BC. While some scholars have suggested that pot-baked bread was for special occasions – festivals, temple offerings, etc. – the Old Kingdom bread mould has been found as a major component of ceramic assemblages in sites of all kinds, from Egypt's traditional southern border at Elephantine to 1st dynasty outposts in southern Palestine. It seems Egyptians in many different settings and times had a taste for their pot-baked bread.

In our bakeries, low walls of stone rubble and Nile clay enclosed the two chambers, which measured about 5.25 m (17 ft 3 in.) north–south by 2.5 m (8 ft 2 in.) east–west, about 10 × 5 cubits. Under a layer of mud-brick tumble in each chamber we came across homogeneous black ash, which we called 'black velvet'. Each room had an entrance at the southwest corner, a hearth platform in the southeast corner and large vats in the northwest corner. Each also contained a cache of nearly complete and broken *bedja* pots at the south end, a few flat bread trays and half a jar made of Nile clay. Beneath the ash, which the bakers had allowed gradually to accumulate, we found a series of circular holes in a trench along the east wall – we anticipated these egg-carton-like baking pits

from a much more ruined bakery that we discovered that same season near the Wall of the Crow.

Both intact bakeries had originally contained three vats [15.26]; in one only two of these remained, the third having been removed in ancient times, leaving behind a clear impression. The bottoms of the vats broke during their use and they had been reinforced with pieces of limestone and granite. The marl clay that composed the floor was packed around the vats to more than half their height, making it easier, one would imagine, for someone to kneel rather than stand and bend over the vats to mix their contents. It is possible that someone stood in the vats, doing the mixing with feet and legs, a practice shown at least once in Old Kingdom tomb art.

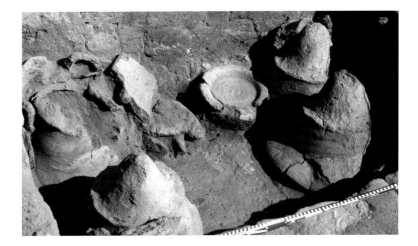

TOP
15.25 Bell-shaped *bedja* moulds and flat platters for baking bread in a storage compartment formed into a wall beside the rear kitchen chambers in one of the galleries.

ABOVE
15.26 Archaeologist John Nolan excavating the large vats in one of the bakeries.

Reconstructing an ancient bakery

In our bakeries we found all the essential equipment required for the production processes in baking bread as depicted in Old Kingdom scenes and figurines. In September–October 1993 *National Geographic* provided the funds to recreate a bakery based on the evidence we had discovered, for the purpose of experimental baking with ancient methods.

Old Kingdom tomb scenes show two bell-shaped ceramic pots placed rim to rim as a kind of portable oven for baking bread in open pits. Our *bedja* pots were unusually large, as much as 35 cm (14 in.) in diameter and up to the same depth. Put together in the manner of the tomb scenes, rim to rim, they would create an interior space 70 cm (27½ in.) in height. If the dough were to swell to fill the entire space, this would produce a huge loaf of bread. In fact certain tomb scenes do show offering bearers carrying conical bread loaves of the size and shape that would be produced by our pots.

The three large ceramic vats in the northwest corner of our bakeries were probably for storing materials and for mixing dough, and we presume that the fireplace in the form of an open platform in the opposite southeast corner was for stacking and heating the pots. The egg-carton-like rows of holes at the bottom of a shallow trench along the eastern wall must have been for holding the dough-filled pots, each covered by another pot placed upside down. Hot coals and embers in the trench provided the heat that baked the bread.

There is little evidence that the ancient Egyptians of the pyramid age used bread wheat, *Triticum aestivum*, which is high in gluten and gives the elasticity that allows air pockets to expand during baking, resulting in a light crumb and crispy crust. According to palaeobotanical evidence recovered from our site and most ancient Egyptian sites dating to prior to the Ptolemaic Period, the ancient Egyptians used primarily barley and emmer wheat, which have small amounts of gluten. The volume of the bread moulds indicates that the bakers were making a leavened bread, but, even so, the lack of gluten would suggest that the loaves would have been so heavy as to be almost inedible, much less suitable for festive occasions.

With some of these questions in mind we took advantage of Dr Edward Wood's volunteer services. Ed is a pathologist who has interest in one of the world's oldest cultigens, yeast. He set up a company, Sourdoughs International, and is the author of *World Sourdoughs from Antiquity*. Ed and his wife Jean curate a collection of wild and domesticated varieties of yeast that they have 'captured' from places as diverse as China, Saudi Arabia and a bakery in modern downtown Giza.

Ed contacted us shortly after we found the bakeries in 1991. He was intrigued by the possibility – although remote – that yeast spores from the pyramid age could be reactivated in the way scientists have revived beer yeast from an early 19th-century shipwreck. We were interested in understanding more about Old Kingdom baking. Ed brought to Egypt a supply of both emmer and barley flour that he had irradiated to kill any lingering modern yeast. With a dish of flour and water,

Ed successfully enticed and captured wild yeast from the balcony of his room in the Mena House Hotel (he thought the yeast were lurking nearby in date palms).

Our experiment was limited by the schedule of the *National Geographic* team, who were investigating a story on Egypt's Old Kingdom. While certain controls were enforced, we did not have the time required for more than a few repetitions and modifications of the experiment. We were trying to replicate in the space of two weeks a process that the Egyptians had used for over 400 years.

Our site was on private land some distance from the foot of the Saqqara Plateau. The top of the Djoser Step Pyramid looked like an upside down bread pot rising over the horizon. We kept our plan of the ancient Giza bakeries close at hand as a template and built a high-fidelity copy, including the contours of the floor, the vat emplacements, the open fireplace and a canopy supported by posts that corresponded with post holes in the original. It was rather surprising to see that it took the team – two men with donkeys, five labourers and two professional builders – about two and a half hours to build the low walls of one bakery using the sand, mud, water and limestone rubble we had gathered. We had spent weeks meticulously mapping walls of the same size and composition.

The next requirement was a set of pots that matched the Old Kingdom bread moulds as well as large vats similar to those we had found *in situ*. We purchased ready-made vats from the pottery market in Old Cairo. These were approximately the same size as our ancient ones, but slightly different in form. For the bread moulds we wanted to be closer to the originals, and went to a potter who usually produced wheel-turned vessels of finely levigated clay. We needed bread moulds that were handmade of clay heavily tempered with chaff and sand and of a roughly conical form. As it turned out, however, the 30 or so moulds the potter made for us did not match the originals in the thickness of the walls, porosity of the clay or exterior profile.

It was very illuminating to see the full complement of vats and bread pots laid out and set within the space of the bakery. The low walls must have served as 'counter space' for the empty pots and finished bread. Ed Wood's requirements for sourdough also provided us with insights. It was clear, for example, that we needed separate containers for water, flour and ferment – perhaps the reason for the three vats in the northwest corner. A separate vat, of which there was evidence along the west wall of one of our bakeries, was probably for mixing these ingredients.

Even the design deficiencies of our bread pots provided a better understanding of ancient practices. For example, the sharp inflections of the exterior walls of the pots are important for the ancient practice of stacking about a dozen pots over an open fire in order to preheat them. Our round-bodied pots were almost impossible to stack. The high porosity and thickness of the walls of the original pots provide a significant control of ambient heat to prevent scorching the crust before the crumb is baked through. The thin walls and dense clay of

our pots meant that the exterior of the bread burnt black while the interior remained unbaked. We had to insulate the pots from the hot coals with a ring of sand.

We believe we also discovered why the ancient bakers needed to stack heat the empty pots over an open fire first. When we did not preheat the pots that we turned upside down as lids, the bread did not bake through. And why were the ancient Egyptians making bread in large pots as opposed to the much simpler method of slapping dough against a hot surface to make flat bread? The loaves were massive, heavy and could have fed several people for a few days. With the

unusually large *bedja* pots and the multiple pot sockets (24 in one bakery), the Egyptians were reaching for an economy of scale while replicating the household mode of production many times over.

In the end we did produce edible bread from various combinations of barley and emmer – albeit a bit too sour even for most sourdough tastes. (We allowed the dough to sit too long so the lactobacilli symbiotic with the yeast became too numerous.) While much of the data is anecdotal, the insights are useful for interpreting our ancient bakeries and we have some clues as to why this kind of production was so common in Old Kingdom Egypt. The exercise also usefully reminds us that specific attributes of specific artifacts are not trivial or accidental. Rather they are the keys to an artifact's function, the knowledge of which contributes to understanding the structures of everyday life that are the fabric of society and economy.

15.27 The 1993 bakery replica sponsored by *National Geographic*. Mark Lehner, Ed Wood and Mohamed Abd el-Qadar discuss how to lift the hot pots without using modern protective gloves.

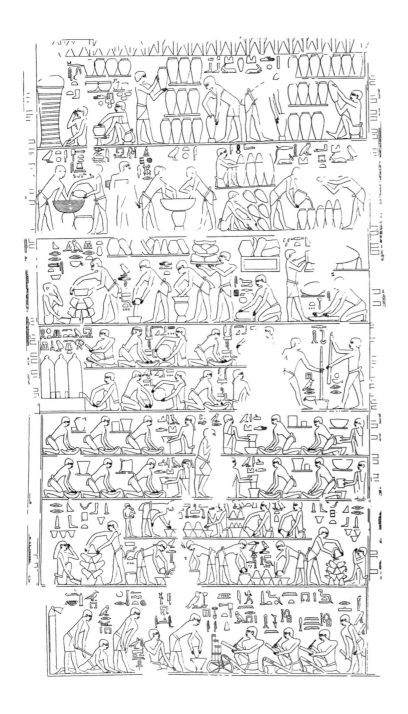

15.28 Bread baking and beer brewing in the *Per Shena*, a kind of commissariat and food production house, represented in a painted relief-carved scene from the 5th dynasty tomb of Ty at Saqqara.

Bread and beer were staple rations in ancient Egypt. In Old Kingdom tomb scenes, bread baking and beer brewing take place in the same labour establishment. The workers probably used lightly baked dough, in which the yeast was activated but not killed by the heat, for the beer mash, while froth from the beer may have gone back into the dough. In a time without refrigeration, this recycling might have preserved a kind of sourdough culture. In tomb scenes, bakery-breweries were part of the

Per Shena, a food production house attached to large estates, including bakeries, breweries and granaries [**15.28**].

We have identified other bakeries across the site on the basis of the rectangular form of the chamber, the fill of 'black velvet' ash and vats that are revealed on the ancient surface of the settlement. The bakeries we excavated in 1991 turned out to sit within a gallery-like enclosure of modular width and length on the eastern side of Gallery Set IV. Bakeries also lie outside the Gallery Complex east of the Hypostyle Hall, west and east of the Manor, at the back southern ends of several of the galleries and in the northern end of the Western Extension south of the Wall of the Crow. A series of magazines formed of fieldstone walls along the southern side of South Street may also have been bakeries. In short, the Gallery Complex is flanked, east, west and south, by dozens of bakeries that turned out batches of large heavy loaves.

The loaves and fishes must have fed a multitude, very likely those accommodated in the galleries. If a rotating labour force was housed in the galleries, then logically these bakeries are facilities for producing the labourers' daily bread. And the fact that more than 50 per cent of the half a million pottery fragments that we have excavated, weighed and counted are from bread moulds suggests these were busy facilities.

The Royal Administrative Building

In the far southeast of our site we came upon the corner of what at first appeared to be a very large enclosure with double fieldstone walls. Intensive excavations in 2002 revealed it to be a large royal building, which measures 48 m (157 ft) wide, for storage and administration [**15.29**]. The outer wall of the two is in fact a continuation of the Enclosure Wall that runs from the Wall of the Crow and wraps round the western and southern sides of the Gallery Complex. Where it approaches the royal building from the west, the Enclosure Wall turns and runs north for 15 m (49 ft) and then turns 90 degrees again to run parallel with the north wall of the building, forming a narrow corridor in between. The Royal Administrative Building, as we called it, or RAB for short, existed before authorities added the Enclosure Wall to form what we named

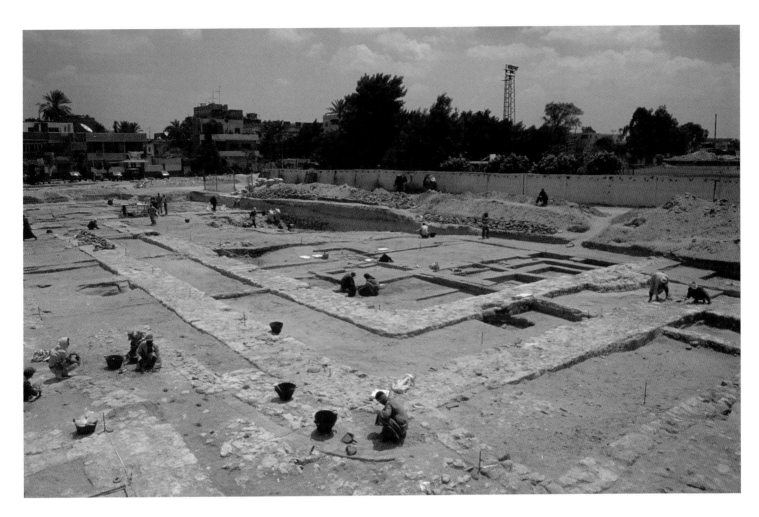

RAB Street, an alternative route outside the Gallery Complex from the northwest to the RAB enclosure. A single fieldstone wall defines the eastern side of the royal building and separates it from the small houses of the Eastern Town.

Courts and chambers occupy the interior northwestern corner of the RAB. Excavation here turned up diverse artifacts suggesting a range of activities. Little balls of clay with finger marks and pieces pinched off might be evidence of preparing the extra-fine clay used to seal string locks on bags, boxes and doors, or for sealing ceramic pots. Sealings, and facilities for making them, are often taken as evidence of administration. From one crate of possible sealings picked out of the deposits in the RAB we quickly registered more than 195 sealings, 170 of which are inscribed or incised. As a comparison, in the entire six previous seasons between 1988 and 1998, we recovered 470 inscribed or incised sealings. While the RAB sealings clearly indicate intense administrative activity here, we

were later to find even more sealings in the large houses of the Western Town.

In the RAB we also found little mud tokens that the inhabitants might have used as counters. Some are round and oval, possibly standing for a kind of pitta-like bread called *pesen* in ancient Egyptian. Others appear to be intentional quarter-*pesen* loaves. One small mud token has the form of a haunch of beef. Elsewhere on the site we have found small conical mud tokens – possibly representing the conical bread made in the bread moulds so ubiquitous across the site.

Pottery objects that might be loom shuttles and mud weights from the northwestern corner indicate weaving. Other deposits yielded evidence of working copper and alabaster.

A storehouse of pharaoh A thick wall of mud brick, later fieldstone, enclosed a sunken court, about 19 m (62 ft) wide east–west, in the eastern side of the RAB enclosure. Stone from the collapsed

15.29 Excavations during 2002 in the large enclosure we called the Royal Administrative Building (RAB). View to the southeast.

379

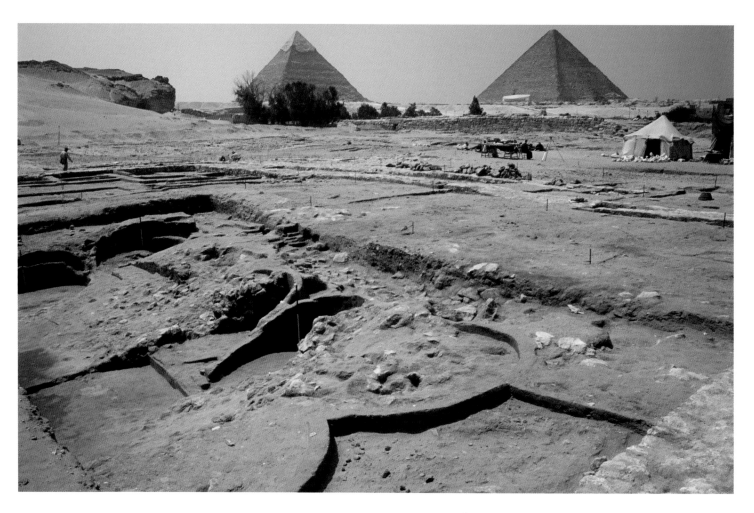

15.30 Ruins of large silos (2.62 m diameter or 5 cubits), probably for storing grain, excavated in the RAB enclosure. Placing the silos into a sunken court facilitated filling them from above. View to the northwest towards the Wall of the Crow and the pyramids of Khufu (right) and Khafre (left), and the Gebel el-Qibli (far left).

and robbed wall filled the court. When we removed this fill we found seven, possibly eight mud-brick silos, probably for grain storage, lining the side of the court [**15.30**]. Each silo is about 2.6 to 2.7 m (around 8 ft 6 in., or 5 ancient Egyptian royal cubits) in diameter. Since we have almost no other evidence of large-scale grain storage, the silos resolve the issue of storing raw materials for the numerous bakeries we found across the site. Grain could have been released from openings low in the silos and into the open court and then dispersed from this central storehouse, protected behind the double walls of the RAB and under the direction of royal administrators.

By 2003, we had excavated only 55 m (180 ft) of the huge RAB north–south, including part of the sunken court of storage silos. The rest of the building lies under the modern soccer field and Abu el-Hol Sports Club – in order to excavate more of the building, the sports club would first have to be moved.

The Eastern Town

In 2002, because of construction work on a new high-security wall for the greater pyramid zone, we moved our clearing as far east as we could before the new wall's foundation trench was excavated. This work immediately exposed marl plaster lines – the signature of walls. Here we revealed an arrangement very different from the formal, large-scale, planned architecture of the Gallery Complex and the RAB. We found instead a warren of small rooms and courtyards, much denser than in the Gallery Complex, with mud-lined bins, ash-filled smaller chambers and several small circular domestic granaries, with interior diameters of just over 1 m (3 ft, probably 2 cubits intended). In the trench for the new security wall, we saw two or three circular or semicircular mud-brick features that could be more domestic granaries. We traced the walls of this 'Eastern Town' in the mud mass for 95 m (312 ft) to the north, where they disappear under alluvial layers left by the annual Nile inundation.

Here, in a settlement less planned and more self-organized than the Gallery Complex, small silos and ash-filled chambers suggest that its residents, perhaps families, stored grain and cooked for themselves. We also find hearths and kitchens in the Manor, Main Street Gatehouse, the so-called Workers' Houses along the west side of the Hypostyle Hall and in the houses in the back parts of the galleries, features which suggest that the residents of each of these units cooked within their living quarters and were not totally reliant on the large-scale production facilities in their midst. The Eastern Town, so different from the rest of the complex, yet similar to many ancient Near Eastern villages, was probably home to long-term residents.

At the northwest of the RAB, on the Gallery Complex side, a curved mud-brick wall around the corner of the Enclosure Wall constricted the east end of South Street to 90 cm (35 in.), probably to control passage from the Eastern Town into the Gallery Complex.

In 2004 we excavated, and in 2005 restored, one complete house, the ETH (Eastern Town House), a small urban estate consisting of a core house with a central room containing a bench and sleeping platform, flanked by open courts with hearths [15.31, 15.32]. Courts on the east contained a vat embedded in the floor, a small round silo and a compartment where the residents might have ground the grain into flour.

The Western Town

Having found more of the settlement to the east, might it also extend to the west and south of the Enclosure Wall, running alongside and under the modern soccer field? In 2003 two test trenches hinted that it certainly did, though we had no idea what an extensive area it covered. In 2004 we cleared a large area west of the soccer field as far south as a deep depression (Lagoon 1) filled with sand soaked in ground water.

As in the Eastern Town, as soon as we lifted the sandy overburden, marl lines and brick patterns of ancient plastered walls appeared in the surface of the mud mass. We mapped the walls over a large area, tracing many of them from trenches that remained after people had robbed the bricks for reuse elsewhere, probably shortly after the

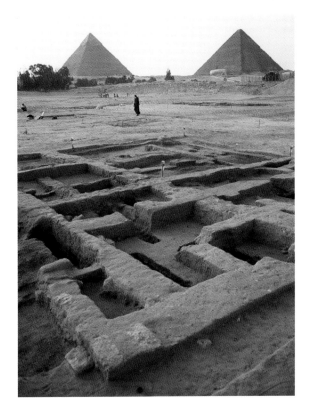

15.31, 15.32 Eastern Town House (ETH) as excavated in 2004, view to the northwest, and as reconstructed by Wilma Wetterstrom, based on the remains of a silo, bin, hearths and *in situ* pottery vessels.

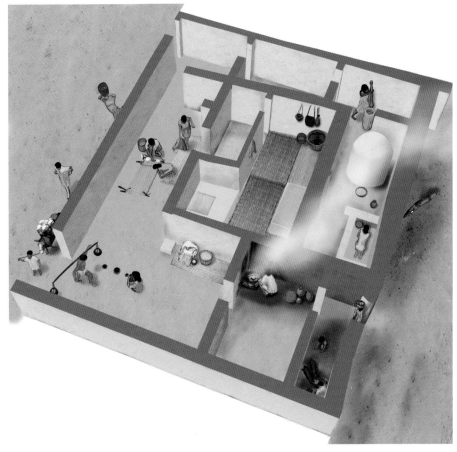

settlement was abandoned. The robbers removed the bricks so neatly that often they left the marl plaster intact, as a ghost of the ancient walls.

We dubbed this zone the Western Town. Like the Gallery Complex, the Western Town is oriented slightly west of north. Unlike the regularity of the Gallery Complex, the overall layout seems to be an urban maze, albeit largely orthogonal, with a dense network of walls made of mud brick and fieldstone. We can discern three long north–south strips, the central one of which was originally open space but was then invaded by the small courts and chambers of the large houses that seem to have occupied the site. People accessed the Western Town from RAB street, where a trapezoidal building may have housed a watcher of all those who came and went, via a path we dubbed the Western Roadway, 1.5 m (5 ft) wide. This led 60 m (196 ft) straight south to separate enclosures we distinguish, by the thickness and length of their walls, as large House Units 1, 2 and 3 [15.33].

If the wall ensembles we uncovered do represent large houses, they are on a grander scale than any we have seen in the town thus far. House 1 covered 400 sq. m (4,305 sq. ft), the size of smaller elite houses at New Kingdom Amarna, though nowhere near as expansive as the mansions in

15.33 Remains of House 1 with the dump of Pottery Mound to the right and the small Old Kingdom mastaba to the far left. View to the west.

the 12th dynasty pyramid town of Senwosret II at Illahun. But, like those mansions, the large houses in the Western Town probably housed high administrators.

The boundaries of the house units are not certain, but they appear to consist of a residential core surrounded by work and storage areas. All have at least one or two large chambers that might have been reception rooms, connected to smaller chambers. A large central chamber in Unit 1 was furnished with a mud-brick bench running along two walls, similar to the benches in village houses today. Black paint still adheres to the plaster at the base of the walls. To the west, in an even larger room, 8.5 m (28 ft) north–south by 3.5 m (11 ft 5 in.) east–west, we revealed in the southwestern corner a broad, sloped, bed platform with a raised 'footboard'. The platform is wide enough for two people. Two pilasters framed the southern end of this, the largest interior chamber we have found on the site. On the floor we found a heap of fragments of red-painted, moulded marl plaster, most probably from the decoration of the niche in which the master (couple?) of the house lay.

The courts and chambers surrounding the core units of these large houses were probably for work and storage. A bakery and/or kitchen occupied a

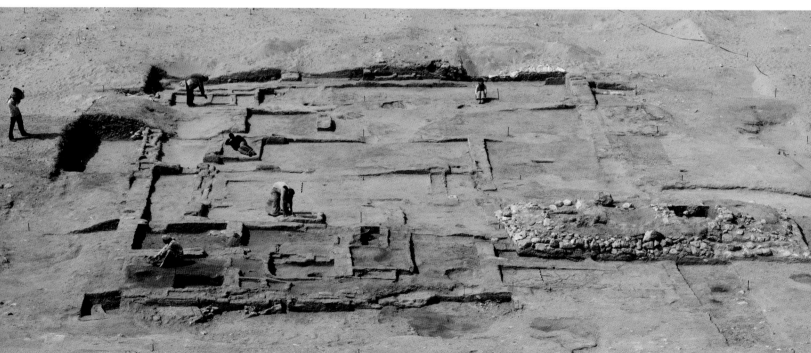

series of chambers that spanned the eastern end of Unit 1, while in Unit 2 four large magazines line up along a narrow corridor. A small room at one end of Unit 3 contains a set of three pedestals, similar to ones found elsewhere on the site and probably used to support storage bins. We found more and larger sets of pedestals south of House 1. We excavated one pedestal set in a broad, square courtyard under a heap of pottery and other trash that we named Pottery Mound.

Pottery Mound provided telling material about the occupants of the large houses. When we excavated two small squares, sampling less than half of the mound, we found astonishing amounts of pottery – mostly crude red ware jars, so called 'beer jars' and bread moulds – ash, animal bone and seal impressions.

Richard Redding's study of the animal bone has revealed a striking predominance of cattle bones. In the rest of the Workers' Town the average ratio of cattle to sheep/goat is 0.4:1; in the Pottery Mound sample it is 14:1. Prime beef was a mainstay of the diet of inhabitants of the Western Town. Most of the animals slaughtered were under 10 months old. Intriguingly, the majority of the bones also belonged to hind limbs, which prompts the question of what happened to the fore limbs? In Egyptian tomb scenes, the front legs of cattle are given as offerings. It seems likely therefore that the missing fore limbs were used in mortuary rituals. High-status occupants of the Western Town ate the rest of the animals and discarded the bones in Pottery Mound.

Other surprising faunal finds in Pottery Mound were the remains of gazelle and two leopard teeth, evidence of hunting, an elite activity. Is it possible that these teeth were from leopard-skin garments, as depicted in tomb scenes worn by the *sem*-priest, a high-ranking official (often the tomb-owner's son) who performed the offering rituals? In any case, the faunal remains from the Pottery Mound point to residents of very high status.

The sealings bear this out. Our two excavation squares in the Pottery Mound have yielded 1,034 pieces of mud sealings impressed by cylinder seals, possibly the largest cache of Old Kingdom sealings excavated in Egypt to date [**15.34**]. They are all fragmentary, retaining only a portion of the image they once bore from the original seal.

15.34 Some of the over 1,000 clay sealings impressed with cylinder seals found in the Pottery Mound. John Nolan has suggested that they came from a nearby scribal workshop.

Fortunately, however, John Nolan and Ali Witsell of our team have been able to identify multiple images impressed by the same seal, and by examining these replicate sealings they could often piece together graphically the seal's original image. Of 1,034 impressed sealings, we discovered 284 that bear replicate impressions. Even more striking was that these appear to have been made by just 19 different cylinder seals. Texts on the sealings often reveal the titles of the seals' owners and the names of the kings under whom they served. Of the 19 seals, 16 belonged to very high-level scribes in the royal administration who held titles such as 'Scribe of the Royal Document' and 'Scribe of the King's Writing Case'. On seven of the seals the Scribes of the Royal Documents are specifically dedicated to royal instructions – these men may have been associated with educating noble and royal children in the king's household. And of the 19 cylinder seals reconstructed, 3 include the name of Khafre and 11 of Menkaure; five have no preserved royal names.

Many of the sealings had been used to seal papyrus documents or flat-topped boxes, such as those used for scribal toolkits, both indications that the scribes who owned the seals were working nearby. John Nolan suggests that one of the houses included a scribal workshop, and our minds turn to the large central room in House 1 with a long L-shaped bench lining the western and southern walls. Some sealings had been used to seal doors (they have the tell-tale signs of the impression of the corner between the door and its jamb), which perhaps were in proximity to Pottery Mound. Taken together, the analysis of the faunal remains and the evidence from the sealings lead to the conclusion that scribes with some of the highest

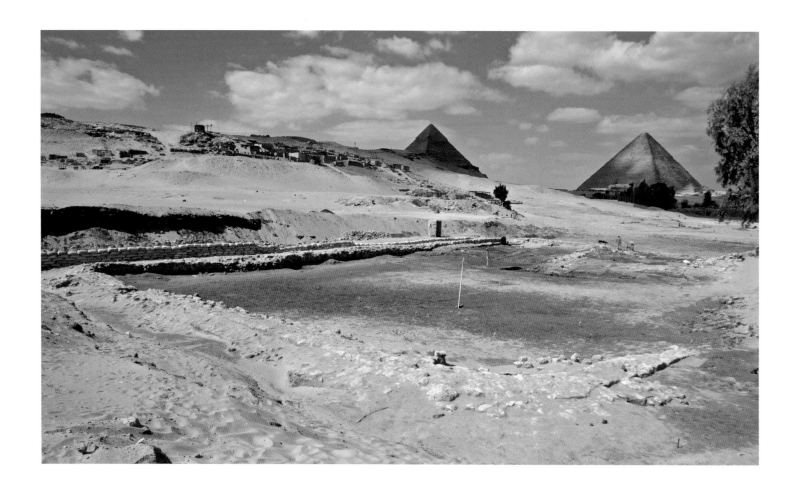

15.35 The corral enclosure ('Lagoon 2') stretching south of Standing Wall Island, possibly an abattoir. View to the northwest, with the Workers' Cemetery on the Maadi Formation slope above right.

titles in the land, officials who answered directly to the Vizier, were working in the vicinity. In recent field seasons we have begun to find some of the same titles on sealings from within House 1, as well as more leopard teeth.

Between the large house units a sea of walls spreads across the Western Town. We do not yet know if these walls belong to additional, contiguous large houses, or to courts and chambers for supporting industries, or to small houses like those around the large villas in 18th dynasty Amarna. Additional large units may occupy the northern part of the Western Town, up to the Enclosure Wall. At the southern end the structures appear to be much smaller, with thin walls less aligned to the cardinal directions than the large houses. These could be small residential units like those in the Eastern Town, but even more crowded.

The small units give way to broken pottery in ashy deposits that cover a slope down into the deep and broad depression, filled with sand saturated in ground water, that we call Lagoon 1. Here we

thought we had lost the settlement. Was this an ancient feature of the site? Probably so, because 50 m (165 ft) to the south the site reappeared, in the form of two enclosures opening south, defined by fieldstone walls standing unusually high – up to 1.5 m (5 ft) above the ruin surface. Standing Wall Island, as we called the double enclosure, might contain the abattoir that delivered the choice meat to the high-status residents of the Western Town. In 2011 we followed the outer, western wall south, freeing it from sand and rubbish several metres deep. It loops around like a paper clip to enclose another depression that we labelled Lagoon 2 [15.35]. Richard Redding recognized in the rounded corners, and the broad corridor leading into the enclosure from the northeast, the shape of a cattle corral, comparing it to ethnographic examples and depictions of corrals in Egyptian art from the Early Dynastic to the New Kingdom.

Here, then, in addition to the facilities that supplied loaves and fishes, we have the production place for prime beef (and probably mutton), at the

far southern corner of the site, downwind for the sake of the elite living 50 m (165 ft) north to spare them the odours of animals and their slaughter, but in close enough proximity to ensure no poaching.

The Wall of the Crow and the Workers' Town

The Gallery System 'hangs' to the south off the east end of the gigantic wall made of limestone blocks known as the Wall of the Crow (Heit el-Ghurab), which was both a massive presence throughout our excavations and also an enigma – when was it built, what was its function, and how did it relate to our Workers' Town?

In 2001 we explored the eastern end of the wall and cleared the great gate through its centre, one of the largest gates in the ancient world [15.36]. Until our excavations, horse and camel riders would pass over the sandy fill under its gigantic lintels; now it is the relatives of the deceased buried in the Coptic Cemetery immediately west of the southern side. Removing the sand revealed the impressive dimensions of the gateway, around 2.5 m (8 ft 2 in. or 5 cubits) wide and 7 m (23 ft) high. Because the wall is over 10 m (33 ft) thick at the base, the gate is also a tunnel, with a well-prepared roadway sloping down nearly 3 m (10 ft), paved with compacted ceramic fragments.

Our work also demonstrated that the Wall of the Crow was built up against the northwestern corner of the northern block of galleries, after that mud-brick complex had been completed. The sides of the wall are battered: the builders intended a sloping wall with a rounded top, a larger version of the enclosure walls around the pyramids. The precise purpose of this immense structure, which must have been visible for the last 4,500 years, is not certain. One suggestion is that the 4th dynasty Egyptians built the wall, 200 m (656 ft) long and 10 m (almost 33 ft) high and thick, to direct wadi floodwaters away from their facility. They may have also been interested in controlling the flow of people and material into the Gallery Complex. We know from our work north of the wall that the builders prepared an artificial terrace of limestone debris and marl clay stretching at least 30 m (98 ft) north from the bottom of the slope through the great gate. Core drilling indicates a canal or waterway further north, feeding into the

basin we recently found east of the Khentkawes Town, and possibly also into basins fronting on to the Menkaure and Khafre valley temples and the Sphinx Temple. The principal quarries for core stone for the pyramids lie further northwest, and, higher on the plateau, are the construction yards for pyramid building. The wall may also have been intended as a boundary between the sacred precinct on the plateau above, with its pyramids, temples and tombs, and the secular world of the workers and their daily lives below.

Each night while the pyramids were still under construction, the builders and labourers must have stopped work and returned through the gate in the Wall of the Crow to fill our Workers' Town to be fed and to rest. Or were the returnees ensconced in the galleries by members of a royal guard force, policing the colossal projects? The function of the galleries as barracks is admittedly an inference. But if teams of 40 to 50 or more people filled the gallery fronts, and possibly the second-floor lofts, maybe even sleeping on the roof terraces spanning the entire gallery blocks if the builders filled the vaults over individual galleries, with each gallery supervised by an overseer who lived in the substantial house at the back, then more than 2,000 (possibly young) people could have slept in the galleries. If the

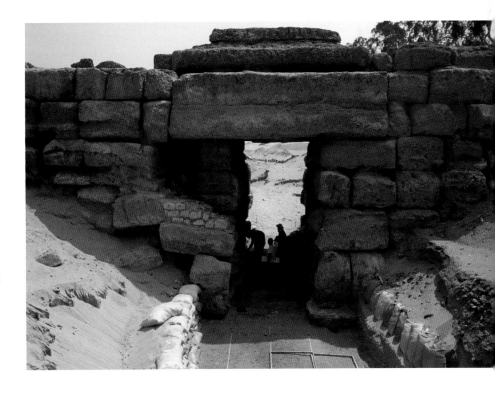

15.36 The Great Gate in the Wall of the Crow, northern side, after AERA excavations in 2001. This is one of the largest gates from the ancient world.

Gallery Complex accommodated such numbers, its footprint suggests the kind of regimentation and close-order drill that William H. McNeill discussed in his book *Keeping Together in Time: Dance and Drill in Human History*.[14] This degree of control and uniformity of action, presumably for the very task of building the mammoth Giza pyramids, may have temporarily replaced natural sodalities or communities, or perhaps the rotating teams were recruited on the basis of such homespun fellowships. In either case, regimentation, close-order drill, sleeping together and eating from a common 'table' can promote a strong *esprit de corps*.

The large quantities of meat-bearing bones of sheep, goat and cattle might suggest that large-scale fellowship for pyramid building was as much, or more, a ritual as a civil event. Building for the royal house on the scale of the early giant pyramids must certainly have been the kind of obligatory labour so well attested in ancient Egypt. Yet the very size of those pyramids, and the lack of written documentation, leaves us unaware of the extent to which such building was accompanied by the feasting associated with the large-scale ritual events known for other ancient cultures. In lieu of texts, we can only suspect such cultural facets in relation to pyramid building on the basis of archaeological data. Here, the clues lie in the vast architectural complex of modular units comprising mostly empty space accompanied by quantities of animal bone – sufficient, on the basis of New Kingdom meat rations, to feed several thousand people daily.

Development of the Workers' Town

The phasing of the Workers' Town – which parts were in use at one time, were rebuilt or built over – is a complex puzzle. In general, where we have excavated deeply into the southern and eastern parts of the site we find older walls from a layout different from that of the Gallery Complex, which was superimposed on the previous phase of the settlement. Immediately off the eastern end of the Wall of the Crow we found the thick mud-brick western wall of the northern block (Gallery Set I) built over and slightly displaced from an older wall, apparently an earlier phase of the first gallery to the west. Perhaps builders expanded the galleries with the southern blocks (Sets II, III and IV) later.

We believe that the main phase of the Gallery Complex we have mapped, and where we have excavated down to the latest floor (mainly in Sets II and III), was built during the reign of Khafre, whose sealings we have found, but that its final use as a barracks dates to the reign of Menkaure, whose name occurs most often on the sealings. So far we have no sealings of Khufu, but we hold out the possibility that the earliest, underlying phase dates back to his reign. To excavate the underlying level is a daunting task, and would probably require removing large areas of the main Gallery Complex phase.

As discussed in Chapter 4 (p. 56), between 1971 and 1975 Karl Kromer directed an Austrian team excavating a colossal heap of mud-brick building and settlement debris dumped behind the southern knoll, the Gebel el-Qibli, of the Maadi Formation that rises just above our excavation site. The material here included seal impressions of Khufu and Khafre, ash, animal bone, fish hooks, quantities of broken pottery and crude folk-art carvings, as well as painted plaster and faience tiles, which we might expect from higher-status dwellings.[15]

Kromer suggested the debris represented the remains of a settlement that the Egyptians had razed to build Menkaure's valley temple on its location, removing the debris and tipping it up behind the Gebel el-Qibli. We wonder, however, whether the material derives from the lower phase of the Heit el-Ghurab site, which the occupants partially demolished when they built the main phase of the Gallery Complex, and disposed of the remains over the high desert ridge. Perhaps that is why Kromer found sealings of Khufu and Khafre, but none of Menkaure, while we find Khafre and Menkaure, but none of Khufu.

Life in the Workers' Town: focusing the picture

Richard Redding, our faunal analyst, noted that remains of cattle often occurred with those of Nile perch – the highest-quality combination of mammal and fish meat. Of all the fish found at our site, perch was the most costly to procure since it had to be caught singly with a hook and line in the deep channel of the Nile. On the other hand, enormous harvests of catfish could have been taken just after the Nile inundation (October–November), when they spawned in the shallow waters flooding

the basins alongside the river. Late in the season, as the floodwaters receded, catfish and tilapia would have been even easier to catch as they became trapped in the residual waters left in smaller depressions within the great basins.

This cattle/perch combination is more prevalent in the large houses, such as House 1 in the Western Town, and in the Eastern Town, than in the galleries. The Eastern Town also contained more pig bone. Pig is a village animal, it can eat almost anything, provides abundant calories, but does not move well over long distances like sheep, goat and cattle. In Gallery III.4 the fare was sheep, goat and catfish, with the ratio of goat to sheep higher here than anywhere else. Evidence from the chipped stone tools adds extra information. Significant numbers of pieces from retouch, that is sharpening flakes and knives, came from North Street Gatehouse, where the cattle/perch combination was high, suggesting butchering took place here. In Old Kingdom tomb scenes of butchering large cattle, the butchers have rods attached to their kilts by a strip of cloth or rope [15.37]. They sheath the rod in the back of their kilts like a gun in a holster and, when they need to sharpen their knives, they pull the rod out and use the end to push off small retouch flakes such as those we found in North Street Gatehouse.

We note that North Street Gatehouse is not anywhere as expansive as House 1, and yet its position, like the houses at the points of access to Main Street, South Street and the Western Roadway penetrating the Western Town, suggests that here lived someone of authority and control, answerable to those who lived in the Western Town. As a client of high administrators, this person may have enjoyed the perks of good meat in the distributions from the households of authority. Faunal and

lithic remains suggest cattle meat came into the site on the hoof. After slaughtering, workers dried, smoked or salted the meat, and they distributed the meat, either processed or fresh, through the large households of the Western Town, where administrators sent parts out to others down the hierarchy of control.

The animal bone also tells us something about life in the galleries. The fact that each gallery has rear chambers containing evidence of cooking, roasting or baking might indicate a degree of self-sufficient production within a system of provisioning. The work gangs housed in the galleries might have received a sheep, or more often a goat, either as standard rations or for the numerous feasts so well attested in the tomb inscriptions (feasts of the decades, half-months, months, of New Year, of such gods as Thoth, Sokar and Min). The animal would most likely have been delivered on the hoof and slaughtered immediately. The ratio of meat-bearing (long limb) to non-meat-bearing bones (knuckles, jaws, etc.) is very close to what we would expect if the butchering took place close to the place the bone was excavated. We have to remember that there was no refrigeration (though smoking, drying and salting would help in preservation), so meat would have been freshest – and safest – if slaughtered on site, and this might have taken place in the broad streets fronting the gallery entrances. Perhaps the drain or channel that we found running down the centre of Main Street was for cleaning up after slaughter.

Overall it appears that the people occupying the houses along the edges of the Gallery Complex lived a better life than those within. In addition to more costly meats and fish, the residents of the houses ate a richer variety of plant foods. In general the

15.37 Drawing of a painted, relief-carved scene from the tomb of Ty at Saqqara, but fairly standard in chapels of high-status tombs, depicting men slaughtering and butchering cattle. One sharpens a flint knife by pressure-flaking with a rod tied to his kilt by a cord, as others use the knives to cut the foreleg of the animal, which they will then present as offerings to the deceased.

Complex was the equivalent of the towns built for massive modern construction projects, such as the Hoover Dam or the Aswan High Dam in Egypt.

The ancient town under the modern city

We know that, as large and complex as it is, the Heit el-Ghurab site that we have so far uncovered in our archaeological marathon formed only one part of a much vaster settlement that served as the main Nile port of its time, with harbours and waterways.

In the 19th century only a few small villages dotted the Nile valley floor along the foot of the Giza Plateau, the closest being Nazlet es-Samman, lying at the base of the plateau east of the Eastern Cemetery. In 1869 'Pyramids Road' connecting downtown Giza with the plateau was built as part of the preparations for the celebration of the opening of the Suez Canal. Since then, greater metropolitan modern Cairo (of which Giza is a subdivision) has flowed down Pyramids Road, submerging the small villages in a sea of modern urbanism, part of the largest city in Africa, lapping up against the Giza pyramids plateau and the Great Sphinx. In the late 1980s a sewage system was begun for the expanding suburbs of Nazlet es-Samman, Nazlet el-Batran and Kafr el-Gebel. The system required a whole network of trenches, cut to various depths, and scores of borings and core samples in the valley floor just in front of the Sphinx and pyramids. The project, undertaken by the Cairo Waste Water Project and the British–American consortium AMBRIC, covered an area west of the old channel known as the Bahr el-Libeini as far as the desert edge, a distance of about 1.5 km (1 mile), and stretched roughly 2 km (1½ miles) north of the Pyramids Road and 3 km (2 miles) south of it [15.39].

Michael Jones, under the direction of Zahi Hawass, monitored borings throughout this conurbation and a continuous trench along the Mansouriyah Canal that runs through the centre of the town. As expected, ancient remains were encountered, including the causeway of the Khufu pyramid, as well as basalt slabs that revealed the location of that king's valley temple (see Chapter 8, p. 186), hitherto unknown.

As part of the pre-construction site investigation, AMBRIC supervised the drilling of 73 auger borings

ABOVE
15.38 Painted relief scene depicting a woman kneading dough for bread, from the tomb of Kagemni at Saqqara.

OPPOSITE
15.39 Extract from the 1977 map of Giza showing low ground (blue), possibly vestiges of ancient basins and waterways, indicated by the 18-m contour in the area east of the Khafre valley temple and Sphinx to the Mansouriyah, Collecteur el-Sissi and Libeini Canals. The position of the large building near the Abu Taleb Bridge is highlighted in yellow.

density of plant remains at Giza is extremely low compared to other sites. But the densities are higher in the gatehouses, and highest in the Eastern Town, possibly because the inhabitants here carried out the initial processing of plant material. While we found dozens of bakeries flanking and within the Gallery Complex, most of the quern and grinding stones came from the Eastern Town or the east side of the adjacent RAB. Town people must have ground grain stored in the RAB silos for flour for all the bakeries. In this and other ways the town and gatehouses acted as filters for the Gallery Complex.

Such food processing constituted part of 'normal' village activities [15.38], in contrast to the unique tasks of pyramid building that probably occupied the labourers who bunked in the Gallery Complex. The Eastern Town was also typical of a village in that the residents ate pig – more than elsewhere on the site. Pig was not a high-status animal, but it was raised in villages as a cottage industry and is more characteristic of village life than of an administrative complex. The less regimented ground plan of the Eastern Town also suggests that the daily movements of its inhabitants must have been freer and less structured than those who occupied the galleries.

It could be in fact that in Eastern Town we have a settlement that was normal in certain ways for villages of its time – except that it acted as a filter and support for the highly unusual, specialized settlement within the Enclosure Wall. The Gallery

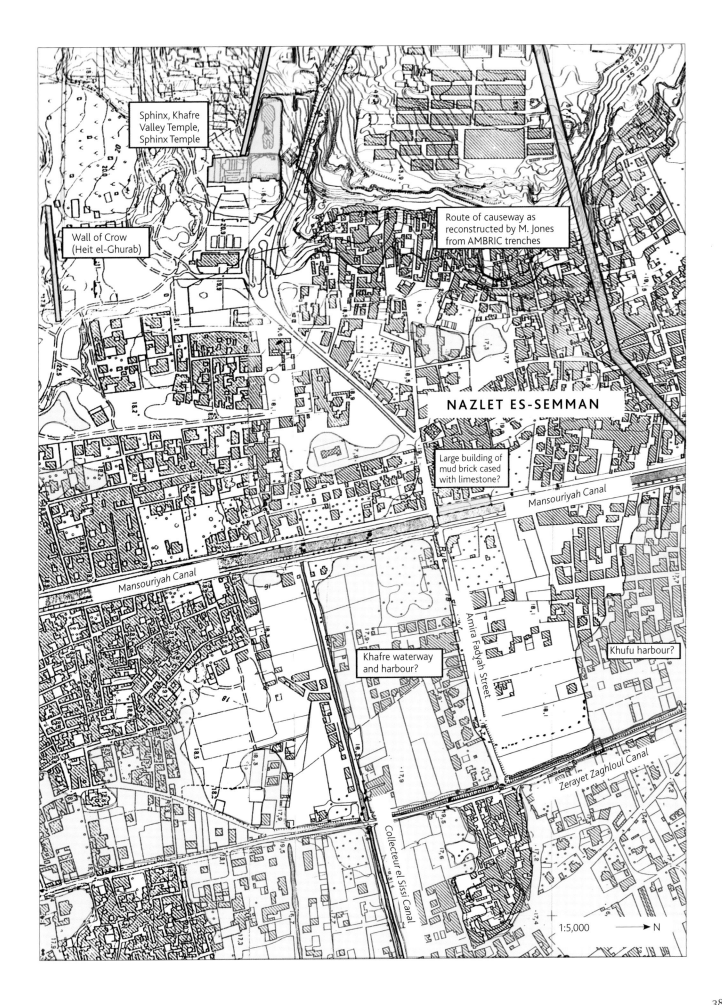

Sphinx, Khafre
Valley Temple,
Sphinx Temple

Wall of Crow
(Heit el-Ghurab)

Route of causeway as
reconstructed by M. Jones
from AMBRIC trenches

NAZLET ES-SEMMAN

Large building of
mud brick cased
with limestone?

Mansouriyah Canal

Mansouriyah Canal

Khafre waterway
and harbour?

Khufu harbour?

Amira Fadyah Street

Zerayet Zaghloul Canal

Collecteur el Sissi Canal

1:5,000 ➤ N

throughout the whole project area, between 20 and 30 m (66 and 98 ft) deep, to provide information about subsurface soil conditions. The test borings penetrated natural silts and gravel far below the level of human occupation. Here was an opportunity to assess the archaeological material in the environmental context of the area. The drill holes gave evidence of fluctuations in silt and sand accumulations on the margins of the Nile floodplain over a long period. The borings were widely spaced, but many of the cores taken within an area of 3 sq. km (over 1 sq. mile) east of the Giza pyramids hit settlement material at 3–6 m (10–20 ft) below modern ground level. A continuous spread of early settlement lies under this area.

The AMBRIC trenches for the sewage pipes gave a long vertical exposure of the archaeological material encountered in the borings. From a point approximately 50 m (164 ft) south of the location of the Khufu valley temple, a continuous horizon of mud-brick buildings, layers of ash and other rubbish containing large quantities of Old Kingdom pottery runs southwards for 1.8 km (1 mile). Two major levels of mud-brick buildings were identifiable throughout the entire exposure. The lower layer was founded on desert sand devoid of any trace of human activity. The natural surface appears to have been an undulating landscape of low mounds or dunes. It is remarkable that the builders did not level the surface much before they built, except in one case, discussed below.

A layer of dense black ash between the natural surface and the bottom of the earliest walls obviously represents a large-scale fire. The cause of the fire was not readily apparent, since no structural material was visible that might have been destroyed in a conflagration. It is possible that that the builders burned off grass and scrub that covered the landscape, perhaps quite dense in places, to prepare the ground for buildings.

In 1990, a main trench along the Mansouriyah Canal, just north of the Abu Taleb Bridge, reportedly cut through two large perpendicular mud-brick walls faced with roughly squared limestone blocks [15.40]. The walls belong to a building of monumental proportions, aligned to the south side of the Khufu pyramid. More walls were traced along Sphinx Street, heading west into Nazlet es-Semman towards the Sphinx,

Mansouriyah Street (north–south) and beneath the Mansouriyah Canal. A part of the trench along Sphinx Street revealed a mud-brick floor laid immediately over natural sand east of a main wall. Here, at least, it appears that the ground was levelled prior to construction, and the absence of the ashy layers suggests that this took place without the fire noted above.

The mud-brick paved area was relatively clean. Fallen brickwork, rather than accumulated rubbish, lay upon it. However, in the Mansouriyah Street trench the lowest stratum over the underlying ash deposit contained large quantities of broken pottery, fragments of bone, charcoal, animal dung and carbonized remains of other organic material. It seems that material found in this context belonged to activities in the nearby buildings described above.

The 8,000 pottery sherds collected from the deposit demonstrate a classic Old Kingdom occupation. Among large numbers of fragments of red burnished Nile silt bowls ('Meidum bowl' types) there are some new forms not previously recorded in the local ceramics derived from cemetery contexts. The coarser Nile silt wares are represented by a relatively high proportion of so-called 'beer jars' and by frequent bell-shaped bread moulds, many of which are preserved almost intact.

The bone material found in the same context (Phase I) came entirely from domestic animals. Fragments of cattle, pigs and sheep were identifiable, including the teeth. Bone had been sliced into pieces, perhaps to extract marrow, and shows butchering marks.

Phase I of the occupation ended when its buildings were demolished and partly levelled with rubbish. The rubbish which overlay and sealed Phase I contained a far higher percentage of coarse domestic potsherds, from platters, bread moulds, etc., than finer burnished wares. It was also characterized by burnt material in pockets of black ash. It is significant that there was no indication of burnt mud brick. It is possible that Phase I dates to the 4th dynasty, like the Heit el-Ghurab site, and could be its eastward extension, and also like that site, people abandoned it at the end of the dynasty.

On top of the rubbish overlying Phase I, a second, upper level of building was constructed: Phase II. Closely spaced smaller walls of mud brick

15.40 The main AMBRIC trench along the Mansouriyah Canal, south of Giza, opposite the Heit el-Ghurab site, in 1991. View to the north.

characterized this level; no stone was used. It is not clear whether the large building near the Abu Taleb Bridge was demolished and built over in this way. To the east, in the part revealed most clearly, a substantial secondary settlement evolved in an area below and alongside the modern Mansouriyah Canal.

During the occupation of Phase II, no major rebuilding or large vertical accumulation of rubbish occurred. A considerable amount of pottery was retrieved from this single horizon, which showed that Phase II ended before the diagnostic forms of Old Kingdom pottery went out of use, and the area seems never to have been occupied again until modern times. Clean, wind-blown desert sand sealed the upper surface of the Old Kingdom occupation.

Excavations of a trench across the Mansouriyah Canal revealed a striking piece of evidence for the ancient appearance of the landscape here. The east end of this trench encountered a high dune of sand, which sloped downwards, apparently beneath the two phases of Old Kingdom buildings. A picture thus emerges of a settlement facing the Giza pyramids, which were probably under construction at the time, but secluded behind a sandbank to

the east. Both borings and open trenches east of the sandbank have revealed further Old Kingdom settlement, so we should perhaps see here built up areas of dunes and sandbanks covered with grass and scrub, or, perhaps, the high western levee of a Nile channel.

Today most ancient settlement sites in Egypt either lie under wet fields, which are difficult to excavate, or are covered by modern towns and villages. The AMBRIC sewage project offered a unique opportunity to find out more than the pyramids, temples and tombs can tell us about the people of the pyramid age. With the Heit el-Ghurab excavations, the AMBRIC results give us benchmarks for what may well have been the largest Old Kingdom settlement in Egypt. The archaeological material extends for 3 sq. km (just over 1 sq. mile) south of the valley temple of Khufu, suggesting that a 900-ha (2,224-acre) area was settled in the Old Kingdom.

Harbours and waterways

Canals and basins, so typical of the pre-modern Nile floodplain, must have broken up this vast area of Old Kingdom settlement. The ancient engineers

would have required waterways and harbours as close to the edge of the plateau as possible to bring in the massive amount of stone and other material for building the pyramids. Paradoxically, the Nile's convex floodplain meant that the highest part of the land was along the river itself, while the lowest land was along the desert edge where lakes might be left by the receding annual inundation. Most likely the pyramid builders took advantage of natural discharge channels that conducted the flood into broad basins from a western branch of the Nile.

Standing water might have fronted the valley temple of the completed pyramid complex, forming either a functional or a symbolic harbour. In spite of the 2–4 m (6 ft 6 in. to 13 ft) of alluvial mud laid down by the annual inundation of the Nile since the Old Kingdom, subtle depressions may mark the deeper channels and harbours.

As the AMBRIC trenches showed, Old Kingdom settlement east of the Giza Plateau included some very large structures. In 1993, during construction of new apartment buildings east of Zaghloul Street, a large wall of limestone and basalt blocks was unearthed, at a level about 15 m (49 ft) above sea level – very near the level of the basalt blocks of the Khufu valley temple which were found

490 m (1,608 ft) to the east. This is also close to the foundation level of the Wall of the Crow south of the Sphinx. The 'Zaghloul Street Wall' may have partially enclosed a large harbour of the Khufu pyramid complex.

A colossal modern apartment and shopping complex now stands on the site of the wall, but in 1994 we uncovered 65 m (213 ft) of its length north–south. The wall consists of a limestone foundation, about 4 m (13 ft) wide, with basalt slabs about 3.5 m (11 ft 6 in.) wide across the top. We could not determine the depth (or height) of the wall because its base lay below the water table. The remains probably represent the foundation of a wall that may have been built up higher with inclined sides formed of a casing of basalt or limestone and a core of packed limestone chips.

The wall is orientated slightly more than 19 degrees west of true north, roughly parallel to the orientation of Zaghloul Street, which itself follows an old drainage ditch or canal called Zerayet Zaghloul, and to the north–south part of the old canal further east called Collecteur el-Sissi. We note that the large perpendicular walls cased with limestone near the Abu Taleb Bridge were also oriented northwest. We take these orientations as vestiges of an old Nile channel that ran northwest along the course of the old Libeini Canal, a little further east.

The Zaghloul Street Wall is also located east of a very subtle and wide depression that extends from the probable location of the Khufu valley temple. This broad low area is defined by the contour line marking 18 m (59 ft) above sea level that curves westwards just in front of the Khufu valley temple.

Michael Jones documented other parts of limestone walls that turned up in the sewage trenches along Zaghloul Street, about 250 m (820 ft) south and 200 m (656 ft) north of the long stretch of wall, perhaps belonging to the same enclosure as the Zaghloul Street Wall wall running east–west. These wall segments, along with the longer stretch east of Zaghloul Street and the Khufu valley temple pavement, suggest a rectangular enclosure – perhaps a harbour – 450 m east–west × 450 m north–south (202,500 sq. m) framing the depression in front of the Khufu valley temple. The AMBRIC cores show very deep clay and silt filling below 15 m (49 ft) above sea level in the

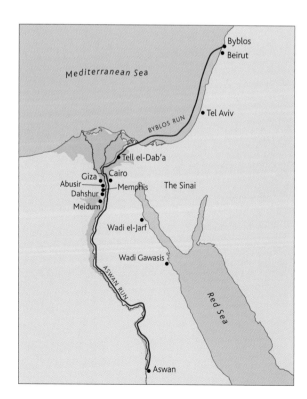

15.41 The Heit el-Ghurab site at Giza was not only the base for pyramid construction, but also a major port on the Nile for bringing in materials and supplies from distant places, including stone from Aswan. Sherds from jars from the Levant have been identified in excavations at the site, as well as charcoal from wood from Levantine cedars, pine, cypress and oak. The jars may have contained olive oil, resin or wine.

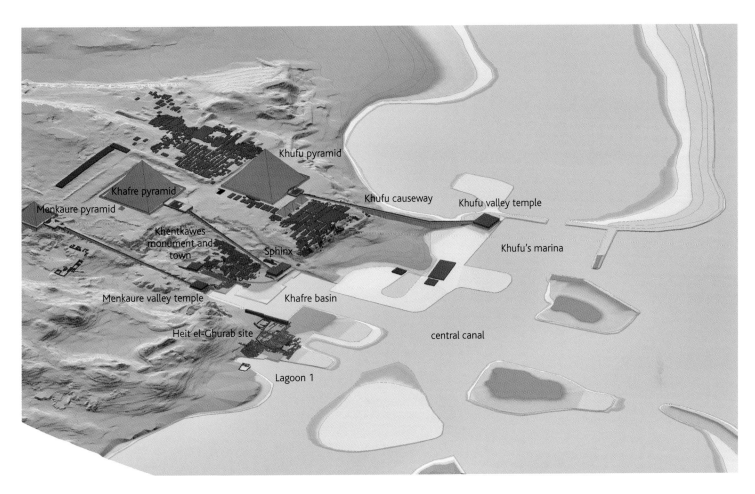

area of the hypothetical basin, and evidence of an Old Kingdom Nile channel running immediately east of the Zaghloul Street Wall, along the course of the Libeini and Marioutiyah canals.

A second, southerly, large basin, rectangular in shape, extends between Amirah Fadya Street and the old canal, Collecteur el-Sissi. This basin is orientated in the general direction of the Sphinx Temple and Khafre valley temple. Again, the core drill logs show this channel basin filled with clay and silt to extraordinary depths, below the general Old Kingdom horizon at 15 m (49 ft) above sea level. Here we see a central canal basin where boats could deliver stone and other material to the low southeast corner of the Giza Plateau [**15.41**, **15.42**].[16]

Text and archaeology: Northern *Gerget* of Khufu and Southern *Tjeniu* of Khafre reconsidered

As we saw earlier in this chapter, ancient texts give us two early names of settlements at Giza,

'the Northern *Gerget* ['settlement'] of Khufu', and the 'Southern *Tjeniu* ['cultivation edge' or bank of the floodplain] of Khafre'. Perhaps the settlement extending from the location of the Khufu valley temple, glimpsed in the AMBRIC sewage trenches, is the Northern *Gerget* of Khufu. We now believe our area south of the Wall of the Crow is a good possibility for the 'Southern Bank' or 'Southern Border of Khafre'. These may have been the precursors of the smaller, and more formally recognized, pyramid towns named after the names of the pyramids, such as 'Great is Khafre', and determined with the *niwt* hieroglyph, crossing paths within a circle.

Egyptologists who have studied the nature and function of the Old Kingdom pyramid towns consider it probable that a royal residence would have been one of its major components. No Old Kingdom palace has ever been found, although one from the Early Dynastic Period was partially cleared at Hierakonpolis, and so we have to look back several hundred years, or forwards to the Middle

15.42 Reconstruction of water transport infrastructure at Giza during the flood peak (August to September), consisting of canals, harbours, basins and marinas, all now buried beneath the present-day floodplain along the base of the Giza Plateau. Graphic by Rebekah Miracle.

393

Kingdom and New Kingdom, for palaces to imagine the form that an Old Kingdom palace might have taken. According to David O'Connor's studies, New Kingdom palaces tended to be in front of and to the right of the exit from major temples, as at Karnak and Amenhotep III's festival city of Malkata. The east–west temple axis and the north–south palace axes represented the axes of the world.[17]

The Old Kingdom pyramids are the largest temple complexes of their time. Our excavation area is just to the right front of the valley temple entrances of the Khafre and Menkaure pyramid complexes. The colossal stone Wall of the Crow with its large gateway has long hinted at a royal presence in this area, and we have discovered the substantial settlement for bivouacking crews, and for production and administration. The Royal Administrative Building (most of which lies under the modern soccer field) is probably not a residential palace. Nonetheless, unlike modern bread factories and fish-packing plants, Old Kingdom food-production facilities probably did not exist in isolation – production in early Egypt was household-based. Middle and New Kingdom granaries, bakeries, breweries, carpentry and weaving shops were attached in modular fashion to large households, even when they were part of overarching 'state' (that is, royal household) enterprises. It is possible that the large buildings and pavement hit by AMBRIC trenches along Sphinx Street were part of a palatial complex along a central waterway or basin that both connected and separated the settlement south of the Wall of the Crow from that to the north, flanking the Khufu valley temple and its fronting basin.

Although we began with a search for the ordinary labourers of the pyramid workforce, we continue our excavations south of the Wall of the Crow with both the common workers and palaces of the Giza pyramid kings in our minds.

The Khentkawes Town

Slightly higher than our Workers' Town spread out on the low desert at the southeastern base of the Giza Plateau lie the remains of two other 4th dynasty settlements, both excavated in the early 20th century. One is the town built in front of the Khentkawes monument, and the other

a settlement that invaded the central court of the Menkaure valley temple [15.43]. Unlike the expansive 'company town' south of the Wall of the Crow, which people abandoned near the end of the 4th dynasty, these settlements lasted, with a period of abandonment and resuscitation, for more than 300 years, carrying on to the end of the Old Kingdom. With them we have, most probably, the true pyramid 'towns' – attested in the hieroglyphic titles of their overseers etched in stone as part of their tomb texts. So far, we have found no inscription mentioning the town of Khentkawes. It has been suggested that the two settlements together formed Menkaure's pyramid town.

Since 2005 we have been exploring these two settlements, in the hope that we could extract new information, even though the Khentkawes Town had been left exposed to the elements and badly eroded – walls that had stood waist high after previous excavations now rose only a few centimetres. How do these relate, if at all, to the Heit el-Ghurab settlement, and what might they tell us about the wider urban context in which it functioned? We believe that while the multitude of people – those rotating in and out of obligatory labour, and those serving in the households of high officials who controlled them – moved with the royal house to south Saqqara and Abusir when pyramid building at Giza ended, some people stayed on, aggregating around the valley temples of the three kings, and along the causeway of the mysterious Queen Mother, Khentkawes.

Selim Hassan excavated the Khentkawes Town in 1932–33 (see also Chapter 12), but from his report we know little of the life history of this sizeable town, which occupies an area of nearly 5 ha (12 acres). The buildings are set within a thick outer enclosure wall that runs around the Khentkawes monument and encloses the entire town, stretching 150 m (490 ft) east from the royal tomb. Along the north side of a causeway running straight west to the queen's tomb, Hassan excavated a series of fairly modular houses. At the western end of the row, closest to the queen's tomb, a slightly larger building with thicker walls contains magazines that might have held equipment related to the *Wabet*, or embalming hall, used in the burial ritual (see Chapter 6 for more on these rituals). Nearby, off the northeastern corner of the Khentkawes monument,

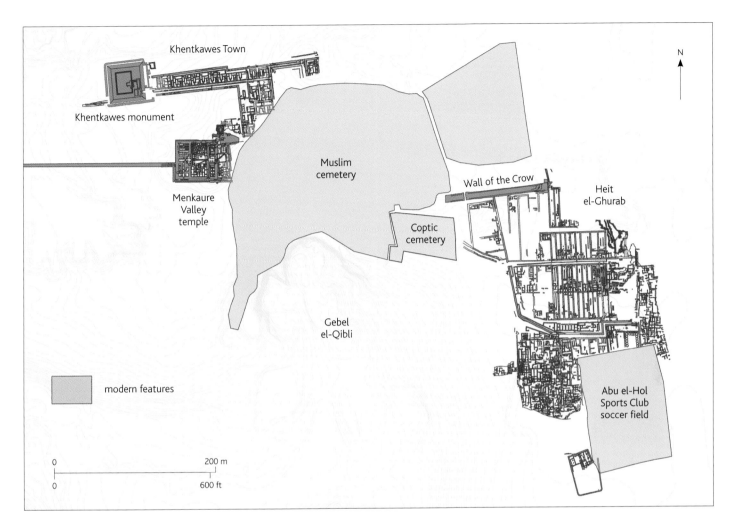

Khentkawes Town

Khentkawes monument

Menkaure
Valley
temple

Muslim
cemetery

Coptic
cemetery

Gebel
el-Qibli

Wall of the Crow

Heit
el-Ghurab

Abu el-Hol
Sports Club
soccer field

N

modern features

0 200 m

0 600 ft

Hassan found a court, drain and bedrock tank that he identified as part of the embalming complex (also discussed in Chapter 12).

The enclosure walls form roads running along the fronts and backs of the houses, which have entrances on the southeast and northwest. Hassan spoke of 'kitchens', some with ovens, though he reported little of the artifacts and other remains within; one house included a number of granaries. The first six houses (A–F) of the straight line of ten, nearest the queen's tomb, are larger than the others. Their standard layout and location along the causeway from the Khentkawes monument suggest that each may have initially been occupied by priests in charge of maintaining the queen's funerary cult. At the eastern end of the causeway are four smaller houses (G–J).

The eastern end of the town turns south 90 degrees to form an L-shape. Larger house-like buildings (K, L and M), a water tank, silos and

magazines occupy the 'foot' of this L-shape. It was not until our work here, as outlined in Chapter 11, that the reason for this abrupt turn was realized: the town runs flush along the upper edge of a deep vertical drop quarried into the bedrock. Lateral ramps ascend north and south to the causeway threshold from a terrace along the western and northern sides of a deep basin. At the end of a long corridor running more than 40 m (130 ft) east from the base of the northern ramp, we found a terrace forming the eastern side of the basin and supporting a house with grain silos and bakeries. During the peak of the annual flood, water filled the basin, which then served as a harbour for small boats.

At the point where the town makes a right-angle to the south, the last two houses in the line along the causeway (I and J) are in fact related as a block to two larger houses of the foot of the 'L', on the other side of the causeway (K and L). This rectangular set

15.43 Map of the Khentkawes monument and town and the Menkaure valley temple showing their spatial relationship, on the opposite side of the modern cemetery, wadi and the Gebel el-Qibli, to the Heit el-Ghurab settlement. Modern contours are shown at 1-m intervals.

of four buildings belongs to an earlier phase of the town: when the builders created the narrow, walled causeway they quarried a tunnel with steps under it so that people could still communicate between the two sides along a street running north–south. People inhabited the Khentkawes Town until the end of the Old Kingdom, in two major building phases, with a phase of abandonment in between – as Reisner had also recognized at the Menkaure valley temple settlement.

The southern larger houses, possibly a single complex, were entered from the north through a swinging wooden doorway in the enclosure wall, and then by the north–south street and tunnel under the causeway. Hassan mentions traces of painted decoration in bands of red, white and black remaining on the walls of Building M. A corridor ran west to a stairway ascending to a higher terrace that supported a series of granaries in a court with a water tank adjacent. Stone thresholds with pivot sockets suggest that wooden doors closed either end of the corridor.

In order to understand more fully the nature of the houses in the town, their function, organization and phasing, in 2009 we decided to excavate one of the better-preserved structures, House E [15.44, 15.45]. Although Hassan had emptied it in 1932, and in spite of severe erosion since, we were able to ascertain four phases of modifications and rebuilds, as well as a period of abandonment followed by reoccupation – a much more complex picture than that presented by Hassan. House E covers around 189 sq. m (2,034 sq. ft) and originally included four elongated north–south rooms and one transverse chamber, with an open courtyard across much of the north side of the house that extended across House F to the east. Two entrances opened from the courtyard to the northern street; other doorways on the south side opened into the house. A central L-shaped room with thick ash over the floor was evidently the kitchen, while an inner, more private chamber with a possible bed niche may have been a bedroom. In a room next to this we found evidence of a number of hearths and an open passage into the neighbouring House D, suggesting that the inhabitants of the two houses shared cooking facilities here.

When people later blocked certain doorways, they drastically altered the flow of space within the house. First, builders added an east–west wall between the houses and the southern enclosure wall to create the causeway (1.6 m/5 ft 3 in. wide) running straight from the queen's chapel to the valley complex. The broader street on the other side of the new wall fed into the southern foot of the town. Openings 1.2 m (4 ft) wide at regular 8-m (26-ft) intervals rendered the causeway highly permeable from this direction. Next, someone blocked the two northern entrances of House E so that access to the northern street was only through the courtyard from House F. Subsequently the northern courtyard was completely blocked from the house, leaving it exclusively for House F. An L-shaped partition wall in the courtyard now screened off four silos, probably granaries.

We found much evidence that the inhabitants abandoned the town for some time, with people returning later to reoccupy it. Evidence from House E shows that the returnees repaired and rebuilt walls using different techniques and types of mud bricks from their predecessors. The later occupants cut back the faces of older walls, probably to remove decayed or broken bricks, and even had to rebuild walls from the base up, indicating they might have been robbed.

The doorway at the southeast corner of House E might have been left open to the causeway – the erosion here left this point ambiguous. But we are certain that the causeway doorways of Houses A, B, C and D were blocked when people reoccupied the town, probably midway through the reign of Pepi II, very late in the Old Kingdom, when by royal decree that king renewed services in the adjacent Menkaure valley temple, about 147 years, we believe, after the end of the first occupation. At this time access to the causeway – and the proceeds from the queen's offerings – may have been limited to fewer residents of the northern town. They now absorbed into their own household rooms in adjacent houses.

This glimpse of House E through time forces us to rethink the history and function of the entire town. What we have long perceived as separate, individual houses actually intermingled to a significant degree – rooms in one house were more easily accessible, or indeed only accessible, from the house next door. House E also adds to the mounting evidence of a hiatus and reoccupation of the town.

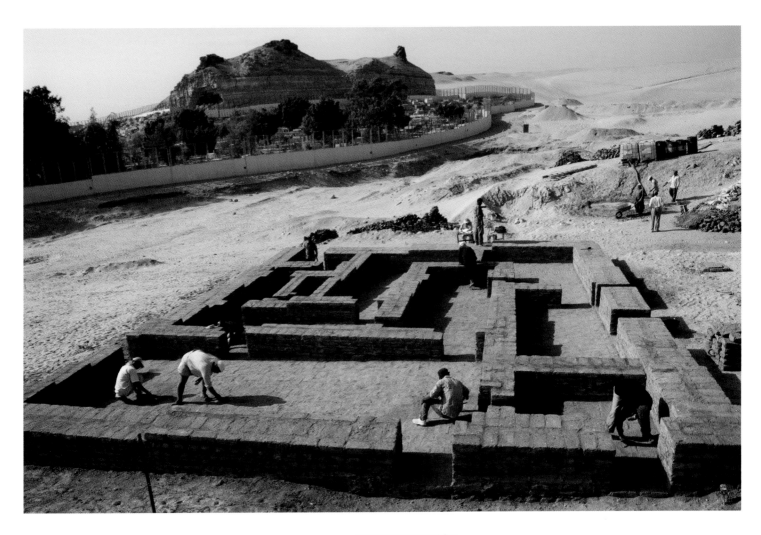

One puzzle of the Khentkawes complex is the causeway and its relation to the town. Instead of the completely secluded corridor between upper and lower temples that we see in kings' pyramid complexes, here the causeway is an open, narrow passage along the very front of a line of houses. The doorways, and possible windows, of some of the houses open into it, and at least 12 openings, with limestone thresholds, pierce the southern causeway wall, but off-axis in relation to the doorways of the houses. In some ways the wall forming the causeway seems almost like an extra frontage to the houses, providing protection from the heat and sun. However, the narrow passage (1.6 m/5 ft 3 in. wide) created by the wall lines up directly with the entrance to the queen's chapel at the upper west end, and to the top of the ramps leading up from the 'harbour' at the lower east end, and so must have functioned in the same way as the causeways of kings' pyramids.

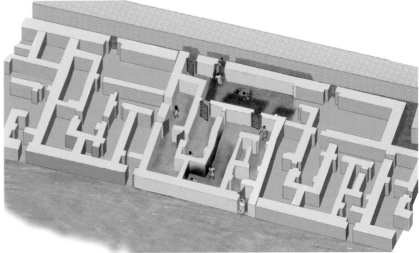

15.44, 15.45 House E in the Khentkawes Town, reconstructed in bricks and mortar (top) and graphically (by Wilma Wetterstrom) during its earlier phase of occupation.

The Menkaure pyramid town

The foot end of the Khentkawes Town abuts a broad ramp ('the Ramp') sloping up to the northern end of a wide terrace along the eastern front of the Menkaure valley temple. We now know this ramp and terrace formed the main access from the east to the Menkaure valley temple. When he excavated the walls and spaces built on this terrace in 1932, Hassan mistakenly believed they comprised the valley temple of Khentkawes I.

The misunderstanding comes in part from the fact that between 1908 and 1910 George Reisner excavated and then backfilled the Menkaure valley temple, while Hassan excavated most of the Annex on the terrace 22 years later. In 1908 Reisner was not able to locate an eastern wall either of the second phase of the temple or of the town that people had built over the walls of the first valley temple. Around 7.5 m (25 ft) east of the southeast corner of the valley temple his excavations were encroaching on the modern Muslim cemetery that was then beginning to fill the mouth of the Main Wadi; the residents of Nazlet es-Samman pleaded with him to stop. Reisner believed that the ancient town stretched about 70 m (230 ft) east of the east wall of the first temple. He was able to excavate only the far southwest corner of the Annex stretching east of the temple proper.

Selim Hassan's excavations approached the eastern front of the valley temple from the north, following the 'foot' of the L-shaped Khentkawes Town. Hassan pushed excavations about 10 m (33 ft) further east and identified the eastern town wall of the Annex and a vestibule with four alabaster column bases that opened north, through a small portico, to the top of the broad ramp (see also Chapter 12). While Hassan re-cleared the eastern wall of the Menkaure valley temple, much of the temple lay reburied under Reisner's backfill.

We are re-excavating the Menkaure valley temple 100 years after Reisner to study the devolution of the expansive 4th dynasty royal city to a village of caretakers, so it is a fitting end to a chapter on pyramid settlements. Working on a smaller scale and stratigraphically, examining each feature, we are finding evidence that the crowded warren within the temple and the pre-planned Khentkawes Town must have functioned together, at the same time. People abandoned and, after a hiatus, reoccupied both of the conjoined settlements.

The Menkaure valley temple town was the last element in Reisner's profile of a pyramid. It was more the rule than the exception in ancient Egypt that mud-brick houses came to form an urban agglomeration that clustered around and even within temples, including those of fine stone. We now recognize three major periods of settlement here, comprised of small mud-brick houses and round silo granaries.

First we found a glacis-like drop of the eastern enclosure wall of the terrace or Annex east of the temple, which Shepseskaf's builders completed upon the foundation of enormous limestone blocks laid in place during the reign of his father, Menkaure. Without the terrace, raised to a similar level upon a foundation of limestone debris, anyone exiting the main temple doorway would have been confronted with a drop of 2 m (over 6 ft). Builders must have planned the terrace as part of the Menkaure valley temple from its inception.

The ramp ascending to the terrace offered the main access up to the eastern front doorway [15.46]. So, like other valley temples (those of Khafre and Pepi II, for example), two ways approached the Menkaure valley temple: the broad ramp on the northeast and the causeway corridor on the south. On the floor of the eastern Annex, and on that of the valley temple court, people founded the first small houses, bins and granaries. Town and temple evolved together almost from the very beginning, from the end of the 4th dynasty when the royal house moved away to South Saqqara and Abusir for building the stone memorial complexes for the king.

No doubt those who stayed at Giza benefited from temple revenues and offerings. Based on a later decree for this temple, and decrees for other pyramid temples, residents of the pyramid town, and proxy-holders, carried out the ritual service and remained exempt from taxes extracted in the form of commodities and labour. Reisner wrote that he found a first period of small domestic structures built directly on the floor of the court, but we know little of their layout. Over time, they built up over the eroded mud-brick walls of the temple, and over earlier domestic structures. His plan, showing all superposed phases at once, conveyed

the impression that this pyramid town was a small, crowded 'sacred slum' that housed those tax-exempt persons who carried on the service of the long-dead king (see 11.36). In a second period, people built on top of a layer of accumulated debris that had covered the court, and on the ruins of the first domestic structures. Selim Hassan also talks of two periods of domestic structures he found in the southern end of the eastern Annex. We now recognize some order in the 'sacred slum'. Like Reisner, we can distinguish in the middle period five rectilinear apartments in the southern side of the court, while round silos and little square bins – perhaps for storing caretakers' allotments of temple revenues – crowd the northern side.

As discussed in Chapter 11, about the time of this middle period of settlement, or shortly before, builders erected a thick screen wall across the open portico on the western side of the court in order to prevent the settlement from expanding into the offering hall and sanctuary. We have clear stratigraphic evidence that during this phase builders also installed or renewed the limestone threshold of the eastern doorway of the valley temple, the limestone threshold from the columned vestibule and pathway down the centre axis of the court (between the northern bins and silos from the southern apartments), and the limestone ramp that led up through the screen wall and to the offering hall, which was accessed by a doorway flanked by Menkaure's four alabaster statues. Beyond lay the inner sanctuary. So around the time of the middle occupation in the court, builders renewed the focus of the cult and the reason for the town's existence.

Reisner believed that it was in the 5th dynasty that builders installed the screen wall, limestone path and ramp in the court. We have evidence that it was during the same period that builders installed the large limestone threshold of the eastern temple entrance, and the limestone pathway connecting the eastern central vestibule (Vestibule 1), with its four alabaster column bases, to the vestibule in the northern end of the terrace, opening north on to the broad ramp.

This second vestibule (Vestibule 2), which Hassan believed to be part of the Khentkawes valley temple, also features four alabaster column bases, identical to those of Vestibule 1 inside the Menkaure valley

temple. We believe that both actually belong to Menkaure's valley temple. The alabaster column bases were part of this 5th dynasty renewal, we think by King Niuserre.

So it is likely that the middle period layout of five apartments in the southern court, and the bins and granaries in the northern court, date to the middle of the 5th dynasty, when certain people rebuilt, reorganized and settled there as part of a renewal of Menkaure's pious foundation.

Then at some point late in the 5th or early 6th dynasty a flash flood severely damaged the temple, cutting a canyon through its western wall and pooling in the court. Reisner saw clear and dramatic evidence of this destructive event,

15.46 The broad ramp rises to the northern entrance (left) into the eastern Annex of the Menkaure valley temple. Formed of Nile clay over a core of quarry debris, the ramp expands in width from 7 m (23 ft) to 12.2 m (40 ft) as it rises. View to the west.

perhaps the second in the history of the temple. Following a hiatus people began to rebuild, creating the third period of settlement structures here, and the walls of what Reisner called 'the second temple', which, he suggested, dated to the late 6th dynasty, probably the middle of the reign of Pepi II, based on a decree of that pharaoh on a limestone stela found at the base of the jambs of the eastern doorway in Vestibule 1. No doubt people were encouraged, or appointed, to move back into the deserted pyramid town and temple, and perhaps also the town of Khentkawes immediately to the north. They maintained the cult of the king in the pyramid's upper temple and in a dark closet-sized sanctuary at the rear of the valley temple.

In the dust and rubbish of the magazines, Reisner found examples of temple equipment, including some of Menkaure's sculpture, such as the famous slate triads and the dyad of the king and a queen described in Chapter 11, unsurpassed in quality in any period (see box, p. 282). Not all the royal sculpture was preserved: the residents of the town had smashed some to manufacture stone vases.

The 'slumminess' of the temple housing set in over time, especially in the later phase of occupation, as the inflow from estates and royal largesse shrank. We have to think that in its heyday, Menkaure's facilities for the storage and production of produce from his pyramid endowments must have encompassed far more than the small housing near the temple itself. We now consider the possibility that the Khentkawes Town and the occupation within the Menkaure valley temple might have been an administrative unity, a combined pyramid town for both sovereigns.

Ascending the Giza plateau: living on high
The relationship between the Khentkawes Town and Menkaure's valley temple was one of the unresolved problems left by Reisner's and Hassan's excavations. The area between them was left blank on the map. In our systematic clearing, excavation and survey we have found that the 4th dynasty builders created a monumental, terraced landscape from limestone quarry debris, mud brick and small limestone masonry. They created the broad ramp as a primary access to the Menkaure valley temple and to the necropolis beyond, to the west.

The ramp ascends the plateau from east to west between low, thick shoulder walls. The pyramid builders may have initially used this massive structure for hauling up huge, non-local stones such as the granite blocks used in Menkaure's pyramid and upper temple. At its lower end the ramp is truncated by an erosion channel we call the Cut, but we calculate its width here as about 7 m (23 ft). At the top, it broadens to 12.2 m (40 ft) as it rises at a slope of 6 degrees to a low square pedestal or podium and a large, stepped basin (Water Tank 2).

The Annex and Vestibule 2 open on to the upper southern side of the ramp – in fact the ramp was the only way the valley temple could be accessed during this phase. North of the ramp and outside the enclosure wall of the Khentkawes Town, fieldstone and mud-brick houses stand as extramural additions to the Menkaure valley temple settlement and the Khentkawes Town. The ramp continued to be maintained over a long period of time, as shown by successive resurfacings.

The complex arrangement of ramps, terrace, stairs and long sloping corridor east of the Khentkawes Town conveys to us just how exalted and elevated were the pyramids and temples of Giza, even at the lower ends of their sloping causeways. Taking into account the evidence that the 4th dynasty floodplain lay about 4.5 m (14 ft 9 in.) lower than the valley floor today, the Menkaure valley temple and the eastern edge of the Khentkawes Town would have stood 6 to 8 m (20–26 ft) above the valley floor of their time.

The nature of the Giza pyramid towns
So what do we now know about the pyramid towns at Giza? And how do they compare? In the waning years of the 4th dynasty people occupied at the same time the Workers' Town, the Khentkawes Town and the Menkaure valley temple town. But both these latter temple towns were much longer lived than the Workers' Town. We find evidence in both for two major phases of occupation separated by a period of abandonment. In the interim, the climate may have become much drier and the locale more arid and desert-like.

The Khentkawes Town, planned and carefully laid out, must have been in practice a part of the

same conjoined community as the Menkaure valley temple community. We know little of that community in its first stage, but the second period of five apartments fitted into the southern valley temple court suggests some planning, although in the northern court, the superposed storage bins and silos – deposit boxes for temple revenue shares – give more of an impression of an unplanned, organic development over time. In the third and final occupation period, mud-brick houses crowded up against the eastern temple wall in the Annex and then squeezed into the interior spaces of the temple.

The large settlement south of the Wall of the Crow was a 'company town', put up to house the infrastructure and part of the vast workforce for building the three giant Giza pyramids and their temples and tombs. We know little of an underlying, older phase. Its second phase, the one we have mapped, lasted around 35 to 50 years, and then was decommissioned when pyramid construction ceased at Giza.

Egyptologists have interpreted the Khentkawes and Menkaure valley temple settlements as 'sacred towns', attached to the temples and probably inhabited by priests ostensibly serving the memory of the king or queen by maintaining their cult. Overseers and priests lived in the houses of the Khentkawes Town, while rotating staff stayed in houses outside the main town. A permanent population of around 100 would be consistent with estimates for towns of smaller 4th dynasty pyramids and with an estimate of about six people per house in the town. The smaller houses of the Menkaure valley temple were not the principal residences of the people who occupied them. They housed dependents of estate holders who rotated in and out of service, overseeing shares of the temple offerings.

Given the monumentality of the broad ramp between these two temple towns, however, and the location, it is also possible that they functioned as gateways to the necropolis, controlling access up to the plateau for the generations of Egyptians who continued to make monumental tombs and receive burial in the great Giza Necropolis, long after the Workers' Town went out of business.

How they might have built the pyramids

So how *were* the pyramids built? Most who ask this question have in mind the large stone-block pyramids of the 4th dynasty at Giza – the 'classic Egyptian pyramid' – but there are many different kinds of pyramids throughout the history of pyramid building in Egypt. So while 'how the ancient Egyptians could have done it', or 'how they might have done it', is a necessary place to start, there is no simple, discrete answer to the question of how the pyramids were built, for each presented specific conditions and required a particular set of tasks.

PREVIOUS PAGES
16.2 A worker unloads
a 'one-man stone' from a
felucca (sail boat) barge.
The stone was shipped
from the quarries on
the Nile.

16.2 Pyramid age
hammers: (above) a
dolerite hammer stone
and (below) a wooden
mallet, worn where it
repeatedly hit the head of
a copper chisel.

Many enthusiastic ideas about pyramid building
wilt quickly when examining the Giza pyramids
closely under the bright light of the Egyptian sun.
Our proposals for how the builders accomplished
their task must square with bedrock reality –
ground truth at Giza. In this chapter we will discuss
how the 4th dynasty Egyptians might have built
pyramids. In Chapter 17 we will look at the physical
evidence for our scenarios specific to each pyramid
in its unique physical context.

For any project, the builders first had to organize
the landscape to lay out the sites for the pyramid,
causeway and temples and to accommodate with
efficiency the quarries, workyards, transport roads,
harbour, storage areas and workers' settlement.
They also had to set up supply lines for all
the building materials and for fuel to support
construction and to provide food for the workforce.
For each of the gigantic Giza pyramids all these
aspects had to be in harmony to ensure that the
pyramid was completed within the lifetime of
the king.

Tools, techniques and operations

Pyramid building was a composite task requiring
many specific tools, techniques and operations.
The Egyptian builders used their tools – plumb
bobs, string, rope, ramps and embankments, wood
and stone hammers [16.2], levers and hauling
sledges, copper chisels and saws – to execute certain
techniques: measuring, setting points, extending
lines, tumbling, dragging, pivoting, levering,
cutting, pounding, chiselling, sharpening, abrading
and polishing stone. Techniques were combined
into operations: finding true north; squaring the
pyramid base; quarrying blocks; loading and
unloading transport sledges; hauling, lifting,
dressing, fitting and setting blocks; controlling the
rise and run of the pyramid slope; maintaining
alignments; mitring the outer pyramid face, etc.

The pyramid builders drew on their entire
infrastructure, that is to say, the sum total of all
the necessary tools, techniques and operations
that in combination made up their technical
system. Manufacturing the tools, preparing food
for the workforce and managing fires to process
the massive amounts of prepared gypsum mortar
were all also aspects of the technical system of the

pyramid builders at Giza. Like any technical system,
that of the ancient Egyptians was fully embedded in
their culture and society.

Selecting a site

Khufu's father, Sneferu, first established the
arrangement of the basic elements into the classic
pyramid complex at Meidum when he added a
small temple at the eastern base of the pyramid and
a long causeway running down to a valley temple
and landing dock at the edge of the floodplain.
The new arrangement required that the pyramid
be close to the valley floor, where a canal could
reach it, yet far enough out in the desert to achieve
the dramatic approach by the long causeway.
Ideally, the pyramid site would be fairly flat.

But the pyramid planners had many more
things to think about in selecting a site. They
needed a source – preferably close by – for an
enormous quantity of core stone that would
form the bulk of the pyramid. In addition, they
needed materials from which to make ramps,
and with pyramids as massive as Khufu's and
Khafre's, the volume required for ramps, roadways
and embankments would have been on a scale
comparable to that of the pyramid itself. If they
wanted to finish in reasonable time, certainly
within the lifetime of the king, the overseers
needed a large workforce. Commuting – by walking,
donkey or boat – would have cut drastically
into building hours. Labourers, possibly in their
thousands, needed to be housed and fed close to
the construction site.

At Giza, although they might quarry the bulk
of stone for the pyramid mass near the site,
they also had to transport thousands of tons of
Turah limestone for the outer casing from the
quarries on the opposite, eastern side of the valley.
Huge granite beams would have come from Aswan,
800 km (500 miles) to the south. Deliveries also
included wood for levers, sledges and tracks, and
for fuel for fires for making gypsum mortar and
copper tools and for cooking food. Raw materials,
including gypsum and basalt from the Fayum and
copper from Sinai, needed transport, offloading
and storage. All this, and a port of arrival for
unskilled workers who rotated in and out of the
project, required a substantial harbour with quays

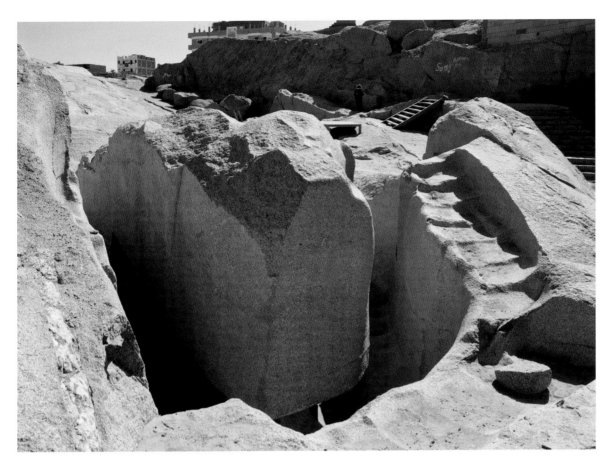

LEFT AND BELOW LEFT
16.3, 16.4 An unfinished colossal statue in the (New Kingdom) Obelisk Quarry at Aswan. During the entire Bronze Age (from the Old through the New Kingdoms), the Egyptians quarried granite statues or blocks by using diorite hammer stones to pound out trenches to the desired shape or squared off natural granite boulders. Patches mark the work allotment of one man. The separation trench pounded underneath the unfinished statue (below left) reveals similar patches. Working closely side by side, stone masons had to pound under the piece to separate it by snapping it off its narrow spine. They abandoned this piece because of cracks.

for regular deliveries and space for turnaround. Facilities for temporary storage and production of food and tools also needed accommodating.

Quarries

A large quarry, preferably close by, would be the source for core stone for the inner bulk of the pyramid. Geological stratification of the local limestone bedrock would determine the quality and size of the core blocks. Other quarries on the east bank at Turah yielded the fine white, homogeneous stone for the outer pyramid casing. These quarries took the form of galleries cut deep within the limestone escarpment to follow the best layers of stone. The quarrymen would begin with a 'lead' shelf cut along what would become the ceiling of the gallery, then extract the stone in terraces or banks.

The builders also required granite from Aswan. It is thought that in this early period the builders simply transported and then shaped the numerous natural granite boulders found along the 1st Cataract of the Nile. Given that granite is so much harder to work than limestone, this may be largely true. But the ceiling beams of Khufu's burial vault, and of four of the five stress-relieving chambers above it, are huge, about 5.5 m (18 ft)

long and weighing between 40 and 60 tons. It is likely therefore that these were separated, like the limestone blocks, by channelling the rock at Aswan, although unlike the limestone, the channels had to be carved by excruciating pounding with hand-held dolerite hammer stones [**16.3, 16.4, 16.5**].

Stone cutting, pounding, cleaving, drilling, sawing, trimming and polishing

The iron tools of modern masons make short work of cutting limestone. A heavy hammer called a *shahoota* in Arabic thins to a razor-sharp line of

ABOVE
16.5 Pyramid builders used many dolerite hammers of various shapes and sizes, some hafted. This one is from outside the New Kingdom tomb of Akhenaten at Amarna.

405

16.6 Mason's marks on a quarry channel in the Central Field East at Giza. The long strokes were made by a copper point driven by a wooden mallet.

teeth at both ends. Iron, because of its hardness, delivers substantial force to a small area. The stone masons grip the hammer's wooden shaft just below the head and strike the stone rhythmically at an acute angle to shave the surface with great accuracy. The combed pattern resulting from the sharp teeth is a clear sign of modern masonry. The fine teeth of a similarly shaped hammer in copper would wear away in the first few blows.

Modern masons use their iron hammers in ways that are probably similar to how their ancient ancestors used stone hammers. They split very large blocks by first etching a line using one corner of a heavy, flat-headed hammer, then pound the surface directly. The reverberating sound of the blow tells them just when the block is about to split and fall away at the desired cleavage. Modern masons use the flat end of smaller hammers to dress the surface of a block by hitting it directly to pop thin flakes. Ancient masons did the same, albeit with heavy stone hammers.

Pyramid masons used copper for chisels and possibly for pick hammers. After the Old Kingdom, the ancient Egyptians used bronze, an alloy of copper with 8–10 per cent tin, which makes it harder. Ancient copper ores might contain other metals: stannite is a copper-tin ore, a natural bronze, but is rare. Copper ore sometimes contains arsenic, which increases the hardness of the metal – when properly annealed, arsenical copper can approach the hardness of steel. But analysis of tools such as rounded bar chisels hammered to a cutting edge recovered from the pyramid age, including from places where it seems the masons left them inadvertently (such as in unfinished galleries under Djoser's Step Pyramid), indicates rather plain copper.

Copper chisels will cut limestone, but the ancient masons must have had to sharpen and rework their tools far more frequently than their modern counterparts. Master stone carver Nick Fairplay estimated that one tool sharpener would be occupied full-time for every 100 stonecutters. The ancient masons also made ample use of a metal point, or 'nail', to work limestone [16.6]. Like masons and sculptors of all times and places, the point is used to rough out the desired form in the stone. We see evidence of its use in long, thin, deep strokes on the walls of tomb shafts and

in unfinished work such as in the Subterranean Chamber underneath Khufu's pyramid.

Pyramid age Egyptians also sawed and drilled very hard stone. How did they do this with only soft copper tools? Probably with the assistance of quartz sand in a wet slurry – the quartz does the cutting, the metal tools simply guide the abrasive mixture.

Establishing the layout
Finding north

The question is often asked, how did the ancient Egyptians orient the pyramids so accurately? As their first major operation, pyramid builders had to survey the square of the base. First they had to find true north or orient the base to the cardinal directions. We might assume they started with true north, marked a line, extended it the length of a side and then turned the corners at right angles to establish the four sides of the base.

It is clear that the ancient Egyptians held the northern sky in high regard. The Pyramid Texts and other sacred literature call the circumpolar stars 'the Imperishable Ones' because they neither rise nor set as they circle around the celestial pole about 23 degrees up in the northern sky. Certain texts hint that the ancient Egyptians also used the northern stars for orientating their buildings. An inscription from the Temple of Dendera has the king 'looking at the sky, observing the stars and turning his gaze towards the Great Bear [Ursa minor]'. A scene on a wall of the temple of Edfu, dating two millennia after the Old Kingdom pyramids, shows the king performing foundation ceremonies for the temple with Seshat and Thoth, the divine couple associated with writing and science. One of these ceremonies was known as 'stretching the cord', in which the temple alignment was established by stretching a rope between two stakes that had been hammered in. A fragment of a scene from the 5th dynasty sun temple of Niuserre near Abusir shows the king and the goddess Seshat pounding long stakes connected by a looping cord, suggesting that this tradition was known in the Old Kingdom.

Citing these texts and scenes, I. E. S. Edwards suggested in his book *The Pyramids* that the ancient surveyors could have used the rising and setting of a northern star to find true north. To do this, they first constructed an absolutely horizontal circular

Cutting hard stones

W. M. F. Petrie examined in detail evidence of working hard stones at Giza, including the striations visible in ancient Egyptian saw cuts in basalt and granite such as along the sides of the granite sarcophagus in the King's Chamber of the Great Pyramid. He also scrutinized the cylindrical drill holes made for pivot sockets in the doorways of the Khafre valley temple, and the cylindrical cores that had resulted from such drill holes. He concluded that the ancient Egyptian masons used copper or bronze saws and drills studded with such hard stones as diamonds, beryl and corundum. But these hard cutting materials are scarcely known or entirely absent in Egypt. The modern archaeologist immediately has to wonder about the foreign sources, procurement and trade networks that such materials would imply, especially given the scale of work in granite and other hard stone found at all periods in ancient Egypt.

Denys Stocks, on the other hand, has demonstrated that sand, all too common in the Egyptian desert, used in combination with tools and techniques that closely approximate those of the ancients, does cut granite. In one of the largest modern quarries at Aswan, we witnessed Stocks's experiments. Aswan quarry workers put down their carbide steel chisels to take up a toothless bronze 'saw' blade. With very persistent hard labour and plain desert sand they made a cut into a large granite slab. For 20 hours three men used a bow drill reconstructed from ancient representations, with a copper tube and sand as a bit, to sink a circular hole 6 cm (almost 2½ in) deep. A little hammering with chisels extracted the core, a tapered cylinder of granite with striations very similar to the examples from the 4th dynasty Giza pyramids that had so intrigued and puzzled Petrie.

Stocks believes that the Egyptians cut the sharp-edged hieroglyphs and minute details in reliefs by using flint chips as disposable short-life chisels. He instructed one of us (Lehner) to carve a small hieroglyph, an *ankh* ('life') sign, in a chunk of pink granite by using sharp flint flakes (the flint edges chipped with each stroke, but powdered away some of granite at the same time). Under Stocks's tutelage, after several hours I had a presentable glyph in sunken relief. Perhaps with just some of the time, training and generations of experience of the ancient masons, I might even be able achieve those crisp, sharp edges we see on the pharaonic monuments.

Stocks has also successfully cut and drilled granite with copper and bronze, producing the same striated cuts as seen on 4th dynasty work. Stocks found a loss of 1 millimetre (0.039 in.) of metal in the blade for every 3 millimetres of depth in the cut.[1] The 1:3 ratio of copper to stone reveals how costly were the great hard stone sarcophagi of the elite Egyptian tombs in a culture that later valued things in units of copper called *deben*. Overseers weighed the workers' metal tools at the beginning and end of each day, to see if any minute shavings had been stolen.

The labour that goes into a single hole drilled through granite makes us appreciate the cost of producing tens of thousands of hard-stone vases in Egypt's early formative period (some 40,000 were found under the Step Pyramid of Djoser at Saqqara alone). When we see what it takes to cast a broad blade of copper or bronze using separate small crucibles, we gain insight into the order of magnitude of mining, smelting and casting saws and chisels to cut stone for the colossal pyramids of Giza.

16.7, **16.8** Crisply cut hieroglyphs – the sun sign in the top of a cartouche – in granite form part of the name of Sahure at Abusir. Below are sandstone fragments used as abraders for smoothing the modern experimental cutting of a sun sign in granite.

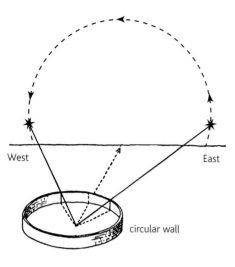

16.9 Finding true north using a circular wall and bisecting the rising and setting points of a star, as suggested by I. E. S. Edwards. The resulting line is only as long as the radius of the circle, and would need to be extended more than 230 m (755 ft).

West East

circular wall

16.10 Modern reconstruction of a gnomon, a stake or pole positioned vertically using a plumb line. Its shadow cast by the sun before and after midday can be used to ascertain the meridian.

wall, 'with a diameter of a few feet on the already levelled rock-bed of the pyramid'.[2] Standing in the centre of the circle and facing north, the observer could mark the point at which a star rose above the wall on his right (east) and where it set below the wall on his left (west). The bisection of the angle between rising and setting points (plumbed down to the base of the wall) and the centre of the circle would give true north [**16.9**].

Kate Spence has suggested that the pyramid surveyors could have found north by observing two circumpolar stars, Kochab, in the bowl of the Little Dipper (Ursa Minor, or Little Bear), and Mizar, in the handle of the Big Dipper or Plough in the constellation Ursa Major (the Great Bear), when they aligned above and below the pole star.[3] Since the celestial North Pole was only aligned exactly with these stars in 2467 BC, Spence takes that as the date of the founding of the Great Pyramid.

These theories may work as mental operations, but they present practical problems. Spence's method requires the Egyptians to have used a plumb line to measure the alignment of the two stars above and below the celestial pole and project it on to the ground. The celestial pole is some 26 degrees above the horizon. Anyone who has used a plumb line extensively in mapping or building knows that the higher above the head it is held, the harder it is to keep it from swinging. We must envisage some kind of large wooden frame to hold the plumb line high and steady. It is also difficult to envisage how either stellar method could have been carried out in darkness without the aid

of modern illumination. Spence visualizes a ring of 'torches everywhere'. If so, the trick must have been to illuminate the desired line on the ground, and the plumb line hanging from the frame, without obscuring the light of the distant stars. Finally, all this would have to have been done in the very brief moment when Kochab and Mizar aligned with the pole.

The same scenes and texts of building foundations also speak of 'the shadow' and the 'stride of Re' in connection with the 'stretching of the cord' ceremonies. Martin Isler maintains that the Egyptians could have accomplished the astonishing precision of north alignment with a simple pole, or gnomon: 'a stick in the ground, a bit of cord, and a shadow'.[4] The shadow method is based on the awareness that the sun rises and sets in equal and opposite angles to the meridian (true north). A stake or pole is plumbed to vertical; the length of its shadow on a level surface is measured about two to three hours before noon [**16.10**]. This becomes the diameter of a circle that is scribed with a cord and stick with the pole as its centre. As the sun rises in the sky towards noon, the shadow contracts. In the afternoon it lengthens again at an angle with the morning shadow. When its end reaches the circle, the bisection of the angle between morning and afternoon corresponds to the meridian. The method is most accurate if carried out during the solstices.

Extending the line

However they found true north, the ancient surveyors then had to extend the resulting north line. If they used the circle and star method, their initial north line was only a few feet long. Had they simply extended it to the more than 230 m (755 ft) of Khufu's pyramid base, the slightest inaccuracy would have vastly increased what surveyors call the angle of error. They somehow had to measure the entire distance of one side of the pyramid base along this extended line and then turn good right angles to make the corners. Finally, they had to measure the perpendicular sides to the opposite corners and turn another set of right angles.

The various suggestions for the method of finding north all assume an initial starting point – the centre of the circle in both Edward's north star and in Isler's sun/shadow method. Using the shadow method, the builders might have erected a series of gnomons, arrayed roughly north–south, but staggered slightly east–west. By performing the bisection of the morning and afternoon shadow for each gnomon circle, they would have achieved a series of short north lines that were parallel to and partially overlapped down the north–south direction. They could have used each short north line as a check for extending the north orientation by measuring the appropriate amount across to a master reference line for the pyramid base.

Isler also suggested another method, inspired by the scenes of 'stretching the cord' in which the king and the goddess Seshat hold stakes with a cord looped double around each stake. In this method a double cord is pulled at a tangent to either side of the round stakes. The line is off if one cord bends on the last stake while the other cord passes without touching the stake; the line is accurate when both cords are precisely tangent to the stake. The exact line is the split between the parallel cords. This requires poles of the same diameter. While ancient carpenters could have achieved this, we cannot take this kind of standardization for granted in a technology that did not know the lathe.

We should also not overlook the level of accuracy that can be achieved from simply sighting by eye. The Giza diagonal is a line that touches the southeastern corners of the pyramids of Khufu, Khafre and Menkaure (though Khafre's southeastern corner is set back a couple of metres

from this diagonal). If you walk eastwards along the southern Maadi Formation ridge with your eyes on the pyramids, the three giant structures begin to close up as you approach this alignment. At one particular spot, in the lee of a small knoll, the southeastern edges of all three main pyramids coincide, and Khufu disappears behind Khafre and Menkaure. One step, less than a metre (3 ft), backwards (west) or forwards (east) and the three separate pyramids reappear, no longer in line. That is a small step for an alignment on a scale of many kilometres. The Egyptian surveyors might have achieved much by stretching a line over an already determined trajectory and simply sighting beyond for its extrapolation. At best, any error would be compensating – one way off in one extrapolation, the other in the next, and averaging out rather than accumulating over successive extensions.

Marking and maintaining a line with an actual cord would have required stakes embedded in the ground. The builders could have simply pounded them in when they staked out a temple down on the valley floor where the ground was soft, or for a pyramid built on desert clays and gravel. But the *final* layout (after a series of ever-closer approximations) of the pyramids of Khufu and Khafre was on prepared limestone bedrock. Here the builders either had to etch or paint lines on the rock floor, or they would have had to quarry out small holes in which to set the stakes.

It is likely that the ancient surveyors set a reference line outside the actual baseline of the pyramid because the baseline would have been scrapped, scratched, pounded and covered with debris as they began to build the bottom of the pyramid. The lowest casing blocks of the largest Giza pyramids weighed up to several tons, and moving them into position would have effaced any temporarily drawn baseline.

Right angles

For the corners, the ancient surveyors could have achieved a right angle in three ways. First, they could have used the 'Sacred' or Pythagorean triangle – three of any unit on one side, four on the other and five on the hypotenuse. Such triangles seem to be present in the design and layout of the Old Kingdom upper temples attached to pyramids,

though the evidence is not conclusive. Or they could have used the Egyptian set square – an A-shaped tool with perpendicular legs set at right angles and a cross brace. One leg is placed on the already established line and the perpendicular is taken from the other leg. The square is then flipped and the operation repeated. The exact perpendicular is taken from the small angle of error between the two positions. Thirdly, they could have used a measuring cord to pull two intersecting arcs of the same radius from two points on the same line. A line connecting the points of intersection will be at a right angle to the original line.

Levelling

Pyramid theorists often imagine that the builders constructed their pyramids on a base that was conveniently square and level, but this does not exist in bedrock reality for the Giza pyramids (see Chapter 17), and we can therefore discard the old ideas. One theory is that the builders used water contained in a grid of channels that covered the base area – an idea probably inspired by the grid of channels cut on the northwest terrace of the Khafre pyramid (which actually would not have worked at all in this way – see 9.16). Water poured into the channels would find its own level and the builders could have marked the surface level of the water, then drained it and cut the bottom of the channels to a uniform depth measured below the water line. But this theory becomes untenable when we recall that the builders left a massif of bedrock thrusting up into the cores of both the Khufu and Khafre pyramids. In fact they did not level the entire base, but they did achieve precise levelling on the top of the pyramid platform or the first courses of outer casing stone. How?

Again, the solution may have been incremental measurements with compensating errors. We know that pharaonic builders used a wooden triangle with an extended hypotenuse that was held above the surface to be levelled. A plumb line suspended from the apex of the two sides hangs across the centre of the hypotenuse when it is horizontal. The extended hypotenuse element provides a greater horizontal length from which the builders could measure down to points on the plane to be dressed, in this case the tops of courses of

pyramid blocks. Nonetheless, given the impressive accuracy of levelling on the Giza pyramids, such as Khufu's foundation platform and Khafre's first course, we would still expect an outside reference – such as the water channels – yet such remains unknown.

Bringing in materials

Once the builders had the pyramid base marked out, they could begin bringing in the stone for core and casing. In addition to the bulk building stone, the construction process consumed large quantities of wood for fuel for the fires needed to forge and mend copper tools, roast raw gypsum to make mortar, and to bake bread and brew beer for workers. The wood came from small trees, mainly *Acacia nilotica*, and scrub systematically harvested from the Egyptian landscape. The human workforce also required a continuous supply of fuel – such as grain for starch and calories, and fowl, fish, sheep, goats and cattle for protein. Food came from provincial farms, estate land set aside specifically for the purpose of feeding the pyramid complex. The Egyptians transported such supplies by river on small cargo ships, frequently depicted in Old Kingdom tombs with a hooded matwork cabin at the stern and decks loaded with produce.

The king expressed supreme confidence in laying out base areas such as those of Khafre or Khufu (53,000 sq. m/570,487 sq. ft), which would require the completion of a pyramid as high as 145.5 m (480.6 ft). Massive amounts of stone had to be quarried, moved and placed in position at a regular pace to ensure that the pyramid was finished within the king's lifetime. As already mentioned, fine white limestone came from the quarries of the eastern horizon, principally Turah, and granite from Aswan, while alabaster and basalt for temple pavements came from a variety of places. Alabaster was also used for statuary, as were granite and gneiss; diorite and quartzite were needed for pounding and polishing tools.

Long-distance delivery by water

The Nile and its boats were the means of transport of such bulk stone from distant sources. In the tomb scenes we see coffins, possibly of stone, transported on small boats and raised off the deck

on a series of supports. Surviving carved reliefs from the causeway of the 5th dynasty pyramid of Unas at Saqqara include a scene of transporting large granite columns with capitals in the form of palms [**16.11**]. Unas' builders did in fact erect such columns, ranging from 5.5 to 6.5 m (18 to 21 ft) in height, in his pyramid temples. The relief scene shows two columns, resting on sledges raised off the deck by a support framework of beams or girders, laid end to end on a single barge. The supporting beams probably spread the weight of the load on the deck, but they could also have played a role in loading and unloading – critical operations considering a 50-ton block of granite, like those in the Khufu pyramid, could easily capsize any boat if rolled too far to one side.

Reginald Engelbach thought that Hatshepsut's great granite obelisks were loaded and unloaded from the large barges shown on the walls of her Deir el-Bahri temple by building an earthen embankment around each barge up to the level of the deck; once the obelisk was loaded or removed, the barge could be excavated from the embankment.[5] Another possible method for unloading would be to bring the barge into a narrow canal where a series of great cedar beams were thrust underneath the load between supports. With the ends of the beams resting on the banks of the canal, the transport barge was then weighted with ballast and slipped out from under the load.

The inscription above the scene of transporting the Unas granite columns reads 'the coming of these barges from Elephantine, laden with [granite] columns of 20 cubits'. Twenty cubits would mean that each column was 10.46 m (34 ft 4 in.) tall; more likely the figure is the total length of both columns. By chance we have a fragment of an inscription belonging to the unnamed official who

was responsible for the delivery of Unas' columns. He claims to have made the journey (back?) in seven days, indicating a round-the-clock speed of 5.5 km (3.4 miles) per hour. The inscription actually reads 'four days in transit'.

Weni, an official of the 6th dynasty, served three kings. For the last of these, Merenre, he fetched an alabaster offering table from the quarry at Hatnub and granite from Elephantine Island at Aswan for a false door and other parts of the king's pyramid. As a unique window on to pyramid-building supply operations in the Old Kingdom, Weni's tomb biography is worth quoting. He refers to the king's pyramid as 'my mistress':

His majesty sent me to Ibhat to bring the sarcophagus 'chest of the living' together with its lid, and the costly august pyramidion for the pyramid 'Merenre-appears-in-splendour', my mistress. His majesty sent me to Yebu [Elephantine] to bring a granite false-door, and its libation stone and granite lintels, and to bring granite portals and libation stones for the upper chamber of the pyramid 'Merenre-appears-in-splendour', my mistress. I travelled north with (them) to the pyramid 'Merenre-appears-in-splendour' in six barges and three tow-boats of eight ribs in a single expedition. Never had Yebu and Ibhat been done in a single expedition under any king…

His majesty sent me to Hatnub to bring a great altar of alabaster of Hatnub. I brought this altar down for him in seventeen days. After it was quarried from Hatnub, I had it go downstream in this barge I had built for it, a barge of acacia wood of 60 cubits [31.5 m/103 ft] in length and 30 cubits [15.75 m/51 ft 8 in.] in width. Assembled in seventeen days, in the third month of summer,

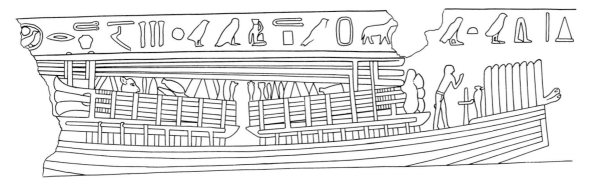

16.11 Transporting granite columns by barge, as depicted in relief-carved scenes from the causeway of the Unas pyramid at Saqqara, 5th dynasty.

when there was no water on the sandbanks, it landed at the pyramid 'Merenre-appears-in-splendour' in safety...

His majesty sent me to dig canals in Upper Egypt, and to build three barges and four tow boats of acacia wood of Wawat [Lower Nubia]. Then the foreign chiefs of Irtjet, Wawat, Yam and Medja cut the timber for them. I did it all in one year. Floated, they were loaded with very large granite blocks for the pyramid, 'Merenre-appears-in-splendour.'[6]

Weni's boasts about his achievements in the 6th dynasty contrast with the silence of the officials who were responsible for far greater loads of granite and alabaster for the gigantic pyramids of the 4th dynasty – all that we once heard about the likes of Hemiunu and Ankh-haf are their titles, 'Overseer of All the King's Works'. But now we have Merer's Journal, the actual papyrus log of an 'Inspector and his phyle' over the course of multiple days as they made round trips from Turah to Giza to deliver fine limestone for the pyramid, *Akhet Khufu* (pp. 29–30 and 526–27). Their boat, 25 to 30 m (82–98 ft) long, contained Merer's team of 40 men and their load, perhaps as much as 70–80 tons, or about 30 blocks at 2.5 tons each. Merer's team entered Giza by a water gate called *Ro-she* Khufu, a kind of port authority. Merer's Journal names Ankh-haf as the Overseer of this as well.

16.12 Line drawing of a scene from the Middle Kingdom tomb of Djehuti-hotep at El-Bersheh, showing 172 men in teams pulling a statue of a size estimated to weigh 58 tons.

Stone hauling overland

It is interesting to note from Weni's account that local peoples of Lower Nubia assembled the boats on the spot from native wood. When Egyptian shipbuilders used larger and costlier pieces of cedar from Lebanon, they stitched them together with rope, so that they could be taken apart and reassembled. Once the pieces had become worn out and could no longer be incorporated into the ship, the pyramid builders might have used them like railroad ties in tracks along which heavy stones were dragged overland to the building site. Metropolitan Museum excavators, most recently Dieter Arnold, found tracks like this beside the pyramids of Lisht.

Hauling tracks were needed to get the load from the quarry to the river or canal, and then from the waterway to the building site. They had to be hard and solid – nothing stops a 2-ton stone block more quickly than coming to rest on soft sand. At Lisht the transport roads, 5 m (16 ft 5 in.) wide, were composed of limestone chips and mortar. Wooden beams were inserted so that their upper faces were buried in the fill. The beams seem therefore to have been to help provide a solid bedding. In at least one of these transport tracks a thin layer of alluvial mud might have been deposited as a wet lubricant for the runners of the sledge.

A number of tomb scenes show the Egyptians pulling statues of wood or stone on sledges.

One worker usually pours liquid, probably water, under the front of the runners of the sledge. The most famous scene of this kind is from the Middle Kingdom tomb of Djehuti-hotep, which shows 172 men pulling what would have been approximately a 58-ton statue [**16.12**]. This works out at one-third of a ton per workman, which might have been possible on a surface that is fairly friction-free. Modern experiments have confirmed such figures: in his work at the Karnak Temple, the French Egyptologist and engineer Henri Chevrier used a sledge and a water-lubricated track to move a 5- or 6-ton block with only six workers.[7]

To test the many theories about pyramid building, the television science series NOVA decided to construct a small pyramid at Giza using as far as possible ancient tools and techniques, and hired one of us (Lehner), as well as Roger Hopkins, a stone mason, as consultants for the project. In the course of building the NOVA pyramid, we discovered that 10 to 12 men could easily pull 2-ton blocks mounted on sledges up an inclined roadway [**16.13**]. We designed our track based on those found at Lisht, laying it between retaining walls of broken limestone and tafla (desert clay), which is extremely slippery when wet. Tafla also occurs in the interstices and underneath large building blocks in the Giza temples, so it was used as both a packing material and a lubricant. In the NOVA experiment, the load moved best when the upper surfaces of the wooden sleeper beams were exposed, because they provided a hard surface across the field of wet tafla. When the tafla covered the beams, the sledge became bogged down in the wet clay. At Lisht, the densely packed gypsum mortar may have provided a similarly hard surface so that it was not necessary for the wooden sleeper beams to be exposed.

Another source of motive power for large loads was animals. A number of ancient scenes show the Egyptians using cattle to drag stone or assist humans in pulling, and at the 11th dynasty Mentuhotep complex in Luxor excavators found the carcasses of draft cattle in the builders' debris. As Dieter Arnold points out, cattle allow 'greater force [to be] distributed over a smaller area',[8] one ox being the equivalent of five men.

Rope was clearly an essential element in all operations involving stone moving, indeed in much of pyramid building. The Egyptians had

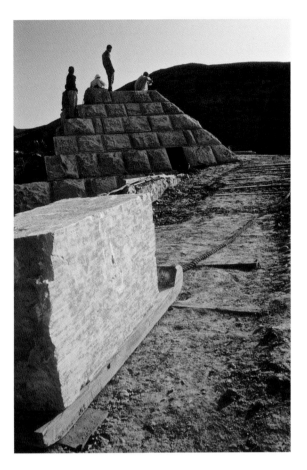

16.13 A large stone on a sledge in the process of being hauled up a ramp with wooden cross-ties packed in limestone debris and desert clay, as used for the 1991 NOVA pyramid-building experiment.

long experience with rope made from the fibres of grasses and papyrus before they embarked on pyramid building. The hulls of the largest ships, like the cedar barque of Khufu found in the rock-cut trench next to his pyramid, were composed of large separate wooden planks stitched together with thick rope. Rope was also used for rigging and trusses. Tomb scenes show lines of men pulling on thick rope to tow boats laden with heavy coffins.

The experience of modern quarrymen demonstrates that rope that is too dry lacks tensile strength and will snap under the strain of heavy loads. For tumbling large blocks they use rope of 4 cm (1½ in.) diameter treated with oil. The rope must not be too thick for the pullers to get a good grip, otherwise they lose some force in their pull.

Tumbling Modern workers move large stones about the workyard by simply tumbling or rolling them [**16.14**]. We have watched as they put a rope lasso around the top of a 2- or 3-ton block, with as few as 13 men pulling on a single or double length of rope and four men pushing from behind while

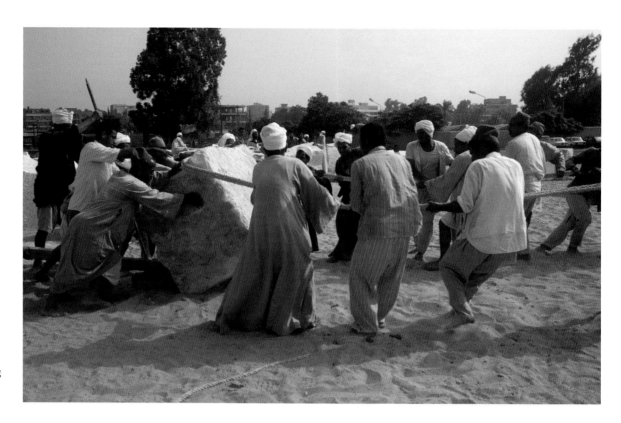

16.14 A team of around 20 men moving a 2–3-ton block by tumbling, during the 1991 NOVA pyramid-building experiment.

two men prise up the back of the block with levers (a total group of 19–20). One tug lifts the back end of the block enough to get purchase with the levers. The block can then pivot on its lower front edge and fall over onto its front face. Experienced quarrymen usually put a large fragment of limestone, or a low stack of smaller limestone pieces, on the ground in front of the block. These smaller stones prevent the block from landing absolutely flat on the ground, which would make it difficult to get levers underneath for the next roll, and they also act as a fulcrum enabling the workers to pivot the blocks easily for another tumble. In this process the workers try not to allow a heavy load to fall completely flat on its face until it has reached its final destination.

Tumbling is a practical method of moving blocks, especially where there is sufficient space, but it takes time. It would have been difficult to tumble all the blocks up the incline of a ramp with the efficiency required to build a pyramid within the king's lifetime.

Sledges Scenes on tomb and temple walls show the ancient Egyptians moving heavy loads resting on sledges as they are transported over land or on great barges. The sledge ensured the load was not flat on the ground, even on board the ship.

Loading the sledge was a preliminary operation that we should not take for granted. In our NOVA pyramid-building experiment, by the time our custom-made and not inexpensive replicas of ancient wooden sledges arrived at the site, our team had several days experience tumbling blocks and had become quite good at it. They had no experience, however, in loading the sledge. In their first attempt they put the sledge on the track and tumbled a 4.5-ton block next to it so that a final roll would mount the block on the sledge. However, the block hit the sledge just along one edge, pushing it down into the soft sand and chewing the edge to splinters. With several more attempts, however, the men became adept at loading a multi-ton block on to a much lighter wooden sledge – the first of many lessons which demonstrated that where we could not match the ancient results with simple tools and techniques, it was owing to the lack of several *lifetimes* of practice, and not because we were missing some mysterious and secret technology.

Rollers Rollers, small solid cylinders of hard wood, can be used for moving heavy loads. A basic requirement is that both the underside surface of the load (or the sledge that carries it) and the surface of the road must be hard and smooth. If such conditions are met, it is easy for a team to pull or push the load using rollers. We found that as few as 10 men on two lines could pull a 2-ton block up a gradient that probably matched the lower parts of pyramid construction ramps. However,

unless a crew possesses a gargantuan supply of wooden rollers (which are themselves labour-intensive to produce in a country short of trees and lacking the modern lathe), the rollers must be taken from behind the load after it has just passed, quickly brought to the front and carefully placed below the runners of the sledge – a kind of wheeled way that continually recycles itself forwards ahead of the load.

With the load advancing at a fair speed, it takes great skill to place each successive roller just ahead of the load. The person in charge is the key to the operation – he must take each roller from someone who collects it from the rear and then place it on the track exactly perpendicular to the direction of the load to ensure that the operation advances in a straight line. If a roller is turned slightly, the load follows it off to one side of the track, and if the track runs across soft sand, the load will probably become stuck, necessitating strenuous work with levers to lift it back onto the track and to reorient it in the right direction. If the sides of the track fall away to thin air, as they very well might have in the upper reaches of the rising pyramid, the departure from the track could have had disastrous consequences – not only the loss of the block, but also grievous injury to any crews working below.

The quantity of wood required for this technique in a landscape where it was not abundant, and the need to plane it smooth in the absence of the mechanical lathe, may mean that it was only of restricted application.

Roller balls The ancient Egyptians used round balls of the hard black stone dolerite to manoeuvre heavy loads. Such balls started out as hammer stones with one slightly pointed end, but became rounded by being turned continually during pounding to get the advantage of a percussion edge. George Reisner reported finding dolerite balls underneath heavy sarcophagi in tombs at Giza – they functioned like ball bearings to position the sarcophagus in the tight confines of the subterranean chambers. One or two workmen can easily pivot a 2-ton block on a hard round cobblestone; when they have the block in its desired position, they hold it up with a lever while they remove the pivot stone and bed the block.

Raising the blocks

For lifting blocks, the ancient Egyptians could have used two basic tools: the inclined plane and the lever. Some assembly of ropes, wood and stone might also be possible.

Ramps

The form of the construction ramps, or whether they were used at all, is one of the thorniest problems of pyramid building. Any ramps used in building the giant pyramids would have been enormous structures in their own right. They would also have been mostly temporary, and we should expect to find massive dumped deposits of whatever material they were composed of. Many books about the pyramids suggest that the material was mud brick. Ramps found beside the Middle Kingdom pyramids at Lisht have mud-brick retaining walls with a fill of Nile alluvial mud, bricks and stone rubble. At Giza the builders would have used locally available material and construction embankments. Ramps that remain intact from the pyramid age are composed of limestone chips, gypsum and tafla.

How many haulers?

How many men did it take to haul in the daily requirement of stone to keep up the pace of pyramid construction? The distance from the Khufu quarry to the southwestern base of the pyramid is about 320 m (1,050 ft). A workable slope of just over 6 degrees over this terrain would bring the ramp to about 30 m (98 ft) above the pyramid base, at which level 40–50 per cent of the pyramid mass would already be finished. Assuming they could move 1 km (0.6 mile) an hour, a division of 20 men could make the trip in about 19 minutes. With a rest and return with an empty sledge they might move 1 stone an hour or 10 stones in a 10-hour day. To move 340 stones would require 34 divisions of 20 men or 680 haulers. Ten stones a day seems rather ambitious for a division; if it was half this, in order to keep up the rate of supply the number of haulers would be about double, around 1,400 men. Obviously, the delivery rate would not be constant and the numbers of haulers per stone would have to grow as the slope of the ramps increased to reach the higher courses.

This mixture occurs in millions of cubic metres at the site, filling the vast quarried areas along the southeast of the plateau.

As for the configuration of construction ramps, we can reduce the numerous theories to two major types – a ramp that ascends one face of the pyramid by sloping up at an angle in a straight line from some distance away, and one or more ramps that begin near the base and wrap around the pyramid as it rises during construction.

Both theories have problems. In order to maintain a low functional slope of about 1 unit of rise in 10 units of length, the builders needed to lengthen a straight-on ramp each time they raised its height against the pyramid as it grew. They either stopped construction work on the pyramid during these enlargements, or they built the ramp in two halves – one side serving pyramid-building traffic while the ramp crew raised and lengthened the other half. But the ramp would need to be extremely long in order to maintain a functional slope up to the highest part of the pyramid. This is the biggest problem.

A wrap-around ramp might have taken two major forms: either supported on the slope of the pyramid faces or supported on the ground and leaning against the pyramid faces with a rising roadbed.

The first form requires that sufficient extra stock of stone is left on the undressed casing courses to form steps wide enough to support the ramp on the 52–53-degree slope of the pyramid faces, which would have left the entire pyramid cloaked as it rose. In this case, the builders could not back-sight their work to control the square and slope. Both proposals run into trouble near the top of the pyramid, where the faces of the pyramid become too narrow to support a ramp from one corner to the next.

With any ramp that winds its way up and around the pyramid we have to resolve the difficulty of how the long line of men pulling the ropes of a sledge with its heavy load could turn the corners. In the NOVA experiment we embedded two stout wooden posts, each 20 cm (8 in.) in diameter and spaced 85 cm (33 ½ in.) apart, deep into the corner of our ramp and lubricated them with oil to prevent the ropes burning [16.15]. A slab of limestone set in the roadbed gave a hard surface for levering, or for using a pivot, to turn the load. When the pullers reached the corner, they reconfigured the ropes around the posts so that some men pulled from around the corner while others pulled down slope with the ropes reversing direction around the posts. After a little levering on the hard surface, within seconds the load was turned, ready to continue up.

16.15 The ramp for our experimental NOVA pyramid building experiment wound around the pyramid as it grew. Wooden posts embedded at the corners assisted the haulers in changing the direction of the loaded sledges.

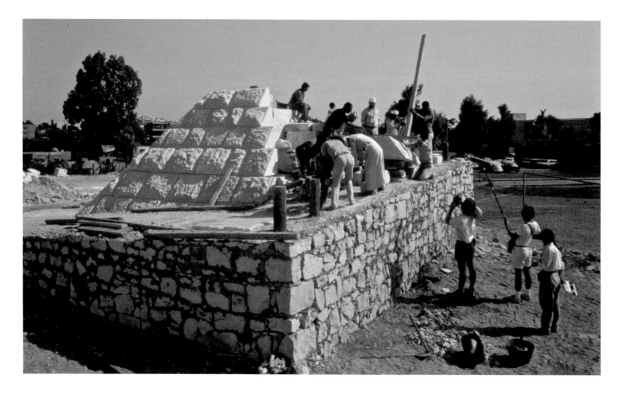

Levering

Some pyramid theorists say that no matter what its configuration, a ramp represents just too much material – rivalling the bulk of the pyramid itself – to have been practical. They therefore suggest that the ancient builders levered the stones up. The basic technique consists of lifting first one side of a block and placing supports underneath, then the opposite side and placing more supports under that. But this idea requires, and assumes, very regular wide courses, like a stairway.

Martin Isler agreed that the pyramid builders used ramps for the lowest part of the pyramid, but he proposed that the builders used extensive levering for raising stones to the higher levels. He illustrated his idea with drawings of massive central stairways of mud brick ascending the centre of each pyramid face, making them look a little like Maya pyramids or Mesopotamian ziggurats.[8] Stone could have been levered up these steps onto working platforms that were founded on projecting casing stones. The builders rocked the stones up, levering up one side and then the other, and tumbled them over each step of the supply stairway.

Isler agreed to test his method with a 680-kg (1,500-lb) stone on the unfinished south side of the NOVA pyramid. Although his initial drawings show the large wooden levers being used under the blocks, Isler asked the masons to carve two lever sockets on the lower edge of the two sides of his block. Here is a bit of a glitch, since most core stones of the pyramids do not have side sockets, although casing stones sometimes do, presumably for sideways adjustments. Two levers, each operated by two men, were inserted on opposite sides of the block. Two additional men then put in supports under each side as it was levered up. Each pull of the levers raised the side of the block just enough to slip in a well-planed flat board [**16.16**].

This prompts the question of how much flat-planed lumber would have been required for the Khufu pyramid. The amount of wood needed for levers and sledges alone must have been enormous; raising all the blocks on lumber supports greatly increases that quantity. If the supports must be planed smooth, the amount of woodworking also vastly increases. But if the supports were not planed smooth, the stack that underpins the block as it is raised before it is moved over to its final desired level

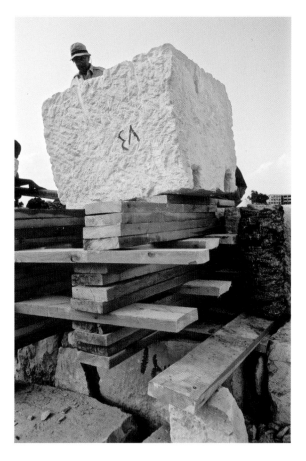

16.16 Martin Isler inspects a stone block, raised incrementally on a support of planed lumber, just before workers tipped it into place on the 1991 experimental NOVA pyramid.

would not be stable. Even with our machine-planed boards for the NOVA pyramid, the support stack – 12 layers of board per 72-cm (28-in.) rise – was becoming unwieldy, as were the fulcrums, which were stacks of limestone pieces. In order to get purchase, the fulcrum had to be raised as the block went up. In Isler's NOVA experiment the men raised the block 86 cm (34 in.) after a tense two hours. They slid it over onto its intended course level using a rope lasso as a brake to stop the block tumbling too far.

All in all, the levering worked, but it was very time consuming and it is doubtful that most of the stones of the pyramid were raised in this way. However, it is very possible that levering was the only means to raise the blocks of the highest courses, near the apex, once the builders had brought them as high as they could on ramps.

Maintaining slope and alignment

In one sense, we can conceive of a pyramid as an infinite series of squares within squares, each one successively smaller and raised just the right amount to provide the desired slope of the four sides which meet at the top point. To control the square of each level and the appropriate size for its respective height, the builders could have

transferred a system of measurement and control up onto the top of the truncated pyramid as it rose. If they built the core masonry ahead of the fine outer casing, they could have measured out to the facial lines of the pyramid from reference points and lines on the core.

The inner step pyramid

Pyramid theorists have suggested that every pyramid contains an inner step pyramid. Some believe that the rise and run of the steps have a specific relationship to the slope of the outer casing. The pyramid of Meidum inspires this idea: the completed steps had fine sharp corners and faces that could have served as references for measuring set amounts out to the slope of the enlarged true pyramid. Here, however, it is probable that the builders cased the inner step pyramid as an earlier finished phase, which they later enlarged into the true pyramid as an afterthought. We do not know whether the large Dahshur pyramids of the 4th dynasty are built with an inner step pyramid. The Giza pyramids show evidence of a stepped inner construction that is too irregular to have served as a control in itself (see Chapter 17).

We know from texts that the ancient Egyptians determined the slopes of walls with a measurement called *seked*, the amount that the face of the wall is set back for a rise of 1 cubit (0.525 m/1 ft 9 in.). A set back of 1 cubit for a rise of 1 cubit results in a 45-degree slope. How did the masons lay out the *seked* angle? They perhaps used a wooden set square that was made to the desired slope, placing it against the side face of each block with its base set on the levelled foundation platform or the top of the course below. Ideally, in order to make use of a triangle, they needed to work with a surface that was absolutely parallel to the ground. It is difficult to ascertain angles against verticals that are not perfectly perpendicular to the horizontal bedding plane. Using a string or plumb line against the vertical side of the triangle may have helped, but strings move, causing problems with measurements.

At best, the error in each block would have been compensating rather than cumulative, over hundreds and thousands of blocks. Also, the pyramid builders could have used long-distance markers positioned on the ground to sight to as checks for the cumulative slope and for the centre and diagonals of the squares of the pyramid levels.

Trouble at the top

The fact that the four sides of the pyramid narrow towards closure at the top means that the builders ran out of room for ramps and for men to pull on ropes – the problems are the same for pyramids of any size, since they all come to a point. Theorists therefore fall back on levering as the technique that the ancient builders used to raise the last blocks of the pyramid.

The apex of the experimental NOVA pyramid was too high for raising stones with steel cable and the scoop of a borrowed loader (though a crane would have done the job), so we also used levering for the last few blocks. When it came time for the final capstone, there was much debate as to how to get it to the top. Our ramp wrapped around and up two-thirds of the height of our small pyramid. From there the stepped unfinished courses at the back led up to a small platform where the four sides awaited the closure of the capstone. The masons roughed out the apex stone on the ground. It was small enough for the men to be able to carry it on a wooden frame, yet sufficiently heavy that they realized as soon as they lifted it that there could be no setting it down or turning back. They practically ran the load up and around the ramp.

The most dangerous moment was when the crew ascended the stepped courses to the apex and tilted the load. The capstone threatened to slide off and crash down the pyramid. We wondered whether for each and every ancient pyramid there was such a final moment of uncertainty and tension; it certainly amplified immensely the sense of relief and joy when the men succeeded in locking the apex in place. In 1994, archaeologists discovered a scene carved in relief in fine limestone from the causeway of the 5th dynasty pyramid of Sahure at Abusir showing the dancing, singing and celebration that broke out with the setting of the capstone.

So much for the theories of how the pyramids might have been built – now we must turn to the reality on the ground at Giza.

Calculating workers: modern insights into ancient numbers

Modern quarrymen perform a more efficient set of techniques made possible by the development of iron, as opposed to the wood, stone and copper tools available to the ancient pyramid builders. In place of wooden levers, which required large sockets, they use iron wedges, shims and feathers, hammered into slots that need be only 7 or 8 cm (around 3 in.) high, 38 cm (15 in.) long and 14 cm (5½ in.) deep. A series of such wedges splits the block from its bed. This is one example of the superiority of iron tools over those used by the ancient builders that we encounter again and again in our experiments: iron and steel delivers more force to a significantly smaller area, giving an enormous mechanical advantage.

Another example is the way modern workmen make ample use of the iron lever or crowbar. The best stone setter is not necessarily the strongest, but the most skilful in the use of the crowbar and small pivoting manoeuvres. The crowbar delivers a great deal of strength to a small point, whereas a copper rod would simply buckle and bend. A wooden lever needs to be much thicker – and more of them are required – to manoeuvre a block that could be handled with one stout iron rod.

In spite of this great difference between modern quarrymen and their ancient counterparts, our observations of their work led to a significant insight about the numbers of men that Khufu might have employed to prepare and set the requisite 340 cu. m (12,000 cu. ft) of stone per 10-hour day if he built his 2,650,000 cu. m (93,584,000 cu. ft) in only 23 years. Simple intuition might tell us that it would have taken many thousands. But as modern workers quarried 186 stones in 22 days – 8.3 stones a day – with 12 men, so

Khufu could have quarried 340 stones a day (1 cubic metre is about the average size of the pyramid core blocks) with only 491 men. However, this does not take into account the iron tool advantage – the modern quarrymen's toolkit also includes iron cable and a winch, whereas Khufu would have needed a division of men simply to separate and pull each block away from the quarry wall. (Could this have been the same division that hauled the block on up to the pyramid?) A division probably numbered between 10 and 20 men. If we add 20 men to the modern crew, making 32, the calculation yields 1,311 men needed for Khufu's daily delivery. A quarry team of 2,000, which might compensate for the other iron tool advantages, could probably have extracted the daily stone requirements – and would fit nicely within the area of the Khufu quarry at Giza.

We might then hazard an estimate of the number of stone setters required for building a pyramid. There is not enough room for more than 10 men to work with a stone of 2.5 tons, and many core stones are much smaller. Of these, eight were handlers, though no more than four men could work at any one time on levers. Two masons would suffice to do the cutting. Two such setting crews could have worked from each side of each corner of the outer casing on the small queens' pyramids. Two more setting crews could have worked out towards the corners from the centre of each face, making a total of 160 men working on the casing.

For the Khufu pyramid we might estimate the delivery of about 34 stones each hour. A logjam would result if the setting crews did not keep up, so if each stone had 10 setters we arrive at a setting crew of 340 for the pyramid. We should also bear in mind that the cutting, fitting and setting of the irregular core masonry blocks could have been done much more quickly than the outer casing. Nevertheless, we might expect that the rate of custom cutting and setting the blocks was slower than the transport and delivery, so that it would not be unreasonable to imagine setting crews totalling about 1,000 men, particularly on the lower courses of the pyramid.

16.17 In the modern granite quarries at Aswan iron wedges and chisels are pounded into slots cut in granite bedrock to split off a large piece.

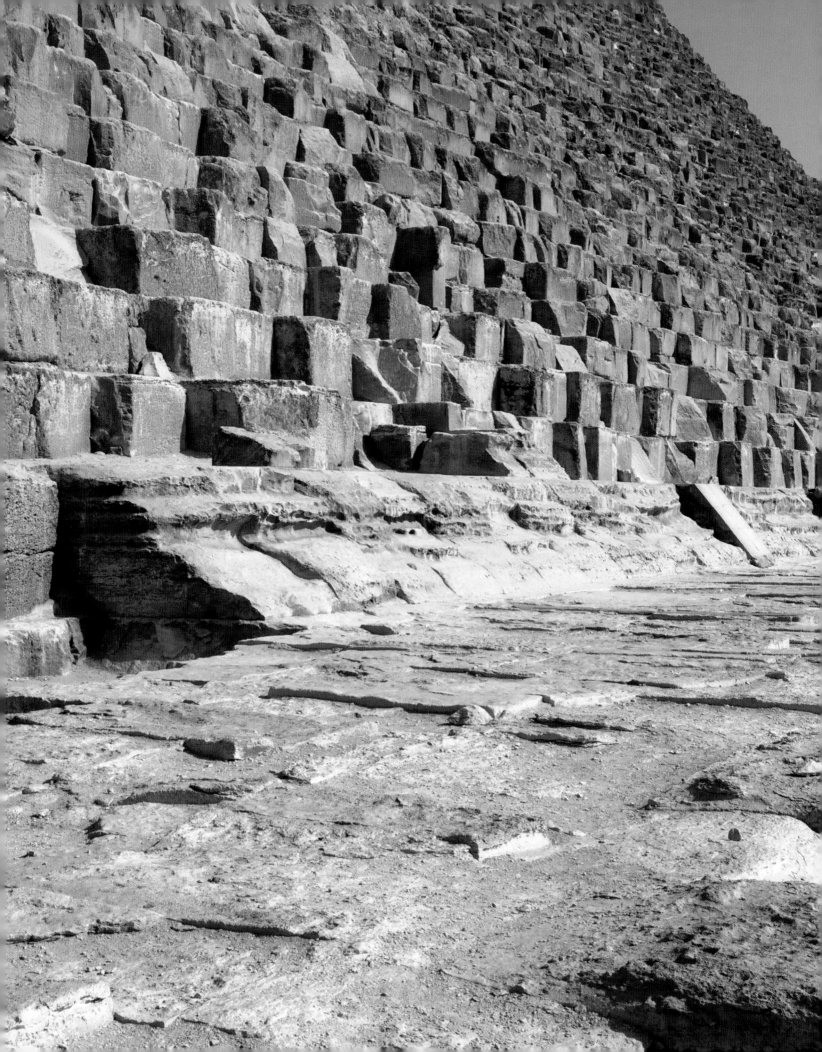

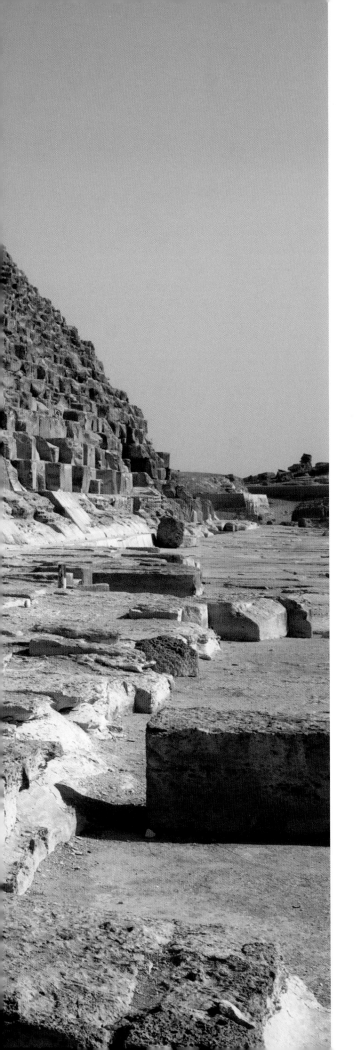

CHAPTER 17
Giza on the ground: the pyramid projects

Giza proved to be the perfect location for the source stone and infrastructure needed to build the world's largest pyramids in the megalithic tradition. The pyramids stand upon the Moqattam Formation, a sheet of limestone that rises on the north-northwest and slopes gently to the south-southeast. Limestone is sedimentary rock, formed in this case, as detailed in Chapter 3, in seas that invaded northeast Africa 65 to 35 million years ago. As tectonic forces lifted the Egyptian tableland, the seas retreated northwards; about 50 million years ago during one sea regression the headwaters were in the vicinity of present-day Giza. Here, along the diagonal on which the three Giza pyramids are aligned, a submarine embankment trapped millions of nummulites – unicellular planktonic organisms, now extinct, that secreted a calcite shell in the form of a disc. Today, if you look at the rock just east of the Khufu pyramid in the area of the mortuary temple, you will see it is composed mostly of fossilized nummulites compacted together.

PREVIOUS PAGES
17.1 The Great Pyramid of Khufu, west side. Khufu's builders made the pyramid baseline in casing stones on a finely levelled platform flush with the pavement of the surrounding court. Much of the casing, though badly weathered, the platform and pavement remain on the west side. View to the south.

BELOW
17.2 The quarried face of the Gebel el-Qibli ('Southern Mount') showing thin marly tafla and brecciated limestone layers, which are not so good for large blocks but useful for smaller pieces for making secondary fieldstone walls, ramps and embankments. View to the southeast.

As the Eocene waters retreated further to the north, the shallow waters along the south-southeast slope of the nummulite embankment supported a shoal and coral reef. Eventually the low part of the pyramid plateau became a shallow lagoon, laying down silts and mud that petrified as the layers we see in the lion body of the Great Sphinx. They form a sequence of thin, clayey layers interspersed with thicker, hard layers. Later ingression of the seawaters laid down the younger Maadi Formation to the south of the Sphinx and the pyramids. The Maadi Formation thrusts forward as a prominent knoll, the Gebel el-Qibli ('Southern Mount'), about 300 m (984 ft) south of the Sphinx, which overlooks a broad wadi, or valley, between it and the Moqattam Formation [**17.2**]. The Maadi Formation layers are thin and crumbly and rich in layers of calcareous desert clay, tafla.

The hard and brittle nummulite embankment would turn out to be a perfect base for a pyramid, which could thus be founded on solid bedrock rather than, as at Meidum and Dahshur, on desert clays and gravel. The alternating sequence of layers downslope provided an excellent opportunity for extracting large stone blocks for the pyramid's core by cutting along the soft layers [**17.3**]. The crumbly stone and tafla of the Maadi Formation bluffs, while not so good for extracting large blocks, was valuable as a source of small broken-stone fill (*dubsch* in Arabic) and the desert clay – both used in large quantities – that would furnish the materials for ramps and embankments. The broad wadi – the Main Wadi – between the two limestone formations would serve as a conduit for materials from outside Giza: delivered here, they could join the flow of materials up the construction ramps. A natural depression at the mouth of the wadi may have already retained water after each annual flood. Here a lake and old channel remained perhaps from the time, near the beginning of Egyptian history, when the Nile flowed much closer to the Western Desert. Just south of the main Giza quarry would be a quarry for auxiliary structures.

With the entire thrust of the workforce orientated towards the south-southeast, the logical place for storage and production (of bread, beer, other food, metal and wood tools, gypsum mortar) would be the span of low desert just south of the harbour (where we are now excavating). Workers could be accommodated in this area as well as on the low desert sand all along the base of the eastern escarpment, except where

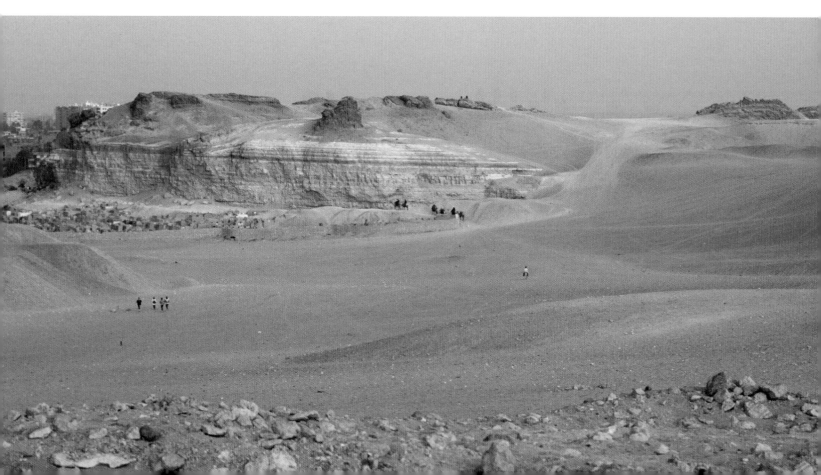

the 4th dynasty builders excavated and dredged the mouth of the wadi for a harbour basin. The Gebel el-Qibli, which thrusts up and forwards above the wadi, was the perfect checkpoint to monitor the colossal transformation of this landscape into the vehicle for the everlasting life of the god-king and, in his wake, the society he commanded.

Thus the landscape tells part of the story of how the Egyptians built the pyramids. The big items – supply ramp, quarry, harbour and settlement – were disturbances on a geological scale. Across the Giza Plateau, in each of the three main royal pyramid complexes, the workers left jobs unfinished, as they did in many of the mastabas and rock-cut tombs that surround the pyramids and make up the great Giza Necropolis. These unfinished jobs, or 'frozen construction moments', are the story of the pyramids on the human scale. They reveal the hands of individual ancient Egyptians and provide us with valuable glimpses of how the builders and workmen carved chambers out of the living rock, marked the pyramid axes and controlled the slope, ensured the square as the structure rose, locked together the fine outer casing stones and moved gigantic multi-ton blocks.

Each of the pyramids of Egypt, even the three that shared this same site, Giza, has to be approached in its own unique topographic context in order to perceive and understand properly the traces that the builders left behind of their tools, techniques and operations discussed in the previous chapter. The evidence indicates that there was, in this early period, no manual of pyramid building; each major project displays its own idiosyncrasies of layout and levelling, masonry and general organization. Still, certain basic skills, methods and materials were common to all three mammoth projects.

I. The Khufu project
Selecting a site

Khufu's planners recognized the advantages of this landscape as they planned a pyramid that would exceed any of the three that Sneferu, Khufu's father, had built. Even before any artificial levelling of the base of the pyramid, the site they chose, the far northeastern edge of the Moqattam Formation at around 60 m (197 ft) above sea level,

was the most naturally level place on the plateau, where the contours flatten out. To the north, until modern dumping extended the escarpment, only about 70 m (230 ft) separated the north side of the pyramid from the cliff edge, where it drops 40 m (130 ft) to the floodplain stretching away towards the opening expanse of the Nile Delta. The eastern escarpment, towards the Nile Valley, is about 350 m (1,150 ft) from the east side of the pyramid.

In placing the pyramid here, Khufu's builders chose the far northeast end of the *strike* of the formation. (The strike, as noted in Chapter 3, is any line perpendicular to the slope – if you walk on a hill without going up or down you are following its strike.) At this location they had less of the southeasterly slope to level off for the base area. The fact that they did not have to cut away a large amount of rock, perhaps 7 m (23 ft) at most, to achieve a level base is indicated by the absence of a deep cut through the natural rock on the northwest, such as can be seen along the north and west sides of the Khafre pyramid.

Being close to the northern limit of the plateau also allowed a good run for the rise of a ramp to deliver stone from the far southern quarries up to the top of the planned pyramid, a height of more than 140 m (459 ft). But they also needed to build a ceremonial ramp – the causeway from the east.

17.3 An outcrop in the Central Field quarry immediately north of the Khentkawes monument. Quarrymen cut corridors, here 6 m (20 ft) wide and 10 m (33 ft) deep, in the original plateau surface (top), to separate blocks. Later builders cut tombs into the bedrock. View to the east.

The steep drop of the escarpment to the valley meant Khufu's builders would have to construct a colossal foundation to carry a causeway that could reach the level of the floodplain, almost 50 m (165 ft) lower than the base of the pyramid. To achieve a functional slope for the causeway, they would have to make it more than 700 m (2,297 ft) long.

Plans of the plateau from the 18th and 19th centuries, at a time when much of the causeway foundation existed east of the escarpment, show the slight angle of the causeway to the north, which increased after its descent of the escarpment. The masonry-built foundation for the Khufu causeway ran from a point here, known locally as Senn el-Agouz, 'the Old Tooth', to the location of the valley temple. Large blocks of the foundation can still be seen at the edge of the escarpment, and the linear hump of the buried causeway foundation can be discerned projecting northeast from the corner of the escarpment in the 1:5,000 maps made from aerial photographs in 1977. Georges Goyon excavated trenches near the escarpment that indicate that at this point the foundation reached an astounding height of 20–22 m (66–72 ft); where it actually crossed the cliff, the height may have increased to 30 m (98 ft).[1]

Khufu's quarry

Looking at the Khufu pyramid in its setting in the topography, it is fairly clear that the main supply ramp did not ascend from the west, since there is no ancient quarry within reasonable distance in that direction. Also, west of the pyramid Khufu's builders were constructing the mastabas of the Western Cemetery for his senior officials perhaps as early as his Year 5, and the ramp could not have covered the emerging necropolis. Likewise, the supply ramp probably did not ascend to the pyramid from the east, since Khufu also began the Eastern Cemetery perhaps as early as Year 15, by which stage the ramp must have been servicing construction on the upper parts of the pyramid. And no quarry exists to the east, just the escarpment falling to the low desert and then the floodplain. There was no appreciable advantage to having the main ramp on the north: the escarpment is at its steepest here, as noted above, dropping 40 m (131 ft) to low desert or flood basin. The only

side of the pyramid available for the major supply ramp is on the south. Khufu's builders must have taken the major part, if not all, of the stone for the inner pyramid core from the local quarries along the southern slope of the Moqattam Formation.

In fact a large quarry basin opens just here, 300–600 m (984–1,968 ft) south of the Khufu pyramid in the western part of what is known as the Central Field (see Chapter 12). The quarry measures about 230 m (755 ft) east–west at its widest, and at least 400 m (1,312 ft) north–south. Beginning in 1928, Cairo University excavators exposed the southern end of the western edge, just south of the Menkaure causeway. At the centre, the bottom of the quarry is 30 m (98 ft) deeper than the high western edge. During his 1935 season Selim Hassan exposed the deepest part of the quarry near the tomb of Khnum-ba-f.[2] In this area the builders removed blocks for the pyramid core, leaving shelves, about 1.5 m (5 ft) high, in the bedrock [17.4]. The long narrow channels they cut to define the width of the blocks are still visible in the surface, and the banks and channels to separate the blocks are very similar to those in modern quarries.

Hassan only partially excavated the great piles of stone rubble and debris as high as 23 m (75 ft) that filled the quarry basin (it is probably because of these vast deposits that the quarry area remains largely a blank on plans of the Central Field). He trenched into the mounds without revealing much development of the cemetery here, no doubt because of the labour that would have been necessary to remove the debris down to the rock floor of the quarry in order to build tombs.

At the north, the floor of the quarry slopes up to the Khafre causeway. The east and west sides of the quarry roughly line up with the east and west sides of the Khufu pyramid. The width of the quarry (230 m/755 ft) multiplied by its length (400 m/1,310 ft), multiplied by a depth of 30 m (100 ft), gives a figure for its volume of 2,760,000 cu. m (97,470,000 cu. ft). It has been estimated that the Khufu pyramid contains some 2,590,000 cu. m of stone. The quarry is not, however, rectangular, and it must be remembered that the floor of the quarry is not uniform, but appears to slope up to the north. Allowance must also be made for rock wasted, from 30 to 50 per cent, in the channelling necessary to extract the stone blocks.

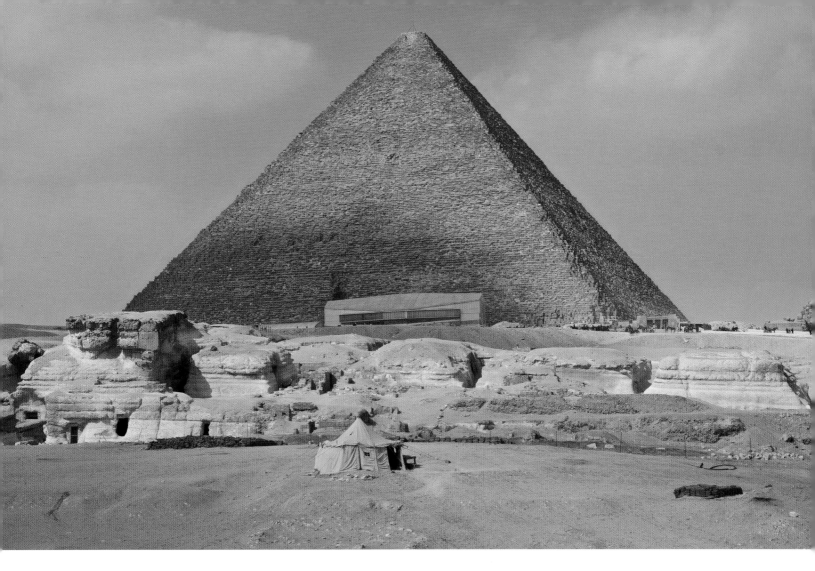

A small incline or ramp of debris was left at the northwestern corner of the quarry, just east of the long-known tomb of Nebemakhet (LG 86). Today this slope gives access to the Cairo University rest house complex. The Khafre causeway passes the quarry on the north. The western face of the quarry, the most pronounced and exposed side, must have been clear in the later 4th dynasty when the quarrymen cut the tombs of Nebemakhet, Nikaure (LG 87), Sekhemkare (LG 89), Niuserre (G 8140), Persenet (LG 88) and Debehen (LG 90) into the bedrock face. These tombs all date to the time of Khafre's reign or later, and three of them belong to children of Khafre, suggesting that by the time of his reign this area was no longer used for quarrying. Penetrating the natural bedrock here, Khafre's children were almost tucking their tombs under the very base of their father's pyramid.

Although the quarry's western edge was always visible above the surface, in the 19th century the quarry was still filled with millions of cubic metres of limestone chips, gypsum, sand and tafla – likely the remains of the construction ramp, which the workers pushed back into the quarry as they completed the pyramid. The fact that most of the quarry was buried led early pyramid explorers, including Petrie, to believe that the stone for the pyramids had mostly been brought from across the river. However, this must be the quarry that furnished the bulk of the core stone for the Great Pyramid.

Cutting stone for Khufu

It is probably true, as is often stated, that the Khufu pyramid has the best masonry of any of the hundred or so pyramids in Egypt. In fact Khufu's 'Great Pyramid' is so exceptional that we should probably not take it as the exemplar of how the Egyptians built pyramids, though people often do. Since it is assumed to be the best, we can, however, take it as a standard against which to judge the quality of other pyramids – for instance for the finesse of the casing stones that still exist at the centre of its northern base.

17.4 The Khufu pyramid and quarry: illuminated in the foreground are large, rectangular quarry blocks of bedrock that quarry workers isolated by cutting channels the width of hotel corridors. These remain in the Central Field East quarry quadrant where the 4th dynasty builders never worked the quarry completely; if they had, they would have removed these blocks. View to the north-northwest.

Stone studies

George Reisner opened his magisterial study *A History of the Giza Necropolis* with a chapter on topography at Giza in which he attempted to point out the various quarries.[3] He maintained that the north and east faces of the cliff near the Khufu pyramid had been quarried back. Although this needs more study, it appears to us that these rock faces were not much exploited for building stone, for the reason that the rock here is not suitable for extracting building stone such as that found in the layers forming Members II and III (see Chapter 3), exposed along the south part of the formation (and in the body and head of the Sphinx). Except for those in the Central Field and southeast of the Menkaure pyramid, the several quarries that Reisner identified probably fed the construction of the mastaba cemeteries. Reisner did not correlate his typologies of cemetery features and their chronological order with the quarry and construction sequence that produced the pyramids. He did recognize differing qualities of limestone in the core constructions at Giza, but not in geological terms.

In their book *Die Steine der Pharaonen*, R. Klemm and D. Klemm stated that the results of their chemical analysis for 21 elements indicate that core stone for the Menkaure pyramid derives from the quarries immediately to the southeast of the pyramid.[4] The agreement between their analysis and what Reisner and other Egyptologists surmised is seen as a corroboration of the method. However, this throws up somewhat unusual results for the Khufu pyramid. Their study indicates that core material for this pyramid is of heterogeneous origin, deriving from quarries ranging from the Cairo area to Asyut (stone from the Khafre pyramid is traced to the quarries at Maasara on the east bank of the Nile). Given the serious implications of this picture of quarries throughout the Nile Valley feeding the Khufu pyramid project, some questions come to mind. On what basis were samples selected from various parts of a given pyramid or quarry? Were all the quarries at Giza sampled? From which geological layer in the quarries did they take the samples? In other words, what degree of stratigraphic control did they establish for the different layers and qualities of limestone in the quarries? Would the chemical trace analysis of different geological layers in the Giza quarries show a greater or lesser match with the blocks of the pyramids or with other quarries in Egypt? Whatever the case, the claim of heterogeneous origins for the core stone of the Giza pyramids certainly deserves more investigation. But even if some core stone does derive from quarries on the east bank and in Upper Egypt, much of it must have been quarried locally at Giza, and the observations about the general organization of the work given here would not be seriously altered.

We can also measure the 'slop factor' in the pyramid core. Whatever irregularity we find in the core of Khufu's pyramid only increases in other pyramids. As we saw in Chapter 8, the reality of the core is not millions of well-squared, carefully laid blocks. Rather, the builders filled the pyramid mass with stones which range from large blocks to small chunks, and pieces of all shapes and sizes, with great blobs of mortar and stone rubble in the wide spaces between. We must keep this variation of masonry in mind when considering the work of the stonecutters.

Khufu's crude stonecutting and dressing

Evidence of the rough, early stages of stonecutting and dressing can be seen in the quarry channels at Giza, but also in the Subterranean Chamber of the Khufu pyramid – a kind of inverse quarry [**17.5**]. This chamber resembles the gallery quarries across the Nile Valley, and provides an illustration of how the supervisors divided the labour into halves. Quarrymen left the entire eastern half of the room

17.5 Southwestern corner of the Subterranean Chamber, where Khufu's quarrymen left the work unfinished. The square humps and depressions are each a single man's allotment of stone to be removed as their team hollowed out the chamber.

freed from the bedrock. They divided the western half into quarters of the total chamber volume. When they stopped work, they left the lower quarter of the chamber as a bank of solid rock, subdivided into north and south eighths of the chamber's volume by a channel through the floor. On either side of this channel, we see attached to the bank thin walls of bedrock that divide the upper part of the chamber into halves – or sixteenths of the total chamber. On either side of the partition walls, narrow walls and channels form square compartments with a hump in the middle of each, showing how one worker channelled around the perimeter of his allotment, and then broke down the hump in the middle.

Probably a single quarryman was allotted each cubicle of bedrock. Using stone or copper picks and pointed copper chisels (the 'nail'), he would have worked down the 'removal channels', after which he could pound away the hump that was isolated by the channelling. The most difficult job of all was making lead channels that moved the work further into the solid rock. One man produced a lead channel that can still be seen in the upper southwest corner of the chamber, lying on his belly and swinging the pick on the end of a long handle. Until a recent cleaning, chips still remained from this roughing out of a pyramid chamber.

Khufu's fine masonry dressing

Nick Fairplay, a master stone carver whom we met at the Cathedral of St John the Divine in New York City, provided us with some of our most useful insights into stoneworking in all our years of working at Giza. Looking closely at chisel marks on the walls of the Grand Gallery in Khufu's pyramid, he could see just where an individual chiseller paused, resharpened his tool, then continued to dress the surface. Just before the sharpening interlude, the corners of the chisel began to bend and etch deeper lines at the edges of the cutting channel.

Fairplay also pointed out one of several examples of how the Old Kingdom builders accomplished projects of such seemingly impossible scale by repeating a small, modular task many, many, many times. Wherever we see the tool marks of a dressed surface in places where the masons did not sand them off with an even finer dressing,

the chisels are all the width of a finger or less. It is hard to achieve a sharp cutting edge of any greater breadth in soft copper. The mark of the finger-sized chisel is everywhere – on the Grand Gallery and stress relieving chambers inside the Khufu pyramid, the casings of the queens' pyramids and mastabas at Giza, and in the passageway of the Meidum pyramid; on the join faces and undersides of the intact casing blocks at the top of the Khafre pyramid the chisel marks are 8 mm (5/16 in.) or less in width.

At the base of the queens' pyramids east of Khufu we can see the marks of four different stages of tools and techniques in working the fine limestone of the foundation and outer casing. Where the masons left the casing and foundation blocks mostly rough, their initial dressing removed large flakes and fragments, probably using a hammer to hit a pick or pointed chisel, leaving hand-sized, shallow, dish-shaped depressions. At the place where the smooth face of the pyramid slope meets the undressed extra stock of stone, we see the dimpled percussion pattern of small hammer stones and then the long marks left by the narrow flat chisel [17.6]. As the slope of the pyramid begins, they erased their tool marks by sanding the faces of the casing stones to a smooth and even surface.

17.6 The different stages of dressing pyramid casing blocks are revealed by the tool marks left on the surface. At the bottom the stone has been pounded flat, leaving dimples. The course above has been smoothed, and remains so where it was covered by sand and debris for centuries. Where this surface was exposed, it has weathered back to rough.

Khufu's hard stonecutting and dressing

Khufu's masons also had to work much harder stones than limestone. Numerous saw marks can still be seen on the sides and bottoms of the extremely hard, black basalt slabs of the Khufu upper temple [**17.7**]. Some of the cuts retain a dried mixture of quartz sand and gypsum tinted green from the copper of the blade. Petrie also observed marks from saws on the red granite sarcophagus in the King's Chamber.

An even larger granite sarcophagus, which is now in the Cairo Museum, was removed by Reisner from the tomb of Djedefhor (G 7210-7220), one of the great mastabas in the cemetery east of the Khufu pyramid. Intriguingly, half of the barrel-vaulted lid is still attached on the underside of the sarcophagus.[5] The masons – perhaps to ensure a good fit – fashioned the lid as one piece on the bottom of the sarcophagus and then proceeded to saw it off. The etched and red-painted guideline still exists. The masons were cutting from both sides in a semicircular pattern when the lid snapped, and so they left half of it still attached to the underside of the giant coffer.

All such saw cuts show fine striations of a millimetre or less in thickness. The same is true of small cylindrical drill holes and drill cores known from the Old Kingdom and later. Good examples are found in the door sockets of the Khafre valley temple. As discussed in the previous chapter, Petrie, after he had reflected on minute details of ancient Egyptian granite work, concluded that the ancient Egyptian masons used saws and drills of copper or bronze studded with such hard stones as diamonds, beryl and corundum, but the scarcity or absence of these materials in Egypt makes this unlikely.[6] Instead, the copper saws and cylindrical drills were toothless (any teeth would have worn away after a few turns or strokes) and they were not the cutting implements in themselves, but just the guides for quartz sand that wore down the granite.

Planning a pyramid: evidence of the Trial Passages

Some 87.5 m (287 ft) east of the Khufu pyramid, north of the queens' pyramids and on the other side of the causeway from them, the 4th dynasty builders left a set of features cut into the bedrock surface that reveal much about the initial stages of planning and executing a pyramid. Perring and Vyse thought the passages might represent the beginning of a fourth subsidiary pyramid.[7] Petrie instead saw them as practice models of the Khufu pyramid passages and so designated them 'Trial Passages' [**17.8**].[8]

The passages, which have an opening at the north and the south ends, descend 10 m (33 ft) below the bedrock surface. At the north opening the floor of the passage is cut into steps, as if to receive masonry, and then slopes down, 1.05 m (2 cubits/3 ft 5 in.) wide and 1.2 m (3 ft 11 in.) high, at an angle of 26 deg. 32 min. for a distance of 21 m (69 ft). At a distance of 11 m (36 ft) from the north edge of the north opening, another passage of the same height and width opens from the ceiling of the descending passage and slopes upwards at the same angle. The lower end of this ascending passage narrows by about 13 cm (4 in.); as with the similar arrangement in the Khufu pyramid, it is there to hold plug blocks. The ascending passage opens out, 5.8 m (19 ft) from its beginning, to a wider corridor that rises up to the surface at the south opening. Like its counterpart in the Grand Gallery in Khufu's pyramid, the ascending passage is the same width, 1.05 m (3 ft 5 in.), at floor level, but is flanked east and west by ramps, about half a metre (20 in.) wide and 60 cm

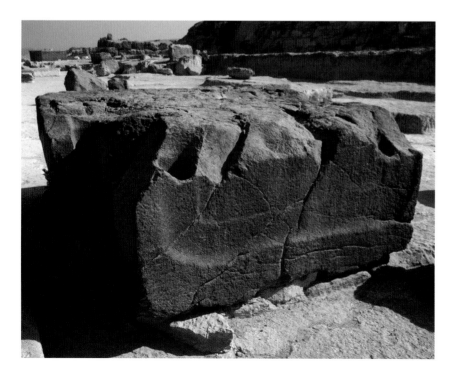

17.7 Basalt block *in situ* where it formed the threshold of the central doorway to the upper temple of the Khufu pyramid. Saw cuts are visible on the eastern side (in shadow), while the front face reveals marks of pounding the stone down in panels. Two pairs of holes in the top served for pivot and bolt sockets of a double swinging wooden door.

(24 in.) tall, cut out of the bedrock walls. The total width of the corridor (passage plus ramps) is 2.02 m (6 ft 8 in.). A vertical square shaft, about 70 cm (27½ in.) wide, descends from the bedrock surface down to the juncture between the ascending and descending passages.

As Petrie recognized, these passages are a foreshortened copy of the passages in the Khufu pyramid, corresponding to the Descending Passage, the Ascending Passage and the beginning of the Grand Gallery. A cutting at the beginning of the replica 'grand gallery' corresponds to the beginning of the Horizontal Passage to the Queen's Chamber in the Khufu pyramid. The square vertical shaft in the Trial Passages appears to relate to the 'well' or Service Shaft in the pyramid, although in the replica it is located differently in respect to the other passages. However, it does have about the same cross-section dimensions as the pyramid Service Shaft as it descends from the lower west wall of the Grand Gallery, where it is cut vertically and lined with masonry, to the point it enters the bedrock at the so-called 'Grotto', a cave-like feature where the pyramid masonry meets the natural rock of the plateau. The correspondences between the slope angles and the cross-section dimensions of the passages in replica and pyramid are striking.

If the replica passages were a kind of trial run for those in Khufu's pyramid, his workers must have made them before they built the pyramid passages. From this we would have to conclude that the elements represented in the replica were part of a preconceived plan – this would be the death knell for the idea that Khufu's three pyramid chambers reflect two changes in plan for his burial place during the construction of the pyramid, because the model includes the Descending Passage, which implies the intention to cut the Subterranean Chamber, the Ascending Passage and the beginning of the Horizontal Passage to the Queen's Chamber, and the beginning of the Grand Gallery.

The Trial Passages could be classed along with certain other architectural models, such as a portable model in wood and limestone of the chambers in the Middle Kingdom pyramid of Amenemhet III at Hawara. As such, the Trial Passages indicate one way that the 4th dynasty architects might 'draft' out their ideas – the ancient equivalent of a modern architect's 'blueprint' and

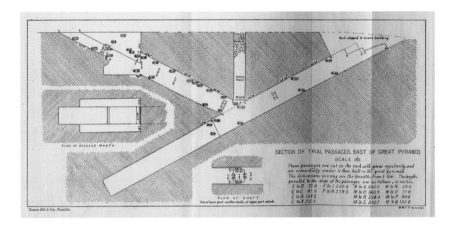

maquette. The Trial Passages thus offer us a lesson in how this particular generation of Egyptians planned a pyramid.

Three features prompt us to consider that Khufu's builders initially intended to raise a pyramid over these passages, in which case they would provide an even more direct instruction of how they planned a pyramid. The first feature is a curious trench alongside the Trial Passages; the second is the alignments with the equivalent passages inside the Khufu pyramid; and the third is the alignment of the Trial Passages and the parallel trench with Khufu's queens' pyramids to the south.

Trench marks the axis

To the west of the Trial Passages, between them and the Khufu pyramid, a long, narrow trench (D) is cut into the bedrock surface 5.7 m (18 ft 8 in.) from the western edge of the passages' southern opening (the 'Grand Gallery'). The trench, 7.4 m (24 ft 3 in.) long, 70–71 cm (around 28 in.) wide and ranging from 27 to 44 cm (11–17 in.) deep, is as carefully orientated north–south as the Trial Passages, which it lies parallel to and to which it appears to belong. It is almost exactly the same width as the vertical Service Shaft.

The distance between the centre, north–south axis of Trench D, and the centre, north–south axis of the Trial Passages is 7.055 m (23 ft 2 in.). The distance between the centre, north–south axis of the Khufu pyramid and the axis of its passages to the east is 7.27–7.31 m (23 ft 10 in.–24 ft) as measured by Petrie (plus or minus 0.8 in.).[9] The distance from the axis of the Trial Passages to the west side of Trench D is 7.4 m (24 ft 3 in.). In the same way that the Trial Passages replicate the passages in the

17.8 Petrie's published section of the Trial Passages east of the Khufu pyramid, from his book, *The Pyramids and Temples of Gizeh.*

Khufu pyramid, the relationship between Trench D and the Trial Passages closely reflects that between the axis of the Khufu pyramid and its passages. It is as if Trench D was cut to mark the axis of a pyramid comparable in scale to Khufu's.

Alignments of passages

Even more remarkably, the Trial Passages nearly align with their counterparts in the Khufu pyramid. This came to light when we plotted the Khufu passages in plan and surveyed and mapped the Trial Passages in 1981–82. We found that when we slid the map of the Khufu pyramid directly east, until the centre axis of the pyramid lay over Trench D, the pyramid passages make a close fit with the Trial Passages. In this superimposition, the pyramid Grand Gallery actually falls 5.45 m (little more than 10 cubits/17 ft 11 in.) north of the replica 'grand gallery'. However, the vertical shaft of the Trial Passages comes to within just 80 cm (31½ in.) of an alignment with the beginning of the Grand Gallery, while the 'Service Shaft' at the level of the Grotto (at the original plateau surface) in the pyramid is about 75 cm (29½ in.) north of an alignment with the replica 'grand gallery'. In relation to this, it is also worth remembering that the axis of the King's Chamber aligns with the northern limit of the great mastabas of the Eastern Cemetery.

How could the builders have aligned so closely internal features high up in the Khufu pyramid with features cut into the bedrock surface 195 m (640 ft) down to the east? We must remember that as the pyramid passages and chambers were under construction they would have been open to the sky at the given course of masonry that the workers were adding to the then truncated pyramid. By sighting and extending data lines across the top of the course under construction, the builders could have backsighted to points down on the plateau. They would have had to do this across any supply ramps and foothold embankments, which probably surrounded the pyramid on all sides. In 1930, the architect and engineer Somers Clarke and Reginald Engelbach proposed exactly this kind of 'backsighting' to points marked on the ground outside the base of the pyramid as the method the pyramid builders used to control the axes and diagonals as the pyramid rose.[10]

Did Khufu's builders originally plan to locate the king's own pyramid over the Trial Passages? One argument against this interpretation is that they cut the passages in the bedrock in a foreshortened version of those in the pyramid. At the same time, certain features, such as the fact that the beginning of the replica descending passage is cut into steps to receive masonry like other pyramid passages, suggest it was initially intended to build some kind of pyramid here. Lehner previously suggested that the planned, but unbuilt, pyramid was the satellite pyramid that was an element of royal complexes at this time,[11] but Hawass found the actual satellite pyramid of Khufu in 1993 off the southeast corner of the main pyramid. Perhaps the royal house opted for the latter position when they changed their scheme for the northern end of the Eastern Cemetery, which apparently called for the queens' pyramids to line up south of the centre axis of the unbuilt pyramid, marked by Trench D.

The axes of Khufu's three queens' pyramids, GI-a, b and c, almost align with the west side of Trench D, though the exact axes of these pyramids are hard to determine because their bases are not true squares. So it seems the idea was to align the queens' pyramids with whatever pyramid they initially intended to build over the Trial Passages, which would then have made it the first in a series of four, aligned on a long north–south axis along the east side of the Khufu pyramid.

Aligning pyramids

The foregoing discussion points to the use of Trench D as a marker of an important builder's line. It was either the axis of a pyramid, if the hypothesis of an intended pyramid over the Trial Passages is valid, or an alignment of the centre axes of the queens' pyramids, even if it is not.

We have noted a deep vertical notch carved in the face of the massive lintel of Turah-quality limestone over the entrance to queen's pyramid GI-a. While this may be another axis marker, the notch does not align with the centre of the entrance – it is shifted to the east side of the opening – but it does align nicely with Trench D in the distance to the north. Higher up and further back into the pyramid core is another, cruder lintel, perhaps of locally quarried limestone, which has been exposed

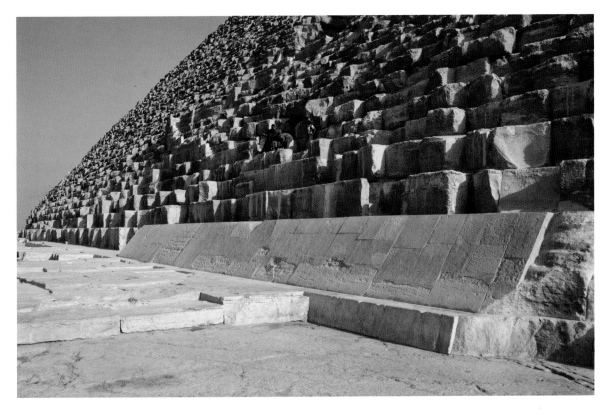

17.9 The north centre base of the Khufu pyramid, where part of the casing, the platform and court pavement are intact, thanks to the pile of stone-robbing debris that remained here until modern times. The upper parts of the western casing stones (foreground) have been reconstructed; two casing stones at the far end (east) are complete. View to the southeast.

by the removal of stone. The face of this lintel also features a deep vertical notch, but shifted this time farther west, aligned more to the west side of Trench D. Perhaps this indicates a changed axis for the rougher core masonry, or simply represents an inaccuracy as the pyramid rose and embankments covered the lower notch and lintel.

The notches are crude axis markers, with no great pretence to accuracy. We have noted them on other monuments – for example, on the back of the western core wall of the Menkaure upper pyramid temple. We have also recorded similar notches and holes (for stakes?) on the bedrock surface that the 4th dynasty builders perhaps used as the kinds of backsights that Clarke and Engelbach suggested for control of the axes and diagonals. One series of notches runs along a staggered northwest to southeast line across the terrace of the Khafre pyramid, on line with the southeast diagonal of that pyramid. Again, the notches show no pretence to fine accuracy, so these markers must have served only as rough and ready reckoners.

Establishing Khufu's base
Successive approximation

While some workers were quarrying stone low down on the southeasterly slope of the Moqattam Formation to provide building materials, others were set to the tasks of orientating, measuring, squaring and levelling the pyramid base at its northern summit [**17.9**]. Because the builders had to start with a sloping surface, these were not discrete, single operations. For all three kings' pyramids at Giza, the masons cut away much higher bedrock on the northwest and built up the surface on the southeast. Curiously, as they did so they left an irregular massif of natural rock protruding inside the square of the pyramid base – up to 7 m (23 ft) high in Khufu's pyramid. Until they had built up the core of the pyramid around and over the top of this protrusion of natural rock, they could not control the square of the base by measuring across the diagonals, for they would have to measure up and over the bedrock.

In order to know where to level, the builders had first to survey and measure the square; but in order to lay out an accurate square on the scale of several modern city blocks, they needed a level surface. The layout and levelling of the Giza

pyramids was a 'chicken and egg' situation. So the builders had to proceed in steps of *successive approximation*. As accurately as possible they measured and orientated the square of the base on the gently sloping plateau surface. They first took aim on true north and laid out their corners and reference lines. They then repeated the operations at several stages as they worked the rock down to the broad terrace on which they would build the pyramid, its surrounding court and enclosure wall, and the upper temple. At various stages they refined their orientation to the cardinal directions and the square of the corners that soon became hidden from one another by the mass of bedrock that they left in the core as they quarried away the rock for the final baseline.

Around the bottom of the bedrock core massif, the builders levelled an area approximately the width of a city street for the pyramid base plus its surrounding court and enclosure wall. They reserved their best levelling in the bedrock for the bed of the platform on which they would lay the bottom course of casing, and, 10 m (33 ft) distant and parallel, for the bed of the enclosure wall of the pyramid court; this was only about as wide as a modern sidewalk [17.10].

Levelling for Khufu's pyramid

As in other aspects of the three Giza pyramids, the builders achieved their most accurate levelling for Khufu. It was off by only 2.5 cm (just under 1 in.) around the entire perimeter of the platform, 53 cm (1 cubit/21 in.) high, built of fine Turah-quality limestone slabs. They then set the bottom level of casing stones, which are cut to the slope

of the pyramid face, a distance of 42 cm (16½ in.) back from the very straight edge of this platform. The blocks of the lower casing are huge – the eastern one of the few left intact at the north centre base is 1.48 m (4 ft 10 in.) high and weighs around 15 tons. The line where the foot of these lowest casing blocks met the platform formed the actual baseline of the Great Pyramid.

But far from being generic, such that we could use it as a model to work out how the ancient Egyptian builders built all pyramids, Khufu's pyramid is unique. His own builders took completely different approaches to building the bases of his queens' pyramids and his satellite pyramid. In place of the fine levelling for the king's pyramid, here the builders draped some of the casing down to accommodate the natural slope of the ground. They set some foundation courses level and others at an inward-sloping angle. Rather than levelling the base, they accommodated the slope in their coursing, so that the lowest course at the highest ground, generally at the northwestern corner, became the fourth or fifth course above ground at the lowest, southeastern corner. Sometimes they were not even consistent in their coursing. In places they continued a single thick course with two courses of thinner blocks, or every now and then setting a thick block to make up the height of two thinner courses. While their finishing was extremely fine, it was also very ad hoc and far less uniform than we might imagine if we took the Great Pyramid as an exemplar. The subsidiary pyramids in themselves provide good demonstrations of different approaches to building a pyramid in some detail (see box).

Surveying Khufu's base

By the time the surveyors came to determine the actual sides and square of the base of the Khufu pyramid for laying the foundation platform and the lowest course of the casing, they must have already performed the necessary operations numerous times, in a process of successive approximation, as they cut down the bedrock to the required level. They began these operations at the original surface of the plateau, some 5 to 10 m (16 to 33 ft) higher, and refined the base in successive stages as they worked the surface down. The first operation they had to perform in all this was to find the cardinal

17.10 The lowest course of the pyramid casing rests upon a platform that projects about 42 cm (16½ in.) from the baseline of the pyramid, except for broader corner slabs, here at the northeast corner. The builders laid a pavement across a court, about 10.2 m (33 ft 5 in.) wide, in jigsaw patterns, flush with the casing platform and stretching to the enclosure wall, shown here as an empty band.

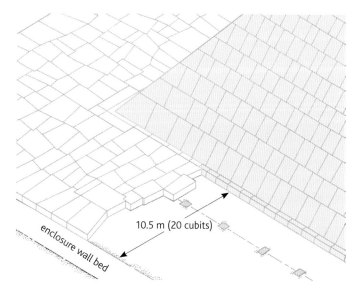

enclosure wall bed

10.5 m (20 cubits)

The subsidiary pyramids

Queen's pyramid GI-a

Almost none of the casing blocks are intact at the base of the first queen's pyramid, GI-a. However, we can see where the workers cut the bedrock into rectangular panels, or patches, marking the positions of the blocks. The panels are 2–3 m (6 ft 7 in.–9 ft 10 in.) long, so each must have received a series of adjacent casing stones; their width varies because the base of the core masonry is very irregular, but generally they are under 2 m (6 ft 7 in.) wide. The builders must have set the casing blocks at a pronounced inward tilt because the panels slope dramatically, by 10 to 20 deg., down and in towards the pyramid core. In fact on the east side a single casing block, 36 cm (14 in.) thick, remains in place; the masons cut the top and bottom parallel and then set it at the pronounced angle of the emplacement in towards the pyramid.

The panels, or emplacements, step up and down from one to another by anywhere between 4 and 46 cm (1½ and 18 in.), apparently because it was easier and more efficient to cut the bedrock than to waste the fine limestone of the casing by cutting it to bring the top of the first course level. In contrast to the king's pyramid, here the builders certainly did not cut a level foundation all round. The emplacements for the corner casing blocks are fairly level, which probably reflects the tendency of the builders, like modern masons, to begin at the corners and build towards the centre.

Queen's pyramid GI-b

At the northwest corner of the second queen's pyramid, GI-b, we see level emplacements, possibly for single large blocks. Along the west side the masons cut emplacements for the lowest casing down into a ragged foundation trench in the bedrock that was never meant to be seen – the intended baseline of the pyramid was the surface of the builders' construction debris that modern excavators have removed.

On this side a stretch of casing remains intact for 14.2 m (46 ft 7 in.); the builders made up the height of this with alternately one or two courses of blocks to create a bedding plane, which they levelled with exactitude. Along the rest of the west side, we see only the emplacements for the missing casing. At the missing southwest corner the builders constructed an emplacement from two slabs that they laid on the bedrock to compensate for the slope of the ground. The northern slab has the etched line of the intended pyramid base.

From the southwest corner along the south side, the builders levelled two emplacements into the bedrock for a length of 3.5 m (11 ft 6 in.); the eastern one is 10 cm (4 in.) higher than the other. (The pyramid foundation here is hard against the yawning boat pit between pyramids GI-b and GI-c.) The casing remains intact further along the south side of GI-b. Here the builders accommodated their coursing to the slope of the bedrock – the bottom course at the southwest corner would have been the fourth course up at the southeast corner (where this course is now missing).

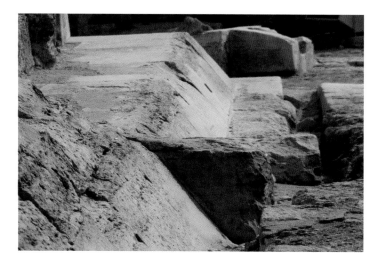

17.11 Undressed extra stock of stone projects from a casing block at the base of queen's pyramid GI-b. As much as half a metre of stone remained to be dressed back to the intended slope of the pyramid. Masons chamfered the protruding extra stock back to the lines where the block intersected the intended slope.

A large block of good Turah-quality limestone at the southeast corner was not intended to be seen – the builders left its edges sticking way out from the corner and faces of the pyramid slope, which they cut into the next course up. On this south side, the builders laid the blocks into a ragged foundation trench and left their faces undressed, without the slope of the pyramid face, for a stretch of about 10 m (33 ft). Again, the 'floor' level of the pyramid was on a layer of compact stone debris that modern excavators removed. The masons cut the pyramid slope only where it would show above this debris, which was the second course up from the base along both the eastern and southern sides.

Further west along the south side, the masons began to dress even the lowest blocks with the pyramid slope, but left one large block at the end entirely undressed; it sticks out as though to provide testimony of how they used the chamfering at the edges of the extra stock on the faces to indicate the plane of the pyramid face (see below). They dressed the pyramid slope into another stretch of this course for a distance of 17 m (56 ft) west of the southeast corner. Here they set the bottom course into a trench cut into the bedrock up to 80 cm (31 in.) deeper than general bedrock floor level between this pyramid and GI-c (the floor itself slopes to the east).

Along the east side the builders set casing blocks 56 cm (22 in.) thick. Here they trimmed them with the pyramid slope down to the sloping bedrock surface and carefully levelled the top of this first course of casing. On the north side they cut a ragged foundation trench into the bedrock into which they set thick casing blocks.

In this pyramid, unlike the single casing block that remains in place in GI-a (see above), the tops of casing blocks that remain do not follow

the inward grade towards the pyramid core but form a level course, the first level plane near the bottom of the pyramid. On the other hand, for two stretches on either side of the entrance, casing blocks of a second course are laid at an inward angle down towards the core. Along this same stretch the bedrock emplacement for the lowest course also slopes inward towards the core.

Queen's pyramid GI-c

Although the builders levelled a large foundation block for the southeast corner of queen's pyramid GI-b, just 3.7 m (12 ft) to the south they did something entirely different for the northeast corner of queen's pyramid GI-c. Here instead of cutting a foundation trench they instead took the slope of the north and east faces of the pyramid all the way down to the rough bedrock surface. On the north face, for a distance of 14 m (46 ft) west, they did little or nothing to level the bedrock, but fitted the bottom of the casing slope, like the uneven hem of a skirt, to accommodate the rise of the surface to the west.

Then, for about 7 m (23 ft) westwards to close to the entrance passage, the builders set the lowest course into a trench cut 55 cm (22 in.) deeper than the bedrock floor level between GI-b and GI-c (as noted in Chapter 8). The blocks all around the entrance are set at an inward tilt, corresponding to the downward slope of the pyramid passage, until the fifth casing course above the base, the top of which is level.

The faces of the foundation blocks that the builders set into the trench near the entrance are undressed all the way to 4.5 m (14 ft 9 in.) from the northwest corner, at which point the course gives out because of the rise of the bedrock surface. The builders cut the pyramid slope into the second course up, which formed the lowest course at the northwest corner. Here again, rather than level the ground, the builders accommodated the natural slope with their coursing – the lowest course at the northwest corner is the second course at the entrance passage and the third at the northeast corner.

As the highest point of bedrock on which the pyramid is built, the northwest corner must have been the builders' starting point for laying out the base. The casing slab here rests on the bedrock and has a line etched into the extra stock of stone left on its north and west sides that would have been used to mark the finished pyramid slope on these sides.

Because of the slope, the bottom course at the northwest corner runs level to become the fourth course up at the southwest corner. At this corner the ancient builders left their construction debris of limestone chips to mask the undressed extra stock of the bottom courses and to form what they intended as the baseline of the pyramid. What we see today is the laid masonry above this. In 1992 the builders' debris was cleared down to bedrock further along the southern side of the pyramid.

Along the south face, the masons left extra stock of stone protruding as much as 80 cm (31 in.) beyond the intended pyramid slope on the lowest two courses of casing blocks. But they bevelled

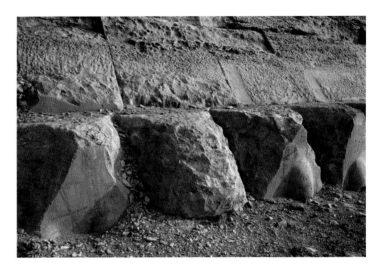

17.12 Extra stock of stone protrudes from the lowest casing blocks of the southern side of queen's pyramid GI-c, which the builders never intended to be seen once they had formed the pyramid floor level and baseline with a layer of their own stoneworking debris. Before making this decision, it seems they chamfered the extra stock back to their intended sloping plane of the pyramid face, as a guide.

or chamfered the sides of this extra stock back to the join with the adjacent block to either side. When they came to cut away the extra stock to free and smooth the pyramid face, this chamfering would show them the line of the plane to cut to. The marks of their cutting tools, and the traces of their techniques, reveal exactly where they stopped, having completed most of the third course up from the bedrock and parts of the second, leaving some blocks half dressed. They did not fully dress the two lowest courses because they intended them to remain unseen, once more creating a ground line for the pyramid on a bank of their debris.

Just as they did at the southeast corner of GI-b, the builders left a huge corner block with undressed faces at the lowest course on the bedrock. Because of the natural southeast slope of the ground, the lowest visible course at the southwest corner became the third course up at the southeast corner.

The absolute level of the top of the third course is maintained even though 12 m (39 ft) west of the southeast corner, the lowest foundation course rises up 35 cm (14 in.), becoming two courses. Such discontinuities in the coursing – with individual courses made up by single thicker blocks or two thinner blocks – prevent us from tracing one consistent course all around the pyramid. But we can count *course levels* that increase or decrease to accommodate the slope of the ground. This reveals that the builders made up the difference from the highest ground at the northwest corner of pyramid GI-c to the lowest ground at the southeast corner with six courses. From the southeast to the northeast corner, the ground rises again, and the coursing takes four steps up, that is, the lowest course on the northeast becomes the fourth course up on the southeast.

Khufu's satellite pyramid GI-d

As with the queens' pyramids, the highest ground of Khufu's satellite pyramid, GI-d, is on the northwest. Today, along the west side, the foundation blocks are almost entirely a modern reconstruction. Here the builders did not cut a foundation trench, but must have laid the lowest casing or foundation course on the gently sloping bedrock surface. A single ancient foundation stone remains in place on the west.

Along the north side, ancient foundation slabs remain for a stretch of 3.2 m (10 ft 6 in.) beginning 1.2 m (3 ft 11 in.) east of the northwest corner. From here to the axis of the pyramid passage, the ancient masons set the lowest course of casing stones into a trench that they cut in the bedrock. Further east, the builders flattened the bedrock for a width of 2.6 m (5 cubits/8 ft 6 in.) and then cut irregular patches or emplacements, 30–35 cm (approximately 12–14 in.) deep, to receive casing or foundation stones. Three inset foundation slabs make up the northeast corner.

On the east side, seven ancient foundation slabs remain in place southward from the northeast corner for a distance of 7.7 m (25 ft 3 in.). Beyond these, weathered casing stones survive, cut with the slope of the pyramid and set down into a trench in the bedrock for a stretch of about 3.8 m (12 ft 6 in.). From here to the southeast corner, three blocks have the slope of the pyramid cut into their upper fact as well as a projection at the foot, so that each carries the baseline plus a bit of the horizontal foundation.

Those who built Khufu's queens' pyramids certainly had the means to level with exactitude, as shown in the tops of the courses of casing that survive well above ground level on parts of GI-c. The datum, or starting point, would have to be the highest point on the ground, which, because of the natural slope to the southeast, was always the northwest corner. Rather than level, the builders accommodated this slope in their coursing of casing blocks, which also means, as we saw in Chapter 8, that the bases of these pyramids are not true squares, though the tops of each course probably are (no one has surveyed the pyramid course by course).

One question remains, however: how did the builders achieve such nicely square and beautifully levelled casing courses with such a rough sloping base and a core with such irregular masonry fill?

directions, probably starting with true north, using one of the methods described in Chapter 16.

Finding true north Khufu's builders must have begun on the east side of his pyramid, where they would have had an unobstructed view of the northern horizon, beyond the wide, open expanse of the Delta, and of the southern horizon across the high desert. On the west they had cut down into the higher natural surface of the bedrock, and this might have obstructed their view to the south. So they would first have determined a line orientated to north, which would become a reference for the eastern base of the pyramid.

Extending the line and measuring distance The ancient surveyors would then have to extend their resulting north line to a length greater than the 230 m (755 ft) of the pyramid sides. The slightest inaccuracy, even a fraction of a millimetre, in the original north line, would vastly increase as this line is extended, in what surveyors call 'the angle of error'.

Egyptian tomb scenes show field surveyors measuring using cords tied with knots that mark increments. This might have been adequate for measuring fields for crops, but probably not for an accurate line over the distance required here, because cords stretch and sag. Perhaps the Giza pyramid surveyors achieved their amazing results by measuring with rods of a given length, laid end over end, just as pre-modern Egyptian farmers measured using the *qassaba*, the 'cane', just under 3 m (10 ft) long.

Ancient Egyptian cubit rods have been found from periods later than the Old Kingdom. The royal cubit, used in building, was 0.525 m (1 ft 9 in.). Joseph Dorner, a modern surveyor and Egyptologist, has shown that the Egyptians could have achieved the length and accuracy of Khufu's baseline with rods of 4 or 8 cubits (2.1 or 4.2 m/7 or 14 ft).[12] As with their other operations for laying out the base, the royal surveyors must have repeated the operation of measuring the length of the sides many times as they worked the sloping bedrock surface into a level strip around the core massif.

Khufu's surveyors' post-holes? When it came to establishing the line for the pyramid platform the masons were faced with another problem. Any setting line that had been scribed on the bedrock surface to mark the outer edge of the platform would have been scuffed and scratched

as the masons cut the emplacements and laid in the large slabs. The line would also have been covered by the extra stock of stone left on the front face of the platform slabs, a practice clearly seen on unfinished masonry on all the pyramids and temples of Giza. The builders must therefore have required an outside reference line from which they could measure in a set amount to the line of the foundation platform.

Around the bases of the pyramids of both Khufu and Khafre we find curious series of holes cut into the bedrock floor in regular lines. The holes around Khufu's pyramid are rectangular, ranging from 45 to 85 cm (18 to 33 in.) deep, with sides varying from 35 to 68 cm (14 to 27 in.). They are spaced between 3.5 and 3.8 m (11 ft 6 in. and 12 ft 6 in.) apart (centre to centre), with the average spacing about 3.675 m (12 ft), or 7 cubits. Along the east side of the Khufu pyramid a consistent line of these holes runs 3 m (almost 10 ft) from the baseline of the foundation platform of the pyramid, and thus nearly 7 m (23 ft) from the bedrock rising in the northeast corner. Another line of similar holes begins at the east end of the north side of the pyramid, although they disappear further down this line towards the west. Similar lines of holes also exist along the south and part of the west sides of the Khufu pyramid, always 3 m (almost 10 ft) from the line of the foundation platform.

The builders fitted many of these holes with slabs of limestone, and obliterated others when they cut into the bedrock for laying the limestone pavement of the pyramid court at the end of the building project. The holes are too large and irregular to accurately mark a reference line, but they are wide enough to contain posts. Since the spacing of the holes shows no pretence to accuracy, the pyramid surveyors certainly did not use these posts for measuring distance. However, we wonder if they might have created a guideline using a line of string or cord tied to pins set into the tops of the posts. Perhaps they then marked the line of the edge of the platform on each slab as it was laid in by measuring inwards from the reference line. When the labourers had to drag in more slabs on a hauling sled, some of the stakes could have been removed, taking down part of the line. Then surveyors could re-establish the missing line segment by sighting from either side.

Constructing Khufu's right angles As with other operations, when Khufu's builders were ready to scribe the actual baseline, they had already performed repeatedly the extension of the line and turning the right angles for the corners.

For the final layout of the pyramid base, the protrusion of the massif of bedrock would have prevented the builders from measuring across the diagonals to check the accuracy of their square. Today at the northeast corner of Khufu's pyramid this massif is exposed where core stones are missing: it rises in four steps to a height of 4 m (13 ft) and is nearly 7 m (23 ft) back from the series of holes that may, as mentioned above, mark the external reference lines for setting and cutting the casing stones to make the base. So how might they have overcome this problem?

i. Using a set square at Khufu northeast
If the surveyors established a right angle by using a set square (see Chapter 16), the size of the square would be important for the accuracy of the lines extended from the corner. At the northeast corner they could have used a square with legs up to 2.5 m (8 ft 2 in.) long without hitting the bedrock core massif. Such a set square would be considerably larger than any known from ancient Egypt, but even at this size, the resulting perpendicular is still extremely short considering the line was extended more than the 230-m (755-ft) length of the pyramid sides. However, they might have used a straight edge, or cord, to extrapolate the line in increments, with compensating, rather than accumulating, errors [**17.13**].

ii. Using the 3-4-5 triangle at Khufu northeast
If Khufu's surveyors established a right angle at the northeast corner using a 3-4-5 triangle, the hypotenuse would have to clear the bedrock massif. Consider a unit of 7 cubits (1 royal cubit = 0.525 m/20½ in. × 7 = 3.675 m/12 ft), which is the average spacing between the holes mentioned above running in a linear series along the sides of the pyramid. Three units of 7 cubits each (= 11.02 m/36 ft) could be laid out along the already established reference line, starting from the point where the corner is to be turned at the intersections of the lines of holes on the east and north sides of the pyramid. The point at which four units to the

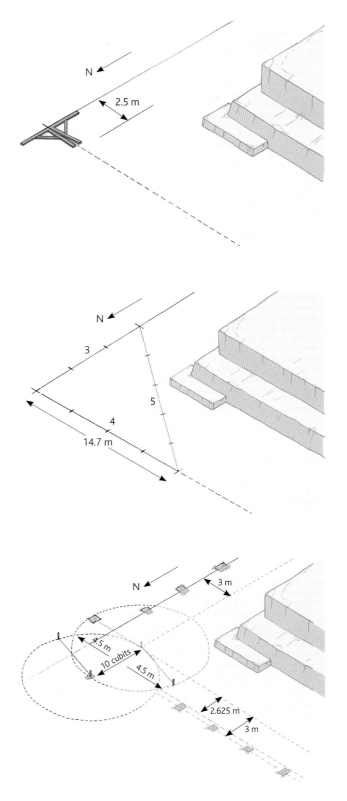

west intersect with five units on the hypotenuse establishes a perpendicular 14.7 m (48 ft) long (0.525 × 7 cubits × 4). The triangle could not have been much larger without running into the bedrock core massif, but it provides a longer perpendicular than a set square [**17.14**].

iii. Using intersecting arcs at Khufu northeast
The intersection of two arcs obtained by pulling measuring cords of the same radius from two points on one line establishes a perpendicular to the line. Some theorists have doubted that the pyramid builders used intersecting arcs because the elasticity of the cord would give inaccurate results. But this method might explain several peculiar features found at the northeast corner of Khufu's pyramid [**17.15**].

Since the edge of the foundation platform was nearly (but not quite) as precise as the baseline of the pyramid, which was set back by between 38 and 42 cm (15 and 16½ in.), one of the first tasks in laying out the pyramid base was to establish the setting line for one side (the east?) of the platform. The next step would be to establish the position of the corners of the platform. At the corners of Khufu's foundation platform the masons laid extraordinarily large slabs; their size and position are still clearly marked on all but the southwest corner by emplacements, or sockets, cut several centimetres into the bedrock floor. Today the spots where the lines of the platform intersect are marked by the lead and bronze plugs that (Sir) David Gill set there during the astronomical Transit Expedition of 1874.[13]

Exactly 10 cubits (5.25 m/17 ft 3 in.) due north of the northeast corner of the foundation platform there is a round hole. If this point and the northeast corner of the platform are taken as the centres of circles to create intersecting arcs, the intersections fall about 4.5 m (14 ft 9 in.) east and west of the line of the eastern platform face, to create a total perpendicular length of 9 m (29 ft 6 in.). The arc from the corner point also touches another hole, due east of the corner point and on the extension of the north line of the platform face. This hole is rectangular like those of the reference lines.

We must note that the perpendicular established by the first mentioned intersections of arcs falls neither along the north platform line nor along the line of holes on this side, but instead falls 2.625 m (half of 10 cubits; 8 ft 7 in.) north of the north platform line, or 37.5 cm (14¾ in.) south of the north line of holes. But the ancient surveyors,

who probably used wooden rods and cord, could have struck arcs anywhere along either the east 'reference' line, later marked by holes, or along the east platform line, to adjust the point of intersections and the position of the perpendicular. Or they could have simply measured a short interval from any perpendicular they had obtained to establish a parallel north reference line for the north line of the platform.

Khufu's ramps

Those claiming the parentage of Khafre who cut their tombs into the bedrock cliff formed by the west side of the western Central Field quarry seem to have located them to avoid huge tips of ancient construction debris in the centre of the quarry. Selim Hassan trenched the deposits, looking for tombs, but did not discover any further development of the cemetery. However, his cuts do reveal tip lines – strata created from the ancient incremental dumping of limestone chips and gypsum. Millions of cubic metres of tan-coloured desert clay, gypsum and limestone chips fill the

quarries south of the pyramids; the quantity of chips must have increased as pyramid and tomb building progressed.

When looking for the remains of the pyramid construction ramps, we should perhaps look no further than the patterning of such debris. But would this kind of material be stable enough to compose a solid ramp, even if held up by walls of stone debris bonded with tafla mortar? It is often assumed that ramps must have had some kind of baulking or shoring of mud brick. Archaeologically, there is a problem with this view. Given the extraordinary amount of mud brick that would have been required, it seems inconceivable that a ramp could have been dismantled and all the mud brick carted away without leaving a trace. In all the trenching and excavation at Giza, and in all the exposed deposits on the surface, there are no large grey or black stains that would signify the dumping of the quantity of mud brick necessary to shore up ramps. Rather, it is massive quantities of broken limestone and limestone chips and dust, gypsum and calcareous desert clay that fill the quarries at Giza, and this must be the material of the ramps.

17.16 Remnant of a ramp left from the Old Kingdom sloping up to the southern end of mastaba G 5220 in the southeastern corner of the Western Cemetery. The ramp is formed of fieldstone retaining walls and debris fill.

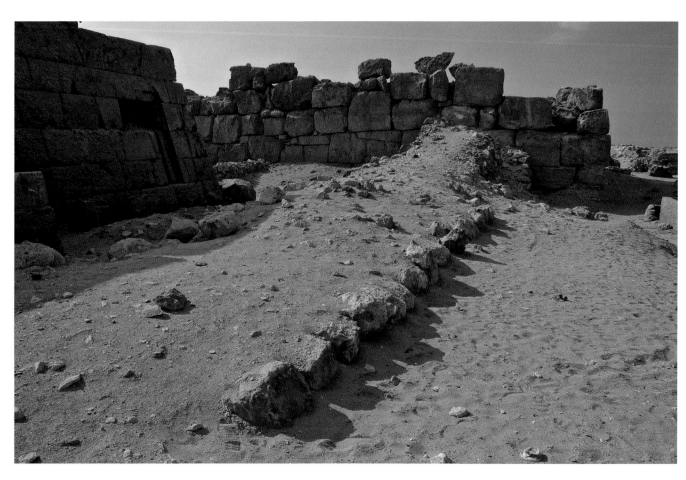

Small ramps remain attached to certain mastaba tombs at Giza, where the builders left them [**17.16**]. For instance, south of queen's pyramid GI-c and the Eastern Cemetery is an arrangement of two parallel walls built of limestone chips and tafla, one of double thickness. Vertical seams separate wall increments about 5.5 m (about 10 ancient cubits/18 ft) long. Modern excavators removed the debris that once filled the space between the walls, but the whole structure could originally have supported a roadway that led in the direction of the mastabas east of the Great Pyramid.

North of the Khafre pyramid, the modern paved road leads up onto an ancient construction embankment. The embankment runs along a colossal unfinished wall of large limestone blocks that forms the south border of the Western Cemetery. The sides of the embankment have collapsed into a sandy slope, but in 1881 Petrie ascertained that the ancient builders created the embankment with a series of walls that formed compartments for retaining debris fill. More recent clearing has exposed the faces of accretions made of fieldstone and mud with marl clay plaster – the Giza builders must have formed the pyramid ramps in a similar fashion.

But would such a ramp have been able to make an ascent of over 100 m (328 ft) skywards, leaning against the ever-narrowing faces of the pyramid? The top of the Khufu pyramid, as preserved, rises to 197.8 m (649 ft) above sea level, while the Central Field quarry floor, 630 m (2,067 ft) to the south, is 32.1 m (105 ft 4 in.) above sea level on its southern limit. The distance from a point at about two-thirds of the height of Khufu's pyramid to the south edge of the Central Field basin quarry is about 635 m (2,083 ft), a little less than the length of the pyramid times three, and a difference in height of 119.8 m (393 ft). A ramp could span this distance with a slope of 10 deg. 41 min. 02 sec., but it would have covered the quarry and blocked the removal of stone.

Overland hauling: the wadi way

An oft-repeated notion is that the pyramid's causeway was a main access for the delivery of materials to the construction site. But since the bulk of material for the pyramid core was raised from the south, non-local materials such as Turah-quality limestone for the casing and granite for the

burial chamber could also have been delivered from this direction, utilizing already existing routes of supply and access. The Main Wadi separating the Moqattam and Maadi Formations would seem to be the natural conduit for these materials to pass through the quarry and up to the construction ramp. As already noted, the knoll rising above the mouth of the wadi offered an excellent vantage point from which to supervise and monitor everything coming and going to the construction site. And indeed our recent excavations have revealed a massive ramp here ascending the plateau between the Menkaure valley temple and the foot of the Khentkawes Town, which was probably used for construction of the Menkaure pyramid and upper temple (see Chapter 15).

And we now have Merer's Journal, a record of multiple round trips of a team delivering stone for Khufu's pyramid by boat from Turah (see pp. 29–30, 526–27). Analysis of both this papyrus text and the landscape suggests Merer and his men docked at the western end of a central canal basin not far east of where the Sphinx would come into being, and dragged their stones up to the southeast corner of Khufu's pyramid on a ramp corresponding to the modern road just here.[14]

From quarry to pyramid

The main supply ramp had to run from the quarry that supplied the greater part of the core stone to the pyramid. In exploiting the large Central Field quarry south of the pyramid, the builders took advantage of the thickly bedded softer limestone of the south part of the Moqattam Formation. The natural slope of the formation already provided an inclined plane from quarry to pyramid. In whatever fashion the ramp ascended the pyramid as it was being built, it had to do so in the space between the pyramid and the cemeteries to the east and west, and the escarpment to the north.

The first stretch might have begun at the northwestern mouth of the quarry, where the quarrymen left an incline down to the bedrock floor. As noted in Chapter 16, a ramp could have covered the 320 m (1,050 ft) from here to the pyramid at the functional slope of just over 6 degrees to reach 30 m (98 ft) above the southwest base of the pyramid. At this height, the pyramid already contained 40–50 per cent of its mass. A ramp

with a roadway 30 m (98 ft) wide would compare to a scribe's specifications for an embankment in Papyrus Anastasi I: width 55 cubits (28.88 m/94 ft 9 in.); length, 730 cubits (382.5 m/1,255 ft); height, 60 cubits (31.44 m/103 ft 2 in.); with a side batter of 15 cubits (7.86 m/25 ft 9 in.).

In 1995 the Giza Inspectorate excavated trenches through thick layers of limestone debris south of the southwest corner of the Khufu pyramid. Remains of fieldstone walls were found running north-northwest that could have been the accretions or retaining walls of the foundation of such a supply ramp.

By Khufu's Year 20, according to Reisner,[15] his builders had completed the Western Cemetery tombs comprising nucleus cemeteries G 4000, which was arrayed east-southeast of tomb G 4000 belonging to Hemiunu, Khufu's 'Overseer of All the King's Works', as well as nucleus cemeteries G 2100 and G 1200, respectively east and west of the large mastaba G 2000. Khufu's builders originally reserved a space, 140–150 m (459–492 ft) wide, between his pyramid and cemeteries G 4000 and G 2100, but later tomb builders filled this space with the Cemetery en Échelon (see Chapter 13). On the north side of Khufu's pyramid there is only about 70 m (230 ft) of plateau surface before the 40-m (131-ft) drop to what is now the Mena House golf course, then the low desert or a floodbasin. On the east side of the pyramid about 50 m (164 ft) separates the pyramid from the queens' pyramids, which were completed by Year 20 of Khufu according to Reisner. The mastabas of the Eastern Cemetery were well underway by Year 12. Khufu's builders also filled part of this space with the upper temple, presumably after they had removed any ramps and embankments for the pyramid construction.

The wrap-around accretion ramp

A ramp could have fitted into the available space flanking the pyramid if a roadway was built atop an accretion that leaned against the completed part of the pyramid. In this scenario, a second stretch, could have been formed by an accretion that leaned against the west side of the pyramid for a distance of 250 m (820 ft) at a slope of 7 deg. 18 min., rising to a height of 62 m (203 ft) above the pyramid base. We reconstruct a third section against the north face of the pyramid, sloping at an angle of 10 deg. 39 min.

for 180 m (591 ft) to a height of 95 m (312 ft) above the pyramid base. At this height the pyramid contains nearly 96 per cent of its total mass. A fourth stretch would lean against the east face of the pyramid and slope at an angle of 12 deg. 58 min. for 100 m (328 ft) to a height of 118 m (387 ft) above the pyramid base. Very near the top, the ramp would lean against the south face of the pyramid, with the accretion on which it was founded resting on lower accretions with a doubled width allowing for a secondary roadway. A further stretch would then slope at an angle of 14 deg. 30 min. for 60 m (197 ft) to a height of 133 m (436 ft) above the pyramid base. The final stretch would be once again against the west face, at a slope of 18 deg. 39 min. for a length of just 40 m (131 ft) to the top of the pyramid, 146.5 m (480 ft 8 in.) above the base. However, in reality the last two or three sections would probably be too steep to have been functional, and so we have to consider alternative ideas for raising the final stones.

In cross section, the support for the roadway on top of this ramp would take the form of accretions leaning against the faces of the pyramid. The faces and diagonals of the ramp accretions would have the same outer slope as the faces (about 52 degrees) and diagonals (41 deg. 59 min.) of the pyramid. If the ramp was built in this form, the ancient Egyptian builders could have taken advantage of long experience in constructing such accretions within the superstructures of earlier pyramids.

The builders would need to have planned such a wrap-around ramp from the beginning of the project. It would have been successively built up on all sides as the pyramid rose during construction, with the roadway on top of the accretions gradually increasing in slope. As the slope becomes steeper towards the top, fewer and fewer stones were being raised. Since the accretions would have covered all four faces, control of the diagonals and the slope of the faces would have been a problem.

The spiral ramp on the pyramid

Other theorists have suggested instead that a spiral or wrap-around ramp could have rested on the sloping face of the pyramid itself. One of the main objections to this idea is that the pyramid is so steep, at 52 to 53 degrees, that the casing, even with the extra stock of stone that the masons did not dress until the whole pyramid had been completed,

could not support ramps. The extra stock of stone on the unfinished granite casing on the lower part of the Menkaure pyramid does not seem sufficient to support a roadway on the 53-degree slope.

One possibility is that at certain intervals the builders set layers of casing stones projecting like a step or ledge, which could support the ramp while being anchored in the pyramid. If they had opted for this solution, the protruding casing stones could either have been staggered diagonally up across the pyramid face to accommodate the rise of the ramp, or set in horizontal courses at intervals so that the base of the retaining wall of the ramp was level but could step up in stages, with the roadbed rising at a gradient.

What can ground truth at Giza contribute to such speculations? No such projecting courses are found in the unfinished 16 lowest courses of granite at the Menkaure pyramid. On the other hand, in our clearing around the base of queen's pyramid GI-c we found that the masons had left a significant amount of extra stone, stepped one course down to another, on the undressed bottom courses of casing blocks. Some project 80 cm (31 in.) or more from the intended final face of the pyramid casing. These courses may be unusual because they are part of the foundation, but if the masons left this much extra stock on all the casing stones or on courses at certain intervals, it could well be enough to support a spiral ramp's retaining wall.

Setting Khufu's stone

The few remaining blocks of the Khufu casing left at the base tempt us to reach for superlatives. His masons fitted together blocks that weigh from 7 to 15 tons with joins so fine that not even a razor blade can slip between them. And they achieved such exquisite joins not only near the front faces of these blocks, but running back for the entire depth of the join towards the core, in many cases more than a metre (3 ft 3 in.).

Rather than pre-cutting the blocks of the fine masonry of the outer casing to a standard shape, the masons sculpted each one for a particular fit with the one already set next to it in the course under construction, like individual pieces of a puzzle. But it was only in the outer casing that they strove to achieve such accuracy, for the massive core

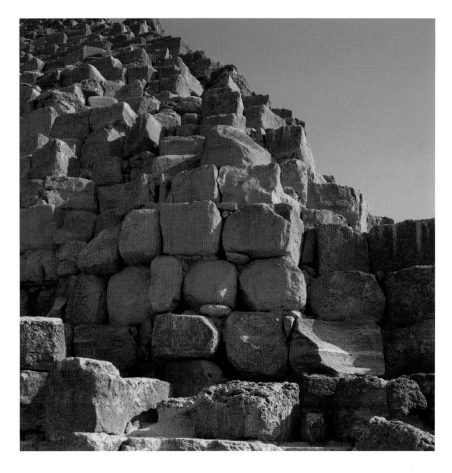

of the pyramid they set the stone with loose and irregular joins, jammed with stone chips and large amounts of gypsum mortar [**17.17**].

When the builders began both the foundation pavement and the bottom course of casing, they probably first set the cornerstones and several stones towards the centre of each face to establish the 'lead lines' of the four sides. Initially, the sides of the corner blocks were left rough as each was moved into position; the stonecutters in the workyard would have only dressed one side – the bottom. The haulers off-loaded the blocks from the sled near their final destination and then might have moved them the short distance to their final resting place on rollers, which would have worked well between the flat bottom of the blocks and the smooth top of the stone below.

The setting crews then parked the rough cornerstones above their final resting place on blocking or wedges placed under the rollers. Only now did the masons cut the two side faces of the block straight and smooth, though not necessarily at right angles to the line of the pyramid face, or

17.17 Loose-fitting core stones at the northwest corner of the Khufu pyramid. When setting the core stones, which are not modular or regular in size or shape, Khufu's builders filled gaps with smaller stones, gypsum mortar and debris.

RIGHT
RIGHT
17.18 Razor-thin etched lines, extrapolating where the intended final plane of the sloping pyramid face intersected the extra stock of stone left on each block. Masons bevelled or chamfered the extra stock back to the line. When it came time to dress the pyramid face, they cut away the extra stock. At the point adjacent blocks 'closed' at the line they knew they had reached the desired plane. The techniques helped prevent waves and pockets, caused by dressing back too far, in the finished sloping face of the pyramid.

BELOW
17.19 The northernmost of the intact casing stones at the centre of the north side of the Khufu pyramid, with an estimated weight of 15 to 17 tons. At the base is a circular socket, possibly to receive the end of a lever that workers used to adjust the block into place.

to the horizontal surface of the platform below. Instead, they trimmed the closest plane to the cleavage faces left by the removal of the block from the quarry. The masons then accurately cut the joining faces between the two adjacent stones by measuring from one face to another with string as they dressed the surfaces, probably starting at the corners of the block and then dressing away the rough stock in between. Since Khufu's casing blocks were limestone, the faces could have been both chiselled and sanded gradually, and with great control, into neat, flat, parallel planes.

If one or both of the stones had already been set down flat on the pavement or course below, the dressing at the lower edge of the join face would have cut, however slightly, into the horizontal surface of the bed below. For this reason the masons carried out all but the finest dressing of the join faces of each stone while it was hoisted on blocking above its final seat. They then often fine-tuned the join face with a final dressing after the block was set down. This accounts for the 'setting lines' that one sees on the top beds of casing courses of the Giza pyramids. Each line marks the join between two missing casing stones that sat on top and were later removed by those who plundered the pyramids for building stone. The surface along one side of these setting lines is often rougher,

showing tool marks, and slightly lower, by 1 mm or less, than the surface on the other side of the line. The higher and smoother surface represents where a block was already flatbedded – set down on the course below – while the rougher and lower surface remains from a final dressing of the join face after the block was set down. It is possible that to achieve the final tight join, the masons ran a saw blade, probably of copper, right down the join, cutting ever so slightly into the top of the course below. They would then nudge the stones together to close the final millimetres of space left by their saw blade.

Let us imagine a corner casing block and the first block on one side, still raised above their intended positions in the course below. Their join faces are trimmed parallel and the corner block is then lowered into its position by first lifting it slightly with levers, then removing the wedges or rollers holding it up. With their final dressing of the join face – possibly using a saw blade – the masons create a line on the horizontal bed below along the bottom corner of the join face. The adjacent block remains on wedges above the bed, and the next block down the line of the course is brought up close to it in turn. The two join faces are trimmed parallel. The first regular block is then lowered down on to the bed. Levers are used for the final adjustment, as the block is pushed against the join face of the corner block. (This is why some pyramid casing blocks, though not all, have lever sockets at the bottom of one join face [**17.19**].)

A thin film of gypsum mortar probably facilitated the adjustment, acting as a lubricant on which the blocks could be 'floated'. Next, a final

dressing of the opposite join face is done, leaving another 'setting line' on the top of the course below. The masons then had to repeat this process for every block of every course of the pyramid casing, and for the finely cut and often massive blocks of the internal passages and chambers. But how, in this gigantic and complex construction process, did the masons control the slope and alignments of the pyramid faces as they set the stones? Some of our most illuminating evidence for this came from our clearing around the bases of Khufu's queens' pyramids.

Maintaining slope and alignment

Once the builders had hauled in and laid sufficient stone to raise the level of courses of the Khufu and Khafre pyramids above the mass of natural bedrock left in the base, the masons could then measure across the square of the truncated pyramid to ensure that its diagonals and sides were of equal length and thereby check its square. By the time the pyramid reached this height, the reference lines on the ground were no longer visible and of no use because they were covered with ramps and building debris, as was the actual surface of the pyramid.

There is good evidence that the pyramid builders dressed down the casing into the four evenly sloping, smooth, flat faces of a pyramid only after they had set all the stone to a good height. But how could they achieve this over such large areas without developing waves and undulations in the faces? And if they could not see the already dressed faces below them in the work completed, how did they make sure that the four faces and corners would meet in an accurate point at the top? The answer is that masons formed the faces of the pyramid into the casing blocks as they were setting them, but left these broad planes concealed until after the stones had all been set in place.

When they custom cut each casing block to fit its neighbour, the masons left extra stone, including along the join surface. This extended out beyond the lines of the planned pyramid face, which they scribed at the top, bottom and sides of each block [17.18]. They transferred the lines of the pyramid face and the correct slope, or rise and run, onto each course of casing. Starting at the bottom, for the baseline of the first course, the masons had to

measure in a set amount from an outside reference line to determine the point where the exterior join between the blocks would intersect with the final baseline of the pyramid. This was marked on the first stones bedded in their final position – the cornerstones and the lead stones in the centre of each face.

The next step was to mark the rise and run on the sides of blocks that they had just set in place – Khufu's builders could have obtained the almost 52-degree angle of his pyramid using a horizontal setback, or run, of 11 units to a vertical rise of 14. In this method they could have measured up 14 units with a plumb line from a point on the already determined baseline, and then measured in 11 to find the top of the slope for that block.

In the case of the queens' pyramids and the Khafre pyramid there was no already levelled foundation and here the masons could have used a square level. As described in Chapter 16, those we know from ancient Egypt have two legs connected

17.20 The west side of queen's pyramid GI-c where pyramid masons stopped dressing down the casing near the bottom. On each block, masons had bevelled the extra stock of stone back to the line of the pyramid slope.

by a crosspiece, the whole forming the shape of a letter A. The tool is level when a plumb line hanging from the apex where the two legs meet at the top falls across the centre of the crosspiece. For determining the slope in the bottom of the pyramid, the angles of the two legs would have to match that of the pyramid slope.

Once they had established and marked the angle of the pyramid face on the sides of the corner and lead blocks, the masons cut away some of the extra stone at their edges back to this line – that is, they bevelled or chamfered the extra stone at the sides back to the sloping lines marked on the join faces of each block, and to the horizontal line of the pyramid face on the top [17.20]. When they brought up the next block in sequence and set it down to create the side join with its mate, this new neighbour at first had extra stone, and extra dressed join face, extending out beyond the chamfered or bevelled sloping side of its existing partner. So the masons cut away this extra stock, and bevelled the join edge of the newer block along the slope of its neighbour. Then, on the opposite free join face, they repeated the procedure, marking the slope and carefully bevelling away the extra stone along this line.

In this way, block by block, the masons created, but left hidden behind extra stock of stone, the sloping planes of the pyramid faces, ready for the final dressing of the pyramid casing after they had set all the blocks. Rather than accumulating, any errors in their measurements would have been compensating – if the slope marked on one block was a little off in one direction, others might be slightly off in another. The errors averaged out.

When the time came to free the final, smooth pyramid faces by dressing off all the extra stock, the masons worked from the top of the pyramid down, as they removed the ramps and debris that had enveloped the pyramid during years of construction. As they chipped away the excess stone on the pyramid face, the space between each block would gradually narrow, closing up towards the final side joins between the individual blocks. Just at the point where the spaces between adjacent blocks closed completely (or, as with the surviving casing blocks at the base, to a join so fine that one could not slip a knife blade in), the masons knew not to cut any deeper into the stone. They had reached the desired plane of the pyramid face.

It would be reasonable – and only human – to find marks in the Khufu foundation pavement where the masons might have cut even slightly too deep in dressing down the bottom casing stones. But no such marks are visible. However, it is unlikely that the masons dressed the face of the casing stones so perfectly down to the sharp angle where they met the baseline before placing them. It is probable instead that they cut a shallow trench or socket into the surface of the pavement into which they set the casing blocks – the bottom of this socket would become the final level of the pyramid baseline and they later cut and smoothed away the excess stone on the pavement surface just in front of the foot of the casing.

Disposing of construction debris

At the completion of the massive project of building the pyramid, the ancient workmen had to remove the ramps and dispose of enormous quantities of debris resulting from the construction process. The advantage of the limestone chips, tafla and gypsum composition of the ramps was that the workers could easily dismantle the retaining walls and embankments and the fill with their picks. Deconstructing a gigantic ramp of dense mud brick might have been more difficult. Khufu's workers solved the problem of where to put all the debris by backfilling the great basin caused by their own quarrying, forming the great mound in the western part of the Central Field.

From Petrie's observations we also know that they dumped waste material from pyramid construction over the north edge of the plateau. He estimated that the debris deposited to the north and south of the pyramid was equal to more than half the bulk of the pyramid; that to the north was stratified and contained pottery, wood fragments, charcoal and string.

In 2004, in order to build administrative structures at the northern entrance of the Giza Plateau, a contractor excavated a great pit on the debris slopes north-northwest of the Khufu pyramid. The southern side of this pit created a towering section 10 m (33 ft) tall that cut through the dramatically stratified tip lines of the pyramid builders. The ancient workers filled a bedrock gully, about 20 m (66 ft) lower than the base level of the

pyramid, first forming a platform rising 4–5 m (13–16 ft) above the tops of bedrock humps and stretching northwest from the base of the pyramid. They then dumped to either side of this tip line and created layers that slope down about 40 degrees to the west and east, just as modern excavators dispose of their waste material to either side of a Decauville rail line – except of course in the Old Kingdom the work was done by lines of men with reed baskets. Layers of large limestone chips followed by layers of fine powder and small chips relate to the sequence of dressing masonry (mostly the fine limestone of the outer casing).

This situation proved perfect for the preservation of organic material – it was high enough (more than 40 m/131 ft above sea level) above the moisture of the floodplain while the gaps between the chips allowed both air circulation and reduction of compression. Working with the inspectors of the Ministry of Antiquities Giza Inspectorate in several sections, we retrieved 4,500-year-old pieces of wood, reed, lengths of rope and string of all thicknesses (from fine linen string to pulling rope), cloth (probably parts of clothing), chipped chert tools and large cattle bones (including jaws, teeth and a skull fragment with horn). Were these cattle used as draft animals, then eaten? In one case the cattle bone is surrounded by frayed reed, probably the remains of the basket into which some worker tossed it. Looking up the vertical face of the layers of limestone chips, the reed stuck out in great quantities, like whiskers on an unshaven face. Much of this material, as well as the thinner rope and twine, must derive from the baskets that the workers used in the disposal of the material, while the numerous chips and splinters of wood, perfectly preserved, must be the remains of levers, hammers, wedges and sledges, all evidence, on the individual, human scale, of building the Great Pyramid of Giza.

II. The Khafre project
Selecting a site

Khufu's builders could select the site for his pyramid on a completely empty plateau. When Khafre's builders came to survey the lines for laying out his pyramid base, they may have carefully considered certain alignments with Khufu's existing pyramid. At the same time, the design of the entire Giza Necropolis, from one complex to the next, was not so much a premeditated pattern laid down from the very beginning of Khufu's reign as an organic development, with the builders accommodating certain conceptual or ideological considerations to the fundamental geological and topographical constraints.

Given the general dip of the Moqattam Formation from the northwest to the southeast at 3 to 6 degrees, the strike runs northeast to southwest. This may in part explain why Khafre and Menkaure built southwest on the great diagonal that almost touches the southeast corner of all three kings' pyramids – it seems the builders wanted to found the bases of the pyramids at about the same level. In fact, the bases of Khufu and Khafre differ in elevation by about 10 m (33 ft), while those of Khafre and Menkaure are at about the same elevation.

Khafre's quarries

A major reason for siting Khafre's pyramid to the southwest of Khufu's was that Khafre had to avoid his predecessor's quarry, which had been exploited to a depth of up to 30 m (98 ft) on its steep western edge, just tens of metres from the southeastern corner of where Khafre's builders positioned his pyramid. Some of Khafre's children used this western quarry face to create their rock-cut tombs [17.21], thus situating their burials to the right and front of Khafre's causeway and upper temple, in the equivalent position in relation to their father's pyramid and temple as the giant mastaba tombs of Khufu's children in the Eastern Cemetery.

Southern Khafre quarry

Khafre must have selected another place to quarry the stone for his pyramid core, perhaps creating a deep quarry to the south-southeast of his pyramid, in the Main Wadi. This area is largely unexcavated, but in 2003 we carried out a remote sensing electromagnetic conductivity survey of the wadi with Tremaine and Associates. At a point at the southeast corner of the fieldstone enclosure wall of the Menkaure pyramid where it runs along the wadi's edge, the wadi makes a steep descent of 22 m (72 ft), from 47 to 25 m (154 to 84 ft) above sea level,

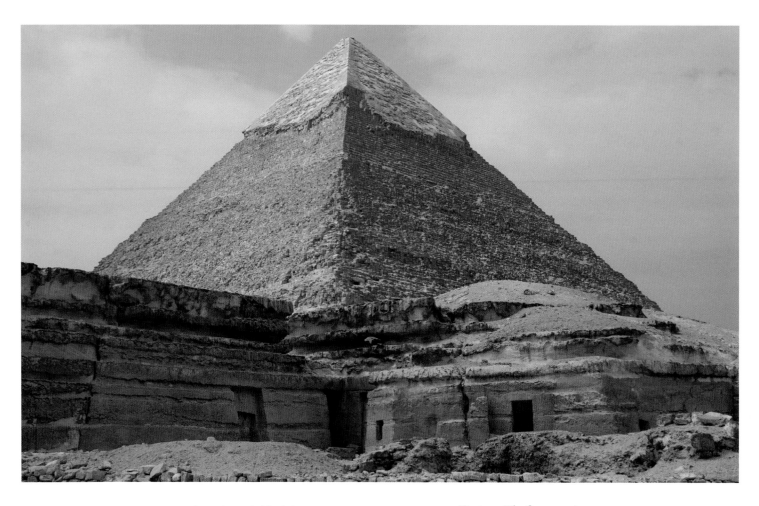

17.21 Rock-cut tombs in the deep, northwestern corner of the Khufu quarry, with the Khafre pyramid rising behind. Tombs in the face of the quarry north of these belong to sons and one daughter of Khafre – they positioned them here to be in the same relative position to their father's pyramid as Khufu's sons and daughters were in relation to his pyramid.

into a broad sand-filled depression, some 250 m (820 ft) wide. The Tremaine team's remote sensing detected a yawning cavity, at least 6 m (20 ft) deep, in this low sandy stretch of wadi. This is east-southeast of the mouth of what we have identified as the main Khufu quarry.

The subsurface depression could be a deeper basin quarry where Khafre's forces extracted stone for his pyramid core. In the southwest corner of the depression, the electromagnetic conductivity detected an L-shaped anomaly that could be the quarry edges. Perhaps these data, when precisely located on the map of the area, will help to define a major quarry that can then be added to the overall picture of the stone extraction and supply areas of southern Giza.

As with the Khufu quarry, an additional advantage of exploiting stone here was that the natural dip from south-southeast to north-northwest would have facilitated the transport of the major bulk of the material in the early stages of the project. Again we find a great quantity of stone construction debris dumped in overlapping tip lines within the basin quarry, as well as to the north of the later Menkaure causeway.

Eastern Khafre quarries

It is also possible that Khafre quarried stone for his pyramid to its east, between the pyramid and the Great Sphinx, along the northern side of his causeway. If one imagines the original bedrock surface at the height of the top of the Sphinx's head, then clearly an enormous amount of stone has been removed, leaving the head of the Sphinx as an island or remnant of the upper layers.

Our excavations in 2004–05 showed that the floor of most of this quarry is flat, with a slope to the east, and not deeply exploited for stone. In the Saite Period (26th dynasty, 664–525 BC), 2,000 years after the 4th dynasty, prominent members of society cut deep shaft tombs in this floor, surrounded by chapels of which only parts of the masonry foundations have survived. The western end of the quarry, below and north of the western end of the Khafre causeway embankment, is much deeper.

A bridge of bedrock that slopes up from south to north towards the mastaba cemetery east of the Khufu pyramid separates the shallow quarry behind the Sphinx from the deeper Sphinx ditch. Quarrymen in the 4th dynasty probably left this

bridge in order to transfer stone from the eastern part of the Central Field up to the Eastern Cemetery to the north.

To the south of the Khafre causeway a triangular area of bedrock, with its base running from the Khentkawes tomb to the Khafre causeway and its hypotenuse from the Khentkawes tomb to the head of the Sphinx, was not so deeply worked. It was probably Khafre's quarrymen who began to slice the bedrock here into great rectangular quarry blocks, which they then subdivided with narrow channels to isolate blocks of the desired size. One can walk between the giant quarry blocks through corridors the size of hotel hallways and see the narrower channels, wide enough for one person to drive the channel forwards through the rock, and also where the quarry workers isolated one of the enormous blocks of the kind they used to form the core of the pyramid temples of Khafre and Menkaure [**17.22**].

The quarry blocks in a crescent-shaped area from the eastern edge of the Central Field to the south side of Khafre's causeway are more conspicuously worked than those closer to the Khentkawes cube. Herbert Ricke thought that the multi-ton blocks for Khafre's upper temple and valley temple derived from the quarry that isolated the Sphinx, and these quarry blocks in the crescent-shaped area

were probably also exploited at this time for the monolithic core blocks for his pyramid temples and Sphinx Temple.[16] High-ranking Egyptians of the later Old Kingdom utilized the quarry blocks as superstructures for their rock-cut tombs.

Both Menkaure and Khafre had to build up their causeways in part out of huge, locally quarried stone blocks in order to bridge the quarries of their respective predecessors. However, the Khafre causeway, while partially formed of blocks, is also founded upon another bridge of bedrock, this one separating the shallow quarry to the north of it from the more worked quarry to the south, which is the west part of the Central Field. It seems unlikely that Khufu would have reserved this rock for his successor's causeway, and it must therefore have been Khafre who exploited the quarry north of his causeway.

The Khafre quarries and valley complex
Khafre seized upon an outcrop of unexploited bedrock at the southeast corner of the Moqattam Formation for fashioning the Sphinx as part of his valley complex. The 4th dynasty planners appear to have carefully surveyed the position of the Sphinx, its terraces and the alignment of its temple at the far northeastern angle of this outcrop. As they

17.22 Quarry blocks southwest of the Sphinx, which workers created by cutting wide channels that were then subdivided with thinner channels. They isolated blocks the size of the monolithic core stones used in Khafre's pyramid temples and the Sphinx Temple.

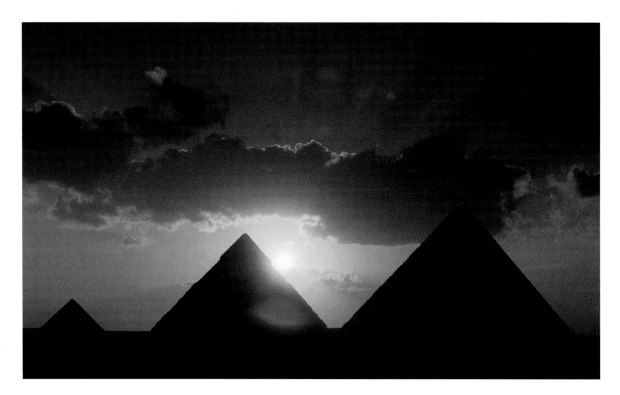

17.23 Solar alignments are discernible in the configurations of the pyramids and other elements at Giza – but are these the result of developments in the solar cult at the time, or did they influence them?

quarried, they deliberately reserved the rock for the Sphinx head and the upper rim of its core body, perhaps already in Khufu's reign. This suggests that the Sphinx, the Sphinx Temple and the Khafre valley temple are situated where they are because:

1 An outcrop of the thickly bedded Member II and Member III stone here could be reserved for the Sphinx and exploited for the large core blocks for the temples.
2 The shift of the Sphinx and the Sphinx Temple axis to the south of the Khafre pyramid axis allowed an alignment with the rising and setting of the sun at its due east and west positions – the equinoxes.

Hence we can see the whole arrangement explained in terms of the physical constraints – the 'challenge of architecture' – but also with hints at the ideological function of the Sphinx complex, namely, an important advance in the solar cult during Khafre's reign. The two of course may be interrelated – the ideological statement made by the monuments may have been partly forethought and partly an ad hoc response as the workforce accommodated Khafre's pyramid complex to the physical constraints. Perhaps the designers saw that by locating the Sphinx and valley complex at just this point, the sun at its most northerly setting would sink below the horizon midway between Khufu's and Khafre's pyramids, creating

the *akhet* ('horizon') ideogram on the scale of acres. One wonders to what extent such dramatic configurations inspired and advanced the solar cult themes, rather than the reverse [**17.23**].

Khafre's ramps

The area south of the Khufu pyramid and west of the Sphinx is filled with the same kind of stone rubble debris that fills much of the west part of the Central Field (see above, p. 444). Old 20th-century photos reveal sections of a linear berm, certainly the remains of a long ramp or embankment, sloping up from east to west in the direction of the Khafre pyramid, along the north side of this quarry. Unfortunately, more recent debris has covered much of this berm, and it has been partially removed by modern machinery in efforts to clear the area, but it shows distinctly in the old photos and its eastern, low end remains uncovered. Where someone has dug into it, we have been able to observe cross walls of fieldstone that are probably retaining walls for debris fill – the same sort of casemate construction of ramps and embankments that we have found other examples of at Giza and elsewhere. The fill is broken stone, limestone chips, tafla and gypsum.

We are looking at the remains of a supply ramp, previously unrecognized, from this quarry up towards the Khafre pyramid, perhaps just one of a series of ramps and embankments that

originally delivered stone up to the pyramid as it rose. We imagine a large linear section of ramp from the eastern quarries running along the north of the Khafre causeway and rising to possibly 30 m (98 ft), above the northeast corner of the pyramid base. From that point, as with the Khufu pyramid construction, the delivery roadway might have been laid on a series of accretions of broken stone and clay that wrapped up and around the rising pyramid like an envelope. Another ramp-embankment might have supported a second delivery road from a deep southern extension of the old Khufu quarry. Together these two great armatures fed stone from the Moqattam Formation's southeasterly rim up to the growing pyramid.

Establishing the layout of the Khafre pyramid
Western upper terrace lines

Builders set the northwest corner of the Khafre pyramid and its court on a terrace that they cut down 10.5 m (just over 34 ft) lower than the original surface of the Moqattam Formation. They began their layout work on this original surface, a kind of upper terrace on the pyramid's west and north sides, and left behind traces of all the major stages of preparing to raise a large pyramid.

On the west side of the Khafre pyramid are the so-called Workmen's Barracks, built on the upper terrace of the original plateau surface (see Chapter 15, p. 361). This upper terrace spans 74 m (243 ft) between the fieldstone wall forming the east side of the barracks enclosure on one side and the edge where it drops to the lower terrace on which the pyramid is built on the other. Three parallel channels run along its length: the first on the east is approximately 15 m (49 ft) from the ledge; the next is about 20 m (66 ft) further west; the third is 20 m further west again, and about 20 m east of the fieldstone wall of the Workmen's Barracks. These channels have never been properly mapped, and are largely sanded in, but they show up clearly in the raking light of the late afternoon sun when viewed from the top of the Menkaure pyramid. They appear to mark quarry strips, and we wonder if they could have been options for Khafre's builders to cut the western limit of the lower terrace where

they would found the pyramid [17.24]. The builders appear to have begun working the bedrock down at the northern end of these channels, beyond the alignment with the north side of the pyramid.

Khafre's builders cut similar channels on the upper terrace surface north of the pyramid; in fact the first, closest to the pyramid, can still be traced running east–west about 10 m (33 ft) from the northern edge of the lower terrace. To the north of this channel, between it and the debris embankment builders left along the megalithic limestone wall that forms the southern border of Khufu's Western Cemetery, the bedrock is mostly quarried away. But between the channel and the ledge that drops to the lower terrace the quarry workers left the original bedrock intact. This isolated strip of natural rock must have served as a ramp or bridge for taking stone from their

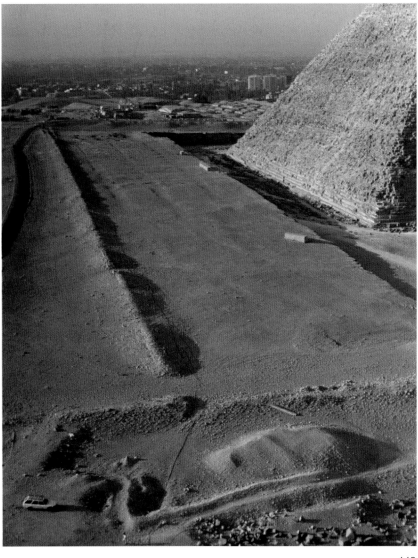

17.24 Narrow channels cut into the upper terrace west of Khafre's pyramid mark quarry strips and possible options for creating the lower terrace of the pyramid. View to the north, seen from the top of the Menkaure pyramid.

quarrying down to the lower terrace, utilizing the natural eastward slope of the Moqattam Formation. We see indications that the builders extended the three channels north of the pyramid beyond the ends of those on the west side, but quarrymen here gouged out the corner. Workers built an embankment to bridge the hole where the two sets of channels met outside the northwest corner of the pyramid, which still exists.

In sum, it looks like quarrying began along these long guide channels to create a much broader lower terrace – wider by 55 m (180 ft) on the west and about the same on the north – which would make it roughly 110–150 m (361–492 ft) wide on the north and south of the pyramid. This larger area would have resulted in Khafre's pyramid being more centred within the lower terrace as defined by a section of the fieldstone enclosure wall on the south, which is 135 m (443 ft) from the south side of the pyramid, and the megalithic boundary wall of the Western Cemetery on the north, which is around 130 m (426 ft) from the pyramid on that side. At some point the quarrymen stopped this operation, leaving just the channel closest to the pyramid on its north side, and most of the three channels on its west, as silent testimony of how they had begun to organize the earliest layout and levelling operations for building the Khafre pyramid.

In 1985 we located small holes at certain intervals along the upper edge of the ledge to the west. These have yet to be mapped, but they could relate to the subsequent decision, perhaps to save time, to lower an area of bedrock closer to the pyramid, reducing the size of the lower terrace, which is 57.3 m (188 ft) wide on the north side and 27.6 m (91 ft) on the west.

The lower terrace: the 'quarry grid'

On the prepared bedrock terrace on the north and west sides of the pyramid, and on the surface of the huge, laid-in limestone blocks on its east and south, Khafre's builders created a bed, about 13.5 m (44 ft 3 in.) wide, for the pavement of limestone slabs of the pyramid court and its enclosure wall. The builders very carefully sloped the surface away from the outer line of the court's enclosure wall, no doubt so that rainwater would drain away from it.

In the northwest corner of the lower terrace a grid pattern of narrow channels divides the bedrock into squares; the grid is orthogonal, but at an angle to the orientation of the Khafre pyramid and its terrace. An oft-repeated idea is that these are a relic of the method Khafre's builders used to quarry blocks to be used in building – the bedrock squares defining the sizes of the blocks that they removed. Another explanation for this grid is that the quarrymen could have flooded channels with water to use as a reference level when they were dressing down the surface.

In our survey work in the mid-1980s in this area we did not find any of the wedge-shaped cuttings along the edges of the squares that might be expected if the quarrymen had used levers to prise blocks from them. Such marks are commonly seen in other bedrock surfaces and quarries at Giza. Furthermore, the channels defining the quarry grid are neither even nor level, and so could not have held a water reservoir for use in levelling.

In fact, this bedrock grid of squares and channels may have had more to do with the creation of the very regular, deliberate, slope of the floor away from the outer line of the enclosure wall down to the north of the pyramid court. The top surface of the quarry grid slopes slightly to the east. Although its surface is not level, it is within 5–15 cm (2–6 in.) of the surface of the level of the socle or plinth for the pyramid casing and for the enclosure wall bed (as measured at the northwest corner). This suggests that the top of the grid squares and the enclosure wall bed and casing socle are the relics of an older surface, and that the square bedrock patches were, like the blocks of bedrock remaining in the unfinished Subterranean Chamber of the Khufu pyramid, allotments for individual workmen to work down to the intended surface.

Survey stake holes, troughs and trenches?

As around the Khufu pyramid, lines of holes can also be found around the Khafre pyramid. However, the nature of the holes and their position with respect to the pyramid are very different, reflecting once again, perhaps, the ad hoc nature of pyramid building at this time. Parallel to the base of the Khafre pyramid on all four sides are distinct lines of small holes, from 30–40 cm (12–16 in.) in diameter at roughly 10-cubit intervals. The most

consistent series is situated along the raised edge cut into the bedrock floor that marks where the outside of the enclosure wall once stood, about 13.5 m (44 ft) from the pyramid base. Along this line, the holes occur in pairs – the first of each pair is about 20 cm (8 in.) from the line of the enclosure wall, while the second ranges from 85 cm to 1.05 m (33 in. to 3 ft 5 in.) from the line. The holes of each pair are staggered with respect to each other by varying amounts, from 20 cm to 1.64 m (from 8 in. to 5 ft 5 in.). In contrast to the rectangular holes around the Khufu pyramid, they are always round, with diameters ranging from 30 to 47 cm (12 to 18½ in.). The pairs suggest that lines were run twice, with the stakes or posts positioned in at about the same place, but offset slightly and by varying amounts. The distance between the holes on each of the double lines most often ranges between 5.2 and 5.3 m (17 to 17 ft 5 in., or 10 cubits), although it can be as much as 5.12–5.87 m (16 ft 10 in. to 19 ft 3 in.). These spacings clearly show no pretence to accuracy.

On the east side of the pyramid, where the enclosure wall runs to the rear of the upper temple, the wall's outer line is weathered and it is difficult to trace this outer series of holes. But a more regular and well-defined line of double, staggered holes runs 9.1 to 9.9 m (30 to 32 ft 6 in.) from the pyramid base, a distance that puts them close to the inner side of the enclosure wall. On the other three sides of the pyramid it is the outer series that are double, staggered and more pronounced. We wonder if the inner line is more defined on the east because this was the best side of the pyramid for sighting to true north as the view is unrestricted.

Could these series of holes be for stakes used by the pyramid surveyors, as we suggested for the holes around Khufu (though the latter were different in shape, spacing and positioning)? Or could the holes have been for scaffolding to dress the enclosure wall? Holscher mapped similar holes in the bedrock floor of the Khafre upper temple, where he interpreted them as sockets for scaffold posts to dress the court statues. Similar holes can also be seen spaced about every 10 cubits down the axis of the Khafre causeway, where they would not have functioned as scaffold sockets.

Khafre's builders also cut trenches into the bedrock at the four corners of the pyramid court,

which are connected to the slight but clearly discernible trough or impluvium fashioned in the bedrock of the court itself (see Chapter 9, p. 201). While this system may well have had both the practical and perhaps ideological purpose of collecting and storing the rainwater that flowed off the pyramid faces, we have also considered the possibility that the pyramid builders used the court troughs and trenches, together with lines carried on posts in the series of holes, as a system of levelling and laying out the final 'cut' of the pyramid base, court and enclosure wall (see below).

Levelling

In spite of a long-held notion that builders prepared a level surface as a base on which to build the pyramids, we see again that this is not the case at the bottom of Khafre's pyramid. The builders left a natural bedrock massif rising in steps several

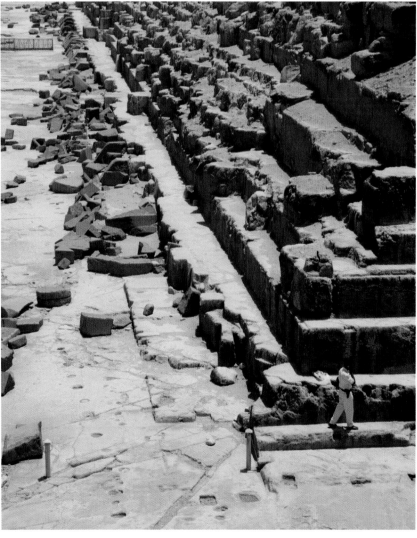

17.25 View to the north down the level top of the bedrock and masonry that backed the first course of casing in granite of the Khafre pyramid. Robbers left pieces of granite casing blocks scattered down the line. In the foreground is the emplacement or socket for the very large, rectangular granite corner stone, flanked by small square sockets for levers that workers used to lower it into place. On the left is a line of holes of unknown purpose.

metres high in the pyramid core, along the base of which the masons cut a wide panel into sockets of various depths to receive the individual granite casing blocks to bring them flush at the top (it was easier to cut away the natural limestone of the base than the much harder granite). The height of the casing socle varies by as much as 35 cm (14 in.) from one emplacement to another.

Thus the cross-section of the bedrock underlying Khafre's pyramid consists of the natural massif left isolated in the core, the casing socle, with 'seats' for the individual blocks of the lower granite casing cut to various heights, the court impluvium, the enclosure wall bed and the slope away from the pyramid court – all of which the builders carefully sculpted as a set piece. And this was the final stage in the process of laying out the pyramid base through the successive approximation of the lines and orientations that had begun 10.5 m (34 ft) higher at the northwest corner, with the layout channels on the original plateau surface. The builders only created the actual baseline of the pyramid when they laid in the limestone paving across the 10.1 m (just under 34 ft) width of the court, bringing it up against a vertical foot cut into the bottom of the granite casing blocks so that the top surface of the pavement met the bottom of the pyramid slope.

Based on the evidence of the unfinished granite casing at the Menkaure pyramid (see below), cutting the foot in the bottom of the casing to create the pyramid baseline might have been the last operation the pyramid builders performed, as they removed the extra stock of stone on the outer face of the casing. To do this, they would have needed some outside reference line for control and we might envisage a taut and levelled rope carried on pins fixed into posts or stakes set in the series of holes discussed above that surround the entire perimeter of the pyramid. From this line the builders could accurately measure 90-degree offsets of a fixed amount to determine the final line of the base of the pyramid as the masons dressed back the extra stock of stone on each block, and then laid in the pavement up flush.

When they needed to bring in large blocks in the early stage of setting the pyramid casing, they could pull up some of the stakes while still maintaining most of the line, then reset them by careful extrapolation from sections of the line left in place.

One of us (Lehner) has in the past hypothesized that the builders might have cut all the stakes to the same height with reference to water that flooded the court troughs or impluviums around the base of the pyramid – once they had been filled to a certain height, the excess water could have been drained off through the corner trenches.[17] However, one argument against this is that the impluviums seem too shallow (40 cm/16 in. maximum), and water would evaporate too quickly. Another suggestion, perhaps more probable, is that the 6-m (20-ft) long deeper parts of these troughs were 'leads' that the quarrymen sunk deeper into the bedrock, ahead of their general levelling, as they worked the bedrock down in a series of successive approximations to the final lines and orientations on the lower terrace of the pyramid.

Whatever controls the builders used to achieve the straightness of their lines, their orientations and levelling, they had to be able transfer them and maintain them as they laid in the masonry around the isolated bedrock core as the pyramid rose. And we have to admit that we have no clear picture of the actual steps in how they did this. However they achieved it, it does appear that the top of the first course was the builders' datum for extremely fine levelling control [**17.25**]. The top of this course and the enclosure wall bed are the most level surfaces around the Khafre pyramid – our spot height measurements using a modern surveyor's level show an average difference in level between the northwest and southwest corners of just 3 cm (1³⁄₁₆ in.).

Khafre's core and casing

Our interpretation of how Khafre's builders controlled the pyramid shape, its square, slope (rise and run) and orientation, duplicates many of the same questions and ambiguities encountered in our understanding of how Khufu's builders managed the same or similar tasks. Here, we will mention just some features that hint at the procedures of this next generation of pyramid builders.

We have often stood at the base of Khafre's pyramid and looked up as the raking light of the sun passed across one of the lofty diagonals that rise to the intact casing at the summit. At the southeast corner in particular, highlighted in the

contrast between the shaded eastern face and illuminated southern one, we can see how core and casing appear to be two distinct, but conjoined, constructions. Above the rubble and scree-like accretion that covers the lower two-thirds of the pyramid body, the sharp corners – the arris lines – of the more regular, stepped masonry and the intact casing where the two faces meet show perceptibly different orientations.

We have also climbed high up the pyramid to the point just below the overhang of the intact casing, and looked back down the corner to the southeast. There we can see a series of notches, similar to the carved axis markers on the lintel of the entrance of queen's pyramid GI-a and on the back wall of the Menkaure upper temple. Here, roughly on line with Khafre's southeast diagonal, the notches extend across the rock floor, ranging from 14 to 18 cm (5½ to 7 in.) wide and from 30 cm to 1.06 m (12 in. to 3 ft 6 in.) long, and separated by stretches of floor between 2.3 and 3.3 m (7 ft 6 in. and 11 ft) long. This must surely be the kind of backsight that architects and engineers and pyramid-building theorists, such as Clarke and Engelbach, have long suggested the ancients used to maintain their building lines as the pyramid rose.

But used for which of the differently orientated arris lines – core or casing? Probably the core, because the notches, again, have no pretence to great accuracy, and the stepped courses of the core, while regular, are far cruder than the fine Turah-limestone casing.

In fact those core stepped courses superficially appear sufficiently regular that some theorists have taken them as the control for the rise and run – therefore the slope – of the outer faces of the fine casing stone, or as stepped working platforms for levering stones up the pyramid face. During one of our climbs up Khafre's southwest corner we took notes on the masonry from the bottom up – and at close range neither suggestion seems probable.

The 'more regular' upper core courses range in height from 0.85 to 1.2 m (2 ft 9 in. to 3 ft 11 in.), and the widths of the 'steps' – the tops of the blocks left exposed by the set back of the course above – also vary from 0.58 to 1.1 m (1 ft 11 in. to 3 ft 7 in.). This is just too narrow to have served as platforms for workers levering blocks up the face of the pyramid. Furthermore, we noted that the masons cut the

tops of these steps into a rebate, or shallow step, probably done on the spot to receive the backing stones between the blocks and the outer casing. This further reduces the available flat surface – for example, the rebate on a step 75 cm (29½ in.) wide leaves only 43 cm (17 in.) of more even surface.

We also see that while the blocks of this more regular stepped core masonry are roughly squared, the front faces and corners bulge and are rounded. This is not the result of weathering – on many blocks the original pecked or pounded surface is still visible (the workers appear to have shaped the blocks by pounding rather than chiselling). The irregularity of the blocks is revealed further in the variations in the spaces where they join one another. Behind these stepped courses, here and there in gaps, we can glimpse the fill consisting of large limestone pieces (they can hardly be called 'blocks') that are even more irregular, trapezoidal and pointed. Overall, then, none of the pieces of the core masonry, neither in the fill nor the apparently more regular stepped courses, is a cube or well-planed block such as might be thought necessary for fine control of pyramid lines.

Articulation of core and casing

The backing slabs – stones that filled in between core and casing – also range considerably in height or thickness, the thicker ones probably serving as backing for two casing stones. On one bright sunny day when we climbed Khafre's southwest corner at noon we edged our way across the southern face of the pyramid to a point just under the overhanging casing in the centre of the face. We noted where the masons laid two courses of backing stones, 51 and 44 cm (20 and 17 in.) thick, against the face of one course of the stepped core and fitted a lower, third backing stone, step-like, into the shallow rebate that they cut into the course of regular masonry below. Above these three backing stones, the masons then set a large casing block, so that its underside overhung and was not in contact with the top of the next step in the regular core masonry, leaving a gap of 21 cm (8 in.).

The wide gaps between core blocks and backing stones and beneath the casing block were filled with debris. The stepped core was built first and at this particular spot the masons used the three backing stones and debris fill as a bed for laying down the

17.26 Casing stones, backing stones and core stones intact at the southwest corner, south side, of the Khafre pyramid, looking northwest. The front faces of the casing stones are not flush, but stagger by millimetres.

casing. There was thus no direct articulation here between the core and the casing.

But it is hard to generalize this into a standard practice, because just slightly further west, the undersides of casing stones are at about the same level as the tops of the stepped core masonry – that is, the coursing of the casing 'catches up' with the steps of the core masonry. Altogether, the evidence suggests ad hoc fixing and modifications as the pyramid rose, with the builders adjusting things at intervals to keep control of the square of the pyramid and to ensure that its diagonals would meet at the apex.

On another day we climbed up the opposite, northeast, corner of the Khafre pyramid, again taking notes on the masonry on the way up. We even braved the challenge of vertigo to peer out and up over the vast sheet of casing where it jutted out from the core masonry on which we were standing. The casing stones are certainly well planed on their outer face – fine, homogeneous Turah-limestone tanned with the patina of age. They show no standardization of size, with courses we could measure ranging from 35 cm to 82 cm (13–32 in.).[18] It was also apparent that the outer faces of the casing stagger in and out by a few millimetres, rather than being flush, as we might expect if the masons had trimmed them in one operation from the top down [17.26]. Perhaps, as noted in Chapter 9, in the tight confines near the top, where the planes of the pyramid shrink towards the apex, they had to use another method, such as cutting the slope into the face of each of the stones before setting them. It is also possible that the stones have shifted

and settled as robbers, thousands of years later, pulled the stones off the pyramid lower down. And we should note that not all of the dressed (granite) casing stones on the Menkaure pyramid are flush, and these were certainly dressed in place (see 17.29).

Alignments of Khafre's valley complex

The features that we took to be markers left by the ancient surveyors in the Khufu and Khafre pyramid courts prompted us to search for any possible equivalents that might trace the alignment between the south side of the Sphinx Temple with the south face of the Khafre pyramid. If extended down the plateau, the line of the south base of the pyramid falls on a prominent seam running through the massive core work of the southwest corner of the temple. Since the south wall of the Sphinx Temple is angled slightly southeast–northwest, the line of the pyramid base falls on the north side of a rock-cut trench or socle just in front of the temple's southeast corner. Herbert Ricke saw the trench as marking the original northern enclosure wall for the valley temple, which, according to his reconstruction, was removed when the Sphinx Temple was built.

Ricke also concluded that the seam running through the core work of all four corners of the Sphinx Temple marked the outside of the walls of the temple in its first building phase.[19] The north and south colonnades of the temple (with the additional 12 pillars making up the total of 24 for the colonnades) were added after the interior of the temple had been largely finished with granite sheathing. To accommodate the addition, the central sections of the north and south walls were pushed back, and great limestone core blocks were added to the outside corners of the temple, which were never finished off. The alignment with the south side of the Khafre pyramid therefore falls on the exterior line of the original south wall of the Sphinx Temple at the southwest corner in its first building phase.

A long and narrow trench runs just under the south wall of the Sphinx Temple, about 12 m (39 ft) west of the front corner. Ricke interpreted this as a drain that served the lower terrace before the erection of the Sphinx Temple. However, it does not seem to lead to any point that might serve this

purpose, and its south end is cut vertically, rather than at a gradient, which we would expect if it were a drain. Could such trenches, like those at the corners of the Khafre pyramid, have been used as 'leads' for dropping down a control or reference point when bedrock was being quarried away at a place where an alignment was desired? We might also compare the 'drains' to the channel marking the axis of an unbuilt pyramid over the so-called Trial Passages east of the Khufu pyramid (see p. 428).

If the extremely long east–west alignment between the Khafre pyramid and the Sphinx Temple was indeed more than fortuitous, and if it was orientated to the east–west line of the equinoctial sunrise–sunset, it might seem reasonable to expect some kind of backsight marker at the highest point of the formation to the west of the Khafre pyramid. In fact, we located another rock-cut trench at this point, apparently on line with the south side of the Khafre pyramid and close to the main traverse survey point (GP7) of the Giza Plateau Mapping Project.

Stone hauling

In our excavations in the northeast corner of the rock-cut sanctuary in which the Sphinx sits we uncovered features cut into the levelled floor that testify to the way the 4th dynasty Egyptians moved the unusually large limestone 'core blocks' destined for the Sphinx Temple walls. The cuttings represent the last blocks the quarrymen removed from the sides of the Sphinx ditch for constructing the upper course of the northwest corner of the Sphinx Temple, which they never completed.

The most prominent features were wedge-shaped holes, each just wide enough to take a large wooden lever, which occurred in groups of three. All the cuttings slope down to their deepest part, ending with an almost vertical face. They record where the quarrymen inserted three thick levers underneath blocks as they rested on the bedrock floor, in order to raise and move them incrementally. The kind of wooden lever that would have been needed to move such a multi-ton limestone block is represented in the lower register of the scene of hauling a large colossus in the El-Bersheh tomb of Djehuti-hotep, where three men are needed to carry a large wooden beam with a series of notches cut into one side (see 16.12).[20]

We identified one such set of three lever sockets under the end of a large core block that had been brought up into position next to another block. The masons had already cut the ends of the two blocks parallel, at angles to the outer sides, so that they would join neatly when placed in their

17.27 Wedge-shaped cuttings in the underside of a massive, multi-ton core block in the western wall of Khafre's upper pyramid temple. They served as sockets for the ends of thick wooden levers that workers used to move and adjust the block.

final position. But it appears that the builders had abandoned these large core blocks, and another higher up on a bank of Old Kingdom debris, en route to their intended locations on the third course of the northwest corner when they suddenly stopped work on the entire complex.

Such wedge-shaped lever sockets are revealing, because they track exactly where the Egyptians moved large stones, and testify to how they did so, with rows of men handling large levers. We have also found lever sockets cut into the bedrock floor under the edges of core blocks still in place in the temple walls. Core blocks forming the southern wall of the Sphinx Temple and Khafre's upper pyramid temple have the lever sockets cut into their lower edge, rather than into the floor beneath them [17.27]. Elsewhere, we have identified long rows of such lever sockets on the bedrock floor of the western Central Field quarry in excavations near the western side of the Khentkawes monument and also cut along the softer, marly limestone beds in the Menkaure pyramid quarry.

III. The Menkaure project
Selecting a site

Menkaure's surveyors positioned his pyramid to continue and complete the great northeast–southwest Giza diagonal. Looking back from the southwest to the northeast, a line cuts the diagonal of Menkaure's first queen's pyramid (GIII-a), touches the southeast corner of his pyramid (GIII), cuts the diagonal of his upper temple, passes the southeast corner of the Khafre pyramid (GII) court, cuts the diagonal of the front part of Khafre's upper temple, touches the southeast corner of Khufu's pyramid (GI), very nearly cuts the diagonal of his first queen's pyramid (GI-a) and ends in a large block of masonry built into the northeast-facing escarpment.

There are other alignments on the Giza Plateau too. Menkaure's surveyors also roughly aligned the front of his upper temple to the west, rear side of Khafre's pyramid, just as Khafre's surveyors aligned the front of his upper temple to the west side of Khufu's pyramid. We can only speculate at the meaning, beyond aesthetic sensibility. The great diagonal was probably related to the direction (to the northeast) of Heliopolis, centre of the solar cult, across the Delta apex. It is in these generations of Giza pyramid builders that kings began to call themselves 'Son of the Sun'.

By now the Giza pyramid diagonal was also parallel to the main quarries, which extended from the Sphinx about 1 km (0.6 miles) to the southwest. It may be that continuing this line had a practical imperative as well, for the fact that Menkaure's pyramid was situated with its southeast corner on the great diagonal meant that his complex was nearing the south-southwestern limit of the Moqattam Formation bedrock exposure, with its ideal bedding for extracting large blocks.

Menkaure's quarry

The horseshoe-shaped Menkaure quarry is just southeast of his pyramid [17.28], and as in the much larger Khufu quarry in the western Central Field, the workers cut into the slope of the Moqattam Formation to create a taller vertical exposure of the natural limestone beds from which they could extract their blocks. And also as in the west Central Field quarry, people of higher status later exploited the deep, northern face of the Menkaure quarry to carve their rock-cut tombs. Between their masonry additions to the rock face, we can still see lines of wedge or lever sockets, placed in rows along a softer yellow limestone layer. Having separated the block around three sides, the quarrymen would prise it up from the lower layer, probably using wooden levers. Another vertical exposure of the bedrock quarry walls to the east reveals narrow channels, the vertical definitions of huge limestone blocks no doubt intended for the core walls of Menkaure's pyramid temples (most probably the valley temple), which mark the end of Giza's megalithic masonry tradition.

The upper edge of the quarry is sufficiently exposed at several points to allow us to get a measure of its overall size: 200 m (656 ft) long northwest–southeast by 100 m (328 ft) wide, and about 12 m (39 ft) from its high northwest edge (about 60 m/197 ft a.s.l.) to the sand filling the bottom (about 48 m/157 ft a.s.l.). However, to our knowledge no one has excavated to the central quarry floor. Our remote sensing using electromagnetic conductivity (EM), with Tremaine and Associates, indicates the sand is at least 3 m (10 ft) deep. A rectilinear anomaly indicates a

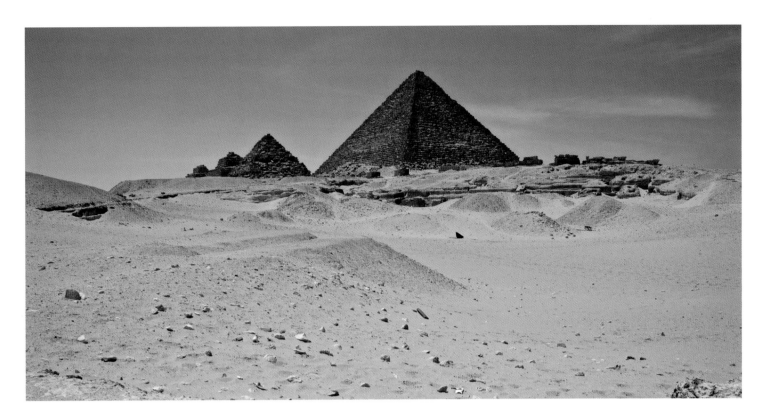

structure, which we can possibly discern in faint surface contours. This might be a rectangular enclosure built onto the northeast side of the quarry. If the quarry volume is reckoned to be around 300,000 cu. m (10,600,000 cu. ft), it compares very favourably with the calculated 260,000 cu. m (9,182,000 cu. ft) of the Menkaure pyramid volume and the estimated 60,000 cu. m (2,120,000 cu. ft) of his temples, causeway and queens' pyramids, giving a total of 320,000 cu. m (11,300,000 cu. ft).[21] Here, as Reisner and Dows Dunham speculated, is the discrete hole that produced the pile that is Menkaure's pyramid.

As discussed in Chapter 11, the unfinished state of the Menkaure pyramid complex has left us many 'frozen construction moments', not the least of which is the tableau we find around the quarry. Beyond its low southeastern edge, an industrial settlement of fieldstone walls, houses and hearths for baking and copper work nestles in an acute elbow bend of a massive fieldstone wall, part of the wider enclosure of fieldstone walls around the upper part of the Menkaure complex (see also Chapter 15, p. 363). Here, we imagine, the quarrymen retired at the end of a day's work, and members of their team worked on a large cache of Egyptian alabaster for statues or, perhaps, for an alabaster paving for Menkaure's temple (although it was never begun). Their overseers probably occupied the several houses placed here and there

about the court. Some of the quarrymen may have slept in long galleries, not unlike those we found in the Workers' City south of the Wall of the Crow (Chapter 15). These galleries attached to the outside of the massive north–south fieldstone enclosure wall, and to another wall running west, parallel to the Menkaure causeway, and some 78 m (256 ft) south of it, which further enclosed the quarry yard on the north.

Menkaure's ramps and causeway

Although they never finished dressing down the lower 16 or more courses of the pyramid's granite casing, the builders do appear to have removed any ramps or embankments that might have been in place against the pyramid when Menkaure died and his successor, Shepseskaf, had to complete the project quickly.

In spite of this removal, our work has exposed what might be the nearest thing to a pyramid supply and construction ramp ever found at Giza. This discovery came just at the point where the axis of the Menkaure causeway crosses the western ledge of the Khufu quarry in the western Central Field. By Menkaure's reign, this quarry had been deeply exploited, and three of Khafre's senior children had cut their tombs into the bedrock of the western ledge north of the Menkaure causeway line.

17.28 A view looking into the mouth of the horseshoe-shaped quarry southeast of the Menkaure pyramid that may have provided stone for the pyramid.

The ancient Egyptians bridged the gap caused by the quarry with a huge bank of debris. In 1980 Cairo University excavated into the southern side of this bank and uncovered a striking portion of the terraced western wall of the quarry. Horizontal and vertical red-painted lines and cubit notations stood out still fresh against the white limestone exposed after centuries of being protected by the debris. At the bottom of the terraces and debris, the excavations uncovered two blocks that quarrymen had dislodged from the bedrock but yet not dragged away. In the channel left between the blocks and the quarry wall, a faint mark could be seen on the rock with a cartouche that appeared to be Menkaure's.

Then, in 2004, the Giza Inspectorate excavated the top and northern side of the debris bank. A fieldstone retaining wall on the north had been increasingly exposed by the horse and camel tourist traffic. It turned out to be the top of a third course of accretion walls supporting a ramp, 11 m (36 ft) wide, that ascended the nearly 10-m (33-ft) high western quarry ledge. The three tiers of leaning walls were composed of desert marl clay, mud and broken limestone, and retained limestone rubble fill. Leaning in towards the centre of the ramp, the walls are built as accretions, their tops forming steps like the old step pyramid masonry of the 3rd dynasty. The base of the ramp thus formed is at least 20 m (66 ft) wide, and possibly wider because a lower, fourth tier, might remain buried in the debris fill. The excavations also exposed one of the upper retaining walls on the south of the bank, which had been masked by later debris.

It is significant that the three-tier ramp is shifted north of an alignment with the actual axis of the Menkaure causeway. As part of the 2004 excavations the Giza Inspectorate also re-exposed sections of the mud-brick causeway walls and pavement further west up the slope of the plateau, where Reisner had uncovered them during his work nearly 100 years earlier (only the bottom course of bricks remained). A survey and extrapolation of the lines of these walls, and of the stone walls of the entrance hall of the Menkaure upper temple, showed that the axis of the causeway would cross the western quarry ledge about 10 m (33 ft) south of the three-tier fieldstone ramp. The ramp therefore was probably built for construction purposes, perhaps to take blocks from the southerly extension of the western quarry face

to the upper monuments of the Menkaure complex. Although it is an impressive, solid structure, ascending more than 10 m (33 ft) of the height of the quarry face, such ramps and embankments could be easily broken up into their constituent materials: desert marl clay and pieces of stone. This ramp offers a glimpse of the kinds of ramps and embankments that must have risen to even greater heights with the pyramids as they were built.

When the builders came to extend the pyramid causeway directly east over the quarry edge to continue to the valley temple, they realized the line would miss the axis of the ramp. So they tipped additional debris over the southern side of the ramp, creating the bank of debris that buried the terraced western face of the quarry.

Although Reisner located the causeway corridor where it met the back western wall of the Menkaure valley temple, the Giza Inspectorate found no trace of its mud-brick walls on the debris bank. They did, however, discover two mysterious mud-brick pillars, which might have been built up incrementally through the debris as it was dumped, and which were perhaps intended to mark the axis of the causeway where it was to cross the quarry ledge. It is possible that workers under Shepseskaf never completed this stretch of the causeway, leaving another 'frozen construction moment' that today informs us of their operations.

Layout and levelling of the Menkaure pyramid

At the northwestern corner of the ground around the Menkaure pyramid, we see the same kind of grid pattern of removal channels isolating squares of bedrock as at the northwest corner of the Khafre pyramid terrace. And as there, the grid is a system to control the labour force in dressing down the surface, rather than marking a process of extracting blocks.

From our study of the Khafre pyramid we realize that the builders created its final base, court and enclosure wall bed, and the outer terrace as a set piece – the final stage in a process that began with the original sloping plateau surface, some 10.5 m (34 ft) higher on the northwest. Menkaure's builders faced the same kind of situation, though the difference in height between the original

surface and the intended pyramid base was not as great as for Khafre. But, just as the masons did not finish dressing down the casing, so they had only just begun the work of dressing down the broader terrace and came nowhere near completing the vast bedrock planes that so uniformly slope away from the pyramid court around Khafre's pyramid.

So Menkaure's builders did not create a flat, level surface under the entire pyramid, and they had only just started to create the surrounding terrace, even though the pyramid stood complete. As described in Chapter 11, they left the northwest base of the pyramid in a trench, 1.7 m (5 ft 7 in.) deep, cut into bedrock. They could have removed the outer side of this trench if they had reached the stage of levelling the terrace.

After Menkaure's death his son and successor Shepseskaf finished his father's temples with a casing of plastered mud brick. As part of his hasty completion of the complex, his masons built an enclosure wall of mud brick over the uneven surface around the pyramid. Reisner found a part of that enclosure wall on the east side, where it met the western wall of the upper pyramid temple.

Menkaure's core and casing

Menkaure's builders used imported red granite for the lowest 16 courses of his pyramid casing. The fact that they never completely dressed this casing to achieve the flat, sloping planes of the pyramid faces offers us another picture of the way they incorporated the rise and run of the pyramid slope into the casing as they set it in place.

Menkaure's masons followed the same procedure as Khufu's workers had on his queens' pyramids, although their task was now literally much harder because the casing is granite instead of Turah limestone. When they moved one block next to another in a course they hammered and pounded (rather than chiselled, because this is granite, not soft limestone) their join faces parallel to ensure a good fit and extended the line of the join beyond the intended plane of the pyramid face. Before they set the blocks in their final position, they marked the line of the pyramid slope on the side and top of each, straightening and checking the continuous line along the top of the whole course as they composed it, block by block. They then

hammered away the join between casing blocks, crudely bevelling or chamfering away from the line and leaving a protrusion of extra stock on the front. Looking at the whole from the outside today, as every visitor does, the casing looks like a series of protrusions of rough, bulbous stone on the face of each individual block [**17.29**].

Apart from one dressed patch on the northern pyramid face around the entrance and another behind the inner chapel on the east, all the granite casing blocks have this rough extra stock of stone projecting from a sloping line of about 51 degrees that represents the final intended pyramid face. On the finely levelled upper surface of the blocks of the highest course of intact casing stone on the northern pyramid face we can see a continuous straight line running along the entire length of the of the course. This is the line where the pyramid face intersects the projecting extra stock of rough granite and forms the masons' insurance. Had they ever reached the stage of dressing the face of the granite casing they would know just how much stone to remove, and when to stop, to achieve the flat, smooth plane sloping at the correct angle, without waves or undulations. One interesting aspect is that the extra granite beyond this line is darker, perhaps the patina of age-long exposure, or perhaps the traces of mud-brick ramps or even the use of fire.

Menkaure's masons did manage to complete the upper limestone casing, as shown by fragments with worked faces in the debris around the base. However, none of this limestone casing remains in place.

17.29 Extra stock of stone was left protruding from the granite casing on the northern side of the Menkaure pyramid. Masons bevelled the edges of each protrusion back to the line of the pyramid face, which they freed in a patch around the entrance (foreground). Hieroglyphs remain here from an inscription that invoked Menkaure's (reconstituted) burial, probably dating to the Saite Period.

Menkaure's baseline

The fact that Menkaure's masons did not dress the courses of granite casing down to the base or level the surrounding court and terrace outside the pyramid enclosure creates problems for our understanding of how pyramid builders controlled levels for the rising courses as they built the pyramid. It also means of course that any 'precise' baseline measurements, on which many theories are founded, can only be theoretical.

While the base of the Menkaure pyramid has never been completely excavated, Petrie did manage to locate the foot of the casing at some points around the perimeter. As with all the granite casing blocks, the builders had bevelled the outer faces, following the intended slope line of the pyramid face, as described above. At the base, this slope ended about 15 to 46 cm (6 to 18 in.) above the foundation, indicating that Menkaure's builders, like Khafre's in the previous generation, would have dressed a vertical foot at the bottom of the lowest casing course, and that the pavement of the court, when laid, would have met the top of this foot, finally forming the true baseline. Thus, contrary to what we might expect, the clean baseline was the final, rather than the first, task of creating the pyramid.

The result is that there is no true baseline of the Menkaure pyramid. We have only the bottom of the slope that the masons had bevelled into the side joins of the granite casing blocks, which stops at different levels. In which case, how did they control the pyramid's square? The great differences in thickness of the blocks of the lowest course (from 1.11 to 1.4 m/3 ft 8 in. to 4 ft 7 in.) means that the builders could not have used the bottom as their base reference for control. However, while leaving the bottoms at different levels on the rough foundation they made the top of the first course level and flush.

Like Khafre's builders, Menkaure's masons must have used the top of the first course as their reference. When laying the bottom course they may have used a temporary outside reference line, and perhaps we might find traces of this in the form of the lines of holes, as around the Khufu and Khafre bases (see above), if the area around the pyramid was completely cleared.

Megalithic temple masonry

In the unfinished state of the pyramid temples, especially the upper temple, Menkaure's builders left us abundant evidence of their construction methods and procedures. They continued the tradition begun by Khafre of using locally quarried limestone monoliths for the core of the temple walls, hence the term 'core blocks'. Reisner calculated Menkaure's heaviest blocks weigh some 100 to 220 tons.[22] He also noted that the builders had dressed the upper temple platform to receive each of the core blocks of the walls individually.

While the rest of Menkaure's upper temple was hastily finished off in mud brick by Shepseskaf's masons, the southwestern part remained as it had been left at Menkaure's death, and this included evidence of how the builders raised the enormous core blocks into position in the upper courses. In the large space of Room 10 the builders created a construction plane or ramp of limestone rubble, retained by a stone-rubble wall; on this were two platforms at the level of the first and second courses of core blocks. Reisner believed the workmen dragged the last colossal core blocks up through a gap in the west wall of the temple, near the southwest corner.[23] Just behind this wall, Reisner found another construction plane or ramp of worn boulders that he believed was used in a later period for building the inner temple tucked between the main upper temple and the pyramid. But we wonder whether Menkaure's builders might also have left this ramp when their construction work stopped, having used it to drag the heavy core blocks up through the gap in the western wall into unfinished Room 10.

If it had been completed, the whole upper temple would have been cased with granite, but when Shepseskaf finished it, his masons covered any of the granite casing that had been put in place, as well as areas that had not yet been sheathed, with a thicker casing of plastered mud brick. Reisner peeled off this mud brick, revealing both the granite and also the bright red masons' marks, levelling lines, cubit notations and the names of work gangs painted on the fresh limestone surfaces of the core blocks that had remained protected until that time by the mud brick.

We can thus see exactly the point the builders had reached in adding the granite casing when

work stopped, presumably because Menkaure died. Although the pyramid casing had not yet been fully dressed down, Menkaure's masons had completed the granite casing in the western recessed bay and the deep hall of the upper temple, some of which was later robbed. They had also begun, but not finished, adding the casing in the temple's entrance hall and parts of the court, which had been destroyed before Reisner's excavations. Beyond this there were single granite blocks in place, or nearly so, in the porter's room and in the southern portico, and rows of casing blocks in the northern corridor that leads back to the inner temple doorway [17.30]. The impression we get is one of crews working rather haphazardly, and possibly slowing down.

The long corridor shows their procedure as they added the casing. Starting in the centre, the builders had begun to sheath the walls with black granite blocks, each weighing 4 to 5 tons. Reisner observed that, as with Khafre's pyramid casing and the granite sheathing of the Sphinx Temple, the masons cut emplacements in a foundation platform individually for each granite block. They also cut deeply into the softer limestone of the giant core blocks to accommodate the different widths of the granite blocks to bring their front faces flush. Here, instead of chamfering or bevelling the excessive stock of stone away from the joins as they did on

the red granite casing on the pyramid, they did the opposite, leaving a ridge of extra stock on each block just along the joins, so as not to splinter the join edges as they pounded the front faces smooth. They must have intended to work the excess stone ridge away later, more carefully, but never reached this stage. At the same time, another team at the southeast corner of the corridor was engaged in removing any excess stock of stone on the core blocks to make them ready to be custom cut to fit the individual granite casing blocks. Then, apparently suddenly, the workmen stopped, and the blocks of stone retained the evidence of exactly what task they were engaged in at the precise moment the work ceased.

All the features, marks, sockets, scorings and tool strokes discussed in this chapter may perhaps seem individually insignificant, and are certainly generally overlooked, but in fact they offer us some of our best and most compelling evidence of how the Giza pyramids were built – an achievement that some regard as not humanly possible. In answer to such doubters, these are the traces left by the tools, techniques and operations, and the individuals – quarrymen, masons, labourers, overseers and craftsmen – who achieved such incredible feats.

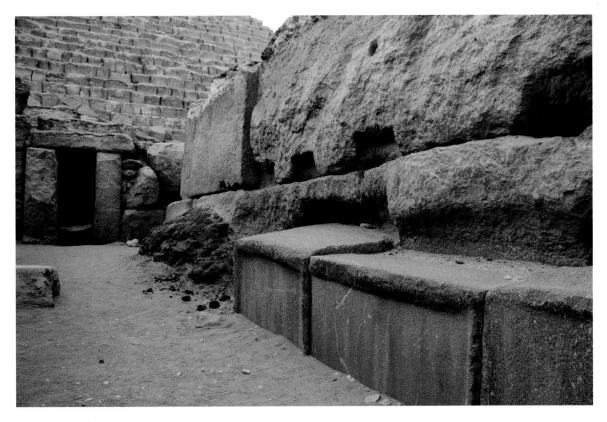

17.30 Dark granite casing blocks on the north side of the northern corridor of the Menkaure upper pyramid temple. Such casing was intended to cover completely the enormous limestone core blocks, one of which, above, has lever sockets on the underside. Shepseskaf finished the casing instead in plastered mud brick, some of which remains in a heap. The doorway leads to the temple's inner offering hall. View to the west-northwest.

CHAPTER 18
The abandonment of Giza

One remarkable fact in the history of the Giza Necropolis is that

this great cemetery and its massive monuments, now so well

known and celebrated, stood almost completely abandoned by

the ancient Egyptians from the end of the Old Kingdom to the

dawn of the New Kingdom, a gap of almost 600 years.

Transition

Certain texts in Giza tombs indicate that there was no dramatic political break in the transition from the 4th to the 5th dynasty, with several officials clearly spanning the two. Khafre's son, Sekhemkare, served under successive kings from the end of the 4th dynasty – Menkaure and Shepseskaf – to the beginning of the 5th – Userkaf and Sahure – as he recorded in an inscription in his tomb (G 8154). An official named Netjerpunisut was in royal favour from the reigns of Djedefre to Sahure, while Ptahshepses, High Priest of Ptah under Niuserre, had been brought up in the households of Menkaure and Shepseskaf.

Priests of Khufu, Khafre and Menkaure are known from the 4th dynasty to the end of the 8th dynasty (four priests of Khufu are known from the 8th dynasty, and one each for Khafre and Menkaure). But in the 6th dynasty the tomb texts cease to mention 25 of the 64 known estates of Khufu, and of the 53 estates attested for Khafre, only one dates with certainty to the 6th dynasty.[1] While such individuals as Qar and Idu (see Chapter 7) continued to hold titles connected with the Giza kings, the economic power of the royal pyramid complexes of these rulers was in decline in the later Old Kingdom. Nevertheless, the same texts indicate continuity of service in the Giza temples through the 5th and 6th dynasties.

The evidence from archaeology at Giza complements that from the texts. In the early 20th century Uvo Hölscher's excavations uncovered evidence that the Khafre temples had remained in use to the end of the 6th dynasty. He noted that the exterior sides of stones that capped the tops of the walls of Khafre's upper temple showed marked weathering, whereas the sides that joined to other stones were not eroded, indicating that the temple stood intact to its upper levels for a long time.[2]

It is fairly certain that a series of Old Kingdom rock-cut tombs created in the north cliff of the great amphitheatre in which the Sphinx lay was begun after the giant statue was created; some of the higher tombs in the cliff were probably much later, perhaps New Kingdom, cut when the lower tombs were already buried in sand. Of the total of 18 tombs, three were inscribed, revealing that they belonged to Ankh-re, In-ka-f and Kai-wehemu. In-ka-f was a Prophet of Sahure of the

5th dynasty; the other two inscribed tombs could be either 5th or 6th dynasty. According to Selim Hassan, all the tombs except that of Ankh-re were left incomplete.[3] So although kings of this time had moved away from Giza to build their pyramids at Saqqara and Abusir, courtiers continued to construct tombs in the principal cemeteries at the old royal site throughout the 5th and 6th dynasties, up to the very end of the Old Kingdom. In the 5th dynasty we see at Giza a surge in tomb building, or the taking over of unused 4th dynasty tombs by individuals who in their youth may have worked at Giza in the late 4th dynasty (see Chapter 13). East of the Khentkawes Town, in our excavations, we found the Silo Building Complex, an administrative and baking complex in the town that flourished in the 5th dynasty (see Chapter 15). Many of the tombs in the Workers' Cemetery also date to the 5th dynasty [18.2].

Abandonment and robbing of the Giza monuments

The Eastern and Western cemeteries sanded up quickly at the end of the 6th dynasty. George Reisner saw evidence that prior to this, 'systematic and open plundering was carried out when the streets were only slightly encumbered with drift sand'.[4] Later, offering places and burials were created in the sand fill and mastaba cores of the cemeteries. According to Reisner these intrusive burials 'were obviously later than Dyn. VI, but appeared to be generally earlier than Dyn. XII', thus placing them in the First Intermediate Period.[5] Many scholars now believe that the plundering and robbing began in the First Intermediate Period and that 5th dynasty kings still paid attention to the monuments at Giza.

During the entire Middle Kingdom and Second Intermediate Period no one carried out cult activity in any of the Giza temples, the cemeteries were abandoned and no new construction took place. One small statue and a statuette from somewhere in the vicinity of the Sphinx represent the Middle Kingdom, though for both their exact find spot is vague.

In fact, certain archaeological discoveries hint that a fair amount of plunder was already taking place in the temples at Giza in the 5th

PREVIOUS PAGES
18.1 Granite cornice blocks of the Khafre valley temple that lie directly on the southern entrance ramp, or on a thin layer of sand scorched black, signal the destruction of the temple and the end of Khafre's cult. From the 2008 excavations of Zahi Hawass and the Giza Inspectorate; view to the west.

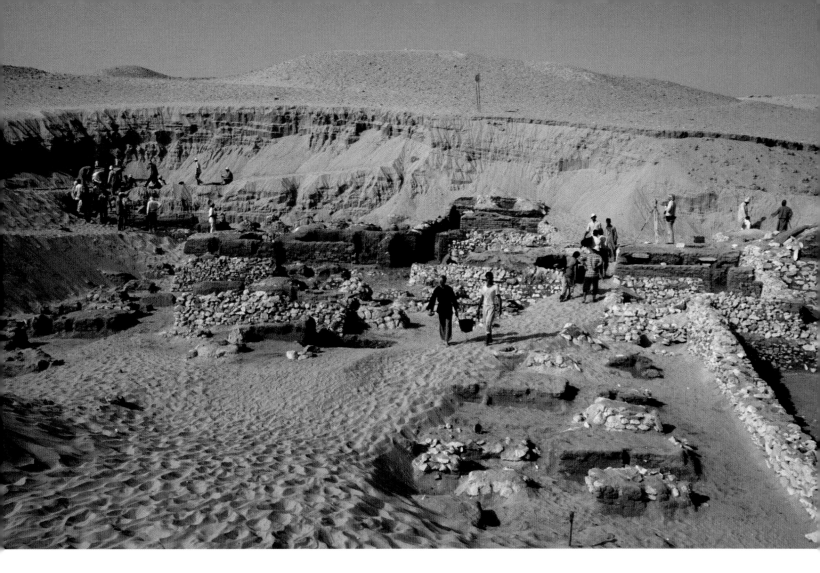

18.2 Excavations in 1991 revealed the mud-brick and fieldstone tombs of the Workers' Cemetery under a deep sand cover; view to the west.

dynasty. Reisner concluded in connection with the Menkaure upper temple that 'it is apparent from the plundering and decay of the crude brick inner temple, that the whole Pyramid Temple was neglected like the Valley Temple during Dynasty V. But in Dynasty VI, both these temples, for reasons which now escape us, became the object of a certain amount of pious attention.'⁶ Statues of Menkaure that had adorned his valley temple were being attacked before the temple was rebuilt in the 6th dynasty. The statues were broken up for making model vessels of the kind commonly found in 5th and 6th dynasty mastaba tombs.

As noted in Chapter 15, the entrance door into the vestibule of the town in front of Menkaure's valley temple turned on a pivot socket carved into the left foot of a broken diorite statue of Khafre inscribed with his Horus and cartouche names. Hermann Junker discovered that structures attached to some of the mastabas of Cemetery GI-S, the mastaba row south of the Khufu pyramid, were being used as makeshift workshops to hack up statues of Khafre to make stone implements

and vessels. Junker dated the mastabas to the reign of Menkaure, but thought that the destruction of Khafre's statues took place at end of the Old Kingdom or in the First Intermediate Period. In his view, the plunderers first destroyed the alabaster statues in Khafre's upper temple, then, under the cover of darkness, brought the pieces to Cemetery GI-S for recarving into model vessels for burial equipment.

Breaking up royal statues and plundering mastaba tombs are small-scale acts that individuals or small groups could have carried out during times of slackening control. This vandalism might have been made easier because the royal house and necropolis had moved to Saqqara and Abusir, leaving local people – the caretakers of the temples themselves – to produce funerary vases from neglected royal statues. But robbing the Khafre temples was a more massive undertaking.

The systematic stripping of all the granite and alabaster from the Sphinx Temple interior, the exterior of the Khafre valley temple and upper temple, and the careful removal and hauling away

of colossal statues that must have weighed many tons, suggests royal power. As noted in Chapter 9 (p. 200), someone removed colossal granite statues from the *serdab* chambers in the Khafre upper temple by hacking gaping corridors over 4 m (13 ft) wide through more than 6 m (20 ft) of limestone core wall to reach the ends of both corridors. Hölscher rightly recognized the extent of the authority, forethought and care that this implies. So when did a royal house quarry the Khafre temples carefully for stone and statues?

The evidence for the date of the robbing of the Khafre upper temple is not entirely clear. Hölscher found 'Hor-em-akhet', the New Kingdom name of the Sphinx, inscribed on one of the limestone core blocks of the temple, which had therefore been stripped of its granite sheathing by the time that the name was in use. On the south side of the court he also discovered a mud-brick ramp that must have been used for hauling material from the temple, and he considered that this also dated to the New Kingdom. For his massive granite Dream Stela in front of the Sphinx, Thutmose IV reused a lintel from Khafre's upper temple, most probably from the entrance doorway at the end of the causeway. The Overseer of Works, May, of Ramesses II inscribed his name in large hieroglyphs on the terrace walls northwest of the Khafre pyramid, no doubt as he quarried the pyramid for stone for the Ptah temple at Memphis, where granite casing blocks like those of Khafre have been found.

Hölscher's excavations along the front of Khafre's valley temple established beyond doubt that this temple was stripped of its granite sheathing before the end of the 18th dynasty. A depth of 1 or 2 m (3–6½ ft) of sand on the bedrock terrace contained pieces of the granite façade and small fragments of statues. Mud-brick walls that rested on this sand layer closed the main entrances to the temple. The next major layer was a villa, typical of those at Amarna, built right up against the front wall of Khafre's valley temple. Hölscher dated the villa to the end of the 18th dynasty on the basis of both its layout and the numerous sherds of blue-painted pottery characteristic of that period that he found associated with the villa (see also Chapter 19).

The floor of the villa was around 5 m (16 ft) above the thresholds of the temple doorways. However, the villa was built on a foundation platform consisting of debris fill in a casemate grid of mud-brick walls that extended down to within 2–2.45 m (6½–8 ft) of the Old Kingdom floor – that is, nearly to the level of the mud-brick walls that closed off the temple entrances. In fact the foundation walls reached down to the same level as the lower course of granite casing stones still preserved on the front of the valley temple. At the north end of the temple's façade, the rear mud-brick wall of the house rested directly upon the granite block flanking the entrance inscribed 'beloved of Hathor'. The façade of the valley temple must have been stripped of its granite sheathing before the villa was built. A long corridor occupied the rear of the house, the west wall of which was built directly over the already revealed limestone core blocks of the valley temple.

Hölscher raised the interesting question of whether the interior of the valley temple was still accessible in the 18th dynasty. When Mariette cleared the interior, he found that the great granite architraves had crashed to the floor, blocking passage through the chambers. Hölscher concluded that this, combined with the lack of a ceiling, indicated that the interior was no longer in use, and had probably been choked with sand.[7] The shafts in the southeast core work of the temple which served for later burials[8] indicate that the temple eventually filled to the point where it was shown in Wilkinson's early map as only 'pits, probably unopened' in a great sand heap.[9]

From all this evidence it would appear that Khafre's valley temple was stripped sometime between the end of the 6th dynasty and the end of the 18th dynasty. Herbert Ricke believed there had been two periods of robbing in the Khafre valley complex. The first was when people removed all the granite and alabaster from the Sphinx Temple; while the second saw the valley temple stripped of its granite sheathing. He based his conclusion on the fact that when Émile Baraize was clearing the interior of the Sphinx Temple he found fragments of granite cornice and limestone ceiling in debris that sloped from the top of the temple's south wall down into the court. These pieces had been ripped off the north wall of the valley temple at a time when the adjacent Sphinx Temple was already stripped of its granite and filled with debris.[10]

On the basis of blocks inscribed with the names of Khufu and Khafre found embedded in the Lisht pyramid of the 12th dynasty pharaoh Amenemhet I [**18.3**], Ricke assigns the first period of robbing, when the Sphinx Temple was stripped, to that pharaoh's reign. Ricke does not give a date for the second period of robbing, but he does note a red granite block inscribed with Khafre's name found at Tanis, where it was allegedly taken in the time of Ramesses II, which he believes could have come from the south wall of one of the entrance ramps of the Sphinx Temple. Ricke also points out that a piece of the valley temple's granite cornice was found in 1934 in the Ptah Temple in Mit Rahina.

In fact, the names of four Old Kingdom rulers occur on reused blocks found in the mortuary complex of Amenemhet I, which were most likely taken from the funerary monuments of these kings. In addition to Khufu and Khafre, we find the names of Unas and Pepi II. Hans Goedicke, who published these pieces, thought that the blocks belonging to Khufu probably derived from his upper temple and valley temple. A block with Khafre's name was found in a plunderers' passage on the north side of Amenemhet's pyramid. It is part of a red granite architrave bearing the cartouche name of the king flanked by falcons wearing the double crown – probably the top of the king's Horus name – a *uraeus* and the back parts of two falcons in flight with outstretched wings. Ricke used this piece in his reconstruction of the Khafre upper temple court; however, there is some doubt that it came from this temple.[11]

But these reused pieces of Old Kingdom royal monuments do not necessarily indicate that Amenemhet I systematically plundered his predecessors' monuments for the great bulk of the raw material for his Lisht pyramid, at least from what has been documented so far. Rather, they suggest a picking up of pieces with royal inscriptions from several sites, perhaps from monuments that had already been robbed. Goedicke stated that none of the pieces showed signs of having been 'forcibly removed from its setting, though most of them are too fragmentary for this to be apparent if this had been the case'. He also mentions the literary tradition that the looting of the Old Kingdom pyramids took place in the First Intermediate Period and concludes: 'Thus it appears probable, although it cannot be proved, that the destruction of the relevant Old Kingdom monuments occurred before the reign of Amenemhet I.'[12]

The abandonment and destruction of the Giza monuments may therefore have already begun before the Middle Kingdom, a period which saw the great necropolis of earlier times ignored, its temples left untended and neglected, its former glories and status forgotten – except for people picking up fragments already broken off the temples. Builders began to exploit the Giza pyramid complexes for recycled stone as early as the Old Kingdom, a practice that they continued into the New Kingdom, even as they resurrected the Sphinx as a state and popular god, Horemakhet; this Giza monument, at least, enjoyed a renewed importance and veneration.

18.3 Cast of an architrave of Khafre discovered reused in the entrance corridor of the pyramid of Amenemhet I (12th dynasty) at Lisht, and still in place. Metropolitan Museum of Art, New York (N.A. 1999.1); original 405 cm (160 in.) long.

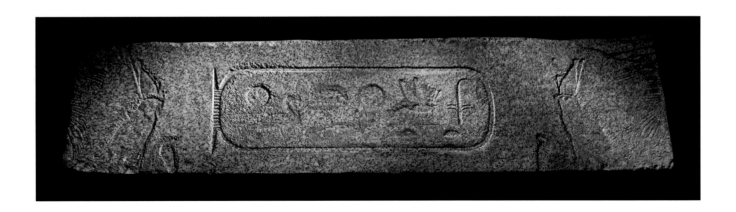

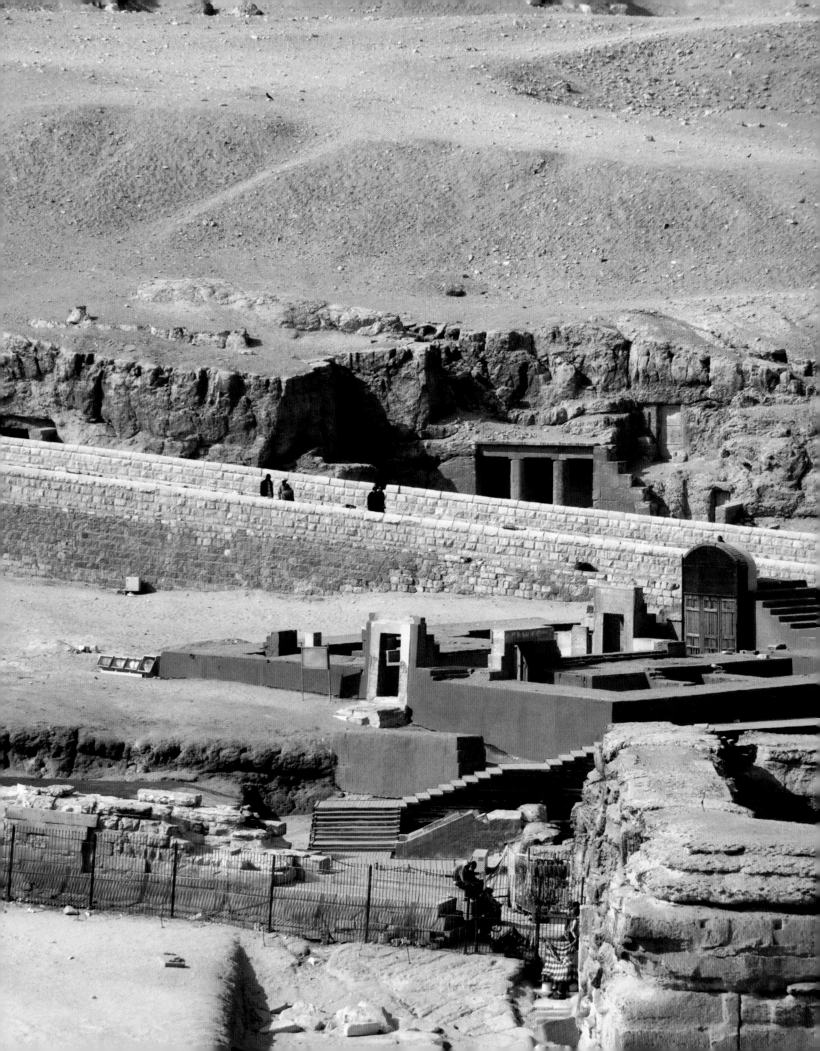

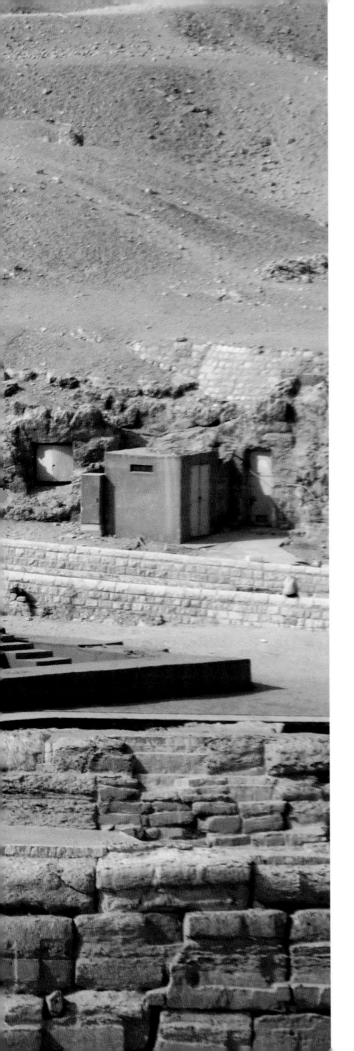

CHAPTER 19
New Kingdom revival

In the 18th dynasty, following their successful wars of liberation from the foreign rule of the Hyksos, the Egyptians built a new kingdom that developed into an empire. Thutmose III was the great conquering pharaoh of the New Kingdom – he has been called the Napoleon of ancient Egypt for expanding the empire as far as the Euphrates and into the Levant. As his base and depot for launching his campaigns to the north, Thutmose III may have established an arsenal at Memphis called the *Peru-Nefer* ('the Good Going Forth'). Princes were ensconced at Memphis in training for their ascension to the throne, and were perhaps in charge of the *Peru-Nefer*. The arsenal was part of a general re-emergence of Memphis as a military and administrative centre at this time, as well as a residence for kings and princes, and it is to this re-emergence of the old capital that Giza owes its renaissance after a millennium of neglect.

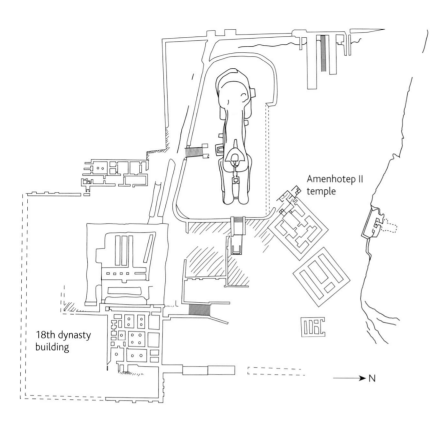

Amenhotep II
temple

18th dynasty
building

→ N

PREVIOUS PAGES
19.1 The temple of
Amenhotep II northeast
of the Sphinx, looking
across the rear of the
Khafre valley temple
and over the remains
of the walls of Khafre's
causeway. The mud-
brick walls of the temple
have been largely
reconstructed. View to
the north.

ABOVE
19.2 Sketch plan of the
New Kingdom (18th and
19th dynasties) complex
built in mud brick around
the Sphinx sanctuary
and the Khafre valley
temple, with a terrace
over the ruins of the
Sphinx Temple. A thick,
cartouche-shaped wall
surrounded the Sphinx,
an Amarna-style villa
attached on to the front
of the valley temple, and
'Tutankhamun's Rest
House' lay at the rear
of the valley temple.

As they expanded their dominion abroad, the
kings of Egypt built new stone temples on the
sites of ancient shrines all over their native land.
At Medamud, Elephantine, Hierakonpolis, Abydos
and Coptos, New Kingdom builders erected
what Barry Kemp calls 'Mature Formal' temples
of stone above 'Early Formal' Middle Kingdom
temples which had been built upon 'Preformal'
sanctuaries and shrines.[1] At Elephantine,
Hierakonpolis and Coptos it was Thutmose III
who built the 'Mature Formal' temple. On a statue
of himself, Minmose, Overseer of Works in the
Temples of the Gods of Upper and Lower Egypt for
Thutmose III and perhaps later for Amenhotep II,
listed 19 temples for which the king placed him in
charge of work.

It was within the context of this great building
programme that interest was renewed in certain of
the Giza monuments, and in particular the Sphinx.
The most striking parallel between the renewal
of the cult of the Sphinx at Giza and provincial
temple building is the configuration of the temple
at Elephantine, where Thutmose III placed his
sanctuary of the stone temple of the goddess Satet
directly over the simple Old Kingdom shrine in

a niche between granite boulders. A shaft down
through the temple foundations established a
symbolic communication with the temple's origins.
Similarly at the Sphinx, the sands were cleared
to establish contact with an image of primordial
kingship par excellence.

Thutmose I, Thutmose IV, Amenhotep III,
Tutankhamun, Ramesses I, Seti I and Ramesses II
all endowed domains at Memphis, and structures,
or additions to structures, are attested for four
of these kings in the proximity of the Sphinx
[**19.2**]. Selim Hassan perhaps had the list of these
Memphite domains in mind when he assigned a
poorly documented mud-brick structure behind
the Amenhotep II temple to Thutmose I, although
he gives no evidence for this identification.[2] It is
possible that the mud-brick building with an
Amarna-style floor plan and quantities of blue-
painted pottery attached to the front of the Khafre
valley temple belonged to Amenhotep III, for it
is clearly late 18th dynasty, as Hölscher noted
(see Chapter 18, p. 466).

But in all the inscribed New Kingdom
monuments dedicated to the Sphinx, we find
little mention of the actual 4th dynasty kings
who created the Giza Necropolis. There was no
cult of these distant kings at Giza during the New
Kingdom heyday of Sphinx veneration. Although
Amenhotep II on his great limestone stela in the
temple he built here calls the Sphinx sanctuary
the abode of Khnum-Khuf (Khufu) and Khafre,
mentioning his wish to 'make their names live',
and although, along with his son Thutmose IV, he
probably restored the Sphinx statue, neither he nor
later kings did much to revive the long-abandoned
temples of the 4th dynasty kings themselves.

The Amenhotep II temple

Amenhotep II, the son and successor of the warrior
pharaoh Thutmose III, built his mud-brick temple
to the front and northeast of the Sphinx, on the
bedrock terrace (Terrace III) above and along the
north of the Sphinx ditch and Sphinx Temple.
Selim Hassan excavated the temple in 1936,
uncovering the ground plan consisting of a main
inner hall with a smaller hall and side chambers.
The bases of the mud-brick walls were cased in
limestone, and these and the jambs and other

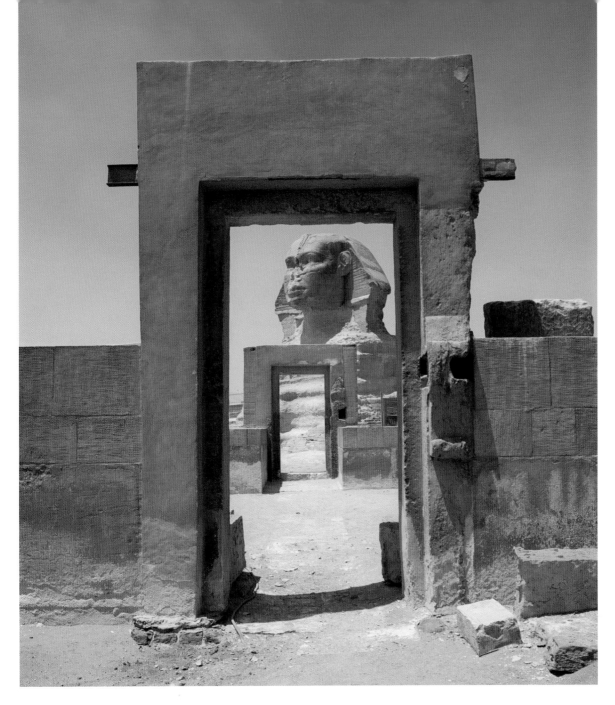

limestone elements remain in place. Amenhotep II's tall, round-topped limestone stela forms the centrepiece of the sanctuary, standing on the temple axis. On it, as well as making a reference to Khufu and Khafre [**19.4**], Amenhotep recounts how his father had heard in the palace of his son's skill with horses. 'He said in his heart, "it is he who will be lord of the entire land...".' The text relates that as soon as Amenhotep became king, he ordered the building of his temple to Horemakhet, and the stela relates his ascension to the throne.

Amenhotep II's builders orientated the temple northeast–southwest so that its axis is directed towards the Sphinx's head. If one crouches at the base of the stela and looks outwards back along

19.3 The inner limestone doorway to the Amenhotep II temple sanctuary frames the head of the Sphinx. The axis of the temple is orientated northeast to southwest, so that the winter solstice sun sets along the curve of the Sphinx's *nemes* headdress.

LEFT
19.4 Cartouches of Khufu and Khafre on the large limestone stela Amenhotep II erected in the sanctuary of the mud-brick temple he dedicated to the Sphinx as the god Haroun Horemakhet.

the axis, the inner doorway to the temple sanctuary frames the Sphinx's head [**19.3**]. At the winter solstice, the sun's disk sinks exactly along the curve of the back of the Sphinx's *nemes* headdress.

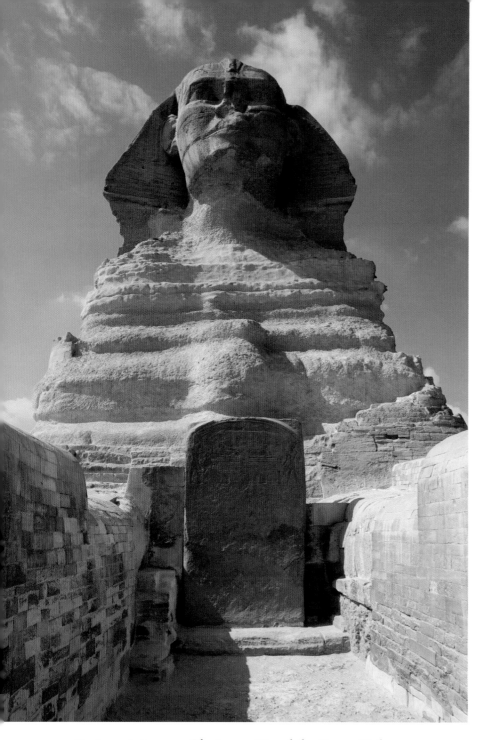

19.5 The Dream Stela of Thutmose IV, in the Sphinx's embrace, features a text that tells of the Sphinx promising kingship to the prince in return for salvaging the colossal image. The stela was the centrepiece of a small open-air chapel, of which only the bottom of the south wall remains.

Thutmose IV and the Dream Stela

Amenhotep II's own son and successor, Thutmose IV, might have overseen the building of his father's temple at the Sphinx when he was crown prince and residing in Memphis. In the first year of his reign, about 1400 BC, Thutmose IV set up his own impressive granite stela, 3.6 m (12 ft) tall, in a prominent position at the base of the Sphinx's chest between the forepaws [19.5]. It is called the Dream Stela because of the hieroglyphic story it tells of an episode during a hunting expedition in the vicinity of Giza that Thutmose took part in when he was a prince – though apparently not the crown prince.

Thutmose relates how towards noon he fell asleep in the shadow of the Sphinx. The Sphinx appeared to him in a dream, lamenting that its body was in a ruinous state and that the sand of the desert had invaded its lair, and offering Thutmose the throne in exchange for his assistance in repairing it and clearing the sand. What must have been a good part of the remainder of the story is missing, but Thutmose did indeed become king. At the top of the stela he etched a double scene of himself making offerings and libations to the Sphinx, dated to the first year of his reign [19.6]. Thutmose refers to the Sphinx as 'this very great statue of Khepri', god of the rising sun, and 'Khepri-Re-Atum', the sun god in all its aspects – rising, zenith and setting [19.7]. Thutmose also calls the Sphinx Horemakhet, 'Horus in the Horizon', as do the inscriptions in the Amenhotep II Temple and on numerous smaller New Kingdom stelae of private people found here.

Thutmose IV surrounded the Sphinx ditch with massive mud-brick walls to act as barriers against the encroaching sand, which Émile Baraize excavated in 1926. The walls curved at the corners so that the Sphinx lay within a gigantic cartouche. Around the northwestern corner of the Sphinx ditch the wall rose 3 or 4 m (10 or 13 ft) high, and rested on a foundation of loose stones, while in the southeast corner Baraize found an even larger wall, 8 m (26 ft) tall from the floor of the Sphinx, curving around the corner from the Khafre causeway to meet the west wall of the Sphinx Temple. He traced the continuation of the wall as it ran along the top of the monolithic limestone blocks of the Sphinx Temple west wall. Here, the mud-brick retaining wall rested on a foundation, about 2.5 m (8 ft) high and more than 5 m (16 ft) wide, composed of a core of limestone rubble and mud and lined on the side facing the Sphinx with small unmortared limestone blocks. Thutmose IV's builders impressed his royal cartouche on some of the bricks of these walls.

The tall body of the Sphinx and massive mud-brick protective walls built by Thutmose IV created a corridor around the colossus, sitting on the floor of its sanctuary. Scores of pilgrims to the Sphinx then set their small stelae in the wall along the north side of this sanctuary. On this side most of the stela show the Sphinx facing right, as does the actual Sphinx. We can imagine visitors circumambulating the

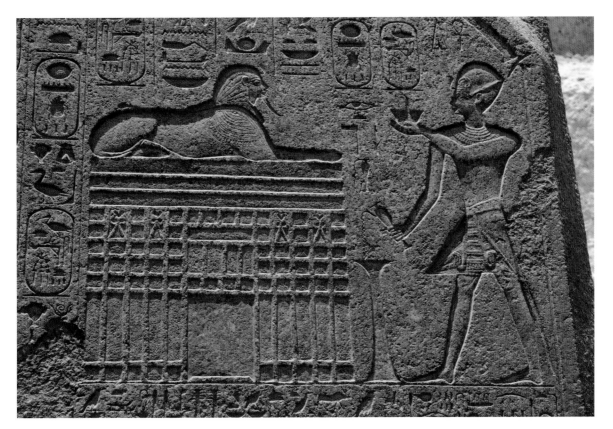

LEFT

19.6 Thutmose IV offering to the Sphinx, which sits upon a high pedestal with the 'palace façade' doorway and panelling. The pedestal prompts theories of a temple or hall under the Sphinx, but Thutmose IV's artists may have seen it simply as a way to bring the Sphinx level with the face of the king.

BELOW

19.7 'Lo, a very great statue of Khepri rests in this place' read the hieroglyphs of the middle register, referring to the Sphinx (the word for statue is written with the sphinx hieroglyph), in this detail from the Dream Stela text. Khepri was a god of creation and the rising sun.

mighty statue viewing the colourful advertisements of previous visitors studding the walls. It is also possible that in the New Kingdom, when the walls of the Khafre causeway were dismantled, the causeway embankment provided a good platform for visitors to view the Sphinx from the south-southeast, as it does for tourists today; from this vantage point the Sphinx also faces right.

A statue at the Sphinx's chest

In 1816 Caviglia excavated a small open-air chapel in the embrace of the paws of the Sphinx, demarcated by screen walls of variously sized limestone slabs perpendicular to the forepaws at the level of the back toes (see p. 6.9). Thutmose IV's Dream Stela formed the back wall and focus of the chapel, but it may not have been the first royal monument to grace this *chapelle royale* – the king may have installed a colossal statue of his father, Amenhotep II, against the chest of the even more colossal statue. Several Egyptologists and art historians have speculated that a figure of a god or New Kingdom pharaoh stood here. Uvo Hölscher, for instance, who excavated the Khafre pyramid

temples, suggested that the boss on the chest is the weathered remains of a royal figure under the protection of Horemakhet, or a god standing before the king as the Sphinx, but thought that it could have been carved later than the 4th dynasty.[3]

Among the numerous New Kingdom 'private stelae' found in the vicinity, six, or possibly seven, show a royal statue at the chest of the Sphinx.

On one, with a cartouche most probably of Thutmose IV, the king himself is shown as a statue striding forth between the Sphinx's paws. Three stelae, designated A, B and C by Hassan,[4] belong to princes and date to the reign of Amenhotep II. The owner of A and B was, like Thutmose IV, a Chief Master of Horses at Memphis and was perhaps Webensenu, an older brother of Thutmose IV who should have become king, but we cannot be certain because the names and other inscriptions were intentionally erased on these two stelae.

On Stela A a small figure of the king between the Sphinx's paws wears the blue crown (*khepresh*) and stands on a low socle or base, indicating that this was a statue and not the king in person. Above the king an inscription gives the name and titles of Amenhotep II, but both figure and inscription are incised much more lightly than the rest of the relief; someone could have added them later. On Stela B the royal statue at the chest of the Sphinx wears the triangular skirt and the *nemes* headdress rather than the blue crown. An inscription above the statue identifies it once again as Amenhotep II.

On Stela C only the lower part of the statue between the Sphinx's forepaws remains, and given the poor quality of the published photographs we have to take Hassan's word that the figure is present in the relief (the location of these stelae is now unknown). A text above the back of the Sphinx expands upon the relationship between Sphinx and royal statue: 'Protection, life, stability, power and health around and behind him like Re' – it is the Sphinx who personifies and bestows these qualities, around and behind the king.

The words for 'around and behind' are *za ha*; the word *ha* is derived from a noun, 'back of the head'. *Za ha,* Alan Gardiner noted, is '"protection around" a person, where there may be a sense of enveloping from behind, as with wings, etc.'.[5] Gardiner had in mind the famous diorite statue of Khafre, which shows the king with the Horus falcon, god of kingship, enveloping the back of Khafre's head in its wings (see 6.13). In the New Kingdom, from the early 18th dynasty, the same concept was expressed in large statues of a divine animal with a small figure of the king tucked against the chest and under the chin. The best known is the statue of the cow goddess, Hathor, protecting Amenhotep II, found at Deir el-Bahri, but there are also statues of the king between the forepaws and under the chin of the sacred ram. The king is linked with, but subordinate to, the deity, who is represented on a much larger scale; this is in contrast to the Old Kingdom where the king is larger than the god.

The relationship between the Sphinx and the king, as expressed by the *za ha* (protection from around and behind) concept and embodied in a royal statue against the giant chest, was spelled out in the relief decoration carved on the two flat plates that connected the Sphinx's long curled divine beard to its chest, also found by Caviglia (see Chapters 5 and 9), decoration which undoubtedly dates to the New Kingdom. When the plates were in place, a kneeling pharaoh wearing the *nemes* would have lifted the hieroglyph for a broad collar just below the Sphinx's chin [**19.8**]. Beneath the pharaoh's arms a group of glyphs reads *ankh za ha-ef*, 'life and protection around and behind him'.

This inscription must have indicated that the Sphinx is the protector, but whom did the god protect 'around and behind'? Certainly in the New Kingdom it was the pharaoh himself as he stood in the chapel between the outstretched paws of the giant. But it was also the statue of the king, striding forth from the chest of the leonine body.

Evidence at the base of the Sphinx's chest hints at the former presence of a colossal royal statue. Thutmose IV's stela does not rest directly against the chest of the Sphinx, but against a three-tiered stack of massive limestone blocks forming a platform 2.3 m (7 ft 6 in.) out in front of the chest. This gives ample room for the base of a royal statue to stand in front of the boss on the Sphinx's chest.

A stack of masonry standing higher against the chest in Henry Salt's sketches of Caviglia's excavation could have been the remains of masonry that attached the statue to the chest. The gap in the earliest restoration masonry (Phase I; see Chapter 10) at the centre of the chest is where the back pillar of support masonry behind the statue was taken away, probably when the statue was removed.

19.8 Drawings of fragments of a plate that may have been original to the bedrock-carved statue, but which fell and was replaced in the New Kingdom. The relief-carved design, certainly New Kingdom, depicts a kneeling pharaoh offering up a broad collar of gold to the Sphinx (original fragment now in the Cairo Museum).

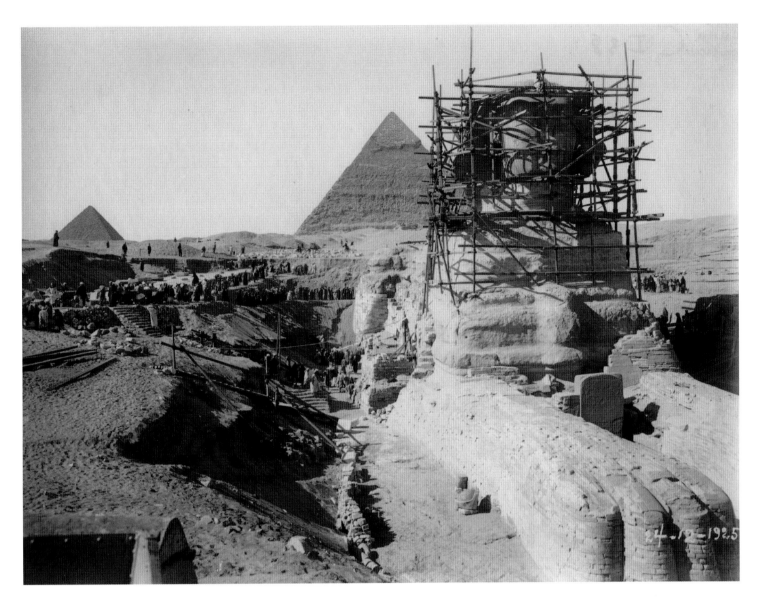

From our detailed study of the chapel we believe that the earliest restoration masonry is contemporary or close in time to the Thutmose IV stela, since the limestone blocks framing it are uniform with the restoration on the Sphinx's paws and chest. So, the missing royal statue must be a part of the same restitution of the Sphinx as a cult object as the little chapel in the 18th dynasty. The Sphinx and royal statue expressed a theme that was a hallmark for the time: the king under the protection of a god in the form of a sacred animal.

Lehner believes that in order not to be completely dwarfed by the large size of the stela and the immensity of the Sphinx, a statue that stood on the platform behind the Thutmose IV stela must have been more than 5 m (16 ft) tall. A height of around 7.8 m (26 ft) would have been required to bring the top of the statue to the

underside of the divine beard, as in our graphic and computer models of the reconstructed Sphinx in the New Kingdom (see 19.15). Several of the archival photographs of the Baraize excavation show a large limestone double crown and the front part of a limestone head sitting beside the south forepaw of the Sphinx [**19.9**]. However, a king wearing the double crown standing in the *za ha-ef* position in front of the Sphinx is unlikely, in part because on all the private stelae the statue is shown wearing the *nemes* or the blue crown. The double crown and face fragment must therefore derive from another statue that was in close proximity to the Sphinx, and the only other possibility is the Osiride statue that Mariette reported that he found on the south side of the Sphinx (see Chapter 10, p. 236, and below).

19.9 Photograph of Baraize's excavation of the south Sphinx flank taken 24 December 1925. A double crown and face of a royal statue rests on the cleared bedrock floor beside the forepaw. In the background, workers have cleared the mysterious masonry boxes attached to the Sphinx.

The cult of royal confirmation

A common theme in the inscriptions of princes and kings found around the Sphinx is a royal promenade to the Giza pyramids, with a pause at the Sphinx. The motif is first attested in the reign of Thutmose I, when his son Amenmose, overseer of his father's army, left an inscription recording a visit associated with martial acts and hunting.

The narrative etched on the limestone stela of Amenhotep II is the grandest example of the princely visit associated with acts of military prowess, particularly skill with horses, which the Semitic goddess Astarte is said to rejoice in. The text on the granite stela of Thutmose IV exalts his target shooting, hunting and chariotry – 'his horses being faster than the wind' – and the 'army rejoicing through love of him'. The same theme is expressed, again in association with hunting, horsemanship and martial might, in a stela that Seti I placed within the Amenhotep II temple. One fragment of relief carving from the Sphinx actually shows a New Kingdom royal chariot with rearing horses and attendants.

There may have been some topographical reason that this royal 'sporting tradition' was associated with Giza, in addition to its simple proximity to Memphis and the *Peru-Nefer* arsenal. Until the 1930s, immediately east and southeast of the Sphinx a very flat stretch of low desert stretched more than 400 m (1,312 ft) east of the escarpment and continued for about 4 km (2½ miles) to the south. It can be clearly seen in early drawings and photographs, such as those of Lepsius and the views published by Reisner. In the New Kingdom, this tract of sand may have provided good ground for military and horse exercises. This same tract of sand covers the Heit el-Ghurab site: New Kingdom princes might thus have raced above the ruins of our Lost City of the Pyramids.

A more profound meaning to the 'sporting' expressions of royal prowess, however, involves the name *Setepet*, 'the Elect' or 'Chosen', given to the Sphinx sanctuary in the New Kingdom. On the stelae, the Sphinx often bears the epithet *khenty Setepet*, 'the one who presides before the *Setepet*' – the Sphinx was the guarantor and protector of divine kingship, conferred, for Thutmose IV at least, in a dream. Thus the royal cult, as opposed to the popular cult, was that of a colossal ancient image of the god-king ordaining royal status. Royal promenades to Giza, full of vigour and bravado, were actually pilgrimages to a place of primeval kingship, where kings and princes could confirm their status as sons of the god.

Amenhotep II inscribed his Sphinx stela in the first year of his reign, as did his son, Thutmose IV. And it was Thutmose IV's divine father, Horemakhet-Khepri-Re-Atum in the image of the Sphinx, who ordained, 'like a father speaks to his son', that Thutmose would become king. In the 19th dynasty Ramesses II left a stela somewhere between, or immediately in front of, the Sphinx's forepaws in his first year of rule. It may also have been in his first year that Ramesses II left his other monuments at the Sphinx, such as the two stelae in the inner chapel that flanked that of Thutmose IV.

Royal national park

The cult of royal confirmation led to the building of a kind of royal national park on and around the ruins of the old Khafre valley complex and Sphinx, with an elaborate arrangement of terraces, platforms, enclosures, stairways, rest houses and temples. Unfortunately, archaeological investigations removed most of these later structures in order to get down to the level of the 4th dynasty temples, and so a complete map of the New Kingdom structures has never emerged. Although Baraize did not publish the details of his 11-year excavations, he left 226 photographs that show the enormous deposits and superimposed architectural layouts that surrounded the Sphinx precinct in the New Kingdom [**19.10**]. These were successively built over in the Late Period and Greco-Roman times.

As well as the 'cartouche wall', a second line of defence against the drifting sands ran along the upper western ledge of the Sphinx ditch in the form of a mud-brick wall with regularly spaced bastions. Two massive bastions are attached to the western side of the wall just above the southwest corner of the ditch. From here a thinner mud wall ran eastwards along the shoulder of the Khafre causeway, then turned to meet an oblong mud-brick building orientated north–south at the back of the valley temple, known as Tutankhamun's Rest House (see box, p. 479), which was excavated by Baraize.

OPPOSITE ABOVE
19.10 Stratified structures east of the Sphinx, over the ruins of the Sphinx Temple, after Baraize's excavations in the 1920s and early 1930s. He removed most of the 18th and 19th dynasty terraces, leaving a central podium or chapel and, in the southeast corner, the stairways descending from the villa attached to the Khafre valley temple. Baraize excavated the southwest corner of the Sphinx Temple to floor level, while leaving part of a Roman stairway at the northwest corner (lower left). To the north (left), he has left the total depth of deposits, which Selim Hassan excavated in 1936. View to the east, from the top of the Sphinx's head.

OPPOSITE BELOW
19.11 The mud-brick stairway that descended to the level of the 18th dynasty terrace over the Sphinx Temple ruins from the royal villa attached to the façade of the Khafre valley temple. View to the southwest.

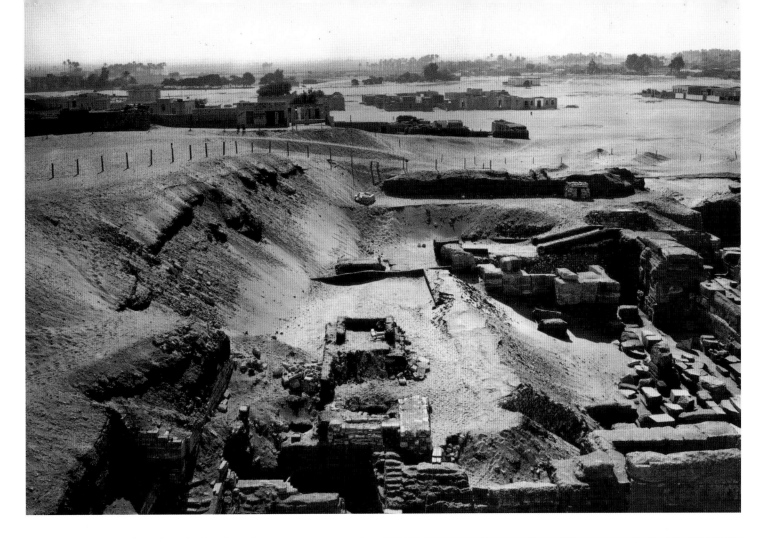

Baraize continued to clear the bastioned enclosure wall as it ran southwards from the southeast corner of Tutankhamun's Rest House, then eastwards along the southern side of the Khafre valley temple. Near the end of his work he found a stretch of the same wall running north–south to the east of the royal villa of the late 18th dynasty in Amarna style attached to the front of the Khafre valley temple. New sections of the wall were discovered by the SCA in 2010 to the east and north of the valley temple. Thutmose IV's bastioned wall thus defined the entire area of the royal national park, with the Sphinx at its centre. At various places along the wall the king set at least 16 limestone stelae, each depicting one of a string of deities, thus creating a pantheon surrounding the Sphinx. These were the gods of Egypt's principal places, such as Amun-re of Thebes, Wadjit of the old Delta capitals Pe and Dep, Thoth of Hermopolis, Atum of Heliopolis and Ptah of Memphis.

Already by the New Kingdom, the sand had accumulated on top of the debris of earlier structures to such an extent that the stairs were needed to reach down into the Sphinx sanctuary [**19.11**]. From the northwestern corner of the royal

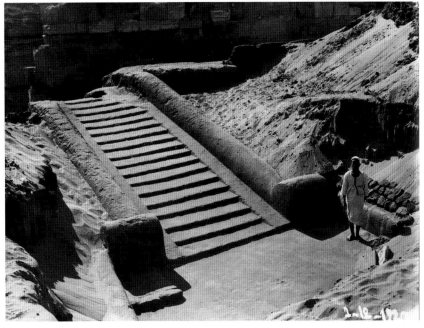

Amarna-style villa, a stairway descended in broad shallow steps with rounded banisters on either side. The stairway opened into a small courtyard defined by low rounded walls. Passing two square structures, possibly chapels, a way led to a broad

dromos or mud viewing platform directly in front of and facing the Sphinx. Emerging from their rest houses built up against the ancient ruins of the Khafre valley temple, royalty would have descended stairways to this broad viewing platform, which mostly covered the ruins of the lower Sphinx Temple. They could then proceed either to the north, through a corridor that led to the entrance of the Amenhotep II temple, or directly west, down into the floor of the Sphinx sanctuary itself.

Another narrow stairway led down to the Sphinx floor (Terrace II) via a landing of limestone slabs. Based on limestone pieces that Baraize found on the spot, a doorway at this upper landing was inscribed on the jambs and lintel with the name and titulary of Thutmose IV. The *men* sign in Thutmose IV's cartouches had been hammered out; it was probably mistaken for the name Amun during Akhenaten's reign, and subsequently replaced.

The stairway led to the heart of the cult – the small chapel at the chest of the giant statue. Standing there, a newly ascended king such as Thutmose IV or Ramesses II could experience the sensation of tracing his descent back to far more ancient kings – even to Khufu and Khafre – back indeed to the primeval god-king in the form of the Sphinx, now called Horemakhet, whose image towered above him.

Other rulers added their own mark to the New Kingdom Sphinx complex. Ramesses II must have built or added to Tutankhamun's Rest House and other structures on the site, judging from several pieces inscribed with his name. Ay, Horemheb, Seti I and Merenptah all left stelae or inscribed architectural elements at the site.

In addition to the royal inscriptions, scores of stelae were dedicated in honour of the Sphinx by officials, scribes, military leaders, builders and sculptors. Selim Hassan excavated most of these from 1936 to 1938, but some were found during the previous Baraize excavations, while even the early excavations of Hölscher and Mariette turned up 'private' stelae dedicated to Horemakhet. As noted above, many of these were once embedded in the face of the huge mud-brick walls that Thutmose IV had built around the Sphinx ditch. Excavations have also turned up numerous small votive sphinxes and falcons, images of Horemakhet, either uninscribed or labelled simply, 'made by...'.

The gods of the Sphinx

The accumulated architectural layout around the Sphinx is the evidence of a long-term and active cult, both royal and popular. It appears that royal interest in the site was strongest during the 18th and 19th dynasties, but the cult of the Sphinx, in the particular form of devotion to the god Horemakhet, continued through the late New Kingdom, Third Intermediate Period and down into Roman times.

Horemakhet

The name and concept of the Sphinx as Horemakhet, 'Horus in the Horizon', is an invention of the New Kingdom. We first hear of the Sphinx as Horemakhet in texts dated to the very beginning of the 18th dynasty, in the reign of Amenhotep I. The name remained at all times almost completely restricted to the Giza Sphinx – there was never a generalized, widely distributed cult of Horemakhet, because this was a deity invented for an existing, unique and already ancient statue, rather than the more usual statue carved to represent an ancient deity. Of course, in the ancient Egyptians' view, Horemakhet was not something new: on the contrary, according to the Thutmose IV stela, this was 'the sacred place of the beginning of time...'.

Thutmose IV's stela also indicates that sand covered the Sphinx until his time, and the excavations of Hölscher, Baraize and Hassan added to the picture of a tremendous mound of debris covering the Sphinx site by the 18th dynasty. Thus anyone approaching Giza from Memphis to the southeast would have seen the huge Sphinx head projecting out of the sands or the rock-cut ditch that hid its body – the head of a pharaoh, the incarnation of Horus, distinguished by the *nemes* scarf of kingship, framed by the pyramids of Khufu and Khafre, like the two mountains framing the sun disk in the hieroglyph for 'horizon'. This was literally a figure of Horus in the horizon, where the Horus head replaced the sun disk. Emerging from the desert sand and the natural rock of the plateau, the Sphinx must have also conveyed both the chthonic (underworld) and solar qualities of the sun god as creator.

Horemakhet is close in idea to the god Horakhty, or Re-Horakhty, 'Re-Horus, the one of the Horizon' [**19.13**, **19.14**]. In fact, the Sphinx was sometimes called Horakhty on the stelae.

The 'Rest House of Tutankhamun'

Tutankhamun's Rest House has never been mapped or published, and Baraize removed it in the course of his excavations. A limestone door frame was inscribed with the name of Tutankhamun, as well as that of his queen Ankhesenamun, which had been plastered over and that of Ramesses II added. In the foundations Baraize discovered numerous pieces of stelae dedicated to the Sphinx as Horemakhet and to Horus as the falcon with the name Horemakhet. He also recovered small sphinxes and falcons of limestone and faience, little blue 'porcelain' ears (for the god to hear prayers) and many pottery vessels. Pierre Lacau noted that these were not foundation deposits, but ex-votos – all were broken before interment. This material included the earliest New Kingdom inscription known from the site, dating to Amenhotep I. It was not clear from the excavation whether they had been buried before or after the building was erected.

Although unpublished, we can determine the nature and location of the 'rest house' from the photographs of the Baraize excavation, which include both detailed and panoramic views to the south, probably from the top of the Sphinx. The building was rectangular, orientated north–south, and measured about 12–13 m (39–43 ft) wide and 35 m (115 ft) long. The north end of the building stood about 5 m (16 ft) from the south side of the Khafre causeway. Plaster probably originally covered the entire building.

The builders created 11 rooms arranged on the east and west of a central wall, with two entrances on the east providing access. Inside the southern entrance a left turn (south) brought one before another doorway – it was the frame of this that was inscribed with Tutankhamun's name. After passing through the doorway, one turned right to face an entrance to a square room with two limestone pillars, of which only the bases remained. In the antechamber entered through Tutankhamun's doorway, one could pass the entrance to the pillared room and proceed south to two small chambers attached to the east wall of the building. Limestone slabs lined the floor and base of the walls, and a limestone slab ran across the threshold, fronted by a small limestone porch, so that one had to step over the slab when entering the cubicle. A hole under the wall separating the two small chambers led directly to a basin carved from a single piece of limestone sunk into the floor at the base of the partition wall in the north chamber. The hole and basin were for draining water from the adjacent chamber and the two chambers appear to constitute a bath.

As the name given by Egyptologists implies, this building looks very much like a rest house of the kind that may have existed to receive royal visits. Given the 'sporting tradition' of princes and kings hunting and performing military manoeuvres at Giza, it might have been after such occasions that they washed and rested here.

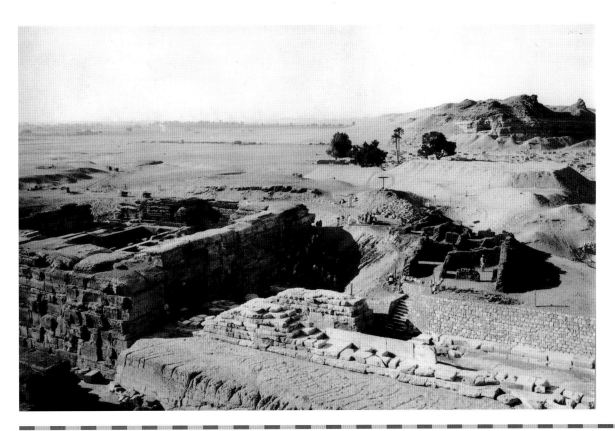

19.12 The 'Rest House of Tutankhamun' founded on sand about 5 m (16 ft) behind the Khafre valley temple, before Émile Baraize removed it during his excavations in 1932. View to the south from the top of the Sphinx, with the Gebel el-Qibli in the background.

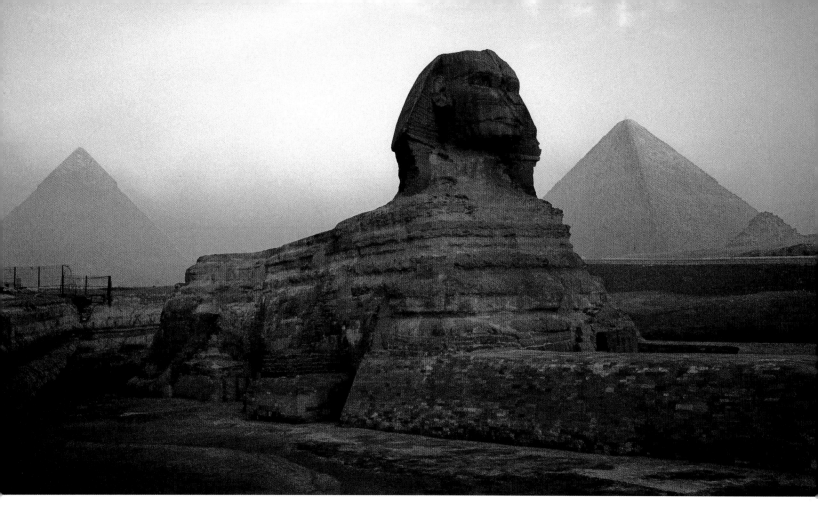

19.13, 19.14 'Sphinx em-akhet' and Horemakhet: seen from the southeast, the direction of Memphis, the Sphinx sits midway between the Khufu and Khafre pyramids, taking the place of the sun setting between two mountains in the hieroglyph for 'horizon'. This is scribed in the name Horemakhet – Horus in the Horizon (right, lower register) in Thutmose IV's Dream Stela. The horizon is the place of rebirth and ascension.

Like Horakhty, Horemakhet, the Sphinx, was a celestial and solar deity. On his stela, Thutmose IV calls the Sphinx 'a very great image of Khepri', 'Horemakhet-Khepri-Re-Atum' and an 'image made for Atum-Re-Horemakhet'. This is to say that the Sphinx is an image of the sun god in all his aspects – rising (Khepri), zenith (Re) and setting (Atum). The assimilation of Horemakhet with Atum, the primeval sun god, is suggested on several of the small stelae of private persons: Atum-Horakhty; Re Horakhty Atum, Lord of the sky; and Houroun-Atum, father of the gods. Christiane Zivie-Coche sees Horemakhet's solar character as an elaborate theological construction under the influence of Heliopolis, the centre of Egypt's solar cult.[6]

The model offered by the Sphinx as a focus of personal piety, pilgrimages and votive offerings later became typical for other colossal statues in the New Kingdom. It was not until a generation after Thutmose IV that the New Kingdom Egyptians created colossal statues on the scale of the Sphinx, and these statues too were then worshipped as forms of the sun god. In fact it is possible that the Sphinx may have been the prototype for the association between colossal size and sun worship. But it must be emphasized that the Sphinx precedes any other statues at this scale by 1,200 years.

Rainer Stadelmann believes that Horemakhet began as a local god of folk religion, which soon became the object of a royal cult.[7] This aspect of folk worship brings in another name given to the Sphinx in the New Kingdom.

Horoun

Nineteen of the small stelae dedicated to the Sphinx, and a few of the royal monuments, refer to the Sphinx as some variant of Horoun (also spelled Haroun). A Semitic deity, Horoun was a denizen of the deserts and associated with caverns and hiding places, a chthonic god who had power over snakes, demons and forces of chaos. The name probably

derives from the root *hwr*, 'depth' or 'bottom'. In Upper Egypt Horoun was identified with the god Shed, likewise a desert protector against snakes and a 'hypostatization of an aspect of Horus', while in the Delta he was 'associated with military outposts controlling desert routes'.[8] Stadelmann characterizes Horoun as an underworld god of battle.[9]

The earliest reference to the god Horoun, other than as part of a personal name, is found on six faience foundation plaques of Amenhotep II that appeared on the New York antiquities market in 1936. These were inscribed with the king's name and 'beloved of Horoun-Horemakhet'. Other plaques and six model jars that were part of the same cache were inscribed with the name of Amenhotep II as 'beloved of Horemakhet'. The ritual foundation items must have come from the Amenhotep II temple at the Sphinx, which had just come to light in 1936. These items generated considerable discussion and some reservations about their authenticity.

The Amenhotep II foundation plaques are considerably earlier than other royal mentions of Horoun – most of the 19 small votive stelae that include the name date from the 19th dynasty. In royal contexts the name occurs on the door frame of Tutankhamun from the mud-brick building behind the Khafre valley temple and on a door jamb of the Amenhotep II temple added by Seti I; otherwise, only the name Horemakhet and not Horoun is found in the Amenhotep II temple inscriptions.

New Kingdom visitors might have identified the Sphinx with Horoun because of the assonance of their names, *hr* (Horus) and *hwr(wn)*. Like Horemakhet, Horoun is designated in Giza stelae as 'The Great God, Lord of the Sky' and, more rarely, 'Ruler of Eternity'. On many of the stelae Horoun and Horemakhet are assimilated into a compound name. Unlike the cult of Horemakhet, however, that of Horoun was known over a wider area than just Giza after the 18th dynasty. Asiatic immigrants, and then Egyptians, may have also identified the Great Sphinx with Horoun simply because it was situated in the desert and, by New Kingdom times, was submerged in a fairly deep depression created by accumulated debris and sand around the sides of its natural rock-cut sanctuary.

The Asiatics were probably Syrians and Canaanites brought to the Memphite area after the wars of conquest of Thutmose III and Amenhotep II. Horoun came to Egypt at about the same time as the foreign deities Reshep and Astarte, the first mentions of whom are on the great limestone stela of Amenhotep II. The two latter deities, along with Baal, were particularly associated with the *Peru-Nefer* ('the Good Going Forth'), the 18th dynasty arsenal that Thutmose III established at Memphis. The Sphinx's lair in a kind of desert cavern may thus have reminded Asiatic immigrants of their native god, but it also fitted with a distinctly native Egyptian tradition of their own cavern god, Sokar, the most hidden form of Osiris, Lord of the Underworld.

Reconstructing the resurrected Sphinx

But what exactly did the Sphinx, this immense symbol of royal and religious power, look like in its New Kingdom form? The Sphinx as left by its Old Kingdom builders differed significantly from the Sphinx that the Egyptians excavated from the sand and restored in the 18th dynasty – and again

19.15 Reconstruction of the resurrected New Kingdom Sphinx, with the restored long, curled, divine beard, a royal statue at the chest, and the open-air chapel before the Thutmose IV Dream Stela.

from the one we see today. Centuries of erosion have resulted in the worn and damaged Sphinx so familiar to the modern world, but this is far from its colourful and complex appearance during the heyday of its veneration in the New Kingdom.

As discussed in Chapter 10, a principal aim of the ARCE Sphinx Project led by Lehner from 1979 to 1983 was the preparation of true-to-scale, contoured drawings of the monument and its details, which could then be used to attempt a reconstruction of its ancient appearance. The face did not have to be reconstructed since the finished surfaces preserved on the head of the Sphinx are original 4th dynasty sculpture; they are not a New Kingdom recarving. For fragmentary elements, notably the beard and the uraeus, I (Lehner) drew the surviving pieces to scale and matched them to the finished surfaces on the Sphinx. Other features that are missing entirely, such as the breast lappets of the *nemes* headdress, were reconstructed from the equivalents from other sphinxes and royal statues. In this way we arrived at a reconstructed profile and frontal view of the Sphinx with the 4th dynasty head and face and the New Kingdom additions to the body and other structures around it [**19.15**].

In order to enhance this reconstruction the drawings produced from the fieldwork and photogrammetry were digitized by Tom Jaggers, of the Jerde Partnership Inc., in Venice, California, to produce three-dimensional images of the Sphinx plans and elevations. The process of creating a computer model of the Sphinx was a bit like sculpting the statue again in computer memory. We then adapted this computer model of the Sphinx to illustrate what it looked like after its 18th dynasty renewal.

Chest statue

In the graphic reconstruction the royal statue at the chest was shown wearing the *nemes* scarf, and either the *shendyt* skirt or alternatively the triangular skirt. On the well-known statue of Amenhotep II in the protection of the Hathor cow from Deir el-Bahri the pharaoh wears the triangular skirt, as do both Thutmose IV and Ramesses II on their stelae in the Sphinx chapel. (The reason that these stelae do not show the royal statue at the chest of the Sphinx is possibly because the king himself takes its place; i.e., the king impersonated by the statue moves down and turns to offer incense and libations.) We stood the royal statue on a plinth about 1 m (3 ft) thick, leaving the figure 6.8 m (22 ft 4 in.) tall and bringing its feet almost level with the Sphinx's paws, not unlike some of the New Kingdom depictions on votive stelae.

In the computer rendering, we 'borrowed' one of the contoured photogrammetric images of Ramesses from the Small Temple of Abu Simbel and placed this behind the Thutmose IV stela at the chest of the Sphinx, so that its contour lines would correspond to our survey grid lines (see 10.21). It is clear that the Ramesses statue was designed especially for the massive cliff-side sloping façade, a scale 2 or 3 m (6 ft 6 in. to 10 ft) larger than its 6.8 m (22 ft) in the reconstruction of the Sphinx. The head is oversized relative to the body, and the figure seems to stride forwards while tilting slightly backwards. At Abu Simbel the odd proportion of the head is compensated for by the perspective of the observer at the feet of the statue, and so also at the Sphinx the proportions look better from the ground view in the chapel.

The gap in the masonry veneer at the centre of the Sphinx's chest and the stack of stones at this point in Salt's sketches and other details indicate that there was a masonry attachment between the Sphinx's chest and the statue. This offered a broad support for a long divine beard and its much narrower bridging plate. The computer images indicate that the beard may have thrust forward more than in the drawn reconstruction, as it does in the relief-carved sphinx on the Thutmose IV stela, where it projects forwards so that it would be just over the back of the royal statue's head.

The chapel

Henry Salt's sketches of the chapel between the paws of the Sphinx, on which we based our reconstruction, capture the appearance of this structure in the very last phase of antiquity. The low front walls of the inner chapel and the pavement of brick-sized limestone slabs give the impression of being fairly late, dating, we might guess, to the Roman restorations of the pavement, stairs and viewing platform out in front of the Sphinx. A runnel in the bedrock floor marks an earlier threshold and also hints that the entrance and pavement are not original.

The back wall, taken up entirely by the Thutmose IV stela, and the side walls belong to the 18th dynasty. Although the stelae of Ramesses II were set into the side walls – one on the south and the other on the north – the walls themselves may date to the time of Thutmose IV, judging from the material found in the base of the southern one. Abundant evidence of ancient blue paint from the fill of the side wall probably relates to the small bits of Egyptian blue pigment that occur in the interstices of the masonry of large slabs that frame the Thutmose IV stela and reconstructing the south forepaw. Ramesses II may therefore have simply set his stelae into walls that already existed. It is also possible that whatever surface was painted blue in the 18th dynasty was repainted in the 19th dynasty, when Ramesses might have renewed the side walls of the chapel and erected his stelae – one of Salt's sketches gives the impression that the Ramesses II stelae were integral parts of the side walls.

It is very likely that the crenellations on the top of the chapel wall refer to the same architectural device that ran along the top of the great temple enclosure walls in the New Kingdom, as indicated by models and relief scenes. The crenellations make the temple the citadel of the god. And so, on a small scale but with grandiose intent, the open-air chapel at the heart of the Sphinx was a citadel of Horemakhet.

Colour

It may be hard for us to imagine today, but it is very likely that during its reconstruction in the 18th dynasty the entire Sphinx was painted in bright colours [**19.16**]. We know this is certainly the case for other statues made of wood, limestone and even hard stone. Traces of red still remain on the face of the Sphinx, and red powder from ancient paint pours out of the seams of the masonry veneer. According to Salt's notes, when Caviglia first excavated the chapel, 'all these remains, together with the tablets, walls, and platform of the temple had been ornamented with red'.[10]

In the core of the south wall of the chapel, we found fragments of blue with a calcite backing, as well as Egyptian blue powder (pigment) adhering to sherds. We also found scattered bits of Egyptian blue throughout the masonry of the chapel, while scant traces of yellow pigment are found on the

items in the fill of the chapel wall. The broken off uraeus head retained traces of painted gesso on its surface, with red on the eyes and flecks of white and black elsewhere; the top is yellow and there are yellow traces along the back break.

It seems probable that the Sphinx's eyebrows and divine beard were painted blue in the 18th dynasty. Blue was the traditional colour for these features for gods and divine creatures. The Story of the Shipwrecked Sailor testifies to this, for the gigantic serpent, Lord of the Island of the Ka, was '30 cubits, his beard was over 2 cubits long. His body was overlaid with gold, his eyebrows were of real lapis lazuli'.[11] The association of divine facial hair and the colour of lapis lazuli also applied to the beard, for the beard of a god was said to be of lapis lazuli. Traces of blue are preserved on the beard of the Hatshepsut granite sphinx in the Metropolitan Museum (MMA 31.3.167). The traces of red paint on the Sphinx beard fragments in the Cairo Museum may result from a late repainting of virtually the

19.16 Artist's reconstruction of the New Kingdom Sphinx, brightly coloured, with the open-air chapel in front, based on evidence from the masonry of the chapel.

entire monument in red. Blue is also preserved in the recessed band of the pleating of the *nemes* headscarf of the Hatshepsut sphinx, while traces of yellow remain on the raised bands. The tail of the *nemes* was probably blue, as it is on the seated colossus of Hatshepsut (MMA 27.3.163).

So the revitalized Giza Sphinx of the 18th dynasty was probably given life by painting the face red, the beard and eyebrows blue, and the *nemes* blue and yellow. Stelae contemporary with Amenhotep II depict a shoulder mantle and folded wing on the Sphinx and it is not impossible that those who renewed the Sphinx painted these features on to the Sphinx body to indicate, as the stelae say, 'Horus Behedite, Lord of the Sky, Great God, variegated of plumage'. The evidence suggests that the giant statue thus became a complex composite of iconography after the New Kingdom Egyptians excavated it from the sands and embellished it.

Giza as the mysterious Rosetau

Rosetau was a dark, mysterious and secret place in the Netherworld of the imagination of the New Kingdom Egyptians. But there were two places in their universe known as Rosetau. One existed in the Afterlife, while the other was in this world – the Memphis necropolis, namely the Giza Plateau and specifically the area around the Great Sphinx.

The name Rosetau comes from the technical term, *setau*, for a sloping ramp. I. E. S. Edwards pointed out that the pyramid causeway was called *ro-seta*, 'Entrance of the Haul'.[12] The same term was also used for the subterranean tombs of the New Kingdom. *Setau* is the plural noun from the verb *seta*, 'drag', 'pull', and of persons to 'usher in'. *Ro*, 'mouth', or 'opening', forms a compound with *setau*, 'passages', so that a simple translation might be 'mouth of the passages', or 'entrance into the underground galleries'. *Ro-setau* must designate a place: the 'place of dragging'. Every necropolis was a place of dragging the dead in sarcophagi to their tombs, many of which had sloping subterranean passages. Some Egyptologists have therefore rendered *Ro-setau* as 'necropolis' in general. But the New Kingdom Egyptians elevated the 'place of hauling' or 'dragging' to a mysterious mythical domain of the Netherworld, and they identified this realm specifically with the ancient Giza Plateau.

A stela of Ramesses III mentions the village of Rosetau. Ancient texts also distinguish 'Upper Rosetau' and the 'Valley of Upper Rosetau', terms which must refer to the plateau and the Main Wadi to the south and southeast of the Moqattam Formation leading up in the direction of the Menkaure pyramid. Perhaps the most explicit reference to Giza and the Sphinx as Rosetau occurs on the Dream Stela of Thutmose IV. According to the text, the hour of rest for the king and his followers was spent in the 'Place of the Select of Horemakhet beside Sokar in Rosetau'. The god Sokar is already associated with the place name Rosetau in the Pyramid Texts; by the New Kingdom Sokar was intimately associated with Osiris and merged with him in the cult at Giza. Thutmose IV states literally that the place of Sokar in Rosetau is just next to the Sphinx.

The Afterlife or Netherworld Rosetau is the central focus of the Middle Kingdom Book of Two Ways. In the New Kingdom it is at the heart of a composition of scenes and texts that decorated the long sloping corridors or burial chambers of the royal tombs in the Valley of the Kings. This work was called 'Writing of the Hidden Rooms' or *Am Duat*, the 'Book of What Is in the Underworld'. The underworld is divided into 12 Hours of the Night, with each hour split into three registers. In the central register the sun god journeys through the night in his barque accompanied by his entourage, while the registers above and below represent the realms through which they pass, with various beings and phenomena encountered along the way. The registers sweep in parallel order down the corridors and around the walls of the burial chamber in the subterranean royal tombs (see Chapter 7, p. 138).

The entire composition of *Am Duat* is concerned with the death of the king and his identification with the sun god in his nocturnal journey through the Netherworld. The end goal of this journey is his resurrection through the gates of the Horizon in the 12th Hour, but the key moment takes place in the 4th and 5th Hours in the realm of Rosetau. Among all the arcana, these hours of the *Am Duat* are concerned prosaically with the burial of the royal body. And here the centrepiece is the 'Flesh of Sokar' in his cavern – that is, the royal corpse in the tomb and sarcophagus. Rosetau is the nadir of the Netherworld, the deepest and darkest region where

the body confronts decay – the deepest and darkest fear of the royal cult.

What did the mythical Rosetau of the Netherworld have to do with Giza as Rosetau? In the mythical Rosetau the sun god addresses the hidden Sokar and activates him from his dormant state. When the young prince Thutmose slept in the shadow of the giant statue – in the 'Place of the Select of Horemakhet beside Sokar in Rosetau' – the Sphinx, like Sokar in *Am Duat*, was at this time covered with sand. The god did not address the prince in the form of his flesh (Sokar), nor as his *ba* (Osiris), but as the fully manifest sun god, Khepri-Re-Atum. Just as the words spoken to the dormant Sokar in the cavern of Rosetau activated the divine force that enables the sun's morning ascension, so the sun god's words to the sleeping prince, through his manifestation of the Sphinx, set in motion the prince's ascension to the throne of Egypt.

Osiris, Lord of Rosetau

The cult of Osiris at the Sphinx may have developed from that of Sokar in the 18th dynasty. Texts mentioning Osiris, Lord of Rosetau, begin in the reign of Ramesses II and become more frequent thereafter. Through the New Kingdom the Sphinx became closely associated with Osiris in this form. So many of the New Kingdom and later monuments found at Giza invoke Osiris, Lord of Rosetau, that Egyptologists long suspected that from this time there must have been a chapel or temple to the god in this form near the Sphinx (see also Chapter 20).

Topographical directions to the location of Osiris, Lord of Rosetau, are given on the Inventory Stela (also known as the 'Stela of Cheops' Daughter'), probably dating to the 26th dynasty, that Mariette found in 1853 in the Isis Temple (see below and Chapter 20). The text specifies that 'the Mound of Horoun-Horemakhet [probably the Amenhotep II temple] is on the south of the House of Isis, Mistress of the Pyramid, and on the north of Osiris, Lord of Rosetau'. The Sphinx precinct is said to be 'north of Osiris, Lord of Rosetau', and the Isis Temple is 'on the northwest of the House of Osiris, Lord of Rosetau'. The topographical relations between the Isis Temple, the Horoun-Horemakhet Temple and the Sphinx sanctuary are generally correct, and so we might be justified in assuming that the missing

temple of Osiris, Lord of Rosetau, lay south or southeast of the Sphinx, as discussed in more detail in the next chapter.

The Osiris statue and the Sphinx

In his all-too-brief remarks about his massive excavations of the Sphinx published decades later, Auguste Mariette said that in 1853 he found pieces of a colossal statue of Osiris around the curious large masonry box attached to the south side of the Sphinx just behind its elbow (see Chapter 10, p. 236). According to Mariette, the Osiris statue was composed of separate blocks.[13] Laorty-Hadji, a traveller who happened to have seen Mariette excavating at the Sphinx, wrote in his travelogue that there were 28 blocks.[14]

Some of these pieces were still lying around over 70 years later when Baraize cleared the Sphinx ditch. He took several photographs of the south large box as his excavation progressed to the west and south, between the Sphinx and the Khafre causeway. In photographs of Baraize's work we see steps descending from the south over the Khafre causeway embankment. These could be Baraize's temporary steps, such as he installed for workers elsewhere. They come down to a platform about 2 m (6½ ft) high, which could be ancient. More steps lead east from the platform down to the floor of the Sphinx ditch. One photograph shows workers ascending the opposite, west side of the platform, which suggests steps on that side as well.

There is some doubt about whether this is an ancient structure or whether Baraize's workers constructed it from blocks that they found lying about in the debris. On balance it seems likely that it is ancient. As Baraize's workmen dismantled the lower double stairway, apparently with no documentation other than these photographs, they exposed a mud core for the platform, and possibly also a mud core or foundation for a stairway ascending to the higher ground above the Khafre causeway. If ancient, it formed a connection to the royal Rest House of Tutankhamun, lying farther south. Platforms with double stairways were associated with Osiris, or the king in the guise of Osiris.

In a gaping hole through the masonry of the Sphinx body inside the large box, Baraize found two

shaped limestone pieces, one of which one could be a torso, and part of a large double crown and face of limestone lay nearby. As his photographs show, Baraize moved these pieces around the southeastern corner of the Sphinx ditch (see 19.9). During our work at the Sphinx between 1979 and 1983, we found the statue pieces in the southeastern corner of the Sphinx sanctuary at the base of the Khafre causeway, substantially weathered since the 1926 photographs. The double crown and a face is now barely recognizable. A third piece at this location may represent the knee and shin of a statue. When complete, the crown was about 1.6 m (5 ft) tall – a standing royal statue in proportion to the crown would have been about 7.5 m (25 ft) tall.

A double crown may be more appropriate for an Osiride royal statue – that is, a depiction of the king in the guise of Osiris, Lord of the Underworld and resurrection – than for an actual representation of Osiris. Such statues are an integral part of the cult of royal renewal, representing the hypostasis of the king as a divine entity distinct from his existence as earthly sovereign, and are associated with the Sed Festival, a royal jubilee. Could such a statue have had anything to do with the well-attested cult of Osiris, Lord of Rosetau at Giza? The position of the statue at the right shoulder of the Sphinx fits the topographical directions for the 'House of Osiris, Lord of Rosetau' given on the Inventory Stela.

The Osiride statue might have been housed in a naos. An ancient Egyptian naos was, in effect, a miniature temple that usually sat on a high stone socle or plinth; in fact, the enigmatic masonry boxes attached to the Sphinx may be best explained as being supports for naoi. The ground plan of a naos, with its closed back and side walls, and open front wall with jambs for the double-leafed wooden door that could be opened to service the divine image, is exactly the hieroglyph for *per*, 'house' or 'temple'. Naoi for Osiris, which are often depicted in statues holding miniature versions, can have either flat or rounded tops. On the Inventory Stela, the figure of Osiris, Lord of Rosetau, is actually shown in a shrine with a rounded top, as he is in a fragment of relief from the Isis Temple. While this is a common convention, it could reflect the form of the naos in which the figure of Osiris resided at Giza. A colossal naos might have been considered the 'house' or 'temple' (*per*) of the Osiride statue.

As part of our graphic reconstruction of the Sphinx in New Kingdom times we included a naos on top of the south large box on the Sphinx's shoulder. In order to accommodate the 7.5-m (25-ft) tall statue, the naos would have risen about 8.3 m (27 ft) high from the top of the box, and 11.6 m (38 ft) above ground level, with a width of 3.75 m (12 ft 4 in.), allowing for walls 50 cm (20 in.) thick. This would have been an impressive structure in its own right. The many limestone blocks that Baraize found around the base of the box might have told the story of whether the naos in fact existed. There is also some question of whether a naos of this size could have been built up from the tops of the walls of the south large box. For comparison, we looked at a large naos of Amasis at Mendes of a similar size, albeit carved from a single block of granite. It stood on a pedestal of rough limestone blocks of the sort that filled the south large box as packing masonry. The similarity between the pedestal of the Mendes naos and the Sphinx south large box is, putting aside the question of the existence of the naos, one of the few indications that the Phase II masonry, which completes the rounded shoulder of the box, is 26th dynasty.

Way station to Rosetau?

Egyptologists have suspected that the missing temple of Osiris, Lord of Rosetau, may have been near Kafr el-Gebel, once a village but now a suburb of Cairo, a short distance southeast of the Sphinx. A number of inscriptions and architectural fragments that carry the name of Ramesses II and his son Khaemwase have been found here. Khaemwase was the high priest of Ptah at Memphis, but he is also known for being the earliest Egyptian archaeologist. He restored Old Kingdom pyramids at Saqqara and left inscriptions to record his actions. Some Egyptologists suspected that Khaemwase's tomb was in the vicinity of Kafr el-Batran village. Lepsius saw a granite jamb of Khaemwase there. Other fragments mention Sokar-Osiris, or Osiris, Lord of Rosetau. Could these have derived from the missing temple of Osiris, Lord of Rosetau?

In 1985 the mud-brick walls and relief-carved limestone accoutrements of a small chapel of Osiris, Lord of Rosetau, were exposed during the construction of modern apartment buildings in

Kafr el-Gebel.[15] Salvage excavations revealed that the building was evidently constructed like the Amenhotep II temple at the Sphinx, with plastered mud-brick walls with limestone jambs, lintels and inset stelae. The relief carving and hieroglyphic texts on these pieces repeatedly invoke Sokar and Osiris, Lord of Rosetau. The texts also invoke Ramesses II, 'beloved of Osiris, Lord of Rosetau, and Tia and Tia'. This same husband and wife were perhaps the two most important people in Memphis – in all Egypt even – for a stretch of the long reign of Ramesses II. Tia was the king's sister, and her husband was Superintendent of the Treasury.

A small square pillar from the little temple is inscribed on four sides with different gods. On one side the god, probably Re, is addressed as 'shining in the eastern horizon of the sky'; the opposite side invokes Khepri-Re, the morning sun. The two other sides invoke, respectively, Osiris, Wennefer, Foremost of the West, and Osiris, Lord of Rosetau.

Two stelae are dedicated by the Scribe of the Treasury, Iurudef, to Sokar-Osiris, Lord of Rosetau. In 1984 Geoffrey Martin found the mortal remains of this man within the larger tomb complex of Tia and Tia at Saqqara; Iurudef was the most trusted member of their entourage.[16] He shows himself with his wife Akhsu, two daughters and two sons. Iurudef addresses 'the Great God, Ruler of the Living Ones, Osiris, Lord of Rosetau, praise be to you lord of eternity...'.

Modern cement and red-brick apartment blocks now cover the site of the small Ramesside building found at Kafr el-Gebel. It seems to have been a chapel, temple or perhaps a way station shrine on the path from Memphis to Giza. All the pieces seem to be from the same structure, a 19th dynasty shrine, built perhaps by Iurudef for his powerful patrons, Tia and Tia, who in turn dedicated it to their sovereign Ramesses II. So far, there is no evidence that it was built on the site of an older shrine to Sokar or Osiris that would constitute the missing temple of the Lord of Rosetau.

The temple of Isis

Since Osiris is represented at Giza as the Lord of Rosetau, and his son Horus is represented in the guise of the Sphinx, Horemakhet, so Isis would complete the core trinity of the New Kingdom pantheon. Isis begins to appear on temple walls and sarcophagi in the 18th dynasty, but Christiane Zivie-Coche has pointed out that any mention of Isis in Egypt as the focus of an autonomous cult with her own temple is rare in the 18th dynasty. Only in the 19th dynasty did Seti I dedicate a chapel to Isis in his Abydos temple, and by Ramesside times an independent Isis cult had developed. At Giza Isis took on the special and particular form, Mistress of the Pyramids.

By the 21st dynasty (see Chapter 20) the chapel of the southernmost pyramid of Khufu's queens, GI-c, had been converted into a small temple of Isis, and in the Late Period she became known at Giza as the Mistress of the Pyramids. But there are hints of Isis worship near this spot already in the 18th dynasty. Reisner, who cleared the area of the temple in 1924–26, found a number of small faience rings and scarabs somewhere in the debris between queens' pyramids GI-b and GI-c, in the fills of pits in the mastabas to the east and in the debris on top of the mastabas. The rings bear the names of every king from the great conqueror Thutmose III to the end of the 18th dynasty, and some names of 19th dynasty kings. Reisner recorded no exact provenance for the rings nor do his excavation records indicate a general archaeological layer in Street G 7000 or in the vicinity of the Isis Temple that can be assigned to the New Kingdom. Yet the rings must testify to a popular cult in the Eastern Cemetery and to pilgrimages during that period.

A series of small triangles, probably pubic and associated with Isis, were etched on to the lower eastern casing of pyramid GI-c, perhaps during the New Kingdom. Zivie-Coche suggested that in the 18th dynasty, Egyptians could have excavated the area east of GI-c from the sand, just as they excavated the Sphinx and the area east of the giant recumbent statue. At pyramid GI-c, they may have built a small chapel with walls of mud brick and doors of limestone, like the temple of Amenhotep II at the Sphinx. Egyptians of the 21st dynasty who expanded and rebuilt the temple might have taken these walls down, and excavated away the New Kingdom occupation layers.

Other New Kingdom objects testify to the cult of Isis at this time. A stela of Prince Amenemopet, a son of Amenhotep II, may evoke the image of the 18th dynasty Isis Temple. In one register the prince

and his bearer do homage to Isis. The goddess Isis is shown wearing the crown of Hathor and sitting within a kiosk supported by Hathor-headed columns – perhaps representing a real shrine or temple. Such columns characterize Ptolemaic mammisi, or 'birth houses', in the temple of Isis at Philae. A stela of a man named May from the reign of Ramesses II shows Isis again wearing the Hathor crown, and names 'Osiris, Lord of Rosetau, Sokar, Lord of Shetyet, Isis the Divine Mother and Horus who-protects-his-father'. And among the small stelae set in the walls that Thutmose IV built around the Sphinx was one of Isis, 'Lady of the Sky, Mistress of the Two Lands' [**19.17**]. These various documents make it probable that the little pyramid chapel of the 4th dynasty queen was already the focus of Isis worship before being completely rebuilt in the 21st dynasty.

Why did the New Kingdom Egyptians choose this particular queen's chapel as an abode for the spirit of Isis? We can only guess that it was because it was the best preserved of the queen's chapels, or perhaps because it was the closest to the Sphinx. Located at the low southern end of Queens' Street, the GI-c chapel may have been deeply buried in sand and therefore better preserved than

the chapels of the other two queens' pyramids. Christiane Zivie-Coche compared this cult to a similar development in the pyramid complex of the 5th dynasty pharaoh Sahure, where a popular cult of the lion goddess Sekhmet flourished for a long time, possibly because of an image of the Old Kingdom cat goddess Bastet carved in relief on the temple walls. Perhaps an image of Khufu's queen struck the New Kingdom visitors to Giza as being that of the goddess, though we know hardly anything of the relief-carved scenes that decorated the GI-c pyramid chapel. Seen from due east down in the floodplain, pyramid GI-c stands alone, in silhouette, just between the pyramids of Khufu and Khafre, so it is an apt focus for a goddess who is Mistress of the Pyramids, as Isis became known in the Late Period.

We suspect that in the New Kingdom cults at Giza the Egyptians played out the story of the divine family and their central myth: Isis as the wife of Osiris and mother of Horus, god of kingship. Osiris is here Lord of Rosetau, while the Sphinx is the son Horus in the Horizon, Horemakhet, coming forth like the divine birth from the horizon of the Giza Plateau, crowned by the pyramids of which Isis, the wife and mother, is the Mistress in her temple high on the plateau. It seems that members of the royal house and commoners of the Memphite nome alike made pilgrimage to the foot of the small pyramid to worship Isis. A path quite possibly followed the route of the modern road that descends past the Sphinx on the south from the Great Pyramid.

Sacrificing the historical Khafre for the gods

On his large stela at the centre of his temple, Amenhotep II refers to the 'Pyramids of Horemakhet'. While he does mention Khufu and Khafre, clearly by now the Sphinx as the embodiment of the god took far greater precedence over the historical rulers.

As outlined in Chapter 18, at the same time as they reconstructed and venerated the Sphinx, the New Kingdom pharaohs probably quarried granite from Khafre's pyramid complex. Granite casing blocks, likely from Khafre's pyramid, have been found in the New Kingdom Ptah Temple at Memphis. And the 15-ton Dream Stela of

19.17 Stela of Thutmose IV showing him worshipping Isis, 'Lady of the Sky and Mistress of the Two Lands', one of a series that Thutmose IV set into his bastioned mud-brick enclosure wall around the greater zone of the Sphinx and Khafre valley temple.

NC 2: the mysterious cave

Every year we hear strange stories about Giza and the pyramids from people we call 'pyramidiots'. This is a good place to discuss the tomb NC 2 and the cave it intersects, made famous and mysterious by 'New Age' forums, which claimed this was an unknown cave.

George Reisner gave the label NC (North Cliff) to three tombs at the eastern end of the higher of two escarpments that step down into the northern wadi bounding the northwest rim of the Giza Plateau. All three are unfinished, though NC 2 is the largest and most complete. During the Second World War, the three tombs were used as air raid shelters for team members, one of whom, Nicholas Melnikoff, mapped them in 1939.

In 1946 William Stevenson Smith wrote in a note on Melnikoff's plan that NC 2 dated to the New Kingdom, possibly the 18th dynasty, but gave no reason. In fact, we can compare the recessed inner bay with its pillars and central axis corridor to similar features in Old Kingdom rock-cut tombs in the Central Field West quarry, which date from the late 4th into the 5th dynasties. However, we should see the burial of animal, mainly bird, mummies in the North Cliff tombs, and the extensions of its chambers for that purpose, as features of the Late Period. Though not mentioned by either Reisner or Smith, when hollowing out the southern end of NC 2 the tomb makers broke into a huge natural cave with one fissure running south, perhaps for a hundred metres or more. Nor did Melnikoff map the cave, even

though it had been known for more than a century. Henry Salt, working with Caviglia, and Howard Vyse had all visited this tomb.

Then in 1980–81, Ibrahim Helmy, entomologist and researcher for the Naval Medical Research Unit in Cairo, found his way into the 'Dabh (hyena) Cave', as he says locals call it, at the back of NC 2. Helmy was looking for bats,[17] and returned to the cave with Giza Antiquities Inspector Essama El-Banna. The team investigated two passages, one of which led to three box-like chambers. One of us (Lehner) later went into NC 2 and the Dabh Cave, making it through the large northern room ('the Dome') and to the end of its narrow southern extension.

Then in 2008, Andrew and Sue Collins, and Nigel Skinner-Simpson came to Giza looking for a ground feature to correspond with the star Deneb, in the constellation Cygnus (the Northern Cross). Thinking they had found it, they dubbed NC 2 the 'Tomb of the Birds' and claimed the cave was unknown. The Collins team detailed their explorations in a film and a book,[18] and the news went viral, mostly on New Age forums.

One of us (Hawass) directed archaeologists of the Giza Inspectorate in excavations inside NC 2 in 2009–10. Unfortunately, events forced the work to stop when the team had mapped only the upper level. We imagine that the original makers of Tomb NC 2 broke into the cave by accident. Later people then incorporated the tombs and the caves into a network of chambers and passages for burying mummies of sacred animals, including birds, somewhat like the catacombs at Saqqara.

19.18 Archaeologists investigating the tomb NC 2. The tomb's entrance opens to chambers in the form of an inverted T. Two pillars carved out of the living rock support the ceiling of an inner recessed bay, the bar of the T, which leads to a corridor. Single niches were carved into the wall on each side of the corridor.

The unfinished statue of Ramesses II: Menkaure recycled

It was not just stone from Khafre's complex that the New Kingdom pharaohs recycled. Our excavations revealed striking evidence also for quarrying the pyramid of Menkaure in the Ramesside Period. In June 1996, the Supreme Council of Antiquities and the Giza Inspectorate of Antiquities began to reinvestigate the area around the Menkaure pyramid.

On the north side of the northeast corner of the first queen's pyramid, GIII-a, next to the foundations, we uncovered a large pair-statue of red granite, lying face up and slightly tilted on one side. Two standing figures had been roughed out, the heads directed to the west. The block measures nearly 3.4 m (11 ft) in height and weighs an estimated 3.5 tons.

Only the rough outlines of two standing male figures are visible, without much detail. The one on the left wears a short kilt; he has a *nemes* headdress topped by a sun disk, a *uraeus* on his forehead and a straight royal beard. Both arms rest against his body. In his right hand he holds a piece of linen (the *mekes*), and with his left hand he touches the hand of the second figure. The statue on the right is a similar male figure also bearing a sun disk on top of a long wig and also wearing a *uraeus*. However, his beard is longer and, although broken at the end, it can only be reconstructed as a divine beard that thickens into a curl at its end. The base of the statue is similarly rough and bears no inscriptions. The pair must represent the king, probably Ramesses II, accompanied by a solar deity. The god's sun disk is noticeably larger than that of the king.

A large crack split the block in two across the centre of the piece, which may be why the sculptors abandoned it unfinished. The statue had been carved from a block extracted from the lowest courses of queen's pyramid GIII-a, possibly from the north side where there is a gap of similar dimensions in the casing. Small granite fragments, the debitage of the sculpture, were found around it. Elsewhere in the corridor between Menkaure's pyramid and its subsidiary pyramids, the tumbled granite blocks from the casing show signs of having been reworked *in situ* into offering tables, paving slabs and column drums. One block bears on one side a rough hieroglyph for *t* and on the other a *hetep* ('offering') sign in relief. Stone pounders and hammers were found nearby, along with the traces of some black powder which may have been produced by the New Kingdom stoneworkers.

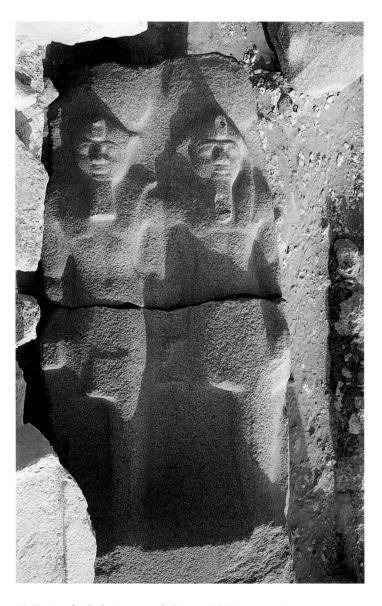

19.19 An unfinished pair statue of a king, probably Ramesses II, and a solar deity. New Kingdom sculptors took the huge block of stone from the GIII-a pyramid casing and then abandoned their sculpture when it cracked across the middle.

Thutmose IV is a reused lintel from over a doorway in one of Khafre's temples, as is clear from looking at lintels still in place in the Khafre valley temple. The back of the Dream Stela features the same ledge that forms the top of the door frame, and the same two sockets and pivot-holes for a standard Egyptian double-leaf swinging door. Since the bottom sockets of such doors were cut directly into the bedrock floor of the temples, we can trace where Thutmose removed the lintel. The space between the sockets fits only three doors in the Khafre upper temple, one being the entrance to that temple from the causeway.

This suggests an explanation for the similarity of the Phase I Sphinx restoration blocks to Old

Kingdom masonry. The range of thickness of the Phase I slabs matches very closely the slabs that form the walls of the Khafre causeway where a small section survives near its exit from the valley temple. It is very possible that Thutmose had his workmen remove blocks from the causeway to restore the Sphinx. After they had worked their way up the causeway taking blocks for the Sphinx, Thutmose then had them drag the lintel from the upper temple down to between the forepaws where he erected it to inscribe the story of his selection by the Sphinx for the throne of Egypt.

The stripping and recycling of Khafre's pyramid complex continued into the 19th dynasty. Uvo Hölscher, who excavated the Khafre temples in 1909, found a New Kingdom mud-brick ramp on the south side of Khafre's upper temple that was probably used for hauling away its granite pillars and sheathing. The Overseer of Works for Ramesses II, May, was brazen enough to leave his name etched into the rock walls beside the northwest corner of Khafre's pyramid.

Super deity on earth

The story of the New Kingdom at Giza is one of the rejuvenation of the Sphinx, which in some ways can be seen as an 18th dynasty monument as much as a 4th dynasty one. While it is tempting to take the Thutmose IV stela at face value and credit him with being the first to excavate the Sphinx from the sands, the evidence suggests that it was his predecessors, in particular his father, Amenhotep II, who began the effort to rescue and rehabilitate the Sphinx. The sand that filled the rock-cut sanctuary was dug out and dumped to the front of the great statue. The first of a series of viewing platforms and approaches to the Sphinx was built on the ruins of Old Kingdom temples at about the level of its chest, with stairways descending to the floor of the Sphinx sanctuary and the cult in the chapel at the base of its chest.

The 18th dynasty masons found the Sphinx in a seriously deteriorated condition, with the softer Member II layers of most of the body badly weathered. They filled the deeper recesses with packing of limestone blocks, gypsum mortar, sand and rubble, and gave the Sphinx a new outer skin of large limestone slabs, possibly, as mentioned,

taken from the walls of the Khafre causeway. The masons also found pieces of the Old Kingdom divine beard and retrimmed the rear faces to make it easier to restore them with mortar. Even more than in the Old Kingdom, the beard needed support, so they built a column of masonry over the boss that Khafre's sculptors had left for the same reason on the lower part of the chest. At the front of this support they erected a statue of a king so that his image would stride forth beneath the divine beard and within the protective embrace of Horemakhet. In addition to this and the Osiride statue on the south large box, at least two of the three other boxes suggest additional statues, shrines or naoi.

It may seem strange and inappropriate to us that the New Kingdom pharaohs would strip the complex of Khafre to repair the Sphinx. But each pharaoh was just another incarnation of Horus; each had his own special Horus name, Khafre's being User-ib, 'Strong Hearted'. As part of a revitalization of the kingdom and the cult of kingship during Egypt's period of greatest empire, Thutmose IV may have seen nothing wrong in recycling material from the ruins of Horus User-ib to give rebirth to the Sphinx as Horus in the Horizon.

The New Kingdom rebirth of the Sphinx was part of a burst of temple building nationwide, a reaching back to past glories in the wake of overwhelming military victories and renewed national pride and exuberance. In the early 18th dynasty, the Old Kingdom sanctuary at Giza was the abode of the most colossal royal/divine image that had ever been created. Within a generation of Thutmose IV, kings would make colossal images of themselves on a scale that rivalled the Sphinx. Like the Sphinx, these colossi were places of prayer and pilgrimage, associated with the sun. We can only speculate to what extent the Sphinx actually inspired these later colossi.

With the royal statue at its chest, the Sphinx was a powerful image for bestowing divine confirmation to princes and newly ascended kings in its *Setepet*, 'Place of Elect', or 'Place of Choosing'. The 18th dynasty kings wanted to unite their own image with this image so that, like the colossi of their successors, the Sphinx would 'convey to the viewer the impression that the union of king and godhead had created a super deity on earth.'[19]

CHAPTER 20
Giza in the Late Period

Most Egyptologists are familiar with the great enclosures that gave access up into the Saqqara necropolis in the Late Period. The Anubeion housed the precinct of the jackal god, Anubis. The Bubasteion was the domain of cat goddess, Bastet. Another approach led to the Serapeum from the north, through the Abusir Wadi, past the Sacred Animal Necropolis. In the minds of the Egyptians of the Late Period (from the end of the Third Intermediate Period to the arrival of Alexander the Great), such sacred totem animals – the cat, jackal, bull, baboon and ibis – represented two millennia of the generic, ancestral dead. Shrines and chapels lined grand processional ways through the enclosures.

PREVIOUS PAGES
20.1 The much added-to southern wall of the Isis Temple, expanded from the Old Kingdom chapel of queen's pyramid GI-c during the New Kingdom and Late Period.

Few, however, realize that similar processional ways led from the east up into the Giza Necropolis, not towards sacred animal shrines, but to small temples associated with members of the central, divine trinity: Osiris, Isis and Horus. Three ways led to the temples of these divinities that formed this Giza trinity. As pilgrims approached from Memphis, they could visit, from south to north, the Temple of Osiris, Lord of Rosetau; the Sphinx sanctuary of Horoun-Horemakhet; and the Temple of Isis, Mistress of the Pyramids. By the Saite Period (26th dynasty; 664–525 BC), these were the main points of interest at Giza. But stone robbers and archaeologists have removed and excavated – and failed to document – most of the evidence of the Late Period processional ways at Giza [**20.2**].

The Temple of Osiris, Lord of Rosetau

In Roman times, Pliny the Elder (xxxvi, 76) mentioned a village called Busiris at the foot of the pyramid plateau.[1] This Busiris, like 14 other villages of the same name in Egypt, developed out of the ancient Per-Wesir, 'Temple (or house) of Osiris'. As discussed in Chapter 19, Osiris at Giza had the epithet 'Lord of Rosetau'. The Giza Busiris was probably a continuation of *wehyet Rosetau*, the 'village of Rosetau', attested on a stela of Ramesses III more than a millennium earlier. Rosetau, 'entrance into the underground galleries', was both a mythical underworld place and the Giza Necropolis itself.

As we have seen, the evidence strongly suggests that Osiris, Lord of Rosetau, had his own temple at Giza, and it may have been the first stop on a southerly approach up to the Giza Plateau. Christiane Zivie-Coche has shown that in the Late Period this deity had priests and other functionaries with such titles as 'Master of Secrets of Rosetau'.[2] Either this temple has not yet been excavated, or archaeologists have failed to recognize that in the Late Period people identified one of the existing older structures that we know of, such as the Khafre valley temple, as the 'House of Osiris, Lord of Rosetau'. There are in fact several intriguing possibilities for its location.

Directions on the Inventory Stela, also called the Stela of Cheops' Daughter (p. 507), place the Temple of Osiris, Lord of Rosetau, south or southeast of the Sphinx. According to the text on the stela, 'the Mound (or temenos) of Horoun-Horemakhet is on the south of the House of Isis, Mistress of the Pyramids, and on the north of Osiris, Lord of Rosetau', while the Sphinx precinct is said to be 'north of Osiris, Lord of Rosetau' and the Isis Temple is 'on the northwest of the House of Osiris Lord of Rosetau'. Since the relative topographical positions of the Isis Temple (in the chapel of one of Khufu's queens' pyramids, GI-c), the Horoun-

Horemakhet temple (of Amenhotep II) and the Sphinx sanctuary are generally correct in this text, we might assume that the location of the missing temple of Osiris, Lord of Rosetau probably is too.

If so, this would place the Osiris temple just south-southeast of the Sphinx enclosure, which is of course where we find the Khafre valley temple. The New Kingdom Egyptians built an Amarna-style villa onto the front of the valley temple, on a casemate foundation resting on sand around 5 m (16 ft) above the bedrock terrace, and the so-called Rest House of Tutankhamun lay immediately south of the valley temple (see Chapter 19). Uvo Hölscher, who excavated the front of the valley temple in 1909, doubted that the New Kingdom Egyptians could have utilized the interior of the temple because of the fallen architraves and toppled pillars that Mariette found when he emptied it in the mid-19th century. These jumbled elements resulted from people plundering the temple for stone, possibly well before the New Kingdom. Why would the New Kingdom royals build installations all around the valley temple, but not make use of the interior? Could the valley temple have somehow evolved in the perceptions of the later Egyptians into a Temple of Osiris, Lord of Rosetau, just as the Sphinx became Horemakhet, and the chapel of the pyramid of one of Khufu's queens became the Temple of Isis, Mistress of the Pyramids?

In the layer above the southern part of the Amarna-style villa, Hölscher excavated a smaller square building of at least five rooms, including a stone-lined central chamber and doorway that gave access from the north. This hardly looks domestic, and may have been some kind of small shrine, which Hölscher dated tentatively to the Late or Ptolemaic periods – perhaps part of the Temple of Osiris, Lord of Rosetau?

In addition to the Inventory Stela, other tantalizing clues hint that the missing Osiris temple lies in close proximity to the Sphinx, somewhere to its south-southeast. In this area the Lepsius expedition found the bottom of a kneeling granite statue of the 26th dynasty king Psamtek II. The back pillar of the statue, now in the Berlin Museum, is inscribed with the king's names, 'living like Ra, beloved of Osiris, Lord of Rosetau', and 'beloved of Sokar-Osiris, Lord of Rosetau'. The statue may have once graced the missing temple.

A Saite Period cube statue of a man named Senbef, unpublished but photographed by Jean Yoyotte in the Cairo antiquities market in 1956, appeals to the prophets and purification priests who ascended towards the temple of 'Osiris, Lord of Rosetau'. The antiquities dealer told Yoyotte that the piece had been found in the Coptic Cemetery at Giza, south of the great gate in the Wall of the Crow. So the Osiris temple could perhaps be somewhere between the Sphinx and the great stone gate, which may have remained open as a portal of the sacred way 2,000 years after the 4th dynasty Egyptians built it.

South of the Wall of the Crow, Late Period burials on the site of the Workers' Town might also point us towards the missing Osiris temple. Two thousand years after the 4th dynasty occupation of the ancient settlement, people of the Late Period through to the Persian and Roman Periods, down to the 2nd century AD, dug burial pits through a sand layer and often down into the 'mud mass' of the settlement ruins. In the Late Period a common practice was to place the dead in mud coffins with moulded face masks [20.3]. The plastered and painted coffins carried inscriptions invoking the compound deity Ptah-Sokar-Osiris, and Osiris, Lord of Rosetau.

The Giza Plateau Mapping Project (GPMP) has excavated over 300 of these burials south of the

The Osiris graves

When the Ministry of Housing and Construction planned to build a ring road extension south of the pyramids at Giza and north of Zawiyet el-Aryan, we (Hawass), as Director of the Giza Pyramids, oversaw salvage excavation at the site. (The building project was later cancelled under pressure from the Giza Antiquities administration and UNESCO.) The excavation, carried out by the late Ihab Aamer, an Inspector of Antiquities, revealed a large symbolic cemetery for the god Osiris. Although the cemetery was only partially excavated, more than 60 symbolic graves were documented, most in a poor state of preservation and only a few in good condition.

The symbolic burials were created as small rock-cut graves or shallow shafts cut into the bedrock to a depth of around 1 m (3 ft). We found single, symbolic, wood coffins, with an average size of 30 to 50 cm (12–20 in.), buried in the graves. The coffins contained mummified statues covered with linen, about 15–20 cm (6–8 in.) long, made of mud mixed with barley or wheat. A significant characteristic of the statues is that the male sexual organs are in an erect position. Symbolic vessels made of pottery or alabaster, amulets and funerary jewelry made of metal and semi-precious stone surrounded the coffins.

The cemetery is dated to the Ptolemaic Period; one funerary vessel bore the cartouche of Ptolemy IV. According to ritual texts inscribed on the Dendera temple, the symbolic and ritual burial of the god Osiris took place annually, and we believe that these rituals took place at Giza.

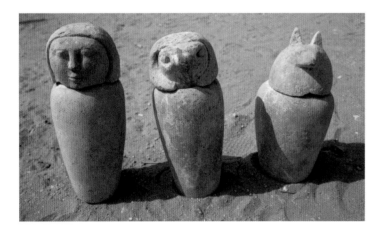

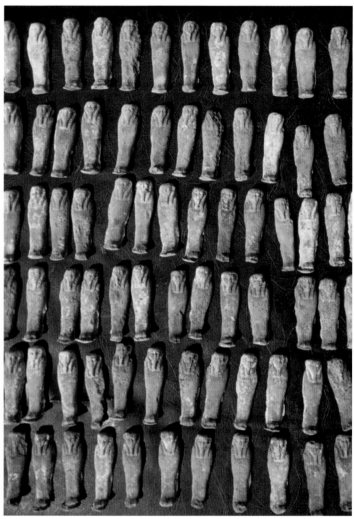

20.4, 20.5 Canopic jars of limestone and faience shabtis (servant statues in mummy form to perform tasks for the deceased in the Afterlife) from the symbolic Ptolemaic Period burials on the route of the ring road across southern Giza.

Wall of the Crow and north of the ancient town's Main Street, but even this is just a small sample of an estimated 5,000 to 6,000 burials in this zone. The majority of burials align west–east, with the head to the west and so in the direction of any path that led from the south and passed through the gate in the Wall of the Crow.

The burials extend up to the entrance to the modern Christian Coptic Cemetery, where the antiquities dealer told Yoyotte the Saite Period statue of Senbef had been found. It is possible that the Late Period burials flanked a processional way leading through the gate in the Wall of the Crow to the temple of Osiris, Lord of Rosetau, in the

same way that Late Period burials at Saqqara lay alongside the Serapeum Way.

Could the missing Giza Osiris temple lie unexcavated south-southeast of the Sphinx and Khafre valley temple? A straight line drawn from the gate in the Wall of the Crow to the Khafre valley temple hits a large, low-lying mound, which has never been excavated. Selim Hassan wrote that during his 1937–38 season of excavation around the Sphinx he moved his work to the southeast of the Khafre valley temple where he mentions a mud-brick 'temple', and suggests it was the Temple of Osiris, Lord of Rosetau. However, Hassan published no plans or descriptions of this temple.

In the early 1970s Hans Goedicke excavated a thick mud-brick wall, since left exposed, running east–west about 40 m (131 ft) south of the Khafre valley temple. This is probably part of the great mud-brick enclosure wall that the 18th dynasty pharaoh Thutmose IV created around the Sphinx, but it could also have delimited a sanctuary of Sokar-Osiris that evolved into the House of Osiris, Lord of Rosetau, mentioned so frequently in Late Period texts. Only further excavation will tell.

As discussed in Chapter 19 (pp. 486–87), in 1985, during construction work to build apartments in the area of Kafr el-Gebel, a part of the Giza Necropolis situated southeast of the pyramids, further evidence emerged. Salvage excavations supervised from 1985 to 1987 by Ahmed Moussa uncovered the mud-brick walls and limestone elements from small chapel or temple dedicated in honour of Ramesses II to Osiris, Lord of Rosetau, who is mentioned in inscribed texts found at the site. It is possible that these are remains of a chapel or way station related to the Osiris temple. A large Ptolemaic Period cemetery containing symbolic graves perhaps relating to the ritual burial of Osiris also attests to the importance of this god at Giza.

The Sphinx: temenos of Horemakhet

We have numerous attestations to the continued importance of the Sphinx following its rejuvenation in the New Kingdom, though little trace remains of any Late Period architectural modifications to the mud-brick structures of the New Kingdom royal national park around the recumbent statue. As with most of the New Kingdom elements, the Late Period

modifications were removed over the course of the large-scale excavations of Émile Baraize and Selim Hassan in the 1920s and 1930s. Some evidence does survive, however, in a few notes and sketches, the more than 200 photographs of the Baraize excavation and the information that Selim Hassan published about his work at the Sphinx.

By the Late Period, Thutmose IV's massive mud-brick wall that enclosed the immediate Sphinx ditch like a giant cartouche held back more than a millennium's worth of drift sand, with the Sphinx crouching deep down within its cavern-like enclosure. The cartouche opened to a broad terrace to the east bordered north and south by mud-brick walls.

In front of the Khafre valley temple some of the New Kingdom walls were still visible, while some were buried by the ever-accumulating sand. Hölscher's 1909 work at the front of the Khafre valley temple showed the enormity of the deposits that had built up over the ages to a depth of more than 8 m (26 ft) down to the bedrock terrace in front of the temple. As noted before, John Gardner Wilkinson's map, drawn before Mariette's excavations, labels the mound covering the site of the valley temple, 'pits, probably unopened'. Some of these pits are wide, deep shafts typical of the Late Period found at Giza [20.6]. They descend into chambers within the massive limestone core of the southeast corner of the temple.

At the northern side of the Amarna-style villa, from the northeast corner of the Khafre valley

20.6 A wide, deep shaft cut into the bedrock, typical of Late Period elite tombs, which cluster along the Khafre causeway and elsewhere at Giza. This shaft was sunk into the Central Field West quarry cemetery, south of the Khafre causeway.

temple, a massive, mud-brick wall, 4.3 m (14 ft) broad, ran east. This was a thickening and rebuild at a higher level of the 18th dynasty wall that formed part of Thutmose IV's wide enclosure around the entire area of the Sphinx and valley temple (see Chapter 19). About 15 m (49 ft) further east, Baraize's photographic record shows another thick, massive wall built in segments of pan-bedded (curved or dipping) mud-brick courses typical of Late Period enclosurè walls around temple sites. The wall was founded at least 10 m (33 ft) above the Old Kingdom rock floor. It stops at an opening approximately on line with the Sphinx.

Another segment of similarly constructed wall still stands north of the Sphinx ditch running east from the Sphinx amphitheatre immediately south of the Late Period tomb of Ptahirdis (discussed below). Together with the older Thutmose IV mud-brick walls enclosing the Sphinx ditch, these Late Period walls must have formed a broad temenos around the Sphinx and the area of the viewing platform built over the Sphinx Temple ruins. This enclosure was the Late Period 'House of Horoun-Horemakhet' mentioned in the Inventory Stela (see p. 507).

The Processional Way and Sphinx Terrace

In the Late Period or Greco-Roman Period, a limestone-paved ceremonial avenue, about 5 m (16 ft) wide, led to the Sphinx viewing terrace from an eastern limestone stairway which descended from a higher level down through the opening in the enclosure wall [20.7]. In the middle of the avenue a square limestone structure opened to the west towards the Sphinx. It appears this was the remains of a chapel, shrine or naos, perhaps for the statue of a deity that faced the Sphinx.

Another square structure of plastered mud-brick straddled the southern edge of the avenue. The thick walls, preserved up to about 40 cm (16 in.) high, form an angular U-shape that opens on to the avenue. The interior walls, with a cornice moulding around the rim, retained the traces of painted graffiti, possibly the legs of the fertility god Bes. The structure must have served as the base for another shrine on the route to the Sphinx.

These arrangements were built over the older New Kingdom mud-brick terraces, stairs, walls and small courts, which were in turn built on debris that filled and covered the Old Kingdom Sphinx Temple. At the western side of the Late

20.7 Photograph taken during Émile Baraize's excavations of the area east of the Sphinx; view to the east, from the top of the Sphinx head. The Greco-Roman or Late Period processional way, paved with limestone, enters through an opening in a massive mud-brick wall typical of Late Period walls around temples. The path broadens out to a terrace leading to a wide stairway that descended to the Sphinx floor before its forepaws. In the centre of the view, the New Kingdom mud-brick stairway still remains at a lower level. At bottom right, excavations have reached the floor of the Old Kingdom Sphinx Temple.

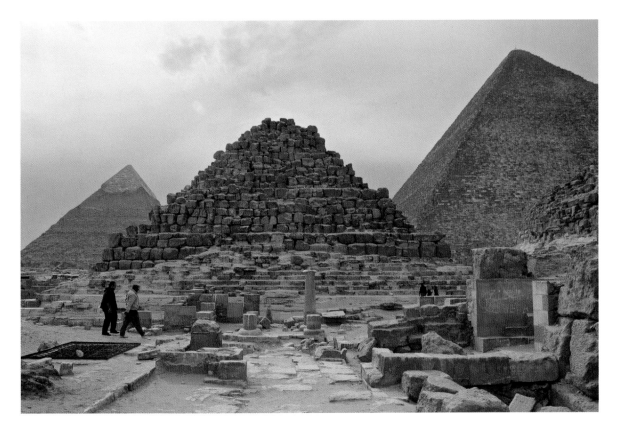

20.8 Ruins of the Temple of Isis, Mistress of the Pyramids, adapted from the 4th dynasty chapel of queen's pyramid GI-c. View to the west with the pyramids of Khufu (right) and Khafre (left) in the background.

Period terrace, in line with the Sphinx, another set of limestone stairs, bordered on the north by a limestone wall, descended to the floor of the Sphinx sanctuary.

In 1933–34, Baraize's excavators began to remove the enormous amount of debris that towered above the north side of the Sphinx viewing platform, and came upon a square mud-brick building with thick, massive walls almost level with the base of the pan-bedded mud-brick wall that ran north–south out in front of the Sphinx Temple. No plan or description of this enigmatic structure has been published, but it measures about 14.5 m (47.6 ft) east–west × 17.6 m (57.7 ft) north–south, with an axis slightly west of south. It seems to point towards a mud-brick podium associated with the earlier terrace in front of the Sphinx. The side of the building facing towards the Sphinx viewing terrace featured a front porch encased with limestone slabs.

This building is visible in an aerial photograph of the Sphinx site that Herbert Ricke published as the lower frontispiece of his Sphinx Temple study.[3] The wider aerial view of the Giza Plateau in his upper frontispiece shows the Sphinx site *after* the excavations of Selim Hassan. Here we can see the earlier Amenhotep II Temple that Hassan found and cleared when he took over the excavations of the site from Baraize. The building from Baraize's 1933–34 season is slightly east of the Amenhotep II

Temple, which must have lain partially buried underneath it. The Amenhotep II Temple was orientated west of south so that it pointed to the Sphinx's head. The correspondence in position and approximate orientation suggests that the later building could have been a Late Period replacement for the Horoun-Horemakhet Temple of Amenhotep II.

The Temple of Isis, Mistress of the Pyramids

The heart of Giza in the Late Period, or at least what we have most information about during this time, was the Temple of Isis. At the eastern base of the southernmost of the three pyramids belonging to Khufu's queens, GI-c, the little chapel, built 2,000 years earlier, formed the core of a temple dedicated to this goddess [20.8].

A cult was dedicated to Isis here possibly as early as the 18th dynasty (see Chapter 19), but it expanded greatly in the 21st dynasty, during the Third Intermediate Period, at a time when the worship of the goddess enjoyed widespread popularity in Egypt and beyond. In the Giza temple, not surprisingly, Isis was worshipped under the epithet 'Mistress of the Pyramids'.

It was not until Auguste Mariette's excavations between 1855 and 1858 that anything was known about the small Temple of Isis at the eastern base

of GI-c, though unfortunately he did not leave much in the way of a description of the precise location of his finds. He did mention, however, that in his day the residents of the nearby villages were dismantling the temple and reusing blocks in their houses, and this is perhaps why he excavated here during his work on the Khafre valley temple. Just over two decades later, Petrie wrote that 'official excavations by the authorities disclosed some fresh parts of the temple'.[4] The work must have taken place between 1880 and 1882; about this time inscribed fragments from the Isis Temple found their way into the Cairo Museum register.

The Isis Temple came under George Reisner's concession for the Eastern Cemetery, and he cleared the area between 1924 and 1926 as he began to work his way up 'Queens' Street' from south to north. Otherwise called Street G 7000, this runs between the line of the three Khufu queens' pyramids (GI-a, b, c) on the west and the large mastabas on the east [20.9]. The post-Old Kingdom monuments were not Reisner's greatest priority, and he was all the more distracted from later remains by the momentous discovery in 1925 of the tomb of Hetepheres at the northern end of the street. He did, however, leave an enormous amount of unpublished documentation from his excavations.

Christiane Zivie-Coche drew on the Reisner archive for her definitive study, *Giza au premier millénnaire* (Boston: Museum of Fine Arts, 1991), upon which we base much of the information in this chapter.

In 1980–81 Michael Jones and Angela Milward carried out a short season of cleaning, surveying and mapping at the Isis Temple as part of the ARCE Sphinx Project, directed by James Allen and Mark Lehner, and for which Christiane Zivie-Coche was the historian and epigrapher.

The Isis Temple: origins and antecedents

The Isis cult at Giza reached its apogee in the Late Period. Why worship Isis here, at the foot of the pyramid tomb of a queen who lived 2,000 years earlier? When that queen was alive, the principal female deities were Hathor, Bastet and Neith, who figure prominently in Old Kingdom names and titles. Priestesses of Hathor, especially in the form of Hathor, Mistress of the Sycamore, were buried at Giza in the Old Kingdom, and in one of the famous triads of Menkaure from his valley temple, Hathor of the Sycamore flanks the king (see Chapter 11). On a 4th dynasty false door, a woman named Teti bore the title 'Priestess of Hathor foremost of the Estate of Khafre'. Herbert Ricke thought the 'estate' might have indicated the Sphinx Temple, and

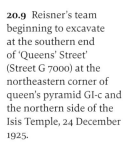

20.9 Reisner's team beginning to excavate at the southern end of 'Queens' Street' (Street G 7000) at the northeastern corner of queen's pyramid GI-c and the northern side of the Isis Temple, 24 December 1925.

he pointed out the fact that Hathor and Bastet were invoked in the inscriptions flanking the two doorways of the Khafre valley temple.

Did the Old Kingdom cult of Hathor at Giza lead to the Late Period cult of Isis, Mistress of the Pyramids? Zivie-Coche points out that the cults of Hathor of the Sycamore and Neith were probably focused south of Giza, at Memphis. The associations of Hathor at Giza are entirely related to the funerary royal cult in the pyramid complexes of the 4th dynasty kings, rather than being independent cults with their own chapels. Most problematic is the almost complete silence of hieroglyphic sources during the entire Middle Kingdom. It is likely that the association of Isis with the southernmost of Khufu's queens' pyramids began sometime during the New Kingdom.

As discussed in Chapter 19, pieces of relief carving and hieroglyphic texts and votive rings with the names of 18th dynasty pharaohs found in the area provide evidence of a New Kingdom Isis cult. The chapel at the base of pyramid GI-c may have been chosen for this cult simply because, by the 18th dynasty, it was the best preserved of the three belonging to Khufu's queens. Angela Milward and Michael Jones suggest that the Isis cult may have focused on the chapel of pyramid GI-c because the sanctuary had already been dug out by stone robbers, and so represented the kind of grotto or speos that the ancient Egyptians associated with Hathor, who they identified with Isis, as for instance on the Inventory Stela.

Expansion of the Isis Temple in the 21st dynasty

During the 21st dynasty the Priests of Amun in Thebes ruled over the south of Egypt, while the dynasty founded by Smendes ruled in the north, including Memphis. It became the custom at this time to bury rulers and nobility within temple precincts, a fact which helps us to understand the development of the Isis cult, since it is within this historical context that we find the earliest burials within the Isis Temple.

From the evidence of a fragment of a door lintel that Mariette found reused in the construction of a house in a nearby village, the 21st dynasty pharaoh Psusennes I, founder of the new capital city of Tanis in the eastern Delta, was the first to enlarge the little Temple of Isis at Giza. Here we

find the most ancient mention of Isis as Mistress of the Pyramids, along with the royal cartouches of Psusennes, as part of the title of a priest whose incomplete name is compounded with Ptah. Already the Isis Temple had a clergy – a 'divine father' as priests were sometimes called. This priest could have been the man named Ptah-ka on a similar lintel found in the ruins of Memphis at Mit Rahina, who shares some of the same titles as the priest at the Isis Temple. The Ptah-ka from Mit Rahina was also attached to the missing Temple of Osiris, Lord of Rosetau, at Giza.

Six pieces of columns from the Isis Temple, inscribed with the name of Psusennes' successor, Amenemope, depict various forms of the compound deity Ptah-Sokar-Osiris. Egyptologists noticed that on one column fragment (JE 28161), the original royal name Ramesses II had been changed to make the prenomen of Amenemope. Here the king offers wine to Osiris in his booth, behind which stands 'Isis the Great, The Divine Mother, ruler of the sky, Mistress of the Pyramids'. We must conclude that in the 21st dynasty Amenemope reused columns of Ramesses II, in which case the title, Isis, Mistress of the Pyramids, may have already been current in the New Kingdom. On the other hand, this is the only example in the New Kingdom textual corpus from Giza where Isis is called Mistress of the Pyramids, so the title could have been added to the column when it was reused for Amenemope.

At some point a small hall of four columns was built directly east of the Old Kingdom GI-c chapel. The walls of this hall had disappeared by the time of the first excavations, but the four columns remained to a height of 1.5 m (just under 5 ft). In spite of certain difficulties in matching the known column fragments to these four column stubs in Room 2, it is likely that the fragments belong here, and that Amenemope built, or usurped from Ramesses II, the little columned hall. Paint traces – blue on the plumes of Osiris' Atef crown, red on his vestments – suggest this was a colourful chamber. The hall was devoted to Ptah-Sokar-Osiris in his several manifestations, well known from other Late Period sources, and this god is backed by Isis, 'the Great, the Divine Mother, Ruler of the Sky, Mistress of the Pyramids'.

The 21st dynasty must therefore have seen a substantial expansion of the Temple of Isis,

now established with its own clergy. A lintel with Amenemope's name invoking 'Isis the Great, the [Divine] Mother...' may come from a small kiosk or pronaos east of the hall with four columns. Two column bases, 55 cm (22 in.) in diameter, belonging to this pronaos remained in the ground when Reisner excavated here; by the 1980s an electrical pole had replaced one of the bases. Channels in the pavement east of the two columns indicate a door fixture. The small Isis Temple was expanding eastwards across 'Queens' Street'.

Through the troubled times of the 22nd and 23rd dynasties, when Egypt fragmented into rival kingdoms and principalities dominated by rulers of Libyan extraction, the Isis Temple functioned at least as a sacred burial precinct. Someone built two chambers (Rooms 4 and 5) against the northern end of the original chapel of pyramid GI-c and divided Room 5 into 'burial boxes', in which Reisner found two wooden coffins and hundreds of poor-quality shabtis, the small figurines that accompanied the dead to perform tasks on their behalf in the Afterlife. One of the coffins was inscribed along the sides from the foot to the head with a hieroglyphic text that addressed: 'Ptah-Sokar-Osiris, and Osiris, who presides over the west, the Great God, Lord of Abydos...'. The burial belonged to a person named Bepeshes, a Libyan name, whose title is either 'born of a Chief of the Ma' or 'Chief of the Ma', one of the dominant Libyan tribes.

The Isis Temple in the Saite Period (26th dynasty)

Pharaohs of the 26th dynasty ruled from the Delta capital of Sais between 664 and 525 BC, hence it is known as the Saite Period. It ended when the Persians, led by King Cambyses, invaded Egypt, after which Egypt became a satrapy of the Persian Achaemenid Empire with Memphis as the administrative capital.

The Saite Period is known as a time of renaissance, when high dignitaries were buried within the heart of ancient cemeteries at Giza and Saqqara. Ancient materials were re-employed, old titles were revived and ancient art motifs reproduced. The Saites did not limit their archaizing interests to the Old Kingdom, but also copied Middle and New Kingdom elements. Memphis played a central role in this revival. Not only was the old capital pivotal to Upper Egypt and Lower

Egypt, but the city and its vast necropolis, now stretching from Giza to Saqqara, was also a cultural conservatory, a 'vocabulary of forms', for the Saite revival. The Egyptian cults continued.

At the beginning of the 26th dynasty the Isis Temple consisted of the Old Kingdom pyramid chapel, with the hall of four columns on its east fronted by the kiosk or pronaos with two columns, and augmented on the north of the GI-c chapel by added chambers divided into burial boxes. Through the Saite Period the temple expanded north and south. Officials built themselves funerary chapels (including Harbes), as independent annexes north of the east–west axis, filling in the space of the old 'Queens' Street' between the queen's pyramid and the huge double mastaba G 7130-40 of Khufukhaf and his wife. Other people built chapels incrementally eastwards, both north and south of the axis, restricting the approach to a narrow doorway, entrance hall and corridor. Beyond this narrow passage, a small limestone ramp led over the western edge of the Old Kingdom mastaba into the kiosk, columned hall and inner sanctuary. Like the Sphinx, the Old Kingdom chapel of GI-c, possibly already dug out below its original floor level to an even deeper level, was now at the end of a long descending eastern approach to a grotto deep down within the sand-encumbered ancient necropolis.

Harbes: devotee of Isis

We know the owner of only one of the constellation of funerary chapels within the Isis Temple precinct – Harbes [20.10]. An official of the court of Psamtek I, Harbes was deeply devoted to the Giza trilogy: Isis, Mistress of the Pyramids, Osiris, Lord of Rosetau, and Horemakhet. He consecrated several statues to these deities and made a donation to Osiris of land to which he owned the rights. He and his father were probably buried in his chapel, as was his mother.

Harbes' chapel is a simple rectangular room, about 4 × 5 m (13 × 16 ft), built between the western face of mastaba G 7130-40 and Chapel 6, which was probably added later. Small modular limestone blocks, about 40 × 45 cm (16 × 18 in.), possibly quarried from the Old Kingdom mastaba casings, were used to build the chapel, which opens to the south directly north of the doorway into the

20.10 Remains of the 26th dynasty chapel of Harbes, which opened north off the processional way leading to the Isis Temple. View to the north-northeast.

BELOW
20.11 Relief of the goddess Isis suckling a king (in the form of the young Horus), from the north wall of the chapel of Harbes; now in the Princeton University Art Museum (y198); 46 cm (18 in.) high.

entrance kiosk of the inner temple. Its pavement is slightly raised above the court in front of the kiosk. Four engaged columns may have once supported lotus-form capitals, two each against the east and west walls; the inner columns survive to a height of 1.5 m (5 ft).

Curiously, Reisner found a large, heavy, Old Kingdom statue of a seated man within the chapel, which remained in place until recently. Old Kingdom statues were also found in the original GI-c chapel and in the area of the four-columned hall, probably removed from chapels attached to the large mastabas of the Eastern Field. Whether the devotees of Isis placed these in the temple as blessed ancestral images from a long bygone era, or someone abandoned the statues as they hauled them out for plunder, we do not know. Harbes' chapel was badly damaged and repaired before Reisner's excavations and was further restored after his work.

Although Harbes' chapel was still a work in progress, relief carvings decorated much of its north and east walls, in a style imitating Old Kingdom relief decoration. The graffiti of a family of priests who served not long after Harbes' time were later added (see below). From sections of the reliefs still in place, together with fragments that went

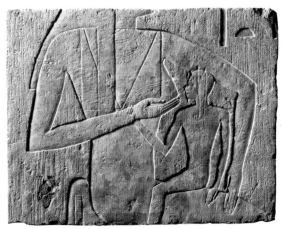

abroad, we know that the carvings included a scene showing Isis wearing a long tunic, tripartite wig and Hathor crown, seated on a throne and holding on her lap a naked infant with the braided side lock of youth [**20.11**]. She is called '[Isis] the Great, the divine mother, Mistress of the Gods', and the infant is labelled 'Harsiese' (Horus, son of Isis). Harbes kneels before the goddess in an attitude of adoration. Hieroglyphs identify him as 'Director of the Palace, son of Peftjau-em-awy-Shu, born of the Mistress of the House, Shepenset'. Other fragments reveal that Harbes was depicted in the company of a mummiform god, perhaps Osiris, and Isis and

Nephthys, who protect Osiris. This great scene of adoration occupied the east wall, between the first and second columns. From piecing together other fragments now dispersed, it seems another composition including Osiris faced towards the southern opening of the chapel, and it is probable that there was a symmetrical scene on the west wall.

We know the names of Harbes' father and mother, but not of his wife and children, and we are ignorant of his family origins. It seems his father, Peftjau-em-awy-Shu, was a specialist in liquid offerings and libations within a temple – either that of Isis or of Osiris, Lord of Rosetau. Harbes commissioned a stela recording his donation of a large piece of land to Osiris, Lord of Rosetau, possibly for cult services for his father, who may have been buried here. Reisner found a limestone statuette, about 33 cm (13 in.) high, of Harbes' mother, Shepenset, with its upper torso and feet missing. He also discovered two of her shabtis, among some 20 others, in 'loculi' cut into the bedrock walls of the original 4th dynasty burial chamber at the bottom of Shaft B in mastaba G 7130. Plunderers have shifted much material from place to place, before and after modern excavations, but it is likely that Harbes' mother was buried somewhere within the Isis Temple precinct. And when she was, Harbes ordered craftsmen to carve a statuette of her to 'make her name last'.

A limestone table of offerings for Harbes, about 40 cm (16 in.) square, suggests that Harbes himself is buried somewhere within the Isis Temple, but his burial has not been located and no other funerary equipment belonging to him has been found. No shaft has been discovered in his chapel, though the pattern of the pavement suggests one may be concealed below the centre of the floor. Zivie-Coche suggested that Harbes might be buried under Chapel 6, which seems to form an ensemble with that of Harbes.[5]

The number of good-quality monuments ascribed to Harbes gives us the impression that he was a dignitary of high rank [20.12]. However, his titles, some of which are revivals from the Old Kingdom, are of moderate importance and are civil or honorific. *Hery-seshtau*, Master of Secrets, is a frequent title in all epochs for individuals in the administration of a temple or royal office, and *wdpw nsw*, Royal Cup-bearer, was also quite

common. He was also Chief of the King's Servants, but his most important title may have been Chief of the Sealers, or Chief of the Treasurers.

Harbes worshipped all three deities of the Late Period Giza trilogy, but he especially venerated Isis. He held no sacerdotal titles except that of *kebeh*-priest and built his chapel within the Isis Temple precinct by virtue of his devotion to this goddess and by right of his civil position, not as a member of the clergy.

A family of Giza priests

We are not aware of any relationship between Harbes or his parents and priests of the Isis Temple, but a family of priests who for six generations held the title of Prophet of Isis, Mistress of the Pyramids, etched their hieroglyphic graffiti in little rectangular patches and long thin columns on the east and north walls of Harbes' chapel [20.13]. For the first three generations the title was transmitted from father to son. The fifth generation lived around the 34th year of the Persian king Darius I (488 BC); if we allow 30 years to a generation, we can estimate 610 BC as the date for the first generation, that is towards the end of Psamtek I's reign, probably soon after Harbes died, and adding up to approximately 180 years in total for this remarkable line of priests. Most of the third and all of the second generation are known from the genealogies mentioned in the graffiti of members of the other generations. Pami, who lived in the reign of Psamtek I, was the ancestor of the family, whose members also had connections in the Ptah Temple at Memphis and who were integrated into the religious framework of the greater Memphite region. These graffiti are a window on to religious activity and local history during the 26th dynasty and Persian periods.

These priests were not only prophets of Isis, Mistress of the Pyramids, but also of Horemakhet, the Sphinx, and of the 4th dynasty kings Khufu, Djedefre, Khafre and Menkaure. Pa-sheri-en-iset I was Prophet (*hem netjer*) of Horemakhet, or 'Divine Father and Prophet of Horemakhet'. Strangely, in spite of the great revival of attention to the Sphinx as Horemakhet in the New Kingdom, no priests or functionaries of Horemakhet are recorded from that time. In fact we know of no priests of Horemakhet other than those who left the Isis Temple graffiti,

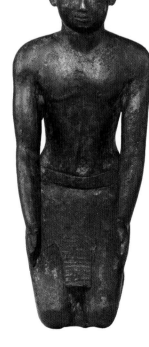

20.12 A kneeling bronze figure of Harbes, identified by an inscription on the back of the belt; now in the Brooklyn Museum (37.360E); 11.7 cm (4⅝ in.) high.

where the title Prophet of Horemakhet precedes the titles of priesthood of the 4th dynasty kings.

So that the divine family would receive his attestations forever, the priest Pa-sheri-en-iset inscribed his graffito, one of the largest compositions, on the east wall immediately in front of the image of Isis seated on a throne holding the naked infant Harsiese. Another priest is named Khufu-em-akhet ('Khufu in the Horizon'), after the name of the Great Pyramid, *Akhet Khufu* ('Horizon of Khufu'), which towered above the little temple. Pa-sheri-en-iset II's titulary is the most elaborate, tying the priesthood of Isis, Mistress of the Pyramids, to that of the four major kings of the 4th dynasty. All the title strings include 'Prophet of Khufu', who is always designated 'King of Upper and Lower Egypt' (*niswt bity*). Pa-sheri-en-iset II also calls himself priest of *Akhet Khufu*, but without the ideographic determinative of a pyramid or city sign. The fact that he considers himself a priest of the place, *Akhet Khufu*, rather than of the king, Khufu, shows that these priests probably based their revival on what they could glean from the 2,000-year-old inscriptions on the ruined walls of the Old Kingdom chapels, where *Akhet Khufu* is the name of the pyramid and its associated town, rather than from an investigation into official archives.

While people of the Saite Period revived many Old Kingdom titles for actual offices and functions, in this case the priesthood of the long-gone kings was probably more fiction than fact – not a true restoration of their funerary cults. The titles did, however, serve to honour and revere the dead kings, a fact which does not quite fit with a tradition, relayed by Herodotus, that Khufu and Khafre were reviled in popular memory. Zivie-Coche points out that ancient Egyptian officialdom never damned the memories of these kings, for there is evidence that their names were curated in all periods, not just in the 26th dynasty.

Other titles of this family of priests incorporated the sacred place name Rosetau, a term as we have seen that referred primarily to Giza, though Rosetau titles were also associated with Ptah, chief god of Memphis. A father, son (Shepensenut) and grandson (Shed) were prophets and Sem priests, libators, fumigators, Masters of Secrets and conveyors of offerings of Rosetau. Pa-sheri-en-iset was a prophet of Harendotes, Lord of Rosetau,

and he places this title between his titles of Priest of Horemakhet and Khufu. Harendotes, Ptah and Sokar are all gods said to be of Rosetau, like Osiris, and the names Ptah and Sokar are often compounded with that of Osiris. 'Master of Secrets of Rosetau' is a well-known title, often encountered in contemporary documents from the Memphite region. At Giza the Rosetau titles are associated with incense, food offerings and liquids of a funerary character. Osiris, Lord of Rosetau at Giza, had his own clergy – we know the name of several members.

Three of the Isis Temple priests, Pami, Pa-sheri-en-iset II and Psamtek, include just before their personal name the title President or Overseer of the Necropolis, which again is also found at Memphis. Zivie-Coche suggests that each village would have had its own person in charge of the local cemetery, and in the case of Giza these priests would have superintended the whole necropolis in this period.

20.13 Thin columns of hieroglyphs giving the names and titles of members of a family of priests, each a Prophet of Isis, Mistress of the Pyramids, were etched as graffiti into the walls of the Harbes chapel in the Isis Temple.

Reinventing the 4th dynasty

Perhaps by copying the style of their Old Kingdom predecessors, the Late Period Egyptians also hoped to resurrect some of their glory. They revived Old Kingdom religious texts, artistic scenes and official titles; important people sank great tomb shafts in proximity to the Old Kingdom pyramids; and they nurtured the cult of Isis, the queen mother of the gods and wife of Osiris, who gives birth to Horus in the central myth of kingship, choosing the queen's chapel at the southern end of 'Queens' Street' for its centre. At the same time that they transformed 4th dynasty monuments into divinities' houses, the Saite Period Egyptians sought to reinvent and re-enact the 4th dynasty itself, witnessed by the fact that they made a pretence of reviving the funerary priesthoods of Khufu, Djedefre, Khafre and Menkaure. A curious set of evidence suggests they even attempted to make a sham version for their times of the burial of Menkaure (see also Chapter 11).

When he first entered the Third Pyramid in 1837, Howard Vyse found in the limestone bedrock antechamber the fragments of a wooden coffin [20.14], with the remains of a human mummy. The form of the coffin dates it to the 26th dynasty, as does the use of Pyramid Text Spell 368:638 for the two columns of hieroglyphs down the centre of the cover:

> O Osiris, the King of Upper and Lower Egypt, Menkaure, living eternally, born of the sky, child of Nut, heir of Geb...divide.... Your mother Nut is over you. In their name, 'Mystery of the Sky', they cause that you will exist like a god without enemies, King of Upper and Lower Egypt, Menkaure, Living Forever.

It is not unusual for a Saite sarcophagus to borrow spells from the Pyramid Texts, but what does strike us as strange is that someone seems to have employed them in such an official manner for a typically 26th dynasty (or possibly 27th dynasty, Persian Period) coffer that is said to be for the 4th dynasty king Menkaure.

It is evident that people of the Saite and Persian periods penetrated the chambers of the Menkaure pyramid, but we do not know what they found. Menkaure's outer basalt sarcophagus must have

been still in place (Howard Vyse removed it, though it was lost in the Mediterranean when the ship carrying it to England sank), but what about the rest of the burial equipment, or the king's mummy? It is probable that the original burial had been plundered long before. If the Late Period Egyptians found the original mummy, albeit desecrated, perhaps the priests of the Giza Necropolis and ancient kings restored it with a new inner wooden coffin. If not, who would they have buried under the identity of Menkaure? To add to the mystery, radiocarbon dating of the remains found by Howard Vyse with the wooden coffin suggested that this mummy was of the early Christian era. Once again, someone must have penetrated the pyramid and chosen its chambers for a burial. This was not uncommon – all across the Giza Necropolis, Late Period peoples reused Old Kingdom tombs and temples for burying their dead.

Zivie-Coche points to other evidence of a resurrection of the cults of the original Giza dynasty. Scarabs were issued, though we know not where, bearing Menkaure's name. It is in his reign that certain chapters in the Book of the Dead state that Djedefhor (who was Khufu's son) discovered a magical formula in the temple at Hermopolis.

The story of the reburial of Menkaure and the revival of his memory became all the more curious in 1968 when the government Antiquities Service discovered an inscription after clearing debris away from the north side of the Menkaure pyramid [20.15]. The text, consisting of five lines of hieroglyphs, was engraved into the red granite casing of the pyramid, which here had been dressed, about 50 cm (20 in.) below the entrance. As mentioned in Chapter 11, Roman Gundacker examined the inscription and concluded that in it the 26th dynasty king Apries recorded that he restored Menkaure's burial.[6] Gundacker detects places for cartouches that show Menkaure as the tomb owner, Shepseskaf as the host of the original burial (perhaps with a date) and Apries as the restorer. This would explain the Saite-style wooden sarcophagus found in the Antechamber.

This text must be part of the Saite Period revival of the cult of Menkaure and his reburial. On the other hand, we know that Khaemwase, the son of Ramesses II and High Priest of Memphis in the 19th dynasty, who restored the ancient monuments

20.14 Engraving of the wooden anthropoid coffin made in the 26th dynasty for the 4th dynasty king Menkaure. Howard Vyse found the coffin pieces in the Menkaure pyramid antechamber (upper chamber). It is now in the British Museum (EA6647) (see also 11.10 for the actual coffin).

20.15 The inscription on the north side of the Menkaure pyramid, only discovered in 1968 when debris was cleared away.

and left inscriptions to record his activity, was active at Giza, though we have not found any definite mention of him on the pyramids. Zivie-Coche points out that based on parallels with his texts on other royal monuments, the presence of four cartouches makes it more likely that the inscription belongs to Khaemwase.[7] In this case, we would add the 19th dynasty to the Saite and Christian periods as times of intervention into the Menkaure pyramid. Both Zivie-Coche and I. E. S. Edwards suggest that it might have been this inscription that the Roman author Diodorus (I, 64, 9) mentions as identifying Menkaure as the builder of the third pyramid.[8]

A tall tale of Khufu and the Sphinx: the Inventory Stela

In 1858 a small, inscribed limestone block brought the Isis Temple under the intense scrutiny of Egyptologists. The piece is known in English as the Inventory Stela, because of the inventory of figures of deities that the text lists, and by French Egyptologists as the 'Stèle de la fille de Chéops'

(the Stela of Cheops' Daughter), because the text mentions Khufu building a pyramid for a daughter named Henutsen. The Inventory Stela was an anomaly for the emerging understanding of Old Kingdom history at the time, as well as providing a window on the topography of Giza in the Late Period.

Mariette only briefly mentions finding the stela (Cairo JE 2091) framed in, or fallen from, one of the walls in the Isis Temple, he is not precise which. It measures just 70 cm (27½ in.) high and 42 cm (16½ in.) wide, and a large return at the bottom, 10 cm (4 in.) deep and 17.5 cm (7 in.) high, gives the whole piece an L-shaped profile. A raised border on the sides and top frames the central panel, which is lightly incised with four registers of figures and text. It is the text around the border that immediately made this otherwise unattractive little stela highly unusual and interesting [**20.16**].

The framing text begins in the name of Khufu – with both his Horus name (as an incarnation of the falcon god of kingship) and his personal name, written with the sedge and bee of Upper and Lower Egypt. Such a complete invocation is rare for Khufu

in his own time. It then relates how Khufu found the Isis Temple in ruins:

> Live Horus Medjedu, the King of Upper and Lower Egypt, Khufu, given Life!
>
> He found the House of Isis, Mistress of the Pyramids next to the House of Horoun [the Sphinx], and northwest of the House of Osiris, Lord of Rosetau. He built his pyramid next to the temple of this goddess and he built a pyramid for the royal daughter, Henutsen, next to this temple.
>
> He made for his mother, Isis, divine mother, Hathor lady of the sky, an inventory engraved on a stela. He renewed for her the divine offerings, and he reconstructed her temple, having found it in ruin. He renewed it and the gods in their places.

The immediate irony and anomaly is that, whereas we see evidence for the fact that the priests of the Isis Temple renewed the names and possibly the burials, if not the offering cults of the 4th dynasty kings, here the text says that long before this, the oldest of the Giza kings renewed the name, offerings and the temple of Isis.

20.16 The Inventory Stela, so called because it gives inventories of figures and emblems of deities in the temple of Isis, is inscribed in the name of Khufu, stating that he renewed the temple. Mariette found the stela in the Isis Temple in 1858, but did not give a precise location.

The four horizontal registers of the central panel show 22 sacred emblems, cult objects and deities for the Isis Temple. These are relevant to the Giza cults of the time. The images of deities in human or animal form are actually depictions of statues, with details of their material and height specified, from 20 cm (8 in.) to 1.5 m (5 ft), though most are around 30 cm (12 in.) high. They are representations of representations. Most are made of gilded wood, acacia or ebony; some are of black copper or schist, with inlaid eyes and crowns of gold, silver or copper. An Apis bull and Horemakhet Sphinx in the lowest register lack material specifications. The giant bedrock Sphinx itself might have stood for Horemakhet, though it is possible smaller sphinxes also graced the little temple.

Zivie-Coche points out that the order of the 22 figures listed is that of a religious procession.[9] The first images in the upper register are the standards of the jackal god, Wepwawet, whose name means 'the Opener of Ways', and then of the gods Horus and Thoth. Such standards often figured at the heads of royal processions. Fittingly, Isis, Mistress of the Pyramids, appears in the second register as the central, essential element of the whole panel. She sits in a naos facing her sacred barque, which rests on a stand at a way station of rest, such as punctuated sacred processions. She is labelled 'Isis, the Great, Mistress of the Pyramids, Hathor, who is in the barque'. Isis is followed by Nephthys, with whom she is always intimately associated, and then Isis herself again, in different names and aspects – Meskenset, who determines destiny, and Isis-scorpion, Selket, who protects children – represented by the infant Horus upon her knees – from the deadly bites of scorpions. The panel shows Isis again in three other aspects, more difficult to determine, in a sanctuary and on a throne.

Next comes Osiris, standing mummiform in a naos just below Isis. Here he appears simply as Osiris, rather than being designated as 'Lord of Rosetau'. He is a member of the divine trinity with Isis and Horus, who is shown twice in different guises as an infant on the knees of the goddess: as Harendotes, the Avenger of his Father, and as Harpocrates, the Infant. A third infant, again on the knees of the goddess, wears the white crown, but the name is unreadable. Ptah and the leonine

Sekhmet, parent gods of the trinity of Memphis, stand in the third register, and their son, Nefertem, is represented in the fourth register in the form of his emblem on a stand, with the Apis bull above. The identity of the large cobra in the fourth register is uncertain; Zivie-Coche suggests it is Hathor in her form of the *uraeus*.[10]

The legend of Horemakhet, represented by the figure of the Sphinx at one side of the fourth register, is related in the long text at the end of the panel. It begins with two or three vertical lines in front of the Sphinx, continues with four horizontal lines on the ledge or return at the base of the stela, then resumes and finishes with three vertical columns in front of the Sphinx, separated from the initial lines by a blank column.

The temenos of Horoun-Horemakhet is south of the House of Isis, Mistress of the Pyramid(s), and north of Osiris, Lord of Rosetau. The writings of the sanctuary...of Horemakhet were brought to make an inventory...of these divine words of the great...his effigy, his surface entirely (covered) with writings...he made...which is in gilded stone of seven cubits after he...the environs after contemplating 'the storm over the hill of the sycamore', so named because there is a large sycamore consumed by the fire of heaven... in the temenos of Horemakhet conforming to the model that is engraved...all the animals sacrificed.... He laid out an offering table for the [*kerhet*] vessels and the [*henu*] vessels of the flesh of...which are presented and eaten in front of the seven gods...engraved beside this statue in the hour of the night. The...of this god...in stone. That he may be...in stone. That he may be durable. That he may be living eternally and forever, his face (turned) towards the east.

Alternative ancient history or literary apparatus?

On the Inventory Stela, Khufu is said to have found the Isis Temple in ruins, restored the images of the gods to their places and renewed offerings to the Sphinx. The text is a favourite of alternative Egyptology and New Agers, who would like the Giza pyramids and Sphinx to be older than Khufu – the remnants of a Lost Civilization, usually Atlantis. To the extent that they even take into account the abundance of archaeological and historical

evidence for the 4th dynasty society of Khufu, Khafre and Menkaure, the alternative theorists hold that the Egyptians of these generations usurped and renewed older structures at Giza, particularly the Sphinx; and superficially the Inventory Stela says exactly this. However, Egyptologists see no evidence that the style and content of the text, the form of the icons or even the worship of Isis in independent temples existed during the 4th dynasty. Thus, the suggestion that Khufu is supposed to have issued the stela is an anachronism. Likewise, while the iconography and deities do not correspond to the known expressions of Old Kingdom religion, they are typical of the Late Period, especially the 26th dynasty, and so the Inventory Stela cannot be a faithful copy of an older inventory.

We know of other temple inventories, and more might have survived if early examples had not been written on perishable papyrus. As far as the evidence permits us to say, Egyptians began to record inventories of sacred objects on stone after the 25th dynasty. The lists of statues they contain are extremely useful in giving us an idea of the functions of the temples. Stone-inscribed inventories become more numerous from the Ptolemaic and Roman periods, with examples found in shrines and the walls of crypts in temples at Dendera and el-Tod.

Zivie-Coche thinks that the Inventory Stela was probably inscribed during the reign of Psamtek I, and thus corresponds to the significant expansion of the Isis Temple in the Saite Period. It also falls in line with a series of commemorations of the 4th dynasty kings: the apparent (fictive?) reburial of Menkaure in a coffin typical of the Saite or Persian periods; the use on this and on other Saite sarcophagi of the Pyramid Texts; and the revival of the names of the 4th dynasty kings by priests of the Isis Temple. The Inventory Stela is not the only inscription from late antiquity that casts itself as a text from Egypt's earliest periods. Perhaps the other that is most well known is the 'Famine Stela' from Sahel, dated explicitly to Year 18 of Netjerykhet, Djoser, the 3rd dynasty builder of the Saqqara Step Pyramid, but almost certainly dating from the reign of Ptolemy V, two and a half millennia after Djoser.

The authors of the Inventory Stela wanted their work to pass as a historical text of the time of

Khufu, as this would then confer on their temple the authenticity of venerable antiquity, connecting it with the age when mighty kings built Egypt's largest monuments. Scholars view the story of Khufu's archaeology as an example of a common ancient literary device called the 'authenticating apparatus' – a shrine or temple is said to have been more ancient than it actually was in order to give authenticity to the fledgling cult. The great old age of the Giza 4th dynasty legitimized the cult's priests and partisans.

The 4th dynasty in Egyptian memory

In spite of such complexities, the Inventory Stela demonstrates the importance of the cult of the Sphinx as Horoun-Horemakhet in the Late Period. As with the Isis Temple, the Late Period Egyptians must have carried out a partial restoration of the colossal Sphinx statue. The text seems to indicate that, under the imprimatur of Khufu, they renewed the cult of the Sphinx with a perpetual burnt offering according to rules set down in a previous period. An inventory of the divine images logically follows a restoration of the temple and the renewal of worship.

According to Zivie-Coche, the text expresses the official reality of the period, which may not have corresponded to the popular reality. Herodotus (II, 124–29) circulated the tradition that Khufu and Khafre were tyrants, while Menkaure was more just. He reported that Khufu reduced the Egyptians to misery, closed the sanctuaries and stopped the sacrifices. He also said that the Egyptian priests told him that the pharaoh was so perverse, he turned his daughter over to prostitution and used each of the stones she charged for her services to build one of the queen's pyramids. So great was the cruelty of Khufu and Khafre that the Egyptians in Herodotus' day refused even to speak their names. On the other hand, the Ptolemaic priest Manetho wrote of the fame of Khufu's piety among the Egyptians, and said that he composed a sacred book.

Zivie-Coche suggests that the narratives of king, courtesan and pyramid reflect the contradiction between popular, oral tradition, and official, written history. One aspect common to both traditions – princess versus courtesan – is that the pharaoh Khufu built a pyramid for his daughter; whether her name was actually Henutsen we do not know.

How fictitious the revival of the cults of the ancient kings in the 26th dynasty was in reality is probably revealed by Herodotus' account. Could the same priests who claimed to be priests of the 4th dynasty kings have told Herodotus the popular story of princess as prostitute? The accounts Herodotus heard, allegedly from the priests, have some echoes in the Egyptian tales, such as the Middle Kingdom legend told in the Papyrus Westcar, which also presents Khufu in a not particularly advantageous light. It is difficult for us, looking back almost three millennia to the Saite and Persian periods, to know what people thought about a king removed from them by another two millennia. The evidence suggests that the memory of Khufu and Khafre was always mixed: never simply good or bad.

Burial ground of the late greats

It is an odd fact that Giza was little used as a necropolis between the Old Kingdom and the Late Period. While there are important New Kingdom cemeteries at Saqqara, at Giza the New Kingdom revival of the Sphinx as Horemakhet was not associated with an adjacent burial ground. True, Giza was on the northern periphery of the re-emergent capital of Memphis, yet it had become provincial. This sacred site of great antiquity was largely covered by a massive accumulation of sand. But in the Late Period, with the expansion of the Giza cults to include Osiris, Lord of Rosetau, and Isis, Mistress of the Pyramids, once again both elite and commoners chose to be buried at Giza. Until recently, however, archaeologists have not focused as much attention on the Late Period cemeteries at Giza as on tombs of the Old Kingdom. They documented and published the architecture and finds of the later tombs in much less detail.

Some of the burials belonged to prominent people from distant centres, especially the Delta. But many of the dead, such as the estimated several thousand poorer folk buried south of the Wall of the Crow, must have lived in a settlement near to the Giza Plateau [20.17]. Little or nothing of Late Period settlement at Giza has been excavated. Zivie-Coche suggests that it must have evolved from the *wehyet Rosetau*, the 'village of Rosetau', mentioned in a Ramesside stela. The village

continued to thrive after the Late Period as the village mentioned by Pliny called Busiris, from Per-Wesir, 'Temple (or house) of Osiris'. We imagine it must lie somewhere under the modern villages – now practically Cairo suburbs – of Nazlet es-Samman, Kafr el-Gebel and Nazlet el-Batran. These villages of the recent pre-modern period extend north to south on the low land, parallel to the stretch of Late Period cemeteries on the Giza Plateau.

Most high-ranking people of this time were buried in three principal zones at Giza: the Eastern Cemetery, east of the Khufu pyramid; the Central Field, along the Khafre pyramid causeway; and in the South Field, on the southern slope of the Gebel el-Qibli ('the Southern Mount'), the prominent knoll of the Maadi Formation overlooking the wide central wadi south of the Sphinx. Low-status people buried thousands of their dead in the Central and South Fields. The Western Cemetery, the Old Kingdom mastaba field west of the Khufu pyramid, was hardly used, probably because of its isolation from the cult centres of Osiris, Horemakhet and Isis, and also because it was completely sanded in.

The Eastern Cemetery in the Late Period

Scattered ring bezels and scarabs from the sandy surface of the Eastern Cemetery reveal that people were visiting this part of the Giza Necropolis during the New Kingdom, probably visiting the Isis Temple, where worship of the goddess was already associated with queen's pyramid GI-c. Sparse remains of funerary objects hint further that some New Kingdom people may have buried their dead within the ruins of the Eastern Cemetery. Occasionally we can read their names and titles, including those of Pahem-netjer, a Sem priest and Great Chief of the Artisans, written on the bottom of one of his shabtis that must have been plundered from his tomb somewhere in the Eastern Cemetery and discarded.

By the Late Period, judging from the quantities of objects found in the surface debris on the tops of the ruined Old Kingdom mastabas and in the streets and avenues of the orthogonally planned cemetery, individuals were buried over much of the area of the Eastern Cemetery, in addition to the burials within the Isis Temple. Zivie-Coche discerns

two possible zones of concentration within this scatter of funerary objects: one south of the Isis Temple and the other along the eastern rim of the Eastern Field, near the edge of the escarpment. Could these zones have lined the route of ascent from the House of Horoun-Horemakhet, the Sphinx temenos, to the House of Isis, Mistress of the Pyramids? Zivie-Coche's reconstruction of the Late Period burial grounds at Giza was made more difficult by the lack of care taken by the excavators – even Reisner's notes were cursory and ambiguous on the topic. However, she was able to distinguish three classes of Late Period tombs in the Eastern Cemetery.[11] The first, and least elaborate, which were also the most recent, were found in the fill of the streets and avenues of the mastaba field, dating from the Late Period through to Roman times. Late Period people simply placed their dead in the soil and debris and covered the bodies with crude structures of mud brick and stones. A second type of Late Period burial took the form of niches for sarcophagi and other funerary equipment cut in the burial chambers of the Old Kingdom mastabas and of queen's pyramid GI-a. Thirdly, Late Period people also cut completely new large shafts, up to 12 m (39 ft) deep.

The burial objects from the Eastern Cemetery tend to be neither rich nor fine, and the shabtis

20.17 Mud 'slipper coffin' of a Late Period burial immediately east of the east end of the Wall of the Crow site, excavated by a team under Jessica Kaiser in 2001. Archaeologists sacrificed the vertical stratigraphic section (the baulk) to maintain the integrity of the burial.

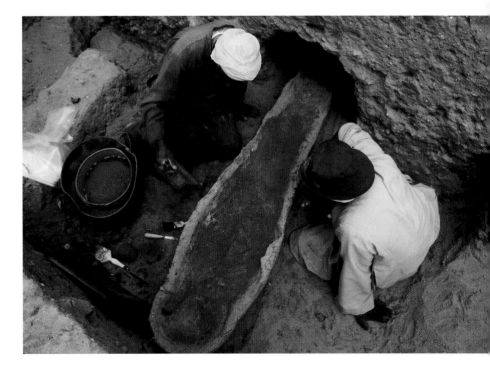

are of mediocre quality. From their names and titles we can guess that some of the dead, for instance Pami (the ancestor of the priestly family?), Hotep, a divine father of the Mistress of the Pyramids, and Shepensenut, a temple libator, must have served in the Isis Temple. Of course the prime burial ground was within the Isis Temple itself, resulting in the constellation of fine chapels and tombs along its east–west axis.

The Central Field in the Late Period

Within what Egyptologists refer to as the Central Field of the Giza Plateau are three distinct zones, distributed north and south of the Khafre causeway:

1 Central Field North (CFN) – the zone north of the Khafre causeway, between it and cemeteries GI-S and the Eastern Cemetery.
2 Central Field West (CFW) – the debris-filled quarry south of the Khafre causeway, which had probably furnished most of the core stone for the Khufu pyramid.
3 Central Field East (CFE) – the triangular area south of the Khafre causeway from the Khentkawes monument to the Sphinx, with rectangular quarry blocks and a concentration of Old Kingdom rock-cut tombs.

Some prominent people of the Late Period reused 2,000-year-old rock-cut tombs from the Old Kingdom. In a pit near the tomb of Nikauhor, one of Khafre's children, along the western edge of the Central Field quarry, Selim Hassan found the cover of a sarcophagus of a man named Hor-em-akhbit who lived during the Ptolemaic Period and who served as priest under the rulers Ptolemy III Euergetes and Berenice, and Ptolemy IV Philopater and Arsinoë; he was also priest of the gods Onuris, Khonsu and Osiris. A man and a woman, named Harsiesis, son of Tekaas, and Isis-em-akhbit, reused another Old Kingdom rock-cut tomb (No. 14), where Hassan found their anthropoid sarcophagi.

Other high-ranking people sank tomb shafts in the eastern and western parts of the Central Field. However, most of the deep tomb shafts of the elite are near the Khafre causeway, forming roughly linear series along both sides of it, running from east to west. Sometimes the shafts clip the edges of

the causeway and even cut right through it, both honouring and honoured by this ruined sacred way. By the Saite Period the causeway had probably long been robbed of its roof and walls and existed solely as a massive bedrock embankment engulfed by sand. Nonetheless, the Late Period tombs roughly align to it, just as contemporary tombs lined the Serapeum Way at Saqqara, so the causeway must have retained some significance as a sacred route to the west.

The shaft tombs correspond to a classic Memphite as opposed to a Theban type of elite Late Period tomb. While the Theban tombs are tripartite vertical arrangements, consisting of a standing superstructure, sub-surface cult complex with a sunken open 'sun court', and a deeper level for the actual burial, contemporary tombs in the Memphite cemeteries are large, deep shafts, with a sarcophagus at the bottom and a chapel above. Some tombs include a secondary shaft for introducing the burial. In the Memphite tombs the sarcophagi take several forms, but the classic type is anthropoid (mummy-shaped), plump and square, with broad faces, large noses, smooth unarticulated mummiform bodies and slightly protruding feet. Inside the massive stone sarcophagi were inner anthropoid coffins of gilded cedar wood decorated with inlaid design, which in turn sometimes contained gilded silver mummy masks, numerous amulets and golden stalls for the fingers and toes of the mummy. In some cases the sarcophagi are set into a raised bedrock pedestal, created by quarrying the surrounding floor down to form a trench or moat, so that the deceased is symbolically buried as the god of death and resurrection, Osiris, on his Netherworld mound of resurrection.

For some reason, the Old Kingdom Egyptians had scarcely used the area north of the Khafre causeway for their tombs, so this was open ground for high-status burial in the Late Period. When Lepsius was working at Giza, as a result of either his clearance or excavations that preceded him, five large shaft tombs yawned open through the debris. The Lepsius expedition numbered these tombs LG 81–85. During excavations under the SCA, we found four more tombs, and also ascertained that the 4th dynasty Egyptians had quarried this triangular area north of the Khafre causeway down by about 2.5 m (8 ft), leaving a raised bank for the

causeway, but built no tombs in the expansive bedrock plane sloping east and south. Much later, grandees of the Late Period utilized this limestone slope for their chapels and tomb shafts.

The tomb furthest west (LG 81/G 9700) was cut into the north-facing side of the bedrock foundation of the Khafre causeway, just below the upper pyramid temple. At the front of the tomb a portico of four columns leads into the main chamber, with a deep shaft sunk through the floor, followed by a smaller back room. Sand has buried the entire tomb since Lepsius recorded it and the traditional relief scenes, borrowed from Old Kingdom tomb chapels, that decorated the walls of the main chamber. These showed the tomb owner and his wife, whose names were not preserved, attending to butchering and offerings. A lone shabti associated with this tomb bears a name that may be that of the proprietor – it is the same as that of the Great Sphinx, Horemakhet.

The tomb of a general named Amasis (LG 83/G 9550) is one of those that cut right through the middle of the causeway, about halfway along its length. No traces of a superstructure exist, nor have any ever been recorded – if this tomb and others did possess superstructures, they would have stood directly in the path of the causeway. It may have been in this shaft that Howard Vyse mentions finding a sarcophagus and shabtis with the name Amasis, along with pieces of linen, bone and gold leaf, but it appears that someone had already entered the tomb. The anthropoid sarcophagus, now in St Petersburg, belonged to Amasis, Overseer of the Army, who was the son of King Amasis (Ahmose II) of the 26th dynasty. The figure of a winged Hathor was engraved above 13 vertical columns of text of Chapter 72 of the Book of the Dead. Additional columns flanking Hathor contain words spoken by Isis and Nephthys, while registers of demons and deities line the sides of the sarcophagus. A peculiarity is that the name of Amasis and his title, 'Overseer of the Army', have been chipped away throughout the text.

Another anthropoid sarcophagus of black granite belonged to the mother of General Amasis, Nakht-bastet-iru. A third sarcophagus, which belonged to a woman named Ta-sheri-en-ta-ihet, daughter of Disneb, was engraved with Pyramid Texts and Chapter 174 of the Book of the Dead.

Campbell's Tomb

The tomb furthest east of this group (LG 84/G 9500), is also the largest and is known as Campbell's Tomb, after a Scottish diplomatic officer who participated in Howard Vyse's work. LG 84 is so large that it remains a principal feature of the landscape, about 55 m (160 ft) due west of the Sphinx depression, and is still open to this day, with only its southwest corner sanded in [20.18]. The tomb is unusual in consisting of a huge central shaft, 8 × 9.3 m (26 × 30 ft 6 in.) and 16.3 m (53 ft 6 in.) deep, surrounded by a moat-like trench, 1.6 m (5 ft 3 in.) wide, 14.5 m (47 ft 7 in.) square on its inner side, and more than 22 m (72 ft) deep; the shaft sits slightly to the north within the square formed by the perimeter trench. Five bedrock bracings or bridges on each side cross between the outer edge of the trench and the rock around the central shaft, as well as additional thick connectors at the corners. The deep perimeter trench leaves the floor of the central shaft raised on an island of bedrock, like Saite shaft tombs at Saqqara – again making the central burial a representation of Osiris embedded within his mound. Howard Vyse saw remains of an arched roof over the trench, which when complete must have resembled a thick, round-topped enclosure wall around the central shaft.

The main burial lay in a vaulted chamber built of fine Turah-quality white limestone masonry. The chamber's ceiling was flat at the top, with sloping sides that met the springing of an upper arch from the side walls; the top of this ceiling formed the floor of a second small chamber above, 2.5 m (8 ft 2 in.) high, which was in turn covered by the arched ceiling of the outer chamber, four masonry courses thick [20.20].

Howard Vyse entered the upper chamber through a breach that robbers had forced into its western end. In the centre of the floor he found a circular opening stopped up with a stone and coarse pottery. In the floor of the space below – the roof of the burial chamber itself – was another similar opening. Someone had already entered and removed the stone stopper. Inside the chamber Howard Vyse discovered a large stone slab that had formed a massive lid over an outer stone container for the inner, anthropoid sarcophagus of grey basalt, now in the British Museum [20.19]. The outer box rested on a heap of stones and a layer

20.18 Campbell's Tomb is a large, unusual tomb and is still a notable feature of the Giza landscape. It contained the burial of Pakap, from the 26th dynasty, but may have been in use for around 100 years. The Sphinx is visible in the background.

OPPOSITE LEFT
20.19 Inner anthropoid grey basalt sarcophagus of Pakap, which Howard Vyse found in the central burial chamber of Campbell's Tomb, now in the British Museum (BM 1384); 2.6 m (8ft 6 in.) long.

OPPOSITE RIGHT
20.20 John Shae Perring's plans, profiles and epigraphy of Campbell's Tomb.

of clean sand; rows of hieroglyphs engraved into its lower sides quoted the Pyramid Texts (Spell 266) and gave the name of the man buried at the centre of this unusual tomb:

> [Wehibre]-em-akhet, his great name, Pakap, his good name [or nickname], appearing as the god, Nefertem, on the lotus bloom which is at the nose of Re, he will issue forth from the horizon <daily> and the gods will be cleansed at the sight of him.

Near the shoulders of the sarcophagus, niches contained shabtis standing in double rows and wrapped in fine cloth. A square pit, 3 m (9 ft 10 in.) deep, close to the end of the sarcophagus might have once held the canopic chest or offerings.

The original entrance to the burial chamber was via a narrow, square, vertical shaft descending from the surface of the western bedrock wall around the larger central shaft containing the chamber. Workmen could have used this secondary

shaft to facilitate the lowering of the two heavy stone sarcophagi to the bottom of the main shaft. Having placed the sarcophagi on sand filling the main shaft, workers could gradually lower the heavy stones to the bottom of the shaft by removing the sand via the side shaft; they then constructed the fine limestone burial chamber around them.

Pakap's name appears several times in his tomb, for instance in an inscription in a narrow groove lined with plaster that runs round all sides of the main shaft near the bottom, together with spells from the Pyramid Texts and the Book of the Dead, and again, along with Spell 266, on the lid of his inner anthropoid sarcophagus. Pakap was Steward of Fields in the South and North, Judge of Scribes, Inspector of Scribes and Chief of the Scribes of the Royal Repast. He must have lived in the 26th dynasty reign of Apries because his great name incorporates one of the names of that king, but we do not know his genealogy, or why he chose Giza for his unusual, large tomb.

The secondary shaft west of the main shaft gave access to a passage that led south to another burial chamber containing a crude anthropoid basalt sarcophagus, the lid of which is now in the Ashmolean Museum, Oxford. This belonged to an Overseer of the Treasury and Overseer of All the King's Works named Ptahotep, son of a woman called Harenpetesnakht. Ptahotep probably died in the Persian Period, in the reign of Darius I or his successor, Xerxes. If so, Campbell's Tomb was used for burials over a period of 100 years.

An additional, smaller shaft descends through the southeast corner of the bedrock surrounding the main shaft. This gives access to two chambers

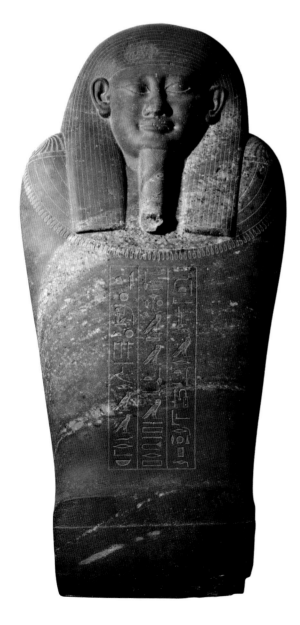

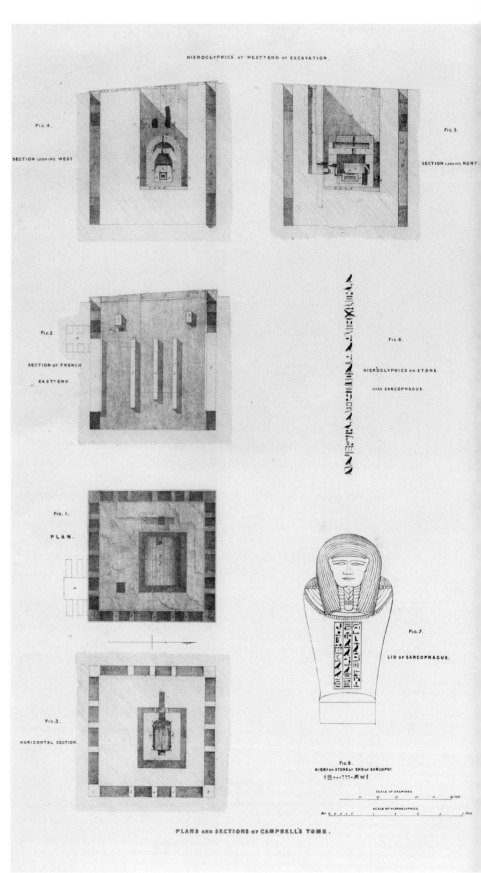

Excavations in Cemetery CFN

In 2004 one of us (Hawass) resumed excavations in the area north of the Khafre causeway and west of the Sphinx for the first time in decades, in a low sandy area that stretches about 70 m (230 ft) east–west and 50 m (164 ft) north–south. Here, the deep tomb shafts of the Late Period penetrate into a quarried bedrock surface about 0.5–2 m (1 ft 7 in.–6 ft 7 in.) below the sandy overburden. A new system of tomb numbers was allocated, beginning with T301 for Campbell's Tomb.

Here, for the first time we found the masonry remains of enclosures and superstructures around the tomb shafts. The masonry superstructures consisted of very well cut and prepared blocks of fine white Turah-quality limestone. Large rectangular blocks formed the floor and the outside walls of the structures, while medium-sized square blocks filled the cores of the walls. However, people have removed almost everything except the foundations of walls and some of the pavement. From Roman times to the Middle Ages, fine limestone from pharaonic monuments was used for making lime. Indeed, we found a massive deposit of crushed and fragmentary Turah limestone that resulted from exploiting the cemetery as a quarry, possibly as early as the Roman Period.

The walls of a well-built superstructure run on a north–south axis around T302, a short distance to the northwest of Campbell's Tomb. The basic plan appears to have included small limestone chapels, like those known above Saite tombs at Saqqara. Remains include what appears to be plaster-covered masonry, such as that which cased the upper parts of Late Period tombs at Saqqara.

We also found cruder masonry structures, lacking the preparation of the bedrock or stone block foundations of the 26th dynasty structures in the area. The superstructure of T304, east of T302, belongs to this phase. It consists of walls formed of local limestone with mud mortar and mud brick. The shafts were roughly cut and not straight.

By 2007 we had excavated four previously unknown large burial shafts, T304, T305, T306 and T307, and two small, incomplete shafts less than 1 m (3 ft) deep. The large tombs are simple shafts cut into the bedrock to depths that vary from 4 to 22 m (13 to 72 ft) and lack inscriptions or decoration.

T304, immediately northwest of Campbell's Tomb, was the richest. The shaft, 2.77 × 2.54 m (9 ft × 8 ft 4 in.), descends 6 m (19 ft 8 in.) to six burial pits, three on the west and three on the south. The pits are around 2.3 m (7 ft 6 in.) long, 75 cm (2 ft 6 in.) wide and 1.5 m (4 ft 11 in.) deep, separated by narrow rock partitions. In the first pit on the west, we found a deteriorated wooden box that contained 400 small shabtis made of green faience. The shaft continues to a deeper level, but we have yet to reach the bottom and the main burial chamber.

The shaft of T305, to the west of T304, descended 4.65 m (15 ft 3 in.) to three burial pits off the west, east and south sides. The western pit contained a limestone sarcophagus missing its lid. At the end of the northern pit we found the remains of a child, along with a typical 26th dynasty shabti of green faience and broken pottery.

We then cleared T306, 6 m (20 ft) north of T305. At a depth of 18 m (59 ft) we came upon a burial niche in the eastern side, which contained an amulet of a female deity, a schist scarab and an amulet in the form of *akhet* (the hieroglyph for 'horizon'). The shabtis were in poor condition and lacked any inscription. We then cleared the main shaft to a depth of 22 m (72 ft), uncovering a burial chamber on the west, extending 6.2 m (20 ft 4 in.) by 5.6 m (18 ft 4 in.) wide, filled with sand and limestone fragments. We had to stop the excavation when we encountered the water table at a depth of 23 m (75 ft).

During the 2007 season we began to excavate a fourth, previously unknown tomb shaft, T307, west of T306. At a depth of 3.9 m (12 ft 10 in.) we came upon a burial pit, 2.15 m (7 ft) wide, filled with sand mixed with bones. Two other burial pits opened in the western wall, one containing two sarcophagi and a number of amulets, including a Djed pillar and scarabs. One of the sarcophagi, 2.15 m (7 ft) long, is very unusual in having an egg shape; within it were remains of bones, shabtis, amulets and scarabs. The other burial pit featured a sarcophagus carved from the bedrock, covered by debris and limestone blocks. Inside we found a large number of shabtis, ritual vessels, amulets and scarabs. Another burial niche opened of the south side at a depth of 5.2 m (17 ft).

to the south and another chamber to the north, all at a higher level than the main chamber. The northern chamber has nine niches for additional burials, three of which contained sarcophagi – two made of granite and one of basalt. One was the grey granite sarcophagus of Nesisut I, now in the British Museum. Nesisut I was the son of a man named Amasis, Priest of the Red Crown and of Wadjit, Mistress of Imet. His mother, Tasa-en-ankh, was a Mistress of the House. Nesisut's long list of titles included Count and Prince, Unique Friend [of the King], Chancellor of the King of Upper and Lower Egypt, Chief of the Treasury, Purification Priest of the Temples of Memphis and, like his father, Priest of the Red Crown. He must have been an important man indeed. Two long symmetrical series of funerary divinities presenting offerings to Maat are engraved into the massive monolithic tub or bottom of the sarcophagus.

One of the southern chambers contained another sarcophagus, this one anthropoid and of beautiful

workmanship, albeit missing its head and left shoulder, which also now resides in the British Museum. It belonged to another Nesisut (II), who was the son of Wadjit-em-het, Lady of the House, and Pasheri-en-ihet, who, like Nesisut I and his father, was also Priest of the Red Crown and of Wadjit, Mistress of Imet. Nesisut II also held a long string of titles that included Prince, Chancellor of Lower Egypt, Great One of the Antechamber, Royal Herald, Royal Scribe of the Repast, Servant of the Red Crown, Purification Priest of the Temples of Memphis, Libator, and Priest of Imhotep, son of Ptah. The name of his mother, and the titles he and his father held, indicate this family was from Imet, modern Tell Nabasha, in the far northeastern Delta.

The two Nesisuts may well have come from the same place, and clearly followed similar careers, as their titles demonstrate. They were probably interred at some time during the 30th dynasty, so well after Ptahotep, and as many as 200 years after Pakap, for whom the main shaft was initially cut. Perhaps the main shaft was filled with sand (and covered by a chapel), while the outer moat or trench allowed access to it and the subsidiary tombs. We might suspect a family tomb used over several generations, but the evidence suggests only that the two Nesisuts were possibly related. In any case, Campbell's Tomb by itself demonstrates the longevity of the Late Period necropolis at Giza.

The Osiris Shaft (the Water Shaft)

The so-called Osiris Shaft is the largest Late Period tomb that cuts into the Khafre causeway. It is sunk through the southern side of the embankment a little more than halfway between the valley and upper temples. Almost directly on line with the Sphinx and 195 m (640 ft) west of the Sphinx depression, it has become a target of New Age theorists, who suspect that the tomb is an underground link between tunnels connecting the Sphinx and the Great Pyramid.

However, the major features of the so-called Osiris Shaft mark it as a classic elite tomb of the Late Period. It is probable that, like the Saite shafts in the Central Field North that Lepsius saw and numbered, the Osiris Shaft was always visible, with its rim opening high in the top of the

causeway embankment. Selim Hassan cleared it in his sixth season, and mentioned a masonry-built superstructure:

> During this [Saite] period, it was the custom for well-to-do persons to cut for themselves very wide and deep shafts ending in a spacious hall out of which opened a series of chambers, each containing a sarcophagus...Sometimes the shaft is cut abnormally deep, and in this case it is divided into stages as it descends. The most striking example of this kind of shaft is that which was cut in the causeway of the Second Pyramid, and discovered by me in our 6th season's work. Upon the surface of the causeway they first built a platform in the shape of a mastaba, using stones taken from the ruins of the covered corridor of the causeway.[12]

Hassan goes on to describe the system of shafts and chambers on the three levels, the lowest of which, a remarkable 33 m (108 ft) below the top of the first shaft (A) in the causeway embankment, was filled with water – hence the Osiris Shaft was also called the Water Shaft. Although Hassan could see through the water in the submerged lowest chamber, he was unable to reduce the water level even after continual pumping.

Since they could not empty the lower chamber of water, the Antiquities Service workers simply extended the pipes from the pump on the second level all the way up to and out of the main shaft, to create a source of pure, clean groundwater to the nearby rest house of Cairo University at the northeast corner of the Central Field West quarry. In addition they left the iron ladders all the way down to the water level, and over the decades local guards and dragomen would take visitors, including the authors, down the corroded ladders through the three shafts to the water-filled lowest chamber. What a strange sensation it was for us to be swimming in the dark, save for our electric torches, 33 m (108 ft) below ground. Paddling about the unfinished, cave-like chamber, we could see unexcavated debris of ancient pottery and bone (probably human) and the tantalizing rock-cut edges of shafts or channels.

After a flurry of New Age interest, which prompted geophysical surveys and film projects

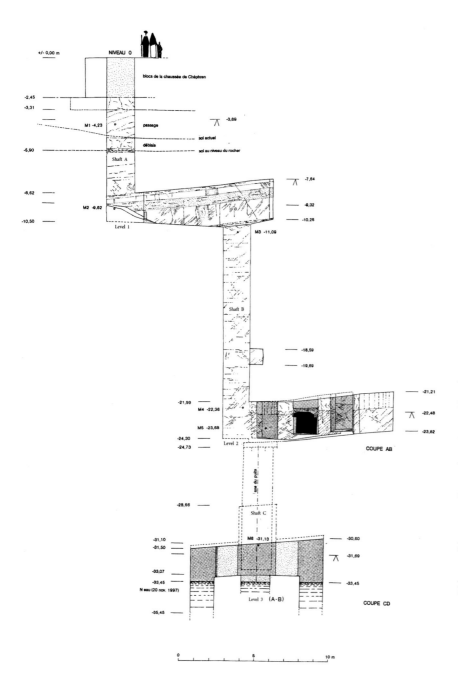

Osiris Shaft dimensions: principal parts

Shaft A

	2.6 × 3 m (8 ft 6 in. × 9 ft 10 in.)
Depth	9.62 m (31 ft 7 in.)

Level 1 Chamber A

Length	8.6 m (28 ft 2 in.)
Max. width	3.85 m (12 ft 8 in.)
Max. height	2.6 m (8 ft 6 in.), 5 ancient Egyptian royal cubits

Shaft B

	1.9 × 1.9 m (6 ft 3 in. × 6 ft 3 in.)
Depth	13.3 m (43 ft 8 in.)

Level 2 Chamber B

Length	6.8 m (22 ft 4 in.)
Max. height	2.6 m (8 ft 6 in.), 5 ancient Egyptian royal cubits

Chambers C–H

Lengths	2–3.2 m (6 ft 7 in.–10 ft 6 in.)
Heights	1.58–2.5 m (5 ft 2 in.–8 ft 2 in.)
Widths	1.5–2.4 m (4 ft 11 in.–7 ft 11 in.)

Shaft C

	1.65 × 1.9 m (5 ft 5 in. × 6 ft 3 in.)
Depth	8.77 m (28 ft 9 in.)

Level 3 Chamber I

Length	8.84 m (29 ft) west; 9.09 m (29 ft 9 in.)
Width	8.6 m (28 ft 3 in.) south; 9.2 m (30 ft 2 in.) north
Emplacement	5.24 m (17 ft 2 in.) north; 5.56 m (18 ft 3 in.) east; 5.76 m (18 ft 11 in.) south; 6.04 m (19 ft 10 in.) west

20.21 Profile of the so-called Osiris Shaft, a complex system of shafts and chambers on three levels. Drawing by Georges Castel.

in the mid-1990s, one of us (Hawass) decided to excavate and systematically explore this tomb, beginning in the summer of 1999.[13] Esmail Osman, formerly the head of Osman Contractors, provided equipment to pump more vigorously and lower the water level in the bottom chamber. In preliminary work we sent divers into the water to retrieve artifacts and samples for dating purposes. Our work laid bare the essential outlines of the lower, main chamber, which has a structure and character open to interpretation and inspired us to name it the Osiris Shaft. Georges Castel of the French Institute in Cairo mapped the architecture of the tomb in plan and section, taking detailed measurements of the Osiris Shaft from top to bottom, which we incorporate here [**20.21–20.23**].

The Osiris Shaft opens in the western edge of the Khafre causeway, where the 4th dynasty builders

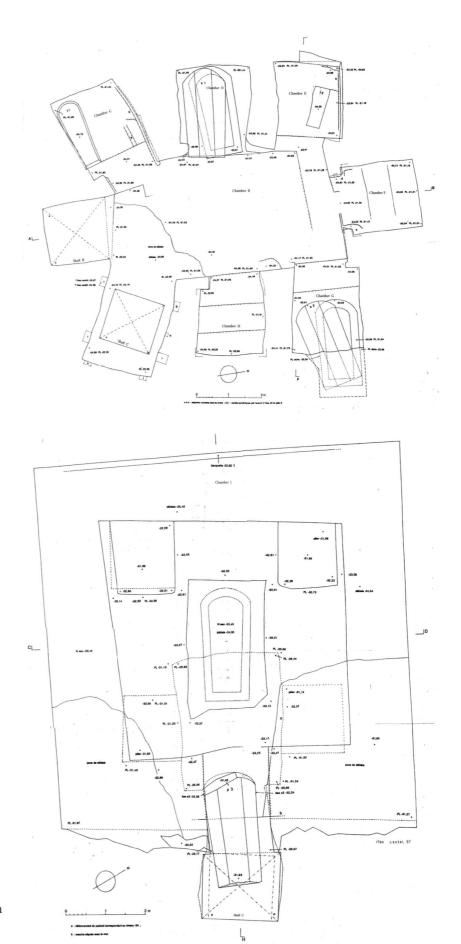

20.22, 20.23 Diagrams of Osiris Shaft Level 2, with chambers B–H, and Level 3. The shaft down to the lowest level descends from the southeast corner niche (bottom left) of Level 2. Drawings by Georges Castel.

augmented the embankment with large blocks of locally quarried limestone. It is probable that the causeway had largely sanded up by the time the quarrymen began to excavate the tomb shaft, because otherwise they might not have launched into such a deep undertaking so near the edge of the causeway embankment. The eastern side of the first shaft, the main entrance to the tomb (A), clips the tunnel that passes under the causeway of Khafre – equivalent to those under the causeways of Khufu, Menkaure and Khentkawes. Today, access into the shaft is at the point where it broke through the west wall at the southern end of the tunnel. For many decades an iron fence with a padlocked gate kept people from entering the shaft, except for those the guards let in.

Overall, the tomb complex consists of three vertical shafts (A, B, C), each leading in turn to one of the three separate levels (1, 2, 3), with systems of chambers opening off them. The first vertical shaft (Shaft A) descends vertically, with roughly hewn walls, for a depth of 10.6 m (34 ft 9 in.), ending in a rectangular chamber (Chamber A), forming Level 1. The ceiling of this large chamber slopes up to the north from the point where it opens from the shaft.

The second shaft (B), narrower than the first, opens in the floor of the northern end of Chamber A and descends to a depth below the causeway surface of 24.3 m (79 ft 9 in.) to Level 2, where another chamber (B) extends to the north. Once again the quarrymen created an upwards slope in the ceiling and floor as they carved the chamber out. Six smaller chambers open off Chamber B, three to the west (C–E), one to the north (F) on the axis of Chamber B, and two to the east (G, H), as well as a niche of similar size to the chambers that forms the opening to Shaft C. The first chamber on the west (C) contains a large granite sarcophagus set into a pit cut into the floor; inside were the badly decayed remains of a skeleton and shabtis and pottery sherds of the 26th dynasty. Chamber D contains a basalt sarcophagus in a

shape typical of the 26th dynasty; its lid had been slid ajar, probably in ancient times. In clearing the floor south of the sarcophagus we discovered a large number of shabtis and pottery sherds. Chamber G also contained a sarcophagus, partly set into a niche, with its lid pushed open. Near the sarcophagus we found the remains of human bones, shabtis of blue faience and pottery sherds, all dating to the Late Period.

The third shaft (C) descends vertically from the southeastern subsidiary chamber on Level 2.

In the northern, southern and eastern sides, the quarrymen carved seven rectangular notches, which were probably for stout wooden cross beams used to hoist waste up from quarrying the lower chamber and also to lower the large sarcophagus down into it.

Shaft C drops to an opening on the west of Chamber I, which forms the main feature of the lowest, flooded level, Level 3. The chamber was probably unfinished, and the quarrymen left their intended square slightly trapezoidal. As with the upper two main chambers, the ceiling sloped from north to south. Our clearing and explorations revealed that as they created the chamber, the quarrymen left a rectangular bedrock emplacement as a kind of island in the centre, with four square pillars, about 1.5 m (4 ft 11 in.) thick, at its corners. It was almost surrounded by a trench or moat, 1.3–2 m (4 ft 3 in. to 6 ft 7 in.) wide, a feature also found in certain other Late Period tombs at Abusir and Saqqara, which is now filled with water.

The quarrymen left the floor leading from the entrance to the chamber at the bottom of Shaft C at the same level as the central island, thus forming a kind of bridge across the trench. The moat is therefore interrupted on the south side, giving it the shape of the hieroglyph for 'house' (*pr*).

In the centre of the large emplacement, the quarrymen created a cavity for a basalt sarcophagus, leaving surrounding walls of bedrock about 2 m (6 ft 7 in.) thick. The lower part of a large black basalt sarcophagus, 2.28 m long and 1.08 m wide (7 ft 6 in. × 3 ft 7 in.), still lies in its pit in the centre of the island; its massive lid lay partially across the floor of Shaft C and the bridge [20.24]. Inside the sarcophagus we found the remains of a skeleton, and from the northern part of the room we retrieved scarabs, amulets in the form of the Djed pillar, an emblem of Osiris, and two schist amulets in the form of Osiris.

With the mummy interred in its sarcophagus embedded in the subterranean bedrock island, the arrangement is once again symbolic of the burial of Osiris, as in other large, elite shaft tombs of the Late Period at Giza (Campbell's Tomb, for example), and at Saqqara and Abusir, and, in a different configuration, at Thebes. It is indeed an Osiris shaft. And since, as noted in the publication of the Osiris Shaft, the burial 'is thus similar to an island

20.24 Zahi Hawass examining the large granite sarcophagus at the bottom of the so-called Osiris Shaft.

with the sarcophagus in the middle surrounded by water in the shape of the *pr* [house] sign',[14] the main burial chamber can be 'read' as the hieroglyphic phrase, *pr Wsir*, 'House of Osiris'. The *pr*-shaped moat, filled with water since the rise of the water table (perhaps already in the Late Period?), makes this Osiris Shaft unique. It calls to mind the cult of the 'House of Osiris Lord of Rosetau', so active in the Late Period, but already a focus of worship at Giza in the New Kingdom.

Three distinct levels are also a hallmark of Late Period tombs of high-status people, especially at Thebes, and here the tripartite vertical structure characteristic of Theban Saite tombs is combined with the large shaft and central sarcophagus feature of Memphite tombs of this period. The third, lowest level, is a variation of a distinctively Memphite pattern for high-status tombs of the Late Period. This lowest chamber must have been created at the same time as, or shortly after, the second-level chamber (B) with its seven subsidiary compartments, because the access to the lower level is from one of those compartments. A central chamber with subsidiary burial compartments is distinctively Saite, as are the sarcophagi that three of the compartments contain.

Tombs in the Sphinx temenos

Before leaving central Giza for the South Field, we should mention four tombs of people who had the privilege to be buried within the temenos of the Sphinx, the 'House of Horemakhet'. Nothing of what we know from texts found in two of the tombs explains the reason for this honour.

The tombs were cut into the east-facing ledge in the northwest corner of the Sphinx amphitheatre, the larger quarry in which the Sphinx was created. Henry Salt and John Gardner Wilkinson saw and documented these tombs, and Samuel Birch mentioned them in his article about Caviglia's excavations at the Sphinx.[15] The plans published by Howard Vyse and Birch show that these tombs were at the back of galleries formed by stone and mud-brick walls that extended east from a mud-brick enclosure wall running north–south along the top edge of the bedrock quarry face. Only part of the southernmost wall still stands, and we interpret this as part of the mud-brick enclosure

that formed the Sphinx temenos in the Late Period. Immediately south of this wall, one of the tombs was fronted by a platform with four small columns, now entirely disappeared. The next tomb to the north was approached through a very narrow corridor between a long limestone wall on the south and a thick fieldstone wall on the north; both walls are now completely missing. The third tomb, north of the stone wall, was also fronted by a platform, which still survives, and a court open to the east with an altar, though these have disappeared. The fourth tomb, last on the north, was approached by a narrow stairway confined between two thin mud-brick walls, which no longer exist.

None of the decoration or texts that Salt and Wilkinson described in two of the tombs survived at the site. We know from their records, however, that the third tomb from the south belonged to a man named Ptahirdis. He decorated the walls of his court with traditional offering scenes and selections from the Pyramid Texts, though his inner rock-cut chamber seems not to have been decorated. The shaft to the burial chamber opened in the middle of the floor. Ptahirdis held the quite common title *rekh niswt*, 'One Known of the King', but we do not know much else about him or his parentage. He is perhaps the same Ptahirdis who dedicated a statue of Osiris found in the Eastern Field, now in the Museum of Fine Arts, Boston.

The next tomb to the south belonged to a man named Pedubaste. The upper rock-cut level of his tomb consists of a single simple chamber with the burial shaft opening in the centre. Wilkinson recorded the relief carving that decorated the east-facing façade. In the area above the doorway Osiris sat in a double shrine; the texts invoke him once as 'Lord of Rosetau'. Texts on either side of the door invoke funerary deities to protect the deceased Pedubaste, who is represented raising his hands in adoration. Pedubaste is shown again at the base of the door with text that includes his titles. The ballooning style of his skirt suggests a date in the 27th or 30th dynasties. Pedubaste was the son of a man named Hor, and his mother's name was Djed-hor. His long string of titles included Prince, Count, Chancellor of the King of Lower Egypt, Unique Friend (of the king), 'who does what the god of his town loves', and Commander of the Army. He is also said to be efficacious in the Temple

of Mahes. This, and his title 'Priest of Bastet' (the cat goddess), indicates that he and his family may have originated in the town of Taremu – the Greek Leontopolis, modern Tell Muqdam.

Late Period tombs in the Southern Field

The east-sloping Maadi Formation ridge runs from the Gebel el-Qibli at the southern edge of the Central Wadi to the south for a little under a kilometre and then turns to run west as a gentle slope into another broad wadi, the Southern Wadi, that marks the southern boundary of the Giza Necropolis. Egyptologists refer to the whole stretch as the Southern Field. Petrie's work here, followed in recent decades by my (Hawass's) excavations, both indicate that Old Kingdom tombs like those comprising the Workers' Cemetery probably occupy the entire east-facing escarpment, still hidden under a thick blanket of sand where we have not excavated. We have also encountered large Saite tomb shafts at the top of the ridge, along with poor, low-status Late Period burials like those punctuating the 4th dynasty settlement ruins in the plain below the ridge. But the main concentration of Late Period tombs is on the south-facing slope of the Southern Wadi.

This Southern Field is the least known and published part of the Giza Necropolis. Lepsius investigated the area and assigned numbers 102 to 106 to five Late Period tombs cut into the natural ridge here. Sand has since covered these tombs, but they are marked on his plan located round the southeast corner of the escarpment where it turns to the west. Lepsius ascribed the tombs to the period of Psamtek, without specifiying which of the pharaohs of that name. The tombs feature vaulted entrances cut into the friable bedrock. In LG 106, according to the plan, the entrance leads to a rectangular court or room, about 3.5 to 4 m long (11 ft 6 in. to 13 ft) and 2.5 to 3 m (8 ft 2 in. to 9 ft 10 in.) wide, followed by two rooms approximately 3.5 m (11 ft 6 in.) square with shafts opening in the floor. The second shaft leads to the burial chamber, which is divided into separate compartments for sarcophagi. The first shaft leads to a dead end, but connects to the first, halfway down, by a horizontal tunnel. In LG 102 Lepsius's team found a number of shabtis of the 'Chief of

the Great Prison, the Royal Herald, Wadj-her, called Psamtek-sa-Sekhmet, justified, son of Tashri-Min [his mother], justified'. Zivie-Coche dates this text to the 27th dynasty or later. A series of shabtis of blue-green faience up to 20 cm (8 in.) long were inscribed with Chapter 6 of the Book of the Dead. These are now in Berlin and in private collections.

During his 1906–07 field season, Petrie had a team exploring the Maadi Formation ridges in the Southern Field. On the east-facing ridge directly above our Workers' Cemetery, he found a series of Old Kingdom tombs, which he dated to the 5th and 6th dynasties. His team also excavated the southeast corner of the ridge and south-facing slope of the wadi, and the plain below, where they investigated a tomb each from the 1st, 2nd and 3rd dynasties (the last of these being 'Covington's Tomb'), as described in Chapter 4. Petrie did not mark any of his team's finds from that season on an overall map, and this must rank as one of the poorest documented of all his prolific excavations. The major find was the 26th dynasty Tomb of Tjary (described in more detail below), which we can locate today by its remains standing on the south-facing slope along the Southern Wadi.

Petrie copied the relief-carved texts and scenes that he found in the tomb, some while on site and some from photographs, and these form a valuable record, since as early as 1911 thieves attacked the tomb, in spite of the fact that Petrie had reburied it. It was this that prompted the head of the Antiquities Service, Gaston Maspero, to draft the first strong Egyptian law against the sale of antiquities. Thieves removed more of the tomb between 1945 and 1975.

In the same area Petrie's team excavated 'later burials', which 'yielded very little that was worth note'.[16] Some of these burials included sets of three nested decorated wooden coffins of very poor artistic quality. Petrie mentioned in passing collecting the astounding number of '1,400 skulls of about 600–300 B.C.', which, he wrote, went to University College, London, for study. This huge collection of skulls must have come from a cemetery of low-status people that was as dense and extensive as the burial ground we are excavating south of the Wall of the Crow, where we estimate there are up to around 6,000 graves sunk into the ruins of the 4th dynasty settlement. When

we consider that Selim Hassan reported (albeit only briefly) finding numerous poor and simple Late Period burials above the ruins of the Khentkawes Town, it becomes clear that a vast Late Period cemetery of common people must have extended along the north, east and south of the Gebel el-Qibli. As noted above, this cemetery must have been the counterpart of a settlement of the same period that may lie beneath the modern suburbs of Kafr el-Gebel and Nazlet el-Batran.

Ahmed Bey Kamal worked briefly in the Southern Field in 1907 and reported on four Saite tombs, possibly some of those also documented by Lepsius. He also mentioned a tomb in 'the mountain south of the Sphinx', without locating it precisely.[17] According to Kamal its shaft was 30 m (98 ft) deep and ended in a single burial chamber. It had already been cleared by Mariette, who, at the base of the shaft, found a rough limestone sarcophagus with the remains of a wooden coffin and mummy. A line of text in a band down the length of the lid gave the name Ni-wahib-Re, son of Padit-jau-khef, and of a Mistress of the House whose name is untranslatable. The text invokes Osiris, the great god, Lord of Rosetau.

Abd el-Moneim Abu Bakr worked in the Southern Field for the Antiquities Service in 1945–46, including the area of Tjary's tomb, but unfortunately did not publish a report (a brief account was given by Ursula Schweitzer).[18] What remains on the site indicates that he cleared rock-cut graves with small courts and vaulted chapels over deep shafts ending in subterranean chambers with multiple niches for family burials. Objects included painted wooden sarcophagi, shabtis and stelae dedicated to Osiris, Lord of Rosetau. These objects also provide some names and titles, such as Padiset, a Judge, son of Tairy, a Singer of the Pure Foundation of Ptah, and Chief of the Singers of Pharaoh, Osorkon, with the name Neferibre-sa-neith, son of Iahmes and Amen-merytes. Zivie-Coche reports seeing objects from the Abu Bakr excavations in the 1970s in a storeroom, including two wooden statues of Ptah-Sokar-Osiris and two coffers topped by a couchant Anubis.

Jean Yoyotte and Philippe Brissaud worked in the Southern Field during the winter of 1972, conducting a preliminary survey of the area from Covington's Tomb (the 3rd dynasty mastaba) at the top of the hill to the Tomb of Tjary and excavating some test trenches. They investigated part of the area that Abu Bakr had cleared and confirmed that most of the tombs on this slope date to the Saite and Greco-Roman periods. Many of the tombs consist of small, stone-walled mastabas built around vaulted chambers, but the superstructures, in the weak limestone of the Maadi Formation, have often disappeared. The tombs had been plundered, and fragments of low-quality funerary masks, amulets, shabtis and human bone are still scattered across the site. The slope also included poorer burials, with the bodies simply rolled in a shroud and buried in the sand.

The Tomb of Tjary

The 26th dynasty Tomb of Tjary is unique in taking the form of a cross. A long entrance court or hall to the south (possibly unroofed) leads to a central chamber, from which doorways open to chambers on the north, west and east; all four inner chambers were once covered by vaulted roofs [**20.25**]. The tomb extended 17.4 m (57 ft) with a maximum width of 9.5 m (31 ft 2 in.) and was originally 3.25 m (10 ft 8 in.) high. The superstructure of the tomb took the form of a mastaba consisting of debris fill between fine white Turah-quality limestone walls. It must have made a very striking impression against the hillside and lower surrounding mastaba tombs of lesser quality built of the darker local limestone.

Since Petrie explored the tomb in 1906–07[19] it has been the repeated target of thieves. What is left has been partly restored twice in modern times. However, the entire remains of the eastern room were removed and many of the pieces found their way to the Brooklyn Museum, where the curators registered them in 1934. They then partially reconstructed the room on the basis of photographs. In 1948 or 1949 the Brooklyn Museum exchanged this ensemble with the National Ethnology Institute in Bogota, Colombia.

From the floor of the southern entrance court, 10.5 m (34 ft 5 in.) long and 5.35 m (17 ft 7 in.) wide, a shaft led 12 m (39 ft 4 in.) down to the subterranean level of the tomb, with two chambers aligned north–south. In the northern subterranean chamber a burial niche opened off the centre of the north

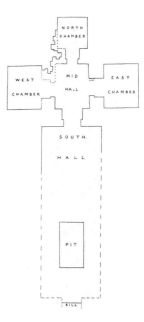

20.25 Petrie's drawing of the ground plan of the Tomb of Tjary.

wall and contained a trench for the sarcophagus. The niche was partially cut into the friable bedrock and partly built with a wall and vaulted ceiling on the north. A ledge between the built sides and the trench allowed the placement of stone slabs to cover the burial. Three additional niches, roughly hewn from the natural rock, opened off each of the other sides of the chamber. More burial niches opened off the southern subterranean room, which was less finely worked. The substructure of the Tomb of Tjary was never completely examined and mapped. Wafaa el-Sadeek, who examined the tomb in the 1970s, wrote:

> The southern chamber contains a rectangular pattern of incisions in the floor, approximately 1.00 m × 1.20 m [3 × 3 ft 11 in.], just to the southeast of the descent of the shaft, which could conceivably be the mouth of another shaft. But because of the condition of the lower part of the shaft, and the chambers themselves (similar shafts have claimed lives nearby), further work is not advisable in the area.[20]

The exterior east and west walls of the court and exterior wall of the southern façade, as well as the south walls of the eastern and western rooms, were decorated with scenes of Tjary in adoration before Osiris, accompanied by Isis and Nephthys. The inner walls of the entrance court were decorated with painted relief carving, but only the bases of the walls remain today. The scenes showed Tjary and one of his wives entertained by a performance by harpists and singers. Copies of the Coffin Texts graced the north interior wall of the court. Representations of Tjary with one of his wives and his mother were carved onto the door jambs.

The interior east and west walls of the central room, which had suffered much damage, were decorated with funerary and religious themes [**20.26**]. In the small northern room the scenes were entirely dedicated to Osiris. On the west wall the god of the dead stands between two goddesses, while Tjary adores Osiris on the east wall and a figure of the Djed pillar, an Osirian symbol of stability, graces the wall to the right of the entrance. Tjary's grandfather, also named Tjary, and grandmother, Ta-sheb-neith, were depicted in the width of the doorway opening into the eastern room. On either side of this door were scenes of Tjary embraced by Hathor and Anubis, both deities who receive the dead into the Netherworld. Symmetrical scenes covered the north and south walls of the eastern room and showed Tjary receiving offerings from sons by two different mothers – Psamtek, son of Tjary and Ta-remetj-en-Bastet on the south, and Genufsetkap, son of Tjary and Tadihor on the north. The south wall also shows Tjary himself and his son Psamtek performing the same rites before his grandfather, Tjary, and father, Gemsetkap. On the east wall Tjary adores the god Thoth and 16 rams' heads. The central part of the north wall showed two couchant Anubis jackals, face to face.

Petrie's record of the eastern room showed that a band of hieroglyphs, now completely lost, ran around the walls, beginning south of the doorway and ending north of it, which reads:

> An offering that the king gives to Ptah-Sokar-Osiris, the Great God, Lord of Rosetau, that he may give splendour in heaven and might on earth, justified in the necropolis, to the *ka* of Revered with Osiris, the Foremost of Rosetau, Libator of the Temple of Sobek of Sedjet, Chief of Fowl and Fish, Chief of the Police,

20.26 Petrie made detailed drawings to record the scenes in the Tomb of Tjary (also opposite). Here Tjary stands in adoration before Osiris.

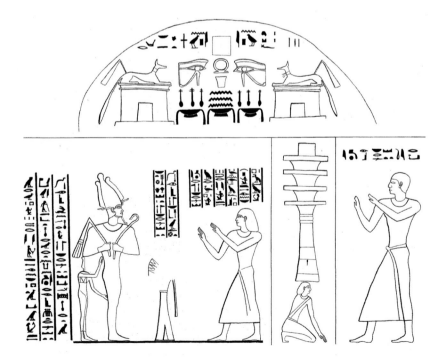

Tjary, justified, son of Gemsetkap, justified, born of Tadehor, Lady of Honour.

In the western room a scene of Anubis preparing the mummy graced the centre of the north wall [**20.27**]. Under the frieze that went round the chamber, 50 guardians accompanied the texts taken from Chapter 146 of the Book of the Dead.

Tjary's principal title was Chief of the Police, so he joins a list of another Overseer of Police, his son, two Overseers of the Army and an Overseer of the Great Prison attested from Late Period tombs at Giza. As Overseer of Police, a title used in the Old and Middle Kingdoms and revived (like others) in the Saite Period, he must have had responsibilities for corvée for the state. We are not certain of the range of responsibilities covered by his other title, Chief of Fowl and Fish. Tjary was also a Libator and Priest in the Temples of Sobek and Horus of Crocodilopolis (Sedjet). In the references to Neith and Osiris of Sais in the titles of his grandparents and in epithets of Tjary, Zivie-Coche traces a family origin in Sais, the Delta capital.[21] The fact that Tjary and family had responsibilities in the Fayum and Memphis might explain why he chose Giza, located midway between these locales and his hometown, for his sumptuous tomb.

Conclusion: Late Period Giza

In the Late Period, Giza was an outlying site to the central Memphite–Saqqara necropolis, with its gigantic sacred animal precincts. And at Giza the Late Period Egyptians did not develop the elaborate and immense sacred animal cults with their corresponding architectural complexes as they did at Saqqara, though they did deposit animal mummies in a few caches (see box, p. 489).[22] However, with its towering pyramids, it was a site of enormous prestige during the Saite revival. Here, on the plateau of Giza, the Late Period Egyptians revitalized the names and memorials of the 4th dynasty pyramid-building kings, even as they brought about the transformation of their monuments into loci of the gods of the national divine trinity: Osiris, Isis and Horus in their local aspects as Lord of Rosetau, Mistress of the Pyramids and Horoun-Horemakhet, each in their own temenos.

And once again Giza became a vast burial ground, both within these sacred precincts and across wide areas to the south, continuing in use throughout the Late Period. A century or two after Tjary was buried in his tomb, Herodotus made his visit to Egypt and heard the tales of the wicked pharaoh Cheops (Khufu) who had built the Great Pyramid some 2,000 years before. He was followed by other Greek and then Roman travellers and writers, and they in turn by adventurers and explorers, and finally archaeologists and excavators, including ourselves, and New Agers and alternative theorists, all fascinated by the story of Giza – and so we come full circle, from the earliest times to the present. Eternal Giza.

20.27 Isis presides over Anubis preparing the mummy, with guardian deities, in Petrie's drawing of the scene on the north wall of the western room of the Tomb of Tjary.

AFTERWORD
Giza developments

Several important discoveries and projects are taking the story of Giza forwards, even as we write this book.

The journal of Merer

The discovery of the Wadi el-Jarf papyri from the time of Khufu offers an amazing textual window on the building operations on the Great Pyramid and sheds light on real individuals in the obscure history of the early Old Kingdom (see also pp. 29–30).

A team from the French Institute in Cairo (IFAO) and the University of Paris-Sorbonne under Pierre Tallet were excavating between 2011 and 2013 at a port complex of Khufu at Wadi el-Jarf on the Red Sea.[1] They discovered remains of boats and equipment, but also, astonishingly, papyri, including rolls up to 50 and 80 cm (20–31 in.) long [21.1]. However, the papyri are not about Red Sea trade. They are almost entirely about building the Great Pyramid.

The journal of a man named Merer comprises one of two major sets of documents, the other being

21.1 Pierre Tallet points to a hieroglyphic term in a fragment of the Wadi el-Jarf papyri, mounted under glass.

accounts of provisions for Merer's team. Holding the title *sehedj*, which Egyptologists sometimes translate as 'Inspector', Merer records, day-by-day, the movements and work of his team, a phyle of men who make round trips by boat from the eastern quarries of Turah at Giza to deliver stones for building Khufu's pyramid on the opposite bank.

Merer's journal entries make it almost certain that the team must have navigated around the Heit el-Ghurab site, perhaps called here by the previously unknown name *Ankh Khufu*. The seasonally flooded back bay we have found swinging west into the southern end of the Heit el-Ghurab site was probably an extension of the 'Lake (*she*) of Khufu', where, the papyri report, Merer and his men would sometimes stay overnight.

Some of Merer's journal entries lend support for our reconstructions of the pyramid port at Giza, its barracks, harbours and waterways. Merer and his team might have stayed in an earlier phase of the galleries we have excavated and mapped that date to the reigns of Khafre and Menkaure. On the basis of the papyri, Tallet suggests that 'Merer and his phyle' (a *za*) as the papyri call this team, amounted to 40 men, the same as our estimate for the numbers in the galleries we have mapped.

When arriving from Turah South into the *She Khufu*, the 'Lake Khufu' (or 'Basin of Khufu'), Merer's team must have sailed along a western Nile branch corresponding to the track of the modern Marioutiyah Canal, around the Heit el-Ghurab peninsular settlement and into the central canal basin. There they would have off-loaded fine limestone blocks for the pyramid casings directly east of the Sphinx. When arriving from Turah North, they probably came along the line of the modern Pyramids Road, entered the gateway marked by the Nazlet el-Sissi and Nazlet el-Batran village mounds, and then sailed directly into the central canal basin to the off-loading place east of where Khafre would (later) finish the Sphinx.

In one of his journal entries, Merer records how his phyle joined forces with other phyles and gangs

hauling stones or towing boats, with subordinates of the 'Elite' or 'Chosen Phyles' (*setep-zau*) and a work gang (*aper*) under the supervision of Prince Ankh-haf, Overseer of the *Ro-She* Khufu, known from other sources as an Overseer of All the King's Works and Vizier, and a half-brother of Khufu.

On another occasion, Merer and his phyle join some 15 other phyles, subdivisions of *aper* gangs, the total perhaps amounting to 600 additional men. Merer's men removed wooden piles or bollards of a 'dike', again under the supervision of Ankh-haf as Overseer of the *Ro-She* Khufu. Tallet suggests this workforce may have been opening the basins after the rising Nile flood built up a sufficient head of water, so that crews could deliver stone by boat during the peak of the flood season. The task here was to flood the entire hydraulic system that connected basins and waterways of Khufu's pyramid complex with the Nile.

Not least of the contributions of the Wadi el-Jarf Papyri are what they can tell us about the chronology of Khufu's reign. The fact that Merer worked under the supervision of Ankh-haf might show that Hemiunu, who like Ankh-haf was Overseer of All the King's Work, died before the pyramid was finished and that Ankh-haf took over and completed the pyramid, which must have been near the end of the project and Khufu's life.

ScanPyramids, searching for anomalies

ScanPyramids is an international mission under the authority of the Egyptian Ministry of Antiquities, initiated and coordinated by Profesor Hany Helal (Cairo University Faculty of Engineering) and Mehdi Tayoubi (HIP – Heritage Innovation Preservation Institute), that set out to search for unknown structural cavities in the pyramids. These would be apparent as 'anomalies' in the pyramid fabric.

One of the techniques the mission used is based on detecting elementary particles called *muons*. Muons travel through space and pass straight through material structures, including our bodies – millions and millions every day. More muons will pass through open spaces or through less dense materials than through solid or denser material in a given structure. Muon hits are collected by special equipment over a certain time interval, and then displayed as an image, like an X-ray, of gross

differences in the structure. Muon detectors, or scintillator 'telescopes', can be used to detect voids within huge structures, such as the Great Pyramid.[2] Another technique used is infrared themography, which detects infrared energy and displays it as an image of temperature distribution [**21.2**]. Points of interest detected by the infrared thermography can then be examined with muography.

After a year of applying muon tomography and infrared thermography, ScanPyramids announced two anomalies – possible cavities – in the Great Pyramid. One, called C1, at 110 m (360 ft) high on the northeastern angle of the pyramid, is similar to the so-called 'Cave' (C2) on this angle at 81 m (260 ft) high and the other was behind the western gabled 'chevron' blocks above the opening of the Descending Passage.

The Notch and the Cave
Some three millennia after Khufu's pyramid was built, stone robbers stripped it of the fine, white, outer limestone casing blocks that Merer and his men had shipped over from the eastern quarries at Turah. This special stone could be reused in buildings, and probably also burnt for lime.

In the process of plundering the casing blocks, high on the northeastern shoulder of the pyramid the stone robbers also pulled away a good number of the irregular 'core stones' that make up the bulk of pyramid [**21.3**]. In the process, between the 105th and 111th courses, they created the Notch, 5.5 m (18 ft) deep, north–south, 4.4 m (14 ft 6 in.) wide east–west, and 5.8 m (19 ft) high. Why did the robbers dig so much deeper at this high corner

21.2 Equipment being set up for the infrared thermography survey of the Great Pyramid.

21.3 View of the south side of the Notch high on the northeast corner of the Great Pyramid, at the 106th course above ground level.

point? Perhaps they were curious because of the looser core stones and large gaps, and glimpsed a space so large we call it a Cave.

At the 106th course above ground level, you can enter the Cave through a gap in the back corner of the Notch. In 2013 Yukinori Kawae and a team from the Japanese TV production company TV Man Union climbed up. (For AERA, he led a team that laser-scanned the Khentkawes Monument in 2006–07.) From their videotape, Kawae and his colleagues used a 'structure from motion' (SFM) technique to map the cave in 3D,[3] and measurements here are taken from their description. The Cave extends 3.3 × 2.9 (10 ft 10 in. × 9 ft 6 in.) and rises 2.3 m (7 ft 6 in.) high. Someone trimmed stones of the middle of three core courses to widen the cave.

In 2016, ScanPyramids turned their muon 'telescopes' to scan the complete northeastern angle of the pyramid. After collecting muon hits for 3 months, day and night, ScanPyramids team members detected the 'Cave' (C2), and also at this edge of the pyramid at a height of 110 m (360 ft), very possibly another cavity of the same volume (C1).

Of course, to know if an anomaly – a spot receiving more muon hits – is a hidden passage or chamber, we have to know how porous the pyramid is overall, and whether other such anomalies exist in the fabric as a result of the construction techniques of the builders. For years it has been one of our principal pyramid preoccupations that theorists of all kinds do not recognize or acknowledge the actual fabric of the pyramid core. Rather, we all tend to default to a mental template that Khufu's builders tightly fitted together 2.3 million squared, well-laid blocks to fill and form the pyramid in regular courses. After 44 years of investigations, we are here to tell you that pyramid core masonry is more analogous to Swiss cheese than Cheddar. It is also often written that the average pyramid block weighs 2.5 tons. In fact, no stone is the same size or shape as any other.[4]

The entrance into the Cave appears to be narrower than any of the surrounding stones, so it must be a void left by the builders. Perhaps they filled it with looser material that robbers pulled away. Kawae and colleagues point out that prior geophysical surveys found other cavities in the Great Pyramid, including one beyond the western wall of the Horizontal Passage. Drilling indicated this void was filled with sand.[5] They conclude that the builders left empty spaces, or ones filled with sand and debris, on purpose to economize on stone and to save labour.

If the Cave is a construction gap, how many others did the builders leave in a given part of the pyramid core? The Review Committee, chaired by Dr Zahi Hawass (with Rainer Stadelmann, Miroslav Bárta and Mark Lehner) therefore recommended to the Minister of Antiquities that 'ScanPyramids should establish baseline data on the core construction of pyramids, so as to properly interpret anomalies. ScanPyramids is required to scan a sample area or section of the Pyramid to determine average or background porosity and to determine anomalous spaces.'

Entrance recess anomaly

ScanPyramids also reported a cavity behind the western edge of the gabled 'chevron' stones above the opening of the Descending Passage [**21.3**]. To assess these results we should review what we know about how Old Kingdom pyramid builders

constructed entrance passages and chambers, and how Khufu's builders in particular approached these problems.

Not only did Khufu's engineers bridge the Descending Passage, only 1.05 m (3 ft 5 in.) wide, with a gigantic lintel block, they then topped it with a second tier lintel of Turah-quality limestone, and, above that put in two tiers of colossal gabled, or 'chevron' stones as the ScanPyramids team refers to them. Inward slanting stonework visible to the front and sides of the surviving chevrons shows that more beams, now missing, once brought the gable forwards to the plane of the casing. Builders set the inward slanted masonry to receive and brace the ends of the chevrons.

Above the King's Chamber, Khufu's builders stacked five stress-relieving chambers, and roofed the uppermost one with huge gabled beams to send the weight and thrust of the pyramid down away from chambers. Khufu's builders were the first to use such chevrons. So, above both the King's Chamber and the Descending Passage opening, they may have over-engineered, especially since we know that their predecessors struggled with structural failures when they built the first three of the 4th dynasty's gigantic, true pyramids for Khufu's father, Sneferu, at Meidum and Dahshur.

Infrared thermography by Jean-Claude Barré and Laval University (Quebec, Canada), part of the ScanPyramids consortium, revealed thermal behaviour that does not correlate with that of the surrounding area.[6] Though the team acknowledges that environmental, material and structural factors could cause such a thermo hot spot, they see it as 'most probably related to ... internal structure'.[7]

The latest ScanPyramids report shows another hot spot on the entrance gable in the area immediately under the apex of the lower rafters.[8] [21.4, 21.5] Just here, Khufu's masons left two prominent humps from their unfinished dressing back of the underside of the gable. The humps define three sockets, possible putlog sockets to receive the ends of massive wooden beams that temporarily supported the rafters during construction.

In both cases, could relatively larger construction spaces and fill between the 'normal' core work and the gable structure retain more heat throughout the hours of the day and night relative to the background?

ABOVE AND LEFT
21.4, 21.5 An infrared survey of the massive gables, or chevrons, above the entrance to the Great Pyramid. A thermal 'hot spot', which retains heat longer than surrounding stones, has been recorded here. The pyramid fabric at this point (left) is formed of a packing of gypsum mortar and stone chips.

BELOW
21.6 Nagoya University detector plates set up in the Descending Passage below the juncture with the Ascending Passage. The plates record 'hits' of muons passing through the pyramid – more muons would hit the plate if they passed through empty spaces hidden within the pyramid core. Such spaces would show as anomalies.

These preliminary results at the pyramid entrance gable prompted ScanPyramids to explore this zone with muon tomography. They set up the detectors inside the Descending Passage [21.6], using improved chemical emulsions on the detector plates and a longer exposure time of 67 days

(as opposed to 40 days in prior scanning work). The display shows a pixellated red square of greater muon hits that corresponds to the rear side of the entrance recess.

One side of the square of greater muon hits shows a pointed, triangular extension, indicating a void between the Descending Passage and the recess. So far, ScanPyramids cannot estimate the size, configuration or exact position of the anomaly, but they locate it somewhere between the downward slope of the Descending Passage and a horizontal plane extending south, into the pyramid core, and hypothesize it is a horizontal passage.

Putting aside the possibility that Khufu's designers might have over-engineered the entrance gable out of insecurity, ScanPyramids members theorize that the masons would not have created the colossal gable simply for the existing Descending Passage. In support of this idea, they point out that the builders set the rafters vertically, not following the angle of the Descending Passage. So they project another passage leading south into the pyramid from the 'chevrons', which were used to shift weight from this hidden passage.

We should keep in mind two alternative possibilities as to how Khufu's engineers built this colossal configuration. The first is that they composed the ensemble of lintels and rafters, the Descending Passage and its juncture with the Ascending Passage, in whole or in parts, relatively

free-standing, ahead of laying in the core work around it. The second possibility is that they built it into a *construction gap*.

Either process – building ahead of the pyramid core, or building into an existing trench in the pyramid core – would have left gaps between the standard core work and the arrangement of lintels, rafters and the Descending Passage. Several muon detectors have been put in place to attempt to 'see' the cavity from different angles.

Eastern base anomaly

At a press conference on 9 November 2015, then Minister of Antiquities Mamdouh El-Damaty and ScanPyramids team members announced that two weeks of infrared scanning revealed a place at the eastern base of the pyramid, south of the northeastern corner, that retained heat more than its surroundings. Dr Zahi Hawass soon pointed out that this 'hot spot' includes cement pillars added in modern times in an alcove to support overhanging blocks [21.7]. The area that retains heat longer than its surroundings includes the northern of the two modern cement pillars, but not the southern. This is an interesting spot: gypsum mortar with limestone chips is stuffed into wide seams between smaller blocks that give the alcove the look of a blocked passage. However, we might find many such spots on the core of the Great Pyramid.

Most important for proper assessment is the large joint or fissure that runs through the bedrock floor of the pyramid, and possibly into the bedrock massif projecting up into the core behind the alcove [21.8]. The fissure is directly aligned with the alcove where ScanPyramids sees a thermo-anomaly. Khufu's builders originally filled the fissure with limestone slabs, but where these later had been removed, modern antiquities authorities re-filled it with smaller stones. Such obvious physical features must be taken into account in any discussion of geophysical anomalies in the pyramid.

Latest measurements of the Great Pyramid

One of the aspects of the Great Pyramid of Khufu that is always held up for greatest admiration is the astonishing accuracy of the base, as noted in Chapter 8. Yet of the total length of the four sides of around 920 m (3,018 ft), roughly only 50 m (165 ft) of

21.7 Alcove created by the removal of stone from the Great Pyramid core work, east side, south of the northeastern corner. Two modern cement pillars support overhanging stones, above a fill of smaller stones and mortar. ScanPyramids announced a thermo-anomaly in the upper right (north) corner of the alcove.

Because of the way Glen Dash achieved his results, any future survey could only establish another set of estimates, with its own probabilities. We also found that what remains of the original builders' lines is already less than when J. R. Cole and Ludwig Borchardt surveyed and mapped the pyramid base in 1925–26, or even when Goodman and Lehner surveyed it in 1984–85, because of wear and tear and tourism.

And the conclusion? To a 95 per cent confidence level, Dash found:

1 Best estimates thus far make the maximum difference in the level of the **platform** (rather than the casing baseline, which is hard to calculate) from north to south as 4.7 cm (1.9 in.).

2 The average deviation of the sides from cardinal directions is 3 minutes 54 seconds plus or minus 44 seconds

3 The *greatest* difference in the length of the sides, each measuring a little more than 230 m (755 ft), is 18.3 cm (7.1 in.) (*italic* numbers in table below). The north and south sides deviate most. A comparison of the mean values of the estimates of the lengths of the sides produces a maximum difference between any two sides of 7.8 cm (3 in.).

It is also possible within the 95 per cent confidence windows for all four sides to have been the same length to within 5 mm – equal almost to perfection. Compare the maximum on the east with the minimum on the west (**bold** numbers in the table).

21.8 The fissure on line with the alcove where ScanPyramids announced a thermo-anomaly in 2015. View to the west.

casing line survives. At the corners, both casing and platform are entirely missing. A surveyor therefore has to take what points she or he can, and then extrapolate the baselines and estimate where they once intersected at the corners.

In 2015, AERA and a Glen Dash Foundation Survey (GDFS) team completed the most definitive survey of the baselines of the Great Pyramid. Glen Dash took an explicitly statistical approach. He first analysed and plotted the unpublished data from the survey of the Great Pyramid base by Mark Lehner and CALTRANS surveyor David Goodman in 1984–85. Then Joel Paulson, a professional surveyor and archaeologist, was brought in to obtain a more complete data set.[9] Paulson and the GDFS team surveyed points on what is left of original builders' lines. Dash used these points to provide estimates for the pyramid corners, rather than giving definitive, discrete values for the lengths of the sides. The possible locations of the corners fall within such and such a range, with a certain degree of probability.[10]

Measurements of sides of the Great Pyramid

Side	Minimum (m)	Mean (m)	Maximum (m)
North	*230.256*	230.329	230.402
East	230.295	230.334	**230.373**
South	230.329	230.384	*230.439*
West	**230.378**	230.407	230.436
Total	921.257	921.453	921.650
Average	230.314	230.363	230.412

Chronology

This chronological table is based on that in *Ancient Egyptian Chronology*, edited by Erik Hornung, Rolf Krauss and David A. Warburton (Leiden and Boston: Brill, 2006), 490–95. A collaborative work, it brings together articles by Egyptologists for each of the major periods.

Late Predynastic Period — c. 3000 BC

Early Dynastic Period

1st dynasty	2920–2730
Hor-Aha (Menes); Djer; Djet; Den; Adjib; Semerhket; Qa'a	
2nd dynasty	2730–2590
Hetepsekhemwy; Raneb; Ninetjer; Peribsen; Sekhemib; Sened; Khasekhemwy	
3rd dynasty	2592–2544
Djoser	2592–2566
Sekhemkhet	2565–2559
Khaba	2559–?
Nebka	?
Huni	?–2544

Old Kingdom

4th dynasty	2543–2436
Sneferu	2543–2510
Khufu (Cheops)	2509–2483
Djedefre	2482–2475
Khafre (Chephren)	2472–2448
Menkaure (Mycerinus)	2447–2442
Shepseskaf	2441–2436
5th dynasty	2435–2306
Userkaf	2435–2429
Sahure	2428–2416
Neferirkare	2415–2405
Raneferef	2404
Shepseskare	2403
Niuserre	2402–2374
Menkauhor	2373–2366
Djedkare Isesi	2365–2322
Unas	2321–2306
6th dynasty	2305–2118
Teti	2305–2279
Pepi I	2276–2228
Merenre	2227–2217
Pepi II	2216–2153
7th/8th dynasties	2150–2118

First Intermediate Period

9th/10th dynasties	2118–1980
11th dynasty (Theban)	2080–1940

Middle Kingdom

11th dynasty	1980–1940
12th dynasty	1939–1760

Second Intermediate Period

13th dynasty	1759–1630
14th dynasty	contemporary with 13th or 15th
15th–17th dynasties	?–1540

New Kingdom

18th dynasty	1539–1292
Ahmose	1539–1515
Amenhotep I	1514–1494
Thutmose I	1493–1483
Thutmose II	1482–1480
Thutmose III	1479–1425
Hatshepsut	1479–1458
Amenhotep II	1425–1400
Thutmose IV	1400–1390
Amenhotep III	1390–1353
Amenhotep IV/ Akhenaten	1353–1336
Smenkhare/ Nefernefruaten	1336–1334
Nefernefruaten	1334–?
Tutankhamun	?–1324
Ay	1323–1320
Horemheb	1319–1292
19th dynasty	1292–1191
Ramesses I	1292–1291
Seti I	1290–1279
Ramesses II	1279–1213
Merenptah	1213–1203
Seti II	1202–1198
Amenmesse	1202–1200
Siptah	1197–1193
Tawosret	1192–1191
20th dynasty	1190–1077

Third Intermediate Period

21st–25th dynasties	1076–723

Late Period

25th dynasty	722–655
26th dynasty	664–525
27th dynasty	525–404
28th dynasty	404–399
29th dynasty	399–380
30th dynasty	380–343
2nd Persian Period	343–332
Greco-Roman Period	332 BC – AD 395

Notes

Chapter 2: Quests, puzzles and questions (pp. 22–33)

1 Greaves 1646: Preface.
2 Several years ago this human skeletal material was moved to the physical anthropological laboratory of the Supreme Council of Antiquities at Giza.
3 Tallet et al. 2012; Tallet and Marouard 2012; Tallet 2013; Tallet and Marouard 2014; Tallet 2017. The translation on p. 30 is adapted from Tallet 2017, 150, Papyrus B1.
4 Herodotus 1972, Book II, 124, 178–79.
5 Josephus 1960, chapter IX.1, 55.
6 Kemp 1989, 149–57.

Chapter 3: Giza in context (pp. 34–45)

1 For a survey of the main relevant literature, see Introduction in Frajzyngier and Shay 2012. We thank Prof. Gene Gragg of the Oriental Institute, Unversity of Chicago for this reference.
2 Butzer 1959 and 1976.
3 Kröpelin et al. 2008; Kuper and Kröpelin 2006.
4 Bunbury 2009.
5 Jeffreys and Tavares 1994.
6 Aigner 1982 and 1983.

Chapter 4: Giza before Khufu: beginnings as a burial ground (pp. 46–61)

1 Daressy 1905.
2 Wilkinson 1999, 61–62.
3 Petrie 1907, 7.
4 Covington states that the enclosure wall is heavier on the south, which his plan does not show: Covington 1905, 196.
5 Covington 1905, 215.
6 Garstang 1903, 8.
7 Martin 1997, 284, note 3, reports that R. Fazzini of the Brooklyn Museum gave him the map. It was given in turn to the Cincinnati Art Museum, which houses material from Covington's excavations, as well as manuscripts that Martin did not see.
8 Petrie 1907, 8.
9 Kromer 1991.
10 Petrie 1907, 8.
11 Kromer 1978.
12 Manuelian 2009, 138.
13 Manuelian 2009, 116.
14 Manuelian 2009, 116.
15 Manuelian 2009, 117, fig. 13.
16 Manuelian 2009, 109.
17 Reader 2014, 36, quoting Lepsius 1853, 53–54.

Chapter 5: Origins of the pyramid (pp. 62–79)

1 Dreyer 1991.
2 O'Connor 2009, 182–94.
3 Petrie 1900, 4.
4 Emery 1958.
5 Kemp 1989.
6 Dreyer 1998, 31–34.
7 Stadelmann 1985b.
8 Kaiser 1969.
9 Rainer Stadelmann suggests that Sneferu may have ruled Egypt for nearly half a century – 46 or 48 years, living to 75 years old – in order to complete his three gigantic pyramids at Meidum and Dahshur. Other Egyptologists question the doubling of his reign, but he probably did reign longer than the 24 years that the Late New Kingdom king list in the Turin Royal Canon assigns him. Stadelmann 1987a.
10 Stadelmann 1982.
11 Petrie et al. 1910, 24–28.

Chapter 6: Explorers, scholars and expeditions (pp. 80–107)

1 Zivie-Coche 2004, 41ff.
2 Herodotus 1972, Book II, 126.
3 Herodotus 1972, Book II, 126.
4 As quoted in Hassan 1953b, 122.
5 As quoted in Fodor 1970, 340.
6 Fodor 1970, 347–53.
7 Diodorus 1968, Book I, 63.4–9.
8 Strabo 1967, 91–93.
9 al-Baghdadi 1965.
10 Norden 1755.
11 al-Baghdadi 1965.
12 al-Baghdadi 1965.
13 al-Baghdadi 1965.
14 Haarmann 1980.
15 Haarmann 1978, 374.
16 Belon du Mans 1970. Chesneau and Thevet 1984.
17 Prosper Alpinus 1979, chapter 6.
18 Greaves 1646, Preface.
19 Le Maserier 1735.
20 Bruce 1790, 41.
21 Stadelmann 1990, 20–21.
22 As recorded by Richard William Howard Vyse: Vyse 1842, 113.
23 Belzoni 1820, 270–71.
24 Lepsius 1852, 33.
25 Petrie 1883, Introduction, xvi.
26 http://www.gizapyramids.org/

Chapter 7: Pyramids: funeral, palace and ritual process (pp. 108–139)

1 Kemp 1983, 85.
2 Blackman 1918, 119.
3 Brovarski 1977.
4 Altenmüller 1973, 754.
5 Altenmüller 1973, 758–59.
6 Reeder 1994.
7 Wilson 1944.
8 Bonnet 1953.
9 Arnold 1977.
10 Hawass 1995b.
11 Hawass 1987, 146–47.
12 Posener-Kriéger 1976.
13 Posener-Kriéger 1976, 577, n. 1; Helck 1957, 98.
14 Malek 2003, 113.
15 Porter and Moss 1974, 278, plan 23, D-8.
16 Stadelmann 1981a.
17 Posener-Krieger 1976, 570.
18 Trench and Fuscaldo 1989.
19 Rossi 1999.
20 Kemp 1989, passim. Baines 1970 notes on p. 396 'the tendency of Egyptian creation myths to add extra elements to already complex bases (such as the incorporation of the *bn* in a creation myth…)'.
21 Allen 1988, 9–10.
22 Allen 1988, 13.
23 Baines 1970, 392.
24 Baines 1970, 393; Otto 1975.
25 Allen 1988, 17.
26 Edwards 1985, 277.
27 Edwards 1985, 276.
28 Allen 1989, 8–9.
29 Deaton 1988.
30 Allen 1989, 14.
31 Hornung 1984, 109.
32 Piankoff and Rambova 1954, 267.
33 Allen 1989, 25.

Chapter 8: The Great Pyramid of Khufu (pp. 140–187)

1 Kuper and Förster 2003; Kuhlmann 2005.
2 Tallet et al. 2012; Tallet and Marouard 2012; Tallet 2013; Tallet and Marouard 2014; Tallet 2017.
3 The method used was linear regression analysis: Dash 2015a and 2015b.
4 Stadelmann 1991.
5 Stadelmann 1985a.
6 Dormion and Goidin 1986; Dormion 2004.
7 Lehner 1998.
8 Kerisel 1993.
9 Maragioglio and Rinaldi 1965, 120–21 (English/ Italian).
10 Lauer 1971.
11 Borchardt 1932.
12 Lauer 1971.
13 Thomas 1953.
14 Edwards 1993, 285.
15 Edgar and Edgar 1910, vol. I, 185.
16 Verner 2002b, 202.
17 Vyse 1840, vol. I, 275–76.
18 Lucas 1962, 236–37.
19 Smyth 1880, 427–28.
20 Smyth 1880, 428–29.
21 Stadelmann 1994.
22 'Dr Grant and Mr Dixon have successfully proved that there was not jointing, and that the thin plate was a "left," and very skilfully left, part of the grand block composing that portion of the wall on either side. The block, therefore, had had the air-channel tube … sculptured into it.' Smyth 1880, 430.
23 Edgar and Edgar 1910, vol. I, 299.
24 Edgar and Edgar 1910, vol. I, 185.
25 Richardson et al. 2013; Hawass et al. 2011.
26 Nour et al. 1960; Jenkins 1980.
27 For a description and summary of these marks, see Verner 2002a, esp. 375–77.
28 Abu Bakr and Moustafa 1971.
29 Altenmüller 2002.
30 Waseda University 1993.

31 Kurokochi and Yoshimura 2015 (Japanese with summary in English). The report notes that at that stage, five species of wood had been identified: *Cedrus libani* (cedar of Lebanon), *Cupressus sempervirens* (cypress), *Juniperus excelsa* (juniper), *Acacia nilotica* (acacia) and *Ziziphus spina-christi* (jujube). The team began taking measurements of the individual wooden pieces manually and with a 3D scanner, during the course of which they identified inscriptions left by the ancient carpenters.

32 Junker 1951, 9–12.

33 Lehner 1985.

34 Hawass 1996a and Hawass 1997b.

35 Hawass 1997b.

36 Hawass 1996a, 386.

37 Hawass 1996a, 394.

38 Measurements are based on Maragioglio and Rinaldi 1965, unless otherwise stated.

39 Gardiner 1925, 2–5.

40 Romer 2007, 331–37.

41 Reisner 1942, 72.

42 Reisner 1942, 71–72.

43 Jánosi 1996.

44 Reisner and Smith 1955, 6.

45 Reisner 1942, 72.

46 Lehner 1985. For two versions of Hetepheres tomb chamber: Reisner 1942, 129, fig. 63, and Maragioglio and Rinaldi 1965, Tv. 12, figs 5, 8.

47 Measurements of G1-a according to different researchers:
Reisner (1942, 71): 49.5 m (162 ft)
Lehner (1985, 51): N side 46 m (151 ft)
Maragioglio and Rinaldi (1965, 78–80): 47 m (154 ft/90 cubits; from an imaginary plane passing horizontally through the pyramid from the northwest corner).

48 After Maragioglio and Rinaldi 1965, Tv. 11, Fig. 2

49 Jánosi 1996, 108–10.

50 Reisner 1942, 129ff., whose measurements vary from those of Maragioglio and Rinaldi (above), recorded the following:
GI-a Bedrock: 5.03 × 4.40 × 2.79 m
 Encased: 3.55 × 2.97 × 2.49 m
GI-b Bedrock: 5.33 × 5.38 × 3.93 m
 Encased: 3.88 × 3.12 × 3.35 m
GI-c Bedrock: 4.67 × 5.38 × 3.39 m
 Encased: 3.73 × 2.89 × 2.90 m

51 Hawass 1995b.

52 Hawass 1997a.

Chapter 9: The second pyramid: Khafre (pp. 188–213)

1 Valloggia 2011.

2 Maragioglio and Rinaldi 1966, 52.

3 Averages taken from Petrie 1883, 105, 107.

4 Stadelmann 1990, 179.

5 Stadelmann 1990, 179.

6 Hawass 1987, 146–47.

7 Hölscher 1912, 26–28; Hölscher and Steindorff 1909, 5–6.

8 Ricke 1950, 112–14; Ricke 1970, 23 and 26, 55–58.

9 Ricke 1950, 50.

10 Jánosi 1994.

11 Ricke 1950, 50–51.

12 Maragioglio and Rinaldi 1966, 120.

13 Ricke 1950, 45.

14 Hawass 1987, 152–54.

15 Ricke 1950, 55.

16 Hölscher 1912, 29.

17 Maragioglio and Rinaldi 1966, 68, 72–74.

18 Hassan 1946; Hawass 1987, 172–81, including dimensions of all the pits.

19 Maragioglio and Rinaldi 1966, 94.

20 Hölscher 1912, 34–35, pl. XIII.

21 Hölscher 1912, 107.

22 Abd el-'Al and Yousef 1977; Lacovara and Lehner 1985.

23 Alexanian et al. 2010.

24 Ricke 1970.

25 Mariette 1882, 97–100; Mariette and de Rougé 1862.

26 Petrie 1883, 129–34.

27 Hölscher 1912, 15–23, 37–49.

28 Hassan 1949, 1953.

29 Mariette 1882, 98–99.

30 Ricke 1950.

31 Ricke 1950, 102–14 and 86–102.

32 Hawass 1997, 245–48.

33 Hölscher 1912, 37–39; Hölscher and Steindorff 1909.

Chapter 10: The Great Sphinx (pp. 214–241)

1 To recap: Member I is made up of hard layers of the shoal and reef. Marine mud and silts accumulated to form the fairly regular sequence of soft marly layers interspersed with harder beds make up Member II; the softer layers result from turbulent waters that churned up the mud and silts, while the intervening harder layers represent calmer waters with more compact sedimentation. Member III, which forms the head of the Sphinx, is a stone of harder quality formed in those calmer waters.

2 Russmann 1989, 82.

3 The object in the British Museum is BM 1204, 5.44-48; the cast in the Cairo Museum is TL 16/3, 29/1.

4 Stadelmann 1985, 125–26; Stadelmann 2003.

5 Museum of Fine Arts Boston 21.351; Smith 1949, pl. 12; Arnold et al. 1999, 255, cat. no. 58.

6 Borchardt 1911, 37–39, Bl. 10–11; Johnson 1990, 87, no. 344; 89, no. 36.

7 Ricke 1970.

8 Hölscher 1912.

9 Ricke 1970, 1–43.

10 Gardiner 1916, 91.

11 Ricke 1970, 38–39.

12 Ricke laid out the evidence that, even as the building was in progress, a design change required the builders to dismantle granite casing from the interior of the north and south walls, move the huge core blocks of the centre of those walls to widen the ambulatory and to create pillared colonnades like those already finished along the east and west sides of the court. Among other traces, this left telltale

seams running through the great hubs of core blocks at the corners of the temple.

13 In fact, in the western corners of two courses of core blocks rest on the bedrock ledge between Terrace I and Terrace II; this takes the place of the first course.

14 Birch 1860; Vyse 1842, 108–10.

15 Ricke 1970, 33–34.

16 Lehner 1992.

17 Mariette 1882. 'Notes additionnelles. B. Grand Sphinx de Gyzèh'; Rougé 1854.

18 Hawass and Lehner 1994.

19 glendash.com/archaeology.html

20 Laorty-Hadji 1856, 382

21 Moussa et al. 1977.

22 The second survey was never formally published. SRI International Interim Report: Sphinx Exploration Project. Unpublished 1978. Vickers 1981; Lambert T. Dolphin published a report online under the title 'Geophysical Studies around the Sphinx' (1978).

23 Rifken 1991.

24 Spanel 1988, 3, 11.

25 Roeder 1941, 154–60.

26 Schoch 1992.

27 Stadelmann 1985, 125–26; Stadelmann 2003.

28 The idea was proposed in a television documentary 'Secrets of the Sphinx' in 2004.

Chapter 11: The third pyramid: Menkaure (pp. 242–283)

1 Maragioglio and Rinaldi 1967.

2 Petrie 1883, 112–13.

3 Petrie 1883, 111.

4 Vyse 1840, vol. II, 85–87, 93–96, plate opposite 94.

5 Zivie-Coche 1991, 97–101

6 Gundacker 2009.

7 Published in Reisner 1931.

8 Reisner 1931, 15, 25, 31.

9 Ricke 1950, fig. 22.

10 Ricke 1950, 55–60.

11 Reisner 1931, 26; Maragioglio and Rinaldi 1967, 52; Grinsell 1947, 14; Fakhry 1961, 141; Ricke 1950, 59.

12 Smith 1958, 100.

13 Lacovara and Reeves 1987.

14 Reisner 1931, 26–29.

15 Maragioglio and Rinaldi 1967, 120.

16 Hawass 1997c.

17 Saleh 1974, 153–54, pl. 34 a–c.

18 Hawass 1987, 258–85.

19 Reisner 1931, 55.

20 Jánosi 1992b; Callender and Jánosi 1997; Edel 1953 and 1954.

21 Hawass 1997c.

22 The rebate is about 1.5 cm (½ in.) deep and 63 cm (25 in.) wide on one side and about 40 cm (16 in.) wide on the other. Jánosi 1996, 95–96.

23 Here the raised panels around the rebate on the underside are 52 cm (c. 1 cubit/20.5 in.) wide on one side, and 50 cm (just under 20 in.) on the other.

23 Jánosi reported that the broken capstone

retained sections of three smoothly finished sides and that its original width was 1.125 m (15 palms/3 ft 8 in.). A square rebated or sunken area was carved on the underside, 7.5 cm (1 palm/3 in.) deep and measuring 1 cubit square (about 52.5 cm/ 21 in.). The sunken square would have fitted over a raised section of corresponding size on the course below, thus fixing the capstone. With an angle of slope of 52 deg. the pyramidion would have been about 10 palms (75 cm/29.5 in.) high. Jánosi 1996, 100–01; Jánosi 1992a.

24 Reisner 1931, 56.
25 Reisner 1931, 57.
26 Reisner 1931, 59.
27 Reisner 1931, 57.
28 Reisner 1931, 63.
29 Maragioglio and Rinaldi 1967, 62.
30 Vyse 1840, vol. II, 46–47.
31 Vyse 1840, vol. II, 48; Reisner 1931, 63.
32 Reisner 1931, 64.
33 Reisner 1931, 64.
34 Reisner 1931, 66.
35 Reisner 1931, 67.
36 Maragioglio and Rinaldi 1967, 110.
37 Reisner 1931, 34.
38 Reisner 1931, 39.
39 Hassan 1943, esp. 54ff.
40 Maragioglio and Rinaldi 1967, 74.
41 Hassan 1943, 59.
42 Hassan 1943, 53ff.
43 Hassan 1943, 54
44 Reisner 1931, 37, 110, pls 54–60.
45 Arnold 1999, 68; Friedmann 2008.

Chapter 12: The Khentkawes monument: Giza's punctuation point (pp. 284–311)
1 Hölscher 1912, 6; Reisner 1931, 4.
2 Hassan 1943, 1–102.
3 Maragioglio and Rinaldi noted that at least two of the niches next to the southeast corner had been completed, one 'almost completely visible except for the upper part'. Maragioglio and Rinaldi 1967, 170.
4 Maragioglio and Rinaldi 1967, 172.
5 Maragioglio and Rinaldi 1967, 172.
6 Hassan 1943, 18–23.
7 Maragioglio and Rinaldi 1967, 172.
8 The bedrock floor rises as a socle or bench, about 2 cm (just under 1 in.) high, along the eastern wall, south of the entrance passage, where it is 65 cm (25½ in.) wide, and along the western wall north of the granite false door slab decoration, where it is 90 cm (35 in.) wide. The masons left the socle when they cut slightly down into the floor as they trimmed the face of the casing, now mostly missing, against the bedrock walls. The distance between the western and eastern socle gives the width of the chamber between the encased walls. Subtracting the width of the socles (the intended baseline of the casing) at the northern and southern ends gives the length of the room.
9 The deep central niche is 25 cm (almost 10

in.) wide and 14 cm (5½ in.) deep. The simple false door panels, 26 cm (10¼ in.) wide, form a higher plane with central niches 3 cm (1⅕ in.) wide between panels 8 cm (3 in) wide. These plus the deep niche occupy a width of 78 cm (31 in.). To either side of this, the third, higher plane features more complex false door patterns with two-step compound niches, 9 cm (3½ in.) wide, flanked by panels 8 cm (3 in.) wide.
10 On the northern side the beams measure 1.46 m (4 ft 9 in.), 3 m (9 ft 10 in.) and 3.55 m (11 ft 8 in.) long, and on the southern side, 2.53 m (8 ft 4 in.) and 3.54 m (11 ft 7 in.) long. They range from 70 to 95 cm (28–37 in.) high and 46 to 61 cm (18–24 in.) wide.
11 Both holes are up against the ceiling. That in the northern wall is 42 cm (16½ in.) wide, 46 cm (18 in.) high, and about 17 cm (6½ in.) deep. The hole in the southern wall is 42 cm (16½ in.) wide, 34 cm (13⅖ in.) wide and 24 cm (9½ in.) deep. A single wooden beam would need to be about 8.17 m (26 ft 10 in.) long in order to span the length of the vestibule and fit into the two holes.
12 Hassan 1943, 26.
13 Hassan 1943, 26.
14 The cutting in the southern wall, 67 cm (26⅓ in.) wide, is rectangular, extends down to the base of the wall and looks like an unfinished entrance to one of the grottos, though is not as high, rising 74 cm (29 in.) off the highest floor level (compared to 90 to 97 cm (35½ – 38 in.) for the height of the grotto entrances). The top of this cutting is 45 cm (17¾ in.) deep for a distance of 25 cm (10 in.) below the top edge, and from there to its base the cutting bellies out with a curved back to a maximum depth of 73 cm (28¾ in.) deep on its eastern side and a depth of 49 cm (19⅓ in.) on its western edge. If this hole was to receive a wooden beam, perhaps to assist manoeuvering the sarcophagus, the curved and shallower western side may indicate they swung the end of the beam in from that side, though it would seem easier to do so from the east where there is greater space.
 The vertical cross section of the hole, 63 cm (25 in.) wide, in the northern wall, is somewhat funnel-shaped. It is directly on line with the hole on the southern wall, but it is shallower, only 24 cm (9½ in.) deep on its western side, while the eastern side curves out to the plane of the wall. This makes it likely that the workers swung the end of a beam into this socket from the east. However, unlike the cutting in the southern wall, this one is round-topped, and only 42 cm (16½ in.) high with its lower edge 40 cm (15¾ in.) above the base of the wall or the top of the higher ledge along the northern side. This means that if workers used this hole to receive the end of a wooden beam that they wanted to be horizontal and inserted the other end in the hole in the southern wall, they would need to have built up supports within or in front of that hole. Or, perhaps a beam placed at

an angle from the upper northern hole to the bottom of the southern hole served them some purpose.
 The western sides of these holes align exactly with the lower ledge along the base of the western wall, while the eastern sides of the holes align with the western side of the deepest cutting of the stepped, sunken floor. Is it possible a wooden beam, with its ends placed into these holes as sockets, played a role in placing the lid on to the top of the sarcophagus?
15 The measurements of the height of a few of the blocks give the range of the thickness of each of the five courses, which diminish bottom up.
 Thickness of core blocks on the eastern side of Mastaba:
 Course 1 1.44–1.56 m (4 ft 9 in.–5 ft 1 in.)
 Course 2 1.26–1.43 m (4 ft 2 in.–4ft 8 in.)
 Course 3 0.90–1.09 m (2 ft 11 in.–3 ft 7 in.)
 Course 4 0.94–1.14 m (3 ft 1 in.–3 ft 9 in.)
 Course 5 1.05–1.22m (3ft 5 in.–4 ft)
 The first three major courses of the mastaba faces become thinner, and then courses 4 and 5 thicken.
16 The vertical distance from rebate to rebate on courses 2, 4 and 5 range from 0.97 to 1.13 m (3 ft 2 in.–3 ft 8 in.), with an average of 1.04 m (3ft 5 in.), which suggests the masons intended a spacing of 2 cubits (1.05 m/3ft 5 in.). The first and second courses differ. The average height of the first course blocks is around 1.47 m (4 ft 10 in.) to the bottom of the blocks on the top of the pedestal terrace. The average of the vertical distance from the rebate on the first course to that on the second is about 1.3 m (4 ft 3 in.).
17 The five upper courses of stones decrease in thickness from 52 cm (20½ in.; 1 cubit) for course 6, to 46 cm (18 in.) for course 7, and 40 cm (15¾ in.) for courses 7 to 10.
18 The top of the highest stone on the north is 40 to 48 cm (15¾ –19 in.) above the level of the top of the highest stone on the south.
19 Hassan 1943, 33.
20 Hassan 1943, fig. 1 and 32; he calls it a 'girdle-wall'.
21 Hassan 1943, 32 and 93–94.
22 Hassan 1943, pl. XIVa.
23 Tavares 2008; Lehner 2009.
24 Lehner 2011 and 2012.
25 Lehner and Wetterstrom 2014; Lehner 2014.

Chapter 13: The development of the Giza cemeteries (pp. 312–337)
1 Schmitz 1976, 18.
2 Jánosi 2005, 104–06.
3 Roveri 1969, 112f., Tv. XVI.
4 Roveri 1969, 117–19, Tv. XXXII–XXXIII; Smith 1933.
5 Drioton 1954.
6 Reisner 1942, Appendix B, p. 416.
7 Jánosi 2005, 233–36.
8 Valloggia 2011.
9 Baud et al. 2003.
10 Jánosi 2006, 183.

[11] Jánosi 2005, 232.
[12] Manuelian 2006, 227.
[13] Jánosi 2005, 267, Tab. 13.
[14] Jánosi 2005, 269–72.
[15] Jánosi 2005, 259, from L. Flentye personal communication.
[16] Hassan 1943, 125–50, figs. 71–105 and pls 36–39.
[17] Lepsius 1849–59, II, Bl. 14; Hassan 1943, 140, fig. 81.
[18] Omara 1952, Chart VI.
[19] Strudwick 2005, 200, no. 111.
[20] Strudwick 2005, 78, no 5.
[21] Jánosi 2005, 313.
[22] Jánosi 2005, 376–77, Abb. 99–100.
[23] Herein lies a dispute between Egyptologists, who transcribe and translate it either: 'who gave me its place' or 'who gave it to my father'. We follow Strudwick 2005, 271, no. 200, who follows Edel 1955–64, 442.
[24] Hassan 1943, 170, fig. 119.
[25] Kloth 2002, 38–39.
[26] Strudwick 2005, 322.
[27] Hassan 1943, 119–20.
[28] Dunham and Simpson 1974, 10, fig. 4.
[29] Jánosi 2005, 302–07, Abb. 72.
[30] Callender and Jánosi 1997, 1–22; Porter and Moss 1974, 273.
[31] Porter and Moss 1974, 249; Hassan 1946, 3–8.
[32] Porter and Moss 1974, 256; Callender 2012, 134–35.
[33] Porter and Moss 1974, 243–44; Hassan 1950, 31–34, 43–65; Callender 2012, 154–58.
[34] Jánosi 2005, 302–07.
[35] Kamal 1910; Daressy 1910.
[36] Callender and Jánosi 1997, 15.
[37] Callender 2012, 113.
[38] Edel 1953 and 1954; Strudwick 2005, 381, no. 277.
[39] Jánosi 2005, 427.
[40] Roth 1994.
[41] Callender and Jánosi 1997.
[42] Callender and Jánosi 1997, 8–9.
[43] Callender and Jánosi 1997, 6–7.
[44] Callender and Jánosi 1997, 10.
[45] Lesko 1998, 152.
[46] Smith 1949, 41–42.
[47] Callender and Jánosi 1997, 8.
[48] Bolshakov 1992.
[49] Jánosi 1997, 20, n. 32; Junker 1934, 172ff. We don't know how to interpret these royal sons in terms of sequence or rank. In the 4th dynasty only princes actually born to the king's wife had the right to the title, often in tandem with the title of Vizier. Only at the end of the 4th dynasty do we see a change with Sesat-hetep (in the Cemetery en Échelon), who was not a biological 'bodily' king's son but bears the title as well as that of Vizier.
[50] Manuelian 2009, 780.
[51] Reisner 1942, 306–07.
[52] Manuelian 2009, 155.
[53] We use here for convenience the chronology of Baines and Malek 1991.

[54] Junker 1938, 169, Abb. 30.
[55] Jones 2000, 362, no. 1342.
[56] Junker 1938, 171, Abb. 31.
[57] Breasted 1906–07, 115–16.
[58] Gauthier 1925; Nolan 2010, 394–95.
[59] Nolan 2010, 365–66.
[60] Nolan 2010 371, 381.
[61] Jánosi 2006, 179.
[62] Jánosi 2006, 181.

Chapter 14: The Workers' Cemetery (pp. 338–353)

[1] Hawass 1996b.
[2] Hawass 1995a.
[3] Hawass 2012, 25.
[4] Hawass 1998.
[5] Hawass 1999b, cat. nos 89–92.
[6] Hawass 2012, 41.
[7] Fischer 1996.
[8] Hawass 2004.
[9] Hawass 2006b.
[10] Hawass 1999a.
[11] Hawass 1995a.
[12] Hussein et al. 2003.
[13] Hawass and Senussi 2008.

Chapter 15: Living at Giza: worker settlements and pyramid towns (pp. 354–401)

[1] Stadelmann 1981b, 1983 and 1985.
[2] Kemp 1989, 146.
[3] Roth 1991.
[4] Junker 1938, 163; for work on restoration, Hawass 1999a.
[5] Edel 1956.
[6] Posener-Krieger 1976, 302, 304–05.
[7] Stadelmann 1981a.
[8] Petrie 1883, 101–03.
[9] Conard and Lehner 2001.
[10] Saleh 1974.
[11] The excavations are reported and discussed in issues of Aeragram, the official newsletter of Ancient Egypt Research Associates, and past issues are available to download at http://www.aeraweb.org/publications/aeragram-newsletter/
[12] Kemp 1989, 157.
[13] Zaccagnini 1993.
[14] McNeill 1995.
[15] Kromer 1978.
[16] Lehner 2016.
[17] O'Connor 1995.

Chapter 16: How they might have built the pyramids (pp. 402–419)

[1] Petrie 1883, 170; Petrie 1917, 44–45; Stocks 2005.
[2] Edwards 2001, 200.
[3] Spence 2000.
[4] Isler 2001, 133–56.
[5] Engelbach 1923, 64.
[6] Lichtheim 1975, 21–22.
[7] Chevrier 1970; p. 20 has an explanation of this technique.
[8] Arnold 1991, 64
[9] Isler 2001, 246–66.

Chapter 17: Giza on the ground: the pyramid projects (pp. 420–461)

[1] Goyon 1967, 46–69.
[2] Hassan 1953a, xi–xii.
[3] Reisner 1942, 10–19.
[4] Klemm and Klemm, 1981, 12–20.
[5] Roveri 1969, 112, Tv. XVI.
[6] Petrie 1883, 170; Petrie 1917, 44–45.
[7] Vyse 1840, I, 189.
[8] Petrie 1883, 50–51, pl. III.
[9] Petrie 1883, 55–56.
[10] Clarke and Engelbach 1930.
[11] Lehner 1985, 44–50.
[12] Dorner 1981 and 1985.
[13] Forbes 1916, 75–78.
[14] Tallet et al. 2012; Tallet and Marouard 2012; Tallet 2013; Tallet and Marouard, 2014; Tallet 2017; Lehner forthcoming.
[15] Reisner 1942, 84–85.
[16] Ricke 1970, 1–43.
[17] Lehner 1983.
[18] The size of the courses we could reach measured, from lower to higher, 82, 67, 35, 45, 66, 44 and 45 cm (32, 26, 13, 18, 26, 17 and 18 in.) thick.
[19] Ricke 1970.
[20] Newberry 1893–94, I, pl. X.
[21] Stadelmann 1990, 259.
[22] Reisner 1931, 29.
[23] Reisner 1931, 74.
[24] Reisner 1931, 75.

Chapter 18: The abandonment of Giza (pp. 462–467)

[1] For the numbers of funerary estates, see Khaled 2008, p. 47.
[2] Hölscher 1912, 80–81.
[3] Hassan 1960, 11–26.
[4] Reisner 1942, 14.
[5] Reisner 1942, 15.
[6] Reisner 1931, 32.
[7] Hölscher 1912, 83.
[8] Petrie 1883, 45–46.
[9] Wilkinson 1878, 360.
[10] Ricke 1970, 24–25.
[11] Goedicke 1971; Jánosi 2016, 27–49.
[12] Goedicke 1971, 7.

Chapter 19: New Kingdom revival (pp. 468–491)

[1] Kemp 1989, 66.
[2] Hassan 1953, 67.
[3] Hölscher 1912, 18.
[4] Hassan 1963, 83–95.
[5] Gardiner 1969, 130.
[6] Zivie-Coche 2004, 45.
[7] Stadelmann 1987b, 439.
[8] Dijk 1989, 62–63.
[9] Stadelmann 1987b, 436–37.
[10] Vyse 1842, 110.
[11] Lichtheim 1975, 212.
[12] Edwards 1976, 293.
[13] Mariette 1882, 95.
[14] Laorty-Hadji 1856, 382.
[15] Abd el-Aal 2009; Hawass 2006c.

[16] Martin 1991, 134–39.
[17] Martiny 1981.
[18] 'The Lost Caves of Giza', Forgotten History Series – 7, ATA-Memphis 2011; Collins 2009.
[19] Bell 1985, 271, n. 97.

Chapter 20: Giza in the Late Period (pp. 492–525)
[1] Pliny 1962, xxxvi, 76.
[2] Zivie-Coche 1976.
[3] Ricke 1970.
[4] Petrie 1883, 156.
[5] Zivie-Coche 1991, 182.
[6] Gundacker 2009, 18–25.
[7] Zivie-Coche 1991, 100.
[8] Zivie-Coche 1991, 100.
[9] Zivie-Coche 1991, 218–38.
[10] Zivie-Coche 1991, 237.
[11] Zivie-Coche 1991, 267–81.
[12] Hassan 1944, 193.
[13] Hawass 2007.
[14] Hawass 2007, 388.
[15] Birch 1860.
[16] Petrie 1907, 29.
[17] Kamal 1908, 85–86.
[18] Schweitzer 1950, 118.
[19] Petrie 1907, 28–29, pls. 32–37.
[20] el-Sadeek 1984, 21.
[21] Zivie-Coche 1991, 293–97.

[22] In addition, in a rock-cut tomb in the western Central Field, the original owner of which remains unknown, Selim Hassan found a cache of ibis mummies, perhaps deposited here because an ibis is depicted in the relief-carved decoration on one of the walls. At the Sphinx, Hassan found a buried cache of mummified shrew mice alongside the north wall of the 18th dynasty Amenhotep II temple, where someone must have placed them during the Late Period at the bottom of a pit that they dug from a higher level. In the south slope of the Southern Field, Petrie found 'in the cemetery some tombs full of animal skeletons' including 192 cats, but also 7 mongoose, 3 wild dog and a fox: Petrie 1907, 29.

Afterword: Giza developments (pp. 526–531)
[1] Tallet et al. 2012; Tallet and Marouard 2012; Tallet 2013; Tallet and Marouard 2014; Tallet 2017.
[2] In 2012 Glen Dash and Mark Lehner were in correspondence with Alan Bross, A. Pla-Dalmau and P. Rubinov of the Fermi National Accelerator Laboratory about applying muography to the Great Pyramid. From the 2012 correspondence came a paper: 'High-resolution muon tomography of the Great Pyramid', submitted to *Geoscientific Instrumentation, Methods and Data Systems*.
[3] Kawae et al. 2014.
[4] Lehner 2002.
[5] Following an architectural study in 1984 by French architects Jean Patric Goidin and Gilles Dormion, and gravimetric studies in 1986, which revealed differential densities in the pyramid beyond the Horizontal Passage, they drilled through the blocks of the western side of the passage to hit clean sand; Dormion and Goidin 1986; Dormion 2004.
[6] Just to the right and above the hieroglyphic inscription that Lepsius carved in 1842 for the King of Prussia on the occasion of the king's 47th birthday. For an English version, see pp. 98–99 in the present work and Lepsius 1853, 56–57.
[7] *ScanPyramids October 2016 First Year Activity Report* (HIP Institute).
[8] *ScanPyramids October 2016 First Year Activity Report* (HIP Institute), 20 (un-numbered pages).
[9] Dash 2012; Lehner and Goodman 1986.
[10] Dash 2015a and 2015b.

Bibliography

Abbreviations

ASAE Annales du Service des Antiquités de l'Égypte
BIFAO Bulletin de l'Institut Français d'Archéologie Orientale
IFAO Institut Français d'Archéologie Orientale
JARCE Journal of the American Research Center in Egypt
JEA Journal of Egyptian Archaeology
JNES Journal of Near Eastern Studies
MDAIK Mitteilungen des Deutschen Archäologischen Instituts Abteilung Kairo
RdE Revue d'Égyptologie
ZÄS Zeitschrift für Ägyptische Sprache und Altertumskunde

Abd el-Aal, S. S. 2009. 'Some blocks belonging to the Tias from Kafr el-Gebel', in U. Rössler-Köhler and T. Tawfik (eds), *Die ihr vorbeigehen werdet…* (Berlin: Walter de Gruyter), 1–3
Abd el'Al, Abdel Hafez, and A. Yousef. 1977. 'An Enigmatic Wooden Object Discovered Beside the Southern Side of the Giza Second Pyramid', *ASAE* 62, 103–20, pls I–XV
Abu Bakr, A. M. and A. Y. Moustafa. 1971. 'The funerary boat of Khufu', in *Beitrage zür ägyptischen Bauforschung und Altertumskunde* (=*Festschrift Ricke*) (Wiesbaden: Franz Steiner Verlag), 1–16

Aigner, T. 1982. 'Zur Geologie und Geoarchäologie des Pyramidenplateaus von Giza, Ägypten', *Natur und Museum* 112, 377–88
Aigner, T. 1983. 'Facies and Origin of Nummulitic Buildups: An Example from the Giza Pyramids Plateau (Middle Eocene, Egypt)', *Neues Jahrbuch für Geologie und Paläontologie* 166, 347–68
al-Baghdadi, Abd al-latif. 1965. *The Eastern Key: Kitab al-ifadah wa'l-i'tibar of 'Abd al-latif al-Baghdadi*, trans. K. Hafuth, J. A. Videan and I. Videan (London: Allen and Unwin)
Alexanian, Nicole, et al. 2010. 'The Necropolis of Dahshur. Seventh Excavation Report Autumn 2009 and Spring 2010'. www.dainst.org
Allen, James P. 1988. *Genesis in Egypt: The Philosophy of Ancient Egyptian Creation Accounts* (New Haven: Yale Egyptological Studies 2, W. K. Simpson, ed.)
Allen, James P. 1989. 'The Cosmology of the Pyramid Texts', in James P. Allen, Jan Assmann, Alan B. Lloyd, Robert K. Ritner and David P. Silverman, *Religion and Philosophy in Ancient Egypt* (New Haven: Yale Egyptological Studies 3, W. K. Simpson, ed.), 1–28
Prosper Alpinus. 1979. *Rerum Aegyptiarum, Liber I, Histoire Naturelle de l'Égypte*, chapter 6, Voyageurs occidentaux en Égypte 20, IFAO. *Histoire Naturelle de l'Égypte*
Altenmüller, Hartwig. 1973. 'Bestattung,' *Lexikon der Ägyptologie*, Band I, Lieferung 5 (Wiesbaden: Otto Harrasiwitz)
Altenmüller, Hartwig. 2002. 'Funerary Boats and Boat Pits of the Old Kingdom', *Archiv Orientální* 70, 269–90
Arnold, Dieter. 1977. 'Rituale und Pyramidentempel', *MDAIK* 33, 1–14
Arnold, Dieter. 1991. *Building in Egypt* (Oxford and New York: Oxford University Press)
Arnold, Dorothea. 1999. *When the Pyramids Were Built. Egyptian Art of the Old Kingdom* (New York: Metropolitan Museum of Art)
Arnold, Dorothea, Krzysztof Grzymski and Christiane Ziegler (eds). 1999. *Egyptian Art in the Age of the Pyramids*, (New York: Metropolitan Museum of Art/Abrams)
Baines, John. 1970. '*Bnbn:* Mythological and Linguistic Notes', *Orientalia* 39, 389–404
Baines, John, and Malek, Jaromir. 1991. *Cultural Atlas of Ancient Egypt* (New York: Facts on File)
Baud, Michel, et al. 2003. 'Le Cimetière F d'Abou Roach, nécropole royale de Rêdjedef (IVe dynastie)', *BIFAO* 103, 17–71
Bell, Lanny. 1985. 'Luxor Temple and the Cult of the Royal Ka', *JNES* 44, 251–94
Belon du Mans, Pierre. 1970. *Le Voyage en Égypte…*, 1547. Voyageurs occidentaux en Égypte 1, IFAO
Belzoni, Giovanni Battista. 1820. *Narrative of the Operations and Recent Discoveries in Egypt and Nubia* (London: John Murray)
Birch, Samuel. 1860. 'On excavations by Capt. Caviglia, in 1816, behind and in the neighbourhood of the Great Sphinx', *Museum of Classical Antiquities* 2, 27–34

Blackman, A. M. 1918. 'Some notes on the ancient Egyptian practice of washing the dead', *JEA* 5.2, 117–24

Bolshakov, A. 1992. 'Princess Hm.t-ra(w). The First Mention of Osiris?' *Chronique d'Égypte* 67, 203–10

Bonnet, Hans. 1953. 'Ägyptische Baukunst und Pyramidenkult', *JNES* 12, 257–73

Borchardt, Ludwig. 1911. *Statuen und Statuetten von Königen und Privatleuten, vol. 1* (Berlin: Reichsdruckerei)

Borchardt, Ludwig. 1932. *Einiges zur dritten Bauperiode der grossen Pyramide bei Gise*, 5–7. Beiträge zur ägyptischen Bauforschung und Altertumskunde, 1 (Cairo: Selbstverlag des Herausgebers)

Breasted, James Henry. 1906–07. *Ancient Records of Egypt. Historical documents from the earliest times to the Persian Conquest*, 6 vols (Chicago: The University of Chicago Press)

Brovarski, Edward. 1977. 'The Doors of Heaven', *Orientalia* 46, 107–15

Bruce, James. 1790. *Travels to Discover the Source of the Nile*, Vol. I (London: G. G. J. and J. Robinson)

Bunbury, Judith. 2009. 'Egypt and the Global Cooling Crisis', *Ancient Egypt* 10.1, 50–55

Butzer, K. W. 1959. 'Environment and Human Ecology in Egypt during Predynastic and Early Dynastic Times', *Bulletin de la Société de Géographie d'Égypte* 32, 43–87

Butzer, K. W. 1976. *Early Hydraulic Civilization in Egypt: A Study in Cultural Ecology* (Chicago: Chicago University Press)

Callender, Vivienne G. 2012. *In Hathor's Image I. The Wives and Mothers of Egyptian Kings from Dynasties I–VI* (Prague: Charles University)

Callender, Vivienne G., and Peter Jánosi. 1997. 'The Tomb of Queen Khamerernebty II at Giza. A Reassessment', *MDAIK* 53, 1–22.

Chesneau, Jean; André Thevet. 1984. *Voyages en Égypte, 1549–1522*, Voyageurs occidentaux en Égypte 24, IFAO

Chevrier, Henri. 1970. 'Techniques de la construction dans l'ancienne Égypte, II. Problèmes posés par les obélisques', *RdE* 22, 15–39

Clarke, Somers, and Reginald Engelbach. 1930. *Ancient Egyptian Masonry: The Building Craft* (London: Oxford University Press)

Collins, Andrew. 2009. *Beneath the Pyramids: Egypt's Greatest Secret Uncovered* (Virginia Beach: A.R.E. Press)

Conard, Nicholas J. and Mark Lehner. 2001. 'The 1988/1989 Excavation of Petrie's Workmen's Barracks at Giza', *JARCE* 38, 20–60

Covington, M. D. 1905. 'Mastaba Mount Excavations', *ASAE* 6, 193–218

Daressy, G. G. 1905. 'Un edifice archaïque à Nezlet Batran', *ASAE* 6, 99–106

Daressy, Georges. 1910. 'La tombe de la mère de Chéfren', *ASAE*, 10, 41–49

Dash, Glen. 2012. 'New Angles on the Great Pyramid', *Aeragram* 13.2, 10–19

Dash, Glen. 2015a. 'What was the original size of the Great Pyramid's Footprint?, *Aeragram* 16.1, 8–11

Dash, Glen. 2015b. 'The Great Pyramid's Footprint: Results from Our 2015 Survey', *Aeragram* 16.2, 8–14.

Deaton, J. C. 1988. 'The Old Kingdom Evidence for the Function of the Pyramids,' *Varia Aegyptiaca* 4, 193–200

Dijk, Jacobus van. 1989. 'The Canaanite god Hauron and his cult in Egypt', *Göttinger Miszellen* 107, 59–68

Diodorus. 1968. *Diodorus of Sicily Vol. 1,* C. H. Oldfather (trans.) (London: William Heinmann Ltd)

Dormion, Gilles. 2004. *La chambre de Chéops* (Paris, Grande Livre du Mois)

Dormion, Gilles, and Jean-Patrice Goidin. 1986. *Khéops, nouvelle enquête* (Paris, Editions Recherche sur les Civilisations)

Dorner, Joseph. 1981. 'Die Absteckung und astronomische Orientierung ägyptischer Pyramiden' (PhD Thesis, University of Innsbruck)

Dorner, Joseph. 1985. 'Studien über die Bauvermessung und astronomische Orientierung', *Archiv für Orientforschung* 32, 165–66

Dreyer, Günter. 1991. 'Zur rekonstruktion der Oberbauten der Königsgräber der 1. Dynastie in Abydos', *MDAIK* 47 (Festschrift Kaiser), 93–104

Dreyer, Günter. 1998. 'Der erste König der 3. Dynastie', in *Stationen: Beiträge zur Kulturgeschichte Ägyptens Rainer Stadelman gewidmet*, H. Guksch and D. Polz (eds) (Mainz: Philipp von Zabern)

Drioton, Étienne. 1939. *Les Sphinx et les Pyramides de Giza* (Cairo: L'Imprimerie de l'Institut Français d'Archéologie Orientale au Caire)

Drioton, Etienne. 1954. 'Une liste de rois de la IVe dynastie dans l'Ouâdi Hammâmât', *Bulletin de la Société Française d'Égyptologie* 16, 3–11

Dunham, D., and W. K. Simpson. 1974. *The Mastaba of Mersyankh III*. Giza Mastabas 1 (Boston: Museum of Fine Arts)

Edel, E. 1953. 'Inschriften des Alten Reichs: IV. Die Grabinschrift der Königin Hcj-mrr-nbtj', *Mitteilungen des Instituts für Orientforschung* 1, 333–36

Edel, Elmer. 1954. 'Inschriften des Alten Reichs: V. Zur Frage der Eigentümerin des Galarzagrabes', *Mitteilungen des Instituts für Orientforschung* 2, 183–87

Edel, Elmer. 1955–64. *Altägyptische Grammatik*, 2 vols Analecta Orientalia 34, 29 (Rome: Pontificium Biblicum)

Edel, Elmer. 1956. 'Beiträge zum ägyptischen Lexicon III', *ZÄS* 81, 68–73

Edgar, John, and Morton Edgar. 1910. *The Great Pyramid Passages and Chambers* (Glasgow: Bone & Hulley)

Edwards, I. E. S. 1985. *The Pyramids of Egypt* (Harmondsworth: Penguin); rev. eds 1993; 2001

El-Naggar, Salah. 2001. 'Le port funéraire de Khéops', in *Comment Construisaient les Égyptiens* (Dijon: Dossiers d'archéologie 265), 122–31

Emery, Walter. 1958. *Excavations at Saqqara 1937–1938, Hor-Aha* (Cairo: Government Press)

Engelbach, Reginald. 1923. *The Problem of the Obelisks, from a Study of the Unfinished Obelisk at Aswan* (London: T. Fisher Unwin)

Fakhry, Ahmed. 1961. *The Pyramids* (Chicago: University of Chicago Press)

Fischer, H. G. 1996. Egyptian Studies III. *Varia Nova* (The Metropolitan Museum of Art, New York), 238–39, fig. 1

Fodor, A. 1970. 'The Origins of the Arabic Legends of the Pyramids', *Acta Orientalia Academiae Scientiarum Hungaricae*, XXIII:3, 335–63

Forbes, George. 1916. *David Gill, Man and Astronomer; Memories of Sir David Gill, K.C.B., H.M. Astronomer (1879–1907) at the Cape of Good Hope*, (London: John Murray)

Frajzyngier, Zygmunt, and Erin Shay (eds). 2012. *The Afroasiatic Languages* (Cambridge and New York: Cambridge University Press)

Friedmann, Florence Dunn. 2008. 'The Menkaure Dyad(s)', in Stephen E. Thompson and Peter Der Manuelian (eds), *Egypt and Beyond. Essays Presented to Leonard H. Lesko*, (Providence, RI: Department of Egyptology and Ancient Western Asian Studies, Brown University), 109–44

Gardiner, Alan H. 1916. 'Some Personifications, II', *Proceedings of the Society of Biblical Archaeology, 46th Session*, 38, 83–94

Gardiner, Alan H. 1925. 'The Secret Chambers of the Sanctuary of Thoth', *JEA* 11, 2–5

Gardiner, Alan H. 1969. *Egyptian Grammar* (3rd ed.) (London: Oxford University Press)

Garstang, J. 1903. *Mahâsna and Bêt Khâllaf*, Egyptian Research Account 1901 (London: Bernard Quaritch)

Gauthier, Henri. 1925. 'Le roi Zadfré, successeur immediate de Khoufou-Khéops', *ASAE* 25, 178–80

Goedicke, Hans. 1971. *Re-used Blocks from the Pyramid of Amenemhet I at Lisht* (New York: The Metropolitan Museum of Art Egyptian Expedition, no. 20)

Goyon, Georges. 1967. 'La chaussée monumentale et le temple de la vallée de la pyramide de Khéops', *BIFAO* 67, 46–69

Greaves, J. 1646. *Pyramidographia, or a description of the pyramids in Ægypt* (London)

Grinsell, Leslie. 1947. *Egyptian Pyramids* (Gloucester: John Bellows)

Gundacker, Roman. 2009. 'Die Inschrift an der Nordseite der Mykerinospyramide', *Sokar* 19, 22–29

Haarmann, Ulrich. 1978. 'Die Sphinx: Synkretistische Volksreligiosität im spätmittelalterlichen islamischen Ägypten', *Saeculum* 29, 367–84

Haarmann, Ulrich. 1980. 'Regional Sentiment in Medieval Islamic Egypt', *Bulletin of the School of Oriental and African Studies*, 43, 55–66.

Hassan, Selim. 1932. *Excavations at Gîza I. 1929–1930* (Oxford: Oxford University Press)

Hassan, Selim. 1936. *Excavations at Gîza II. 1930–1931* (Cairo: Government Press, Bulaq)

Hassan, Selim. 1941. *Excavations at Gîza III. 1931–1932* (Cairo: Government Press, Bulaq)

Hassan, Selim. 1943. *Excavations at Giza, IV. 1932–1933* (Cairo: Government Press, Bulaq)

Hassan, Selim. 1944. *Excavations at Giza Vol. V. 1933–1934* (Cairo: Government Press)

Hassan, Selim. 1946. *Excavations at Gîza VI. 1934–1935. Part 1: The Solar-boats of Khafra, their Origin and Development, together with the Mythology of the Universe which they are supposed to traverse* (Cairo: Government Press)

Hassan, Selim. 1949. *The Sphinx. Its History in the Light of Recent Excavations* (Cairo: Government Press)

Hassan, Selim 1950. *Excavations at Gîza VI. 1934–1935. Part III: The Mastabas of the Sixth Season and their Description* (Cairo: Government Press)

Hassan, Selim. 1953a. *Excavations at Gîza VII. 1935–1936. The Mastabas of the Seventh Season and their Description* (Cairo: Government Press, 1953)

Hassan, Selim. 1953b. *Excavations at Gîza VIII. 1936–1937. The Great Sphinx and its Secrets. Historical Studies in the Light of Recent Excavations* (Cairo: Government Press)

Hassan, Selim. 1960a. *Excavations at Giza. IX. The Mastabas of the Eighth Season and Their Description* (Cairo: Government Press)

Hassan, Selim. 1960b, *Excavations at Gîza X. 1938–39. The Great Pyramid of Khufu and its Mortuary Chapel* (Cairo: General Organisation for Government Printing Offices)

Hawass, Zahi. 1987. 'The Funerary Establishment of Khufu, Khafra and Menkaura during the Old Kingdom', Ph.D. diss., University of Pennsylvania (Ann Arbor, MI: UMI)

Hawass, Zahi. 1995a. 'A Group of Unique Statues Discovered at Giza II. An Unfinished Reserve Head and a Statuette of an Overseer', in Rainer Stadelmann and Hourig Sourouzian (eds), *Kunst des Alten Reiches: Symposium im Deutschen Archäologischen Institut Kairo am 29. und 30. Oktober 1991.* Sonderschrift des Deutschen Archäologischen Instituts Abteilung Kairo 28. (Mainz am Rhein: Philipp von Zabern), 97–101

Hawass, Zahi. 1995b. 'Programs of the Royal Funerary Complexes of the Fourth Dynasty', in David O'Connor and David P. Silverman (eds) *Ancient Egyptian Kingship*, (Leiden, New York, Köln: E. J. Brill), 221–62

Hawass, Zahi. 1996a. 'The Discovery of the Satellite Pyramid of Khufu (GI-d)', in Peter Der Manuelian (ed.), *Studies in Honor of William Kelly Simpson. Vol. 1*, (Boston: Museum of Fine Arts), 379–98

Hawass, Zahi. 1996b. 'The Workmen's Community at Giza', in Manfred Bietak (ed.), *Haus und Palast im alten Ägypten, International Symposium 8–11 April 1992, Kairo* (Vienna: Denkschriften der Gesamtakademie 14), 53–67

Hawass, Zahi. 1997a. 'The Discovery of the Harbors of Khufu and Khafre at Giza', in Catherine Berger and Bernard Mathieu (eds), *Études sur l'Ancien Empire et la nécropole de Saqqâra, dédiées à Jean-Philippe Lauer*, Orientalia Monspeliensia IX (Montpellier: Université Paul Valéry), 245–56

Hawass, Zahi. 1997b. 'The Discovery of the Pyramidion of the Satellite Pyramid of Khufu (GI-d), with an Appendix by Joseph Dorner', in *Iubilate Conlegae: Studies in Memory of Abdel Aziz Sadek. Part 1*, Charles C. Van Siclen III (ed.). Varia Aegyptiaca 10 (San Antonio: Van Siclen Books), 105–24

Hawass, Zahi. 1997c. 'The Discovery of a Pair-Statue near the Pyramid of Menkaure at Giza', *MDAIK* 53, 289–93

Hawass, Zahi. 1998. 'A Group of Unique Statues Discovered at Giza III. The Statues of Inty-sdw from Tomb GSE 1915', in Nicolas Grimal (ed.) *Les Critères de datation stylistiques à l'ancien empire.* (Cairo: IFAO), 17–208

Hawass, Zahi. 1999a. 'A Group of Unique Statues Found at Giza IV: The Tomb of the Overseer of the Craftsmen and his Wife', in Christiane Ziegler and Nadine Palayret (eds), *L'art de l'ancien Empire égyptien. Actes du colloque organisé au musée du Louvre par le Service culturel les 3 et 4 avril 1998* (Paris: Editions de la Documentation française), 79–98

Hawass, Zahi. 1999b. 'Four statues of the artisan Inti-shedu', in Dorothea Arnold et al., *Egyptian Art in the Age of the Pyramids* (New York: Metropolitan Museum of Art), 300-03

Hawass, Zahi. 2004. 'The Tombs of the Pyramid Builders – The Tomb of the Artisan Petety and his Curse', in Gary N. Knoppers and A. Hirsch (eds), *Egypt, Israel, and the Ancient Mediterranean World. Studies in Honor of Donald B. Redford, Probleme der Ägyptologie 20* (Leiden: Brill), 21–39

Hawass, Zahi. 2005. 'Khufu's National Project: the Great Pyramid of Giza in year 2528 BC', in Peter Jánosi (ed.), *Structure and Significance: Thoughts on Ancient Egypt Architecture* (Vienna: Verlag der Osterreichischen Akademie der Wissenschaften)

Hawass, Zahi. 2006a. 'Unique Statues from Giza V: The Exceptional Statue of the Priest Kai and his Family', in Khaled Daoud, Shafia Bedier and Sawsan Abd El-Fatah (eds), *Studies in Honor of Ali Radwan*, Supplément aux Annales du Service des Antiquités de l'Égypte 34, 25–37

Hawass, Zahi. 2006b. 'Unique Statues Found at Giza VIII: The Tomb and the Statue of Wenen-em-niut' in Zahi Hawass and K. Daoud (eds), *Studies in Honor of Ali Hassan*, Annales du Service des Antiquités de l'Égypte 80, 229–55

Hawass, Zahi. 2006c. 'The excavation at Kafr el-Gebel season 1987–88', in Khaled Daoud and Sawsan Abd el-Fatah (eds), *The World of Ancient Egypt. Essays in Honor of Ahmed Abd el-Qader El-Sawi.* Supplément aux Annales du Services des Anitquités de l'Égypte, Cahier 35, 121–45

Hawass, Zahi. 2006d. *Mountains of the Pharaohs: The Untold Story of the Pyramid Builders* (Cairo: American University in Cairo Press)

Hawass, Zahi. 2007. 'The Discovery of the Osiris Shaft at Giza', in Zahi A. Hawass and Janet Richards (eds), *The Archaeology and Art of Ancient Egypt. Essays in Honor of David B. O'Connor*, Volume I. Annales du Service des Antiquités de l'Égypte, Cahier no. 36 (Cairo: Supreme Council of Antiquities), 379–98

Hawass, Zahi. 2012. *Newly Discovered Statues from Giza 1990–2009* (Cairo: Ministry of State for Antiquities)

Hawass, Zahi. 2015. *Magic of the Pyramids: My Adventures in Archaeology* (Milan: Harmakis Edizione)

Hawass, Zahi, and Mark Lehner. 1994. 'The Passage under the Sphinx', in Catherine Berger, Gisèle Clerc and Nicolas Grimal (eds), *Hommages à Jean Leclant*, Bibliothèque d'Étude 106/1 (Cairo: IFAO), 201–16

Hawass, Zahi, and Ashraf Senussi. 2008. *Old Kingdom Pottery from Giza* (Cairo: Supreme Council of Antiquities)

Hawass, Z., S. Whitehead, T. C. Ng, and R. Richardson. 2011. 'First report: Video survey of the southern shaft of the Queen's Chamber in the Great Pyramid', *ASAE* 84, 202–17

Helck, Wolfgang. 1957. 'Bemerkungen zu den Pyramidenstädten im Alten Reich', *MDAIK* 15, 91–111

Herodotus. 1972. *The Histories*, trans. Aubrey de Sélincourt, revised edition with new introduction and notes by A. R. Burn (London: Penguin Books)

Hölscher, Uvo. 1912. *Das Grabdenkmal des Königs Chephren.* Veröffentlichungen der Ernst von Sieglin Expedition in Ägypten, 1 (Leipzig: J.C. Hinrichs,)

Hölscher, Uvo, and G. Steindorff. 1909. 'Die Ausgrabung des Totentempels der Chephren Pyramide durch die Sieglin Expedition 1909', *ZÄS* 46, 1–13

Hornung, Erik. 1984. *Ägyptische Unterweltsbücher* (Zurich: Artemis)

Hussein, F. H., J. Shabaan, Z. Hawass and A. Jarry el-Din. 2003. 'Anthropological differences between workers and high officials from the Old Kingdom at Giza', in Zahi Hawass and Lyla Pinch Brock (eds), *Egyptology at the Dawn of the Twenty-First Century, Proceedings of the Eighth International Congress of Egyptologists II, Cairo, 2000* (Cairo: American University in Cairo Press), 324–31

Isler, Martin. 2001. *Sticks, Stones, and Shadows. Building the Egyptian Pyramid* (Norman: University of Oklahoma Press)

Jánosi, Peter. 1992a. 'Das Pyramidion der Pyramide G III-a. Bermurkungen zu den Pyramidenspitzen des Alten Reiches', in Ulrich Luft (ed.), *Intellectual Heritage of Egypt. Studies presented to László Kákosy by friends and colleagues on the occasion of his 60th birthday.* Studia Aegyptiaca XIV (Budapest: Universite Eotvos Lorand), 301–08

Jánosi, Peter. 1992b. 'The Queens of the Old Kingdom and their Tombs', *Bulletin of the Australian Centre for Egyptology* 3, 51–57

Jánosi, Peter. 1994. 'Die Entwicklung und Deutung des Totenopferraumes in den Pyramidentempeln des Alten Reiches', in Rolf Gundlach and Matthias Rochholz (eds), *Ägyptische Tempel – Struktur, Funktion und Programm (Aketn der Ägyptologischen Tempeltagungen in Gosen 1990 und in Mainz 1992)* (Hildesheim: Gerstenberg Verlag)

Jánosi, Peter. 1996. *Die Pyramidenanlagen der Königinnen. Untersuchungen zu einem Grabtyp des Alten und Mittleren Reiches.* Untersuchungen der Zweigstelle Kairo des Österreichischen Archäologischen Instituts, 13 (Vienna: Verlag der Österreichischen Akademie der Wissenschaften)

Jánosi, Peter. 1997. 'Gab es Kronprinzen in der 4. Dynastie?' *Göttinger Miszellen* 158, 15–32

Jánosi, Peter. 2005. *Giza in der 4. Dynastie* (Vienna: Österreichischen Akademie der Wissenschaften)

Jánosi, Peter. 2006. 'Old Kingdom tombs and dating – problems and priorities. The Cemetery en Échelon at Giza', in Miroslav Bárta (ed.), *The Old Kingdom Art and Archaeology: Proceedings of the Conference Prague, May 31–June 4, 2004* (Prague: Czech Institute of Egyptology), 175–85

Jánosi, Peter. 2016. 'What did the court in the Pyramid Temple of Khafre look like?', in I. Hein, N. Billings and E. Meyer-Dietrich (eds), *The Pyramids, Between Life and Death. Proceedings of the Workshop Held at Uppsala University, Uppsala, May 31st–June 1st, 2012* (Uppsala: Uppsala University)

Jeffreys, David, and Ana Tavares. 1994. 'The Historic Landscape of Early Dynastic Memphis', *MDAIK* 50, 143–73

Jenkins, Nancy. 1980. *The Boat Beneath the Pyramid* (New York: Holt, Rinehart and Winston; London: Thames & Hudson)

Johnson, S. 1990. *The Cobra Goddess of Ancient Egypt: Predynastic, Early Dynastic and Old Kingdom Periods* (London: Kegan Paul)

Jones, Dilwyn. 2000. *An Index of Ancient Egyptian Titles, Epithets and Phrases of the Old Kingdom*, Vol. 1. *BAR International Series*, vol. 866. (Oxford: Archaeopress)

Josephus. 1960. *Complete Works*, trans. William Whiston (Grand Rapids: Kregel Publications)

Junker, Hermann. 1934. *Gîza II. Die Mastabas der beginnenden V. Dynastie auf dem Westfriedhof* (Vienna and Leipzig: Hölder-Pichler-Tempsky)

Junker, Hermann. 1938. *Gîza III. Die Mastabas der vorgeschrittenen V. Dynastie auf dem Westfriedhof* (Vienna and Leipzig: Hölder-Pichler-Tempsky)

Junker, Hermann. 1951. *Gîza X, Der Friedhof südlich der Cheopspyramide*, Österreichische Akademie der Wissenschaften (Vienna: Rudolf M. Rohrer)

Kaiser, Werner. 1969. 'Zu den königlichen Talbezirken der 1. und 2. Dynastie in Abydos und zur Baugeschichte des Djoser-Grabdenkmals', *MDAIK* 25, 1–22

Kamal, Ahmed Bey. 1908. 'Notes prises aux cours des Inspection, I', *ASAE* 9, 85–86

Kamal, Ahmed Bey. 1910. '*Rapport sur les fouilles du comte de Galarza*', *ASAE* 10, 116–21

Kanawati, Naguib, and A. McFarlane. 2001. *Tombs at Giza*. Vols 1 and 2 (Warminster: Aris and Philips)

Kawae, Y., Y. Yoshimuro, I. Kanaya and F. Chiba. 2014. '3D Reconstruction and Its Interpretation of the "Cave" of the Great Pyramid: An Inductive Approach', *The Sixth Old Kingdom Art and Archaeology Conference, July 2nd – 6th, 2014*, Warsaw, Poland. Abstract of papers: http://egiptologia.orient.uw.edu.pl/wp-content/uploads/sites/45/2014/12/OKAA-Abstrakty-web.pdf – accessed 16 June 2017

Kemp, B. J. 1983. 'Old Kingdom, Middle Kingdom and Second Intermediate Period, c. 2686–1552 BC', in B. G. Trigger, B.J. Kemp, D. O'Connor, and A. B. Lloyd (eds), *Ancient Egypt: A Social History* (Cambridge: Cambridge University Press), 71–182

Kemp, B. J. 1989. *Ancient Egypt: Anatomy of a Civilization* (London: Routledge; 2nd ed. 2005)

Kerisel, Jean. 1993. 'Pyramide de Khéops: Dernières recherches', *RdE* 44, 33–54

Khaled, Mohamed Ismail. 2008. The Old Kingdom Royal Funerary Domains (PhD thesis, Charles University, Prague)

Klemm, R., and D. Klemm. 1981. *Die Steine der Pharaonen* (Munich: Staatliche Sammlung Aegyptischer Kunst)

Kloth, Nicole. 2002. *Die (auto-) biographischen Inschriften des ägyptischen Alten Reiches: Untersuchungen zu Phraseologie und Entwicklung.* Studien zur altägyptischen Kultur Beihefte 8 (Hamburg: Helmut Buske)

Kromer, Karl. 1978. *Siedlungsfunde aus dem frühen Alten Reich in Giseh: Österreichische Ausgrabungen 1971–1975* (Vienna: Österreichischen Akademie der Wissenschaften)

Kromer, Karl. 1991. *Nezlet Batran. Eine Mastaba aus dem Alten Reich bei Giseh (Ägypten). Österreichische Ausgrabungen 1981–1983* (Vienna: Österreichischen Akademie der Wissenschaften)

Kröpelin, S. D., et al. 2008. 'Climate-Driven Ecosystem Succession in the Sahara: The Past 6000 Years', *Science* 320, 765–68

Kuhlmann, K.-P. 2005. 'Der Wasserberf des Djedefre (Chufu 0/1). Ein Lagerplatz mit Expedition sinschriften der 4. Dynastie im Raum der Oase Dachla', *MDAIK* 61, 243–89

Kuper, R., and F. Förster. 2003. 'Khufu's "mefat" expeditions into the Libyan Desert', *Egyptian Archaeology* 23, 25–28.

Kuper, R., and S. Kröpelin. 2006. 'Climate-Controlled Holocene Occupation in the Sahara: Motor of Africa's Evolution', *Science* 313, 803–07

Kurokochi, Hiromasa, and Sakuji Yoshimura. 2015. 'Report of the Activity in 2015, Project of the Solar Boat', *Journal of Egyptian Studies*, 22, 5–14 (Japanese with summary in English)

Lacovara, Peter, and Mark Lehner. 1985. 'An enigmatic object explained', *JEA* 71, 169–74

Lacovara, Peter, and C. N. Reeves. 1987. 'The Colossal Statue of Mycerinus Reconsidered', *RdE* 38, 111–15

Laorty-Hadji, R. P. 1856. *L'Égypte* (Paris: Bolle Lasalle)

Lauer, Jean-Philippe. 1971. 'Raison premiere et utilisation pratique de la "grande galerie" dans la pyramide de Kheops', in *Aufsätze Zum 70. Geburtstag von Herbert Ricke*, 133–43. Beiträge zur ägyptischen Bauforschung und Altertumskunde, 12 (Wiesbaden: Franz Steiner Verlag)

Lehner, Mark. 1983. 'Some Observations on the Layout of the Khufu and Khafre Pyramids' *JARCE* 20, 7–25

Lehner, Mark. 1985. *The Pyramid Tomb of Hetep-Heres and the Satellite Pyramid of Khufu*, Deutsches Archäologisches Institut Abteilung Kairo 19 (Mainz: Phillip von Zabern)

Lehner, Mark. 1992. 'Reconstructing the Sphinx', *Cambridge Archaeological Journal* 2, 3–26

Lehner, Mark. 1998. 'Niches, Slots, Grooves and Stains: Internal Frameworks in the Khufu Pyramid?', in Heike Guksch and Daniel Polz (eds), *Stationen: Beiträge zur Kulturgeschichte Ägyptens: Rainer Stadelmann Gewidmet,* (Mainz: Philipp von Zabern), 101–13

Lehner, Mark. 2002. 'The Fabric of a Pyramid: Ground Truth', *Aeragram* 5 (2), 4–5

Lehner, Mark. 2009. 'Valley Complex for a Queen Who Would Be King', *Aeragram* 10.2, 7–9

Lehner, Mark. 2011. 'KKT+E: The Buried Basin and the Town Beyond', *Aeragram* 12.1, 10–13

Lehner, Mark. 2012. 'Conundrums and Surprises: The Silo Building Complex', *Aeragram* 13.2, 6–9

Lehner, Mark. 2014. 'On the Waterfront: Canals and Harbors in the Time of Giza Pyramid-Building' *Aeragram* 15, 14–23

Lehner, Mark. 2015a. 'The monument and the formerly so-called valley temple of Khentkawes I: Four Observations', in F. Coppens, J. Janák, and H. Vymazalova (eds), *Royal vs. divine authority, 7. Symposium on Egyptian Royal Ideology.* Königtum, Staat und Gesellschaft früher Hochkulturen 4.4 (Wiesbaden: Harrassowitz), , 215–74

Lehner, Mark. 2015b. 'Shareholders: The Menkaure Valley Temple occupation in context', in P. Der Manuelian and T. Schneider (eds), *Towards a New History for the Egyptian Old Kingdom: Perspectives on the Pyramid Age*, Harvard Egyptological Studies 1 (Leiden and Boston: Brill), , 227–314

Lehner, Mark. 2015c. 'Labor and the Pyramids', in Piotr Stenkeller and Michael Hudson (eds), *Labor in the Ancient World*, The International Scholars Conference on Ancient Near Eastern Economics, vol. 5 (Dresden: Islet)

Lehner, Mark. 2016. 'The name and nature of the Heit el-Ghurab Old Kingdom site: Worker's town, pyramid town, and the port hypothesis', in Irmgard Hein, Nills Billing and Erika Meyer-Dietrich (eds), *The Pyramids: Between Life and*

Death. Proceedings of the Workshop held at Uppsala University, Uppsala, May 31st to June 1st, 2012 (Uppsala: Uppsala Universitet), 99–160

Lehner, Mark. Forthcoming. 'Lake Khufu: On the Waterfront at Giza', Profane Landscapes, Sacred Places, conference held at Charles University, June 26–27, 2014

Lehner, Mark, and David Goodman. 1986. 'Unraveling the Mystery of Pyramid Construction', *P.O.B. – Point of Beginning* 11.4, 12–19

Lehner, Mark, and Wilma Wetterstrom. 2007. *Giza Report: The Giza Plateau Mapping Project* (Boston, MA: Ancient Egypt Research Associates)

Lehner, Mark, and Wilma Wetterstrom. 2014. 'Construction Hub to Cult Center: Re-purposing, Old Kingdom Style', *Aeragram* 15, 2–5

Le Maserier, Abbé. 1735. *Description de l'Égypte composée sur les Memoires de M. de Maillet* (Paris)

Lepsius, C. R. 1849–59. *Denkmäler aus Ägypten und Äthiopien* (Berlin; Nicolai)

Lepsius, Richard. 1852. *Discoveries in Egypt, Ethiopia, and the Peninsula of Sinai*, edited, with notes, by Kenneth R. H. Mackenzie (London: Richard Bentley)

Lepsius, Richard. 1853. *Letters from Egypt, Ethiopia, and the Peninsula of Sinai*, trans. Leonora and Joanna B. Horner (London: Henry G. Bohn)

Lesko, Barbara S. 1998. 'Queen Khamerernebty and Her Sculpture', in, L. H. Lesko (ed.), *Ancient Egyptian and Mediterranean Studies in Memory of William A. Ward* (Providence: Brown University), 149–62

Lichtheim, Miriam. 1975. *Ancient Egyptian Literature. A Book of Readings. Volume I: The Old and Middle Kingdoms* (Berkeley: University of California Press)

Lucas, Alfred. 1962. *Ancient Egyptian Materials and Industries* (London: Edward Arnold, 4th ed.)

McNeill, William H. 1995. *Keeping Together in Time: Dance and Drill in Human History* (Cambridge, MA: Harvard University Press)

Malek, Jaromir. 2003. 'The Old Kingdom (*c.* 2686–2160 BC)' in Ian Shaw (ed.), *The Oxford History of Ancient Egypt* (Oxford: Oxford University Press), 83–108

Manuelian, Peter Der. 2003. *Slab Stelae of the Giza Necropolis* (New Haven: Peabody Museum of Natural History of Yale University, Philadelphia: University of Pennsylvania Museum of Archaeology and Anthropology)

Manuelian, Peter Der. 2006. 'A Re-examination of Reisner's Nucleus Cemetery Concept at Giza: Preliminary Remarks on Cemetery G 2100', in M. Bárta (ed.), *The Old Kingdom Art and Archaeology: Proceedings of the Conference, Prague May 31–June 4, 2004* (Prague: Czech Institute of Archaeology, 2006), 221–30

Manuelian, Peter Der. 2009. 'On the Early History of Giza: The "Lost" Wadi Cemetery (Giza Archives Gleanings, III)', *JEA* 95, 106–40

Maragioglio, Vito, and Celeste Rinaldi. 1965. *L'Architettura delle Piramidi Menfite. IV: La Grande Piramide de Cheope.* Trans. Jennifer Anne Jellis Zanini (Rome: Centro per le Antichita e la Storia dell'Arte del Vicino Oriente) (English/Italian)

Maragioglio, Vito, and Celeste Rinaldi. 1966. *L'Architettura della piramidi menfite, V. Le piramidi di Zedefra e di Chefren* (Rapallo: Tipografia Canessa)

Maragioglio, Vito, and Celeste Rinaldi. 1967. *L'Architettura delle Piramidi Menfite, VI. La Grande Fossa di Zauiet el Aryan, la Piramide di Micerino, il Mastabat Faraun, la Tomba di Khentkhaus* (Rapallo: Officine Grafiche Canessa)

Mariette, Auguste. 1882. *Le Sérapéum de Memphis* (Paris: F. Vieweg)

Mariette, A., and M. de Rougé. 1862. 'Fouilles dirigées par M. Mariette dans la vallée du Nil pendant la champagne d'hiver de 1859–60', *Academie des Inscriptions et Belles Lettres: Comptes rendus des séances de l'année 1860*, IV, 71–72

Martin, Geoffrey T. 1991. *The Hidden Tombs of Memphis* (London: Thames & Hudson)

Martin, Geoffrey T. 1997. '"Covington's Tomb" and Related Early Monuments at Gîza', in Catherine Berger and Bernard Mathieu (eds), *Études sur l'Ancien Empire et la nécropole de Saqqâra, dédiées à Jean-Philippe Lauer*, Orientalia Monspeliensia IX (Montpellier: Université Paul Valéry)

Martiny, Alany. 1981. 'Bats Lead Researcher to Prehistoric Cave Dwelling', *Cairo Today* 2 (13), August, 15–17

Moussa, Ali Helmi, Lambert T. Dolphin and Gamal Mokhtar. 1977. *Applications of modern sensing techniques to Egyptology: a report of the 1977 field experiments by a joint team* (Menlo Park CA: SRI International, Radio Physics Laboratory), 64–67

Newberry, P. E. 1893–94. *El Bersheh* (London: Egypt Exploration Fund)

Nolan, John. 2010. 'Mud Sealings and Fourth Dynasty Administration at Giza', (PhD Dissertation: Department of Near Eastern Languages and Civilizations, University of Chicago)

Norden, Frederik. 1755. *Voyage d'Égypte et de Nubie* (Copenhagen)

Nour, M. Z., Z. Iskander, M. S. Osman and A. Y. Moustafa. 1960. *The Cheops Boats, Part I* (Cairo: Antiquities Department of Egypt)

O'Connor, David. 1995. 'Beloved of Maat, the Horizon of Re: The Royal Palace in New Kingdom Egypt', in David O'Connor and David P. Silverman (eds), *Ancient Egyptian Kingship* (Leiden: Brill), 263–300

O'Connor, David. 2009. *Abydos. Egypt's First Pharaohs and the Cult of Osiris* (London and New York: Thames & Hudson)

Omara, S. M. 1952. *The Structural Features of the Giza Pyramids Area.* Ph.D Thesis, University of Cairo

Otto, E. 1975. 'Benben', *Lexikon der Ägyptologie*, Band I (Wiesbaden: Otto Harrasiwitz), 694–95

Petrie, W. M. F. 1883. *The Pyramids and Temples of Gizeh* (London: Field and Tuer); new edition with an updated chapter by Z. Hawass, 1990 (London: Histories & Mysteries of Man)

Petrie, W. M. F. 1900. *The Royal Tombs of the First Dynasty*, I (London: Egypt Exploration Fund)

Petrie, W. M. F. 1907. *Gizeh and Rifeh* (London: School of Archaeology in Egypt and Egyptian Research Account)

Petrie, W. M. F. 1917. *Tools and Weapons* (London: British School of Archaeology in Egypt)

Petrie, W. M. F., Ernest Mackay and Gerald Wainwright. 1910. *Meydum and Memphis (III)* (London: School of Archaeology in Egypt)

Piankoff A., and N. Rambova. 1954. *The Tomb of Ramesses VI*, Bollingen Series 40:1 (New York: Pantheon)

Pliny. 1962. *Pliny: Natural History.* D. E. Eichholz trans. Volume X. Libri XXXVI–XXXVII (London: William Heinemann Ltd/Cambridge: Massachusetts, Harvard University Press)

Porter, Bertha, and Rosalind L. B. Moss. 1974. *Topographical Bibliography of Ancient Egyptian Hieroglyphic Texts, Reliefs, and Paintings 3: Memphis (Abû Rawâsh to Dahshûr)* (Oxford: The Clarendon Press, 1931). 2nd ed. *3: Memphis, Part 1 (Abû Rawâsh to Abûsîr)*, revised and augmented by Jaromir Malek (Oxford: The Clarendon Press, 1974)

Posener-Kriéger, Paule. 1976. *Les Archives du temple funéraire de Néferirkarê-Kakaï (Les papyrus d'Abousir): traduction et commentaire*, Bibliothèque de'Etude LXV/2, 2 vols (Cairo: IFAO)

Reader, Colin. 2014. 'The Sphinx: Evolution of a Concept', *Ancient Egypt* 14.6, 34–39

Reeder, Greg. 1994. 'Rite of passage: the enigmatic Tekenu', *KMT* 5, no. 3, 53–59

Reisner, George A. 1931. *Mycerinus. The Temples of the Third Pyramid at Giza* (Cambridge, MA: Harvard University Press)

Reisner, G. A. 1942. *A History of the Giza Necropolis I* (Cambridge, MA: Harvard University Press)

Reisner G. A., and W. S. Smith. 1955. *A History of the Giza Necropolis II: The Tomb of Hetep-heres the Mother of Cheops* (Cambridge, MA: Harvard University Press)

Richardson, R., et al. 2013. 'The "Djedi" robot exploration of the southern shaft of the Queen's Chamber in the Great Pyramid of Giza, Egypt', *Journal of Field Robotics* 30, 323–48

Ricke, Herbert. 1950. *Bemerkungen zur Ägyptischen Baukunst des Alten Reichs*. Vol. II. Beiträge zur ägyptischen Bauforschung und Altertumskunde, 5 (Cairo: Schweizerisches Institute für Ägyptische Bauforschung un Altertumskunde in Kairo)

Ricke, Herbert. 1970. *Der Harmachistempel des Chefrens in Giseh*. Siegfried Schott, *Ägyptische Quellen zum Plan des Sphinxtempels*. Beiträge zur ägyptischen Bauforschung und Altertumskunde, 10 (Wiesbaden: In Kommission im F. Steiner Verlag)

Rifken, Glen. 1991. 'Rebuilding the Sphinx with PCs', *New York Times*, 25 September 1991, C7

Roeder, Günther. 1941. 'Lebensgroße Tonmodelle aus einer altägyptischen Bildhauerwerkstatt', *Jahrbuch der preussischen Kunstsammlungen* 62:4, 145–70

Roeten, Leo. 2014. *The Decoration on the Cult Chapel Walls of the Old Kingdom Tombs at Giza: A New Approach to their Interaction* (Leiden: Brill)

Roeten, Leo. 2016. *Chronological Developments in the Old Kingdom Tombs in the Necropoleis of Giza, Saqqara, and Abusir. Toward an Economic Decline during the Early Dynastic Period and the Old Kingdom* (Oxford: Archaeopress Publishing Ltd)

Romer, John. 2007. *The Great Pyramid, Ancient Egypt Revisited* (Cambridge and New York: Cambridge University Press)

Rossi, Corinna. 1999. 'Note on the pyramidion found at Dahshur', *JEA* 85, 219–22

Roth, Ann Macy. 1991. *Egyptian Phyles in the Old Kingdom: The Evolution of a System of Social Organization*, Studies in Ancient Oriental Civilization 48 (Chicago: The Oriental Institute of the University of Chicago)

Roth, Ann Macy. 1994. 'The Practical Economics of Tomb-Building in the Old Kingdom: A Visit to the Necropolis in the Carrying Chair', in D. Silverman (ed.), *For His Ka: Essays Offered in memory of Klaus Baer*. SAOC 55 (Chicago: The Oriental Institute), 227–40

Rougé, E. de. 1854. 'Note sur le fouille exécutées par M. Mariette autour du grand Sphinx de Gizeh', *L'Athenaeum français* 28, 82–84

Roveri, Anna Maria Donadoni. 1969. *I Sarcofagi egizi dalle origine alla fine dell'antico regno* (Rome: Istituto di Studi del Vicino Oriente – Università)

Russmann, Edna R. 1989. *Egyptian Sculpture: Cairo and Luxor* (Austin: University of Texas Press)

Sadeek, Waafa el-. 1984. *Twenty-Sixth Dynasty Necropolis at Gizeh*. Beiträge zur Ägyptologie Band 5 (Vienna, Institute für Afrikanistik und Agyptologie der Universität Wien)

Saleh, Abdel-Aziz. 1974. 'Excavations around Mycerinus Pyramid Complex', *MDAIK* 30, 131–54

Schmitz, Bettina (ed.). 1996. *Untersuchungen zu Idu II, Giza: ein interdisziplinäres Projekt* (Hildesheim: Gerstenberg Verlag)

Schmitz, Bettina. 1976. *Untersuchungen zum Title SNJSWT 'Königssohn'* Habelts Dissertationsdrucke, Reihe Ägyptologie, vol. 2 (Bonn: Rudolf Habelt Verlage)

Schoch, R. M. 1992. 'Redating the Great Sphinx of Giza', *KMT: A Modern Journal of Ancient Egypt* 3/2, 52–59 and 66–70

Schweitzer, Ursula. 1950. 'Archäologischer Bericht aus Ägypten', *Orientalia* 19, 118

Smith, W. S. 1933. 'The Coffin of Prince Min-khaf', *JEA* 19, 150–59

Smith, William Stevenson. 1949. *A History of Egyptian Sculpture and Painting in the Old Kingdom* (Boston and London: Museum of Fine Arts and Oxford University Press, 2nd ed.)

Smith, William Stevenson. 1958. *The Art and Architecture of Ancient Egypt* (Harmondsworth: Penguin)

Smyth, Charles Piazzi. 1880. *Our Inheritance in the Great Pyramid* (London: Wm. Isbister, 4th ed.)

Spanel, Donald. 1988. *Through Ancient Eyes: Egyptian Portraiture* (Birmingham, Alabama: Birmingham Museum of Art)

Spence, Kate. 2000. 'Ancient Egyptian chronology and the astronomical orientation of pyramids', *Nature* 406, 320–24

Stadelmann, Rainer. 1981a. 'Die [khentjou-she] der Königsbezirk [she n per-âa] und die Namen der Grabanlagen der Frühzeit', *BIFAO* 81s, 153–64

Stadelmann, Rainer. 1981b. 'La ville de pyramide à l'Ancien Empire', *RdE* 33 (1981), 66–77

Stadelmann, Rainer. 1982. 'Snofru und die Pyramiden von Meidum und Daschur', *MDAIK* 36, 437–49

Stadelmann, Rainer. 1983. 'Pyramidenstadt' in W. Helck and W. Westerndorf (eds), *Lexicon der Ägyptologie* V (Wiesbaden: O. Harrassowitz), 9–14

Stadelmann, Rainer. 1985a. *Die ägyptischen Pyramiden. Vom Ziegelbau zum Weltwunder* (Mainz: Philipp von Zabern)

Stadelmann, Rainer. 1985b. 'Die Oberbauten der Königsgräber der 2. Dynastie in Sakkara', *Mélanges Gamal eddin Mokhtar*, Bibliothèque d'Étude 97/2 (Cairo: IFAO), 295–307

Stadelmann, Rainer. 1987a. 'Beiträge zur Geschichte des alten Reiches', *MDAIK* 43, 229–40

Stadelmann, Rainer. 1987b. 'Ramses II, Harmachis und Hauron', in Jürgen Osing and Günter Dreyer (eds), *Form und Mass. Beiträge zur Literatur, Sprache und Kunst des alten Ägypten; Festschrift für Gerhard Fecht* (Wiesbaden: Harrassowitz), 436–39

Stadelmann, Rainer. 1990. *Die grossen Pyramiden von Giza*, (Graz: Akademische Druck – u. Verlaganstalt)

Stadelmann, Rainer. 1991. 'Das Dreikammersystem der Königsgraber der Frühzeit und des Alten Reiches', *MDAIK* 47, 373–87

Stadelmann, Rainer. 1994. 'Die sogenannten Luftkanäle der Cheopspyramide: Modellkorridore für den Aufstieg des Königs zum Himmel; Mit einem Beitrag von Rudolf Gantenbrink', *MDAIK* 50, 285–94

Stadelmann, Rainer. 2003. 'The Great Sphinx of Giza', in Zahi Hawass and Lyla Pinch Brock (eds), *Egyptology at the Dawn of the Twenty-First Century, Proceedings of the Eighth International Congress of Egyptologists, Cairo, 2000, vol. 1, Archaeology* (Cairo and New York: The American University in Cairo Press), 464–69

Stocks, D. A. 2005. 'Auf den Spuren von Cheops' Handwerkern: Bemerkungen zu Werkzeugen und Bautechniken bei der Errichtung der Grossen Pyramide von Giza', *Sokar* 10, 4–9

Strabo. 1967. *The Geography of Strabo, vol. 8*, H. L. Jones (trans.) (London: William Heinemann Ltd)

Strudwick, N. 2005. *Texts from the Pyramid Age* (Leiden and Boston: Brill)

Tallet, Pierre. 2013. 'Les Papyrus de la Mer Rouge (Ouadi el-Jarf, Golfe de Suez), *Comptes Rendus des Séances de l'Année*, 1015–24

Tallet, Pierre. 2017. *Les Papyrus de la Mer Rouge I: 'Le Journal de Merer' (Papyrus Jarf A et B)* MIFAO 136 (Cairo: IFAO)

Tallet, Pierre, and Gregory Marouard. 2012, 'Wadi al-Jarf – An early pharaonic harbour on the Red Sea coast', *Egyptian Archaeology* 40, 40–43

Tallet, Pierre, G. Marouard and D. Laisney. 2012. 'Un port de la IVe Dynastie au Ouadi al-Jarf (mer Rouge)', *BIFAO* 112, 399–446

Tallet, Pierre, and Gregory Marouard. 2014. 'Wadi al-Jarf – The Harbor of Khufu on the Red Sea Coast, Egypt', *Near Eastern Archaeology* 77.1, 4–14

Tavares, Ana. 2008. 'Two Royal Towns: Old Digs, New Finds', *Aeragram* 9.2, 8–11

Thomas, Elizabeth. 1953. 'Air channels in the Great Pyramid', *JEA* 39, 113

Trench Jorge A., and Perla Fuscaldo. 1989. 'Observations on the Pyramidions', *Göttinger Miszellen* 113, 81–90

Valloggia, Michel. 2011. *Abou Rawash I: Le Complex funéraire royal de Rêdjedef*. Fouilles de l'IFAO 63.1 (Cairo: IFAO) 5–9

Verner, Miroslav. 2002a. 'Archaeological Remarks on the 4th and 5th Dynasty Chronology', *Archiv Orientální* 70, 363–418

Verner, Miroslav. 2002b. *Pyramid* (Cairo: American University in Cairo Press)

Vickers, R. 1981. *Application of Resistivity and Radar Techniques to Archaeological Surveys* (Menlo Park, CA: SRI International)

Vyse, Colonel Howard . 1840. *Operations Carried on at the Pyramids of Gizeh* (London: James Fraser), 3 vols

Vyse, Colonel Howard. 1842. *Appendix to Operations Carried on at the Pyramids of Giza in 1837, Vol. III* (London: John Weale)

Waseda University. 1993. *Analysis of Sample Wood and the Air Taken out of the Second Boat Pit of King Khufu* (Tokyo: Waseda University Egyptian Cultural Centre)

Wilkinson, J. G. 1878. *Manners and Customs of the Ancient Egyptians*, new edition revised by Samuel Birch (London: John Murray)

Wilkinson, Toby A. H. 1999. *Early Dynastic Egypt* (London: Routledge)

Wilson, John A. 1944. 'Funeral Services of the Egyptian Old Kingdom', *JNES* 3, 201–18

Zaccagnini, Carlo. 1993. 'Appendix I: Comments on the Parallel Wall Structures', in Gernot Wilhelm and Carlo Zaccagnini, *Tell Karrana 3, Tell Jikan, Tell Khirbet Salih*. (Mainz am Rhein: Philipp von Zabern), 29–51

Zivie-Coche, Christiane M. 1976. *Giza au deuxième millénaire*, Bibliothèque d'Étude 70 (Cairo: IFAO)

Zivie-Coche, Christiane M. 1991. *Giza au premier millenaire, autour du temple d'Isis, dame des pyramides* (Boston: Museum of Fine Arts)

Zivie-Coche, Christiane. 2004. *Sphinx: History of a Monument*, trans. David Lorton (Ithaca and London: Cornell University Press)

Sources of Illustrations

a=above, b=below, c=centre, l=left, r=right

Tom Aigner 43a; akg-images 107; Sergio Anelli/Mondadori Portfolio/akg-images 86; Bildarchiv Steffens/akg-images 312–13; Hervé Champollion/akg-images 108–9, 134; A. Dagli-Orti/De Agostini Picture Library/akg-images 135; G. Dagli-Orti/De Agostini Picture Library/akg-images 100, 129, 321b; IAM/akg-images 84; Andrea Jemolo/akg-images 113; Prisma/Album/akg-images 320; G. Sioen/De Agostini Picture Library/akg-images 138a; The Art Archive/Alamy Stock Photo 18; Damien Davies/Alamy Stock Photo 46–47; Danita Dellmont/Alamy Stock Photo 62–63; Tor Eigeland/Alamy Stock Photo 140–41; Heritage Image Partnership Ltd/Alamy Stock Photo 64, 110; Georg Ebers, *Egypt Descriptive, Historical and Picturesque*, 1878 506; *Annales du Service des Antiquités de l'Egypte*, vol. 6, 1905 49a, 50, 51, 53; Copyright Ancient Egypt Research Associates 10, 19, 38, 164b, 292, 293, 300, 361, 365, 367, 368, 369b, 371b, 372a, 374, 381b, 392, 393, 395, 397b; Archive Lacau 219br, 234, 475, 477, 479, 498; Henri Béchard 80–81; Phoebe A. Hearst Museum of Anthropology and the Regents of the University of California, Berkeley 317b; Museum of Fine Arts, Boston 28r, 57, 103, 176l, 263, 269, 280, 315, 500, 505; British Library, London 1, 24, 89b, 90, 93, 94, 96, 118, 119, 154b, 182, 267, 515r; British Museum, London 158, 219bl, 227a, 251a, 515l; Brooklyn Museum of Fine Art 504; Egypt Antiquities Service, Cairo 167a, 276a; Egyptian Museum, Cairo 40, 65, 209, 330; German Archaeological Institute, Cairo 66b, 72; Djedi Team 162b; Egypt Exploration Society, London 70, 71; Kenneth Garrett 377, 402–3; Ron Watts/Getty Images 338–39; Giza Laser Scanning Survey 340; John Greaves, *Pyramidographia*, 1646 89a; Zahi Hawass 13, 142, 161, 344, 345b, 346, 349r, 350, 363r, 489, 490, 518, 519, 520; Hermann Junker, *Giza I*, 1929 105; Yukinori Kawae 528; Athanasius Kircher, *Turris Babel*, 1679 87; Mark Lehner 2–3, 4–5, 11, 14–15, 16, 17, 21, 22–23, 26, 31, 34–35, 39, 43b, 45, 60, 61, 68, 73, 74, 75, 77, 78, 114, 115a, 137, 143a, 144, 145, 147, 149, 150, 151, 153, 154a, 155, 164a, 165, 166, 167a, 169, 171, 173, 174, 178, 179, 180, 181, 184, 185, 186, 187, 188–89, 191a, 192, 193, 194, 195a, 196, 197, 198, 199, 200, 202, 203, 205, 206, 207, 208, 213, 214–15, 217, 219a, 221, 222, 224, 225, 226, 227b, 228, 229, 230, 232, 235, 237, 238, 239, 242–43, 245, 246, 248, 249, 250, 251b, 252, 253, 257, 259, 260, 261, 262, 266, 271, 272, 273, 275, 276b, 277, 278, 279, 284–85, 286a, 287, 288, 289, 290, 291, 294, 296, 297, 298, 301, 303, 307, 309, 310, 314, 317a, 318, 319, 321a, 322, 325, 328, 333, 335, 336, 337, 341, 342, 343, 345a, 347, 351, 354–55, 357, 358, 359, 360, 362, 363l, 364, 369a, 370, 371a, 372b, 373, 375, 378, 379, 380, 381a, 382, 383, 384, 385, 387, 388, 389. 391. 397a, 399, 404, 405, 406, 407, 408, 413, 414, 416, 417, 419, 420–21, 422, 423, 425, 426, 427, 428, 431, 433, 434, 438, 441, 442, 443, 446, 447, 449, 451, 454, 455, 457, 459, 461, 462-463, 465, 467, 468–69, 471, 472, 473, 474, 480, 481, 488, 492-493, 494, 495, 496, 497, 499, 503a, 507, 511, 514, 526, 529c, 530, 531; John and Edgar Morton, *The Great Pyramid passages and chambers*, 1910 159; NASA 36; William H. Bond/National Geographic Creative 483; Kenneth Garrett/National Geographic Creative 348, 349l; Claude E. Petrone/National Geographic Creative 170; New York Public Library 91, 111a, 324, 326, 327; David O'Connor 67; W. M. F. Petrie, *Gizeh and Rifeh*, 1907 48, 49b, 523, 524, 525; W. M. F. Petrie, *Illahun, Kahun and Gurob*, 1889–90 33; W. M. F. Petrie, *The Pyramids and Temples of Gizeh*, 1883 101, 429; Princeton University Art Museum 503b; Rutherford Picture Library 52a; Museum of Fine Arts, Boston/Scala 28l, 29a, 30, 177, 255, 274, 282, 283, 332; ScanPyramids Mission 527, 529a, 529b; Charles Piazzi Smyth, *Our Inheritance in the Great Pyramid*, 1877 25; Pierre Tallet 29b; Sandro Vaninni 162a.

Acknowledgments

The late William Kelly Simpson, Mark's advisor at Yale University, first suggested in 1985 that he take on this book with Colin Ridler and Thames & Hudson. We thank Colin for his dedication and persistence, for over 30 years, to see it to completion. We cannot thank enough Sarah Vernon-Hunt, also of Thames & Hudson. Sarah worked tirelessly for decades on the various drafts of the often inchoate text. We thank Julene Knox for considerable text editing, Sally Nicholls for illustration editing on behalf of Thames & Hudson, Rowena Alsey for designing the book and Celia Falconer for its production.

Thanks also to Ali Witsell, Elise MacArthur and Wilma Wetterstrom, for their proof reading, research, edits and illustrations on behalf of AERA, and to GIS directors Camilla Mazzucato and Rebekah Miracle for maps and illustrations gleaned from AERA's GIS. We thank Mohsen Kamel as AERA Egypt's Executive Director. For their direction of AERA's field research, we thank Mohsen Kamel and Ana Tavares, and Richard Redding, Mary Anne Murray, John Nolan and Claire Malleson for guiding AERA's research agenda and material culture analysis. Too numerous to mention are AERA team members and field school students and teachers from the Ministry of Antiquities who generated new information on Giza and the Pyramids. Special thanks to David Goodman for establishing AERA's basic survey control, Glen Dash for carrying on Giza Plateau Mapping Project aims and activities, Thomas Aigner for basic understanding of Giza geology, Freya Sadarangani and Daniel Jones for excellence in excavation and recording, and Yukinori Kawae for his laser scanning. We learned much from Michael Jones' monitoring and survey of the AMBRIC wastewater project in the late 1980s.

We thank the Egyptian Ministry of Antiquities, and the many colleagues in Ministry headquarters and at the Giza Inspectorate for generous help and collaboration over many years, in particular former Directors of Giza, Mansour Boraik and the late Kamal Waheed. We thank the American Research Center in Egypt for years of support for AERA-directed field schools and conservation projects at Giza.

David Koch and Ann Lurie provided sustained, major support that made possible AERA's growth and accomplishments and Mark's work on this book over the years. For major support of AERA, we thank Charles Simonyi, Peter Norton, Ted Waitt, Marjorie Fisher and anonymous donors. AERA Board members James Allen, Glen Dash, Ed Fries, Janice Jerde, Lou Hughes, Piers Litherland, Bruce Ludwig, Ann Lurie, Richard Redding, Matthew McCauley, and the late John Jerde and George Link have made all of AERA's work possible. We owe special thanks to Douglas C. Rawles and Reed Smith LLP for legal counsel, to Matthew McCauley, for founding AERA, and to Bruce Ludwig for kick-starting AERA's independent operation.

We would also like to thank the many people who have assisted Zahi on excavations at Giza, first the Egyptian archaeologists Mahmoud Afifi, Mansour Boraik, Alaa Sahat, Mamdouh Taha, Tarek Elawady, Adel Okasha, Shaban Abdel Gawad and Essam Sehab, and secondly also those who created artwork: Noha Abdel Hafiz, Amany Abdel Hamied and Nagwa Hussien.

The directors of Egypt's antiquities have also greatly supported us at Giza and receive our sincere gratitude: Drs Ahmed Kadry, Ali Radwan and Gamal Mokhtar, and we would like to express thanks also to Dr Mahmoud Mabrouk for his important work on the Sphinx restoration, and Drs Mohamed Ismael, Mohamed Megahed and Nashwa Gabr for their valued assistance to us.

Finally we thank all the Reises (overseers) and the workmen, without whom it would not have been possible for us to have made the discoveries at Giza that we've described in this book.

Index